PHILOSOPHY
OF ART AND AESTHETICS

PHILOSOPHY
OF ART
AND AESTHETICS

From Plato to Wittgenstein

FRANK A. TILLMAN

Vassar College

STEVEN M. CAHN

New York University

HARPER & ROW, PUBLISHERS
New York, Evanston, and London

CONTENTS

PREFACE

This book brings together in a single volume historically important theories of art and recent and contemporary discussions of aesthetic problems. It is designed to serve both as a text for courses in aesthetics or philosophy of art and as an introduction to these subjects for all who are interested in the arts.

The meanings of the two terms "art" and "aesthetics" must be clarified in order to understand what has been included in this volume. The senses of both terms are extremely varied, and the meanings we commonly associate with them have active histories.

The term "art" possesses a special sort of ambiguity. Not only is it used to denote both a skill (a special bit of know-how) and the product of some skill, but it is also used in both a broad and a narrow sense. In its broad sense "art" refers to any human skill, be it writing a poem, making a pair of shoes, or predicting an eclipse. In its narrow sense "art" designates a

special class of skills or products now known as the "fine arts": the arts of painting, music, dance, sculpture, literature, and architecture.

Art in this narrow sense was unknown in Plato's day. He employed the term "technè" (usually translated as "art") to mean any special craft or skill. Although Plato developed distinctions that would eventually aid the gradual emancipation of the fine arts from other disciplines, even as late as the seventeenth century science and art were not clearly distinguished. Optics and poetry, astronomy and painting were all classed together.

The study of art was finally separated from science in the eighteenth century. Alexander Baumgarten (1714–1762) introduced the term "aesthetics" (from the Greek word αἴσθησις, meaning "perception") to designate a new science of perception that would study the vivid images of the imagination. He held that our response to art is unique and not precisely intellectual, that the beauty and perfection that we find in works of art do not consist of concepts but of sense impressions. Thus dignity was given to what had been denigrated as inferior, and a separate place was made for aesthetics among the other disciplines: physics, epistemology, and ethics.

The meaning of the term "aesthetics" was soon changed from its etymological sense to fit the special interests of philosophers and critics of the arts. Baumgarten himself restricted its meaning to the science of the beautiful. Other philosophers followed a similar course. Although Kant in his *Critique of Pure Reason* used the term "aesthetics" to refer to the *a priori* elements in any sensory experience, in his *Critique of Judgment* he developed a theory of aesthetic judgment whose object was the beautiful. Kant held that we experience beauty insofar as the object of beauty, whether a flower or a painting, enables us to disengage ourselves from the practical and mundane needs of life.

The separation of aesthetics from other disciplines was one step toward the isolation of art from life which gradually occurred during the nineteenth century. Schopenhauer, for example, treated the arts as vehicles by means of which one could escape the cycle of human experience that alternates eternally between the pain of privation and the boredom of satiation; by becoming absorbed with masterpieces of the arts, especially music, the human will might be temporally stilled.

Studies in aesthetics during the late nineteenth and early twentieth centuries were either continuations of the theme of art in isolation or reactions against that theme and some of its social consequences, for example, the enjoyment of art by the idle few and the development of museum art. Clive Bell's notion of significant form and the emphasis by others on puristic criticism were all continuations of the theme of a disengaged art. The literary philosophy of Leo Tolstoy and the democratic aesthetic of John Dewey were each in its own way a reaction against the desocialization of art. Tolstoy believed that the artist could produce a literature that would deeply influence and change his society instead of

merely appealing to a few esthetes and bewildering the masses. Dewey based his philosophy of art on the thesis that the aesthetic response permeates all of experience and is not restricted to a few moments at a concert or in a gallery.

Finally, in the light of developments in analytic philosophy certain contemporary aestheticians have identified aesthetics with the philosophy of criticism. Aesthetics so conceived studies (1) the meaning of words used in describing works of art, words such as "unity," "style," "intention," "representation," and "aesthetic object"; (2) the categories of interpretative criticism such as the meaning, truth, and significance of works of art; (3) the reasons offered and the types of argument employed in making value judgments about works of art.

In the light of this miniscule history of terms, it is apparent that a short answer to the question "What is the subject matter of aesthetics?" must beg questions requiring detailed discussion. Thus, unless a book of readings is designed to support a particular theory of aesthetics, it must display points of such wide interest and diversity that it serves to re-create the incessant dialectic in aesthetics. That has been our aim in this book.

The book has been divided into four parts:

Part I Ancient and Medieval Reflections on Art (from Plato to St. Augustine)

Part II The Modern Tradition (from Hume through Kant, Hegel, Schopenhauer, and Nietzsche to Croce and Dewey)

Part III Recent Reflections on Art (including selections from such diverse figures as Freud, Langer, and Sartre)

Part IV Contemporary Aesthetic Analysis (covering the wide range of problems in the philosophy of criticism)

The presentation of papers on contemporary aesthetics and the philosophy of criticism will exhibit the on-going interest of contemporary philosophers in aesthetic questions. The inclusion of traditional contributions may prevent those who do not remember the past from repeating mistakes that have been identified long ago or from confusing what is merely current with what is new.

FRANK A. TILLMAN
STEVEN M. CAHN

ACKNOWLEDGMENTS

Merry Ann Jancovic deserves our special thanks for her valuable assistance in compiling the bibliography and her help in preparing the manuscript for publication. We also wish to thank Philip Finkelpearl, Linda Nochlin Pommer, and Homer Pearson for their suggestions regarding the parts of the bibliography devoted to literature, the visual arts, and music. We thank Eva Anda, Elizabeth Schwartz, Marilyn Telen, and Virginia Warren for their help during the final stages of production. We are grateful to Jere Grant of Harper & Row for her expert assistance and advice in copyediting and production.

PART I

ANCIENT AND MEDIEVAL
REFLECTIONS ON ART

PLATO

ION

Plato (c. 427–347 B.C.), born in Athens, was the most famous student of Socrates. His writings, all in dialogue form, are among the foundations of Western thought.

Persons of the Dialogue

SOCRATES ION

Socrates. Welcome, Ion. Are you from your native city of Ephesus? 530

Ion. No, Socrates; but from Epidaurus, where I attended the festival of Aesculapius.

Soc. Indeed! Do the Epidaurians have a contest of rhapsodes in his honour?

Ion. O yes; and of other kinds of music.

Soc. And were you one of the competitors—and did you succeed?

Ion. I—we—obtained the first prize of all, Socrates. b

Soc. Well done; now we must win another victory, at the Panathenaea.

Reprinted from *The Dialogues of Plato*, translated by B. Jowett (4th ed.; Oxford: The Clarendon Press, 1953), pp. 103–117, by permission of the publisher.

Ion. It shall be so, please heaven.

Soc. I have often envied the profession of a rhapsode, Ion; for it is a part of your art to wear fine clothes and to look as beautiful as you can, while at the same time you are obliged to be continually in the company of many good poets, and especially of Homer, who is the best and most divine of them, and to understand his mind, and not merely learn his

c words by rote; all this is a thing greatly to be envied. I am sure that no man can become a good rhapsode who does not understand the meaning of the poet. For the rhapsode ought to interpret the mind of the poet to his hearers, but how can he interpret him well unless he knows what he means? All this is much to be envied, I repeat.

Ion. Very true, Socrates; interpretation has certainly been the most laborious part of my art; and I believe myself able to speak about Homer

d better than any man; and that neither Metrodorus of Lampsacus, nor Stesimbrotus of Thasos, nor Glaucon, nor anyone else who ever was, had as good ideas about Homer as I have, or as many.

Soc. I am glad to hear you say so, Ion; I see that you will not refuse to acquaint me with them.

Ion. Certainly, Socrates; and you really ought to hear how exquisitely I display the beauties of Homer. I think that the Homeridae should give me a golden crown.[1]

Soc. I shall take an opportunity of hearing your embellishments of him

531 at some other time. But just now I should like to ask you a question: Does your art extend to Hesiod and Archilochus, or to Homer only?

Ion. To Homer only; he is in himself quite enough.

Soc. Are there any things about which Homer and Hesiod agree?

Ion. Yes; in my opinion there are a good many.

Soc. And can you interpret what Homer says about these matters better than what Hesiod says?

b *Ion.* I can interpret them equally well, Socrates, where they agree.

Soc. But what about matters in which they do not agree? for example, about divination of which both Homer and Hesiod have something to say,—

Ion. Very true.

Soc. Would you or a good prophet be a better interpreter of what these two poets say about divination, not only when they agree, but when they disagree?

Ion. A prophet.

Soc. And if you were a prophet, and could interpret them where they agree, would you not know how to interpret them also where they disagree?

Ion. Clearly.

c *Soc.* But how did you come to have this skill about Homer only, and

[1] [Or, 'I think I have well deserved the golden crown given me by the Homeridae.']

not about Hesiod or the other poets? Does not Homer speak of the same themes which all other poets handle? Is not war his great argument? and does he not speak of human society and of intercourse of men, good and bad, skilled and unskilled, and of the gods conversing with one another and with mankind, and about what happens in heaven and in the world below, and the generations of gods and heroes? Are not these the themes d of which Homer sings?

Ion. Very true, Socrates.

Soc. And do not the other poets sing of the same?

Ion. Yes, Socrates; but not in the same way as Homer.

Soc. What, in a worse way?

Ion. Yes, in a far worse.

Soc. And Homer in a better way?

Ion. He is incomparably better.

Soc. And yet surely, my dear friend Ion, where many people are discussing numbers, and one speaks better than the rest, there is somebody who can judge which of them is the good speaker?

Ion. Yes.

Soc. And he who judges of the good will be the same as he who e judges of the bad speakers?

Ion. The same.

Soc. One who knows the science of arithmetic?

Ion. Yes.

Soc. Or again, if many persons are discussing the wholesomeness of food, and one speaks better than the rest, will he who recognizes the better speaker be a different person from him who recognizes the worse, or the same?

Ion. Clearly the same.

Soc. And who is he, and what is his name?

Ion. The physician.

Soc. And speaking generally, in all discussions in which the subject is the same and many men are speaking, will not he who knows the good know the bad speaker also? For obviously if he does not know the bad, 532 neither will he know the good, when the same topic is being discussed.

Ion. True.

Soc. We find, in fact, that the same person is skilful in both?

Ion. Yes.

Soc. And you say that Homer and the other poets, such as Hesiod and Archilochus, speak of the same things, although not in the same way; but the one speaks well and the other not so well?

Ion. Yes; and I am right in saying so.

Soc. And if you know the good speaker, you ought also to know the b inferior speakers to be inferior?

Ion. It would seem so.

Soc. Then, my dear friend, can I be mistaken in saying that Ion is

equally skilled in Homer and in other poets, since he himself acknowledges that the same person will be a good judge of all those who speak of the same things; and that almost all poets do speak of the same things?

Ion. Why then, Socrates, do I lose attention and have absolutely no
c ideas of the least value and practically fall asleep when anyone speaks of any other poet; but when Homer is mentioned, I wake up at once and am all attention and have plenty to say?

Soc. The reason, my friend, is not hard to guess. No one can fail to see that you speak of Homer without any art or knowledge. If you were able to speak of him by rules of art, you would have been able to speak of all other poets; for poetry is a whole.

Ion. Yes.
d *Soc.* And when anyone acquires any other art as a whole, the same may be said of them. Would you like me to explain my meaning, Ion?

Ion. Yes, indeed, Socrates; I very much wish that you would: for I love to hear you wise men talk.

Soc. O that we were wise, Ion, and that you could truly call us so; but you rhapsodes and actors, and the poets whose verses you sing, are
e wise; whereas I am a common man, who only speak the truth. For consider what a very commonplace and trivial thing is this which I have said—a thing which any man might say: that when a man has acquired a knowledge of a whole art, the inquiry into good and bad is one and the same. Let us consider this matter; is not the art of painting a whole?

Ion. Yes.

Soc. And there are and have been many painters good and bad?

Ion. Yes.

Soc. And did you ever know anyone who was skilful in pointing out
533 the excellences and defects of Polygnotus the son of Aglaophon, but incapable of criticizing other painters; and when the work of any other painter was produced, went to sleep and was at a loss, and had no ideas; but when he had to give his opinion about Polygnotus, or whoever the painter might be, and about him only, woke up and was attentive and had plenty to say?

Ion. No indeed, I have never known such a person.

Soc. Or take sculpture—did you ever know of anyone who was skilful
b in expounding the merits of Daedalus the son of Metion, or of Epeius the son of Panopeus, or of Theodorus the Samian, or of any individual sculptor; but when the works of sculptors in general were produced, was at a loss and went to sleep and had nothing to say?

Ion. No indeed; no more than the other.

Soc. And if I am not mistaken, you never met with anyone among flute-players or harp-players or singers to the harp or rhapsodes who was
c able to discourse of Olympus or Thamyras or Orpheus, or Phemius the rhapsode of Ithaca, but was at a loss when he came to speak of Ion of Ephesus, and had no notion of his merits or defects?

Ion. I cannot deny what you say, Socrates. Nevertheless I am con-

scious in my own self, and the world agrees with me, that I do speak better and have more to say about Homer than any other man; but I do not speak equally well about others. After all, there must be some reason for this; what is it?

Soc. I see the reason, Ion; and I will proceed to explain to you what I imagine it to be. The gift which you possess of speaking excellently d about Homer is not an art, but, as I was just saying, an inspiration; there is a divinity moving you, like that contained in the stone which Euripides calls a magnet, but which is commonly known as the stone of Heraclea. This stone not only attracts iron rings, but also imparts to them a similar power of attracting other rings; and sometimes you may see a number of e pieces of iron and rings suspended from one another so as to form quite a long chain: and all of them derive their power of suspension from the original stone. In like manner the Muse first of all inspires men herself; and from these inspired persons a chain of other persons is suspended, who take the inspiration. For all good poets, epic as well as lyric, compose their beautiful poems not by art, but because they are inspired and possessed. And as the Corybantian revellers when they dance are not in 534 their right mind, so the lyric poets are not in their right mind when they are composing their beautiful strains: but when falling under the power of music and metre they are inspired and possessed; like Bacchic maidens who draw milk and honey from the rivers when they are under the influence of Dionysus but not when they are in their right mind. And the soul of the lyric poet does the same, as they themselves say; for they tell us that they bring songs from honeyed fountains, culling them out of the b gardens and dells of the Muses; they, like the bees, winging their way from flower to flower. And this is true. For the poet is a light and winged and holy thing, and there is no invention in him until he has been inspired and is out of his senses, and reason is no longer in him: no man, while he retains that faculty, has the oracular gift of poetry.

Many are the noble words in which poets speak concerning the actions of men; but like yourself when speaking about Homer, they do not speak c of them by any rules of art: they are simply inspired to utter that to which the Muse impels them, and that only; and when inspired, one of them will make dithyrambs, another hymns of praise, another choral strains, another epic or iambic verses, but not one of them is of any account in the other kinds. For not by art does the poet sing, but by power divine; had he learned by rules of art, he would have known how to speak not of one theme only, but of all; and therefore God takes away reason from poets, and uses them as his ministers, as he also uses the d pronouncers of oracles and holy prophets, in order that we who hear them may know them to be speaking not of themselves, who utter these priceless words while bereft of reason, but that God himself is the speaker, and that through them he is addressing us. And Tynnichus the Chalcidian affords a striking instance of what I am saying: he wrote no poem that anyone would care to remember but the famous paean which is in every-

e one's mouth, one of the finest lyric poems ever written, simply an inven-
tion of the Muses, as he himself says. For in this way God would seem
to demonstrate to us and not to allow us to doubt that these beautiful
poems are not human, nor the work of man, but divine and the work of
God; and that the poets are only the interpreters of the gods by whom
they are severally possessed. Was not this the lesson which God intended
535 to teach when by the mouth of the worst of poets he sang the best of
songs? Am I not right, Ion?

Ion. Yes, indeed, Socrates, I feel that you are; for your words touch
my soul, and I am persuaded that in these works the good poets, under
divine inspiration, interpret to us the voice of the Gods.

Soc. And you rhapsodists are the interpreters of the poets?

Ion. There again you are right.

Soc. Then you are the interpreters of interpreters?

Ion. Precisely.

b *Soc.* I wish you would frankly tell me, Ion, what I am going to ask
of you: When you produce the greatest effect upon the audience in the
recitation of some striking passage, such as the apparition of Odysseus
leaping forth on the floor, recognized by the suitors and shaking out his
arrows at his feet, or the description of Achilles springing upon Hector,
or the sorrows of Andromache, Hecuba, or Priam,—are you in your right
c mind? Are you not carried out of yourself, and does not your soul in an
ecstasy seem to be among the persons or places of which you are speaking,
whether they are in Ithaca or in Troy or whatever may be the scene of
the poem?

Ion. That proof strikes home to me, Socrates. For I must frankly con-
fess that at the tale of pity my eyes are filled with tears, and when I speak
of horrors, my hair stands on end and my heart throbs.

d *Soc.* Well, Ion, and what are we to say of a man who at a sacrifice
or festival, when he is dressed in an embroidered robe, and has golden
crowns upon his head, of which nobody has robbed him, appears weeping
or panic-stricken in the presence of more than twenty thousand friendly
faces, when there is no one despoiling or wronging him;—is he in his right
mind or is he not?

Ion. No indeed, Socrates, I must say that, strictly speaking, he is not
in his right mind.

Soc. And are you aware that you produce similar effects on most of the
spectators?

e *Ion.* Only too well; for I look down upon them from the stage, and
behold the various emotions of pity, wonder, sternness, stamped upon
their countenances when I am speaking: and I am obliged to give my
very best attention to them; for if I make them cry I myself shall laugh,
and if I make them laugh I myself shall cry, when the time of payment
arrives.

Soc. Do you know that the spectator is the last of the rings which, as
I am saying, receive the power of the original magnet from one another?

The rhapsode like yourself and the actor are intermediate links, and the poet himself is the first of them. Through all these God sways the souls 536 of men in any direction which He pleases, causing each link to communicate the power to the next. Thus there is a vast chain of dancers and masters and under-masters of choruses, who are suspended, as if from the stone, at the side of the rings which hang down from the Muse. And every poet has some Muse from whom he is suspended, and by whom he is said to be possessed, which is nearly the same thing; for he is taken b hold of. And from these first rings, which are the poets, depend others, some deriving their inspiration from Orpheus, others from Musaeus; but the greater number are possessed and held by Homer. Of whom, Ion, you are one, and are possessed by Homer; and when anyone repeats the words of another poet you go to sleep, and know not what to say; but when anyone recites a strain of Homer you wake up in a moment, and your soul leaps within you, and you have plenty to say; for not by art or c knowledge about Homer do you say what you say, but by divine inspiration and by possession; just as the Corybantian revellers too have a quick perception of that strain only which is appropriated to the god by whom they are possessed, and have plenty of dances and words for that, but take no heed of any other. And you, Ion, when the name of Homer is mentioned have plenty to say, and have nothing to say of others. You ask, d 'Why is this?' The answer is that your skill in the praise of Homer comes not from art but from divine inspiration.

Ion. That is good, Socrates; and yet I doubt whether you will ever have eloquence enough to persuade me that I praise Homer only when I am mad and possessed; and if you could hear me speak of him I am sure you would never think this to be the case.

Soc. I should like very much to hear you, but not until you have answered a question which I have to ask. On what part of Homer do you e speak well?—not surely about every part?

Ion. There is no part, Socrates, about which I do not speak well: of that I can assure you.

Soc. Surely not about things in Homer of which you have no knowledge?

Ion. And what is there in Homer of which I have no knowledge?

Soc. Why, does not Homer speak in many passages about arts? For 537 example, about driving; if I can only remember the lines I will repeat them.

Ion. I remember, and will repeat them.

Soc. Tell me then, what Nestor says to Antilochus, his son, where he bids him be careful of the turn at the horse-race in honour of Patroclus.

Ion. 'Bend gently,' he says, 'in the polished chariot to the left of them, and urge the horse on the right hand with whip and voice; and slacken the rein. And when b you are at the goal, let the left horse draw near, so that the nave of the well-wrought wheel may appear to graze the extremity; but have a care not to touch the stone.'[2]

[2] *Il.* xxiii. 335.

c *Soc.* Enough. Now, Ion, will the charioteer or the physician be the better judge of the propriety of these lines?

Ion. The charioteer, clearly.

Soc. And will the reason be that this is his art, or will there be any other reason?

Ion. No, that will be the reason.

Soc. And every art is appointed by God to have knowledge of a certain work; for that which we know by the art of the pilot we shall not succeed in knowing also by the art of medicine?

d *Ion.* Certainly not.

Soc. Nor shall we know by the art of the carpenter that which we know by the art of medicine?

Ion. Certainly not.

Soc. And this is true of all the arts;—that which we know with one art we shall not know with the other? But let me ask a prior question: You admit that there are differences of arts?

Ion. Yes.

Soc. You would argue, as I should, that if there are two kinds of knowledge, dealing with different things, these can be called different arts?

Ion. Yes.

e *Soc.* Yes, surely; for if the object of knowledge were the same, there would be no meaning in saying that the arts were different,—since they both gave the same knowledge. For example, I know that here are five fingers, and you know the same. And if I were to ask whether I and you became acquainted with this fact by the help of the same art of arithmetic, you would acknowledge that we did?

Ion. Yes.

538 *Soc.* Tell me, then, what I was intending to ask you,—whether in your opinion this holds universally? If two arts are the same, must not they necessarily have the same objects? And if one differs from another, must it not be because the object is different?

Ion. That is my opinion, Socrates.

Soc. Then he who has no knowledge of a particular art will have no right judgement of the precepts and practice of that art?

b *Ion.* Very true.

Soc. Then which will be the better judge of the lines which you were reciting from Homer, you or the charioteer?

Ion. The charioteer.

Soc. Why, yes, because you are a rhapsode and not a charioteer.

Ion. Yes.

Soc. And the art of the rhapsode is different from that of the charioteer?

Ion. Yes.

Soc. And if a different knowledge, then a knowledge of different matters?

Ion. True.

Soc. You know the passage in which Hecamede, the concubine of Nestor, is described as giving to the wounded Machaon a posset, as he c says,

'Made with Pramnian wine; and she grated cheese of goat's milk with a grater of bronze, and at his side placed an onion which gives a relish to drink.'[3]

Now would you say that the art of the rhapsode or the art of medicine was better able to judge of the propriety of these lines?

Ion. The art of medicine.

Soc. And when Homer says,

'And she descended into the deep like a leaden plummet, which, set in the horn d of ox that ranges the fields, rushes along carrying death among the ravenous fishes',[4]

will the art of the fisherman or of the rhapsode be better able to judge what these lines mean, and whether they are accurate or not?

Ion. Clearly, Socrates, the art of the fisherman.

Soc. Come now, suppose that you were to say to me: 'Since you, Socrates, are able to assign different passages in Homer to their corre- e sponding arts, I wish that you would tell me what are the passages of which the excellence ought to be judged by the prophet and prophetic art;' and you will see how readily and truly I shall answer you. For there are many such passages particularly in the Odyssey; as, for example, the passage in which Theoclymenus the prophet of the house of Melampus says to the suitors: —

'Wretched men! what is happening to you? Your heads and your faces and your 539 limbs underneath are shrouded in night; and the voice of lamentation bursts forth, and your cheeks are wet with tears. And the vestibule is full, and the court is full, of ghosts descending into the darkness of Erebus, and the sun has perished out of b heaven, and an evil mist is spread abroad.'[5]

And there are many such passages in the Iliad also; as for example in the description of the battle near the rampart, where he says: —

'As they were eager to pass the ditch, there came to them an omen: a soaring eagle, skirting the people on his left, bore a huge blood-red dragon in his talons, still c living and panting; nor had he yet resigned the strife, for he bent back and smote the bird which carried him on the breast by the neck, and he in pain let him fall from him to the ground into the midst of the multitude. And the eagle, with a cry, was borne afar on the wings of the wind.'[6] d

These are the sort of things which I should say that the prophet ought to consider and determine.

Ion. And you are quite right, Socrates, in saying so.

Soc. Yes, Ion, and you are right also. And as I have selected from the Iliad and Odyssey for you passages which describe the office of the prophet e

[3] *Il.* xi. 639, 640.
[4] *Il.* xxiv. 80.
[5] *Od.* xx. 351.
[6] *Il.* xii. 200.

and the physician and the fisherman, do you, who know Homer so much better than I do, Ion, select for me passages which relate to the rhapsode and the rhapsode's art, and which the rhapsode ought to examine and judge of better than other men.

Ion. All passages, I should say, Socrates.

Soc. Not all, Ion, surely. Have you already forgotten what you were saying? A rhapsode ought to have a better memory.

540 *Ion.* Why, what am I forgetting?

Soc. Do you remember that you declared the art of the rhapsode to be different from the art of the charioteer?

Ion. Yes, I remember.

Soc. And you admitted that being different they would know different objects?

Ion. Yes.

Soc. Then upon your own showing the rhapsode, and the art of the rhapsode, will not know everything?

Ion. I should exclude such things as you mention, Socrates.

b *Soc.* You mean to say that you would exclude pretty much the subjects of the other arts. As he does not know all of them, which of them will he know?

Ion. He will know what a man and what a woman ought to say, and what a freeman and what a slave ought to say, and what a ruler and what a subject.

Soc. Do you mean that a rhapsode will know better than the pilot what the ruler of a sea-tossed vessel ought to say?

Ion. No; the pilot will know best.

c *Soc.* Or will the rhapsode know better than the physician what the ruler of a sick man ought to say?

Ion. Again, no.

Soc. But he will know what a slave ought to say?

Ion. Yes.

Soc. Suppose the slave to be a cowherd; the rhapsode will know better than the cowherd what he ought to say in order to soothe infuriated cows?

Ion. No, he will not.

Soc. But he will know what a spinning-woman ought to say about the working of wool?

d *Ion.* No.

Soc. At any rate he will know what a general ought to say when exhorting his soldiers?

Ion. Yes, that is the sort of thing which the rhapsode will be sure to know.

Soc. What! Is the art of the rhapsode the art of the general?

Ion. I am sure that I should know what a general ought to say.

Soc. Why, yes, Ion, because you may possibly have the knowledge of a general as well as that of a rhapsode; and you might also have a

knowledge of horsemanship as well as of the lyre, and then you would know when horses were well or ill managed. But suppose I were to ask you: By the help of which art, Ion, do you know whether horses are well e managed, by your skill as a horseman or as a performer on the lyre— what would you answer?

Ion. I should reply, by my skill as a horseman.

Soc. And if you judged of performers on the lyre, you would admit that you judged of them as a performer on the lyre, and not as a horseman?

Ion. Yes.

Soc. And in judging of the general's art, do you judge as a general, or as a good rhapsode?

Ion. To me there appears to be no difference between them.

Soc. What do you mean? Do you mean to say that the art of the 541 rhapsode and of the general is the same?

Ion. Yes, one and the same.

Soc. Then he who is a good rhapsode is also a good general?

Ion. Certainly, Socrates.

Soc. And he who is a good general is also a good rhapsode?

Ion. No; I do not agree to that.

Soc. But you do agree that he who is a good rhapsode is also a good b general.

Ion. Certainly.

Soc. And you are the best of Hellenic rhapsodes?

Ion. Far the best, Socrates.

Soc. And are you also the best general, Ion?

Ion. To be sure, Socrates; and Homer was my master.

Soc. But then, Ion, why in the name of goodness do you, who are the best of generals as well as the best of rhapsodes in all Hellas, go about reciting rhapsodies when you might be a general? Do you think that the Hellenes are in grave need of a rhapsode with his golden crown, and have c no need at all of a general?

Ion. Why, Socrates, the reason is that my countrymen, the Ephesians, are the servants and soldiers of Athens, and do not need a general; and that you and Sparta are not likely to appoint me, for you think that you have enough generals of your own.

Soc. My good Ion, did you never hear of Apollodorus of Cyzicus?

Ion. Who may he be?

Soc. One who, though a foreigner, has often been chosen their general by the Athenians: and there is Phanosthenes of Andros, and Heraclides d of Clazomenae, whom they have also appointed to the command of their armies and to other offices, although aliens, after they had shown their merit. And will they not choose Ion the Ephesian to be their general, and honour him, if they deem him qualified? Were not the Ephesians originally Athenians, and Ephesus is no mean city? But, indeed, Ion, if e

you are correct in saying that by art and knowledge you are able to praise Homer, you do not deal fairly with me, and after all your professions of knowing many glorious things about Homer, and promises that you would exhibit them, you only deceive me, and so far from exhibiting the art of which you are a master, will not, even after my repeated entreaties, explain to me the nature of it. You literally assume as many forms as Proteus, twisting and turning up and down, until at last you slip away from me in the disguise of a general, in order that you may 542 escape exhibiting your Homeric lore. And if you have art, then, as I was saying, in falsifying your promise that you would exhibit Homer, you are not dealing fairly with me. But if, as I believe, you have no art, but speak all these beautiful words about Homer unconsciously under his inspiring influence, then I acquit you of dishonesty, and shall only say that you are inspired. Which do you prefer to be thought, dishonest or inspired?

b *Ion.* There is a great difference, Socrates, between the two alternatives; and inspiration is by far the nobler.

Soc. Then, Ion, I shall assume the nobler alternative; and attribute to you in your praises of Homer inspiration, and not art.

PLATO

THE REPUBLIC

BOOK X

Of the many excellences which I perceive in the order of our State, 595
there is none which upon reflection pleases me better than the rule about
poetry.

To what do you refer?

To our refusal to admit the imitative kind of poetry, for it certainly
ought not to be received; as I see far more clearly now that the parts of
the soul have been distinguished. b

What do you mean?

Speaking in confidence, for you will not denounce me to the tragedians
and the rest of the imitative tribe, all poetical imitations are ruinous to the
understanding of the hearers, unless as an antidote they possess the knowl-
edge of the true nature of the originals.

Reprinted from *The Dialogues of Plato*, translated by B. Jowett (4th ed.; Oxford:
The Clarendon Press, 1953), pp. 468–485, by permission of the publisher.

Explain the purport of your remark.

Well, I will tell you, although I have always from my earliest youth had an awe and love of Homer which even now makes the words falter c on my lips, for he seems to be the great captain and teacher of the whole of that noble tragic company; but a man is not to be reverenced more than the truth, and therefore I will speak out.

Very good, he said.

Listen to me then, or rather, answer me.

Put your question.

Can you give me a general definition of imitation? for I really do not myself understand what it professes to be.

A likely thing, then, that I should know.

596 There would be nothing strange in that, for the duller eye may often see a thing sooner than the keener.

Very true, he said; but in your presence, even if I had any faint notion, I could not muster courage to utter it. Will you inquire yourself?

Well then, shall we begin the inquiry at this point, following our usual method: Whenever a number of individuals have a common name, we assume that there is one corresponding idea or form[1]:—do you understand me?

I do.

Let us take, for our present purpose, any instance of such a group; b there are beds and tables in the world—many of each, are there not?

Yes.

But there are only two ideas or forms of such furniture—one the idea of a bed, the other of a table.

True.

And the maker of either of them makes a bed or he makes a table for our use, in accordance with the idea—that is our way of speaking in this and similar instances—but no artificer makes the idea itself: how could he?

Impossible.

c And there is another artificer,—I should like to know what you would say of him.

Who is he?

One who is the maker of all the works of all other workmen.

What an extraordinary man!

Wait a little, and there will be more reason for your saying so. For this is the craftsman who is able to make not only furniture of every kind, but all that grows out of the earth, and all living creatures, himself included; and besides these he can make earth and sky and the gods, and all the things which are in heaven or in the realm of Hades under the earth.

[1] [Or (probably better): 'we have been accustomed to assume that there is one single idea corresponding to each group of particulars; and to these we give the same name (as we give the idea).' See J. A. Smith, *C.R.* xxxi (1917).]

He must be a wizard and no mistake. d

Oh! you are incredulous, are you? Do you mean that there is no such maker or creator, or that in one sense there might be a maker of all these things but in another not? Do you see that there is a way in which you could make them all yourself?

And what way is this? he asked.

An easy way enough; or rather, there are many ways in which the feat might be quickly and easily accomplished, none quicker than that of turning a mirror round and round—you would soon enough make the sun and the heavens, and the earth and yourself, and other animals and e plants, and furniture and all the other things of which we were just now speaking, in the mirror.

Yes, he said; but they would be appearances only.

Very good, I said, you are coming to the point now. And the painter too is, as I conceive, just such another—a creator of appearances, is he not?

Of course.

But then I suppose you will say that what he creates is untrue. And yet there is a sense in which the painter also creates a bed? Is there not?

Yes, he said, but here again, an appearance only.

And what of the maker of the bed? were you not saying that he too 597 makes, not the idea which according to our view is the real object denoted by the word bed, but only a particular bed?

Yes, I did.

Then if he does not make a real object he cannot make what *is*, but only some semblance of existence; and if any one were to say that the work of the maker of the bed, or of any other workman, has real existence, he could hardly be supposed to be speaking the truth.

Not, at least, he replied, in the view of those who make a business of these discussions.

No wonder, then, that his work too is an indistinct expression of truth. b

No wonder.

Suppose now that by the light of the examples just offered we inquire who this imitator is?

If you please.

Well then, here we find three beds: one existing in nature, which is made by God, as I think that we may say—for no one else can be the maker?

No one, I think.

There is another which is the work of the carpenter?

Yes.

And the work of the painter is a third?

Yes.

Beds, then, are of three kinds, and there are three artists who superintend them: God, the maker of the bed, and the painter?

Yes, there are three of them.

God, whether from choice or from necessity, made one bed in nature
c and one only; two or more such beds neither ever have been nor ever
will be made by God.

Why is that?

Because even if He had made but two, a third would still appear behind
them of which they again both possessed the form, and that would be the
real bed and not the two others.

Very true, he said.

d God knew this, I suppose, and He desired to be the real maker of a real
bed, not a kind of maker of a kind of bed, and therefore He created a bed
which is essentially by nature one only.

So it seems.

Shall we, then, speak of Him as the natural author or maker of the
bed?

Yes, he replied; inasmuch as by the natural process of creation He is the
author of this and of all other things.

And what shall we say of the carpenter—is not he also the maker of
a bed?

Yes.

But would you call the painter an artificer and maker?

Certainly not.

Yet if he is not the maker, what is he in relation to the bed?

e I think, he said, that we may fairly designate him as the imitator of
that which the others make.

Good, I said; then you call him whose product is third in the descent
from nature, an imitator?

Certainly, he said.

And so if the tragic poet is an imitator, he too is thrice removed from
the king and from the truth; and so are all other imitators.

That appears to be so.

Then about the imitator we are agreed. And what about the painter?
598 —Do you think he tries to imitate in each case that which originally exists
in nature, or only the creations of artificers?

The latter.

As they are or as they appear? you have still to determine this.

What do you mean?

I mean to ask whether a bed really becomes different when it is seen
from different points of view, obliquely or directly or from any other
point of view? Or does it simply appear different, without being really so?
And the same of all things.

b Yes, he said, the difference is only apparent.

Now let me ask you another question: Which is the art of painting
designed to be—an imitation of things as they are, or as they appear—
of appearance or of reality?

Of appearance, he said.

Then the imitator is a long way off the truth, and can reproduce all things because he lightly touches on a small part of them, and that part an image. For example: A painter will paint a cobbler, carpenter, or any other artisan, though he knows nothing of their arts; and, if he is a good c painter, he may deceive children or simple persons when he shows them his picture of a carpenter from a distance, and they will fancy that they are looking at a real carpenter.

Certainly.

And surely, my friend, this is how we should regard all such claims: whenever any one informs us that he has found a man who knows all the arts, and all things else that anybody knows, and every single thing with a higher degree of accuracy than any other man—whoever tells us this, I d think that we can only retort that he is a simple creature who seems to have been deceived by some wizard or imitator whom we met, and whom he thought all-knowing, because he himself was unable to analyse the nature of knowledge and ignorance and imitation.

Most true.

And next, I said, we have to consider tragedy and its leader, Homer; for we hear some persons saying that these poets know all the arts; and all things human; where virtue and vice are concerned, and indeed all e divine things too; because the good poet cannot compose well unless he knows his subject, and he who has not this knowledge can never be a poet. We ought to consider whether here also there may not be a similar illusion. Perhaps they may have come across imitators and been deceived by them; they may not have remembered when they saw their works that these 599 were thrice removed from the truth, and could easily be made without any knowledge of the truth, because they are appearances only and not realities? Or, after all, they may be in the right, and good poets do really know the things about which they seem to the many to speak so well?

The question, he said, should by all means be considered.

Now do you suppose that if a person were able to make the original as well as the image, he would seriously devote himself to the image-making branch? Would he allow imitation to be the ruling principle of his life, as if he had nothing higher in him?

I should say not. b

But the real artist, who had real knowledge of those things which he chose also to imitate, would be interested in realities and not in imitations; and would desire to leave as memorials of himself works many and fair; and, instead of being the author of encomiums, he would prefer to be the theme of them.

Yes, he said, that would be to him a source of much greater honour and profit.

Now let us refrain, I said, from calling Homer or any other poet to account regarding those arts to which his poems incidentally refer: we

c will not ask them, in case any poet has been a doctor and not a mere imi-
tator of medical parlance, to show what patients have been restored to
health by a poet, ancient or modern, as they were by Asclepius; or what
disciples in medicine a poet has left behind him, like the Asclepiads. Nor
shall we press the same question upon them about the other arts. But we
have a right to know respecting warfare, strategy, the administration of
d States and the education of man, which are the chiefest and noblest sub-
jects of his poems, and we may fairly ask him about them. 'Friend
Homer,' then we say to him, 'if you are only in the second remove from
truth in what you say of virtue, and not in the third—not an image maker,
that is, by our definition, an imitator—and if you are able to discern what
pursuits make men better or worse in private or public life, tell us what
State was ever better governed by your help? The good order of Lacedae-
e mon is due to Lycurgus, and many other cities great and small have been
similarly benefited by others; but who says that you have been a good
legislator to them and have done them any good? Italy and Sicily boast of
Charondas, and there is Solon who is renowned among us; but what city
has anything to say about you?' Is there any city which he might name?

I think not, said Glaucon; not even the Homerids themselves pretend
that he was a legislator.

600 Well, but is there any war on record which was carried on successfully
owing to his leadership or counsel?

There is not.

Or is there anything comparable to those clever improvements in the
arts, or in other operations, which are said to have been due to men of
practical genius such as Thales the Milesian or Anarcharsis the Scythian?

There is absolutely nothing of the kind.

But, if Homer never did any public service, was he privately a guide
b or teacher of any? Had he in his lifetime friends who loved to associate
with him, and who handed down to posterity an Homeric way of life, such
as was established by Pythagoras who was especially beloved for this
reason and whose followers are to this day conspicuous among others by
what they term the Pythagorean way of life?

Nothing of the kind is recorded of him. For surely, Socrates, Creo-
phylus, the companion of Homer, that child of flesh, whose name always
makes us laugh, might be more justly ridiculed for his want of breeding,
c if what is said is true, that Homer was greatly neglected by him in his own
day when he was alive?

Yes, I replied, that is the tradition. But can you imagine, Glaucon,
that if Homer had really been able to educate and improve mankind—if
he had been capable of knowledge and not been a mere imitator—can you
imagine, I say, that he would not have attracted many followers, and been
honoured and loved by them? Protagoras of Abdera, and Prodicus of Ceos,
and a host of others, have only to whisper to their contemporaries: 'You
d will never be able to manage either your own house or your own State until

you appoint us to be your ministers of education'—and this ingenious device of theirs has such an effect in making men love them that their companions all but carry them about on their shoulders. And is it conceivable that the contemporaries of Homer, or again of Hesiod, would have allowed either of them to go about as rhapsodists, if they had really been able to help mankind forward in virtue? Would they not have been as unwilling to part with them as with gold, and have compelled them to stay at home with them? Or, if the master would not stay, then the disciples would have e followed him about everywhere, until they had got education enough?

Yes, Socrates, that, I think, is quite true.

Then must we not infer that all these poetical individuals, beginning with Homer, are only imitators, who copy images of virtue and the other themes of their poetry, but have no contact with the truth? The poet is like a painter who, as we have already observed, will make a likeness of a cobbler 601 though he understands nothing of cobbling; and his picture is good enough for those who know no more than he does, and judge only by colours and figures.

Quite so.

In like manner the poet with his words and phrases[2] may be said to lay on the colours of the several arts, himself understanding their nature only enough to imitate them; and other people, who are as ignorant as he is, and judge only from his words, imagine that if he speaks of cobbling, or of military tactics, or of anything else, in metre and harmony and rhythm, he speaks very well—such is the sweet influence which melody b and rhythm by nature have. For I am sure that you know what a poor appearance the works of poets make when stripped of the colours which art puts upon them, and recited in simple prose. You have seen some examples?

Yes, he said.

They are like faces which were never really beautiful, but only blooming, seen when the bloom of youth has passed away from them?

Exactly.

Come now, and observe this point: The imitator or maker of the image knows nothing, we have said, of true existence; he knows appearances c only. Am I not right?

Yes.

Then let us have a clear understanding, and not be satisfied with half an explanation.

Proceed.

Of the painter we say that he will paint reins, and he will paint a bit?

Yes.

And the worker in leather and brass will make them?

Certainly.

[2] Or, 'with his nouns and verbs'.

But does the painter know the right form of the bit and reins? Nay, hardly even the workers in brass and leather who make them; only the horseman who knows how to use them—he knows their right form.

Most true.

And may we not say the same of all things?

d What?

That there are three arts which are concerned with all things: one which uses, another which makes, a third which imitates them?

Yes.

And the excellence and beauty and rightness of every structure, animate or inanimate, and of every action of man, is relative solely to the use for which nature or the artist has intended them.

True.

e Then beyond doubt it is the user who has the greatest experience of them, and he must report to the maker the good or bad qualities which develop themselves in use; for example, the flute-player will tell the flute-maker which of his flutes is satisfactory to the performer;[3] he will tell him how he ought to make them, and the other will attend to his instructions?

Of course.

So the one pronounces with knowledge about the goodness and badness of flutes, while the other, confiding in him, will make them accordingly?

True.

The instrument is the same, but about the excellence or badness of it
602 the maker will possess a correct belief, since he associates with one who knows, and is compelled to hear what he has to say; whereas the user will have knowledge?

True.

But will the imitator have either? Will he know from use whether or no that which he paints is correct or beautiful? or will he have right opinion from being compelled to associate with another who knows and gives him instructions about what he should paint?

Neither.

Then an imitator will no more have true opinion than he will have knowledge about the goodness or badness of his models?

I suppose not.

The imitative poet will be in a brilliant state of intelligence about the theme of his poetry?

Nay, very much the reverse.

b And still he will go on imitating without knowing what makes a thing good or bad, and may be expected therefore to imitate only that which appears to be good to the ignorant multitude?

Just so.

[3] [Or, to avoid the repetition of υπηρετεῖν in a different sense: 'will make a report to the flutemaker, *who assists him in his playing*, about the flutes'.]

Thus far then we are pretty well agreed that the imitator has no knowledge worth mentioning of what he imitates. Imitation is only a kind of play or sport, and the tragic poets, whether they write in iambic or in heroic verse, are imitators in the highest degree?

Very true.

And now tell me, I conjure you,—this imitation is concerned with an c object which is thrice removed from the truth?

Certainly.

And what kind of faculty in man is that to which imitation makes its special appeal?

What do you mean?

I will explain: The same body does not appear equal to our sight when seen near and when seen at a distance?

True.

And the same objects appear straight when looked at out of the water, and crooked when in the water; and the concave becomes convex, owing to the illusion about colours to which the sight is liable. Thus every sort d of confusion is revealed within us; and this is that weakness of the human mind on which the art of painting in light and shadow, the art of conjuring, and many other ingenious devices impose, having an effect upon us like magic.

True.

And the arts of measuring and numbering and weighing come to the rescue of the human understanding—there is the beauty of them—with the result that the apparent greater or less, or more or heavier, no longer have the mastery over us, but give way before the power of calculation and measuring and weighing?

Most true. e

And this, surely, must be the work of the calculating and rational principle in the soul?

To be sure.

And often when this principle measures and certifies that some things are equal, or that some are greater or less than others, it is, at the same time, contradicted by the appearance which the objects present?

True.

But did we not say that such a contradiction is impossible—the same faculty cannot have contrary opinions at the same time about the same thing?

We did; and rightly.

Then that part of the soul which has an opinion contrary to measure 603 can hardly be the same with that which has an opinion in accordance with measure?

True.

And the part of the soul which trusts to measure and calculation is likely to be the better one?

Certainly.

And therefore that which is opposed to this is probably an inferior principle in our nature?

No doubt.

This was the conclusion at which I was seeking to arrive when I said
b that painting or drawing, and imitation in general, are engaged upon productions which are far removed from truth, and are also the companions and friends and associates of a principle within us which is equally removed from reason, and that they have no true or healthy aim.

Exactly.

The imitative art is an inferior who from intercourse with an inferior has inferior offspring.

Very true.

And is this confined to the sight only, or does it extend to the hearing also, relating in fact to what we term poetry?

Probably the same would be true of poetry.

Do not rely, I said, on a probability derived from the analogy of paint-
c ing; but let us once more go directly to that faculty of the mind with which imitative poetry has converse, and see whether it is good or bad.

By all means.

We may state the question thus: —Imitation imitates the actions of men, whether voluntary or involuntary, on which, as they imagine, a good or bad result has ensued, and they rejoice or sorrow accordingly. Is there anything more?

No, there is nothing else.

But in all this variety of circumstances is the man at unity with himself —or rather, as in the instance of sight there was confusion and opposition
d in his opinions about the same things, so here also is there not strife and inconsistency in his life? Though I need hardly raise the question again, for I remember that all this has been already admitted; and the soul has been acknowledged by us to be full of these and ten thousand similar oppositions occurring at the same moment?

And we were right, he said.

Yes, I said, thus far we were right; but there was an omission which
e must now be supplied.

What was the omission?

Were we not saying that a good man, who has the misfortune to lose his son or anything else which is most dear to him, will bear the loss with more equanimity than another?

Yes, indeed.

But will he have no sorrow, or shall we say that although he cannot help sorrowing, he will moderate his sorrow?

The latter, he said, is the truer statement.

604 Tell me: will he be more likely to struggle and hold out against his

sorrow when he is seen by his equals, or when he is alone in a deserted place?

The fact of being seen will make a great difference, he said.

When he is by himself he will not mind saying many things which he would be ashamed of any one hearing, and also doing many things which he would not care to be seen doing?

True.

And doubtless it is the law and reason in him which bids him resist; while it is the affliction itself which is urging him to indulge his sorrow? b

True.

But when a man is drawn in two opposite directions, to and from the same object, this, as we affirm, necessarily implies two distinct principles in him?

Certainly.

One of them is ready to follow the guidance of the law?

How do you mean?

The law would say that to be patient under calamity is best, and that we should not give way to impatience, as the good and evil in such things are not clear, and nothing is gained by impatience; also, because no c human thing is of serious importance, and grief stands in the way of that which at the moment is most required.

What is most required? he asked.

That we should take counsel about what has happened, and when the dice have been thrown, according to their fall, order our affairs in the way which reason deems best; not, like children who have had a fall, keeping hold of the part struck and wasting time in setting up a howl, but always accustoming the soul forthwith to apply a remedy, raising up that which is d sickly and fallen, banishing the cry of sorrow by the healing art.

Yes, he said, that is the true way of meeting the attacks of fortune.

Well then, I said, the higher principle is ready to follow this suggestion of reason?

Clearly.

But the other principle, which inclines us to recollection of our troubles and to lamentation, and can never have enough of them, we may call irrational, useless, and cowardly?

Indeed, we may.

Now does not the principle which is thus inclined to complaint, furnish e a great variety of materials for imitation? Whereas the wise and calm temperament, being always nearly equable, is not easy to imitate or to appreciate when imitated, especially at a public festival when a promiscuous crowd is assembled in a theatre. For the feeling represented is one to which they are strangers.

Certainly.

Then the imitative poet who aims at being popular is not by nature 605

made, nor is his art intended, to please or to affect the rational principle in the soul; but he will appeal rather to the lachrymose and fitful temper, which is easily imitated?

Clearly.

And now we may fairly take him and place him by the side of the painter, for he is like him in two ways: first, inasmuch as his creations have an inferior degree of truth—in this, I say, he is like him; and he is b also like him in being the associate of an inferior part of the soul; and this is enough to show that we shall be right in refusing to admit him into a State which is to be well ordered, because he awakens and nourishes this part of the soul, and by strengthening it impairs the reason. As in a city when the evil are permitted to wield power and the finer men are put out of the way, so in the soul of each man, as we shall maintain, the imitative poet implants an evil constitution, for he indulges c the irrational nature which has no discernment of greater and less, but thinks the same thing at one time great and at another small—he is an imitator of images and is very far removed from the truth.

Exactly.

But we have not yet brought forward the heaviest count in our accusation: —the power which poetry has of harming even the good (and there are very few who are not harmed), is surely an awful thing?

Yes, certainly, if the effect is what you say.

Hear and judge: The best of us, as I conceive, when we listen to a passage of Homer or one of the tragedians, in which he represents some d hero who is drawling out his sorrows in a long oration, or singing, and smiting his breast—the best of us, you know, delight in giving way to sympathy, and are in raptures at the excellence of the poet who stirs our feelings most.

Yes, of course I know.

But when any sorrow of our own happens to us, then you may observe that we pride ourselves on the opposite quality—we would fain be quiet and patient; this is considered the manly part, and the other which e delighted us in the recitation is now deemed to be the part of a woman.

Very true, he said.

Now we can be right in praising and admiring another who is doing that which any one of us would abominate and be ashamed of in his own person?

No, he said, that is certainly not reasonable.

606 Nay, I said, quite reasonable from one point of view.

What point of view?

If you consider, I said, that when in misfortune we feel a natural hunger and desire to relieve our sorrow by weeping and lamentation, and that this very feeling which is starved and suppressed in our own calamities is satisfied and delighted by the poets;—the better nature in each of us, not having been sufficiently trained by reason or habit, allows the

sympathetic element to break loose because the sorrow is another's; and the b
spectator fancies that there can be no disgrace to himself in praising and
pitying any one who while professing to be a brave man, gives way to
untimely lamentation; he thinks that the pleasure is a gain, and is far from
wishing to lose it by rejection of the whole poem. Few persons ever reflect,
as I should imagine, that the contagion must pass from others to them-
selves. For the pity which has been nourished and strengthened in the
misfortunes of others is with difficulty repressed in our own.

How very true! c

And does not the same hold also of the ridiculous? There are jests
which you would be ashamed to make yourself, and yet on the comic stage,
or indeed in private, when you hear them, you are greatly amused by
them, and are not at all disgusted at their unseemliness;—the case of pity
is repeated;—there is a principle in human nature which is disposed to
raise a laugh, and this, which you once restrained by reason because you
were afraid of being thought a buffoon, is now let out again; and having
stimulated the risible faculty at the theatre, you are betrayed unconsciously
to yourself into playing the comic poet at home.

Quite true, he said. d

And the same may be said of lust and anger and all the other affections,
of desire and pain and pleasure, which are held to be inseparable from
every action—in all of them poetry has a like effect; it feeds and waters
the passions instead of drying them up; she lets them rule, although they
ought to be controlled if mankind are ever to increase in happiness and
virtue.

I cannot deny it.

Therefore, Glaucon, I said, whenever you meet with any of the eulo- e
gists of Homer declaring that he has been the educator of Hellas, and that
he is profitable for education and for the ordering of human things, and
that you should take him up again and again and get to know him and
regulate your whole life according to him, we may love and honour those
who say these things—they are excellent people, as far as their lights ex- 607
tend; and we are ready to acknowledge that Homer is the greatest of poets
and first of tragedy writers; but we must remain firm in our conviction
that hymns to the gods and praises of famous men are the only poetry
which ought to be admitted into our State. For if you go beyond this and
allow the honeyed Muse to enter, either in epic or lyric verse, not law and
the reason of mankind, which by common consent have ever been deemed
best,[4] but pleasure and pain will be the rulers in our State.

That is most true, he said.

And now since we have reverted to the subject of poetry, let this our b
defence serve to show the reasonableness of our former judgement in
sending away out of our State an art having the tendencies which we have

[4] [Or: 'law, and the principle which the community in every case has pronounced
to be the best'.]

described; for reason constrained us. But that she may not impute to us any harshness or want of politeness, let us tell her that there is an ancient quarrel between philosophy and poetry; of which there are many proofs, such as the saying of 'the yelping hound howling at her lord', or of one 'mighty in the vain talk of fools', and 'the mob of sages circumventing

c Zeus', and the 'subtle thinkers who are beggars after all';[5] and there are innumerable other signs of ancient enmity between them. Notwithstanding this, let us assure the poetry which aims at pleasure, and the art of imitation, that if she will only prove her title to exist in a well-ordered State we shall be delighted to receive her—we are very conscious of her charms; but it would not be right on that account to betray the truth. I dare say, Glaucon, that you are as much charmed by her as I am, especially when

d she appears in Homer?

Yes, indeed, I am greatly charmed.

Shall I propose, then, that she be allowed to return from exile, but upon this condition only—that she make a defence of herself in some lyrical or other metre?

Certainly.

And we may further grant to those of her defenders who are lovers of poetry and yet not poets the permission to speak in prose on her behalf: let them show not only that she is pleasant but also useful to States and to human life, and we will listen in a kindly spirit; for we shall surely be the

e gainers if this can be proved, that there is a use in poetry as well as a delight?

Certainly, he said, we shall be the gainers.

If her defence fails, then, my dear friend, like other persons who are enamoured of something, but put a restraint upon themselves when they think their desires are opposed to their interests, so too must we after the manner of lovers give her up, though not without a struggle. We too are inspired by that love of such poetry which the education of noble States

608 has implanted in us, and therefore we shall be glad if she appears at her best and truest; but so long as she is unable to make good her defence, this argument of ours shall be a charm to us, which we will repeat to ourselves while we listen to her strains; that we may not fall away into the childish love of her which captivates the many. At all events we are well aware[6] that poetry,[7] such as we have described, is not to be regarded seriously as attaining to the truth; and he who listens to her, fearing for

b the safety of the city which is within him, should be on his guard against her seductions and make our words his law.

Yes, he said, I quite agree with you.

[5] [Reading and sense uncertain. The origin of all these quotations is unknown.]
[6] Or, if we accept Madvig's ingenious but unnecessary emendation ἀσόμεθα, 'At all events we will sing, that', &c.
[7] [i.e. *imitative* poetry. The word imitation, in the recent argument, had not the same sense as in Book III; but it has always been implied that there might be poetry which is not imitative.]

Yes, I said, my dear Glaucon, for great is the issue at stake, greater than appears, whether a man is to be good or bad. And what will any one be profited if under the influence of honour or money or power, aye, or under the excitement of poetry, he neglect justice and virtue?

Yes, he said; I have been convinced by the argument, as I believe that anyone else would have been.

And yet we have not described the greatest prizes and rewards which c await virtue.

What, are there any greater still? If there are, they must be of an inconceivable greatness.

Why, I said, what was ever great in a short time? The whole period from childhood to age is surely but a little thing in comparison with eternity?

Say rather 'nothing', he replied.

And should an immortal being be anxious for this little time rather than for the whole? d

For the whole, certainly. But why do you ask?

Are you not aware, I said, that the soul of man is immortal and imperishable?

He looked at me in astonishment, and said: No, by heaven: And are you really prepared to maintain this?

Yes, I said, I ought to be, and you too—there is no difficulty in proving it.

I see a great difficulty; but I should like to hear you state this argument of which you make so light.

Listen then.

I am attending.

There is a thing which you call good and another which you call evil?

Yes, he replied.

Would you agree with me in thinking that the corrupting and destroy- e ing element is the evil, and the saving and improving element the good?

True.

And you admit that everything has a good and also an evil; as ophthalmia is the evil of the eyes and disease of the whole body; as blight is of corn, 609 and rot of timber, or rust of copper and iron: in everything, or in almost everything, there is an inherent evil and disease?

Yes, he said.

PLATO

SYMPOSIUM

b And the admission has been already made that love is of something which one lacks and has not?

True, he said.

Then Love lacks and has not beauty?

Certainly, he replied.

And would you call that beautiful which lacks beauty and does not possess it in any way?

Certainly not.

c Then would you still say that Love is beautiful?

Agathon replied: I fear that I said what I did without understanding.

Indeed, you made a very good speech, Agathon, replied Socrates; but there is yet one small question which I would fain ask:—Is not the good also the beautiful?

Reprinted from *The Dialogues of Plato*, translated by B. Jowett (4th ed.; Oxford: The Clarendon Press, 1953), pp. 533–543, by permission of the publisher.

Yes.

Then in lacking the beautiful, love lacks also the good?

I cannot refute you, Socrates, said Agathon: —Be it as you say.

Say rather, beloved Agathon, that you cannot refute the truth; for Socrates is easily refuted.

And now, taking my leave of you, I will rehearse a tale of love which d I heard from Diotima of Mantinea, a woman wise in this and many other kinds of knowledge, who in the days of old, when the Athenians offered sacrifice before the coming of the plague, delayed the disease ten years. She was my instructress in the art of love, and I shall try to repeat to you what she said to me, beginning with the propositions on which Agathon and I are agreed; I will do the best I can do without any help. As you, Agathon, suggested, it is proper to speak first of the being and nature of Love, and then of his works. (I think it will be easiest e for me if in recounting my conversation with the wise woman I follow its actual course of question and answer.) First I said to her in nearly the same words which he used to me, that Love was a mighty god, and likewise fair; and she proved to me, as I proved to him, that by my own showing Love was neither fair nor good. 'What do you mean, Diotima,' I said, 'is Love then evil and foul?' 'Hush,' she cried; 'must that be foul which is not fair?' 'Certainly,' I said. 'And is that which is not wise, 202 ignorant? do you not see that there is a mean between wisdom and ignorance?' 'And what may that be?' I said. 'Right opinion,' she replied; 'which, as you know, being incapable of giving a reason, is not knowledge (for how can knowledge be devoid of reason?) nor again ignorance (for neither can ignorance attain the truth), but is clearly something which is a mean between ignorance and wisdom.' 'Quite true,' I replied. 'Do not then insist,' b she said, 'that what is not fair is of necessity foul, or what is not good evil; or infer that because Love is not fair and good he is therefore foul and evil; for he is in a mean between them.' 'Well,' I said, 'Love is surely admitted by all to be a great god.' 'By those who know or by those who do not know?' 'By all.' 'And how, Socrates,' she said with a smile, 'can c Love be acknowledged to be a great god by those who say that he is not a god at all?' 'And who are they?' I said. 'You and I are two of them,' she replied. 'How can that be?' I said. 'It is quite intelligible,' she replied; 'for you yourself would acknowledge that the gods are happy and fair—of course you would—would you dare to say that any god was not?' 'Certainly not,' I replied. 'And you mean by the happy, those who are the possessors of things good and things fair?' 'Yes.' 'And you admitted that Love, because he was in want, desires those good and fair things of which d he is in want?' 'Yes, I did.' 'But how can he be a god who has no portion in what is good and fair?' 'Impossible.' 'Then you see that you also deny the divinity of Love.'

'What then is Love?' I asked; 'Is he mortal?' 'No.' 'What then?' 'As in the former instance, he is neither mortal nor immortal, but in a mean

e between the two.' 'What is he, Diotima?' 'He is a great spirit (δαίμων), and
like all spirits he is intermediate between the divine and the mortal.' 'And
what,' I said, 'is his power?' 'He interprets between gods and men, convey-
ing and taking across to the gods the prayers and sacrifices of men, and to
men the commands of the gods and the benefits they return; he is the
mediator who spans the chasm which divides them, and therefore by him
the universe is bound together, and through him the arts of the prophets
203 and the priest, their sacrifices and mysteries and charms, and all prophecy
and incantation, find their way. For God mingles not with man; but
through Love all the intercourse and converse of gods with men, whether
they be awake or asleep, is carried on. The wisdom which understands
this is spiritual; all other wisdom, such as that of arts and handicrafts, is
mean and vulgar. Now these spirits or intermediate powers are many and
diverse, and one of them is Love.' 'And who,' I said, 'was his father, and
b who his mother?' 'The tale,' she said, 'will take time; nevertheless I will
tell you. On the day when Aphrodite was born there was a feast of all the
gods, among them the god Poros or Plenty, who is the son of Metis or
Sagacity. When the feast was over, Penia or Poverty, as the manner is on
such occasions, came about the doors to beg. Now Plenty, who was the
worse for nectar (there was no wine in those days), went into the garden
of Zeus and fell into a heavy sleep; and Poverty considering that for her
there was no plenty, plotted to have a child by him, and accordingly she
c lay down at his side and conceived Love, who partly because he is
naturally a lover of the beautiful, and because Aphrodite is herself beauti-
ful, and also because he was begotten during her birthday feast, is her
follower and attendant. And as his parentage is, so also are his fortunes.
In the first place he is always poor, and anything but tender and fair,
d as the many imagine him; and he is rough and squalid, and has no shoes,
nor a house to dwell in; on the bare earth exposed he lies under the open
heaven, in the streets, or at the doors of houses, taking his rest; and like
his mother he is always in distress. Like his father too, whom he also
partly resembles, he is always plotting against the fair and good; he is
bold, enterprising, strong, a mighty hunter, always weaving some intrigue
or other, keen in the pursuit of wisdom, fertile in resources; a philosopher
e at all times, terrible as an enchanter, sorcerer, sophist. He is by nature
neither mortal nor immortal, but alive and flourishing at one moment
when he is in plenty, and dead at another moment in the same day, and
again alive by reason of his father's nature. But that which is always flow-
ing in is always flowing out, and so he is never in want and never in
wealth; and, further, he is in a mean between ignorance and knowledge.
204 The truth of the matter is this: No god is a philosopher or seeker after
wisdom, for he is wise already; nor does any man who is wise seek after
wisdom. Neither do the ignorant seek after wisdom; for herein is the evil
of ignorance, that he who is neither a man of honour nor wise is never-
theless satisfied with himself: there is no desire when there is no feeling

of want.' 'But who then, Diotima,' I said, 'are the lovers of wisdom, if they are neither the wise nor the foolish?' 'A child may answer that question,' b she replied; 'they are those who are in a mean between the two; Love is one of them. For wisdom is a most beautiful thing, and Love is of the beautiful; and therefore Love is also a philosopher or lover of wisdom, and being a lover of wisdom is in a mean between the wise and the ignorant. And of this, too, his birth is the cause; for his father is wealthy and wise, and his mother poor and foolish. Such, my dear Socrates, is the nature of the spirit Love. The error in your conception of him was very natural; from what you say yourself, I infer that it arose because you c thought that Love is that which is loved, not that which loves; and for that reason, I think, Love appeared to you supremely beautiful. For the beloved is the truly beautiful, and delicate, and perfect, and blessed; but the active principle of love is of another nature, and is such as I have described.'

I said: 'O thou stranger woman, thou sayest well; but, assuming Love to be such as you say, what is the use of him to men?' 'That, Socrates,' d she replied, 'I will attempt to unfold: of his nature and birth I have already spoken; and you acknowledge that love is of the beautiful. But someone will say: What does it consist in, Socrates and Diotima?—or rather let me put the question more clearly, and ask: When a man loves the beautiful, what does his love desire?' I answered her 'That the beautiful may be his.' 'Still,' she said, 'the answer suggests a further question: What is given by the possession of beauty?' 'To what you have asked,' I replied, 'I have no answer ready.' 'Then,' she said, 'let me put the word "good" in the place of the beautiful, and repeat the question once e more: If he who loves loves the good, what is it then that he loves?' 'The possession of the good.' 'And what does he gain who possesses the good?' 'Happiness,' I replied; 'there is less difficulty in answering that question.' 'Yes,' she said, 'the happy are made happy by the acquisition of good 205 things. Nor is there any need to ask why a man desires happiness; the answer is already final.' 'You are right,' I said. 'And is this wish and this desire common to all? and do all men always desire their own good, or only some men?—what say you?' 'All men,' I replied; 'the desire is common to all.' 'Why, then,' she rejoined, 'are not all men, Socrates, said to love, but only some of them? whereas you say that all men are always b loving the same things.' 'I myself wonder,' I said, 'why this is.' 'There is nothing to wonder at,' she replied; 'the reason is that one part of love is separated off and receives the name of the whole, but the other parts have other names.' 'Give an illustration,' I said. She answered me as follows: 'There is creative activity which, as you know, is complex and manifold. All that causes the passage of non-being into being is a "poesy" or creation, and the processes of all art are creative; and the masters of arts c are all poets or creators.' 'Very true.' 'Still,' she said, 'you know that they are not called poets, but have other names; only that one portion of

creative activity which is separated off from the rest, and is concerned
with music and metre, is called by the name of the whole and is termed
poetry, and they who possess poetry in this sense of the word are called
poets.' 'Very true,' I said. 'And the same holds of love. For you may say
d generally that all desire of good and happiness is only the great and
subtle power of love; but they who are drawn towards him by any other
path, whether the path of money-making or gymnastics or philosophy, are
not called lovers—the name of the whole is appropriated to those whose
desire takes one form only—they alone are said to love, or to be lovers.' 'I
dare say,' I replied, 'that you are right.' 'Yes,' she added, 'and you hear
e people say that lovers are seeking for their other half; but I say that they
are seeking neither for the half of themselves, nor for the whole, unless
the half or the whole be also a good; men will cut off their own hands and
feet and cast them away, if they think them evil. They do not, I imagine,
each cling to what is his own, unless perchance there be someone who
206 calls what belongs to him the good, and what belongs to another the
evil; for there is nothing which men love but the good. Is there anything?'
'Certainly, I should say, that there is nothing.' 'Then,' she said, 'the
simple truth is, that men love the good.' 'Yes,' I said. 'To which must be
added that they love the possession of the good?' 'Yes, that must be added.'
'And not only the possession, but the everlasting possession of the good?'
'That must be added too.' 'Then love,' she said, 'may be described generally
as the love of the everlasting possession of the good?' 'That is most true.'
b 'Then if this be always the nature of love, can you tell me further,' she
went on, 'what is the manner of the pursuit? what are they doing who
show all this eagnerness and heat which is called love? and what is the
object which they have in view? Answer me.' 'Nay, Diotima,' I replied, 'if
I knew, I should not be wondering at your wisdom, neither should I
come to learn from you about this very matter.' 'Well,' she said, 'I will
teach you:—The object which they have in view is birth in beauty,
c whether of body or soul.' 'I do not understand you,' I said; 'the oracle re-
quires an explanation.' 'I will make my meaning clearer,' she replied. 'I
mean to say, that all men are bringing to the birth in their bodies and in
their souls. There is a certain age at which human nature is desirous of
procreation—procreation which must be in beauty and not in deformity.
The union of man and woman is a procreation; it is a divine thing, for
conception and generation are an immortal principle in the mortal creature,
and in the inharmonious they can never be. But the deformed is inhar-
d monious with all divinity, and the beautiful harmonious. Beauty, then, is
the destiny or goddess of parturition who presides at birth, and therefore,
when approaching beauty, the procreating power is propitious, and expan-
sive, and benign, and bears and produces fruit: at the sight of ugliness
she frowns and contracts and has a sense of pain, and turns away, and
shrivels up, and not without a pang refrains from procreation. And this is
the reason why, when the hour of procreation comes, and the teeming

nature is full, there is such a flutter and ecstasy about beauty whose approach is the alleviation of the bitter pain of travail. For love, Socrates, e is not, as you imagine, the love of the beautiful only.' 'What then?' 'The love of generation and of birth in beauty.' 'Yes,' I said. 'Yes, indeed,' she replied. 'But why of generation? Because to the mortal creature, generation is a sort of eternity and immortality, and if, as has been already admitted, love is of the everlasting possession of the good, all men will 207 necessarily desire immortality together with good: whence it must follow that love is of immortality.'

All this she taught me at various times when she spoke of love. And I remember her once saying to me, 'What is the cause, Socrates, of love, and the attendant desire? See you not how all animals, birds as well as beasts, in their desire of procreation, are in agony when they take the infection of love, which begins with the desire of union and then passes b to the care of offspring, on whose behalf the weakest are ready to battle against the strongest even to the uttermost, and to die for them, and will let themselves be tormented with hunger, or make any other sacrifice, in order to maintain their young. Man may be supposed to act thus from reason; but why should animals have these passionate feelings? Can you c tell me why?' Again I replied that I did not know. She said to me: 'And do you expect ever to become a master in the art of love, if you do not know this?' 'But I have told you already, Diotima, that my ignorance is the reason why I come to you, for I am conscious that I want a teacher; tell me then the cause of this and of the other mysteries of love.' 'Marvel not,' she said, 'if you believe that love is of the immortal, as we have several times acknowledged; for here again, and on the same principle too, the mortal nature is seeking as far as is possible to be everlasting and im- d mortal: and this is only to be attained by generation, because generation always leaves behind a new and different existence in the place of the old. Nay, even in the life of the same individual there is succession and not absolute uniformity: a man is called the same, and yet in the interval between youth and age, during which every animal is said to have life and identity, he is undergoing a perpetual process of loss and reparation— hair, flesh, bones, blood, and the whole body are always changing. Which is true not only of the body, but also of the soul, whose habits, tempers, e opinions, desires, pleasures, pains, fears, never remain the same in any one of us, but are always coming and going. What is still more surprising, it is equally true of science; not only do some of the sciences come to life in our minds, and others die away, so that we are never the same in 208 regard to them either: but the same fate happens to each of them individually. For what is implied in the word "recollection", but the departure of knowledge, which is ever being forgotten, and is renewed and preserved by recollection, and appears to be the same although in reality new, according to that law by which all mortal things are preserved, not absolutely the same, but by substitution, the old worn-out mortality leaving

another new and similar existence behind—unlike the divine, which is
b wholly and eternally the same? And in this way, Socrates, the mortal
body, or mortal anything, partakes of immortality; but the immortal in
another way. Marvel not then at the love which all men have of their off-
spring; for that universal love and interest is for the sake of immortality.'

I was astonished at her words, and said: 'Is this really true, O most
c wise Diotima?' And she answered with all the authority of an accomplished
sophist: 'Of that, Socrates, you may be assured;—think only of the ambi-
tion of men, and you will wonder at the senselessness of their ways, unless
you consider how they are stirred by the passionate love of fame. They
are ready to run all risks, even greater than they would have run for their
d children, and to pour out money and undergo any sort of toil, and even
to die, "if so they leave an everlasting name". Do you imagine that
Alcestis would have died to save Admetus, or Achilles to avenge Patroclus,
or your own Codrus in order to preserve the kingdom for his sons, if
they had not imagined that the memory of their virtues, which still survives
among us, would be immortal? Nay,' she said, 'I am persuaded that all men
do all things, and the better they are the more they do them, in hope of
e the glorious fame of immortal virtue; for they desire the immortal.

'Those who are pregnant in the body only, betake themselves to women
and beget children—this is the character of their love; their offspring, as
they hope, will preserve their memory and give them the blessedness and
immortality which they desire for all future time. But souls which are
209 pregnant—for there certainly are men who are more creative in their souls
than in their bodies, creative of that which is proper for the soul to con-
ceive and bring forth: and if you ask me what are these conceptions, I
answer, wisdom, and virtue in general—among such souls are all creative
poets and all artists who are deserving of the name inventor. But the
greatest and fairest sort of wisdom by far is that which is concerned with
the ordering of states and families, and which is called temperance and
b justice. And he who in youth has the seed of these implanted in his soul,
when he grows up and comes to maturity desires to beget and generate.
He wanders about seeking beauty that he may get offspring—for from
deformity he will beget nothing—and naturally embraces the beautiful
rather than the deformed body; above all, when he finds a fair and noble
and well-nurtured soul, he embraces the two in one person, and to such
c a one he is full of speech about virtue and the nature and pursuits of a
good man, and he tries to educate him. At the touch and in the society of
the beautiful which is ever present to his memory, even when absent, he
brings forth that which he had conceived long before, and in company
with him tends that which he brings forth; and they are married by a far
nearer tie and have a closer friendship than those who beget mortal
children, for the children who are their common offspring are fairer and
more immortal. Who, when he thinks of Homer and Hesiod and other
d great poets, would not rather have their children than ordinary human

ones? Who would not emulate them in the creation of children such as theirs, which have preserved their memory and given them everlasting glory? Or who would not have such children as Lycurgus left behind him to be the saviours, not only of Lacedaemon, but of Hellas, as one may say? There is Solon, too, who is the revered father of Athenian laws; and many others there are in many other places, both among Hellenes and e barbarians, who have given to the world many noble works, and have been the parents of virtue of every kind; and many temples have been raised in their honour for the sake of children such as theirs; which were never raised in honour of anyone, for the sake of his mortal children.

'These are the lesser mysteries of love, into which even you, Socrates, 210 may enter; to the greater and more hidden ones which are the crown of these, and to which, if you pursue them in a right spirit, they will lead, I know not whether you will be able to attain. But I will do my utmost to inform you, and do you follow if you can. For he who would proceed aright in this matter should begin in youth to seek the company of corporeal beauty; and first, if he be guided by his instructor aright, to love one beautiful body only—out of that he should create fair thoughts; and soon he will of himself perceive that the beauty of one body is akin to b the beauty of another; and then if beauty of form in general is his pursuit, how foolish would he be not to recognize that the beauty in every body is one and the same! And when he perceives this he will abate his violent love of the one, which he will despise and deem a small thing, and will become a steadfast lover of all beautiful bodies. In the next stage he will consider that the beauty of the soul is more precious than the beauty of the outward form; so that if a virtuous soul have but a little comeliness, he will be content to love and tend him, and will search out and bring to c the birth thoughts which may improve the young, until he is compelled next to contemplate and see the beauty in institutions and laws, and to understand that the beauty of them all is of one family, and that personal beauty is a trifle; and after institutions his guide will lead him on to the sciences, in order that, beholding the wide region already occupied by d beauty, he may cease to be like a servant in love with one beauty only, that of a particular youth or man or institution, himself a slave mean and narrow-minded; but drawing towards and contemplating the vast sea of beauty, he will create many fair and noble thoughts and discourses in boundless love of wisdom, until on that shore he grows and waxes strong, and at last the vision is revealed to him of a single science, which is the science of beauty everywhere. To this I will proceed; please to give me e your very best attention:

'He who has been instructed thus far in the things of love, and who has learned to see the beautiful in due order and succession, when he comes toward the end will suddenly perceive a nature of wondrous beauty (and this, Socrates, is the final cause of all our former toils)—a nature 211 which in the first place is everlasting, knowing not birth or death, growth

or decay; secondly, not fair in one point of view and foul in another, or at one time or in one relation or at one place fair, at another time or in another relation or at another place foul, as if fair to some and foul to others, or in the likeness of a face or hands or any other part of the bodily frame, or in any form of speech or knowledge, or existing in any individual being, as for example, in a living creature, whether in heaven, or in earth, or anywhere else; but beauty absolute, separate, simple, and everlasting, which is imparted to the ever growing and perishing beauties of all other beautiful things, without itself suffering diminution, or increase, or any change. He who, ascending from these earthly things under the influence of true love, begins to perceive that beauty, is not far from the end. And the true order of going, or being led by another, to the things of love, is to begin from the beauties of earth and mount upwards for the sake of that other beauty, using these as steps only, and from one going on to two, and from two to all fair bodily forms, and from fair bodily forms to fair practices, and from fair practices to fair sciences, until from fair sciences he arrives at the science of which I have spoken, the science which has no other object than absolute beauty, and at last knows that which is beautiful by itself alone. This, my dear Socrates,' said the stranger of Mantinea, 'is that life above all others which man should live, in the contemplation of beauty absolute; a beauty which if you once beheld, you would see not to be after the measure of gold, and garments, and fair boys and youths, whose presence now entrances you; and you and many a one would be content to live seeing them only and conversing with them without meat or drink, if that were possible—you only want to look at them and to be with them. But what if a man had eyes to see the true beauty—the divine beauty, I mean, pure and clear and unalloyed, not infected with the pollutions of the flesh and all the colours and vanities of mortal life—thither looking, and holding converse with the true beauty simple and divine? Remember how in that communion only, beholding beauty with that by which it can be beheld, he will be enabled to bring forth, not images of beauty, but realities (for he has hold not of an image but of a reality), and bringing forth and nourishing true virtue will properly become the friend of God and be immortal, if mortal man may. Would that be an ignoble life?'

PLATO

PHAEDRUS

Soc. Know then, fair youth, that the former discourse was the word
of Phaedrus, the son of Pythocles, of the deme Myrrhina. And this which 244
I am about to utter is the recantation of Stesichorus the son of Euphemus,
who comes from the town of Himera, and is to the following effect: 'False
was that word of mine' that the beloved ought to accept the non-lover
when he might have the lover, because the one is sane, and the other mad.
It might be so if madness were simply an evil; but there is also a madness
which is a divine gift, and the source of the chiefest blessings granted to
men. For prophecy is a madness, and the prophetess at Delphi and the
priestesses at Dodona when out of their senses have conferred great bene- b
fits on Hellas, both in public and private life, but when in their senses
few or none. And I might also tell you how the Sibyl and other inspired
persons have given to many an one many an intimation of the future which

Reprinted from *The Dialogues of Plato*, translated by B. Jowett (4th ed.; Oxford:
The Clarendon Press, 1953), pp. 150–164, by permission of the publisher.

has saved them from falling. But it would be tedious to speak of what every one knows.

c There will be more reason in appealing to the ancient inventors of names, who would never have connected prophecy (μαντική), which foretells the future and is the noblest of arts, with madness (μανική), or called them both by the same name, if they had deemed madness to be a disgrace or dishonour;—they must have thought that there was an inspired madness which was a noble thing; for the two words, μαντική and μανική, are really the same, and the letter τ is only a modern and tasteless insertion. And this is confirmed by the name which was given by them to the rational investigation of futurity, whether made by the help of birds or other signs—this, for as much as it is an art which supplies from the reasoning faculty mind (νοῦς) and information (ἰστορία) to human thought

d (οἴησις), they originally termed οἰονοιστική, but the word has been lately altered and made sonorous by the modern introduction of the letter Omega (οἰονοιστική and οἰωνιστική), and in proportion as prophecy (μαντική) is more perfect and august than augury, both in name and fact, in the same proportion, as the ancients testify, is madness superior to a sane mind (σωφροσύνη), for the one is only of human, but the other of divine, origin. Again, where plagues and mightiest woes have bred in certain families, owing to some ancient blood-guiltiness, there madness, inspiring

e and taking possession of those whom destiny has appointed, has found deliverance, having recourse to prayers and religious rites. And learning thence the use of purifications and mysteries, it has sheltered from evil, future as well as present, the man who has some part in this gift, and has

245 afforded a release from his present calamity to one who is truly possessed, and duly out of his mind. The third kind is the madness of those who are possessed by the Muses; which taking hold of a delicate and virgin soul, and there inspiring frenzy, awakens lyrical and all other numbers; with these adorning the myriad actions of ancient heroes for the instruction of posterity. But he who, having no touch of the Muses' madness in his soul, comes to the door and thinks that he will get into the temple by the help of art—he, I say, and his poetry are not admitted; the sane man disappears and is nowhere when he enters into rivalry with the madman.

b I might tell of many other noble deeds which have sprung from inspired madness. And therefore, let not the mere thought of this frighten us, and let us not be scared and confused by an argument which says that the temperate friend is to be chosen rather than the inspired, but let him further show that love is not sent by the gods for any good to lover or beloved; if he can do so we will allow him to carry off the palm. And we, on our part, must prove in answer to him that the madness of

c love is the greatest of heaven's blessings, and the proof shall be one which the wise will receive, and the witling disbelieve. But first of all, let us view the affections and actions of the soul divine and human, and try to ascertain the truth about them. The beginning of our proof is as follows:—

The soul through all her being is immortal, for that which is ever in motion is immortal; but that which moves another and is moved by another, in ceasing to move ceases also to live. Only the self-moving, since it cannot depart from itself, never ceases to move, and is the fountain and beginning of motion to all that moves besides. Now, the beginning is unbegotten, for that which is begotten must have a beginning; but this d itself cannot be begotten of anything, for if it were dependent upon something, then the begotten would not come from a *beginning*. But since it is unbegotten, it must also be indestructible. For surely if a beginning were destroyed, then it could neither come into being itself from any source, nor serve as the beginning of other things, if it be true that all things must have a beginning. Thus it is proved that the self-moving is the beginning of motion; and this can neither be destroyed nor begotten, else the whole heavens and all creation[1] would collapse and stand still, and, e lacking all power of motion, never again have birth. But whereas the self-moving is proved to be immortal, he who affirms that this is the very meaning and essence of soul will not be put to confusion. For every body which is moved from without is soul-less, but that which is self-moved from within is animate, and our usage makes it plain what is the nature of the soul. But if this be true, that the soul is identical with the 246 self-moving, it must follow of necessity that the soul is unbegotten and immortal. Enough of her immortality: let us pass to the description of her form.

To show her true nature would be a theme of large and more than mortal discourse, but an image of it may be given in a briefer discourse within the scope of man; in this way, then, let us speak. Let the soul be compared to a pair of winged horses and charioteer joined in natural union. Now the horses and the charioteers of the gods are all of them noble and of noble descent, but those of other races are mixed. First, you b must know that the human charioteer drives a pair; and next, that one of his horses is noble and of noble breed, and the other is ignoble and of ignoble breed; so that the management of the human chariot cannot but be a difficult and anxious task. I will endeavour to explain to you in what way the mortal differs from the immortal creature. The soul in her totality has the care of inanimate being everywhere, and traverses the whole heaven in divers forms appearing;—when perfect and fully winged c she soars upward, and orders the whole world; whereas the imperfect soul, losing her wings and drooping in her flight at last settles on the solid ground—there, finding a home, she receives an earthly frame which appears to be self-moved, but is really moved by her power; and this composition of soul and body is called a living and mortal creature. For immortal no such union can be reasonably believed to be; although fancy, not having seen nor surely known the nature of God, may imagine an immortal creature having both a body and also a soul which are united d

[1] [According to another reading, 'and the whole earth'.]

throughout all time. Let that, however, be as God wills, and be spoken of acceptably to him. And now let us ask the reason why the soul loses her wings!

 The wing is the corporeal element which is most akin to the divine, and which by nature tends to soar aloft and carry that which gravitates downwards into the upper region, which is the habitation of the gods.
e The divine is beauty, wisdom, goodness, and the like; and by these the wing of the soul is nourished, and grows apace; but when fed upon evil and foulness and the opposite of good, wastes and falls away. Zeus, the mighty lord, holding the reins of a winged chariot, leads the way in heaven, ordering all and taking care of all; and there follows him the
247 array of gods and demi-gods, marshalled in eleven bands; Hestia alone abides at home in the house of heaven; of the rest they who are reckoned among the princely twelve march in their appointed order. They see many blessed sights in the inner heaven, and there are many ways to and fro, along which the blessed gods are passing, every one doing his own work; he may follow who will and can, for jealousy has no place in the celestial
b choir. But when they go to banquet and festival, then they move up the steep to the top of the vault of heaven. The chariots of the gods in even poise, obeying the rein, glide rapidly; but the others labour, for the vicious steed goes heavily, weighing down the charioteer to the earth when his steed has not been thoroughly trained: —and this is the hour of agony and extremest conflict for the soul. For the immortals, when they are at the end of their course, go forth and stand upon the outside
c of heaven; its revolution carries them round, and they behold the things beyond. But of the heaven which is above the heavens, what earthly poet ever did or ever will sing worthily? It is such as I will describe; for I must dare to speak the truth, when truth is my theme. There abides the very being with which true knowledge is concerned; the colourless, form-
d less, intangible essence, visible only to mind, the pilot of the soul. The divine intelligence, being nurtured upon mind and pure knowledge, and the intelligence of every soul which is capable of receiving the food proper to it, rejoices at beholding reality once more, after so long a time, and gazing upon truth, is replenished and made glad, until the revolution of the world brings her round again to the same place. In the revolution she beholds justice, and temperance, and knowledge absolute, not that to which becoming belongs, nor that which is found, in varying forms, in
e one or other of those regions which we men call *real*, but real knowledge really present where true being is. And beholding the other true existences in like manner, and feasting upon them, she passes down into the interior of the heavens and returns home; and there the charioteer putting up his horses at the stall, gives them ambrosia to eat and nectar to drink.
248 Such is the life of the gods; but of other souls, that which follows God best and is likest to him lifts the head of the charioteer into the outer world, and is carried round in the revolution, troubled indeed by the

steeds, and with difficulty beholding true being; while another only rises and falls, and sees, and again fails to see by reason of the unruliness of the steeds. The rest of the souls are also longing after the upper world and they all follow, but not being strong enough they are carried round below the surface, plunging, treading on one another, each striving to be b first; and there is confusion and perspiration and the extremity of effort; and many of them are lamed or have their wings broken through the ill driving of the charioteers; and all of them after a fruitless toil, not having attained to the mysteries of true being, go away, and feed upon opinion [or appearance]. The reason why the souls exhibit this exceeding eager-ness to behold the Plain of Truth is that pasturage is found there, which is suited to the highest part of the soul; and the wing on which the soul c soars is nourished with this. And there is a law of Destiny, that the soul which attains any vision of truth in company with a god is preserved from harm until the next period, and if attaining always is always un-harmed. But when she is unable to follow, and fails to behold the truth, and through some ill-hap sinks beneath the double load of forgetfulness and vice, and her wings fall from her and she drops to the ground, then the law ordains that this soul shall at her first birth pass, not into any d other animal, but only into man; and the soul which has seen most of truth shall be placed in the seed from which a philosopher, or artist, or some musical and loving nature will spring; that which has seen truth in the second degree shall be some righteous king or warrior chief; the soul which is of the third class shall be a politician, or economist, or trader; the fourth shall be a lover of gymnastic toils, or a physician; the fifth shall lead the life of a prophet or hierophant; to the sixth the char- e acter of a poet or some other imitative artist will be assigned; to the seventh the life of an artisan or husbandman; to the eighth that of a sophist or demagogue; to the ninth that of a tyrant;—all these are states of probation, in which he who does righteously improves, and he who does unrighteously deteriorates, his lot.

Ten thousand years must elapse before the soul of each one can return to the place from whence she came, for she cannot grow her wings in less, save only the soul of a philosopher, guileless and true, or of a lover, 249 who has been guided by philosophy. And these when the third period comes round, if they have chosen this life three times in succession, have wings given them, and go away at the end of three thousand years. But the others[2] receive judgement when they have completed their first life, and after the judgement they go, some of them to the houses of correction which are under the earth, and are punished; others to some place in heaven whither they are lightly borne by justice, and there they live in a manner worthy of the life which they led here when in the form of b men. And in the thousandth year, both arrive at a place where they must

[2] The philosopher alone is not subject to judgement ($\kappa\rho\iota\sigma\iota\varsigma$), for he has never lost the vision of truth.

draw lots and choose their second life, and they may take any which they please. And now the soul of a man may pass into the life of a beast, or that which has once been a man return again from the beast into human form. But the soul which has never seen the truth will not pass into the human form. For a man must have intelligence by what is called the Idea, a unity gathered[3] together by reason from the many particulars of

c sense. This is the recollection of those things which our soul once saw while following God—when regardless of that which we now call being she raised her head up towards the true being. And therefore the mind of the philosopher alone has wings; and this is just, for he is always, according to the measure of his abilities, clinging in recollection to those things in which God abides, and in beholding which He is what He is. And he who employs aright these memories is ever being initiated into perfect mysteries and alone becomes truly perfect. But, as he forgets

d earthly interests and is rapt in the divine, the vulgar deem him mad, and rebuke him; they do not see that he is inspired.

Thus far I have been speaking of the fourth and last kind of madness, which is imputed to him who, when he sees the beauty of earth, is transported with the recollection of the true beauty; he would like to fly away, but he cannot; he is like a bird fluttering and looking upward and careless of the world below; and he is therefore thought to be mad.

e And I have shown this of all inspirations to be the noblest and highest and the offspring of the highest to him who has or shares in it, and that he who loves the beautiful is called a lover because he partakes of it. For, as has been already said, every soul of man has in the way of nature

250 beheld true being; this was the condition of her passing into the form of man. But all souls do not easily recall the things of the other world; they may have seen them for a short time only, or they may have been unfortunate in their earthly lot, and, having had their hearts turned to unrighteousness through some corrupting influence, they may have lost the memory of the holy things which once they saw. Few only retain an adequate remembrance of them; and they, when they behold here any

b image of that other world, are rapt in amazement; but they are ignorant of what this rapture means, because they do not clearly perceive. For there is no radiance in our earthly copies of justice or temperance or those other things which are precious to souls: they are seen through a glass dimly; and there are few who, going to the images, behold in them the realities, and these only with difficulty. But beauty could be seen, brightly shining, by all who were with that happy band,—we philosophers following in the train of Zeus, others in company with other gods; at

c which time we beheld the beatific vision and were initiated into a mystery which may be truly called most blessed, celebrated by us in our state of innocence, before we had any experience of evils to come, when we were

[3] [Plato proposes here an etymology of the word ξυνιέναι, understand.]

admitted to the sight of apparitions innocent and simple and calm and happy, which we beheld shining in pure light, pure ourselves and not yet enshrined in that living tomb which we carry about, now that we are imprisoned in the body, like an oyster in his shell. Let me linger over the memory of scenes which have passed away.

But of beauty, I repeat that we saw her there shining in company with the celestial forms; and coming to earth we find her here too, shining in clearness through the clearest aperture of sense. For sight is the most d piercing of our bodily senses; though not by that is wisdom seen; her loveliness would have been transporting if there had been a visible image of her, and the other ideas, if they had visible counterparts, would be equally lovely. But this is the privilege of beauty, that being the loveliest she is also the most palpable to sight. Now he who is not newly initiated e or who has become corrupted, does not easily rise out of this world to the sight of true beauty in the other, when he contemplates her earthly namesake, and instead of being awed at the sight of her, he is given over to pleasure, and like a brutish beast he rushes on to enjoy and beget; 251 he consorts with wantonness, and is not afraid or ashamed of pursuing pleasure in violation of nature. But he whose initiation is recent, and who has been the spectator of many glories in the other world, is amazed when he sees anyone having a godlike face or form, which is the expression of divine beauty; and at first a shudder runs through him, and again the old awe steals over him; then looking upon the face of his beloved as of a god he reverences him, and if he were not afraid of being thought a downright madman, he would sacrifice to his beloved as to the image of a god; then while he gazes on him there is a sort of reaction, and the shudder passes into an unusual heat and perspiration; for, as he receives b the effluence of beauty through the eyes, the wing moistens and he warms. And as he warms, the parts out of which the wing grew, and which had been hitherto closed and rigid, and had prevented the wing from shooting forth, are melted, and as nourishment streams upon him, the lower end of the wing begins to swell and grow from the root upwards; and the growth extends under the whole soul—for once the whole was winged. During this process the whole soul is all in a state of ebullition and effervescence,—which may be compared to the irritation and c uneasiness in the gums at the time of cutting teeth,—bubbles up, and has a feeling of uneasiness and tickling; but when in like manner the soul is beginning to grow wings, the beauty of the beloved meets her eye and she receives the sensible warm motion of particles which flow towards her, therefore called emotion (ἵμερος), and is refreshed and warmed by them, and then she ceases from her pain with joy. But when she is parted d from her beloved and her moisture fails, then the orifices of the passage out of which the wing shoots dry up and close, and intercept the germ of the wing; which, being shut up with the emotion, throbbing as with the pulsations of an artery, pricks the aperture which is nearest, until at

length the entire soul is pierced and maddened and pained, and at the recollection of beauty is again delighted. And from both of them together the soul is oppressed at the strangeness of her condition, and is in a great
e strait and excitement, and in her madness can neither sleep by night nor abide in her place by day. And wherever she thinks that she will behold the beautiful one, thither in her desire she runs. And when she has seen him, and bathed herself in the waters of beauty, her constraint is loosened, and she is refreshed, and has no more pangs and pains; and this is the
252 sweetest of all pleasures at the time, and is the reason why the soul of the lover will never forsake his beautiful one, whom he esteems above all; he has forgotten mother and brethren and companions, and he thinks nothing of the neglect and loss of his property; the rules and proprieties of life, on which he formerly prided himself, he now despises, and is ready to sleep like a servant, wherever he is allowed, as near as he can
b to his desired one, who is the object of his worship, and the physician who can alone assuage the greatness of his pain. And this state, my dear imaginary youth to whom I am talking, is by men called love, and among the gods has a name at which you, in your simplicity, may be inclined to mock; there are two lines in the apocryphal writings of Homer in which the name occurs. One of them is rather outrageous, and not altogether metrical. They are as follows: —

> Mortals call him fluttering love,
> But the immortals call him winged one,
> Because the growing of wings[4] is a necessity to him.

c You may believe this, but not unless you like. At any rate the plight of lovers and its cause are such as I have described.

Now the lover who is taken to be the attendant of Zeus is better able to bear the winged god, and can endure a heavier burden; but the attendants and companions of Ares, who made the circuit in his company, when under the influence of love they fancy that they have been at all wronged, are ready to kill and put an end to themselves and their beloved. And
d he who followed in the train of any other god, while he is unspoiled and the impression lasts, honours and imitates him, as far as he is able; and after the manner of his god he behaves in his intercourse with his beloved and with the rest of the world during the first period of his earthly existence. Every one chooses his love from the ranks of beauty according to his character, and this he makes his god, and fashions and adorns as a sort of image which he is to fall down and worship. The
e followers of Zeus desire that their beloved should have a soul like him; and therefore they seek out someone of a philosophical and imperial nature, and when they have found him and loved him, they do all they can to confirm such a nature in him, and if they have no experience of such a disposition hitherto, they learn of anyone who can teach them, and

[4] Or, reading πτερόφοιτον, 'the movement of wings'.

themselves follow in the same way. And they have the less difficulty in finding the nature of their own god in themselves, because they have been 253 compelled to gaze intensely on him; their recollection clings to him, and they become possessed of him, and receive from him their character and disposition, so far as man can participate in God. The qualities of their god they attribute to the beloved, wherefore they love him all the more, and if, like the Bacchic Nymphs, they draw inspiration from Zeus, they pour out their own fountain upon him, wanting to make him as like as possible to their own god. But those who were the followers of Hera seek a royal love, and when they have found him they do just the same b with him; and in like manner the followers of Apollo and of every other god, walking in the ways of their god, seek a love who is to be made like him whom they serve, and when they have found him, they themselves imitate their god, and persuade their love to do the same, and educate him into the manner and nature of the god as far as they each can; for no feelings of envy or jealousy are entertained by them towards their beloved, but they do their utmost to create in him the greatest likeness of themselves and of the god whom they honour. Thus fair and bliss- c ful to the beloved is the desire of the inspired lover, and the initiation of which I speak into the mysteries of true love, if he be captured by the lover and their purpose is effected. Now the beloved is taken captive in the following manner: —

At the beginning of this tale, I divided each soul into three parts—two having the form of horses and the third being like a charioteer; the divi- d sion may remain. I have said that one horse was good, the other bad, but I have not yet explained in what the goodness or badness of either consists, and to that I will now proceed. The right-hand horse is upright and cleanly made; he has a lofty neck and an aquiline nose; his colour is white, and his eyes dark; he is one who loves honour with modesty and temperance, and the follower of true opinion; he needs no touch of the whip, but is guided by word and admonition only. The other is a crooked, lumbering animal, put together anyhow; he has a short, thick neck; he e is flat-faced and of a dark colour, with grey eyes and blood-red complexion;[5] the mate of insolence and pride, shag-eared and deaf, hardly yielding to whip and spur. Now when the charioteer beholds the vision of love, and has his whole soul warmed through sense, and is full of the prickings and ticklings of desire, the obedient steed, then as always 254 under the government of shame, refrains from leaping on the beloved; but the other, heedless of the pricks and of the blows of the whip, plunges and runs away, giving all manner of trouble to his companion and the charioteer, whom he forces to approach the beloved and to remember the joys of love. They at first indignantly oppose him and will not be urged on to do terrible and unlawful deeds; but at last, when he persists in b

[5] Or with grey and blood-shot eyes.

plaguing them, they yield and agree to do as he bids them. And now they are at the spot and behold the flashing beauty of the beloved; which when the charioteer sees, his memory is carried to the true beauty, whom he beholds in company with Modesty like an image placed upon a holy pedestal. He sees her, but he is afraid and falls backwards in adoration,

c and by his fall is compelled to pull back the reins with such violence as to bring both the steeds on their haunches, the one willing and unresisting, the unruly one very unwilling; and when they have gone back a little, the one is overcome with shame and wonder, and his whole soul is bathed in perspiration; the other, when the pain is over which the bridle and the fall had given him, having with difficulty taken breath, is full of wrath and reproaches, which he heaps upon the charioteer and his fellow steed, for want of courage and manhood, declaring that they have been false

d to their agreement and guilty of desertion. Again they refuse, and again he urges them on, and will scarce yield to their prayer that he would wait until another time. When the appointed hour comes, they make as if they had forgotten, and he reminds them, fighting and neighing and dragging them on, until at length he, on the same thoughts intent, forces them to draw near again. And when they are near he stoops his head and puts up his tail, and takes the bit in his teeth and pulls shamelessly.

e Then the charioteer is worse off than ever; he falls back like a racer at the barrier, and with a still more violent wrench drags the bit out of the teeth of the wild steed and covers his abusive tongue and jaws with blood, and forces his legs and haunches to the ground and punishes him sorely. And when this has happened several times and the villain has ceased from his wanton way, he is tamed and humbled, and follows the will of the charioteer, and when he sees the beautiful one he is ready to die of fear. And from that time forward the soul of the lover follows the beloved in modesty and holy fear.

255 And so the beloved who, like a god, has received every true and loyal service from his lover, not in pretence but in reality, being also himself of a nature friendly to his admirer, if in former days he has blushed to own his passion and turned away his lover, because his youthful companions or others slanderously told him that he would be disgraced, now

b as years advance, at the appointed age and time, is led to receive him into communion. For fate which has ordained that there shall be no friendship among the evil has also ordained that there shall ever be friendship among the good. And the beloved when he has received him into communion and intimacy, is quite amazed at the good will of the lover; he recognizes that the inspired friend is worth all other friends or kinsmen; they have nothing of friendship in them worthy to be compared with his. And when this feeling continues and he is nearer to him and embraces him, in gymnastic exercises and at other times of meeting, then

c the fountain of that stream, which Zeus when he was in love with Gany-

mede named Desire, overflows upon the lover, and some enters into his soul, and some when he is filled flows out again; and as a breeze or an echo rebounds from the smooth rocks and returns whence it came, so does the stream of beauty, passing through the eyes which are the windows of the soul, come back to the beautiful one; there arriving and quickening the passages of the wings, watering them and inclining them d to grow, and filling the soul of the beloved also with love. And thus he loves, but he knows not what; he does not understand and cannot explain his own state; he appears to have caught the infection of blindness from another; the lover is his mirror in whom he is beholding himself, but he is not aware of this. When he is with the lover, both cease from their pain, but when he is away then he longs as he is longed for, and has love's image, love for love [Anteros] lodging in his breast, which he calls e and believes to be not love but friendship only, and his desire is as the desire of the other, but weaker; he wants to see him, touch him, kiss, embrace him, and probably not long afterwards his desire is accomplished. When they meet, the wanton steed of the lover has a word to say to the charioteer; he would like to have a little pleasure in return for 256 many pains, but the wanton steed of the beloved says not a word, for he is bursting with passion which he understands not;—he throws his arms round the lover and embraces him as his dearest friend; and, when they are side by side, he is not in a state in which he can refuse the lover anything, if he ask him; although his fellow steed and the charioteer oppose him with the arguments of shame and reason. After this their happiness depends upon their self-control; if the better elements of the mind which lead to order and philosophy prevail, then they pass their b life here in happiness and harmony—masters of themselves and orderly— enslaving the vicious and emancipating the virtuous elements of the soul; and when the end comes, they are light and winged for flight, having conquered in one of the three heavenly or truly Olympian victories; nor can human discipline or divine inspiration confer any greater blessing on man than this. If, on the other hand, they leave philosophy and lead the lower life of ambition, then probably, after wine or in some other careless c hour, the two wanton animals take the two souls when off their guard and bring them together, and they accomplish that desire of their hearts which to the many is bliss; and this having once enjoyed they continue to enjoy, yet rarely, because they have not the approval of the whole soul. They too are dear, but not so dear as the others; and it is for each other that they live, throughout the time of their love and afterwards. They d consider that they have given and taken from each other the most sacred pledges, and they may not break them and fall into enmity. At last they pass out of the body, unwinged, but eager to soar, and thus obtain no mean reward of love and madness. For those who have once begun the heavenward pilgrimage may not go down again to darkness and the

journey beneath the earth, but they live in light always; happy companions in their pilgrimage, and when the time comes at which they receive their
e wings they have the same plumage because of their love.

Thus great are the heavenly blessings which the friendship of a lover will confer upon you, my youth. Whereas the attachment of the non-lover, which is alloyed with a worldly prudence and has worldly and niggardly ways of doling out benefits, will breed in your soul those vulgar qualities
257 which the populace applaud, will send you bowling round the earth during a period of nine thousand years, and leave you a fool in the world below.

And thus, dear Eros, I have made and paid my recantation, as well and as fairly as I could; more especially in the matter of the poetical figures which I was compelled to use, because Phaedrus would have them. And now forgive the past and accept the present, and be gracious and merciful to me, and do not in thine anger deprive me of sight, or take from me the art of love which thou hast given me, but grant that I may be yet
b more esteemed in the eyes of the fair. And if Phaedrus or I myself said anything rude in our first speeches, blame Lysias, who is the father of the brat, and let us have no more of his progeny; bid him study philosophy, like his brother Polemarchus; and then his lover Phaedrus will no longer halt between two opinions, but will dedicate himself wholly to love and to philosophical discourses.

Phaedr. I join in the prayer, Socrates, and say with you, if this be for
c my good, may your words come to pass. But I have long been amazed at this second oration, which you have made so much finer than the first. And I begin to be afraid that I shall lose conceit of Lysias, and that he will appear tame in comparison, even if he be willing to put another as fine and as long as yours into the field, which I doubt. For quite lately one of your politicians was abusing him on this very account; and called him a 'speech-writer' again and again. So that a feeling of pride may probably induce him to give up writing speeches.

Soc. What a very amusing notion! But I think, my young man, that
d you are much mistaken in your friend if you imagine that he is frightened at a little noise; and, possibly, you think that his assailant meant his remark as a reproach?

Phaedr. I thought, Socrates, that he did. And you are doubtless aware that the greatest and most influential statesmen are ashamed of writing speeches and leaving other written compositions, lest they should be called sophists by posterity.

PLATO

LAWS

BOOK II

Athenian Stranger. And now we have to consider whether the insight 652
into human nature is the only benefit derived from well-ordered potations,
or whether there are not other advantages great and much to be desired.
The argument seems to imply that there are. But how and in what way
these are to be attained, will have to be considered attentively, or we may
be entangled in error.

Cleinias. Proceed.

Ath. Let me once more recall our doctrine of right education; which,
if I am not mistaken, depends on the due regulation of convivial inter- 653
course.

Cle. You talk rather grandly.

Ath. Pleasure and pain I maintain to be the first perceptions of chil-

Reprinted from *The Dialogues of Plato*, translated by B. Jowett (4th ed.: Ox-
ford: The Clarendon Press, 1953), pp. 218–226, by permission of the publisher.

dren, and I say that they are the forms under which virtue and vice are originally present to them. As to wisdom and true and fixed opinions, happy is the man who acquires them, even when declining in years; and we may say that he who possesses them, and the blessings which are
b contained in them, is a perfect man. Now I mean by education that training which is given by suitable habits to the first instincts of virtue in children;—when pleasure, and friendship, and pain, and hatred are rightly implanted in souls not yet capable of understanding the nature of them, and who find them, after they have attained reason, to be in harmony with her. This harmony of the soul, taken as a whole, is virtue; but the particular training in respect of pleasure and pain, which leads you
c always to hate what you ought to hate, and love what you ought to love, from the beginning of life to the end, may be separated off; and, in my view, will be rightly called education.

Cle. I think, stranger, that you are quite right in all that you have said and are saying about education.

Ath. I am glad to hear that you agree with me; for, indeed, the discipline of pleasure and pain which, when rightly ordered, is a principle of education, has been often relaxed and corrupted in human life. And the
d Gods, pitying the toils which our race is born to undergo, have appointed holy festivals, wherein men alternate rest with labour; and have given them the Muses and Apollo, the leader of the Muses, and Dionysus, to be companions in their revels, that these may be saved from degeneration, and men partake in spiritual nourishment in company with the Gods. I should like to know whether a common saying is in our opinion true to nature or not. For men say that the young of all creatures cannot be quiet in their bodies or in their voices; they are always wanting to move
e and cry out; some leaping and skipping, and overflowing with sportiveness and delight at something, others uttering all sorts of cries. But, whereas the animals have no perception of order or disorder in their movements, that is, of rhythm or harmony, as they are called, to us the Gods, who,
654 as we say, have been appointed to be our companions in the dance, have given the pleasurable sense of harmony and rhythm; and so they stir us into life, and we follow them, joining hands together in dances and songs; and these they call choruses, which is a term naturally expressive of cheerfulness. Shall we begin, then, with the acknowledgement that education is first given through Apollo and the Muses? What do you say?

Cle. I assent.

b *Ath.* And the uneducated is he who has not been trained in the chorus, and the educated is he who has been well trained?

Cle. Certainly.

Ath. And the chorus is made up of two parts, dance and song?

Cle. True.

Ath. Then he who is well educated will be able to sing and dance well?

Cle. I suppose that he will.

Ath. Let us see; what are we saying?

Cle. What?

Ath. He sings well and dances well; now must we add that he sings what is good and dances what is good? c

Cle. Let us make the addition.

Ath. We will suppose that he knows the good to be good, and the bad to be bad, and makes use of them accordingly: which now is the better trained in dancing and music—he who is able to move his body and use his voice in what he understands to be the right manner, but has no d delight in good or hatred of evil; or he who is scarcely correct in gesture and voice and in understanding, but is right in his sense of pleasure and pain, and welcomes what is good, and is offended at what is evil?

Cle. There is a great difference, stranger, in the two kinds of education.

Ath. If we three know what is good in song and dance, then we truly know also who is educated and who is uneducated; but if not, then we certainly shall not know wherein lies the safeguard of education, and e whether there is any or not.

Cle. True.

Ath. Let us follow the scent like hounds, and go in pursuit of beauty of figure, and melody, and song, and dance; if these escape us, there will be no use in talking about true education, whether Hellenic or barbarian.

Cle. Yes.

Ath. Now what is meant by beauty of figure, or beautiful melody? When a manly soul is in trouble, and when a cowardly soul is in similar 655 case, are they likely to use the same figures and gestures, or to give utterance to the same sounds?

Cle. How can they, when the very colours of their faces differ?

Ath. Good, my friend; I may observe, however, in passing, that in music there certainly are figures and there are melodies: and music is concerned with harmony and rhythm, so that you may speak of a melody or figure having good rhythm or good harmony—the term is correct enough; but to speak metaphorically of a melody or figure having a 'good colour', as the masters of choruses do, is not allowable, although you can speak of the melodies or figures of the brave and the coward, b praising the one and censuring the other. And not to be tedious, let us say that the figures and melodies which are expressive of virtue of soul of body, or of images of virtue, are without exception good, and those which are expressive of vice are the reverse of good.

Cle. Your suggestion is excellent; and let us answer that these things are so.

Ath. Once more, are all of us equally delighted with every sort of dance? c

Cle. Far otherwise.

Ath. What, then, leads us astray? Are beautiful things not the same to us all, or are they the same in themselves, but not in our opinion of

them? For no one will admit that forms of vice in the dance are more beautiful than forms of virtue, or that he himself delights in the forms d of vice, and others in a muse of another character. And yet most persons say, that the excellence of music is to give pleasure to our souls. But this is intolerable and blasphemous; there is, however, a much more plausible account of the delusion.

Cle. What?

Ath. The adaptation of art to the characters of men. Choric movements are imitations of manners and the performers range over all the various actions and chances of life with characterization and mimicry; and those to whom the words, or songs, or dances are suited, either by e nature or habit or both, cannot help feeling pleasure in them and applauding them, and calling them beautiful. But those whose natures, or ways, or habits are unsuited to them, cannot delight in them or applaud them, and they call them base. There are others, again, whose natures are right and their habits wrong, or whose habits are right and their natures wrong, and they praise one thing, but are pleased at another. For they say that all these imitations are pleasant, but not good. And in the 656 presence of those whom they think wise, they are ashamed of dancing and singing in the baser manner, in a way which would indicate deliberate approval; and yet, they have a secret pleasure in them.

Cle. Very true.

Ath. And is any harm done to the lover of vicious dances or songs, or any good done to the approver of the opposite sort of pleasure?

Cle. I think that there is.

b *Ath.* 'I think' is not the word, but I would say, rather, 'I am certain'. For must they not have the same effect as when a man associates with bad characters, whom he likes and approves rather than dislikes, and only censures playfully because he has but a suspicion of their badness? In that case, he who takes pleasure in them will surely become like those in whom he takes pleasure, even though he be ashamed to praise them. This result is quite certain; and what greater good or evil can a human being undergo?

Cle. I know of none.

c *Ath.* Then in a city which has good laws, or in future ages is to have them, bearing in mind the instruction and amusement which are given by music, can we suppose that the poets are to be allowed to teach in the dance anything which they themselves like, in the way of rhythm, or melody, or words, to the young children of any well-conditioned parents? Is the poet to train his choruses as he pleases, without reference to virtue or vice?

Cle. That is surely quite unreasonable, and is not to be thought of.

d *Ath.* And yet he may do this in almost any state with the exception of Egypt.

Cle. And what are the laws about music and dancing in Egypt?

Ath. You will wonder when I tell you: Long ago they appear to have recognized the very principle of which we are now speaking—that their young citizens must be habituated to forms and strains of virtue. These they fixed, and exhibited the patterns of them in their temples; and no e painter, no other representative artist is allowed to innovate upon them, or to leave the traditional forms and invent new ones. To this day, no alteration is allowed either in these arts, or in music at all. And you find that their works of art are painted or moulded in the same forms which they had ten thousand years ago;—this is literally true and no exaggeration,—their ancient paintings and sculptures are not a whit better or worse than the work of today, but are made with just the same skill. 657

Cle. How extraordinary!

Ath. I should rather say, How statesmanlike, how worthy of a legislator! I know that other things in Egypt are not so well. But what I am telling you about music is true and deserving of consideration, because showing that a lawgiver may institute melodies which have a natural truth and correctness without any fear of failure. To do this, however, must be the work of God, or of a divine person; in Egypt they have a tradition that their ancient chants which have been preserved for so many ages b are the composition of the Goddess Isis. And therefore, as I was saying, if a person can only find in any way the natural melodies, he may confidently embody them in a fixed and legal form. For the love of novelty which arises out of pleasure in the new and weariness of the old, has not strength enough to corrupt the consecrated song and dance, under the plea that they have become antiquated. At any rate, they are far from being corrupted in Egypt.

Cle. Your arguments seem to prove your point. c

Ath. May we not confidently say that the true use of music and of choral festivities is as follows: We rejoice when we think that we prosper, and again we think that we prosper when we rejoice?

Cle. Exactly.

Ath. And when rejoicing in our good fortune, we are unable to be still?

Cle. True.

Ath. Our young men break forth into dancing and singing, and we d who are their elders deem that we are fulfilling our part in life when we look on at them. Having lost our agility, we delight in their sports and merry-making, because we love to think of our former selves; and gladly institute contests for those who are able to awaken in us the memory of our youth.

Cle. Very true.

Ath. Is it altogether unmeaning to say, as the common people do about festivals, that he should be adjudged the wisest of men, and the e winner of the palm, who gives us the greatest amount of pleasure and mirth? For on such occasions, and when mirth is the order of the day,

ought not he to be honoured most, and, as I was saying, bear the palm,
658 who gives most mirth to the greatest number? Now is this a true way of
speaking or of acting?

Cle. Possibly.

Ath. But, my dear friend, let us distinguish between different cases,
and not be hasty in forming a judgement: One way of considering the
question will be to imagine a festival at which there are entertainments
of all sorts, including gymnastic, musical, and equestrian contests: the
citizens are assembled; prizes are offered, and proclamation is made that
b anyone who likes may enter the lists, and that he is to bear the palm
who gives the most pleasure to the spectators—there is to be no regulation
about the manner how; but he who is most successful in giving pleasure
is to be crowned victor, and deemed to be the pleasantest of the candi-
dates. What is likely to be the result of such a proclamation?

Cle. In what respect?

Ath. There would be various exhibitions: one man, like Homer, will
exhibit a rhapsody, another a performance on the lute; one will have a
tragedy, and another a comedy. Nor would there be anything astonishing
c in someone imagining that he could gain the prize by exhibiting a puppet-
show. Suppose these competitors to meet, and not these only, but innumer-
able others as well—can you tell me who ought to be the victor?

Cle. I do not see how anyone can answer you, or pretend to know,
unless he has heard with his own ears the several competitors; the ques-
tion is absurd.

Ath. Well, then, if neither of you can answer, shall I answer this ques-
tion which you deem so absurd?

Cle. By all means.

Ath. If very small children are to determine the question, they will
decide for the puppet-show.

d *Cle.* Of course.

Ath. The older children will be advocates of comedy; educated women,
and young men, and people in general, will favour tragedy.

Cle. Very likely.

Ath. And I believe that we old men would have the greatest pleasure
in hearing a rhapsodist recite well the Iliad and Odyssey, or one of the
Hesiodic poems, and would award an overwhelming victory to him. But,
who would really be the victor?—that is the question.

Cle. Yes.

e *Ath.* Clearly you and I will have to declare that those whom we old
men adjudge victors ought to win; for our ways are far and away better
than any which at present exist anywhere in the world.

Cle. Certainly.

Ath. Thus far I too should agree with the many, that the excellence
of music is to be measured by pleasure. But the pleasure must not be
that of chance persons; the fairest music is that which delights the best and

best educated, and especially that which delights the one man who is pre- 659
eminent in virtue and education. And therefore the judges must be men
of character, for they will require wisdom and have still greater need of
courage; the true judge must not draw his inspiration from the theatre,
nor ought he to be unnerved by the clamour of the many and his own
incapacity; nor again, knowing the truth, ought he through cowardice
and unmanliness carelessly to deliver a lying judgement, with the very b
same lips which have just appealed to the Gods before he judged. He
is sitting not as the disciple of the theatre, but, in his proper place, as
their instructor, and he ought to be the enemy of all pandering to the
pleasure of the spectators.[1] The ancient and common custom of Hellas
was the reverse of that which now prevails in Italy and Sicily, where
the judgement is left to the body of spectators, who determine the victor
by show of hands. But this custom has been the destruction of the poets c
themselves; for they are now in the habit of composing with a view to
please the bad taste of their judges, and the result is that the spectators
instruct themselves;—and also it has been the ruin of the theatre; they
ought to be having characters put before them better than their own, and
so receiving a higher pleasure, but now by their own act the opposite
result follows. What inference is to be drawn from all this? Shall I tell
you?

Cle. What?

Ath. The inference at which we arrive for the third or fourth time is,
that education is the constraining and directing of youth towards that d
right reason, which the law affirms, and which the experience of the
eldest and best has agreed to be truly right. In order, then, that the soul
of the child may not be habituated to feel joy and sorrow in a manner
at variance with the law, and those who obey the law, but may rather
follow the law and rejoice and sorrow at the same things as the aged—
in order, I say, to produce this effect, chants appear to have been invented, e
which really enchant, and are designed to implant that harmony of which
we speak. And, because the mind of the child is incapable of enduring
serious training, they are called plays and songs, and are performed in
play; just as when men are sick and ailing in their bodies, their attendants
give them wholesome diet in pleasant meats and drinks, but unwholesome 660
diet in disagreeable things, in order that they may learn, as they ought,
to like the one, and to dislike the other. And similarly the true legislator
will persuade, and, if he cannot persuade, will compel the poet to express,
as he ought, by fair and noble words, in his rhythms, the figures, and in
his melodies, the music of temperate and brave and in every way good
men.

[1] [Or, taking τοῖς with θεαταῖς, 'the enemy of all spectators who respond with
pleasure in a mistaken and unsuitable way'.]

ARISTOTLE

POETICS

Aristotle (384–322 B.C.), Plato's most famous student, dealt systematically with every area of human inquiry. His Poetics has had a profound influence on the development of Western literature.

I
1447 a

I propose to treat of Poetry in itself and of its various kinds, noting the essential quality of each; to inquire into the structure of the plot as requisite to a good poem; into the number and nature of the parts of which a poem is composed; and similarly into whatever else falls within the same inquiry. Following, then, the order of nature, let us begin with the principles which come first.

Epic poetry and Tragedy, Comedy also Dithyrambic poetry, and the music of the flute and of the lyre in most of their forms, are all in their general conception modes of imitation. They differ, however, from one another in three respects,—the medium, the objects, the manner or mode of imitation, being in each case distinct.

For as there are persons who, by conscious art or mere habit, imitate and represent various objects through the medium of colour and form, or

From Butcher: *Aristotle's Theory of Poetry and Fine Art*, Dover Publications, Inc., New York, 1951. Reprinted through the permission of the publisher.

again by the voice; so in the arts above mentioned, taken as a whole, the imitation is produced by rhythm, language, or 'harmony,' either singly or combined.

Thus in the music of the flute and of the lyre, 'harmony' and rhythm alone are employed; also in other arts, such as that of the shepherd's pipe, which are essentially similar to these. In dancing, rhythm alone is used without 'harmony'; for even dancing imitates character, emotion, and action, by rhythmical movement.

There is another art which imitates by means of language alone, and that either in prose or verse—which verse, again, may either combine different metres or consist of but one kind—but this has hitherto been without a name. For there is no common term we could apply to the mimes of Sophron and Xenarchus and the Socratic dialogues on the one hand; and, on the other, to poetic imitations in iambic, elegiac, or any similar metre. People do, indeed, add the word 'maker' or 'poet' to the name of the metre, and speak of elegiac poets, or epic (that is, hexameter) poets, as if it were not the imitation that makes the poet, but the verse that entitles them all indiscriminately to the name. Even when a treatise on medicine or natural science is brought out in verse, the name of poet is by custom given to the author; and yet Homer and Empedocles have nothing in common but the metre, so that it would be right to call the one poet, the other physicist rather than poet. On the same principle, even if a writer in his poetic imitation were to combine all metres, as Chaeremon did in his Centaur, which is a medley composed of metres of all kinds, we should bring him too under the general term poet. So much then for these distinctions.

There are, again, some arts which employ all the means above mentioned,—namely, rhythm, tune, and metre. Such are Dithyrambic and Nomic poetry, and also Tragedy and Comedy; but between them the difference is, that in the first two cases these means are all employed in combination, in the latter, now one means is employed, now another.

Such, then, are the differences of the arts with respect to the medium of imitation.

Since the objects of imitation are men in action, and these men must be either of a higher or a lower type (for moral character mainly answers to these divisions, goodness and badness being the distinguishing marks of moral differences), it follows that we must represent men either as better than in real life, or as worse, or as they are. It is the same in painting. Polygnotus depicted men as nobler than they are, Pauson as less noble, Dionysius drew them true to life.

Now it is evident that each of the modes of imitation above mentioned will exhibit these differences, and become a distinct kind in imitating objects that are thus distinct. Such diversities may be found even in dancing, flute-playing, and lyre-playing. So again in language, whether prose or verse unaccompanied by music. Homer, for example, makes men

1447 b

II
1448 a

better than they are; Cleophon as they are; Hegemon the Thasian, the inventor of parodies, and Nicochares, the author of the Deiliad, worse than they are. The same thing holds good of Dithyrambs and Nomes; here too one may portray different types, as Timotheus and Philoxenus differed in representing their Cyclopes. The same distinction marks off Tragedy from Comedy; for Comedy aims at representing men as worse, Tragedy as better than in actual life.

III There is still a third difference—the manner in which each of these objects may be imitated. For the medium being the same, and the objects the same, the poet may imitate by narration—in which case he can either take another personality as Homer does, or speak in his own person, unchanged—or he may present all his characters as living and moving before us.

These, then, as we said at the beginning, are the three differences which distinguish artistic imitation,—the medium, the objects, and the manner. So that from one point of view, Sophocles is an imitator of the same kind as Homer—for both imitate higher types of character; from another point of view, of the same kind as Aristophanes—for both imitate persons acting and doing. Hence, some say, the name of 'drama' is given to such poems, as representing action. For the same reason the Dorians claim the invention both of Tragedy and Comedy. The claim to Comedy is put forward by the Megarians,—not only by those of Greece proper, who allege that it originated under their democracy, but also by the Megarians of Sicily, for the poet Epicharmus, who is much earlier than Chionides and Magnes, belonged to that country. Tragedy too is claimed by certain Dorians of the Peloponnese. In each case they appeal to the evidence of language. The outlying villages, they say, are by them called κῶμαι, by the Athenians δῆμοι: and they assume that Comedians were so named not from κωμάζειν, 'to revel,' but because they wandered from village to village (κατὰ κώμας), being excluded contemptuously from the city.

1448 b They add also that the Dorian word for 'doing' is δρᾶν, and the Athenian, πράττειν.

This may suffice as to the number and nature of the various modes of imitation.

IV Poetry in general seems to have sprung from two causes, each of them lying deep in our nature. First, the instinct of imitation is implanted in man from childhood, one difference between him and other animals being that he is the most imitative of living creatures, and through imitation learns his earliest lessons; and no less universal is the pleasure felt in things imitated. We have evidence of this in the facts of experience. Objects which in themselves we view with pain, we delight to contemplate when reproduced with minute fidelity: such as the forms of the most ignoble animals and of dead bodies. The cause of this again is, that to learn gives the liveliest pleasure, not only to philosophers but to men in general; whose capacity, however, of learning is more limited. Thus the

reason why men enjoy seeing a likeness is, that in contemplating it they find themselves learning or inferring, and saying perhaps, 'Ah, that is he.' For if you happen not to have seen the original, the pleasure will be due not to the imitation as such, but to the execution, the colouring, or some such other cause.

Imitation, then, is one instinct of our nature. Next, there is the instinct for 'harmony' and rhythm, metres being manifestly sections of rhythm. Persons, therefore, starting with this natural gift developed by degrees their special aptitudes, till their rude improvisations gave birth to Poetry.

Poetry now diverged in two directions, according to the individual character of the writers. The graver spirits imitated noble actions, and the actions of good men. The more trivial sort imitated the actions of meaner persons, at first composing satires, as the former did hymns to the gods and the praises of famous men. A poem of the satirical kind cannot indeed be put down to any author earlier than Homer; though many such writers probably there were. But from Homer onward, instances can be cited,—his own Margites, for example, and other similar compositions. The appropriate metre was also here introduced; hence the measure is still called the iambic or lampooning measure, being that in which people lampooned one another. Thus the older poets were distinguished as writers of heroic or of lampooning verse.

As, in the serious style, Homer is pre-eminent among poets, for he alone combined dramatic form with excellence of imitation, so he too first laid down the main lines of Comedy, by dramatising the ludicrous instead of writing personal satire. His Margites bears the same relation to Comedy 1449 a
that the Iliad and Odyssey do to Tragedy. But when Tragedy and Comedy came to light, the two classes of poets still followed their natural bent: the lampooners became writers of Comedy, and the Epic poets were succeeded by Tragedians, since the drama was a larger and higher form of art.

Whether Tragedy has as yet perfected its proper types or not; and whether it is to be judged in itself, or in relation also to the audience,— this raises another question. Be that as it may, Tragedy—as also Comedy —was at first mere improvisation. The one originated with the authors of the Dithyramb, the other with those of the phallic songs, which are still in use in many of our cities. Tragedy advanced by slow degrees; each new element that showed itself was in turn developed. Having passed through many changes, it found its natural form, and there it stopped.

Aeschylus first introduced a second actor; he diminished the importance of the Chorus, and assigned the leading part to the dialogue. Sophocles raised the number of actors to three, and added scene-painting. Moreover, it was not till late that the short plot was discarded for one of greater compass, and the grotesque diction of the earlier satyric form for the stately manner of Tragedy. The iambic measure then replaced the trochaic tetrameter, which was originally employed when the poetry was of the

satyric order, and had greater affinities with dancing. Once dialogue had come in, Nature herself discovered the appropriate measure. For the iambic is, of all measures, the most colloquial: we see it in the fact that conversational speech runs into iambic lines more frequently than into any other kind of verse; rarely into hexameters, and only when we drop the colloquial intonation. The additions to the number of 'episodes' or acts, and the other accessories of which tradition tells, must be taken as already described; for to discuss them in detail would, doubtless, be a large undertaking.

V Comedy is, as we have said, an imitation of characters of a lower type, —not, however, in the full sense of the word bad, the Ludicrous being merely a subdivision of the ugly. It consists in some defect or ugliness which is not painful or destructive. To take an obvious example, the comic mask is ugly and distorted, but does not imply pain.

The successive changes through which Tragedy passed, and the authors of these changes, are well known, whereas Comedy has had no history, because it was not at first treated seriously. It was late before 1449 b the Archon granted a comic chorus to a poet; the performers were till then voluntary. Comedy had already taken definite shape when comic poets, distinctively so called, are heard of. Who furnished it with masks, or prologues, or increased the number of actors,—these and other similar details remain unknown. As for the plot, it came originally from Sicily; but of Athenian writers Crates was the first who, abandoning the 'iambic' or lampooning form, generalised his themes and plots.

Epic poetry agrees with Tragedy in so far as it is an imitation in verse of characters of a higher type. They differ, in that Epic poetry admits but one kind of metre, and is narrative in form. They differ, again, in their length: for Tragedy endeavours, as far as possible, to confine itself to a single revolution of the sun, or but slightly to exceed this limit; whereas the Epic action has no limits of time. This, then, is a second point of difference; though at first the same freedom was admitted in Tragedy as in Epic poetry.

Of their constituent parts some are common to both, some peculiar to Tragedy: whoever, therefore, knows what is good or bad Tragedy, knows also about Epic poetry. All the elements of an Epic poem are found in Tragedy, but the elements of a Tragedy are not all found in the Epic poem.

VI Of the poetry which imitates in hexameter verse, and of Comedy, we will speak hereafter. Let us now discuss Tragedy, resuming its formal definition, as resulting from what has been already said.

Tragedy, then, as an imitation of an action that is serious, complete, and of a certain magnitude; in language embellished with each kind of artistic ornament, the several kinds being found in separate parts of the play; in the form of action, not of narrative; through pity and fear effecting

the proper purgation of these emotions. By 'language embellished,' I mean language into which rhythm, 'harmony,' and song enter. By 'the several kinds in separate parts,' I mean, that some parts are rendered through the medium of verse alone, others again with the aid of song.

Now as tragic imitation implies persons acting, it necessarily follows, in the first place, that Spectacular equipment will be a part of Tragedy. Next, Song and Diction, for these are the medium of imitation. By 'Diction' I mean the mere metrical arrangement of the words: as for 'Song,' it is a term whose sense every one understands.

Again, Tragedy is the imitation of an action; and an action implies personal agents, who necessarily possess certain distinctive qualities both of character and thought; for it is by these that we qualify actions them- 1450 a selves, and these—thought and character—are the two natural causes from which actions spring, and on actions again all success or failure depends. Hence, the Plot is the imitation of the action:—for by plot I here mean the arrangement of the incidents. By Character I mean that in virtue of which we ascribe certain qualities to the agents. Thought is required wherever a statement is proved, or, it may be, a general truth enunciated. Every Tragedy, therefore, must have six parts, which parts determine its quality—namely, Plot, Character, Diction, Thought, Specta- cle, Song. Two of the parts constitute the medium of imitation, one the manner, and three the objects of imitation. And these complete the list. These elements have been employed, we may say, by the poets to a man; in fact, every play contains Spectacular elements as well as Character, Plot, Diction, Song, and Thought.

But most important of all is the structure of the incidents. For Tragedy is an imitation, not of men, but of an action and of life, and life consists in action, and its end is a mode of action, not a quality. Now character determines men's qualities, but it is by their actions that they are happy or the reverse. Dramatic action, therefore, is not with a view to the representation of character: character comes in as subsidiary to the actions. Hence the incidents and the plot are the end of a tragedy; and the end is the chief thing of all. Again, without action there cannot be a tragedy; there may be without character. The tragedies of most of our modern poets fail in the rendering of character; and of poets in general this is often true. It is the same in painting; and here lies the difference between Zeuxis and Polygnotus. Polygnotus delineates character well: the style of Zeuxis is devoid of ethical quality. Again, if you string together a set of speeches expressive of character, and well finished in point of diction and thought, you will not produce the essential tragic effect nearly so well as with a play which, however deficient in these respects, yet has a plot and artistically constructed incidents. Besides which, the most power- ful elements of emotional interest in Tragedy—Peripeteia or Reversal of the Situation, and Recognition scenes—are parts of the plot. A further proof is, that novices in the art attain to finish of diction and precision of

portraiture before they can construct the plot. It is the same with almost all the early poets.

The Plot, then, is the first principle, and, as it were, the soul of a tragedy: Character holds the second place. A similar fact is seen in painting. The most beautiful colours, laid on confusedly, will not give as much pleasure as the chalk outline of a portrait. Thus Tragedy is the imitation of an action, and of the agents mainly with a view to the action.

Third in order is Thought,—that is, the faculty of saying what is possible and pertinent in given circumstances. In the case of oratory, this is the function of the political art and of the art of rhetoric: and so indeed the older poets make their characters speak the language of civic life; the poets of our time, the language of the rhetoricians. Character is that which reveals moral purpose, showing what kind of things a man chooses or avoids. Speeches, therefore, which do not make this manifest, or in which the speaker does not choose or avoid anything whatever, are not expressive of character. Thought, on the other hand, is found where something is proved to be or not to be, or a general maxim is enunciated.

Fourth among the elements enumerated comes Diction; by which I mean, as has been already said, the expression of the meaning in words; and its essence is the same both in verse and prose.

Of the remaining elements Song holds the chief place among the embellishments.

The Spectacle has, indeed, an emotional attraction of its own, but, of all the parts, it is the least artistic, and connected least with the art of poetry. For the power of Tragedy, we may be sure, is felt even apart from representation and actors. Besides, the production of spectacular effects depends more on the art of the stage machinist than on that of the poet.

VII These principles being established, let us now discuss the proper structure of the Plot, since this is the first and most important thing in Tragedy.

Now, according to our definition, Tragedy is an imitation of an action that is complete, and whole, and of a certain magnitude; for there may be a whole that is wanting in magnitude. A whole is that which has a beginning, a middle, and an end. A beginning is that which does not itself follow anything by causal necessity, but after which something naturally is or comes to be. An end, on the contrary, is that which itself naturally follows some other thing, either by necessity, or as a rule, but has nothing following it. A middle is that which follows something as some other thing follows it. A well constructed plot, therefore, must neither begin nor end at haphazard, but conform to these principles.

Again, a beautiful object, whether it be a living organism or any whole composed of parts, must not only have an orderly arrangement of parts, but must also be of a certain magnitude; for beauty depends on magnitude and order. Hence a very small animal organism cannot be beautiful; for the view of it is confused, the object being seen in an almost imperceptible

moment of time. Nor, again, can one of vast size be beautiful; for as the 1451 a
eye cannot take it all in at once, the unity and sense of the whole is lost
for the spectator; as for instance if there were one a thousand miles long.
As, therefore, in the case of animate bodies and organisms a certain
magnitude is necessary, and a magnitude which may be easily embraced
in one view; so in the plot, a certain length is necessary, and a length
which can be easily embraced by the memory. The limit of length in
relation to dramatic competition and sensuous presentment, is no part of
artistic theory. For had it been the rule for a hundred tragedies to com-
pete together, the performance would have been regulated by the water-
clock,—as indeed we are told was formerly done. But the limit as fixed by
the nature of the drama itself is this:—the greater the length, the more
beautiful will the piece be by reason of its size, provided that the whole
be perspicuous. And to define the matter roughly, we may say that the
proper magnitude is comprised within such limits, that the sequence of
events, according to the law of probability or necessity, will admit of a
change from bad fortune to good, or from good fortune to bad.

Unity of plot does not, as some persons think, consist in the unity of VIII
the hero. For infinitely various are the incidents in one man's life which
cannot be reduced to unity; and so, too, there are many actions of one
man out of which we cannot make one action. Hence the error, as it
appears, of all poets who have composed a Heracleid, a Theseid, or other
poems of the kind. They imagine that as Heracles was one man, the story
of Heracles must also be a unity. But Homer, as in all else he is of sur-
passing merit, here too—whether from art or natural genius—seems to
have happily discerned the truth. In composing the Odyssey he did not
include all the adventures of Odysseus—such as his wound on Parnassus,
or his feigned madness at the mustering of the host—incidents between
which there was no necessary or probable connexion: but he made the
Odyssey, and likewise the Iliad, to centre round an action that in our
sense of the word is one. As therefore, in the other imitative arts, the
imitation is one when the object imitated is one, so the plot, being an
imitation of an action, must imitate one action and that a whole, the
structural union of the parts being such that, if any one of them is dis-
placed or removed, the whole will be disjointed and disturbed. For a
thing whose presence or absence makes no visible difference, is not an
organic part of the whole.

It is, moreover, evident from what has been said, that it is not the IX
function of the poet to relate what has happened, but what may happen,
—what is possible according to the law of probability or necessity. The
poet and the historian differ not by writing in verse or in prose. The work 1451 b
of Herodotus might be put into verse, and it would still be a species of
history, with metre no less than without it. The true difference is that
one relates what has happened, the other what may happen. Poetry, there-
fore, is a more philosophical and a higher thing than history: for poetry

tends to express the universal, history the particular. By the universal I mean how a person of a certain type will on occasion speak or act, according to the law of probability or necessity; and it is this universality at which poetry aims in the names she attaches to the personages. The particular is—for example—what Alcibiades did or suffered. In Comedy this is already apparent: for here the poet first constructs the plot on the lines of probability, and then inserts characteristic names;—unlike the lampooners who write about particular individuals. But tragedians still keep to real names, the reason being that what is possible is credible: what has not happened we do not at once feel sure to be possible: but what has happened is manifestly possible: otherwise it would not have happened. Still there are even some tragedies in which there are only one or two well known names, the rest being fictitious. In others, none are well known,—as in Agathon's Antheus, where incidents and names alike are fictitious, and yet they give none the less pleasure. We must not, therefore, at all costs keep to the received legends, which are the usual subjects of Tragedy. Indeed, it would be absurd to attempt it; for even subjects that are known are known only to a few, and yet give pleasure to all. It clearly follows that the poet or 'maker' should be the maker of plots rather than of verses; since he is a poet because he imitates, and what he imitates are actions. And even if he chances to take an historical subject, he is none the less a poet; for there is no reason why some events that have actually happened should not conform to the law of the probable and possible, and in virtue of that quality in them he is their poet or maker.

Of all plots and actions the epeisodic are the worst. I call a plot 'epeisodic' in which the episodes or acts succeed one another without probable or necessary sequence. Bad poets compose such pieces by their own fault, good poets, to please the players; for, as they write show 1452 a pieces for competition, they stretch the plot beyond its capacity, and are often forced to break the natural continuity.

But again, Tragedy is an imitation not only of a complete action, but of events inspiring fear or pity. Such an effect is best produced when the events come on us by surprise; and the effect is heightened when, at the same time, they follow as cause and effect. The tragic wonder will then be greater than if they happened of themselves or by accident; for even coincidences are most striking when they have an air of design. We may instance the statue of Mitys at Argos, which fell upon his murderer while he was a spectator at a festival, and killed him. Such events seem not to be due to mere chance. Plots, therefore, constructed on these principles are necessarily the best.

X Plots are either Simple or Complex, for the actions in real life, of which the plots are an imitation, obviously show a similar distinction. An action which is one and continuous in the sense above defined, I call Simple, when the change of fortune takes place without Reversal of the Situation and without Recognition.

A Complex action is one in which the change is accompanied by such Reversal, or by Recognition, or by both. These last should arise from the internal structure of the plot, so that what follows should be the necessary or probable result of the preceding action. It makes all the difference whether any given event is a case of *propter hoc* or *post hoc*.

Reversal of the Situation is a change by which the action veers round XI to its opposite, subject always to our rule of probability or necessity. Thus in the Oedipus, the messenger comes to cheer Oedipus and free him from his alarms about his mother, but by revealing who he is, he produces the opposite effect. Again in the Lynceus, Lynceus is being led away to his death, and Danaus goes with him, meaning to slay him; but the outcome of the preceding incidents is that Danaus is killed and Lynceus saved.

Recognition, as the name indicates, is a change from ignorance to knowledge, producing love or hate between the persons destined by the poet for good or bad fortune. The best form of recognition is coincident with a Reversal of the Situation, as in the Oedipus. There are indeed other forms. Even inanimate things of the most trivial kind may in a sense be objects of recognition. Again, we may recognise or discover whether a person has done a thing or not. But the recognition which is most intimately connected with the plot and action is, as we have said, the recognition of persons. This recognition, combined with Reversal, will produce either pity or fear; and actions producing these effects are 1452 b those which, by our definition, Tragedy represents. Moreover, it is upon such situations that the issues of good or bad fortune will depend. Recognition, then, being between persons, it may happen that one person only is recognised by the other—when the latter is already known—or it may be necessary that the recognition should be on both sides. Thus Iphigenia is revealed to Orestes by the sending of the letter; but another act of recognition is required to make Orestes known to Iphigenia.

Two parts, then, of the Plot—Reversal of the Situation and Recogni- XII tion—turn upon surprises. A third part is the Scene of Suffering. The Scene of Suffering is a destructive or painful action, such as death on the stage, bodily agony, wounds and the like.

[The Parts of Tragedy which must be treated as elements of the whole have been already mentioned. We now come to the quantitative parts— the separate parts into which Tragedy is divided—namely, Prologue, Episode, Exode, Choric song; this last being divided into Parode and Stasimon. These are common to all plays: peculiar to some are the songs of actors from the stage and the Commoi.

The Prologue is that entire part of a tragedy which precedes the Parode of the Chorus. The Episode is that entire part of a tragedy which is between complete choric songs. The Exode is that entire part of a tragedy which has no choric song after it. Of the Choric part the Parode is the first undivided utterance of the Chorus: the Stasimon is a Choric ode without anapaests or trochaic tetrameters: the Commos is a joint lamentation of

Chorus and actors. The parts of Tragedy which must be treated as elements of the whole have been already mentioned. The quantitative parts— the separate parts into which it is divided—are here enumerated.]

XIII As the sequel to what has already been said, we must proceed to consider what the poet should aim at, and what he should avoid, in constructing his plots; and by what means the specific effect of Tragedy will be produced.

A perfect tragedy should, as we have seen, be arranged not on the simple but on the complex plan. It should, moreover, imitate actions which excite pity and fear, this being the distinctive mark of tragic imitation. It follows plainly, in the first place, that the change of fortune presented must not be the spectacle of a virtuous man brought from prosperity to adversity: for this moves neither pity nor fear; it merely shocks us. Nor, again, that of a bad man passing from adversity to prosperity: for nothing can be
1453 a more alien to the spirit of Tragedy; it possesses no single tragic quality; it neither satisfies the moral sense nor calls forth pity or fear. Nor, again, should the downfall of the utter villain be exhibited. A plot of this kind would, doubtless, satisfy the moral sense, but it would inspire neither pity nor fear; for pity is aroused by unmerited misfortune, fear by the misfortune of a man like ourselves. Such an event, therefore, will be neither pitiful nor terrible. There remains, then, the character between these two extremes,—that of a man who is not eminently good and just, yet whose misfortune is brought about not by vice or depravity, but by some error or frailty. He must be one who is highly renowned and prosperous,—a personage like Oedipus, Thyestes, or other illustrious men of such families.

A well constructed plot should, therefore, be single in its issue, rather than double as some maintain. The change of fortune should be not from bad to good, but, reversely, from good to bad. It should come about as the result not of vice, but of some great error or frailty, in a character either such as we have described, or better rather than worse. The practice of the stage bears out our view. At first the poets recounted any legend that came in their way. Now, the best tragedies are founded on the story of a few houses,—on the fortunes of Alcmaeon, Oedipus, Orestes, Meleager, Thyestes, Telephus, and those others who have done or suffered something terrible. A tragedy, then, to be perfect according to the rules of art should be of this construction. Hence they are in error who censure Euripides just because he follows this principle in his plays, many of which end unhappily. It is, as we have said, the right ending. The best proof is that on the stage and in dramatic competition, such plays, if well worked out, are the most tragic in effect; and Euripides, faulty though he may be in the general management of his subject, yet is felt to be the most tragic of the poets.

In the second rank comes the kind of tragedy which some place first. Like the Odyssey, it has a double thread of plot, and also an opposite catastrophe for the good and for the bad. It is accounted the best because of the

weakness of the spectators; for the poet is guided in what he writes by the wishes of his audience. The pleasure, however, thence derived is not the true tragic pleasure. It is proper rather to Comedy, where those who, in the piece, are the deadliest enemies—like Orestes and Aegisthus—quit the stage as friends at the close, and no one slays or is slain.

Fear and pity may be aroused by spectacular means; but they may also XIV
result from the inner structure of the piece, which is the better way, and 1453 b
indicates a superior poet. For the plot ought to be so constructed that, even without the aid of the eye, he who hears the tale told will thrill with horror and melt to pity at what takes place. This is the impression we should receive from hearing the story of the Oedipus. But to produce this effect by the mere spectacle is a less artistic method, and dependent on extraneous aids. Those who employ spectacular means to create a sense not of the terrible but only of the monstrous, are strangers to the purpose of Tragedy; for we must not demand of Tragedy any and every kind of pleasure, but only that which is proper to it. And since the pleasure which the poet should afford is that which comes from pity and fear through imitation, it is evident that this quality must be impressed upon the incidents.

Let us then determine what are the circumstances which strike us as terrible or pitiful.

Actions capable of this effect must happen between persons who are either friends or enemies or indifferent to one another. If an enemy kills an enemy, there is nothing to excite pity either in the act or the intention,—except so far as the suffering in itself is pitiful. So again with indifferent persons. But when the tragic incident occurs between those who are near or dear to one another—if, for example, a brother kills, or intends to kill, a brother, a son his father, a mother her son, a son his mother, or any other deed of the kind is done—these are the situations to be looked for by the poet. He may not indeed destroy the framework of the received legends—the fact, for instance, that Clytemnestra was slain by Orestes and Eriphyle by Alcmaeon—but he ought to show invention of his own, and skilfully handle the traditional material. Let us explain more clearly what is meant by skilful handling.

The action may be done consciously and with knowledge of the persons, in the manner of the older poets. It is thus too that Euripides makes Medea slay her children. Or, again, the deed of horror may be done, but done in ignorance, and the tie of kinship or friendship be discovered afterwards. The Oedipus of Sophocles is an example. Here, indeed, the incident is outside the drama proper; but cases occur where it falls within the action of the play: one may cite the Alcmaeon of Astydamas, or Telegonus in the Wounded Odysseus. Again, there is a third case,—<to be about to act with knowledge of the persons and then not to act. The fourth case is> when some one is about to do an irreparable deed through ignorance, and makes the discovery before it is done. These are the only possible ways.

For the deed must either be done or not done,—and that wittingly or unwittingly. But of all these ways, to be about to act knowing the persons, and then not to act, is the worst. It is shocking without being tragic, for

1454 a no disaster follows. It is, therefore, never, or very rarely, found in poetry. One instance, however, is in the Antigone, where Haemon threatens to kill Creon. The next and better way is that the deed should be perpetrated. Still better, that it should be perpetrated in ignorance, and the discovery made afterwards. There is then nothing to shock us, while the discovery produces a startling effect. The last case is the best, as when in the Cresphontes Merope is about to slay her son, but, recognising who he is, spares his life. So in the Iphigenia, the sister recognises the brother just in time. Again in the Helle, the son recognises the mother when on the point of giving her up. This, then, is why a few families only, as has been already observed, furnish the subjects of tragedy. It was not art, but happy chance, that led the poets in search of subjects to impress the tragic quality upon their plots. They are compelled, therefore, to have recourse to those houses whose history contains moving incidents like these.

Enough has now been said concerning the structure of the incidents, and the right kind of plot.

XV In respect of Character there are four things to be aimed at. First, and most important, it must be good. Now any speech or action that manifests moral purpose of any kind will be expressive of character: the character will be good if the purpose is good. This rule is relative to each class. Even a woman may be good, and also a slave; though the woman may be said to be an inferior being, and the slave quite worthless. The second thing to aim at is propriety. There is a type of manly valour; but valour in a woman, or unscrupulous cleverness, is inappropriate. Thirdly, character must be true to life: for this is a distinct thing from goodness and propriety, as here described. The fourth point is consistency: for though the subject of the imitation, who suggested the type, be inconsistent, still he must be consistently inconsistent. As an example of motiveless degradation of character, we have Menelaus in the Orestes: of character indecorous and inappropriate, the lament of Odysseus in the Scylla, and the speech of Melanippe: of inconsistency, the Iphigenia at Aulis,—for Iphigenia the suppliant in no way resembles her later self.

As in the structure of the plot, so too in the portraiture of character, the poet should always aim either at the necessary or the probable. Thus a person of a given character should speak or act in a given way, by the rule either of necessity or of probability; just as this event should follow that by necessary or probable sequence. It is therefore evident that the unravelling

1454 b of the plot, no less than the complication, must arise out of the plot itself, it must not be brought about by the *Deus ex Machina*—as in the Medea, or in the Return of the Greeks in the Iliad. The *Deus ex Machina* should be employed only for events external to the drama,—for antecedent or subsequent events, which lie beyond the range of human knowledge, and which require to be reported or foretold; for to the gods we ascribe the power

of seeing all things. Within the action there must be nothing irrational. If the irrational cannot be excluded, it should be outside the scope of the tragedy. Such is the irrational element in the Oedipus of Sophocles.

Again, since Tragedy is an imitation of persons who are above the common level, the example of good portrait-painters should be followed. They, while reproducing the distinctive form of the original, make a likeness which is true to life and yet more beautiful. So too the poet, in representing men who are irascible or indolent, or have other defects of character, should preserve the type and yet ennoble it. In this way Achilles is portrayed by Agathon and Homer.

These then are rules the poet should observe. Nor should he neglect those appeals to the senses, which, though not among the essentials, are the concomitants of poetry; for here too there is much room for error. But of this enough has been said in our published treatises.

What Recognition is has been already explained. We will now enume- XVI rate its kinds.

First, the least artistic form, which, from poverty of wit, is most commonly employed—recognition by signs. Of these some are congenital,— such as 'the spear which the earth-born race bear on their bodies,' or the stars introduced by Carcinus in his Thyestes. Others are acquired after birth; and of these some are bodily marks, as scars; some external tokens, as necklaces, or the little ark in the Tyro by which the discovery is effected. Even these admit of more or less skilful treatment. Thus in the recognition of Odysseus by his scar, the discovery is made in one way by the nurse, in another by the swine-herds. The use of tokens for the express purpose of proof—and, indeed, any formal proof with or without tokens—is a less artistic mode of recognition. A better kind is that which comes about by a turn of incident, as in the Bath Scene in the Odyssey.

Next come the recognitions invented at will by the poet, and on that account wanting in art. For example, Orestes in the Iphigenia reveals the fact that he is Orestes. She, indeed, makes herself known by the letter; but he, by speaking himself, and saying what the poet, not what the plot requires. This, therefore, is nearly allied to the fault above mentioned:—for Orestes might as well have brought tokens with him. Another similar instance is the 'voice of the shuttle' in the Tereus of Sophocles.

The third kind depends on memory when the sight of some object 1445 a awakens a feeling: as in the Cyprians of Dicaeogenes, where the hero breaks into tears on seeing the picture; or again in the 'Lay of Alcinous,' where Odysseus, hearing the minstrel play the lyre, recalls the past and weeps; and hence the recognition.

The fourth kind is by process of reasoning. Thus in the Choëphori:— 'Some one resembling me has come: no one resembles me but Orestes: therefore Orestes has come.' Such too is the discovery made by Iphigenia in the play of Polyidus the Sophist. It was a natural reflexion for Orestes to make, 'So I too must die at the altar like my sister.' So, again, in the Tydeus of Theodectes, the father says, 'I came to find my son, and I lose

my own life.' So too in the Phineidae: the women, on seeing the place, in-
ferred their fate:—'Here we are doomed to die, for here we were cast
forth.' Again, there is a composite kind of recognition involving false
inference on the part of one of the characters, as in the Odysseus Disguised
as a Messenger. A said <that no one else was able to bend the bow;
. . . hence B (the disguised Odysseus) imagined that A would>
recognise the bow which, in fact, he had not seen; and to bring about a
recognition by this means—the expectation that A would recognise the
bow—is false inference.

But, of all recognitions, the best is that which arises from the incidents
themselves, where the startling discovery is made by natural means. Such
is that in the Oedipus of Sophocles, and in the Iphigenia; for it was natural
that Iphigenia should wish to dispatch a letter. These recognitions alone
dispense with the artificial aid of tokens or amulets. Next come the recog-
nitions by process of reasoning.

XVII In constructing the plot and working it out with the proper diction, the
poet should place the scene, as far as possible, before his eyes. In this way,
seeing everything with the utmost vividness, as if he were a spectator of
the action, he will discover what is in keeping with it, and be most unlikely
to overlook inconsistencies. The need of such a rule is shown by the fault
found in Carcinus. Amphiaraus was on his way from the temple. This
fact escaped the observation of one who did not see the situation. On the
stage, however, the piece failed, the audience being offended at the over-
sight.

Again, the poet should work out his play, to the best of his power,
with appropriate gestures; for those who feel emotion are most convincing
through natural sympathy with the characters they represent; and one who
is agitated storms, one who is angry rages, with the most life-like reality.
Hence poetry implies either a happy gift of nature or a strain of madness.
In the one case a man can take the mould of any character; in the other,
he is lifted out of his proper self.

As for the story, whether the poet takes it ready made or constructs it
1455 b for himself, he should first sketch its general outline, and then fill in the
episodes and amplify in detail. The general plan may be illustrated by
the Iphigenia. A young girl is sacrificed; she disappears mysteriously from
the eyes of those who sacrificed her; she is transported to another country,
where the custom is to offer up all strangers to the goddess. To this min-
istry she is appointed. Some time later her own brother chances to arrive.
The fact that the oracle for some reason ordered him to go there, is outside
the general plan of the play. The purpose, again, of his coming is outside
the action proper. However, he comes, he is seized, and, when on the point
of being sacrificed, reveals who he is. The mode of recognition may be
either that of Euripides or of Polyidus, in whose play he exclaims very
naturally:—'So it was not my sister only, but I too, who was doomed to be
sacrificed'; and by that remark he is saved.

After this, the names being once given, it remains to fill in the episodes.

We must see that they are relevant to the action. In the case of Orestes, for example, there is the madness which led to his capture, and his deliverance by means of the purificatory rite. In the drama, the episodes are short, but it is these that give extension to Epic poetry. Thus the story of the Odyssey can be stated briefly. A certain man is absent from home for many years; he is jealously watched by Poseidon, and left desolate. Meanwhile his home is in a wretched plight—suitors are wasting his substance and plotting against his son. At length, tempest-tost, he himself arrives; he makes certain persons acquainted with him; he attacks the suitors with his own hand, and is himself preserved while he destroys them. This is the essence of the plot; the rest is episode.

Every tragedy falls into two parts,—Complication and Unravelling or XVIII Dénouement. Incidents extraneous to the action are frequently combined with a portion of the action proper, to form the Complication; the rest is the Unravelling. By the Complication I mean all that extends from the beginning of the action to the part which marks the turning-point to good or bad fortune. The Unravelling is that which extends from the beginning of the change to the end. Thus, in the Lynceus of Theodectes, the Complication consists of the incidents presupposed in the drama, the seizure of the child, and then again * * <The Unravelling> extends from the accusation of murder to the end.

There are four kinds of Tragedy, the Complex, depending entirely on Reversal of the Situation and Recognition; the Pathetic (where the motive 1456 a is passion),—such as the tragedies on Ajax and Ixion; the Ethical (where the motives are ethical),—such as the Phthiotides and the Peleus. The fourth kind is the Simple. <We here exclude the purely spectacular element>, exemplified by the Phorcides, the Prometheus, and scenes laid in Hades. The poet should endeavour, if possible, to combine all poetic elements; or failing that, the greatest number and those the most important; the more so, in face of the cavilling criticism of the day. For whereas there have hitherto been good poets, each in his own branch, the critics now expect one man to surpass all others in their several lines of excellence.

In speaking of a tragedy as the same or different, the best test to take is the plot. Identity exists where the Complication and Unravelling are the same. Many poets tie the knot well, but unravel it ill. Both arts, however, should always be mastered.

Again, the poet should remember what has been often said, and not make an Epic structure into a Tragedy—by an Epic structure I mean one with a multiplicity of plots—as if, for instance, you were to make a tragedy out of the entire story of the Iliad. In the Epic poem, owing to its length, each part assumes its proper magnitude. In the drama the result is far from answering to the poet's expectation. The proof is that the poets who have dramatised the whole story of the Fall of Troy, instead of selecting portions, like Euripides; or who have taken the whole tale of Niobe, and not a part of her story, like Aeschylus, either fail utterly or meet with poor success on the stage. Even Agathon has been known to fail from this

one defect. In his Reversals of the Situation, however, he shows a marvellous skill in the effort to hit the popular taste,—to produce a tragic effect that satisfies the moral sense. This effect is produced when the clever rogue, like Sisyphus, is outwitted, or the brave villain defeated. Such an event is probable in Agathon's sense of the word: 'it is probable,' he says, 'that many things should happen contrary to probability.'

The Chorus too should be regarded as one of the actors; it should be an integral part of the whole, and share in the action, in the manner not of Euripides but of Sophocles. As for the later poets, their choral songs pertain as little to the subject of the piece as to that of any other tragedy. They are, therefore, sung as mere interludes,—a practice first begun by Agathon. Yet what difference is there between introducing such choral interludes, and transferring a speech, or even a whole act, from one play to another?

XIX It remains to speak of Diction and Thought, the other parts of Tragedy having been already discussed. Concerning Thought, we may assume what is said in the Rhetoric, to which inquiry the subject more strictly belongs. Under Thought is included every effect which has to be produced by speech, the subdivisions being,—proof and refutation; the excitation of the 1456 b feelings, such as pity, fear, anger, and the like; the suggestion of importance or its opposite. Now, it is evident that the dramatic incidents must be treated from the same points of view as the dramatic speeches, when the object is to evoke the sense of pity, fear, importance, or probability. The only difference is, that the incidents should speak for themselves without verbal exposition; while the effects aimed at in speech should be produced by the speaker, and as a result of the speech. For what were the business of a speaker, if the Thought were revealed quite apart from what he says?

. . .

XXII The perfection of style is to be clear without being mean. The clearest style is that which uses only current or proper words; at the same time it is mean:—witness the poetry of Cleophon and of Sthenelus. That diction, on the other hand, is lofty and raised above the commonplace which employs unusual words. By unusual, I mean strange (or rare) words, metaphorical, lengthened,—anything, in short, that differs from the normal idiom. Yet a style wholly composed of such words is either a riddle or a jargon; a riddle, if it consists of metaphors; a jargon, if it consists of strange (or rare) words. For the essence of a riddle is to express true facts under impossible combinations. Now this cannot be done by any arrangement of ordinary words, but by the use of metaphor it can. Such is the riddle:—'A man I saw who on another man had glued the bronze by aid of fire,' and others of the same kind. A diction that is made up of strange (or rare) terms is a jargon. A certain infusion, therefore, of these elements is necessary to style; for the strange (or rare) word, the metaphorical, the

ornamental, and the other kinds above mentioned, will raise it above the commonplace and mean, while the use of proper words will make it perspicuous. But nothing contributes more to produce a clearness of diction that is remote from commonness than the lengthening, contraction, and alteration of words. For by deviating in exceptional cases from the normal idiom, the language will gain distinction; while, at the same time, the partial conformity with usage will give perspicuity. The critics, therefore, are in error who censure these licenses of speech, and hold the author up to ridicule. Thus Eucleides, the elder, declared that it would be an easy matter to be a poet if you might lengthen syllables at will. He caricatured the practice in the very form of his diction, as in the verse:

1458 b

'Επιχάρην εἶδον Μαραθῶνάδε βαδίζοντα,

or,

οὐκ ἄν γ' ἐράμενος τὸν ἐκείνου ἐλλέβορον.

To employ such license at all obtrusively is, no doubt, grotesque; but in any mode of poetic diction there must be moderation. Even metaphors, strange (or rare) words, or any similar forms of speech, would produce the like effect if used without propriety and with the express purpose of being ludicrous. How great a difference is made by the appropriate use of lengthening, may be seen in Epic poetry by the insertion of ordinary forms in the verse. So, again, if we take a strange (or rare) word, a metaphor, or any similar mode of expression, and replace it by the current or proper term, the truth of our observation will be manifest. For example Aeschylus and Euripides each composed the same iambic line. But the alteration of a single word by Euripides, who employed the rarer term instead of the ordinary one, makes one verse appear beautiful and the other trivial. Aeschylus in his Philoctetes says:

φαγέδαινα <δ'> ἥ μου σάρκας ἐσθίει ποδός.

Euripides substitutes θοινᾶται 'feasts on' for ἐσθίει 'feeds on.' Again, in the line,

νῦν δέ μ' ἐὼν ὀλίγος τε καὶ οὐτιδανὸς καὶ ἀεικής,

the difference will be felt if we substitute the common words,

νῦν δέ μ' ἐὼν μικρός τε καὶ ἀσθενικὸς καὶ ἀειδής.

Or, if for the line,

δίφρον ἀεικέλιον καταθεὶς ὀλίγην τε τράπεζαν,

we read,

δίφρον μοχθηρὸν καταθεὶς μικράν τε τράπζαν.

Or, for ἠιόνες βοόωσιν, ἠιόνες κράζουσιν.

Again, Ariphrades ridiculed the tragedians for using phrases which no one would employ in ordinary speech: for example, δωμάτων ἄπο instead of

1459 a ἀπὸ δωμάτων, σέθεν, ἐγὼ δέ νιν, Ἀχιλλέως πέρι instead of περὶ Ἀχιλλέως, and
the like. It is precisely because such phrases are not part of the current
idiom that they give distinction to the style. This, however, he failed to see.

It is a great matter to observe propriety in these several modes of
expression, as also in compound words, strange (or rare) words, and
so forth. But the greatest thing by far is to have a command of metaphor.
This alone cannot be imparted by another; it is the mark of genius, for to
make good metaphors implies an eye for resemblances.

Of the various kinds of words, the compound are best adapted to dithy-
rambs, rare words to heroic poetry, metaphors to iambic. In heroic poetry,
indeed, all these varieties are serviceable. But in iambic verse, which repro-
duces, as far as may be, familiar speech, the most appropriate words are
those which are found even in prose. These are,—the current or proper,
the metaphorical, the ornamental.

Concerning Tragedy and imitation by means of action this may suffice.

XXIII As to that poetic imitation which is narrative in form and employs a
single metre, the plot manifestly ought, as in a tragedy, to be constructed
on dramatic principles. It should have for its subject a single action, whole
and complete, with a beginning, a middle, and an end. It will thus re-
semble a living organism in all its unity, and produce the pleasure proper
to it. It will differ in structure from historical compositions, which of neces-
sity present not a single action, but a single period, and all that happened
within that period to one person or to many, little connected together as
the events may be. For as the sea-fight at Salamis and the battle with the
Carthaginians in Sicily took place at the same time, but did not tend to any
one result, so in the sequence of events, one thing sometimes follows
another, and yet no single result is thereby produced. Such is the practice,
we may say, of most poets. Here again, then, as has been already observed,
the transcendent excellence of Homer is manifest. He never attempts to
make the whole war of Troy the subject of his poem, though that war
had a beginning and an end. It would have been too vast a theme and
not easily embraced in a single view. If, again, he had kept it within
moderate limits, it must have been over-complicated by the variety of
the incidents. As it is, he detaches a single portion, and admits as episodes
many events from the general story of the war—such as the Catalogue of
the ships and others—thus diversifying the poem. . . .

XXIV Again, Epic poetry must have as many kinds as Tragedy: it must be
simple, or complex, or 'ethical,' or 'pathetic.' The parts also, with the ex-
ception of song and spectacle, are the same; for it requires Reversals of the
Situation, Recognitions, and Scenes of Suffering. Moreover, the thoughts
and the diction must be artistic. In all these respects Homer is our earliest
and sufficient model. Indeed each of his poems has a twofold character.
The Iliad is at once simple and 'pathetic,' and the Odyssey complex (for
Recognition scenes run through it), and at the same time 'ethical.'
Moreover, in diction and thought they are supreme.

Epic poetry differs from Tragedy in the scale on which it is constructed, and in its metre. As regards scale or length, we have already laid down an adequate limit:—the beginning and the end must be capable of being brought within a single view. This condition will be satisfied by poems on a smaller scale than the old epics, and answering in length to the group of tragedies presented at a single sitting.

Epic poetry has, however, a great—a special—capacity for enlarging its dimensions, and we can see the reason. In Tragedy we cannot imitate several lines of actions carried on at one and the same time; we must confine ourselves to the action on the stage and the part taken by the players. But in Epic poetry, owing to the narrative form, many events simultaneously transacted can be presented; and these, if relevant to the subject, add mass and dignity to the poem. The Epic has here an advantage, and one that conduces to grandeur of effect, to diverting the mind of the hearer, and relieving the story with varying episodes. For sameness of incident soon produces satiety, and makes tragedies fail on the stage.

As for the metre, the heroic measure has proved its fitness by the test of experience. If a narrative poem in any other metre or in many metres were now composed, it would be found incongruous. For of all measures the heroic is the stateliest and the most massive; and hence it most readily admits rare words and metaphors, which is another point in which the narrative form of imitation stands alone. On the other hand, the iambic 1460 a and the trochaic tetrameter are stirring measures, the latter being akin to dancing, the former expressive of action. Still more absurd would it be to mix together different metres, as was done by Chaeremon. Hence no one has ever composed a poem on a great scale in any other than heroic verse. Nature herself, as we have said, teaches the choice of the proper measure.

Homer, admirable in all respects, has the special merit of being the only poet who rightly appreciates the part he should take himself. The poet should speak as little as possible in his own person, for it is not this that makes him an imitator. Other poets appear themselves upon the scene throughout, and imitate but little and rarely. Homer, after a few prefatory words, at once brings in a man, or woman, or other personage; none of them wanting in characteristic qualities, but each with a character of his own.

The element of the wonderful is required in Tragedy. The irrational, on which the wonder depends for its chief effects, has wider scope in Epic poetry, because there the person acting is not seen. Thus, the pursuit of Hector would be ludicrous if placed upon the stage—the Greeks standing still and not joining in the pursuit, and Achilles waving them back. But in the Epic poem the absurdity passes unnoticed. Now the wonderful is pleasing: as may be inferred from the fact that every one tells a story with some addition of his own, knowing that his hearers like it. It is Homer who has chiefly taught other poets the art of telling lies skilfully.

The secret of it lies in a fallacy. For, assuming that if one thing is or becomes, a second is or becomes, men imagine that, if the second is, the first likewise is or becomes. But this is a false inference. Hence, where the first thing is untrue, it is quite unnecessary, provided the second be true, to add that the first is or has become. For the mind, knowing the second to be true, falsely infers the truth of the first. There is an example of this in the Bath Scene of the Odyssey.

Accordingly, the poet should prefer probable impossibilities to improbable possibilities. The tragic plot must not be composed of irrational parts. Everything irrational should, if possible, be excluded; or, at all events, it should lie outside the action of the play (as, in the Oedipus, the hero's ignorance as to the manner of Laius' death); not within the drama,—as in the Electra, the messenger's account of the Pythian games; or, as in the Mysians, the man who has come from Tegea to Mysia and is still speechless. The plea that otherwise the plot would have been ruined, is ridiculous; such a plot should not in the first instance be constructed. But once the irrational has been introduced and an air of likelihood imparted to it, we must accept it in spite of the absurdity. Take even the irrational incidents in the Odyssey, where Odysseus is left upon the shore of Ithaca. How intolerable even these might have been would be apparent if an inferior poet were to treat the subject. As it is, the absurdity is veiled by the poetic charm with which the poet invests it.

1460 b

The diction should be elaborated in the pauses of the action, where there is no expression of character or thought. For, conversely, character and thought are merely obscured by a diction that is over brilliant.

XXV With respect to critical difficulties and their solutions, the number and nature of the sources from which they may be drawn may be thus exhibited.

The poet being an imitator, like a painter or any other artist, must of necessity imitate one of three objects,—things as they were or are, things as they are said or thought to be, or things as they ought to be. The vehicle of expression is language,—either current terms or, it may be, rare words or metaphors. There are also many modifications of language, which we concede to the poets. Add to this, that the standard of correctness is not the same in poetry and politics, any more than in poetry and any other art. Within the art of poetry itself there are two kinds of faults, —those which touch its essence, and those which are accidental. If a poet has chosen to imitate something, <but has imitated it incorrectly> through want of capacity, the error is inherent in the poetry. But if the failure is due to a wrong choice—if he has represented a horse as throwing out both his off legs at once, or introduced technical inaccuracies in medicine, for example, or in any other art—the error is not essential to the poetry. These are the points of view from which we should consider and answer the objections raised by the critics.

First as to matters which concern the poet's own art. If he describes

the impossible, he is guilty of an error; but the error may be justified, if the end of the art be thereby attained (the end being that already mentioned),—if, that is, the effect of this or any other part of the poem is thus rendered more striking. A case in point is the pursuit of Hector. If, however, the end might have been as well, or better, attained without violating the special rules of the poetic art, the error is not justified: for every kind of error should, if possible, be avoided.

Again, does the error touch the essentials of the poetic art, or some accident of it? For example,—not to know that a hind has no horns is a less serious matter than to paint it inartistically.

Further, if it be objected that the description is not true to fact, the poet may perhaps reply,—'But the objects are as they ought to be': just as Sophocles said that he drew men as they ought to be; Euripides, as they are. In this way the objection may be met. If, however, the representation be of neither kind, the poet may answer,—'This is how men say the thing is.' This applies to tales about the gods. It may well be that these stories are not higher than fact nor yet true to fact: they are, very possibly, what Xenophanes says of them. But anyhow, 'this is what is said.' Again, a description may be no better than the fact: still, it was the fact; as in the passage about the arms: 'Upright upon their butt-ends stood the spears.' This was the custom then, as it now is among the Illyrians. 1461 a

Again, in examining whether what has been said or done by some one is poetically right or not, we must not look merely to the particular act or saying, and ask whether it is poetically good or bad. We must also consider by whom it is said or done, to whom, when, by what means, or for what end; whether, for instance, it be to secure a greater good, or avert a greater evil.

Other difficulties may be resolved by due regard to the usage of language. . . .

. . .

In general, the impossible must be justified by reference to artistic requirements, or to the higher reality, or to received opinion. With respect to the requirements of art, a probable impossibility is to be preferred to a thing improbable and yet possible. Again, it may be impossible that there should be men such as Zeuxis painted. 'Yes,' we say, 'but the impossible is the higher thing; for the ideal type must surpass the reality.' To justify the irrational, we appeal to what is commonly said to be. In addition to which, we urge that the irrational sometimes does not violate reason; just as 'it is probable that a thing may happen contrary to probability.'

Things that sound contradictory should be examined by the same rules as in dialectical refutation—whether the same thing is meant, in the same relation, and in the same sense. We should therefore solve the ques-

tion by reference to what the poet says himself, or to what is tacitly
assumed by a person of intelligence.

The element of the irrational, and, similarly, depravity of character,
are justly censured when there is no inner necessity for introducing them.
Such is the irrational element in the introduction of Aegeus by Euripides
and the badness of Menelaus in the *Orestes*.

Thus, there are five sources from which critical objections are drawn.
Things are censured either as impossible, or irrational, or morally hurtful,
or contradictory, or contrary to artistic correctness. The answers should be
sought under the twelve heads above mentioned.

XXVI The question may be raised whether the Epic or Tragic mode of imita-
tion is the higher. If the more refined art is the higher, and the more
refined in every case is that which appeals to the better sort of audience,
the art which imitates anything and everything is manifestly most unre-
fined. The audience is supposed to be too dull to comprehend unless some-
thing of their own is thrown in by the performers, who therefore indulge in
restless movements. Bad flute-players twist and twirl, if they have to repre-
sent 'the quoit-throw,' or hustle the coryphaeus when they perform the
'Scylla.' Tragedy, it is said, has this same defect. We may compare the
opinion that the older actors entertained of their successors. Mynniscus used
to call Callippides 'ape' on account of the extravagance of his action, and
1462 a the same view was held of Pindarus. Tragic art, then, as a whole, stands to
Epic in the same relation as the younger to the elder actors. So we are
told that Epic poetry is addressed to a cultivated audience, who do not
need gesture; Tragedy, to an inferior public. Being then unrefined, it is
evidently the lower of the two.

Now, in the first place, this censure attaches not to the poetic but to
the histrionic art; for gesticulation may be equally overdone in epic recita-
tion, as by Sosistratus, or in lyrical competition, as by Mnasitheus the
Opuntian. Next, all action is not to be condemned—any more than all
dancing—but only that of bad performers. Such was the fault found in
Callippides, as also in others of our own day, who are censured for repre-
senting degraded women. Again, Tragedy like Epic poetry produces its
effect even without action; it reveals its power by mere reading. If, then,
in all other respects it is superior, this fault, we say, is not inherent in it.

And superior it is, because it has all the epic elements—it may even use
the epic metre—with the music and spectacular effects as important
accessories; and these produce the most vivid of pleasures. Further, it
has vividness of impression in reading as well as in representation. More-
1462 b over, the art attains its end within narrower limits; for the concentrated
effect is more pleasurable than one which is spread over a long time and
so diluted. What, for example, would be the effect of the *Oedipus* of
Sophocles, if it were cast into a form as long as the *Iliad*? Once more,
the Epic imitation has less unity; as is shown by this, that any Epic poem
will furnish subjects for several tragedies. Thus if the story adopted by

the poet has a strict unity, it must either be concisely told and appear truncated; or, if it conform to the Epic canon of length, it must seem weak and watery. <Such length implies some loss of unity,> if, I mean, the poem is constructed out of several actions, like the Iliad and the Odyssey, which have many such parts, each with a certain magnitude of its own. Yet these poems are as perfect as possible in structure; each is in the highest degree attainable, an imitation of a single action.

If, then, Tragedy is superior to Epic poetry in all these respects, and, moreover, fulfils its specific function better as an art—for each art ought to produce, not any chance pleasure, but the pleasure proper to it, as already stated—it plainly follows that Tragedy is the higher art, as attaining its end more perfectly.

Thus much may suffice concerning Tragic and Epic poetry in general; their several kinds and parts, with the number of each and their differences; the causes that make a poem good or bad; the objections of the critics and the answers to these objections. * * *

ARISTOTLE

POLITICS

BOOK VIII. 5

Concerning music there are some questions which we have already raised; these we may now resume and carry further; and our remarks will serve as a prelude to this or any other discussion of the subject. It is not easy to determine the nature of music, or why any one should have a knowledge of it. Shall we say, for the sake of amusement and relaxation, like sleep or drinking, which are not good in themselves, but are pleasant, and at the same time 'make care to cease,' as Euripides says? And therefore men rank them with music, and make use of all three,—sleep, drinking, music,—to which some add dancing. Or shall we argue that music conduces to virtue, on the ground that it can form our minds and habituate us to true pleasures as our bodies are made by gymnastic to be of a certain character? Or shall we say that it contributes to the enjoyment of leisure

From *The Politics of Aristotle*, translated by B. Jowett, Book VIII, Sections 5–7 (Oxford: The Clarendon Press, 1855).

and mental cultivation, which is a third alternative? Now obviously youth are not to be instructed with a view to their amusement, for learning is no pleasure, but is accompanied with pain. Neither is intellectual enjoyment suitable to boys of that age, for it is the end, and that which is imperfect cannot attain the perfect or end. But perhaps it may be said that boys learn music for the sake of the amusement which they will have when they are grown up. If so, why should they learn themselves, and not, like the Persian and Median kings, enjoy the pleasure and instruction which is derived from hearing others? (for surely skilled persons who have made music the business and profession of their lives will be better performers than those who practise only to learn). If they must learn music, on the same principle they should learn cookery, which is absurd. And even granting that music may form the character, the objection still holds: why should we learn ourselves? Why cannot we attain true pleasure and form a correct judgment from hearing others, like the Lacedae- 1339 b monians?—for they, without learning music, nevertheless can correctly judge, as they say, of good and bad melodies. Or again, if music should be used to promote cheerfulness and refined intellectual enjoyment, the objection still remains—why should we learn ourselves instead of enjoying the performances of others? We may illustrate what we are saying by our conception of the Gods; for in the poets Zeus does not himself sing or play on the lyre. Nay, we call professional performers vulgar; no freeman would play or sing unless he were intoxicated or in jest. But these matters may be left for the present.

The first question is whether music is or is not to be a part of education. Of the three things mentioned in our discussion, which is it?—Education or amusement or intellectual enjoyment, for it may be reckoned under all three, and seems to share in the nature of all of them. Amusement is for the sake of relaxation, and relaxation is of necessity sweet, for it is the remedy of pain caused by toil, and intellectual enjoyment is universally acknowledged to contain an element not only of the noble but of the pleasant, for happiness is made up of both. All men agree that music is one of the pleasantest things, whether with or without song; as Musaeus says,

'Song is to mortals of all things the sweetest.'

Hence and with good reason it is introduced into social gatherings and entertainments, because it makes the hearts of men glad: so that on this ground alone we may assume that the young ought to be trained in it. For innocent pleasures are not only in harmony with the perfect end of life, but they also provide relaxation. And whereas men rarely attain the end, but often rest by the way and amuse themselves, not only with a view to some good, but also for the pleasure's sake, it may be well for them at times to find a refreshment in music. It sometimes happens that men make amusement the end, for the end probably contains some ele-

ment of pleasure, though not any ordinary or lower pleasure; but they mistake the lower for the higher, and in seeking for the one find the other, since every pleasure has a likeness to the end of action. For the end is not eligible, nor do the pleasures which we have described exist, for the sake of any future good but of the past, that is to say, they are the alleviation of past toils and pains. And we may infer this to be the reason why men seek happiness from common pleasures. But music is pursued, not only as an alleviation of past toil, but also as providing recreation. 1340 a And who can say whether, having this use, it may not also have a nobler one? In addition to this common pleasure, felt and shared in by all (for the pleasure given by music is natural, and therefore adapted to all ages and characters), may it not have also some influence over the character and the soul? It must have such an influence if characters are affected by it. And that they are so affected is proved by the power which the songs of Olympus and of many others exercise; for beyond question they inspire enthusiasm, and enthusiasm is an emotion of the ethical part of the soul. Besides, when men hear imitations, even unaccompanied by melody or rhythm, their feelings move in sympathy. Since then music is a pleasure, and virtue consists in rejoicing and loving and hating aright, there is clearly nothing which we are so much concerned to acquire and to cultivate as the power of forming right judgments, and of taking delight in good dispositions and noble actions. Rhythm and melody supply imitations of anger and gentleness, and also of courage and temperance and of virtues and vices in general, which hardly fall short of the actual affections, as we know from our own experience, for in listening to such strains our souls undergo a change. The habit of feeling pleasure or pain at mere representations is not far removed from the same feeling about realities; for example, if any one delights in the sight of a statue for its beauty only, it necessarily follows that the sight of the original will be pleasant to him. No other sense, such as taste or touch, has any resemblance to moral qualities; in sight only there is a little, for figures are to some extent of a moral character, and [so far] all participate in the feeling about them. Again, figures and colours are not imitations, but signs of moral habits, indications which the body gives of states of feeling. The connexion of them with morals is slight, but in so far as there is any, young men should be taught to look, not at the works of Pauson, but at those of Polygnotus, or any other painter or statuary who expresses moral ideas. On the other hand, even in mere melodies there is an imitation of character, for the musical modes differ essentially from one another, and those who hear them are differently affected by each. Some of them 1340 b make men sad and grave, like the so-called Mixolydian, others enfeeble the mind, like the relaxed harmonies, others, again, produce a moderate and settled temper, which appears to be the peculiar effect of the Dorian; the Phrygian inspires enthusiasm. The whole subject has been well treated by philosophical writers on this branch of education, and they confirm

their arguments by facts. The same principles apply to rhythms: some have a character of rest, others of motion, and of these latter again, some have a more vulgar, others a nobler movement. Enough has been said to show that music has a power of forming the character, and should therefore be introduced into the education of the young. The study is suited to the stage of youth, for young persons will not, if they can help, endure anything which is not sweetened by pleasure, and music has a natural sweetness. There seems to be in us a sort of affinity to harmonies and rhythms, which makes some philosophers say that the soul is a harmony, others, that she possesses harmony.

BOOK VIII. 6

And now we have to determine the question which has been already raised, whether children should be themselves taught to sing and play or not. Clearly there is a considerable difference made in the character by the actual practice of the art. It is difficult, if not impossible, for those who do not perform to be good judges of the performance of others. Besides, children should have something to do, and the rattle of Archytas, which people give to their children in order to amuse them and prevent them from breaking anything in the house, was a capital invention, for a young thing cannot be quiet. The rattle is a toy suited to the infant mind, and [musical] education is a rattle or toy for children of a larger growth. We conclude then that they should be taught music in such a way as to become not only critics but performers.

The question what is or is not suitable for different ages may be easily answered; nor is there any difficulty in meeting the objection of those who say that the study of music is vulgar. We reply (1) in the first place, that they who are to be judges must also be performers, and that they should begin to practise early, although when they are older they may be spared the execution; they must have learned to appreciate what is good and to delight in it, thanks to the knowledge which they acquired in their youth. As to (2) the vulgarizing effect which music is supposed to exercise, this is a question [of degree], which we shall have no difficulty in determining, when we have considered to what extent freemen who are being trained to political virtue should pursue the art, what melodies and what rhythms they should be allowed to use, and what instruments 1341 a should be employed in teaching them to play, for even the instrument makes a difference. The answer to the objection turns upon these distinctions; for it is quite possible that certain methods of teaching and learning music do really have a degrading effect. It is evident then that the learning of music ought not to impede the business of riper years, or to degrade the body or render it unfit for civil or military duties, whether for the early practice or for the later study of them.

The right measure will be attained if students of music stop short of

the arts which are practised in professional contests, and do not seek to acquire those fantastic marvels of execution which are now the fashion in such contests, and from these have passed into education. Let the young pursue their studies until they are able to feel delight in noble melodies and rhythms, and not merely in that common part of music in which every slave or child and even some animals find pleasure.

From these principles we may also infer what instruments should be used. The flute, or any other instrument which requires great skill, as for example the harp, ought not to be admitted into education, but only such as will make intelligent students of music or of the other parts of education. Besides, the flute is not an instrument which has a good moral effect; it is too exciting. The proper time for using it is when the performance aims not at instruction, but at the relief of the passions. And there is a further objection; the impediment which the flute presents to the use of the voice detracts from its educational value. The ancients therefore were right in forbidding the flute to youths and freemen, although they had once allowed it. For when their wealth gave them greater leisure, and they had loftier notions of excellence, being also elated with their success, both before and after the Persian War, with more zeal than discernment they pursued every kind of knowledge, and so they introduced the flute into education. At Lacedaemon there was a Choragus who led the Chorus with a flute, and at Athens the instrument became so popular that most freemen could play upon it. The popularity is shown by the tablet which Thrasippus dedicated when he furnished the Chorus to Ecphantides. Later experience enabled men to judge what was or was not really conducive to virtue, and they rejected both the flute and several other old-fashioned instruments, such as the Lydian harp, the many-

1341 b stringed lyre, the 'heptagon,' 'triangle,' 'sambuca,' and the like—which are intended only to give pleasure to the hearer, and require extraordinary skill of hand. There is a meaning also in the myth of the ancients, which tells how Athene invented the flute and then threw it away. It was not a bad idea of theirs, that the Goddess disliked the instrument because it made the face ugly; but with still more reason may we say that she rejected it because the acquirement of flute-playing contributes nothing to the mind, since to Athene we ascribe both knowledge and art.

Thus then we reject the professional instruments and also the professional mode of education in music—and by professional we mean that which is adopted in contests, for in this the performer practises the art, not for the sake of his own improvement, but in order to give pleasure, and that of a vulgar sort, to his hearers. For this reason the execution of such music is not the part of a freeman but of a paid performer, and the result is that the performers are vulgarized, for the end at which they aim is bad. The vulgarity of the spectator tends to lower the character of the music and therefore of the performers; they look to him—he makes

them what they are, and fashions even their bodies by the movements which he expects them to exhibit.

BOOK VIII. 7

We have also to consider rhythms and harmonies. Shall we use them all in education or make a distinction? and shall the distinction be that which is made by those who are engaged in education, or shall it be some other? For we see that music is produced by melody and rhythm, and we ought to know what influence these have respectively on education, and whether we should prefer excellence in melody or excellence in rhythm. But as the subject has been very well treated by many musicians of the present day, and also by philosophers who have had considerable experience of musical education, to these we would refer the more exact student of the subject; we shall only speak of it now after the manner of the legislator, having regard to general principles.

We accept the division of melodies proposed by certain philosophers into ethical melodies, melodies of action, and passionate or inspiring melodies, each having, as they say, a mode or harmony corresponding to it. But we maintain further that music should be studied, not for the sake of one, but of many benefits, that is to say, with a view to (1) education, (2) purification (the word 'purification' we use at present without explanation, but when hereafter we speak of poetry, we will treat the subject with more precision); music may also serve (3) for intellectual enjoyment, for relaxation and for recreation after exertion. It is clear, therefore, that all the harmonies must be employed by us, but not all of them in the same manner. In education ethical melodies are to be preferred, but we may listen to the melodies of action and passion when they are performed by others. For feelings such as pity and fear, or, again, enthusiasm, exist very strongly in some souls, and have more or less influence over all. Some persons fall into a religious frenzy, whom we see disenthralled by the use of mystic melodies, which bring healing and purification to the soul. Those who are influenced by pity or fear and every emotional nature have a like experience, others in their degree are stirred by something which specially affects them, and all are in a manner purified and their souls lightened and delighted. The melodies of purification likewise give an innocent pleasure to mankind. Such are the harmonies and the melodies in which those who perform music at the theatre should be invited to compete. But since the spectators are of two kinds—the one free and educated, and the other a vulgar crowd composed of mechanics, labourers, and the like—there ought to be contests and exhibitions instituted for the relaxation of the second class also. And the melodies will correspond to their minds; for as their minds are perverted from the natural state, so there are exaggerated and corrupted harmonies which

1342 a

are in like manner a perversion. A man receives pleasure from what is natural to him, and therefore professional musicians may be allowed to practise this lower sort of music before an audience of a lower type. But, for the purposes of education, as I have already said, those modes and melodies should be employed which are ethical, such as the Dorian; though we may include any others which are approved by philosophers who have had a musical education. The Socrates of the Republic is wrong 1342 b in retaining only the Phrygian mode along with the Dorian, and the more so because he rejects the flute; for the Phrygian is to the modes what the flute is to musical instruments—both of them are exciting and emotional. Poetry proves this, for Bacchic frenzy and all similar emotions are most suitably expressed by the flute, and are better set to the Phrygian than to any other harmony. The dithyramb, for example, is acknowledged to be Phrygian, a fact of which the connoisseurs of music offer many proofs, saying, among other things, that Philoxenus, having attempted to compose his Tales as a dithyramb in the Dorian mode, found it impossible, and fell back into the more appropriate Phrygian. All men agree that the Dorian music is the gravest and manliest. And whereas we say that the extremes should be avoided and the mean followed, and whereas the Dorian is a mean between the other harmonies [the Phrygian and the Lydian], it is evident that our youth should be taught the Dorian music.

Two principles have to be kept in view, what is possible, what is becoming: at these every man ought to aim. But even these are relative to age; the old, who have lost their powers, cannot very well sing the severe melodies, and nature herself seems to suggest that their songs should be of the more relaxed kind. Wherefore the musicians likewise blame Socrates, and with justice, for rejecting the relaxed harmonies in education under the idea that they are intoxicating, not in the ordinary sense of intoxication (for wine rather tends to excite men), but because they have no strength in them. And so with a view to a time of life when men begin to grow old, they ought to practise the gentler harmonies and melodies as well as the others. And if there be any harmony, such as the Lydian above all others appears to be, which is suited to children of tender age, and possesses the elements both of order and of education, clearly [we ought to use it, for] education should be based upon three principles—the mean, the possible, the becoming, these three.

PLOTINUS

ENNEAD I

*Plotinus (*A.D.* 205–270) was the founder of Neo-Platonism, a philosophical movement which is based on a mystical interpretation of Plato's thought.*

SIXTH TRACTATE

Beauty

1. Beauty addresses itself chiefly to sight; but there is a beauty for the hearing too, as in certain combinations of words and in all kinds of music, for melodies and cadences are beautiful; and minds that lift themselves above the realm of sense to a higher order are aware of beauty in the conduct of life, in actions, in character, in the pursuits of the intellect; and there is the beauty of the virtues. What loftier beauty there may be, yet, our argument will bring to light.

What, then, is it that gives comeliness to material forms and draws

the ear to the sweetness perceived in sounds, and what is the secret of the beauty there is in all that derives from Soul?

Is there some One Principle from which all take their grace, or is there a beauty peculiar to the embodied and another for the bodiless? Finally, one or many, what would such a Principle be?

Consider that some things, material shapes for instance, are gracious not by anything inherent but by something communicated, while others are lovely of themselves, as, for example, Virtue.

The same bodies appear sometimes beautiful, sometimes not; so that there is a good deal between being body and being beautiful.

What, then, is this something that shows itself in certain material forms? This is the natural beginning of our inquiry.

What is it that attracts the eyes of those to whom a beautiful object is presented, and calls them, lures them, towards it, and fills them with joy at the sight? If we possess ourselves of this, we have at once a standpoint for the wider survey.

Almost everyone declares that the symmetry of parts towards each other and towards a whole, with, besides, a certain charm of colour, constitutes the beauty recognized by the eye, that in visible things, as indeed in all else, universally, the beautiful thing is essentially symmetrical, patterned.

But think what this means.

Only a compound can be beautiful, never anything devoid of parts; and only a whole; the several parts will have beauty, not in themselves, but only as working together to give a comely total. Yet beauty in an aggregate demands beauty in details: it cannot be constructed out of ugliness; its law must run throughout.

All the loveliness of colour and even the light of the sun, being devoid of parts and so not beautiful by symmetry, must be ruled out of the realm of beauty. And how comes gold to be a beautiful thing? And lightning by night, and the stars, why are these so fair?

In sounds also the simple must be proscribed, though often in a whole noble composition each several tone is delicious in itself.

Again since the one face, constant in symmetry, appears sometimes fair and sometimes not, can we doubt that beauty is something more than symmetry, that symmetry itself owes its beauty to a remoter principle?

Turn to what is attractive in methods of life or in the expression of thought; are we to call in symmetry here? What symmetry is to be found in noble conduct, or excellent laws, in any form of mental pursuit?

What symmetry can there be in points of abstract thought?

The symmetry of being accordant with each other? But there may be accordance or entire identity where there is nothing but ugliness: the proposition that honesty is merely a generous artlessness chimes in the most perfect harmony with the proposition that morality means weakness of will; the accordance is complete.

Then again, all the virtues are a beauty of the Soul, a beauty authentic beyond any of these others; but how does symmetry enter here? The Soul, it is true, is not a simple unity, but still its virtue cannot have the symmetry of size or of number: what standard of measurement could preside over the compromise or the coalescence of the Soul's faculties or purposes?

Finally, how by this theory would there be beauty in the Intellectual-Principle, essentially the solitary?

2. Let us, then, go back to the source, and indicate at once the Principle that bestows beauty on material things.

Undoubtedly this Principle exists; it is something that is perceived at the first glance, something which the Soul names as from an ancient knowledge and, recognizing, welcomes it, enters into unison with it

But let the Soul fall in with the Ugly and at once it shrinks within itself, denies the thing, turns away from it, not accordant, resenting it.

Our interpretation is that the Soul—by the very truth of its nature, by its affiliation to the noblest Existents in the hierarchy of Being—when it sees anything of that kin, or any trace of that kinship, thrills with an immediate delight, takes its own to itself, and thus stirs anew to the sense of its nature and of all its affinity.

But, is there any such likeness between the loveliness of this world and the splendours in the Supreme? Such a likeness in the particulars would make the two orders alike: but what is there in common between beauty here and beauty There?

We hold that all the loveliness of this world comes by communion in Ideal-Form.

All shapelessness whose kind admits of pattern and form, as long as it remains outside of Reason and Idea, is ugly by that very isolation from the Divine-Thought. And this is the Absolute Ugly: an ugly thing is something that has not been entirely mastered by pattern, that is by Reason, the Matter not yielding at all points and in all respects to Ideal-Form.

But where the Ideal-Form has entered, it has grouped and co-ordinated what from a diversity of parts was to become a unity: it has rallied confusion into co-operation: it has made the sum one harmonious coherence: for the Idea is a unity and what it moulds must come to unity as far as multiplicity may.

And on what has thus been compacted to unity, Beauty enthrones itself, giving itself to the parts as to the sum: when it lights on some natural unity, a thing of like parts, then it gives itself to that whole. Thus, for an illustration, there is the beauty, conferred by craftsmanship, of all a house with all its parts, and the beauty which some natural quality may give to a single stone.

This, then, is how the material thing becomes beautiful—by communicating in the thought (Reason, Logos) that flows from the Divine.

3. And the Soul includes a faculty peculiarly addressed to Beauty—
one incomparably sure in the appreciation of its own, when Soul entire
is enlisted to support its judgement.

Or perhaps the Soul itself acts immediately, affirming the Beautiful
where it finds something accordant with the Ideal-Form within itself,
using this Idea as a canon of accuracy in its decision.

But what accordance is there between the material and that which
antedates all Matter?

On what principle does the architect, when he finds the house standing
before him correspondent with his inner ideal of a house, pronounce it
beautiful? Is it not that the house before him, the stones apart, is the
inner idea stamped upon the mass of exterior matter, the indivisible ex-
hibited in diversity?

So with the perceptive faculty: discerning in certain objects the Ideal-
Form which has bound and controlled shapeless matter, opposed in nature
to Idea, seeing further stamped upon the common shapes some shape
excellent above the common, it gathers into unity what still remains
fragmentary, catches it up and carries it within, no longer a thing of
parts, and presents it to the Ideal-Principle as something concordant and
congenial, a natural friend: the joy here is like that of a good man who
discerns in a youth the early signs of a virtue consonant with the achieved
perfection within his own soul.

The beauty of colour is also the outcome of a unification: it derives
from shape, from the conquest of the darkness inherent in Matter by the
pouring-in of light, the unembodied, which is a Rational-Principle and
an Ideal-Form.

Hence it is that Fire itself is splendid beyond all material bodies, hold-
ing the rank of Ideal-Principle to the other elements, making ever up-
wards, the subtlest and sprightliest of all bodies, as very near to the
unembodied; itself alone admitting no other, all the others penetrated
by it: for they take warmth but this is never cold; it has colour primally;
they receive the Form of colour from it: hence the splendour of its light,
the splendour that belongs to the Idea. And all that has resisted and is
but uncertainly held by its light remains outside of beauty, as not having
absorbed the plenitude of the Form of colour.

And harmonies unheard in sound create the harmonies we hear and
wake the Soul to the consciousness of beauty, showing it the one essence
in another kind: for the measures of our sensible music are not arbitrary
but are determined by the Principle whose labour is to dominate Matter
and bring pattern into being.

Thus far of the beauties of the realm of sense, images and shadow-
pictures, fugitives that have entered into Matter—to adorn, and to ravish,
where they are seen.

4. But there are earlier and loftier beauties than these. In the sense-

bound life we are no longer granted to know them, but the Soul, taking no help from the organs, sees and proclaims them. To the vision of these we must mount, leaving sense to its own low place.

As it is not for those to speak of the graceful forms of the material world who have never seen them or known their grace—men born blind, let us suppose—in the same way those must be silent upon the beauty of noble conduct and of learning and all that order who have never cared for such things, nor may those tell of the splendour of virtue who have never known the face of Justice and of Moral-Wisdom beautiful beyond the beauty of Evening and of Dawn.

Such vision is for those only who see the Soul's sight—and at the vision, they will rejoice, and awe will fall upon them and a trouble deeper than all the rest could ever stir, for now they are moving in the realm of Truth.

This is the spirit that Beauty must ever induce, wonderment and a delicious trouble, longing and love and a trembling that is all delight. For the unseen all this may be felt as for the seen; and this the Souls feel for it, every Soul in some degree, but those the more deeply that are the more truly apt to this higher love—just as all take delight in the beauty of the body but all are not stung as sharply, and those only that feel the keener wound are known as Lovers.

5. These Lovers, then, lovers of the beauty outside of sense, must be made to declare themselves.

What do you feel in presence of the grace you discern in actions, in manners, in sound morality, in all the works and fruits of virtue, in the beauty of Souls? When you see that you yourselves are beautiful within, what do you feel? What is this Dionysiac exultation that thrills through your being, this straining upwards of all your soul, this longing to break away from the body and live sunken within the veritable self?

These are no other than the emotions of Souls under the spell of love.

But what is it that awakens all this passion? No shape, no colour, no grandeur of mass: all is for a Soul, something whose beauty rests upon no colour, for the moral wisdom the Soul enshrines and all the other hueless splendour of the virtues. It is that you find in yourself, or admire in another, loftiness of spirit; righteousness of life; disciplined purity; courage of the majestic face; gravity, modesty that goes fearless and tranquil and passionless; and, shining down upon all, the light of godlike Intellection.

All these noble qualities are to be reverenced and loved, no doubt, but what entitles them to be called beautiful?

They exist: they manifest themselves to us: anyone that sees them must admit that they have reality of Being; and is not Real-Being really beautiful?

But we have not yet shown by what property in them they have

wrought the Soul to loveliness: what is this grace, this splendour as of Light, resting upon all the virtues?

Let us take the contrary, the ugliness of the Soul, and set that against its beauty: to understand, at once, what this ugliness is and how it comes to appear in the Soul will certainly open our way before us.

Let us then suppose an ugly Soul, dissolute, unrighteous: teeming with all the lusts; torn by internal discord; beset by the fears of its cowardice and the envies of its pettiness; thinking, in the little thought it has, only of the perishable and the base; perverse in all its impulses; the friend of unclean pleasures; living the life of abandonment to bodily sensation and delighting in its deformity.

What must we think but that all this shame is something that has gathered about the Soul, some foreign bane outraging it, soiling it, so that, encumbered with all manner of turpitude, it has no longer a clean activity or a clean sensation, but commands only a life smouldering dully under the crust of evil; that, sunk in manifold death, it no longer sees what a Soul should see, may no longer rest in its own being, dragged ever as it is towards the outer, the lower, the dark?

An unclean thing, I dare to say; flickering hither and thither at the call of objects of sense, deeply infected with the taint of body, occupied always in Matter, and absorbing Matter into itself; in its commerce with the Ignoble it has trafficked away for an alien nature its own essential Idea.

If a man has been immersed in filth or daubed with mud, his native comeliness disappears and all that is seen is the foul stuff besmearing him: his ugly condition is due to alien matter that has encrusted him, and if he is to win back his grace it must be his business to scour and purify himself and make himself what he was.

So, we may justly say, a Soul becomes ugly—by something foisted upon it, by sinking itself into the alien, by a fall, a descent into body, into Matter. The dishonour of the Soul is in its ceasing to be clean and apart. Gold is degraded when it is mixed with earthly particles; if these be worked out, the gold is left and is beautiful, isolated from all that is foreign, gold with gold alone. And so the Soul; let it be but cleared of the desires that come by its too intimate converse with the body, emancipated from all the passions, purged of all that embodiment has thrust upon it, withdrawn, a solitary, to itself again—in that moment the ugliness that came only from the alien is stripped away.

6. For, as the ancient teaching was, moral-discipline and courage and every virtue, not even excepting Wisdom itself, all is purification.

Hence the Mysteries with good reason adumbrate the immersion of the unpurified in filth, even in the Nether-World, since the unclean loves filth for its very filthiness, and swine foul of body find their joy in foulness.

What else is Sophrosyny, rightly so-called, but to take no part in the

pleasures of the body, to break away from them as unclean and unworthy of the clean? So too, Courage is but being fearless of the death which is but the parting of the Soul from the body, an event which no one can dread whose delight is to be his unmingled self. And Magnanimity is but disregard for the lure of things here. And Wisdom is but the Act of the Intellectual-Principle withdrawn from the lower places and leading the Soul to the Above.

The Soul thus cleansed is all Idea and Reason, wholly free of body, intellective, entirely of that divine order from which the wellspring of Beauty rises and all the race of Beauty.

Hence the Soul heightened to the Intellectual-Principle is beautiful to all its power. For Intellection and all that proceeds from Intellection are the Soul's beauty, a graciousness native to it and not foreign, for only with these is it truly Soul. And it is just to say that in the Soul's becoming a good and beautiful thing is its becoming like to God, for from the Divine comes all the Beauty and all the Good in beings.

We may even say that Beauty *is* the Authentic-Existents and Ugliness is the Principle contrary to Existence: and the Ugly is also the primal evil; therefore its contrary is at once good and beautiful, or is Good and Beauty: and hence the one method will discover to us the Beauty-Good and the Ugliness-Evil.

And Beauty, this Beauty which is also The Good, must be posed as The First: directly deriving from this First is the Intellectual-Principle which is pre-eminently the manifestation of Beauty; through the Intellectual-Principle Soul is beautiful. The beauty in things of a lower order —actions and pursuits for instance—comes by operation of the shaping Soul which is also the author of the beauty found in the world of sense. For the Soul, a divine thing, a fragment as it were of the Primal Beauty, makes beautiful to the fullness of their capacity all things whatsoever that it grasps and moulds.

7. Therefore we must ascend again towards the Good, the desired of every Soul. Anyone that has seen This, knows what I intend when I say that it is beautiful. Even the desire of it is to be desired as a Good. To attain it is for those that will take the upward path, who will set all their forces towards it, who will divest themselves of all that we have put on in our descent: so, to those that approach the Holy Celebrations of the Mysteries, there are appointed purifications and the laying aside of the garments worn before, and the entry in nakedness—until, passing, on the upward way, all that is other than the God, each in the solitude of himself shall behold that solitary-dwelling Existence, the Apart, the Unmingled, the Pure, that from Which all things depend, for Which all look and live and act and know, the Source of Life and of Intellection and of Being.

And one that shall know this vision—with what passion of love shall

he not be seized, with what pang of desire, what longing to be molten into one with This, what wondering delight! If he that has never seen this Being must hunger for It as for all his welfare, he that has known must love and reverence It as the very Beauty; he will be flooded with awe and gladness, stricken by a salutary terror; he loves with a veritable love, with sharp desire; all other loves than this he must despise, and disdain all that once seemed fair.

This, indeed, is the mood even of those who, having witnessed the manifestation of Gods or Supernals, can never again feel the old delight in the comeliness of material forms: what then are we to think of one that contemplates Absolute Beauty in Its essential integrity, no accumulation of flesh and matter, no dweller on earth or in the heavens—so perfect Its purity—far above all such things in that they are non-essential, composite, not primal but descending from This?

Beholding this Being—the Choragus of all Existence, the Self-Intent that ever gives forth and never takes—resting, rapt, in the vision and possession of so lofty a loveliness, growing to Its likeness, what Beauty can the Soul yet lack? For This, the Beauty supreme, the absolute, and the primal, fashions Its lovers to Beauty and makes them also worthy of love.

And for This, the sternest and the uttermost combat is set before the Souls; all our labour is for This, lest we be left without part in this noblest vision, which to attain is to be blessed in the blissful sight, which to fail of is to fail utterly.

For not he that has failed of the joy that is in colour or in visible forms, not he that has failed of power or of honours or of kingdom has failed, but only he that has failed of only This, for Whose winning he should renounce kingdoms and command over earth and ocean and sky, if only, spurning the world of sense from beneath his feet, and straining to This, he may see.

8. But what must we do? How lies the path? How come to vision of the inaccessible Beauty, dwelling as if in consecrated precincts, apart from the common ways where all may see, even the profane?

He that has the strength, let him arise and withdraw into himself, foregoing all that is known by the eyes, turning away for ever from the material beauty that once made his joy. When he perceives those shapes of grace that show in body, let him not pursue: he must know them for copies, vestiges, shadows, and hasten away towards That they tell of. For if anyone follow what is like a beautiful shape playing over water— is there not a myth telling in symbol of such a dupe, how he sank into the depths of the current and was swept away to nothingness? So too, one that is held by material beauty and will not break free shall be precipitated, not in body but in Soul, down to the dark depths loathed of the

Intellective-Being, where, blind even in the Lower-World, he shall have commerce only with shadows, there as here.

'Let us flee then to the beloved Fatherland': this is the soundest counsel. But what is this flight? How are we to gain the open sea? For Odysseus is surely a parable to us when he commands the flight from the sorceries of Circe or Calypso—not content to linger for all the pleasure offered to his eyes and all the delight of sense filling his days.

The Fatherland to us is There whence we have come, and There is The Father.

What then is our course, what the manner of our flight? This is not a journey for the feet; the feet bring us only from land to land; nor need you think of coach or ship to carry you away; all this order of things you must set aside and refuse to see: you must close the eyes and call instead upon another vision which is to be waked within you, a vision, the birthright of all, which few turn to use.

9. And this inner vision, what is its operation?

Newly awakened it is all too feeble to bear the ultimate splendour. Therefore the Soul must be trained—to the habit of remarking, first, all noble pursuits, then the works of beauty produced not by the labour of the arts but by the virtue of men known for their goodness: lastly, you must search the souls of those that have shaped these beautiful forms.

But how are you to see into a virtuous Soul and know its loveliness?

Withdraw into yourself and look. And if you do not find yourself beautiful yet, act as does the creator of a statue that is to be made beautiful: he cuts away here, he smoothes there, he makes this line lighter, this other purer, until a lovely face has grown upon his work. So do you also: cut away all that is excessive, straighten all that is crooked, bring light to all that is overcast, labour to make all one glow of beauty and never cease chiselling your statue, until there shall shine out on you from it the godlike splendour of virtue, until you shall see the perfect goodness surely established in the stainless shrine.

When you know that you have become this perfect work, when you are self-gathered in the purity of your being, nothing now remaining that can shatter that inner unity, nothing from without clinging to the authentic man, when you find yourself wholly true to your essential nature, wholly that only veritable Light which is not measured by space, not narrowed to any circumscribed form nor again diffused as a thing void of term, but ever unmeasurable as something greater than all measure and more than all quantity—when you perceive that you have grown to this, you are now become very vision: now call up all your confidence, strike forward yet a step—you need a guide no longer—strain, and see.

This is the only eye that sees the mighty Beauty. If the eye that adventures the vision be dimmed by vice, impure, or weak, and unable in its

cowardly blenching to see the uttermost brightness, then it sees nothing even though another point to what lies plain to sight before it. To any vision must be brought an eye adapted to what is to be seen, and having some likeness to it. Never did eye see the sun unless it had first become sunlike, and never can the Soul have vision of the First Beauty unless itself be beautiful.

Therefore, first let each become godlike and each beautiful who cares to see God and Beauty. So, mounting, the Soul will come first to the Intellectual-Principle and survey all the beautiful Ideas in the Supreme and will avow that this is Beauty, that the Ideas are Beauty. For by their efficacy comes all Beauty else, by the offspring and essence of the Intellectual-Being. What is beyond the Intellectual-Principle we affirm to be the nature of Good radiating Beauty before it. So that, treating the Intellectual-Cosmos as one, the first is the Beautiful: if we make distinction there, the Realm of Ideas constitutes the Beauty of the Intellectual Sphere; and The Good, which lies beyond, is the Fountain at once and Principle of Beauty: the Primal Good and the Primal Beauty have the one dwelling-place and, thus, always, Beauty's seat is There.

ENNEAD V

EIGHTH TRACTATE

On the Intellectual Beauty

1. It is a principle with us that one who has attained to the vision of the Intellectual Cosmos and grasped the beauty of the Authentic Intellect will be able also to come to understand the Father and Transcendent of that Divine Being. It concerns us, then, to try to see and say, for ourselves and as far as such matters may be told, how the Beauty of the divine Intellect and of the Intellectual Cosmos may be revealed to contemplation.

Let us go to the realm of magnitudes:—suppose two blocks of stone lying side by side: one is unpatterned, quite untouched by art; the other has been minutely wrought by the craftsman's hands into some statue of god or man, a Grace or a Muse, or if a human being, not a portrait but a creation in which the sculptor's art has concentrated all loveliness.

Now it must be seen that the stone thus brought under the artist's hand to the beauty of form is beautiful not as stone—for so the crude block would be as pleasant—but in virtue of the Form or Idea introduced by the art. This form is not in the material; it is in the designer before ever it enters the stone; and the artificer holds it not by his equipment

of eyes and hands but by his participation in his art. The beauty, therefore, exists in a far higher state in the art; for it does not come over integrally into the work; that original beauty is not transferred; what comes over is a derivative and a minor: and even that shows itself upon the statue not integrally and with entire realization of intention but only in so far as it has subdued the resistance of the material.

Art, then, creating in the image of its own nature and content, and working by the Idea or Reason-Principle of the beautiful object it is to produce, must itself be beautiful in a far higher and purer degree since it is the seat and source of that beauty, indwelling in the art, which must naturally be more complete than any comeliness of the external. In the degree in which the beauty is diffused by entering into matter, it is so much the weaker than that concentrated in unity; everything that reaches outwards is the less for it, strength less strong, heat less hot, every power less potent, and so beauty less beautiful.

Then again every prime cause must be, within itself, more powerful than its effect can be: the musical does not derive from an unmusical source but from music; and so the art exhibited in the material work derives from an art yet higher.

Still the arts are not to be slighted on the ground that they create by imitation of natural objects; for, to begin with, these natural objects are themselves imitations; then, we must recognize that they give no bare reproduction of the thing seen but go back to the Reason-Principles from which Nature itself derives, and, furthermore, that much of their work is all their own; they are holders of beauty and add where nature is lacking. Thus Pheidias wrought the Zeus upon no model among things of sense but by apprehending what form Zeus must take if he chose to become manifest to sight.

· · ·

5. All that comes to be, work of nature or of craft, some wisdom has made: everywhere a wisdom presides at a making.

No doubt the wisdom of the artist may be the guide of the work; it is sufficient explanation of the wisdom exhibited in the arts; but the artist himself goes back, after all, to that wisdom in Nature which is embodied in himself; and this is not a wisdom built up of theorems but one totality, not a wisdom consisting of manifold detail co-ordinated into a unity but rather a unity working out into detail.

Now, if we could think of this as the primal wisdom, we need look no further, since, at that, we have discovered a principle which is neither a derivative nor a 'stranger in something strange to it'. But if we are told that, while this Reason-Principle is in Nature, yet Nature itself is its source, we ask how Nature came to possess it; and, if Nature derived it from some other source, we ask what that other source may be; if, on the contrary, the principle is self-sprung, we need look no further: but

if (as we assume) we are referred to the Intellectual-Principle we must make clear whether the Intellectual-Principle engendered the wisdom: if we learn that it did, we ask whence: if from itself, then inevitably it is itself Wisdom.

The true Wisdom, then (found to be identical with the Intellectual-Principle), is Real Being; and Real Being is Wisdom; it is wisdom that gives value to Real Being; and Being is Real in virtue of its origin in wisdom. It follows that all forms of existence not possessing wisdom are, indeed, Beings in right of the wisdom which went to their forming, but, as not in themselves possessing it, are not Real Beings.

We cannot, therefore, think that the divine Beings of that sphere, or the other supremely blessed There, need look to our apparatus of science: all of that realm (the very Beings themselves), all is noble image, such images as we may conceive to lie within the soul of the wise—but There not as inscription but as authentic existence. The ancients had this in mind when they declared the Ideas (Forms) to be Beings, Essentials.

ST. AUGUSTINE

DE MUSICA

Augustine (354–430), a saint of the Catholic Church, was a key figure in the transition from Greek philosophy to medieval thought.

BOOK VI

We must not hate what is below us, but rather with God's help put it in its right place, setting in right order what is below us, ourselves, and what is above us, and not being offended by the lower, but delighting only in the higher. "The soul is weighed in the balance by what delights her", *delectatio quippe pondus est animae*. Delight or enjoyment sets the soul in her ordered place. "Where your treasure is, there will your heart be also" (Matth. 6 21). Where the delight is, there is the treasure; where the heart is, there is the blessedness or misery. The higher things are those in which equality resides, supreme, unshaken, unchangeable, eternal; where there is no time, because no mutability; whence, in imitation of eternity, times in our world are made, ordered, and modified, as long as the circling sky continually returns to its place of starting, recalling

x. 29

Reprinted from *St. Augustine's De Musica*, translated by W. F. Jackson Knight, London, The Orthological Institute, 1949, pp. 107–120; 122–124.

thither the heavenly bodies too, with the days, months, years, periods of five years, *lustra*, and other cycles of time which are marked by the stars, according to the laws of equality, unity, and order. So earthly things are subject to heavenly things, seeming to associate the cycles of their own durations in rhythmic succession with the song of the great whole, *universitatis*.

xi. 30 In this array there are many things which to us appear out of order and confused, because we have been attached, *assuti* [nearly all MSS *assueti*], to their order, their station in existence, according to our own limited merits, not knowing the glorious plan which Divine Providence has in operation, *gerat*, concerning us. It is as if some one were put to stand like a statue in a corner of a fine, large house, and found that, being a part of it himself, he could not perceive the beauty of the structure, *fabrica*. A soldier on the battlefield cannot see the dispositions of the whole army. If syllables in a poem had life and perception for just as long as their sounds lasted, the rhythmicality and beauty of the whole intricately inwoven work could not give them pleasure. They could not review and approve the whole poem, which is built of their own transient selves. God made sinful man ugly; but it was not an ugly act to make him so. Man became ugly by his own wish. He lost the whole, which, in obedience to God's laws, he once possessed, and was given his place in part of it, since he is unwilling to practise, *agere*, the law, and therefore is governed by the law instead. Lawful acts are just, and just acts are not essentially ugly. Even in our bad deeds there are good works of God. Man, as man, is good. Adultery is bad. But from adultery, a bad act of man, is born a man, a good act of God.

xi. 31 To return, those rhythms excel by virtue of the beauty of reason, which, if we were cut off from them altogether when we incline towards the body, would cease to govern the Progressive Rhythm perceptible to sense, and to create perceptible beauties of temporal durations by bodily movement. . . . It is the same psyche which receives all these impulses, which are in fact its own, multiplying them in some sense within itself, and making them capable of being remembered. This particular power of the psyche is called memory, and it is an instrument of great assistance in the busy activities of human life, *magnum quoddam adiutorium in huius uitae negotiosissimis actibus*.

xi. 32 Whatever things are retained by memory from movements of the psyche performed in response to the body's affects, *passiones*, are called in Greek phantasies, φαντασίαι, for which there is no satisfactory equivalent in Latin. To treat these phantasies as things ascertained and understood, *pro cognitis atque pro perceptis*, is to live the life of mere opinion, *opinabilis uita est*, the life that is set at the very point where error has entry, *introitu*. For such phantasies, moving within the psyche, a seething welter at the mercy of diverse and contradictory blasts from the wind of attention, *intentionis*, come into mutual contact, and from one another

procreate new movements within the psyche, which are no longer things delivered by impressions from, *de*, the senses, resulting from impacts delivered by bodily affects, *ex occursionibus passionum corporis impressi de sensibus*, and retained afterwards by the psyche, but are now rather the images of images, *imaginum imagines*, to which the conventional name of phantasms has been given, *quae phantasmata dici placuit*. I think differently about my father whom I have seen and about my grandfather whom I have never seen. My thought of my father comes from memory, but my thought of my grandfather comes from mental movements arising out of other mental movements which are contained in memory. Their origin is hard to discover and to explain. I think that, if I had never seen any human bodies, I could not imagine, *figurare*, them. Whatever I make out of anything which I have seen, I make by means of memory. There is a difference between finding a phantasy in memory and making a phantasm from, *de*, memory. The power, *uis*, of the psyche can do all of this. But it is the greatest error to mistake even true phantasms for ascertained facts; though there is, *quamquam sit*, in both these classes of being something which we can without absurdity say that we know, that is, either something which we have perceived, or else something of which we can form a mental image, *imaginari*. I am not rash to assert that I had a father and a grandfather, but it would be utter insanity if I ventured to say, *dementissime dixerim*, that they were the very men whom my mind, *animus*, holds, either in phantasy or in a phantasm. There are people who follow their phantasms in headlong haste; and indeed we can say that the universal cause of false opinion is the mistake of regarding phantasies or phantasms as true facts ascertained by sense-perception, *per sensum*. We should, of course, resist them; we must not accommodate to them our mental activity, *mens*, wrongly thinking that, just because there is, *dum est*, an element of thought in them, therefore it is by our understanding, *intelligentia*, that we apprehend them.

But, if rhythm of this sort, occurring in a soul, *anima*, abandoned to xi. 33
temporal things, has a beauty within the limitations of its own kind, even though it is only transiently that it stimulates that soul, *quamquam eam transeundo actitent*, why would Divine Providence regard this kind of beauty with jealous disapproval, *inuideat?* This kind of beauty is formed out of, *de*, our penal mortality, which, by a law of God, a law most just, we have fully deserved. But he has not so forsaken us that we cannot be recalled from carnal delight, and quickly retrace our way, *recurrere*, for His pity stretches out its hand. Carnal delight powerfully fixes in the memory all that it derives from our treacherous senses. This intimacy, *consuetudo*, between our souls and the flesh, the result of carnal affection, is called the flesh in the Divine Scriptures. The flesh wrestles with the mental part of us, *mens*, and so the Apostle could say, *cum iam dici potest apostolicum illud*, "With the mind I myself serve the law of God; but with the flesh the law of sin" (Rom. 7 [25]). But when the mental part

of us is uplifted to attachment to spiritual things, the impulse of this intimacy is broken; it is gradually suppressed, and then extinguished. It was stronger when we followed it; when we bridle it, it still has some strength, but it is now weaker. If we with firm steps draw back from every lascivious thought, in which there must always be a reduction of the soul's full existence, our delight in the Rhythm of Reason is restored, and our whole life is turned to God, not now receiving pleasure from the body, but giving to it a rhythm of health. This result happens because the outer man is consumed away, and the man himself is transformed into something finer.

xii. 34 But memory gathers, *excipit*, not only the carnal movements of the mind, *animi*, that constitute the rhythm of which we have just spoken, but also spiritual movements, which we have now shortly to treat. Being simple, they have need of fewer words; but they have the utmost need of undisturbed mental activity, *plurimum seuerae mentis*. That equality which we failed to find, fixed and enduring, in perceptible rhythm, but which we recognized as shadowed in it while it passed us by, would nowhere have been an object of our mind's aspiration, *appeteret*, if somewhere it had not become known to our mind. But it cannot have been somewhere in the world of space and time, *locorum et temporum*. Spatial things expand, *tument;* temporal things pass, *pratereunt*. Where then can it have been? Not in bodily forms, which can never be called truly equal to one another if they are fairly weighed by free judgment, *liquido examine*, nor in intervals of time, in which we never know whether something is longer or shorter in duration than something else, the inequality being unobserved by our perception. Where then is that equality at which we must be looking, if we are so led to desire equality in bodily things and their movements, and yet dare not trust them, when we consider them with care? Presumably it is in the place which is higher and finer than any bodily things, *ibi puto quod est corporibus excellentius;* but whether that is in the soul, or above it, is obscure.

xii. 35 Our rhythmic or metric art, which is used by makers of verses, comprises certain rhythmical measurements, *numeri*, according to which they make the verses. The measurements, that is, the rhythm, remain when the verses stop or pass. The verse or rhythm which passes is really manufactured, *fabricari*, by the rhythm which remains. The art is an active conformation, *affectio*, of the mind, *animus*, of the artist. This conformation is not in the mind of any man who is unskilled, or who has forgotten the art. Now one who has forgotten a rhythm can be reminded of it by questions asked of him. The rhythm returns to his memory, but obviously not from the questioner. The man who had forgotten makes movements within the sphere of his own mental activity, *apud mentem suam*, in response to something, and hence the forgotten thing may be restored, *redhibeatur*. Can he even be reminded of the quantities of syllables, which vary in their temporal duration according to the decree of

the ancients? For if these quantities had been stable, securely fixed by nature or doctrine, modern scholars would not have been committing the errors in quantity which they do commit. We cannot say that everything forgotten can be recalled to memory by questions; we could not be made by questions to remember a dinner eaten a year ago, *ante annum*; nor could questions recall to memory detailed quantities of syllables. The *I* of *Italia*, Italy, was made short ⌣ in the past by the wish of some individual men. Now it is long −, *Ī Italia*, made long by the wish of others. This is convention. But no one, past, present, or future, can by his wish make 1 + 2 anything but 3, or prevent 2 from being twice 1, *ut duo uni non duplo respondeant*. If one who has never learnt rhythm, that is, not one who has learnt and then forgotten it, is thoroughly questioned about it, and answers are elicited from him, then, just as arithmetical answers about 1 and 2 and the rest can be elicited by questions, so too the learner may learn the art of rhythm, except the quantities of syllables, which depend on authority. The questioner does not impart anything, but the learner acts within himself in such a way as to understand what is asked, and answers. Through this mental movement rhythm is imprinted on his faculty of mental activity, *mens*, and he achieves the active conformation, *affectio*, which is called art.

This rhythm is immutable and eternal, with no inequality possible in xii. 36 it. Therefore it must come from God. The learner who is questioned moves inwardly to God to understand immutable truth; and unless he retains in memory the same movement which once he made, the learner cannot be recalled to an apprehension of that same immutable truth without external help.

Presumably the learner had abandoned thoughts of that truth, and xiii. 37 needed to be recalled by memory, because he was intent, *attentus*, on something else. What distracted him from thoughts of the supreme, immutable equality, must have been either equal in value, *par* or higher, or lower. Obviously it must have been lower. [Not necessarily.] The soul admits that immutable equality exists, but also that it is itself lower than it, because it looks sometimes at this equality and sometimes at something else. Set on various objects, the soul performs a variety of temporal rhythms, with no existence, *nulla est*, in the realm of eternal and immutable things. This active conformation, *affectio*, by which the soul first understands what are eternal things, then realizes that temporal things are inferior to them even when they are in itself, and finally knows that the higher is more to be sought than the lower, is wisdom, *prudentia*.

The soul has, then, the power to know eternal things as things to xiii. 38 which it should cling fast, *inhaerendum*, but it has not at the same time the power to do so. To find the reason, we must observe what we notice most attentively, and for what we show great care, for that is what we love much. We love the beautiful. True, some love ugly things, the "lovers of putrefaction", in Greek σαπρόφιλοι. But what matters is how much more

beautiful are the things which most people like. Clearly no one loves what disgusts the perception, that is, sheer repulsiveness, *foeditas*. Beautiful things please by proportion, *numero*, and here as we have shewn equality is not found only in sounds for the ear and in bodily movements, but also in visible forms, in which hitherto equality has been identified with beauty even more customarily than in sounds. Nothing can be proportionate or rhythmic, *numerosus*, without equality, with pairs of equivalent members responding to each other, *paria paribus*. All that is single, *singula*, must have some central place, so that equality may be preserved in the intervals extending to the central individual part, *ad ea*, from either side, *de utraque parte*. Visible light has the presidency, *principatum*, over all colours, colour of course being a source of delight in bodily forms. And in all light and all colours we aspire to something which is in harmony, *congruit*, with our eyes. We turn away from too bright a light, and dislike looking at what is too dark, just as we shrink from too loud a sound and do not like a whisper. Nothing here depends on intervals of time, but everything on the actual sound which is here the very light of the rhythm, *numerorum*, the sound to which silence is the contrary, just as darkness is the contrary to light. In all this we act according to our nature's capacity, *modo*, seeking according to agreeability or rejecting according to disagreeability, though we perceive that what is disagreeable to us is often agreeable to the other animals; and we are in fact here too rejoicing in what is really a code, *quodam iure*, of equality, discovering that, in ways remote from our usual thinking, equivalences have yet been furnished to match one another, *paria paribus tributa*. In smell, taste, and touch this may equally be observed, and could easily be explored, but it would take too long to unravel the secret in detail, *enucleatius persequi*. Every perceptible thing which pleases us, pleases us by equality or similitude. Where there is equality or similitude, there is rhythmicality, *numerositas*, for nothing is so equal or so similar to anything as one is to one.

xiii. 39 All this, as we have discovered, is not passively sustained by the soul from physical bodies, but actively performed by the soul in physical bodies. Love of active performance, in reaction to the affects of its own body, diverts the soul from contemplation of eternal things, and care for the pleasure of perception calls its attention away, *auocans intentionem*. . . .

xiii. 40 The general love of activity, *generalis amor actionis*, which diverts us from truth, starts from pride, *superbia*, the vice which made the soul prefer to imitate God rather than to serve God. Rightly it is written in the Holy Books, "The beginning of a man's pride is to revolt, *apostatare*, from God", and "The beginning of all sin is pride". No statements show better what pride is than this—"Why is earth and ashes proud, because in his life he hath cast away his bowels?" (Ecclesiasticus 10 [9]). The soul by itself is nothing, or it would not have been mutable, and suffered

default from its own essence, *defectum ab essentia*. The whole quality of the soul's existence, *quicquid autem illi esse est* [Aristotle's τὸ τί ἦν εἶναι αὐτῷ], is from God, and therefore, while it remains within its own order of being, it is enlivened, *uegetatur*, in mental activity and in self-consciousness, *mente atque conscientia*, by God's presence. Such goodness the soul has deeply within it. To become distended with pride is to move towards the external and to become empty within, that is, to exist less and less fully, *quod est minus minusque esse*. To move away to what is outside is to sacrifice what is deeply inside, and to put God far away, by a distance not of space but of mental condition, *mentis affectu*.

Such a soul's appetite is to have other souls subjected to it, not the souls of animals, *pecorum*, which is allowed by Divine law, but rational souls, the souls that are its relatives and friends and partners under the same law, *id est proximas suas et sub eadem lege socias atque consortes*. The soul has conceived the desire to behave, concerning, *de*, them with pride, regarding this behaviour concerning them as so much more excellent than behaviour concerning physical bodies as every soul is better than every body. But only God can act upon rational souls directly and not through the body. Yet it so transpires through our condition of sinfulness that souls are permitted to act concerning other souls, *ut permittantur animae de animis aliquid agere*, moving them by signals conveyed by the physical body of either of the souls involved, *significando eas mouentes per alterutra corpora*, either with natural gestures, as facial expression or a nod, or by conventional indications, *placitis*, such as words. We give orders and apply persuasion, and carry out all other actions by which souls act concerning, *de*, or with, *cum*, other souls, by means of signs. Now it follows from the code by which we live that whatever, in pride, desires to excel all else rules not even its own parts and its own body without difficulty, *difficultate*, and pain, partly because of stupidity within itself and partly because it is depressed by the weight of mortal members. By these rhythmical movements, by means of which souls behave in response to, *agunt ad*, one another, they are diverted, through aspiration to honours and tributes of praise, from any deep understanding, *perceptione*, of that other truth, the truth that is pure and unsullied, *sincera*. It is only from God that a soul can win true honour. He can render it blessed, living in His presence in unseen life of righteousness and piety.

Accordingly, the movements extruded by a soul in concern with, *de*, xiii. 42 what clings to itself, and in concern with other souls subject to it, are like Progressive Rhythm, for the soul is acting as if upon its own body. The movements which it extrudes, in its desire to gather souls into its flock, *aggregare*, or to subject them, *subdere*, to itself, are counted among Occursive Rhythm. For the soul is acting virtually in the realm of the senses, straining, *id moliens*, to compel something, which is fetched to it from outside, to become one with itself, or alternatively, if it cannot become one with itself, to repel it. Memory now gathers, *excipit*, both kinds of

xiii. 41

movement, and renders them recordable, that is, capable of being recollected, as the phantasies and phantasms of past actions, in a seething welter. Involved with this is something which can be called a "Weighing Rhythm", *tamquam examinatores numeri*, whose task is to discern which activities prove convenient to the active soul and which inconvenient. This rhythm we should not be sorry to call "Perceptive Rhythm", *sensuales numeri*, for it consists of the perceptible indications, *sensibilia signa*, by means of which souls behave in response to, *agunt ad*, other souls. When a soul is involved, *implicata*, with all these serious distractions, *intentiones*, it is scarcely surprising if it is diverted from the contemplation of truth, only possible for it in so far as it has respite, *respirat*, from them. It is not allowed to remain in the truth, because it has not won final victory over them, *euicit*. That is why the soul has not inherently and simultaneously both the power to know on what it should take its stand, *consistendum*, and also the power to do so.

xiv. 43 After thus considering, as well as we could, how the soul is tainted with defilement and weighted by its load, it remains for us to see that action, *actio*, is commanded of the soul by Divine authority, *divinitus*, so that through such action it may be purged and unburdened, and may then fly back to peace, and may enter into the joy of its Lord. But of course the Holy Scriptures, with the authority that is theirs, are all the time telling us to love God, our Lord, from our whole heart, our whole soul, and our whole mind, *ex toto corde, ex tota anima, et ex tota mente*, and our neighbor, *proximum*, as ourself. So there is scarcely much for us to say. If we were to refer all the movements of human action and all the rhythms, which we have examined, to this great end, without doubt we shall be cleansed, *mundabimur*. Yet on the other hand the difficulty of practical obedience is as great as the time taken to hear the command is short.

xiv. 44 It is easy to love colours, musical sounds, *uoces*, cakes, roses, and the body's soft, smooth surface, *corpora leniter mollia*. In all of them the soul is in quest of nothing except equality and similitude, and even when it reflects with some thoughtfulness it scarcely detects, amid such dark shadows, the trace of it *eius* [the text may be corrupt]. If so, it must indeed be easy to love God. For when the soul thinks of Him, as well as it can with the wounds and the stains impeding its thoughts, even so it cannot believe, *suspicatur*, that in Him there is anything unequal, or unlike Himself, or divided by space, *seclusum locis*, or varied in time. Our soul delights in the construction of tall houses, and indulgence in the efforts involved, *extendi*, in such operations. Here, if it is the proportion, *numeri*, which is the source of pleasure, and I find nothing else that can be, all the equality and similitude discernible would be derided by the arguments of true and methodical reason, *ratio disciplinae*. Why, then, does our soul slip from the truest citadel of equality, and then, with the mere débris which it drags from it, *ruinis suis*, erect terrestial structures, *machinas*, instead? The reason is not the promise of Him who knows not, *ignorat*, to deceive,

"For my yoke is easy" (Matth. II 30). Indeed, the love of this world is far more laborious. In this world the soul looks for permanence, *constantia*, and eternity, but never finds them, because only the lowest kind of beauty can be achieved by such transience, and whatever there is in this world which in any decree copies, *imitatur*, permanence, is transmitted, *traicitur*, through, *per*, our soul by God; for an appearance, *species*, which is changeable only in time, is precedent, *prior*, to an appearance which is changeable both in time and in space. The Lord has taught the soul of men what they should not love. "Love not the world. . . . For all that is in the world, the lust of the flesh, and lust of the eyes, and the pride of life <is not of the Father, but is of the world>" (I John 2 $^{15-16}$).

Now consider what kind of man he is, who finds a better method with xiv. 45
which to meet these occurrences. A man who relates, not to mere pleasure, but to the preservation of his bodily self all such rhythms whose source is in the body and in the responses to the affects of the body, and who brings into use, *redigit*, the residue from such rhythms retained in the memory, and others operating from, *de*, other souls in the vicinity, or extruded in order to attach, *adiungere*, to the soul those other souls, or their residue retained in memory, not for its own proud ambition to excel, but for the advantage of those other souls themselves; and who employs that other rhythm, which presides, with an examiner's control, over such rhythms of either kind which subsist in the transience of perception, not for the purpose of satisfying an unjustifiable and harmful curiosity, *curiositas*, but only for essential proof or disproof—such a man, surely, performs every rhythm without being entrapped in their entanglements. His choice is that bodily health should not be obstructed, *ut non impediatur*, and he refers every action to the advantage of his neighbour, whom by the bond of nature he must love as himself. He would obviously be a great man and a great gentleman, *humanissimus*.

Rhythm which does not attain the level of reason is devoid of beauty; xiv. 46
and any love of the lower beauty defiles the soul. The soul loves not only equality but order also. It has lost its true order. But it still resides in the order of things where, and how, truest order requires it to reside. There is a difference between possessing, *tenere*, order, and being possessed, *teneri*, by order. The soul possesses order by itself, *seipsa*, loving all that is higher than itself, that is, in fact, God, and also the souls that are its companions, loving them as itself. By virtue of this love it orders, that is, sets in right order, all that is lower than itself, without becoming defiled. What defiles the soul is not evil, for even the body, though it is very low in the scale, is a creature of God, and is only scorned when it is compared with the dignity of the soul. Gold is defiled even by the purest silver, if it is alloyed with it. We must not deny to rhythm which is concerned with our penal mortality its inclusion within the works of the Divine fabrication, for such rhythm is within its own kind beautiful. But we must not love such rhythm as if it could make us blessed. We must treat it as we

would a plank amid the waves of the sea, not casting it away as a burden, but not embracing it and clinging to it as if we imagined it firmly fixed. We must use such rhythm well, so that eventually we may dispense with it. For love of our neighbour, a love as strong as, according to the command, it must be, is the surest step towards an ability to cling to God; indeed, we should not, *et non*, only be possessed by the order which He imposes, but also possess our own order sure.

xv. 47 Even on the evidence of Perceptive Rhythm, the soul is proved to like order. Why else is the first foot a pyrrhic ∪ ∪, the second an iamb ∪ −, the third a trochee − ∪, and so on? It may be said that this is not a matter of intuitive perception, but of reason. Yet Perceptive Rhythm has at least the credit for the equivalence by which eight long syllables occupy the same duration as sixteen short syllables; though it prefers a mixture, *misceri exspectat*, of long and short syllables together. Reason, in fact, judges perception. Proceleumatics ∪ ∪ ∪ ∪ are reported by perception as equal to spondees − −. Here reason finds only a potentiality, *potentia* [δύναμις], of order. Long syllables are only long by comparison with short syllables, and short syllables short by comparison with long syllables. Iambic ∪ − verse, however slowly pronounced, is always in ratio 1 : 2, and remains iambic ∪ −. But purely pyrrhic ∪ ∪ verse, pronounced slowly enough, becomes spondaic − −, not, of course, according to any rule of grammar, but according to the requirement of music [or metre]. Dactyls − ∪ ∪ and anapaests ∪ ∪ − remain dactyls and anapaests, on account of the comparison between long and short syllables which is always present, however long the duration, *mora*, in pronunciation may be. Again, at the ends and beginnings of sequences of feet, half-feet are added according to different laws, all needing to have the same ictus, *plausus*, as the contiguous feet, and the final half-foot requiring to have sometimes two short syllables in place of one long syllable. Throughout, sense-perception applies its modifications. Now here quantitative equality will not account for everything, for either choice might have been made without loss of equality. Decisions are enforced by the bond of right order. It would take too long to display here the rest of the evidence for this, which is provided by durations of time. So too perception, in dealing with visible forms, rejects some of them, for example a figure bending over too far or standing on its head, and so on, when there is no loss of equality, but there is some fault of order. In all that we perceive and in all that we make, we gradually get used to what at first we rejected. It is by order that we weave our pleasure into one. We only like what has a beginning harmoniously woven on to the middle part, and a middle part harmoniously woven on to the end.

xiv. 48 Therefore we must not place our joys in carnal pleasure, nor in honour and tributes of praise, nor in our thought for anything extrinsic to our body, *forinsecus;* for we have God within us, and there all that we love is fixed and changeless. Temporal things are with us, but we are not ourselves involved in them, and we feel no pain in being parted from all that

is outside our bodies. Even our bodies themselves can be taken from us without pain, or at least without much pain, and restored where, by the death of their old nature, they may be formed anew. The concentration, *attentio*, of the soul, fixed on some part of the body, becomes readily involved in transactions in which is no peace, and in a devotion to some private operation in neglect of universal law, though even such an operation can never be quite estranged from the totality ruled by God. Thus even he who does not love the laws is still subjected to them.

Now if we normally think with closest attention about immaterial, xv. 49 changeless things, and if it happens that, at the time, we are performing temporal rhythm in one of the kinds of bodily movement which are ordinary and quite easy, such as walking or singing, we may never notice the rhythm, though it depends on our own activity, and so, too, if we are occupied in our own vain phantasms, again we perform the rhythm, but do not notice it. Now how much more, and how much more constantly, when this "corruptible must put on incorruption, and this mortal must put on immortality" (I Cor. 15 [53]), that is, when God has revived our mortal bodies, as the Apostle says, "by his Spirit that dwelleth in" us (Rom. 8 [11]), how much more, concentrated on the One God, and on truth seen perspicuous, or, as we are told, "face to face", shall we perceive, with joy, the rhythm by which we actuate, *agimus*, our bodies with no unpeacefulness? For we can hardly be expected to believe that the soul, which can derive joy from the things which are good through its own self only, cannot derive joy from the things from which its own goodness comes.

. . .

God has arranged that even a sinful and sorrowful soul can be moved xvii. 56 by rhythm and can rightly perform it, even down to the lowest corruption of the flesh. So degraded, rhythm becomes less and less beautiful, but it must always have some beauty. God is jealous of no beauty due to the soul's damnation, regression, or persistence, *permansione*. Number, the base of rhythm, begins from unity. It has beauty by equality and by similitude, and it has interconnection by order. All nature requires order. It seeks to be like itself, and it possesses its own safety and its own order, in spaces or in times or in bodily form, by methods of balance. We have to admit that in number and rhythm all, without exception and without limit, starting from the single origin of unity, is complete and secure, in a structure of equality and similitude and wealth of goodness, cohering from unity onwards in most intimate affection.

Deus creator omnium has a pleasant rhythm for the ear, but the soul xvii. 57 loves the sequence far more for the health and truth in it. We must not believe the dull wits, to use no harsher term, *ut mitius loquar*, of those who say that nothing can come from nothing, for God Almighty is said to have by His act disproved it. A craftsman, *faber*, operates rationally with rhythm in his art, using Perceptive Rhythm in the artistic tradition, *consuetudine*, and, besides that, Progressive Rhythm, with which he makes

bodily movements, according to intervals of time, or visible forms in wood, rhythmic with intervals of space. If so, surely nature, in obedience to God, can in the ultimate beginning make the wood used by the craftsman, and make it from nothing. Of course it can. The numerical or rhythmic structure of a tree is spatial, and it must be preceded by a numerical or rhythmic structure which is temporal. All growing things in the vegetable world, *stirpes*, grow by temporal dimensions, and it is from some deeply abstruse numerical system in them that they put forth their reproductive power. Such, perhaps even more truly such, is the growth of physical bodies in the animal world, where the disposition of limbs and all else is based on rhythmic intervals and equality. Every tiny particle must be distended beyond the size of an indivisible point, *impertili nota*. They are all made from elements, and the elements themselves must be made from nothing. It cannot be supposed that they contain anything of less worth or lowlier than earth. But even earth has its equality of parts, and its length, breadth, and height. In it there is a regular progression, *analogia*, which may be Latinized as "corrationality", from point, *impertilis nota*, through length to breadth and height. All is due to the supreme eternal presidency of numerical rhythm, similitude, equality, and order. If this presidency of mathematical structure is taken from earth, nothing remains. Clearly God in the beginning made earth out of nothing at all.

xvii. 58 The specific appearance of earth, which distinguishes it from the other elements, shews a kind of unity in so far as so base an element is capable of it. No part of it, *et nulla pars*, is unlike the whole of it. This element occupies the lowest place, which is entirely suited to its well-being, so harmoniously are its parts interconnected. The nature of water is spread all over earth. Water is a unity, all the more beautiful and transparent on account of a yet greater similitude of its parts, *speciosior et perlucidior propter maiorem similitudinem partium*, on guard over its order and its security. Air has still greater unity and internal regularity than water. Finally the sky, where the totality of visible things ends, is the highest of all the elements, and has the greatest well-being. Anything which the ministry of carnal perception can count, and anything contained in it, cannot be furnished with, or possess, any numerical rhythm in space which can be estimated, unless previously a numerical rhythm in time has preceded in silent movement. Before even that, there comes vital movement, agile with temporal intervals, and it modifies what it finds, serving the Lord of All Things. Its numerical structure is undistributed into intervals of time; the durations are supplied by potentiality; here, beyond, *supra quam*, even the rational and intellectual rhythm of blessed and saintly souls, here is the very Law of God, by which a leaf falls not, and for which, *cui*, the very hairs of our head are numbered; and, no nature intervening, *excipientes*, they transmit them to the law of earth, and the law below.

PART II

THE MODERN
TRADITION

DAVID HUME

OF THE STANDARD OF TASTE

David Hume (1711–1776), Scottish philosopher and historian, was a leading representative of empiricism, the theory that all knowledge is ultimately based on sense experience.

The great variety of Taste, as well as of opinion, which prevails in the world, is too obvious not to have fallen under every one's observation. Men of the most confined knowledge are able to remark a difference of taste in the narrow circle of their acquaintance, even where the persons have been educated under the same government, and have early imbibed the same prejudices. But those, who can enlarge their view to contemplate distant nations and remote ages, are still more surprized at the great inconsistence and contrariety. We are apt to call *barbarous* whatever departs widely from our own taste and apprehension: But soon find the epithet of reproach retorted on us. And the highest arrogance and self-conceit is at last startled, on observing an equal assurance on all sides, and scruples, amidst such a contest of sentiment, to pronounce positively in its own favour.

Reprinted from *Essays, Moral, Political and Literary*, edited by T. H. Green and T. H. Grose, Vol. I, pp. 266–284 (New Edition; London: Longmans, Green & Co., Ltd., 1882).

As this variety of taste is obvious to the most careless enquirer; so will it be found, on examination, to be still greater in reality than in appearance. The sentiments of men often differ with regard to beauty and deformity of all kinds, even while their general discourse is the same. There are certain terms in every language, which import blame, and others praise; and all men, who use the same tongue, must agree in their application of them. Every voice is united in applauding elegance, propriety, simplicity, spirit in writing; and in blaming fustian, affectation, coldness, and a false brilliancy: But when critics come to particulars, this seeming unanimity vanishes; and it is found, that they had affixed a very different meaning to their expressions. In all matters of opinion and science, the case is opposite: The difference among men is there oftener found to lie in generals than in particulars; and to be less in reality than in appearance. An explanation of the terms commonly ends the controversy; and the disputants are suprized to find, that they had been quarrelling, while at bottom they agreed in their judgment.

Those who found morality on sentiment, more than on reason, are inclined to comprehend ethics under the former observation, and to maintain, that, in all questions, which regard conduct and manners, the difference among men is really greater than at first sight it appears. It is indeed obvious, that writers of all nations and all ages concur in applauding justice, humanity, magnanimity, prudence, veracity; and in blaming the opposite qualities. Even poets and other authors, whose compositions are chiefly calculated to please the imagination, are yet found, from HOMER down to FENELON, to inculcate the same moral precepts, and to bestow their applause and blame on the same virtues and vices. This great unanimity is usually ascribed to the influence of plain reason; which, in all these cases, maintains similar sentiments in all men, and prevents those controversies, to which the abstract sciences are so much exposed. So far as the unanimity is real, this account may be admitted as satisfactory: But we must also allow that some part of the seeming harmony in morals may be accounted for from the very nature of language. The word *virtue*, with its equivalent in every tongue, implies praise; as that of *vice* does blame: And no one, without the most obvious and grossest impropriety, could affix reproach to a term, which in general acceptation is understood in a good sense; or bestow applause, where the idiom requires disapprobation. HOMER's general precepts, where he delivers any such, will never be controverted; but it is obvious, that, when he draws particular pictures of manners, and represents heroism in ACHILLES and prudence in ULYSSES, he intermixes a much greater degree of ferocity in the former, and of cunning and fraud in the latter, than FENELON would admit of. The sage ULYSSES in the GREEK poet seems to delight in lies and fictions; and often employs them without any necessity or even advantage: But his more scrupulous son, in the FRENCH epic writer, exposes himself to the most imminent perils, rather than depart from the most exact line of truth and veracity.

The admirers and followers of the ALCORAN insist on the excellent moral precepts interspersed throughout that wild and absurd performance. But it is to be supposed, that the ARABIC words, which correspond to the ENGLISH, equity, justice, temperance, meekness, charity, were such as, from the constant use of that tongue, must always be taken in a good sense; and it would have argued the greatest ignorance, not of morals, but of language, to have mentioned them with any epithets, besides those of applause and approbation. But would we know, whether the pretended prophet had really attained a just sentiment of morals? Let us attend to his narration; and we shall soon find, that he bestows praise on such instances of treachery, inhumanity, cruelty, revenge, bigotry, as are utterly incompatible with civilized society. No steady rule of right seems there to be attended to; and every action is blamed or praised, so far only as it is beneficial or hurtful to the true believers.

The merit of delivering true general precepts in ethics is indeed very small. Whoever recommends any moral virtues, really does no more than is implied in the terms themselves. That people, who invented the word *charity*, and used it in a good sense, inculcated more clearly and much more efficaciously, the precept, *be charitable*, than any pretended legislator or prophet, who should insert such a *maxim* in his writings. Of all expressions, those, which, together with their other meaning, imply a degree either of blame or approbation, are the least liable to be perverted or mistaken.

It is natural for us to seek a *Standard of Taste;* a rule, by which the various sentiments of men may be reconciled; at least, a decision, afforded, confirming one sentiment, and condemning another.

There is a species of philosophy, which cuts off all hopes of success in such an attempt, and represents the impossibility of ever attaining any standard of taste. The difference, it is said, is very wide between judgment and sentiment. All sentiment is right; because sentiment has a reference to nothing beyond itself, and is always real, wherever a man is conscious of it. But all determinations of the understanding are not right; because they have a reference to something beyond themselves, to wit, real matter of fact; and are not always conformable to that standard. Among a thousand different opinions which different men may entertain of the same subject, there is one, and but one, that is just and true; and the only difficulty is to fix and ascertain it. On the contrary, a thousand different sentiments, excited by the same object, are all right: Because no sentiment represents what is really in the object. It only marks a certain conformity or relation between the object and the organs or faculties of the mind; and if that conformity did not really exist, the sentiment could never possibly have being. Beauty is no quality in things themselves: It exists merely in the mind which contemplates them; and each mind perceives a different beauty. One person may even perceive deformity, where another is sensible of beauty; and every individual ought to acquiesce in

his own sentiment, without pretending to regulate those of others. To seek the real beauty, or real deformity, is as fruitless an enquiry, as to pretend to ascertain the real sweet or real bitter. According to the disposition of the organs, the same object may be both sweet and bitter; and the proverb has justly determined it to be fruitless to dispute concerning tastes. It is very natural, and even quite necessary, to extend this axiom to mental, as well as bodily taste; and thus common sense, which is so often at variance with philosophy, especially with the sceptical kind, is found, in one instance at least, to agree in pronouncing the same decision.

But though this axiom, by passing into a proverb, seems to have attained the sanction of common sense; there is certainly a species of common sense which opposes it, at least serves to modify and restrain it. Whoever would assert an equality of genius and elegance between OGILBY and MILTON, or BUNYAN and ADDISON, would be thought to defend no less an extravagance, than if he had maintained a mole-hill to be as high as TENERIFFE, or a pond as extensive as the ocean. Though there may be found persons, who give the preference to the former authors; no one pays attention to such a taste; and we pronounce without scruple the sentiment of these pretended critics to be absurd and ridiculous. The principle of the natural equality of tastes is then totally forgot, and while we admit it on some occasions, where the objects seem near an equality, it appears an extravagant paradox, or rather a palpable absurdity, where objects so disproportioned are compared together.

It is evident that none of the rules of composition are fixed by reasonings *a priori*, or can be esteemed abstract conclusions of the understanding, from comparing those habitudes and relations of ideas, which are eternal and immutable. Their foundation is the same with that of all the practical sciences, experience; nor are they any thing but general observations, concerning what has been universally found to please in all countries and in all ages. Many of the beauties of poetry and even of eloquence are founded on falsehood and fiction, on hyperboles, metaphors, and an abuse or perversion of terms from their natural meaning. To check the sallies of the imagination, and to reduce every expression to geometrical truth and exactness, would be the most contrary to the laws of criticism; because it would produce a work, which, by universal experience, has been found the most insipid and disagreeable. But though poetry can never submit to exact truth, it must be confined by rules of art, discovered to the author either by genius or observation. If some negligent or irregular writers have pleased, they have not pleased by their transgressions of rule or order, but in spite of these transgressions: They have possessed other beauties, which were conformable to just criticism; and the force of these beauties has been able to overpower censure, and give the mind a satisfaction superior to the disgust arising from the blemishes. ARIOSTO pleases; but not by his monstrous and improbable fictions, by his bizarre mixture of the serious and comic styles, by the want of coherence in his stories,

or by the continual interruptions of his narration. He charms by the force and clearness of his expression, by the readiness and variety of his inventions, and by his natural pictures of the passions, especially those of the gay and amorous kind: And however his faults may diminish our satisfaction, they are not able entirely to destroy it. Did our pleasure really arise from those parts of his poem, which we denominate faults, this would be no objection to criticism in general: It would only be an objection to those particular rules of criticism, which would establish such circumstances to be faults, and would represent them as universally blameable. If they are found to please, they cannot be faults; let the pleasure, which they produce, be ever so unexpected and unaccountable.

But though all the general rules of art are founded only on experience and on the observation of the common sentiments of human nature, we must not imagine, that, on every occasion, the feelings of men will be conformable to these rules. Those finer emotions of the mind are of a very tender and delicate nature, and require the concurrence of many favourable circumstances to make them play with facility and exactness, according to their general and established principles. The least exterior hindrance to such small springs, or the least internal disorder, disturbs their motion, and confounds the operation of the whole machine. When we would make an experiment of this nature, and would try the force of any beauty or deformity, we must choose with care a proper time and place, and bring the fancy to a suitable situation and disposition. A perfect serenity of mind, a recollection of thought, a due attention to the object; if any of these circumstances be wanting, our experiment will be fallacious, and we shall be unable to judge of the catholic and universal beauty. The relation, which nature has placed between the form and the sentiment, will at least be more obscure; and it will require greater accuracy to trace and discern it. We shall be able to ascertain its influence not so much from the operation of each particular beauty, as from the durable admiration, which attends those works, that have survived all the caprices of mode and fashion, all the mistakes of ignorance and envy.

The same HOMER, who pleased at ATHENS and ROME two thousand years ago, is still admired at PARIS and at LONDON. All the changes of climate, government, religion, and language, have not been able to obscure his glory. Authority or prejudice may give a temporary vogue to a bad poet or orator; but his reputation will never be durable or general. When his compositions are examined by posterity or by foreigners, the enchantment is dissipated, and his faults appear in their true colours. On the contrary, a real genius, the longer his works endure, and the more wide they are spread, the more sincere is the admiration which he meets with. Envy and jealousy have too much place in a narrow circle; and even familiar acquaintance with his person may diminish the applause due to his performances: But when these obstructions are removed, the beauties, which are naturally fitted to excite agreeable sentiments, immediately display their energy;

and while the world endures, they maintain their authority over the minds of men.

It appears then, that, amidst all the variety and caprice of taste, there are certain general principles of approbation or blame, whose influence a careful eye may trace in all operations of the mind. Some particular forms or qualities, from the original structure of the internal fabric, are calculated to please, and others to displease; and if they fail of their effect in any particular instance, it is from some apparent defect or imperfection in the organ. A man in a fever would not insist on his palate as able to decide concerning flavours; nor would one, affected with the jaundice, pretend to give a verdict with regard to colours. In each creature, there is a sound and a defective state; and the former alone can be supposed to afford us a true standard of taste and sentiment. If, in the sound state of the organ, there be an entire or a considerable uniformity of sentiment among men, we may thence derive an idea of the perfect beauty; in like manner as the appearance of objects in day-light, to the eye of a man in health, is denominated their true and real colour, even while colour is allowed to be merely a phantasm of the senses.

Many and frequent are the defects in the internal organs, which prevent or weaken the influence of those general principles, on which depends our sentiment of beauty or deformity. Though some objects, by the structure of the mind, be naturally calculated to give pleasure, it is not to be expected, that in every individual the pleasure will be equally felt. Particular incidents and situations occur, which either throw a false light on the objects, or hinder the true from conveying to the imagination the proper sentiment and perception.

One obvious cause, why many feel not the proper sentiment of beauty, is the want of that *delicacy* of imagination, which is requisite to convey a sensibility of those finer emotions. This delicacy every one pretends to: Every one talks of it; and would reduce every kind of taste or sentiment to its standard. But as our intention in this essay is to mingle some light of the understanding with the feelings of sentiment, it will be proper to give a more accurate definition of delicacy, than has hitherto been attempted. And not to draw our philosophy from too profound a source, we shall have recourse to a noted story in DON QUIXOTE.

It it with good reason, says SANCHO to the squire with the great nose, that I pretend to have a judgment in wine: This is a quality hereditary in our family. Two of my kinsmen were once called to give their opinion of a hogshead, which was supposed to be excellent, being old and of a good vintage. One of them tastes it; considers it; and after mature reflection pronounces the wine to be good, were it not for a small taste of leather, which he perceived in it. The other, after using the same precautions, gives also his verdict in favour of the wine; but with the reserve of a taste of iron, which he could easily distinguish. You cannot imagine how much they were both ridiculed for their judgment. But who laughed in the end?

On emptying the hogshead, there was found at the bottom, an old key with a leathern thong tied to it.

The great resemblance between mental and bodily taste will easily teach us to apply this story. Though it be certain, that beauty and deformity, more than sweet and bitter, are not qualities in objects, but belong entirely to the sentiment, internal or external; it must be allowed, that there are certain qualities in objects, which are fitted by nature to produce those particular feelings. Now as these qualities may be found in a small degree, or may be mixed and confounded with each other, it often happens, that the taste is not affected with such minute qualities, or is not able to distinguish all the particular flavours, amidst the disorder, in which they are presented. Where the organs are so fine, as to allow nothing to escape them; and at the same time so exact as to perceive every ingredient in the composition: This we call delicacy of taste, whether we employ these terms in the literal or metaphorical sense. Here then the general rules of beauty are of use; being drawn from established models, and from the observation of what pleases or displeases, when presented singly and in a high degree: And if the same qualities, in a continued composition and in a smaller degree, affect not the organs with a sensible delight or uneasiness, we exclude the person from all pretensions to this delicacy. To produce these general rules or avowed patterns of composition is like finding the key with the leathern thong; which justified the verdict of SANCHO's kinsmen, and confounded those pretended judges who had condemned them. Though the hogshead had never been emptied, the taste of the one was still equally delicate, and that of the other equally dull and languid: But it would have been more difficult to have proved the superiority of the former, to the conviction of every by-stander. In like manner, though the beauties of writing had never been methodized, or reduced to general principles; though no excellent models had ever been acknowledged; the different degrees of taste would still have subsisted, and the judgment of one man been preferable to that of another; but it would not have been so easy to silence the bad critic, who might always insist upon his particular sentiment, and refuse to submit to his antagonist. But when we show him an avowed principle of art; when we illustrate this principle by examples, whose operation, from his own particular taste, he acknowledges to be conformable to the principle; when we prove, that the same principle may be applied to the present case, where he did not perceive or feel its influence: He must conclude, upon the whole, that the fault lies in himself, and that he wants the delicacy, which is requisite to make him sensible of every beauty and every blemish, in any composition or discourse.

It is acknowledged to be the perfection of every sense or faculty, to perceive with exactness its most minute objects, and allow nothing to escape its notice and observation. The smaller the objects are, which become sensible to the eye, the finer is that organ, and the more elaborate its make

and composition. A good palate is not tried by strong flavours; but by a mixture of small ingredients, where we are still sensible of each part, notwithstanding its minuteness and its confusion with the rest. In like manner, a quick and acute perception of beauty and deformity must be the perfection of our mental taste; nor can a man be satisfied with himself while he suspects, that any excellence or blemish in a discourse has passed him unobserved. In this case, the perfection of the man, and the perfection of the sense or feeling, are found to be united. A very delicate palate, on many occasions, may be a great inconvenience both to a man himself and to his friends: But a delicate taste of wit or beauty must always be a desirable quality; because it is the source of all the finest and most innocent enjoyments, of which human nature is susceptible. In this decision the sentiments of all mankind are agreed. Wherever you can ascertain a delicacy of taste, it is sure to meet with approbation; and the best way of ascertaining it is to appeal to those models and principles, which have been established by the uniform consent and experience of nations and ages.

But though there be naturally a wide difference in point of delicacy between one person and another, nothing tends further to encrease and improve this talent, than *practice* in a particular art, and the frequent survey or contemplation of a particular species of beauty. When objects of any kind are first presented to the eye or imagination, the sentiment, which attends them, is obscure and confused; and the mind is, in a great measure, incapable of pronouncing concerning their merits or defects. The taste cannot perceive the several excellences of the performance; much less distinguish the particular character of each excellency, and ascertain its quality and degree. If it pronounce the whole in general to be beautiful or deformed, it is the utmost that can be expected; and even this judgment, a person, so unpractised, will be apt to deliver with great hesitation and reserve. But allow him to acquire experience in those objects, his feeling becomes more exact and nice: He not only perceives the beauties and defects of each part, but marks the distinguishing species of each quality, and assigns it suitable praise or blame. A clear and distinct sentiment attends him through the whole survey of the objects; and he discerns that very degree and kind of approbation or displeasure, which each part is naturally fitted to produce. The mist dissipates, which seemed formerly to hang over the object: The organ acquires greater perfection in its operations; and can pronounce, without danger of mistake, concerning the merits of every performance. In a word, the same address and dexterity, which practice gives to the execution of any work, is also acquired by the same means, in the judging of it.

So advantageous is practice to the discernment of beauty, that, before we can give judgment on any work of importance, it will even be requisite, that that very individual performance be more than once perused by us, and be surveyed in different lights with attention and deliberation. There

is a flutter or hurry of thought which attends the first perusal of any piece, and which confounds the genuine sentiment of beauty. The relation of the parts is not discerned: The true characters of style are little distinguished: The several perfections and defects seem wrapped up in a species of confusion, and present themselves indistinctly to the imagination. Not to mention, that there is a species of beauty, which, as it is florid and superficial, pleases at first; but being found incompatible with a just expression either of reason or passion, soon palls upon the taste, and is then rejected with disdain, at least rated at a much lower value.

It is impossible to continue in the practice of contemplating any order of beauty, without being frequently obliged to form *comparisons* between the several species and degrees of excellence, and estimating their proportion to each other. A man, who has had no opportunity of comparing the different kinds of beauty, is indeed totally unqualified to pronounce an opinion with regard to any object presented to him. By comparison alone we fix the epithets of praise or blame, and learn how to assign the due degree of each. The coarsest daubing contains a certain lustre of colours and exactness of imitation, which are so far beauties, and would affect the mind of a peasant or Indian with the highest admiration. The most vulgar ballads are not entirely destitute of harmony or nature; and none but a person, familiarized to superior beauties, would pronounce their numbers harsh, or narration uninteresting. A great inferiority of beauty gives pain to a person conversant in the highest excellence of the kind, and is for that reason pronounced a deformity: As the most finished object, with which we are acquainted, is naturally supposed to have reached the pinnacle of perfection, and to be entitled to the highest applause. One accustomed to see, and examine, and weigh the several performances, admired in different ages and nations, can only rate the merits of a work exhibited to his view, and assign its proper rank among the productions of genius.

But to enable a critic the more fully to execute this undertaking, he must preserve his mind free from all *prejudice*, and allow nothing to enter into his consideration, but the very object which is submitted to his examination. We may observe, that every work of art, in order to produce its due effect on the mind, must be surveyed in a certain point of view, and cannot be fully relished by persons, whose situation, real or imaginary, is not comfortable to that which is required by the performance. An orator addresses himself to a particular audience, and must have a regard to their particular genius, interests, opinions, passions, and prejudices; otherwise he hopes in vain to govern their resolutions, and inflame their affections. Should they even have entertained some prepossessions against him, however unreasonable, he must not overlook this disadvantage; but, before he enters upon the subject, must endeavour to conciliate their affection, and acquire their good graces. A critic of a different age or nation, who should peruse this discourse, must have all these circumstances in his eye, and must place himself in the same situation as the audience, in order

to form a true judgment of the oration. In like manner, when any work is addressed to the public, though I should have a friendship or enmity with the author, I must depart from this situation; and considering myself as a man in general, forget, if possible, my individual being and my peculiar circumstances. A person influenced by prejudice, complies not with this condition; but obstinately maintains his natural position, without placing himself in that point of view, which the performance supposes. If the work be addressed to persons of a different age or nation, he makes no allowance for their peculiar views and prejudices; but, full of the manners of his own age and country, rashly condemns what seemed admirable in the eyes of those for whom alone the discourse was calculated. If the work be executed for the public, he never sufficiently enlarges his comprehension, or forgets his interest as a friend or enemy, as a rival or commentator. By this means, his sentiments are perverted; nor have the same beauties and blemishes the same influence upon him, as if he had imposed a proper violence on his imagination, and had forgotten himself for a moment. So far his taste evidently departs from the true standard; and of consequence loses all credit and authority.

It is well known, that in all questions, submitted to the understanding, prejudice is destructive of sound judgment, and perverts all operations of the intellectual faculties: It is no less contrary to good taste; nor has it less influence to corrupt our sentiment of beauty. It belongs to *good sense* to check its influence in both cases; and in this respect, as well as in many others, reason, if not an essential part of taste, is at least requisite to the operations of this latter faculty. In all the nobler productions of genius, there is a mutual relation and correspondence of parts; nor can either the beauties or blemishes be perceived by him, whose thought is not capacious enough to comprehend all those parts, and compare them with each other, in order to perceive the consistence and uniformity of the whole. Every work of art has also a certain end or purpose, for which it is calculated; and is to be deemed more or less perfect, as it is more or less fitted to attain this end. The object of eloquence is to persuade, of history to instruct, of poetry to please by means of the passions and the imagination. These ends we must carry constantly in our view, when we peruse any performance; and we must be able to judge how far the means employed are adapted to their respective purposes. Besides, every kind of composition, even the most poetical, is nothing but a chain of propositions and reasonings; not always, indeed, the justest and most exact, but still plausible and specious, however disguised by the colouring of the imagination. The persons introduced in tragedy and epic poetry, must be represented as reasoning, and thinking, and concluding, and acting, suitably to their character and circumstances; and without judgment, as well as taste and invention, a poet can never hope to succeed in so delicate an undertaking. Not to mention, that the same excellence of faculties which contributes to the improvement of reason, the same clearness of conception, the same

exactness of distinction, the same vivacity of apprehension, are essential to the operations of true taste, and are its infallible concomitants. It seldom, or never happens, that a man of sense, who has experience in any art, cannot judge of its beauty; and it is no less rare to meet with a man who has a just taste without a sound understanding.

Thus, though the principles of taste be universal, and, nearly, if not entirely the same in all men; yet few are qualified to give judgment on any work of art, or establish their own sentiment as the standard of beauty. The organs of internal sensation are seldom so perfect as to allow the general principles their full play, and produce a feeling correspondent to those principles. They either labour under some defect, or are vitiated by some disorder; and by that means, excite a sentiment, which may be pronounced erroneous. When the critic has no delicacy, he judges without any distinction, and is only affected by the grosser and more palpable qualities of the object: The finer touches pass unnoticed and disregarded. Where he is not aided by practice, his verdict is attended with confusion and hesitation. Where no comparison has been employed, the most frivolous beauties, such as rather merit the name of defects, are the object of his admiration. Where he lies under the influence of prejudice, all his natural sentiments are perverted. Where good sense is wanting, he is not qualified to discern the beauties of design and reasoning, which are the highest and most excellent. Under some or other of these imperfections, the generality of men labour; and hence a true judge in the finer arts is observed, even during the most polished ages, to be so rare a character: Strong sense, united to delicate sentiment, improved by practice, perfected by comparison, and cleared of all prejudice, can alone entitle critics to this valuable character; and the joint verdict of such, wherever they are to be found, is the true standard of taste and beauty.

But where are such critics to be found? By what marks are they to be known? How distinguish them from pretenders? These questions are embarrassing; and seem to throw us back into the same uncertainty, from which, during the course of this essay, we have endeavoured to extricate ourselves.

But if we consider the matter aright, these are questions of fact, not of sentiment. Whether any particular person be endowed with good sense and a delicate imagination, free from prejudice, may often be the subject of dispute, and be liable to great discussion and enquiry: But that such a character is valuable and estimable will be agreed in by all mankind. Where these doubts occur, men can do no more than in other disputable questions, which are submitted to the understanding: They must produce the best arguments, that their invention suggests to them; they must acknowledge a true and decisive standard to exist somewhere, to wit, real existence and matter of fact; and they must have indulgence to such as differ from them in their appeals to this standard. It is sufficient for our present purpose, if we have proved, that the taste of all individuals is

not upon an equal footing, and that some men in general, however difficult to be particularly pitched upon, will be acknowledged by universal sentiment to have a preference above others.

But in reality the difficulty of finding, even in particulars, the standard of taste, is not so great as it is represented. Though in speculation, we may readily avow a certain criterion in science and deny it in sentiment, the matter is found in practice to be much more hard to ascertain in the former case than in the latter. Theories of abstract philosophy, systems of profound theology, have prevailed during one age: In a successive period, these have been universally exploded: Their absurdity has been detected: Other theories and systems have supplied their place, which again gave place to their successors: And nothing has been experienced more liable to the revolutions of chance and fashion than these pretended decisions of science. The case is not the same with the beauties of eloquence and poetry. Just expressions of passion and nature are sure, after a little time, to gain public applause, which they maintain for ever. ARISTOTLE, and PLATO, and EPICURUS, and DESCARTES, may successively yield to each other: But TERENCE and VIRGIL maintain an universal, undisputed empire over the minds of men. The abstract philosophy of CICERO has lost its credit: The vehemence of his oratory is still the object of our admiration.

Though men of delicate taste be rare, they are easily to be distinguished in society, by the soundness of their understanding and the superiority of their faculties above the rest of mankind. The ascendant, which they acquire, gives a prevalence to that lively approbation, with which they receive any productions of genius, and renders it generally predominant. Many men, when left to themselves, have but a faint and dubious perception of beauty, who yet are capable of relishing any fine stroke, which is pointed out to them. Every convert to the admiration of the real poet or orator is the cause of some new conversion. And though prejudices may prevail for a time, they never unite in celebrating any rival to the true genius, but yield at last to the force of nature and just sentiment. Thus, though a civilized nation may easily be mistaken in the choice of their admired philosopher, they never have been found long to err, in their affection for a favorite epic or tragic author.

But notwithstanding all our endeavours to fix a standard of taste, and reconcile the discordant apprehensions of men, there still remain two sources of variation, which are not sufficient indeed to confound all the boundaries of beauty and deformity, but will often serve to produce a difference in the degrees of our approbation or blame. The one is the different humours of particular men; the other, the particular manners and opinions of our age and country. The general principles of taste are uniform in human nature: Where men vary in their judgments, some defect or perversion in the faculties may commonly be remarked; proceeding either from prejudice, from want of practice, or want of delicacy; and

there is just reason for approving one taste, and condemning another. But where there is such a diversity in the internal frame or external situation as is entirely blameless on both sides, and leaves no room to give one the preference above the other; in that case a certain degree of diversity in judgment is unavoidable, and we seek in vain for a standard, by which we can reconcile the contrary sentiments.

A young man, whose passions are warm, will be more sensibly touched with amorous and tender images, than a man more advanced in years, who takes pleasure in wise, philosophical reflections concerning the conduct of life and moderation of the passions. At twenty, OVID may be the favourite author; HORACE at forty; and perhaps TACITUS at fifty. Vainly would we, in such cases, endeavour to enter into the sentiments of others, and divest ourselves of those propensities, which are natural to us. We choose our favourite author as we do our friend, from a conformity of humour and disposition. Mirth or passion, sentiment or reflection; whichever of these most predominates in our temper, it gives us a peculiar sympathy with the writer who resembles us.

One person is more pleased with the sublime; another with the tender; a third with raillery. One has a strong sensibility to blemishes, and is extremely studious of correctness: Another has a more lively feeling of beauties, and pardons twenty absurdities and defects for one elevated or pathetic stroke. The ear of this man is entirely turned towards conciseness and energy; that man is delighted with a copious, rich, and harmonious expression. Simplicity is affected by one; ornament by another. Comedy, tragedy, satire, odes, have each its partizans, who prefer that particular species of writing to all others. It is plainly an error in a critic, to confine his approbation to one species or style of writing, and condemn all the rest. But it is almost impossible not to feel a predilection for that which suits our particular turn and disposition. Such preferences are innocent and unavoidable, and can never reasonably be the object of dispute, because there is no standard, by which they can be decided.

For a like reason, we are more pleased, in the course of our reading, with pictures and characters, that resemble objects which are found in our own age or country, than with those which describe a different set of customs. It is not without some effort, that we reconcile ourselves to the simplicity of ancient manners, and behold princesses carrying water from the spring, and kings and heroes dressing their own victuals. We may allow in general, that the representation of such manners is no fault in the author, nor deformity in the piece; but we are not so sensibly touched with them. For this reason, comedy is not easily transferred from one age or nation to another. A FRENCHMAN or ENGLISHMAN is not pleased with the ANDRIA of TERENCE, or CLITIA of MACHIAVEL; where the fine lady, upon whom all the play turns, never once appears to the spectators, but is always kept behind the scenes, suitably to the reserved humour of the ancient GREEKS and modern ITALIANS. A man of learning and reflection

can make allowance for these peculiarities of manners; but a common audience can never divest themselves so far of their usual ideas and sentiments, as to relish pictures which in no wise resemble them.

But here there occurs a reflection, which may, perhaps, be useful in examining the celebrated controversy concerning ancient and modern learning; where we often find the one side excusing any seeming absurdity in the ancients from the manners of the age, and the other refusing to admit this excuse, or at least, admitting it only as an apology for the author, not for the performance. In my opinion, the proper boundaries in this subject have seldom been fixed between the contending parties. Where any innocent peculiarities of manners are represented, such as those above mentioned, they ought certainly to be admitted; and a man, who is shocked with them, gives an evident proof of false delicacy and refinement. The poet's *monument more durable than brass*, must fall to the ground like common brick or clay, were men to make no allowance for the continual revolutions of manners and customs, and would admit of nothing but what was suitable to the prevailing fashion. Must we throw aside the pictures of our ancestors, because of their ruffs and fardingales? But where the ideas of morality and decency alter from one age to another, and where vicious manners are described, without being marked with the proper characters of blame and disapprobation; this must be allowed to disfigure the poem, and to be a real deformity. I cannot, nor is it proper I should, enter into such sentiments; and however I may excuse the poet, on account of the manners of his age, I never can relish the composition. The want of humanity and of decency, so conspicuous in the characters drawn by several of the ancient poets, even sometimes by HOMER and the GREEK tragedians, diminishes considerably the merit of their noble performances, and gives modern authors an advantage over them. We are not interested in the fortunes and sentiments of such rough heroes: We are displeased to find the limits of vice and virtue so much confounded: And whatever indulgence we may give to the writer on account of his prejudices, we cannot prevail on ourselves to enter into his sentiments, or bear an affection to characters, which we plainly discover to be blameable.

The case is not the same with moral principles, as with speculative opinions of any kind. These are in continual flux and revolution. The son embraces a different system from the father. Nay, there scarcely is any man, who can boast of great constancy and uniformity in this particular. Whatever speculative errors may be found in the polite writings of any age or country, they detract but little from the value of those compositions. There needs but a certain turn of thought or imagination to make us enter into all the opinions, which then prevailed, and relish the sentiments or conclusions derived from them. But a very violent effort is requisite to change our judgment of manners, and excite sentiments of approbation or blame, love or hatred, different from those to which the

mind from long custom has been familiarized. And where a man is confident of the rectitude of that moral standard, by which he judges, he is justly jealous of it, and will not pervert the sentiments of his heart for a moment, in complaisance to any writer whatsoever.

Of all speculative errors, those, which regard religion, are the most excusable in compositions of genius; nor is it ever permitted to judge of the civility or wisdom of any people, or even of single persons, by the grossness or refinement of their theological principles. The same good sense, that directs men in the ordinary occurrences of life, is not hearkened to in religious matters, which are supposed to be placed altogether above the cognizance of human reason. On this account, all the absurdities of the pagan system of theology must be overlooked by every critic, who would pretend to form a just notion of ancient poetry; and our posterity, in their turn, must have the same indulgence to their forefathers. No religious principles can ever be imputed as a fault to any poet, while they remain merely principles, and take not such strong possession of his heart, as to lay him under the imputation of *bigotry* or *superstition*. Where that happens, they confound the sentiments of morality, and alter the natural boundaries of vice and virtue. They are therefore eternal blemishes, according to the principle above mentioned; nor are the prejudices and false opinions of the age sufficient to justify them.

It is essential to the ROMAN catholic religion to inspire a violent hatred of every other worship, and to represent all pagans, mahometans, and heretics as the objects of divine wrath and vengeance. Such sentiments, though they are in reality very blameable, are considered as virtues by the zealots of that communion, and are represented in their tragedies and epic poems as a kind of divine heroism. This bigotry has disfigured two very fine tragedies of the FRENCH theatre, POLIEUCTE and ATHALIA; where an intemperate zeal for particular modes of worship is set off with all the pomp imaginable, and forms the predominant character of the heroes. 'What is this,' says the sublime JOAD to JOSABET, finding her in discourse with MATHAN, the priest of BAAL, 'Does the daughter of DAVID speak to this traitor? Are you not afraid, lest the earth should open and pour forth flames to devour you both? Or lest these holy walls should fall and crush you together? What is his purpose? Why comes that enemy of God hither to poison the air, which we breathe, with his horrid presence?' Such sentiments are received with great applause on the theatre of PARIS; but at LONDON the spectators would be full as much pleased to hear ACHILLES tell AGAMEMNON, that he was a dog in his forehead, and a deer in his heart, or JUPITER threaten JUNO with a sound drubbing, if she will not be quiet.

RELIGIOUS principles are also a blemish in any polite composition, when they rise up to superstition, and intrude themselves into every sentiment, however remote from any connection with religion. It is no excuse

for the poet, that the customs of his country had burthened life with so many religious ceremonies and observances, that no part of it was exempt from that yoke. It must for ever be ridiculous in PETRARCH to compare his mistress LAURA, to JESUS CHRIST. Nor is it less ridiculous in that agreeable libertine, BOCCACE, very seriously to give thanks to GOD ALMIGHTY and the ladies, for their assistance in defending him against his enemies.

GOTTHOLD LESSING

LAOCOON

Gotthold Lessing (1729–1781) was a German dramatist and critic.

II

Be it truth or fable that Love made the first attempt in the imitative arts, thus much is certain: that she never tired of guiding the hand of the great masters of antiquity. For although painting, as the art which reproduces objects upon flat surfaces, is now practised in the broadest sense of that definition, yet the wise Greek set much narrower bounds to it. He confined it strictly to the imitation of beauty. The Greek artist represented nothing that was not beautiful. Even the vulgarly beautiful, the beauty of inferior types, he copied only incidentally for practice or recreation. The perfection of the subject must charm in his work. He was too great to require the beholders to be satisfied with the mere barren pleasure arising from a successful likeness or from consideration of the

Reprinted from *Laocoon*, translated by Ellen Frothingham, New York, Farrar, Straus & Giroux (Noonday Press), pp. 16–139, 1957.

artist's skill. Nothing in his art was dearer to him or seemed to him more noble than the ends of art.

. . .

III

. . . the realm of art has in modern times been greatly enlarged. Its imitations are allowed to extend over all visible nature, of which beauty constitutes but a small part. Truth and expression are taken as its first law. As nature always sacrifices beauty to higher ends, so should the artist subordinate it to his general purpose, and not pursue it further than truth and expression allow. Enough that truth and expression convert what is unsightly in nature into a beauty of art.

Allowing this idea to pass unchallenged at present for whatever it is worth, are there not other independent considerations which should set bounds to expression, and prevent the artist from choosing for his imitation the culminating point of any action?

The single moment of time to which art must confine itself, will lead us, I think, to such considerations. Since the artist can use but a single moment of ever-changing nature, and the painter must further confine his study of this one moment to a single point of view, while their works are made not simply to be looked at, but to be contemplated long and often, evidently the most fruitful moment and the most fruitful aspect of that moment must be chosen. Now that only is fruitful which allows free play to the imagination. The more we see the more we must be able to imagine; and the more we imagine, the more we must think we see. But no moment in the whole course of an action is so disadvantageous in this respect as that of its culmination. There is nothing beyond, and to present the uttermost to the eye is to bind the wings of Fancy, and compel her, since she cannot soar beyond the impression made on the senses, to employ herself with feebler images, shunning as her limit the visible fulness already expressed. When, for instance, Laocoon sighs, imagination can hear him cry; but if he cry, imagination can neither mount a step higher, nor fall a step lower, without seeing him in a more endurable, and therefore less interesting, condition. We hear him merely groaning, or we see him already dead.

Again, since this single moment receives from art an unchanging duration, it should express nothing essentially transitory. All phenomena, whose nature it is suddenly to break out and as suddenly to disappear, which can remain as they are but for a moment; all such phenomena, whether agreeable or otherwise, acquire through the perpetuity conferred upon them by art such an unnatural appearance, that the impression they produce becomes weaker with every fresh observation, till the whole subject at last wearies or disgusts us. La Mettrie, who had himself painted and

engraved as a second Democritus, laughs only the first time we look at him. Looked at again, the philosopher becomes a buffoon, and his laugh a grimace. So it is with a cry. Pain, which is so violent as to extort a scream, either soon abates or it must destroy the sufferer. Again, if a man of firmness and endurance cry, he does not do so unceasingly, and only this apparent continuity in art makes the cry degenerate into womanish weakness or childish impatience. This, at least, the sculptor of the Laocoon had to guard against, even had a cry not been an offence against beauty, and were suffering without beauty a legitimate subject of art.

· · ·

IV

A review of the reasons here alleged for the moderation observed by the sculptor of the Laocoon in the expression of bodily pain, shows them to lie wholly in the peculiar object of his art and its necessary limitations. Scarce one of them would be applicable to poetry.

Without inquiring here how far the poet can succeed in describing physical beauty, so much at least is clear, that since the whole infinite realm of perfection lies open for his imitation, this visible covering under which perfection becomes beauty will be one of his least significant means of interesting us in his characters. Indeed, he often neglects it altogether, feeling sure that if his hero has gained our favor, his nobler qualities will either so engross us that we shall not think of his body, or have so won us that, if we think of it, we shall naturally attribute to him a beautiful, or, at least, no unsightly one. Least of all will he have reference to the eye in every detail not especially addressed to the sense of sight. When Virgil's Laocoon screams, who stops to think that a scream necessitates an open mouth, and that an open mouth is ugly? Enough that "clamores horrendos ad sidera tollit" is fine to the ear, no matter what its effect on the eye. Whoever requires a beautiful picture has missed the whole intention of the poet.

Further, nothing obliges the poet to concentrate his picture into a single moment. He can take up every action, if he will, from its origin, and carry it through all possible changes to its issue. Every change, which would require from the painter a separate picture, costs him but a single touch; a touch, perhaps, which, taken by itself, might offend the imagination, but which, anticipated, as it has been, by what preceded, and softened and atoned for by what follows, loses its individual effect in the admirable result of the whole. Thus were it really unbecoming in a man to cry out in the extremity of bodily pain, how can this momentary weakness lower in our estimation a character whose virtues have previously won our regard? Virgil's Laocoon cries; but this screaming Laocoon is the same we know and love as the most far-seeing of patriots and the tenderest of

fathers. We do not attribute the cry to his character, but solely to his intolerable sufferings. We hear in it only those, nor could they have been made sensible to us in any other way.

Who blames the poet, then? Rather must we acknowledge that he was right in introducing the cry, as the sculptor was in omitting it.

. . .

VIII

. . . The gods and other spiritual beings represented by the artist are not precisely the same as those introduced by the poet. To the artist they are personified abstractions which must always be characterized in the same way, or we fail to recognize them. In poetry, on the contrary, they are real beings, acting and working, and possessing, besides their general character, qualities and passions which may upon occasion take precedence. Venus is to the sculptor simply love. He must therefore endow her with all the modest beauty, all the tender charms, which, as delighting us in the beloved object, go to make up our abstract idea of love. The least departure from this ideal prevents our recognizing her image. Beauty distinguished more by majesty than modesty is no longer Venus but Juno. Charms commanding and manly rather than tender, give us, instead of a Venus, a Minerva. A Venus all wrath, a Venus urged by revenge and rage, is to the sculptor a contradiction in terms. For love, as love, never is angry, never avenges itself. To the poet, Venus is love also, but she is the goddess of love, who has her own individuality outside of this one characteristic, and can therefore be actuated by aversion as well as affection. What wonder, then, that in poetry she blazes into anger and rage, especially under the provocation of insulted love?

The artist, indeed, like the poet, may, in works composed of several figures, introduce Venus or any other deity, not simply by her one characteristic, but as a living, acting being. But the actions, if not the direct results of her character, must not be at variance with it. Venus delivering to her son the armor of the gods is a subject equally suitable to artist and poet. For here she can be endowed with all the grace and beauty befitting the goddess of love. Such treatment will be of advantage as helping us the more easily to recognize her. But when Venus, intent on revenging herself on her contemners, the men of Lemnos, wild, in colossal shape, with cheeks inflamed and dishevelled hair, seizes the torch, and, wrapping a black robe about her, flies downward on the storm-cloud,—that is no moment for the painter, because he has no means of making us recognize her. The poet alone has the privilege of availing himself of it. He can unite it so closely with some other moment when the goddess is the true Venus, that we do not in the fury forget the goddess of love. Flaccus does this,—

> Neque enim alma videri
> Jam tumet; aut tereti crinem subnectitur auro,
> Sidereos diffusa sinus. Eadem effera et ingens
> Et maculis suffecta genas; pinumque sonantem
> Virginibus Stygiis, nigramque simillima pallam.[1]

And Statius also,—

> Illa Paphon veterem centumque altaria linquens,
> Nec vultu nec crine prior, solvisse jugalem
> Ceston, et Idalias procul ablegasse volucres
> Fertur. Erant certe, media qui noctis in umbra
> Divam, alios ignes majoraque tela gerentem,
> Tartarias inter thalamis volitasse sorores
> Vulgarent: utque implicitis arcana domorum
> Anguibus, et sæva formidine cuncta replerit
> Limina.[2]

Or, we may say, the poet alone possesses the art of so combining negative with positive traits as to unite two appearances in one. No longer now the tender Venus, her hair no more confined with golden clasps, no azure draperies floating about her, without her girdle, armed with other flames and larger arrows, the goddess hastens downward, attended by furies of like aspect with herself. Must the poet abstain from the use of this device because artists are debarred from it? If painting claim to be the sister of poetry, let the younger at least not be jealous of the elder, nor seek to deprive her of ornaments unbecoming to herself.

XIII

If Homer's works were completely destroyed, and nothing remained of the Iliad and Odyssey but this series of pictures proposed by Caylus, should we from these—even supposing them to be executed by the best masters—form the same idea that we now have of the poet's descriptive talent alone, setting aside all his other qualities as a poet?

Let us take the first piece that comes to hand,—the picture of the plague.[1] What do we see on the canvas? Dead bodies, the flame of funeral pyres, the dying busied with the dead, the angry god upon a cloud discharging his arrows. The profuse wealth of the picture becomes poverty in the poet. Should we attempt to restore the text of Homer from this

[1] Argonaut. lib. ii. v. 102–106. "Gracious the goddess is not emulous to appear, nor does she bind her hair with the burnished gold, letting her starry tresses float about her. Wild she is and huge, her cheeks suffused with spots; most like to the Stygian virgins with crackling torch and black mantle."

[2] Thebaid. lib. v. 61–64. "Leaving ancient Paphos and the hundred altars, not like her former self in countenance or the fashion of her hair, she is said to have loosened the nuptial girdle and have sent away her doves. Some report that in the dead of night, bearing other fires and mightier arms, she had hasted with the Tartarean sisters to bed-chambers, and filled the secret places of homes with twining snakes, and all thresholds with cruel fear."

picture, what can we make him say? "Thereupon the wrath of Apollo was kindled, and he shot his arrows among the Grecian army. Many Greeks died, and their bodies were burned." Now let us turn to Homer himself:[3]

> "Ὡς ἔφατ' εὐχόμενος, τοῦ δ' ἔκλυε Φοῖβος 'Απόλλων,
> βῆ δὲ κατ' Οὐλύμποιο καρήνων χωόμενος κῆρ,
> τόξ' ὤμοισιν ἔχων ἀμφηρεφέα τε φαρέτρην.
> ἔκλαγξαν δ' ἄρ' ὀϊστοὶ ἐπ' ὤμων χωομένοιο,
> αὐτοῦ κινηθέντος· ὁ δ' ἤϊε νυκτὶ ἐοικώς.
> ἕζετ' ἔπειτ' ἀπάνευθε νεῶν, μετὰ δ' ἰὸν ἕηκεν·
> δεινὴ δὲ κλαγγὴ γένετ' ἀργυρέοιο βιοῖο.
> οὐρῆας μὲν πρῶτον ἐπώχετο καὶ κύνας ἀργούς,
> αὐτὰρ ἔπειτ' αὐτοῖσι βέλος ἐχεπευκὲς ἐφιεὶς
> βάλλ'· αἰεὶ δὲ πυραὶ νεκύων καίοντο θαμειαί.

The poet here is as far beyond the painter, as life is better than a picture. Wrathful, with bow and quiver, Apollo descends from the Olympian towers. I not only see him, but hear him. At every step the arrows rattle on the shoulders of the angry god. He enters among the host like the night. Now he seats himself over against the ships, and, with a terrible clang of the silver bow, sends his first shaft against the mules and dogs. Next he turns his poisoned darts upon the warriors themselves, and unceasing blaze on every side of corpse-laden pyres. It is impossible to translate into any other language the musical painting heard in the poet's words. Equally impossible would it be to infer it from the canvas. Yet this is the least of the advantages possessed by the poetical picture. Its chief superiority is that it leads us through a whole gallery of pictures up to the point depicted by the artist.

But the plague is perhaps not a favorable subject for a picture. Take the council of the gods,[4] which is more particularly addressed to the eye. An open palace of gold, groups of the fairest and most majestic forms, goblet in hand, served by eternal youth in the person of Hebe. What architecture! what masses of light and shade! what contrasts! what variety of expression! Where shall I begin, where cease, to feast my eyes? If

[3] Iliad i. 44–53. Tableaux tirés de l'Iliade, p. 70.

> Down he came,
> Down from the summit of the Olympian mount,
> Wrathful in heart; his shoulders bore the bow
> And hollow quiver; there the arrows rang
> Upon the shoulders of the angry god,
> As on he moved. He came as comes the night,
> And, seated from the ships aloof, sent forth
> An arrow; terrible was heard the clang
> Of that resplendent bow. At first he smote
> The mules and the swift dogs, and then on man
> He turned the deadly arrow. All around
> Glared evermore the frequent funeral piles.
> —BRYANT

the painter thus enchant me, how much more will the poet! I open the book and find myself deceived. I read four good, plain lines, which might very appropriately be written under the painting. They contain material for a picture, but are in themselves none.[4]

> Οἱ δὲ θεοὶ πὰρ Ζηνὶ καθήμενοι ἠγορόωντο
> χρυσέῳ ἐν δαπέδῳ, μετὰ δέ σφισι πότνια Ἥβη
> νέκταρ ἐῳνοχόει· τοὶ δὲ χρυσέοις δεπάεσσιν
> δειδέχατ᾽ ἀλλήλους, Τρώων πόλιν εἰσορόωντες.

Apollonius, or a more indifferent poet still, would not have said it worse. Here Homer is as far behind the artist as, in the former instance, he surpassed him.

Yet, except in these four lines, Caylus finds no single picture in the whole fourth book of the Iliad. "Rich as this book is," he says, "in its manifold exhortations to battle, in the abundance of its conspicuous and contrasting characters, in the skill with which the masses to be set in motion are brought before us, it is yet entirely unavailable for painting." "Rich as it otherwise is," he might have added, "in what are called poetic pictures." For surely in this fourth book we find as many such pictures, and as perfect, as in any of the whole poem. Where is there a more detailed, a more striking picture than that of Pandarus breaking the truce at the instigation of Minerva, and discharging his arrow at Menelaus? than that of the advance of the Grecian army? or of the mutual attack? or of the deed of Ulysses, whereby he avenges the death of his friend Leucus?

What must we conclude, except that not a few of the finest pictures in Homer are no pictures for the artist? that the artist can extract pictures from him where he himself has none? that such of his as the artist can use would be poor indeed did they show us no more than we see on the canvas? what, in short, but a negative answer to my question? Painted pictures drawn from the poems of Homer, however numerous and however admirable they may be, can give us no idea of the descriptive talent of the poet.

XIV

If it, then, be true that a poem not in itself picturesque may yet be rich in subjects for an artist, while another in a high degree picturesque may yield him nothing, this puts an end to the theory of Count Caylus, that the test of a poem is its availability for the artist, and that a poet's

[4] Iliad iv. 1–4. Tableaux tirés de l'Iliade, p. 30.
> Meantime the immortal gods with Jupiter
> Upon his golden pavement sat and held
> A council. Hebe, honored of them all,
> Ministered nectar, and from cups of gold
> They pledged each other, looking down on Troy.
> —BRYANT

rank should depend upon the number of pictures he supplies to the painter.

Far be it from us to give this theory even the sanction of our silence. Milton would be the first to fall an innocent victim. Indeed, the contemptuous judgment which Caylus passes upon the English poet would seem to be the result not so much of national taste as of this assumed rule. Milton resembles Homer, he says, in little excepting loss of sight. Milton, it is true, can fill no picture galleries. But if, so long as I retained my bodily eye, its sphere must be the measure of my inward vision, then I should esteem its loss a gain, as freeing me from such limitations.

The fact that "Paradise Lost" furnishes few subjects for a painter no more prevents it from being the greatest epic since Homer, than the story of the passion of Christ becomes a poem, because you can hardly insert the head of a pin in any part of the narrative without touching some passage which has employed a crowd of the greatest artists. The evangelists state their facts with the dryest possible simplicity, and the painter uses their various details while the narrators themselves manifested not the smallest spark of genius for the picturesque. There are picturesque and unpicturesque facts, and the historian may relate the most picturesque without picturesqueness, as the poet can make a picture of those least adapted to the painter's use.

To regard the matter otherwise is to allow ourselves to be misled by the double meaning of a word. A picture in poetry is not necessarily one which can be transferred to canvas. But every touch, or every combination of touches, by means of which the poet brings his subject so vividly before us that we are more conscious of the subject than of his words, is picturesque, and makes what we call a picture; that is, it produces that degree of illusion which a painted picture is peculiarly qualified to excite, and which we in fact most frequently and naturally experience in the contemplation of the painted canvas.

XV

Experience shows that the poet can produce this degree of illusion by the representation of other than visible objects. He therefore has at his command whole classes of subjects which elude the artist. Dryden's "Ode on Cecilia's Day" is full of musical pictures, but gives no employment to the brush. But I will not lose myself in examples of this kind, for they after all teach us little more than that colors are not tones, and ears not eyes.

I will confine myself to pictures of visible objects, available alike to poet and painter. What is the reason that many poetical pictures of this class are unsuitable for the painter, while many painted pictures lose their chief effect in the hands of the poet?

Examples may help us. I revert to the picture of Pandarus in the fourth

book of the Iliad, as one of the most detailed and graphic in all Homer. From the seizing of the bow to the flight of the arrow every incident is painted; and each one follows its predecessor so closely, and yet is so distinct from it, that a person who knew nothing of the use of a bow could learn it from this picture alone. Pandarus brings forth his bow, attaches the string, opens the quiver, selects a well-feathered arrow never before used, adjusts the notch of the arrow to the string, and draws back both string and arrow; the string approaches his breast, the iron point of the arrow nears the bow, the great arched bow springs back with a mighty twang, the cord rings, and away leaps the eager arrow speeding towards the mark.

Caylus cannot have overlooked this admirable picture. What, then, did he find which made him judge it no fitting subject for an artist? And what in the council and carousal of the gods made that seem more adapted to his purpose? The subjects are visible in one case as in the other, and what more does the painter need for his canvas?

The difficulty must be this. Although both themes, as representing visible objects, are equally adapted to painting, there is this essential difference between them: one is a visible progressive action, the various parts of which follow one another in time; the other is a visible stationary action, the development of whose various parts takes place in space. Since painting, because its signs or means of imitation can be combined only in space, must relinquish all representations of time, therefore progressive actions, as such, cannot come within its range. It must content itself with actions in space; in other words, with mere bodies, whose attitude lets us infer their action. Poetry, on the contrary—

XVI

But I will try to prove my conclusions by starting from first principles.

I argue thus. If it be true that painting employs wholly different signs or means of imitation from poetry,—the one using forms and colors in space, the other articulate sounds in time,—and if signs must unquestionably stand in convenient relation with the thing signified, then signs arranged side by side can represent only objects existing side by side, or whose parts so exist, while consecutive signs can express only objects which succeed each other, or whose parts succeed each other, in time.

Objects which exist side by side, or whose parts so exist, are called bodies. Consequently bodies with their visible properties are the peculiar subjects of painting.

Objects which succeed each other, or whose parts succeed each other in time, are actions. Consequently actions are the peculiar subjects of poetry.

All bodies, however, exist not only in space, but also in time. They continue, and, at any moment of their continuance, may assume a different

appearance and stand in different relations. Every one of these momentary appearances and groupings was the result of a preceding, may become the cause of a following, and is therefore the centre of a present, action. Consequently painting can imitate actions also, but only as they are suggested through forms.

Actions, on the other hand, cannot exist independently, but must always be joined to certain agents. In so far as those agents are bodies or are regarded as such, poetry describes also bodies, but only indirectly through actions.

Painting, in its coexistent compositions, can use but a single moment of an action, and must therefore choose the most pregnant one, the one most suggestive of what has gone before and what is to follow.

Poetry, in its progressive imitations, can use but a single attribute of bodies, and must choose that one which gives the most vivid picture of the body as exercised in this particular action.

Hence the rule for the employment of a single descriptive epithet, and the cause of the rare occurrence of descriptions of physical objects.

I should place less confidence in this dry chain of conclusions, did I not find them fully confirmed by Homer, or, rather, had they not been first suggested to me by Homer's method. These principles alone furnish a key to the noble style of the Greek, and enable us to pass just judgment on the opposite method of many modern poets who insist upon emulating the artist in a point where they must of necessity remain inferior to him.

I find that Homer paints nothing but progressive actions. All bodies, all separate objects, are painted only as they take part in such actions, and generally with a single touch. No wonder, then, that artists find in Homer's pictures little or nothing to their purpose, and that their only harvest is where the narration brings together in a space favorable to art a number of beautiful shapes in graceful attitudes, however little the poet himself may have painted shapes, attitudes, or space. If we study one by one the whole series of pictures proposed by Caylus, we shall in every case find proof of the justness of these conclusions.

. . .

XVII

But, it may be urged, the signs employed in poetry not only follow each other, but are also arbitrary; and, as arbitrary signs, they are certainly capable of expressing things as they exist in space. Homer himself furnishes examples of this. We have but to call to mind his shield of Achilles to have an instance of how circumstantially and yet poetically a single object can be described according to its coexistent parts.

I will proceed to answer this double objection. I call it double, because a just conclusion must hold, though unsupported by examples, and on the

other hand the example of Homer has great weight with me, even when I am unable to justify it by rules.

It is true that since the signs of speech are arbitrary, the parts of a body can by their means be made to follow each other as readily as in nature they exist side by side. But this is a property of the signs of language in general, not of those peculiar to poetry. The prose writer is satisfied with being intelligible, and making his representations plain and clear. But this is not enough for the poet. He desires to present us with images so vivid, that we fancy we have the things themselves before us, and cease for the moment to be conscious of his words, the instruments with which he effects his purpose. That was the point made in the definition given above of a poetical picture. But the poet must always paint; and now let us see in how far bodies, considered in relation to their parts lying together in space, are fit subjects for this painting.

How do we obtain a clear idea of a thing in space? First we observe its separate parts, then the union of these parts, and finally the whole. Our senses perform these various operations with such amazing rapidity as to make them seem but one. This rapidity is absolutely essential to our obtaining an idea of the whole, which is nothing more than the result of the conception of the parts and of their connection with each other. Suppose now that the poet should lead us in proper order from one part of the object to the other; suppose he should succeed in making the connection of these parts perfectly clear to us; how much time will he have consumed?

The details, which the eye takes in at a glance, he enumerates slowly one by one, and it often happens that, by the time he has brought us to the last, we have forgotten the first. Yet from these details we are to form a picture. When we look at an object the various parts are always present to the eye. It can run over them again and again. The ear, however, loses the details it has heard, unless memory retain them. And if they be so retained, what pains and effort it costs to recall their impressions in the proper order and with even the moderate degree of rapidity necessary to the obtaining of a tolerable idea of the whole.

. . .

Once more, then, I do not deny that language has the power of describing a corporeal whole according to its parts. It certainly has, because its signs, although consecutive, are nevertheless arbitrary. But I deny that this power exists in language as the instrument of poetry. For illusion, which is the special aim of poetry, is not produced by these verbal descriptions of objects, nor can it ever be so produced. The coexistence of the body comes into collision with the sequence of the words, and although while the former is getting resolved into the latter, the dismemberment of the whole into its parts is a help to us, yet the reunion of these parts into a whole is made extremely difficult, and not infrequently impossible.

. . .

XVIII

And shall Homer nevertheless have fallen into those barren descriptions of material objects?

Let us hope that only a few such passages can be cited. And even those few, I venture to assert, will be found really to confirm the rule, to which they appear to form an exception.

The rule is this, that succession in time is the province of the poet, coexistence in space that of the artist.

To bring together into one and the same picture two points of time necessarily remote, as Mazzuoli does the rape of the Sabine women and the reconciliation effected by them between their husbands and relations; or as Titian does, representing in one piece the whole story of the Prodigal Son,—his dissolute life, his misery, and repentance,—is an encroachment of the painter on the domain of the poet, which good taste can never sanction.

To try to present a complete picture to the reader by enumerating in succession several parts or things which in nature the eye necessarily takes in at a glance, is an encroachment of the poet on the domain of the painter, involving a great effort of the imagination to very little purpose.

Painting and poetry should be like two just and friendly neighbors, neither of whom indeed is allowed to take unseemly liberties in the heart of the other's domain, but who exercise mutual forbearance on the borders, and effect a peaceful settlement for all the petty encroachments which circumstances may compel either to make in haste on the rights of the other.

. . .

XX

To return, then, to my road, if a saunterer can be said to have a road.

What I have been saying of bodily objects in general applies with even more force to those which are beautiful.

Physical beauty results from the harmonious action of various parts which can be taken in at a glance. It therefore requires that these parts should lie near together; and, since things whose parts lie near together are the proper subjects of painting, this art and this alone can imitate physical beauty.

The poet, who must necessarily detail in succession the elements of beauty, should therefore desist entirely from the description of physical beauty as such. He must feel that these elements arranged in a series cannot possibly produce the same effect as in juxtaposition; that the concentrating glance which we try to cast back over them immediately after

their enumeration, gives us no harmonious picture; and that to conceive the effect of certain eyes, a certain mouth and nose taken together, unless we can recall a similar combination of such parts in nature or art, surpasses the power of human imagination.

. . .

XXI

But are we not robbing poetry of too much by taking from her all pictures of physical beauty?

Who seeks to take them from her? We are only warning her against trying to arrive at them by a particular road, where she will blindly grope her way in the footsteps of a sister art without ever reaching the goal. We are not closing against her other roads whereon art can follow only with her eyes.

Homer himself, who so persistently refrains from all detailed descriptions of physical beauty, that we barely learn, from a passing mention, that Helen had white arms[5] and beautiful hair,[6] even he manages nevertheless to give us an idea of her beauty, which far surpasses any thing that art could do. Recall the passage where Helen enters the assembly of the Trojan elders. The venerable men see her coming, and one says to the others:[7]—

Οὐ νέμεσις Τρῶας καὶ ἐϋκνήμιδας Ἀχαιοὺς
τοιῆδ᾽ ἀμφὶ γυναικὶ πολὺν χρόνον ἄλγεα πάσχειν·
αἰνῶς ἀθανάτῃσι θεῇς εἰς ὦπα ἔοικεν.

What can give a more vivid idea of her beauty than that cold-blooded age should deem it well worth the war which had cost so much blood and so many tears?

What Homer could not describe in its details, he shows us by its effect. Paint us, ye poets, the delight, the attraction, the love, the enchantment of beauty, and you have painted beauty itself. . . .

Yet another way in which poetry surpasses art in the description of physical beauty, is by turning beauty into charm. Charm is beauty in motion, and therefore less adapted to the painter than the poet. The painter can suggest motion, but his figures are really destitute of it.

[5] Iliad iii. 121.
[6] Ibid. 319.
[7] Ibid. 156–158.
 Small blame is theirs if both the Trojan knights
 And brazen-mailed Achaians have endured
 So long so many evils for the sake
 Of that one woman. She is wholly like
 In feature to the deathless goddesses.
 —BRYANT

Charm therefore in a picture becomes grimace, while in poetry it remains what it is, a transitory beauty, which we would fain see repeated. It comes and goes, and since we can recall a motion more vividly and easily than mere forms and colors, charm must affect us more strongly than beauty under the same conditions.

. . .

. . . Here we have, therefore, a fresh illustration of what was urged above, that the poet, even when speaking of a painting or statue, is not bound to confine his description within the limits of art.

IMMANUEL KANT
CRITIQUE OF JUDGMENT

Immanuel Kant (1724–1804), professor at the University of Königsberg, has been one of the most influential philosophers of modern times. The Critique of Judgment *is one of three critiques in which Kant synthesized rationalism, the thesis that our basic knowledge of the world is obtained through pure reason, and empiricism, the theory that all knowledge is ultimately based on sense experience.*

FIRST DIVISION

Analytic of the Aesthetical Judgment

FIRST BOOK

ANALYTIC OF THE BEAUTIFUL

FIRST MOMENT

Reprinted (some footnotes deleted) from *Critique of Judgment*, translated by J. H. Bernard, New York, Hafner Publishing Company, 1951, by permission of the publisher.

145

OF THE JUDGMENT OF TASTE,[1]
ACCORDING TO QUALITY

§ 1. THE JUDGMENT OF TASTE IS AESTHETICAL

In order to distinguish whether anything is beautiful or not, we refer
the representation, not by the understanding to the object for cognition,
but by the imagination (perhaps in conjunction with the understanding)
to the subject and its feeling of pleasure or pain. The judgment of taste
is therefore not a judgment of cognition, and is consequently not logical
but aesthetical, by which we understand that whose determining ground
can be *no other than subjective.* Every reference of representations, even
that of sensations, may be objective (and then it signifies the real [element]
of an empirical representation), save only the reference to the feeling of
pleasure and pain, by which nothing in the object is signified, but
through which there is a feeling in the subject as it is affected by the
representation.

To apprehend a regular, purposive building by means of one's cognitive
faculty (whether in a clear or a confused way of representation) is some-
thing quite different from being conscious of this representation as con-
nected with the sensation of satisfaction. Here the representation is
altogether referred to the subject and to its feeling of life, under the name
of the feeling of pleasure or pain. This establishes a quite separate faculty
of distinction and of judgment, adding nothing to cognition, but only
comparing the given representation in the subject with the whole faculty
of representations, of which the mind is conscious in the feeling of its
state. Given representations in a judgment can be empirical (consequently,
aesthetical); but the judgment which is formed by means of them is
logical, provided they are referred in the judgment to the object. Con-
versely, if the given representations are rational, but are referred in a
judgment simply to the subject (to its feeling), the judgment is so far
always aesthetical.

§ 2. THE SATISFACTION WHICH DETERMINES THE JUDGMENT
OF TASTE IS DISINTERESTED

The satisfaction which we combine with the representation of the
existence of an object is called "interest." Such satisfaction always has
reference to the faculty of desire, either as its determining ground or as
necessarily connected with its determining ground. Now when the ques-

[1] The definition of "taste" which is laid down here is that it is the faculty of
judging of the beautiful. But the analysis of judgments of taste must show what is
required in order to call an object beautiful. The moments to which this judgment
has regard in its reflection I have sought in accordance with the guidance of
logical functions of judgment (for in a judgment of taste a reference to the under-
standing is always involved). I have considered the moment of quality first because
the aesthetical judgment upon the beautiful first pays attention to it.

tion is if a thing is beautiful, we do not want to know whether anything depends or can depend on the existence of the thing, either for myself or for anyone else, but how we judge it by mere observation (intuition or reflection). If anyone asks me if I find that palace beautiful which I see before me, I may answer: I do not like things of that kind which are made merely to be stared at. Or I can answer like that Iroquois Sachem, who was pleased in Paris by nothing more than by the cook shops. Or again, after the manner of Rousseau, I may rebuke the vanity of the great who waste the sweat of the people on such superfluous things. In fine, I could easily convince myself that if I found myself on an uninhabited island without the hope of ever again coming among men, and could conjure up just such a splendid building by my mere wish, I should not even give myself the trouble if I had a sufficiently comfortable hut. This may all be admitted and approved, but we are not now talking of this. We wish only to know if this mere representation of the object is accompanied in me with satisfaction, however indifferent I may be as regards the existence of the object of this representation. We easily see that, in saying it is *beautiful* and in showing that I have taste, I am concerned, not with that in which I depend on the existence of the object, but with that which I make out of this representation in myself. Everyone must admit that a judgment about beauty, in which the least interest mingles, is very partial and is not a pure judgment of taste. We must not be in the least prejudiced in favor of the existence of the things, but be quite indifferent in this respect, in order to play the judge in things of taste.

· · ·

§ 3. THE SATISFACTION IN THE PLEASANT IS BOUND UP WITH INTEREST

That which pleases the senses in sensation is "pleasant." Here the opportunity presents itself of censuring a very common confusion of the double sense which the word "sensation" can have, and of calling attention to it. All satisfaction (it is said or thought) is itself sensation (of a pleasure). Consequently everything that pleases is pleasant because it pleases (and according to its different degrees or its relations to other pleasant sensations it is *agreeable, lovely, delightful, enjoyable,* etc.). But if this be admitted, then impressions of sense which determine the inclination, fundamental propositions of reason which determine the will, mere reflective forms of intuition which determine the judgment, are quite the same as regards the effect upon the feeling of pleasure. For this would be pleasantness in the sensation of one's state; and since in the end all the operations of our faculties must issue in the practical and unite in it as their goal, we could suppose no other way of estimating things and their worth than that which consists in the gratification that they promise. It is

of no consequence at all how this is attained, and since then the choice of means alone could make a difference, men could indeed blame one another for stupidity and indiscretion, but never for baseness and wickedness. For thus they all, each according to his own way of seeing things, seek one goal, that is, gratification.

If a determination of the feeling of pleasure or pain is called sensation, this expression signifies something quite different from what I mean when I call the representation of a thing (by sense, as a receptivity belonging to the cognitive faculty) sensation. For in the latter case the representation is referred to the object, in the former simply to the subject, and is available for no cognition whatever, not even for that by which the subject *cognizes* itself.

In the above elucidation we understand by the word "sensation" an objective representation of sense; and, in order to avoid misinterpretation, we shall call that which must always remain merely subjective and can constitute absolutely no representation of an object by the ordinary term "feeling." The green color of the meadows belongs to *objective* sensation, as a perception of an object of sense; the pleasantness of this belongs to *subjective* sensation by which no object is represented, i.e. to feeling, by which the object is considered as an object of satisfaction (which does not furnish a cognition of it).

Now that a judgment about an object by which I describe it as pleasant expresses an interest in it, is plain from the fact that by sensation it excites a desire for objects of that kind; consequently the satisfaction presupposes, not the mere judgment about it, but the relation of its existence to my state, so far as this is affected by such an object. Hence we do not merely say of the pleasant, *it pleases*, but, *it gratifies*. I give to it no mere assent, but inclination is aroused by it; and in the case of what is pleasant in the most lively fashion there is no judgment at all upon the character of the object, for those [persons] who always lay themselves out for enjoyment (for that is the word describing intense gratification) would fain dispense with all judgment.

§ 4. THE SATISFACTION IN THE GOOD IS BOUND UP WITH INTEREST

Whatever by means of reason pleases through the mere concept is *good*. That which pleases only as a means we call *good for something* (the useful), but that which pleases for itself is *good in itself*. In both there is always involved the concept of a purpose, and consequently the relation of reason to the (at least possible) volition, and thus a satisfaction in the *presence* of an object or an action, i.e. some kind of interest.

In order to find anything good, I must always know what sort of a thing the object ought to be, i.e. I must have a concept of it. But there is no need of this to find a thing beautiful. Flowers, free delineations, outlines intertwined with one another without design and called [conven-

tional] foliage, have no meaning, depend on no definite concept, and yet they please. The satisfaction in the beautiful must depend on the reflection upon an object, leading to any concept (however indefinite), and it is thus distinguished from the pleasant, which rests entirely upon sensation.

It is true, the pleasant seems in many cases to be the same as the good. Thus people are accustomed to say that all gratification (especially if it lasts) is good in itself, which is very much the same as to say that lasting pleasure and the good are the same. But we can soon see that this is merely a confusion of words, for the concepts which properly belong to these expressions can in no way be interchanged. The pleasant, which, as such, represents the object simply in relation to sense, must first be brought by the concept of a purpose under principles of reason, in order to call it good, as an object of the will. But that there is [involved] a quite different relation to satisfaction in calling that which gratifies at the same time *good* may be seen from the fact that, in the case of the good, the question always is whether it is mediately or immediately good (useful or good in itself); but on the contrary in the case of the pleasant, there can be no question about this at all, for the word always signifies something which pleases immediately. (The same is applicable to what I call beautiful.)

. . .

However, notwithstanding all this difference between the pleasant and the good, they both agree in this that they are always bound up with an interest in their object; so are not only the pleasant (§ 3), and the mediate good (the useful) which is pleasing as a means toward pleasantness somewhere, but also that which is good absolutely and in every aspect, viz. moral good, which brings with it the highest interest. For the good is the object of will (i.e. of a faculty of desire determined by reason). But to wish for something and to have a satisfaction in its existence, i.e. to take an interest in it, are identical.

§ 5. COMPARISON OF THE THREE SPECIFICALLY DIFFERENT KINDS OF SATISFACTION

The pleasant and the good have both a reference to the faculty of desire, and they bring with them, the former a satisfaction pathologically conditioned (by impulses, *stimuli*), the latter a pure practical satisfaction which is determined not merely by the representation of the object but also by the represented connection of the subject with the existence of the object. [It is not merely the object that pleases, but also its existence.][2] On the other hand, the judgment of taste is merely *contemplative;* i.e., it is a judgment which, indifferent as regards the existence of an object, compares its character with the feeling of pleasure and pain. But this

[2] [Second edition.]

contemplation itself is not directed to concepts; for the judgment of taste is not a cognitive judgment (either theoretical or practical), and thus is not *based* on concepts, nor has it concepts as its *purpose.*

The pleasant, the beautiful, and the good designate then three different relations of representations to the feeling of pleasure and pain, in reference to which we distinguish from one another objects or methods of representing them. And the expressions corresponding to each, by which we mark our complacency in them, are not the same. That which *gratifies* a man is called *pleasant;* that which merely *pleases* him is *beautiful;* that which is *esteemed* [or approved][3] by him, i.e. that to which he accords an objective worth, is *good.* Pleasantness concerns irrational animals also, but beauty only concerns men, i.e. animal, but still rational, beings—not merely *quâ* rational (e.g. spirits), but *quâ* animal also—and the good concerns every rational being in general. This is a proposition which can only be completely established and explained in the sequel. We may say that, of all these three kinds of satisfaction, that of taste in the beautiful is alone a disinterested and *free* satisfaction; for no interest, either of sense or of reason, here forces our assent. Hence we may say of satisfaction that it is related in the three aforesaid cases to *inclination,* to *favor,* or to *respect.* Now *favor* is the only free satisfaction. An object of inclination and one that is proposed to our desire by a law of reason leave us no freedom in forming for ourselves anywhere an object of pleasure. All interest presupposes or generates a want, and, as the determining ground of assent, it leaves the judgment about the object no longer free.

. . .

Explanation of the Beautiful Resulting from the First Moment

Taste is the faculty of judging of an object or a method of representing it by an *entirely disinterested* satisfaction or dissatisfaction. The object of such satisfaction is called *beautiful.*

SECOND MOMENT

OF THE JUDGMENT OF TASTE, ACCORDING TO QUANTITY

§ 6. THE BEAUTIFUL IS THAT WHICH APART FROM CONCEPTS IS REPRESENTED AS THE OBJECT OF A UNIVERSAL SATISFACTION

This explanation of the beautiful can be derived from the preceding explanation of it as the object of an entirely disinterested satisfaction. For the fact of which everyone is conscious, that the satisfaction is for him quite disinterested, implies in his judgment a ground of satisfaction for

[3] [Second edition.]

all men. For since it does not rest on any inclination of the subject (nor upon any other premeditated interest), but since the person who judges feels himself quite *free* as regards the satisfaction which he attaches to the object, he cannot find the ground of this satisfaction in any private conditions connected with his own subject, and hence it must be regarded as grounded on what he can presuppose in every other person. Consequently he must believe that he has reason for attributing a similar satisfaction to everyone. He will therefore speak of the beautiful as if beauty were a characteristic of the object and the judgment logical (constituting a cognition of the object by means of concepts of it), although it is only aesthetical and involves merely a reference of the representation of the object to the subject. For it has this similarity to a logical judgment that we can presuppose its validity for all men. But this universality cannot arise from concepts; for from concepts there is no transition to the feeling of pleasure or pain (except in pure practical laws, which bring an interest with them such as is not bound up with the pure judgment of taste). Consequently the judgment of taste, accompanied with the consciousness of separation from all interest, must claim validity for every man, without this universality depending on objects. That is, there must be bound up with it a title to subjective universality.

§ 7. COMPARISON OF THE BEAUTIFUL WITH THE PLEASANT AND THE GOOD BY MEANS OF THE ABOVE CHARACTERISTIC

As regards the pleasant, everyone is content that his judgment, which he bases upon private feeling and by which he says of an object that it pleases him, should be limited merely to his own person. Thus he is quite contented that if he says, "Canary wine is pleasant," another man may correct his expression and remind him that he ought to say, "It is pleasant *to me*." And this is the case not only as regards the taste of the tongue, the palate, and the throat, but for whatever is pleasant to anyone's eyes and ears. To one, violet color is soft and lovely; to another, it is washed out and dead. One man likes the tone of wind instruments, another that of strings. To strive here with the design of reproving as incorrect another man's judgment which is different from our own, as if the judgments were logically opposed, would be folly. As regards the pleasant, therefore, the fundamental proposition is valid: *everyone has his own taste* (the taste of sense).

The case is quite different with the beautiful. It would (on the contrary) be laughable if a man who imagined anything to his own taste thought to justify himself by saying: "This object (the house we see, the coat that person wears, the concert we hear, the poem submitted to our judgment) is beautiful *for me*." For he must not call it *beautiful* if it merely pleases him. Many things may have for him charm and pleasantness—no one troubles himself at that—but if he gives out anything as beautiful, he supposes in others the same satisfaction; he judges not

merely for himself, but for everyone, and speaks of beauty as if it were a property of things. Hence he says "the *thing* is beautiful"; and he does not count on the agreement of others with this his judgment of satisfaction, because he has found this agreement several times before, but he *demands* it of them. He blames them if they judge otherwise and he denies them taste, which he nevertheless requires from them. Here, then, we cannot say that each man has his own particular taste. For this would be as much as to say that there is no taste whatever, i.e. no aesthetical judgment which can make a rightful claim upon everyone's assent.

At the same time we find as regards the pleasant that there is an agreement among men in their judgments upon it in regard to which we deny taste to some and attribute it to others, by this not meaning one of our organic senses, but a faculty of judging in respect of the pleasant generally. Thus we say of a man who knows how to entertain his guests with pleasures (of enjoyment for all the senses), so that they are all pleased, "he has taste." But here the universality is only taken comparatively; and there emerge rules which are only *general* (like all empirical ones), and not *universal*, which latter the judgment of taste upon the beautiful undertakes or lays claim to. It is a judgment in reference to sociability, so far as this rests on empirical rules. In respect of the good it is true that judgments make rightful claim to validity for everyone; but the good is represented only *by means of a concept* as the object of a universal satisfaction, which is the case neither with the pleasant nor with the beautiful.

§ 8. THE UNIVERSALITY OF THE SATISFACTION IS REPRESENTED IN A JUDGMENT OF TASTE ONLY AS SUBJECTIVE

This particular determination of the universality of an aesthetical judgment, which is to be met with in a judgment of taste, is noteworthy, not indeed for the logician, but for the transcendental philosopher. It requires no small trouble to discover its origin, but we thus detect a property of our cognitive faculty which without this analysis would remain unknown.

First, we must be fully convinced of the fact that in a judgment of taste (about the beautiful) the satisfaction in the object is imputed to *everyone*, without being based on a concept (for then it would be the good). Further, this claim to universal validity so essentially belongs to a judgment by which we describe anything as *beautiful* that, if this were not thought in it, it would never come into our thoughts to use the expression at all, but everything which pleases without a concept would be counted as pleasant. In respect of the latter, everyone has his own opinion; and no one assumes in another agreement with his judgment of taste, which is always the case in a judgment of taste about beauty. I may call the first the taste of sense, the second the taste of reflection, so far as the first lays down mere private judgments and the second judgments supposed to be generally valid (public), but in both cases aestheti-

cal (not practical) judgments about an object merely in respect of the relation of its representation to the feeling of pleasure and pain. Now here is something strange. As regards the taste of sense, not only does experience show that its judgment (of pleasure or pain connected with anything) is not valid universally, but everyone is content not to impute agreement with it to others (although actually there is often found a very extended concurrence in these judgments). On the other hand, the taste of reflection has its claim to the universal validity of its judgments (about the beautiful) rejected often enough, as experience teaches, although it may find it possible (as it actually does) to represent judgments which can demand this universal agreement. In fact it imputes this to everyone for each of its judgments of taste, without the persons that judge disputing as to the possibility of such a claim, although in particular cases they cannot agree as to the correct application of this faculty.

Here we must, in the first place, remark that a universality which does not rest on concepts of objects (not even on empirical ones) is not logical but aesthetical; i.e. it involves no objective quantity of the judgment, but only that which is subjective. For this I use the expression *general validity*, which signifies the validity of the reference of a representation, not to the cognitive faculty, but to the feeling of pleasure and pain for every subject. (We can avail ourselves also of the same expression for the logical quantity of the judgment, if only we prefix "objective" to "universal validity," to distinguish it from that which is merely subjective and aesthetical.)

A judgment with *objective universal validity* is also always valid subjectively; i.e. if the judgment holds for everything contained under a given concept, it holds also for everyone who represents an object by means of this concept. But from a *subjective universal validity*, i.e. aesthetical and resting on no concept, we cannot infer that which is logical because that kind of judgment does not extend to the object. But, therefore, the aesthetical universality which is ascribed to a judgment must be a particular kind, because it does not unite the predicate of beauty with the concept of the object, considered in its whole logical sphere, and yet extends it to the whole sphere of judging persons.

In respect of logical quantity, all judgments of taste are *singular* judgments. For because I must refer the object immediately to my feeling of pleasure and pain, and that not by means of concepts, they cannot have the quantity of objective generally valid judgments. Nevertheless, if the singular representation of the object of the judgment of taste, in accordance with the conditions determining the latter, were transformed by comparison into a concept, a logically universal judgment could result therefrom. E.g., I describe by a judgment of taste the rose that I see as beautiful. But the judgment which results from the comparison of several singular judgments, "Roses in general are beautiful," is no longer described simply as aesthetical, but as a logical judgment based on an aesthetical one. Again the judgment, "The rose is pleasant" (to use) is,

although aesthetical and singular, not a judgment of taste but of sense. It is distinguished from the former by the fact that the judgment of taste carries with it an *aesthetic quantity* of universality, i.e. of validity for everyone, which cannot be found in a judgment about the pleasant. It is only judgments about the good which, although they also determine satisfaction in an object, have logical and not merely aesthetical universality, for they are valid of the object as cognitive of it, and thus are valid for everyone.

If we judge objects merely according to concepts, then all representation of beauty is lost. Thus there can be no rule according to which anyone is to be forced to recognize anything as beautiful. We cannot press [upon others] by the aid of any reasons or fundamental propositions our judgment that a coat, a house, or a flower is beautiful. People wish to submit the object to their own eyes, as if the satisfaction in it depended on sensation; and yet, if we then call the object beautiful, we believe that we speak with a universal voice, and we claim the assent of everyone, although on the contrary all private sensation can only decide for the observer himself and his satisfaction.

We may see now that in the judgment of taste nothing is postulated but such a *universal voice*, in respect of the satisfaction without the intervention of concepts, and thus the *possibility* of an aesthetical judgment that can, at the same time, be regarded as valid for everyone. The judgment of taste itself does not *postulate* the agreement of everyone (for that can only be done by a logically universal judgment because it can adduce reasons); it only *imputes* this agreement to everyone, as a case of the rule in respect of which it expects, not confirmation by concepts, but assent from others. The universal voice is, therefore, only an idea (we do not yet inquire upon what it rests). It may be uncertain whether or not the man who believes that he is laying down a judgment of taste is, as a matter of fact, judging in conformity with that idea; but that he refers his judgment thereto, and consequently that it is intended to be a judgment of taste, he announces by the expression "beauty." He can be quite certain of this for himself by the mere consciousness of the separating off everything belonging to the pleasant and the good from the satisfaction which is left; and this is all for which he promises himself the agreement of everyone—a claim which would be justifiable under these conditions, provided only he did not often make mistakes, and thus lay down an erroneous judgment of taste.

§ 9. INVESTIGATION OF THE QUESTION WHETHER IN THE JUDGMENT
OF TASTE THE FEELING OF PLEASURE PRECEDES
OR FOLLOWS THE JUDGING OF THE OBJECT

The solution of this question is the key to the critique of taste, and so is worthy of all attention.

If the pleasure in the given object precedes, and it is only its universal

communicability that is to be acknowledged in the judgment of taste about the representation of the object, there would be a contradiction. For such pleasure would be nothing different from the mere pleasantness in the sensation, and so in accordance with its nature could have only private validity, because it is immediately dependent on the representation through which the object *is given*.

Hence it is the universal capability of communication of the mental state in the given representation which, as the subjective condition of the judgment of taste, must be fundamental and must have the pleasure in the object as its consequent. But nothing can be universally communicated except cognition and representation, so far as it belongs to cognition. For it is only thus that this latter can be objective, and only through this has it a universal point of reference, with which the representative power of everyone is compelled to harmonize. If the determining ground of our judgment as to this universal communicability of the representation is to be merely subjective, i.e. is conceived independently of any concept of the object, it can be nothing else than the state of mind, which is to be met with in the relation of our representative powers to each other, so far as they refer a given representation to *cognition in general.*

The cognitive powers, which are involved by this representation, are here in free play, because no definite concept limits them to a definite rule of cognition. Hence the state of mind in this representation must be a feeling of the free play of the representative powers in a given representation with reference to a cognition in general. Now a representation by which an object is given that is to become a cognition in general requires *imagination* for the gathering together the manifold of intuition, and *understanding* for the unity of the concept uniting the representations. This state of *free play* of the cognitive faculties in a representation by which an object is given must be universally communicable, because cognition, as the determination of the object with which given representations (in whatever subject) are to agree, is the only kind of representation which is valid for everyone.

The subjective universal communicability of the mode of representation in a judgment of taste, since it is to be possible without presupposing a definite concept, can refer to nothing else than the state of mind in the free play of the imagination and the understanding (so far as they agree with each other, as is requisite for *cognition in general*). We are conscious that this subjective relation, suitable for cognition in general, must be valid for everyone, and thus must be universally communicable, just as if it were a definite cognition, resting always on that relation as its subjective condition.

This merely subjective (aesthetical) judging of the object, or of the representation by which it is given, precedes the pleasure in the same and is the ground of this pleasure in the harmony of the cognitive faculties; but on that universality of the subjective conditions for judging of objects

is alone based the universal subjective validity of the satisfaction bound up by us with the representation of the object that we call beautiful.

That the power of communicating one's state of mind, even though only in respect of the cognitive faculties, carries a pleasure with it, this we can easily show from the natural propension of man toward sociability (empirical and psychological). But this not enough for our design. The pleasure that we feel is, in a judgment of taste, necessarily imputed by us to everyone else, as if, when we call a thing beautiful, it is to be regarded as a characteristic of the object which is determined in it according to concepts, though beauty, without a reference to the feeling of the subject, is nothing by itself. But we must reserve the examination of this question until we have answered that other—if and how aesthetical judgments are possible *a priori*.

We now occupy ourselves with the easier question, in what way we are conscious of a mutual subjective harmony of the cognitive powers with one another in the judgment of taste—is it aesthetically by mere internal sense and sensation, or is it intellectually by the consciousness of our designed activity, by which we bring them into play?

If the given representation which occasions the judgment of taste were a concept uniting understanding and imagination in the judging of the object, into a cognition of the object, the consciousness of this relation would be intellectual (as in the objective schematism of the judgment of which the *Critique*[4] treats). But then the judgment would not be laid down in reference to pleasure and pain, and consequently would not be a judgment of taste. But the judgment of taste, independently of concepts, determines the object in respect of satisfaction and of the predicate of beauty. Therefore that subjective unity of relation can only make itself known by means of sensation. The excitement of both faculties (imagination and understanding) to indeterminate but yet, through the stimulus of the given sensation, harmonious activity, viz. that which belongs to cognition in general, is the sensation whose universal communicability is postulated by the judgment of taste. An objective relation can only be thought, but yet, so far as it is subjective according to its conditions, can be felt in its effect on the mind; and, of a relation based on no concept (like the relation of the representative powers to a cognitive faculty in general), no other consciousness is possible than that through the sensation of the effect, which consists in the more lively play of both mental powers (the imagination and the understanding) when animated by mutual agreement. A representation which, as individual and apart from comparison with others, yet has an agreement with the conditions of universality which it is the business of the understanding to supply, brings the cognitive faculties into that proportionate accord which we require for all cognition, and so regard as holding for everyone who is

4 [*The Critique of Pure Reason*, "Analytic," Bk. II, Ch. 1.]

determined to judge by means of understanding and sense in combination (i.e. for every man).

Explanation of the Beautiful Resulting from the Second Moment

The *beautiful* is that which pleases universally without [requiring] a concept.

THIRD MOMENT

OF JUDGMENTS OF TASTE, ACCORDING TO THE RELATION OF THE PURPOSES WHICH ARE BROUGHT INTO CONSIDERATION IN THEM

§ 10. OF PURPOSIVENESS IN GENERAL

If we wish to explain what a purpose is according to its transcendental determinations (without presupposing anything empirical like the feeling of pleasure), [we say that] the purpose is the object of a concept, in so far as the concept is regarded as the cause of the object (the real ground of its possibility); and the causality of a *concept* in respect of its *object* is its purposiveness (*forma finalis*). Where then not merely the cognition of an object but the object itself (its form and existence) is thought as an effect only possible by means of the concept of this latter, there we think a purpose. The representation of the effect is here the determining ground of its cause and precedes it. The consciousness of the causality of a representation, for *maintaining* the subject in the same state, may here generally denote what we call pleasure; while on the other hand pain is that representation which contains the ground of the determination of the state of representations into their opposite [of restraining or removing them].[5]

The faculty of desire, so far as it is determinable to act only through concepts, i.e. in conformity with the representation of a purpose, would be the will. But an object, or a state of mind, or even an action is called purposive, although its possibility does not necessarily presuppose the representation of a purpose, merely because its possibility can be explained and conceived by us only so far as we assume for its ground a causality according to purposes, i.e. in accordance with a will which has regulated it according to the representation of a certain rule. There can be, then, purposiveness without purpose, so far as we do not place the causes of this form in a will, but yet can only make the explanation of its possibility intelligible to ourselves by deriving it from a will. Again, we are not always forced to regard what we observe (in respect of its possibility) from the point of view of reason. Thus we can at least observe a purposiveness according to form, without basing it on a purpose (as the mate-

[5] [Second edition.]

rial of the *nexus finalis*), and remark it in objects, although only by reflection.

§ 11. THE JUDGMENT OF TASTE HAS NOTHING AT ITS BASIS
BUT THE FORM OF THE PURPOSIVENESS OF AN OBJECT
(OR OF ITS MODE OF REPRESENTATION)

Every purpose, if it be regarded as a ground of satisfaction, always carries with it an interest—as the determining ground of the judgment—about the object of pleasure. Therefore no subjective purpose can lie at the basis of the judgment of taste. But also the judgment of taste can be determined by no representation of an objective purpose, i.e. of the possibility of the object itself in accordance with principles of purposive combination, and consequently by no concept of the good, because it is an aesthetical and not a cognitive judgment. It therefore has to do with no *concept* of the character and internal or external possibility of the object by means of this or that cause, but merely with the relation of the representative powers to one another, so far as they are determined by a representation.

Now this relation in the determination of an object as beautiful is bound up with the feeling of pleasure, which is declared by the judgment of taste to be valid for everyone; hence a pleasantness [merely] accompanying the representation can as little contain the determining ground [of the judgment] as the representation of the perfection of the object and the concept of the good can. Therefore it can be nothing else than the subjective purposiveness in the representation of an object without any purpose (either objective or subjective), and thus it is the mere form of purposiveness in the representation by which an object is *given* to us, so far as we are conscious of it, which constitutes the satisfaction that we without a concept judge to be universally communicable; and, consequently, this is the determining ground of the judgment of taste.

§ 12. THE JUDGMENT OF TASTE RESTS ON A PRIORI GROUNDS

To establish *a priori* the connection of the feeling of a pleasure or pain as an effect, with any representation whatever (sensation or concept) as its cause, is absolutely impossible, for that would be a [particular][6] causal relation which (with objects of experience) can always only be cognized *a posteriori* and through the medium of experience itself. We actually have, indeed, in the *Critique of Practical Reason*, derived from universal moral concepts *a priori* the feeling of respect (as a special and peculiar modification of feeling which will not strictly correspond either to the pleasure or the pain that we get from empirical objects). But there we could go beyond the bounds of experience and call in a causality which rested on a supersensible attribute of the subject, viz. freedom. And even there,

[6] [First edition.]

properly speaking, it was not this *feeling* which we derived from the idea of the moral as cause, but merely the determination of the will. But the state of mind which accompanies any determination of the will is in itself a feeling of pleasure and identical with it, and therefore does not follow from it as its effect. This last must only be assumed if the concept of the moral as a good precede the determination of the will by the law, for in that case the pleasure that is bound up with the concept could not be derived from it as from a mere cognition.

Now the case is similar with the pleasure in aesthetical judgments, only that here it is merely contemplative and does not bring about an interest in the object, while on the other hand in the moral judgment it is practical.[7] The consciousness of the mere formal purposiveness in the play of the subject's cognitive powers, in a representation through which an object is given, is the pleasure itself, because it contains a determining ground of the activity of the subject in respect of the excitement of its cognitive powers, and therefore an inner causality (which is purposive) in respect of cognition in general, without however being limited to any definite cognition, and consequently contains a mere form of the subjective purposiveness of a representation in an aesthetical judgment. This pleasure is in no way practical, neither like that arising from the pathological ground of pleasantness, nor that from the intellectual ground of the presented good. But yet it involves causality, viz. of *maintaining* without further design the state of the representation itself and the occupation of the cognitive powers. We *linger* over the contemplation of the beautiful because this contemplation strengthens and reproduces itself, which is analogous to (though not of the same kind as) that lingering which takes place when a [physical] charm in the representation of the object repeatedly arouses the attention, the mind being passive.

§ 13. THE PURE JUDGMENT OF TASTE IS INDEPENDENT OF CHARM AND EMOTION

Every interest spoils the judgment of taste and takes from its impartiality, especially if the purposiveness is not, as with the interest of reason, placed before the feeling of pleasure but grounded on it. This last always happens in an aesthetical judgment upon anything, so far as it gratifies or grieves us. Hence judgments so affected can lay no claim at all to a universally valid satisfaction, or at least so much the less claim, in proportion as there are sensations of this sort among the determining grounds

[7] [Cf. *Metaphysic of Morals*, Introduction I. "The pleasure which is necessarily bound up with the desire (of the object whose representation affects feeling) may be called *practical* pleasure, whether it be cause or effect of the desire. On the contrary, the pleasure which is not necessarily bound up with the desire of the object, and which, therefore, is at bottom not a pleasure in the existence of the object of the representation, but clings to the representation only, may be called mere contemplative pleasure or *passive satisfaction*. The feeling of the latter kind of pleasure we call *taste*." (Abbott trans.—Ed.)]

of taste. That taste is always barbaric which needs a mixture of *charms* and *emotions* in order that there may be satisfaction, and still more so if it make these the measure of its assent.

Nevertheless charms are often not only taken account of in the case of beauty (which properly speaking ought merely to be concerned with form) as contributory to the aesthetical universal satisfaction, but they are passed off as in themselves beauties; and thus the matter of satisfaction is substituted for the form. This misconception, however, which like so many others, has something true at its basis, may be removed by a careful determination of these concepts.

A judgment of taste on which charm and emotion have no influence (although they may be bound up with the satisfaction in the beautiful) — which therefore has as its determining ground merely the purposiveness of the form—is a *pure judgment of taste*.

§ 14. ELUCIDATION BY MEANS OF EXAMPLES

Aesthetical judgments can be divided just like theoretical (logical) judgments into empirical and pure. The first assert pleasantness or unpleasantness; the second assert the beauty of an object or of the manner of representing it. The former are judgments of sense (material aesthetical judgments); the latter [as formal][8] are alone strictly judgments of taste.

A judgment of taste is therefore pure only so far as no merely empirical satisfaction is mingled with its determining ground. But this always happens if charm or emotion have any share in the judgment by which anything is to be described as beautiful.

Now here many objections present themselves which, fallaciously put forward, charm not merely as a necessary ingredient of beauty, but as alone sufficient [to justify] a thing's being called beautiful. A mere color, e.g. the green of a grass plot, a mere tone (as distinguished from sound and noise), like that of a violin, are by most people described as beautiful in themselves, although both seem to have at their basis merely the matter of representations, viz. simply sensation, and therefore only deserve to be called pleasant. But we must at the same time remark that the sensations of colors and of tone have a right to be regarded as beautiful only in so far as they are *pure*. This is a determination which concerns their form and is the only [element] of these representations which admits with certainty of universal communicability; for we cannot assume that the quality of sensations is the same in all subjects, and we can hardly say that the pleasantness of one color or the tone of one musical instrument is judged preferable to that of another in the same way by everyone.

· · ·

[8] [Second edition.]

But as regards the beauty attributed to the object on account of its form, to suppose it to be capable of augmentation through the charm of the object is a common error and one very prejudicial to genuine, uncorrupted, well-founded taste. We can doubtless add these charms to beauty, in order to interest the mind by the representation of the object, apart from the bare satisfaction [received], and thus they may serve as a recommendation of taste and its cultivation, especially when it is yet crude and unexercised. But they actually do injury to the judgment of taste if they draw attention to themselves as the grounds for judging of beauty. So far are they from adding to beauty that they must only be admitted by indulgence as aliens, and provided always that they do not disturb the beautiful form in cases when taste is yet weak and unexercised.

In painting, sculpture, and in all the formative arts—in architecture and horticulture, so far as they are beautiful arts—the *delineation* is the essential thing; and here it is not what gratifies in sensation but what pleases by means of its form that is fundamental for taste. The colors which light up the sketch belong to the charm; they may indeed enliven the object for sensation, but they cannot make it worthy of contemplation and beautiful. In most cases they are rather limited by the requirements of the beautiful form, and even where charm is permissible it is ennobled solely by this.

Every form of the objects of sense (both of external sense and also mediately of internal) is either *figure* or *play*. In the latter case it is either play of figures (in space, viz. pantomime and dancing) or the mere play of sensations (in time). The *charm* of colors or of the pleasant tones of an instrument may be added, but the *delineation* in the first case and the composition in the second constitute the proper object of the pure judgment of taste. To say that the purity of colors and of tones, or their variety and contrast, seem to add to beauty does not mean that they supply a homogeneous addition to our satisfaction in the form because they are pleasant in themselves; but they do so because they make the form more exactly, definitely, and completely, intuitible, and besides, by their charm [excite the representation, while they][9] awaken and fix our attention on the object itself.

Even what we call "ornaments" [*parerga*],[10] i.e. those things which do not belong to the complete representation of the object internally as elements, but only externally as complements, and which augment the satisfaction of taste, do so only by their form; as, for example, [the frames of pictures[11] or] the draperies of statues or the colonnades of palaces. But if the ornament does not itself consist in beautiful form, and if it is used as a golden frame is used, merely to recommend the painting by its *charm*, it is then called finery and injures genuine beauty.

[9] [Second edition.]
[10] [Second edition.]
[11] [Second edition.]

Emotion, that is a sensation in which pleasantness is produced by means of a momentary checking and a consequent more powerful outflow of the vital force, does not belong at all to beauty. But sublimity [with which the feeling of emotion is bound up][12] requires a different standard of judgment from that which is at the foundation of taste; and thus a pure judgment of taste has for its determining ground neither charm nor emotion—in a word, no sensation as the material of the aesthetical judgment.

<div align="center">

§ 15. THE JUDGMENT OF TASTE IS QUITE INDEPENDENT
OF THE CONCEPT OF PERFECTION

</div>

Objective purposiveness can only be cognized by means of the reference of the manifold to a definite purpose, and therefore only through a concept. From this alone it is plain that the beautiful, the judging of which has at its basis a merely formal purposiveness, i.e. a purposiveness without purpose, is quite independent of the concept of the good, because the latter presupposes an objective purposiveness, i.e. the reference of the object to a definite purpose.

Objective purposiveness is either external, i.e. the *utility*, or internal, i.e. the *perfection* of the object. That the satisfaction in an object, on account of which we call it beautiful, cannot rest on the representation of its utility is sufficiently obvious from the two preceding sections; because in that case it would not be an immediate satisfaction in the object, which is the essential condition of a judgment about beauty. But objective internal purposiveness, i.e. perfection, comes nearer to the predicate of beauty; and it has been regarded by celebrated philosophers[13] as the same as beauty, with the proviso, *if it is thought in a confused way.* It is of the greatest importance in a critique of taste to decide whether beauty can thus actually be resolved into the concept of perfection.

To judge of objective purposiveness we always need, not only the concept of a purpose, but (if that purposiveness is not to be external utility but internal) the concept of an internal purpose which shall contain the ground of the internal possibility of the object. Now as a purpose in general is that whose *concept* can be regarded as the ground of the possibility of the object itself; so, in order to represent objective purposiveness in a thing, the concept of *what sort of thing it is to be* must come first. The agreement of the manifold in it with this concept (which furnishes the rule for combining the manifold) is the *qualitative perfection* of the thing. Quite different from this is *quantitative* perfection, the completeness of a thing after its kind, which is a mere concept of magnitude

[12] [Second edition.]

[13] [Kant probably refers here to Baumgarten (1714–1762), who was the first writer to give the name of aesthetics to the philosophy of taste. He defined beauty as "perfection apprehended through the senses." Kant is said to have used as a textbook at lectures a work by Meier, a pupil of Baumgarten's, on this subject.]

(of totality).[14] In this *what the thing ought to be* is conceived as already determined, and it is only asked if it has *all* its requisites. The formal [element] in the representation of a thing, i.e. the agreement of the manifold with a unity (it being undetermined what this ought to be), gives to cognition no objective purposiveness whatever. For since abstraction is made of this unity as *purpose* (what the thing ought to be), nothing remains but the subjective purposiveness of the representations in the mind of the intuiting subject. And this, although it furnishes a certain purposiveness of the representative state of the subject, and so a facility of apprehending a given form by the imagination, yet furnishes no perfection of an object, since the object is not here conceived by means of the concept of a purpose. For example, if in a forest I come across a plot of sward around which trees stand in a circle and do not then represent to myself a purpose, viz. that it is intended to serve for country dances, not the least concept of perfection is furnished by the mere form. But to represent to oneself a formal *objective* purposiveness without purpose, i.e. the mere form of a *perfection* (without any matter and without the *concept* of that with which it is accordant, even if it were merely the idea of conformity to law in general), is a veritable contradiction.

Now the judgment of taste is an aesthetical judgment, i.e. such as rests on subjective grounds, the determining ground of which cannot be a concept, and consequently cannot be the concept of a definite purpose. Therefore by means of beauty, regarded as a formal subjective purposiveness, there is in no way thought a perfection of the object, as a purposiveness alleged to be formal but which is yet objective. And thus to distinguish between the concepts of the beautiful and the good as if they were only different in logical form, the first being a confused, the second a clear concept of perfection, but identical in content and origin, is quite fallacious. For then there would be no *specific* difference between them, but a judgment of taste would be as much a cognitive judgment as the judgment by which a thing is described as good; just as when the ordinary man says that fraud is unjust he bases his judgment on confused grounds, while the philosopher bases it on clear grounds, but both on identical principles of reason. I have already, however, said that an aesthetical judgment is unique of its kind and gives absolutely no cognition (not even a confused cognition) of the object; this is only supplied by a logical judgment. On the contrary, it simply refers the representation, by which an object is given, to the subject, and brings to our notice no characteristic of the object, but only the purposive form in the determination of

[14] [Cf. Preface to the *Metaphysical Elements of Ethics*, p. v: "The word *perfection* is liable to many misconceptions. It is sometimes understood as a concept belonging to Transcendental Philosophy; viz. the concept of the *totality* of the manifold, which, taken together, constitutes a Thing; sometimes, again, it is understood as belonging to *Teleology*, so that it signifies the agreement of the characteristics of a thing with a *purpose*. Perfection in the former sense might be called *quantitative* (material), in the latter *qualitative* (formal), perfection."]

the representative powers which are occupying themselves therewith. The judgment is called aesthetical just because its determining ground is not a concept, but the feeling (of internal sense) of that harmony in the play of the mental powers, so far as it can be felt in sensation. On the other hand, if we wish to call confused concepts and the objective judgment based on them aesthetical, we will have an understanding judging sensibly or a sense representing its objects by means of concepts [both of which are contradictory].[15] The faculty of concepts, be they confused or clear, is the understanding; and although understanding has to do with the judgment of taste as an aesthetical judgment (as it has with all judgments), yet it has to do with it, not as a faculty by which an object is cognized, but as the faculty which determines the judgment and its representation (without any concept) in accordance with its relation to the subject and the subject's internal feeling, in so far as this judgment may be possible in accordance with a universal rule

. . .

Explanation of the Beautiful Derived from This Third Moment

Beauty is the form of the *purposiveness* of an object, so far as this is perceived in it *without any representation of a purpose*.[16]

FOURTH MOMENT

OF THE JUDGMENT OF TASTE, ACCORDING TO THE MODALITY OF THE SATISFACTION IN THE OBJECT

§ 18. WHAT THE MODALITY IN A JUDGMENT OF TASTE IS

I can say of every representation that it is at least *possible* that (as a cognition) it should be bound up with a pleasure. Of a representation that I call *pleasant* I say that it *actually* excites pleasure in me. But the *beautiful* we think as having a *necessary* reference to satisfaction. Now this necessity is of a peculiar kind. It is not a theoretical objective necessity, in which case it would be cognized *a priori* that everyone *will feel* this satisfaction in the object called beautiful by me. It is not a practical

[15] [Second edition.]

[16] It might be objected to this explanation that there are things in which we see a purposive form without cognizing any purpose in them, like the stone implements often gotten from old sepulchral tumuli with a hole in them, as if for a handle. These, although they plainly indicate by their shape a purposiveness of which we do not know the purpose, are nevertheless not described as beautiful. But if we regard a thing as a work of art, that is enough to make us admit that its shape has reference to some design and definite purpose. And hence there is no immediate satisfaction in the contemplation of it. On the other hand a flower, e.g. a tulip, is regarded as beautiful, because in perceiving it we find a certain purposiveness which, in our judgment, is referred to no purpose at all.

necessity, in which case, by concepts of a pure rational will serving as a rule for freely acting beings, the satisfaction is the necessary result of an objective law and only indicates that we absolutely (without any further design) ought to act in a certain way. But the necessity which is thought in an aesthetical judgment can only be called exemplary, i.e. a necessity of the assent of *all* to a judgment which is regarded as the example of a universal rule that we cannot state. Since an aesthetical judgment is not an objective cognitive judgment, this necessity cannot be derived from definite concepts and is therefore not apodictic. Still less can it be inferred from the universality of experience (of a complete agreement of judgments as to the beauty of a certain object). For not only would experience hardly furnish sufficiently numerous vouchers for this, but also, on empirical judgments, we can base no concept of the necessity of these judgments.

§ 19. THE SUBJECTIVE NECESSITY, WHICH WE ASCRIBE TO THE JUDGMENT OF TASTE, IS CONDITIONED

The judgment of taste requires the agreement of everyone, and he who describes anything as beautiful claims that everyone *ought* to give his approval to the object in question and also describe it as beautiful. The *ought* in the aesthetical judgment is therefore pronounced in accordance with all the data which are required for judging, and yet is only conditioned. We ask for the agreement of everyone else, because we have for it a ground that is common to all; and we could count on this agreement, provided we were always sure that the case was correctly subsumed under that ground as rule of assent.

§ 20. THE CONDITION OF NECESSITY WHICH A JUDGMENT OF TASTE ASSERTS IS THE IDEA OF A COMMON SENSE

If judgments of taste (like cognitive judgments) had a definite objective principle, then the person who lays them down in accordance with this latter would claim an unconditioned necessity for his judgment. If they were devoid of all principle, like those of the mere taste of sense, we would not allow them in thought any necessity whatever. Hence they must have a subjective principle which determines what pleases or displeases only by feeling and not by concepts, but yet with universal validity. But such a principle could only be regarded as a *common sense*, which is essentially different from common understanding which people sometimes call common sense (*sensus communis*); for the latter does not judge by feeling but always by concepts, although ordinarily only as by obscurely represented principles.

Hence it is only under the presupposition that there is a common sense (by which we do not understand an external sense, but the effect resulting from the free play of our cognitive powers) —it is only under this presupposition, I say, that the judgment of taste can be laid down.

§ 21. HAVE WE GROUND FOR PRESUPPOSING A COMMON SENSE?

Cognitions and judgments must, along with the conviction that accompanies them, admit of universal communicability; for otherwise there would be no harmony between them and the object, and they would be collectively a mere subjective play of the representative powers, exactly as scepticism desires. But if cognitions are to admit of communicability, so must also the state of mind—i.e. the accordance of the cognitive powers with a cognition generally and that proportion of them which is suitable for a representation (by which an object is given to us) in order that a cognition may be made out of it—admit of universal communicability. For without this as the subjective condition of cognition, cognition as an effect could not arise. This actually always takes place when a given object by means of sense excites the imagination to collect the manifold, and the imagination in its turn excites the understanding to bring about a unity of this collective process in concepts. But this accordance of the cognitive powers has a different proportion according to the variety of the objects which are given. However, it must be such that this internal relation, by which one mental faculty is excited by another, shall be generally the most beneficial for both faculties in respect of cognition (of given objects); and this accordance can only be determined by feeling (not according to concepts). Since now this accordance itself must admit of universal communicability, and consequently also our feeling of it (in a given representation), and since the universal communicability of a feeling presupposes a common sense, we have grounds for assuming this latter. And this common sense is assumed without relying on psychological observations, but simply as the necessary condition of the universal communicability of our knowledge, which is presupposed in every logic and in every principle of knowledge that is not sceptical.

§ 22. THE NECESSITY OF THE UNIVERSAL AGREEMENT THAT IS THOUGHT IN A JUDGMENT OF TASTE IS A SUBJECTIVE NECESSITY, WHICH IS REPRESENTED AS OBJECTIVE UNDER THE PRESUPPOSITION OF A COMMON SENSE

In all judgments by which we describe anything as beautiful, we allow no one to be of another opinion, without, however, grounding our judgment on concepts, but only on our feeling, which we therefore place at its basis, not as a private, but as a common feeling. Now this common sense cannot be grounded on experience, for it aims at justifying judgments which contain an *ought*. It does not say that everyone *will* agree with my judgment, but that he *ought*. And so common sense, as an example of whose judgment I here put forward my judgment of taste and on account of which I attribute to the latter an *exemplary* validity, is a mere ideal norm, under the supposition of which I have a right to make into a rule for everyone a judgment that accords therewith, as well as the satisfaction in an object expressed in such judgment. For the principle which concerns

the agreement of different judging persons, although only subjective, is yet assumed as subjectively universal (an idea necessary for everyone), and thus can claim universal assent (as if it were objective) provided we are sure that we have correctly subsumed [the particulars] under it.

This indeterminate norm of a common sense is actually presupposed by us, as is shown by our claim to lay down judgments of taste. Whether there is in fact such a common sense, as a constitutive principle of the possibility of experience, or whether a yet higher principle of reason makes it only into a regulative principle for producing in us a common sense for higher purposes; whether, therefore, taste is an original and natural faculty or only the idea of an artificial one yet to be acquired, so that a judgment of taste with its assumption of a universal assent in fact is only a requirement of reason for producing such harmony of sentiment; whether the ought, i.e. the objective necessity of the confluence of the feeling of any one man with that of every other, only signifies the possibility of arriving at this accord, and the judgment of taste only affords an example of the application of this principle—these questions we have neither the wish nor the power to investigate as yet; we have now only to resolve the faculty of taste into its elements in order to unite them at last in the idea of a common sense.

Explanation of the Beautiful Resulting from the Fourth Moment

The *beautiful* is that which without any concept is cognized as the object of a *necessary* satisfaction.

GENERAL REMARK ON THE FIRST SECTION OF THE ANALYTIC

If we seek the result of the preceding analysis, we find that everything runs up into this concept of taste—that it is a faculty for judging an object in reference to the imagination's *free conformity to law*. Now, if in the judgment of taste the imagination must be considered in its freedom, it is in the first place not regarded as reproductive, as it is subject to the laws of association, but as productive and spontaneous (as the author of arbitrary forms of possible intuition). And although in the apprehension of a given object of sense it is tied to a definite form of this object and so far has no free play (such as that of poetry), yet it may readily be conceived that the object can furnish it with such a form containing a collection of the manifold as the imagination itself, if it were left free, would project in accordance with the *conformity to law of the understanding* in general. But that the *imaginative power* should be *free* and yet *of itself conformed to law*, i.e. bringing autonomy with it, is a contradiction. The understanding alone gives the law. If, however, the imagination is compelled to proceed according to a definite law, its product in respect of form is determined by concepts as to what it ought to be. But then, as is above shown, the satisfaction is not that in the beautiful, but in the good (in perfection,

at any rate in mere formal perfection), and the judgment is not a judgment of taste. Hence it is a conformity to law without a law; and a subjective agreement of the imagination and understanding—without such an objective agreement as there is when the representation is referred to a definite concept of an object—can subsist along with the free conformity to law of the understanding (which is also called purposiveness without purpose) and with the peculiar feature of a judgment of taste.

Now geometrically regular figures, such as a circle, a square, a cube, etc., are commonly adduced by critics of taste as the simplest and most indisputable examples of beauty, and yet they are called regular because we can only represent them by regarding them as mere presentations of a definite concept which prescribes the rule for the figure (according to which alone it is possible). One of these two must be wrong, either that judgment of the critic which ascribes beauty to the said figures, or ours which regards purposiveness apart from a concept as requisite for beauty.

Hardly anyone will say that a man must have taste in order that he should find more satisfaction in a circle than in a scrawled outline, in an equilateral and equiangular quadrilateral than in one which is oblique, irregular, and as it were deformed, for this belongs to the ordinary understanding and is not taste at all. Where, e.g., our design is to judge of the size of an area or to make intelligible the relation of the parts of it, when divided, to one another and to the whole, then regular figures and those of the simplest kind are needed, and the satisfaction does not rest immediately on the aspect of the figure, but on its availability for all kinds of possible designs. A room whose walls form oblique angles, or a parterre of this kind, even every violation of symmetry in the figure of animals (e.g. being one-eyed), of buildings, or of flower beds, displeases because it contradicts the purpose of the thing, not only practically in respect of a definite use of it, but also when we pass judgment on it as regards any possible design. This is not the case in the judgment of taste, which when pure combines satisfaction or dissatisfaction—without any reference to its use or to a purpose—with the mere *consideration* of the object.

The regularity which leads to the concept of an object is indeed the indispensable condition (*conditio sine qua non*) for grasping the object in a single representation and determining the manifold in its form. This determination is a purpose in respect of cognition, and in reference to this it is always bound up with satisfaction (which accompanies the execution of every, even problematical, design). There is here, however, merely the approval of the solution satisfying a problem, and not a free and indefinite purposive entertainment of the mental powers with what we call beautiful, where the understanding is at the service of imagination, and not *vice versa*.

In a thing that is only possible by means of design—a building, or even an animal—the regularity consisting in symmetry must express the unity of the intuition that accompanies the concept of purpose, and this regularity belongs to cognition. But where only a free play of the representative

powers (under the condition, however, that the understanding is to suffer no shock thereby) is to be kept up, in pleasure gardens, room decorations, all kinds of tasteful furniture, etc., regularity that shows constraint is avoided as much as possible. Thus in the English taste in gardens or in bizarre taste in furniture, the freedom of the imagination is pushed almost near to the grotesque, and in this separation from every constraint of rule we have the case where taste can display its greatest perfection in the enterprises of the imagination.

All stiff regularity (such as approximates to mathematical regularity) has something in it repugnant to taste; for our entertainment in the contemplation of it lasts for no length of time, but it rather, in so far as it has not expressly in view cognition or a definite practical purpose, produces weariness. On the other hand, that with which imagination can play in an unstudied and purposive manner is always new to us, and one does not get tired of looking at it. Marsden, in his description of Sumatra, makes the remark that the free beauties of nature surround the spectator everywhere and thus lose their attraction for him. On the other hand, a pepper garden, where the stakes on which this plant twines itself form parallel rows, had much attractiveness for him if he met with it in the middle of a forest. And he hence infers that wild beauty, apparently irregular, only pleases as a variation from the regular beauty of which one has seen enough. But he need only have made the experiment of spending one day in a pepper garden to have been convinced that, if the understanding has put itself in accordance with the order that it always needs by means of regularity, the object will not entertain for long—nay, rather it will impose a burdensome constraint upon the imagination. On the other hand, nature, which there is prodigal in its variety even to luxuriance, that is subjected to no constraint of artificial rules, can supply constant food for taste. Even the song of birds, which we can bring under no musical rule, seems to have more freedom, and therefore more for taste, than a song of a human being which is produced in accordance with all the rules of music; for we very much sooner weary of the latter if it is repeated often and at length. Here, however, we probably confuse our participation in the mirth of a little creature that we love with the beauty of its song, for if this were exactly imitated by man (as sometimes the notes of the nightingale are), it would seem to our ear quite devoid of taste.

Again, beautiful objects are to be distinguished from beautiful views of objects (which often on account of their distance cannot be more clearly cognized). In the latter case taste appears, not so much in what the imagination *apprehends* in this field, as in the impulse it thus gets to *fiction*, i.e. in the peculiar fancies with which the mind entertains itself, while it is continually being aroused by the variety which strikes the eye. An illustration is afforded, e.g. by the sight of the changing shapes of a fire on the hearth or of a rippling brook; neither of these has beauty, but they bring with them a charm for the imagination because they entertain it in free play.

SECOND BOOK

ANALYTIC OF THE SUBLIME

DEDUCTION OF [PURE][17] AESTHETICAL JUDGMENTS

§ 31. OF THE METHOD OF DEDUCTION OF JUDGMENTS OF TASTE

A deduction, i.e. the guarantee of the legitimacy of a class of judgments, is only obligatory if the judgment lays claim to necessity. This it does if it demands even subjective universality or the agreement of everyone, although it is not a judgment of cognition, but only one of pleasure or pain in a given object, i.e. it assumes a subjective purposiveness thoroughly valid for everyone, which must not be based on any concept of the thing, because the judgment is one of taste.

We have before us in the latter case no cognitive judgment—neither a theoretical one based on the concept of a *nature* in general formed by the understanding, nor a (pure) practical one based on the idea of *freedom*, as given *a priori* by reason. Therefore we have to justify *a priori* the validity, neither of a judgment which represents what a thing is, nor of one which prescribes that I ought to do something in order to produce it. We have merely to prove for the judgment generally the *universal validity* of a singular judgment that expresses the subjective purposiveness of an empirical representation of the form of an object, in order to explain how it is possible that a thing can please in the mere act of judging it (without sensation or concept) and how the satisfaction of one man can be proclaimed as a rule for every other, just as the act of judging of an object for the sake of a *cognition* in general has universal rules.

. . .

§ 34. THERE IS NO OBJECTIVE PRINCIPLE OF TASTE POSSIBLE

By a principle of taste I mean a principle under the condition of which we could subsume the concept of an object and thus infer, by means of a syllogism, that the object is beautiful. But that is absolutely impossible. For I must immediately feel pleasure in the representation of the object, and of that I can be persuaded by no grounds of proof whatever. Although, as Hume says,[18] all critics can reason more plausibly than cooks, yet the

[17] [Second edition.]

[18] [Essay XVIII, "The Sceptic": "Critics can reason and dispute more plausibly than cooks or perfumers. We may observe, however, that this uniformity among human kind, hinders not, but that there is a considerable diversity in the sentiments of beauty and worth, and that education, custom, prejudice, caprice, and humour, frequently vary our taste of this kind. . . . Beauty and worth are merely of a relative nature, and consist in an agreeable sentiment, produced by an object in a particular mind, according to the peculiar structure and constitution of that mind." (In *Hume's Moral and Political Philosophy*, ed. Aiken, "Hafner Library of Classics" #3, 1948, pp. 338 ff.—Ed.)]

170

same fate awaits them. They cannot expect the determining ground of their judgment [to be derived] from the force of the proofs, but only from the reflection of the subject upon its own proper state (of pleasure or pain), all precepts and rules being rejected.

But although critics can and ought to pursue their reasonings so that our judgments of taste may be corrected and extended, it is not with a view to set forth the determining ground of this kind of aesthetical judgments in a universally applicable formula, which is impossible; but rather to investigate the cognitive faculties and their exercise in these judgments, and to explain by examples the reciprocal subjective purposiveness, the form of which, as has been shown above, in a given representation, constitutes the beauty of the object.

. . .

§ 36. OF THE PROBLEM OF A DEDUCTION OF JUDGMENTS OF TASTE

The concept of an object in general can immediately be combined with the perception of an object, containing its empirical predicates, so as to form a cognitive judgment; and it is thus that a judgment of experience is produced. At the basis of this lie *a priori* concepts of the synthetical unity of the manifold of intuition, by which the manifold is thought as the determination of an object. These concepts (the categories) require a deduction, which is given in the *Critique of Pure Reason;* and by it we can get the solution of the problem: how are synthetical *a priori* cognitive judgments possible? This problem concerns then the *a priori* principles of the pure understanding and its theoretical judgments.

But with a perception there can also be combined a feeling of pleasure (or pain) and a satisfaction, that accompanies the representation of the object and serves instead of its predicate; thus there can result an aesthetical noncognitive judgment. At the basis of such a judgment—if it is not a mere judgment of sensation but a formal judgment of reflection, which imputes the same satisfaction necessarily to everyone—must lie some *a priori* principle, which may be merely subjective (if an objective one should prove impossible for judgments of this kind), but also as such may need a deduction, that we may thereby comprehend how an aesthetical judgment can lay claim to necessity. On this is founded the problem with which we are now occupied: how are judgments of taste possible? This problem, then, has to do with the *a priori* principles of the pure faculty of judgment in *aesthetical* judgments, i.e. judgments in which it has not (as in theoretical ones) merely to subsume under objective concepts of understanding and in which it is subject to a law, but in which it is itself, subjectively, both object and law.

This problem then may be thus represented: how is a judgment possible in which merely from *our own* feeling of pleasure in an object, independently of its concept, we judge that this pleasure attaches to the representa-

tion of the same object *in every other subject*, and that *a priori* without waiting for the accordance of others?

It is easy to see that judgments of taste are synthetical, because they go beyond the concept and even beyond the intuition of the object, and add to that intuition as predicate something that is not a cognition, viz. a feeling of pleasure (or pain). Although the predicate (of the *personal* pleasure bound up with the representation) is empirical, nevertheless, as concerns the required assent of *everyone* the judgments are *a priori*, or desire to be regarded as such; and this is already involved in the expressions of this claim. Thus this problem of the *Critique of Judgment* belongs to the general problem of transcendental philosophy: how are synthetical *a priori* judgments possible?

§ 37. WHAT IS PROPERLY ASSERTED A PRIORI OF AN OBJECT IN A JUDGMENT OF TASTE

That the representation of an object is immediately bound up with pleasure can only be internally perceived; and if we did not wish to indicate anything more than this, it would give a merely empirical judgment. For I cannot combine a definite feeling (of pleasure or pain) with any representation, except where there is at bottom an *a priori* principle in the reason determining the will. In that case the pleasure (in the moral feeling) is the consequence of the principle, but cannot be compared with the pleasure in taste, because it requires a definite concept of a law; and the latter pleasure, on the contrary, must be bound up with the mere act of judging, prior to all concepts. Hence also all judgments of taste are singular judgments, because they do not combine their predicate of satisfaction with a concept, but with a given individual empirical representation.

And so it is not the pleasure, but the *universal validity of this pleasure*, perceived as mentally bound up with the mere judgment upon an object, which is represented *a priori* in a judgment of taste as a universal rule for the judgment and valid for everyone. It is an empirical judgment [to say] that I perceive and judge an object with pleasure. But it is an *a priori* judgment [to say] that I find it beautiful, i.e. I attribute this satisfaction necessarily to everyone.

§ 38. DEDUCTION OF JUDGMENTS OF TASTE

If it be admitted that, in a pure judgment of taste, the satisfaction in the object is combined with the mere act of judging its form, it is nothing else than its subjective purposiveness for the judgment which we feel to be mentally combined with the representation of the object. The judgment, as regards the formal rules of its action, apart from all matter (whether sensation or concept), can only be directed to the subjective conditions of its employment in general (it is applied neither to a particular mode of sense

nor to a particular concept of the understanding), and consequently to that subjective [element] which we can presuppose in all men (as requisite for possible cognition in general). Thus the agreement of a representation with these conditions of the judgment must be capable of being assumed as valid *a priori* for everyone. That is, we may rightly impute to everyone the pleasure or the subjective purposiveness of the representation for the relation between the cognitive faculties in the act of judging a sensible object in general.[19]

Remark

This deduction is thus easy, because it has no need to justify the objective reality of any concept, for beauty is not a concept of the object and the judgment of taste is not cognitive. It only maintains that we are justified in presupposing universally in every man those subjective conditions of the judgment which we find in ourselves; and further, that we have rightly subsumed the given object under these conditions. The latter has indeed unavoidable difficulties which do not beset the logical judgment. There we subsume under concepts, but in the aesthetical judgment under a merely sensible relation between the imagination and understanding mutually harmonizing in the representation of the form of the object—in which case the subsumption may easily be deceptive. Yet the legitimacy of the claim of the judgment in counting upon universal assent is not thus annulled; it reduces itself merely to judging as valid for everyone the correctness of the principle from subjective grounds. For as to the difficulty or doubt concerning the correctness of the subsumption under that principle, it makes the legitimacy of the claim of an aesthetical judgment in general to such validity and the principle of the same as little doubtful as the alike (though neither so commonly nor readily) faulty subsumption of the logical judgment under its principle can make the latter, an objective principle, doubtful.

. . .

§ 40. OF TASTE AS A KIND OF SENSUS COMMUNIS

We often give to the judgment, if we are considering the result rather than the act of its reflection, the name of a sense, and we speak of a sense of truth, or of a sense of decorum, of justice, etc. And yet we know, or at least we ought to know, that these concepts cannot have their place in sense, and further, that sense has not the least capacity for expressing universal rules; but that no representation of truth, fitness, beauty, or justice, and so forth could come into our thoughts if we could not rise

[19] In order to be justified in claiming universal assent for an aesthetical judgment that rests merely on subjective grounds, it is sufficient to assume: (1) That the subjective conditions of the judgment, as regards the relation of the cognitive powers thus put into activity to a cognition in general, are the same in all men. This must be true, because otherwise men would not be able to communicate their

beyond sense to higher faculties of cognition. *The common understanding of men*, which, as the mere healthy (not yet cultivated) understanding, we regard as the least to be expected from anyone claiming the name of man, has therefore the doubtful honor of being given the name of "common sense" (*sensus communis*); and in such a way that, by the name "common" (not merely in our language, where the word actually has a double signification, but in many others), we understand "vulgar," that which is everywhere met with, the possession of which indicates absolutely no merit or superiority.

But under the *sensus communis* we must include the idea of a sense *common to all*, i.e. of a faculty of judgment which, in its reflection, takes account (*a priori*) of the mode of representation of all other men in thought, in order, as it were, to compare its judgment with the collective reason of humanity, and thus to escape the illusion arising from the private conditions that could be so easily taken for objective, which would injuriously affect the judgment. This is done by comparing our judgment with the possible rather than the actual judgments of others, and by putting ourselves in the place of any other man, by abstracting from the limitations which contingently attach to our own judgment. This again is brought about by leaving aside as much as possible the matter of our representative state, i.e. sensation, and simply having respect to the formal peculiarities of our representation or representative state. Now this operation of reflection seems perhaps too artificial to be attributed to the faculty called *common sense*, but it only appears so when expressed in abstract formulae. In itself there is nothing more natural than to abstract from charm or emotion if we are seeking a judgment that is to serve as a universal rule.

. . .

I take up again the threads interrupted by this digression, and I say that taste can be called *sensus communis* with more justice than sound understanding can, and that the aesthetical judgment rather than the intellectual may bear the name of a sense common to all,[20] if we are willing to use the word "sense" of an effect of mere reflection upon the mind, for then we understand by sense the feeling of pleasure. We could even define taste as the faculty of judging of that which makes *universally communicable*, without the mediation of a concept, our feeling in a given representation.

The skill that men have in communicating their thoughts requires also a relation between the imagination and the understanding in order to asso-

representations or even their knowledge. (2) The judgment must merely have reference to this relation (consequently to the *formal condition* of the judgment) and be pure, i.e. not mingled either with concepts of the object or with sensations, as determining grounds. If there has been any mistake as regards this latter condition, then there is only an inaccurate application of the privilege, which a law gives us, to a particular case; but that does not destroy the privilege itself in general.

[20] We may designate taste as *sensus communis aestheticus*, common understanding as *sensus communis logicus*.

ciate intuitions with concepts, and concepts again with those concepts, which then combine in a cognition. But in that case the agreement of the two mental powers is *according to law*, under the constraint of definite concepts. Only where the imagination in its freedom awakens the understanding and is put by it into regular play, without the aid of concepts, does the representation communicate itself, not as a thought, but as an internal feeling of a purposive state of the mind.

Taste is then the faculty of judging *a priori* of the communicability of feelings that are bound up with a given representation (without the mediation of a concept).

If we could assume that the mere universal communicability of a feeling must carry in itself an interest for us with it (which, however, we are not justified in concluding from the character of a merely reflective judgment), we should be able to explain why the feeling in the judgment of taste comes to be imputed to everyone, so to speak, as a duty.

. . .

§ 45. BEAUTIFUL ART IS AN ART IN SO FAR AS IT SEEMS LIKE NATURE

In a product of beautiful art, we must become conscious that it is art and not nature; but yet the purposiveness in its form must seem to be as free from all constraint of arbitrary rules as if it were a product of mere nature. On this feeling of freedom in the play of our cognitive faculties, which must at the same time be purposive, rests that pleasure which alone is universally communicable, without being based on concepts. Nature is beautiful because it looks like art, and art can only be called beautiful if we are conscious of it as art while yet it looks like nature.

For whether we are dealing with natural or with artificial beauty, we can say generally: *That is beautiful which pleases in the mere act of judging it* (not in the sensation of it or by means of a concept). Now art has always a definite design of producing something. But if this something were bare sensation (something merely subjective), which is to be accompanied with pleasure, the product would please in the act of judgment only by mediation of sensible feeling. And again, if the design were directed toward the production of a definite object, then, if this were attained by art, the object would only please by means of concepts. But in both cases the art would not please *in the mere act of judging*, i.e. it would not please as beautiful but as mechanical.

Hence the purposiveness in the product of beautiful art, although it is designed, must not seem to be designed, i.e. beautiful art must *look* like nature, although we are conscious of it as art. But a product of art appears like nature when, although its agreement with the rules, according to which alone the product can become what it ought to be, is *punctiliously* observed, yet this is not *painfully* apparent; [the form of the schools does not obtrude itself]—it shows no trace of the rule having been before the eyes of the artist and having fettered his mental powers.

§ 46. BEAUTIFUL ART IS THE ART OF GENIUS

Genius is the talent (or natural gift) which gives the rule to art. Since talent, as the innate productive faculty of the artist, belongs itself to nature, we may express the matter thus: Genius is the innate mental disposition (*ingenium*) *through which* nature gives the rule to art.

Whatever may be thought of this definition, whether it is merely arbitrary or whether it is adequate to the concept that we are accustomed to combine with the word *genius* (which is to be examined in the following paragraphs), we can prove already beforehand that, according to the signification of the word here adopted, beautiful arts must necessarily be considered as arts of *genius*.

For every art presupposes rules by means of which in the first instance a product, if it is to be called artistic, is represented as possible. But the concept of beautiful art does not permit the judgment upon the beauty of a product to be derived from any rule which has a *concept* as its determining ground, and therefore has at its basis a concept of the way in which the product is possible. Therefore beautiful art cannot itself devise the rule according to which it can bring about its product. But since at the same time a product can never be called art without some precedent rule, nature in the subject must (by the harmony of its faculties) give the rule to art; i.e. beautiful art is only possible as a product of genius.

We thus see (1) that genius is a *talent* for producing that for which no definite rule can be given; it is not a mere aptitude for what can be learned by a rule. Hence *originality* must be its first property. (2) But since it also can produce original nonsense, its products must be models, i.e. *exemplary*, and they consequently ought not to spring from imitation, but must serve as a standard or rule of judgment for others. (3) It cannot describe or indicate scientifically how it brings about its products, but it gives the rule just as nature does. Hence the author of a product for which he is indebted to his genius does not know himself how he has come by his ideas; and he has not the power to devise the like at pleasure or in accordance with a plan, and to communicate it to others in precepts that will enable them to produce similar products. (Hence it is probable that the word "genius" is derived from *genius*, that peculiar guiding and guardian spirit given to a man at his birth, from whose suggestion these original ideas proceed.) (4) Nature, by the medium of genius, does not prescribe rules to science but to art, and to it only in so far as it is to be beautiful art.

§ 47. ELUCIDATION AND CONFIRMATION OF THE ABOVE EXPLANATION OF GENIUS

Everyone is agreed that genius is entirely opposed to the *spirit of imitation*. Now since learning is nothing but imitation, it follows that the greatest ability and teachableness (capacity) regarded *quâ* teachableness

cannot avail for genius. Even if a man thinks or composes for himself and does not merely take in what others have taught, even if he discovers many things in art and science, this is not the right ground for calling such a (perhaps great) *head* a genius (as opposed to him who, because he can only learn and imitate, is called a *shallowpate*). For even these things could be learned; they lie in the natural path of him who investigates and reflects according to rules, and they do not differ specifically from what can be acquired by industry through imitation. Thus we can readily learn all that Newton has set forth in his immortal work on the *Principles of Natural Philosophy*, however great a head was required to discover it, but we cannot learn to write spirited poetry, however express may be the precepts of the art and however excellent its models. The reason is that Newton could make all his steps, from the first elements of geometry to his own great and profound discoveries, intuitively plain and definite as regards consequence, not only to himself but to everyone else. But a Homer or a Wieland cannot show how his ideas, so rich in fancy and yet so full of thought, come together in his head, simply because he does not know and therefore cannot teach others. In science, then, the greatest discoverer only differs in degree from his laborious imitator and pupil, but he differs specifically from him whom nature has gifted for beautiful art. And in this there is no depreciation of those great men to whom the human race owes so much gratitude, as compared with nature's favorites in respect of the talent for beautiful art. For in the fact that the former talent is directed to the ever advancing greater perfection of knowledge and every advantage depending on it, and at the same time to the imparting this same knowledge to others—in this it has a great superiority over [the talent of] those who deserve the honor of being called geniuses. For art stands still at a certain point; a boundary is set to it beyond which it cannot go, which presumably has been reached long ago and cannot be extended further. Again, artistic skill cannot be communicated; it is imparted to every artist immediately by the hand of nature; and so it dies with him, until nature endows another in the same way, so that he only needs an example in order to put in operation in a similar fashion the talent of which he is conscious.

If now it is a natural gift which must prescribe its rule to art (as beautiful art), of what kind is this rule? It cannot be reduced to a formula and serve as a precept, for then the judgment upon the beautiful would be determinable according to concepts; but the rule must be abstracted from the fact, i.e. from the product, on which others may try their own talent by using it as a model, not to be *copied* but to be *imitated*. How this is possible is hard to explain. The ideas of the artist excite like ideas in his pupils if nature has endowed them with a like proportion of their mental powers. Hence models of beautiful art are the only means of handing down these ideas to posterity. This cannot be done by mere descriptions, especially not in the case of the arts of speech; and in this latter classical

models are only to be had in the old dead languages, now preserved only as "the learned languages."

Although mechanical and beautiful art are very different, the first being a mere art of industry and learning and the second of genius, yet there is no beautiful art in which there is not a mechanical element that can be comprehended by rules and followed accordingly, and in which therefore there must be something *scholastic* as an essential condition. For [in every art] some purpose must be conceived; otherwise we could not ascribe the product to art at all; it would be a mere product of chance. But in order to accomplish a purpose, definite rules from which we cannot dispense ourselves are requisite. Now since the originality of the talent constitutes an essential (though not the only) element in the character of genius, shallow heads believe that they cannot better show themselves to be full-blown geniuses than by throwing off the constraint of all rules; they believe, in effect, that one could make a braver show on the back of a wild horse than on the back of a trained animal. Genius can only furnish rich *material* for products of beautiful art; its execution and its *form* require talent cultivated in the schools, in order to make such a use of this material as will stand examination by the judgment. But it is quite ridiculous for a man to speak and decide like a genius in things which require the most careful investigation by reason. One does not know whether to laugh more at the impostor who spreads such a mist round him that we cannot clearly use our judgment, and so use our imagination the more, or at the public which naïvely imagines that his inability to cognize clearly and to comprehend the masterpiece before him arises from new truths crowding in on him in such abundance that details (duly weighed definitions and accurate examination of fundamental propositions) seem but clumsy work.

§ 48. OF THE RELATION OF GENIUS TO TASTE

For *judging* of beautiful objects as such, *taste* is requisite; but for beautiful art, i.e. for the *production* of such objects, *genius* is requisite.

If we consider genius as the talent for beautiful art (which the special meaning of the word implies) and in this point of view analyze it into the faculties which must concur to constitute such a talent, it is necessary in the first instance to determine exactly the difference between natural beauty, the judging of which requires only taste, and artificial beauty, the possibility of which (to which reference must be made in judging such an object) requires genius.

A natural beauty is a *beautiful thing;* artificial beauty is a *beautiful representation* of a thing.

In order to judge of a natural beauty as such, I need not have beforehand a concept of what sort of thing the object is to be; i.e. I need not know its material purposiveness (the purpose), but its mere form pleases

by itself in the act of judging it without any knowledge of the purpose. But if the object is given as a product of art and as such is to be declared beautiful, then, because art always supposes a purpose in the cause (and its causality), there must be at bottom in the first instance a concept of what the thing is to be. And as the agreement of the manifold in a thing with its inner destination, its purpose, constitutes the perfection of the thing, it follows that in judging of artificial beauty the perfection of the thing must be taken into account; but in judging of natural beauty (as *such*) there is no question at all about this. It is true that in judging of objects of nature, especially objects endowed with life, e.g. a man or a horse, their objective purposiveness also is commonly taken into consideration in judging of their beauty; but then the judgment is no longer purely aesthetical, i.e. a mere judgment of taste. Nature is no longer judged inasmuch as it appears like art, but in so far as it *is* actual (although superhuman) art; and the teleological judgment serves as the basis and condition of the aesthetical, as a condition to which the latter must have respect. In such a case, e.g. if it is said "That is a beautiful woman," we think nothing else than this: nature represents in her figure the purposes in view in the shape of a woman's figure. For we must look beyond the mere form to a concept, if the object is to be thought in such a way by means of a logically conditioned aesthetical judgment.

Beautiful art shows its superiority in this, that it describes as beautiful things which may be in nature ugly or displeasing. The Furies, diseases, the devastations of war, etc., may [even regarded as calamitous] be described as very beautiful, as they are represented in a picture. There is only one kind of ugliness which cannot be represented in accordance with nature without destroying all aesthetical satisfaction, and consequently artificial beauty, viz. that which excites *disgust*. For in this singular sensation, which rests on mere imagination, the object is represented as it were obtruding itself for our enjoyment, while we strive against it with all our might. And the artistic representation of the object is no longer distinguished from the nature of the object itself in our sensation, and thus it is impossible that it can be regarded as beautiful. The art of sculpture again, because in its products art is almost interchangeable with nature, excludes from its creations the immediate representation of ugly objects; e.g. it represents death by a beautiful genius, the warlike spirit by Mars, and permits [all such things] to be represented only by an allegory or attribute that has a pleasing effect, and thus only indirectly by the aid of the interpretation of reason, and not for the mere aesthetical judgment.

So much for the beautiful representation of an object, which is properly only the form of the presentation of a concept, by means of which this latter is communicated universally. But to give this form to the product of beautiful art, mere taste is requisite. By taste the artist estimates his work after he has exercised and corrected it by manifold examples from art

or nature, and after many, often toilsome, attempts to content himself he finds that form which satisfies him. Hence this form is not, as it were, a thing of inspiration or the result of a free swing of the mental powers, but of a slow and even painful process of improvement, by which he seeks to render it adequate to his thought, without detriment to the freedom of the play of his powers.

But taste is merely a judging and not a productive faculty, and what is appropriate to it is therefore not a work of beautiful art. It can only be a product belonging to useful and mechanical art or even to science, produced according to definite rules that can be learned and must be exactly followed. But the pleasing form that is given to it is only the vehicle of communication and a mode, as it were, of presenting it, in respect of which we remain free to a certain extent, although it is combined with a definite purpose. Thus we desire that table appointments, a moral treatise, even a sermon, should have in themselves this form of beautiful art, without it seeming to be *sought;* but we do not therefore call these things works of beautiful art. Under the latter class are reckoned a poem, a piece of music, a picture gallery, etc.; and in some works of this kind asserted to be works of beautiful art we find genius without taste, while in others we find taste without genius.

§ 49. OF THE FACULTIES OF THE MIND THAT CONSTITUTE GENIUS

We say of certain products of which we expect that they should at least in part appear as beautiful art, they are without *spirit*, although we find nothing to blame in them on the score of taste. A poem may be very neat and elegant, but without spirit. A history may be exact and well arranged, but without spirit. A festal discourse may be solid and at the same time elaborate, but without spirit. Conversation is often not devoid of entertainment, but it is without spirit; even of a woman we say that she is pretty, an agreeable talker, and courteous, but without spirit. What then do we mean by spirit?

Spirit, in an aesthetical sense, is the name given to the animating principle of the mind. But that by means of which this principle animates the soul, the material which it applies to that [purpose], is what puts the mental powers purposively into swing, i.e., into such a play as maintains itself and strengthens the mental powers in their exercise.

Now I maintain that this principle is no other than the faculty of presenting *aesthetical ideas*. And by an aesthetical idea I understand that representation of the imagination which occasions much thought, without however any definite thought, i.e. any *concept*, being capable of being adequate to it; it consequently cannnot be completely compassed and made intelligible by language. We easily see that it is the counterpart (pendant) of a *rational idea*, which conversely is a concept to which no *intuition* (or representation of the imagination) can be adequate.

The imagination (as a productive faculty of cognition) is very powerful in creating another nature, as it were, out of the material that actual nature gives it. We entertain ourselves with it when experience becomes too commonplace, and by it we remold experience, always indeed in accordance with analogical laws, but yet also in accordance with principles which occupy a higher place in reason (laws, too, which are just as natural to us as those by which understanding comprehends empirical nature). Thus we feel our freedom from the law of association (which attaches to the empirical employment of imagination), so that the material supplied to us by nature in accordance with this law can be worked up into something different which surpasses nature.

Such representations of the imagination we may call *ideas*, partly because they at least strive after something which lies beyond the bounds of experience and so seek to approximate to a presentation of concepts of reason (intellectual ideas), thus giving to the latter the appearance of objective reality, but especially because no concept can be fully adequate to them as internal intuitions. The poet ventures to realize to sense, rational ideas of invisible beings, the kingdom of the blessed, hell, eternity, creation, etc.; or even if he deals with things of which there are examples in experience—e.g. death, envy and all vices, also love, fame, and the like— he tries, by means of imagination, which emulates the play of reason in its quest after a maximum, to go beyond the limits of experience and to present them to sense with a completeness of which there is no example in nature. This is properly speaking the art of the poet, in which the faculty of aesthetical ideas can manifest itself in its entire strength. But this faculty, considered in itself, is properly only a talent (of the imagination).

If now we place under a concept a representation of the imagination belonging to its presentation, but which occasions in itself more thought than can ever be comprehended in a definite concept and which consequently aesthetically enlarges the concept itself in an unbounded fashion, the imagination is here creative, and it brings the faculty of intellectual ideas (the reason) into movement; i.e. by a representation more thought (which indeed belongs to the concept of the object) is occasioned than can in it be grasped or made clear.

Those forms which do not constitute the presentation of a given concept itself but only, as approximate representations of the imagination, express the consequences bound up with it and its relationship to other concepts, are called (aesthetical) *attributes* of an object whose concept as a rational idea cannot be adequately presented. Thus Jupiter's eagle with the lightning in its claws is an attribute of the mighty king of heaven, as the peacock is of his magnificent queen. They do not, like *logical attributes*, represent what lies in our concepts of the sublimity and majesty of creation, but something different, which gives occasion to the imagination to spread itself over a number of kindred representations that

arouse more thought than can be expressed in a concept determined by words. They furnish an *aesthetical idea*, which for that rational idea takes the place of logical presentation; and thus, as their proper office, they enliven the mind by opening out to it the prospect into an illimitable field of kindred representations. But beautiful art does this not only in the case of painting or sculpture (in which the term "attribute" is commonly employed); poetry and rhetoric also get the spirit that animates their works simply from the aesthetical attributes of the object, which accompany the logical and stimulate the imagination, so that it thinks more by their aid, although in an undeveloped way, than could be comprehended in a concept and therefore in a definite form of words. For the sake of brevity I must limit myself to a few examples only.

When the great King in one of his poems expresses himself as follows:

> Oui, finissons sans trouble et mourons sans regrets,
> En laissant l'univers comblé de nos bienfaits.
> Ainsi l'astre du jour au bout de sa carriere,
> Répand sur l'horizon une douce lumière;
> Et les derniers rayons qu'il darde dans les airs,
> Sont les derniers soupirs qu'il donne a l'univers;

he quickens his rational idea of a cosmopolitan disposition at the end of life by an attribute which the imagination (in remembering all the pleasures of a beautiful summer day that are recalled at is close by a serene evening) associates with that representation, and which excites a number of sensations and secondary representations for which no expression is found. On the other hand, an intellectual concept may serve conversely as an attribute for a representation of sense, and so can quicken this latter by means of the idea of the supersensible, but only by the aesthetical [element], that subjectively attaches to the concept of the latter, being here employed. Thus, for example, a certain poet says, in his description of a beautiful morning:

> The sun arose
> As calm from virtue springs.

The consciousness of virtue, if we substitute it in our thoughts for a virtuous man, diffuses in the mind a multitude of sublime and restful feelings, and a boundless prospect of a joyful future, to which no expression that is measured by a definite concept completely attains.[21]

In a word, the aesthetical idea is a representation of the imagination

[21] Perhaps nothing more sublime was ever said and no sublimer thought ever expressed than the famous inscription on the Temple of Isis (Mother Nature): "I am all that is and that was and that shall be, and no mortal hath lifted my veil." Segner availed himself of this idea in a *suggestive* vignette prefixed to his *Natural Philosophy*, in order to inspire beforehand the pupil whom he was about to lead into that temple with a holy awe, which should dispose his mind to serious attention. [J. A. de Segner (1704–1777) was Professor of Natural Philosophy at Göttingen and the author of several scientific works of repute.]

associated with a given concept, which is bound up with such a multi-
plicity of partial representations in its free employment that for it no
expression marking a definite concept can be found; and such a represen-
tation, therefore, adds to a concept much ineffable thought, the feeling of
which quickens the cognitive faculties, and with language, which is the
mere letter, binds up spirit also.

The mental powers, therefore, whose union (in a certain relation) con-
stitutes genius are imagination and understanding. In the employment of
the imagination for cognition, it submits to the constraint of the under-
standing and is subject to the limitation of being conformable to the con-
cept of the latter. On the contrary, in an aesthetical point of view it is free
to furnish unsought, over and above that agreement with a concept, abun-
dance of undeveloped material for the understanding, to which the under-
standing paid no regard in its concept but which it applies, though not
objectively for cognition, yet subjectively to quicken the cognitive powers
and therefore also indirectly to cognitions. Thus genius properly consists
in the happy relation [between these faculties], which no science can
teach and no industry can learn, by which ideas are found for a given
concept; and, on the other hand, we thus find for these ideas the expression
by means of which the subjective state of mind brought about by them, as
an accompaniment of the concept, can be communicated to others. The
latter talent is, properly speaking, what is called spirit; for to express
the ineffable element in the state of mind implied by a certain representa-
tion and to make it universally communicable—whether the expression be
in speech or painting or statuary—this requires a faculty of seizing the
quickly passing play of imagination and of unifying it in a concept (which
is even on that account original and discloses a new rule that could not
have been inferred from any preceding principles or examples) that can
be communicated without any constraint [of rules].[22]

If, after this analysis, we look back to the explanation given above of
what is called *genius*, we find: first, that it is a talent for art, not for
science, in which clearly known rules must go beforehand and determine
the procedure. Secondly, as an artistic talent it presupposes a definite con-
cept of the product as the purpose, and therefore understanding; but it also
presupposes a representation (although an indeterminate one) of the
material, i.e. of the intuition, for the presentment of this concept, and,
therefore a relation between the imagination and the understanding.
Thirdly, it shows itself, not so much in the accomplishment of the proposed
purpose in a presentment of a definite concept, as in the enunciation or
expression of aesthetical ideas which contain abundant material for that
very design; and consequently it represents the imagination as free from
all guidance of rules and yet as purposive in reference to the presentment

[22] [Second edition.]

of the given concept. Finally, in the fourth place, the unsought undesigned subjective purposiveness in the free accordance of the imagination with the legality of the understanding presupposes such a proportion and disposition of these faculties as no following of rules, whether of science or of mechanical imitation, can bring about, but which only the nature of the subject can produce.

In accordance with these suppositions, genius is the exemplary originality of the natural gifts of a subject in the *free employment* of his cognitive faculties. In this way the product of a genius (as regards what is to be ascribed to genius and not to possible learning or schooling) is an example, not to be imitated (for then that which in it is genius and constitutes the spirit of the work would be lost), but to be followed by another genius, whom it awakens to a feeling of his own originality and whom it stirs so to exercise his art in freedom from the constraint of rules, that thereby a new rule is gained for art; and thus his talent shows itself to be exemplary. But because a genius is a favorite of nature and must be regarded by us as a rare phenomenon, his example produces for other good heads a school, i.e. a methodical system of teaching according to rules, so far as these can be derived from the peculiarities of the products of his spirit. For such persons beautiful art is so far imitation, to which nature through the medium of a genius supplied the rule.

But this imitation becomes a mere *aping* if the scholar *copies* everything down to the deformities, which the genius must have let pass only because he could not well remove them without weakening his idea. This mental characteristic is meritorious only in the case of a genius. A certain *audacity* in expression—and in general many a departure from common rules— becomes him well, but it is in no way worthy of imitation; it always remains a fault in itself which we must seek to remove, though the genius is, as it were, privileged to commit it, because the inimitable rush of his spirit would suffer from overanxious carefulness. *Mannerism* is another kind of aping, viz. of mere *peculiarity* (originality) in general, by which a man separates himself as far as possible from imitators, without however possessing the talent to be at the same time *exemplary*. There are indeed in general two ways (*modi*) in which such a man may put together his notions of expressing himself; the one is called a *manner (modus aestheticus)*, the other a *method (modus logicus)*. They differ in this that the former has no other standard than the *feeling* of unity in the presentment, but the latter follows definite *principles;* hence the former alone avails for beautiful art. But an artistic product is said to show *mannerism* only when the exposition of the artist's idea is *founded* on its very singularity and is not made appropriate to the idea itself. The ostentatious *(précieux)*, contorted, and affected [manner adopted] to differentiate oneself from ordinary persons (though devoid of spirit) is like the behavior of a man of whom we say that he hears himself talk, or who stands and moves about as if he were on a stage in order to be stared at; this always betrays a bungler.

§ 50. OF THE COMBINATION OF TASTE WITH GENIUS IN THE PRODUCTS OF BEAUTIFUL ART

To ask whether it is more important for the things of beautiful art that genius or taste should be displayed is the same as to ask whether in it more depends on imagination or on judgment. Now since in respect of the first an art is rather said to be *full of spirit*, but only deserves to be called a *beautiful* art on account of the second, this latter is at least, as its indispensable condition (*conditio sine qua non*), the most important thing to which one has to look in the judging of art as beautiful art. Abundance and originality of ideas are less necessary to beauty than the accordance of the imagination in its freedom with the conformity to law of the understanding. For all the abundance of the former produces in lawless freedom nothing but nonsense; on the other hand, the judgment is the faculty by which it is adjusted to the understanding.

Taste, like the judgment in general, is the discipline (or training) of genius; it clips its wings, it makes it cultured and polished; but, at the same time, it gives guidance as to where and how far it may extend itself if it is to remain purposive. And while it brings clearness and order into the multitude of the thoughts [of genius], it makes the ideas susceptible of being permanently and, at the same time, universally assented to, and capable of being followed by others, and of an ever progressive culture. If, then, in the conflict of these two properties in a product something must be sacrificed, it should be rather on the side of genius; and the judgment, which in the things of beautiful art gives its decision from its own proper principles, will rather sacrifice the freedom and wealth of the imagination than permit anything prejudicial to the understanding.

For beautiful art, therefore, *imagination, understanding, spirit,* and *taste* are requisite.[23]

§ 51. OF THE DIVISION OF THE BEAUTIFUL ARTS

We may describe beauty in general (whether natural or artificial) as the expression of aesthetical ideas; only that in beautiful art this idea must be occasioned by a concept of the object, while in beautiful nature the mere reflection upon a given intuition, without any concept of what the object is to be, is sufficient for the awakening and communicating of the idea of which that object is regarded as the expression.

If, then, we wish to make a division of the beautiful arts, we cannot

[23] The three former faculties are *united* in the first instance by means of the fourth. Hume gives us to understand in his *History of England* that although the English are inferior in their productions to no people in the world as regards the evidences they display of the three former properties, *separately* considered, yet they must be put after their neighbors the French as regards that which unites these properties. [In his *Observations on the Beautiful and Sublime,* § 4, *sub init.,* Kant remarks that the English have the keener sense of the *sublime,* the French of the *beautiful.*]

choose a more convenient principle, at least tentatively, than the analogy of art with the mode of expression of which men avail themselves in speech, in order to communicate to one another as perfectly as possible not merely their concepts but also their sensations.[24] This is done by *word*, *deportment*, and *tone* (articulation, gesticulation, and modulation). It is only by the combination of these three kinds of expression that communication between the speaker [and his hearers] can be complete. For thus thought, intuition, and sensation are transmitted to others simultaneously and conjointly.

There are, therefore, only three kinds of beautiful arts: the arts of *speech*, the *formative* arts, and the art of the *play of sensations* (as external sensible impressions). We may also arrange a division by dichotomy: thus beautiful art may be divided into the art of expression of thoughts and of intuitions, and these further subdivided in accordance with their form or their matter (sensation). But this would appear to be too abstract, and not so accordant with ordinary concepts.

(1) The arts of speech are *rhetoric* and *poetry*. *Rhetoric* is the art of carrying on a serious business of the understanding as if it were a free play of the imagination; *poetry*, the art of conducting a free play of the imagination as if it were a serious business of the understanding.

The *orator*, then, promises a serious business, and in order to entertain his audience conducts it as if it were a mere *play* with ideas. The *poet* merely promises an entertaining play with ideas, and yet it has the same effect upon the understanding as if he had only intended to carry on its business. The combination and harmony of both cognitive faculties, sensibility and understanding, which cannot dispense with each other but which yet cannot well be united without constraint and mutual prejudice, must appear to be undesigned and so to be brought about by themselves; otherwise it is not *beautiful* art. Hence, all that is studied and anxious must be avoided in it, for beautiful art must be free art in a double sense. It is not a work like a mercenary employment, the greatness of which can be judged according to a definite standard, which can be attained or paid for; and again, though the mind is here occupied, it feels itself thus contended and aroused without looking to any other purpose (independently of reward).

The orator therefore gives something which he does not promise, viz. an entertaining play of the imagination; but he also fails to supply what he did promise, which is indeed his announced business, viz. the purposive occupation of the understanding. On the other hand, the poet promises little and announces a mere play with ideas; but he supplies something which is worth occupying ourselves with, because he provides in this play food for the understanding and, by the aid of imagination, gives life to his

[24] The reader is not to judge this scheme for a possible division of the beautiful arts as a deliberate theory. It is only one of various attempts which we may and ought to devise.

concepts. [Thus the orator on the whole gives less, the poet more, than he promises.]²⁵

(2) The formative arts, or those by which expression is found for ideas in *sensible intuition* (not by representations of mere imagination that are aroused by words), are either arts of *sensible truth* or of *sensible illusion*. The former is called *plastic*, the latter *painting*. Both express ideas by figures in space: the former makes figures cognizable by two senses, sight and touch (although not by the latter as far as beauty is concerned); the latter only by one, the first of these. The aesthetical idea (the archetype or original image) is fundamental for both in the imagination, but the figure which expresses this (the ectype or copy) is either given in its bodily extension (as the object itself exists) or as it paints itself on the eye (according to its appearance when projected on a flat surface). In the first case the condition given to reflection may be either the reference to an actual purpose or only the semblance of it.

To *plastic*, the first kind of beautiful formative art, belong *sculpture* and *architecture*. The first presents corporeally concepts of things, *as they might have existed in nature* (though as beautiful art it has regard to aesthetical purposiveness). The second is the art of presenting concepts of things that are possible *only through art* and whose form has for its determining ground, not nature, but an arbitrary purpose, with the view of presenting them with aesthetical purposiveness. In the latter the chief point is a certain *use* of the artistic object, by which condition the aesthetical ideas are limited. In the former the main design is the mere *expression* of aesthetical ideas. Thus statues of men, gods, animals, etc., are of the first kind; but temples, splendid buildings for public assemblies, even dwelling houses, triumphal arches, columns, mausoleums, and the like, erected in honorable remembrance, belong to architecture. Indeed all house furniture (upholsterer's work and such like things which are for use) may be reckoned under this art, because the suitability of a product for a certain use is the essential thing in an *architectural work*. On the other hand, a mere *piece of sculpture*, which is simply made for show and which is to please in itself, is as a corporeal presentation a mere imitation of nature, though with a reference to aesthetical ideas; in it *sensible truth* is not to be carried so far that the product ceases to look like art and looks like a product of the elective will.

Painting, as the second kind of formative art, which presents a *sensible illusion* artificially combined with ideas, I would divide into the art of the beautiful *depicting of nature* and that of the beautiful *arrangement of its products*. The first is *painting proper*, the second is the art of *landscape gardening*. The first gives only the illusory appearance of corporeal extension; the second gives this in accordance with truth, but only the appearance of utility and availableness for other purposes than the mere

²⁵ [Second edition.]

play of the imagination in the contemplation of its forms.[26] This latter is nothing else than the ornamentation of the soil with a variety of those things (grasses, flowers, shrubs, trees, even ponds, hillocks, and dells) which nature presents to an observer, only arranged differently and in conformity with certain ideas. But, again, the beautiful arrangement of corporeal things is only apparent to the eye, like painting; the sense of touch cannot supply any intuitive presentation of such a form. Under painting in the wide sense I would reckon the decoration of rooms by the aid of tapestry, bric-a-brac, and all beautiful furniture which is merely available to be *looked* at; and the same may be said of the art of tasteful dressing (with rings, snuffboxes, etc.). For a bed of various flowers, a room filled with various ornaments (including under this head even ladies' finery), make at a fête a kind of picture which, like pictures properly so called (that are not intended to *teach* either history or natural science), has in view merely the entertainment of the imagination in free play with ideas and the occupation of the aesthetical judgment without any definite purpose. The detailed work in all this decoration may be quite distinct in the different cases and may require very different artists, but the judgment of taste upon whatever is beautiful in these various arts is always determined in the same way, viz. it only judges the forms (without any reference to a purpose) as they present themselves to the eye, either singly or in combination, according to the effect they produce upon the imagination. But that formative art may be compared (by analogy) with deportment in speech is justified by the fact that the spirit of the artist supplies by these figures a bodily expression to his thought and its mode, and makes the thing itself, as it were, speak in mimic language. This is a very common play of our fancy, which attributes to lifeless things a spirit suitable to their form by which they speak to us.

(3) The art of the beautiful play of sensations (externally produced), which admits at the same time of universal communication, can be concerned with nothing else than the proportion of the different degrees of the disposition (tension) of the sense to which the sensation belongs, i.e. with its tone. In this far-reaching signification of the word it may be divided into the artistic play of the sensations of hearing and sight, i.e. into *music* and the *art of color*. It is noteworthy that these two senses,

[26] That landscape gardening may be regarded as a species of the art of painting, although it presents its forms corporeally, seems strange. But since it actually takes its forms from nature (trees, shrubs, grasses, and flowers from forest and field—at least in the first instance) and so far is not an art like plastic, and since it also has no concept of the object and its purpose (as in architecture) conditioning its arrangements, but involves merely the free play of the imagination in contemplation, it so far agrees with mere aesthetical painting which has no definite theme (which arranges sky, land, and water so as to entertain us by means of light and shade only). In general the reader is only to judge of this as an attempt to combine the beautiful arts under one principle, viz. that of the expression of aesthetical ideas (according to the analogy of speech), and not to regard it as a definitive analysis of them.

beside their susceptibility for impressions so far as these are needed to gain concepts of external objects, are also capable of a peculiar sensation bound up therewith of which we cannot strictly decide whether it is based on sense or reflection. This susceptibility may sometimes be wanting, although in other respects the sense, as regards its use for the cognition of objects, is not at all deficient but is peculiarly fine. That is, we cannot say with certainty whether colors or tones (sounds) are merely pleasant sensations or whether they form in themselves a beautiful play of sensations, and as such bring with them in aesthetical judgment a satisfaction in the form [of the object]. If we think of the velocity of the vibrations of light or in the second case of the air, which probably far surpasses all our faculty of judging immediately in perception the time interval between them, we must believe that it is only the *effect* of these vibrations upon the elastic parts of our body that is felt, but that the *time interval* between them is not remarked or brought into judgment; and thus that only pleasantness, and not beauty of composition, is bound up with colors and tones. But on the other hand, first, we think of the mathematical [element] which enables us to pronounce on the proportion between these oscillations in music and thus to judge of them; and by analogy with which we easily may judge of the distinctions between colors. Secondly, we recall instances (although they are rare) of men who, with the best sight in the world, cannot distinguish colors and, with the sharpest hearing, cannot distinguish tones; while for those who can do this the perception of an altered quality (not merely of the degree of sensation) in the different intensities in the scale of colors and tones is definite; and further, the very number of these is fixed by *intelligible* differences. Thus we may be compelled to see that both kinds of sensations are to be regarded, not as mere sensible impressions, but as the effects of a judgment passed upon the form in the play of divers sensations. The difference in our definition, according as we adopt the one or the other opinion in judging of the grounds of music, would be just this: either, as we have done, we must explain it as the beautiful play of sensations (of hearing), or else as a play of *pleasant* sensations. According to the former mode of explanation, music is represented altogether as a *beautiful* art; according to the latter, as a *pleasant* art (at least in part).

§ 52. OF THE COMBINATION OF BEAUTIFUL ARTS IN ONE
AND THE SAME PRODUCT

Rhetoric may be combined with a pictorial presentation of its subjects and objects in a *theatrical piece;* poetry may be combined with music in a *song,* and this again with pictorial (theatrical) presentation in an *opera;* the play of sensations in music may be combined with the play of figures in the *dance,* and so on. Even the presentation of the sublime, so far as it belongs to beautiful art, may combine with beauty in a *tragedy in verse,*

in a *didactic poem*, in an *oratorio;* and in these combinations beautiful art
is yet more artistic. Whether it is also more beautiful may in some of these
cases be doubted (since so many different kinds of satisfaction cross one
another). Yet in all beautiful art the essential thing is the form, which is
purposive as regards our observation and judgment, where the pleasure is
at the same time cultivation and disposes the spirit to ideas, and conse-
quently makes it susceptible of still more of such pleasure and entertain-
ment. The essential element is not the matter of sensation (charm or emo-
tion), which has only to do with enjoyment; this leaves behind nothing
in the idea, and it makes the spirit dull, the object gradually distasteful,
and the mind, on account of its consciousness of a disposition that con-
flicts with purpose in the judgment of reason, discontented with itself
and peevish.

If the beautiful arts are not brought into more or less close combination
with moral ideas, which alone bring with them a self-sufficing satisfaction,
this latter fate must ultimately be theirs. They then serve only as a distrac-
tion, of which we are the more in need the more we avail ourselves of
them to disperse the discontent of the mind with itself, so that we thus
render ourselves ever more useless and ever more discontented. The
beauties of nature are generally of most benefit in this point of view, if
we are early accustomed to observe, appreciate, and admire them.

§ 53. COMPARISON OF THE RESPECTIVE AESTHETICAL WORTH OF THE BEAUTIFUL ARTS

Of all the arts *poetry* (which owes its origin almost entirely to genius
and will least be guided by precept or example) maintains the first rank.
It expands the mind by setting the imagination at liberty and by offering,
within the limits of a given concept, amid the unbounded variety of pos-
sible forms accordant therewith, that which unites the presentment of this
concept with a wealth of thought to which no verbal expression is com-
pletely adequate, and so rising aesthetically to ideas. It strengthens the
mind by making it feel its faculty—free, spontaneous, and independent
of natural determination—of considering and judging nature as a phenome-
non in accordance with aspects which it does not present in experience
either for sense or understanding, and therefore of using it on behalf of,
and as a sort of schema for, the supersensible. It plays with illusion,
which it produces at pleasure, but without deceiving by it; for it declares
its exercise to be mere play, which however can be purposively used by
the understanding. Rhetoric, in so far as this means the art of persuasion,
i.e. of deceiving by a beautiful show (*ars oratoria*), and not mere elegance
of speech (eloquence and style), is a dialectic which borrows from poetry
only so much as is needful to win minds to the side of the orator before
they have formed a judgment and to deprive them of their freedom; it
cannot therefore be recommended either for the law courts or for the

pulpit. For if we are dealing with civil law, with the rights of individual persons, or with lasting instruction and determination of people's minds to an accurate knowledge and a conscientious observance of their duty, it is unworthy of so important a business to allow a trace of any luxuriance of wit and imagination to appear, and still less any trace of the art of talking people over and of captivating them for the advantage of any chance person. For although this art may sometimes be directed to legitimate and praiseworthy designs, it becomes objectionable when in this way maxims and dispositions are spoiled in a subjective point of view, though the action may objectively be lawful. It is not enough to do what is right; we should practice it solely on the ground that it is right. Again, the mere concept of this species of matters of human concern, when clear and combined with a lively presentation of it in examples, without any offense against the rules of euphony of speech or propriety of expression, has by itself for ideas of reason (which collectively constitute eloquence) sufficient influence upon human minds; so that it is not needful to add the machinery of persuasion, which, since it can be used equally well to beautify or to hide vice and error, cannot quite lull the secret suspicion that one is being artfully overreached. In poetry everything proceeds with honesty and candor. It declares itself to be a mere entertaining play of the imagination, which wishes to proceed as regards form in harmony with the laws of the understanding; and it does not desire to steal upon and ensnare the understanding by the aid of sensible presentation.[27]

After poetry, *if we are to deal with charm and mental movement,* I would place that art which comes nearest to the art of speech and can very naturally be united with it, viz. *the art of tone.* For although it speaks by means of mere sensations without concepts, and so does not, like poetry, leave anything over for reflection, it yet moves the mind in a greater variety of ways and more intensely, although only transitorily. It is, however, rather enjoyment than cultivation (the further play of thought that is excited by its means is merely the effect of a, as it were, mechanical association), and in the judgment of reason it has less worth than any other

[27] I must admit that a beautiful poem has always given me a pure gratification, while the reading of the best discourse, whether of a Roman orator or of a modern parliamentary speaker or of a preacher, has always been mingled with an unpleasant feeling of disapprobation of a treacherous art which means to move men in important matters like machines to a judgment that must lose all weight for them on quiet reflection. Readiness and accuracy in speaking (which taken together constitute rhetoric) belong to beautiful art, but the art of the orator (*ars oratoria*), the art of availing oneself of the weaknesses of men for one's own designs (whether these be well meant or even actually good does not matter), is worthy of no *respect.* Again, this art only reached its highest point, both at Athens and at Rome, at a time when the state was hastening to its ruin and true patriotic sentiment had disappeared. The man who, along with a clear insight into things, has in his power a wealth of pure speech, and who with a fruitful imagination capable of presenting his ideas unites a lively sympathy with what is truly good, is the *vir bonus dicendi peritus,* the orator without art but of great impressiveness, as Cicero has it, though he may not always remain true to this ideal.

of the beautiful arts. Hence, like all enjoyment, it desires constant change and does not bear frequent repetition without producing weariness. Its charm, which admits of universal communication, appears to rest on this that every expression of speech has in its context a tone appropriate to the sense. This tone indicates more or less an affection of the speaker and produces it also in the hearer, which affection excites in its turn in the hearer the idea that is expressed in speech by the tone in question. Thus as modulation is, as it were, a universal language of sensations intelligible to every man, the art of tone employs it by itself alone in its full force, viz. as a language of the affections, and thus communicates universally according to the laws of association the aesthetical ideas naturally combined therewith. Now these aesthetical ideas are not concepts or determinate thoughts. Hence the form of the composition of these sensations (harmony and melody) only serves instead of the form of language, by means of their proportionate accordance, to express the aesthetical idea of a connected whole of an unspeakable wealth of thought, corresponding to a certain theme which produces the dominating affection in the piece. This can be brought mathematically under certain rules, because it rests in the case of tones on the relation between the number of vibrations of the air in the same time, so far as these tones are combined simultaneously or successively. To this mathematical form, although not represented by determinate concepts, alone attaches the satisfaction that unites the mere reflection upon such a number of concomitant or consecutive sensations with this their play, as a condition of its beauty valid for every man. It is this alone which permits taste to claim in advance a rightful authority over everyone's judgment.

But in the charm and mental movement produced by music, mathematics has certainly not the slightest share. It is only the indispensable condition (*conditio sine qua non*) of that proportion of the impressions in their combination and in their alternation by which it becomes possible to gather them together and prevent them from destroying each other, and to harmonize them so as to produce a continual movement and animation of the mind, by means of affections consonant therewith, and thus a delightful personal enjoyment.

If, on the other hand, we estimate the worth of the beautiful arts by the culture they supply to the mind and take as a standard the expansion of the faculties which must concur in the judgment for cognition, music will have the lowest place among them (as it has perhaps the highest among those arts which are valued for their pleasantness), because it merely plays with sensations. The formative arts are far before it in this point of view, for in putting the imagination in a free play, which is also accordant with the understanding, they at the same time carry on a serious business. This they do by producing a product that serves for concepts as a permanent self-commendatory vehicle for promoting their union with sensibility and thus, as it were, the urbanity of the higher cognitive powers. These two species of art take quite different courses; the first

proceeds from sensations to indeterminate ideas, the second from determinate ideas to sensations. The latter produce *permanent*, the former only *transitory* impressions. The imagination can recall the one and entertain itself pleasantly therewith; but the other either vanish entirely, or, if they are recalled involuntarily by the imagination, they are rather wearisome than pleasant. Besides, there attaches to music a certain want of urbanity from the fact that, chiefly from the character of its instruments, it extends its influence further than is desired (in the neighborhood), and so as it were obtrudes itself and does violence to the freedom of others who are not of the musical company. The arts which appeal to the eyes do not do this, for we need only turn our eyes away if we wish to avoid being impressed. The case of music is almost like that of the delight derived from a smell that diffuses itself widely. The man who pulls his perfumed handkerchief out of his pocket attracts the attention of all around him, even against their will, and he forces them, if they are to breathe at all, to enjoy the scent; hence this habit has gone out of fashion.[28]

Among the formative arts I would give the palm to painting, partly because as the art of delineation it lies at the root of all the other formative arts, and partly because it can penetrate much further into the region of ideas and can extend the field of intuition in conformity with them further than the others can.

. . .

SECOND DIVISION

Dialectic of the Aesthetical Judgment

§ 55

A faculty of judgment that is to be dialectical must in the first place be rationalizing, i.e. its judgments must claim universality[29] and that *a priori*, for it is in the opposition of such judgments that dialectic consists. Hence the incompatibility of aesthetical judgments of sense (about the pleasant

[28] Those who recommend the singing of spiritual songs at family prayers do not consider that they inflict a great hardship upon the public by such *noisy* (and therefore in general pharisaical) devotions, for they force the neighbors either to sing with them or to abandon their meditations. [Kant suffered himself from such annoyances, which may account for the asperity of this note. At one period he was disturbed by the devotional exercises of the prisoners in the adjoining jail. In a letter to the burgomaster "he suggested the advantage of closing the windows during these hymn-singings, and added that the warders of the prison might probably be directed to accept less sonorous and neighbor-annoying chants as evidence of the penitent spirit of their captives" (Wallace's *Kant*, p. 42).]

[29] We may describe as a rationalizing judgment (*judicium ratiocinans*) one which proclaims itself as universal, for as such it can serve as the major premise of a syllogism. On the other hand, we can only speak of a judgment as rational (*judicium ratiocinatum*) which is thought as the conclusion of a syllogism, and consequently as grounded *a priori*.

and the unpleasant) is not dialectical. And again, the conflict between judgments of taste, so far as each man depends merely on his own taste, forms no dialectic of taste, because no one proposes to make his own judgment a universal rule. There remains, therefore, no other concept of a dialectic which has to do with taste than that of a dialectic of the critique of taste (not of taste itself) in respect of its *principles*, for here concepts that contradict one another (as to the ground of the possibility of judgments of taste in general) naturally and unavoidably present themselves. The Transcendental Critique of Taste will therefore contain a part which can bear the name of a Dialectic of the Aesthetical Judgment, only if and so far as there is found an antinomy of the principles of this faculty which renders its conformity to law, and consequently also its internal possibility, doubtful.

§ 56. REPRESENTATION OF THE ANTINOMY OF TASTE

The first commonplace of taste is contained in the proposition, with which every tasteless person proposes to avoid blame: *everyone has his own taste.* That is as much as to say that the determining ground of this judgment is merely subjective (gratification or grief), and that the judgment has no right to the necessary assent of others.

The second commonplace invoked even by those who admit for judgments of taste the right to speak with validity for everyone is: *there is no disputing about taste.* That is as much as to say that the determining ground of a judgment of taste may indeed be objective, but that it cannot be reduced to definite concepts; and that consequently about the judgment itself nothing can be *decided* by proofs, although much may rightly be *contested.* For *contesting* [quarreling] and *disputing* [controversy] are doubtless the same in this, that, by means of the mutual opposition of judgments they seek to produce their accordance, but different in that the latter hopes to bring this about according to definite concepts as determining grounds, and consequently assumes *objective concepts* as grounds of the judgment. But where this is regarded as impracticable, controversy is regarded as alike impracticable.

We easily see that, between these two commonplaces, there is a proposition wanting which, though it has not passed into a proverb, is yet familiar to everyone, viz. *there may be a quarrel about taste* (although there can be no controversy). But this proposition involves the contradictory of the former one. For wherever quarreling is permissible, there must be a hope of mutual reconciliation; and consequently we can count on grounds of our judgment that have not merely private validity, and therefore are not merely subjective. And to this the proposition, *everyone has his own taste,* is directly opposed.

There emerges therefore in respect of the principle of taste the following antinomy:

(1) *Thesis*. The judgment of taste is not based upon concepts, for otherwise it would admit of controversy (would be determinable by proofs).

(2) *Antithesis*. The judgment of taste is based on concepts, for otherwise, despite its diversity, we could not quarrel about it (we could not claim for our judgment the necessary assent of others).

§ 57. SOLUTION OF THE ANTINOMY OF TASTE

There is no possibility of removing the conflict between these principles that underlie every judgment of taste, . . . except by showing that the concept to which we refer the object in this kind of judgment is not taken in the same sense in both maxims of the aesthetical judgment. This twofold sense or twofold point of view is necessary to our transcendental judgment, but also the illusion which arises from the confusion of one with the other is natural and unavoidable.

The judgment of taste must refer to some concept; otherwise it could make absolutely no claim to be necessarily valid for everyone. But it is not therefore capable of being proved *from* a concept, because a concept may be either determinable or in itself undetermined and undeterminable. The concepts of the understanding are of the former kind; they are determinable through predicates of sensible intuition which can correspond to them. But the transcendental rational concept of the supersensible, which lies at the basis of all sensible intuition, is of the latter kind, and therefore cannot be theoretically determined further.

Now the judgment of taste is applied to objects of sense, but not with a view of determining a *concept* of them for the understanding; for it is not a cognitive judgment. It is thus only a private judgment, in which a singular representation intuitively perceived is referred to the feeling of pleasure, and so far would be limited as regards its validity to the individual judging. The object is *for me* an object of satisfaction; by others it may be regarded quite differently—everyone has his own taste.

Nevertheless there is undoubtedly contained in the judgment of taste a wider reference of the representation of the object (as well as of the subject), whereon we base an extension of judgments of this kind as necessary for everyone. At the basis of this there must necessarily be a concept somewhere, though a concept which cannot be determined through intuition. But through a concept of this sort we know nothing, and consequently it can *supply no proof* for the judgment of taste. Such a concept is the mere pure rational concept of the supersensible which underlies the object (and also the subject judging it), regarded as an object of sense and thus as phenomenal. For if we do not admit such a reference, the claim of the judgment of taste to universal validity would not hold good. If the concept on which it is based were only a mere confused concept of the understanding, like that of perfection, with which we could bring

the sensible intuition of the beautiful into correspondence, it would be at least possible in itself to base the judgment of taste on proofs, which contradicts the thesis.

But all contradiction disappears if I say: the judgment of taste is based on a concept (viz. the concept of the general ground of the subjective purposiveness of nature for the judgment); from which, however, nothing can be known and proved in respect of the object, because it is in itself undeterminable and useless for knowledge. Yet at the same time and on that very account the judgment has validity for everyone (though, of course, for each only as a singular judgment immediately accompanying his intuition), because its determining ground lies perhaps in the concept of that which may be regarded as the supersensible substrate of humanity.

The solution of an antinomy only depends on the possibility of showing that two apparently contradictory propositions do not contradict each other in fact, but that they may be consistent, although the explanation of the possibility of their concept may transcend our cognitive faculties. That this illusion is natural and unavoidable by human reason, and also why it is so and remains so, although it ceases to deceive after the analysis of the apparent contradiction, may be thus explained.

In the two contradictory judgments we take the concept on which the universal validity of a judgment must be based in the same sense, and yet we apply to it two opposite predicates. In the thesis we mean that the judgment of taste is not based upon *determinate* concepts, and in the antithesis that the judgment of taste is based upon a concept, but an *indeterminate* one (viz. of the supersensible substrate of phenomena). Between these two there is no contradiction.

We can do nothing more than remove this conflict between the claims and counterclaims of taste. It is absolutely impossible to give a definite objective principle of taste in accordance with which its judgments could be derived, examined, and established, for then the judgment would not be one of taste at all. The subjective principle, viz. the indefinite idea of the supersensible in us, can only be put forward as the sole key to the puzzle of this faculty whose sources are hidden from us; it can be made no further intelligible.

The proper concept of taste, that is of a merely reflective aesthetical judgment, lies at the basis of the antinomy here exhibited and adjusted. Thus the two apparently contradictory principles are reconciled—*both can be true*, which is sufficient. If, on the other hand, we assume, as some do, *pleasantness* as the determining ground of taste (on account of the singularity of the representation which lies at the basis of the judgment of taste) or, as others will have it, the principle of perfection (on account of the universality of the same), and settle the definition of taste accordingly, then there arises an antinomy which it is absolutely impossible to adjust except by showing that *both* the contrary (not merely contradictory) *propositions are false*. And this would prove that the concept

on which they are based is self-contradictory. Hence we see that the removal of the antinomy of the aesthetical judgment takes a course similar to that pursued by the critique in the solution of the antinomies of pure theoretical reason. And thus here, as also in the *Critique of Practical Reason*, the antinomies force us against our will to look beyond the sensible and to seek in the supersensible the point of union for all our *a priori* faculties, because no other expedient is left to make our reason harmonious with itself.

Remark I

As we so often find occasion in transcendental philosophy for distinguishing ideas from concepts of the understanding, it may be of use to introduce technical terms to correspond to this distinction. I believe that no one will object if I propose some. In the most universal signification of the word, ideas are representations referred to an object, according to a certain (subjective or objective) principle, but so that they can never become a cognition of it. They are either referred to an intuition, according to a merely subjective principle of the mutual harmony of the cognitive powers (the imagination and the understanding), and they are then called *aesthetical;* or they are referred to a concept according to an objective principle, although they can never furnish a cognition of the object, and are called *rational ideas.* In the latter case the concept is a *transcendent* one, which is different from a concept of the understanding, to which an adequately corresponding experience can always be supplied and which therefore is called *immanent.*

An *aesthetical idea* cannot become a cognition because it is an *intuition* (of the imagination) for which an adequate concept can never be found. A *rational idea* can never become a cognition because it involves a concept (of the supersensible) corresponding to which an intuition can never be given.

Now I believe we might call the aesthetical idea an *inexponible* representation of the imagination, and a rational idea an *indemonstrable* concept of reason. It is assumed of both that they are not generated without grounds, but (according to the above explanation of an idea in general) in conformity with certain principles of the cognitive faculties to which they belong (subjective principles in the one case, objective in the other).

Concepts of the understanding must, as such, always be demonstrable [if by demonstration we understand, as in anatomy, merely *presentation*];[30] i.e. the object corresponding to them must always be capable of being given in intuition (pure or empirical), for thus alone could they become cognitions. The concept of *magnitude* can be given *a priori* in the intuition of space, e.g. of a right line, etc.; the concept of *cause* in impenetrability, in the collision of bodies, etc. Consequently both can be authenticated by

[30] [Second edition.]

means of an empirical intuition, i.e. the thought of them can be proved (demonstrated, verified) by an example; and this must be possible, for otherwise we should not be certain that the concept was not empty, i.e. devoid of any object.

In logic we ordinarily use the expressions "demonstrable" or "indemonstrable" only in respect of *propositions*, but these might be better designated by the titles respectively of *mediately and immediately certain* propositions; for pure philosophy has also propositions of both kinds, i.e. true propositions, some of which are susceptible of proof and others not. It can, as philosophy, prove them on *a priori* grounds, but it cannot demonstrate them, unless we wish to depart entirely from the proper meaning of his word, according to which *to demonstrate (ostendere, exhibere)* is equivalent to presenting a concept in intuition (whether in proof or merely in definition). If the intuition is *a priori* this is called construction; but if it is empirical, then the object is displayed by means of which objective reality is assured to the concept. Thus we say of an anatomist that he demonstrates the human eye if, by a dissection of this organ, he makes intuitively evident the concept which he has previously treated discursively.

It hence follows that the rational concept of the supersensible substrate of all phenomena in general, or even of that which must be placed at the basis of our arbitrary will in respect of the moral law, viz. of transcendental freedom, is already, in kind, an indemonstrable concept and a rational idea, while virtue is so in degree. For there can be given in experience, as regards its quality, absolutely nothing corresponding to the former, whereas in the latter case no empirical product attains to the degree of that causality which the rational idea prescribes as the rule.

As in a rational idea the *imagination* with its intuitions does not attain to the given concept, so in an aesthetical idea the *understanding* by its concepts never attains completely to that internal intuition which the imagination binds up with a given representation. Since, now, to reduce a representation of the imagination to concepts is the same thing as to *expound* it, the aesthetical idea may be called an *inexponible* representation of the imagination (in its free play). I shall have occasion in the sequel to say something more of ideas of this kind; now I only note that both kinds of ideas, rational and aesthetical, must have their principles and must have them in reason—the one in the objective, the other in the subjective principles of its employment.

We can consequently explain *genius* as the faculty of *aesthetical ideas*, by which at the same time is shown the reason why in the products of genius it is the nature (of the subject), and not a premeditated purpose, that gives the rule to the art (of the production of the beautiful). For since the beautiful must not be judged by concepts, but by the purposive attuning of the imagination to agreement with the faculty of concepts in general, it cannot be rule and precept which can serve as the subjective standard of that aesthetical but unconditioned purposiveness in beautiful

art than can rightly claim to please everyone. It can only be that in the subject which is nature and cannot be brought under rules of concepts, i.e. the supersensible substrate of all his faculties (to which no concept of the understanding extends), and consequently that with respect to which it is the final purpose given by the intelligible [part] of our nature to harmonize all our cognitive faculties. Thus alone is it possible that there should be *a priori* at the basis of this purposiveness, for which we can prescribe no objective principle, a principle subjective and yet of universal validity.

Remark II

The following important remark occurs here: There are *three kinds of antinomies* of pure reason, which, however, all agree in this that they compel us to give up the otherwise very natural hypothesis that objects of sense are things in themselves, and force us to regard them merely as phenomena and to supply to them an intelligible substrate (something supersensible of which the concept is only an idea and supplies no proper knowledge). Without such antinomies, reason could never decide upon accepting a principle narrowing so much the field of its speculation and could never bring itself to sacrifices by which so many otherwise brilliant hopes must disappear. For even now, when by way of compensation for these losses a greater field in a practical aspect opens out before it, it appears not to be able without grief to part from those hopes and disengage itself from its old attachment.

That there are three kinds of antinomies has its ground in this that there are three cognitive faculties—understanding, judgment, and reason—of which each (as a superior cognitive faculty) must have its *a priori* principles. For reason, in so far as it judges of these principles and their use, inexorably requires, in respect of them all, the unconditioned for the given conditioned; and this can never be found if we consider the sensible as belonging to things in themselves and do not rather supply to it, as mere phenomenon, something supersensible (the intelligible substrate of nature both external and internal) as the reality in itself [*Sache an sich selbst*]. There are then: (1) *for the cognitive faculty* an antinomy of reason in respect of the theoretical employment of the understanding extended to the unconditioned, (2) *for the feeling of pleasure and pain* an antinomy of reason in respect of the aesthetical employment of the judgment, and (3) *for the faculty of desire* an antinomy in respect of the practical employment of the self-legislative reason; so far as all these faculties have their superior principles *a priori*, and, in conformity with an inevitable requirement of reason, must judge and be able to determine their object, *unconditionally* according to those principles.

As for the two antinomies of the theatrical and practical employment of the superior cognitive faculties, we have already shown their *unavoidableness* if judgments of this kind are not referred to a supersensible sub-

strate of the given objects as phenomena, and also the *possibility of their solution* as soon as this is done. And as for the antinomies in the employment of the judgment, in conformity with the requirements of reason and their solution, which is here given, there are only two ways of avoiding them. Either: we must deny that any *a priori* principle lies at the basis of the aesthetical judgment of taste; we must maintain that all claim to necessary universal agreement is a groundless and vain fancy, and that a judgment of taste only deserves to be regarded as correct because *it happens* that many people agree about it; and this, not because we *assume* an *a priori* principle behind this agreement, but because (as in the taste of the palate) of the contingent similar organization of the different subjects. Or: we must assume that the judgment of taste is really a disguised judgment of reason upon the perfection discovered in a thing and the reference of the manifold in it to a purpose, and is consequently only called aesthetical on account of the confusion here attaching to our reflection, although it is at bottom teleological. In the latter case we could declare the solution of the antinomies by means of transcendental ideas to be needless and without point, and thus could harmonize these laws of taste with objects of sense, not as mere phenomena but as things in themselves. But we have shown in several places in the exposition of judgments of taste how little either of these expedients will satisfy.

However, if it be granted that our deduction at least proceeds by the right method, although it be not yet plain enough in all its parts, three ideas manifest themselves. First, there is the idea of the supersensible in general, without any further determination of it, as the substrate of nature. Secondly, there is the idea of the same as the principle of the subjective purposiveness of nature for our cognitive faculty. And thirdly, there is the idea of the same as the principle of the purposes of freedom and of the agreement of freedom with its purposes in the moral sphere.

· · ·

§ 59. OF BEAUTY AS THE SYMBOL OF MORALITY

Intuitions are always required to establish the reality of our concepts. If the concepts are empirical, the intuitions are called *examples*. If they are pure concepts of understanding, the intuitions are called *schemata*. If we desire to establish the objective reality of rational concepts, i.e. of ideas, on behalf of theoretical cognition, then we are asking for something impossible, because absolutely no intuition can be given which shall be be adequate to them.

All *hypotyposis* (presentation, *subjectio sub adspectum*), or sensible illustration, is twofold. It is either *schematical*, when to a concept comprehended by the understanding the corresponding intuition is given, or it is *symbolical*. In the latter case, to a concept only thinkable by the reason, to which no sensible intuition can be adequate, an intuition is supplied with

which accords a procedure of the judgment analogous to what it observes in schematism, i.e. merely analogous to the rule of this procedure, not to the intuition itself, consequently to the form of reflection merely and not to its content.

There is a use of the word *symbolical* that has been adopted by modern logicians which is misleading and incorrect, i.e. to speak of the *symbolical* mode of representation as if it were opposed to the *intuitive*, for the symbolical is only a mode of the intuitive. The latter (the intuitive, that is), may be divided into the *schematical* and the *symbolical* modes of representation. Both are hypotyposes, i.e. presentations (*exhibitiones*), not mere *characterizations* or designations of concepts by accompanying sensible signs which contain nothing belonging to the intuition of the object and only serve as a means for reproducing the concepts, according to the law of association of the imagination, and consequently in a subjective point of view. These are either words or visible (algebraical, even mimetical) signs, as mere expressions for concepts.[31]

All intuitions which we supply to concepts *a priori* are therefore either *schemata* or *symbols*, of which the former contain direct, the latter indirect, presentations of the concept. The former do this demonstratively; the latter by means of an analogy (for which we avail ourselves even of empirical intuitions) in which the judgment exercises a double function, first applying the concept to the object of a sensible intuition, and then applying the mere rule of the reflection made upon that intuition to a quite different object of which the first is only the symbol. Thus a monarchical state is represented by a living body if it is governed by national laws, and by a mere machine (like a hand mill) if governed by an individual absolute will; but in both cases only *symbolically*. For between a despotic state and a hand mill there is, to be sure, no similarity; but there is a similarity in the rules according to which we reflect upon these two things and their causality. This matter has not been sufficiently analyzed hitherto, for it deserves a deeper investigation; but this is not the place to linger over it. Our language [i.e. German] is full of indirect presentations of this sort, in which the expression does not contain the proper schema for the concept, but merely a symbol for reflection. Thus the words *ground* (support, basis), *to depend* (to be held up from above), to *flow* from something (instead of, to follow), *substance* (as Locke expresses it, the support of accidents), and countless others are not schematical but symbolical hypotyposes and expressions for concepts, not by means of a direct intuition, but only by analogy with it, i.e. by the transference of reflection upon an object of intuition to a quite different concept to which perhaps an intuition can never directly correspond. If we are to give the name of "cognition" to a mere mode of representation (which is quite permissible if the

[31] The intuitive in cognition must be opposed to the discursive (not to the symbolical). The former is either *schematical*, by *demonstration*, or *symbolical*, as a representation in accordance with a mere *analogy*.

latter is not a principle of the theoretical determination of what an object is in itself, but of the practical determination of what the idea of it should be for us and for its purposive use), then all our knowledge of God is merely symbolical; and he who regards it as schematical, along with the properties of understanding, will, etc., which only establish their objective reality in beings of this world, falls into anthropomorphism, just as he who gives up every intuitive element falls into deism, by which nothing at all is cognized, not even in a practical point of view.

Now I say the beautiful is the symbol of the morally good, and that it is only in this respect (a reference which is natural to every man and which every man postulates in others as a duty) that it gives pleasure with a claim for the agreement of everyone else. By this the mind is made conscious of a certain ennoblement and elevation above the mere sensibility to pleasure received through sense, and the worth of others is estimated in accordance with a like maxim of their judgment. That is the *intelligible* to which, as pointed out in the preceding paragraph, taste looks, with which our higher cognitive faculties are in accord, and without which a downright contradiction would arise between their nature and the claims made by taste. In this faculty the judgment does not see itself, as in empirical judging, subjected to a heteronomy of empirical laws; it gives the law to itself in respect of the objects of so pure a satisfaction, just as the reason does in respect of the faculty of desire. Hence, both on account of this inner possibility in the subject and of the external possibility of a nature that agrees with it, it finds itself to be referred to something within the subject as well as without him, something which is neither nature nor freedom, but which yet is connected with the supersensible ground of the latter. In this supersensible ground, therefore, the theoretical faculty is bound together in unity with the practical in a way which, though common, is yet unknown. We shall indicate some points of this analogy, while at the same time we shall note the differences.

(1) The beautiful pleases *immediately* (but only in reflective intuition, not, like morality, in its concept). (2) It pleases *apart from any interest* (the morally good is indeed necessarily bound up with an interest, though not with one which precedes the judgment upon the satisfaction, but with one which is first of all produced by it). (3) The *freedom* of the imagination (and therefore of the sensibility of our faculty) is represented in judging the beautiful as harmonious with the conformity to law of the understanding (in the moral judgment the freedom of the will is thought as the harmony of the latter with itself, according to universal laws of reason). (4) The subjective principle in judging the beautiful is represented as *universal*, i.e. as valid for every man, though not cognizable through any universal concept. (The objective principle of morality is also expounded as universal, i.e. for every subject and for every action of the same subject, and thus as cognizable by means of a universal concept.) Hence the moral judgment is not only susceptible of definite constitutive

principles, but is possible *only* by grounding its maxims on these in their universality.

A reference to this analogy is usual even with the common understanding [of men], and we often describe beautiful objects of nature or art by names that seem to put a moral appreciation at their basis. We call buildings or trees majestic and magnificent, landscapes laughing and gay; even colors are called innocent, modest, tender, because they excite sensations which have something analogous to the consciousness of the state of mind brought about by moral judgments. Taste makes possible the transition, without any violent leap, from the charm of sense to habitual moral interest, as it represents the imagination in its freedom as capable of purposive determination for the understanding, and so teaches us to find even in objects of sense a free satisfaction apart from any charm of sense.

. . .

Now taste is at bottom a faculty for judging of the sensible illustration of moral ideas (by means of a certain analogy involved in our reflection upon both these), and it is from this faculty also and from the greater susceptibility grounded thereon for the feeling arising from the latter (called moral feeling) that that pleasure is derived which taste regards as valid for mankind in general and not merely for the private feeling of each. Hence it appears plain that the true propaedeutic for the foundation of taste is the development of moral ideas and the culture of the moral feeling, because it is only when sensibility is brought into agreement with this that genuine taste can assume a definite invariable form.

G. W. F. HEGEL

THE PHILOSOPHY OF FINE ART
(INTRODUCTION)

G. W. F. Hegel (1770–1831), a professor at the University of Berlin, attempted to formulate a complete system of philosophy. Basic to this system is the concept of absolute mind of which religion, philosophy, and art are three manifestations.

. . . The kind of art, however, which *we* ourselves propose to examine is one which is *free* in its aim and its means. That art in general can serve other objects, and even be merely a pastime, is a relation which it possesses in common with thought itself. From one point of view thought likewise, as science subservient to other ends, can be used in just the same way for finite purposes and means as they chance to crop up, and as such serviceable faculty of science is not self-determined, but determined by something alien to it. But, further, as distinct from such subservience to particular objects, science is raised of its own essential resources in free independence to truth, and exclusively united with its own aims in discovering the true fulfilment in that truth.

Fine art is not art in the true sense of the term until it is also thus free, and its *highest* function is only then satisfied when it has established

Reprinted (footnotes deleted) from *The Philosophy of Fine Art*, translated by F. P. B. Osmaston, London, G. Bell & Sons, Ltd., 1920, pp. 10–11, 33–72, 76–77, 95–122, by permission of the publisher.

itself in a sphere which it shares with religion and philosophy, becoming thereby merely one mode and form through which the *Divine*, the profoundest interests of mankind, and spiritual truths of widest range, art brought home to consciousness and expressed. It is in works of art that nations have deposited the richest intuitions and ideas they possess; and not infrequently fine art supplies a key of interpretation to the wisdom and religion of peoples; in the case of many it is the only one. This is an attribute which art shares in common with religion and philosophy, the peculiar distinction in the case of art being that its presentation of the most exalted subject-matter is in sensuous form, thereby bringing them nearer to Nature and her mode of envisagement, that is closer to our sensitive and emotional life. The world, into the profundity of which thought penetrates, is a supersensuous one, a world which to start with is posited as a Beyond in contrast to the immediacy of ordinary conscious life and present sensation. It is the freedom of reflecting consciousness which disengages itself from this immersion in the *"this side,"* or immediacy, in other words sensuous reality and finitude. But the mind is able, too, to heal the *fracture* which is thus created in its progression. From the wealth of its own resources it brings into being the works of fine art as the primary bond of mediation between that which is exclusively external, sensuous and transitory, and the medium of pure thought, between Nature and its finite reality, and the infinite freedom of a reason which comprehends. Now it was objected that the *element of art* was, if we view it as a whole, of an *unworthy* character, inasmuch as it consisted of appearance and deceptions inseparable from such. Such a contention would of course be justifiable, if we were entitled to assume that appearance had no *locus standi* at all. An appearance or show is, however, essential to actuality. There could be no such thing as truth if it did not appear, or, rather, let itself appear, were it not further true for some *one* thing or person, *for* itself as also *for* spirit. Consequently it cannot be appearance in general against which such an objection can be raised, but the particular mode of its manifestation under which art makes actual what is essentially real and true. If, then, the appearance, in the medium of which art gives determinate existence to its creations, be defined as *deception*, such an objection is in the first instance intelligible if we compare it with the *external world* of a phenomena, and its *immediate* relation to ourselves as material substance, or view it relatively to our own world of emotions, that is our inward sensuous life. Both these are worlds to which in our everyday life, the life, that is, of visible experience, we are accustomed to attach the worth and name of reality, actuality and truth as contrasted with that of art, which fails to possess such reality as we suppose. Now it is just this entire sphere of the empirical world, whether on its personal side or its objective side, which we ought rather to call in a stricter sense than when we apply the term to the world of art, merely a show or appearance, and an even more unyielding form of deception. It is only beyond the immediacy of emotional life and that world of external objects that we

shall discover reality in any true sense of the term. Nothing is actually real but that which is actual in its own independent right and substance, that which is at once of the substance of Nature and of mind, which, while it is actually *here* in present and determinate existence, yet retains under such limitation an essential and self-concentred being, and only in virtue of such is truly real. The predominance of these universal powers is precisely that which art accentuates and manifests. In the external and soulworld of ordinary experience we have also no doubt this essence of actuality, but in the chaotic congeries of particular detail, encumbered by the immediacy of sensuous envisagement, and every kind of caprice of condition, event, character, and so forth. Now it is just the show and deception of this false and evanescent world which art disengages from the veritable significance of phenomena to which we have referred, implanting in the same a reality of more exalted rank born of mind. The phenomena of art therefore are not merely not appearance and nothing more; we are justified in ascribing to them, as contrasted with the realities of our ordinary life, an actually higher reality and more veritable existence. To as little extent are the representations of art a deceptive appearance as compared with the assumed truer delineations of historical writing. For immediate existence also does not belong to historical writing. It only possesses the intellectual appearance of the same as the medium of its delineations, and its content remains charged with the entire contingent *materia* of ordinary reality and its events, developments and personalities, whereas the work of art brings us face to face with the eternal powers paramount in history with this incidental association of the immediate sensuous present and its unstable appearance expunged.

If, however, it is in contrast with philosophic thought and religious and ethical principles, that the mode of appearance of the shapes of art, is described as a deception, there is certainly this in support of the view that the mode of revelation attained by a content in the realm of thought is the truest reality. In comparison, nevertheless, with the appearance of immediate sensuous existence and that of historical narration, the show of art possesses the advantage that, in its own virtue, it points beyond itself, directing us to a somewhat spiritual, which it seeks to envisage to the conceptive mind. Immediate appearance, on the contrary, does not give itself out to be thus illusive, but rather to be the true and real, though as a matter of fact such truth is contaminated and obstructed by the immediately sensuous medium. The hard rind of Nature and the everyday world offer more difficulty to the mind in breaking through to the Idea than do the products of art.

. . .

. . . What in the first instance is known to us under current conceptions of a work of art may be subsumed under the three following determinations:

ART IS :

(1) A work of art is no product of Nature. It is brought into being through the agency of man.

(2) It is created essentially *for* man; and, what is more, it is to a greater or less degree delivered from a sensuous medium, and addressed to his *senses*.

(3) It contains an *end* bound up with it.

1. With regard to the first point, that a work of art is a product of human activity, an inference has been drawn from this (*a*) that such an activity, being the conscious production of an external object can also be *known* and *divulged*, and learned and reproduced by others. For that which one is able to effect, another—such is the notion—is able to effect or to imitate, when he has once simply mastered the way of doing it. In short we have merely to assume an acquaintance with the rules of art-production universally shared, and anybody may then, if he cares to do so, give effect to executive ability of the same type, and produce works of art. It is out of reasoning of this kind that the above mentioned theories, with their provision of rules, and their prescriptions formulated for practical acceptance, have arisen. Unfortunately that which is capable of being brought into effect in accordance with suggestions of this description can only be something formally regular and mechanical. For only that which is mechanical is of so exterior a type that only an entirely empty effort of will and dexterity is required to accept it among our working conceptions, and forthwith to carry it out; an effort, in fact, which is not under the necessity to contribute out of its own resources anything concrete such as is quite outside the prescriptive power of such general rules.

This is apparent with most vividness when precepts of this kind are not limited to what is purely external and mechanical, but extend their pretensions to the activity of the artist in the sense that implies wealth of significance and intelligence. In this field our rules pass off to purely indefinite generalities, such as "the theme ought to be interesting, and each individual person must speak as is appropriate to his status, age, sex and situation." But if rules are really to suffice for such a purpose their directions ought to be formulated with such directness of detail that, without any further co-operation of mind, they could be executed precisely in the manner they are prescribed. Such rules being, in respect to this content, abstract, clearly and entirely fall short of their pretension of being able to complete the artistic consciousness. Artistic production is not a formal activity in accordance with a series of definitions; it is, as an activity of soul, constrained to work out of its own wealth, and to bring before the mind's eye a wholly other and far richer content, and a more embracing and unique creation than ever can be thus prescribed. In particular cases such rules may prove of assistance, in so far, that is, as they contain something really definite and consequently useful for practice. But even here their guidance will only apply to conditions wholly external.

(*b*) This above indicated tendency has consequently been wholly given up; but writers in doing so have only fallen as unreservedly into the opposite extreme. A work of art came to be looked upon, and so far rightly, as no longer the product of an activity *shared by all men*, but rather as a creation of a mind gifted in an extraordinary degree. A mind of this type has in this view *merely* to give free vent to its peculiar endowment, regarded as a specific natural power. It has to free itself absolutely from a pursuit of rules of universal application, as also from any admixture of conscious reflection with its creative and, as thus viewed, wholly instinctive powers, or rather it should be on its guard therefrom, the assumption being that such an exercise of conscious thought can only act on its creations as an infection and a taint. Agreeably to such a view the work of art has been heralded as the product of *talent* and *genius;* and it is mainly the aspect of natural gift inseparable from the ordinary conception of talent and genius, which has been emphasized. There is to some extent real truth in this. Talent is specific, genius universal capacity. With neither of these can a man endow himself *simply* by the exercise of his self-conscious activity. . . .

. . . The real and indeed sole point to maintain as essential is the thesis that although artistic talent and genius essentially implies an element of natural power, yet it is equally indispensable that it should be thoughtfully cultivated, that reflection should be brought to bear on the particular way it is exercised, and that it should be also kept alive with use and practice in actual work. The fact is that an important aspect of the creating process is merely facility in the use of a medium; that is to say, a work of art possesses a purely technical side, which extends to the borders of mere handicraft. This is most obviously the case in architecture and sculpture, less so in painting and music, least of all in poetry. A facility here is not assisted at all by inspiration; what is solely indispensable is reflection, industry, and practice. Such technical skill an artist simply *must* possess in order that he may be master over the external material, and not be thwarted by its obstinacy.

Add to this that the more exalted the rank of an artist the more profoundly ought he to portray depths of soul and mind; and these are not to be known by flashlight, but are exclusively to be sounded, if at all, by the direction of the man's own intelligence on the world of souls and the objective world. In this respect, therefore, once more *study* is the means whereby the artist brings to consciousness such a content, and appropriates the material and structure of his conceptions. At the same time no doubt one art will require such a conscious reception and cognitive mastery of the content in question more than another. Music, for example, which has exclusively to deal with the entirely undefined motion of the soul within, with the musical tones of that which is, relatively, feeling denuded of positive thought, has little or no need to bring home to consciousness the substance of intellectual conception. For this very reason musical talent

declares itself as a rule in very early youth, when the head is still empty and the emotions have barely had a flutter; it has, in fact, attained real distinction at a time in the artist's life when both intelligence and life are practically without experience. And for the matter of that we often enough see very great accomplishment in musical composition and execution hung together with considerable indigence of mind and character. It is quite another matter in the case of poetry. What is of main importance here is a presentation of our humanity rich in subject-matter and reflective power, of its profounder interests, and of the forces which move it. Here at least mind and heart must themselves be richly and profoundly disciplined by life, experience, and thought before genius itself can bring into being the fruit that is ripe, the content that has substance, and is essentially consummate. . . .

(c) A third view, held relatively to the idea of a work of art as a product of human activity, concerns the position of such towards the phenomena of Nature. The natural tendency of ordinary thinking in this respect is to assume that the product of human art is of *subordinate* rank to the works of Nature. The work of art possesses no feeling of its own; it is not through and through a living thing, but, regarded as an external object, is a dead thing. It is usual to regard that which is alive of higher worth than what is dead. We may admit, of course, that the work of art is not in itself capable of movement and alive. The living, natural thing is, whether looked at within or without, an organization with the life-purpose of such worked out into the minutest detail. The work of art merely attains to the show of animation on its surface. Below this it is ordinary stone, wood, or canvas, or in the case of poetry idea, the medium of such being speech and letters. But this element of external existence is not that which makes a work a creation of fine art. A work of art is only truly such in so far as originating in the human spirit, it continues to belong to the soil from which it sprang, has received, in short, the baptism of the mind and soul of man, and only presents that which is fashioned in consonance with such a sacrament. An interest vital to man, the spiritual values which the single event, one individual character, one action possesses in its devolution and final issue, is seized in the work of art and emphasized with greater purity and clarity than is possible on the ground of ordinary reality where human art is not. And for this reason the work of art is of higher rank than any product of Nature whatever, which has not submitted to this passage through the mind. In virtue of the emotion and insight, for example, in the atmosphere of which a landscape is portrayed by the art of painting, this creation of the human spirit assumes a higher rank than the purely natural landscape. Everything which partakes of spirit is better than anything begotten of mere Nature. However this may be, the fact remains that no purely natural existence is able, as art is, to represent divine ideals.

And further, all that the mind borrows from its own ideal content it

is able, even in the direction of external existence, to endow with *perma-nence*. The individual living thing on the contrary is transitory; it vanishes and is unstable in its external aspect. The work of art persists. At the same time it is not mere continuation, but rather the form and pressure thereon of the mintage of soul-life which constitutes its true pre-eminence as contrasted with Nature's reality.

But this higher position we have thus assigned to the work of art is yet further contested by another prevalent conception of ordinary ideas. It is contended that Nature and all that proceeds from her are a work of God, created by His goodness and wisdom. The work of art is on the contrary *merely* a human product fashioned by human hands according to human design. The fallacy implied in this contrast between the products of Nature viewed as a divine creation and human activity as of wholly finite energy consists in the apparent assumption that God is not operative in and through man, but limits the sphere of His activity to Nature alone. We must place this false conception entirely on one side if we are de-sirous of penetrating to the true idea of art; or rather, as opposed to such a conception we ought to accept the extreme opposite thereto, namely, that God is more honoured by that which mind makes and creates than by everything brought into being and fashioned in the natural process. For not only is there a divinity in man, but it is actually effective in him in a form which is adequate to the essential nature of God in a far higher degree than in the work of Nature. God is a Spirit, and it is only in man that the medium, through which the Divine passes, possesses the form of spirit fully conscious of the activity in which it manifests its ideal pres-ence. In Nature the medium correspondent to this is the unconscious sen-suous and external *materia*, which is by many degrees inferior to con-sciousness in its worth. In the products of art God works precisely as He works through the phenomena of Nature. The divine substance, however, as it is asserted in the work of art has secured, being begotten of spirit life itself, a highway commensurable to its existence; determinate existence in the unconscious sensuousness of Nature is not a mode of appearance adequate to the Divine Being.

(*d*) Assuming, then, that the work of art is a creation of man in the sense that it is the offspring of mind or spirit we have still a further ques-tion in conclusion, which will help us to draw a more profound inference still from our previous discussion. That question is, "What is the human *need* which stimulates art-production?" On the one hand the artistic activ-ity may be regarded as the mere play of accident, or human conceits, which might just as well be left alone as attempted. For, it may be urged, there are other and better means for carrying into effect the aims of art, and man bears within himself higher and more weighty interests, than art is capable of satisfying. In contrast to such a view art appears to origi-nate in a higher impulse, and to satisfy more elevated needs, nay, at certain times the highest and most absolute of all, being, as it has been,

united to the most embracing views of entire epochs and nations upon the constitution of the world and the nature of their religion.

. . .

The universal and absolute want from which art on its side of essential form arises originates in the fact that man is a *thinking* consciousness, in other words that he renders explicit *to himself*, and from his own substance, what he is and all in fact that exists. The objects of Nature exist exclusively in immediacy and *once for all*. Man, on the contrary, as mind *reduplicates* himself. He is, to start with, an object of Nature as other objects; but in addition to this, and no less truly, he exists *for himself;* he observes himself, makes himself present to his imagination and thought, and only in virtue of this active power of self-realization is he actually mind or spirit. This consciousness of himself man acquires in a twofold way; in the *first* instance *theoretically*. This is so in so far as he is under a constraint to bring himself in his own inner life to consciousness—all which moves in the human heart, all that surges up and strives therein— and generally, so far as he is impelled to make himself an object of perception and conception, to fix for himself definitively that which thought discovers as essential being, and in all that he summons out of himself, no less than in that which is received from without, to recognize only himself. And *secondly*, this realization is effected through a *practical* activity. In other words man possesses an impulse to assert himself in that which is presented him in immediacy, in that which is at hand as an external something to himself, and by doing so at the same time once more to recognize himself therein. This purpose he achieved by the alteration he effects in such external objects, upon which he imprints the seal of his inner life, rediscovering in them thereby the features of his own determinate nature. And man does all this, in order that he may as a free agent divest the external world of its stubborn alienation from himself—and in order that he may enjoy in the configuration of objective fact an external reality simply of himself. The very first impulse of the child implies in essentials this practical process of deliberate change in external fact. A boy throws stones into the stream, and then looks with wonder at the circles which follow in the water, regarding them as a result in which he sees something of his own doing. This human need runs through the most varied phenomena up to that particular form of self-reproduction in the external fact which is presented us in human art. And it is not merely in relation to external objects that man acts thus. He treats himself, that is, his natural form, in a similar manner: he will not permit it to remain as he finds it; he alters it deliberately. This is the rational ground of all ornament and decoration, though it may be as barbarous, tasteless, entirely disfiguring, nay, as injurious as the crushing of the feet of Chinese ladies, or the slitting of ears and lips. For it is among the really cultured alone that a change of figure, behaviour, and every

mode and manner of self-expression will issue in harmony with the dictates of mental elevation.

This universal demand for artistic expression is based on the rational impulse in man's nature to exalt both the world of his soul experience and that of Nature for himself into the conscious embrace of mind as an object in which he rediscovers himself. He satisfies the demand of this spiritual freedom by making explicit to his *inner* life all that exists, no less than from the further point of view giving a realized *external* embodiment to the self made thus explicit. And by this reduplication of what is his own he places before the vision and within the cognition of himself and others what is within him. This is the free rationality of man, in which art as also all action and knowledge originates. We shall investigate at a later stage the specific need for art as compared with that for other political and ethical action, or that for religious ideas and scientific knowledge.

2. We have hitherto considered the work of art under the aspect that it is fashioned by man; we will now pass over to the second part of our definition, that it is produced for his *sense-apprehension*, and consequently is to a more or less degree under obligations to a sensuous medium.

(*a*) This reflection has been responsible for the inference that the function of fine art is to arouse feeling, more precisely the feeling which suits us—that is, pleasant feeling. From such a point of view writers have converted the investigation of fine art into a treatise on the emotions and asked what kind of feelings art ought to excite—take fear, for example, and compassion—with the further question how such can be regarded as pleasant, how in short, the contemplation of a misfortune can bring satisfaction. This tendency of reflection dates for the most part from the times of Moses Mendelssohn, and many such trains of reasoning may be found in his writings. A discussion of this kind, however, did not carry the problem far. Feeling is the undefined obscure region of spiritual life. What is felt remains cloaked in the form of the separate personal experience under its most abstract persistence; and for this reason the distinctions of feeling are wholly abstract; they are not distinctions which apply to the subject-matter itself. To take examples—fear, anxiety, care, dread, are of course one type of emotion under various modifications; but in part they are purely quantitative degrees of intensity, and in part forms which reflect no light on their content itself, but are indifferent to it. In the case of fear, for instance, an existence is assumed, for which the individual in question possesses an interest, but sees at the same time the negative approach which threatens to destroy this existence, and thereupon discovers in immediate fusion within himself the above interest and the approach of that negative as a contradictory affection of his personal life. A fear of this sort, however, does not on its own account condition any particular content; it may associate with itself subject-matter of the most opposed and varied character. The feeling merely as such is in short a wholly empty

form of a subjective state. Such a form may no doubt in certain cases itself be essentially complex, as we find it is with hope, pain, joy, and pleasure; it may also in this very complexity appropriate various modes of content, as, for example, we have a feeling of justice, an ethical feeling, a sublime religious feeling, and so forth; but despite the fact that a content of this kind is present in different modes of feeling, no light whatever is thereby thrown on such content which will disclose its essential and definite character. The feeling throughout remains a purely subjective state which belongs to me, one in which the concrete fact vanishes, as though contracted to a vanishing point in the most abstract of all spheres. For this reason an inquiry over the nature of the emotions which art ought or ought not to arouse, comes simply to a standstill in the undefined; it is an investigation which deliberately abstracts from genuine content and its concrete substance and notion. Reflection upon feeling is satisfied with the observation of the personal emotional state and its singularity, instead of penetrating and sounding the matter for study, in other words the work of art, and in doing so bidding good-bye to the wholly subjective state and its conditions. In feeling, however, it is just this subjective state void of content which is not merely accepted, but becomes the main thing; and that is precisely why people are so proud of having emotions. And for no other reason that is why such an investigation is tedious owing to its indefinite nature and emptiness, and even repellent in its attention to trivial personal idiosyncrasies.

(*b*) Inasmuch, however, as the work of art is not merely concerned with exciting some kind of emotion or other—for this is an object it would share without any valid distinction with eloquence, historical composition, religious edification and much else—but is only a work of art in so far as it is beautiful, it occurred to reflective minds to discover a *specific feeling for beauty*, and a distinct *sense-faculty* correspondent with it. In such an inquiry it soon became clear that a sense of this kind was no definite and mere instinct rigidly fixed by Nature, which was able by itself and independently to distinguish the beautiful. As a consequence the demand was made for *culture* as a condition precedent to such a sense, and the sense of beauty as thus cultivated was called *taste*, which, albeit an instructed apprehension and discovery of the beautiful, was none the less assumed to persist in the character of immediate feeling. We have already discussed the way in which abstract theory attempted to form such a sense of taste, and how external and one-sided that sense remained. While the critical sense generally of the time when such ideas were in currency was lacking in the *universality* of its principles, as a *specific* critique of particular works of art it was less concerned to substantiate a judgment *more decisive* than hitherto—indeed the material to effectuate this was not as yet forthcoming—than to promote in a general way the *cultivation* of such a taste. Consequently this educative process also came to a halt in the region of the more indefinite, and merely busied itself by its reflec-

tions in the fitting out of feeling as a sense of beauty in such a way that beauty could immediately be discovered whenever and wherever it might chance to appear. The real depth of the subject-matter remained notwithstanding a closed book to such a taste. Profundity of this kind demands not merely sensitive reception and abstract thought, but the reason in its concrete grasp and the most sterling qualities of soul-life. Taste on the contrary is merely directed to the outside surfaces, which are the playground of the feelings, and upon which one-sided principles may very well pass as currency. But for this very reason our so-called good taste is scared by every kind of profounder artistic effect, and is dumb where the ideal significance is in question, and all mere externalities and accessories vanish. For when great passions and the movements of a profound soul assert themselves, we do not bother ourselves any more with the finer distinctions of taste and its retail traffic in trifles. It is conscious that genius leaves such ground far behind it in its stride; and shrinking before that power feels on its part far from comfortable, not knowing very well which way to turn.

(c) Thus it is the further change has come about that critics of art-production no longer have an eye simply to the education of taste, or are intent upon the illustration of such a sense. The *connoisseur*, or art-scholar, has taken the place of the man, or judge of artistic taste. The positive side of art-scholarship, in so far as it implies a sound and exhaustive acquaintance with the entire embrace of what is distinctive and peculiar in a given work of art, we have already maintained to be a necessary condition of artistic research. A work of art, owing to its nature, which, if it is material from one point of view, is also related to a particular person, originates from specific conditions of the most varied kind, among which as exceptionally important we may mention the date and place of its origins, the characteristic personality of the artist, and, above all, the degree of executive accomplishment secured by the art. All these points of view have to be taken into consideration if we wish to obtain a view and knowledge of such a work which is clear in its outlines, and founded on a true basis, nay, even wish to enjoy it rightly. It is with these that our art-scholarship is mainly occupied; and all that it can do for us in this way should be gratefully accepted. Though it is quite true such art-scholarship must be reckoned as of essential importance, it ought not to be regarded as the sole, or indeed the highest, constituent in the relation of the contemplative spirit to a work of art and art generally. Such art-scholarship (this is the defective tendency) may restrict itself wholly to a knowledge of purely external characteristics, either on the side of technique or historical condition, or in other directions; it may continue to possess the barest inkling of the true nature of a given work, or simply no knowledge at all. It may even form a depreciatory verdict on the value of profounder inquiries as compared with purely matter of fact, technical, and historical knowledge. Yet even so an art-scholarship, assuming it to

be really genuine and thorough, at least proceeds upon grounds and knowledge which are definite, and an intelligent judgment; and it is association with such that our more accurate review of the distinct, if also to some extent exterior, aspects of a work of art, and our estimate of their relative significance, is secured.

(*d*) Following the above observations upon the modes of inquiry which were suggested by that aspect of a work of art in which, as itself an object with a material medium, it possessed an essential relation to man as himself receptive through sense, we will now examine this point of view in its more essential connection with art itself. We propose to do this partly (*a*) in respect to the art-product viewed as an object, partly (*β*) as regards the personal characteristics of the artist, his genius, talent, and so forth. We do not, however, propose to enter into matter which can in this connection exclusively proceed from the knowledge of art according to its universal concept. The truth is we are not as yet in the full sense on scientific ground; we have merely reached the province of external reflection.

(*a*) There is no question, then, that a work of art is presented to sensuous apprehension. It is submitted to the emotional sense, whether outer or inner, to sensuous perception and the imaged sense, precisely as the objective world is so presented around us, or as is our own inward sensitive nature. Even a speech, for example, may be addressed to the sensuous imagination and feeling. Notwithstanding this fact, however, the work of art is not exclusively directed to the *sensuous* apprehension, viewed, that is, as an object materially conditioned. Its position is of the nature, that along with its sensuous presentation it is fundamentally addressed to the *mind*. The mind is intended to be affected by it and to receive some kind of satisfaction in it.

This function of the work of art at once makes it clear how it is that it is in no way intended to be a natural product or, on the side where it impinges on Nature, to possess the living principle of Nature. This, at least, is a fact whether the natural product is ranked lower or higher than a *mere* work of art, as people are accustomed to express themselves in the tone of depreciation.

In other words the sensuous aspects of a work of art has a right to determinate existence only in so far as it exists for the human mind, not, however, in so far as itself, as a material object, exists for itself independently.

If we examine more closely in what way the sensuous *materia* is presented to man we find that what is so can be placed under various relations to the mind.

(*aa*) The lowest in grade and that least compatible with relation to intelligence is purely sensuous sensation. It consists primarily in mere looking, listening, just as in times of mental overstrain it may often be a relaxation to go about without thought, and merely listen and have a look round. The mind, however, does not rest in the mere apprehension

of external objects through sight and hearing; it makes them objective to its own inward nature, which thereupon is impelled itself to give effect to itself in these things as a further step under a sensuous mode, in other words, it relates itself to them as *desire*. In this appetitive relation to the external world man, as a sensuous particular thing, stands in a relation of opposition to things in general as in the same way particulars. He does not address himself to them with open mind and the universal ideas of thought; he retains an isolated position, with its personal impulses and interests, relatively to objects as fixed in their obduracy as himself, and makes himself at home in them by using them, or eating them up altogether, and, in short, gives effect to his self-satisfaction by the sacrifice he makes of them. In this negative relation desire requires for itself not merely the superficial show of external objects, but the actual things themselves in their material concrete existence. Mere pictures of the wood, which it seeks to make use of, or of the animals, which it hopes to eat up, would be of no service to desire. Just as little is it possible for desire to suffer the object to remain in its freedom; its craving is just this to force it to annihilate this self-subsistency and freedom of external facts, and to demonstrate that these things are only there to be destroyed and devoured. But at the same time the particular person is neither himself free, begirt as he is by the particular limited and transitory interests of his desires, for his definite acts do not proceed from the essential universality and rationality of his will, neither is he free relatively to the external world, for desire remains essentially determined by things and related to them.

This relation, then, of desire is not that in which man is related to the work of art. He suffers it to exist in its free independence as an object; he associates himself with it without any craving of this kind, rather as with an object reflective of himself, which exists solely for the contemplative faculty of mind. For this reason, as we have said, the work of art, although it possesses sensuous existence, does not require sensuous concrete existence, nor yet the animated life of such objects. Or, rather, we should add, it *ought* not to remain on such a level, in so far as its true function is exclusively to satisfy spiritual interests, and to shut the door on all approach to mere desire. Hence we can understand how it is that practical desire rates the particular works of Nature in the organic or inorganic world, which are at its service, more highly than works of art, which are obviously useless in this sense, and only contribute enjoyment to other capacities of man's spirit.

(*ββ*) A second mode under which the externally present comes before the conscious subject is, as contrasted with the single sensuous perception and active desire, the purely theoretical relation to the *intelligence*. The theoretic contemplation of objects has no interest in consuming the same in their particularity and satisfying or maintaining itself through the sense by their means; its object is to attain a knowledge of them in their *univer-*

sality, to seek out their ideal nature and principle, to comprehend them according to their notional idea. Consequently this contemplative interest is content to leave the particular things as they are, and stands aloof from them in their objective singularity, which is not the object of such a faculty's investigation. For the rational intelligence is not a property of the particular person in the sense that desire is so; it appertains to his singularity as being itself likewise essentially universal. So long as it persists in this relation of universality to the objects in question, it is his reason in its universal potency which is attempting to discover *itself* in Nature, and thereby the inward or essential being of the natural objects, which his sensuous existence does not present under its mode of immediacy, although such existence is founded therein. This interest of contemplation, the satisfaction of which is the task of *science*, is, however, shared in this scientic form just as little by art as it shared in the common table of those impulses of the purely practical desire. Science can, it is true, take as its point of departure the sensuous thing in its singularity, and possess itself of some conception, how this individual thing is present in its specific colour or form. But for all that this isolated thing of sense as such possesses no further relation to mind, inasmuch as the interest of intelligence makes for the universal, the law, the thought and notion of the object, and consequently not only does it forsake it in its immediate singularity, but it actually transforms it within the region of idea, converting a concrete object of sense into an abstract subject-matter of thought, that is converting it into something other than the same object of its sensuous perception actually was. The artistic interest does not follow such a process, and is distinct from that of science for this reason. The contemplation of art restricts its interest simply in the way in which the work of art, as external object, in the directness of its definition, and in the singularity wherein it appears to sense, is manifested in all its features of colour, form, and sound, or as a single isolated vision of the whole; it does not go so far beyond the immediately received objective character as to propose, as is the case with science, the ideal or conceptive thinking of this particular objectivity under the terms of the rational and universal notion which underlies it.

The interest of art, therefore, is distinguishable from the practical interest of desire in virtue of the fact that it suffers its object to remain in its free independence, whereas desire applies it, even to the point of destruction, to its own uses. The contemplation of art, on the other hand, differs from that of a scientific intelligence in an analogous way in virtue of the fact that it cherishes an interest for the object in its isolated existence, and is not concerned to transform the same into terms of universal thought and notion.

(γγ) It follows, then, that, though the sensuous *materia* is unquestionably present in a work of art, it is only as surface or *show* of the sensuous that it is under any necessity to appear. In the sensuous appear-

ance of the work of art it is neither the concrete material stuff, the empirically perceived completeness and extension of the internal organism which is the object of desire, nor is it the universal thought of pure ideality, which in either case the mind seeks for. Its aim is the sensuous presence, which, albeit suffered to persist in its sensuousness, is equally entitled to be delivered from the framework of its purely material substance. Consequently, as compared with the immediately envisaged and incorporated object of Nature, the sensuous presence in the work of art is transmuted to mere semblance or *show*, and the work of art occupies a midway ground, with the directly perceived objective world on one side and the ideality of pure thought on the other. It is not as yet pure thought, but, despite the element of sensuousness which adheres to it, it is no longer purely material existence, in the sense at least that stones, plants, and organic life are such. The sensuous element in a work of art is rather itself somewhat of ideal intension, which, however, as not being actually the ideal medium of thought, is still externally presented at the same time as an object. This semblance of the sensuous presents itself to the mind externally as the form, visible appearance, and harmonious vibration of things. This is always assuming that it suffers the objects to remain in their freedom as objective facts, and does not seek to penetrate into their inward essence by abstract thought, for by doing so they would (as above explained) entirely cease to exist for it in their external singularity.

For this reason the sensuous aspect of art is only related to the two *theoretical* senses of *sight* and *hearing;* smell, on the other hand, taste, and the feeling of touch are excluded from the springs of art's enjoyment. Smell, taste, and touch come into contact with matter simply as such, and with the immediate sensuous qualities of the same; smell with the material volatization through the air; taste with the material dissolution of substance, and touch or mere bodily feeling with qualities such as heat, coldness, smoothness, and so forth. On this account these senses cannot have to do with the objects of art, which ought to subsist in their actual and very independence, admitting of no purely sensuous or rather physical relation. The pleasant for such senses is not the beauty of art. Thus art on its sensuous side brings before us deliberately merely a shadow-world of shapes, tones, and imaged conceptions, and it is quite beside the point to maintain that it is simply a proof of the impotence and limitations of man that he can only present us with the surface of the physical world, mere *schemata*, when he calls into being his creative works. In art these sensuous shapes and tones are not offered as exclusively for themselves and their form to our direct vision. They are presented with the intent to secure in such shape satisfaction for higher and more spiritual interests, inasmuch as they are mighty to summon an echo and response in the human spirit evoked from all depths of its conscious life. In this way the sensuous is *spiritualized* in art, or, in other words, the life of *spirit* comes to dwell in it under sensuous guise.

(β) For this reason, however, a product of art is only possible in so far as it has received its passage through the mind, and has originated from the productive activity of mind. This brings us to another question we have to answer, and it is this: "How is the sensuous or material aspect, which is imperative as a condition of art, operative in the artist as conjoined to his personal productive activity?" Now this mode or manner of artistic production contains, as an activity personal to the artist, in essentials just the same determinants which we found posited in the work of art. It must be a spiritual activity, which however, at the same time possesses in itself the element of sensuousness and immediacy. It is neither, on the one hand, purely mechanical work, such as is purely unconscious facility in sleight of hand upon physical objects, or a stereotyped activity according to teachable rule of thumb; nor, on the other hand, is it a productive process of science, which tends to pass from sensuous things to abstract ideas and thoughts, or is active exclusively in the medium of pure thought. In contrast to these the two aspects of mental idea and sensuous material must in the artistic product be united. For example, it would be possible in the case of poetical compositions to attempt to embody what was the subject-matter in the form of prosaic thought in the first instance, and only after doing so to attach to the same imaginative ideas rhymes and so on, so that as a net result such imagery would be appendent to the abstract reflections as so much ornament and decoration. An attempt of this kind, however, could only lead us to a poor sort of poetry, for in it we should have operative a twofold kind of activity in its *separation*, which in the activity of genuine artistic work only holds good in inseparable unity. It is this true kind of creative activity which forms what is generally described as the artistic *imagination*. It is the rational element, which in its import as spirit only exists, in so far as it actively forces its way into the presence of consciousness, yet likewise, and only subject to this condition, displays all its content to itself under a sensuous form. This activity possesses therefore a spiritual content, but it clothes the same in sensuous image, and for this reason that it is only able to come to a knowledge of the same under this sensuous garb. We may compare such a process with that of a man of experience in life, a man, shall we add, of real geniality and wit, who—while at the same time being fully conscious in what the main importance of life consists, what are the things which essentially bind men together, what moves them and is the mainspring of their lives—nevertheless has neither brought home this content in universal maxims, nor indeed is able to unfold it to others in the generalities of the reflective process, but makes these mature results of his intelligence without exception clear to himself and others in particular cases, whether real or invented, or by examples and such like which hit the mark. For in the ideas of such a man everything shapes itself into the concrete image determinate in its time and place, to which therefore the addition of names and any other detail of

external condition causes no difficulty. Yet such a kind of imagination rather rests on the recollection of conditions, he has lived through, actual experience, than it is a creative power of itself. Memory preserves and renews the particularity and external fashion of such previous events with all their more distinct circumstances, but on the other hand does not suffer the universal to appear independently. The creative imagination of an artist is the imagination of a great mind and a big heart; it is the grasp and excogitation of ideas and shapes, and, in fact, nothing less than this grasp of the profoundest and most embracing human interests in the wholly definite presentation of imagery borrowed from objective experience. A consequence of this is, that imagination of this type is based in a certain sense on a natural gift, a general talent for it, as we say, because its creative power essentially implies an aspect of sense presentation. It is no doubt not unusual to speak in the same way of scientific "talent." The sciences, however, merely presuppose the general capacity for thought, which does not possess, as imagination does, together with its intellectual activity, a reference to the concrete testimony of Nature, but rather precisely abstracts from the activity that form in which we find it in Nature. It would be, therefore, truer to the mark if we said there is no specific scientific talent in the sense of a purely natural endowment. Imagination, on the other hand, combines within it a mode of instinct-like creativeness. In other words the essential plasticity and material element in a work of art is subjectively present in the artist as part of his native disposition and impulse, and as his unconscious activity belongs in part to that which man receives straight from Nature. No doubt the entire talent and genius of an individual is not wholly exhausted by that we describe as natural capability. The creation of art is quite as much a spiritual and self-cognized process; but for all that we affirm that its spirituality contains an element of plastic or configurative facility which Nature confers on it. For this reason, though almost anybody can reach a certain point in art, yet, in order to pass beyond this—and it is here that the art in question really begins—a talent for art which is inborn and of a higher order altogether is indispensable.

Considered simply as a natural basis a talent of this kind asserts itself for the most part in early youth, and is manifested in the restless persistency, ever intent with vivacity and alertness, to create artistic shapes in some particular sensuous medium, and to make this mode of expression and utterance the unique one or the one of main importance and most suitable. And thus also a virtuosity up to a certain point in the technique of art which is arrived at with ease is a sign of inborn talent. A sculptor finds everything convertible into plastic shape, and from early days takes to modelling clay; and so on generally whatever men of such innate powers have in their minds, whatever excites and moves their souls, becomes forthwith a plastic figure, a drawing, a melody, or a poem.

(γ) Thirdly, and in conclusion: the *content* of art is also in some

respects borrowed from the objective world perceived in sense, that is Nature; or, in any case, if the content is also of a spiritual character, it can only be grasped in such a way, that the spiritual element therein, as human relations, for example, are displayed in the form of phenomena which possess objective reality.

3. There is yet another question to solve, namely, what the interest or the *End* is, which man proposes to himself in the creation of the content embodied by a work of art. This was, in fact, the third point of view, which we propounded relatively to the art-product. Its more detailed discussion will finally introduce us to the true notional concept of art itself.

If we take a glance at our ordinary ideas on this subject, one of the most prevalent is obviously

(*a*) The principle of the imitation of Nature. According to this view the essential aim or object of art consists in imitation, by which is understood a facility in copying natural forms as present to us in a manner which shall most fully correspond to such facts. The success of such an exact representation of Nature is assumed to afford us complete satisfaction.

(*a*) Now in this definition there is to start with absolutely nothing but the formal aim to bring about the bare repetition a second time by man, so far as his means will permit of this, of all that was already in the external world, precisely too in the way it is there. A repetition of this sort may at once be set down as

(*aa*) A *superfluous* task for the reason that everything which pictures, theatrical performances represent by way of imitation—animals, natural scenery, incidents of human life—we have already elsewhere before us in our gardens or at home, or in other examples of the more restricted or extended reaches of our personal acquaintance. Looked at, moreover, more closely, such a superfluity of energy can hardly appear otherwise than a presumptuous trifling; it is so because

(*ββ*) It lags so far behind Nature. In other words art is limited in its means of representation. It can only produce one-sided illusions, a semblance, to take one example, of real fact addressed exclusively to *one* sense. And, moreover, if it does wholly rely on the bare aim of *mere* imitation, instead of Nature's life all it gives us ever is the mere pretence of its substance. For some such reason the Turks, who are Mohammedans, will not put up with any pictures or copies of men and other objects. When James Bruce, in his travels through Abyssinia, showed a painted fish to a Turk, that worthy was at first astonished; but, quickly recovering himself, he made answer as follows: "If this fish shall rise up against you at the last day, and say, 'You have certainly given me a body, but no living soul,' how are you going to justify yourself against such a complaint?" . . . There are, no doubt, no less examples of completely deceptive imitation. The painted grapes of Zeuxis have been accepted from antiquity and long after as an instance of art's triumph, and also of

that of the principle of imitation, because, we are told, actual doves pecked at them. . . . But if we will only reflect a moment on such and other instances we can only come to the conclusion that instead of praising works of art, because they have deceived *even* doves and monkeys, the foolish people ought to be condemned who imagine that the quality of a work of art is enhanced if they are able to proclaim an effect of the same so miserable as the supreme and last word they can say for it. In short, to sum up, we may state emphatically that in the mere business of imitation art cannot maintain its rivalry with Nature, and if it makes the attempt it must look like a worm which undertakes to crawl after an elephant.

(γγ) Having regard, then, to this invariable failure, that is, relative failure of human imitation as contrasted with the natural prototype, we have no end left us but the pleasure offered by sleight of hand in its effort to produce something which resembles Nature. And it is unquestionably a fact that mankind are able to derive enjoyment from the attempt to reproduce with their individual labour, skill, and industry what they find around them. But a delight and admiration of this kind also becomes, if taken alone, indeed just in proportion as the copy follows slavishly the thing copied, so much the more icily null and cold, or brings its reaction of surfeit and repugnance. There are portraits which, as has been drily remarked, are positively shameless in their likeness; and Kant brings forward a further example of this pleasure in imitation pure and simple to the effect that we are very soon tired of a man—and there really are such—who is able to imitate the nightingale's song quite perfectly; for we no sooner find that it is a man who is producing the strain than we have had enough of it. We then take it to be nothing but a clever trick, neither the free outpouring of Nature, nor yet a work of art. We expect, in short, from the free creative power of men something quite other than a music of this kind, which only retains our interest when, as in the case of the nightingale's note, it breaks forth in unpremeditated fashion, resembling in this respect the rhythmic flood of human feeling, from the native springs of its life. And as a general rule this delight we experience in the skill of imitation can only be of a restricted character; it becomes a man better to derive enjoyment from that which he brings to birth from himself. In this respect the invention of every insignificant technical product is of higher rank; and mankind may feel more proud at having invented the hammer, nail, and so forth, than in making themselves adepts as imitators. For this abstract zest in the pursuit of imitation is on the same lines as the feat of the man who had taught himself to throw lentils through a small aperture without missing. He made an exhibition of this feat to Alexander, and Alexander merely made him a present as a reward for this art, empty and useless as it was, of a bushel of lentils.

(β) Inasmuch as, moreover, the principle of imitation is purely formal, *objective beauty* itself disappears, if that principle is accepted as the end.

For the question is then no longer what is the *constitution* of that which is to be imitated, but simply whether the copy is *correct* or no. The object and the content of the beautiful comes to be regarded as a matter of indifference. When, in other words, putting the principle of mere imitation on one side, we speak, in connection with animals, human beings, places, actions, and characters, of a distinction between beauty and ugliness, it remains none the less the fact that relatively to such a principle we are referring to a distinction which does not properly belong to an art for which we have appropriated this principle of imitation to the exclusion of all others. In such a case, therefore, whenever we select objects and attempt to distinguish between their beauty and ugliness, owing to this absence of a standard we can apply to the infinite forms of Nature, we have in the final resort only left us the *personal taste*, which is fixed by no rule, and admits of no discussion. And, in truth, if we start, in the selection of objects for representation, from that which mankind *generally* discover as beautiful and ugly, and accept accordingly for artistic imitation, in other words, form their particular taste, there is no province in the domain of the objective world which is not open to us, and which is hardly likely to fail to secure its admirer. At any rate, among men we may assume that, though the case of every husband and his wife may be disputed, yet at least every bridegroom regards his bride as beautiful, very possibly being the only person who does so; and that an individual taste for a beauty of this kind admits of no fixed rules at all may be regarded as a bit of luck for both parties. If, moreover, we cast a glance wholly beyond mere individuals and their accidental taste to that of nations, this again is fully of diversity and opposition. . . . Indeed, if we consider the works of art of those extra-European peoples, their images of gods, for instance, which have been imaginatively conceived as worthy of veneration and sublime, they can only appear to us as frightful idols; their music will merely ring in our ears as an abominable noise, while, from the opposite point of view, such aliens will regard our sculptures, paintings, and musical compositions as having no meaning or actually ugly.

(γ) But even assuming that we abstract from an objective principle of art, and retain the beautiful as established on the subjective and individual taste, we shall soon discover, from the point of view of art itself, that the imitation of natural objects, which appeared to be a universal principle, and indeed one secured by important authorities, is not to be relied upon, at least under this general and wholly abstract conception of it. If we look at the particular arts we cannot fail to observe that, albeit painting and sculpture portray objects which resemble those of Nature, or the type of which is essentially borrowed from Nature, the works of architecture on the contrary—and this, too, is one of the *fine* arts —quite as little as the compositions of poetry, to the extent at least that these latter are not restricted to mere description, cannot justly be de-

scribed as imitations of Nature. At any rate, if we are desirous of maintaining such a thesis with respect to the arts thus excluded, we should find ourselves forced to make important deviations from the track, in order to condition our proposition in various ways, and level down our so-called truth at least to the plane of probability. But once accept probability, and we should again be confronted with a great difficulty in determining precisely what is and what is not probable; and in the end no one could really think of or succeed, even if he did so, in excluding from poetry all compositions of an entirely capricious and completely imaginative character.

The end or object of art must therefore consist in something other than the purely formal imitation of what is given to objective sense, which invariably can merely call into being technical *legerdemain* and not *works* of art. It is no doubt an essential constituent of a work of art that it should have natural forms as a foundation, because the mode of its representation is in external form, and thereby along with it in that of natural phenomena. In painting it is obviously an important study to learn to copy with accuracy colours in their mutual relations, such as light effects and reflections, and so forth, and, with no less accuracy, the forms and shapes of objects carried into their most subtle gradations of line. It is in this respect that in modern times more particularly the principle of the imitation of Nature and naturalism generally has come into vogue. The object has been to recall an art, which has deteriorated into weakness and nebulosity, to the strength and determinate outlines of Nature, or, in yet another direction, as against the purely arbitrary caprice and convention of a studio, which is in truth as remote from Nature as it is from art, and merely indicates the path of art's declension, to assert the claim of the legitimate, direct, and independent, no less than coherent stability of natural fact. But while admitting that from a certain point of view such an effort is reasonable enough, yet for all that the naturalism which it demands, taken by itself, is neither the substantive thing, not yet of primary importance, in the true basis of art; and although the external fact in its natural appearance constitutes an element of essential value, yet the objective fact alone does not supply the *standard* of rightness, nor is the mere imitation of external phenomena, in their external shape that is, the *end* of art.

(*b*) And as a consequence of this we have the further question— "What is the true *content* of art, and with what aim is that content brought before us?" On this head we are confronted by the common opinion that it is the task and object of art to bring before our sense, feeling, and power of emulation *every thing* that the spirit of man can perceive or conceive. Art has in short to realize for us the well-known saying, "*Nihil humani a me alienum puto.*" Its object is therefore declared to be that of arousing and giving life to slumbering emotions, inclinations, passions of *every* description, of filling the heart up to the brim; of com-

pelling mankind, whether cultured or the reverse, to pass through all that the human soul carries in its most intimate and mysterious chambers, all that it is able to experience and reproduce, all that the heart is able to stir and evoke in its depths and its countlessly manifold possibilities; and yet further to deliver to the domain of feeling and the delight of our vision all that the mind may possess of essential and exalted being in its thought and the Idea—that majestic hierarchy of the noble, eternal, and true; and no less to interpret for us misfortune and misery, wickedness and crime; to make the hearts of men realize through and through all that is atrocious and dreadful, no less than every kind of pleasure and blessedness; and last of all to start the imagination like a rover among the day-dream playing-fields of the fancy, there to revel in the seductive mirage of visions and emotions which captivate the senses. All this infinitely manifold content—so it is held—it is the function of art to explore, in order that by this means the experience of our external life may be repaired of its deficiencies, and yet from a further point of view that the passions we share with all men may be excited, not merely that the experiences of life may not have us unmoved, but that we ourselves may thereafter long to make ourselves open channels of a universal experience. Such a stimulus is not presented on the plane of actual experience itself, but can only come through the semblance of it, that is to say through the illusions which art, in its creations, substitutes for the actual world. And the possibility of such a deception, by means of the semblances of art, depends on the fact that all reality must for man pass through the medium of the vision and imaginative idea; and it is only after such a passage that it penetrates the emotional life and the will. In such a process it is of no consequence whether it is immediate external reality which claims his attention, or whether the result is effected by some other way, in other words by means of images, symbols, and ideas, which contain and display the content of such actuality. Men are able to imagine things, which do not actually exist, as if they did exist. Consequently it is precisely the same thing for our emotional life, whether it is the objective world or merely the show of the same, in virtue of which a situation, a relation, or any content of life, in short, is brought home to us. Either mode is equally able to stir in us an echo to the essential secret which it carries, whether it be in grief or joy, in agitation or convulsion, and can cause to flow through us the feelings and passions of anger, hate, pity, anxiety, fear, love, reverence and admiration, honour and fame.

The awakening of every kind of emotion in us, the drawing our soul through every content of life, the realization of all these movements of soul-life by means of a presence which is only external as an illusion—this it is which, in the opinion described, is pre-eminently regarded as the peculiar and transcendent power of artistic creation.

We must not, however, overlook the fact that in this view of art as a means to imprint on the soul and the mind what is good and evil alike,

to make man more strong in the pursuit of what is noblest, no less than enervate his definite course, by transporting his emotional life through the most sensuous and selfish desires, the task as yet proposed to art remains throughout of an entirely formal character; without possessing independently an assured aim all that art can offer is the empty form for every possible kind of ideal and formative content.

(c) As a matter of fact art does not possess this formal side, namely, that it is able to bring before our senses and feeling and artistically adorn every possible kind of material, precisely as the thoughts of ordinary reflection elaborate every possible subject-matter and modes of action, supplying the same with its equipment of reasons and vindications. In the presence, however, of such a variety of content we cannot fail to observe that these diversified emotions and ideas, which it is assumed art has to stimulate or enforce, intersect each other, contradict and mutually cancel each other. Indeed, under this aspect, the more art inspires men to emotions thus opposed, to that extent precisely it merely enlarges the cleavage in their feelings and passions, and sets them staggering about in Bacchantic riot, or passes over into sophistry and scepticism precisely as your ordinary free thinkers do. This variety of the material of art itself compels us, therefore, not to remain satisfied with so formal a determination. Our rational nature forces its way into this motley array of discord, and demands to see the resurrection of a higher and more universal purpose from these elements despite their opposition, and to be conscious of its attainment. Just in a similar manner the social life of mankind and the State are no doubt credited with the aim that in them *all* human capacities and *all* individual potencies should meet with expansion and expression in *all* their features and tendencies. But in opposition to so formal a view there very quickly crops up the question in what *unity* these manifold manifestations are to be concentrated, and what *single end* they must have for their fundamental concept and ultimate end. Just as in the case of the notional concept of the human State so too there arises in that of human art the need, as to a part thereof, for an end *common* to the particular aspects, no less than in part for one which is more exalted and *substantive* in its character.

As such a substantive end the conclusion of reflection is readily brought home to us that art possesses at once the power and function to mitigate the savagery of mere desires.

(a) With regard to this first conception we have merely to ascertain what characteristic peculiar to art implies this possibility of eliminating this rawness of desire, and of fettering and instructing the impulses and passions. Coarseness in general has its ground-root in an unmitigated self-seeking of sensuous impulses, which take their plunge off and are exclusively intent on the satisfaction of their concupiscence. Sensual desire is, however, all the more brutal and domineering, in proportion as, in its isolation and confinement, it appropriates the *entire man*, so that he does not retain the power to separate himself in his universal capacity from

this determinacy and to maintain the conscious presence of such univer-
sality. Even if the man in such a case exclaims, "the passion is mightier
than myself," though it is true no doubt that for that man's mind the
abstract ego is separate from the particular passion, yet it is purely so in
a formal way. All that such a separation amounts to is that as against
the force of the passion the ego, in its universal form or competency, is
of no account at all. The savageness of passion consists therefore in the
fusion of the ego as such a universal with the confined content of its
desire, so that a man no longer possesses volitional power outside this
single passion. Such savageness and untamed force of the possibilities of
passion art mitigates in the first instance to the extent that it brings home
to the mind and imagination of man what he does actually feel and carry
into effect in such a condition. And even if art restricts itself to this that
it places before the vision of the mind pictures of passion, nay, even
assuming such to be flattering pictures, yet for all that a power of amelio-
ration is contained therein. At least we may say, that by this means is
brought before a man's intelligence what apart from such presentment
he merely *is*. The man in this way contemplates his impulses and inclina-
tions; and whereas apart from this they whirl him away without giving
him time to reflect, he now sees them outside himself and already, for the
reason that they come before him rather as objects than a part of himself,
he begins to be free from them as aliens. For this reason it may often
happen that an artist, under the weight of grief, mitigates and weakens
the intensity of his own emotions in their effect upon him by the artistic
representation of them. Comfort, too, is to be found even in tears. The
man who to start with is wholly given up to and concentrated in sorrow,
is able thus, at any rate, to express that which is merely felt within in
a direct way. Yet more alleviating is the utterance of such inner life in
words, images, musical sound, and shapes.

It was therefore a good old custom in the case of funerals and layings-
out to appoint wailing women, in order to give audible expression to
grief, or generally to create an external sympathy. For manifestations of
sympathy bring the content of human sorrow to the sufferer in an objective
form; he is by their repetition driven to reflect upon it, and the burden is
thereby made lighter. And so it has from of old been considered that to
weep or to speak oneself out are equally means whereby freedom is se-
cured from the oppressing burden, or at least the heart is appreciably
lifted. Consequently the mitigation of the violence of passions admits of
this general explanation that man is released from his unmediated con-
finement in an emotion, becomes aware of it as a thing external to him-
self, to which he is consequently obliged to place himself in an ideal
relation. Art, while still remaining within the sphere of the senses, faces
man from the might of his sensitive experience by means of its representa-
tions. No doubt we frequently hear that pet phrase of many that it is
man's duty to remain in immediate union with Nature. Such union is in

its unmediated purity nothing more or less than savagery and wildness; and art, precisely in the way that it dissolves this unity for human beings, lifts them with gentle hands over this inclosure in Nature. The way men are occupied with the objects of art's creation remains throughout of a contemplative character; and albeit in the first instance it educates merely an attention to the actual facts portrayed, yet over and beyond this, and with a power no less decisive, it draws man's attention to their significance, it forces him to compare their content with that of others, and to receive without reserve the general conclusions of such a survey and all the ramifications such imply.

(β) To the characteristic above discussed adheres in natural sequence the second which has been predicated of art as its essential aim, namely, the *purification* of the passions, an instruction, that is, and a building to *moral* completeness. For the defining rôle that art has to bridle savage nature and educate the passions remained one wholly formal and general, so that the further question must arise as to a *specific* kind and an essential and *culminating* point of such an educative process.

($\alpha\alpha$) The doctrine of the purification of the passions shares in the defect previously noted as adhering to the mitigation of desires. It does, however, emphasize more closely the fact that the representations of art needed a standard, by means of which it would be possible to estimate their comparative worth and unworth. This standard is just their effectiveness to separate what is pure from that which is the reverse in the passions. Art, therefore, requires a content which is capable of expressing this purifying power, and in so far as the power to assert such effectiveness is assumed to constitute the substantive end of art, the purifying content will consist in asserting that effective power before consciousness in its *universality* and *essentiality*.

($\beta\beta$) It is a deduction from the point of view just described that it is the end of art to *instruct*. Thus, on the one hand, the peculiar character of art consists in the movement of the emotions and in the satisfaction which is found in this movement, even in fear, compassion, in painful agitation and shock—that is to say, in the satisfying concern of the feelings and passions, and to that extent in a complacent, delighted, or enthusiastic attitude to the objects of art and their presentation and effect: while, on the other hand, this artistic object is held to discover its higher standard exclusively in its power to instruct, in the *fabula docet*, and thereby in the usefulness, which the work of art is able to exercise on the recipient. . . .

In respect, then, to such instruction we have to ask whether the idea is that the same ought to be direct or indirect in the work of art, explicit or implicit.

Now if the question at issue is one of general importance to art about a universal rather than contingent purpose, such an ultimate end, on account of the essential spirituality of art, can only be itself of spiritual

import; in other words, so far from being of accidental importance it must be true in virtue of its own nature and on its own account. An end of this kind can only apply to instruction in so far as a genuine and essentially explicit content is brought before the mind by means of the work of art. From such a point of view we are entitled to affirm that it is the function of art to accept so much the more of a content of this nature within its compass in proportion to the nobility of its rank, and that only in the verity of such a content will it discover the standard according to which the pertinency of or the reverse of what is expressed is adjudged. Art is in truth the primary *instructress* of peoples.

But, on the other hand, if the object of instruction is so entirely treated as an *end* that the universal nature of the content presented cannot fail to be asserted and rendered bluntly and on its own account explicit as abstract thesis, prosaic reflection or general maxim, rather than merely in an indirect way contained by implication in the concrete embodiment of art, then and in that case, by means of such a separation, the sensuous, plastic configuration, which is precisely that which makes the artistic product a *work of art*, is merely an otiose accessory, a husk, a semblance, which are expressly posited as nothing more than *shell* and semblance. Thereby the very nature of a work of art is abused. For the work of art ought not to bring before the imaginative vision a content in its universality as such, but rather this universality under the mode of individual concreteness and distinctive sensuous particularity. If the work in question does not conform to such a principle, but rather sets before us the generalization of its content with the express object of instruction pure and simple, then the imaginative no less than the material aspect of it are merely an external and superfluous ornament, and the work of art is itself a shattered thing within that ornament, a ruin wherein form and content no longer appear as a mutually adherent growth. For, in the case supposed, the particular object of the senses and the ideal content apprehended by the mind have become external to one another.

Furthermore, if the object of art is assumed to consist in utilitarian *instruction* of this kind, that other aspect of delight, entertainment, and diversion is simply abandoned on its own account as *unessential;* it has now to look for its substance to the utility of the matter of instruction, to which it is simply an accompaniment. But this amounts to saying, that art does not carry its vocation and purpose in itself, but that its fundamental conception is in something else, to which it subserves as a *means.* Art becomes, in short, merely one of the many means, which are either of use, or may be employed to secure, the aim of instruction. This brings us to the boundary line where art can only cease to be an end on its own independent account; it is deliberately deposed either to the mere plaything of entertainment, or a mere means of instruction.

(γγ) The line of this limit is most emphasized when the question is raised as to the end or object of highest rank for the sake of which the

passions have to be purified or men have to be instructed. This goal has frequently in modern times been identified with *moral improvement*, and the end of art is assumed to consist in this that its function is to prepare our inclinations and impulses, and generally to conduct us to the supreme goal of moral perfection. In this view we find instruction and purification combined. The notion is that art by the insight it gives us of genuine moral goodness, in other words, through its instruction, at the same time summons us to the process of purification, and in this way alone can and ought to bring about the improvement of mankind as the right use they can make of it and its supreme object.

With reference to the relation in which art stands to the end of improvement, we may practically say the same thing as we did about the didactic end. It may readily be admitted that art as its principle ought not to make the immoral and its advance its end. But it is one thing deliberately to make immorality the aim of its presentation and another not expressly to do so in the case of morality. It is possible to deduce an excellent moral from any work of art whatever; but such depends, of course, on a particular interpretation and consequently on the individual who draws the moral. The defence is made of the most immoral representations on the ground that people ought to become acquainted with evil and sin in order to act morally. Conversely, it has been maintained that the portrayal of Mary Magdalene, the fair sinner, who afterwards repented, has seduced many into sin, because art makes repentance look so beautiful, and you must first sin before you can repent. The doctrine of moral improvement, however logically carried out, is not merely satisfied that a moral should be conceivably deducible from a work of art through interpretation; on the contrary, it would have the moral instruction clearly made to emerge as the substantive aim of the work; nay, further, it would deliberately exclude from art's products all subjects, characters, actions, and events which fail to be moral in its own sense. For art, in distinction from history and the sciences, which have their subject-matter determined for them, has a choice in the selection of its subjects.

. . .

(*d*) When discussing moral improvement as the ultimate end accepted for art it was found that its principle pointed to a higher standpoint. It will be necessary also to vindicate this standpoint for art.

Thereby the false position to which we have already directed attention vanishes, namely, that art has to serve as a means for moral ends and the moral end of the world generally by means of its didactive and ameliorating influence, and by doing so has its essential aim not in itself, but in something else. If we therefore continue still to speak of an end or goal of art, we must at once remove the perverse idea, which in the question, "What is the end?" will still make it include the supplemental query,

"What is the use?" The perverseness consists in this that the work of art would then have to be regarded as related to something else, which is presented us as what is essential and ought to be. A work of art would in that case be merely a useful instrument in the realization of an end which possessed real and independent importance outside the realm of art. As opposed to this we must maintain that it is art's function to reveal *truth* under the mode of art's sensuous or material configuration, to display the reconciled antithesis previously described, and by this means to prove that it possesses its final aim in itself, in this representation in short and self-revelation. For other ends such as instruction, purification, improvement, procuring of wealth, struggle after fame and honour have nothing whatever to do with this work of art as such, still less do they determine the fundamental idea of it.

It is then from this point of view, into which the reflective consideration of our subject-matter finally issues, that we have to grasp the fundamental idea of art in terms of its ideal or inward necessity, as it is also from this point of view that historically regarded the true appreciation and acquaintance with art took its origin. For that antithesis, to which we have drawn attention, did not merely assert its presence within the general thought of educated men, but equally in philosophy as such. It was only after philosophy was in a position to overcome this opposition absolutely that it grasped the fundamental notion of its own content, and, to the extent it did so, the idea of Nature and of art.

For this reason, as this point of view implies the re-awakening of philosophy in the widest connotation of the term, so also it is the re-awakening of the science of art. We may go further and affirm that aesthetic as a science is in a real sense primarily indebted to this re-awakening for its true origination, and art for its higher estimation.

· · ·

V

1. After the above introductory observations we may now pass on to the consideration of our subject itself. We are, however, still within the introduction; and being so I do not propose to attempt anything more than indicate by way of sketch the main outlines of the general course of the scientific inquiry which is to follow it. Inasmuch, however, as we have referred to art as issuing from the absolute Idea itself, and, indeed, have assigned as its end the sensuous presentation of the Absolute itself, it will be incumbent on us to conduct this survey of the entire field in such a way, as at least to disclose generally, how the particular parts originate in the notional concept of the beauty of art. We must therefore attempt to awaken some idea of this notion in its broadest significance.

It has already been stated that the content of art is the Idea, and the form of its display the configuration of the sensuous or plastic image. It is

further the function of art to mediate these two aspects under the recon-
ciled mode of free totality. The *first* determinant implied by this is the
demand that the content, which has to secure artistic representation, shall
disclose an essential capacity for such display. If this is not so all that we
possess is a defective combination. A content that, independently, is ill
adapted to plastic form and external presentment is compelled to accept
this form, or a matter that is of itself prosaic in its character is driven to
make the best it can of a mode of presentation which is antagonistic to
its nature.

The *second* requirement, which is deducible from the first, is the de-
mand that the content of art should be nothing essentially abstract. This
does not mean, however, that it should be merely concrete in the sense
that the sensuous object is such in its contrast to all that is spiritual and
the content of thought, regarding these as the essentially simple and
abstract. Everything that possesses truth for Spirit, no less than as part
of Nature, is essentially concrete, and, despite its universality, possesses
both ideality and particularity essentially within it. When we state, for
example, of God that he is simple One, the Supreme Being as such, we
have thereby merely given utterance to a lifeless abstraction of the irra-
tional understanding. Such a God, as He is thus not conceived in His
concrete truth, can supply no content for art, least of all plastic art. Con-
sequently neither the Jews nor the Turks have been able to represent
their God, who is not even an abstraction of the understanding in the
above sense, under the positive mode in which Christians have repre-
sented Him. For in Christianity God is conceived in His Truth, and as
such essentially concrete, as personality, as the subjective focus of con-
scious life, or, more accurately defined, as Spirit. And what He is as
Spirit is made explicit to the religious apprehension as a trinity of persons,
which at the same time are, in their independence, regarded as One.
Here is essentiality, universality, and particularity, no less than their
reconciled unity, and it is only a unity such as this which gives us the
concrete. And inasmuch as a content, in order to unveil truth at all, must
be of this concrete character, art makes the demand for a like concrete-
ness, and, for this reason, that a purely abstract universal does not in itself
possess the property to proceed to particularity and external manifestation,
and to unity with itself therein.

If, then, a sensuous form and configuration is to be correspondent with
a true and therefore concrete content, such must in the third place like-
wise be as clearly individual, entirely concrete and a self-enclosed unity.
This character of concreteness, predictable of both aspects of art, the con-
tent no less than the representation, is just the point in which both coalesce
and fall in with one another. The natural form of the human body is, for
example, such a sensuous concrete capable of displaying Spirit in its essen-
tial concreteness and of adapting itself wholly to such a presentment. For
which reason we must quit ourselves of the idea that it is a matter of

mere accident that an actual phenomenon of the objective world is accepted as the mode in which to embody such a form coalescent with truth. Art does not lay hold of this form either because it is simply there or because there is no other. The concrete content itself implies the presence of external and actual, we may even add the sensuous appearance. But to make this possible this sensuous concrete, which is essentially impressed with a content that is open to mind, is also essentially addressed to the inward conscious life, and the external mode of its configuration, whereby it is visible to perception and the world of idea, has for its aim the being there exclusively for the soul and mind of man. This is the sole reason that content and artistic conformation are dovetailed one into the other. The *purely* sensuous concrete, that is external Nature as such, does not exclusively originate in such an end. The variously coloured plumage of birds is resplendent unseen; the notes of this song are unheard. The Cereus, which only blossoms for a night, withers away without any admiration from another in the wilderness of the southern forests; and these forests, receptacles themselves of the most beautiful and luxuriant vegetation, with the richest and most aromatic perfumes, perish and collapse in like manner unenjoyed. The work of art has no such naive and independent being. It is essentially a question, an address to the responding soul of man, an appeal to affections and intelligence.

Although the endowment by art of sensuous shape is not in this respect accidental, yet on the other hand it is not the highest mode of grasping the spiritually concrete. Thought is a higher mode of presentment than that of the sensuous concrete. Though abstract in a relative sense; yet it must not be one-sided, but concrete thinking, in order to be true and rational. The extent to which a definite content possesses for its appropriate form sensuous artistic representation, or essentially requires, in virtue of its nature, a higher and more spiritual embodiment is a question of difference exemplified at once if we compare the Greek gods with God as conceived under Christian ideas. The Greek god is not abstract, but individual, and is in close association with the natural human form. The Christian God is also, no doubt, a concrete personality, but under the mode of pure spiritual actuality, who is cognized as Spirit and in Spirit. His medium of determinate existence is therefore essentially knowledge of the mind and not external natural shape, by means of which His representation can only be imperfect, and not in the entire depths of His idea or notional concept.

Inasmuch, however, as it is the function of art to represent the Idea to immediate vision in sensuous shape and not in the form of thought and pure spirituality in the strict sense, and inasmuch as the value and intrinsic worth of this presentment consists in the correspondence and unity of the two aspects, that is the Idea and its sensuous shape, the supreme level and excellence of art and the reality, which is truly consonant with its notion, will depend upon the degree of intimacy and union

with which idea and configuration appear together in elaborated fusion. The higher truth consequently is spiritual content which has received the shape adequate to the conception of its essence; and this it is which supplies the principle of division for the philosophy of art. For before the mind can attain to the true notion of its absolute essence, it is constrained to traverse a series of stages rooted in this very notional concept; and to this course of stages which it unfolds to itself, corresponds a coalescent series, immediately related therewith, of the plastic types of art, under the configuration whereof mind as art-spirit presents to itself the consciousness of itself.

This evolution within the art-spirit has further itself two sides in virtue of its intrinsic nature. *First*, that is to say, the development is itself a spiritual and universal one; in other words there are the definite and comprehensive views of the world in their series of gradations which give artistic embodiment to the specific but widely embracing consciousness of Nature, man, and God. *Secondly*, this ideal or *universal* art-development has to provide for itself immediate existence and sensuous configuration, and the definite modes of this art-actualization in the sensuous medium are themselves a totality of necessary distinctions in the realm of art—that is to say, they are the *particular types* of art. No doubt the types of artistic configuration on the one hand are, in respect to their spirituality, of a general character, and not restricted to any one material, and the sensuous existence is similarly itself of varied multiplicity of medium. Inasmuch, however, as this material potentially possesses, precisely as the mind or spirit does, the Idea for its inward soul or significance, it follows that a definite sensuous involves with itself a closer relation and secret bond of association with the spiritual distinctions and specific types of artistic embodiment.

Relatively to these points of view our philosophy will be divided into three fundamental parts.

First, we have a *general* part. It has for its content and object the universal Idea of fine art, conceived here as the Ideal, together with the more elaborated relation under which it is placed respectively to Nature and human artistic production.

Secondly, we have evolved from the notional concept of the beauty of art a *particular* part, in so far as the essential distinctions, which this idea contains in itself, are unfolded in a graduated series of *particular* modes of configuration.

Thirdly, there results a *final* part which has to consider the particularized content of fine art itself. It consists in the advance of art to the sensuous realization of its shapes and its consummation in a system of the several arts and their genera and species.

2. In respect to the first and second of these divisions it is important to recollect, in order to make all that follows intelligible, that the Idea, viewed as the beautiful in art, is not the Idea in the strict sense, that is

as a metaphysical Logic apprehends it as the Absolute. It is rather the
Idea as carried into concrete form in the direction of express realization,
and as having entered into immediate and adequate unity with such reality.
For the *Idea as such*, although it is both potentially and explicitly true,
is only truth in its universality and not as yet presented in objective
embodiment. The Idea as fine art, however, is the Idea with the more
specific property of being essentially individual reality, in other words, an
individual configuration of reality whose express function it is to make
manifest the Idea—in its appearance. This amounts to the demand that
the Idea and its formative configuration as concrete realization must be
brought together under a mode of complete adequacy. The Idea as so
conceived, a reality, that is to say, moulded in conformity with the notional
concept of the Idea, is the Ideal. The problem of such consonancy might,
in the first instance, be understood in the wholly formal sense that the
Idea might be any idea so long as the actual shape, it matters not what
the shape might be, represented this particular Idea and no other. In
that case, however, the required truth of the Ideal is a fact simply inter-
changeable with mere correctness, a correctness which consists in the
expression of any significance in a manner adapted to it, provided that its
meaning is thereby directly discoverable in the form. The Ideal, however,
is not to be thus understood. According to the standard or test of its own
nature any content whatever can receive adequate presentation, but it does
not necessarily thereby possess a claim to be the fine art of the Ideal.
Nay, more, in comparison with ideal beauty the presentation will even
appear defective. And in this connection we may once for all observe—
though actual proof is reserved to a later stage—that the defects of a
work of art are not invariably to be attributed to defects of executive
skill. *Defectiveness of form* arises also from *defectiveness of content*. The
Chinese, Hindoos, and Egyptians, for example, in their artistic images,
sculptured deities and idols, never passed beyond a formless condition,
or a definition of shape that was vicious and false, and were unable to
master true beauty. And this was so for the reason that their mythological
conceptions, the content and thought of their works of art, were still
essentially indeterminate, or only determinate in a false sense, did not,
in fact, attain to a content which was absolute in itself. Viewed in this
sense the excellence of works of art is so much the greater in the degree
that their content and thought is ideal and profound. And in affirming
this we have not merely in our mind the degree of executive mastery
displayed in the grasp and imitation of natural form as we find it in the
objective world. For in certain stages of the artistic consciousness and
its reproductive effects the desertion and distortion of the conformations
of Nature is not so much due to unintentional technical inexperience or
lack of ability, as it is to deliberate alteration, which originates in the
mental content itself, and is demanded by the same. From this point of
view there is therefore imperfect art, which, both in technical and other

respects, may be quite consummate in its *own specific sphere*, yet if tested with the true notion of art and the Ideal can only appear as defective. Only in the highest art are the Idea and the artistic presentation truly consonant with one another in the sense that the objective embodiment of the Idea is in itself essentially and as realized the true configuration, because the content of the Idea thus expressed is itself in truth the genuine content. It is appertinent to this, as already noted, that the Idea must be defined in and through itself as concrete totality, thereby essentially possessing in itself the principle and standard of its particularization and definition as thus manifested objectively. For example, the Christian imagination will only be able to represent God in human form and with man's means of spiritual expression, because it is herein that God Himself is fully known in Himself as mind or Spirit. Determinacy is, as it were, the bridge to phenomenal presence. Where this determinacy is not totality derived from the Idea itself, where the Idea is not conceived as that which is self-definitive and self-differentiating, it remains abstract and possesses its definition, and with it the principle for the particular mode of embodiment adapted to itself not within itself but as something outside it. And owing to this the Idea is also still abstract and the configuration it assumes is not as yet posited by itself. The Idea, however, which is essentially concrete, carries the principle of its manifestation in itself, and is thereby the means of its own free manifestation. Thus it is only the truly concrete Idea that is able to evoke the true embodiment, and this appropriate coalescence of both is the Ideal.

3. But inasmuch as in this way the Idea is concrete unity, this unity can only enter the artistic consciousness by the expansion and further mediation of the particular aspects of the Idea; and it is through this evolution that the beauty of art receives a *totality of particular stages and forms*. Therefore, after we have considered fine art in its essence and on its own account, we must see how the beautiful in its entirety breaks up into its particular determinations. This gives, as our second part, the *doctrine of the types of art*. The origin of these types is to be found in the varied ways under which the Idea is conceived as the content of art; it is by this means that a distinction in the mode of form under which it manifests itself is conditioned. These types are therefore simply the different modes of relation which obtain between the Idea and its configuration, relations which emanate from the Idea itself, and thereby present us with the general basis of division for this sphere. For the principle of division must always be found in the notional concept, the particularization and division of which it is.

We have here to consider *three* relations of the Idea to its external process of configuration.

(*a*) *First*, the origin of artistic creation proceeds from the Idea when, being itself still involved in defective definition and obscurity, or in vicious and untrue determinacy, it becomes embodied in the shapes of art. As

indeterminate it does not as yet possess in itself that individuality which
the Ideal demands. Its abstract character and one-sidedness leaves its ob-
jective presentment still defective and contingent. Consequently this first
type of art is rather a mere search after plastic configuration than a
power of genuine representation. The Idea has not as yet found the for-
mative principle within itself, and therefore still continues to be the mere
effort and strain to find it. We may in general terms describe this form
as the *symbolic* type of art. The abstract Idea possesses in it its external
shape outside itself in the purely material substance of Nature, from
which the shaping process proceeds, and to which in its expression it is
entirely yoked. Natural objects are thus in the first instance left just as
they are, while, at the same time the substantive Idea is imposed upon
them as their significance, so that their function is henceforth to express
the same, and they claim to be interpreted, as though the Idea itself was
present in them. A rationale of this is to be found in the fact that the
external objects of reality do essentially possess an aspect in which they
are qualified to express a universal import. But as a completely adequate
coalescence is not yet possible, all that can be the outcome of such a
relation is an *abstract attribute*, as when a lion is understood to symbolize
strength.

On the other hand this abstractness of the relation makes present to
consciousness no less markedly how the Idea stands relatively to natural
phenomena as an alien; and albeit it expatiates in all these shapes, having
no other means of expression among all that is real, and seeks after itself
in their unrest and defects of genuine proportion, yet for all that it finds
them inadequate to meet its needs. It consequently exaggerates natural
shapes and the phenomena of Nature in every degree of indefinite and
limitless extension; it flounders about in them like a drunkard, and
seethes and ferments, doing violence to their truth with the distorted
growth of unnatural shapes, and strives vainly by the contrast, hugeness,
and splendour of the forms accepted to exalt the phenomena to the plane
of the Idea. For the Idea is here still more or less indeterminate, and
unadaptable, while the objects of Nature are wholly definite in their shape.

Hence, on account of the incompatibility of the two sides of ideality
and objective form to one another, the relation of the Idea to the other
becomes a *negative* one. The former, being in its nature ideal, is unsatis-
fied with such an embodiment, and posits itself as its inward or ideally
universal substance under a relation of *sublimity* over and above all this
inadequate superfluity of natural form. In virtue of this sublimity the
natural phenomena, of course, and the human form and event are accepted
and left simply as they are, but at the same time, recognized as unequal
to their significance, which is exalted far above all earthly content.

These features constitute in general terms the character of the primi-
tive artistic pantheism of the East, which, on the one hand, charges the
meanest objects with the significance of the absolute Idea, or, on the

other, compels natural form, by doing violence to its structure, to express its world-ideas. And, in consequence, it becomes bizarre, grotesque, and deficient in taste, or turns the infinite but abstract freedom of the substantive Idea contemptuously against all phenomenal existence as alike nugatory and evanescent. By such means the significance cannot be completely presented in the expression, and despite all straining and endeavour the final inadequacy of plastic configuration to Idea remains insuperable. Such may be accepted as the first type of art—symbolic art with its yearning, its fermentation, its mystery, and sublimity.

(*b*) In the *second* type of art, which we propose to call *"Classical,"* the twofold defect of symbolic art is annulled. Now the symbolic configuration is imperfect, because, first, the Idea here only enters into consciousness in *abstract* determinacy or indeterminateness: and, secondly, by reason of the fact that the coalescence of import with embodiment can only throughout remain defective, and in its turn also wholly abstract. The classical art-type solves both these difficulties. It is, in fact, the free and adequate embodiment of the Idea in the shape which, according to its notional concept, is uniquely appropriate to the Idea itself. The Idea is consequently able to unite in free and completely assonant concord with it. For this reason the classical type of art is the first to present us with the creation and vision of the complete Ideal, and to establish the same as realized fact.

The conformability, however, of notion and reality in the classical type ought not to be taken in the purely *formal* sense of the coalescence of a content with its external form, any more than this was possible in the case of the Ideal. Otherwise every copy from Nature, and every kind of portrait, every landscape, flower, scene, and so forth, which form the aim of the presentment, would at once become classical in virtue of the fact of the agreement it offers between such content and form. In classical art, on the contrary, the characteristic feature of the content consists in this, that it is itself concrete Idea, and as such the concrete spiritual; for it is only that which pertains to Spirit which is veritable ideality. To secure such a content we must find out that in Nature which on its own account is that which is essentially and explicitly appropriate to the spiritual. It must be the *original* notion itself which has invented the form for concrete spirituality, and now the *subjective* notion—in the present case the spirit of art—has merely *discovered* it, and made it, as an existence possessed of naturel shape, concordant with free and individual spirituality. Such a configuration, which the Idea essentially possesses as spiritual, and indeed as individually determinate spirituality, when it must perforce appear as a temporal phenomenon, is the *human form*. Personification and anthropomorphism have frequently been abused as a degradation of the spiritual. But art, in so far as its function is to bring to vision the spiritual in sensuous guise, must advance to such anthropomorphism, inasmuch as Spirit is only adequately presented to perception in its bodily presence. The

transmigration of souls in this respect an abstract conception, and physiology ought to make it one of its fundamental principles, that life has necessarily, in the course of its evolution, to proceed to the human form, for the reason that it is alone the visible phenomenon adequate to the expression of intelligence.

The human bodily form, then, is employed in the classical type of art not as purely sensuous existence, but exclusively as the existence and natural shape appropriate to mind. It has therefore to be relieved of all the defective excrescences which adhere to it in its purely physical aspect, and from the contingent finiteness of its phenomenal appearance. The external shape must in this way be purified in order to express in itself the content adequate for such a purpose; and, furthermore, along with this, that the coalescence of import and embodiment may be complete, the spirituality which constitutes the content must be of such a character that it is completely able to express itself in the natural form of man, without projecting beyond the limits of such expression within the sensuous and purely physical sphere of existence. Under such a condition Spirit is at the same time defined as particular, the spirit of mind of man, not as simply absolute and eternal. In this latter case it is only capable of asserting and expressing itself as intellectual being.

Out of this latter distinction arises, in its turn, the defect which brings about the dissolution of the classical type of art, and makes the demand for a third and higher form, namely the *romantic* type.

(c) The romantic type of art annuls the completed union of the Idea and its reality, and occurs, if on a higher plane, to the difference and opposition of both sides, which remained unovercome in symbolic art. The classical type of art no doubt attained the highest excellence of which the sensuous embodiment of art is capable. The defect, such as it is, is due to the defect which obtains in art itself throughout, the limitations of its entire province, that is to say. The limitation consists in this, that art in general and, agreeably to its fundamental idea, accepts for its object Spirit, the notion of which is infinite concrete universality, under the guise of sensuously concrete form. In the classical type it sets up the perfected coalescence of spiritual and sensuous existence as adequate conformation of both. As a matter of fact, however, in this fusion mind itself is not represented agreeably to its *true notional concept*. Mind is the infinite subjectivity of the Idea, which as absolute inwardness, is not capable of freely expanding in its entire independence, so long as it remains within the mould of the bodily shape, fused therein as in the existence wholly congenial to it.

To escape from such a condition the romantic type of art once more cancels that inseparable unity of the classical type, by securing a content which passes beyond the classical stage and its mode of expression. This content, if we may recall familiar ideas—is coincident with what Christianity affirms to be true of God as Spirit, in contrast to the Greek faith

in gods which forms the essential and most fitting content of classical art. In Greek art the concrete ideal substance is potentially, but not as fully realized, the unity of the human and divine nature; a unity which for the very reason that it is purely *immediate* and not wholly explicit, is manifested without defect under an immediate and *sensuous* mode. The Greek god is the object of naive intuition and sensuous imagination. His shape is therefore the bodily form of man. The sphere of his power and his being is individual and individually limited; and in his opposition to the individual person is an essence and a power with whom the inward life of soul is merely potentially in unity, but does not itself possess this unity as inward subjective knowledge. The higher stage is the *knowledge* of this *implied* unity, which in its latency the classical art-type receives as its content and is able to perfectly represent in bodily shape. This elevation of mere potentiality into self-conscious knowledge constitutes an enormous difference. It is nothing less than the infinite difference which, for example, separates man generally from the animal creation. Man is animal; but even in his animal functions he is not restricted within the potential sphere as the animal is, but becomes conscious of them, learns to understand them, and raises them—as, for instance, the process of digestion—into self-conscious science. By this means man dissolves the boundaries of his merely potential immediacy; in virtue of the very fact that he knows himself to be animal he ceases to be merely animal, and as mind is endowed with self-knowledge.

If, then, in this way the unity of the human and divine nature, which in the previous stage was potential, is raised out of this immediate into a self-conscious unity, it follows that the genuine medium for the reality of this content is no longer the sensuous and immediate existence of what is spiritual, that is, the physical body of man, but the *self-aware* inner life of *soul itself*. Now it is Christianity—for the reason that it presents to mind God as *Spirit*, and not as the particular individual spirit, but as absolute in spirit and in truth—which steps back from the sensuousness of imagination into the inward life of reason, and makes *this* rather than *bodily* form the medium and determinate existence of its content. So also, the unity of the human and divine nature is a conscious unity exclusively capable of realization by means of *spiritual* knowledge, and in *Spirit*. The new content secured thereby is consequently not indefeasibly bound up with the sensuous presentation, as the mode completely adequate, but is rather delivered from this immediate existence, which has to be hypostatized as a negative factor, overcome and reflected back into the spiritual unity. In this way romantic art must be regarded as art transcending itself, albeit within the boundary of its own province, and in the form of art itself.

We may therefore briefly summarize our conclusion that in this third stage the object of art consists in the free and concrete presence of spiritual activity, whose vocation it is to appear as such a presence or activity for

the inner world of conscious intelligence. In consonance with such an object art cannot merely work for sensuous perception. It must deliver itself to the inward life, which coalesces with its object simply as though this were none other than itself, in other words, to the intimacy of soul, to the heart, the emotional life, which as the medium of Spirit itself essentially strives after freedom, and seeks and possesses its reconciliation only in the inner chamber of spirit. It is this inward or ideal world which constitutes the content of the romantic sphere: it will therefore necessarily discover its representation as such inner idea or feeling, and in the show or appearance of the same. The world of the soul and intelligence cele-brates its triumph over the external world, and, actually in the medium of that outer world, makes that victory to appear, by reason of which the sensuous appearance sinks into worthlessness.

On the other hand, this type of art, like every other, needs an external vehicle of expression. As already stated, the spiritual content has here withdrawn from the external world and its immediate unity into its own world. The sensuous externality of form is consequently accepted and represented, as in the symbolic type, as unessential and transient; further-more the subjective finite spirit and volition is treated in a similar way; a treatment which even includes the idiosyncracies or caprice of indi-viduals, character, action, or the particular features of incident and plot. The aspect of external existence is committed to contingency and handed over to the adventurous action of imagination, whose caprice is just as able to reflect the facts given *as* they are, as it can change the shapes of the external world into a medley of its own invention and distort them to mere caricature. For this external element has no longer its notion and significance in its own essential province, as in classical art. It is now discovered in the emotional realm, and this is manifested in the medium of that realm itself rather than in the external and *its* form of reality, and is able to secure or recover again the condition of reconciliation with itself in every accident, in all the chance circumstance that falls into independent shape, in all misfortune and sorrow, nay, in crime itself.

Hence it comes about that the characteristics of symbolic art, its indif-ference, incompatibility and severance of Idea from configurative expres-sion, are here reproduced once more, if with essential difference. And this difference consists in the fact that in romantic art the Idea, whose defec-tiveness, in the case of the symbol, brought with it the defect of external form, has to display itself as Spirit and in the medium of soul-life as essentially self-complete. And it is to complete fundamentally this higher perfection that it withdraws itself from the external element. It can, in short, seek and consummate its true reality and manifestation nowhere but in its own domain.

This we may take to be in general terms the character of the symbolic, classical, and romantic types of art, which in fact constitute the three relations of the Idea to its embodiment in the realm of human art. They

consist in the aspiration after, the attainment and transcendency of the Ideal, viewed as the true concrete notion of beauty.

4. In contrast to these two previous divisions of our subject the *third* part presupposes the notional concept of the Ideal, and the universal art-types. It in other words consists in their realization through specific sensuous media. We have consequently no longer to deal with the inner or ideal evolution of the beauty of art in conformity with its widest and most fundamental determinations. What we have now before us to consider is how these ideal determinants pass into actual existence, how they are distinguishable in their external aspect, and how they give an independent and a realized shape to every element implied in the evolution of this Idea of beauty as *a work of art*, and not merely as a *universal type*. Now it is the peculiar differences immanent in the Idea of beauty which are carried over by it into external existence. For this reason in this third fundamental division these general art-types must themselves supply the basic principle for the articulation and definition of the *particular arts*. Or, to put the same thing another way, the several species of art possess in themselves the same essential differences, which we have already become acquainted with as the universal art-types. *External* objectivity, however, to which these types are subjected in a sensuous and consequently *specific* material, necessitates the differentiation of these types into diverse and independent modes of realization, in other words, those of particular arts. Each general type discovers its determinate character in one determinate external material or medium, in which its adequate presentation is secured under the manner it prescribes. But, from another point of view, these types of art, inasmuch as their definition is none the less consistent with the fact of the *universality* of their typical import, break through the boundaries of their *specific* realization in some definite art-species, and achieve an existence in other arts no less, although their position in such is of subordinate importance. For this reason, albeit the particular arts belong specifically to one of these general art-types respectively, the *adequate* external embodiment whereof they severally constitute, yet this does not prevent them, each after its own mode of external configuration, from representing the totality of these art-types. To summarize, then, in this third principal division we are dealing with the beauty of art, as it unveils itself in a world of realized beauty by means of the arts and their creations. The content of this world is the beautiful, and the true beautiful, as we have seen, is spiritual being in concrete form, the Ideal; or apprehended with still more intimacy it is the absolute mind and truth itself. This region of divine truth artistically presented to sensuous vision and emotion forms the centre of the entire world of art. It is the independent, free and divine Image, which has completely appropriated the externality of form and medium, and now wears them simply as the means of its self-manifestation. Inasmuch, however, as the beautiful is unfolded here as *objective* reality, and in this process is differentiated into particular

aspects and phases, this centre posits its extremes, as realized in their peculiar actuality, in antithetical relation to itself. Thus one of these extremes consists of an objectivity as yet devoid of mind, which we may call the natural environment of God. Here the external element, when it receives form, remains as it was, and does not possess its spiritual aim and content in itself, but in another. The other extreme is the divine as inward, something known, as the manifold particularized *subjective* existence of Deity. It is the truth as operative and vital in sense, soul, and intelligence of particular persons, which does not persist as poured forth into its mould of external shape, but returns into the inward life of individuals. The Divine is under such a mode at once distinguishable from its pure manifestation as Godhead, and passes itself thereby into the variety of particularization which belongs to every kind of particular subjective knowledge, feeling, perception, and emotion. In the analogous province of religion with which art, at its highest elevation, is immediately connected, we conceive the same distinction as follows. First, we imagine the natural life on Earth in its finitude as standing on one side; but then, secondly, the human consciousness accepts God for its object, in which the distinction between objectivity and subjectivity falls away; then, finally, we advance from God as such to the devotion of the *community*, that is to God as He is alive and present in the subjective consciousness. These three fundamental modifications present themselves in the world of art in independent evolution.

(*a*) The *first* of the particular arts with which, according to their fundamental principle, we have to start is architecture considered as a fine art. Its function consists in so elaborating the external material of inorganic Nature that the same becomes intimately connected with Spirit as an artistic and external environment. Its medium is matter itself as an external object, a heavy mass that is subject to mechanical laws; and its forms persist as the forms of inorganic Nature coordinated with the relations of the abstract understanding such as symmetry and so forth. In this material and in these forms the Ideal is incapable of realization as concrete spirituality, and the reality thus presented remains confronting the Idea as an external fabric with which it enters into no fusion, or has only entered so far as to establish an abstract relation. And it is in consequence of this that the fundamental type of the art of building is that of *symbolism*. Architecture is in fact the first pioneer on the highway toward the adequate realization of Godhead. In this service it is put to severe labour with objective nature, that it may disengage it by its effort from the confused growth of finitude and the distortions of contingency. By this means it levels a space for the God, informs His external environment, and builds Him His temple, as a fit place for the concentration of Spirit, and its direction to the absolute objects of intelligent life. It raises an enclosure for the congregation of those assembled, as a defence against the threatening of the tempest, against rain, the hurricane, and savage animals. It in short reveals the will thus to assemble, and although under an external re-

lation, yet in agreement with the principles of art. A significance such as this it can to a greater or less extent import into its material and its forms, in proportion as the determinate content of its fabric, which is the object of its operations and effort, is more or less significant, is more concrete or more abstract, more profound in penetrating its own essential depth, or more obscure and superficial. Indeed architecture may in this respect proceed so far in the execution of such a purpose as to create an adequate artistic existence for such an ideal content in its very forms and material. In doing so, however, it has already passed beyond its peculiar province and is diverted into the stage immediately above it of sculpture. For the boundary of sculpture lies precisely in this that it retains the spiritual as an inward being which persists in direct contrast to the external embodiment of architecture. It can consequently merely point to that which is absorbed in soul-life as to something external to itself.

(*b*) Nevertheless, as above explained, the external and inorganic world is purified by architecture, it is coordinated under symmetrical laws, and made cognate with mind, and as a result the temple of God, the house of His community, stands before us. Into this temple, in the *second* place, the God Himself enters in the lightning-flash of individuality which smites its way into the inert mass, permeating the same with its presence. In other words the infinite and no longer purely symmetrical form belonging to intelligence brings as it were to a focus and informs the shape in which it is most at home. This is the task of *sculpture*. In so far as in it the inward life of Spirit, to which the art of architecture can merely point away to, makes its dwelling within the sensuous shape and its external material, and to the extent that these two sides come into plastic communion with one another in such a manner that neither is predominant, sculpture receives as its fundamental type the *classical* art-form.

For this reason the sensuous element on its own account admits of no expression here which is not affected by spiritual affinities, just as, conversely, sculpture can reproduce with completeness no spiritual content, which does not maintain throughout adequate presentation to perception in bodily form. What sculpture, in short, has to do is to make the presence of Spirit stand before us in its bodily shape and in immediate union therewith at rest and in blessedness; and this form has to be made vital by means of the content of spiritual individuality. The external sensuous material is consequently no longer elaborated either in conformity with its mechanical quality alone, as a mass of weight, nor in shapes of the inorganic world simply, nor in entire indifference to colour, etc. It is carried into the ideal forms of the human figure, and, we may add, in the completeness of all three spatial dimensions. In other words and relatively to such a process we must maintain for sculpture that in it the inward or ideal content of Spirit are first revealed in their eternal repose and essential self-stability. To such repose and unity with itself there can only

correspond that external shape which itself persists in such unity and repose. And this condition is satisfied by configuration viewed in its *abstract spatiality*. The spirit which sculpture represents is that which is essentially sound, not broken up in the play of chance conceits and passions; and for this reason its external form also is not dissolved in the manifold variety of appearance, but exhibits itself under this one presentment only as the abstraction of space in the totality of its dimensions.

Assuming, then, that the art of architecture has executed its temple, and the hand of sculpture has placed therein the image of the god, we have in the *third* place to assume the *community* of the faithful as confronting the god thus presented to vision in the wide chambers of his dwelling-place. Now this community is the spiritual reflection into its own world of that sensuous presence, the subjective and inward animating life of soul, in its union with which, both for the artistic content and the external material which manifests it, the determining principle may be identified with particularization in varied shapes and qualities, individualization and the life of soul which they imply. The downright and solid fact of unity the god possesses in sculpture breaks up into the multiplicity of a world of particular souls, whose union is no longer sensuous but wholly ideal.

Here for the first time God Himself is revealed as veritably Spirit—viz., the Spirit revealed in His community. Here at last He is seen apprehended as this moving to-and-fro, as this alternation between His own essential unity and His realization in the knowledge of individual persons and that separation which it involves, as also in the universal spiritual being and union of the many. In such a community God is disengaged from the abstraction of His unfolded self-seclusion and self-identity, no less than from the immediate absorption in bodily shape, in which He is presented by sculpture. He is, in a word, lifted into the actual sphere of spiritual existence and knowledge, into the reflected appearance, whose manifestation is essentially inward and the life of heart and soul. Thereby the higher content is now the nature of Spirit, and that in its ultimate or absolute shape. But at the same time the separation to which we have alluded displays this as *particular* spiritual being, a specific emotional life. Moreover, for the reason that the main thing here is not the untroubled repose of the God in himself, but his manifestation simply, the Being which is *for another*, self-revealment in fact, it follows that, on the plane we have now reached, all the varied content of human subjectivity in its vital movement and activity, whether viewed as passion, action, or event, or more generally the wide realm of human feeling, volition and its discontinuance, become one and all for their own sake objects of artistic representation.

Agreeably with such a content the sensuous element of art has likewise to show itself potentially adapted to such particularization and the display of such an inward content of heart and mind. Media of this description

are supplied by colour, musical tones, and finally in sound as mere signs for ideal perceptions and conceptions; and we further obtain the means of realizing with the use of such media a content of this kind in the arts of painting, music, and poetry. Throughout this sphere the sensuous medium is found to be essentially disparate in itself and throughout posited as ideal. In this way it responds in the highest degree to the fundamentally spiritual content of art, and the coalescence of spiritual significance and sensuous material attains a more intimate union than was possible either in architecture or sculpture. At the same time such a union is necessarily more near to soul-life, leaning exclusively to the subjective side of human experience; one which, in so far as form and content are thus constrained to particularization and to posit their result as ideal, can only be actually effected at the expense of the objective universality of the content as also of the fusion with the immediately sensuous medium.

The arts, then, which are lifted into a higher strain of ideality, abandoning as they do the symbolism of architecture and the classical Ideal of sculpture, accept their predominant type from the *romantic* artform; and these are the arts most fitted to express its mode of configuration. They are, however, a totality of arts, because the romantic type is itself essentially the most concrete.

(*c*) The articulation of this *third sphere* of the particular arts may be fixed as follows:

(*α*) *The first* art which comes next to sculpture is that of painting. It avails itself for a medium of its content and the plastic configuration of the same of visibility as such, to the extent that it is differentiated in its own nature, in other words is defined in the continuity of colour. No doubt the material of architecture and sculpture is likewise both visible and coloured. It is, however, not, as in painting, visibility in its pure nature, not the essentially simple light, which by its differentiating of itself in its opposition to darkness, and in association with that darkness gives rise to colour. This quality of visibility made essentially ideal and treated as such no longer either requires, as in architecture, the abstractly mechanical qualities of mass as appropriate to materials of weight, nor, as is the case with sculpture, the complete dimensuration of spatial condition, even when concentrated into organic forms. The visibility and the making apparent, which belong to painting, possess differences of quality under a more ideal mode—that is, in the specific varieties of colour—which liberates art from the objective totality of spatial condition, by being limited to a plane surface.

On the other hand the content also attains the widest compass of particularity. Whatever can find a place in the human heart, as emotion, idea, and purpose, whatever it is capable of actually shaping—all such diversity may form part of the varied presentations of painting. The entire world of particular existence, from the most exalted embodiment of mind to the most insignificant natural fact, finds a place here. For it is possible even

for finite Nature, in its particular scenes and phenomena, to form part of such artistic display, provided only that we have some reference to conscious life which makes it akin to human thought and emotion.

(β) The *second* art which continues the further realization of the romantic type and forms a distinct contrast to painting is that of *music*. Its medium, albeit still sensuous, yet proceeds into still profounder subjectivity and particularization. We have here, too, the deliberate treatment of the sensuous medium as ideal, and it consists in the negation and idealization into the isolated unity of a single point, the indifferent external collocation of space, whose complete appearance is retained by painting and deliberately feigned in its completeness. This isolated point, viewed as this process of negation, is an essentially concrete and active process of cancellation within the determinate substance of the material medium, viewed, that is, as motion and vibration of the material object within itself and in its relation to itself. Such an inchoate ideality of matter, which no longer appears under the form of space, but as temporal ideality, is sound or tone. We have here the sensuous set down as negated, and its abstract visibility converted into audibility. In other words sound liberates the ideal content from its fetters in the material substance. This earliest secured inwardness of matter and impregnation of it with soul-life supplies the medium for the intimacy and soul of Spirit—itself as yet indefinite—permitting, as it does, the echo and reverberation of man's emotional world through its entire range of feelings and passions. In this way music forms the centre of the romantic arts, just as sculpture represents the midway point of arrest between architecture and the arts of the romantic subjectivity. Thus, too, it forms the point of transition between the abstract, spatial sensuousness of painting and the abstract spirituality of poetry. Music carries within itself, like architecture, and in contrast to the emotional world simply and its inward self-seclusion, a relation of quantity conformable to the principles of the understanding and their modes of co-ordinated configuration.

(γ) We must look for our *third* and most spiritual type of artistic presentation among the romantic arts in that of *poetry*. The supreme characteristic of poetry consists in the power with which it brings into vassalage of the mind and its conceptions the sensuous element from which music and painting began to liberate art. For sound, the only remaining external material retained by poetry, is in it no longer the feeling of the sonorous itself, but is a mere sign without independent significance. And it is, morever, a sign of idea which has become essentially concrete, and not merely of indefinite feeling and its subtle modes and gradations. And this is how sound develops into the Word, as essentially articulate voice, whose intention it is to indicate ideas and thoughts. The purely negative moment to which music advanced now asserts itself as the wholly concrete point, the point which is mind itself, the self-conscious individual, which produces from itself the infinite expansion of its

ideas and unites the same with the temporal condition of sound. Yet this sensuous element, which was still in music immediately united to emotion, is in poetry separated from the content of consciousness. Mind, in short, here determines this content for its own sake and apart from all else into the content of idea; to express such idea it no doubt avails itself of sound, but employs it merely as a sign without independent worth or substance. Thus viewed, the sound here may be just as well reproduced by the mere letter, for the audible, like the visible, is here reduced to a mere indication of mind. For this reason, the true medium of poetical representation is the poetical imagination and the intellectual presentation itself; and inasmuch as this element is common to all types of art it follows that poetry is a common thread through them all, and is developed independently in each. Poetry is, in short, the universal art of the mind, which has become essentially free, and which is not fettered in its realization to an externally sensuous material, but which is creatively active in the space and time belonging to the inner world of ideas and emotion. Yet it is precisely in this its highest phase, that art terminates, by transcending itself; it is just here that it deserts the medium of a harmonious presentation of mind in sensuous shape and passes from the poetry of imaginative idea into the prose of thought.

Such we may accept as the articulate totality of the particular arts; they are the external art of architecture, the objective art of sculpture and the subjective arts of painting, music, and poetry. Many other classifications than these have been attempted, for a work of art presents such a wealth of aspects, that it is quite possible, as has frequently been the case, to make first one and then another the basis of division. For instance, you may take the sensuous medium simply. Architecture may then be viewed as a kind of crystallization; sculpture, as the organic configuration of material in its sensuous and spatial totality; painting as the coloured surface and line, while in music, space, as such, passes over into the point or moment of time replete with content in itself, until we come finally to poetry, where the external medium is wholly suppressed into insignificance. Or again, these differences have been viewed with reference to their purely abstract conditions of space and time. Such abstract divisions of works of art may, as their medium also may be consequentially traced in their characteristic features. They cannot, however, be worked out as the final and fundamental principle, because such aspects themselves derive their origins from a higher principle, and must therefore fall into subordination thereto.

This higher principle we have discovered in the types of art—symbolic, classical, and romantic—which are the universal stages or phases of the Idea of beauty itself.

Their relation to the individual arts in their concrete manifestation as embodiment is of a kind that these arts constitute the real and positive existence of these general art-types. For *symbolic* art attains its most ade-

quate realization and most pertinent application in *architecture*, in which it expatiates in the full import of its notion, and is not as yet depreciated, as it were, into the merely inorganic nature dealt with by some other art. The *classical* type of art finds it unfettered realization, on the other hand, in sculpture, treating architecture merely as the enclosure which surrounds it, and being unable to elaborate painting and music into the wholly adequate forms of its content. Finally, the *romantic* art-type is supreme in the products of painting and music, and likewise in poetical composition, as their pre-eminent and unconditionally adequate modes of expression. Poetry is, however, conformable to all types of the beautiful, and its embrace reaches them all for the reason that the poetic imagination is its own proper medium, and imagination is essential to every creation of beauty, whatever its type may be.

To sum up, then, what the particular arts realize in particular works of art, are according to their fundamental conception, simply the universal types which constitute the self-unfolding Idea of beauty. It is as the external realization of this Idea that the wide Pantheon of art is being raised; and the architect and builder thereof is the spirit of beauty as it gradually comes to self-cognition, and to complete which the history of the world will require its evolution of centuries.

ARTHUR SCHOPENHAUER
THE WORLD AS WILL AND IDEA

Arthur Schopenhauer (1788–1860), a German philosopher noted for his pessimistic view of life, was profoundly influenced by doctrines advanced in Buddhist texts. He views art as an important means of escape from the pains and privations of life.

BOOK III

§ 30. In the First Book the world was explained as mere *idea*, object for a subject. In the Second Book we considered it from its other side, and found that in this aspect it is *will*, which proved to be simply that which this world is besides being idea. In accordance with this knowledge we called the world as idea, both as a whole and in its parts, the *objectification of will*, which therefore means the will become object, *i.e.*, idea. Further, we remember that this objectification of will was found to have many definite grades, in which, with gradually increasing distinctness and completeness, the nature of will appears in the idea, that is to say, presents itself as object. In these grades we already recognised the Platonic Ideas, for the grades are just the determined species, or the original unchanging

Reprinted (footnotes deleted) from *The World as Will and Idea*, translated by R. B. Haldane and J. B. Kemp, Volume I, London: Routledge and Kegan Paul, Ltd., 1950, and New York: Humanities Press Inc., by permission of the publishers.

forms and qualities of all natural bodies, both organised and unorganised, and also the general forces which reveal themselves according to natural laws. These Ideas, then, as a whole express themselves in innumerable individuals and particulars, and are related to these as archetypes to their copies. The multiplicity of such individuals is only conceivable through time and space, their appearing and passing away through causality, and in all these forms we recognise merely the different modes of the principle of sufficient reason, which is the ultimate principle of all that is finite, of all individual existence, and the universal form of the idea as it appears in the knowledge of the individual as such. The Platonic Idea, on the other hand, does not come under this principle, and has therefore neither multiplicity nor change. While the individuals in which it expresses itself are innumerable, and unceasingly come into being and pass away, it remains unchanged as one and the same, and the principle of sufficient reason has for it no meaning. As, however, this is the form under which all knowledge of the subject comes, so far as the subject knows as an *individual*, the Ideas lie quite outside the sphere of its knowledge. If, therefore, the Ideas are to become objects of knowledge, this can only happen by transcending the individuality of the knowing subject. The more exact and detailed explanation of this is what will now occupy our attention.

. . .

§ 33. Since now, as individuals, we have no other knowledge than that which is subject to the principle of sufficient reason, and this form of knowledge excludes the Ideas, it is certain that if it is possible for us to raise ourselves from the knowledge of particular things to that of the Ideas, this can only happen by an alteration taking place in the subject which is analogous and corresponds to the great change of the whole nature of the object, and by virtue of which the subject, so far as it knows an Idea, is no more individual.

It will be remembered from the preceding book that knowledge in general belongs to the objectification of will at its higher grades, and sensibility, nerves, and brain, just like the other parts of the organised being, are the expression of the will at this stage of its objectivity, and therefore the idea which appears through them is also in the same way bound to the service of will as a means ($\mu\eta\chi\alpha\nu\eta$) for the attainment of its now complicated ($\pi\text{o}\lambda\upsilon\tau\epsilon\sigma\tau\epsilon\rho\alpha$) aims for sustaining a being of manifold requirements. Thus originally and according to its nature, knowledge is completely subject to the will, and, like the immediate object, which, by means of the application of the law of causality, is its starting-point, all knowledge which proceeds in accordance with the principle of sufficient reason remains in a closer or more distant relation to the will. For the individual finds his body as an object among objects, to all of which it is related and connected according to the principle of sufficient reason. Thus all investigations of these relations and connections lead back to his body,

and consequently to his will. Since it is the principle of sufficient reason which places the objects in this relation to the body, and, through it, to the will, the one endeavour of the knowledge which is subject to this principle will be to find out the relations in which objects are placed to each other through this principle, and thus to trace their innumerable connections in space, time, and causality. For only through these is the object *interesting* to the individual, *i.e.*, related to the will. Therefore the knowledge which is subject to the will knows nothing further of objects than their relations, knows the objects only so far as they exist at this time, in this place, under these circumstances, from these causes, and with these effects—in a word, as particular things; and if all these relations were to be taken away, the objects would also have disappeared for it, because it knew nothing more about them. We must not disguise the fact that what the sciences consider in things is also in reality nothing more than this; their relations, the connections of time and space, the causes of natural changes, the resemblance of forms, the motives of actions,—thus merely relations. What distinguishes science from ordinary knowledge is merely its systematic form, the facilitating of knowledge by the comprehension of all particulars in the universal, by means of the subordination of concepts, and the completeness of knowledge which is thereby attained.

· · ·

§ 34. The transition which we have referred to as possible, but yet to be regarded as only exceptional, from the common knowledge of particular things to the knowledge of the Idea, takes place suddenly; for knowledge breaks free from the service of the will, by the subject ceasing to be merely individual, and thus becoming the pure will-less subject of knowledge, which no longer traces relations in accordance with the principle of sufficient reason, but rests in fixed contemplation of the object presented to it, out of its connection with all others, and rises into it.

· · ·

If, raised by the power of the mind, a man relinquishes the common way of looking at things, gives up tracing, under the guidance of the forms of the principle of sufficient reason, their relations to each other, the final goal of which is always a relation to his own will; if he thus ceases to consider the where, the when, the why, and the whither of things, and looks simply and solely at the *what;* if, further, he does not allow abstract thought, the concepts of the reason, to take possession of his consciousness, but, instead of all this, gives the whole power of his mind to perception, sinks himself entirely in this, and lets his whole consciousness be filled with the quiet contemplation of the natural object actually present, whether a landscape, a tree, a mountain, a building, or whatever it may be; inasmuch as he *loses* himself in this object (to use a pregnant German idiom), *i.e.*, forgets even his individuality, his will, and only continues to exist as the pure subject, the clear mirror of the object, so that it is as if the object alone were

there, without any one to perceive it, and he can no longer separate the perceiver from the perception, but both have become one, because the whole consciousness is filled and occupied with one single sensuous picture; if thus the object has to such an extent passed out of all relation to something outside it, and the subject out of all relation to the will, then that which is so known is no longer the particular thing as such; but it is the *Idea*, the eternal form, the immediate objectivity of the will at this grade; and, therefore, he who is sunk in this perception is no longer individual, for in such perception the individual has lost himself; but he is *pure*, will-less, painless, timeless *subject of knowledge*. . . . In such contemplation the particular thing becomes at once the *Idea* of its species, and the perceiving individual becomes *pure subject of knowledge*. The individual, as such, knows only particular things; the pure subject of knowledge knows only Ideas. For the individual is the subject of knowledge in its relation to a definite particular manifestation of will, and in subjection to this. This particular manifestation of will is, as such, subordinated to the principle of sufficient reason in all its forms; therefore, all knowledge which relates itself to it also follows the principle of sufficient reason, and no other kind of knowledge is fitted to be of use to the will but this, which always consists merely of relations to the object. The knowing individual as such, and the particular things known by him, are always in some place, at some time, and are links in the chain of causes and effects. The pure subject of knowledge and his correlative, the Idea, have passed out of all these forms of the principle of sufficient reason: time, place, the individual that knows, and the individual that is known, have for them no meaning. . . . When the Platonic Idea appears, in it subject and object are no longer to be distinguished, for the Platonic Idea, the adequate objectivity of will, the true world as idea, arises only when the subject and object reciprocally fill and penetrate each other completely; and in the same way the knowing and the known individuals, as things in themselves, are not to be distinguished. For if we look entirely away from the true *world as idea*, there remains nothing but *the world as will*. The will is the "in-itself" of the Platonic Idea, which fully objectifies it; it is also the "in-itself" of the particular thing and of the individual that knows it, which objectify it incompletely. As will, outside the idea and all its forms, it is one and the same in the object contemplated and in the individual, who soars aloft in this contemplation, and becomes conscious of himself as pure subject. These two are, therefore, in themselves not different, for in themselves they are will, which here knows itself; and multiplicity and difference exist only as the way in which this knowledge comes to the will, *i.e.*, only in the phenomenon, on account of its form, the principle of sufficient reason.

. . .

§ 35. In order to gain a deeper insight into the nature of the world, it is absolutely necessary that we should learn to distinguish the will as

thing-in-itself from its adequate objectivity, and also the different grades in which this appears more and more distinctly and fully, *i.e.*, the Ideas themselves, from the merely phenomenal existence of these Ideas in the forms of the principle of sufficient reason, the restricted method of knowledge of the individual. We shall then agree with Plato when he attributes actual being only to the Ideas, and allows only an illusive, dream-like existence to things in space and time, the real world for the individual. Then we shall understand how one and the same Idea reveals itself in so many phenomena, and presents its nature only bit by bit to the individual, one side after another. Then we shall also distinguish the Idea itself from the way in which its manifestation appears in the observation of the individual, and recognise the former as essential and the latter as unessential. Let us consider this with the help of examples taken from the most insignificant things, and also from the greatest. When the clouds move, the figures which they form are not essential, but indifferent to them; but that as elastic vapour they are pressed together, drifted along, spread out, or torn asunder by the force of the wind: this is their nature, the essence of the forces which objectify themselves in them, the Idea; their actual forms are only for the individual observer. To the brook that flows over stones, the eddies, the waves, the foam-flakes which it forms are indifferent and unessential; but that it follows the attraction of gravity, and behaves as inelastic, perfectly mobile, formless, transparent fluid: this is its nature; this, *if known through perception*, is its Idea; these accidental forms are only for us so long as we know as individuals. . . . What appears in the clouds, the brook, and the crystal is the weakest echo of that will which appears more fully in the plant, more fully still in the beast, and most fully in man. But only the essential in all these grades of its objectification constitutes the Idea; on the other hand, its unfolding or development, because broken up in the forms of the principle of sufficient reason into a multiplicity of many-sided phenomena, is unessential to the Idea, lies merely in the kind of knowledge that belongs to the individual and has reality only for this. The same thing necessarily holds good of the unfolding of that Idea which is the completest objectivity of will. Therefore, the history of the human race, the throng of events, the change of times, the multifarious forms of human life in different lands and countries, all this is only the accidental form of the manifestation of the Idea, does not belong to the Idea itself, in which alone lies the adequate objectivity of the will, but only to the phenomenon which appears in the knowledge of the individual, and is just as foreign, unessential, and indifferent to the Idea itself as the figures which they assume are to the clouds, the form of its eddies and foam-flakes to the brook, or its trees and flowers to the ice.

To him who has thoroughly grasped this, and can distinguish between the will and the Idea, and between the Idea and its manifestation, the events of the world will have significance only so far as they are the

letters out of which we may read the Idea of man, but not in and for themselves. He will not believe with the vulgar that time may produce something actually new and significant; that through it, or in it, something absolutely real may attain to existence, or indeed that it itself as a whole has beginning and end, plan and development, and in some way has for its final aim the highest perfection (according to their conception) of the last generation of man, whose life is a brief thirty years. . . . In the manifold forms of human life and in the unceasing change of events, he will regard the Idea only as the abiding and essential, in which the will to live has its fullest objectivity, and which shows its different sides in the capacities, the passions, the errors and the excellences of the human race; in self-interest, hatred, love, fear, boldness, frivolity, stupidity, slyness, wit, genius, and so forth, all of which crowding together and combining in thousands of forms (individuals), continually create the history of the great and the little world, in which it is all the same whether they are set in motion by nuts or by crowns. Finally, he will find that in the world it is the same as in the dramas of Gozzi, in all of which the same persons appear, with like intention, and with a like fate; the motives and incidents are certainly different in each piece, but the spirit of the incidents is the same; the actors in one piece know nothing of the incidents of another, although they performed in it themselves; therefore, after all experience of former pieces, Pantaloon has become no more agile or generous, Tartaglia no more conscientious, Brighella no more courageous, and Columbine no more modest.

. . .

§ 36. History follows the thread of events; it is pragmatic so far as it deduces them in accordance with the law of motivation, a law that determines the self-manifesting will wherever it is enlightened by knowledge. At the lowest grades of its objectivity, where it still acts without knowledge, natural science, in the form of etiology, treats of the laws of the changes of its phenomena, and, in the form of morphology, of what is permanent in them. This almost endless task is lightened by the aid of concepts, which comprehend what is general in order that we may deduce what is particular from it. Lastly, mathematics treats of the mere forms, time and space, in which the Ideas, broken up into multiplicity, appear for the knowledge of the subject as individual. All these, of which the common name is science, proceed according to the principle of sufficient reason in its different forms, and their theme is always the phenomenon, its laws, connections, and the relations which result from them. But what kind of knowledge is concerned with that which is outside and independent of all relations, that which alone is really essential to the world, the true content of its phenomena, that which is subject to no change, and therefore is known with equal truth for all time, in a word, the *Ideas*, which are the direct and adequate objectivity of the thing in-itself, the will? We answer,

Art, the work of genius. It repeats or reproduces the eternal Ideas grasped through pure contemplation, the essential and abiding in all the phenomena of the world; and according to what the material is in which it reproduces, it is sculpture or painting, poetry or music. Its one source is the knowledge of Ideas; its one aim the communication of this knowledge. While science, following the unresting and inconstant stream of the fourfold forms of reason and consequent, with each end attained sees further, and can never reach a final goal nor attain full satisfaction, any more than by running we can reach the place where the clouds touch the horizon; art, on the contrary, is everywhere at its goal. For it plucks the object of its contemplation out of the stream of the world's course, and has it isolated before it. And this particular thing, which in that stream was a small perishing part, becomes to art the representative of the whole, an equivalent of the endless multitude in space and time. It therefore pauses at this particular thing; the course of time stops; the relations vanish for it; only the essential, the Idea, is its object. We may, therefore, accurately define it as the *way of viewing things independent of the principle of sufficient reason*, in opposition to the way of viewing them which proceeds in accordance with that principle, and which is the method of experience and of science. This last method of considering things may be compared to a line infinitely extended in a horizontal direction, and the former to a vertical line which cuts it at any point. The method of viewing things which proceeds in accordance with the principle of sufficient reason is the rational method, and it alone is valid and of use in practical life and in science. The method which looks away from the content of this principle is the method of genius, which is only valid and of use in art. The first is the method of Aristotle; the second is, on the whole, that of Plato. The first is like the mighty storm, that rushes along without beginning and without aim, bending, agitating, and carrying away everything before it; the second is like the silent sunbeam, that pierces through the storm quite unaffected by it. The first is like the innumerable showering drops of the waterfall, which, constantly changing, never rest for an instant; the second is like the rainbow, quietly resting on this raging torrent. Only through the pure contemplation described above, which ends entirely in the object, can Ideas be comprehended; and the nature of *genius* consists in pre-eminent capacity for such contemplation. Now, as this requires that a man should entirely forget himself and the relations in which he stands, *genius* is simply the completest *objectivity*, *i.e.*, the objective tendency of the mind, as opposed to the subjective, which is directed to one's own self—in other words, to the will. Thus genius is the faculty of containing in the state of pure perception, of losing oneself in perception, and of enlisting in this service the knowledge which originally existed only for the service of the will; that is to say, genius is the power of leaving one's own interests, wishes, and aims entirely out of sight, thus of entirely renouncing one's own personality for a time, so as to remain *pure knowing subject*,

clear vision of the world; and this not merely at moments, but for a sufficient length of time, and with sufficient consciousness, to enable one to reproduce by deliberate art what has thus been apprehended, and "to fix in lasting thoughts the wavering images that float before the mind." It is as if, when genius appears in an individual, a far larger measure of the power of knowledge falls to his lot than is necessary for the service of an individual will; and this superfluity of knowledge, being free, now becomes subject purified from will, a clear mirror of the inner nature of the world. This explains the activity, amounting even to disquietude, of men of genius, for the present can seldom satisfy them, because it does not fill their consciousness. This gives them that restless aspiration, that unceasing desire for new things, and for the contemplation of lofty things, and also that longing that is hardly ever satisfied, for men of similar nature and of like stature, to whom they might communicate themselves; whilst the common mortal, entirely filled and satisfied by the common present, ends in it, and finding everywhere his like, enjoys that peculiar satisfaction in daily life that is denied to genius.

Imagination has rightly been recognised as an essential element of genius; it has sometimes even been regarded as identical with it; but this is a mistake. As the objects of genius are the eternal Ideas, the permanent, essential forms of the world and all its phenomena, and as the knowledge of the Idea is necessarily knowledge through perception, is not abstract, the knowledge of the genius would be limited to the Ideas of the objects actually present to his person, and dependent upon the chain of circumstances that brought these objects to him, if his imagination did not extend his horizon far beyond the limits of his actual personal existence, and thus enable him to construct the whole out of the little that comes into his own actual apperception, and so to let almost all possible scenes of life pass before him in his own consciousness. Further, the actual objects are almost always very imperfect copies of the Ideas expressed in them; therefore the man of genius requires imagination in order to see in things, not that which Nature has actually made, but that which she endeavoured to make, yet could not because of that conflict of her forms among themselves which we referred to in the last book. We shall return to this farther on in treating of sculpture. The imagination then extends the intellectual horizon of the man of genius beyond the objects which actually present themselves to him, both as regards quality and quantity. Therefore extraordinary strength of imagination accompanies, and is indeed a necessary condition of genius. But the converse does not hold, for strength of imagination does not indicate genius; on the contrary, men who have no touch of genius may have much imagination. For as it is possible to consider a real object in two opposite ways, purely objectively, the way of genius grasping its Idea, or in the common way, merely in the relations in which it stands to other objects and to one's own will, in accordance with the principle of sufficient reason, it is also possible to perceive an

imaginary object in both of these ways. Regarded in the first way, it is a means to the knowledge of the Idea, the communication of which is the work of art; in the second case, the imaginary object is used to build castles in the air congenial to egotism and the individual humour, and which for the moment delude and gratify; thus only the relations of the phantasies so linked together are known. The man who indulges in such an amusement is a dreamer; he will easily mingle those fancies that delight his solitude with reality, and so unfit himself for real life: perhaps he will write them down, and then we shall have the ordinary novel of every description, which entertains those who are like him and the public at large, for the readers imagine themselves in the place of the hero, and then find the story very agreeable.

The common mortal, that manufacture of Nature which she produces by the thousand every day, is, as we have said, not capable, at least not continuously so, of observation that in every sense is wholly disinterested, as sensuous contemplation, strictly so called, is. He can turn his attention to things only so far as they have some relation to his will, however indirect it may be. Since in this respect, which never demands anything but the knowledge of relations, the abstract conception of the thing is sufficient, and for the most part even better adapted for use; the ordinary man does not linger long over the mere perception, does not fix his attention long on one object, but in all that is presented to him hastily seeks merely the concept under which it is to be brought, as the lazy man seeks a chair, and then it interests him no further. This is why he is so soon done with everything, with works of art, objects of natural beauty, and indeed everywhere with the truly significant contemplation of all the scenes of life. He does not linger; only seeks to know his own way in life, together with all that might at any time become his way. Thus he makes topographical notes in the widest sense; over the consideration of life itself as such he wastes no time. The man of genius, on the other hand, whose excessive power of knowledge frees it at times from the service of will, dwells on the consideration of life itself, strives to comprehend the Idea of each thing, not its relations to other things; and in doing this he often forgets to consider his own path in life, and therefore for the most part pursues it awkwardly enough. While to the ordinary man his faculty of knowledge is a lamp to lighten his path, to the man of genius it is the sun which reveals the world. This great diversity in their way of looking at life soon becomes visible in the outward appearance both of the man of genius and of the ordinary mortal. The man in whom genius lives and works is easily distinguished by his glance, which is both keen and steady, and bears the stamp of perception, of contemplation. This is easily seen from the likenesses of the few men of genius whom Nature has produced here and there among countless millions. On the other hand, in the case of an ordinary man, the true object of his contemplation, what he is prying into, can be easily seen from his glance, if indeed it is not quite stupid

and vacant, as is generally the case. Therefore the expression of genius in a face consists in this, that in it a decided predominance of knowledge over will is visible, and consequently there also shows itself in it a knowledge that is entirely devoid of relation to will, *i.e., pure knowing.* On the contrary, in ordinary countenances there is a predominant expression of will; and we see that knowledge only comes into activity under the impulse of will, and thus is directed merely by motives.

Since the knowledge that pertains to genius, or the knowledge of Ideas, is that knowledge which does not follow the principle of sufficient reason, so, on the other hand, the knowledge which does follow that principle is that which gives us prudence and rationality in life, and which creates the sciences. Thus men of genius are affected with the deficiencies entailed in the neglect of this latter kind of knowledge. Yet what I say in this regard is subject to the limitation that it only concerns them in so far as and while they are actually engaged in that kind of knowledge which is peculiar to genius; and this is by no means at every moment of their lives, for the great though spontaneous exertion which is demanded for the comprehension of Ideas free from will must necessarily relax, and there are long intervals during which men of genius are placed in very much the same position as ordinary mortals, both as regards advantages and deficiencies. On this account the action of genius has always been regarded as an inspiration, as indeed the name indicates, as the action of a superhuman being distinct from the individual himself, and which takes possession of him only periodically. The disinclination of men of genius to direct their attention to the content of the principle of sufficient reason will first show itself, with regard to the ground of being, as dislike of mathematics; for its procedure is based upon the most universal forms of the phenomenon space and time, which are themselves merely modes of the principle of sufficient reason, and is consequently precisely the opposite of that method of thought which seeks merely the content of the phenomenon, the Idea which expresses itself in it apart from all relations. The logical method of mathematics is also antagonistic to genius, for it does not satisfy but obstructs true insight, and presents merely a chain of conclusions in accordance with the principle of the ground of knowing. The mental faculty upon which it makes the greatest claim is memory, for it is necessary to recollect all the earlier propositions which are referred to. Experience has also proved that men of great artistic genius have no faculty for mathematics; no man was ever very distinguished for both. . . . Further, as quick comprehension of relations in accordance with the laws of causality and motivation is what specially constitutes prudence or sagacity, a prudent man, so far as and while he is so, will not be a genius, and a man of genius, so far as and while he is so, will not be a prudent man. Lastly, perceptive knowledge generally, in the province of which the Idea always lies, is directly opposed to rational or abstract knowledge, which is guided by the principle of the ground of knowing. It is also well known that

we seldom find great genius united with pre-eminent reasonableness; on the contrary, persons of genius are often subject to violent emotions and irrational passions. But the ground of this is not weakness of reason, but partly unwonted energy of that whole phenomenon of will—the man of genius—which expresses itself through the violence of all his acts of will, and partly preponderance of the knowledge of perception through the senses and understanding over abstract knowledge, producing a decided tendency to the perceptible, the exceedingly lively impressions of which so far outshine colourless concepts, that they take their place in the guidance of action, which consequently becomes irrational. Accordingly the impression of the present moment is very strong with such persons, and carries them away into unconsidered action, violent emotions and passions. Moreover, since, in general, the knowledge of persons of genius has to some extent freed itself from the service of will, they will not in conversation think so much of the person they are addressing as of the thing they are speaking about, which is vividly present to them; and therefore they are likely to judge or narrate things too objectively for their own interests; they will not pass over in silence what would more prudently be concealed, and so forth. Finally, they are given to soliloquising, and in general may exhibit certain weaknesses which are actually akin to madness. It has often been remarked that there is a side at which genius and madness touch, and even pass over into each other, and indeed poetical inspiration has been called a kind of madness: *amabilis insania*, Horace calls it . . . It might seem from this that every advance of intellect beyond the ordinary measure, as an abnormal development, disposes to madness. In the meantime, however, I will explain as briefly as possible my view of the purely intellectual ground of the relation between genius and madness, for this will certainly assist the explanation of the real nature of genius, that is to say, of that mental endowment which alone can produce genuine works of art. But this necessitates a brief explanation of madness itself.

A clear and complete insight into the nature of madness, a correct and distinct conception of what constitutes the difference between the sane and the insane, has, as far as I know, not as yet been found. Neither reason nor understanding can be denied to madmen, for they talk and understand, and often draw very accurate conclusions; they also, as a rule, perceive what is present quite correctly, and apprehend the connection between cause and effect. Visions, like the phantasies of delirium, are no ordinary symptom of madness: delirium falsifies perception, madness the thoughts. For the most part, madmen do not err in the knowledge of what is immediately *present;* their raving always relates to what is *absent* and *past*, and only through these to their connection with what is present. Therefore it seems to me that their malady specially concerns the memory; not indeed that memory fails them entirely, for many of them know a great deal by heart, and sometimes recognise persons whom they

have not seen for a long time; but rather that the thread of memory is broken, the continuity of its connection destroyed, and no uniformly connected recollection of the past is possible. Particular scenes of the past are known correctly, just like the particular present; but there are gaps in their recollection which they fill up with fictions, and these are either always the same, in which case they become fixed ideas, and the madness that results is called monomania or melancholy; or they are always different, momentary fancies, and then it is called folly, *fatuitas*. This is why it is so difficult to find out their former life from lunatics when they enter an asylum. The true and the false are always mixed up in their memory. Although the immediate present is correctly known, it becomes falsified through its fictitious connection with an imaginary past; they therefore regard themselves and others as identical with persons who exist only in their imaginary past; . . . If the madness reaches a high degree, there is complete absence of memory, so that the madman is quite incapable of any reference to what is absent or past, and is only determined by the caprice of the moment in connection with the fictions which, in his mind, fill the past. . . . The knowledge of the madman has this in common with that of the brute, both are confined to the present. What distinguishes them is that the brute has really no idea of the past as such, though the past acts upon it through the medium of custom, so that, for example, the dog recognises its former master even after years, that is to say, it receives the wonted impression at the sight of him; but of the time that has passed since it saw him it has no recollection. The madman, on the other hand, always carries about in his reason an abstract past, but it is a false past, which exists only for him, and that either constantly, or only for the moment. The influence of this false past prevents the use of the true knowledge of the present which the brute is able to make. The fact that violent mental suffering or unexpected and terrible calamities should often produce madness, I explain in the following manner. All such suffering is as an actual event confined to the present. It is thus merely transitory, and is consequently never excessively heavy; it only becomes unendurably great when it is lasting pain; but as such it exists only in thought, and therefore lies in the *memory*. If now such a sorrow, such painful knowledge or reflection, is so bitter that it becomes altogether unbearable, and the individual is prostrated under it, then, terrified Nature seizes upon *madness* as the last resource of life; the mind so fearfully tortured at once destroys the thread of its memory, fills up the gaps with fictions, and thus seeks refuge in madness from the mental suffering that exceeds its strength, just as we cut off a mortified limb and replace it with a wooden one. The distracted Ajax, King Lear, and Ophelia may be taken as examples; for the creations of true genius, to which alone we can refer here, as universally known, are equal in truth to real persons; besides, in this case, frequent actual experience shows the same thing. A faint analogy of this kind of transition from pain to madness is to be found in

the way in which all of us often seek, as it were mechanically, to drive away a painful thought that suddenly occurs to us by some loud exclamation or quick movement—to turn ourselves from it, to distract our minds by force.

We see, from what has been said, that the madman has a true knowledge of what is actually present, and also of certain particulars of the past, but that he mistakes the connection, the relations, and therefore falls into error and talks nonsense. Now this is exactly the point at which he comes into contact with the man of genius; for he also leaves out of sight the knowledge of the connection of things, since he neglects that knowledge of relations which conforms to the principle of sufficient reason, in order to see in things only their Ideas, and to seek to comprehend their true nature, which manifests itself to perception, and in regard to which *one thing* represents its whole species, in which way, as Goethe says, one case is valid for a thousand. The particular object of his contemplation, or the present which is perceived by him with extraordinary vividness, appear in so strong a light that the other links of the chain to which they belong are at once thrown into the shade, and this gives rise to phenomena which have long been recognised as resembling those of madness. That which in particular given things exists only incompletely and weakened by modifications, is raised by the man of genius, through his way of contemplating it, to the Idea of the thing, to completeness: he therefore sees everywhere extremes, and therefore his own action tends to extremes; he cannot hit the mean, he lacks soberness, and the result is what we have said. He knows the Ideas completely but not the individuals. Therefore it has been said that a poet may know mankind deeply and thoroughly, and may yet have a very imperfect knowledge of men. He is easily deceived, and is a tool in the hands of the crafty.

§ 37. Genius, then, consists, according to our explanation, in the capacity for knowing, independently of the principle of sufficient reason, not individual things, which have their existence only in their relations, but the Ideas of such things, and of being oneself the correlative of the Idea, and thus no longer an individual, but the pure subject of knowledge. Yet this faculty must exist in all men in a smaller and different degree; for if not, they would be just as incapable of enjoying works of art as of producing them; they would have no susceptibility for the beautiful or the sublime; indeed, these words could have no meaning for them. We must therefore assume that there exists in all men this power of knowing the Ideas in things, and consequently of transcending their personality for the moment, unless indeed there are some men who are capable of no æsthetic pleasure at all. The man of genius excels ordinary men only by possessing this kind of knowledge in a far higher degree and more continuously. Thus, while under its influence he retains the presence of mind which is necessary to enable him to repeat in a voluntary and intentional

work what he has learned in this manner; and this repetition is the work of art. Through this he communicates to others the Idea he has grasped. This Idea remains unchanged and the same, so that æsthetic pleasure is one and the same whether it is called forth by a work of art or directly by the contemplation of nature and life. The work of art is only a means of facilitating the knowledge in which this pleasure consists. That the Idea comes to us more easily from the work of art than directly from nature and the real world, arises from the fact that the artist, who knew only the Idea, no longer the actual, has reproduced in his work the pure Idea, has abstracted it from the actual, omitting all disturbing accidents. The artist lets us see the world through his eyes. That he has these eyes, that he knows the inner nature of things apart from all their relations, is the gift of genius, is inborn; but that he is able to lend us this gift, to let us see with his eyes, is acquired, and is the technical side of art. Therefore, after the account which I have given in the preceding pages of the inner nature of æsthetical knowledge in its most general outlines, the following more exact philosophical treatment of the beautiful and the sublime will explain them both, in nature and in art, without separating them further. First of all we shall consider what takes place in a man when he is affected by the beautiful and the sublime; whether he derives this emotion directly from nature, from life, or partakes of it only through the medium of art, does not make any essential, but merely an external, difference.

§ 38. In the æsthetical mode of contemplation we have found *two inseparable constituent parts*—the knowledge of the object, not as individual thing but as Platonic Idea, that is, as the enduring form of this whole species of things; and the self-consciousness of the knowing person, not as individual, but as *pure will-less subject of knowledge*. The condition under which both these constituent parts appear always united was found to be the abandonment of the method of knowing which is bound to the principle of sufficient reason, and which, on the other hand, is the only kind of knowledge that is of value for the service of the will and also for science. Moreover we shall see that the pleasure which is produced by the contemplation of the beautiful arises from these two constituent parts, sometimes more from the one, sometimes more from the other, according to what the object of the æsthetical contemplation may be.

All *willing* arises from want, therefore from deficiency, and therefore from suffering. The satisfaction of a wish ends it; yet for one wish that is satisfied there remain at least ten which are denied. Further, the desire lasts long, the demands are infinite; the satisfaction is short and scantily measured out. But even the final satisfaction is itself only apparent; every satisfied wish at once makes room for a new one; both are illusions; the one is known to be so, the other not yet. No attained object of desire can give lasting satisfaction, but merely a fleeting gratification; it is like the alms thrown to the beggar, that keeps him alive to-day that his misery

may be prolonged till the morrow. Therefore, so long as our consciousness is filled by our will, so long as we are given up to the throng of desires with their constant hopes and fears, so long as we are the subject of willing, we can never have lasting happiness nor peace. It is essentially all the same whether we pursue or flee, fear injury or seek enjoyment; the care for the constant demands of the will, in whatever form it may be, continually occupies and sways the consciousness; but without peace no true well-being is possible. The subject of willing is thus constantly stretched on the revolving wheel of Ixion, pours water into the sieve of the Danaids, is the ever-longing Tantalus.

But when some external cause or inward disposition lifts us suddenly out of the endless stream of willing, delivers knowledge from the slavery of the will, the attention is no longer directed to the motives of willing, but comprehends things free from their relation to the will, and thus observes them without personal interest, without subjectivity, purely objectively, gives itself entirely up to them so far as they are ideas, but not in so far as they are motives. Then all at once the peace which we were always seeking, but which always fled from us on the former path of the desires, comes to us of its own accord, and it is well with us. It is the painless state which Epicurus prized as the highest good and as the state of the gods; for we are for the moment set free from the miserable striving of the will; we keep the Sabbath of the penal servitude of willing; the wheel of Ixion stands still.

But this is just the state which I described above as necessary for the knowledge of the Idea, as pure contemplation, as sinking oneself in perception, losing oneself in the object, forgetting all individuality, surrendering that kind of knowledge which follows the principle of sufficient reason, and comprehends only relations; the state by means of which at once and inseparably the perceived particular things is raised to the Idea of its whole species, and the knowing individual to the pure subject of will-less knowledge, and as such they are both taken out of the stream of time and all other relations. It is then all one whether we see the sun set from the prison or from the palace.

Inward disposition, the predominance of knowing over willing, can produce this state under any circumstances. This is shown by those admirable Dutch artists who directed this purely objective perception to the most insignificant objects, and established a lasting monument of their objectivity and spiritual peace in their pictures of *still life*, which the æsthetic beholder does not look on without emotion; for they present to him the peaceful, still, frame of mind of the artist, free from will, which was needed to contemplate such insignificant things so objectively, to observe them so attentively, and to repeat this perception so intelligently; and as the picture enables the onlooker to participate in this state, his emotion is often increased by the contrast between it and the unquiet frame of mind, disturbed by vehement willing, in which he finds himself. In the

same spirit, landscape-painters, and particularly Ruisdael, have often painted very insignificant country scenes, which produce the same effect even more agreeably.

All this is accomplished by the inner power of an artistic nature alone; but that purely objective disposition is facilitated and assisted from without by suitable objects, by the abundance of natural beauty which invites contemplation, and even presses itself upon us. Whenever it discloses itself suddenly to our view, it almost always succeeds in delivering us, though it may be only for a moment, from subjectivity, from the slavery of the will, and in raising us to the state of pure knowing. This is why the man who is tormented by passion, or want, or care, is so suddenly revived, cheered, and restored by a single free glance into nature: the storm of passion, the pressure of desire and fear, and all the miseries of willing are then at once, and in a marvellous manner, calmed and appeased. For at the moment at which, freed from the will, we give ourselves up to pure will-less knowing, we pass into a world from which everything is absent that influenced our will and moved us so violently through it. This freeing of knowledge lifts us as wholly and entirely away from all that, as do sleep and dreams; happiness and unhappiness have disappeared; we are no longer individual; the individual is forgotten; we are only pure subject of knowledge; we are only that *one* eye of the world which looks out from all knowing creatures, but which can become perfectly free from the service of will in man alone. Thus all difference of individuality so entirely disappears, that it is all the same whether the perceiving eye belongs to a mighty king or to a wretched beggar; for neither joy nor complaining can pass that boundary with us. So near us always lies a sphere in which we escape from all our misery; but who has the strength to continue long in it? As soon as any single relation to our will, to our person, even of these objects of our pure contemplation, comes again into consciousness, the magic is at an end; we fall back into the knowledge which is governed by the principle of sufficient reason; we know no longer the Idea, but the particular thing, the link of a chain to which we also belong, and we are again abandoned to all our woe. Most men remain almost always at this standpoint because they entirely lack objectivity, *i.e.*, genius. Therefore they have no pleasure in being alone with nature; they need company, or at least a book. For their knowledge remains subject to their will; they seek, therefore, in objects only some relation to their will, and whenever they see anything that has no such relation, there sounds within them, like a ground bass in music, the constant inconsolable cry, "It is of no use to me;" thus in solitude the most beautiful surroundings have for them a desolate, dark, strange, and hostile appearance.

Lastly, it is this blessedness of will-less perception which casts an enchanting glamour over the past and distant, and presents them to us in so fair a light by means of self-deception. For as we think of days long

gone by, days in which we lived in a distant place, it is only the objects which our fancy recalls, not the subject of will, which bore about with it then its incurable sorrows just as it bears them now; but they are forgotten, because since then they have often given place to others. Now, objective perception acts with regard to what is remembered just as it would in what is present, if we let it have influence over us, if we surrendered ourselves to it free from will. Hence it arises that, especially when we are more than ordinarily disturbed by some want, the remembrance of past and distant scenes suddenly flits across our minds like a lost paradise. The fancy recalls only what was objective, not what was individually subjective, and we imagine that that objective stood before us then just as pure and undisturbed by any relation to the will as its image stands in our fancy now; while in reality the relation of the objects to our will gave us pain then just as it does now. We can deliver ourselves from all suffering just as well through present objects as through distant ones whenever we raise ourselves to a purely objective contemplation of them, and so are able to bring about the illusion that only the objects are present and not we ourselves. Then, as the pure subject of knowledge, freed from the miserable self, we become entirely one with these objects, and, for the moment, our wants are as foreign to us as they are to them. The world as idea alone remains, and the world as will has disappeared.

In all these reflections it has been my object to bring out clearly the nature and the scope of the subjective element in æsthetic pleasure; the deliverance of knowledge from the service of the will, the forgetting of self as an individual, and the raising of the consciousness to the pure will-less, timeless, subject of knowledge, independent of all relations. With this subjective side of æsthetic contemplation, there must always appear as its necessary correlative the objective side, the intuitive comprehension of the Platonic Idea. But before we turn to the closer consideration of this, and to the achievements of art in relation to it, it is better that we should pause for a little at the subjective side of æsthetic pleasure, in order to complete our treatment of this by explaining the impression of the *sublime* which depends altogether upon it, and arises from a modification of it. After that we shall complete our investigation of æsthetic pleasure by considering its objective side.

. . .

§ 39. . . . We have already remarked above that the transition to the state of pure perception takes place most easily when the objects bend themselves to it, that is, when by their manifold and yet definite and distinct form they easily become representatives of their Ideas, in which beauty, in the objective sense, consists. This quality belongs pre-eminently to natural beauty, which thus affords even to the most insensible at least a fleeting æsthetic satisfaction: . . . As long as that which raises us from the knowledge of mere relations subject to the will, to æsthetic con-

templation, and thereby exalts us to the position of the subject of knowledge free from will, is this fittingness of nature, this significance and distinctness of its forms, on account of which the Ideas individualised in them readily present themselves to us; so long is it merely *beauty* that affects us and the sense of the *beautiful* that is excited. But if these very objects whose significant forms invite us to pure contemplation, have a hostile relation to the human will in general, as it exhibits itself in its objectivity, the human body, if they are opposed to it, so that it is menaced by the irresistible predominance of their power, or sinks into insignificance before their immeasurable greatness; if, nevertheless, the beholder does not direct his attention to this eminently hostile relation to his will, but, although perceiving and recognising it, turns consciously away from it, forcibly detaches himself from his will and its relations, and, giving himself up entirely to knowledge, quietly contemplates those very objects that are so terrible to the will, comprehends only their Idea, which is foreign to all relation, so that he lingers gladly over its contemplation, and is thereby raised above himself, his person, his will, and all will: —in that case he is filled with the sense of the *sublime*, he is in the state of spiritual exaltation, and therefore the object producing such a state is called *sublime*. Thus what distinguishes the sense of the sublime from that of the beautiful is this: in the case of the beautiful, pure knowledge has gained the upper hand without a struggle, for the beauty of the object, *i.e.*, that property which facilitates the knowledge of its Idea, has removed from consciousness without resistance, and therefore imperceptibly, the will and the knowledge of relations which is subject to it, so that what is left is the pure subject of knowledge without even a remembrance of will. On the other hand, in the case of the sublime that state of pure knowledge is only attained by a conscious and forcible breaking away from the relations of the same object to the will, which are recognised as unfavourable, by a free and conscious transcending of the will and the knowledge related to it.

This exaltation must not only be consciously won, but also consciously retained, and it is therefore accompanied by a constant remembrance of will; yet not of a single particular volition, such as fear or desire, but of human volition in general, so far as it is universally expressed in its objectivity the human body. If a single real act of will were to come into consciousness, through actual personal pressure and danger from the object, then the individual will thus actually influenced would at once gain the upper hand, the peace of contemplation would become impossible, the impression of the sublime would be lost, because it yields to the anxiety, in which the effort of the individual to right itself has sunk every other thought. A few examples will help very much to elucidate this theory of the æsthetic sublime and remove all doubt with regard to it; at the same time they will bring out the different degrees of this sense of the sublime. It is in the main identical with that of the beautiful, with pure will-less knowing, and the knowledge, that necessarily accompanies

it of Ideas out of all relation determined by the principle of sufficient reason, and it is distinguished from the sense of the beautiful only by the additional quality that it rises above the known hostile relation of the object contemplated to the will in general. Thus there come to be various degrees of the sublime, and transitions from the beautiful to the sublime, according as this additional quality is strong, bold, urgent, near, or weak, distant, and merely indicated. . . .

As man is at once impetuous and blind striving of will (whose pole or focus lies in the genital organs), and eternal, free, serene subject of pure knowing (whose pole is the brain); so, corresponding to this antithesis, the sun is both the source of *light*, the condition of the most perfect kind of knowledge, and therefore of the most delightful of things—and the source of *warmth*, the first condition of life, *i.e.*, of all phenomena of will in its higher grades. Therefore, what warmth is for the will, light is for knowledge. Light is the largest gem in the crown of beauty, and has the most marked influence on the knowledge of every beautiful object. Its presence is an indispensable condition of beauty; its favourable disposition increases the beauty of the most beautiful. Architectural beauty more than any other object is enhanced by favourable light, though even the most insignificant things become through its influence most beautiful. If, in the dead of winter, when all nature is frozen and stiff, we see the rays of the setting sun reflected by masses of stone, illuminating without warming, and thus favourable only to the purest kind of knowledge, not to the will; the contemplation of the beautiful effect of the light upon these masses lifts us, as does all beauty, into a state of pure knowing. But, in this case, a certain transcending of the interests of the will is needed to enable us to rise into the state of pure knowing, because there is a faint recollection of the lack of warmth from these rays, that is, an absence of the principle of life; there is a slight challenge to persist in pure knowing, and to refrain from all willing, and therefore it is an example of a transition from the sense of the beautiful to that of the sublime. It is the faintest trace of the sublime in the beautiful; and beauty itself is indeed present only in a slight degree.

. . .

The following situation may occasion this feeling in a still higher degree: Nature convulsed by a storm; the sky darkened by black threatening thunder-clouds; stupendous, naked, overhanging cliffs, completely shutting out the view; rushing, foaming torrents; absolute desert; the wail of the wind sweeping through the clefts of the rocks. Our dependence, our strife with hostile nature, our will broken in the conflict, now appears visibly before our eyes. Yet, so long as the personal pressure does not gain the upper hand, but we continue in æsthetic contemplation, the pure subject of knowing gazes unshaken and unconcerned through that strife of nature, through that picture of the broken will, and quietly comprehends the Ideas

even of those objects which are threatening and terrible to the will. In this contrast lies the sense of the sublime.

But the impression becomes still stronger, if, when we have before our eyes, on a large scale, the battle of the raging elements, in such a scene we are prevented from hearing the sound of our own voice by the noise of a falling stream; or, if we are abroad in the storm of tempestuous seas, where the mountainous waves rise and fall, dash themselves furiously against steep cliffs, and toss their spray high into the air; the storm howls, the sea boils, the lightning flashes from black clouds, and the peals of thunder drown the voice of storm and sea. Then, in the undismayed beholder, the two-fold nature of his consciousness reaches the highest degree of distinctness. He perceives himself, on the one hand, as an individual, as the frail phenomenon of will, which the slightest touch of these forces can utterly destroy, helpless against powerful nature, dependent, the victim of chance, a vanishing nothing in the presence of stupendous might; and, on the other hand, as the eternal, peaceful, knowing subject, the condition of the object, and, therefore, the supporter of this whole world; the terrific strife of nature only his idea; the subject itself free and apart from all desires and necessities, in the quiet comprehension of the Ideas. This is the complete impression of the sublime. Here he obtains a glimpse of a power beyond all comparison superior to the individual, threatening it with annihilation.

The impression of the sublime may be produced in quite another way, by presenting a mere immensity in space and time; its immeasurable greatness dwindles the individual to nothing. Adhering to Kant's nomenclature and his accurate division, we may call the first kind the dynamical, and the second the mathematical sublime, although we entirely dissent from his explanation of the inner nature of the impression, and can allow no share in it either to moral reflections, or to hypostases from scholastic philosophy.

If we lose ourselves in the contemplation of the infinite greatness of the universe in space and time, meditate on the thousands of years that are past or to come, or if the heavens at night actually bring before our eyes innumerable worlds and so force upon our consciousness the immensity of the universe, we feel ourselves dwindle to nothing; as individuals, as living bodies, as transient phenomena of will, we feel ourselves pass away and vanish into nothing like drops in the ocean. But at once there rises against this ghost of our own nothingness, against such lying impossibility, the immediate consciousness that all these worlds exist only as our idea, only as modifications of the eternal subject of pure knowing, which we find ourselves to be as soon as we forget our individuality, and which is the necessary supporter of all worlds and all times the condition of their possibility. The vastness of the world which disquieted us before, rests now in us; our dependence upon it is annulled by its dependence upon us. All this, however, does not come at once into reflection, but

shows itself merely as the felt consciousness that in some sense or other (which philosophy alone can explain) we are one with the world, and therefore not oppressed, but exalted by its immensity.

. . .

§ 41. . . . When we say that a thing is *beautiful*, we thereby assert that it is an object of our æsthetic contemplation, and this has a double meaning; on the one hand it means that the sight of the thing makes us *objective*, that is to say, that in contemplating it we are no longer conscious of ourselves as individuals, but as pure will-less subjects of knowledge; and on the other hand it means that we recognise in the object, not the particular thing, but an Idea; and this can only happen, so far as our contemplation of it is not subordinated to the principle of sufficient reason, does not follow the relation of the object to anything outside it (which is always ultimately connected with relations to our own will), but rests in the object itself. For the Idea and the pure subject of knowledge always appear at once in consciousness as necessary correlatives, and on their appearance all distinction of time vanishes, for they are both entirely foreign to the principle of sufficient reason in all its forms, and lie outside the relations which are imposed by it; they may be compared to the rainbow and the sun, which have no part in the constant movement and succession of the falling drops. Therefore, if, for example, I contemplate a tree æsthetically, *i.e.*, with artistic eyes, and thus recognise, not it, but its Idea, it becomes at once of no consequence whether it is this tree or its predecessor which flourished a thousand years ago, and whether the observer is this individual or any other that lived anywhere and at any time; the particular thing and the knowing individual are abolished with the principle of sufficient reason, and there remains nothing but the Idea and the pure subject of knowing, which together constitute the adequate objectivity of will at this grade. And the Idea dispenses not only with time, but also with space, for the Idea proper is not this special form which appears before me but its expression, its pure significance, its inner being, which discloses itself to me and appeals to me, and which may be quite the same though the spatial relations of its form be very different.

Since, on the one hand, every given thing may be observed in a purely objective manner and apart from all relations; and since, on the other hand, the will manifests itself in everything at some grade of its objectivity, so that everything is the expression of an Idea; it follows that everything is also *beautiful*.

. . .

§ 43. Matter as such cannot be the expression of an Idea. For, as we found in the first book, it is throughout nothing but causality: its being consists in its causal action. But causality is a form of the principle of sufficient reason; knowledge of the Idea, on the other hand, absolutely

excludes the content of that principle. We also found, in the Second Book, that matter is the common substratum of all particular phenomena of the Ideas, and consequently is the connecting link between the Idea and the phenomenon, or the particular thing. Accordingly for both of these reasons it is impossible that matter can for itself express any Idea. This is confirmed *a posteriori* by the fact that it is impossible to have a perceptible idea of matter as such, but only an abstract conception; in the former, *i.e.*, in perceptible ideas are exhibited only the forms and qualities of which matter is the supporter, and in all of which Ideas reveal themselves. This corresponds also with the fact, that causality (the whole essence of matter) cannot for itself be presented perceptibly, but is merely a definite causal connection. On the other hand, *every phenomenon* of an Idea, because as such it has entered the form of the principle of sufficient reason, or the *principium individuationis*, must exhibit itself in matter, as one of its qualities. So far then matter is, as we have said, the connecting link between the Idea and the *principium individuationis*, which is the form of knowledge of the individual, or the principle of sufficient reason. Plato is therefore perfectly right in his enumeration, for after the Idea and the phenomenon, which include all other things in the world, he gives matter only, as a third thing which is different from both (Timaus, p. 345). The individual, as a phenomenon of the Idea, is always matter. Every quality of matter is also the phenomenon of an Idea, and as such it may always be an object of æsthetic contemplation, *i.e.*, the Idea expressed in it may always be recognised. This holds good of even the most universal qualities of matter, without which it never appears, and which are the weakest objectivity of will. Such are gravity, cohesion, rigidity, fluidity, sensitiveness to light, and so forth.

If now we consider *architecture* simply as a fine art and apart from its application to useful ends, in which it serves the will and not pure knowledge, and therefore ceases to be art in our sense; we can assign to it no other aim than that of bringing to greater distinctness some of those ideas, which are the lowest grades of the objectivity of will; such as gravity, cohesion, rigidity, hardness, those universal qualities of stone, those first, simplest, most inarticulate manifestations of will; the bass notes of nature; and after these light, which in many respects is their opposite. Even at these low grades of the objectivity of will we see its nature revealing itself in discord; for properly speaking the conflict between gravity and rigidity is the sole æsthetic material of architecture; its problem is to make this conflict appear with perfect distinctness in a multitude of different ways. It solves it by depriving these indestructible forces of the shortest way to their satisfaction, and conducting them to it by a circuitous route, so that the conflict is lengthened and the inexhaustible efforts of both forces become visible in many different ways. The whole mass of the building, if left to its original tendency, would exhibit a mere heap or clump, bound as closely as possible to the earth, to which

gravity, the form in which the will appears here, continually presses, while rigidity, also objectivity of will, resists. But this very tendency, this effort, is hindered by architecture from obtaining direct satisfaction, and only allowed to reach it indirectly and by roundabout ways. The roof, for example, can only press the earth through columns, the arch must support itself, and can only satisfy its tendency towards the earth through the medium of the pillars, and so forth. But just by these enforced digressions, just by these restrictions, the forces which reside in the crude mass of stone unfold themselves in the most distinct and multifarious ways; and the purely æsthetic aim of architecture can go no further than this. Therefore the beauty, at any rate, of a building lies in the obvious adaptation of every part, not to the outward arbitrary end of man (so far the work belongs to practical architecture), but directly to the stability of the whole, to which the position, dimensions, and form of every part must have so necessary a relation that, where it is possible, if any one part were taken away, the whole would fall to pieces. For just because each part bears just as much as it conveniently can, and each is supported just where it requires to be and just to the necessary extent, this opposition unfolds itself, this conflict between rigidity and gravity, which constitutes the life, the manifestation of will, in the stone, becomes completely visible, and these lowest grades of the objectivity of will reveal themselves distinctly. In the same way the form of each part must not be determined arbitrarily, but by its end, and its relation to the whole. . . . According to what has been said, it is absolutely necessary, in order to understand the æsthetic satisfaction afforded by a work of architecture, to have immediate knowledge through perception of its matter as regards its weight, rigidity, and cohesion, and our pleasure in such a work would suddenly be very much diminished by the discovery that the material used was pumice-stone; for then it would appear to us as a kind of sham building. We would be affected in almost the same way if we were told that it was made of wood, when we had supposed it to be of stone, just because this alters and destroys the relation between rigidity and gravity, and consequently the significance and necessity of all the parts, for these natural forces reveal themselves in a far weaker degree in a wooden building. Therefore no real work of architecture as a fine art can be made of wood, although it assumes all forms so easily; this can only be explained by our theory. If we were distinctly told that a building, the sight of which gave us pleasure, was made of different kinds of material of very unequal weight and consistency, but not distinguishable to the eye, the whole building would become as utterly incapable of affording us pleasure as a poem in an unknown language. All this proves that architecture does not affect us mathematically, but also dynamically, and that what speaks to us through it, is not mere form and symmetry, but rather those fundamental forces of nature, those first Ideas, those lowest grades of the objectivity of will. The regularity of the building and its parts is partly produced by the direct adaptation of each member

to the stability of the whole, partly it serves to facilitate the survey and comprehension of the whole, and finally, regular figures to some extent enhance the beauty because they reveal the constitution of space as such. But all this is of subordinate value and necessity, and by no means the chief concern; indeed, symmetry is not invariably demanded, as ruins are still beautiful.

Works of architecture have further quite a special relation to light; they gain a double beauty in the full sunshine, with the blue sky as a background, and again they have quite a different effect by moonlight. Therefore, when a beautiful work of architecture is to be erected, special attention is always paid to the effects of the light and to the climate. The reason of all this is, indeed, principally that all the parts and their relations are only made clearly visible by a bright, strong light; but besides this I am of opinion that it is the function of architecture to reveal the nature of light just as it reveals that of things so opposite to it as gravity and rigidity. For the light is intercepted, confined, and reflected by the great opaque, sharply outlined, and variously formed masses of stone, and thus it unfolds its nature and qualities in the purest and clearest way, to the great pleasure of the beholders, for light is the most joy-giving of things, as the condition and the objective correlative of the most perfect kind of knowledge of perception.

Now, because the Ideas which architecture brings to clear perception, are the lowest grades of the objectivity of will, and consequently their objective significance, which architecture reveals to us, is comparatively small; the æsthetic pleasure of looking at a beautiful building in a good light will lie, not so much in the comprehension of the Idea, as in the subjective correlative which accompanies this comprehension; it will consist pre-eminently in the fact that the beholder, set free from the kind of knowledge that belongs to the individual, and which serves the will and follows the principle of sufficient reason, is raised to that of the pure subject of knowing free from will. It will consist then principally in pure contemplation itself, free from all the suffering of will and of individuality. In this respect the opposite of architecture, and the other extreme of the series of the fine arts, is the drama, which brings to knowledge the most significant Ideas. Therefore in the æsthetic pleasure afforded by the drama the objective side is throughout predominant.

Architecture has this distinction from plastic art and poetry: it does not give us a copy but the thing itself. It does not repeat, as they do, the known Idea, so that the artist lends his eyes to the beholder, but in it the artist merely presents the object to the beholder, and facilitates for him the comprehension of the Idea by bringing the actual, individual object to a distinct and complete expression of its nature.

. . .

§ 45. The great problem of historical painting and sculpture is to express directly and for perception the Idea in which the will reaches the

highest grade of its objectification. The objective side of the pleasure afforded by the beautiful is here always predominant, and the subjective side has retired into the background. It is further to be observed that at the next grade below this, animal painting, the characteristic is entirely one with the beautiful; the most characteristic lion, wolf, horse, sheep, or ox, was always the most beautiful also. The reason of this is that animals have only the character of their species, no individual character. In the representation of men the character of the species is separated from that of the individual; the former is now called beauty (entirely in the objective sense), but the latter retains the name, character, or expression, and the new difficulty arises of representing both, at once and completely, in the same individual.

Human beauty is an objective expression, which means the fullest objectification of will at the highest grade at which it is knowable, the Idea of man in general, completely expressed in the sensible form. But however much the objective side of the beautiful appears here the subjective side still always accompanies it. And just because no object transports us so quickly into pure æsthetic contemplation, as the most beautiful human countenance and form, at the sight of which we are instantly filled with unspeakable satisfaction, and raised above ourselves and all that troubles us; this is only possible because this most distinct and purest knowledge of will raises us most easily and quickly to the state of pure knowing, in which our personality, our will with its constant pain, disappears, so long as the pure æsthetic pleasure lasts. Therefore it is that Goethe says: "No evil can touch him who looks on human beauty; he feels himself at one with himself and with the world." That a beautiful human form is produced by nature must be explained in this way. At this its highest grade the will objectifies itself in an individual; and therefore through circumstances and its own power it completely overcomes all the hindrances and opposition which the phenomena of the lower grades present to it. Such are the forces of nature, from which the will must always first extort and win back the matter that belongs to all its manifestations. Further, the phenomenon of will at its higher grades always has multiplicity in its form. Even the tree is only a systematic aggregate of innumerably repeated sprouting fibres. This combination assumes greater complexity in higher forms, and the human body is an exceedingly complex system of different parts, each of which has a peculiar life of its own, *vita propria*, subordinate to the whole. Now that all these parts are in the proper fashion subordinate to the whole, and co-ordinate to each other, that they all work together harmoniously for the expression of the whole, nothing superfluous, nothing restricted; all these are the rare conditions, whose result is beauty, the completely expressed character of the species. So is it in nature. But how in art? One would suppose that art achieved the beautiful by imitating nature. But how is the artist to recognise the perfect work which is to be imitated, and distinguish it from the

failures, if he does not anticipate the beautiful *before experience?* . . .
No knowledge of the beautiful is possible purely *a posteriori*, and from
mere experience; it is always, at least in part, *a priori*, although quite
different in kind, from the forms of the principle of sufficient reason, of
which we are conscious *a priori*. These concern the universal form of
phenomena as such, as it constitutes the possibility of knowledge in
general, the universal *how* of all phenomena, and from this knowledge pro-
ceed mathematics and pure natural science. But this other kind of knowl-
edge *a priori*, which makes it possible to express the beautiful, concerns,
not the form but the content of phenomena, not the *how* but the *what* of
the phenomenon. That we all recognise human beauty when we see it, but
that in the true artist this takes place with such clearness that he shows
it as he has never seen it, and surpasses nature in his representation;
this is only possible because *we ourselves are* the will whose adequate
objectification at its highest grade is here to be judged and discovered.
Thus alone have we in fact an anticipation of that which nature (which
is just the will that constitutes our own being) strives to express. And in
the true genius this anticipation is accompanied by so great a degree of
intelligence that he recognises the Idea in the particular thing, and thus,
as it were, *understands the half-uttered speech of nature*, and articulates
clearly what she only stammered forth. He expresses in the hard marble
that beauty of form which in a thousand attempts she failed to produce,
he presents it to nature, saying, as it were, to her, "That is what you
wanted to say!" And whoever is able to judge replies, "Yes, that is it."
Only in this way was it possible for the genius of the Greeks to find the
type of human beauty and establish it as a canon for the school of sculp-
ture; and only by virtue of such an anticipation is it possible for all of us
to recognise beauty, when it has actually been achieved by nature in the
particular case. This anticipation is the *Ideal*. It is the *Idea* so far as it is
known *a priori*, at least half, and it becomes practical for art, because it
corresponds to and completes what is given *a posteriori* through nature.
The possibility of such an anticipation of the beautiful *a priori* in the artist,
and of its recognition *a posteriori* by the critic, lies in the fact that the
artist and the critic are themselves the "in-itself" of nature, the will which
objectifies itself. For, as Empedocles said, like can only be known by
like: only nature can understand itself: only nature can fathom itself: but
only spirit also can understand spirit.

. . .

Human beauty was explained above as the fullest objectification of will
at the highest grade at which it is knowable. It expresses itself through
the form; and this lies in space alone, and has no necessary connection
with time, as, for example, motion has. Thus far then we may say: the
adequate objectification of will through a merely spatial phenomenon is
beauty, in the objective sense. A plant is nothing but such a merely spatial

phenomenon of will; for no motion, and consequently no relation to time (regarded apart from its development), belongs to the expression of its nature; its mere form expresses its whole being and displays it openly. But brutes and men require, further, for the full revelation of the will which is manifested in them, a series of actions, and thus the manifestation in them takes on a direct relation to time. All this has already been explained in the preceding book; it is related to what we are considering at present in the following way. As the merely spatial manifestation of will can objectify it fully or defectively at each definite grade,—and it is this which constitutes beauty or ugliness,—so the temporal objectification of will, *i.e.*, the action, and indeed the direct action, the movement, may correspond to the will, which objectifies itself in it, purely and fully without foreign admixture, without superfluity, without defect, only expressing exactly the act of will determined in each case;—or the converse of all this may occur. In the first case the movement is made with *grace*, in the second case without it. Thus as beauty is the adequate representation of will generally, through its merely spatial manifestation; *grace* is the adequate representation of will through its temporal manifestation, that is to say, the perfectly accurate and fitting expression of each act of will, through the movement and position which objectify it. Since movement and position presuppose the body, Winckelmann's expression is very true and suitable, when he says, "Grace is the proper relation of the acting person to the action" (Works, vol. i. p. 258). It is thus evident that beauty may be attributed to a plant, but no grace, unless in a figurative sense; but to brutes and men, both beauty and grace. Grace consists, according to what has been said, in every movement being performed, and every position assumed, in the easiest, most appropriate and convenient way, and therefore being the pure, adequate expression of its intention, or of the act of will, without any superfluity, which exhibits itself as aimless, meaningless bustle, or as wooden stiffness. Grace presupposes as its condition a true proportion of all the limbs, and a symmetrical, harmonious figure; for complete ease and evident appropriateness of all positions and movements are only possible by means of these. Grace is therefore never without a certain degree of beauty of person. The two, complete and united, are the most distinct manifestation of will at the highest grade of its objectification.

It was mentioned above that in order rightly to portray man, it is necessary to separate the character of the species from that of the individual, so that to a certain extent every man expresses an Idea peculiar to himself, as was said in the last book. Therefore the arts whose aim is the representation of the Idea of man, have as their problem, not only beauty, the character of the species, but also the character of the individual, which is called, *par excellence, character*. But this is only the case in so far as this character is to be regarded, not as something accidental and quite peculiar to the man as a single individual, but as a side of the

Idea of humanity which is specially apparent in this individual, and the representation of which is therefore of assistance in revealing this Idea. Thus the character, although as such it is individual, must yet be Ideal, that is, its significance in relation to the Idea of humanity generally (the objectifying of which it assists in its own way) must be comprehended and expressed with special prominence.

. . .

In sculpture, beauty and grace are the principal concern. The special character of the mind, appearing in emotion, passion, alternations of knowing and willing, which can only be represented by the expression of the countenance and the gestures, is the peculiar sphere of *painting*. For although eyes and colour, which lie outside the province of sculpture, contribute much to beauty, they are yet far more essential to character. Further, beauty unfolds itself more completely when it is contemplated from various points of view; but the expression, the character, can only be completely comprehended from *one* point of view.

. . .

§ 49. The truth which lies at the foundation of all that we have hitherto said about art, is that the object of art, the representation of which is the aim of the artist, and the knowledge of which must therefore precede his work as its germ and source, is an Idea in Plato's sense, and never anything else; not the particular thing, the object of common apprehension, and not the concept, the object of rational thought and of science. Although the Idea and the concept have something in common, because both represent as unity a multiplicity of real things; yet the great difference between them has no doubt been made clear and evident enough by what we have said about concepts in the First Book, and about Ideas in this book. I by no means wish to assert, however, that Plato really distinctly comprehended this difference; indeed many of his examples of Ideas, and his discussions of them, are applicable only to concepts. Meanwhile we leave this question alone and go on our own way, glad when we come upon traces of any great and noble mind, yet not following his footsteps but our own aim. The *concept* is abstract, discursive, undetermined within its own sphere, only determined by its limits, attainable and comprehensible by him who has only reason, communicable by words without any other assistance, entirely exhausted by its definition. The *Idea* on the contrary, although defined as the adequate representative of the concept, is always object of perception, and although representing an infinite number of particular things, is yet thoroughly determined. It is never known by the individual as such, but only by him who has raised himself above all willing and all individuality to the pure subject of knowing. Thus it is only attainable by the man of genius, and by him who, for the most part through the assistance of the works of genius, has

reached an exalted frame of mind, by increasing his power of pure know-
ing. It is therefore not absolutely but only conditionally communicable,
because the Idea, comprehended and repeated in the work of art, appeals
to every one only according to the measure of his own intellectual worth.
So that just the most excellent works of every art, the noblest productions
of genius, must always remain sealed books to the dull majority of men,
inaccessible to them, separated from them by a wide gulf, just as the
society of princes is inaccessible to the common people. It is true that
even the dullest of them accept on authority recognisedly great works,
lest otherwise they should argue their own incompetence; but they wait in
silence, always ready to express their condemnation, as soon as they are
allowed to hope that they may do so without being left to stand alone;
and then their long-restrained hatred against all that is great and beau-
tiful, and against the authors of it, gladly relieves itself; for such things
never appealed to them, and for that very reason were humiliating to
them. For as a rule a man must have worth in himself in order to recog-
nise it and believe in it willingly and freely in others. On this rests the
necessity of modesty in all merit, and the disproportionately loud praise
of this virtue, which alone of all its sisters is always included in the
eulogy of every one who ventures to praise any distinguished man, in
order to appease and quiet the wrath of the unworthy. What then is
modesty but hypocritical humility, by means of which, in a world swelling
with base envy, a man seeks to obtain pardon for excellences and merits
from those who have none? For whoever attributes to himself no merits,
because he actually has none, is not modest but merely honest.

The *Idea* is the unity that falls into multiplicity on account of the
temporal and spatial form of our intuitive apprehension; the *concept*, on
the contrary, is the unity reconstructed out of multiplicity by the abstrac-
tion of our reason; the latter may be defined as *unitas post rem*, the
former as *unitas ante rem*. Finally, we may express the distinction between
the Idea and the concept, by a comparison, thus: the *concept* is like a
dead receptacle, in which, whatever has been put, actually lies side by
side, but out of which no more can be taken (by analytical judgment)
than was put in (by synthetical reflection); the (Platonic) *Idea*, on the
other hand, develops, in him who has comprehended it, ideas which are
new as regards the concept of the same name; it resembles a living or-
ganism, developing itself and possessed of the power of reproduction,
which brings forth what was not put into it.

It follows from all that has been said, that the concept, useful as it is
in life, and serviceable, necessary and productive as it is in science, is
yet always barren and unfruitful in art. The comprehended Idea, on the
contrary, is the true and only source of every work of art. In its powerful
originality it is only derived from life itself, from nature, from the world,
and that only by the true genius, or by him whose momentary inspiration
reaches the point of genius. Genuine and immortal works of art spring

only from such direct apprehension. Just because the Idea is and remains object of perception, the artist is not conscious in the abstract of the intention and aim of his work; not a concept, but an Idea floats before his mind; therefore he can give no justification of what he does. He works, as people say, from pure feeling, and unconsciously, indeed instinctively. On the contrary, imitators, mannerists, *imitatores, servum pecus*, start, in art, from the concept; they observe what pleases and affects us in true works of art; understand it clearly, fix it in a concept, and thus abstractly, and then imitate it, openly or disguisedly, with dexterity and intentionally. They suck their nourishment, like parasite plants, from the works of others, and like polypi, they become the colour of their food. . . . All imitators, all mannerists, apprehend in concepts the nature of representative works of art; but concepts can never impart inner life to a work. The age, *i.e.*, the dull multitude of every time, knows only concepts, and sticks to them, and therefore receives mannered works of art with ready and loud applause: but after a few years these works become insipid, because the spirit of the age, *i.e.*, the prevailing concepts, in which alone they could take root, have changed. Only true works of art, which are drawn directly from nature and life, have eternal youth and enduring power, like nature and life themselves. For they belong to no age, but to humanity, and as on that account they are coldly received by their own age, to which they disdain to link themselves closely, and because indirectly and negatively they expose the existing errors, they are slowly and unwillingly recognised; on the other hand, they cannot grow old, but appear to us ever fresh and new down to the latest ages. Then they are no longer exposed to neglect and ignorance, for they are crowned and sanctioned by the praise of the few men capable of judging, who appear singly and rarely in the course of ages, and give in their votes, whose slowly growing number constitutes the authority, which alone is the judgment-seat we mean when we appeal to posterity. It is these successively appearing individuals, for the mass of posterity will always be and remain just as perverse and dull as the mass of contemporaries always was and always is. We read the complaints of great men in every century about the customs of their age. They always sound as if they referred to our own age, for the race is always the same. At every time and in every art, mannerisms have taken the place of the spirit, which was always the possession of a few individuals, but mannerisms are just the old cast-off garments of the last manifestation of the spirit that existed and was recognised. From all this it appears that, as a rule, the praise of posterity can only be gained at the cost of the praise of one's contemporaries, and *vice versa*.

§ 50. If the aim of all art is the communication of the comprehended Idea, which through the mind of the artist appears in such a form that it is purged and isolated from all that is foreign to it, and may now be grasped by the man of weaker comprehension and no productive faculty;

if further, it is forbidden in art to start from the concept, we shall not be able to consent to the intentional and avowed employment of a work of art for the expression of a concept; this is the case in the *Allegory*. An allegory is a work of art which means something different from what it represents. But the object of perception, and consequently also the Idea, expresses itself directly and completely, and does not require the medium of something else which implies or indicates it. Thus, that which in this way is indicated and represented by something entirely different, because it cannot itself be made object of perception, is always a concept. Therefore through the allegory a conception has always to be signified, and consequently the mind of the beholder has to be drawn away from the expressed perceptible idea to one which is entirely different, abstract and not perceptible, and which lies quite outside the work of art. The picture or statue is intended to accomplish here what is accomplished far more fully by a book. Now, what we hold is the end of art, representation of a perceivable, comprehensible Idea, is not here the end. No great completeness in the work of art is demanded for what is aimed at here. It is only necessary that we should see what the thing is meant to be, for, as soon as this has been discovered, the end is reached, and the mind is now led away to quite a different kind of idea to an abstract conception, which is the end that was in view. . . . If then an allegorical picture has artistic value, it is quite separate from and independent of what it accomplishes as allegory. Such a work of art serves two ends at once, the expression of a conception and the expression of an Idea. Only the latter can be an end of art; the other is a foreign end, the trifling amusement of making a picture also do service as a legend, as a hieroglyphic, invented for the pleasure of those to whom the true nature of art can never appeal. It is the same thing as when a work of art is also a useful implement of some kind, in which case it also serves two ends; for example, a statue which is at the same time a candelabrum or a caryatide; or a bas-relief, which is also the shield of Achilles. True lovers of art will allow neither the one nor the other. It is true that an allegorical picture may, because of this quality, produce a vivid impression upon the feelings; but when this is the case, a legend would under the same circumstances produce the same effect. For example, if the desire of fame were firmly and lastingly rooted in the heart of a man, because he regarded it as his rightful possession, which is only withheld from him so long as he has not produced the charter of his ownership; and if the Genius of Fame, with his laurel crown, were to appear to such a man, his whole mind would be excited, and his powers called into activity; but the same effect would be produced if he were suddenly to see the word "fame," in large distinct letters on the wall. Or if a man has made known a truth, which is of importance either as a maxim for practical life, or as insight for science, but it has not been believed; an allegorical picture representing time as it lifts the veil, and discloses the naked figure

of Truth, will affect him powerfully; but the same effect would be produced by the legend: "*Le temps découvre la verité.*" For what really produces the effect here is the abstract thought, not the object of perception.

If then, in accordance with what has been said, allegory in plastic and pictorial art is a mistaken effort, serving an end which is entirely foreign to art, it becomes quite unbearable when it leads so far astray that the representation of forced and violently introduced subtilties degenerates into absurdity. Such, for example, is a tortoise, to represent feminine seclusion; the downward glance of Nemesis into the drapery of her bosom, signifying that she can see into what is hidden; the explanation of Bellori that Hannibal Caracci represents voluptuousness clothed in a yellow robe, because he wishes to indicate that her lovers soon fade and become yellow as straw. If there is absolutely no connection between the representation and the conception signified by it, founded on subsumption under the concept, or association of Ideas; but the signs and the things signified are combined in a purely conventional manner, by positive, accidentally introduced laws; then I call this degenerate kind of allegory *Symbolism.* Thus the rose is the symbol of secrecy, the laurel is the symbol of fame, the palm is the symbol of peace, the scallop-shell is the symbol of pilgrimage, the cross is the symbol of the Christian religion. To this class also belongs all significance of mere colour, as yellow is the colour of falseness, and blue is the colour of fidelity. Such symbols may often be of use in life, but their value is foreign to art. They are simply to be regarded as hieroglyphics, or like Chinese word-writing, and really belong to the same class as armorial bearings, the bush that indicates a public-house, the key of the chamberlain, or the leather of the mountaineer. If, finally, certain historical or mythical persons, or personified conceptions, are represented by certain fixed symbols, these are properly called *emblems.* Such are the beasts of the Evangelist, the owl of Minerva, the apple of Paris, the Anchor of Hope, &c. For the most part, however, we understand by emblems those simple allegorical representations explained by a motto, which are meant to express a moral truth, and of which large collections have been made by J. Camerarius, Alciatus, and others. They form the transition to poetical allegory, of which we shall have more to say later. Greek sculpture devotes itself to the perception, and therefore it is *æsthetical;* Indian sculpture devotes itself to the conception, and therefore it is merely *symbolical.*

. . .

§ 52. Now that we have considered all the fine arts in the general way that is suitable to our point of view, beginning with architecture, the peculiar end of which is to elucidate the objectification of will at the lowest grades of its visibility, in which it shows itself as the dumb unconscious tendency of the mass in accordance with laws, and yet already reveals a breach of the unity of will with itself in a conflict between

gravity and rigidity—and ending with the consideration of tragedy, which presents to us at the highest grades of the objectification of will this very conflict with itself in terrible magnitude and distinctness; we find that there is still another fine art which has been excluded from our consideration, and had to be excluded, for in the systematic connection of our exposition there was no fitting place for it—I mean *music*. It stands alone, quite cut off from all the other arts. In it we do not recognise the copy or repetition of any Idea of existence in the world. Yet it is such a great and exceedingly noble art, its effect on the inmost nature of man is so powerful, and it is so entirely and deeply understood by him in his inmost consciousness as a perfectly universal language, the distinctness of which surpasses even that of the perceptible world itself, that . . . we must attribute to music a far more serious and deep significance, connected with the inmost nature of the world and our own self, and in reference to which the arithmetical proportions, to which it may be reduced, are related, not as the thing signified, but merely as the sign. That in some sense music must be related to the world as the representation to the thing represented, as the copy to the original, we may conclude from the analogy of the other arts, all of which possess this character, and affect us on the whole in the same way as it does, only that the effect of music is stronger, quicker, more necessary and infallible. Further, its representative relation to the world must be very deep, absolutely true, and strikingly accurate, because it is instantly understood by every one, and has the appearance of a certain infallibility, because its form may be reduced to perfectly definite rules expressed in numbers, from which it cannot free itself without entirely ceasing to be music. Yet the point of comparison between music and the world, the respect in which it stands to the world in the relation of a copy or repetition, is very obscure. Men have practised music in all ages without being able to account for this; content to understand it directly, they renounce all claim to an abstract conception of this direct understanding itself.

I gave my mind entirely up to the impression of music in all its forms, and then returned to reflection and the system of thought expressed in the present work, and thus I arrived at an explanation of the inner nature of music and of the nature of its imitative relation to the world—which from analogy had necessarily to be presupposed—an explanation which is quite sufficient for myself, and satisfactory to my investigation, and which will doubtless be equally evident to any one who has followed me thus far and has agreed with my view of the world. Yet I recognise the fact that it is essentially impossible to prove this explanation, for it assumes and establishes a relation of music, as idea, to that which from its nature can never be idea, and music will have to be regarded as the copy of an original which can never itself be directly presented as idea. I can therefore do no more than state here, at the conclusion of this Third Book, which has been principally devoted to the consideration of the arts,

the explanation of the marvellous art of music which satisfies myself, and I must leave the acceptance or denial of my view to the effect produced upon each of my readers both by music itself and by the whole system of thought communicated in this work. Moreover, I regard it as necessary, in order to be able to assent with full conviction to the exposition of the significance of music I am about to give, that one should often listen to music with constant reflection upon my theory concerning it, and for this again it is necessary to be very familiar with the whole of my system of thought.

The (Platonic) Ideas are the adequate objectification of will. To excite or suggest the knowledge of these by means of the representation of particular things (for works of art themselves are always representations of particular things) is the end of all the other arts, which can only be attained by a corresponding change in the knowing subject. Thus all these arts objectify the will indirectly only by means of the Ideas; and since our world is nothing but the manifestation of the Ideas in multiplicity, though their entrance into the *principium individuationis* (the form of the knowledge possible for the individual as such), music also, since it passes over the Ideas, is entirely independent of the phenomenal world, ignores it altogether, could to a certain extent exist if there was no world at all, which cannot be said of the other arts. Music is as *direct* an objectification and copy of the whole *will* as the world itself, nay, even as the Ideas, whose multiplied manifestation constitutes the world of individual things. Music is thus by no means like the other arts, the copy of the Ideas, but the *copy of the will itself*, whose objectivity the Ideas are. This is why the effect of music is so much more powerful and penetrating than that of the other arts, for they speak only of shadows, but it speaks of the thing itself. Since, however, it is the same will which objectifies itself both in the Ideas and in music, though in quite different ways, there must be, not indeed a direct likeness, but yet a parallel, an analogy, between music and the Ideas whose manifestation in multiplicity and incompleteness is the visible world. The establishing of this analogy will facilitate, as an illustration, the understanding of this exposition, which is so difficult on account of the obscurity of the subject.

I recognise in the deepest tones of harmony, in the bass, the lowest grades of the objectification of will, unorganised nature, the mass of the planet. It is well known that all the high notes which are easily sounded, and die away more quickly, are produced by the vibration in their vicinity of the deep bass-notes. When, also, the low notes sound, the high notes always sound faintly, and it is a law of harmony that only those high notes may accompany a bass-note which actually already sound along with it of themselves (its *sons harmoniques*) on account of its vibration. This is analogous to the fact that the whole of the bodies and organisations of nature must be regarded as having come into existence through gradual development out of the mass of the planet; this is both their

supporter and their source, and the same relation subsists between the high notes and the bass. There is a limit of depth, below which no sound is audible. This corresponds to the fact that no matter can be perceived without form and quality, *i.e.*, without the manifestation of a force which cannot be further explained, in which an Idea expresses itself, and, more generally, that no matter can be entirely without will. Thus, as a certain pitch is inseparable from the note as such, so a certain grade of the manifestation of will is inseparable from matter. Bass is thus, for us, in harmony what unorganised nature, the crudest mass, upon which all rests, and from which everything originates and develops, is in the world. Now, further, in the whole of the complemental parts which make up the harmony between the bass and the leading voice singing the melody, I recognise the whole gradation of the Ideas in which the will objectifies itself. Those nearer to the bass are the lower of these grades, the still unorganised, but yet manifold phenomenal things; the higher represent to me the world of plants and beasts. The definite intervals of the scale are parallel to the definite grades of the objectification of will, the definite species in nature. The departure from the arithmetical correctness of the intervals, through some temperament, or produced by the key selected, is analogous to the departure of the individual from the type of the species. Indeed, even the impure discords, which give no definite interval, may be compared to the monstrous abortions produced by beasts of two species, or by man and beast. But to all these bass and complemental parts which make up the *harmony* there is wanting that connected progress which belongs only to the high voice singing the melody, and it alone moves quickly and lightly in modulations and runs, while all these others have only a slower movement without a connection in each part for itself. The deep bass moves most slowly, the representative of the crudest mass. Its rising and falling occurs only by large intervals, in thirds, fourths, fifths, never by *one* tone, unless it is a base inverted by double counterpoint. This slow movement is also physically essential to it; a quick run or shake in the low notes cannot even be imagined. The higher complemental parts, which are parallel to animal life, move more quickly, but yet without melodious connection and significant progress. The disconnected course of all the complemental parts, and their regulation by definite laws, is analogous to the fact that in the whole irrational world, from the crystal to the most perfect animal, no being has a connected consciousness of its own which would make its life into a significant whole, and none experiences a succession of mental developments, none perfects itself by culture, but everything exists always in the same way according to its kind, determined by fixed law. Lastly, in the *melody*, in the high, singing, principal voice leading the whole and progressing with unrestrained freedom, in the unbroken significant connection of *one* thought from beginning to end representing a whole, I recognise the highest grade of the objectification of will, the intellectual life and effort of man. As he alone, because endowed

with reason, constantly looks before and after on the path of his actual life and its innumerable possibilities, and so achieves a course of life which is intellectual, and therefore connected as a whole; corresponding to this, I say, the *melody* has significant intentional connection from beginning to end. It records, therefore, the history of the intellectually enlightened will. This will expresses itself in the actual world as the series of its deeds; but melody says more, it records the most secret history of this intellectually-enlightened will, pictures every excitement, every effort, every movement of it, all that which the reason collects under the wide and negative concept of feeling, and which it cannot apprehend further through its abstract concepts. Therefore it has always been said that music is the language of feeling and of passion, as words are the language of reason. . . .

Now the nature of man consists in this, that his will strives, is satisfied and strives anew, and so on for ever. Indeed, his happiness and well-being consist simply in the quick transition from wish to satisfaction, and from satisfaction to a new wish. For the absence of satisfaction is suffering, the empty longing for a new wish, languor, *ennui*. And corresponding to this the nature of melody is a constant digression and deviation from the key-note in a thousand ways, not only to the harmonious intervals to the third and dominant, but to every tone, to the dissonant sevenths and to the superfluous degrees; yet there always follows a constant return to the key-note. In all these deviations melody expresses the multifarious efforts of will, but always its satisfaction also by the final return to an harmonious interval, and still more, to the key-note. The composition of melody, the disclosure in it of all the deepest secrets of human willing and feeling, is the work of genius, whose action, which is more apparent here than anywhere else, lies far from all reflection and conscious intention, and may be called an inspiration. The conception is here, as everywhere in art, unfruitful. The composer reveals the inner nature of the world, and expresses the deepest wisdom in a language which his reason does not understand; as a person under the influence of mesmerism tells things of which he has no conception when he awakes. Therefore in the composer, more than in any other artist, the man is entirely separated and distinct from the artist. Even in the explanation of this wonderful art, the concept shows its poverty and limitation. I shall try, however, to complete our analogy. As quick transition from wish to satisfaction, and from satisfaction to a new wish, is happiness and well-being, so quick melodies without great deviations are cheerful; slow melodies, striking painful discords, and only winding back through many bars to the key-note are, as analogous to the delayed and hardly won satisfaction, sad. The delay of the new excitement of will, languor, could have no other expression than the sustained key-note, the effect of which would soon be unbearable; very monotonous and unmeaning melodies approach this effect. The short intelligible subjects of quick dance music seem to speak only of easily attained common pleasure. On

the other hand, the *Allegro maestoso*, in elaborate movements, long passages, and wide deviations, signifies a greater, nobler effort towards a more distant end, and its final attainment. The *Adagio* speaks of the pain of a great and noble effort which despises all trifling happiness. But how wonderful is the effect of the *minor* and *major!* How astounding that the change of half a tone, the entrance of a minor third instead of a major, at once and inevitably forces upon us an anxious painful feeling, from which again we are just as instantaneously delivered by the major. The *Adagio* lengthens in the minor the expression of the keenest pain, and becomes even a convulsive wail. Dance-music in the minor seems to indicate the failure of that trifling happiness which we ought rather to despise, seems to speak of the attainment of a lower end with toil and trouble. The inexhaustibleness of possible melodies corresponds to the inexhaustibleness of Nature in difference of individuals, physiognomies, and courses of life. The transition from one key to an entirely different one, since it altogether breaks the connection with what went before, is like death, for the individual ends in it; but the will which appeared in this individual lives after him as before him, appearing in other individuals, whose consciousness, however, has no connection with his.

But it must never be forgotten, in the investigation of all these analogies I have pointed out, that music has no direct, but merely an indirect relation to them, for it never expresses the phenomenon, but only the inner nature, the in-itself of all phenomena, the will itself. It does not therefore express this or that particular and definite joy, this or that sorrow, or pain, or horror, or delight, or merriment, or peace of mind; but joy, sorrow, pain, horror, delight, merriment, peace of mind *themselves*, to a certain extent in the abstract, their essential nature, without accessories, and therefore without their motives. Yet we completely understand them in this extracted quintessence. Hence it arises that our imagination is so easily excited by music, and now seeks to give form to that invisible yet actively moved spirit-world which speaks to us directly, and clothe it with flesh and blood, *i.e.*, to embody it in an analogous example. This is the origin of the song with words, and finally of the opera, the text of which should therefore never forsake that subordinate position in order to make itself the chief thing and the music a mere means of expressing it, which is a great misconception and a piece of utter perversity; for music always expresses only the quintessence of life and its events, never these themselves, and therefore their differences do not always affect it. It is precisely this universality, which belongs exclusively to it, together with the greatest determinateness, that gives music the high worth which it has as the panacea for all our woes. Thus, if music is too closely united to the words, and tries to form itself according to the events, it is striving to speak a language which is not its own. . . .

According to all this, we may regard the phenomenal world, or nature, and music as two different expressions of the same thing, which is there-

fore itself the only medium of their analogy, so that a knowledge of it is demanded in order to understand that analogy. Music, therefore, if regarded as an expression of the world, is in the highest degree a universal language, which is related indeed to the universality of concepts, much as they are related to the particular things. Its universality, however, is by no means that empty universality of abstraction, but quite of a different kind, and is united with thorough and distinct definiteness. In this respect it resembles geometrical figures and numbers, which are the universal forms of all possible objects of experience and applicable to them all *a priori*, and yet are not abstract but perceptible and thoroughly determined. All possible efforts, excitements, and manifestations of will, all that goes on in the heart of man and that reason includes in the wide, negative concept of feeling, may be expressed by the infinite number of possible melodies, but always in the universal, in the mere form, without the material, always according to the thing-in-itself, not the phenomenon, the inmost soul, as it were, of the phenomenon, without the body. This deep relation which music has to the true nature of all things also explains the fact that suitable music played to any scene, action, event, or surrounding seems to disclose to us its most secret meaning, and appears as the most accurate and distinct commentary upon it. This is so truly the case, that whoever gives himself up entirely to the impression of a symphony, seems to see all the possible events of life and the world take place in himself, yet if he reflects, he can find no likeness between the music and the things that passed before his mind. For, as we have said, music is distinguished from all the other arts by the fact that it is not a copy of the phenomenon, or, more accurately, the adequate objectivity of will, but is the direct copy of the will itself, and therefore exhibits itself as the metaphysical to everything physical in the world, and as the thing-in-itself to every phenomenon. We might, therefore, just as well call the world embodied music as embodied will; and this is the reason why music makes every picture, and indeed every scene of real life and of the world, at once appear with higher significance, certainly all the more in proportion as its melody is analogous to the inner spirit of the given phenomenon. It rests upon this that we are able to set a poem to music as a song, or a perceptible representation as a pantomime, or both as an opera. Such particular pictures of human life, set to the universal language of music, are never bound to it or correspond to it with stringent necessity; but they stand to it only in the relation of an example chosen at will to a general concept. In the determinateness of the real, they represent that which music expresses in the universality of mere form. For melodies are to a certain extent, like general concepts, an abstraction from the actual. This actual world, then, the world of particular things, affords the object of perception, the special and individual, the particular case, both to the universality of the concepts and to the universality of the melodies. But these two universalities are in a certain respect opposed to each other; for

the concepts contain particulars only as the first forms abstracted from perception, as it were, the separated shell of things; thus they are, strictly speaking, *abstracta;* music, on the other hand, gives the inmost kernel which precedes all forms, or the heart of things. . . .

The unutterable depth of all music by virtue of which it floats through our consciousness as the vision of a paradise firmly believed in yet ever distant from us, and by which also it is so fully understood and yet so inexplicable, rests on the fact that it restores to us all the emotions of our inmost nature, but entirely without reality and far removed from their pain. So also the seriousness which is essential to it, which excludes the absurd from its direct and peculiar province, is to be explained by the fact that its object is not the idea, with reference to which alone deception and absurdity are possible; but its object is directly the will, and this is essentially the most serious of all things, for it is that on which all depends. . . .

In the whole of this exposition of music I have been trying to bring out clearly that it expresses in a perfectly universal language, in a homogeneous material, mere tones, and with the greatest determinateness and truth, the inner nature, the in-itself of the world, which we think under the concept of will, because will is its most distinct manifestation. Further, according to my view and contention, philosophy is nothing but a complete and accurate repetition or expression of the nature of the world in very general concepts, for only in such is it possible to get a view of that whole nature which will everywhere be adequate and applicable. Thus, whoever has followed me and entered into my mode of thought, will not think it so very paradoxical if I say, that supposing it were possible to give a perfectly accurate, complete explanation of music, extending even to particulars, that is to say, a detailed repetition in concepts of what it expresses, this would also be a sufficient repetition and explanation of the world in concepts, or at least entirely parallel to such an explanation, and thus it would be the true philosophy. . . .

. . . I have perhaps already gone too much into detail with regard to some things in this Third Book, or have dwelt too much on particulars. But my aim made it necessary, and it will be the less disapproved if the importance and high worth of art, which is seldom sufficiently recognised, be kept in mind. For if, according to our view, the whole visible world is just the objectification, the mirror, of the will, conducting it to knowledge of itself, and, indeed, as we shall soon see, to the possibility of its deliverance; and if, at the same time, the world as idea, if we regard it in isolation, and, freeing ourselves from all volition, allow it alone to take possession of our consciousness, is the most joy-giving and the only innocent side of life; we must regard art as the higher ascent, the more complete development of all this, for it achieves essentially just what is achieved by the visible world itself, only with greater concentration, more perfectly, with intention and intelligence, and therefore may be called, in the full signi-

ficance of the word, the flower of life. If the whole world as idea is only the visibility of will, the work of art is to render this visibility more distinct. It is the *camera obscura* which shows the objects more purely, and enables us to survey them and comprehend them better. It is the play within the play, the stage upon the stage in "Hamlet."

The pleasure we receive from all beauty, the consolation which art affords, the enthusiasm of the artist, which enables him to forget the cares of life,—the latter an advantage of the man of genius over other men, which alone repays him for the suffering that increases in proportion to the clearness of consciousness, and for the desert loneliness among men of a different race,—all this rests on the fact that the in-itself of life, the will, existence itself, is, as we shall see farther on, a constant sorrow, partly miserable, partly terrible; while, on the contrary, as idea alone, purely contemplated, or copied by art, free from pain, it presents to us a drama full of significance. This purely knowable side of the world, and the copy of it in any art, is the element of the artist. He is chained to the contemplation of the play, the objectification of will; he remains beside it, does not get tired of contemplating it and representing it in copies; and meanwhile he bears himself the cost of the production of that play, *i.e.*, he himself is the will which objectifies itself, and remains in constant suffering. That pure, true, and deep knowledge of the inner nature of the world becomes now for him an end in itself: he stops there. Therefore it does not become to him a quieter of the will, as, we shall see in the next book, it does in the case of the saint who has attained to resignation; it does not deliver him for ever from life, but only at moments, and is therefore not for him a path out of life, but only an occasional consolation in it, till his power, increased by this contemplation and at last tired of the play, lays hold on the real. . . .

FRIEDRICH NIETZSCHE

THE BIRTH OF TRAGEDY

Friedrich Nietzsche (1844–1900) was a German philosopher and poet. He views the highest forms of art as the affirmation of life in the face of its terrors.

I

We shall do a great deal for the science of esthetics, once we perceive not merely by logical inference, but with the immediate certainty of intuition, that the continuous development of art is bound up with the *Apollonian* and *Dionysian* duality: just as procreation depends on the duality of the sexes, involving perpetual strife with only periodically intervening reconciliations. The terms Dionysian and Apollonian we borrow from the Greeks, who disclose to the discerning mind the profound mysteries of their view of art, not, to be sure, in concepts, but in the impressively clear figures of their gods. Through Apollo and Dionysus, the two art-deities of the Greeks, we come to recognize that in the Greek world there existed a

From *The Philosophy of Nietzsche*, pp. 951–985, translated by Clifton P. Fadiman. Copyright 1927 and renewed 1954 by the Modern Library, Inc. Reprinted by permission of Random House, Inc.

sharp opposition, in origin and aims, between the Apollonian art of sculpture, and the non-plastic, Dionysian, art of music. These two distinct tendencies run parallel to each other, for the most part openly at variance; and they continually incite each other to new and more powerful births, which perpetuate an antagonism, only superficially reconciled by the common term "Art"; till at last, by a metaphysical miracle of the Hellenic will, they appear coupled with each other, and through this coupling eventually generate the art-product, equally Dionysian and Apollonian, of Attic tragedy.

In order to grasp these two tendencies, let us first conceive of them as the separate art-worlds of *dreams* and *drunkenness*. These physiological phenomena present a contrast analogous to that existing between the Apollonian and the Dionysian. It was in dreams, says Lucretius, that the glorious divine figures first appeared to the souls of men; in dreams the great shaper beheld the splendid corporeal structure of superhuman beings; and the Hellenic poet, if questioned about the mysteries of poetic inspiration, would likewise have suggested dreams and he might have given an explanation like that of Hans Sachs in the *Mastersingers:*

> "*Mein Freund, das grad' ist Dichters Werk,*
> *dess er sein Träumen deut' and merk'.*
> *Glaubt mir, des Menschen wahrster Wahn*
> *wird ihm im Traume aufgethan:*
> *all' Dichtkunst und Poeterei*
> *ist nichts als Wahrtraum-Deuterei.*"[1]

The beautiful appearance of the dream-worlds, in creating which every man is a perfect artist, is the prerequisite of all plastic art, and in fact, as we shall see, of an important part of poetry also. In our dreams we delight in the immediate apprehension of form; all forms speak to us; none are unimportant, none are superfluous. But, when this dream-reality is most intense, we also have, glimmering through it, the sensation of its appearance: at least this is my experience, as to whose frequency, aye, normality, I could adduce many proofs, in addition to the sayings of the poets. Indeed, the man of philosophic mind has a presentiment that underneath this reality in which we live and have our being, is concealed another and quite different reality, which, like the first, is an appearance; and Schopenhauer actually indicates as the criterion of philosophical ability the occasional ability to view men and things as mere phantoms or dream-pictures. Thus the esthetically sensitive man stands in the same relation to the reality of dreams as the philosopher does to the reality of existence; he is a close and willing observer, for these pictures afford him an interpretation of life, and it is by these processes that he trains himself for life. And it is not only the agreeable and friendly pictures that he experiences in him-

[1] "My friend, that is exactly the poet's task, to mark his dreams and to attach meanings to them. Believe me, man's most profound illusions are revealed to him in dreams; and all versifying and poetizing is nothing but an interpretation of them."

self with such perfect understanding: but the serious, the troubled, the sad, the gloomy, the sudden restraints, the tricks of fate, the uneasy presentiments, in short, the whole Divine Comedy of life, and the Inferno, also pass before him, not like mere shadows on the wall—for in these scenes he lives and suffers—and yet not without that fleeting sensation of appearance. And perhaps many will, like myself, recall that amid the dangers and terrors of dream-life they would at times, cry out in self-encouragement, and not without success. "It is only a dream! I will dream on!" I have likewise heard of persons capable of continuing one and the same dream for three and even more successive nights: facts which indicate clearly that our innermost beings, our common subconscious experiences, express themselves in dreams because they must do so and because they take profound delight in so doing.

This joyful necessity of the dream-experience has been embodied by the Greeks in their Apollo: for Apollo, the god of all plastic energies, is at the same time the soothsaying god. He, who (as the etymology of the name indicates) is the "shining one," the deity of light, is also ruler over the fair appearance of the inner world of fantasy. The higher truth, the perfection of these states in contrast to the incompletely intelligible everyday world, this deep consciousness of nature, healing and helping in sleep and dreams, is at the same time the symbolical analogue of the soothsaying faculty and of the arts generally, which make life possible and worth living. But we must also include in our picture of Apollo that delicate boundary, which the dream-picture must not overstep—lest it act pathologically (in which case appearance would impose upon us as pure reality). We must keep in mind that measured restraint, that freedom from the wilder emotions, that philosophical calm of the sculptor-god. His eye must be "sunlike," as befits his origin; even when his glance is angry and distempered, the sacredness of his beautiful appearance must still be there. And so, in one sense, we might apply to Apollo the words of Schopenhauer when he speaks of the man wrapped in the veil of Mâyâ:[2] *Welt als Wille und Vorstellung*, I. p. 416: "Just as in a stormy sea, unbounded in every direction, rising and falling with howling mountainous waves, a sailor sits in a boat and trusts in his frail barque: so in the midst of a world of sorrows the individual sits quietly, supported by and trusting in his *principium individuationis*." In fact, we might say of Apollo, that in him the unshaken faith in this *principium* and the calm repose of the man wrapped therein receive their sublimest expression; and we might consider Apollo himself as the glorious divine image of the *principium individuationis*, whose gestures and expression tell us of all the joy and wisdom of "appearance," together with its beauty.

In the same work Schopenhauer has depicted for us the terrible *awe* which seizes upon man, when he is suddenly unable to account for the

2 Cf. *World as Will and Idea*, I. 455 ff., trans., by Haldane and Kemp.

cognitive forms of a phenomenon, when the principle of reason, in some one of its manifestations, seems to admit of an exception. If we add to this awe the blissful ecstasy which rises from the innermost depths of man, aye, of nature, at this very collapse of the *principium individuationis*, we shall gain an insight into the nature of the *Dionysian*, which is brought home to us most intimately perhaps by the analogy of *drunkenness*. It is either under the influence of the narcotic draught, which we hear of in the songs of all primitive men and peoples, or with the potent coming of spring penetrating all nature with joy, that these Dionysian emotions awake, which, as they intensify, cause the subjective to vanish into complete self-forgetfulness. So also in the German Middle Ages singing and dancing crowds, ever increasing in number, were whirled from place to place under this same Dionysian impulse. In these dancers of St. John and St. Vitus, we rediscover the Bacchic choruses of the Greeks, with their early history in Asia Minor, as far back as Babylon and the orgiastic Sacæa. There are some, who, from obtuseness, or lack of experience, will deprecate such phenomena as "folk-diseases," with contempt or pity born of the consciousness of their own "healthy-mindedness." But, of course, such poor wretches can not imagine how anemic and ghastly their so-called "healthy-mindedness" seems in contrast to the glowing life of the Dionysian revelers rushing past them.

Under the charm of the Dionysian not only is the union between man and man reaffirmed, but Nature which has become estranged, hostile, or subjugated, celebrates once more her reconcilation with her prodigal son, man. Freely earth proffers her gifts, and peacefully the beasts of prey approach from desert and mountain. The chariot of Dionysus is bedecked with flowers and garlands; panthers and tigers pass beneath his yoke. Transform Beethoven's "Hymn to Joy" into a painting; let your imagination conceive the multitudes bowing to the dust, awestruck—then you will be able to appreciate the Dionysian. Now the slave is free; now all the stubborn, hostile barriers, which necessity, caprice or "shameless fashion" have erected between man and man, are broken down. Now, with the gospel of universal harmony, each one feels himself not only united, reconciled, blended with his neighbor, but as one with him; he feels as if the veil of Mâyâ had been torn aside and were now merely fluttering in tatters before the mysterious Primordial Unity. In song and in dance man expresses himself as a member of a higher community; he has forgotten how to walk and speak; he is about to take a dancing flight into the air. His very gestures bespeak enchantment. Just as the animals now talk, just as the earth yields milk and honey, so from him emanate supernatural sounds. He feels himself a god, he himself now walks about enchanted, in ecstasy, like to the gods whom he saw walking about in his dreams. He is no longer an artist, he has become a work of art: in these paroxysms of intoxication the artistic power of all nature reveals itself to the highest gratification of the Primordial Unity. The noblest clay, the most costly marble, man, is

here kneaded and cut, and to the sound of the chisel strokes of the Diony-
sian world-artist rings out the cry of the Eleusinian mysteries: "Do ye
bow in the dust, O millions? Do you divine your creator, O world?"

II

Thus far we have considered the Apollonian and its antithesis, the
Dionysian, as artistic energies which burst forth from nature herself,
without the mediation of the human artist; energies in which nature's art-
impulses are satisfied in the most immediate and direct way: first, on the
one hand, in the pictorial world of dreams, whose completeness is not
dependent upon the intellectual attitude or the artistic culture of any single
being; and, on the other hand, as drunken reality, which likewise does
not heed the single unit, but even seeks to destroy the individual and re-
deem him by a mystic feeling of Oneness. With reference to these imme-
diate art-states of nature, every artist is an "imitator," that is to say, either
an Apollonian artist in dreams, or a Dionysian artist in ecstasies, or finally
—as for example in Greek tragedy—at once artist in both dreams and
ecstasies: so we may perhaps picture him sinking down in his Dionysian
drunkenness and mystical self-abnegation, alone, and apart from the sing-
ing revelers, and we may imagine how now, through Apollonian dream-
inspiration, his own state, *i.e.,* his oneness with the primal nature of
the universe, is revealed to him in a *symbolical dream-picture.*

So much for these general premises and contrasts. Let us now approach
the *Greeks* in order to learn how highly these *art-impulses of nature* were
developed in them. Thus we shall be in a position to understand and ap-
preciate more deeply that relation of the Greek artist to his archetypes,
which, according to the Aristotelian expression, is "the imitation of nature."
In spite of all the dream-literature and the numerous dream-anecdotes of
the Greeks, we can speak only conjecturally, though with reasonable
assurance, of their *dreams.* If we consider the incredibly precise and un-
erring plastic power of their eyes, together with their vivid, frank delight
in colors, we can hardly refrain (to the shame of all those born later) from
assuming even for their dreams a certain logic of line and contour, colors
and groups, a certain pictorial sequence reminding us of their finest bas-
reliefs, whose perfection would certainly justify us, if a comparison were
possible, in designating the dreaming Greeks as Homers and Homer as a
dreaming Greek: in a deeper sense than that in which modern man,
speaking of his dreams, ventures to compare himself with Shakespeare.

On the other hand, there is no conjecture as to the immense gap which
separates the *Dionysian Greek* from the Dionysian barbarian. From all
quarters of the Ancient World,—to say nothing here of the modern,—
from Rome to Babylon, we can point to the existence of Dionysian festivals,
types which bear, at best, the same relation to the Greek festivals as the
bearded satyr, who borrowed his name and attributes from the goat, does

to Dionysus himself. In nearly every case these festivals centered in extravagant sexual licentiousness, whose waves overwhelmed all family life and its venerable traditions; the most savage natural instincts were unleashed, including even that horrible mixture of sensuality and cruelty which has always seemed to me to be the genuine "witches' brew." For some time, however, it would appear that the Greeks were perfectly insulated and guarded against the feverish excitements of these festivals by the figure of Apollo himself rising here in full pride, who could not have held out the Gorgon's head to any power more dangerous than this grotesquely uncouth Dionysian. It is in Doric art that this majestically-rejecting attitude of Apollo is eternized. The opposition between Apollo and Dionysus became more hazardous and even impossible, when, from the deepest roots of the Hellenic nature, similar impulses finally burst forth and made a path for themselves: the Delphic god, by a seasonably effected reconciliation, now contented himself with taking the destructive weapons from the hands of his powerful antagonist. This reconciliation is the most important moment in the history of the Greek cult: wherever we turn we note the revolutions resulting from this event. The two antagonists were reconciled; the boundary lines thenceforth to be observed by each were sharply defined, and there was to be a periodical exchange of gifts of esteem. At bottom, however, the chasm was not bridged over. But if we observe how, under the pressure of this treaty of peace, the Dionysian power revealed itself, we shall now recognize in the Dionysian orgies of the Greeks, as compared with the Babylonian Sacæa with their reversion of man to the tiger and the ape, the significance of festivals of world-redemption and days of transfiguration. It is with them that nature for the first time attains her artistic jubilee; it is with them that the destruction of the *principium individuationis* for the first time becomes an artistic phenomenon. The horrible "witches' brew" of sensuality and cruelty becomes ineffective: only the curious blending and duality in the emotions of the Dionysian revelers remind us—as medicines remind us of deadly poisons—of the phenomenon that pain begets joy, that ecstasy may wring sounds of agony from us. At the very climax of joy there sounds a cry of horror or a yearning lamentation for an irretrievable loss. In these Greek festivals, nature seems to reveal a sentimental trait; it is as if she were heaving a sigh at her dismemberment into individuals. The song and pantomime of such dually-minded revelers was something new and unheard-of for the Homeric-Grecian world: and the Dionysian *music* in particular excited awe and terror. If music, as it would seem, had been known previously as an Apollonian art, it was so, strictly speaking, only as the wave-beat of rhythm, whose formative power was developed for the representation of Apollonian states. The music of Apollo was Doric architectonics in tones, but in tones that were merely suggestive, such as those of the cithara. The very element which forms the essence of Dionysian music (and hence of music in general) is carefully excluded as un-Apollonian: namely, the emotional power

of the tone, the uniform flow of the melos, and the utterly incomparable world of harmony. In the Dionysian dithyramb man is incited to the greatest exaltation of all his symbolic faculties; something never before experienced struggles for utterance—the annihilation of the veil of Mâyâ, Oneness as the soul of the race, and of nature itself. The essence of nature is now to be expressed symbolically; we need a new world of symbols; for once the entire symbolism of the body is called into play, not the mere symbolism of the lips, face, and speech, but the whole pantomime of dancing, forcing every member into rhythmic movement. Thereupon the other symbolic powers suddenly press forward, particularly those of music, in rhythmics, dynamics, and harmony. To grasp this collective release of all the symbolic powers, man must have already attained that height of self-abnegation which wills to express itself symbolically through all these powers: and so the dithyrambic votary of Dionysus is understood only by his peers! With what astonishment must the Apollonian Greek have beheld him! With an astonishment that was all the greater the more it was mingled with the shuddering suspicion that all this was actually not so very alien to him after all, in fact, that it was only his Apollonian consciousness which, like a veil, hid this Dionysian world from his vision.

III

To understand this, it becomes necessary to level the artistic structure of the *Apollonian culture*, as it were, stone by stone, till the foundations on which it rests become visible. First of all we see the glorious *Olympian* figures of the gods, standing on the gables of this structure. Their deeds, pictured in brilliant reliefs, adorn its friezes. We must not be misled by the fact that Apollo stands side by side with the others as an individual deity, without any claim to priority of rank. For the same impulse which embodied itself in Apollo gave birth in general to this entire Olympian world, and so in this sense Apollo is its father. What terrific need was it that could produce such an illustrious company of Olympian beings?

He who approaches these Olympians with another religion in his heart, seeking among them for moral elevation, even for sanctity, for disincarnate spirituality, for charity and benevolence, will soon be forced to turn his back on them, discouraged and disappointed. For there is nothing here that suggests asceticism, spirituality, or duty. We hear nothing but the accents of an exuberant, triumphant life, in which all things, whether good or bad, are deified. And so the spectator may stand quite bewildered before this fantastic superfluity of life, asking himself what magic potion these mad glad men could have imbibed to make life so enjoyable that, wherever they turned, their eyes beheld the smile of Helen, the ideal picture of their own existence, "floating in sweet sensuality." But to this spectator, who has his back already turned, we must perforce cry: "Go not away, but stay and hear what Greek folk-wisdom has to say of this very life, which with such

inexplicable gayety unfolds itself before your eyes. There is an ancient story that King Midas hunted in the forest a long time for the wise *Silenus*, the companion of Dionysus, without capturing him. When Silenus at last fell into his hands, the king asked what was the best and most desirable of all things for man. Fixed and immovable, the demigod said not a word; till at last, urged by the king, he gave a shrill laugh and broke out into these words: 'Oh, wretched ephemeral race, children of chance and misery, why do ye compel me to tell you what it were most expedient for you not to hear? What is best of all is beyond your reach forever: not to be born, not to *be*, to be *nothing*. But the second best for you—is quickly to die.'"

How is the Olympian world of deities related to this folk-wisdom? Even as the rapturous vision of the tortured martyr to his suffering.

Now it is as if the Olympian magic mountain had opened before us and revealed its roots to us. The Greek knew and felt the terror and horror of existence. That he might endure this terror at all, he had to interpose between himself and life the radiant dream-birth of the Olympians. That overwhelming dismay in the face of the titanic powers of nature, the Moira enthroned inexorably over all knowledge, the vulture of the great lover of mankind, Prometheus, the terrible fate of the wise Œdipus, the family curse of the Atridæ which drove Orestes to matricide: in short, that entire philosophy of the sylvan god, with its mythical exemplars, which caused the downfall of the melancholy Etruscans—all this was again and again overcome by the Greeks with the aid of the Olympian *middle world* of art; or at any rate it was veiled and withdrawn from sight. It was out of the direst necessity to live that the Greeks created these gods. Perhaps we may picture the process to ourselves somewhat as follows: out of the original Titan thearchy of terror the Olympian thearchy of joy gradually evolved through the Apollonian impulse towards beauty, just as roses bud from thorny bushes. How else could this people, so sensitive, so vehement in its desires, so singularly constituted for *suffering*, how could they have endured existence, if it had not been revealed to them in their gods, surrounded with a higher glory? The same impulse which calls art into being, as the complement and consummation of existence, seducing one to a continuation of life, was also the cause of the Olympian world which the Hellenic "will" made use of as a transfiguring mirror. Thus do the gods justify the life of man, in that they themselves live it—the only satisfactory Theodicy! Existence under the bright sunshine of such gods is regarded as desirable in itself, and the real *grief* of the Homeric men is caused by parting from it, especially by early parting: so that now, reversing the wisdom of Silenus, we might say of the Greeks that "to die early is worst of all for them, the next worst—some day to die at all." Once heard, it will ring out again; forget not the lament of the short-lived Achilles, mourning the leaflike change and vicissitude of the race of men and the decline of the heroic age. It is not unworthy of the greatest hero to

long for a continuation of life, aye, even though he live as a slave. At the
Apollonian stage of development, the "will" longs so vehemently for this
existence, the Homeric man feels himself so completely at one with it,
that lamentation itself becomes a song of praise.

Here we should note that this harmony which is contemplated with such
longing by modern man, in fact, this oneness of man with nature (to
express which Schiller introduced the technical term "naïve"), is by no
means a simple condition, resulting naturally, and as if inevitably. It is
not a condition which, like a terrestrial paradise, *must* necessarily be found
at the gate of every culture. Only a romantic age could believe this, an
age which conceived of the artist in terms of Rousseau's *Emile* and imag-
ined that in Homer it had found such an artist Emile, reared in Nature's
bosom. Wherever we meet with the "naïve" in art, we recognize the
highest effect of the Apollonian culture, which in the first place has always
to overthrow some Titanic empire and slay monsters, and which, through
its potent dazzling representations and its pleasurable illusions, must have
triumphed over a terrible depth of world-contemplation and a most keen
sensitivity to suffering. But how seldom do we attain to the naïve—that
complete absorption in the beauty of appearance! And hence how inexpres-
sibly sublime is *Homer*, who, as individual being, bears the same relation
to this Apollonian folk-culture as the individual dream-artist does to the
dream-faculty of the people and of Nature in general. The Homeric "naï-
veté" can be understood only as the complete victory of the Apollonian
illusion: an illusion similar to those which Nature so frequently employs
to achieve her own ends. The true goal is veiled by a phantasm: and while
we stretch out our hands for the latter, Nature attains the former by
means of your illusion. In the Greeks the "will" wished to contemplate
itself in the transfiguration of genius and the world of art; in order to
glorify themselves, its creatures had to feel themselves worthy of glory;
they had to behold themselves again in a higher sphere, without this
perfect world of contemplation acting as a command or a reproach. Such is
the sphere of beauty, in which they saw their mirrored images, the Olym-
pians. With this mirroring of beauty the Hellenic will combated its
artistically correlative talent for suffering and for the wisdom of suffering:
and, as a monument of its victory, we have Homer, the naïve artist.

IV

Now the dream-analogy may throw some light on the problem of the
naïve artist. Let us imagine the dreamer: in the midst of the illusion of the
dream-world and without disturbing it, he calls out to himself: "It is a
dream, I will dream on." What must we infer? That he experiences a deep
inner joy in dream-contemplation; on the other hand, to be at all able to
dream with this inner joy in contemplation, he must have completely lost
sight of the waking reality and its ominous obtrusiveness. Guided by the

dream-reading Apollo, we may interpret all these phenomena to ourselves
somewhat in this way. Though it is certain that of the two halves of our
existence, the waking and the dreaming states, the former appeals to
us as infinitely preferable, important, excellent and worthy of being lived,
indeed, as that which alone is lived: yet, in relation to that mysterious
substratum of our nature of which we are the phenomena, I should,
paradoxical as it may seem, maintain the very opposite estimate of the
value of dream life. For the more clearly I perceive in Nature those omnip-
otent art impulses, and in them an ardent longing for release, for redemp-
tion through release, the more I feel myself impelled to the metaphysical
assumption that the Truly-Existent and Primal Unity, eternally suffering
and divided against itself, has need of the rapturous vision, the joyful
appearance, for its continuous salvation: which appearance we, completely
wrapped up in it and composed of it, are compelled to apprehend as the
True Non-Being,—*i.e.*, as a perpetual becoming in time, space and cau-
sality,—in other words, as empiric reality. If, for the moment, we do
not consider the question of our own "reality," if we conceive of our
empirical existence, and that of the world in general, as a continuously
manifested representation of the Primal Unity, we shall then have to look
upon the dream as an *appearance of appearance*, hence as a still higher
appeasement of the primordial desire for appearance. And that is why the
innermost heart of Nature feels that ineffable joy in the naïve artist and
the naïve work of art, which is likewise only "an appearance of appear-
ance." In a symbolic painting, *Raphael*, himself one of these immortal
"naïve" ones, has represented for us this devolution of appearance to ap-
pearance, the primitive process of the naïve artist and of Apollonian
culture. In his "Transfiguration," the lower half of the picture, with the
possessed boy, the despairing bearers, the bewildered, terrified disciples,
shows us the reflection of suffering, primal and eternal, the sole basis
of the world: the "appearance" here is the counter-appearance of eternal
contradiction, the father of things. From this appearance now arises, like
ambrosial vapor, a new visionary world of appearances, invisible to those
wrapped in the first appearance—a radiant floating in purest bliss, a
serene contemplation beaming from wide-open eyes. Here we have pre-
sented, in the most sublime artistic symbolism, that Apollonian world of
beauty and its substratum, the terrible wisdom of Silenus; and intuitively
we comprehend their necessary interdependence. Apollo, however, again
appears to us as the apotheosis of the *principium individuationis*, in which
alone is consummated the perpetually attained goal of the Primal Unity,
its redemption through appearance. With his sublime gestures, he shows
us how necessary is the entire world of suffering, that by means of it the
individual may be impelled to realize the redeeming vision, and then, sunk
in contemplation of it, sit quietly in his tossing barque, amid the waves.

 If we at all conceive of it as imperative and mandatory, this apotheosis
of individuation knows but one law—the individual, *i.e.*, the delimiting

of the boundaries of the individual, *measure* in the Hellenic sense. Apollo, as ethical deity, exacts measure of his disciples, and, that to this end, he requires self-knowledge. And so, side by side with the esthetic necessity for beauty, there occur the demands "know thyself" and "nothing over-much"; consequently pride and excess are regarded as the truly inimical demons of the non-Apollonian sphere, hence as characteristics of the pre-Apollonian age—that of the Titans; and of the extra-Apollonian world—that of the barbarians. Because of his Titan-like love for man, Prometheus must be torn to pieces by vultures; because of his excessive wisdom, which could solve the riddle of the Sphinx, Œdipus must be plunged into a bewildering vortex of crime. Thus did the Delphic god interpret the Greek past.

Similarly the effects wrought by the *Dionysian* seemed "titan-like" and "barbaric" to the Apollonian Greek: while at the same time he could not conceal from himself that he too was inwardly related to these over-thrown Titans and heroes. Indeed, he had to recognize even more than this: despite all its beauty and moderation, his entire existence rested on a hidden substratum of suffering and of knowledge, which was again revealed to him by the Dionysian. And lo! Apollo could not live without Dionysus! The "titanic" and the "barbaric" were in the last analysis as necessary as the Apollonian.

And now let us take this artistically limited world, based on appearance and moderation; let us imagine how into it there penetrated, in tones ever more bewitching and alluring, the ecstatic sound of the Dionysian festival; let us remember that in these strains all of Nature's excess in joy, sorrow, and knowledge become audible, even in piercing shrieks; and finally, let us ask ourselves what significance remains to the psalmodizing artist of Apollo, with his phantom harp-sound, once it is compared with this demonic folk-song! The muses of the arts of "appearance" paled before an art which, in its intoxication, spoke the truth. The wisdom of Silenus cried "Woe! woe!" to the serene Olympians. The individual, with all his restraint and proportion, succumbed to the self-oblivion of the Dionysian state, forgetting the precepts of Apollo. Excess revealed itself as truth. Contradiction, the bliss born of pain, spoke out from the very heart of Nature. And so, wherever the Dionysian prevailed, the Apollonian was checked and destroyed. But, on the other hand, it is equally certain that, wherever the first Dionysian onslaught was successfully withstood, the authority and majesty of the Delphic god exhibited itself as more rigid and menacing than ever. For to me the *Doric* state and Doric art are explicable only as a permanent citadel of the Apollonian. For an art so defiantly prim, and so encompassed with bulwarks, a training so warlike and rigorous, a political structure so cruel and relentless, could endure for any length of time only by incessant opposition to the titanic-barbaric nature of the Dionysian.

Up to this point we have simply enlarged upon the observation made

at the beginning of this essay: that the Dionysian and the Apollonian, in new births ever following and mutually augmenting one another, controlled the Hellenic genius; that from out the age of "bronze," with its wars of the Titans and its rigorous folk-philosophy, the Homeric world developed under the sway of the Apollonian impulse to beauty; that this "naïve" splendor was again overwhelmed by the influx of the Dionysian; and that against this new power the Apollonian rose to the austere majesty of Doric art and the Doric view of the world. If, then, amid the strife of these two hostile principles, the older Hellenic history thus falls into four great periods of art, we are now impelled to inquire after the *final goal* of these developments and processes, lest perchance we should regard the last-attained period, the period of Doric art, as the climax and aim of these artistic impulses. And here the sublime and celebrated art of *Attic tragedy* and the dramatic dithyramb presents itself as the common goal of both these tendencies, whose mysterious union, after many and long precursory struggles, found glorious consummation in this child,—at once Antigone and Cassandra.

V

We now approach the real goal of our investigation, which is directed towards acquiring a knowledge of the Dionysian-Apollonian genius and its art-product, or at least an anticipatory understanding of its mysterious union. Here we shall first of all inquire after the first evidence in Greece of that new germ which subsequently developed into tragedy and the dramatic dithyramb. The ancients themselves give us a symbolic answer, when they place the faces of *Homer* and *Archilochus* as the forefathers and torchbearers of Greek poetry side by side on gems, sculptures, etc., with a sure feeling that consideration should be given only to these two thoroughly original compeers, from whom a stream of fire flows over the whole of later Greek history. Homer, the aged self-absorbed dreamer, the type of the Apollonian naïve artist, now beholds with astonishment the passionate genius of the warlike votary of the muses, Archilochus, passing through life with fury and violence; and modern esthetics, by way of interpretation, can only add that here the first "objective" artist confronts the first "subjective" artist. But this interpretation helps us but little, because we know the subjective artist only as the poor artist, and throughout the entire range of art we demand specially and first of all the conquest of the Subjective, the release from the ego and the silencing of the individual will and desire; indeed, we find it impossible to believe in any truly artistic production, however insignificant, if it is without objectivity, without pure, detached contemplation. Hence our esthetic must first solve the problem of how the "lyrist" is possible as an artist—he who, according to the experience of all ages, is continually saying "I" and running through the entire chromatic scale of his passions and desires. Compared with

Homer, this very Archilochus appalls us by his cries of hatred and scorn, by his drunken outbursts of desire. Therefore is not he, who has been called the first subjective artist, essentially the non-artist? But in this case, how explain the reverence which was shown to him—the poet—in very remarkable utterances by the Delphic oracle itself, the center of "objective" art?

Schiller has thrown some light on the poetic process by a psychological observation, inexplicable to himself, yet apparently valid. He admits that before the act of creation he did not perhaps have before him or within him any series of images accompanied by an ordered thought-relationship; but his condition was rather that of a *musical mood*. ("With me the perception has at first no clear and definite object; this is formed later. A certain musical mood of mind precedes, and only after this ensues the poetical idea.") Let us add to this the natural and most important phenomenon of all ancient lyric poetry, *the union*, indeed, the *identity*, of the *lyrist with the musician*,—compared with which our modern lyric poetry appears like the statue of a god without a head,—with this in mind we may now, on the basis of our metaphysics of esthetics set forth above, explain the lyrist to ourselves in this manner: In the first place, as Dionysian artist he has identified himself with the Primal Unity, its pain and contradiction. Assuming that music has been correctly termed a repetition and a recast of the world, we may say that he produces the copy of this Primal Unity as music. Now, however, under the Apollonian dream-inspiration, this music reveals itself to him again as a *symbolic dream-picture*. The inchoate, intangible reflection of the primordial pain in music, with its redemption in appearance, now produces a second mirroring as a specific symbol or example. The artist has already surrendered his subjectivity in the Dionysian process. The picture which now shows him his identity with the heart of the world, is a dream-scene, which embodies the primordial contradiction and primordial pain, together with the primordial joy, of appearance. The "I" of the lyrist therefore sounds from the depth of his being: its "subjectivity," in the sense of the modern esthetes, is pure imagination. When Archilochus, the first Greek lyrist, proclaims to the daughters of Lycambes both his mad love and his contempt, it is not his passion alone which dances before us in orgiastic frenzy; but we see Dionysus and the Mænads, we see the drunken reveler Archilochus sunk down in slumber—as Euripides depicts it in the *Bacchæ*, the sleep on the high mountain pasture, in the noonday sun. And now Apollo approaches and touches him with the laurel. Then the Dionyso musical enchantment of the sleeper seems to emit picture sparks, lyrical poems, which in their highest form are called tragedies and dramatic dithyrambs.

The plastic artist, as also the epic poet, who is related to him, is sunk in the pure contemplation of images. The Dionysian musician is, without any images, himself pure primordial pain and its primordial reëchoing. The lyric genius is conscious of a world of pictures and symbols—growing

out of his state of mystical self-abnegation and oneness. This state has a coloring, a causality and a velocity quite different from that of the world of the plastic artist and the epic poet. For the latter lives in these pictures, and only in them, with joyful satisfaction. He never grows tired of contemplating lovingly even their minutest traits. Even the picture of the angry Achilles is only a picture to him, whose angry expression he enjoys with the dream-joy in appearance. Thus, by this mirror of appearance, he is protected against being united and blended with his figures. In direct contrast to this, the pictures of the *lyrist* are nothing but *his very* self and, as it were, only different projections of himself, by force of which he, as the moving center of this world, may say "I": only of course this self is not the same as that of the waking, empirically real man, but the only truly existent and eternal self resting at the basis of things, and with the help of whose images, the lyric genius can penetrate to this very basis.

Now let us suppose that among these images he also beholds *himself* as non-genius, *i.e.*, his subject, the whole throng of subjective passions and agitations directed to a definite object which appears real to him. It may now seem as if the lyric genius and the allied non-genius were one, as if the former had of its own accord spoken that little word "I." But this identity is but superficial and it will no longer be able to lead us astray, as it certainly led astray those who designated the lyrist as the subjective poet. For, as a matter of fact, Archilochus, the passionately inflamed, loving and hating man, is but a vision of the genius, who by this time is no longer merely Archilochus, but a world-genius expressing his primordial pain symbolically in the likeness of the man Archilochus: while the subjectively willing and desiring man, Archilochus, can never at any time be a poet. It is by no means necessary, however, that the lyrist should see nothing but the phenomenon of the man Archilochus before him as a reflection of eternal being; and tragedy shows how far the visionary world of the lyrist may be removed from this phenomenon, which, of course, is intimately related to it.

Schopenhauer, who did not conceal from himself the difficulty the lyrist presents in the philosophical contemplation of art, thought he had found a solution, with which, however, I am not in entire accord. (Actually, it was in his profound metaphysics of music that he alone held in his hands the means whereby this difficulty might be definitely removed: as I believe I have removed it here in his spirit and to his honor.) In contrast to our view, he describes the peculiar nature of songs as follows[3] (*Welt als Wille und Vorstellung*, I. 295):

"It is the subject of will, *i.e.*, his own volition, which the consciousness of the singer feels; often as a released and satisfied desire (joy), but still oftener as a restricted desire (grief), always as an emotion, a passion, a moved frame of mind. Besides this, however, and along with it, by the

[3] *World as Will and Idea*, I, 322, 6th ed. of Haldane and Kemp's Trans.

sight of surrounding nature, the singer becomes conscious of himself as the subject of pure will-less knowing, whose unbroken, blissful peace now appears, in contrast to the stress of desire, which is always restricted and always needy. The feeling of this contrast, this alternation, is really what the lyric as a whole expresses and what principally constitutes the lyrical state of mind. In it pure knowing comes to us as it were to deliver us from desire and its strain; we follow, but only for an instant; desire, the remembrance of our own personal ends, tears us anew from peaceful contemplation; yet ever again the next beautiful surrounding in which the pure will-less knowledge presents itself to us, allures us away from desire. Therefore, in the lyric and the lyrical mood, desire (the personal interest of the ends) and pure perception of the surrounding presented are wonderfully mingled with each other; connections between them are sought for and imagined; the subjective disposition, the affection of the will, imparts its own hue to the perceived surrounding, and conversely, the surroundings communicate the reflex of their color to the will. The true lyric is the expression of the whole of this mingled and divided state of mind."

Who could fail to recognize in this description that lyric poetry is here characterized as an incompletely attained art, which arrives at its goal infrequently and only as it were by leaps? Indeed, it is described as a semi-art, whose essence is said to consist in this, that desire and pure contemplation, *i.e.*, the unesthetic and the esthetic condition, are wonderfully mingled with each other. It follows that Schopenhauer still classsifies the arts as subjective or objective, using the antithesis as if it were a criterion of value. But it is our contention, on the contrary, that this antithesis between the subjective and the objective is especially irrelevant in esthetics, since the subject, the desiring individual furthering his own egoistic ends, can be conceived of only as the antagonist, not as the origin of art. In so far as the subject is the artist, however, he has already been released from his individual will, and has become as it were the medium through which the one truly existent Subject celebrates his release in appearance. For, above all, to our humiliation *and* exaltation, one thing must be clear to us. The entire comedy of art is neither performed for our betterment or education nor are we the true authors of this art-world. On the contrary, we may assume that we are merely pictures and artistic projections for the true author, and that we have our highest dignity in our significance as works of art—for it is only as an *esthetic phenomenon* that existence and the world are eternally *justified*—while of course our consciousness of our own significance hardly differs from that which the soldiers painted on canvas have of the battle represented on it. Thus all our knowledge of art is basically quite illusory, because as knowing beings we are not one and identical with that Being who, as the sole author and spectator of this comedy of art, prepares a perpetual entertainment for himself. Only in so far as the genius in the act of artistic creation coalesces with this primordial artist of the

world, does he catch sight of the eternal essence of art; for in this state he is, in a marvelous manner, like the weird picture of the fairy-tale which can turn its eyes at will and behold itself; he is now at once subject and object, at once poet, actor, and spectator.

VI

In connection with Archilochus, scholarly research, has discovered that he introduced the *folk-song* into literature, and, on account of this, deserved, according to the general estimate of the Greeks, his unique position beside Homer. But what is the folk-song in contrast to the wholly Apollonian epos? What else but the *perpetuum vestigium* of a union of the Apollonian and the Dionysian? Its enormous diffusion among all peoples, further re-enforced by ever-new births, is testimony to the power of this artistic dual impulse of Nature: which leaves its vestiges in the folk-song just as the orgiastic movements of a people perpetuate themselves in its music. Indeed, it might also be historically demonstrable that every period rich in folk-songs has been most violently stirred by Dionysian currents, which we must always consider the substratum and prerequisite of the folk-song.

First of all, however, we must conceive the folk-song as the musical mirror of the world, as the original melody, now seeking for itself a parallel dream-phenomenon and expressing it in poetry. *Melody is therefore primary and universal,* and so may admit of several objectifications in several texts. Likewise, in the naïve estimation of the people, it is regarded as by far the more important and essential element. Melody generates the poem out of itself by a continuous process. *The strophic form of the folk-song* points to the same thing; a phenomenon which I had always beheld with astonishment, until at last I found this explanation. Any one who in accordance with this theory examines a collection of folk-songs, such as *Des Knaben Wunderhorn,* will find innumerable instances of the way the continuously generating melody scatters picture sparks all around, which in their variegation, their abrupt change, their mad precipitation, manifest a power quite unknown to the epic and its steady flow. From the standpoint of the epos, this unequal and irregular pictorial world of lyric poetry is definitely to be condemned: and it certainly has been thus condemned by the solemn epic rhapsodists of the Apollonian festivals in the age of Terpander.

Accordingly, we observe that in the poetry of the folk-song, language is strained to its utmost that it may *imitate music;* and hence with Archilochus begins a new world of poetry, which is basically opposed to the Homeric. And in saying this we have indicated the only possible relation between poetry and music, between word and tone: the word, the picture, the concept here seeks an expression analogous to music and now feels in itself the power of music. In this sense we may discriminate between

two main currents in the history of the language of the Greek people, according to whether their language imitated the world of image and phenomenon, or the world of music. One need only reflect more deeply on the linguistic difference with regard to color, syntactical structure, and vocabulary in Homer and Pindar, in order to understand the significance of this contrast; indeed, it becomes palpably clear that in the period between Homer and Pindar there must have sounded out the *orgiastic flute tones of Olympus*, which, even in Aristotle's time, when music was infinitely more developed, transported people to drunken ecstasy, and which, in their primitive state of development, undoubtedly incited to imitation all the poetic means of expression of contemporaneous man. I here call attention to a familiar phenomenon of our own times, against which our esthetic raises many objections. We again and again have occasion to observe that a Beethoven symphony compels its individual auditors to use figurative speech in describing it, no matter how fantastically variegated and even contradictory may be the composition and make-up of the different pictorial world produced by a piece of music. To exercise its poor wit on such compositions, and to overlook a phenomenon which is certainly worth explaining, is quite in keeping with this esthetic. Indeed, even when the tone-poet expresses his composition in pictures, when for instance he designates a certain symphony as the "pastoral" symphony, or a passage in it as the "scene by the brook," or another as the "merry gathering of rustics," these too are only symbolical representations born of music—and not perhaps the imitated objects of music—representations which can teach us nothing whatsoever concerning the *Dionysian* content of music, and which indeed have no distinctive value of their own beside other pictorial expressions. We have now to transfer this process of a discharge of music in pictures to some fresh, youthful, linguistically creative people, in order to get a notion of how the strophic faculty of speech is stimulated by this new principle of the imitation of music.

If, therefore, we may regard lyric poetry as the fulguration of music in images and concepts, we should now ask: "In what form does music *appear* in the mirror of symbolism and conception?" *It appears as will*, taking the term in Schopenhauer's sense, *i.e.*, as the antithesis of the esthetic, purely contemplative, and passive frame of mind. Here, however, we must make as sharp a distinction as possible between the concept of essence and the concept of phenomenon; for music, according to its essence, cannot possibly be will. To be will it would have to be wholly banished from the realm of art—for the will is the unesthetic-in-itself. Yet though *essentially* it is not will, *phenomenally* it *appears* as will. For in order to express the phenomenon of music in images, the lyrist needs all the agitations of passion, from the whisper of mere inclination to the roar of madness. Impelled to speak of music in Apollonian symbols, he conceives of all nature, and himself therein, only as eternal Will, Desire, Longing. But in so far as he interprets music by means of images, he himself rests in the quiet calm of Apollonian contemplation, though every-

thing around him which he beholds through the medium of music may be confused and violent. Indeed, when he beholds himself through this same medium, his own image appears to him as an unsatisfied feeling: his own willing, longing, moaning, rejoicing, are to him symbols by which he interprets music. This is the phenomenon of the lyrist: as Apollonian genius he interprets music through the image of the will, while he himself, completely released from the desire of the will, is the pure, undimmed eye of day.

Our whole discussion insists that lyric poetry is dependent on the spirit of music just as music itself in its absolute sovereignty does not need the picture and the concept, but merely *endures* them as accompaniments. The poems of the lyrist can express nothing which did not already lie hidden in the vast universality and absoluteness of the music which compelled him to figurative speech. Language can never adequately render the cosmic symbolism of music, because music stands in symbolic relation to the primordial contradiction and primordial pain in the heart of the Primal Unity, and therefore symbolizes a sphere which is beyond and before all phenomena. Rather are all phenomena, compared with it, merely symbols: hence *language*, as the organ and symbol of phenomena, can never, by any means, disclose the innermost heart of music; language, in its attempt to imitate it, can only be in superficial contact with music; while the deepest significance of the latter cannot with all the eloquence of lyric poetry be brought one step nearer to us.

VII

We must now avail ourselves of all the principles of art hitherto considered, in order to find our way through the labyrinth, as we must call it, of *the origin of Greek tragedy*. I do not think I am unreasonable in saying that the problem of this origin has as yet not even been seriously stated, not to say solved, however often the ragged tatters of ancient tradition are sewn together in various combinations and torn apart again. This tradition tells us quite unequivocally, *that tragedy arose from the tragic chorus*, and was originally only chorus and nothing but chorus; and hence we feel it our duty to look into the heart of this tragic chorus as being the real proto-drama. We shall not let ourselves be at all satisfied with that current art-lingo which makes the chorus the "ideal spectator," or has it represent the people in contrast to the aristocratic elements of the scene. This latter explanation has a sublime sound to many a politician. It insists that the immutable moral law was embodied by the democratic Athenians in the popular chorus, which always wins out over the passionate excesses and extravagances of kings. This theory may be ever so forcibly suggested by one of Aristotle's observations; still, it has no influence on the original formation of tragedy, inasmuch as the entire antithesis of king and people, and, in general, the whole politico-social sphere, is excluded from the purely religious origins of tragedy. With this in mind,

and remembering the well-known classical form of the chorus in Aeschylus and Sophocles, we should even deem it blasphemy to speak here of the anticipation of a "constitutional popular representation." From this blasphemy, however, others have not shrunk. The ancient governments knew of no constitutional representation of the people *in praxi*, and it is to be hoped that they did not "anticipate" it in their tragedy either.

Much more famous than this political interpretation of the chorus is the theory of A. W. Schlegel, who advises us to regard the chorus, in a manner, as the essence and extract of the crowd of spectators,—as the "ideal spectator." This view, when compared with the historical tradition that originally tragedy was only chorus, reveals itself for what it is,—a crude, unscientific, yet brilliant generalization, which however, acquires that brilliancy only through its epigrammatic form of expression, the deep Germanic bias in favor of anything called "ideal," and our momentary astonishment. For we are certainly astonished the moment we compare our familiar theatrical public with this chorus, and ask ourselves whether it could ever be possible to idealize something analogous to the Greek tragic chorus out of such a public. We tacitly deny this, and now wonder as much at the boldness of Schlegel's assertion as at the totally different nature of the Greek public. For hitherto we had always believed that the true spectator, who ever he may be, must always remain conscious that he was viewing a work of art, and not an empirical reality. But the tragic chorus of the Greeks is forced to recognize *real beings* in the figures of the drama. The chorus of the Oceanides really believes that it sees before it the Titan Prometheus, and considers itself as real as the god of the scene. And are we to designate as the highest and purest type of spectator, one who, like the Oceanides, regards Prometheus as real and present in body? Is it characteristic of the ideal spectator to run on to the stage and free the god from his torments? We had always believed in an esthetic public, we had considered the individual spectator the better qualified the more he was capable of viewing a work of art as art, that is, esthetically. But now Schlegel tells us that the perfect ideal spectator does not at all allow the world of the drama to act on him *esthetically*, but corporeally and empirically. Oh, these Greeks! we sighed; they upset all our esthetics! . . . But once accustomed to it, we have repeated Schlegel's saying whenever the chorus came up for discussion.

Now, the tradition which is quite explicit here, speaks against Schlegel. The chorus as such, without the stage,—the primitive form of tragedy,— and the chorus of ideal spectators do not go together. What kind of art would that be in which the spectator does not enter as a separate concept? What kind of art is that whose true form is identical with the "spectator as such"? The spectator without the play is nonsense. We fear that the birth of tragedy is to be explained neither by the high esteem for the moral intelligence of the multitude nor by the concept of the spectator minus the play. We must regard the problem as too deep to be even touched by such superficial generalizing.

An infinitely more valuable insight into the significance of the chorus had already been displayed by Schiller in the celebrated Preface to his *Bride of Messina*, where he regards the chorus as a living barrier which tragedy constructs round herself to cut off her contact with the world of reality, and to preserve her ideal domain and her poetical freedom.

With this, his chief weapon, Schiller combats the ordinary conception of the natural, the illusion usually demanded in dramatic poetry. Although it is true that the stage day is merely artificial, the architecture only symbolical, and the metrical language purely ideal in character, nevertheless an erroneous view still prevails in the main: that we should not excuse these conventions merely on the ground that they constitute a poetical license. Now in reality these "conventions" form the essence of all poetry. The introduction of the chorus, says Schiller, is the decisive step by which open and honorable war is declared against all naturalism in art. It would seem that to denigrate this view of the matter our would-be superior age has coined the disdainful catchword "pseudo-idealism." I fear, however, that we, on the other hand, with our present adoration of the natural and the real, have reached the opposite pole of all idealism, namely, in the region of wax-work cabinets. There is an art in these too, as certain novels much in vogue at present evidence: but let us not disturb ourselves at the claim that by any such art the Schiller-Goethian "pseudo-idealism" has been vanquished.

It is indeed an "ideal" domain, as Schiller correctly perceived, in which the Greek satyr chorus, the chorus of primitive tragedy, was wont to dwell. It is a domain raised high above the actual path of mortals. For this chorus the Greek built up the scaffolding of a fictitious *natural state* and on it placed fictitious *natural beings*. On this foundation tragedy developed and so, of course, it could dispense from the beginning with a painful portrayal of reality. Yet it is no arbitrary world placed by whim between heaven and earth; rather is it a world with the same reality and credibility that Olympus with its dwellers possessed for the believing Hellene. The satyr, as the Dionysian chorist, lives in a religiously acknowledged reality under the sanction of the myth and the cult. That tragedy should begin with him, that he should be the voice of the Dionysian tragic wisdom, is just as strange a phenomenon as the general derivation of tragedy from the chorus.

Perhaps we shall have a point of departure for our inquiry, if I put forward the proposition that the satyr, the fictitious natural being, bears the same relation to the man of culture that Dionysian music does to civilization. Concerning this latter, Richard Wagner says that it is neutralized by music just as lamplight is neutralized by the light of day. Similarly, I believe, the Greek man of culture felt himself neutralized in the presence of the satyric chorus: and this is the most immediate effect of the Dionysian tragedy, that the state and society, and in general, the gulfs between man and man give way to an overwhelming feeling of unity leading back to the very heart of nature. The metaphysical comfort

—with which, as I have here intimated, every true tragedy leaves us—
that, in spite of the flux of phenomena, life at bottom is indestructibly
powerful and pleasurable, appears with objective clarity as the satyr cho-
rus, the chorus of natural beings, who as it were live ineradicably behind
every civilization, and who, despite the ceaseless change of generations
and the history of nations, remain the same to all eternity.

With this chorus the deep-minded Hellene consoles himself, he who is
so singularly constituted for the most sensitive and grievous suffering, he
who with a piercing glance has penetrated into the very heart of the
terrible destructive processes of so-called universal history, as also into
the cruelty of nature, and who is in danger of longing for a Buddhistic
negation of the will. Art saves him, and through art life saves him—for
herself.

For we must realize that in the ecstasy of the Dionysian state, with its
annihilation of the ordinary bounds and limits of existence, there is con-
tained a *lethargic* element, in which are submerged all past personal expe-
riences. It is this gulf of oblivion that separates the world of everyday
from the world of Dionysian reality. But as soon as we become conscious
again of this everyday reality, we feel it as nauseating and repulsive; and
an ascetic will-negating mood is the fruit of these states. In this sense
the Dionysian man resembles Hamlet: both have for once penetrated into
the true nature of things,—they have *perceived*, but it is irksome for them
to act; for their action cannot change the eternal nature of things; the
time is out of joint and they regard it as shameful or ridiculous that they
should be required to set it right. Knowledge kills action, action requires
the veil of illusion—it is this lesson which Hamlet teaches, and not the
idle wisdom of John-o'-Dreams who from too much reflection, from a
surplus of possibilities, never arrives at action at all. Not reflection, no!—
true knowledge, insight into the terrible truth, preponderate over all mo-
tives inciting to action, in Hamlet as well as in the Dionysian man. There
is no longer any use in comfort; his longing goes beyond a world after
death, beyond the gods themselves; existence with its glittering reflection
in the gods or in an immortal beyond is abjured. In the consciousness of
the truth once perceived, man now sees everywhere only the terror or the
absurdity of existence; now he can understand the symbolism of Ophelia's
fate; now he can realize the wisdom of the sylvan god Silenus: and he
is filled with loathing.

But at this juncture, when the will is most imperiled, *art* approaches,
as a redeeming and healing enchantress; she alone may transform these
horrible reflections on the terror and absurdity of existence into represen-
tations with which man may live. These are the representation of the
sublime as the artistic conquest of the awful, and of the *comic* as the artistic
release from the nausea of the absurd. The satyric chorus of the dithyramb
is the saving device of Greek art; the paroxysms described above exhaust
themselves in the intermediary world of these Dionysian votaries.

BENEDETTO CROCE

AESTHETICS

Benedetto Croce (1866–1952) is the most famous Italian philosopher of the twentieth century. His philosophy, inspired by Hegel, represents a revival of idealism as applied to art and history.

If we examine a poem in order to determine what it is that makes us feel it to be a poem, we at once find two constant and necessary elements: a complex of *images*, and a *feeling* that animates them. Let us, for instance, recall a passage learnt at school: Virgil's lines (Aeneid, iii, 294, sqq.), in which Aeneas describes how on hearing that in the country to whose shores he had come the Trojan Helenus was reigning, with Andromache, now his wife, he was overcome with amazement and a great desire to see this surviving son of Priam and to hear of his strange adventures. Andromache, whom he meets outside the walls of the city, by the waters of a river renamed Simois, celebrating funeral rites before a cenotaph of green turf and two altars to Hector and Astyanax; her astonishment on seeing him, her hesitation, the halting words in which

Reprinted from Aesthetics, *Encyclopaedia Britannica*, Fourteenth Edition, Volume I, pp. 263–269, Chicago, Encyclopaedia Britannica, Inc., 1938, by permission of the publisher.

she questions him, uncertain whether he is a man or a ghost; Aeneas's no less agitated replies and interrogations, and the pain and confusion with which she recalls the past—how she lived through scenes of blood and shame, how she was assigned by lot as slave and concubine to Pyrrhus, abandoned by him and united to Helenus, another of his slaves, how Pyrrhus fell by the hand of Orestes and Helenus became a free man and a king; the entry of Aeneas and his men into the city, and their reception by the son of Priam in this little Troy, this mimic Pergamon with its new Xanthus, and its Scaean Gate whose threshold Aeneas greets with a kiss—all these details, and others here omitted, are images of persons, things, attitudes, gestures, sayings, joy and sorrow; mere images, not history or historical criticism, for which they are neither given nor taken. But through them all there runs a feeling, a feeling which is our own no less than the poet's, a human feeling of bitter memories, of shuddering horror, of melancholy, of homesickness, of tenderness, of a kind of childish *pietas* that could prompt this vain revival of things perished, these playthings fashioned by a religious devotion, the *parva Troia*, the *Pergama simulata magnis*, the *arentem Xanthi cognomine rivum:* something inexpressible in logical terms, which only poetry can express in full. Moreover, these two elements may appear as two in a first abstract analysis, but they cannot be regarded as two distinct threads, however intertwined; for, in effect, the feeling is altogether converted into images, into this complex of images, and is thus a feeling that is contemplated and therefore resolved and transcended. Hence poetry must be called neither feeling, nor image, nor yet the sum of the two, but "contemplation of feeling" or "lyrical intuition" or (which is the same thing) "pure intuition"—pure, that is, of all historical and critical reference to the reality or unreality of the images of which it is woven, and apprehending the pure throb of life in its ideality. Doubtless, other things may be found in poetry besides these two elements or moments and the synthesis of the two; but these other things are either present as extraneous elements in a compound (reflections, exhortations, polemics, allegories, etc.), or else they are just these image-feelings themselves taken in abstraction from their context as so much material, restored to the condition in which it was before the act of poetic creation. In the former case, they are non-poetic elements merely interpolated into or attached to the poem; in the latter, they are divested of poetry, rendered unpoetical by a reader either unpoetical or not at the moment poetical, who has dispelled the poetry, either because he cannot live in its ideal realm, or for the legitimate ends of historical enquiry or other practical purposes which involve the degradation—or rather, the conversion—of the poem into a document or an instrument.

ARTISTIC QUALITIES.—What has been said of "poetry" applies to all the other "arts" commonly enumerated; painting, sculpture, architecture, music. Whenever the artistic quality of any product of the mind is discussed,

the dilemma must be faced, that either it is a lyrical intuition, or it is something else, something just as respectable, but not art. If painting (as some theorists have maintained) were the imitation or reproduction of a given object, it would be, not art, but something mechanical and practical; if the task of the painter (as other theorists have held) were to combine lines and lights and colours with ingenious novelty of invention and effect, he would be, not an artist, but an inventor; if music consisted in similar combinations of notes, the paradox of Leibniz and Father Kircher would come true, and a man could write music without being a musician; or alternatively we should have to fear (as Proudhon did for poetry and John Stuart Mill for music) that the possible combinations of words or notes would one day be exhausted, and poetry or music would disappear. As in poetry, so in these others arts, it is notorious that foreign elements sometimes intrude themselves; foreign either *a parte objecti* or *a parte subjecti*, foreign either in fact or from the point of view of an inartistic spectator or listener. Thus the critics of these arts advise the artist to exclude, or at least not to rely upon, what they call the "literary" elements in painting, sculpture and music, just as the critic of poetry advises the writer to look for "poetry" and not be led astray by mere literature. The reader who understands poetry goes straight to this poetic heart and feels its beat upon his own; where this beat is silent, he denies that poetry is present, whatever and however many other things may take its place, united in the work, and however valuable they may be for skill and wisdom, nobility of intellect, quickness of wit and pleasantness of effect. The reader who does not understand poetry loses his way in pursuit of these other things. He is wrong not because he admires them, but because he thinks he is admiring poetry.

OTHER FORMS OF ACTIVITY AS DISTINCT FROM ART.—By defining art as lyrical or pure intuition we have implicitly distinguished it from all other forms of mental production. If such distinctions are made explicit, we obtain the following negations:

1. *Art is not philosophy*, because philosophy is the logical thinking of the universal categories of being, and art is the unreflective intuition of being. Hence, while philosophy transcends the image and uses it for its own purposes, art lives in it as in a kingdom. It is said that art cannot behave in an irrational manner and cannot ignore logic; and certainly it is neither irrational nor illogical; but its own rationality, its own logic, is a quite different thing from the dialectical logic of the concept, and it was in order to indicate this peculiar and unique character that the name "logic of sense" or "aesthetic" was invented. The not uncommon assertion that art has a logical character, involves either an equivocation between conceptual logic and aesthetic logic, or a symbolic expression of the latter in terms of the former.

2. *Art is not history*, because history implies the critical distinction

between reality and unreality; the reality of the passing moment and the reality of a fancied world: the reality of fact and the reality of desire. For art, these distinctions are as yet unmade; it lives, as we have said, upon pure images. The historical existence of Helenus, Andromache and Aeneas makes no difference to the poetical quality of Virgil's poem. Here, too, an objection has been raised: namely that art is not wholly indifferent to historical criteria, because it obeys the laws of "verisimilitude"; but, here again, "verisimilitude" is only a rather clumsy metaphor for the mutual coherence of images, which without this internal coherence would fail to produce their effect as images, like Horace's *delphinus in silvis* and *aper in fluctibus*.

3. *Art is not natural science*, because natural science is historical fact classified and so made abstract; nor is it *mathematical science*, because mathematics performs operations with abstractions and does not contemplate. The analogy sometimes drawn between mathematical and poetical creation is based on merely external and generic resemblances; and the alleged necessity of a mathematical or geometrical basis for the arts is only another metaphor, a symbolic expression of the constructive, cohesive and unifying force of the poetic mind building itself a body of images.

4. *Art is not the play of fancy*, because the play of fancy passes from image to image, in search of variety, rest or diversion, seeking to amuse itself with the likenesses of things that give pleasure or have an emotional and pathetic interest; whereas in art the fancy is so dominated by the single problem of converting chaotic feeling into clear intuition, that we recognize the propriety of ceasing to call it fancy and calling it imagination, poetic imagination or creative imagination. Fancy as such is as far removed from poetry as are the works of Mrs. Radcliffe or Dumas *père*.

5. *Art is not feeling in its immediacy.*—Andromache, on seeing Aeneas, becomes *amens, diriguit visu in medio, labitur, longo vix tempore fatur*, and when she speaks *longos ciebat incassum fletus;* but the poet does not lose his wits or grow stiff as he gazes; he does not totter or weep or cry; he expresses himself in harmonious verses, having made these various perturbations the object of which he sings. Feelings in their immediacy are "expressed" for if they were not, if they were not also sensible and bodily facts ("psycho-physical phenomena," as the positivists used to call them) they would not be concrete things, and so they would be nothing at all. Andromache expressed herself in the way described above. But "expression" in this sense, even when accompanied by consciousness, is a mere metaphor from "mental" or "aesthetic expression" which alone really expresses, that is, gives to feeling a theoretical form and converts it into words, song and outward shape. This distinction between contemplated feeling or poetry, and feeling enacted or endured, is the source of the power, ascribed to art, of "liberating us from the passions" and "calming" us (the power of *catharsis*), and of the conse-

quent condemnation, from an aesthetic point of view, of works of art, or parts of them, in which immediate feeling has a place or finds a vent. Hence, too, arises another characteristic of poetic expression—really synonymous with the last—namely its "infinity" as opposed to the "finitude" of immediate feeling or passion; or, as it is also called, the "universal" or "cosmic" character of poetry. Feeling, not crushed but contemplated by the work of poetry, is seen to diffuse itself in widening circles over all the realm of the soul, which is the realm of the universe, echoing and re-echoing endlessly: joy and sorrow, pleasure and pain, energy and lassitude, earnestness and frivolity, and so forth, are linked to each other and lead to each other through infinite shades and gradations; so that the feeling, while preserving its individual physiognomy and its original dominating motive, is not exhausted by or restricted to this original character. A comic image, if it is poetically comic, carries with it something that is not comic, as in the case of Don Quixote or Falstaff; and the image of something terrible is never, in poetry, without an atoning element of loftiness, goodness and love.

6. *Art is not instruction or oratory:* it is not circumscribed and limited by service to any practical purpose whatever, whether this be the inculcation of a particular philosophical, historical or scientific truth, or the advocacy of a particular way of feeling and the action corresponding to it. Oratory at once robs expression of its "infinity" and independence, and, by making it the means to an end, dissolves it in this end. Hence arises what Schiller called the "non-determining" character of art, as opposed to the "determining" character of oratory; and hence the justifiable suspicion of "political poetry"—political poetry being, proverbially, bad poetry.

7. As art is not to be confused with the form of practical action most akin to it, namely instruction and oratory, so *a fortiori*, it must not be confused with other forms directed to the production of certain effects, whether these consist in pleasure, enjoyment and utility, or in goodness and righteousness. We must exclude from art not only meretricious works, but also those inspired by a desire for goodness, as equally, though differently, inartistic and repugnant to lovers of poetry. Flaubert's remark that indecent books lacked *vérité*, is parallel to Voltaire's gibe that certain "poésies sacrées" were really "sacrées, car personne n'y touche."

ART IN ITS RELATIONS.—The "negations" here made explicit are obviously, from another point of view, "relations"; for the various distinct forms of mental activity cannot be conceived as separate each from the rest and acting in self-supporting isolation. This is not the place to set forth a complete system of the forms or categories of the mind in their order and their dialectic; confining ourselves to art, we must be content to say that the category of art, like every other category, mutually presupposes and is presupposed by all the rest: it is conditioned by them all and conditions them all. How could the aesthetic synthesis, which is

poetry, arise, were it not preceded by a state of mental commotion? *Si vis me flere, dolendum est*, and so forth. And what is this state of mind which we have called feeling, but the whole mind, with its past thoughts, volitions and actions, now thinking and desiring and suffering and rejoicing, travailing within itself? Poetry is like a ray of sunlight shining upon this darkness, lending it its own light and making visible the hidden forms of things. Hence it cannot be produced by an empty and dull mind; hence those artists who embrace the creed of pure art or art for art's sake, and close their hearts to the troubles of life and the cares of thought, are found to be wholly unproductive, or at most rise to the imitation of others or to an impressionism devoid of concentration. Hence the basis of all poetry is human personality, and, since human personality finds its completion in morality, the basis of all poetry is the moral consciousness. Of course this does not mean that the artist must be a profound thinker or an acute critic; nor that he must be a pattern of virtue or a hero; but he must have a share in the world of thought and action which will enable him, either in his own person or by sympathy with others, to live the whole drama of human life. He may sin, lose the purity of his heart, and expose himself, as a practical agent, to blame; but he must have a keen sense of purity and impurity, righteousness and sin, good and evil. He may not be endowed with great practical courage; he may even betray signs of timidity and cowardice; but he must feel the dignity of courage. Many artistic inspirations are due, not to what the artist, as a man, is in practice, but to what he is not, and feels that he ought to be admiring and enjoying the qualities he lacks when he sees them in others. Many, perhaps the finest, pages of heroic and warlike poetry are by men who never had the nerve or the skill to handle a weapon. On the other hand, we are not maintaining that the possession of a moral personality is enough to make a poet or an artist. To be a *vir bonus* does not make a man even an orator, unless he is also *dicendi peritus*. The *sine qua non* of poetry is poetry, that form of theoretical synthesis which we have defined above; the spark of poetical genius without which all the rest is mere fuel, not burning because no fire is at hand to light it. But the figure of the pure poet, the pure artist, the votary of pure Beauty, aloof from contact with humanity, is no real figure but a caricature.

That poetry not only presupposes the other forms of human mental activity but is presupposed by them, is proved by the fact that without the poetic imagination which gives contemplative form to the workings of feeling, intuitive expression to obscure impressions, and thus becomes representations and works, whether spoken or sung or painted or otherwise uttered, logical thought could not arise. Logical thought is not language, but it never exists without language, and it uses the language which poetry has created; by means of concepts, it discerns and dominates the representations of poetry, and it could not dominate them unless they, its future subjects, had first an existence of their own. Further, without

the discerning and criticizing activity of thought, action would be impossible; and if action, then good action, the moral consciousness, duty. Every man, however much he may seem to be all logical thinker, critic, scientist, or all absorbed in practical interests or devoted to duty, cherishes at the bottom of his heart his own private store of imagination and poetry; even Faust's pedantic *famulus*, Wagner, confessed that he often had his "grillenhafte Stunden." Had this element been altogether denied him, he would not have been a man, and therefore not even a thinking or acting being. This extreme case is an absurdity; but in proportion as this private store is scanty, we find a certain superficiality and aridity in thought, and a certain coldness in action.

THE SCIENCE OF ART, OR AESTHETICS, AND ITS PHILOSOPHICAL CHARACTER.—The concept of art expounded above is in a sense the ordinary concept, which appears with greater or less clarity in all statements about art, and is constantly appealed to, explicitly or implicitly, as the fixed point round which all discussions on the subject gravitate: and this, not only nowadays, but at all times, as could be shown by the collection and interpretation of things said by writers, poets, artists, laymen and even the common people. But it is desirable to dispel the illusion that this concept exists as an innate idea, and to replace this by the truth, that it operates as an *a priori* concept. Now an *a priori* concept does not exist by itself, but only in the individual products which it generates. Just as the *a priori* reality called Art, Poetry or Beauty does not exist in a transcendent region where it can be perceived and admired in itself, but only in the innumerable works of poetry, of art and of beauty which it has formed and continues to form, so the logical *a priori* concept of art exists nowhere but in the particular judgments which it has formed and continues to form, the refutations which it has effected and continues to effect, the demonstrations it makes, the theories it constructs, the problems and groups of problems, which it solves and has solved. The definitions and distinctions and negations and relations expounded above have each its own history, and have been progressively worked out in the course of centuries, and in them we now possess the fruits of this complex and unremitting toil. Aesthetic, or the science of art, has not therefore the task (attributed to it by certain scholastic conceptions) of defining art once for all and deducing from this conception its various doctrines, so as to cover the whole field of aesthetic science; it is only the perpetual systematization, always renewed and always growing, of the problems arising from time to time out of reflection upon art, and is identical with the solutions of the difficulties and the criticisms of the errors which act as stimulus and material to the unceasing progress of thought. This being so, no exposition of aesthetic (especially a summary exposition such as can alone be given here) can claim to deal exhaustively with the innumerable problems which have arisen and may arise in the course of the

history of aesthetics; it can only mention and discuss the chief, and among these, by preference, those which still make themselves felt and resist solution in ordinary educated thought; adding an implied "et cetera," so that the reader may pursue the subject according to the criteria set before him, either by going again over old discussions, or by entering into those of to-day, which change and multiply and assume new shapes almost daily. Another warning must not be omitted: namely that aesthetics, though a special philosophical science, having as its principle a special and distinct category of the mind, can never, just because it is philosophical, be detached from the main body of philosophy; for its problems are concerned with the relations between art and the other mental forms, and therefore imply both difference and identity. Aesthetics is really the whole of philosophy, but with special emphasis on that side of it which concerns art. Many have demanded or imagined or desired a self-contained aesthetics, devoid of any general philosophical implications, and consistent with more than one, or with any, philosophy; but the project is impossible of execution because self-contradictory. Even those who promise to expound a naturalistic, inductive, physical, physiological or psychological aesthetics—in a word, a non-philosophical aesthetics—when they pass from promise to performance surreptitiously introduce a general positivistic, naturalistic or even materialistic philosophy. And anyone who thinks that the philosophical ideas of positivism, naturalism and materialism are false and out of date, will find it an easy matter to refute the aesthetic or pseudo-aesthetic doctrines which mutually support them and are supported by them, and will not regard their problems as problems still awaiting solution or worthy of discussion—or, at least, protracted discussion. For instance, the downfall of psychological associationism (or the substitution of mechanism for *a priori* synthesis) implies the downfall not only of logical associationism but of aesthetics also, with its association of "content" and "form," or of two "representations," which (unlike Campanella's *tactus intrinsecus*, effected *cum magna suavitate*) was a *contactus extrinsecus* whose terms were no sooner united than they *discedebant*. The collapse of biological and evolutionary explanations of logical and ethical values implies the same collapse in the case of aesthetic value. The proved inability of empirical methods to yield knowledge of reality, which in fact they can only classify and reduce to types, involves the impossibility of an aesthetics arrived at by collecting aesthetic facts in classes and discovering their laws by induction.

INTUITION AND EXPRESSION.—One of the first problems to arise, when the work of art is defined as "lyrical image," concerns the relation of "intuition" to "expression" and the manner of the transition from the one to the other. At bottom this is the same problem which arises in other parts of philosophy: the problem of inner and outer, of mind and matter, of soul and body, and, in ethics, of intention and will, will and action,

and so forth. Thus stated, the problem is insoluble; for once we have divided the inner from the outer, body from mind, will from action, or intuition from expression, there is no way of passing from one to the other or of reuniting them, unless we appeal for their reunion to a third term, variously represented as God or the Unknowable. Dualism leads necessarily either to transcendence or to agnosticism. But when a problem is found to be insoluble in the terms in which it is stated the only course open is to criticize these terms themselves, to inquire how they have been arrived at, and whether their genesis was logically sound. In this case, such inquiry leads to the conclusion that the terms depend not upon a philosophical principle, but upon an empirical and naturalistic classification, which has created two groups of facts called internal and external respectively (as if internal facts were not also external, and as if an external fact could exist without being also internal), or souls and bodies, or images and expressions; and everyone knows that it is hopeless to try to find a dialectical unity between terms that have been distinguished not philosophically or formally but only empirically and materially. The soul is only a soul in so far as it is a body; the will is only a will in so far as it moves arms and legs, or is action; intuition is only intuition in so far as it is, in that very act, expression. An image that does not express, that is not speech, song, drawing, painting, sculpture or architecture—speech at least murmured to oneself, song at least echoing within one's own breast, line and colour seen in imagination and colouring with its own tint the whole soul and organism—is an image that does not exist. We may assert its existence, but we cannot support our assertion; for the only thing we could adduce in support of it would be the fact that the image was embodied or expressed. This profound philosophical doctrine, the *identity of intuition and expression* is, moreover, a principle of ordinary common sense, which laughs at people who claim to have thoughts they cannot express or to have imagined a great picture which they cannot paint. *Rem tene, verba sequentur;* if there are no *verba*, there is no *res*. This identity, which applies to every sphere of the mind, has in the sphere of art a clearness and self-evidence lacking, perhaps, elsewhere. In the creation of a work of poetry, we are present, as it were, at the mystery of the creation of the world; hence the value of the contribution made by aesthetics to philosophy as a whole, or the conception of the One that is All. Aesthetics, by denying in the life of art an abstract spiritualism and the resulting dualism, prepares the way and leads the mind towards idealism or absolute spiritualism.

EXPRESSION AND COMMUNICATION.—Objections to the identity of intuition and expression generally arise from psychological illusions which lead us to believe that we possess at any given moment a profusion of concrete and lively images, when in fact we only possess signs and names for them; or else from faulty analysis of cases like that of the artist who is

believed to express mere fragments of a world of images that exists in his mind in its entirety, whereas he really has in his mind only these fragments, together with—not the supposed complete world, but at most an aspiration or obscure working towards it, towards a greater and richer image which may take shape or may not. But these objections also arise from a confusion between *expression* and *communication*, the latter being really distinct from the image and its expression. Communication is the fixation of the intuition-expression upon an object metaphorically called material or physical; in reality, even here we are concerned not with material or physical things but with a mental process. The proof that the so-called physical object is unreal, and its resolution into terms of mind, is primarily of interest for our general philosophical conceptions, and only indirectly for the elucidation of aesthetic questions; hence for brevity's sake we may let the metaphor or symbol stand and speak of matter or nature. It is clear that the poem is complete as soon as the poet has expressed it in words which he repeats to himself. When he comes to repeat them aloud, for others to hear, or looks for someone to learn them by heart and repeat them to others as in *a schola cantorum*, or sets them down in writing or in printing, he has entered upon a new stage, not aesthetic but practical, whose social and cultural importance need not, of course, be insisted upon. So with the painter; he paints on his panel or canvas, but he could not paint unless at every stage in his work, from the original blur or sketch to the finishing touches, the intuited image, the line and colour painted in his imagination, preceded the brush-stroke. Indeed, when the brush-stroke outruns the image, it is cancelled and replaced by the artist's correction of his own work. The exact line that divides expression from communication is difficult to draw in the concrete case, for in the concrete case the two processes generally alternate rapidly and appear to mingle, but it is clear in idea, and it must be firmly grasped. Through overlooking it, or blurring it through insufficient attention, arise the confusions between *art* and *technique*. Technique is not an intrinsic element of art but has to do precisely with the concept of communication. In general it is a cognition or complex of cognitions disposed and directed to the furtherance of practical action; and, in the case of art, of the practical action which makes objects and instruments for the recording and communicating of works of art; *e.g.*, cognitions concerning the preparation of panels, canvases or walls to be painted, pigments, varnishes, ways of obtaining good pronunciation and declamation and so forth. Technical treatises are not aesthetic treatises, nor yet parts or chapters of them. Provided, that is, that the ideas are rigorously conceived and the words used accurately in relation to them it would not be worth while to pick a quarrel over the use of the word "technique" as a synonym for the artistic work itself, regarded as "inner technique" or the formation of intuition-expressions. The confusion between art and technique is especially beloved by impotent artists, who hope to obtain from practical things and practical

devices and inventions the help which their strength does not enable them to give themselves.

ARTISTIC OBJECTS: THE THEORY OF THE SPECIAL ARTS, AND THE BEAUTY OF NATURE.—The work of communicating and conserving artistic images, with the help of technique, produces the material objects metaphorically called *"artistic objects"* or *"works of art"*: pictures, sculptures and buildings, and, in a more complicated manner, literary and musical writings, and, in our own times, gramophones and records which make it possible to reproduce voices and sounds. But neither these voices and sounds nor the symbols of writing, sculpture and architecture, are works of art; works of art exist only in the minds that create or re-create them. To remove the appearance of paradox from the truth that beautiful objects, beautiful things, do not exist, it may be opportune to recall the analogous case of economic science, which knows perfectly well that in the sphere of economics there are no naturally or physically *useful* things, but only demand and labour, from which physical things acquire, metaphorically, this epithet. A student of economics who wished to deduce the economic value of things from their physical qualities would be perpetrating a gross *ignoratio elenchi.*

Yet this same *ignoratio elenchi* has been, and still is, committed in aesthetic, by the theory of special *arts*, and the limits or peculiar aesthetic character of each. The divisions between the arts are merely technical or physical, according as the artistic objects consist of physical sounds, notes, coloured objects, carved or modelled objects, or constructed objects having no apparent correspondence with natural bodies (poetry, music, painting, sculpture, architecture, etc.). To ask what is the artistic character of each of these arts, what it can and cannot do, what kinds of images can be expressed in sounds, what in notes, what in colours, what in lines, and so forth, is like asking in economics what things are entitled by their physical qualities to have a value and what are not, and what relative values they are entitled to have; whereas it is clear that physical qualities do not enter into the question, and anything may be desired or demanded or valued more than another, or more than anything else at all, according to circumstances and needs. Even Lessing found himself slipping down the slope leading to this truth, and was forced to such strange conclusions as that actions belonged to poetry and bodies to sculpture; even Richard Wagner attempted to find a place in the list for a comprehensive art, namely Opera, including in itself by a process of aggregation the powers of all the arts. A reader with any artistic sense finds in a single solitary line from a poet at once musical and picturesque qualities, sculpturesque strength and architectural structure; and the same with a picture, which is never a mere thing of the eyes but an affair of the whole soul, and exists in the soul not only as colour but as sound and speech. But when we try to grasp these musical or picturesque or other qualities, they elude us

and turn into each other, and melt into a unity, however we may be accustomed to distinguish them by different names; a practical proof that art is one and cannot be divided into arts. One, and infinitely varied; not according to the technical conceptions of the several arts, but according to the infinite variety of artistic personalities and their states of mind.

With this relation (and confusion) between artistic creations and instruments of communication or *objets d'art* must be connected the problem of *natural beauty*. We shall not discuss the question, raised by certain aestheticians, whether there are in nature other poets, other artistic beings, beside man; a ·question which ought to be answered in the affirmative not only out of respect for the song-birds, but, still more, out of respect for the idealistic conception of the world as life and spirituality throughout; even if (as the fairy-tale goes) we have lost the magic herb which when we put it in our mouth, gives us the power of understanding the language of animals and plants. The phrase *natural beauty* properly refers to persons, things and places whose effect is comparable to that of poetry, painting, sculpture and the other arts. There is no difficulty in allowing the existence of such "natural *objets d'art*," for the process of poetic communication may take place by means of objects naturally given as well as by means of objects artificially produced. The lover's imagination creates a woman beautiful to him, and personifies her in Laura; the pilgrim's imagination creates the charming or sublime landscape, and embodies it in the scene of a lake or a mountain; and these creations of theirs are sometimes shared by more or less wide social circles, thus becoming the "professional beauties" admired by everyone and the famous "views" before which all experience a more or less sincere rapture. No doubt, these creations are mortal; ridicule sometimes kills them, satiety may bring neglect, fashion may replace them by others; and—unlike works of art—they do not admit of authentic interpretation. The bay of Naples, seen from the height of one of the most beautiful Neapolitan villas, was after some time described by the Russian lady who owned the villa as *une cuvette bleue*, whose blue encircled by green so wearied her that she sold the villa. But even the *cuvette bleue* was a legitimate poetical creation.

LITERARY KINDS AND AESTHETIC CATEGORIES.—Effects at once greater and more detrimental upon the criticism and historical study of art and literature have been produced by a theory of similar but slightly different origin, the theory of *literacy and artistic kinds*. This, like the foregoing, is based on a classification in itself justifiable and useful. The foregoing is based on a technical or physical classification of artistic objects; this is based on a classification according to the feelings which form their content or motive, into *tragic, comic, lyrical, heroic, erotic, idyllic, romantic* and so on, with divisions and subdivisions. It is useful in practice to distribute an artist's works, for purposes of publication, into these classes, putting lyrics in one volume, dramas in another, poems in a third

and romances in a fourth; and it is convenient, in fact, indispensable, to refer to works and groups of works by these names in speaking and writing of them. But here again we must deny and pronounce illegitimate the transition from these classificatory concepts to the poetic laws of composition and aesthetic criteria of judgment, as when people try to decide that a tragedy must have a subject of a certain kind, characters of a certain kind, a plot of a certain kind and a certain length; and, when confronted by a work, instead of looking for and appraising its own poetry, ask whether it is a tragedy or a poem, and whether it obeys the "laws" of one or other "kind." The literary criticism of the 19th century owed its great progress largely to its abandonment of the criteria of kinds, in which the criticism of the Renaissance and the French classicists had always been entangled, as may be seen from the discussions arising out of the poems of Dante, Ariosto and Tasso, Guarini's *Pastor fido,* Corneille's *Cid,* and Lope de Vega's *comedias.* Artists have profited by this liberation less than critics; for anyone with artistic genius bursts the fetters of such servitude, or even makes them the instruments of his power; and the artist with little or no genius turns his very freedom into a new slavery.

It has been thought that the divisions of kinds could be saved by giving them a philosophical significance; or at any rate one such division, that of lyric, epic and dramatic, regarded as the three moments of a process of objectification passing from the lyric, the outpouring of the ego, to the epic, in which the ego detaches its feeling from itself by narrating it, and thence to the drama, in which it allows this feeling to create of itself its own mouthpieces, the *dramatis personae.* But the lyric is not a pouring-forth; it is not a cry or a lament; it is an objectification in which the ego sees itself on the stage, narrates itself, and dramatizes itself; and this lyrical spirit forms the poetry both of epic and of drama, which are therefore distinguished from the lyric only by external signs. A work which is altogether poetry, like *Macbeth* or *Antony and Cleopatra,* is substantially a lyric in which the various tones and successive verses are represented by characters and scenes.

In the old aesthetics, and even to-day in those which perpetuate the type, an important place is given to the so-called categories of beauty: the *sublime,* the *tragic,* the *comic,* the *graceful,* the *humorous* and so forth, which German philosophers not only claimed to treat as philosophical concepts, whereas they are really mere psychological and empirical concepts, but developed by means of that dialectic which belongs only to pure or speculative concepts, philosophical categories. Thus they arranged them in an imaginary progress culminating now in the Beautiful, now in the Tragic, now in the Humorous. Taking these concepts at their face value, we may observe their substantial correspondence with the concepts of the literary and artistic kinds; and this is the source from which, as excerpts from manuals of literature, they have found their way into philosophy.

As psychological and empirical concepts, they do not belong to aesthetics; and as a whole, in their common quality, they refer merely to the world of feelings, empirically grouped and classified, which forms the permanent matter of artistic intuition.

RHETORIC, GRAMMAR AND PHILOSOPHY OF LANGUAGE.—Every error has in it an element of truth, and arises from an arbitrary combination of things which in themselves are legitimate. This principle may be confirmed by an examination of other erroneous doctrines which have been prominent in the past and are still to a less degree prominent to-day. It is perfectly legitimate, in teaching people to write, to make use of distinctions like that between simple style, ornate style and metaphorical style and its forms, and to point out that here the pupil ought to express himself literally and there metaphorically, or that here the metaphor used is incoherent or drawn out to excessive length, and that here the figure of "preterition," there "hypotyposis" or "irony," would have been suitable. But when people lose sight of the merely practical and didactic origin of these distinctions and construct a philosophical theory of form as divisible into simple form and ornate form, logical form and affective form, and so forth, they are introducing elements of rhetoric into aesthetics and vitiating the true concept of expression. For expression is never logical, but always affective, that is, lyrical and imaginative; and hence it is never metaphorical but always "proper"; it is never simple in the sense of lacking elaboration, or ornate in the sense of being loaded with extraneous elements; it is always adorned with itself, *simplex munditiis*. Even logical thought or science, so far as it is expressed, becomes feeling and imagination, which is why a philosophical or historical or scientific book can be not only true but beautiful, and must always be judged not only logically but also aesthetically. Thus we sometimes say that a book is a failure as theory, or criticism, or historical truth, but a success as a work of art, in view of the feeling animating it and expressed in it. As for the element of truth which is obscurely at work in this distinction between logical form and metaphorical form, dialectic and rhetoric, we may detect in it the need of a science of aesthetics side by side with that of logic; but it was a mistake to try to distinguish the two sciences within the sphere of expression which belongs to one of them alone.

Another element in education, namely the teaching of languages, has no less legitimately, ever since ancient times, classified expressions into periods, propositions and words, and words into various species, and each species according to the variations and combinations of roots and suffixes, syllables and letters; and hence have arisen alphabets, grammars and vocabularies, just as in another way for poetry has arisen a science of prosody, and for music and the figurative and architectural arts there have arisen musical and pictorial grammars and so forth. But here, too, the ancients did not succeed in avoiding an illegitimate transition *ab intel-*

lectu ad rem, from abstractions to reality, from the empirical to the philosophical, such as we have already observed elsewhere; and this involved thinking of speech as an aggregation of words, and words as aggregations of syllables or of roots and suffixes; whereas the *prius* is speech itself, a continuum, resembling an organism, and words and syllables and roots are a *posterius*, an anatomical preparation, the product of the abstracting intellect, not the original or real fact. If grammar, like the rhetoric in the case above considered, is transplanted into aesthetic, the result is a distinction between expression and the means of expression, which is a mere reduplication; for the means of expression are just expression itself, broken into pieces by grammarians. This error, combined with the error of distinguishing between simple and ornate form, has prevented people from seeing that the philosophy of language is not a philosophical grammar, but is wholly devoid of grammatical elements. It does not raise grammatical classifications to a philosophical level; it ignores them, and, when they get in its way, destroys them. The philosophy of language, in a word, is identical with the philosophy of poetry and art, the science of intuition-expression, aesthetics; which embraces language in its whole extension, passing beyond the limits of phonetic and syllabic language, and in its unimpaired reality as living and completely significant expression.

CLASSICAL AND ROMANTIC.—The problems reviewed above belong to the past—a past extending through centuries—rather than to the present; of their mis-stated questions and misconceived solutions there now remain mere relics and superstitions which affect academic treatises more than they do the consciousness and culture of ordinary people. But it is necessary to watch carefully for new shoots from the old stock, which still appear from time to time, in order to cut them down. Such is, in our own time, the theory of styles applied to the history of art (Wölfflin and others) and extended to the history of poetry (Strick and others), a new irruption of rhetorical abstractions into the judgment and history of works of art. But the chief problem of our time, to be overcome by aesthetics, is connected with the crisis in art and in judgments upon art produced by the romantic period. Not that this crisis was not foreshadowed by precedents and parallels in earlier history, like Alexandrian art and that of the late Roman period, and in modern times the Baroque art and poetry which followed upon that of the Renaissance. The crisis of the romantic period, together with sources and characteristics peculiar to itself, had a magnitude all of its own. It asserted an antithesis between *naïve* and *sentimental* poetry, *classical* and *romantic* art, and thus denied the unity of art and asserted a duality of two fundamentally different arts, of which it took the side of the second, as that appropriate to the modern age, by upholding the primary importance in art of feeling, passion and fancy. In part this was a justifiable reaction against the rationalistic literature of

classicism in the French manner, now satirical, now frivolous, weak in
feeling and imagination and deficient in a deep poetic sense; but in part,
romanticism was a rebellion not against *classicism* but against the classical
as such: against the idea of the serenity and infinity of the artistic image,
against catharsis and in favour of a turbid emotionalism that could not
and would not undergo purification. This was very well understood by
Goethe, the poet both of passion and of serenity, and therefore, because
he was a poet, a classical poet; who opposed romantic poetry as "hospital
poetry." Later, it was thought that the disease had run its course and that
romanticism was a thing of the past; but though some of its contents and
some of its forms were dead, its soul was not: its soul consisting in this
tendency on the part of art towards an immediate expression of passions
and impressions. Hence it changed its name but went on living and
working. It called itself "realism," "verism," "symbolism," "artistic style,"
"impressionism," "sensualism," "imagism," "decadentism," and nowadays,
in its extreme forms, "expressionism" and "futurism." The very conception
of art is attacked by these doctrines, which tend to replace it by the
conception of one or other kind of non-art; and the statement that they
are fighting against art is confirmed by the hatred of the extremists of
this movement for museums and libraries and all the art of the past—
that is, for the idea of art which on the whole corresponds with art as it
has been historically realized. The connection of this movement, in its latest
modern form, with industralism and the psychology produced and fostered
by industrialism is obvious. What art is contrasted with is practical life as
lived to-day; and art, for this movement, is not the expression of life and
hence the transcending of life in the contemplation of the infinite and
universal, but the cries and gesticulations and broken colours of life itself.
The real poets and artists, on the other hand, rare at any time, naturally
continue, nowadays as always, to work according to the old and only
idea of what art is, expressing their feelings in harmonious forms; and
the real connoisseurs (rarer, these also, than people think) continue to
judge their work according to this same idea. In spite of this, the tendency
to destroy the idea of art is a characteristic of our age; and this tendency
is based on the *proton pseudos* which confuses mental or aesthetic expres-
sion with natural or practical expression—the expression which passes
confusedly from sensation to sensation and is a mere effect of sensation,
with the expression which art elaborates, as it builds, draws, colours or
models, and which is its beautiful creation. The problem for aesthetics
to-day is the reassertion and defence of the classical as against romanti-
cism: the synthetic, formal theoretical element which is the *proprium* of
art, as against the affective element which it is the business of art to
resolve into itself, but which to-day has turned against it and threatens
to displace it. Against the inexhaustible fertility of creative mind, the
gates of hell shall not prevail; but the hostility which endeavours to make
them prevail is disturbing, even if only in an incidental manner, the artistic

taste, the artistic life and consequently the intellectual and moral life of to-day.

THE CRITICISM AND HISTORY OF ART AND LITERATURE.—Another group of questions raised in works on aesthetics, though not unsuitable to such works, properly belongs to logic and the theory of historical thought. These concern the aesthetic judgment and the history of poetry and the arts. By showing that the aesthetic activity (or art) is one of the forms of mind, a value, a category, or whatever we choose to call it, and not (as philosophers of various schools have thought) an empirical concept referable to certain orders of utilitarian or mixed facts, by establishing the *autonomy of aesthetic value*, aesthetics has also shown that it is the predicate of a special judgment, the *aesthetic judgment*, and the subject-matter of history, of a special history, the history of poetry and the arts, *artistic and literary history*.

The questions that have been raised concerning the aesthetic judgment and artistic and literary history are making allowance for the peculiar character of art, identical with the methodological questions that arise in every field of historical study. It has been asked whether the aesthetic judgment is *absolute* or *relative;* but every historical judgment (and the aesthetic judgment affirming the reality and quality of aesthetic facts is an historical judgment) is always both absolute and relative at once: absolute, in so far as the category involved in the construction possesses universal truth; relative, in so far as the object constructed by that category is historically conditioned: hence in the historical judgment the category is individualized and the individual becomes absolute. Those who in the past have denied the absoluteness of the aesthetic judgment (sensational-istic, hedonistic or utilitarian aestheticians) denied in effect the quality, reality and autonomy of art. It has been asked whether a knowledge of the history of the time—the whole history of the time in question—is necessary for the aesthetic judgment of the art of that time; it certainly is, because, as we know, poetic creation presupposes all the rest of the mind which it is converting into lyrical imagery, and the one aesthetic creation presupposes all the other creations (passions, feelings, customs, etc.) of the given historical moment. Hence may be seen the error both of those who advocate a merely historical judgment upon art (historical critics) and of those who advocate a merely aesthetic (aesthetic critics). The former would find in art all the rest of history (social conditions, biography of the artist, etc.), but would omit that part which is proper to art; the latter would judge the work of art in abstraction from history, depriving it of its real meaning and giving it an imaginary meaning or testing it by arbitrary standards. Lastly, there has appeared a kind of scepticism or pessimism as to the possibility of understanding the art of the past; a scepticism or pessimism which in that case ought to extend to every part of history (history of thought, politics, religion and mo-

rality), and refutes itself by a *reductio ad absurdum*, since what we call contemporary art and history really belong to the past as much as those of more distant ages, and must, like them, be re-created in the present, in the mind that feels them and the intellect that understands them. There are artistic works and periods that remain to us unintelligible; but this only means that we are not now in a position to enter again into their life and to understand them, and the same is true of the ideas and customs and actions of many peoples and ages. Humanity, like the individual, remembers some things and forgets many others; but it may yet, in the course of its mental development, reach a point where its memory of them revives.

A final question concerns the form proper to aristic and literary history, which, in the form that arose in the romantic period, and still prevails to-day, expounds the history of works of art as a function of the concepts and social needs of its various periods, regarding them as aesthetic expressions of these things and connecting them closely with civil history. This tends to obscure and almost to render invisible the peculiar character of the individual work of art, the character which makes it impossible to confuse one work of art with any other, and results in treating them as documents of social life. In practice no doubt this method is tempered by what may be called the "individualizing" method, which emphasizes the individual character of the works; but the mixture has the defects of all eclecticism. To escape this, there is nothing to do but consistently to develop individualizing history, and to treat works of art not in relation to social history but as each a world in itself, into which from time to time the whole of history is concentrated, transfigured and imaginatively transcended in the individuality of the poetic work, which is a creation, not a reflection, a monument, not a document. Dante is not simply a document of the middle ages, nor Shakespeare of the English Renaissance; as such, they have many equals or superiors among bad poets and non-poets. It has been objected that this method imposed on artistic and literary history the form of a series of disconnected essays or monographs; but, obviously, the connection is provided by human history as a whole, of which the personalities of poets constitute a part, and a somewhat conspicuous part (Shakespearian poetry is an event no less important than the Reformation or the French Revolution), and, precisely because they are a part of it, they ought not to be submerged and lost in it, that is, in its other parts, but ought to retain their proper proportions and their original character.

JOHN DEWEY
EXPERIENCE AND NATURE

John Dewey (1859–1952) was a highly influential American philosopher. He developed the pragmatic view that ideas are instruments of action and applied this insight to every area of philosophical inquiry.

EXPERIENCE, NATURE AND ART

Experience, with the Greeks, signified a store of practical wisdom, a fund of insights useful in conducting the affairs of life. Sensation and perception were its occasion and supplied it with pertinent materials, but did not of themselves constitute it. They generated experience when retention was added and when a common factor in the multitude of felt and perceived cases detached itself so as to become available in judgment and exertion. Thus understood, experience is exemplified in the discrimination and skill of the good carpenter, pilot, physician, captain-at-arms; experience is equivalent to art. Modern theory has quite properly extended the application of the term to cover many things that the Greeks would hardly have called "experience," the bare having of aches and pains, or

Reprinted from *Experience and Nature*, Chapter 9, pp. 354–393, First Series, La Salle, Illinois, The Open Court Publishing Company, 1925, by permission of the publisher.

a play of colors before the eyes. But even those who hold this larger sig-
nification would admit, I suppose, that such "experiences" count only when
they result in insight, or in an enjoyed perception, and that only thus do
they define experience in its honorific sense.

Greek thinkers nevertheless disparaged experience in comparison with
something called reason and science. The ground for depreciation was not
that usually assigned in modern philosophy; it was not that experience is
"subjective." On the contrary, experience was considered to be a genuine
expression of cosmic forces, not an exclusive attribute or possession of
animal or of human nature. It was taken to be a realization of inferior
portions of nature, those infected with chance and change, the less *Being*
part of the cosmos. Thus while experience meant art, art reflected the
contingencies and partialities of nature, while science—theory—exhibited
its necessities and universalities. Art was born of need, lack, deprivation,
incompleteness, while science—theory—manifested fullness and totality of
Being. Thus the depreciatory view of experience was identical with a
conception that placed practical activity below theoretical activity, finding
the former dependent, impelled from outside, marked by deficiency of
real being, while the latter was independent and free because complete
and self-sufficing: that is perfect.

In contrast with this self-consistent position we find a curious mixture
in modern thinking. The latter feels under no obligation to present a
theory of natural existence that links art with nature; on the contrary, it
usually holds that science or knowledge is the only *authentic* expression of
nature, in which case art must be an arbitrary addition to nature. But
modern thought also combines exaltation of science with eulogistic appre-
ciation of art, especially of fine or creative art. At the same time it retains
the substance of the classic disparagement of the practical in contrast with
the theoretical, although formulating it in somewhat different language:
to the effect that knowledge deals with objective reality as it is in itself,
while in what is "practical," objective reality is altered and cognitively
distorted by subjective factors of want, emotion and striving. And yet in
its encomium of art, it fails to note the commonplace of Greek observation
—that the fine arts as well as the industrial technologies are affairs of
practice.

This confused plight is partly cause and partly effect of an almost
universal confusion of the artistic and the esthetic. On one hand, there is
action that deals with materials and energies outside the body, assembling,
refining, combining, manipulating them until their new state yields a
satisfaction not afforded by their crude condition—a formula that applies
to fine and useful art alike. On the other hand, there is the delight that
attends vision and hearing, an enhancement of the receptive appreciation
and assimilation of objects irrespective of participation in the operations
of production. Provided the difference of the two things is recognized,
it is no matter whether the words "esthetic" and "artistic" or other terms

be used to designate the distinction, for the difference is not one of words but of objects. But in some form the difference must be acknowledged.

The community in which Greek art was produced was small; numerous and complicated intermediaries between production and consumption were lacking; producers had a virtually servile status. Because of the close connection between production and enjoyable fruition, the Greeks in their perceptive uses and enjoyments were never wholly unconscious of the artisan and his work, not even when they personally were exclusively concerned with delightful contemplation. But since the artist was an artisan (the term artist having none of the eulogistic connotations of present usage), and since the artisan occupied an inferior position, the enjoyment of works of any art did not stand upon the same level as enjoyment of those objects for the realization of which manual activity was not needed. Objects of rational thought, of contemplative insight were the only things that met the specification of freedom from need, labor, and matter. They alone were self-sufficient, self-existent, and self-explanatory, and hence enjoyment of *them* was on a higher plane than enjoyment of works of art.

These conceptions were consistent with one another and with the conditions of social life at the time. Nowadays we have a messy conjunction of notions that are consistent neither with one another nor with the tenor of our actual life. Knowledge is still regarded by most thinkers as direct grasp of ultimate reality, although the practice of knowing has been assimilated to the procedure of the useful arts;—involving, that is to say, doing that manipulates and arranges natural energies. Again while science is said to lay hold of reality, yet "art" instead of being assigned a lower rank is equally esteemed and honored. And when within art a distinction is drawn between production and appreciation, the chief honor usually goes to the former on the ground that it is "creative," while taste is relatively possessive and passive, dependent for its material upon the activities of the creative artist.

If Greek philosophy was correct in thinking of knowledge as contemplation rather than as a productive art, and if modern philosophy accepts this conclusion, then the only logical course is relative disparagement of all forms of production, since they are modes of practice which is by conception inferior to contemplation. The artistic is then secondary to the esthetic: "creation," to "taste," and the scientific *worker*—as we significantly say—is subordinate in rank and worth to the dilettante who enjoys the results of his labors. But if modern tendencies are justified in putting art and creation first, then the implications of this position should be avowed and carried through. It would then be seen that science is an art, that art is practice, and that the only distinction worth drawing is not between practice and theory, but between those modes of practice that are not intelligent, not inherently and immediately enjoyable, and those which are full of enjoyed meanings. When this perception dawns,

it will be a commonplace that art—the mode of activity that is charged with meanings capable of immediately enjoyed possession—is the complete culmination of nature, and that "science" is properly a handmaiden that conducts natural events to this happy issue. Thus would disappear the separations that trouble present thinking: division of everything into nature *and* experience, of experience into practice *and* theory, art *and* science, of art into useful *and* fine, menial *and* free.

Thus the issue involved in experience as art in its pregnant sense and in art as processes and materials of nature continued by direction into achieved and enjoyed meanings, sums up in itself all the issues which have been previously considered. Thought, intelligence, science is the intentional direction of natural events to meanings capable of immediate possession and enjoyment; this direction—which is operative art—is itself a natural event in which nature otherwise partial and incomplete comes fully to itself; so that objects of conscious experience when reflectively chosen, form the "end" of nature. The doings and sufferings that form experience are, in the degree in which experience is intelligent or charged with meanings, a union of the precarious, novel, irregular with the settled, assured and uniform—a union which also defines the artistic and the esthetic. For wherever there is art the contingent and ongoing no longer work at cross purposes with the formal and recurrent but commingle in harmony. And the distinguishing feature of conscious experience, of what for short is often called "consciousness," is that in it the instrumental and the final, meanings that are signs and clews and meanings that are immediately possessed, suffered and enjoyed, come together in one. And all of these things are preëminently true of art.

First, then, art is solvent union of the generic, recurrent, ordered, established phase of nature with its phase that is incomplete, going on, and hence still uncertain, contingent, novel, particular; or as certain systems of esthetic theory have truly declared, though without empirical basis and import in their words, a union of necessity and freedom, a harmony of the many and one, a reconciliation of sensuous and ideal. Of any artistic act and product it may be said both that it is inevitable in its rightness, that nothing in it can be altered without altering all, and that its occurrence is spontaneous, unexpected, fresh, unpredictable. The presence in art, whether as an act or a product, of proportion, economy, order, symmetry, composition, is such a commonplace that it does not need to be dwelt upon. But equally necessary is unexpected combination, and the consequent revelation of possibilities hitherto unrealized. "Repose in stimulation" characterizes art. Order and proportion when they are the whole story are soon exhausted; economy in itself is a tiresome and restrictive taskmaster. It is artistic when it releases.

The more extensive and repeated are the basic uniformities of nature that give form to art, the "greater" is the art, provided—and it is this proviso that distinguishes art—they are indistinguishably fused with the

wonder of the new and the grace of the gratuitous. "Creation" may be asserted vaguely and mystically; but it denotes something genuine and indispensable in art. The merely finished is not fine but ended, done with, and the merely "fresh" is that bumptious impertinence indicated by the slang use of the word. The "magic" of poetry—and pregnant experience has poetical quality—is precisely the revelation of meaning in the old effected by its presentation through the new. It radiates the light that never was on land and sea but that is henceforth an abiding illumination of objects. Music in its immediate occurrence is the most varied and ethereal of the arts, but is in its conditions and structure the most mechanical. These things are commonplaces; but until they are commonly employed in their evidential significance for a theory of nature's nature, there is no cause to apologize for their citation.

The limiting terms that define art are routine at one extreme and capricious impulse at the other. It is hardly worth while to oppose science and art sharply to one another, when the deficiencies and troubles of life are so evidently due to separation between art and blind routine and blind impulse. Routine exemplifies the uniformities and recurrences of nature, caprice expresses its inchoate initiations and deviations. Each in isolation is unnatural as well as inartistic, for nature is an intersection of spontaneity and necessity, the regular and the novel, the finished and the beginning. It is right to object to much of current practice on the ground that it is routine, just as it is right to object to much of our current enjoyments on the ground that they are spasms of excited escape from the thraldom of enforced work. But to transform a just objection against the quality of much of our practical life into a description and definition of practice is on the same plane as to convert legitimate objection to trivial distraction, senseless amusement, and sensual absorption, into a Puritanical aversion to happiness. The idea that work, productive activity, signifies action carried on for merely extraneous ends, and the idea that happiness signifies surrender of mind to the thrills and excitations of the body are one and the same idea. The first notion marks the separation of activity from meaning, and the second marks the separation of receptivity from meaning. Both separations are inevitable as far as experience fails to be art:—when the regular, repetitious, and the novel, contingent in nature fail to sustain and inform each other in a productive activity possessed of immanent and directly enjoyed meaning.

Thus the theme has insensibly passed over into that of the relation of means and consequence, process and product, the instrumental and consummatory. Any activity that is simultaneously both, rather than in alternation and displacement, is art. Disunion of production and consumption is a common enough occurrence. But emphasis upon this separation in order to exalt the consummatory does not define or interpret either art or experience. It obscures their meaning, resulting in a division of art into useful and fine, adjectives which, when they are prefixed to "art," corrupt

and destroy its intrinsic significance. For arts that are merely useful are not arts but routines; and arts that are merely final are not arts but passive amusements and distractions, different from other indulgent dissipations only in dependence upon a certain acquired refinement or "cultivation."

The existence of activities that have no immediate enjoyed intrinsic meaning is undeniable. They include much of our labors in home, factory, laboratory and study. By no stretch of language can they be termed either artistic or esthetic. Yet they exist, and are so coercive that they require some attentive recognition. So we optimistically call them "useful" and let it go at that, thinking that by calling them useful we have somehow justified and explained their occurrence. If we were to ask useful for what? we should be obliged to examine their actual consequences, and when we once honestly and fully faced these consequences we should probably find ground for calling such activities detrimental rather than useful.

We call them useful because we arbitrarily cut short our consideration of consequences. We bring into view simply their efficacy in bringing into existence certain commodities; we do not ask for their effect upon the quality of human life and experience. They are useful to make shoes, houses, motor cars, money, and other things which *may* then be put to use; here inquiry and imagination stop. What they also *make* by way of narrowed, embittered, and crippled life, of congested, hurried, confused and extravagant life, is left in oblivion. But to be useful is to fulfill need. The characteristic human need is for possession and appreciation of the meaning of things, and this need is ignored and unsatisfied in the traditional notion of the useful. We identify utility with the external relationship that some events and acts bear to other things that are their products, and thus leave out the only thing that is essential to the idea of utility, inherent place and bearing in experience. Our classificatory use of the conception of some arts as merely instrumental so as to dispose of a large part of human activity is no solving definition; it rather conveys an immense and urgent problem.

The same statement applies to the conception of merely fine or final arts and works of art. In point of fact, the things designated by the phrase to fall under three captions. There are activities and receptivities to which the name of "self-expression" is often applied as a eulogistic qualification, in which one indulges himself by giving free outward exhibition to his own states without reference to the conditions upon which intelligible communication depends—an act also sometimes known as "expression of emotion," which is then set up for definition of all fine art. It is easy to dispose of this art by calling it a product of egotism due to balked activity in other occupations. But this treatment misses a more significant point. For all art is a process of making the world a different place in which to live, and involves a phase of protest and of compensatory

response. Such art as there is in these manifestations lies in this factor. It is owing to frustration in communication of meanings that the protest becomes arbitrary and the compensatory response wilfully eccentric.

In addition to this type—and frequently mingled with it—there is experimentation in new modes or craftsmanship, cases where the seemingly bizarre and over-individualistic character of the products is due to discontent with existing technique, and is associated with an attempt to find new modes of language. It is aside from the point either to greet these manifestations as if they constituted art for the first time in human history, or to condemn them as not art because of their violent departures from received canons and methods. Some movement in this direction has always been a condition of growth of new forms, a condition of salvation from that mortal arrest and decay called academic art.

Then there is that which in quantity bulks most largely as fine art: the production of buildings in the name of the art of architecture; of pictures in the name of the art of painting; of novels, dramas, etc., in the name of literary art; a production which in reality is largely a form of commercialized industry in production of a class of commodities that find their sale among well-to-do persons desirous of maintaining a conventionally approved status. As the first two modes carry to disproportionate excess that factor of particularity, contingency and difference which is indispensable in all art, deliberately flaunting avoidance of the repetitions and order of nature; so this mode celebrates the regular and finished. It is reminiscent rather than commemorative of the meanings of experienced things. Its products remind their owner of things pleasant in memory though hard in direct-undergoing, and remind others that their owner has achieved an economic standard which makes possible cultivation and decoration of leisure.

Obviously no one of these classes of activity and product or all of them put together, mark off anything that can be called distinctively fine art. They share their qualities and defects with many other acts and objects. But, fortunately, there may be mixed with any one of them, and, still more fortunately, there may occur without mixture, process and product that are characteristically excellent. This occurs when activity is productive of an object that affords continuously renewed delight. This condition requires that the object be, with its successive consequences, indefinitely instrumental to *new* satisfying events. For otherwise the object is quickly exhausted and satiety sets in. Anyone who reflects upon the commonplace that a measure of artistic products is their capacity to attract and retain observation with satisfaction under whatever conditions they are approached, while things of less quality soon lose capacity to hold attention becoming indifferent or repellent upon subsequent approach, has a sure demonstration that a genuinely esthetic object is not exclusively consummatory but is casually productive as well. A consummatory object that

is not also instrumental turns in time to the dust and ashes of boredom. The "eternal" quality of great art is its renewed instrumentality for further consummatory experiences.

When this fact is noted, it is also seen that limitation of fineness of art to paintings, statues, poems, songs and symphonies is conventional, or even verbal. Any activity that is productive of objects whose perception is an immediate good, and whose operation is a continual source of enjoyable perception of other events exhibits fineness of art. There are acts of all kinds that directly refresh and enlarge the spirit and that are instrumental to the production of new objects and dispositions which are in turn productive of further refinements and replenishments. Frequently moralists make the acts *they* find excellent or virtuous wholly final, and treat art and affection as mere means. Estheticians reverse the performance, and see in good *acts* means to an ulterior external happiness, while esthetic appreciation is called a good in itself, or that strange thing an end in itself. But on both sides it is true that in being preëminently fructifying the things designated means are immediate satisfactions. They are their own excuses for being just because they are charged with an office in quickening apprehension, enlarging the horizon of vision, refining discrimination, creating standards of appreciation which are confirmed and deepened by further experiences. It would almost seem when their non-instrumental character is insisted upon as if what was meant were an indefinitely expansive and radiating instrumental efficacy.

The source of the error lies in the habit of calling by the name of means things that are not means at all; things that are only external and accidental antecedents of the happening of something else. Similarly things are called ends that are not ends save accidentally, since they are not fulfilments, consummatory, of means, but merely last terms closing a process. Thus it is often said that a laborer's toil is the means of his livelihood, although except in the most tenuous and arbitrary way it bears no relationship to his real living. Even his wage is hardly an end or consequence of his labor. He might—and frequently does—equally well or ill —perform any one of a hundred other tasks as a condition of receiving payment. The prevailing conception of instrumentality is profoundly vitiated by the habit of applying it to cases like the above, where, instead of an operation of means, there is an enforced necessity of doing one thing as a coerced antecedent of the occurrence of another thing which is wanted.

Means are always at least causal conditions; but causal conditions are means only when they possess an added qualification; that, namely, of being freely used, because of perceived connection with chosen consequences. To entertain, choose and accomplish anything as an end or consequence is to be committed to a like love and care for whatever events and acts are its means. Similarly, consequences, ends, are at least effects; but effects are not ends unless thought has perceived and freely chosen the conditions and processes that are their conditions. The notion that

means are menial, instrumentalities servile, is more than a degradation of means to the rank of coercive and external necessities. It renders all things upon which the name of end is bestowed accompaniments of privilege, while the name of utility becomes an apologetic justification for things that are not portions of a good and reasonable life. Livelihood is at present not so much the consequence of a wage-earner's labor as it is the effect of other causes forming the economic régime, labor being merely an accidental appendage of these other causes.

Paints and skill in manipulative arrangement are means of a picture as end, because the picture is *their* assemblage and organization. Tones and suspectibility of the ear when properly interacting are the means of music, because they constitute, make, are, music. A disposition of virtue is a means to a certain quality of happiness because it is a constituent of that good, while such happiness is means in turn to virtue, as the sustaining of good in being. Flour, water, yeast are means of bread because they are ingredients of bread; while bread is a factor *in* life, not just *to* it. A good political constitution, honest police-system, and competent judiciary, are means of the prosperous life of the community because they are integrated portions of that life. Science is an instrumentality of and for art because it is the intelligent factor *in* art. The trite saying that a hand is not a hand except as an organ of the living body—except as a working coördinated part of a balanced system of activities—applies untritely to all things that are means. The connection of means-consequences is never one of bare succession in time, such that the element that is means is past and gone when the end is instituted. An active process is strung out temporarily, but there is a deposit at each stage and point entering cumulatively and constitutively into the outcome. A genuine instrumentality *for* is always an organ *of* an end. It confers continued efficacy upon the object in which it is embodied.

The traditional separation between some things as mere means and others as mere ends is a reflection of the insulated existence of working and leisure classes, of production that is not also consummatory, and consummation that is not productive. This division is not a *merely* social phenomenon. It embodies a perpetuation upon the human plane of a division between need and satisfaction belonging to brute life. And this separation expresses in turn the mechanically external relationship that exists in nature between situations of disturbed equilibrium, of stress, and strain, and achieved equilibrium. For in nature, outside of man, except when events eventuate in "development" or "evolution" (in which a cumulative carrying forward of consequences of past histories in new efficiencies occurs) antecedent events are external transitive conditions of the occurrence of an event having immediate and static qualities. To animals to whom acts have no meaning, the change in the environment required to satisfy needs has no significance on its own account; such change is a mere incident of ego-centric satisfactions. This physically

external relationship of antecedents and consequents is perpetuated; it continues to hold true of human industry wherever labor and its materials and products are externally enforced necessities for securing a living. Because Greek industry was so largely upon this plane of servile labor, all industrial activity was regarded by Greek thought as a *mere* means, an extraneous necessity. Hence satisfactions due to it were conceived to be the ends or goods of purely animal nature in isolation. With respect to a truly human and rational life, they were not ends or goods at all, but merely "means," that is to say, external conditions that were antecedently enforced requisites of the life conducted and enjoyed by free men, especially by those devoted to the acme of freedom, pure thinking. As Aristotle asserted, drawing a just conclusion from the assumed premises, there are classes of men who are necessary materials of society but who are not integral parts of it. And he summed up the whole theory of the external and coerced relationship of means and ends when he said in this very connection that: "When there is one thing that is means and another thing that is end, there is *nothing common* between them, except in so far as the one, the means, produces, and the other, the end, receives the product."

It would thus seem almost self-evident that the distinction between the instrumental and the final adopted in philosophic tradition as a solving word presents in truth a problem, a problem so deep-seated and far-reaching that it may be said to be *the* problem of experience. For all the intelligent activities of men, no matter whether expressed in science, fine arts, or social relationships, have for their task the conversion of causal bonds, relations of succession, into a connection of means-consequence, into meanings. When the task is achieved the result is art: and in art everything is common between means and ends. Whenever so-called means remain external and servile, and so-called ends are enjoyed objects whose further causative status is unperceived, ignored or denied, the situation is proof positive of limitations of art. Such a situation consists of affairs in which the problem has *not* been solved; namely that of converting physical and brute relationships into connections of meanings characteristic of the possibilities of nature.

It goes without saying that man begins as a part of physical and animal nature. In as far as he reacts to physical things on a strictly physical level, he is pulled and pushed about, overwhelmed, broken to pieces, lifted on the crest of the wave of things, like anything else. His contacts, his sufferings and doings, are matters of direct interaction only. He is in a "state of nature." As an animal, even upon the brute level, he manages to subordinate some physical things to his needs, converting them into materials sustaining life and growth. But in so far things that serve as material of satisfaction and the acts that procure and utilize them are not objects, or things-with-meanings. That appetite as such is blind, is notorious; it may push us into a comfortable result instead of into disaster;

but we are pushed just the same. When appetite is perceived in its meanings, in the consequences it induces, and these consequences are experimented with in reflective imagination, some being seen to be consistent with one another, and hence capable of co-existence and of serially ordered achievement, others being incompatible, forbidding conjunction at one time, and getting in one another's way serially—when this estate is attained, we live on the human plane, responding to things in their meanings. A relationship of cause-effect has been transformed into one of means-consequence. Then consequences belong *integrally* to the conditions which may produce them, and the latter possess character and distinction. The meaning of causal conditions is carried over also into the consequence, so that the latter is no longer a mere end, a last and closing term of arrest. It is marked out in perception, distinguished by the efficacy of the conditions which have entered into it. Its value as fulfilling and consummatory is measurable by subsequent fulfillments and frustrations to which it is contributory in virtue of the causal means which compose it.

Thus to be conscious of meanings or to have an idea, marks a fruition, an enjoyed or suffered arrest of the flux of events. But there are all kinds of ways of perceiving meanings, all kinds of ideas. Meaning may be determined in terms of consequences hastily snatched at and torn loose from their connections; then is prevented the formation of wider and more enduring ideas. Or, we may be aware of meanings, may achieve ideas, that unite wide and enduring scope with richness of distinctions. The latter sort of consciousness is more than a passing and superficial consummation or end: it takes up into itself meanings covering stretches of existence wrought into consistency. It marks the conclusion of long continued endeavor; of patient and indefatigable search and test. The idea is, in short, art and a work of art. As a work of art, it directly liberates subsequent action and makes it more fruitful in a creation of more meanings and more perceptions.

It is the part of wisdom to recognize how sparse and insecure are such accomplishments in comparison with experience in which physical and animal nature largely have their way. Our liberal and rich ideas, our adequate appreciations, due to productive art are hemmed in by an unconquered domain in which we are everywhere exposed to the incidence of unknown forces and hurried fatally to unforeseen consequences. Here indeed we live servilely, menially, mechanically; and we so live as much when forces blindly lead to us ends that are liked as when we are caught in conditions and ends against which we blindly rebel. To call satisfactions which happen in this blind way "ends" in a eulogistic sense, as did classic thought, is to proclaim in effect our servile submission to accident. We may indeed enjoy the goods the gods of fortune send us, but we should recognize them for what they are, not asserting them to be good and righteous *altogether*. For, since they have not been achieved by any art involving deliberate selection and arrangement of forces, we do not

know with what they are charged. It is an old true tale that the god of fortune is capricious, and delights to destroy his darlings after having made them drunk with prosperity. The goods of art are not the less good in their goodness than the gifts of nature; while in addition they are such as to bring with themselves open-eyed confidence. They are fruits of means consciously employed; fulfillments whose further consequences are secured by conscious control of the causal conditions which enter into them. Art is the sole alternative to luck; and divorce from each other of the meaning and value of instrumentalities and ends is the essence of luck. The esoteric character of culture and the supernatural quality of religion are both expressions of the divorce.

The modern mind has formally abjured belief in natural teleology because it found Greek and medieval teleology juvenile and superstitious. Yet facts have a way of compelling recognition of themselves. There is little scientific writing which does not introduce at some point or other the idea of tendency. The idea of tendency unites in itself exclusion of prior design and inclusion of movement in a particular direction, a direction that may be either furthered or counteracted and frustrated, but which is intrinsic. Direction involves a limiting position, a point or goal of culminating stoppage, as well as an initial starting point. To assert a tendency and to be fore-conscious of a possible terminus of movement are two names of the same fact. Such a consciousness may be fatalistic; a sense of inevitable march toward impending doom. But it may also contain a perception of meanings such as flexibly directs a forward movement. The end is then an end-in-view and is in constant and cumulative reënactment at each stage of forward movement. It is no longer a terminal point, external to the conditions that have led up to it; it is the continually developing meaning of present tendencies—the very things which as directed we call "means." The process is art and its product, no matter at what stage it be taken, is a work of art.

To a person building a house, the end-in-view is not just a remote and final goal to be hit upon after a sufficiently great number of coerced motions have been duly performed. The end-in-view is a plan which is *contemporaneously* operative in selecting and arranging materials. The latter, brick, stone, wood and mortar, are means only as the end-in-view is actually incarnate in them, in forming them. Literally, they *are* the end in its present stage of realization. The end-in-view is present at each stage of the process; it is present as the *meaning* of the materials used and acts done; without its informing presence, the latter are in no sense "means"; they are merely extrinsic causal conditions. The statement is generic; it applies equally at every stage. The house itself, when building is complete, is "end" in no exclusive sense. It marks the conclusion of the organization of certain materials and events into effective means; but these material and events still exist in causal interaction with other things. New consequences are foreseen; new purposes, ends-in-view, are entertained; they are em-

bodied in the coördination of the thing built, now reduced to material, although significant material, along with other materials, and thus transmuted into means. The case is still clearer, when instead of considering a process subject to as many rigid external conditions as is the building of a house, we take for illustration a flexibly and freely moving process, such as painting a picture or thinking out a scientific process, when these operations are carried on artistically. Every process of free art proves that the difference between means and end is analytic, formal, not material and chronologic.

What has been said enables us to re-define the distinction drawn between the artistic, as objectively productive, and the esthetic. Both involve a perception of meanings in which the instrumental and the consummatory peculiarly intersect. In esthetic perceptions an object interpenetrated with meanings is given; it may be taken for granted; it invites and awaits the act of appropriative enjoyment. In the esthetic object tendencies are sensed as brought to fruition; in it is embodied a means-consequence relationship, as the past work of his hands was surveyed by the Lord and pronounced good. This good differs from those gratifications to which the name sensual rather than sensuous is given, since the former are pleasing endings that occur in ways not informed with the meaning of materials and acts integrated into them. In appreciative possession, perception goes out to tendencies which *have* been brought to happy fruition in such a way as to release and arouse.

Artistic sense on the other hand grasps tendencies as possibilities; the invitation of these possibilities to perception is more urgent and compelling than that of the given already achieved. While the means-consequence relationship is directly sensed, felt, in both appreciation and artistic production, in the former the scale descends upon the side of the attained; in the latter there predominates the invitation of an existent consummation to bring into existence further perceptions. Art in being, the active productive process, may thus be defined as an esthetic perception together with an *operative* perception of the efficiencies of the esthetic object. In many persons with respect to most kinds of enjoyed perceptions, the sense of possibilities, the arousal or excitation attendant upon appreciation of poetry, music, painting, architecture or landscape remains diffuse and inchoate; it takes effect only in direct and undefined channels. The enjoyed perception of a visual scene is in any case a function of that scene in its total connections, but it does not link up adequately. In some happily constituted persons, this effect is adequately coördinated with other endowments and habits; it becomes an integral part of craft, taking effect in the creation of a new object of appreciation. The integration is, however, progressive and experimental, not momentarily accomplished. Thus every creative effort is temporal, subject to risk and deflection. In that sense the difference between the diffuse and postponed change of action due in an ordinary person to release of energies by an esthetic object, and the special and

axial direction of subsequent action in a gifted person is, after all, a matter of degree.

Without a sense of moving tendencies which are operative in conjunction with a state of fruition, there is appetitive gratification, but nothing that may be termed appreciation. Sense of moving tendencies supplies thrill, stimulation, excitation; sense of completion, consummation, affords composure, form, measure, composition. Emphasize the latter, and appreciation is of the classic type. This type fits conditions where production is professionalized among technical craftsmen, as among the Greeks; it is adapted to a contemplative enjoyment of the achievements of past ages or remote places, where conditions forbid urge to emulation or productive activity of a similar kind. Any work of art that persistently retains its power to generate enjoyed perception or appreciation becomes in time classic.

In so-called romantic art, the sense of tendencies operative beyond the limits of consummation is in excess; a lively sense of unrealized potentialities attaches to the object; but it is employed to enhance immediate appreciation, not to promote further productive achievement. Whatever is peculiarly romantic excites a feeling that the possibilities suggested go beyond not merely actual present realization, but are beyond effective attainment in any experience. In so far intentionally romantic art is wilful, and in so far not art. Excited and uneasy perceptual enjoyment is made ultimate, and the work of art is accommodated to production of these feelings. The sense of unachieved possibilities is employed as a compensatory equivalent for endeavor in achievement. Thus when the romantic spirit invades philosophy the possibilities present in imaginative sentiment are declared to be the real, although "transcendental," substance of Being itself. In complete art, appreciation follows the object and moves with it to its completion; romanticism reverses the process and degrades the object to an occasion for arousing a predetermined type of appreciation. In classicism, objective achievement is primary, an appreciation not only conforms to the object, but the object is employed to compose sentiment and give it distinction. Its vice, as an 'ism, is that it turns the mind to what is given; the given is taken as if it were eternal and wholly separate from generation and movement. Art free from subjection to any "ism" has movement, creation, as well as order, finality.

To institute a difference of *kind* between useful and fine arts is, therefore, absurd, since art involves a peculiar interpenetration of means and ends. Many things are termed useful for reasons of social status, implying deprecation and contempt. Things are sometimes said to belong to the menial arts merely because they are cheap and used familiarly by common people. These things of daily use for ordinary ends may survive in later periods, or be transported to another culture, as from Japan and China to America, and being rare and sought by connoisseurs, rank forthwith as works of fine art. Other things may be called fine because their

manner of use is decorative or socially ostentatious. It is tempting to make a distinction of degree and say that a thing belongs to the sphere of use when perception of its meaning is incidental to something else; and that a thing belongs to fine art when its other uses are subordinate to its use in perception. The distinction has a rough practical value, but cannot be pressed too far. For in production of a painting or a poem, as well as in making a vase or a temple, a perception is also employed as means for something beyond itself. Moreover, the perception of urns, pots and pans as commodities may be intrinsically enjoyable, although these things are primarily perceived with reference to some use to which they are put. The only *basic* distinction is that between bad art and good art, and this distinction, between things that meet the requirements of art and those that do not, applies equally to things of use and of beauty. Capacity to offer to perception meaning in which fruition and efficacy interpenetrate is met by different products in various degrees of fulness; it may be missed altogether by pans and poems alike. The difference between the ugliness of a mechanically conceived and executed utensil and of a meretricious and pretentious painting is one only of content or material; in form, both are articles, and bad articles.

Thinking is pre-eminently an art; knowledge and propositions which are the products of thinking, are works of art, as much so as statuary and symphonies. Every successive stage of thinking is a conclusion in which the meaning of what has produced it is condensed; and it is no sooner stated than it is a light radiating to other things—unless it be a fog which obscures them. The antecedents of a conclusion are as causal and existential as those of a building. They are not logical or dialectical, or an affair of ideas. While a conclusion follows from antecedents, it does not follow from "premises," in the strict, formal sense. Premises are the analysis of a conclusion into its logically justifying grounds; there are no premises till there is a conclusion. Conclusion and premise are reached by a procedure comparable to the use of boards and nails in making a box; or of paint and canvas in making a picture. If defective materials are employed or if they are put together carelessly and awkwardly, the result is defective. In some cases the result is called unworthy, in others, ugly; in others, inept; in others, wasteful, inefficient, and in still others untrue, false. But in each case, the condemnatory adjective refers to the resulting work judged in the light of its method of production. Scientific method or the art of constructing true perceptions is ascertained in the course of experience to occupy a privileged position in undertaking other arts. But this unique position only places it the more securely as an art; it does not set its product, knowledge, apart from other works of art.

The existential origin of valid cognitive perceptions is sometimes recognized in form and denied in substance; the name "psychological" is given to the events which generate valid beliefs. Then a sharp distinction is made between genesis as psychological and validity as logical. Of course lexi-

cographic names are of no special moment; if any one wishes to call the
efficient causes of knowledge and truth psychological, he is entitled to do
so—provided the actual traits of these causative events are recognized.
Such a recognition will note however that psychological does not mean
psychic, or refer to events going on exclusively within the head or "sub-
cutaneously." To become aware of an object cognitively as distinct from
esthetically, involves external physical movements and external physical
appliances physically manipulated. Some of these active changes result in
unsound and defective perceptions; some have been ascertained to result
usually in valid perceptions. The difference is precisely that which takes
place when the art of architecture or sculpture is skilfully conducted or is
carried on carelessly, and without adequate appliances. Sometimes the
operations productive of tested beliefs are called "inductive"; with an
implication in the naming, of discrediting them, as compared with deduc-
tive functions, which are assigned a superior exclusive status. Of deduction,
when thus defined, the following assertions may be made. First, it has
nothing to do with truth about any matter of existence. Secondly, it is not
even concerned with consistency or correctness, save in a formal sense
whose opposite (as has been previously pointed out) is not inconsistency
but nonsense. Thirdly, the meanings which figure in it are the conclusions
of prior inquiries which are "inductive," that is, are products of an experi-
mental art of changing external things by appropriate external movements
and appliances.

Deduction as it actually occurs in science is *not* deduction as deduction
should be according to a common definition. Deduction deals directly with
meanings in their relations to one another, rather than with meanings
directly referred to existence. But these meanings are what they are in
themselves and are related to one another by means of acts of taking and
manipulating—an art of discourse. They possess intellectual import and
enter fruitfully into scientific method only because they are selected,
employed, separated and combined by acts extraneous to them, acts which
are as existential and causative as those concerned in the experimental use
of apparatus and other physical things. The *act* of knowing, whether
solicitous about inference or about demonstration, is always inductive.
There is only one mode of thinking, the inductive, when thinking denotes
anything that actually happens. The notion that there is another kind
called deduction is another evidence of the prevalent tendency in philosophy
to treat functions as antecedent operations, and to take essential meanings
of existence as if they were a kind of Being. As a concrete operation,
deduction is generative, not sterile; but as a concrete operation, it contains
an extraneous act of taking and using which is selective, experimental and
checked constantly by consequences.

Knowledge or science, as a work of art, like any other work of art, con-
fers upon things traits and potentialities which did not *previously* belong
to them. Objection from the side of alleged realism to this statement

springs from a confusion of tenses. Knowledge is not a distortion or perversion which confers upon *its* subject-matter traits which *do* not belong to it, but is an act which confers upon non-cognitive material traits which *did* not belong to it. It marks a change by which physical events exhibiting properties of mechanical energy, connected by relations of push and pull, hitting, rebounding, splitting and consolidating, realize characters, meanings and relations of meanings *hitherto* not possessed by them. Architecture does not add to stone and wood something which does not belong to them, but it does add to them properties and efficacies which they did not possess in their earlier state. It adds them by means of engaging them in new modes of interaction, having a new order of consequences. Neither engineering nor fine art limits itself to imitative reproduction or copying of antecedent conditions. Their products may nevertheless be more effectively natural, more "life like," than were antecedent states of natural existence. So it is with the art of knowing and its works.

The failure to recognize that knowledge is a product of art accounts for an otherwise inexplicable fact: that science lies today like an incubus upon such a wide area of beliefs and aspirations. To remove the dead-weight, however, recognition that it is an art will have to be more than a theoretical avowal that science is made by man for man, although such recognition is probably an initial preliminary step. But the real source of the difficulty is that the art of knowing is limited to such a narrow area. Like everything precious and scarce, it has been artificially protected; and through this very protection it has been dehumanized and appropriated by a class. As costly jewels of jade and pearl belong only to a few, so with the jewels of science. The philosophic theories which have set science on an altar in a temple remote from the arts of life, to be approached only with peculiar rites, are a part of the technique of retaining a secluded monopoly of belief and intellectual authority. Till the art of achieving adequate and liberal perceptions of the meanings of events is incarnate in education, morals and industry, science will remain a special luxury for a few; for the mass, it will consist of a remote and abstruse body of curious propositions having little to do with life, except where it lays the heavy hand of law upon spontaneity, and invokes necessity and mechanism to witness against generous and free aspiration.

Every error is attended with a contrary and compensatory error, for otherwise it would soon be self-revealing. The conception that causes are metaphysically superior to effects is compensated for by the conception that ends are superior esthetically and morally to means. The two beliefs can be maintained together only by removing "ends" out of the region of the causal and efficacious. This is accomplished nowadays by first calling ends intrinsic values, and then by making a gulf between value and existence. The consequence is that science, dealing as it must, with existence, becomes brutal and mechanical, while criticism of values, whether moral or esthetic, becomes pedantic or effeminate, expressing either personal likes

and dislikes, or building up a cumbrous array of rules and authorities. The thing that is needful, discriminating judgment by methods whose consequences improve the art, easily slips through such coarse meshes, and by far the greater part of life goes on in a darkness unillumined by thoughtful inquiry. As long as such a state of thing persists, the argument of this chapter that science is art—like many other propositions of this book— is largely prophetic, or more or less dialectical. When an art of thinking as appropriate to human and social affairs has grown up as that used in dealing with distant stars, it will not be necessary to argue that science is one among the arts and among the works of art. It will be enough to point to observable situations. The separation of science from art, and the division of arts into those concerned with mere means and those concerned with ends in themselves, is a mask for lack of conjunction between power and the goods of life. It will lose plausibility in the degree in which foresight of good informs the display of power.

Evidence of the interpenetration of the efficacious with the final in art is found in the slow emancipation of art from magical rite and cult, and the emergence of science from superstition. For magic and superstition could never have dominated human culture, nor poetry have been treated as insight into natural causes, if means and ends were empirically marked off from each other. The intimacy of their union in one and the same object is that which makes it easy to impute to whatever is consummatory a kind of efficacy which it does not possess. Whatever is final is important; to say this is to enunciate a truism. Lack of instrumentalities and of skill by which to analyze and follow the particular efficacies of the immediately enjoyed object lead to imputation to it of wholesale efficacy in the degree of its importance. To the short-cut pragmatism congenial to natural man, importance measures "reality" and reality in turn defines efficacious power. Loyalties evoked in the passionate citizen by sight of the flag or in the devout Christian by the cross are attributed directly to the intrinsic nature of these objects. Their share in a consummatory experience is translated into a mysterious inner sacred power, an indwelling efficacy. Thus a souvenir of the beloved one, arousing in the lover enjoyment similar to that awakened by the precious one to whom it belonged, possesses delightful, exciting, and consoling efficacies. No matter what things are directly implicated in a consummatory situation, they gain potencies for weal or woe similar to the good or evil which directly marks the situation. Obviously error here resides in the gross and undiscriminating way in which power is attributed; inquiry to reveal the specified elements which form the sequential order is lacking.

It is a commonplace of anthropologists that for the most part clothing originated in situations of unusual awe or prestigious display, rather than as a utility or protection. It was part of a consummatory object, rather than a means to specified consequences. Like the robes of priests, clothes were vestments, and investiture was believed to convey directly to the one cere-

monially garbed dread potency or fascinating charm. Clothes were worn to confer authority; a man did not lend his significance to them. Similarly, a victorious hunter and warrior celebrated a triumphant return to camp by affixing to his person in conspicuous fashion claws and teeth of the wild beast or enemy that his prowess had subjugated. These signal proofs of power were integral portions of the object of admiration, loyalty and reverence. Thus the trophy became an emblem, and the emblem was endowed with mystic force. From a sign of glory it became a cause of glorification, and even when worn by another aroused the acclaim due to a hero. In time such trophies became the documental seal of prestigious authority. They had an intrinsic causal potency of their own. Legal history is full of like instances. Acts originally performed in connection with, say, the exchange of property, performed as part of the dramatic ceremony of taking possession of land, were not treated as mere evidences of title, but as having a mystic power to confer title.

Later, when such things lose their original power and become "mere matters of form," they may still be essential to the legal force of transaction, as seals have had to be affixed to a contract to give it force, even though there was no longer sense or reason in their use. Things which have an efficacy imputed to them simply because they have shared in some eminent consummatory experience are symbols. They are called symbols, however, only afterwards and from without. To the devout in politics and religion they are other than symbols; they are articles possessed of occult potency. To one man, two crossed lines are an indication of an arithmetical operation to be performed; to another, they are evidence of the existence of Christianity as a historic fact, as a crescent is a reminder of the existence of Islam. But to another, a cross is more than a poignant reminder of a tragically significant death; it has intrinsic sacred power to protect and to bless. Since a flag stirs passionate loyalty to sudden and pervasive ebullition, the flag must have properties and potencies not possessed by other and differently configured pieces of cloth; it must be handled with reverence; it is the natural object of ceremonial adoration.

Phenomena like these when manifested in primitive culture are often interpreted as if they were attempts at a causal explanation of natural occurrences; magic is said to be science gone wrong. In reality, they are facts of direct emotional and practical response; beliefs, ideas, interpretations, only come later when responses not being direct and inevitably appropriate seem to demand explanation. As immediate responses they exemplify the fact that anything involved, no matter how incidentally, in a consummatory situation has the power of arousing the awe, excitement, relief, admiration belonging to the situation as a whole. Industry displaces magic, and science reduces myth, when the elements that enter into the constitution of the consummatory whole are discriminated, and each one has its own particular place in sequential order assigned it. Thus materials and efficacies characteristic of different kinds of arts are distinguished.

But because the ceremonial, literary and poetic arts have quite other ways of working and other consequences, than industrial and scientific arts, it is far from following, as current theories assume, that they have no instrumental power at all, or that a sense of their instrumental agency is not involved in their appreciative perception. The pervasive operation of symbolism in human culture is all the proof that is needed to show that an intimate and direct sense of place and connection in a prolonged history enters into the enjoyed and suffered constituents of the history, and especially into the final or terminal members.

Further confirmation of this proposition is found in classic philosophy itself, in its theory that essential forms "make" things *what* they are, even though not causing them to occur. "Essence," as it figures in Greek theory, represents the mysterious potency of earlier "symbols" emancipated from their superstitious context and envisaged in a dialectic and reflective context. The essences of Greek-medieval science were in short poetic objects, treated as objects of demonstrative science, used to explain and understand the inner and ultimate constitution of things. While Greek thought was sufficiently emancipated from magic to deny "efficient" causality to formal and final essences, yet the latter were conceived of as making particular things to be *what* they are, members of natural kinds. Moreover, by a reversal of causal residence, intrinsic seeking for such forms was imputed to changing events. Thus the ground was prepared for the later frank return of patristic and scholastic thought to a frank animistic supernaturalism. The philosophic theory erred, as did magic and myth, regarding the nature of the efficacy involved in ends; and the error was due to the same causes, namely, failure of analysis into elements. It could not have occurred, were there that sharp division between means and ends, fruitions and instrumentalities, assumed by current thought.

In short, the history of human experience is a history of the development of arts. The history of science in its distinct emergence from religious, ceremonial and poetic arts is the record of a differentiation of arts, not a record of separation from art. The chief significance of the account just given, lies, for our present purpose, in its bearing upon the theory of experience and nature. It is not, however, without import for a theory of criticism. The present confusion, deemed chaos by some, in the fine arts and esthetic criticism seems to be an inevitable consequence of the underlying, even if unavowed, separation of the instrumental and the consummatory. The further men go in the concrete the more they are forced to recognize the logical consequence of their controlling assumptions. We owe it to theories of art prevalent to-day in one school of critics that certain implications, long obscured, of the traditional theory of art and nature have been brought to light. Gratitude for this debt should not be stinted because the adherents of the traditional theory regarding the newer views as capricious heresies, wild aberrations. For these critics, in pro-

claiming that esthetic qualities in works of fine art are unique, in asserting their separation from not only every thing that is existential in nature but also from all other forms of good, in proclaiming that such arts as music, poetry, painting have characters unshared with any natural things whatsoever: —in asserting such things the critics carry to its conclusion the isolation of fine art from the useful, of the final from efficacious. They thus prove that the separation of the consummation from the instrumental makes art wholly esoteric.

There are substantially but two alternatives. Either art is a continuation, by means of intelligent selection and arrangement, of natural tendencies of natural events; or art is a peculiar addition to nature springing from something dwelling exclusively within the breast of man, whatever name be given the latter. In the former case, delightfully enhanced perception or esthetic appreciation is of the same nature as enjoyment of any object that is consummatory. It is the outcome of a skilled and intelligent art of dealing with natural things for the sake of intensifying, purifying, prolonging and deepening the satisfactions which they spontaneously afford. That, in this process, new meanings develop, and that these afford uniquely new traits and modes of enjoyment is but what happens everywhere in emergent growths.

But if fine art has nothing to do with other activities and products, then of course it has nothing inherently to do with the objects, physical and social, experienced in other situations. It has an occult source and an esoteric character. It makes little difference what the source and the character be called. By strict logic it makes literally no difference. For if the quality of the esthetic experience is by conception unique, then the words employed to describe it have no significance derived from or comparable to the qualities of other experiences; their signification is hidden and specialized to a degree. Consider some of the terms which are in more or less current use among the critics who carry the isolation of art and the esthetic to its limit. It is sometimes said that art is the expression of the emotions; with the implication that, because of this fact, subject-matter is of no significance except as material through which emotion is expressed. Hence art becomes unique. For in works of science, utility and morals the character of the objects forming this subject-matter is all-important. But by this definition, subject-matter is stripped of all its own inherent characters in art in the degree in which it is genuine art; since a truly artistic work is manifest in the reduction of subject-matter to a mere medium of expression of emotion.

In such a statement emotion either has no significance at all, and it is mere accident that this particular combination of letters is employed; or else, if by emotion is meant the same sort of thing that is called emotion in daily life, the statement is demonstrably false. For emotion in its ordinary sense is something called out *by* objects, physical and personal; it is response *to* an objective situation. It is not something existing somewhere

by itself which then employs material through which to express itself. Emotion is an indication of intimate participation, in a more or less excited way in some scene of nature or life; it is, so to speak, an attitude or disposition which is a function of objective things. It is intelligible that art should select and assemble objective things in such ways as to evoke emotional response of a refined, sensitive and enduring kind; it is intelligible that the artist himself is one capable of sustaining these emotions, under whose temper and spirit he performs his compositions of objective materials. This procedure may indeed be carried to a point such that the use of objective materials is economized to the minimum, and the evocation of the emotional response carried to its relative maximum. But it still remains true that the origin of the art-process lay in emotional responses spontaneously called out by a situation occurring without any reference to art, and without "esthetic" quality save in the sense in which all immediate enjoyment and suffering is esthetic. Economy in use of objective subject-matter may with experienced and trained minds go so far that what is ordinarily called "representation" is much reduced. But what happens is a highly funded and generalized representation of the formal sources of ordinary emotional experience.

The same sort of remark is to be made concerning "significant form" as a definition of an esthetic object. Unless the meaning of the term is so isolated as to be wholly occult, it denotes a selection, for sake of emphasis, purity, subtlety, of those forms which give consummatory significance to every-day subject-matters of experience. "Forms" are not the peculiar property or creation of the esthetic and artistic; they are characters in virtue of which anything meets the requirements of an enjoyable perception. "Art" does not create the forms; it is their selection and organization in such ways as to enhance, prolong and purify the perceptual experience. It is not by accident that some objects and situations afford marked perceptual satisfactions; they do so because of their structural properties and relations. An artist may work with a minimum of analytic recognition of these structures or "forms;" he may select them chiefly by a kind of sympathetic vibration. But they may also be discriminatively ascertained; and an artist may utilize his deliberate awareness of them to create works of art that are more formal and abstract than those to which the public is accustomed. Tendency to composition in terms of the formal characters marks much contemporary art, in poetry, painting, music, even sculpture and architecture. At their worst, these products are "scientific" rather than artistic; technical exercises, sterile and of a new kind of pedantry. At their best, they assist in ushering in new modes of art and by education of the organs of perception in new modes of consummatory objects; they enlarge and enrich the world of human vision.

Thus, by only a slight forcing of the argument, we reach a conclusion regarding the relations of instrumental and fine art which is precisely the opposite of that intended by seclusive estheticians; namely, that fine art

consciously undertaken as such is peculiarly instrumental in quality. It is a device in experimentation carried on for the sake of education. It exists for the sake of a specialized use, use being a new training of modes of perception. The creators of such works of art are entitled, when successful, to the gratitude that we give to inventors of microscopes and microphones; in the end, they open new objects to be observed and enjoyed. This is a genuine service; but only an age of combined confusion and conceit will arrogate to works that perform this special utility the exclusive name of fine art.

Experience in the form of art, when reflected upon, we conclude by saying, solves more problems which have troubled philosophers and resolves more hard and fast dualisms than any other theme of thought. As the previous discussion has indicated, it demonstrates the intersection in nature of individual and generic; of chance and law, transforming one into opportunity and the other into liberation; of instrumental and final. More evidently still, it demonstrates the gratuitous falsity of notions that divide overt and executive activity from thought and feeling and thus separate mind and matter. In creative production, the external and physical world is more than a mere means or external condition of perceptions, ideas and emotions; it is subject-matter and sustainer of conscious activity; and thereby exhibits, so that he who runs may read, the fact that consciousness is not a separate realm of being, but is the manifest quality of existence when nature is most free and most active.

JOHN DEWEY
ART AS EXPERIENCE

HAVING AN EXPERIENCE

Experience occurs continuously, because the interaction of live creature and environing conditions is involved in the very process of living. Under conditions of resistance and conflict, aspects and elements of the self and the world that are implicated in this interaction qualify experience with emotions and ideas so that conscious intent emerges. Oftentimes, however, the experience had is inchoate. Things are experienced but not in such a way that they are composed into *an* experience. There is distraction and dispersion; what we observe and what we think, what we desire and what we get, are at odds with each other. We put our hands to the plow and turn back; we start and then we stop, not because the experience has reached the end for the sake of which it was initiated but because of extraneous interruptions or of an inner lethargy.

In contrast with such experience, we have *an* experience when the material experienced runs its course to fulfillment. Then and then only is it integrated within and demarcated in the general stream of experience from other experiences. A piece of work is finished in a way that is satisfactory; a problem receives its solution; a game is played through; a situation, whether that of eating a meal, playing a game of chess, carrying on a conversation, writing a book, or taking part in a political campaign, is so rounded out that its close is a consummation and not a cessation. Such an experience is a whole and carries with it its own individualizing quality and self-sufficiency. It is *an* experience.

Philosophers, even empirical philosophers, have spoken for the most part of experience at large. Idiomatic speech, however, refers to experiences each of which is singular, having its own beginning and end. For life is no uniform uninterrupted march or flow. It is a thing of histories, each with its own plot, its own inception and movement toward its close, each having its own particular rhythmic movement; each with its own unrepeated quality pervading it throughout. A flight of stairs, mechanical as it is, proceeds by individualized steps, not by undifferentiated progression, and an inclined plane is at least marked off from other things by abrupt discreteness.

Experience in this vital sense is defined by those situations and episodes that we spontaneously refer to as being "real experiences"; those things of which we say in recalling them, "that *was* an experience." It may have been something of tremendous importance—a quarrel with one who was once an intimate, a catastrophe finally averted by a hair's breadth. Or it may have been something that in comparison was slight—and which perhaps because of its very slightness illustrates all the better what is to be an experience. There is that meal in a Paris restaurant of which one says "that *was* an experience." It stands out as an enduring memorial of what food may be. Then there is that storm one went through in crossing the Atlantic—the storm that seemed in its fury, as it was experienced, to sum up in itself all that a storm can be, complete in itself, standing out because marked out from what went before and what came after.

In such experiences, every successive part flows freely, without seam and without unfilled blanks, into what ensues. At the same time there is no sacrifice of the self-identity of the parts. A river, as distinct from a pond, flows. But its flow gives a definiteness and interest to its successive portions greater than exist in the homogenous portions of a pond. In an experience, flow is from something to something. As one part leads into another and as one part carries on what went before, each gains distinctness in itself. The enduring whole is diversified by successive phases that are emphases of its varied colors.

Because of continuous merging, there are no holes, mechanical junctions, and dead centers when we have *an* experience. There are pauses, places of rest, but they punctuate and define the quality of movement. They

sum up what has been undergone and prevent its dissipation and idle evaporation. Continued acceleration is breathless and prevents parts from gaining distinction. In a work of art, different acts, episodes, occurrences melt and fuse into unity, and yet do not disappear and lose their own character as they do so—just as in a genial conversation there is a continuous interchange and blending, and yet each speaker not only retains his own character but manifests it more clearly than is his wont.

An experience has a unity that gives it its name, *that* meal, that storm, that rupture of friendship. The existence of this unity is constituted by a single *quality* that pervades the entire experience in spite of the variation of its constituent parts. This unity is neither emotional, practical, nor intellectual, for these terms name distinctions that reflection can make within it. In discourse *about* an experience, we must make use of these adjectives of interpretation. In going over an experience in mind *after* its occurrence, we may find that one property rather than another was sufficiently dominant so that it characterizes the experience as a whole. There are absorbing inquiries and speculations which a scientific man and philosopher will recall as "experiences" in the emphatic sense. In final import they are intellectual. But in their actual occurrence they were emotional as well; they were purposive and volitional. Yet the experience was not a sum of these different characters; they were lost in it as distinctive traits. No thinker can ply his occupation save as he is lured and rewarded by total integral experiences that are intrinsically worth while. Without them he would never know what it is really to think and would be completely at a loss in distinguishing real thought from the spurious article. Thinking goes on in trains of ideas, but the ideas form a train only because they are much more than what an analytic psychology calls ideas. They are phases, emotionally and practically distinguished, of a developing underlying quality; they are its moving variations, not separate and independent like Locke's and Hume's so-called ideas and impressions, but are subtle shadings of a pervading and developing hue.

We say of an experience of thinking that we reach or draw a conclusion. Theoretical formulation of the process is often made in such terms as to conceal effectually the similarity of "conclusion" to the consummating phase of every developing integral experience. These formulations apparently take their cue from the separate propositions that are premises and the proposition that is the conclusion as they appear on the printed page. The impression is derived that there are first two independent and ready-made entities that are then manipulated so as to give rise to a third. In fact, in an experience of thinking, premises emerge only as a conclusion becomes manifest. The experience, like that of watching a storm reach its height and gradually subside, is one of continuous movement of subject-matters. Like the ocean in the storm, there are a series of waves; suggestions reaching out and being broken in a clash, or being carried onwards

by a coöperative wave. If a conclusion is reached, it is that of a movement of anticipation and cumulation, one that finally comes to completion. A "conclusion" is no separate and independent thing; it is the consummation of a movement.

Hence *an* experience of thinking has its own esthetic quality. It differs from those experiences that are acknowledged to be esthetic, but only in its materials. The material of the fine arts consists of qualities; that of experience having intellectual conclusion are signs or symbols having no intrinsic quality of their own, but standing for things that may in another experience be qualitatively experienced. The difference is enormous. It is one reason why the strictly intellectual art will never be popular as music is popular. Nevertheless, the experience itself has a satisfying emotional quality because it possesses internal integration and fulfillment reached through ordered and organized movement. This artistic structure may be immediately felt. In so far, it is esthetic. What is even more important is that not only is this quality a significant motive in undertaking intellectual inquiry and in keeping it honest, but that no intellectual activity is an integral event (is *an* experience), unless it is rounded out with this quality. Without it, thinking is inconclusive. In short, esthetic cannot be sharply marked off from intellectual experience since the latter must bear an esthetic stamp to be itself complete.

The same statement holds good of a course of action that is dominantly practical, that is, one that consists of overt doings. It is possible to be efficient in action and yet not have a conscious experience. The activity is too automatic to permit of a sense of what it is about and where it is going. It comes to an end but not to a close or consummation in consciousness. Obstacles are overcome by shrewd skill, but they do not feed experience. There are also those who are wavering in action, uncertain, and inconclusive like the shades in classic literature. Between the poles of aimlessness and mechanical efficiency, there lies those courses of action in which through successive deeds there runs a sense of growing meaning conserved and accumulating toward an end that is felt as accomplishment of a process. Successful politicians and generals who turn statesmen like Caesar and Napoleon have something of the showman about them. This of itself is not art, but it is, I think, a sign that interest is not exclusively, perhaps not mainly, held by the result taken by itself (as it is in the case of mere efficiency), but by it as the outcome of a process. There is interest in completing an experience. The experience may be one that is harmful to the world and its consummation undesirable. But it has esthetic quality.

The Greek identification of good conduct with conduct having proportion, grace, and harmony, the *kalon-agathon*, is a more obvious example of distinctive esthetic quality in moral action. One great defect in what passes as morality is its anesthetic quality. Instead of exemplifying wholehearted action, it takes the form of grudging piecemeal concessions to the demands

of duty. But illustrations may only obscure the fact that any practical activity will, provided that it is integrated and moves by its own urge to fulfillment, have esthetic quality.

A generalized illustration may be had if we imagine a stone, which is rolling down the hill, to have an experience. The activity is surely sufficiently "practical." The stone starts from somewhere, and moves, as consistently as conditions permit, toward a place and state where it will be at rest—toward an end. Let us add, by imagination, to these external facts, the ideas that it looks forward with desire to the final outcome; that it is interested in the things it meets on its way, conditions that accelerate and retard its movement with respect to their bearing on the end; that it acts and feels toward them according to the hindering or helping function it attributes to them; and that the final coming to rest is related to all that went before as the culmination of a continuous movement. Then the stone would have an experience, and one with esthetic quality.

If we turn from this imaginary case to our own experience, we shall find much of it is nearer to what happens to the actual stone than it is to anything that fulfills the conditions fancy just laid down. For in much of our experience we are not concerned with the connection of one incident with what went before and what comes after. There is no interest that controls attentive rejection or selection of what shall be organized into the developing experience. Things happen, but they are neither definitely included nor decisively excluded; we drift. We yield according to external pressure, or evade and compromise. There are beginnings and cessations, but no genuine initiations and concludings. One thing replaces another, but does not absorb it and carry it on. There is experience, but so slack and discursive that it is not *an* experience. Needless to say, such experiences are anesthetic.

Thus the non-esthetic lies within two limits. At one pole is the loose succession that does not begin at any particular place and that ends—in the sense of ceasing—at no particular place. At the other pole is arrest, constriction, proceeding from parts having only a mechanical connection with one another. There exists so much of one and the other of these two kinds of experience that unconsciously they come to be taken as norms of all experience. Then, when the esthetic appears, it so sharply contrasts with the picture that has been formed of experience, that it is impossible to combine its special qualities with the features of the picture and the esthetic is given an outside place and status. The account that has been given of experience dominantly intellectual and practical is intended to show that there is no such contrast involved in having an experience; that, on the contrary, no experience of whatever sort is a unity unless it has esthetic quality.

The enemies of the esthetic are neither the practical nor the intellectual. They are the humdrum; slackness of loose ends; submission to convention in practice and intellectual procedure. Rigid abstinence, coerced submis-

sion, tightness on one side and dissipation, incoherence and aimless indulgence on the other, are deviations in opposite directions from the unity of an experience. Some such considerations perhaps induced Aristotle to invoke the "mean proportional" as the proper designation of what is distinctive of both virtue and the esthetic. He was formally correct. "Mean" and "proportion" are, however, not self-explanatory, nor to be taken over in a prior mathematical sense, but are properties belonging to an experience that has a developing movement toward its own consummation.

I have emphasized the fact that every integral experience moves toward a close, an ending, since it ceases only when the energies active in it have done their proper work. This closure of a circuit of energy is the opposite of arrest, of *stasis*. Maturation and fixation are polar opposites. Struggle and conflict may be themselves enjoyed, although they are painful, when they are experienced as means of developing an experience; members in that they carry it forward, not just because they are there. There is, as will appear later, an element of undergoing, of suffering in its large sense, in every experience. Otherwise there would be no taking in of what preceded. For "taking in" in any vital experience is something more than placing something on the top of consciousness over what was previously known. It involves reconstruction which may be painful. Whether the necessary undergoing phase is by itself pleasurable or painful is a matter of particular conditions. It is indifferent to the total esthetic quality, save that there are few intense esthetic experiences that are wholly gleeful. They are certainly not to be characterized as amusing, and as they bear down upon us they involve a suffering that is none the less consistent with, indeed a part of, the complete perception that is enjoyed.

I have spoken of the esthetic quality that rounds out an experience into completeness and unity as emotional. The reference may cause difficulty. We are given to thinking of emotions as things as simple and compact as are the words by which we name them. Joy, sorrow, hope, fear, anger, curiosity, are treated as if each in itself were a sort of entity that enters full-made upon the scene, an entity that may last a long time or a short time, but whose duration, whose growth and career, is irrelevant to its nature. In fact emotions are qualities, when they are significant, of a complex experience that moves and changes. I say, when they are *significant*, for otherwise they are but the outbreaks and eruptions of a disturbed infant. All emotions are qualifications of a drama and they change as the drama develops. Persons are sometimes said to fall in love at first sight. But what they fall into is not a thing of that instant. What would love be were it compressed into a moment in which there is no room for cherishing and for solicitude? The intimate nature of emotion is manifested in the experience of one watching a play on the stage or reading a novel. It attends the development of a plot; and a plot requires a stage, a space, wherein to develop and time in which to unfold. Experience is emotional but there are no separate things called emotions in it.

By the same token, emotions are attached to events and objects in their movement. They are not, save in pathological instances, private. And even an "objectless" emotion demands something beyond itself to which to attach itself, and thus it soon generates a delusion in lack of something real. Emotion belongs of a certainty to the self. But it belongs to the self that is concerned in the movement of events toward an issue that is desired or disliked. We jump instantaneously when we are scared, as we blush on the instant when we are ashamed. But fright and shamed modesty are not in this case emotional states. Of themselves they are but automatic reflexes. In order to become emotional they must become parts of an inclusive and enduring situation that involves concern for objects and their issues. The jump of fright becomes emotional fear when there is found or thought to exist a threatening object that must be dealt with or escaped from. The blush becomes the emotion of shame when a person connects, in thought, an action he has performed with an unfavorable reaction to himself of some other person.

Physical things from far ends of the earth are physically transported and physically caused to act and react upon one another in the construction of a new object. The miracle of mind is that something similar takes place in experience without physical transport and assembling. Emotion is the moving and cementing force. It selects what is congruous and dyes what is selected with its color, thereby giving qualitative unity to materials externally disparate and dissimilar. It thus provides unity in and through the varied parts of an experience. When the unity is of the sort already described, the experience has esthetic character even though it is not, dominantly, an esthetic experience.

Two men meet; one is the applicant for a position, while the other has the disposition of the matter in his hands. The interview may be mechanical, consisting of set questions, the replies to which perfunctorily settle the matter. There is no experience in which the two men meet, nothing that is not a repetition, by way of acceptance or dismissal, of something which has happened a score of times. The situation is disposed of as if it were an exercise in bookkeeping. But an interplay may take place in which a new experience develops. Where should we look for an account of such an experience? Not to ledger-entries nor yet to a treatise on economics or sociology or personnel-psychology, but to drama or fiction. Its nature and import can be expressed only by art, because there is a unity of experience that can be expressed only as an experience. The *experience* is of material fraught with suspense and moving toward its own consummation through a connected series of varied incidents. The primary emotions on the part of the applicant may be at the beginning hope or despair, and elation or disappoinment at the close. These emotions qualify the experience as a unity. But as the interview proceeds, secondary emotions are evolved as variations of the primary underlying one. It is even possible for each attitude and gesture, each sentence, almost every word, to produce more

than a fluctuation in the intensity of the basic emotion; to produce, that is, a change of shade and tint in its quality. The employer sees by means of his own emotional reactions the character of the one applying. He projects him imaginatively into the work to be done and judges his fitness by the way in which the elements of the scene assemble and either clash or fit together. The presence and behavior of the applicant either harmonize with his own attitudes and desires or they conflict and jar. Such factors as these, inherently esthetic in quality, are the forces that carry the varied elements of the interview to a decisive issue. They enter into the settlement of every situation, whatever its dominant nature, in which there are uncertainty and suspense.

There are, therefore, common patterns in various experiences, no matter how unlike they are to one another in the details of their subject matter. There are conditions to be met without which an experience cannot come to be. The outline of the common pattern is set by the fact that every experience is the result of interaction between a live creature and some aspect of the world in which he lives. A man does something; he lifts, let us say, a stone. In consequence he undergoes, suffers, something: the weight, strain, texture of the surface of the thing lifted. The properties thus undergone determine further doing. The stone is too heavy or too angular, not solid enough; or else the properties undergone show it is fit for the use for which it is intended. The process continues until a mutual adaptation of the self and the object emerges and that particular experience comes to a close. What is true of this simple instance is true, as to form, of every experience. The creature operating may be a thinker in his study and the environment with which he interacts may consist of ideas instead of a stone. But interaction of the two constitutes the total experience that is had, and the close which completes it is the institution of a felt harmony.

An experience has pattern and structure, because it is not just doing and undergoing in alternation, but consists of them in relationship. To put one's hand in the fire that consumes it is not necessarily to have an experience. The action and its consequence must be joined in perception. This relationship is what gives meaning; to grasp it is the objective of all intelligence. The scope and content of the relations measure the significant content of an experience. A child's experience may be intense, but, because of lack of background from past experience, relations between undergoing and doing are slightly grasped, and the experience does not have great depth or breadth. No one ever arrives at such maturity that he perceives all the connections that are involved. There was once written (by Mr. Hinton) a romance called "The Unlearner." It portrayed the whole endless duration of life after death as a living over of the incidents that happened in a short life on earth, in continued discovery of the relationships involved among them.

Experience is limited by all the causes which interfere with perception of the relations between undergoing and doing. There may be interference because of excess on the side of doing or of excess on the side of receptivity, of undergoing. Unbalance on either side blurs the perception of relations and leaves the experience partial and distorted, with scant or false meaning. Zeal for doing, lust for action, leaves many a person, especially in this hurried and impatient human environment in which we live, with experience of an almost incredible paucity, all on the surface. No one experience has a chance to complete itself because something else is entered upon so speedily. What is called experience becomes so dispersed and miscellaneous as hardly to deserve the name. Resistance is treated as an obstruction to be beaten down, not as an invitation to reflection. An individual comes to seek, unconsciously even more than by deliberate choice, situations in which he can do the most things in the shortest time.

Experiences are also cut short from maturing by excess of receptivity. What is prized is then the mere undergoing of this and that, irrespective of perception of any meaning. The crowding together of as many impressions as possible is thought to be "life," even though no one of them is more than a flitting and a sipping. The sentimentalist and the day-dreamer may have more fancies and impressions pass through their consciousness than has the man who is animated by lust for action. But his experience is equally distorted, because nothing takes root in mind when there is no balance between doing and receiving. Some decisive action is needed in order to establish contact with the realities of the world and in order that impressions may be so related to facts that their value is tested and organized.

Because perception of relationship between what is done and what is undergone constitutes the work of intelligence, and because the artist is controlled in the process of his work by his grasp of the connection between what he has already done and what he is to do next, the idea that the artist does not think as intently and penetratingly as a scientific inquirer is absurd. A painter must consciously undergo the effect of his every brush stroke or he will not be aware of what he is doing and where his work is going. Moreover, he has to see each particular connection of doing and undergoing in relation to the whole that he desires to produce. To apprehend such relations is to think, and is one of the most exacting modes of thought. The difference between the pictures of different painters is due quite as much to differences of capacity to carry on this thought as it is to differences of sensitivity to bare color and to differences in dexterity of execution. As respects the basic quality of pictures, difference depends, indeed, more upon the quality of intelligence brought to bear upon perception of relations than upon anything else—though of course intelligence cannot be separated from direct sensitivity and is connected, though in a more external manner, with skill.

Any idea that ignores the necessary rôle of intelligence in production

of works of art is based upon identification of thinking with use of one special kind of material, verbal signs and words. To think effectively in terms of relations of qualities is as severe a demand upon thought as to think in terms of symbols, verbal and mathematical. Indeed, since words are easily manipulated in mechanical ways, the production of a work of genuine art probably demands more intelligence than does most of the so-called thinking that goes on among those who pride themselves on being "intellectuals."

I have tried to show in these chapters that the esthetic is no intruder in experience from without, whether by way of idle luxury or transcendent ideality, but that it is the clarified and intensified development of traits that belong to every normally complete experience. This fact I take to be the only secure basis upon which esthetic theory can build. It remains to suggest some of the implications of the underlying fact.

We have no word in the English language that unambiguously includes what is signified by the two words "artistic" and "esthetic." Since "artistic" refers primarily to the act of production and "esthetic" to that of perception and enjoyment, the absence of a term designating the two processes taken together is unfortunate. Sometimes, the effect is to separate the two from each other, to regard art as something superimposed upon esthetic material, or, upon the other side, to an assumption that, since art is a process of creation, perception and enjoyment of it have nothing in common with the creative act. In any case, there is a certain verbal awkwardness in that we are compelled sometimes to use the term "esthetic" to cover the entire field and sometimes to limit it to the receiving perceptual aspect of the whole operation. I refer to these obvious facts as preliminary to an attempt to show how the conception of conscious experience as a perceived relation between doing and undergoing enables us to understand the connection that art as production and perception and appreciation as enjoyment sustain to each other.

Art denotes a process of doing or making. This is as true of fine as of technological art. Art involves molding of clay, chipping of marble, casting of bronze, laying on of pigments, construction of buildings, singing of songs, playing of instruments, enacting rôles on the stage, going through rhythmic movements in the dance. Every art does something with some physical material, the body or something outside the body, with or without the use of intervening tools, and with a view to production of something visible, audible, or tangible. So marked is the active or "doing" phase of art, that the dictionaries usually define it in terms of skilled action, ability in execution. The Oxford Dictionary illustrates by a quotation from John Stuart Mill: "Art is an endeavor after perfection in execution" while Matthew Arnold calls it "pure and flawless workmanship."

The word "esthetic" refers, as we have already noted, to experience as appreciative, perceiving, and enjoying. It denotes the consumer's rather than

the producer's standpoint. It is Gusto, taste; and, as with cooking, overt skillful action is on the side of the cook who prepares, while taste is on the side of the consumer, as in gardening there is a distinction between the gardener who plants and tills and the householder who enjoys the finished product.

These very illustrations, however, as well as the relation that exists in having an experience between doing and undergoing, indicate that the distinction between esthetic and artistic cannot be pressed so far as to become a separation. Perfection in execution cannot be measured or defined in terms of execution; it implies those who perceive and enjoy the product that is executed. The cook prepares food for the consumer and the measure of the value of what is prepared is found in consumption. Mere perfection in execution, judged in its own terms in isolation, can probably be attained better by a machine than by human art. By itself, it is at most technique, and there are great artists who are not in the first ranks as technicians (witness Cézanne), just as there are great performers on the piano who are not great esthetically, and as Sargent is not a great painter.

Craftsmanship to be artistic in the final sense must be "loving"; it must care deeply for the subject matter upon which skill is exercised. A sculptor comes to mind whose busts are marvelously exact. It might be difficult to tell in the presence of a photograph of one of them and of a photograph of the original which was of the person himself. For virtuosity they are remarkable. But one doubts whether the maker of the busts had an experience of his own that he was concerned to have those share who look at his products. To be truly artistic, a work must also be esthetic—that is, framed for enjoyed receptive perception. Constant observation is, of course, necessary for the maker while he is producing. But if his perception is not also esthetic in nature it is a colorless and cold recognition of what has been done, used as a stimulus to the next step in a process that is essentially mechanical.

In short, art, in its form, unites the very same relation of doing and undergoing, outgoing and incoming energy, that makes an experience to be an experience. Because of elimination of all that does 'not contribute to mutual organization of the factors of both action and reception into one another, and because of selection of just the aspects and traits that contribute to their interpenetration of each other, the product is a work of esthetic art. Man whittles, carves, sings, dances, gestures, molds, draws and paints. The doing or making is artistic when the perceived result is of such a nature that *its* qualities *as perceived* have controlled the question of production. The act of producing that is directed by intent to produce something that is enjoyed in the immediate experience of perceiving has qualities that a spontaneous or uncontrolled activity does not have. The artist embodies in himself the attitude of the perceiver while he works.

Suppose, for the sake of illustration, that a finely wrought object, one whose texture and proportions are highly pleasing in perception, has been

believed to be a product of some primitive people. Then there is discovered evidence that proves it to be an accidental natural product. As an external thing, it is now precisely what it was before. Yet at once it ceases to be a work of art and becomes a natural "curiosity." It now belongs in a museum of natural history, not in a museum of art. And the extraordinary thing is that the difference that is thus made is not one of just intellectual classification. A difference is made in appreciative perception and in a direct way. The esthetic experience—in its limited sense —is thus seen to be inherently connected with the experience of making.

The sensory satisfaction of eye and ear, when esthetic, is so because it does not stand by itself but is linked to the activity of which it is the consequence. Even the pleasures of the palate are different in quality to an epicure than in one who merely "likes" his food as he eats it. The difference is not of mere intensity. The epicure is conscious of much more than the taste of the food. Rather, there enter into the taste, as directly experienced, qualities that depend upon reference to its source and its manner of production in connection with criteria of excellence. As production must absorb into itself qualities of the product as perceived and be regulated by them, so, on the other side, seeing, hearing, tasting, become esthetic when relation to a distinct manner of activity qualifies what is perceived.

There is an element of passion in all esthetic perception. Yet when we are overwhelmed by passion, as in extreme rage, fear, jealousy, the experience is definitely non-esthetic. There is no relationship felt to the qualities of the activity that has generated the passion. Consequently, the material of the experience lacks elements of balance and proportion. For these can be present only when, as in the conduct that has grace or dignity, the act is controlled by an exquisite sense of the relations which the act sustains —its fitness to the occasion and to the situation.

The process of art in production is related to the esthetic in perception organically—as the Lord God in creation surveyed his work and found it good. Until the artist is satisfied in perception with what he is doing, he continues shaping and reshaping. The making comes to an end when its result is experienced as good—and that experience comes not by mere intellectual and outside judgment but in direct perception. An artist, in comparison with his fellows, is one who is not only especially gifted in powers of execution but in unusual sensitivity to the qualities of things. This sensitivity also directs his doings and makings.

As we manipulate, we touch and feel, as we look, we see; as we listen, we hear. The hand moves with etching needle or with brush. The eye attends and reports the consequence of what is done. Because of this intimate connection, subsequent doing is cumulative and not a matter of caprice nor yet of routine. In an emphatic artistic-esthetic experience, the relation is so close that it controls simultaneously both the doing and the perception. Such vital intimacy of connection cannot be had if only hand

and eye are engaged. When they do not, both of them, act as organs of the whole being, there is but a mechanical sequence of sense and movement, as in walking that is automatic. Hand and eye, when the experience is esthetic, are but instruments through which the entire live creature, moved and active throughout, operates. Hence the expression is emotional and guided by purpose.

Because of the relation between what is done and what is undergone, there is an immediate sense of things in perception as belonging together or as jarring; as reënforcing or as interfering. The consequences of the act of making as reported in sense show whether what is done carries forward the idea being executed or marks a deviation and break. In as far as the development of an experience is *controlled* through reference to these immediately felt relations of order and fulfillment, that experience becomes dominantly esthetic in nature. The urge to action becomes an urge to that kind of action which will result in an object satisfying in direct perception. The potter shapes his clay to make a bowl useful for holding grain; but he makes it in a way so regulated by the series of perceptions that sum up the serial acts of making, that the bowl is marked by enduring grace and charm. The general situation remains the same in painting a picture or molding a bust. Moreover, at each stage there is anticipation of what is to come. This anticipation is the connecting link between the next doing and its outcome for sense. What is done and what is undergone are thus reciprocally, cumulatively, and continuously instrumental to each other.

The doing may be energetic, and the undergoing may be acute and intense. But unless they are related to each other to form a whole in perception, the thing done is not fully esthetic. The making for example may be a display of technical virtuosity, and the undergoing a gush of sentiment or a revery. If the artist does not perfect a new vision in his process of doing, he acts mechanically and repeats some old model fixed like a blue print in his mind. An incredible amount of observation and of the kind of intelligence that is exercised in perception of qualitative relations characterizes creative work in art. The relations must be noted not only with respect to one another, two by two, but in connection with the whole under construction; they are exercised in imagination as well as in observation. Irrelevancies arise that are tempting distractions; digressions suggest themselves in the guise of enrichments. There are occasions when the grasp of the dominant idea grows faint, and then the artist is moved unconsciously to fill in until his thought grows strong again. The real work of an artist is to build up an experience that is coherent in perception while moving with constant change in its development.

When an author puts on paper ideas that are already clearly conceived and consistently ordered, the real work has been previously done. Or, he may depend upon the greater perceptibility induced by the activity and its sensible report to direct his completion of the work. The mere act of

transcription is esthetically irrelevant save as it enters integrally into the formation of an experience moving to completeness. Even the composition conceived in the head and, therefore, physically private, is public in its significant content, since it is conceived with reference to execution in a product that is perceptible and hence belongs to the common world. Otherwise it would be an aberration or a passing dream. The urge to express through painting the perceived qualities of a landscape is continuous with demand for pencil or brush. Without external embodiment, an experience remains incomplete; physiologically and functionally, sense organs are motor organs and are connected, by means of distribution of energies in the human body and not merely anatomically, with other motor organs. It is no linguistic accident that "building," "construction," "work," designate both a process and its finished product. Without the meaning of the verb that of the noun remains blank.

Writer, composer of music, sculptor, or painter can retrace, during the process of production, what they have previously done. When it is not satisfactory in the undergoing or perceptual phase of experience, they can to some degree start afresh. This retracing is not readily accomplished in the case of architecture—which is perhaps one reason why there are so many ugly buildings. Architects are obliged to complete their idea before its translation into a complete object of perception takes place. Inability to build up simultaneously the idea and its objective embodiment imposes a handicap. Nevertheless, they too are obliged to think out their ideas in terms of the medium of embodiment and the object of ultimate perception unless they work mechanically and by rote. Probably the esthetic quality of medieval cathedrals is due in some measure to the fact that their constructions were not so much controlled by plans and specifications made in advance as is now the case. Plans grew as the building grew. But even a Minerva-like product, if it is artistic, presupposes a prior period of gestation in which doings and perceptions projected in imagination interact and mutually modify one another. Every work of art follows the plan of, and pattern of, a complete experience, rendering it more intensely and concentratedly felt.

It is not so easy in the case of the perceiver and appreciator to understand the intimate union of doing and undergoing as it is in the case of the maker. We are given to supposing that the former merely takes in what is there in finished form, instead of realizing that this taking in involves activities that are comparable to those of the creator. But receptivity is not passivity. It, too, is a process consisting of a series of responsive acts that accumulate toward objective fulfillment. Otherwise, there is not perception but recognition. The difference between the two is immense. Recognition is perception arrested before it has a chance to develop freely. In recognition there is a beginning of an act of perception. But this beginning is not allowed to serve the development of a full perception of the thing recognized. It is arrested at the point where it will serve some

other purpose, as we recognize a man on the street in order to greet or to avoid him, not so as to see him for the sake of seeing what is there.

In recognition we fall back, as upon a stereotype, upon some previously formed scheme. Some detail or arrangement of details serves as cue for bare identification. It suffices in recognition to apply this bare outline as a stencil to the present object. Sometimes in contact with a human being we are struck with traits, perhaps of only physical characteristics, of which we were not previously aware. We realize that we never knew the person before; we had not seen him in any pregnant sense. We now begin to study and to "take in." Perception replaces bare recognition. There is an act of reconstructive doing, and consciousness becomes fresh and alive. *This* act of seeing involves the coöperation of motor elements even though they remain implicit and do not become overt, as well as coöperation of all funded ideas that may serve to complete the new picture that is forming. Recognition is too easy to arouse vivid consciousness. There is not enough resistance between new and old to secure consciousness of the experience that is had. Even a dog that barks and wags his tail joyously on seeing his master return is more fully alive in his reception of his friend than is a human being who is content with mere recognition.

Bare recognition is satisfied when a proper tag or label is attached, "proper" signifying one that serves a purpose outside the act of recognition—as a salesman identifies wares by a sample. It involves no stir of the organism, no inner commotion. But an act of perception proceeds by waves that extend serially throughout the entire organism. There is, therefore, no such thing in perception as seeing or hearing *plus* emotion. The perceived object or scene is emotionally pervaded throughout. When an aroused emotion does not permeate the material that is perceived or thought of, it is either preliminary or pathological.

The esthetic or undergoing phase of experience is receptive. It involves surrender. But adequate yielding of the self is possibly only through a controlled activity that may well be intense. In much of our intercourse with our surroundings we withdraw; sometimes from fear, if only of expending unduly our store of energy; sometimes from preoccupation with other matters, as in the case of recognition. Perception is an act of the going-out of energy in order to receive, not a withholding of energy. To steep ourselves in a subject-matter we have first to plunge into it. When we are only passive to a scene, it overwhelms us and, for lack of answering activity, we do not perceive that which bears us down. We must summon energy and pitch it at a responsive key in order to *take* in.

Every one knows that it requires apprenticeship to see through a microscope or telescope, and to see a landscape as the geologist sees it. The idea that esthetic perception is an affair for odd moments is one reason for the backwardness of the arts among us. The eye and the visual apparatus

may be intact; the object may be physically there, the cathedral of Notre Dame, or Rembrandt's portrait of Hendrik Stoeffel. In some bald sense the latter may be "seen." They may be looked at, possibly recognized, and have their correct names attached. But for lack of continuous inter-action between the total organism and the objects they are not perceived, certainly not esthetically. A crowd of visitors steered through a picture-gallery by a guide, with attention called here and there to some high point, does not perceive; only by accident is there even interest in seeing a picture for the sake of subject matter vividly realized.

For to perceive, a beholder must *create* his own experience. And his creation must include relations comparable to those which the original producer underwent. They are not the same in any literal sense. But with the perceiver, as with the artist, there must be an ordering of the elements of the whole that is in form, although not in details, the same as the process of organization the creator of the work consciously experienced. Without an act of recreation the object is not perceived as a work of art. The artist selected, simplified, clarified, abridged and condensed accord-ing to his interest. The beholder must go through these operations ac-cording to his point of view and interest. In both, an act of abstraction, that is of extraction of what is significant, takes place. In both, there is comprehension in its literal signification—that is, a gathering together of details and particulars physically scattered into an experienced whole. There is work done on the part of the percipient as there is on the part of the artist. The one who is too lazy, idle, or indurated in convention to perform this work will not see or hear. His "appreciation" will be a mixture of scraps of learning with conformity to norms of conventional admiration and with a confused, even if genuine, emotional excitation.

The considerations that have been presented imply both the community and the unlikeness, because of specific emphasis, of *an* experience, in its pregnant sense, and esthetic experience. The former has esthetic quality; otherwise its materials would not be rounded out into a single coherent experience. It is not possible to divide in a vital experience the practical, emotional, and intellectual from one another and to set the properties of one over against the characteristics of the others. The emotional phase binds parts together into a single whole; "intellectual" simply names the fact that the experience has meaning; "practical" indicates that the or-ganism is interacting with events and objects which surround it. The most elaborate philosophic or scientific inquiry and the most ambitious industrial or political enterprise has, when its different ingredients con-stitute an integral experience, esthetic quality. For then its varied parts are linked to one another, and do not merely succeed one another. And the parts through their experienced linkage move toward a consummation and close, not merely to cessation in time. This consummation, moreover,

does not wait in consciousness for the whole undertaking to be finished. It is anticipated throughout and is recurrently savored with special intensity.

Nevertheless, the experiences in question are dominantly intellectual or practical, rather than *distinctively* esthetic, because of the interest and purpose that initiate and control them. In an intellectual experience, the conclusion has value on its own account. It can be extracted as a formula or as a "truth," and can be used in its independent entirety as factor and guide in other inquiries. In a work of art there is no such single self-sufficient deposit. The end, the terminus, is significant not by itself but as the integration of the parts. It has no other existence. A drama or novel is not the final sentence, even if the characters are disposed of as living happily ever after. In a distinctively esthetic experience, characteristics that are subdued in other experiences are dominant; those that are subordinate are controlling—namely, the characteristics in virtue of which the experience is an integrated complete experience on its own account.

In every integral experience there is form because there is dynamic organization. I call the organization dynamic because it takes time to complete it, because it is a growth. There is inception, development, fulfillment. Material is ingested and digested through interaction with that vital organization of the results of prior experience that constitutes the mind of the worker. Incubation goes on until what is conceived is brought forth and is rendered perceptible as part of the common world. An esthetic experience can be crowded into a moment only in the sense that a climax of prior long enduring processes may arrive in an outstanding movement which so sweeps everything else into it that all else is forgotten. That which distinguishes an experience as esthetic is conversion of resistance and tensions, of excitations that in themselves are temptations to diversion, into a movement toward an inclusive and fulfilling close.

Experiencing like breathing is a rhythm of intakings and outgivings. Their succession is punctuated and made a rhythm by the existence of intervals, periods in which one phase is ceasing and the other is inchoate and preparing. William James aptly compared the course of a conscious experience to the alternate flights and perchings of a bird. The flights and perchings are intimately connected with one another; they are not so many unrelated lightings succeeded by a number of equally unrelated hoppings. Each resting place in experience is an undergoing in which is absorbed and taken home the consequences of prior doing, and, unless the doing is that of utter caprice or sheer routine, each doing carries in itself meaning that has been extracted and conserved. As with the advance of an army, all gains from what has been already effected are periodically consolidated, and always with a view to what is to be done next. If we move too rapidly, we get away from the base of supplies—of accrued meanings —and the experience is flustered, thin, and confused. If we dawdle too long after having extracted a net value, experience perishes of inanition.

The *form* of the whole is therefore present in every member. Fulfilling, consummating, are continuous functions, not mere ends, located at one place only. An engraver, painter, or writer is in process of completing at every stage of his work. He must at each point retain and sum up what has gone before as a whole and with reference to a whole to come. Otherwise there is no consistency and no security in his successive acts. The series of doings in the rhythm of experience give variety and movement; they save the work from monotony and useless repetitions. The undergoings are the corresponding elements in the rhythm, and they supply unity; they save the work from the aimlessness of a mere succession of excitations. An object is peculiarly and dominantly esthetic, yielding the enjoyment characteristic of esthetic perception, when the factors that determine anything which can be called *an* experience are lifted high above the threshold of perception and are made manifest for their own sake.

PART III

RECENT REFLECTIONS ON ART

LEO TOLSTOY

WHAT IS ART?

Leo Tolstoy (1828–1910), the noted Russian author, developed the theory that the purpose of art is the communication of emotion.

What then is this conception of beauty, so stubbornly held to by people of our circle and day as furnishing a definition of art?

In the subjective aspect, we call beauty that which supplies us with a particular kind of pleasure.

In the objective aspect, we call beauty something absolutely perfect, and we acknowledge it to be so only because we receive, from the manifestation of this absolute perfection, a certain kind of pleasure; so that this objective definition is nothing but the subjective conception differently expressed. In reality both conceptions of beauty amount to one and the same thing, namely, the reception by us of a certain kind of pleasure, *i.e.* we call "beauty" that which pleases us without evoking in us desire.

Such being the position of affairs, it would seem only natural that the

Reprinted from *What Is Art and Essays on Art* by Leo Tolstoy, translated by Louise and Aylmer Maude, published by Oxford University Press, London (1899), pp. 40–55; 152–161, by permission of the publisher.

science of art should decline to content itself with a definition of art based on beauty (*i.e.* on that which pleases), and seek a general definition, which should apply to all artistic productions, and by reference to which we might decide whether a certain article belonged to the realm of art or not. But no such definition is supplied, as the reader may see from those summaries of the æsthetic theories which I have given, and as he may discover even more clearly from the original æsthetic works, if he will be at the pains to read them. All attempts to define absolute beauty in itself—whether as an imitation of nature, or as suitability to its object, or as a correspondence of parts, or as symmetry, or as harmony, or as unity in variety, etc.—either define nothing at all, or define only some traits of some artistic productions, and are far from including all that everybody has always held, and still holds, to be art.

There is no objective definition of beauty. The existing definitions (both the metaphysical and the experimental) amount only to one and the same subjective definition which (strange as it seems to say so) is, that art is that which makes beauty manifest, and beauty is that which pleases (without exciting desire). Many æstheticians have felt the insufficiency and instability of such a definition, and, in order to give it a firm basis, have asked themselves why a thing pleases. And they have converted the discussion on beauty into a question concerning taste, as did Hutcheson, Voltaire, Diderot, and others. But all attempts to define what taste is must lead to nothing, as the reader may see both from the history of æsthetics and experimentally. There is and can be no explanation of why one thing pleases one man and displeases another, or *vice versâ*. So that the whole existing science of æsthetics fails to do what we might expect from it, being a mental activity calling itself a science, namely, it does not define the qualities and laws of art, or of the beautiful (if that be the content of art), or the nature of taste (if taste decides the question of art and its merit), and then, on the basis of such definitions, acknowledge as art those productions which correspond to these laws, and reject those which do not come under them. But this science of æsthetics consists in first acknowledging a certain set of productions to be art (because they please us), and then framing such a theory of art that all those productions which please a certain circle of people should fit into it. There exists an art canon, according to which certain productions favoured by our circle are acknowledged as being art,—Phidias, Sophocles, Homer, Titian, Raphael, Bach, Beethoven, Dante, Shakespear, Goethe, and others,—and the æsthetic laws must be such as to embrace all these productions. In æsthetic literature you will incessantly meet with opinions on the merit and importance of art, founded not on any certain laws by which this or that is held to be good or bad, but merely on the consideration whether this art tallies with the art canon we have drawn up.

The other day I was reading a far from ill-written book by Folgeldt.

Discussing the demand for morality in works of art, the author plainly says that we must not demand morality in art. And in proof of this he advances the fact that if we admit such a demand, Shakespear's *Romeo and Juliet* and Goethe's *Wilhelm Meister* would not fit into the definition of good art; but since both these books are included in our canon of art, he concludes that the demand is unjust. And therefore it is necessary to find a definition of art which shall fit the works; and instead of a demand for morality, Folgeldt postulates as the basis of art a demand for the important (*Bedeutungsvolles*).

All the existing æsthetic standards are built on this plan. Instead of giving a definition of true art, and then deciding what is and what is not good art by judging whether a work conforms or does not conform to the definition, a certain class of works, which for some reason please a certain circle of people, is accepted as being art, and a definition of art is then devised to cover all these productions. I recently came upon a remarkable instance of this method in a very good German work, *The History of Art in the Nineteenth Century*, by Muther. Describing the pre-Raphaelites, the Decadents and the Symbolists (who are already included in the canon of art), he not only does not venture to blame their tendency, but earnestly endeavours to widen his standard so that it may include them all, they appearing to him to represent a legitimate reaction from the excesses of realism. No matter what insanities appear in art, when once they find acceptance among the upper classes of our society a theory is quickly invented to explain and sanction them; just as if there had never been periods in history when certain special circles of people recognised and approved false, deformed, and insensate art which subsequently left no trace and has been utterly forgotten. And to what lengths the insanity and deformity of art may go, especially when, as in our days, it knows that it is considered infallible, may be seen by what is being done in the art of our circle to-day.

So that the theory of art, founded on beauty, expounded by æsthetics, and, in dim outline, professed by the public, is nothing but the setting up as good, of that which has pleased and pleases us, *i.e.* pleases a certain class of people.

In order to define any human activity, it is necessary to understand its sense and importance. And, in order to do that, it is primarily necessary to examine that activity in itself, in its dependence on its causes, and in connection with its effects, and not merely in relation to the pleasure we can get from it.

If we say that the aim of any activity is merely our pleasure, and define it solely by that pleasure, our definition will evidently be a false one. But this is precisely what has occurred in the efforts to define art. Now, if we consider the food question, it will not occur to anyone to affirm that the importance of food consists in the pleasure we receive when eating it.

Everyone understands that the satisfaction of our taste cannot serve as a basis for our definition of the merits of food, and that we have therefore no right to presuppose that the dinners with cayenne pepper, Limburg cheese, alcohol, etc., to which we are accustomed and which please us, form the very best human food.

And in the same way, beauty, or that which pleases us, can in no sense serve as the basis for the definition of art; nor can a series of objects which afford us pleasure serve as the model of what art should be.

To see the aim and purpose of art in the pleasure we get from it, is like assuming (as is done by people of the lowest moral development, *e.g.* by savages) that the purpose and aim of food is the pleasure derived when consuming it.

Just as people who conceive the aim and purpose of food to be pleasure cannot recognise the real meaning of eating, so people who consider the aim of art to be pleasure cannot realise its true meaning and purpose, because they attribute to an activity, the meaning of which lies in its connection with other phenomena of life, the false and exceptional aim of pleasure. People come to understand that the meaning of eating lies in the nourishment of the body only when they cease to consider that the object of that activity is pleasure. And it is the same with regard to art. People will come to understand the meaning of art only when they cease to consider that the aim of that activity is beauty, *i.e.* pleasure. The acknowledgment of beauty (*i.e.* of a certain kind of pleasure received from art) as being the aim of art, not only fails to assist us in finding a definition of what art is, but, on the contrary, by transferring the question into a region quite foreign to art (into metaphysical, psychological, physiological, and even historical discussions as to why such a production pleases one person, and such another displeases or pleases someone else), it renders such definition impossible. And since discussions as to why one man likes pears and another prefers meat do not help towards finding a definition of what is essential in nourishment, so the solution of questions of taste in art (to which the discussions on art involuntarily come) not only does not help to make clear what this particular human activity which we call art really consists in, but renders such elucidation quite impossible, until we rid ourselves of a conception which justifies every kind of art, at the cost of confusing the whole matter.

To the question, What is this art, to which is offered up the labour of millions, the very lives of men, and even morality itself? we have extracted replies from the existing æsthetics, which all amount to this: that the aim of art is beauty, that beauty is recognised by the enjoyment it gives, and that artistic enjoyment is a good and important thing, because it *is* enjoyment. In a word, that enjoyment is good because it is enjoyment. Thus, what is considered the definition of art is no definition at all, but only a shuffle to justify existing art. Therefore, however strange it may seem to say so, in spite of the mountains of books written about art, no exact

definition of art has been constructed. And the reason of this is that the conception of art has been based on the conception of beauty.

. . .

What is art, if we put aside the conception of beauty, which confuses the whole matter? The latest and most comprehensible definitions of art, apart from the conception of beauty, are the following: — (1 *a*) Art is an activity arising even in the animal kingdom, and springing from sexual desire and the propensity to play (Schiller, Darwin, Spencer), and (1 *b*) accompanied by a pleasurable excitement of the nervous system (Grant Allen). This is the physiological-evolutionary definition. (2) Art is the external manifestation, by means of lines, colours, movements, sounds, or words, of emotions felt by man (Véron). This is the experimental definition. According to the very latest definition (Sully), (3) Art is "the production of some permanent object, or passing action, which is fitted not only to supply an active enjoyment to the producer, but to convey a pleasurable impression to a number of spectators or listeners, quite apart from any personal advantage to be derived from it."

Notwithstanding the superiority of these definitions to the metaphysical definitions which depended on the conception of beauty, they are yet far from exact. (1 *a*) The first, the physiological-evolutionary definition, is inexact, because, instead of speaking about the artistic activity itself, which is the real matter in hand, it treats of the derivation of art. The modification of it (1 *b*), based on the physiological effects on the human organism, is inexact, because within the limits of such definition many other human activities can be included, as has occurred in the neo-æsthetic theories, which reckon as art the preparation of handsome clothes, pleasant scents, and even of victuals.

The experimental definition (2), which makes art consist in the expression of emotions, is inexact, because a man may express his emotions by means of lines, colours, sounds, or words, and yet may not act on others by such expression; and then the manifestation of his emotions is not art.

The third definition (that of Sully) is inexact, because in the production of objects or actions affording pleasure to the producer and a pleasant emotion to the spectators or hearers apart from personal advantage, may be included the showing of conjuring tricks or gymnastic exercises, and other activities which are not art. And, further, many things, the production of which does not afford pleasure to the producer, and the sensation received from which is unpleasant, such as gloomy, heart-rending scenes in a poetic description or a play, may nevertheless be undoubted works of art.

The inaccuracy of all these definitions arises from the fact that in them all (as also in the metaphysical definitions) the object considered is the pleasure art may give, and not the purpose it may serve in the life of man and of humanity.

In order correctly to define art, it is necessary, first of all, to cease to consider it as a means to pleasure, and to consider it as one of the conditions of human life. Viewing it in this way, we cannot fail to observe that art is one of the means of intercourse between man and man.

Every work of art causes the receiver to enter into a certain kind of relationship both with him who produced, or is producing, the art, and with all those who, simultaneously, previously or subsequently, receive the same artistic impression.

Speech, transmitting the thoughts and experiences of men, serves as a means of union among them, and art acts in a similar manner. The peculiarity of this latter means of intercourse, distinguishing it from intercourse by means of words, consists in this, that whereas by words a man transmits his thoughts to another, by means of art he transmits his feelings.

The activity of art is based on the fact a man, receiving through his sense of hearing or sight another man's expression of feeling, is capable of experiencing the emotion which moved the man who expressed it. To take the simplest example: one man laughs, and another, who hears, becomes merry; or a man weeps, and another, who hears, feels sorrow. A man is excited or irritated, and another man, seeing him, comes to a similar state of mind. By his movements, or by the sounds of his voice, a man expresses courage and determination, or sadness and calmness, and this state of mind passes on to others. A man suffers, expressing his sufferings by groans and spasms, and this suffering transmits itself to other people; a man expresses his feeling of admiration, devotion, fear, respect, or love to certain objects, persons, or phenomena, and others are infected by the same feelings of admiration, devotion, fear, respect, or love to the same objects, persons, and phenomena.

And it is on this capacity of man to receive another man's expression of feeling, and experience those feelings himself, that the activity of art is based.

If a man infects another or others, directly, immediately, by his appearance, or by the sounds he gives vent to at the very time he experiences the feeling; if he causes another man to yawn when he himself cannot help yawning, or to laugh or cry when he himself is obliged to laugh or cry, or to suffer when he himself is suffering—that does not amount to art.

Art begins when one person, with the object of joining another or others to himself in one and the same feeling, expresses that feeling by certain external indications. To take the simplest example: a boy, having experienced, let us say, fear on encountering a wolf, relates that encounter; and, in order to evoke in others the feeling he has experienced, describes himself, his condition before the encounter, the surroundings, the wood, his own lightheartedness, and then the wolf's appearance, its movements, the distance between himself and the wolf, etc. All this, if only the boy when telling the story, again experiences the feelings he had lived through and infects the hearers and compels them to feel what

the narrator had experienced, is art. If even the boy had not seen a wolf but had frequently been afraid of one, and if, wishing to evoke in others the fear he had felt, he invented an encounter with a wolf, and recounted it so as to make his hearers share the feelings he experienced when he feared the wolf, that also would be art. And just in the same way it is art if a man, having experienced either the fear of suffering or the attraction of enjoyment (whether in reality or in imagination), expresses these feelings on canvas or in marble so that others are infected by them. And it is also art if a man feels or imagines to himself feelings of delight, gladness, sorrow, despair, courage, or despondency, and the transition from one to another of these feelings, and expresses these feelings by sounds, so that the hearers are infected by them, and experience them as they were experienced by the composer.

The feelings with which the artist infects others may be most various— very strong or very weak, very important or very insignificant, very bad or very good: feelings of love for native land, self-devotion and submission to fate or to God expressed in a drama, raptures of lovers described in a novel, feelings of voluptuousness expressed in a picture, courage expressed in a triumphal march, merriment evoked by a dance, humour evoked by a funny story, the feeling of quietness transmitted by an evening landscape or by a lullaby, or the feeling of admiration evoked by a beautiful arabesque—it is all art.

If only the spectators or auditors are infected by the feelings which the author has felt, it is art.

To evoke in oneself a feeling one has once experienced, and having evoked it in oneself, then, by means of movements, lines, colours, sounds, or forms expressed in words, so to transmit that feeling that others may experience the same feeling—this is the activity of art.

Art is a human activity, consisting in this, that one man consciously, by means of certain external signs, hands on to others feelings he has lived through, and that other people are infected by these feelings, and also experience them.

Art is not, as the metaphysicians say, the manifestation of some mysterious Idea of beauty, or God; it is not, as the æsthetical physiologists say, a game in which man lets off his excess of stored-up energy; it is not the expression of man's emotions by external signs; it is not the production of pleasing objects; and, above all, it is not pleasure; but it is a means of union among men, joining them together in the same feelings, and indispensable for the life and progress towards well-being of individuals and of humanity.

As, thanks to man's capacity to express thoughts by words, every man may know all that has been done for him in the realms of thought by all humanity before his day, and can, in the present, thanks to this capacity to understand the thoughts of others, become a sharer in their activity, and can himself hand on to his contemporaries and descendants

the thoughts he has assimilated from others, as well as those which have arisen within himself; so, thanks to man's capacity to be infected with the feelings of others by means of art, all that is being lived through by his contemporaries is accessible to him, as well as the feelings experienced by men thousands of years ago, and he has also the possibility of transmitting his own feelings to others.

If people lacked this capacity to receive the thoughts conceived by the men who preceded them, and to pass on to others their own thoughts, men would be like wild beasts, or like Kaspar Hauser.[1]

And if men lacked this other capacity of being infected by art, people might be almost more savage still, and, above all, more separated from, and more hostile to, one another.

And therefore the activity of art is a most important one, as important as the activity of speech itself, and as generally diffused.

We are accustomed to understand art to be only what we hear and see in theatres, concerts, and exhibitions; together with buildings, statues, poems, novels. . . . But all this is but the smallest part of the art by which we communicate with each other in life. All human life is filled with works of art of every kind—from cradle-song, jest, mimicry, the ornamentation of houses, dress and utensils, up to church services, buildings, monuments, and triumphal processions. It is all artistic activity. So that by art, in the limited sense of the word, we do not mean all human activity transmitting feelings, but only that part which we for some reason select from it and to which we attach special importance.

This special importance has always been given by all men to that part of this activity which transmits feelings flowing from their religious perception, and this small part of art they have specifically called art, attaching to it the full meaning of the word.

That was how men of old—Socrates, Plato, and Aristotle—looked on art. Thus did the Hebrew prophets and the ancient Christians regard art; thus it was, and still is, understood by the Mahommedans, and thus is it still understood by religious folk among our own peasantry.

Some teachers of mankind—as Plato in his *Republic*, and people such as the primitive Christians, the strict Mahommedans, and the Buddhists— have gone so far as to repudiate all art.

People viewing art in this way (in contradiction to the prevalent view of to-day, which regards any art as good if only it affords pleasure) considered, and consider, that art (as contrasted with speech, which need not be listened to) is so highly dangerous in its power to infect people

[1] "The foundling of Nuremberg," found in the market-place of that town on 26th May 1828, apparently some sixteen years old. He spoke little, and was almost totally ignorant even of common objects. He subsequently explained that he had been brought up in confinement underground, and visited by only one man, whom he saw but seldom.—Trans.

against their wills, that mankind will lose far less by banishing all art than by tolerating each and every art.

Evidently such people were wrong in repudiating all art, for they denied that which cannot be denied—one of the indispensable means of communication, without which mankind could not exist. But not less wrong are the people of civilised European society of our class and day, in favouring any art if it but serves beauty, *i.e.* gives people pleasure.

Formerly, people feared lest among the works of art there might chance to be some causing corruption, and they prohibited art altogether. Now, they only fear lest they should be deprived of any enjoyment art can afford, and patronise any art. And I think the last error is much grosser than the first, and that its consequences are far more harmful.

. . .

But how could it happen that that very art, which in ancient times was merely tolerated (if tolerated at all), should have come, in our times, to be invariably considered a good thing if only it affords pleasure?

It has resulted from the following causes. The estimation of the value of art (*i.e.* of the feelings it transmits) depends on men's perception of the meaning of life; depends on what they consider to be the good and the evil of life. And what is good and what is evil is defined by what are termed religions.

Humanity unceasingly moves forward from a lower, more partial, and obscure understanding of life, to one more general and more lucid. And in this, as in every movement, there are leaders,—those who have understood the meaning of life more clearly than others,—and of these advanced men there is always one who has, in his words and by his life, expressed this meaning more clearly, accessibly, and strongly than others. This man's expression of the meaning of life, together with those superstitions, traditions, and ceremonies which usually form themselves round the memory of such a man, is what is called a religion. Religions are the exponents of the highest comprehension of life accessible to the best and foremost men at a given time in a given society; a comprehension towards which, inevitably and irresistibly, all the rest of that society must advance. And therefore only religions have always served, and still serve, as bases for the valuation of human sentiments. If feelings bring men nearer the ideal their religion indicates, if they are in harmony with it and do not contradict it, they are good; if they estrange men from it and oppose it, they are bad.

If the religion places the meaning of life in worshipping one God and fulfilling what is regarded as His will, as was the case among the Jews, then the feelings flowing from love to that God, and to His law, successfully transmitted through the art of poetry by the prophets, by the psalms, or by the epic of the book of Genesis, is good, high art. All opposing that,

as for instance the transmission of feelings of devotion to strange gods, or of feelings incompatible with the law of God, would be considered bad art. Or if, as was the case among the Greeks, the religion places the meaning of life in earthly happiness, in beauty and in strength, then art successfully transmitting the joy and energy of life would be considered good art, but art which transmitted feelings of effeminacy or despondency would be bad art. If the meaning of life is seen in the well-being of one's nation, or in honouring one's ancestors and continuing the mode of life led by them, as was the case among the Romans and the Chinese respectively, then art transmitting feelings of joy at sacrificing one's personal well-being for the common weal, or at exalting one's ancestors and maintaining their traditions, would be considered good art; but art expressing feelings contrary to this would be regarded as bad. If the meaning of life is seen in freeing oneself from the yoke of animalism, as is the case among the Buddhists, then art successfully transmitting feelings that elevate the soul and humble the flesh will be good art, and all that transmits feelings strengthening the bodily passions will be bad art.

In every age, and in every human society, there exists a religious sense, common to that whole society, of what is good and what is bad, and it is this religious conception that decides the value of the feelings transmitted by art. And therefore, among all nations, art which transmitted feelings considered to be good by this general religious sense was recognised as being good and was encouraged; but art which transmitted feelings considered to be bad by this general religious conception, was recognised as being bad, and was rejected.

. . .

Art, in our society, has been so perverted that not only has bad art come to be considered good, but even the very perception of what art really is has been lost. In order to be able to speak about the art of our society, it is, therefore, first of all necessary to distinguish art from counterfeit art.

There is one indubitable indication distinguishing real art from its counterfeit, namely, the infectiousness of art. If a man, without exercising effort and without altering his standpoint, on reading, hearing, or seeing another man's work, experiences a mental condition which unites him with that man and with other people who also partake of that work of art, then the object evoking that condition is a work of art. And however poetical, realistic, effectful, or interesting a work may be, it is not a work of art if it does not evoke that feeling (quite distinct from all other feelings) of joy, and of spiritual union with another (the author) and with others (those who are also infected by it).

It is true that this indication is an *internal* one, and that there are people who have forgotten what the action of real art is, who expect something else from art (in our society the great majority are in this

state), and that therefore such people may mistake for this æsthetic feeling the feeling of divertisement and a certain excitement which they receive from counterfeits of art. But though it is impossible to undeceive these people, just as it is impossible to convince a man suffering from "Daltonism" that green is not red, yet, for all that, this indication remains perfectly definite to those whose feeling for art is neither perverted nor atrophied, and it clearly distinguishes the feeling produced by art from all other feelings.

The chief peculiarity of this feeling is that the receiver of a true artistic impression is so united to the artist that he feels as if the work were his own and not someone else's,—as if what it expresses were just what he had long been wishing to express. A real work of art destroys, in the consciousness of the receiver, the separation between himself and the artist, nor that alone, but also between himself and all whose minds receive this work of art. In this freeing of our personality from its separation and isolation, in this uniting of it with others, lies the chief characteristic and the great attractive force of art.

If a man is infected by the author's condition of soul, if he feels this emotion and this union with others, then the object which has effected this is art; but if there be no such infection, if there be not this union with the author and with others who are moved by the same work—then it is not art. And not only is infection a sure sign of art, but the degree of infectiousness is also the sole measure of excellence in art.

The stronger the infection the better is the art, as art, speaking now apart from its subject-matter, *i.e.* not considering the quality of the feelings it transmits.

And the degree of the infectiousness of art depends on three conditions: —

(1) On the greater or lesser individuality of the feeling transmitted; (2) on the greater or lesser clearness with which the feeling is transmitted; (3) on the sincerity of the artist, *i.e.* on the greater or lesser force with which the artist himself feels the emotion he transmits.

The more individual the feeling transmitted the more strongly does it act on the receiver; the more individual the state of soul into which he is transferred the more pleasure does the receiver obtain, and therefore the more readily and strongly does he join in it.

The clearness of expression assists infection, because the receiver, who mingles in consciousness with the author, is the better satisfied the more clearly the feeling is transmitted, which, as it seems to him, he has long known and felt, and for which he has only now found expression.

But most of all is the degree of infectiousness of art increased by the degree of sincerity in the artist. As soon as the spectator, hearer, or reader feels that the artist is infected by his own production, and writes, sings, or plays for himself and not merely to act on others, this mental condition of the artist infects the receiver; and, contrariwise, as soon as the spectator,

reader, or hearer feels that the author is not writing, singing, or playing for his own satisfaction,—does not himself feel what he wishes to express, —but is doing it for him, the receiver, a resistance immediately springs up, and the most individual and the newest feelings and the cleverest technique not only fail to produce any infection but actually repel.

I have mentioned three conditions of contagiousness in art, but they may all be summed up into one, the last, sincerity, *i.e.* that the artist should be impelled by an inner need to express his feeling. That condition includes the first; for if the artist is sincere he will express the feeling as he experienced it. And as each man is different from everyone else, his feeling will be individual for everyone else; and the more individual it is,—the more the artist has drawn it from the depths of his nature,— the more sympathetic and sincere will it be. And this same sincerity will impel the artist to find a clear expression of the feeling which he wishes to transmit.

Therefore this third condition—sincerity—is the most important of the three. It is always complied with in peasant art, and this explains why such art always acts so powerfully; but it is a condition almost entirely absent from our upper-class art, which is continually produced by artists actuated by personal aims of covetousness or vanity.

Such are the three conditions which divide art from its counterfeits, and which also decide the quality of every work of art apart from its subject-matter.

The absence of any one of these conditions excludes a work from the category of art and relegates it to that of art's counterfeits. If the work does not transmit the artist's peculiarity of feeling, and is therefore not individual, if it is unintelligibly expressed, or if it has not proceeded from the author's inner need for expression—it is not a work of art. If all these conditions are present, even in the smallest degree, then the work, even if a weak one, is yet a work of art.

The presence in various degrees of these three conditions: individuality, clearness, and sincerity, decides the merit of a work of art, as art, apart from subject-matter. All works of art take rank of merit according to the degree in which they fulfil the first, the second, and the third of these conditions. In one the individuality of the feeling transmitted may predominate; in another, clearness of expression; in a third, sincerity; while a fourth may have sincerity and individuality but be deficient in clearness; a fifth, individuality and clearness, but less sincerity; and so forth, in all possible degrees and combinations.

Thus is art divided from not art, and thus is the quality of art, as art, decided, independently of its subject-matter, *i.e.* apart from whether the feelings it transmits are good or bad.

But how are we to define good and bad art with reference to its subject-matter?

· · ·

Art, like speech, is a means of communication, and therefore of progress, *i.e.* of the movement of humanity forward towards perfection. Speech renders accessible to men of the latest generations all the knowledge discovered by the experience and reflection, both of preceding generations and of the best and foremost men of their own times; art renders accessible to men of the latest generations all the feelings experienced by their predecessors, and those also which are being felt by their best and foremost contemporaries. And as the evolution of knowledge proceeds by truer and more necessary knowledge dislodging and replacing what is mistaken and unnecessary, so the evolution of feeling proceeds through art,—feelings less kind and less needful for the well-being of mankind are replaced by others kinder and more needful for that end. That is the purpose of art. And, speaking now of its subject-matter, the more art fulfils that purpose the better the art, and the less it fulfils it the worse the art.

And the appraisement of feelings (*i.e.* the acknowledgment of these or those feelings as being more or less good, more or less necessary for the well-being of mankind) is made by the religious perception of the age.

In every period of history, and in every human society, there exists an understanding of the meaning of life which represents the highest level to which men of that society have attained,—an understanding defining the highest good at which that society aims. And this understanding is the religious perception of the given time and society. And this religious perception is always clearly expressed by some advanced men, and more or less vividly perceived by all the members of the society. Such a religious perception and its corresponding expression exists always in every society. If it appears to us that in our society there is no religious perception, this it not because there really is none, but only because we do not want to see it. And we often wish not to see it because it exposes the fact that our life is inconsistent with that religious perception.

Religious perception in a society is like the direction of a flowing river. If the river flows at all, it must have a direction. If a society lives, there must be a religious perception indicating the direction in which, more or less consciously, all its members tend.

And so there always has been, and there is, a religious perception in every society. And it is by the standard of this religious perception that the feelings transmitted by art have always been estimated. Only on the basis of this religious perception of their age have men always chosen from the endlessly varied spheres of art that art which transmitted feelings making religious perception operative in actual life. And such art has always been highly valued and encouraged; while art transmitting feelings already outlived, flowing from the antiquated religious perceptions of a former age, has always been condemned and despised. All the rest of art, transmitting those most diverse feelings by means of which people commune together, was not condemned, and was tolerated, if only it did not transmit feelings contrary to religious perception. Thus, for

instance, among the Greeks, art transmitting the feeling of beauty, strength, and courage (Hesiod, Homer, Phidias) was chosen, approved, and encouraged; while art transmitting feelings of rude sensuality, despondency, and effeminacy was condemned and despised. Among the Jews, art transmitting feelings of devotion and submission to the God of the Hebrews and to His will (the epic of Genesis, the prophets, the Psalms) was chosen and encouraged, while art transmitting feelings of idolatry (the golden calf) was condemned and despised. All the rest of art— stories, songs, dances, ornamentation of houses, of utensils, and of clothes —which was not contrary to religious perception, was neither distinguished nor discussed. Thus, in regard to its subject-matter, has art been appraised always and everywhere, and thus it should be appraised, for this attitude towards art proceeds from the fundamental characteristics of human nature, and those characteristics do not change.

I know that according to an opinion current in our times, religion is a superstition, which humanity has outgrown, and that it is therefore assumed that no such thing exists as a religious perception common to us all by which art, in our time, can be estimated. I know that this is the opinion current in the pseudo-cultured circles of to-day. People who do not acknowledge Christianity in its true meaning because it undermines all their social privileges, and who, therefore, invent all kinds of philosophic and æsthetic theories to hide from themselves the meaninglessness and wrongness of their lives, cannot think otherwise. These people intentionally, or sometimes unintentionally, confusing the conception of a religious cult with the conception of religious perception, think that by denying the cult they get rid of religious perception. But even the very attacks on religion, and the attempts to establish a life-conception contrary to the religious perception of our times, most clearly demonstrate the existence of a religious perception condemning the lives that are not in harmony with it.

If humanity progresses, *i.e.* moves forward, there must inevitably be a guide to the direction of that movement. And religions have always furnished that guide. All history shows that the progress of humanity is accomplished not otherwise than under the guidance of religion. But if the race cannot progress without the guidance of religion,—and progress is always going on, and consequently also in our own times,—then there must be a religion of our times. So that, whether it pleases or displeases the so-called cultured people of to-day, they must admit the existence of religion—not of a religious cult, Catholic, Protestant, or another, but of religious perception—which, even in our times, is the guide always present where there is any progress. And if a religious perception exists amongst us, then our art should be appraised on the basis of that religious perception; and, as has always and everywhere been the case, art transmitting feelings flowing from the religious perception of our time should be chosen from all the indifferent art, should be acknowledged, highly

esteemed, and encouraged; while art running counter to that perception should be condemned and despised, and all the remaining indifferent art should neither be distinguished nor encouraged.

The religious perception of our time, in its widest and most practical application, is the consciousness that our well-being, both material and spiritual, individual and collective, temporal and eternal, lies in the growth of brotherhood among all men—in their loving harmony with one another. This perception is not only expressed by Christ and all the best men of past ages, it is not only repeated in the most varied forms and from most diverse sides by the best men of our own times, but it already serves as a clue to all the complex labour of humanity, consisting as this labour does, on the one hand, in the destruction of physical and moral obstacles to the union of men, and, on the other hand, in establishing the principles common to all men which can and should unite them into one universal brotherhood.

And it is on the basis of this perception that we should appraise all the phenomena of our life, and, among the rest, our art also; choosing from all its realms whatever transmits feelings flowing from this religious perception, highly prizing and encouraging such art, rejecting whatever is contrary to this perception, and not attributing to the rest of art an importance not properly pertaining to it.

The chief mistake made by people of the upper classes of the time of the so-called Renaissance,—a mistake which we still perpetuate,—was not that they ceased to value and to attach importance to religious art (people of that period could not attach importance to it, because, like our own upper classes, they could not believe in what the majority considered to be religion), but their mistake was that they set up in place of religious art which was lacking, an insignificant art which aimed only at giving pleasure, *i.e.* they began to choose, to value, and to encourage, in place of religious art, something which, in any case, did not deserve such esteem and encouragement.

One of the Fathers of the Church said that the great evil is not that men do not know God, but that they have set up, instead of God, that which is not God. So also with art. The great misfortune of the people of the upper classes of our time is not so much that they are without a religious art, as that, instead of a supreme religious art, chosen from all the rest as being specially important and valuable, they have chosen a most insignificant and, usually, harmful art, which aims at pleasing certain people, and which, therefore, if only by its exclusive nature, stands in contradiction to that Christian principle of universal union which forms the religious perception of our time. Instead of religious art, an empty and often vicious art is set up, and this hides from men's notice the need of that true religious art which should be present in life in order to improve it.

It is true that art which satisfies the demands of the religious perception of our time is quite unlike former art, but, notwithstanding this

dissimilarity, to a man who does not intentionally hide the truth from himself, it is very clear and definite what does form the religious art of our age. In former times, when the highest religious perception united only some people (who, even if they formed a large society, were yet but one society surrounded by others—Jews, or Athenian or Roman citizens), the feelings transmitted by the art of that time flowed from a desire for the might, greatness, glory, and prosperity of that society, and the heroes of art might be people who contributed to that prosperity by strength, by craft, by fraud, or by cruelty (Ulysses, Jacob, David, Samson, Hercules, and all the heroes). But the religious perception of our times does not select any one society of men; on the contrary, it demands the union of all—absolutely of all people without exception—and above every other virtue it sets brotherly love to all men. And, therefore, the feelings transmitted by the art of our time not only cannot coincide with the feelings transmitted by former art, but must run counter to them.

EDUARD HANSLICK

THE BEAUTIFUL IN MUSIC

Eduard Hanslick (1825–1904) was a highly influential Austrian music critic who developed a formalist theory of music.

Has Music any subject? This has been a burning question ever since people began to reflect upon music. It has been answered both in the affirmative and in the negative. Many prominent men, almost exclusively *philosophers*, among whom we may mention Rousseau, Kant, Hegel, Herbart, Kahlert, &c., hold that music has no subject. The numerous physiologists who endorse this view include such eminent thinkers as Lotze and Helmholtz, whose opinions, strengthened as they are by musical knowledge, carry great weight and authority. Those who contend that music *has a subject* are numerically far stronger: among them are the trained *musicians* of the literary profession, and their convictions are shared by the bulk of the public.

It may seem almost a matter for surprise that just those who are familiar with the technical side of music should be unwilling to concede the

Reprinted from *The Beautiful in Music*, translated by Gustav Cohen, London and New York, 1891, pp. 160–174, Novello, Ewer and Co., 1891.

untenableness of a doctrine which is at variance with those very technical principles, and which thinkers on abstract subjects might perhaps be pardoned for propounding. The reason is, that many of these musical authors are more anxious to save the so-called honour of their art than to ascertain the truth. They attack the doctrine that music has no subject, not as one opinion against another, but as heresy against dogma. The contrary view appears to them in the light of a degrading error and a form of crude and heinous materialism. "What! the art that charms and elevates us; to which so many noble minds have devoted a whole lifetime; which is the vehicle of the most sublime thoughts; *that* art to be cursed with unmeaningness, to be mere food for the senses, mere empty sound!" Hackneyed exclamations of this description which, though made up of several disconnected propositions, are generally uttered in one breath, neither prove nor disprove anything. The question is not a point of honour, not a party-badge, but simply the discovery of truth; and in order to attain this object, it is of the first importance to be clear regarding the points which are under debate.

It is the indiscriminate use of the terms, *contents, subject, matter,* which has been, and still is, responsible for all this ambiguity; the same meaning being expressed by different terms, or the same term associated with different meanings. "*Contents,*" in the true and original sense, is that which a thing *contains,* what it holds within. The *notes* of which a piece of music is composed, and which are the parts that go to make up the whole, are the contents in this sense. The circumstance that nobody will accept this definition as a satisfactory solution, but that it is dismissed as a truism, is due to the word "contents" (subject) being usually confounded with the word "object." An enquiry into the "contents" of musical compositions raises in such people's minds the conception of an "*object*" (subject-matter; topic), which latter, being the idea, the ideal element, they represent to themselves as almost antithetical to the "material part," the musical notes. Music has, indeed, no contents as thus understood; no *subject* in the sense that the subject to be treated is something extraneous to the musical notes. Kahlert is right in emphatically maintaining that music, unlike painting, admits of no "description in words" (Æsth. 380), though his subsequent assumption that a description in words may, at times, "compensate for the want of æsthetic enjoyment," is false. It may be the means, however, of clearly perceiving the real bearing of the question. The query "what" is the subject of the music, must necessarily be answerable in words, if music really has a "*subject,*" because an "indefinite subject" upon which everyone puts a different construction, which can only be felt and not translated into words, is not a subject as we have defined it.

Music consists of successions and forms of sound, and these alone constitute the subject. They again remind us of architecture and dancing which likewise aim at beauty in form and motion, and are also devoid of

a definite subject. Now, whatever be the effect of a piece of music on the individual mind, and howsoever it be interpreted, it has no *subject* beyond the combinations of notes we hear, for music does not only speak *by means of sounds*, it speaks nothing but *sound*.

Krüger—the opponent of Hegel and Kahlert—who is probably the most learned advocate of the doctrine that music has a "subject"—contends that this art presents but a different side of the subject which other arts, such as painting, represent. "All plastic figures," he says (Beiträge, 131), "are in a state of quiescence; they do not exhibit present, but past action, or the state of things at a given moment. The painting, therefore, does not show Apollo vanquishing, but it represents the victor, the furious warrior," &c. Music, on the other hand, "supplies to those plastic and quiescent forms the motive force, the active principle, the inner waves of motion; and whereas in the former instance we knew the true, but inert subject, to be anger, love, &c., we here know the true and active subject to be loving, rushing, heaving, storming, fuming." The latter portion is only partly true, for though music may be said to "rush, heave, and storm," it can neither "love" nor be "angry." These sentiments we ourselves import into the music, and we must here refer our readers to the second chapter of this book. Krüger then proceeds to compare the definiteness of the *painter's subject* with the *musical subject*, and remarks: "The *painter* represents Orestes, pursued by the Furies: his outward appearance, his eyes, mouth, forehead, and posture, give us the impression of flight, gloom, and despair; at his heels the spirits of divine vengeance, whose imperious and sublimely terrible commands he cannot evade, but who likewise present unchanging outlines, features, and attitudes. The *composer* does not exhibit fleeing Orestes in fixed lines, but from a point of view from which the painter cannot portray him: he puts into his music the tremor and shuddering of his soul, his inmost feelings at war, urging his flight," &c. This, in our opinion, is entirely false; the composer is unable to represent Orestes either in one way or another; in fact, *he cannot represent him at all*.

The objection that sculpture and painting are also unable to represent to us a given historical personage, and that we could not know the figure to be *this very* individual, but for our previous knowledge of certain historical facts, does not hold good. True, the figure does not proclaim itself to be Orestes; the man who has gone through such or such experiences, and whose existence is bound up with certain biographic incidents; none but the *poet* can represent that, since he alone can narrate the events; but the painting "Orestes" unequivocally shows us a youth with noble features, in Greek attire, his looks and attitude betokening fear and mental anguish; and it shows us this youth pursued and tormented by the awe-inspiring goddesses of vengeance. All this is clear and indubitable; a visible narrative—no matter whether the youth be called Orestes or otherwise. Only the antecedent causes—namely, that the youth has committed matricide,

&c., cannot be expressed. Now, what can music give us in point of definiteness as a counterpart to the visible subject of the painter—apart from the historical element? Chords of a diminished seventh, themes in minor keys, a rolling bass, &c.—musical forms, in brief, which might signify a woman just as well as a youth; one pursued by myrmidons instead of furies; somebody tortured by jealousy or by bodily pain; one bent on revenge—in short, anything we can think of, if we must needs imagine a subject for the composition.

It seems almost superfluous to expressly recall the proposition, already established by us, that whenever the subject and the descriptive power of music are under debate, *instrumental music* alone can be taken into account. Nobody is likely to disregard this so far as to instance Orestes in Gluck's "Iphigenia," for this "Orestes" is not the *composer's* creation. The words of the poet, the appearance and gestures of the actor, the costume and the painter's decorations produce the complete Orestes. The composer's contribution—the melody—is possibly the most *beautiful* part of all, but it happens to be just that factor which has nothing whatever to do with the real Orestes.

Lessing has shown with admirable perspicuity what the poet and what the sculptor or painter may make of the story of Laocoon. The poet by the aid of speech gives us the historical, individually-defined Laocoon; the painter and sculptor shows us the terrible serpents, crushing in their coils an old man and two boys (of determinate age and appearance, dressed after a particular fashion, &c.), who by their looks, attitudes, and gestures express the agonies of approaching death. Of the *composer* Lessing says nothing, and this was only to be expected, since there is nothing in "Laocoon" which could be turned into music.

We have already alluded to the intimate connection between the question of *subject* in musical compositions and the relation of music to the *beauties of Nature*. The composer looks in vain for models such as those which render the subjects of other art-products both definite and recognisable, and an art for which Nature can provide no æsthetic model must, properly speaking, be incorporeal. A prototype of its mode of manifestation is nowhere to be met with, and it can, therefore, not be included in the range of living experiences. It does not reproduce an already known and classified subject, and for this reason it has no subject that can be taken hold of by the intellect, as the latter can be exercised only on definite conceptions.

The term *subject* (substance) can, properly speaking, be applied to an art-product only, if we regard it as the correlative of *form*. The terms "form" and "substance" supplement each other, and one cannot be thought of except in relation to the other. Wherever the "form" appears mentally inseparable from the "substance," there can be no question of an independent "substance" (subject). Now, in music, substance and form, the subject and its working out, the image and the realised conception are

mysteriously blended in one undecomposable whole. This complete fusion of substance and form is exclusively characteristic of music, and presents a sharp contrast to poetry, painting, and sculpture, inasmuch as these arts are capable of representing the same idea and the same event in different forms. The story of William Tell supplied to Florian the subject for a historical novel, to Schiller the subject for a play, while Goethe began to treat it as an epic poem. The substance is everywhere the same, equally resolvable into prose, and capable of being narrated; always clearly recognisable, and yet the form differs in each case. Aphrodite emerging from the sea is the subject of innumerable paintings and statues, the various forms of which it is, nevertheless, impossible to confuse. In music, no distinction can be made between substance and form, as it has no form independently of the substance. Let us look at this more closely.

In all compositions the independent, æsthetically undecomposable subject of a musical conception is the *theme*, and by the theme, the musical microcosm, we should always be able to test the alleged subject underlying the music as such. Let us examine the leading theme of some composition, say that of Beethoven's Symphony in B flat major. What is its subject (substance)? What its form? Where does the latter commence and the former end? That its subject does not consist of a determinate feeling, we think we have conclusively proved, and this truth becomes only the more evident when tested by this or by any other concrete example. What then is to be called its *subject?* The groups of sounds? Undoubtedly; but they have a form already. And what is the *form?* The groups of sounds again; but here they are a *replete* form. Every practical attempt at resolving a theme into subject and form ends in arbitrariness and contradiction. Take, for instance, a theme repeated by another instrument or in the higher octave. Is the subject changed thereby or the form? If, as is generally the case, the latter is said to be changed, then all that remains as the *subject* of the theme would simply be the series of intervals, the skeleton frame for the musical notation as the score presents them to the eye. But this is not *musical* definiteness, it is an abstract notion. It may be likened to a pavilion with stained window panes, through which the same environment appears, now red, now blue, and now yellow. The environment itself changes neither in *substance* nor in *form*, but merely in *colour*. This property of exhibiting the same forms in countless hues, from the most glaring contrasts down to the finest distinction of shade, is quite peculiar to music and is one of the most fertile and powerful causes of its effectiveness.

A theme originally composed for the piano and subsequently arranged for the orchestra acquires thereby a *new form* but not a *form for the first time*, the formal element being part and parcel of the primary conception. The assertion that a theme by the process of instrumentation changes its subject while retaining its form is even less tenable, as such a theory involves still greater contradictions, the listener being obliged to affirm,

that though he recognises it to be the same subject "it somehow sounds like a different one."

It is true that in looking at a composition in the aggregate and more particularly at musical works of great length, we are in the habit of speaking of form and subject; in such a case, however, these terms are not understood in their primitive and logical sense, but in a specifically *musical* one. What we call the "form" of a Symphony, an Overture, a Sonata, an Aria, a Chorus, &c., is the architectonic combination of the units and groups of units of which a composition is made up; or more definitely speaking, the symmetry of their successions, their contrasts, repetitions, and general working out. But thus understood the subject is identical with the *themes* with which this architectonic structure is built up. Subject is here, therefore, no longer construed in the sense of an "object," but as the subject in a purely musical sense. The words "substance" and "form" in respect of entire compositions are used in an æsthetic, and not in a strictly logical sense. If we wish to apply them to music in the latter sense, we must do so, not in relation to the composition in the aggregate, as a whole consisting of parts, but in relation to its ultimate and æsthetically undecomposable idea. This ultimate idea is the *theme* or *themes*, and in the latter substance and form are indissolubly connected. We cannot acquaint anybody with the "subject" of a theme, *except by playing it.* The subject of a composition can, therefore, not be understood as an object derived from an external source, but as something intrinsically musical; in other words, as the concrete group of sounds in a piece of music. Now, as a composition must comply with the formal laws of beauty, it cannot run on arbitrarily and at random, but must develop gradually with intelligible and organic definiteness, as buds develop into rich blossoms.

Here we have the *principal theme;* the true topic or subject of the entire composition. Everything it contains, though originated by the unfettered imagination, is nevertheless the natural outcome and effect of the theme which determines and forms, regulates and pervades its every part. We may compare it to a self-evident truth which we accept for a moment as satisfactory, but which our mind would fain see tested and developed, and in the musical working out this development takes place analogously to the logical train of reasoning in an argument. The theme, not unlike the chief hero in a novel, is brought by the composer into the most varied states and surrounding conditions, and is made to pass through ever-changing phases and moods—everything, no matter what contrasts it may present, is conceived and formed in relation to the theme.

The epithet *without a subject*, might possibly be applied to the freest form of extemporising, during which the performer indulges in chords, arpeggios, and rosalias, by way of a rest, rather than as a creative effort, and which does not end in the production of a definite and connected whole. Such extempore playing has no individuality of its own, by which

one might recognise or distinguish it, and it would be quite correct to say that it has no subject (in the wider sense of the term), because it has no theme.

Thus the theme or the themes are the real subject of a piece of music.

In æsthetic and critical reviews far too little importance is attached to the *leading theme* of a composition; it alone reveals at once the mind which conceived the work. Every musician, on hearing the first few opening bars of Beethoven's Overture to "Leonore" or Mendelssohn's Overture to "The Hebrides," though he may be totally unaware of the subsequent development of the theme, must recognise at once the treasure that lies before him; whereas the music of a theme from Donizetti's "Fausta" Overture or Verdi's Overture to "Louisa Miller" will, without the need of further examination, convince us that the music is fit only for low music halls. German theorists and executants prize the musical working-out far more than the inherent merits of the theme. But whatever is not contained in the theme (be it overtly or in disguise) is incapable of organic growth, and if the present time is barren of orchestral works of the Beethoven type it is, perhaps, due not so much to an imperfect knowledge of the working out, as to the want of symphonic power and fertility of the *themes*.

On enquiring into the *subject* of music we should, above all, beware of using the term "subject" in a eulogistic sense. From the fact that music has no extrinsic subject (object) it does not follow that it is without any *intrinsic merit*. It is clear that those who, with the zeal of partisanship, contend that music has a "subject," really mean "intellectual merit." We can only ask our readers to revert to our remarks in the third chapter of this book. Music is to be played, but it is not to be played with. Thoughts and feelings pervade with vital energy the musical organism, the embodiment of beauty and symmetry, and though they are not identical with the *organism itself* nor yet *visible*, they are, as it were, its breath of life. The composer *thinks* and *works;* but he thinks and works in *sound*, away from the realities of the external world. We deliberately repeat this commonplace, for even those who admit it in principle, deny and violate it when carried to its logical conclusions. They conceive the act of composing as a translation into sound of a given subject, whereas the sounds themselves are the untranslatable and original tongue. If the composer is obliged to think in sounds, it follows as a matter of course that music has no subject external to itself, for of a subject in this sense we ought to be able to think in *words*.

Though, when examining into the *subject* of music, we rigorously excluded compositions written for given sets of words as being inconsistent with the conception of music pure and simple, yet the masterpieces of vocal music are indispensable for the formation of an accurate judgment respecting the *intrinsic worth* of music. From the simple song to the complex opera and the time-honoured practice of using music for the celebration of religious services, music has never ceased to accompany the

most tender and profound affections of the human mind and has thus been the indirect means of glorifying them.

Apart from the existence of an *intrinsic merit*, there is a second corollary which we wish to emphasize. Though music possesses beauty of form without any extrinsic subject, this does not deprive it of the quality of *individuality*. The act of inventing a certain theme, and the mode of working it out, are always so unique and specific as to defy their inclusion in a wider generality. These processes are distinctly and unequivocally *individual* in nature. A theme of Mozart or Beethoven rests on as firm and independent a foundation as a poem by Goethe, an epigram by Lessing, a statue by Thorwaldsen, or a painting by Overbeck. The independent musical thoughts (themes) possess the identity of a quotation and the distinctness of a painting; they are individual, personal, eternal.

Unable, as we were, to endorse Hegel's opinion respecting the want of intellectual merit in music, it seems to us a still more glaring error on his part to assert that the sole function of music is the expressing of an "inner non-individuality." Even from Hegel's musical point of view, which, while overlooking the inherently form-giving and objective activity of the composer, conceives music as the free manifestation of purely *subjective states*, its want of individuality follows by no means, since the subjectively-producing mind is essentially individual.

How the individuality shows itself in the choice and working out of the various musical elements, we have already pointed out in the third chapter. The *stigma* that music has no subject is, therefore, quite unmerited. Music has a subject—*i.e.*, a musical subject, which is no less a vital spark of the divine fire than the beautiful of any other art. Yet, only by steadfastly denying the existence of any other "subject" in music, is it possible to save its "true subject." The indefinite emotions which at best underlie the other kind of subject, do not explain its spiritual force. The latter can only be attributed to the definite beauty of musical form, as the result of the untrammeled working of the human mind on material susceptible of intellectual manipulation.

EDWARD BULLOUGH

'PSYCHICAL DISTANCE'
AS A FACTOR IN ART
AND AS AN AESTHETIC PRINCIPLE

Edward Bullough (1880–1934) was Professor of Italian Literature at Cambridge University. Like Kant, he stressed the importance of disinterestedness in the appreciation of a work of art.

I

1. The conception of 'Distance' suggests, in connection with Art, certain trains of thought by no means devoid of interest or of speculative importance. Perhaps the most obvious suggestion is that of *actual spatial* distance, i.e. the distance of a work of Art from the spectator, or that of *represented spatial* distance, i.e. the distance represented within the work. Less obvious, more metaphorical, is the meaning of *temporal* distance. The first was noticed already by Aristotle in his *Poetics;* the second has played a great part in the history of painting in the form of perspective; the distinction between these two kinds of distance assumes special importance theoretically in the differentiation between sculpture in the round, and relief-sculpture. Temporal distance, remoteness from us in point of time,

Reprinted from *Aesthetics*, edited by Elizabeth M. Wilkinson, London, Bowes & Bowes, Ltd., 1957, pp. 93–117, by permission of the publishers.

though often a cause of misconceptions, has been declared to be a factor of considerable weight in our appreciation.

It is not, however, in any of these meanings that 'Distance' is put forward here, though it will be clear in the course of this essay that the above-mentioned kinds of distance are rather special forms of the conception of Distance as advocated here, and derive whatever *æsthetic* qualities they may possess from Distance in its *general* connotation. This general connotation is 'Psychical Distance'.

A short illustration will explain what is meant by 'Psychical Distance'. Imagine a fog at sea: for most people it is an experience of acute unpleasantness. Apart from the physical annoyance and remoter forms of discomfort such as delays, it is apt to produce feelings of peculiar anxiety, fears of invisible dangers, strains of watching and listening for distant and unlocalised signals. The listless movements of the ship and her warning calls soon tell upon the nerves of the passengers; and that special, expectant, tacit anxiety and nervousness, always associated with this experience, make a fog the dreaded terror of the sea (all the more terrifying because of its very silence and gentleness) for the expert seafarer no less than for the ignorant landsman.

Nevertheless, a fog at sea can be a source of intense relish and enjoyment. Abstract from the experience of the sea fog, for the moment, its danger and practical unpleasantness, just as every one in the enjoyment of a mountain-climb disregards its physical labour and its danger (though, it is not denied, that these may incidentally enter into the enjoyment and enhance it); direct the attention to the features 'objectively' constituting the phenomenon—the veil surrounding you with an opaqueness as of transparent milk, blurring the outline of things and distorting their shapes into weird grotesqueness; observe the carrying-power of the air, producing the impression as if you could touch some far-off siren by merely putting out your hand and letting it lose itself behind that white wall; note the curious creamy smoothness of the water, hypocritically denying as it were any suggestion of danger; and, above all, the strange solitude and remoteness from the world, as it can be found only on the highest mountain-tops: and the experience may acquire, in its uncanny mingling of repose and terror, a flavour of such concentrated poignancy and delight as to contrast sharply with the blind and distempered anxiety of its other aspects. This contrast, often emerging with startling suddenness, is like a momentary switching on of some new current, or the passing ray of a brighter light, illuminating the outlook upon perhaps the most ordinary and familiar objects—an impression which we experience sometimes in instants of direst extremity, when our practical interest snaps like a wire from sheer over-tension, and we watch the consummation of some impending catastrophe with the marvelling unconcern of a mere spectator.

It is a difference of outlook, due—if such a metaphor is permissible— to the insertion of Distance. This Distance appears to lie between our own

self and its affections, using the latter term in its broadest sense as anything which affects our being, bodily or spiritually, e.g. as sensation, perception, emotional state or idea. Usually, though not always, it amounts to the same thing to say that the Distance lies between our own self and such objects as are the sources or vehicles of such affections.

Thus, in the fog, the transformation by Distance is produced in the first instance by putting the phenomenon, so to speak, out of gear with our practical, actual self; by allowing it to stand outside the context of our personal needs and ends—in short, by looking at it 'objectively', as it has often been called, by permitting only such reactions on our part as emphasise the 'objective' features of the experience, and by interpreting even our 'subjective' affections not as modes of *our* being but rather as characteristics of the phenomenon.

The working of Distance is, accordingly, not simple, but highly complex. It has a *negative*, inhibitory aspect—the cutting-out of the practical sides of things and of our practical attitude to them—and a *positive* side— the elaboration of the experience on the new basis created by the inhibitory action of Distance.

2. Consequently, this distanced view of things is not, and cannot be, our normal outlook. As a rule, experiences constantly turn the same side towards us, namely, that which has the strongest practical force of appeal. We are not ordinarily aware of those aspects of things which do not touch us immediately and practically, nor are we generally conscious of impressions apart from our own self which is impressed. The sudden view of things from their reverse, usually unnoticed, side, comes upon us as a revelation, and such revelations are precisely those of Art. In this most general sense, Distance is a factor in all Art.

3. It is, for this very reason, also an æsthetic principle. The æsthetic contemplation and the æsthetic outlook have often been described as 'objective'. We speak of 'objective' artists as Shakespeare or Velasquez, of 'objective' works or art-forms as Homer's *Iliad* or the drama. It is a term constantly occurring in discussions and criticisms, though its sense, if pressed at all, becomes very questionable. For certain forms of Art, such as lyrical poetry, are said to be 'subjective'; Shelley, for example, would usually be considered a 'subjective' writer. On the other hand, no work of Art can be genuinely 'objective' in the sense in which this term might be applied to a work on history or to a scientific treatise; nor can it be 'subjective' in the ordinary acceptance of that term, as a personal feeling, a direct statement of a wish or belief, or a cry of passion is subjective. 'Objectivity' and 'subjectivity' are a pair of opposites which in their mutual exclusiveness when applied to Art soon lead to confusion.

Nor are they the only pair of opposites. Art has with equal vigour been declared alternately 'idealistic' and 'realistic', 'sensual' and 'spiritual', 'individualistic' and 'typical'. Between the defence of either terms of such antitheses most æsthetic theories have vacilliated. It is one of the conten-

tions of this essay that such opposites find their synthesis in the more fundamental conception of Distance.

Distance further provides the much needed criterion of the beautiful as distinct from the merely agreeable.

Again, it marks one of the most important steps in the process of artistic creation and serves as a distinguishing feature of what is commonly so loosely described as the 'artistic temperament'.

Finally, it may claim to be considered as one of the essential characteristics of the 'æsthetic consciousness', if I may describe by this term that special mental attitude towards, and outlook upon, experience, which finds its most pregnant expression in the various forms of Art.

II

Distance, as I said before, is obtained by separating the object and its appeal from one's own self, by putting it out of gear with practical needs and ends. Thereby the 'contemplation' of the object becomes alone possible. But it does not mean that the relation between the self and the object is broken to the extent of becoming 'impersonal'. Of the alternatives 'personal' and 'impersonal' the latter surely comes nearer to the truth; but here, as elsewhere, we meet the difficulty of having to express certain facts in terms coined for entirely different uses. To do so usually results in paradoxes, which are nowhere more inevitable than in discussions upon Art. 'Personal' and 'impersonal', 'subjective' and 'objective' are such terms, devised for purposes other than æsthetic speculation, and becoming loose and ambiguous as soon as applied outside the sphere of their special meanings. In giving preference therefore to the term 'impersonal' to describe the relation between the spectator and a work of Art, it is to be noticed that it is not impersonal in the sense in which we speak of the 'impersonal' character of Science, for instance. In order to obtain 'objectively valid' results, the scientist excludes the 'personal factor', i.e. his personal wishes as to the validity of his results, his predilection for any particular system to be proved or disproved by his research. It goes without saying that all experiments and investigations are undertaken out of a personal interest in the science, for the ultimate support of a definite assumption, and involve personal hopes of success; but this does not affect the 'dispassionate' attitude of the investigator, under pain of being accused of 'manufacturing his evidence'.

1. Distance does not imply an impersonal, purely intellectually interested relation of such a kind. On the contrary, it describes a *personal* relation, often highly emotionally coloured, but *of a peculiar character*. Its peculiarity lies in that the personal character of the relation has been, so to speak, filtered. It has been cleared of the practical, concrete nature of its appeal, without, however, thereby losing its original constitution. One of the best-known examples is to be found in our attitude towards the events

and characters of the drama: they appeal to us like persons and incidents of normal experience, except that that side of their appeal, which would usually affect us in a directly personal manner, is held in abeyance. This difference, so well known as to be almost trivial, is generally explained by reference to the knowledge that the characters and situations are 'unreal', imaginary. In this sense Witasek[1] operating with Meinong's theory of *Annahmen*, has described the emotions involved in witnessing a drama as *Scheingefühle*, a term which has so frequently been misunderstood in discussions of his theories. But, as a matter of fact, the 'assumption' upon which the imaginative emotional reaction is based is not necessarily the condition, but often the consequence, of Distance; that is to say, the converse of the reason usually stated would then be true: viz. that Distance, by changing our relation to the characters, renders them seemingly fictitious, not that the fictitiousness of the characters alters our feelings toward them. It is, of course, to be granted that the actual and admitted unreality of the dramatic action reinforces the effect of Distance. But surely the proverbial unsophisticated yokel, whose chivalrous interference in the play on behalf of the hapless heroine can only be prevented by impressing upon him that 'they are only pretending', is not the ideal type of theatrical audience. The proof of the seeming paradox that it is Distance which primarily gives to dramatic action the appearance of unreality and not vice versa, is the observation that the same filtration of our sentiments and the same seeming 'unreality' of *actual* men and things occur, when at times, by a sudden change of inward perspective, we are overcome by the feeling that 'all the world's a stage'.

2. This personal, but 'distanced' relation (as I will venture to call this nameless character of our view) directs attention to a strange fact which appears to be one of the fundamental paradoxes of Art: it is what I propose to call 'the antinomy of Distance'.

It will be readily admitted that a work of Art has the more chance of appealing to us the better it finds us prepared for its particular kind of appeal. Indeed, without some degree of predisposition on our part, it must necessarily remain incomprehensible, and to that extent unappreciated. The success and intensity of its appeal would seem, therefore, to stand in direct proportion to the completeness with which it corresponds with our intellectual and emotional peculiarities and the idiosyncrasies of our experience. The absence of such a concordance between the characters of a work and of the spectator is, of course, the most general explanation for differences of 'tastes'.

At the same time, such a principle of concordance requires a qualification, which leads at once to the antinomy of Distance.

Suppose a man, who believes that he has cause to be jealous about his

[1] H. Witasek, 'Zur psychologischen Analyse der æsthetischen Einfühlung', *Ztsch. f. Psychol. u. Physiol. der Sinnesorg.*, 1901, xxv, 1 ff.; *Grundzüge der Aesthetik*, Leipzig, 1904.

wife, witnesses a performance of *Othello*. He will the more perfectly appreciate the situation, conduct and character of Othello, the more exactly the feelings and experiences of Othello coincide with his own—at least he *ought* to on the above principle of concordance. In point of fact, he will probably do anything but appreciate the play. In reality, the concordance will merely render him acutely conscious of his own jealousy; by a sudden reversal of perspective he will no longer see Othello apparently betrayed by Desdemona, but himself in an analogous situation with his own wife. This reversal of perspective is the consequence of the loss of Distance.

If this be taken as a typical case, it follows that the qualification required is that the coincidence should be as complete as is compatible with maintaining Distance. The jealous spectator of *Othello* will indeed appreciate and enter into the play the more keenly, the greater the resemblance with his own experience—*provided* that he succeeds in keeping the Distance between the action of the play and his personal feelings: a very difficult performance in the circumstances. It is on account of the same difficulty that the expert and the professional critic make a bad audience, since their expertness and critical professionalism are *practical* activities, involving their concrete personality and constantly endangering their Distance. [It is, by the way, one of the reasons why Criticism is an art, for it requires the constant interchange from the practical to the distanced attitude and vice versa, which is characteristic of artists.]

The same qualification applies to the artist. He will prove artistically most effective in the formulation of an intensely *personal* experience, but he can formulate it artistically only on condition of a detachment from the experience *qua personal*. Hence the statement of so many artists that artistic formulation was to them a kind of catharsis, a means of ridding themselves of feelings and ideas the acuteness of which they felt almost as a kind of obsession. Hence, on the other hand, the failure of the average man to convey to others at all adequately the impression of an overwhelming joy or sorrow. His personal implication in the event renders it impossible for him to formulate and present it in such a way as to make others, like himself, feel all the meaning and fullness which it possesses for him.

What is therefore, both in appreciation and production, most desirable is the *utmost decrease of Distance without its disappearance*.

3. Closely related, in fact a presupposition to the 'antinomy', is the *variability* of Distance. Herein especially lies the advantage of Distance compared with such terms as 'objectivity' and 'detachment'. Neither of them implies a *personal* relation—indeed both actually preclude it; and the mere inflexibility and exclusiveness of their opposites render their application generally meaningless.

Distance, on the contrary, admits naturally of degrees, and differs not only according to the nature of the *object*, which may impose a greater or smaller degree of Distance, but varies also according to the *individual's capacity* for maintaining a greater or lesser degree. And here one may

remark that not only do *persons differ from each other* in their habitual measure of Distance, but that the *same individual differs* in his ability to maintain it in the face of different objects and of different arts.

There exist, therefore, two different sets of conditions affecting the degree of Distance in any given case: those offered by the object and those realised by the subject. In their interplay they afford one of the most extensive explanations for varieties of æsthetic experience, since loss of Distance, whether due to the one or the other, means loss of æsthetic appreciation.

In short, Distance may be said *to be variable both according to the distancing-power of the individual, and according to the character of the object.*

There are two ways of losing Distance: either to 'underdistance' or to 'over-distance'. 'Under-distancing' is the commonest failing of the *subject*, an excess of Distance is a frequent failing of *Art*, especially in the past. Historically it looks almost as if Art had attempted to meet the deficiency of Distance on the part of the subject and had overshot the mark in this endeavour. It will be seen later that this is actually true, for it appears that over-distanced Art is specially designed for a class of appreciation which has difficulty to rise spontaneously to any degree of Distance. The consequence of a loss of Distance through one or other cause is familiar: the verdict in the case of under-distancing is that the work is 'crudely naturalistic', 'harrowing', 'repulsive in its realism'. An excess of Distance produces the impression of improbability, artificiality, emptiness or absurdity.

The individual tends, as I just stated, to under-distance rather than to lose Distance by over-distancing. *Theoretically* there is no limit to the decrease of Distance. In theory, therefore, not only the usual subjects of Art, but even the most personal affections, whether ideas, percepts or emotions, can be sufficiently distanced to be æsthetically appreciable. Especially artists are gifted in this direction to a remarkable extent. The average individual, on the contrary, very rapidly reaches his limit of decreasing Distance, his 'Distance-limit', i.e. that point at which Distance is lost and appreciation either disappears or changes its character.

In the *practice*, therefore, of the average person, a limit does exist which marks the minimum at which his appreciation can maintain itself in the æsthetic field, and this average minimum lies considerably higher than the Distance-limit of the artist. It is practically impossible to fix this average limit, in the absence of data, and on account of the wide fluctuations from person to person to which this limit is subject. But it is safe to infer that, in art practice, explicit references to organic affections, to the material existence of the body, especially to sexual matters, lie normally below the Distance-limit, and can be touched upon by Art only with special precautions. Allusions to social institutions of any degree of personal importance —in particular, allusions implying any doubt as to their validity—the

questioning of some generally recognised ethical sanctions, references to topical subjects occupying public attention at the moment, and such like, are all dangerously near the average limit and may at any time fall below it, arousing, instead of æsthetic appreciation, concrete hostility or mere amusement.

This difference in the Distance-limit between artists and the public has been the source of much misunderstanding and injustice. Many an artist has seen his work condemned and himself ostracised for the sake of so-called 'immoralities' which to him were bona fide æsthetic objects. His power of distancing, nay, the necessity of distancing feelings, sensations, situations which for the average person are too intimately bound up with his concrete existence to be regarded in that light, have often quite unjustly earned for him accusations of cynicism, sensualism, morbidness or frivolity. The same misconception has arisen over many 'problem plays' and 'problem novels' in which the public have persisted in seeing nothing but a supposed 'problem' of the moment, whereas the author may have been—and often has demonstrably been—able to distance the subject-matter sufficiently to rise above its practical problematic import and to regard it simply as a dramatically and humanly interesting situation.

The variability of Distance in respect to Art, disregarding for the moment the subjective complication, appears both as a general feature in Art, and in the differences between the special arts.

It has been an old problem why the 'arts of the eye and of the ear' should have reached the practically exclusive predominance over arts of other senses. Attempts to raise 'culinary art' to the level of a Fine Art have failed in spite of all propaganda, as completely as the creation of scent or liqueur 'symphonies'. There is little doubt that, apart from other excellent reasons of a partly psycho-physical, partly technical nature, the actual, *spatial distance* separating objects of sight and hearing from the subject has contributed strongly to the development of this monopoly. In a similar manner *temporal remoteness* produces Distance, and objects removed from us in point of time are *ipso facto* distanced to an extent which was impossible for their contemporaries. Many pictures, plays and poems had, as a matter of fact, rather an expository or illustrative significance—as for instance much ecclesiastical Art—or the force of a direct practical appeal—as the invectives of many satires or comedies—which seem to us nowadays irreconcilable with their æsthetic claims. Such works have consequently profited greatly by lapse of time and have reached the level of Art only with the help of temporal distance, while others, on the contrary, often for the same reason have suffered a loss of Distance, through *over*-distancing.

Special mention must be made of a group of artistic conceptions which present excessive Distance in their form of appeal rather than in their actual presentation—a point illustrating the necessity of distinguishing between distancing an object and distancing the appeal of which it is the

source. I mean here what is often rather loosely termed 'idealistic Art', that is, Art springing from abstract conceptions, expressing allegorical meanings, or illustrating general truths. Generalisations and abstractions suffer under this disadvantage that they have too much general applicability to invite a personal interest in them, and too little individual concreteness to prevent them applying to us in all their force. They appeal to everybody and therefore to none. An axiom of Euclid belongs to nobody, just because it compels everyone's assent; general conceptions like Patriotism, Friendship, Love, Hope, Life, Death, concern as much Dick, Tom and Harry as myself, and I, therefore, either feel unable to get into any kind of personal relation to them, or, if I do so, they become at once, emphatically and concretely, *my* Patriotism, *my* Friendship, *my* Love, *my* Hope, *my* Life and Death. By mere force of generalisation, a general truth or a universal ideal is so far distanced from myself that I fail to realise it concretely at all, or, when I do so, I can realise it only as part of my *practical actual being*, i.e. it falls below the Distance-limit altogether. 'Idealistic Art' suffers consequently under the peculiar difficulty that its excess of Distance turns generally into an *under*-distanced appeal—all the more easily, as it is the usual failing of the subject to *under*—rather than to over-distance.

The different special arts show at the present time very marked variations in the degree of Distance which they usually impose or require for their appreciation. Unfortunately here again the absence of data makes itself felt and indicates the necessity of conducting observations, possibly experiments, so as to place these suggestions upon a securer basis. In one single art, viz. the *theatre*, a small amount of information is available, from an unexpected source, namely the proceedings of the censorship committee,[2] which on closer examination might be made to yield evidence of interest to the psychologist. In fact, the whole censorship problem, as far as it does not turn upon purely economic questions, may be said to hinge upon Distance; if every member of the public could be trusted to keep it, there would be no sense whatever in the existence of a censor of plays. There is, of course, no doubt that, speaking generally, theatrical performances *eo ipso* run a special risk of a loss of Distance owing to the material presentment[3] of its subject-matter. The physical presence of living human beings as vehicles of dramatic art is a difficulty which no art has to face in the same way. A similar, in many ways even greater, risk confronts *dancing:* though attracting perhaps a less widely spread human interest, its animal spirits are frequently quite unrelieved by any glimmer of spirituality and consequently form a proportionately stronger lure to under-distancing. In the higher forms of dancing technical execution of the most wearing kind makes up a great deal for its intrinsic tendency towards

[2] Report from the Joint Select Committee of the House of Lords and the House of Commons on Stage Plays (Censorship), 1909.

[3] I shall use the term 'presentment' to denote the manner of presenting, in distinction to 'presentation' as that which is presented.

a loss of Distance, and as a popular performance, at least in southern Europe, it has retained much of its ancient artistic glamour, producing a peculiarly subtle balancing of Distance between the pure delight of bodily movement and high technical accomplishment. In passing, it is interesting to observe (as bearing upon the development of Distance) that this art, once as much a fine art as music and considered by the Greeks as a particularly valuable educational exercise, should—except in sporadic cases —have fallen so low from the pedestal it once occupied. Next to the theatre and dancing stands *sculpture*. Though not using a *living* bodily medium, yet the human form in its full spatial materiality constitutes a similar threat to Distance. Our northern habits of dress and ignorance of the human body have enormously increased the difficulty of distancing Sculpture, in part through the gross misconceptions to which it is exposed, in part owing to a complete lack of standards of bodily perfection, and an inability to realise the distinction between sculptural form and bodily shape, which is the only but fundamental point distinguishing a statue from a cast taken from life. In *painting* it is apparently the form of its presentment and the usual reduction in scale which would explain why this art can venture to approach more closely than sculpture to the normal Distance-limit. . . . *Music* and *architecture* have a curious position. These two most abstract of all arts show a remarkable fluctuation in their Distances. Certain kinds of music, especially 'pure' music, or 'classical' or 'heavy' music, appear for many people over-distanced; light, 'catchy' tunes, on the contrary, easily reach that degree of decreasing Distance below which they cease to be Art and become a pure amusement. In spite of its strange abstractness which to many philosophers has made it comparable to architecture and mathematics, music possesses a sensuous, frequently sensual, character: the undoubted physiological and muscular stimulus of its melodies and harmonies, no less than its rhythmic aspects, would seem to account for the occasional disappearance of Distance. To this might be added its strong tendency, especially in unmusical people, to stimulate trains of thought quite disconnected with itself, following channels of subjective inclinations—day-dreams of a more or less directly personal character. *Architecture* requires almost uniformly a very great Distance; that is to say, the majority of persons derive no æsthetic appreciation from architecture as such, apart from the incidental impression of its decorative features and its associations. The causes are numerous, but prominent among them are the confusion of building with architecture and the predominance of utilitarian purposes, which overshadow the architectural claims upon the attention.

4. That all art requires a Distance-limit beyond which, and a Distance within which only, æsthetic appreciation becomes possible, is the *psychological formulation of a general characteristic of Art*, viz. its *anti-realistic nature*. Though seemingly paradoxical, this applies as much to 'naturalistic' as to 'idealistic' Art. The difference commonly expressed by these epithets

is at bottom merely the difference in the degree of Distance; and this produces, so far as 'naturalism' and 'idealism' in Art are not meaningless labels, the usual result that what appears obnoxiously 'naturalistic' to one person, may be 'idealistic' to another. To say that Art is anti-realistic simply insists upon the fact that Art is not nature, never pretends to be nature and strongly resists any confusion with nature. It emphasizes the *art-character* of Art: 'artistic' is synonymous with 'anti-realistic'; it explains even sometimes a very marked degree of artificiality.

'Art is an imitation of nature', was the current art-conception in the eighteenth century. It is the fundamental axiom of the standard work of that time upon æsthetic theory by the Abbé Du Bos, *Réflexions critiques sur la poésie et la peinture*, 1719; the idea received strong support from the literal acceptance of Aristotle's theory of μίμησις and produced echoes everywhere, in Lessing's *Laokoon* no less than in Burke's famous statement that 'all Art is great as it deceives'. Though it may be assumed that since the time of Kant and of the Romanticists this notion has died out, it still lives in unsophisticated minds. Even when formally denied, it persists, for instance, in the belief that 'Art idealises nature', which means after all only that Art copies nature with certain improvements and revisions. Artists themselves are unfortunately often responsible for the spreading of this conception. Whistler indeed said that to produce Art by imitating nature would be like trying to produce music by sitting upon the piano, but the selective, idealising imitation of nature finds merely another support in such a saying. Naturalism, pleinairism, impressionism, even the guileless enthusiasm of the artist for the works of nature, her wealth of suggestion, her delicacy of workmanship, for the steadfastness of her guidance, only produce upon the public the impression that Art is, after all, an imitation of nature. Then how can it be anti-realistic? The antithesis, Art *versus* nature, seems to break down. Yet if it does, what is the sense of Art?

Here the conception of Distance comes to the rescue. The solution of the dilemma lies in the 'antinomy of Distance' with its demand: utmost decrease of distance without its disappearance. The simple observation that Art is the more effective, the more it falls into line with our predispositions which are inevitably moulded on general experience and nature, has always been the original motive for 'naturalism'. 'Naturalism', 'impressionism' is no new thing; it is only a new name for an innate leaning of Art, from the time of the Chaldeans and Egyptians down to the present day. Even the Apollo of Tenea apparently struck his contemporaries as so startlingly 'naturalistic' that the subsequent legend attributed a superhuman genius to his creator. A constantly closer approach to nature, a perpetual refining of the limit of Distance, yet without overstepping the dividing line of art and nature, has always been the inborn bent of art. To deny this dividing line has occasionally been the failing of naturalism. But no theory of naturalism is complete which does not at the same time allow for the intrinsic idealism of Art: for both are merely degrees in that wide range lying beyond the

Distance-limit. To imitate nature so as to trick the spectator into the deception that it is nature which he beholds, is to forsake Art, its anti-realism, its distanced spirituality, and to fall below the limit into sham, sensationalism or platitude.

But what, in the theory of antinomy of Distance, requires explanation is the existence of an *idealistic, highly distanced* Art. There are numerous reasons to account for it; indeed in so complex a phenomenon as Art, *single* causes can be pronounced almost *a priori* to be false. Foremost among such causes which have contributed to the formation of an idealistic Art appears to stand the subordination of Art to some extraneous purpose of an impressive, exceptional character. Such a subordination has consisted—at various epochs of Art history—in the use to which Art was put to subserve commemorative, hieratic, generally religious, royal or patriotic functions. The object to be commemorated had to stand out from among other still existing objects or persons; the thing or the being to be worshipped had to be distinguished as markedly as possible from profaner objects of reverence and had to be invested with an air of sanctity by a removal from its ordinary context of occurrence. Nothing could have assisted more powerfully the introduction of a high Distance than this attempt to differentiate objects of common experience in order to fit them for their exalted position. Curious, unusual things of nature met this tendency half-way and easily assumed divine rank; but others had to be distanced by an exaggeration of their size, by extraordinary attributes, by strange combinations of human and animal forms, by special insistence upon particular characteristics, or by the careful removal of all noticeably individualistic and concrete features. Nothing could be more striking than the contrast, for example, in Egyptian Art between the monumental, stereotyped effigies of the Pharaohs, and the startlingly realistic rendering of domestic scenes and of ordinary mortals, such as 'the Scribe' or 'the Village Sheikh'. Equally noteworthy is the exceeding artificiality of Russian eikon-painting with its prescribed attributes, expressions and gestures. Even Greek dramatic practice appears to have aimed, for similar purposes and in marked contrast to our stage-habits, at an increase rather than at a decrease of Distance. Otherwise Greek Art, even of a religious type, is remarkable for its *low* Distance value; and it speaks highly for the æsthetic capacities of the Greeks that the degree of realism which they ventured to impart to the representations of their gods, while humanising them, did not, at least at first,[4] impair the reverence of their feelings towards them. But apart from such special causes, idealistic Art of great Distance has appeared at intervals, for apparently no other reason than that the great Distance was felt to be essential to its *art*-character. What is noteworthy and runs counter to many accepted ideas is that such periods were usually epochs of a low level of general culture. These were times, which, like childhood,

[4] That this practice did, in course of time, undermine their religious faith, is clear from the plays of Euripides and from Plato's condemnation of Homer's mythology.

required the marvellous, the extraordinary, to satisfy their artistic longings, and neither realised nor cared for the poetic or artistic qualities of ordinary things. They were frequently times in which the mass of the people were plunged in ignorance and buried under a load of misery, and in which even the small educated class sought rather amusement or a pastime in Art; or they were epochs of a strong practical common sense too much concerned with the rough-and-tumble of life to have any sense of its æsthetic charms. Art was to them what melodrama is to a section of the public at the present time, and its wide Distance was the safeguard of its artistic character. The flowering periods of Art have, on the contrary, always borne the evidence of a narrow Distance. Greek Art, as just mentioned, was realistic to an extent which we, spoilt as we are by modern developments, can grasp with difficulty, but which the contrast with its oriental contemporaries sufficiently proves. During the Augustan period—which Art historians at last are coming to regard no longer as merely 'degenerated' Greek Art— Roman Art achieved its greatest triumphs in an almost naturalistic por-trait-sculpture. In the Renaissance we need only think of the realism of portraiture, sometimes amounting almost to cynicism, of the *désinvolture* with which the mistresses of popes and dukes were posed as madonnas, saints and goddesses apparently without any detriment to the æsthetic appeal of the works, and of the remarkable interpenetration of Art with the most ordinary routine of life, in order to realise the scarcely perceptible dividing line between the sphere of Art and the realm of practical existence. In a sense, the assertion that idealistic Art marks periods of a generally low and narrowly restricted culture is the converse to the oft-repeated statement that the flowering periods of Art coincide with epochs of decadence: for this so-called decadence represents indeed in certain respects a process of disintegration, politically, racially, often na-tionally, but a disruption necessary to the formation of larger social units and to the breakdown of outgrown national restrictions. For this very reason it has usually also been the sign of the growth of personal independ-ence and of an expansion of individual culture.

To proceed to some more special points illustrating the distanced and therefore anti-realistic character of art: both in subject-matter and in the form of presentation Art has always safeguarded its distanced view. Fanci-ful, even fantastic, subjects have from time immemorial been the accredited material of Art. No doubt things, as well as our view of them, have changed in the course of time: *Polyphemus* and the *Lotus-Eaters* for the Greeks, the *Venus-berg* or the *Magnetic Mountain* for the Middle Ages were less incredible, more realistic than to us. But *Peter Pan* or *L'Oiseau Bleu* still appeal at the present day in spite of the prevailing note of realism of our time. 'Probability' and 'improbability' in Art are not to be measured by their correspondence (or lack of it) with actual experience. To do so had involved the theories of the fifteenth to the eighteenth centuries in endless contradictions. It is rather a matter of *consistency* of Distance. The

note of realism, set by a work as a whole, determines *intrinsically* the greater or smaller degree of fancy which it permits; and consequently we feel the loss of Peter Pan's shadow to be infinitely more probable than some trifling improbability which shocks our sense of proportion in a naturalistic work. No doubt also, fairy-tales, fairy-plays, stories of strange adventures were primarily invented to satisfy the craving of curiosity, the desire for the marvellous, the shudder of the unwonted and the longing for imaginary experiences. But by their mere eccentricity in regard to the normal facts of experience they cannot have failed to arouse a strong feeling of Distance.

Again, certain conventional subjects taken from mythical and legendary traditions, at first closely connected with the concrete, practical, life of a devout public, have gradually, by the mere force of convention as much as by their inherent anti-realism, acquired Distance for us today. Our view of Greek mythological sculpture, of early Christian saints and martyrs must be considerably distanced, compared with that of the Greek and medieval worshipper. It is in part the result of lapse of time, but in part also a real change of attitude. Already the outlook of the Imperial Roman had altered, and Pausanias shows a curious dualism of standpoint, declaring the Athene Lemnia to be the supreme achievement of Phidias's genuis, and gazing awe-struck upon the roughly hewn tree-trunk representing some primitive Apollo. Our understanding of Greek tragedy suffers admittedly under our inability to revert to the point of view for which it was originally written. Even the tragedies of Racine demand an imaginative effort to put ourselves back into the courtly atmosphere of red-heeled, powdered ceremony. Provided the Distance is not too wide, the result of its intervention has everywhere been to enhance the *art*-character of such works and to lower their original ethical and social force of appeal. Thus in the central dome of the Church (Sta Maria dei Miracoli) at Saronno are depicted the heavenly hosts in ascending tiers, crowned by the benevolent figure of the Divine Father, bending from the window of heaven to bestow His blessing upon the assembled community. The mere realism of foreshortening and of the boldest vertical perspective may well have made the naïve Christian of the sixteenth century conscious of the Divine Presence—but for us it has become a work of Art.

The unusual, exceptional, has found its especial home in tragedy. It has always—except in highly distanced tragedy—been a popular objection to it that 'there is enough sadness in life without going to the theatre for it'. Already Aristotle appears to have met with this view among his contemporaries clamouring for 'happy endings'. Yet tragedy is not sad; if it were, there would indeed be little sense in its existence. For the tragic is just in so far different from the merely sad, as it is distanced; and it is largely the exceptional which produces the Distance of tragedy: exceptional situations, exceptional characters, exceptional destinies and conduct. Not of course characters merely cranky, eccentric, pathological. The

exceptional element in tragic figures—that which makes them so utterly different from characters we meet with in ordinary experience—is a consistency of direction, a fervour of ideality, a persistence and driving-force which is far above the capacities of average men. The tragic of tragedy would, transposed into ordinary life, in nine cases out of ten, end in drama, in comedy, even in farce, for lack of steadfastness, for fear of conventions, for the dread of 'scenes', for a hundred-and-one petty faithlessnesses towards a belief or an ideal: even if for none of these, it would end in a compromise simply because man forgets and time heals.[5] Again, the sympathy which aches with the sadness of tragedy is another such confusion, the under-distancing of tragedy's appeal. Tragedy trembles always on the knife-edge of a *personal* reaction, and sympathy which finds relief in tears tends almost always towards a loss of Distance. Such a loss naturally renders tragedy unpleasant to a degree: it becomes sad, dismal, harrowing, depressing. But real tragedy (melodrama has a very strong tendency to speculate upon sympathy), truly appreciated, is not sad. 'The pity of it—oh, the pity of it', that essence of all genuine tragedy is not the pity of mild, regretful sympathy. It is a chaos of tearless, bitter bewilderment, of upsurging revolt and rapturous awe before the ruthless and inscrutable fate; it is the homage to the great and exceptional in the man who in a last effort of spiritual tension can rise to confront blind, crowning Necessity even in his crushing defeat.

As I explained earlier, the form of presentation sometimes endangers the maintenance of Distance, but it more frequently acts as a considerable support. Thus the bodily vehicle of *drama* is the chief factor of risk to Distance. But, as if to counterbalance a confusion with nature, other features of stage-presentation exercise an opposite influence. Such are the general theatrical *milieu*, the shape and arrangement of the stage, the artificial lighting, the costumes, *mise en scène* and make-up, even the language, especially verse. Modern reforms of staging, aiming primarily at the removal of artistic incongruities between excessive decoration and the living figures of the actors and at the production of a more homogeneous stage-picture, inevitably work also towards a greater emphasis and homogeneity of Distance. The history of staging and dramaturgy is closely bound up with the evolution of Distance, and its fluctuations lie at the bottom not only of the greater part of all the talk and writing about 'dramatic probability' and the Aristotelian 'unities', but also of 'theatrical illusion'. In *sculpture*, one distancing factor of presentment is its lack of

[5] The famous 'unity of time', so senseless as a 'canon', is all the same often an indispensable condition of tragedy. For in many a tragedy the catastrophe would be even intrinsically impossible, if fatality did not overtake the hero with that rush which gives no time to forget and none to heal. It is in cases such as these that criticism has often blamed the work for 'improbability'—the old confusion between Art and nature—forgetting that the death of the hero is the convention of the art-form, as much as grouping in a picture is such a convention and that probability is not the correspondence with average experience, but consistency of Distance.

colour. The æsthetic, or rather inæsthetic, effect of realistic colouring is in no way touched by the controversial question of its use historically; its attempted resuscitation, such as by Klinger, seems only to confirm its disadvantages. The distancing use even of pedestals, although originally no doubt serving other purposes, is evident to anyone who has experienced the oppressively crowded sensation of moving in a room among life-sized statues placed directly upon the floor. The circumstance that the space of statuary is the same space as ours (in distinction to relief sculpture or painting, for instance) renders a distancing by pedestals, i.e. a removal from our spatial context, imperative.[6] Probably the framing of *pictures* might be shown to serve a similar purpose—though paintings have intrinsically a much greater Distance—because neither their space (perspective and imaginary space) nor their lighting coincides with our (actual) space or light, and the usual reduction in scale of the represented objects prevents a feeling of undue proximity. Besides, painting always retains to some extent a *two*-dimensional character, and this character supplies *eo ipso* a Distance. Nevertheless, life-size pictures, especially if they possess strong relief, and their light happens to coincide with the actual lighting, can occasionally produce the impression of actual presence which is a far from pleasant, though fortunately only a passing, illusion. For decorative purposes, in pictorial renderings of vistas, garden-perspectives and architectural extensions, the removal of Distance has often been consciously striven after, whether with æsthetically satisfactory results is much disputed.

A general help towards Distance (and therewith an anti-realistic feature) is to be found in the unification of presentment'[7] of all art-objects. By unification of presentment are meant such qualities as symmetry, opposition, proportion, balance, rhythmical distribution of parts, light-arrangements, in fact all so-called 'formal' features, 'composition' in the widest sense. Unquestionably, Distance is not the only, nor even the principal function of composition; it serves to render our grasp of the presentation easier and to increase its intelligibility. It may even in itself constitute the principal æsthetic feature of the object, as in linear complexes or patterns, partly also in architectural designs. Yet, its distancing effect can hardly be underrated. For, every kind of visibly intentional arrangement or unification must, by the mere fact of its presence, enforce Distance, by distinguishing the object from the confused, disjointed and scattered forms of actual experience. This function can be gauged in a typical form in cases where compositions produces an exceptionally marked impression of artificiality (not in the bad sense of that term, but in the sense in which

[6] An instance which might be adduced to disprove this point only shows its correctness on closer inspection: for it was on purpose and with the intention of removing Distance, that Rodin originally intended his *citoyens de Calais* to be placed, without pedestals, upon the market-place of that town.

[7] See note 3.

all art is artificial); and it is a natural corollary to the differences of Distance in different arts and of different subjects, that the arts and subjects vary in the degree of artificiality which they can bear. It is this sense of artificial finish which is the source of so much of that elaborate charm of Byzantine work, of Mohammedan decoration, of the hieratic stiffness of so many primitive madonnas and saints. In general the emphasis of composition and technical finish increases with the Distance of the subject-matter: heroic conceptions lend themselves better to verse than to prose; monumental statues require a more general treatment, more elaboration of setting and artificiality of pose than impressionistic statuettes like those of Troubetzkoi; an ecclesiastic subject is painted with a degree of symmetrical arrangement which would be ridiculous in a Dutch interior, and a naturalistic drama carefully avoids the tableau impression characteristic of a mystery play. In a similar manner the variations of Distance in the arts go hand in hand with a visibly greater predominance of composition and 'formal' elements, reaching a climax in architecture and music. It is again a matter of 'consistency of Distance'. At the same time, while from the point of view of the artist this is undoubtedly the case, from the point of view of the public the emphasis of composition and technical finish appears frequently to relieve the impression of highly distanced subjects by *diminishing the Distance of the whole*. The spectator has a tendency to see in composition and finish merely evidence of the artist's 'cleverness', of his mastery over his material. Manual dexterity is an enviable thing to possess in everyone's experience, and naturally appeals to the public *practically*, thereby putting it into a directly personal relation to things which intrinsically have very little personal appeal for it. It is true that this function of composition is hardly an æsthetic one: for the admiration of mere technical cleverness is not an artistic enjoyment, but by a fortunate chance it has saved from oblivion and entire loss, among much rubbish, also much genuine Art, which otherwise would have completely lost contact with our life.

5. This discussion, necessarily sketchy and incomplete, may have helped to illustrate the sense in which, I suggested, Distance appears as a fundamental principle to which such antitheses as idealism and realism are reducible. The difference between 'idealistic' and 'realistic' Art is not a clear-cut dividing-line between the art-practices described by these terms, but is a difference of degree in the Distance-limit which they presuppose on the part both of the artist and of the public. A similar reconciliation seems to me possible between the opposites 'sensual' and 'spiritual', 'individual' and 'typical'. That the appeal of Art is sensuous, even sensual, must be taken as an indisputable fact. Puritanism will never be persuaded, and rightly so, that this is not the case. The senuousness of Art is a natural implication of the 'antinomy of Distance', and will appear again in another connection. The point of importance here is that the whole sensual side of Art is purified, spiritualised, 'filtered' as I expressed it

earlier, by Distance. The most sensual appeal becomes the translucent veil of an underlying spirituality, once the grossly personal and practical elements have been removed from it. And—a matter of special emphasis here—*this spiritual aspect of the appeal is the more penetrating, the more personal and direct its sensual appeal would have been* BUT FOR THE PRESENCE OF DISTANCE. For the artist, to trust in this delicate transmutation is a natural act of faith which the Puritan hesitates to venture upon: which of the two, one asks, is the greater idealist?

6. The same argument applies to the contradictory epithets 'individual' and 'typical'. A discussion in support of the fundamental individualism of Art lies outside the scope of this essay. Every artist has taken it for granted. Besides it is rather in the sense of 'concrete' or 'individualised', that it is usually opposed to 'typical'. On the other hand, 'typical', in the sense of 'abstract', is as diametrically opposed to the whole nature of Art, as individualism is characteristic of it. It is in the sense of 'generalised' as a 'general human element' that it is claimed as a necessary ingredient in Art. This antithesis is again one which naturally and without mutual sacrifice finds room within the conception of Distance. Historically the 'typical' has had the effect of counteracting *under*-distancing as much as the 'individual' has opposed *over*-distancing. Naturally the two ingredients have constantly varied in the history of Art; they represent, in fact, two sets of conditions to which Art has invariably been subject: the personal and the social factors. It is Distance which on one side prevents the emptying of Art of its concreteness and the development of the typical into abstractness; which, on the other, suppresses the directly personal element of its individualism; thus reducing the antitheses to the peaceful interplay of these two factors. It is just this interplay which constitutes the 'antinomy of Distance'.

CLIVE BELL

THE AESTHETIC HYPOTHESIS

*Clive Bell (1881–1961) was a highly influential British art
critic who developed a formalist theory of art according to
which the significance of a work of art lies in its form
rather than its content.*

It is improbable that more nonsense has been written about aesthetics
than about anything else: the literature of the subject is not large enough
for that. It is certain, however, that about no subject with which I am
acquainted has so little been said that is at all to the purpose. The explana-
tion is discoverable. He who would elaborate a plausible theory of aes-
thetics must possess two qualities—artistic sensibility and a turn for clear
thinking. Without sensibility a man can have no aesthetic experience, and,
obviously, theories not based on broad and deep aesthetic experience are
worthless. Only those for whom art is a constant source of passionate emo-
tion can possess the data from which profitable theories may be deduced;
but to deduce profitable theories even from accurate data involves a certain
amount of brain-work, and, unfortunately, robust intellects and delicate
sensibilities are not inseparable. As often as not, the hardest thinkers have

Reprinted from *Art* by Clive Bell, London, Chatto & Windus, Ltd., 1928, pp.
3–37, by permission of the publisher.

had no aesthetic experience whatever. I have a friend blessed with an intellect as keen as a drill, who, though he takes an interest in aesthetics, has never during a life of almost forty years been guilty of an aesthetic emotion. So, having no faculty for distinguishing a work of art from a handsaw, he is apt to rear up a pyramid of irrefragable argument on the hypothesis that a handsaw is a work of art. This defect robs his perspic-uous and subtle reasoning of much of its value; for it has ever been a maxim that faultless logic can win but little credit for conclusions that are based on premises notoriously false. Every cloud, however, has its silver lining, and this insensibility, though unlucky in that it makes my friend incapable of choosing a sound basis for his argument, mercifully blinds him to the absurdity of his conclusions while leaving him in full enjoyment of his masterly dialectic. People who set out from the hypothesis that Sir Edwin Landseer was the finest painter that ever lived will feel no uneasi-ness about an aesthetic which proves that Giotto was the worst. So, my friend, when he arrives very logically at the conclusion that a work of art should be small or round or smooth, or that to appreciate fully a picture you should pace smartly before it or set it spinning like a top, cannot guess why I ask him whether he has lately been to Cambridge, a place he sometimes visits.

On the other hand, people who respond immediately and surely to works of art, though, in my judgment, more enviable than men of massive intel-lect but slight sensibility, are often quite as incapable of talking sense about aesthetics. Their heads are not always very clear. They possess the data on which any system must be based; but, generally, they want the power that draws correct inferences from true data. Having received aesthetic emotions from works of art, they are in a position to seek out the quality common to all that have moved them, but, in fact, they do nothing of the sort. I do not blame them. Why should they bother to examine their feelings when for them to feel is enough? Why should they stop to think when they are not very good at thinking? Why should they hunt for a common quality in all objects that move them in a particular way when they can linger over the many delicious and peculiar charms of each as it comes? So, if they write criticism and call it aesthetics, if they imagine that they are talking about Art when they are talking about particular works of art or even about the technique of painting, if, loving particular works they find tedious the consideration of art in general, perhaps they have chosen the better part. If they are not curious about the nature of their emotion, nor about the quality common to all objects that provoke it, they have my sympathy, and, as what they say is often charming and suggestive, my admiration too. Only let no one suppose that what they write and talk is aesthetics; it is criticism, or just "shop."

The starting-point for all systems of aesthetics must be the personal experience of a peculiar emotion. The objects that provoke this emotion we call works of art. All sensitive people agree that there is a peculiar emo-

tion provoked by works of art. I do not mean, of course, that all works provoke the same emotion. On the contrary, every work produces a different emotion. But all these emotions are recognisably the same in kind; so far, at any rate, the best opinion is on my side. That there is a particular kind of emotion provoked by works of visual art, and that this emotion is provoked by every kind of visual art, by pictures, sculptures, buildings, pots, carvings, textiles, &c., &c., is not disputed, I think, by anyone capable of feeling it. This emotion is called the aesthetic emotion; and if we can discover some quality common and peculiar to all the objects that provoke it, we shall have solved what I take to be the central problem of aesthetics. We shall have discovered the essential quality in a work of art, the quality that distinguishes works of art from all other classes of objects.

For either all works of visual art have some common quality, or when we speak of "works of art" we gibber. Everyone speaks of "art," making a mental classification by which he distinguishes the class "works of art" from all other classes. What is the justification of this classification? What is the quality common and peculiar to all members of this class? Whatever it be, no doubt it is often found in company with other qualities; but they are adventitious—it is essential. There must be some one quality without which a work of art cannot exist; possessing which, in the least degree, no work is altogether worthless. What is this quality? What quality is shared by all objects that provoke our aesthetic emotions? What quality is common to Sta. Sophia and the windows at Chartres, Mexican sculpture, a Persian bowl, Chinese carpets, Giotto's frescoes at Padua, and the master-pieces of Poussin, Piero della Francesca, and Cézanne? Only one answer seems possible—significant form. In each, lines and colours combined in a particular way, certain forms and relations of forms, stir our aesthetic emotions. These relations and combinations of lines and colours, these aesthetically moving forms, I call "Significant Form"; and "Significant Form" is the one quality common to all works of visual art.

At this point it may be objected that I am making aesthetics a purely subjective business, since my only data are personal experiences of a particular emotion. It will be said that the objects that provoke this emotion vary with each individual, and that therefore a system of aesthetics can have no objective validity. It must be replied that any system of aesthetics which pretends to be based on some objective truth is so palpably ridiculous as not to be worth discussing. We have no other means of recognising a work of art than our feeling for it. The objects that provoke aesthetic emotion vary with each individual. Aesthetic judgments are, as the saying goes, matters of taste; and about tastes, as everyone is proud to admit, there is no disputing. A good critic may be able to make me see in a picture that had left me cold things that I had overlooked, till at last, receiving the aesthetic emotion, I recognise it as a work of art. To be continually pointing out those parts, the sum, or rather the combination, of which unite to

produce significant form, is the function of criticism. But it is useless for a critic to tell me that something is a work of art; he must make me feel it for myself. This he can do only by making me see; he must get at my emotions through my eyes. Unless he can make me see something that moves me, he cannot force my emotions. I have no right to consider anything a work of art to which I cannot react emotionally; and I have no right to look for the essential quality in anything that I have not *felt* to be a work of art. The critic can affect my aesthetic theories only by affecting my aesthetic experience. All systems of aesthetics must be based on personal experience—that is to say, they must be subjective.

Yet, though all aesthetic theories must be based on aesthetic judgments, and ultimately all aesthetic judgments must be matters of personal taste, it would be rash to assert that no theory of aesthetics can have general validity. For, though A, B, C, D are the works that move me, and A, D, E, F the works that move you, it may well be that x is the only quality believed by either of us to be common to all the works in his list. We may all agree about aesthetics, and yet differ about particular works of art. We may differ as to the presence or absence of the quality x. My immediate object will be to show that significant form is the only quality common and peculiar to all the works of visual art that move me; and I will ask those whose aesthetic experience does not tally with mine to see whether this quality is not also, in their judgment, common to all works that move them, and whether they can discover any other quality of which the same can be said.

Also at this point a query arises, irrelevant indeed, but hardly to be suppressed: "Why are we so profoundly moved by forms related in a particular way?" The question is extremely interesting, but irrelevant to aesthetics. In pure aesthetics we have only to consider our emotion and its object: for the purposes of aesthetics we have no right, neither is there any necessity, to pry behind the object into the state of mind of him who made it. Later, I shall attempt to answer the question; for by so doing I may be able to develop my theory of the relation of art to life. I shall not, however, be under the delusion that I am rounding off my theory of aesthetics. For a discussion of aesthetics, it need be agreed only that forms arranged and combined according to certain unknown and mysterious laws do move us in a particular way, and that it is the business of an artist so to combine and arrange them that they shall move us. These moving combinations and arrangements I have called, for the sake of convenience and for a reason that will appear later, "Significant Form."

A third interruption has to be met.

"Are you forgetting about colour?" someone inquires. Certainly not; my term "significant form" included combinations of lines and of colours. The distinction between form and colour is an unreal one; you cannot conceive a colourless line or a colourless space; neither can you conceive a formless relation of colours. In a black and white drawing the spaces are

all white and all are bounded by black lines; in most oil paintings the spaces are multi-coloured and so are the boundaries; you cannot imagine a boundary line without any content, or a content without a boundary line. Therefore, when I speak of significant form, I mean a combination of lines and colours (counting white and black as colours) that moves me aesthetically.

Some people may be surprised at my not having called this "beauty." Of course, to those who define beauty as "combinations of lines and colours that provoke aesthetic emotion," I willingly concede the right of substituting their word for mine. But most of us, however strict we may be, are apt to apply the epithet "beautiful" to objects that do not provoke that peculiar emotion produced by works of art. Everyone, I suspect, has called a butterfly or a flower beautiful. Does anyone feel the same kind of emotion for a butterfly or a flower that he feels for a cathedral or a picture? Surely, it is not what I call an aesthetic emotion that most of us feel, generally, for natural beauty. I shall suggest, later, that some people may, occasionally, see in nature what we see in art, and feel for her an aesthetic emotion; but I am satisfied that, as a rule, most people feel a very different kind of emotion for birds and flowers and the wings of butterflies from that which they feel for pictures, pots, temples and statues. Why these beautiful things do not move us as works of art move is another, and not an aesthetic, question. For our immediate purpose we have to discover only what quality is common to objects that do move us as works of art. In the last part of this chapter, when I try to answer the question—"Why are we so profoundly moved by some combinations of lines and colours?" I shall hope to offer an acceptable explanation of why we are less profoundly moved by others.

Since we call a quality that does not raise the characteristic aesthetic emotion "Beauty," it would be misleading to call by the same name the quality that does. To make "beauty" the object of the aesthetic emotion, we must give to the word an over-strict and unfamiliar definition. Everyone sometimes uses "beauty" in an unaesthetic sense; most people habitually do so. To everyone, except perhaps here and there an occasional aesthete, the commonest sense of the word is unaesthetic. Of its grosser abuse, patent in our chatter about "beautiful huntin'" and "beautiful shootin'," I need not take account; it would be open to the precious to reply that they never do so abuse it. Besides, here there is no danger of confusion between the aesthetic and the non-aesthetic use; but when we speak of a beautiful woman there is. When an ordinary man speaks of a beautiful woman he certainly does not mean only that she moves him aesthetically; but when an artist calls a withered old hag beautiful he may sometimes mean what he means when he calls a battered torso beautiful. The ordinary man, if he be also a man of taste, will call the battered torso beautiful, but he will not call a withered hag beautiful because, in the matter of women, it is not to the aesthetic quality that the hag may possess, but to some

other quality that he assigns the epithet. Indeed, most of us never dream of going for aesthetic emotions to human beings, from whom we ask something very different. This "something," when we find it in a young woman, we are apt to call it "beauty." We live in a nice age. With the man-in-the-street "beautiful" is more often than not synonymous with "desirable"; the word does not necessarily connote any aesthetic reaction whatever, and I am tempted to believe that in the minds of many the sexual flavour of the word is stronger than the aesthetic. I have noticed a consistency in those to whom the most beautiful thing in the world is a beautiful woman, and the next most beautiful thing a picture of one. The confusion between aesthetic and sensual beauty is not in their case so great as might be supposed. Perhaps there is none; for perhaps they have never had an aesthetic emotion to confuse with their other emotions. The art that they call "beautiful" is generally closely related to the women. A beautiful picture is a photograph of a pretty girl; beautiful music, the music that provokes emotions similar to those provoked by young ladies in musical farces; and beautiful poetry, the poetry that recalls the same emotions felt, twenty years earlier, for the rector's daughter. Clearly the word "beauty" is used to connote the objects of quite distinguishable emotions, and that is a reason for not employing a term which would land me inevitably in confusions and misunderstandings with my readers.

On the other hand, with those who judge it more exact to call these combinations and arrangements of form that provoke our aesthetic emotions, not "significant form," but "significant relations of form," and then try to make the best of two worlds, the aesthetic and the metaphysical, by calling these relations "rhythm," I have no quarrel whatever. Having made it clear that by "significant form" I mean arrangements and combinations that move us in a particular way, I willingly join hands with those who prefer to give a different name to the same thing.

The hypothesis that significant form is the essential quality in a work of art has at least one merit denied to many more famous and more striking—it does help to explain things. We are all familiar with pictures that interest us and excite our admiration, but do not move us as works of art. To this class belongs what I call "Descriptive Painting"—that is, painting in which forms are used not as objects of emotion, but as means of suggesting emotion or conveying information. Portraits of psychological and historical value, topographical works, pictures that tell stories and suggest situations, illustrations of all sorts, belong to this class. That we all recognise the distinction is clear, for who has not said that such and such a drawing was excellent as illustration, but as a work of art worthless? Of course many descriptive pictures possess, amongst other qualities, formal significance, and are therefore works of art: but many more do not. They interest us; they may move us too in a hundred different ways, but they do not move us aesthetically. According to my hypothesis they are not works of art. They leave untouched our aesthetic emotions because

it is not their forms but the ideas or information suggested or conveyed by their forms that affect us.

Few pictures are better known or liked than Frith's "Paddington Station"; certainly I should be the last to grudge it its popularity. Many a weary forty minutes have I whiled away disentangling its fascinating incidents and forging for each an imaginary past and an improbable future. But certain though it is that Frith's masterpiece, or engravings of it, have provided thousands with half-hours of curious and fanciful pleasure, it is not less certain that no one has experienced before it one half-second of aesthetic rapture—and this although the picture contains several pretty passages of colour, and is by no means badly painted. "Paddington Station" is not a work of art; it is an interesting and amusing document. In it line and colour are used to recount anecdotes, suggest ideas, and indicate the manners and customs of an age: they are not used to provoke aesthetic emotion. Forms and the relations of forms were for Frith not objects of emotion, but means of suggesting emotion and conveying ideas.

The ideas and information conveyed by "Paddington Station" are so amusing and so well presented that the picture has considerable value and is well worth preserving. But, with the perfection of photographic processes and of the cinematograph, pictures of this sort are becoming otiose. Who doubts that one of those *Daily Mirror* photographers in collaboration with a *Daily Mail* reporter can tell us far more about "London day by day" than any Royal Academician? For an account of manners and fashions we shall go, in future, to photographs, supported by a little bright journalism, rather than to descriptive painting. Had the imperial academicians of Nero, instead of manufacturing incredibly loathsome imitations of the antique, recorded in fresco and mosaic the manners and fashions of their day, their stuff, though artistic rubbish, would now be an historical goldmine. If only they had been Friths instead of being Alma Tademas! But photography has made impossible any such transmutation of modern rubbish. Therefore it must be confessed that pictures in the Frith tradition are grown superfluous; they merely waste the hours of able men who might be more profitably employed in works of a wider beneficence. Still, they are not unpleasant, which is more than can be said for that kind of descriptive painting of which "The Doctor" is the most flagrant example. Of course "The Doctor" is not a work of art. In it form is not used as an object of emotion, but as a means of suggesting emotions. This alone suffices to make it nugatory; it is worse than nugatory because the emotion it suggests is false. What it suggests is not pity and admiration but a sense of complacency in our own pitifulness and generosity. It is sentimental. Art is above morals, or, rather, all art is moral because, as I hope to show presently, works of art are immediate means to good. Once we have judged a thing a work of art, we have judged it ethically of the first importance and put it beyond the reach of the moralist. But descriptive pictures which are not works of art, and, therefore, are not necessarily

means to good states of mind, are proper objects of the ethical philosopher's attention. Not being a work of art, "The Doctor" has none of the immense ethical value possessed by all objects that provoke aesthetic ecstasy; and the state of mind to which it is a means, as illustration, appears to me undesirable.

The works of those enterprising young men, the Italian Futurists, are notable examples of descriptive painting. Like the Royal Academicians, they use form, not to provoke aesthetic emotions, but to convey information and ideas. Indeed, the published theories of the Futurists prove that their pictures ought to have nothing whatever to do with art. Their social and political theories are respectable, but I would suggest to young Italian painters that it is possible to become a Futurist in thought and action and yet remain an artist, if one has the luck to be born one. To associate art with politics is always a mistake. Futurist pictures are descriptive because they aim at presenting in line and colour the chaos of the mind at a particular moment; their forms are not intended to promote aesthetic emotion but to convey information. These forms, by the way, whatever may be the nature of the ideas they suggest, are themselves anything but revolutionary. In such Futurist pictures as I have seen—perhaps I should except some by Severini—the drawing, whenever it becomes representative as it frequently does, is found to be in that soft and common convention brought into fashion by Besnard some thirty years ago, and much affected by Beaux-Art students ever since. As works of art, the Futurist pictures are negligible; but they are not to be judged as works of art. A good Futurist picture would succeed as a good piece of psychology succeeds; it would reveal, through line and colour, the complexities of an interesting state of mind. If Futurist pictures seem to fail, we must seek an explanation, not in a lack of artistic qualities that they never were intended to possess, but rather in the minds the states of which they are intended to reveal.

Most people who care much about art find that of the work that moves them most the greater part is what scholars call "Primitive." Of course there are bad primitives. For instance, I remember going, full of enthusiasm, to see one of the earliest Romanesque churches in Poitiers (Notre-Dame-la-Grande), and finding it as ill-proportioned, over-decorated, coarse, fat and heavy as any better class building by one of those highly civilised architects who flourished a thousand years earlier or eight hundred later. But such exceptions are rare. As a rule primitive art is good—and here again my hypothesis is helpful—for, as a rule, it is also free from descriptive qualities. In primitive art you will find no accurate representation; you will find only significant form. Yet no other art moves us so profoundly. Whether we consider Sumerian sculpture or pre-dynastic Egyptian art, or archaic Greek, or the Wei and T'ang masterpieces,[1] or those

[1] The existence of the Ku K'ai-chih makes it clear that the art of this period (fifth to eighth centuries), was a typical primitive movement. To call the great vital art of the Liang, Chen, Wei, and T'ang dynasties a development out of the exquisitely

early Japanese works of which I had the luck to see a few superb examples (especially two wooden Bodhisattvas) at the Shepherd's Bush Exhibition in 1910, or whether, coming nearer home, we consider the primitive Byzantine art of the sixth century and its primitive developments amongst the Western barbarians, or, turning far afield, we consider that mysterious and majestic art that flourished in Central and South America before the coming of the white men, in every case we observe three common characteristics—absence of representation, absence of technical swagger, sublimely impressive form. Nor is it hard to discover the connection between these three. Formal significance loses itself in preoccupation with exact representation and ostentatious cunning.[2]

Naturally, it is said that if there is little representation and less saltimbancery in primitive art, that is because the primitives were unable to catch a likeness or cut intellectual capers. The contention is beside the point. There is truth in it, no doubt, though, were I a critic whose reputation depended on a power of impressing the public with a semblance of knowledge, I should be more cautious about urging it than such people generally are. For to suppose that the Byzantine masters wanted skill, or could not have created an illusion had they wished to do so, seems to imply ignorance of the amazingly dexterous realism of the notoriously bad works of that age. Very often, I fear, the misrepresentation of the primitives must be attributed to what the critics call, "wilful distortion." Be that as it may, the point is that, either from want of skill or want of will, primitives neither create illusions, nor make display of extravagant accomplishment, but concentrate their energies on the one thing needful—the creation of form. Thus have they created the finest works of art that we possess.

Let no one imagine that representation is bad in itself; a realistic form may be as significant, in its place as part of the design, as an abstract. But if a representative form has value, it is as form, not as representation. The representative element in a work of art may or may not be harmful;

refined and exhausted art of the Han decadence—from which Ku K'ai-chih is a delicate straggler—is to call Romanesque sculpture a development out of Praxiteles. Between the two something has happened to refill the stream of art. What had happened in China was the spiritual and emotional revolution that followed the onset of Buddhism.

[2] This is not to say that exact representation is bad in itself. It is indifferent. A perfectly represented form may be significant, only it is fatal to sacrifice significance to representation. The quarrel between significance and illusion seems to be as old as art itself, and I have little doubt that what makes most palaeolithic art so bad is a preoccupation with exact representation. Evidently palaeolithic draughtsmen had no sense of the significance of form. Their art resembles that of the more capable and sincere Royal Academicians: it is a little higher than that of Sir Edward Poynter and a little lower than that of the late Lord Leighton. That this is no paradox let the cave-drawings of Altamira, or such works as the sketches of horses found at Bruniquel and now in the British Museum, bear witness. If the ivory head of a girl from the Grotte du Pape, Brassempouy (*Musée St. Germain*) and the ivory torso found at the same place (*Collection St. Cric*), be, indeed, palaeolithic, then there were good palaeolithic artists who created and did not imitate form. Neolithic art is, of course, a very different matter.

always it is irrelevant. For, to appreciate a work of art we need bring with us nothing from life, no knowledge of its ideas and affairs, no familiarity with its emotions. Art transports us from the world of man's activity to a world of aesthetic exaltation. For a moment we are shut off from human interests; our anticipations and memories are arrested; we are lifted above the stream of life. The pure mathematician rapt in his studies knows a state of mind which I take to be similar, if not identical. He feels an emotion for his speculations which arises from no perceived relation between them and the lives of men, but springs, inhuman or super-human, from the heart of an abstract science. I wonder, sometimes, whether the appreciators of art and of mathematical solutions are not even more closely allied. Before we feel an aesthetic emotion for a combination of forms, do we not perceive intellectually the rightness and necessity of the combination? If we do, it would explain the fact that passing rapidly through a room we recognise a picture to be good, although we cannot say that it has provoked much emotion. We seem to have recognised intellectually the rightness of its forms without staying to fix our attention, and collect, as it were, their emotional significance. If this were so, it would be permissible to inquire whether it was the forms themselves or our perception of their rightness and necessity that caused aesthetic emotion. But I do not think I need linger to discuss the matter here. I have been inquiring why certain combinations of forms move us; I should not have travelled by other roads had I enquired, instead, why certain combinations are perceived to be right and necessary, and why our perception of their rightness and necessity is moving. What I have to say is this: the rapt philosopher, and he who contemplates a work of art, inhabit a world with an intense and peculiar significance of its own; that significance is unrelated to the significance of life. In this world the emotions of life find no place. It is a world with emotions of its own.

To appreciate a work of art we need bring with us nothing but a sense of form and colour and a knowledge of three-dimensional space. That bit of knowledge, I admit, is essential to the appreciation of many great works, since many of the most moving forms ever created are in three dimensions. To see a cube or a rhomboid as a flat pattern is to lower its significance, and a sense of three-dimensional space is essential to the full appreciation of most architectural forms. Pictures which would be insignificant if we saw them as flat patterns are profoundly moving because, in fact, we see them as related planes. If the representation of three-dimensional space is to be called "representation," then I agree that there is one kind of representation which is not irrelevant. Also, I agree that along with our feeling for line and colour we must bring with us our knowledge of space if we are to make the most of every kind of form. Nevertheless, there are magnificent designs to an appreciation of which this knowledge is not necessary: so, though it is not irrelevant to the appreciation of some works of art it is not essential to the appreciation of all. What we must say is

that the representation of three-dimensional space is neither irrelevant nor essential to all art, and that every other sort of representation is irrelevant.

That there is an irrelevant representative or descriptive element in many great works of art is not in the least surprising. Why it is not surprising I shall try to show elsewhere. Representation is not of necessity baneful, and highly realistic forms may be extremely significant. Very often, however, representation is a sign of weakness in an artist. A painter too feeble to create forms that provoke more than a little aesthetic emotion will try to eke that little out by suggesting the emotions of life. To evoke the emotions of life he must use representation. Thus a man will paint an execution, and, fearing to miss with his first barrel of significant form, will try to hit with his second by raising an emotion of fear or pity. But if in the artist an inclination to play upon the emotions of life is often the sign of a flickering inspiration, in the spectator a tendency to seek, behind form, the emotions of life is a sign of defective sensibility always. It means that his aesthetic emotions are weak or, at any rate, imperfect. Before a work of art people who feel little or no emotion for pure form find themselves at a loss. They are deaf men at a concert. They know that they are in the presence of something great, but they lack the power of apprehending it. They know that they ought to feel for it a tremendous emotion, but it happens that the particular kind of emotion it can raise is one that they can feel hardly or not at all. And so they read into the forms of the work those facts and ideas for which they are capable of feeling emotion, and feel for them the emotions that they can feel—the ordinary emotions of life. When confronted by a picture, instinctively they refer back its forms to the world from which they came. They treat created form as though it were imitated form, a picture as though it were a photograph. Instead of going out on the stream of art into a new world of aesthetic experience, they turn a sharp corner and come straight home to the world of human interests. For them the significance of a work of art depends on what they bring to it; no new thing is added to their lives, only the old material is stirred. A good work of visual art carries a person who is capable of appreciating it out of life into ecstasy: to use art as a means to the emotions of life is to use a telescope for reading the news. You will notice that people who cannot feel pure aesthetic emotions remember pictures by their subjects; whereas people who can, as often as not, have no idea what the subject of a picture is. They have never noticed the representative element, and so when they discuss pictures they talk about the shapes of forms and the relations and quantities of colours. Often they can tell by the quality of a single line whether or not a man is a good artist. They are concerned only with lines and colours, their relations and quantities and qualities; but from these they win an emotion more profound and far more sublime than any that can be given by the description of facts and ideas.

This last sentence has a very confident ring—over-confident, some may

think. Perhaps I shall be able to justify it, and make my meaning clearer too, if I give an account of my own feelings about music. I am not really musical. I do not understand music well. I find musical form exceedingly difficult to apprehend, and I am sure that the profounder subtleties of harmony and rhythm more often than not escape me. The form of a musical composition must be simple indeed if I am to grasp it honestly. My opinion about music is not worth having. Yet, sometimes, at a concert, though my appreciation of the music is limited and humble, it is pure. Sometimes, though I have a poor understanding, I have a clean palate. Consequently, when I am feeling bright and clear and intent, at the beginning of a concert for instance, when something that I can grasp is being played, I get from music that pure aesthetic emotion that I get from visual art. It is less intense, and the rapture is evanescent; I understand music too ill for music to transport me far into the world of pure aesthetic ecstasy. But at moments I do appreciate music as pure musical form, as sounds combined according to the laws of a mysterious necessity, as pure art with a tremendous significance of its own and no relation whatever to the significance of life; and in those moments I lose myself in that infinitely sublime state of mind to which pure visual form transports me. How inferior is my normal state of mind at a concert. Tired or perplexed, I let slip my sense of form, my aesthetic emotion collapses, and I begin weaving into the harmonies, that I cannot grasp, the ideas of life. Incapable of feeling the austere emotions of art, I begin to read into the musical forms human emotions of terror and mystery, love and hate, and spend the minutes, pleasantly enough, in a world of turbid and inferior feeling. At such times, were the grossest pieces of onomatopoeic representation—the song of a bird, the galloping of horses, the cries of children, or the laughing of demons—to be introduced into the symphony, I should not be offended. Very likely I should be pleased; they would afford new points of departure for new trains of romantic feeling or heroic thought. I know very well what has happened. I have been using art as a means to the emotions of life and reading into it the ideas of life. I have been cutting blocks with a razor. I have tumbled from the superb peaks of aesthetic exaltation to the snug foothills of warm humanity. It is a jolly country. No one need be ashamed of enjoying himself there. Only no one who has ever been on the heights can help feeling a little crestfallen in the cosy valleys. And let no one imagine, because he has made merry in the warm tilth and quaint nooks of romance, that he can even guess at the austere and thrilling raptures of those who have climbed the cold, white peaks of art.

About music most people are as willing to be humble as I am. If they cannot grasp musical form and win from it a pure aesthetic emotion, they confess that they understand music imperfectly or not at all. They recognise quite clearly that there is a difference between the feeling of the musician for pure music and that of the cheerful concert-goer for

what music suggests. The latter enjoys his own emotions, as he has every right to do, and recognises their inferiority. Unfortunately, people are apt to be less modest about their powers of appreciating visual art. Everyone is inclined to believe that out of pictures, at any rate, he can get all that there is to be got; everyone is ready to cry "humbug" and "impostor" at those who say that more can be had. The good faith of people who feel pure aesthetic emotions is called in question by those who have never felt anything of the sort. It is the prevalence of the representative element, I suppose, that makes the man in the street so sure that he knows a good picture when he sees one. For I have noticed that in matters of architecture, pottery, textiles, &c., ignorance and ineptitude are more willing to defer to the opinions of those who have been blest with peculiar sensibility. It is a pity that cultivated and intelligent men and women cannot be induced to believe that a great gift of aesthetic appreciation is at least as rare in visual as in musical art. A comparison of my own experience in both has enabled me to discriminate very clearly between pure and impure appreciation. Is it too much to ask that others should be as honest about their feelings for pictures as I have been about mine for music? For I am certain that most of those who visit galleries do feel very much what I feel at concerts. They have their moments of pure ecstasy; but the moments are short and unsure. Soon they fall back into the world of human interests and feel emotions, good no doubt, but inferior. I do not dream of saying that what they get from art is bad or nugatory; I say that they do not get the best that art can give. I do not say that they cannot understand art; rather I say that they cannot understand the state of mind of those who understand it best. I do not say that art means nothing or little to them; I say they miss its full significance. I do not suggest for one moment that their appreciation of art is a thing to be ashamed of; the majority of the charming and intelligent people with whom I am acquainted appreciate visual art impurely; and, by the way, the appreciation of almost all great writers has been impure. But provided that there be some fraction of pure aesthetic emotion, even a mixed and minor appreciation of art is, I am sure, one of the most valuable things in the world—so valuable, indeed, that in my giddier moments I have been tempted to believe that art might prove the world's salvation.

Yet, though the echoes and shadows of art enrich the life of the plains, her spirit dwells on the mountains. To him who woos, but woos impurely, she returns enriched what is brought. Like the sun, she warms the good seed in good soil and causes it to bring forth good fruit. But only to the perfect lover does she give a new strange gift—a gift beyond all price. Imperfect lovers bring to art and take away the ideas and emotions of their own age and civilisation. In twelfth-century Europe a man might have been greatly moved by a Romanesque church and found nothing in a T'ang picture. To a man of a later age, Greek sculpture meant much and Mexican nothing, for only to the former could he bring a crowd of

associated ideas to be the objects of familiar emotions. But the perfect lover, he who can feel the profound significance of form, is raised above the accidents of time and place. To him the problems of archaeology, history, and hagiography are impertinent. If the forms of a work are significant its provenance is irrelevant. Before the grandeur of those Sumerian figures in the Louvre he is carried on the same flood of emotion to the same aesthetic ecstasy as, more than four thousand years ago, the Chaldean lover was carried. It is the mark of great art that its appeal is universal and eternal.[3] Significant form stands charged with the power to provoke aesthetic emotion in anyone capable of feeling it. The ideas of men go buzz and die like gnats; men change their institutions and their customs as they change their coats; the intellectual triumphs of one age are the follies of another; only great art remains stable and unobscure. Great art remains stable and unobscure because the feelings that it awakens are independent of time and place, because its kingdom is not of this world. To those who have and hold a sense of the significance of form what does it matter whether the forms that move them were created in Paris the day before yesterday or in Babylon fifty centuries ago? The forms of art are inexhaustible; but all lead by the same road of aesthetic emotion to the same world of aesthetic ecstasy.

[3] Mr. Roger Fry permits me to make use of an interesting story that will illustrate my view. When Mr. Okakura, the Government editor of *The Temple Treasures of Japan*, first came to Europe, he found no difficulty in appreciating the pictures of those who from want of will or want of skill did not create illusions but concentrated their energies on the creation of form. He understood immediately the Byzantine masters and the French and Italian Primitives. In the Renaissance painters, on the other hand, with their descriptive pre-occupations, their literary and anecdotic interests, he could see nothing but vulgarity and muddle. The universal and essential quality of art, significant form, was missing, or rather had dwindled to a shallow stream, overlaid and hidden beneath weeds, so the universal response, aesthetic emotion, was not evoked. It was not till he came on to Henri-Matisse that he again found himself in the familiar world of pure art. Similarly, sensitive Europeans who respond immediately to the significant forms of great Oriental art, are left cold by the trivial pieces of anecdote and social criticism so lovingly cherished by Chinese dilettanti. It would be easy to multiply instances did not decency forbid the labouring of so obvious a truth.

GEORGE SANTAYANA

THE CRITERION OF TASTE

George Santayana (1863–1952) was for many years Professor of Philosophy at Harvard University. His work constitutes a major contribution both to philosophy and literature.

Dogmatism in matters of taste has the same status as dogmatism in other spheres. It is initially justified by sincerity, being a systematic expression of a man's preferences; but it becomes absurd when its basis in a particular disposition is ignored and it pretends to have an absolute or metaphysical scope. Reason, with the order which in every region it imposes on life, is grounded on an animal nature and has no other function than to serve the same; and it fails to exercise its office quite as much when it oversteps its bounds and forgets whom it is serving as when it neglects some part of its legitimate province and serves its master imperfectly, without considering all his interests.

Dialectic, logic, and morals lose their authority and become inept if they trespass upon the realm of physics and try to disclose existences;

Reprinted with the permission of Charles Scribner's Sons from *Reason in Art*, pp. 191–215, by George Santayana (1905). Also by permission of Constable Publishers, London.

while physics is a mere idea in the realm of poetic meditation. So the notorious diversities which human taste exhibits do not become conflicts, and raise no moral problem, until their basis or their function has been forgotten, and each has claimed a right to assert itself exclusively. This claim is altogether absurd, and we might fail to understand how so preposterous an attitude could be assumed by anybody did we not remember that every young animal thinks himself absolute, and that dogmatism in the thinker is only the speculative side of greed and courage in the brute. The brute cannot surrender his appetites nor abdicate his primary right to dominate his environment. What experience and reason may teach him is merely how to make his self-assertion well balanced and successful. In the same way taste is bound to maintain its preferences but free to rationalise them. After a man has compared his feelings with the no less legitimate feelings of other creatures, he can reassert his own with more complete authority, since now he is aware of their necessary ground in his nature, and of their affinities with whatever other interests his nature enables him to recognize in others and to co-ordinate with his own.

A criterion of taste is, therefore, nothing but taste itself in its more deliberate and circumspect form. Reflection refines particular sentiments by bringing them into sympathy with all rational life. There is consequently the greatest possible difference in authority between taste and taste, and while delight in drums and eagle's feathers is perfectly genuine and has no cause to blush for itself, it cannot be compared in scope or representative value with delight in a symphony or an epic. The very instinct that is satisfied by beauty prefers one beauty to another; and we have only to question and purge our æsthetic feelings in order to obtain our criterion of taste. This criterion will be natural, personal, autonomous; a circumstance that will give it authority over our own judgment—which is all moral science is concerned about—and will extend its authority over other minds also, in so far as their constitution is similar to ours. In that measure what is a genuine instance of reason in us, others will recognise for a genuine expression of reason in themselves also.

Æsthetic feeling, in different people, may make up a different fraction of life and vary greatly in volume. The more nearly insensible a man is the more incompetent he becomes to proclaim the values which sensibility might have. To beauty men are habitually insensible, even while they are awake and rationally active. Tomes of æsthetic criticism hang on a few moments of real delight and intuition. It is in rare and scattered instants that beauty smiles even on her adorers, who are reduced for habitual comfort to remembering her past favours. An æsthetic glow may pervade experience, but that circumstance is seldom remarked; it figures only as an influence working subterraneously on thoughts and judgments which in themselves take a cognitive or practical direction. Only when the æsthetic ingredient becomes predominant do we exclaim, How beauti-

ful! Ordinarily the pleasures which formal perception gives remain an undistinguished part of our comfort or curiosity.

Taste is formed in those moments when æsthetic emotion is massive and distinct; preferences then grown conscious, judgments then put into words will reverberate through calmer hours; they will constitute prejudices, habits of apperception, secret standards for all other beauties. A period of life in which such intuitions have been frequent may amass tastes and ideals sufficient for the rest of our days. Youth in these matters governs maturity, and while men may develop their early impressions more systematically and find confirmations of them in various quarters, they will seldom look at the world afresh or use new categories in deciphering it. Half our standards come from our first masters, and the other half from our first loves. Never being so deeply stirred again, we remain persuaded that no objects save those we then discovered can have a true sublimity. These high-water marks of æsthetic life may easily be reached under tutelage. It may be some eloquent appreciations read in a book, or some preference expressed by a gifted friend, that may have revealed unsuspected beauties in art or nature; and then, since our own perception was vicarious and obviously inferior in volume to that which our mentor possessed, we shall take his judgments for our criterion, since they were the source and exemplar of all our own. Thus the volume and intensity of some appreciations, especially when nothing of the kind has preceded, makes them authoritative over our subsequent judgments. On those warm moments hang all our cold systematic opinions; and while the latter fill our days and shape our careers it is only the former that are crucial and alive.

A race which loves beauty holds the same place in history that a season of love or enthusiasm holds in an individual life. Such a race has a pre-eminent right to pronounce upon beauty and to bequeath its judgments to duller peoples. We may accordingly listen with reverence to a Greek judgment on that subject, expecting that what might seem to us wrong about it is the expression of knowledge and passion beyond our range; it will suffice that we learn to live in the world of beauty, instead of merely studying its relics, for us to understand, for instance, that imitation is a fundamental principle in art, and that any rational judgment on the beautiful must be a moral and political judgment, enveloping chance æsthetic feelings and determining their value. What most German philosophers, on the contrary, have written about art and beauty has a minimal importance: it treats artificial problems in a grammatical spirit, seldom giving any proof of experience or imagination. What painters say about painting and poets about poetry is better than lay opinion; it may reveal, of course, some petty jealousy or some partial incapacity, because a special gift often carries with it complementary defects in apprehension; yet what is positive in such judgments is founded on knowledge and avoids the

romancing into which litterateurs and sentimentalists will gladly wander. The specific values of art are technical values, more permanent and definite than the adventitious analogies on which a stray observer usually bases his views. Only a technical education can raise judgments on musical compositions above impertinent autobiography. The Japanese know the beauty of flowers, and tailors and dressmakers have the best sense for the fashions. We ask them for suggestions, and if we do not always take their advice, it is not because the fine effects they love are not genuine, but because they may not be effects which we care to produce.

This touches a second consideration, besides the volume and vivacity of feeling, which enters into good taste. What is voluminous may be inwardly confusing. Excitement, though on the whole and for the moment agreeable, may verge on pain and may be, when it subsides a little, a cause of bitterness. A thing's attractions may be partly at war with its ideal function. In such a case what, in our haste, we call a beauty becomes hateful on a second view, and according to the key of our dissatisfaction we pronounce that effect meretricious, harsh, or affected. These discords appear when elaborate things are attempted without enough art and refinement; they are essentially in bad taste. Rudimentary effects, on the contrary, are pure, and though we may think them trivial when we are expecting something richer, their defect is never intrinsic; they do not plunge us, as impure excitements do, into a corrupt artificial conflict. So wild-flowers, plain chant, or a scarlet uniform are beautiful enough; their simplicity is a positive merit, while their crudity is only relative. There is a touch of sophistication and disease in not being able to fall back on such things and enjoy them thoroughly, as if a man could no longer relish a glass of water. Your true epicure will study not to lose so genuine a pleasure. Better forego some artificial stimulus, though that, too, has its charm, than become insensible to natural joys. Indeed, ability to revert to elementary beauties is a test that judgment remains sound.

Vulgarity is quite another matter. An old woman in a blonde wig, a dirty hand covered with jewels, ostentation without dignity, rhetoric without cogency, all offend by an inner contradiction. To like such things we should have to surrender our better intuitions and suffer a kind of dishonour. Yet the elements offensively combined may be excellent in isolation, so that an untrained or torpid mind will be at a loss to understand the critic's displeasure. Oftentimes barbaric art almost succeeds, by dint of splendour, in banishing the sense of confusion and absurdity; for everything, even reason, must bow to force. Yet the impression remains chaotic, and we must be either partly inattentive or partly distressed. Nothing could show better than this alternative how mechanical barbaric art is. Driven by blind impulse or tradition, the artist has worked in the dark. He has dismissed his work without having quite understood it or really justified it to his own mind. It is rather his excretion than his product. Astonished, very likely, at his own fertility, he has thought himself divinely

inspired, little knowing that clear reason is the highest and truest of inspirations. Other men, observing his obscure work, have then honoured him for profundity; and so mere bulk or stress or complexity have produced a mystical wonder by which generation after generation may be enthralled. Barbaric art is half necromantic; its ascendancy rests in a certain measure on bewilderment and fraud.

To purge away these impurities nothing is needed but quickened intelligence, a keener spiritual flame. Where perception is adequate, expression is so too, and if a man will only grow sensitive to the various solicitations which anything monstrous combines, he will thereby perceive its monstrosity. Let him but enact his sensations, let him pause to make explicit the confused hints that threaten to stupefy him; he will find that he can follow out each of them only by rejecting and forgetting the others. To free his imagination in any direction he must disengage it from the contrary intent, and so he must either purify his object or leave it a mass of confused promptings. Promptings essentially demand to be carried out, and when once an idea has become articulate it is not enriched but destroyed if it is still identified with its contrary. Any complete expression of a barbarous theme will, therefore, disengage its incompatible elements and turn it into a number of rational beauties.

When good taste has in this way purified and digested some turgid medley, it still has a progress to make. Ideas, like men, live in society. Not only has each a will of its own and an inherent ideal, but each finds itself conditioned for its expression by a host of other beings, on whose co-operation it depends. Good taste, besides being inwardly clear, has to be outwardly fit. A monstruous ideal devours and dissolves itself, but even a rational one does not find an immortal embodiment simply for being inwardly possible and free from contradiction. It needs a material basis, a soil and situation propitious to its growth. This basis, as it varies, makes the ideal vary which is simply its expression; and therefore no ideal can be ultimately fixed in ignorance of the conditions that may modify it. It subsists, to be sure, as an eternal possibility, independently of all further earthly revolutions. Once expressed, it has revealed the inalienable values that attach to a certain form of being, whenever that form is actualised. But its expression may have been only momentary, and that eternal ideal may have no further relevance to the living world. A criterion of taste, however, looks to a social career; it hopes to educate and to judge. In order to be an applicable and a just law, it must represent the interests over which it would preside.

There are many undiscovered ideals. There are many beauties which nothing in this world can embody or suggest. There are also many once suggested or even embodied, which find later their basis gone and evaporate into their native heaven. The saddest tragedy in the world is the destruction of what has within it no inward ground of dissolution, death in youth, and the crushing out of perfection. Imagination has its bereave-

ments of this kind. A complete mastery of existence achieved at one moment gives no warrant that it will be sustained or achieved again at the next. The achievement may have been perfect; nature will not on that account stop to admire it. She will move on, and the meaning which was read so triumphantly in her momentary attitude will not fit her new posture. Like Polonius's cloud, she will always suggest some new ideal, because she has none of her own.

In lieu of an ideal, however, nature has a constitution, and this, which is a necessary ground for ideals, is what it concerns the ideal to reckon with. A poet, spokesman of his full soul at a given juncture, cannot consider eventualities or think of anything but the message he is sent to deliver, whether the world can then hear it or not. God, he may feel sure, understands him, and in the eternal the beauty he sees and loves immortally justifies his enthusiasm. Nevertheless, critics must view his momentary ebullition from another side. They do not come to justify the poet in his own eyes; he amply relieves them of such a function. They come only to inquire how significant the poet's expressions are for humanity at large or for whatever public he addresses. They come to register the social or representative value of the poet's soul. His inspiration may have been an odd cerebral rumbling, a perfectly irrecoverable and wasted intuition; the exquisite quality it doubtless had to his own sense is now not to the purpose. A work of art is a public possession; it is addressed to the world. By taking on a material embodiment, a spirit solicits attention and claims some kinship with the prevalent gods. Has it, critics should ask, the affinities needed for such intercourse? Is it humane, is it rational, is it representative? To its inherent incommunicable charms it must add a kind of courtesy. If it wants other approval than its own, it cannot afford to regard no other aspiration.

This scope, this representative faculty or wide appeal, is necessary to good taste. All authority is representative; force and inner consistency are gifts on which I may well congratulate another, but they give him no right to speak for me. Either æsthetic experience would have remained a chaos—which it is not altogether—or it must have tended to conciliate certain general human demands and ultimately all those interests which its operation in any way affects. The more conspicuous and permanent a work of art is, the more is such an adjustment needed. A poet or philosopher may be erratic and assure us that he is inspired; if we cannot well gainsay it, we are at least not obliged to read his works. An architect or a sculptor, however, or a public performer of any sort, that thrusts before us a spectacle justified only in his inner consciousness, makes himself a nuisance. A social standard of taste must assert itself here, or else no efficacious and cumulative art can exist at all. Good taste in such matters cannot abstract from tradition, utility, and the temper of the world. It must make itself an interpreter of humanity and think esoteric dreams less beautiful than what the public eye might conceivably admire.

There are various affinities by which art may acquire a representative or classic quality. It may do so by giving form to objects which everybody knows, by rendering experiences that are universal and primary. The human figure, elementary passions, common types and crises of fate— these are facts which pass too constantly through apperception not to have a normal æsthetic value. The artist who can catch that effect in its fulness and simplicity accordingly does immortal work. This sort of art immediately becomes popular; it passes into language and convention so that its æsthetic charm is apparenty worn down. The old images after a while hardly stimulate unless they be presented in some paradoxical way; but in that case attention will be diverted to the accidental extravagance, and the chief classic effect will be missed. It is the honourable fate or euthanasia of artistic successes that they pass from the field of professional art altogether and become a portion of human faculty. Every man learns to be to that extent an artist; approved figures and maxims pass current like the words and idioms of a mother-tongue, themselves once brilliant inventions. The lustre of such successes is not realy dimmed, however, when it becomes a part of man's daily light; a retrogression from that habitual style or habitual insight would at once prove, by the shock it caused, how precious those ingrained apperceptions continued to be.

Universality may also be achieved, in a more heroic fashion, by art that expresses ultimate truths, cosmic laws, great human ideals. Virgil and Dante are classic poets in this sense, and a similar quality belongs to Greek sculpture and architecture. They may not cause enthusiasm in everybody; but in the end experience and reflection renew their charm; and their greatness, like that of high mountains, grows more obvious with distance. Such eminence is the reward of having accepted discipline and made the mind a clear anagram of much experience. There is a great difference between the depth of expression so gained and richness or realism in details. A supreme work presupposes minute study, sympathy with varied passions, many experiments in expression; but these preliminary things are submerged in it and are not displayed side by side with it, like the foot-notes to a learned work, so that the ignorant may know they have existed.

Some persons, themselves inattentive, imagine, for instance, that Greek sculpture is abstract, that it has left out all the detail and character which they cannot find on the surface, as they might in a modern work. In truth it contains those features, as it were, in solution and in the resultant which, when reduced to harmony, they would produce. It embodies a finished humanity which only varied exercises could have attained, for as the body is the existent ground for all possible actions, in which as actions they exist only potentially, so a perfect body, such as a sculptor might conceive, which ought to be ready for all excellent activities, cannot present them all in act but only the readiness for them. The features that might express them severally must be absorbed and mastered, hid-

den like a sword in its scabbard, and reduced to a general dignity or grace. Though such immersed eloquence be at first overlooked and seldom explicitly acknowledged, homage is nevertheless rendered to it in the most unmistakable ways. When lazy artists, backed by no great technical or moral discipline, think they, too, can produce masterpieces by summary treatment, their failure shows how pregnant and supreme a thing simplicity is. Every man, in proportion to his experience and moral distinction, returns to the simple but inexhaustible work of finished minds, and finds more and more of his own soul responsive to it.

Human nature, for all its margin of variability, has a substantial core which is invariable, as the human body has a structure which it cannot lose without perishing altogether; for as creatures grow more complex a greater number of their organs become vital and indispensable. Advanced forms will rather die than surrender a tittle of their character; a fact which is the physical basis for loyalty and martyrdom. Any deep interpretation of oneself, or indeed of anything, has for that reason a largely representative truth. Other men, if they look closely, will make the same discovery for themselves. Hence distinction and profundity, in spite of their rarity, are wont to be largely recognised. The best men in all ages keep classic traditions alive. These men have on their side the weight of superior intelligence, and, though they are few, they might even claim the weight of numbers, since the few of all ages, added together, may be more than the many who in any one age follow a temporary fashion. Classic work is nevertheless always national, or at least characteristic of its period, as the classic poetry of each people is that in which its language appears most pure and free. To translate it is impossible; but it is easy to find that the human nature so inimitably expressed in each masterpiece is the same that, under different circumstance, dictates a different performance. The deviations between races and men are not yet so great as is the ignorance of self, the blindness to the native ideal, which prevails in most of them. Hence a great man of a remote epoch is more intelligible than a common man of our own time.

Both elementary and ultimate judgments, then, contribute to a standard of taste; yet human life lies between these limits, and an art which is to be truly adjusted to life should speak also for the intermediate experience. Good taste is indeed nothing but a name for those appreciations which the swelling incidents of life recall and reinforce. Good taste is that taste which is a good possession, a friend to the whole man. It must not alienate him from anything except to ally him to something greater and more fertile in satisfactions. It will not suffer him to dote on things, however seductive, which rob him of some nobler companionship. To have a foretaste of such a loss, and to reject instinctively whatever will cause it, is the very essence of refinement. Good taste comes, therefore, from experience, in the best sense of that word; it comes from having united in one's memory and character the fruit of many diverse undertakings. Mere

taste is apt to be bad taste, since it regards nothing but a chance feeling. Every man who pursues an art may be presumed to have some sensibility; the question is whether he has breeding, too, and whether what he stops at is not, in the end, vulgar and offensive. Chance feeling needs to fortify itself with reasons and to find its level in the great world. When it has added fitness to its sincerity, beneficence to its passion, it will have acquired a right to live. Violence and self-justification will not pass muster in a moral society, for vipers possess both, and must nevertheless be stamped out. Citizenship is conferred only on creatures with human and co-operative instincts. A civilised imagination has to understand and to serve the world.

The great obstacle which art finds in attempting to be rational is its functional isolation. Sense and each of the passions suffers from a similar independence. The disarray of human instincts lets every spontaneous motion run too far; life oscillates between constraint and unreason. Morality too often puts up with being a constraint and even imagines such a disgrace to be its essence. Art, on the contrary, as often hugs unreason for fear of losing its inspiration, and forgets that it is itself a rational principle of creation and order. Morality is thus reduced to a necessary evil and art to a vain good, all for want of harmony among human impulses. If the passions arose in season, if perception fed only on those things which action should be adjusted to, turning them, while action proceeded, into the substance of ideas—then all conduct would be voluntary and enlightened, all speculation would be practical, all perceptions beautiful, and all operations arts. The Life of Reason would then be universal.

To approach this ideal, so far as art is concerned, would involve diffusing its processes and no longer confining them to a set of dead and unproductive objects called works of art.

Why art, the most vital and generative of activities, should produce a set of abstract images, monuments to lost intuitions, is a curious mystery. Nature gives her products life, and they are at least equal to their sources in dignity. Why should mind, the actualisation of nature's powers, produce something so inferior to itself, reverting in its expression to material being, so that its witnesses seem so many fossils with which it strews its path? What we call museums—mausoleums, rather, in which a dead art heaps up its remains—are those the places where the Muses intended to dwell? We do not keep in show-cases the coins current in the world. A living art does not produce curiosities to be collected but spiritual necessaries to be diffused.

Artificial art, made to be exhibited, is something gratuitous and sophisticated, and the greater part of men's concern about it is affectation. There is a genuine pleasure in planning a work, in modelling and painting it; there is a pleasure in showing it to a sympathetic friend, who associates himself in this way with the artist's technical experiment and with his

interpretation of some human episode; and there might be a satisfaction in seeing the work set up in some appropriate space for which it was designed, where its decorative quality might enrich the scene, and the curious passer-by might stop to decipher it. The pleasures proper to an ingenuous artist are spontaneous and human; but his works, once delivered to his patrons, are household furniture for the state. Set up to-day, they are outworn and replaced to-morrow, like trees in the parks or officers in the government. A community where art was native and flourishing would have an uninterrupted supply of such ornaments, furnished by its citizens in the same modest and cheerful spirit in which they furnish other commodities. Every craft has its dignity, and the decorative and monumental crafts certainly have their own; but such art is neither singular nor pre-eminent, and a statesman or reformer who should raise somewhat the level of thought or practice in the state would do an infinitely greater service.

The joys of creating are not confined, moreover, to those who create things without practical uses. The merely æsthetic, like rhyme and fireworks, is not the only subject that can engage a playful fancy or be planned with a premonition of beautiful effects. Architecture may be useful, sculture commemorative, poetry reflective, even music, by its expression, religious or martial. In a word, practical exigencies, in calling forth the arts, give them moral functions which it is a pleasure to see them fulfil. Works may not be æsthetic in their purpose, and yet that fact may be a ground for their being doubly delightful in execution and doubly beautiful in effect. A richer plexus of emotions is concerned in producing or contemplating something humanly necessary than something idly conceived. What is very rightly called a *sense* for fitness is a vital experience, involving æsthetic satisfactions and æsthetic shocks. The more numerous the rational harmonies are which are present to the mind, the more sensible movements will be going on there to give immediate delight; for the perception or expectation of an ulterior good is a present good also. Accordingly nothing can so well call forth or sustain attention as what has a complex structure relating it to many complex interests. A work woven out of precious threads has a deep pertinence and glory; the artist who creates it does not need to surrender his practical and moral sense in order to indulge his imagination.

The truth is that mere sensation or mere emotion is an indignity to a mature human being. When we eat, we demand a pleasant vista, flowers, or conversation, and failing these we take refuge in a newspaper. The monks, knowing that men should not feed silently like stalled oxen, appointed some one to read aloud in the refectory; and the Fathers, obeying the same civilised instinct, had contrived in their theology intelligible points of attachment for religious emotion. A refined mind finds as little happiness in love without friendship as in sensuality without love; it may succumb to both, but it accepts neither. What is true of mere sensibility

is no less true of mere fancy. The Arabian Nights—futile enough in any case—would be absolutely intolerable if they contained no Oriental manners, no human passions, and no convinced epicureanism behind their miracles and their tattle. Any absolute work of art which serves no further purpose than to stimulate an emotion has about it a certain luxurious and visionary taint. We leave it with a blank mind, and a pang bubbles up from the very fountain of pleasures. Art, so long as it needs to be a dream, will never cease to prove a disappointment. Its facile cruelty, its narcotic abstraction, can never sweeten the evils we return to at home; it can liberate half the mind only by leaving the other half in abeyance. In the mere artist, too, there is always something that falls short of the gentleman and that defeats the man.

Surely it is not the artistic impulse in itself that involves such lack of equilibrium. To impress a meaning and a rational form on matter is one of the most masterful of actions. The trouble lies in the barren and superficial character of this imposed form: fine art is a play of appearance. Appearance, for a critical philosophy, is distinguished from reality by its separation from the context of things, by its immediacy and significance. A play of appearance is accordingly some little closed circle in experience, some dream in which we lose ourselves by ignoring most of our interests, and from which we awake into a world in which that lost episode plays no further part and leaves no heirs. Art as mankind has hitherto practised it falls largely under this head and too much resembles an opiate or a stimulant. Life and history are not thereby rendered better in their principle, but a mere ideal is extracted out of them and presented for our delectation in some cheap material, like words or marble. The only precious materials are flesh and blood, for these alone can defend and propagate the ideal which has once informed them.

Artistic creation shows at this point a great inferiority to natural reproduction, since its product is dead. Fine art shapes inert matter and peoples the mind with impotent ghosts. What influence it has—for every event has consequences—is not pertinent to its inspiration. The art of the past is powerless even to create similar art in the present, unless similar conditions recur independently. The moments snatched for art have been generally interludes in life and its products parasites in nature, the body of them being materially functionless and the soul merely represented. To exalt fine art into a truly ideal activity we should have to knit it more closely with other rational functions, so that to beautify things might render them more useful and to represent them most imaginatively might be to see them in their truth. Something of the sort has been actually attained by the noblest arts in their noblest phases. A Sophocles or a Leonardo dominates his dreamful vehicle and works upon the real world by its means. These small centres, where interfunctonal harmony is attained, ought to expand and cover the whole field. Art, like religion, needs to be absorbed in the Life of Reason.

What might help to bring about this consummation would be, on the one side, more knowledge; on the other, better taste. When a mind is filled with important and true ideas and sees the actual relations of things, it cannot relish pictures of the world which wantonly misrepresent it. Myth and metaphor remain beautiful so long as they are the most adequate or graphic means available for expressing the facts, but so soon as they cease to be needful and sincere they become false finery. The same thing happens in the plastic arts. Unless they spring from love of their subject, and employ imagination only to penetrate into that subject and interpret it with a more inward sympathy and truth, they become conventional and overgrown with mere ornament. They then seem ridiculous to any man who can truly conceive what they represent. So in putting antique heroes on the stage we nowadays no longer tolerate a modern costume, because the externals of ancient life are too well known to us; but in the seventeenth century people demanded in such personages intelligence and nobleness, since these were virtues which the ancients were clothed with in their thought. A knowledge that should be at once full and appreciative would evidently demand fidelity in both matters. Knowledge, where it exists, undermines satisfaction in what does violence to truth, and it renders such representations grotesque. If knowledge were general and adequate the fine arts would accordingly be brought round to expressing reality.

At the same time, if the rendering of reality is to remain artistic, it must still study to satisfy the senses; but as this study would now accompany every activity, taste would grow vastly more subtle and exacting. Whatever any man said or did or made, he would be alive to its æsthetic quality, and beauty would be a pervasive ingredient in happiness. No work would be called, in a special sense, a work of art, for all works would be such intrinsically; and even instinctive mimicry and reproduction would themselves operate, not when mischief or idleness prompted, but when some human occasion and some general utility made the exercise of such skill entirely delightful. Thus there would need to be no division of mankind into mechanical blind workers and half-demented poets, and no separation of useful from fine art, such as people make who have understood neither the nature nor the ultimate reward of human action. All arts would be practised together and merged in the art of life, the only one wholly useful or fine among them.

SIGMUND FREUD

CREATIVE WRITERS
AND DAY-DREAMING

*Sigmund Freud (1865–1939), the founder of psychoanalysis,
applied his psychological insights to the analysis of artistic
activity.*

We laymen have always been intensely curious to know—like the Cardinal who put a similar question to Ariosto[1]—from what sources that strange being, the creative writer, draws his material, and how he manages to make such an impression on us with it and to arouse in us emotions of which, perhaps, we had not even thought ourselves capable. Our interest is only heightened the more by the fact that, if we ask him,

Reprinted from *The Complete Psychological Works of Sigmund Freud*, Volume
IX, Standard Edition, The Hogarth Press Ltd., London, 1959. By permission of
Sigmund Freud Copyrights Ltd., Mrs. Alix Strachey, and The Hogarth Press Ltd.
Also by permission of Basic Books, Inc., Publishers, New York, 1959, published
in a slightly different version under the title "The Relation of the Poet to Day-
Dreaming," in *The Collected Papers of Sigmund Freud*, edited by Ernest Jones,
Chapter IX, Volume 4.

[1] [Cardinal Ippolito d'Este was Ariosto's first patron, to whom he dedicated the
Orlando Furioso. The poet's only reward was the question: 'Where did you find so
many stories, Lodovico?']

the writer himself gives us no explanation, or none that is satisfactory; and it is not at all weakened by our knowledge that not even the clearest insight into the determinants of his choice of material and into the nature of the art of creating imaginative form will ever help to make creative writers of *us*.

If we could at least discover in ourselves or in people like ourselves an activity which was in some way akin to creative writing! An examination of it would then give us a hope of obtaining the beginnings of an explanation of the creative work of writers. And, indeed, there is some prospect of this being possible. After all, creative writers themselves like to lessen the distance between their kind and the common run of humanity; they so often assure us that every man is a poet at heart and that the last poet will not perish till the last man does.

Should we not look for the first traces of imaginative activity as early as in childhood? The child's best-loved and most intense occupation is with his play or games. Might we not say that every child at play behaves like a creative writer, in that he creates a world of his own, or, rather, re-arranges the things of his world in a new way which pleases him? It would be wrong to think he does not take that world seriously; on the contrary, he takes his play very seriously and he expends large amounts of emotion on it. The opposite of play is not what is serious but what is real. In spite of all the emotion with which he cathects his world of play, the child distinguishes it quite well from reality; and he likes to link his imagined objects and situations to the tangible and visible things of the real world. This linking is all that differentiates the child's 'play' from 'phantasying'.

The creative writer does the same as the child at play. He creates a world of phantasy which he takes very seriously—that is, which he invests with large amounts of emotion—while separating it sharply from reality. Language has preserved this relationship between children's play and poetic creation. It gives [in German] the name of '*Spiel*' ['play'] to those forms of imaginative writing which require to be linked to tangible objects and which are capable of representation. It speaks of a '*Lustspiel*' or '*Trauerspiel*' ['comedy' or 'tragedy': literally, 'pleasure play' or 'mourning play'] and describes those who carry out the representation as '*Schauspieler*' ['players': literally 'show-players']. The unreality of the writer's imaginative world, however, has very important consequences for the technique of his art; for many things which, if they were real, could give no enjoyment, can do so in the play of phantasy, and many excitements which, in themselves, are actually distressing, can become a source of pleasure for the hearers and spectators at the performance of a writer's work.

There is another consideration for the sake of which we will dwell a moment longer on this contrast between reality and play. When the child has grown up and has ceased to play, and after he has been labouring for decades to envisage the realities of life with proper seriousness, he may

one day find himself in a mental situation which once more undoes the contrast between play and reality. As an adult he can look back on the intense seriousness with which he once carried on his games in childhood; and, by equating his ostensibly serious occupations of to-day with his childhood games, he can throw off the too heavy burden imposed on him by life and win the high yield of pleasure afforded by *humour*.[2]

As people grow up, then, they cease to play, and they seem to give up the yield of pleasure which they gained from playing. But whoever understands the human mind knows that hardly anything is harder for a man than to give up a pleasure which he has once experienced. Actually, we can never give anything up; we only exchange one thing for another. What appears to be a renunciation is really the formation of a substitute or surrogate. In the same way, the growing child, when he stops playing, gives up nothing but the link with real objects; instead of *playing*, he now *phantasies*. He builds castles in the air and creates what are called *day-dreams*. I believe that most people construct phantasies at times in their lives. This is a fact which has long been overlooked and whose importance has therefore not been sufficiently appreciated.

People's phantasies are less easy to observe than the play of children. The child, it is true, plays by himself or forms a closed psychical system with other children for the purposes of a game; but even though he may not play his game in front of the grown-ups, he does not, on the other hand, conceal it from them. The adult, on the contrary, is ashamed of his phantasies and hides them from other people. He cherishes his phantasies as his most intimate possessions, and as a rule he would rather confess his misdeeds than tell anyone his phantasies. It may come about that for that reason he believes he is the only person who invents such phantasies and has no idea that creations of this kind are widespread among other people. This difference in the behaviour of a person who plays and a person who phantasies is accounted for by the motives of these two activities, which are nevertheless adjuncts to each other.

A child's play is determined by wishes: in point of fact by a single wish—one that helps in his upbringing—the wish to be big and grown up. He is always playing at being 'grown up', and in his games he imitates what he knows about the lives of his elders. He has no reason to conceal this wish. With the adult, the case is different. On the one hand, he knows that he is expected not to go on playing or phantasying any longer, but to act in the real world; on the other hand, some of the wishes which give rise to his phantasies are of a kind which it is essential to conceal. Thus he is ashamed of his phantasies as being childish and as being unpermissible.

But, you will ask, if people make such a mystery of their phantasying, how is it that we know such a lot about it? Well, there is a class of human

[2] [See Section 7 of Chapter VII of Freud's book on jokes (1905*c*).]

beings upon whom, not a god, indeed, but a stern goddess—Necessity—
has allotted the task of telling what they suffer and what things give
them happiness.[3] These are the victims of nervous illness, who are obliged
to tell their phantasies, among other things, to the doctor by whom they
expect to be cured by mental treatment. This is our best source of
knowledge, and we have since found good reason to suppose that our
patients tell us nothing that we might not also hear from healthy people.

Let us now make ourselves acquainted with a few of the characteristics
of phantasying. We may lay it down that a happy person never phan-
tasies, only an unsatisfied one. The motive forces of phantasies are un-
satisfied wishes, and every single phantasy is the fulfilment of a wish, a
correction of unsatisfying reality. These motivating wishes vary accord-
ing to the sex, character and circumstances of the person who is having
the phantasy; but they fall naturally into two main groups. They are
either ambitious wishes, which serve to elevate the subject's personality;
or they are erotic ones. In young women the erotic wishes predominate
almost exclusively, for their ambition is as a rule absorbed by erotic
trends. In young men egoistic and ambitious wishes come to the fore
clearly enough alongside of erotic ones. But we will not lay stress on the
opposition between the two trends; we would rather emphasize the fact
that they are often united. Just as, in many altar-pieces, the portrait of
the donor is to be seen in a corner of the picture, so, in the majority of
ambitious phantasies, we can discover in some corner or other the lady
for whom the creator of the phantasy performs all his heroic deeds and
at whose feet all his triumphs are laid. Here, as you see, there are strong
enough motives for concealment; the well-brought-up young woman is
only allowed a minimum of erotic desire, and the young man has to learn
to suppress the excess of self-regard which he brings with him from the
spoilt days of his childhood, so that he may find his place in a society
which is full of other individuals making equally strong demands.

We must not suppose that the products of this imaginative activity—
the various phantasies, castles in the air and day-dreams—are stereotyped
or unalterable. On the contrary, they fit themselves in to the subject's
shifting impressions of life, change with every change in his situation,
and receive from every fresh active impression what might be called a
'date-mark'. The relation of a phantasy to time is in general very impor-
tant. We may say that it hovers, as it were, between three times—the
three moments of time which our ideation involves. Mental work is linked
to some current impression, some provoking occasion in the present
which has been able to arouse one of the subject's major wishes. From

[3] [This is an allusion to some well-known lines spoken by the poet-hero in the final
scene of Goethe's *Torquato Tasso*:
 'Und wenn der Mensch in seiner Qual verstummt,
 Gab mir ein Gott, zu sagen, wie ich leide.'
'And when mankind is dumb in its torment, a god granted me to tell how I suffer.']

there it harks back to a memory of an earlier experience (usually an infantile one) in which this wish was fulfilled; and it now creates a situation relating to the future which represents a fulfilment of the wish. What it thus creates is a day-dream or phantasy, which carries about it traces of its origin from the occasion which provoked it and from the memory. Thus past, present and future are strung together, as it were, on the thread of the wish that runs through them.

A very ordinary example may serve to make what I have said clear. Let us take the case of a poor orphan boy to whom you have given the address of some employer where he may perhaps find a job. On his way there he may indulge in a day-dream appropriate to the situation from which it arises. The content of his phantasy will perhaps be something like this. He is given a job, finds favour with his new employer, makes himself indispensable in the business, is taken into his employer's family, marries the charming young daughter of the house, and then himself becomes a director of the business, first as his employer's partner and then as his successor. In this phantasy, the dreamer has regained what he possessed in his happy childhood—the protecting house, the loving parents and the first objects of his affectionate feelings. You will see from this example the way in which the wish makes use of an occasion in the present to construct, on the pattern of the past, a picture of the future.

There is a great deal more that could be said about phantasies; but I will only allude as briefly as possible to certain points. If phantasies become over-luxuriant and over-powerful, the conditions are laid for an onset of neurosis or psychosis. Phantasies, moreover, are the immediate mental precursors of the distressing symptoms complained of by our patients. Here a broad by-path branches off into pathology.

I cannot pass over the relation of phantasies to dreams. Our dreams at night are nothing else than phantasies like these, as we can demonstrate from the interpretation of dreams.[4] Language, in its unrivalled wisdom, long ago decided the question of the essential nature of dreams by giving the name of 'day-dreams' to the airy creations of phantasy. If the meaning of our dreams usually remains obscure to us in spite of this pointer, it is because of the circumstance that at night there also arise in us wishes of which we are ashamed; these we must conceal from ourselves, and they have consequently been repressed, pushed into the unconscious. Repressed wishes of this sort and their derivatives are only allowed to come to expression in a very distorted form. When scientific work had succeeded in elucidating this factor of *dream-distortion*, it was no longer difficult to recognize that night-dreams are wish-fulfilments in just the same way as day-dreams—the phantasies which we all know so well.

So much for phantasies. And now for the creative writer. May we really

[4] Cf. Freud, *The Interpretation of Dreams* (1900a).

attempt to compare the imaginative writer with the 'dreamer in broad daylight',[5] and his creations with day-dreams? Here we must begin by making an initial distinction. We must separate writers who, like the ancient authors of epics and tragedies, take over their material ready-made, from writers who seem to originate their own material. We will keep to the latter kind, and, for the purposes of our comparison, we will choose not the writers most highly esteemed by the critics, but the less pretentious authors of novels, romances and short stories, who neverthe-less have the widest and most eager circle of readers of both sexes. One feature above all cannot fail to strike us about the creations of these story-writers: each of them has a hero who is the centre of interest, for whom the writer tries to win our sympathy by every possible means and whom he seems to place under the protection of a special Providence. If, at the end of one chapter of my story, I leave the hero unconscious and bleeding from severe wounds, I am sure to find him at the beginning of the next being carefully nursed and on the way to recovery; and if the first volume closes with the ship he is in going down in a storm at sea, I am certain, at the opening of the second volume, to read of his miracu-lous rescue—a rescue without which the story could not proceed. The feeling of security with which I follow the hero through his perilous adventures is the same as the feeling with which a hero in real life throws himself into the water to save a drowning man or exposes himself to the enemy's fire in order to storm a battery. It is the true heroic feeling, which one of our best writers has expressed in an inimitable phrase: 'Nothing can happen to *me!*'[6] It seems to me, however, that through this revealing characteristic of invulnerability we can immediately recognize His Majesty the Ego, the hero alike of every day-dream and of every story.[7]

Other typical features of these egocentric stories point to the same kinship. The fact that all the women in the novel invariably fall in love with the hero can hardly be looked on as a portrayal of reality, but it is easily understood as a necessary constituent of a day-dream. The same is true of the fact that the other characters in the story are sharply divided into good and bad, in defiance of the variety of human characters that are to be observed in real life. The 'good' ones are helpers, while the 'bad' ones are the enemies and rivals, of the ego which has become the hero of the story.

We are perfectly aware that very many imaginative writings are far removed from the model of the naïve day-dream; and yet I cannot suppress the suspicion that even the most extreme deviations from that model could be linked with it through an uninterrupted series of transitional cases.

[5] ['*Der Träumer am hellichten Tag.*']

[6] ['Es kann dir nix g'schehen!' This phrase from Anzengruber, the Viennese dramatist, was a favourite one of Freud's. Cf. 'Thoughts on War and Death' (1915*b*), *Standard Ed.*, 14, 296.]

[7] [Cf. 'On Narcissism' (1914*c*), *Standard Ed.*, 14, 91.]

It has struck me that in many of what are known as 'psychological' novels only one person—once again the hero—is described from within. The author sits inside his mind, as it were, and looks at the other characters from outside. The psychological novel in general no doubt owes its special nature to the inclination of the modern writer to split up his ego, by self-observation, into many part-egos, and, in consequence, to personify the conflicting currents of his own mental life in several heroes. Certain novels, which might be described as 'eccentric', seem to stand in quite special contrast to the type of the day-dream. In these, the person who is introduced as the hero plays only a very small active part; he sees the actions and sufferings of other people pass before him like a spectator. Many of Zola's later works belong to this category. But I must point out that the psychological analysis of individuals who are not creative writers, and who diverge in some respects from the so-called norm, has shown us analogous variations of the day-dream, in which the ego contents itself with the role of spectator.

If our comparison of the imaginative writer with the day-dreamer, and of poetical creation with the day-dream, is to be of any value, it must, above all, show itself in some way or other fruitful. Let us, for instance, try to apply to these authors' works the thesis we laid down earlier concerning the relation between phantasy and the three periods of time and the wish which runs through them; and, with its help, let us try to study the connections that exist between the life of the writer and his works. No one has known, as a rule, what expectations to frame in approaching this problem; and often the connection has been thought of in much too simple terms. In the light of the insight we have gained from phantasies, we ought to expect the following state of affairs. A strong experience in the present awakens in the creative writer a memory of an earlier experience (usually belonging to his childhood) from which there now proceeds a wish which finds its fulfilment in the creative work. The work itself exhibits elements of the recent provoking occasion as well as of the old memory.[8]

Do not be alarmed at the complexity of this formula. I suspect that in fact it will prove to be too exiguous a pattern. Nevertheless, it may contain a first approach to the true state of affairs; and, from some experiments I have made, I am inclined to think that this way of looking at creative writings may turn out not unfruitful. You will not forget that the stress it lays on childhood memories in the writer's life—a stress which may perhaps seem puzzling—is ultimately derived from the assumption that a piece of creative writing, like a day-dream, is a continuation of, and a substitute for, what was once the play of childhood.

We must not neglect, however, to go back to the kind of imaginative

[8] [A similar view had already been suggested by Freud in a letter to Fliess of July 7, 1898, on the subject of one of C. F. Meyer's short stories (Freud, 1950a, Letter 92).]

works which we have to recognize, not as original creations, but as the re-fashioning of ready-made and familiar material [p. 149]. Even here, the writer keeps a certain amount of independence, which can express itself in the choice of material and in changes in it which are often quite extensive. In so far as the material is already at hand, however, it is derived from the popular treasure-house of myths, legends and fairy tales. The study of constructions of folk-psychology such as these is far from being complete, but it is extremely probable that myths, for instance, are distorted vestiges of the wishful phantasies of whole nations, the *secular dreams* of youthful humanity.

You will say that, although I have put the creative writer first in the title of my paper, I have told you far less about him than about phantasies. I am aware of that, and I must try to excuse it by pointing to the present state of our knowledge. All I have been able to do is to throw out some encouragements and suggestions which, starting from the study of phantasies, lead on to the problem of the writer's choice of his literary material. As for the other problem—by what means the creative writer achieves the emotional effects in us that are aroused by his creations—we have as yet not touched on it at all. But I should like at least to point out to you the path that leads from our discussion of phantasies to the problems of poetical effects.

You will remember how I have said [p. 145 f.] that the day-dreamer carefully conceals his phantasies from other people because he feels he has reasons for being ashamed of them. I should now add that even if he were to communicate them to us he could give us no pleasure by his disclosures. Such phantasies, when we learn them, repel us or at least leave us cold. But when a creative writer presents his plays to us or tells us what we are inclined to take to be his personal day-dreams, we experience a great pleasure, and one which probably arises from the confluence of many sources. How the writer accomplishes this is his innermost secret; the essential *ars poetica* lies in the technique of overcoming the feeling of repulsion in us which is undoubtedly connected with the barriers that rise between each single ego and the others. We can guess two of the methods used by this technique. The writer softens the character of his egoistic day-dreams by altering and disguising it, and he bribes us by the purely formal—that is, aesthetic—yield of pleasure which he offers us in the presentation of his phantasies. We give the name of an *incentive bonus*, or a *fore-pleasure*, to a yield of pleasure such as this, which is offered to us so as to make possible the release of still greater pleasure arising from deeper psychical sources.[9] In my opinion, all the aesthetic pleasure which

[9] [This theory of 'fore-pleasure' and the 'incentive bonus' had been applied by Freud to jokes in the last paragraphs of Chapter IV of his book on that subject (1905c). The nature of 'fore-pleasure' was also discussed in the *Three Essays* (1905d). See especially *Standard Ed*, 7, 208 ff.]

a creative writer affords us has the character of a fore-pleasure of this kind, and our actual enjoyment of an imaginative work proceeds from a liberation of tensions in our minds. It may even be that not a little of this effect is due to the writer's enabling us thenceforward to enjoy our own day-dreams without self-reproach or shame. This brings us to the threshold of new, interesting and complicated enquiries; but also, at least for the moment, to the end of our discussion.

SUSANNE K. LANGER

THE SYMBOL OF FEELING

*Susanne Langer (1895–) is Professor Emeritus of Phi-
losophy at Connecticut College for Women. She is the author
of numerous works including* Philosophy in a New Key.

In the book to which the present one is a sequel there is a chapter en-
titled "On Significance in Music." The theory of significance there devel-
oped is a special theory, which does not pretend to any further application
than the one made of it in that original realm, namely music. Yet, the
more one reflects on the significance of art generally, the more the music
theory appears as a lead. And the hypothesis certainly suggests itself that
the oft-asserted fundamental unity of the arts lies not so much in parallels
between their respective elements or analogies among their techniques, as
in the singleness of their characteristic import, the meaning of "signifi-
cance" with respect to any and each of them. "Significant Form" (which
really has significance) is the essence of every art; it is what we mean
by calling anything "artistic."

If the proposed lead will not betray us, we have here a principle of analysis that may be applied within each separate art gender in explaining its peculiar choice and use of materials; a criterion of what is or is not relevant in judging works of art in any realm; a direct exhibition of the unity of all the arts (without necessitating a resort to "origins" in fragmentary, doubtful history, and still more questionable prehistory); and the making of a truly general theory of art as such, wherein the several arts may be distinguished as well as connected, and almost any philosophical problems they present—problems of their relative values, their special powers or limitations, their social function, their connection with dream and fantasy or with actuality, etc., etc.—may be tackled with some hope of decision. The proper way to construct a general theory is by generalization of a special one; and I believe the analysis of musical significance in *Philosophy in a New Key* is capable of such generalization, and of furnishing a valid theory of significance for the whole Parnassus.

The study of musical significance grew out of a prior philosophical reflection on the meaning of the very popular term "expression." In the literature of aesthetics this word holds a prominent place; or rather, it holds prominent places, for it is employed in more than one sense and consequently changes its meaning from one book to another, and sometimes even from passage to passage in a single work. Sometimes writers who are actually in close agreement use it in incompatible ways, and literally contradict each other's statements, yet actually do not become aware of this fact, because each will read the word as the other intended it, not as he really used it where it happens to occur. Thus Roger Fry tried to elucidate Clive Bell's famous but cryptic phrase, "Significant Form," by identifying it with Flaubert's "expression of the Idea"; and Bell probably subscribes fully to Fry's exegesis, as far as it goes (which, as Fry remarks, is unfortunately not very far, since the "Idea" is the next hurdle). Yet Bell himself, trying to explain his meaning, says: "It is useless to go to a picture gallery in search of expression; you must go in search of Significant Form." Of course Bell is thinking here of "expression" in an entirely different sense. Perhaps he means that you should not look for the artist's *self*-expression, i.e. for a record of his emotions. Yet this reading is doubtful, for elsewhere in the same book he says: "It seems to me possible, though by no means certain, that created form moves us so profoundly because it expresses the emotion of its creator." Now, is the emotion of the creator the "Idea" in Flaubert's sense, or is it not? Or does the same work have, perhaps, two different expressive functions? And what about the kind we must *not* look for in a picture gallery?

We may, of course, look for any kind of expression we like, and there is even a fair chance that, whatever it be, we shall find it. A work of art is often a spontaneous expression of feeling, i.e., a symptom of the artist's state of mind. If it represents human beings it is probably also a rendering of some sort of facial expression which suggests the feelings those beings are supposed to have. Moreover, it may be said to "express," in another

sense, the life of the society from which it stems, namely to *indicate* customs, dress, behavior, and to reflect confusion or decorum, violence or peace. And besides all these things it is sure to express the unconscious wishes and nightmares of its author. All these things may be found in museums and galleries if we choose to note them.

But they may also be found in wastebaskets and in the margins of schoolbooks. This does not mean that someone has discarded a work of art, or produced one when he was bored with long division. It merely means that all drawings, utterances, gestures, or personal records of any sort express feelings, beliefs, social conditions, and interesting neuroses; "expression" in any of these senses is not peculiar to art, and consequently is not what makes for artistic value.

Artistic significance, or "expression of the Idea," is "expression" in still a different sense and, indeed, a radically different one. In all the contexts mentioned above, the art work or other object functioned as a *sign* that pointed to some matter of fact—how someone felt, what he believed, when and where he lived, or what bedeviled his dreams. But *expression of an idea*, even in ordinary usage, where the "idea" has no capital *I*, does not refer to the signific function, i.e. the indication of a fact by some natural symptom or invented signal. It usually refers to the prime purpose of language, which is discourse, the presentation of mere ideas. When we say that something is well expressed, we do not necessarily believe the expressed idea to refer to our present situation, or even to be true, but only to be given clearly and objectively for contemplation. Such "expression" is the function of symbols: articulation and presentation of *concepts*. Herein symbols differ radically from signals.[1] A signal is comprehended if it serves to make us notice the object or situation it bespeaks. A symbol is understood when we conceive the idea it presents.

The logical difference between signals and symbols is sufficiently explained, I think, in *Philosophy in a New Key* to require no repetition here, although much more could be said about it than that rather general little treatise undertook to say. Here, as there, I shall go on to a consequent of the logical studies, a theory of significance that points the contrast between the functions of art and of discourse, respectively; but this time with reference to all the arts, not only the non-verbal and essentially non-representative art of music.

The theory of music, however, is our point of departure, wherefore it may be briefly recapitulated here as it finally stood in the earlier book:

The tonal structures we call "music" bear a close logical similarity to

[1] In *Philosophy in a New Key* (cited hereafter as *New Key*) the major distinction was drawn between "signs" and "symbols"; Charles W. Morris, in *Signs, Language and Behavior*, distinguishes between "signals" and "symbols." This seems to me a better use of words, since it leaves "sign" to cover both "signal" and "symbol," whereas my former usage left me without any generic term. I have, therefore, adopted his practice, despite the fact that it makes for a discrepancy in the terminology of two books that really belong together.

the forms of human feeling—forms of growth and of attenuation, flowing and stowing, conflict and resolution, speed, arrest, terrific excitement, calm, or subtle activation and dreamy lapses—not joy and sorrow perhaps, but the poignancy of either and both—the greatness and brevity and eternal passing of everything vitally felt. Such is the pattern, or logical form, of sentience; and the pattern of music is that same form worked out in pure, measured sound and silence. Music is a tonal analogue of emotive life.

Such formal analogy, or congruence of logical structures, is the prime requisite for the relation between a symbol and whatever it is to mean. The symbol and the object symbolized must have some common logical form.

But purely on the basis of formal analogy, there would be no telling which of two congruent structures was the symbol and which the meaning, since the relation of congruence, or formal likeness, is symmetrical, i.e. it works both ways. (If John looks so much like James that you can't tell him from James, then you can't tell James from John, either.) There must be a motive for choosing, as between two entities or two systems, one to be the symbol of the other. Usually the decisive reason is that one is easier to perceive and handle than the other. Now sounds are much easier to produce, combine, perceive, and identify, than feelings. Forms of sentience occur only in the course of nature, but musical forms may be invented and intoned at will. Their general pattern may be reincarnated again and again by repeated performance. The effect is actually never quite the same even though the physical repetition may be exact, as in recorded music, because the exact degree of one's familiarity with a passage affects the experience of it, and this factor can never be made permanent. Yet within a fairly wide range such variations are, happily, unimportant. To some musical forms even much less subtle changes are not really disturbing, for instance certain differences of instrumentation and even, within limits, of pitch or tempo. To others, they are fatal. But in the main, sound is a negotiable medium, capable of voluntary composition and repetition, whereas feeling is not; this trait recommends tonal structures for symbolic purposes.

Furthermore, a symbol is used to articulate ideas of something we wish to think about, and until we have a fairly adequate symbolism we cannot think about it. So *interest* always plays a major part in making one thing, or realm of things, the meaning of something else, the symbol or system of symbols.

Sound, as a sheer sensory factor in experience, may be soothing or exciting, pleasing or torturing; but so are the factors of taste, smell, and touch. Selecting and exploiting such somatic influences is self-indulgence, a very different thing from art. An enlightened society usually has some means, public or private, to support its artists, because their work is regarded as a spiritual triumph and a claim to greatness for the whole tribe. But mere epicures would hardly achieve such fame. Even chefs, per-

fumers, and upholsterers, who produce the means of sensory pleasure for others, are not rated as the torchbearers of culture and inspired creators. Only their own advertisements bestow such titles on them. If music, patterned sound, had no other office than to stimulate and soothe our nerves, pleasing our ears as well-combined foods please our palates, it might be highly popular, but never culturally important. Its historic development would be too trivial a subject to engage many people in its lifelong study, though a few desperate Ph.D. theses might be wrung from its anecdotal past under the rubric of "social history." And music conservatories would be properly rated exactly like cooking schools.

Our interest in music arises from its intimate relation to the all-important life of feeling, whatever that relation may be. After much debate on current theories, the conclusion reached in *Philosophy in a New Key* is that the function of music is not stimulation of feeling, but expression of it; and furthermore, not the symptomatic expression of feelings that beset the composer but a symbolic expression of the forms of sentience as he understands them. It bespeaks his imagination of feelings rather than his own emotional state, and expresses what he *knows about* the so-called "inner life"; and this may exceed his personal case, because music is a symbolic form to him through which he may learn as well as utter ideas of human sensibility.

There are many difficulties involved in the assumption that music is a symbol, because we are so deeply impressed with the paragon of symbolic form, namely language, that we naturally carry its characteristics over into our conceptions and expectations of any other mode. Yet music is not a kind of language. Its significance is really something different from what is traditionally and properly called "meaning." Perhaps the logicians and positivistic philosophers who have objected to the term "implicit meaning," on the ground that "meaning" properly so-called is always explicable, definable, and translatable, are prompted by a perfectly rational desire to keep so difficult a term free from any further entanglements and sources of confusion; and if this can be done without barring the concept itself which I have designated as "implicit meaning," it certainly seems the part of wisdom to accept their strictures.

Probably the readiest way to understand the precise nature of musical symbolization is to consider the characteristics of language and then, by comparison and contrast, note the different structure of music, and the consequent differences and similarities between the respective functions of those two logical forms. Because the prime purpose of language is discourse, the conceptual framework that has developed under its influence is known as "discursive reason." Usually, when one speaks of "reason" at all, one tacitly assumes its discursive pattern. But in a broader sense any appreciation of form, any awareness of patterns in experience, is "reason"; and discourse with all its refinements (e.g. mathematical symbolism, which is an extension of language) is only one possible pattern.

For practical communication, scientific knowledge, and philosophical thought it is the only instrument we have. But on just that account there are whole domains of experience that philosophers deem "ineffable." If those domains appear to anyone the most important, that person is naturally inclined to condemn philosophy and science as barren and false. To such an evaluation one is entitled; not, however, to the claim of a better way to philosophical truth through instinct, intuition, feeling, or what have you. Intuition is the basic process of all understanding, just as operative in discursive thought as in clear sense perception and immediate judgment; there will be more to say about that presently. But it is no substitute for discursive logic in the making of any theory, contingent or transcendental.

The difference between discursive and non-discursive logical forms, their respective advantages and limitations, and their consequent symbolic uses have already been discussed in the previous book, but because the theory, there developed, of music as a symbolic form is our starting point here for a whole philosophy of art, the underlying semantic principles should perhaps be explicitly recalled first.

In language, which is the most amazing symbolic system humanity has invented, separate words are assigned to separately conceived items in experience on a basis of simple, one-to-one correlation. A word that is not composite (made of two or more independently meaningful vocables, such as "omni-potent," "com-posite") may be assigned to mean any object *taken as one*. We may even, by fiat, take a word like "omnipotent," and regarding it as one, assign it a connotation that is not composite, for instance by naming a race horse "Omnipotent." Thus Praisegod Barbon ("Barebones") was an indivisible being although his name is a composite word. He had a brother called "If-Christ-had-not-come-into-the-world-thou-wouldst-have-been-damned." The simple correlation between a name and its bearer held here between a whole sentence taken as one word and an object to which it was arbitrarily assigned. Any symbol that names something is "taken as one"; so is the object. A "crowd" is a lot of people, but *taken as a lot*, i.e. as one crowd.

So long as we correlate symbols and concepts in this simple fashion we are free to pair them as we like. A word or mark used arbitrarily to denote or connote something may be called an associative symbol, for its meaning depends entirely on association. As soon, however, as words taken to denote different things are used in combination, something is expressed by the way they are combined. The whole complex is a symbol, because the combination of words brings their connotations irresistibly together in a complex, too, and this complex of ideas is analogous to the word-complex. To anyone who knows the meanings of all the constituent words in the name of Praisegod's brother, the name is likely to sound absurd, because it is a sentence. The concepts associated with the words form a complex concept, the parts of which are related in a pattern analogous to the

word-pattern. Word-meanings and grammatical forms, or rules for word-using, may be freely assigned; but once they are accepted, propositions emerge automatically as the meanings of sentences. One may say that the elements of propositions are *named* by words, but propositions themselves are *articulated* by sentences.

A complex symbol such as a sentence, or a map (whose outlines correspond formally to the vastly greater outlines of a country), or a graph (analogous, perhaps, to invisible conditions, the rise and fall of prices, the progress of an epidemic) is an *articulate form*. Its characteristic symbolic function is what I call *logical expression*. It expresses relations; and it may "mean"—connote or denote—any complex of elements that is of the same articulate form as the symbol, the form which the symbol "expresses."

Music, like language, is an articulate form. Its parts not only fuse together to yield a greater entity, but in so doing they maintain some degree of separate existence, and the sensuous character of each element is affected by its function in the complex whole. This means that the greater entity we call a composition is not merely produced by mixture, like a new color made by mixing paints, but is *articulated*, i.e. its internal structure is given to our perception.

Why, then, is it not a *language* of feeling, as it has often been called? Because its elements are not words—independent associative symbols with a reference fixed by convention. Only as an articulate form is it found to fit anything; and since there is no meaning assigned to any of its parts, it lacks one of the basic characteristics of language—fixed association, and therewith a single, unequivocal reference. We are always free to fill its subtle articulate forms with any meaning that fits them; that is, it may convey an idea of anything conceivable in its logical image. So, although we do receive it as a significant form, and comprehend the processes of life and sentience through its audible, dynamic pattern, it is not a language, because it has no vocabulary.

Perhaps, in the same spirit of strict nomenclature, one really should not refer to its content as "meaning," either. Just as music is only loosely and inexactly called a language, so its symbolic function is only loosely called meaning, because the factor of conventional reference is missing from it. In *Philosophy in a New Key* music was called an "unconsummated" symbol.[2] But meaning, in the usual sense recognized in semantics, includes the condition of conventional reference, or consummation of the symbolic relationship. Music has *import*, and this import is the pattern of sentience—the pattern of life itself, as it is felt and directly known. Let us therefore call the significance of music its "vital import" instead of "meaning," using "vital" not as a vague laudatory term, but as a qualifying

[2] Harvard University Press edition, p. 240; New American Library (Mentor) edition, p. 195.

adjective restricting the relevance of "import" to the dynamism of subjective experience.

So much, then, for the theory of music; music is "significant form," and its significance is that of a symbol, a highly articulated sensuous object, which by virtue of its dynamic structure can express the forms of vital experience which language is peculiarly unfit to convey. Feeling, life, motion and emotion constitute its import.

Here, in rough outline, is the special theory of music which may, I believe, be generalized to yield a theory of art as such. The basic concept is the articulate but non-discursive form having import without conventional reference, and therefore presenting itself not as a symbol in the ordinary sense, but as a "significant form," in which the factor of significance is not logically discriminated, but is felt as a quality rather than recognized as a function. If this basic concept be applicable to all products of what we call "the arts," i.e. if all works of art may be regarded as significant forms in exactly the same sense as musical works, then all the essential propositions in the theory of music may be extended to the other arts, for they all define or elucidate the nature of the symbol and its import.

That crucial generalization is already given by sheer circumstance: for the very term "significant form" was originally introduced in connection with other arts than music, in the development of another special theory; all that has so far been written about it was supposed to apply primarily, if not solely, to visual arts. Clive Bell, who coined the phrase, is an art critic, and (by his own testimony) not a musician. His own introduction of the term is given in the following words:

"Every one speaks of 'art,' making a mental classification by which he distinguishes the class 'works of art' from all other classes. What is the justification of this classification? . . . There must be some one quality without which a work of art cannot exist; possessing which, in the least degree, no work is altogether worthless. What is this quality? What quality is shared by all objects that provoke our aesthetic emotions? What quality is common to Santa Sophia and the Windows at Chartres, Mexican sculpture, a Persian bowl, Chinese carpets, Giotto's frescoes at Padua, and the masterpieces of Poussin, Piero della Francesca, and Cézanne? Only one answer seems possible—significant form. In each, lines and colours combined in a particular way, certain forms and relations of forms, stir our aesthetic emotions. These relations and combinations of lines and colours, these aesthetically moving forms, I call 'Significant Form'; and 'Significant Form' is the one quality common to all works of visual art."[3]

Bell is convinced that the business of aesthetics is to contemplate the aesthetic emotion and its object, the work of art, and that the reason why

[3] *Ibid.*, p. 8.

certain objects move us as they do lies beyond the confines of aesthetics.[4] If that were so, there would be little of interest to contemplate. It seems to me that the *reason* for our immediate recognition of "significant form" is the heart of the aesthetical problem; and Bell himself has given several hints of a solution, although his perfectly justified dread of heuristic theories of art kept him from following out his own observations. But, in the light of the music theory that culminates in the concept of "significant form," perhaps the hints in his art theory are enough.

"Before we feel an aesthetic emotion for a combination of forms," he says (only to withdraw hastily, even before the end of the paragraph, from any philosophical commitment) "do we not perceive intellectually the rightness and necessity of the combination? If we do, it would explain the fact that passing rapidly through a room we recognize a picture to be good, although we cannot say that it has provoked much emotion. We seem to have recognized intellectually the rightness of its forms without staying to fix our attention, and collect, as it were, their emotional significance. If this were so, it would be permissible to inquire whether it was the forms themselves or our perception of their rightness and necessity that caused aesthetic emotion."[5]

Certainly "rightness and necessity" are properties with philosophical implications, and the perception of them a more telling incident than an inexplicable emotion. To recognize that something is right and necessary is a rational act, no matter how spontaneous and immediate the recognition may be; it points to an intellectual principle in artistic judgment, and a rational basis for the feeling Bell calls "the aesthetic emotion." This emotion is, I think a result of artistic perception, as he suggested in the passage quoted above; it is a personal reaction to the discovery of "rightness and necessity" in the sensuous forms that evoke it. Whenever we experience it we are in the presence of Art, i.e. of "significant form." He himself has identified it as the same experience in art appreciation and in pure musical hearing, although he says he has rarely achieved it musically. But if it is common to visual and tonal arts, and if indeed it bespeaks the artistic value of its object, it offers another point of support for the theory that significant form is the essence of all art.

That, however, is about all that it offers. Bell's assertion that every theory of art must begin with the contemplation of "the aesthetic emotion," and that, indeed, nothing else is really the business of aesthetics,[6] seems to me entirely wrong. To dwell on one's state of mind in the presence of a work does not further one's understanding of the work and its value. The question of what gives one the emotion is exactly the question of what makes the object artistic; and that, to my mind, is where philosophical art theory begins.

[4] *Ibid.*, p. 10.
[5] *Ibid.*, p 26.
[6] See reference above, note 4.

The same criticism applies to all theories that begin with an analysis of the "aesthetic attitude": they do not get beyond it. Schopenhauer, who is chiefly responsible for the notion of a completely desireless state of pure, sensuous discrimination as the proper attitude toward works of art, did not make it the starting point of his system, but a consequence. Why, then, has it been so insistently employed, especially of late, as the chief datum in artistic experience?

Probably under pressure of the psychologistic currents that have tended, for the last fifty years at least, to force all philosophical problems of art into the confines of behaviorism and pragmatism, where they find neither development nor solution, but are assigned to vague realms of "value" and "interest," in which nothing of great value or interest has yet been done. The existence of art is accounted for, its value admitted, and there's an end of it. But the issues that really challenge the aesthetician—e.g. the exact nature and degree of interrelation among the arts, the meaning of "essential" and "unessential," the problem of translatability, or transposability, of artistic ideas—either cannot arise in a psychologistic context, or are answered, without real investigation, on the strength of some general premise that seems to cover them. The whole tenor of modern philosophy, especially in America, is uncongenial to serious speculation on the meaning and difficulty and seriousness of art works. Yet the pragmatic outlook, linked as it is with natural science, holds such sway over us that no academic discussion can resist its magnetic, orienting concepts; its basic psychologism underlies every doctrine that really looks respectable.

Now, the watchword of this established doctrine is "experience." If the leading philosophers publish assorted essays under such titles as *Freedom and Experience*,[7] or center their systematic discourse around *Experience and Nature*,[8] so that in their aesthetics, too, we are presented with *The Aesthetic Experience*[9] and *Art as Experience*,[10] it is natural enough that artists, who are amateurs in philosophy, try to treat their subject in the same vein, and write: *Experiencing American Pictures*,[11] or: *Dance—A Creative Art Experience*.[12] As far as possible, these writers who grope more or less for principles of intellectual analysis adopt the current terminology, and therewith they are committed to the prevailing fashion of thought.

Since this fashion has grown up under the mentorship of natural science, it brings with it not only the great ideals of empiricism, namely observation, analysis and verification, but also certain cherished hypotheses, primarily from the least perfect and successful of the sciences, psychology and sociology. The chief assumption that determines the entire

[7] *Essays in Honor of Horace M. Kallen* (1947).
[8] John Dewey (1925).
[9] Laurence Buermeyer (1924).
[10] John Dewey (1934).
[11] Ralph M. Pearson (1943).
[12] Margaret H'Doubler (1940).

procedure of pragmatic philosophy is that all human interests are direct or oblique manifestations of "drives" motivated by animal needs. This premise limits the class of admitted human interests to such as can, by one device or another, be interpreted in terms of animal psychology. An astonishingly great part of human behavior really does bear such interpretation without strain; and pragmatists, so far, do not admit that there is any point where the principle definitely fails, and its use falsifies our empirical findings.

The effect of the genetic premise on art theory is that aesthetic values must be treated either as direct satisfactions, i.e. pleasures, or as instrumental values, that is to say, means to fulfillment of biological needs. It is either a leisure interest, like sports and hobbies, or it is valuable for getting on with the world's work—strengthening morale, integrating social groups, or venting dangerous repressed feelings in a harmless emotional catharsis. But in either case, artistic experience is not essentially different from ordinary physical, practical, and social experience.[13]

The true connoisseurs of art, however, feel at once that to treat great art as a source of experiences not essentially different from the experiences of daily life—a stimulus to one's active feelings, and perhaps a means of communication between persons or groups, promoting mutual appreciation—is to miss the very essence of it, the thing that makes art as important as science or even religion, yet sets it apart as an autonomous, creative function of a typically human mind. If, then, they feel constrained by the prevailing academic tradition to analyze their experience, attitude, response, or enjoyment, they can only begin by saying that aesthetic experience is different from any other, the attitude toward works of art is a highly special one, the characteristic response is an entirely separate emotion, something more than common enjoyment—not related to the pleasures or displeasures furnished by one's actual surroundings, and therefore disturbed by them rather than integrated with the contemporary scene.

This conviction does not spring from a sentimental concern for the

[13] Cf. John Dewey, *Art as Experience*, p. 10: ". . . the forces that create the gulf between producer and consumer in modern society operate to create also a chasm between ordinary and esthetic experience. Finally we have, as a record of this chasm, accepted as if it were normal, the philosophies of art that locate it in a region inhabited by no other creature, and that emphasize beyond all reason the merely contemplative character of the esthetic."

Also I. A. Richards, *Principles of Literary Criticism*, pp. 16–17: "When we look at a picture, read a poem, or listen to music, we are not doing something quite unlike what we were doing on our way to the Gallery or when we dressed in the morning. The fashion in which the experience is caused in us is different, and as a rule the experience is more complex and, if we are successful, more unified. But our activity is not of a fundamentally different type."

Laurence Buermeyer, in *The Aesthetic Experience*, p. 79, follows his account of artistic expression with the statement: "This does not mean, once more, that what the artist has to say is different in kind from what is to be said in actual life, or that the realm of art is in any essential respect divorced from the realm of reality."

glamor and dignity of the arts, as Mr. Dewey suggests;[14] it arises from the fact that when people in whom appreciation for some art—be it painting, music, drama, or what not—is spontaneous and pronounced, are induced by a psychologistic fashion to reflect on their attitude toward the works they appreciate, they find it not at all comparable with the attitude they have toward a new automobile, a beloved creature, or a glorious morning. They feel a different emotion, and in a different way. Since art is viewed as a special kind of "experience," inaccessible to those who cannot enter into the proper spirit, a veritable cult of the "aesthetic attitude" has grown up among patrons of the art gallery and the concert hall.

But the aesthetic attitude, which is supposed to beget the art experience in the presence of suitable objects (what makes them suitable seems to be a minor question, relegated to a time when "science" shall be ready to answer it), is hard to achieve, harder to maintain, and rarely complete. H. S. Langfeld, who wrote a whole book about it, described it as an attitude "that for most individuals has to be cultivated if it is to exist at all in midst of the opposing and therefore disturbing influences which are always present."[15] And David Prall, in his excellent *Aesthetic Analysis*, observes: "Even a young musical fanatic at a concert of his favorite music has some slight attention left for the comfort of his body and his posture, some vague sense of the direction of exits, a degree of attention most easily raised into prominence by any interference with his comfort by his neighbor's movements, or accidental noises coming from elsewhere, whether these indicate the danger of fire or some milder reason for taking action. Complete aesthetic absorption, strictly relevant to one object, is at least rare; the world as exclusively aesthetic surface is seldom if ever the sole object of our attention."[16]

Few listeners or spectators, in fact, ever quite attain the state which Roger Fry described, in *Vision and Design*, as "disinterested intensity of contemplation"[17]—the only state in which one may really perceive a work of art, and experience the aesthetic emotion. Most people are too busy or too lazy to uncouple their minds from all their usual interests before looking at a picture or a vase. That explains, presumably, what he remarked somewhat earlier in the same essay: "In proportion as art becomes purer the number of people to whom it appeals gets less. It cuts out all the romantic overtones which are the usual bait by which men are induced

[14] Speaking of the separation of art from life "that many theorists and critics pride themselves upon holding and even elaborating," he attributes it to the desire to keep art "spiritual," and says in explanation: "For many persons an aura of mingled awe and unreality encompasses the 'spiritual' and the 'ideal' while 'matter' has become . . . something to be explained away or apologized for." John Dewey, *op. cit.*, p. 6.

[15] *The Aesthetic Attitude*, p. 65.

[16] *Aesthetic Analysis*, pp. 7–8.

[17] *Vision and Design*, p. 29.

to accept a work of art. It appeals only to the aesthetic sensibility, and that in most men is comparatively weak."[18]

If the groundwork of all genuine art experience is really such a sophisticated, rare, and artificial attitude, it is something of a miracle that the world recognizes works of art as public treasures at all. And that primitive peoples, from the cave dwellers of Altamira to the early Greeks, should quite unmistakably have known what was beautiful, becomes a sheer absurdity.

There is that, at least, to be said for the pragmatists: they recognize the art interest as something natural and robust, not a precarious hothouse flower reserved for the very cultured and initiate. But the small compass of possible human interests permitted by their biological premises blinds them to the fact that a very spontaneous, even primitive activity may none the less be peculiarly human, and may require long study in its own terms before its relations to the rest of our behavior become clear. To say, as I. A. Richards does, that if we knew more about the nervous system and its responses to "certain stimuli" (note that "certain," when applied to hypothetical data, means "uncertain," since the data cannot be exactly designated) we would find that "the unpredictable and miraculous differences . . . in the total responses which slight changes in the arrangement of stimuli produce, can be fully accounted for in terms of the sensitiveness of the nervous system; and the mysteries of 'forms' are merely a consequence of our present ignorance of the detail of its action,"[19] is not only an absurd pretension (for how do we know what facts we would find and what their implications would prove to be, before we have found them?), but an empty hypothesis, because there is no elementary success that indicates the direction in which neurological aesthetics could develop. If a theoretical beginning existed, one could imagine an extension of the same procedure to describe artistic experience in terms of conditioned reflexes, rudimentary impulses, or perhaps cerebral vibrations; but so far the data furnished by galvanometers and encephalographs have not borne on artistic problems, even to the extent of explaining the simple, obvious difference of effect between a major scale and its parallel minor. The proposition that if we knew the facts we would find them to be thus and thus is merely an article of innocent, pseudo-scientific faith.

The psychological approach, dictated by the general empiricist trend in philosophy, has not brought us within range of any genuine problems of art. So, instead of studying the "slight changes of stimuli" which cause "unpredictable and miraculous changes" in our nervous responses, we might do better to look upon the art object as something in its own right, with properties independent of our prepared reactions—properties which command our reactions, and make art the autonomous and essential factor that it is in every human culture.

[18] *Ibid.*, p. 15.
[19] *Op cit.*, p. 172.

The concept of significant form as an articulate expression of feeling, reflecting the verbally ineffable and therefore unknown forms of sentience, offers at least a starting point for such inquiries. All articulation is difficult, exacting, and ingenious; the making of a symbol requires craftsmanship as truly as the making of a convenient bowl or an efficient paddle, and the techniques of expression are even more important social traditions than the skills of self-preservation, which an intelligent being can evolve by himself, at least in rudimentary ways, to meet a given situation. The fundamental technique of expression—language—is something we all have to learn by example and practice, i.e. by conscious or unconscious training.[20] People whose speech training has been very casual are less sensitive to what is exact and fitting for the expression of an idea than those of cultivated habit; not only with regard to arbitrary rules of usage, but in respect of logical *rightness and necessity* of expression, i.e. saying what they mean and not something else. Similarly, I believe, all making of expressive form is a craft. Therefore the normal evolution of art is in close association with practical skills—building, ceramics, weaving, carving, and magical practices of which the average civilized person no longer knows the importance;[21] and therefore, also, sensitivity to the rightness and necessity of visual or musical forms is apt to be more pronounced and sure in persons of some artistic training than in those who have only a bowing acquaintance with the arts. Technique is the means to the creation of expressive form, the symbol of sentience; the art process is the application of some human skill to this essential purpose.

At this point I will make bold to offer a definition of art, which serves to distinguish a "work of art" from anything else in the world, and at the same time to show why, and how, a utilitarian object may be *also* a work of art; and how a work of so-called "pure" art may fail of its purpose and be simply bad, just as a shoe that cannot be worn is simply bad by failing of its purpose. It serves, moreover, to establish the relation of art to physical skill, or making, on the one hand, and to feeling and expression on the other. Here is the tentative definition, on which the following chapters are built: Art is the creation of forms symbolic of human feeling.

The word "creation" is introduced here with full awareness of its problematical character. There is a definite reason to say a craftsman *produces* goods, but *creates* a thing of beauty; a builder *erects* a house, but *creates* an edifice if the house is a real work of architecture, however modest. An artifact as such is merely a combination of material parts, or a modification of a natural object to suit human purposes. It is not a creation, but an arrangement of given factors. A work of art, on the other hand, is

[20] Cf. *New Key*, Chap. v, "Language."
[21] Yet a pervasive magical interest has probably been the natural tie between practical fitness and expressiveness in primitive artifacts. See *New Key*, chap. ix, "The Genesis of Artistic Import."

more than an "arrangement" of given things—even qualitative things. Something emerges from the arrangement of tones or colors, which was not there before, and this, rather than the arranged material, is the symbol of sentience.

The making of this expressive form is the creative process that enlists a man's utmost technical skill in the service of his utmost conceptual power, imagination. Not the invention of new original turns, nor the adoption of novel themes, merits the word "creative," but the making of any work symbolic of feeling, even in the most canonical context and manner. A thousand people may have used every device and convention of it before. A Greek vase was almost always a creation, although its form was traditional and its decoration deviated but little from that of its numberless forerunners. The creative principle, nonetheless, was probably active in it from the first throw of the clay.

To expound that principle, and develop it in each autonomous realm of art, is the only way to justify the definition, which really is a philosophical theory of art in miniature.

LEONARD MEYER

THE MEANING OF MUSIC

Leonard Meyer, Professor of Music at the University of Chicago, has applied the insights of Gestalt psychology to an analysis of the nature of music.

THE PROBLEM OF MEANING IN MUSIC

The meaning of music has of late been the subject of much confused argument and controversy. The controversy has stemmed largely from disagreements as to what music communicates, while the confusion has resulted for the most part from a lack of clarity as to the nature and definition of meaning itself.

The debates as to what music communicates have centered around the question of whether music can designate, depict, or otherwise communicate referential concepts, images, experiences, and emotional states. This is the old argument between the absolutists and the referentialists. . . .

Because it has not appeared problematical to them, the referentialists

Reprinted from *Emotion and Meaning in Music*, pp. 33–42, by Leonard Meyer by permission of The University of Chicago Press. © 1956 by the University of Chicago.

have not as a rule explicitly considered the problem of musical meaning. Musical meaning according to the referentialists lies in the relationship between a musical symbol or sign and the extramusical thing which it designates.

Since our concern in this study is not primarily with the referential meaning of music, suffice it to say that the disagreement between the referentialists and the absolutists is, as was pointed out at the beginning of this chapter, the result of a tendency toward philosophical monism rather than the result of any logical incompatibility. Both designative and non-designative meanings arise out of musical experience, just as they do in other types of aesthetic experience.

The absolutists have contended that the meaning of music lies specifically, and some would assert exclusively, in the musical processes themselves. For them musical meaning is non-designative. But in what sense these processes are meaningful, in what sense a succession or sequence of non-referential musical stimuli can be said to give rise to meaning, they have been unable to state with either clarity or precision. They have also failed to relate musical meaning to other kinds of meaning—to meaning in general. This failure has led some critics to assert that musical meaning is a thing apart, different in some unexplained way from all other kinds of meaning. This is simply an evasion of the real issue. For it is obvious that if the term "meaning" is to have any signification at all as applied to music, then it must have the same signification as when applied to other kinds of experience.

Without reviewing all the untenable positions to which writers have tenaciously adhered, it seems fair to say that much of the confusion and uncertainty as to the nature of non-referential musical meaning has resulted from two fallacies. On the one hand, there has been a tendency to locate meaning exclusively in one aspect of the communicative process; on the other hand, there has been a propensity to regard all meanings arising in human communication as designative, as involving symbolism of some sort.

Since these difficulties can be best resolved in the light of a general definition of meaning, let us begin with such a definition: ". . . anything acquires meaning if it is connected with, or indicates, or refers to, something beyond itself, so that its full nature points to and is revealed in that connection."[1]

Meaning is thus not a property of things. It cannot be located in the stimulus alone. The same stimulus may have many different meanings. To a geologist a large rock may indicate that at one time a glacier began to recede at a given spot; to a farmer the same rock may point to the necessity of having the field cleared for plowing; and to the sculptor the

[1] Morris R. Cohen, *A Preface to Logic* (New York: Holt, Rinehart and Winston, 1944), p. 47.

rock may indicate the possibility of artistic creation. A rock, a word, or motion in and of itself, merely as a stimulus, is meaningless.

Thus it is pointless to ask what the intrinsic meaning of a single tone or a series of tones is. Purely as physical existences they are meaningless. They become meaningful only in so far as they point to, indicate, or imply something beyond themselves.

Nor can meaning be located exclusively in the objects, events, or experiences which the stimulus indicates, refers to, or implies. The meaning of the rock is the product of the relationship between the stimulus and the thing it points to or indicates.

Though the perception of a relationship can only arise as the result of some individual's mental behavior, the relationship itself is not to be located in the mind of the perceiver. The meanings observed are not subjective. Thus the relationships existing between the tones themselves or those existing between the tones and the things they designate or connote, though a product of cultural experience, are real connections existing objectively in culture. They are not arbitrary connections imposed by the capricious mind of the particular listener.

Meaning, then, is not in either the stimulus, or of what it points to, or the observer. Rather it arises out of what both Cohen and Mead have called the "triadic" relationship between (1) an object or stimulus; (2) that to which the stimulus points—that which is its consequent; and (3) the conscious observer.

Discussions of the meaning of music have also been muddled by the failure to state explicitly what musical stimuli indicate or point to. A stimulus may indicate events or consequences which are different from itself in kind, as when a word designates or points to an object or action which is not itself a word. Or a stimulus may indicate or imply events or consequences which are of the same kind as the stimulus itself, as when a dim light on the eastern horizon heralds the coming of day. Here both the antecedent stimulus and the consequent event are natural phenomena. The former type of meaning may be called designative, the latter embodied.

Because most of the meanings which arise in human communication are of the designative type, employing linguistic signs or the iconic signs of the plastic arts, numerous critics have failed to realize that this is not necessarily or exclusively the case. This mistake has led even avowed absolutists to allow designation to slip in through the secret door of semantic chicanery.

But even more important than designative meaning is what we have called embodied meaning. From this point of view what a musical stimulus or a series of stimuli indicate and point to are not extramusical concepts and objects but other musical events which are about to happen. That is, one musical event (be it a tone, a phrase, or a whole section) has meaning

because it points to and makes us expect another musical event. This is what music means from the viewpoint of the absolutist.

MUSIC AND MEANING

Embodied musical meaning is, in short, a product of expectation. If, on the basis of past experience, a present stimulus leads us to expect a more or less definite consequent musical event, then that stimulus has meaning.

From this it follows that a stimulus or gesture which does not point to or arouse expectations of a subsequent musical event or consequent is meaningless. Because expectation is largely a product of stylistic experience, music in a style with which we are totally unfamiliar is meaningless.

However, once the aesthetic attitude has been brought into play, very few gestures actually appear to be meaningless so long as the listener has some experience with the style of the work in question. For so long as a stimulus is possible within any known style, the listener will do his best to relate it to the style, to understand its meaning.

In and of themselves, for example, the opening chords of Beethoven's Third Symphony have no particular musical stylistic tendency. They establish no pattern of motion, arouse no tensions toward a particular fulfilment. Yet as part of the total aesthetic cultural act of attention they are meaningful. For since they are the first chords of a piece, we not only expect more music but our expectations are circumscribed by the limitations of the style which we believe the piece to be in and by the psychological demand for a more palpable pattern. . . .

Thus the phrase "past experience," used in the definition of meaning given above, must be understood in a broad sense. It includes the immediate past of the particular stimulus or gesture; that which has already taken place in this particular work to condition the listener's opinion of the stimulus and hence his expectations as to the impending, consequent event. In the example given above, the past was silence. But this fact of the past is just as potent in conditioning expectation as a whole section of past events. The phrase "past experience" also refers to the more remote, but ever present, past experience of similar musical stimuli and similar musical situations in other works. That is it refers to those past experiences which constitute our sense and knowledge of style. The phrase also comprehends the dispositions and beliefs which the listener brings to the musical experience . . . as well as the laws of mental behavior which govern his organization of stimuli into patterns and the expectations aroused on the basis of those patterns. . . .

The words "consequent musical event" must be understood to include: (1) those consequents which are envisaged or expected; (2) the events which do, in fact, follow the stimulus, whether they were the ones en-

visaged or not; and (3) the more distant ramifications or events which, because the total series of gestures is presumed to be causally connected, are considered as being the later consequences of the stimulus in question. Seen in this light, the meaning of the stimulus is not confined to or limited by the initial triadic relationship out of which it arises. As the later stages of the musical process establish new relationships with the stimulus, new meanings arise. These later meanings coexist in memory with the earlier ones and, combining with them, constitute the meaning of the work as a total experience.

In this development three stages of meaning may be distinguished.

"Hypothetical meanings" are those which arise during the act of expectation. Since what is envisaged is a product of the probability relationships which exist as part of style, . . . and since these probability relationships always involve the possibility of alternative consequences, a given stimulus invariably gives rise to several alternative hypothetical meanings. One consequent may, of course, be so much more probable than any other that the listener, though aware of the possibility of less likely consequences, is really set and ready only for the most probable. In such a case hypothetical meaning is without ambiguity. In other cases several consequents may be almost equally probable, and, since the listener is in doubt as to which alternative will actually materialize, meaning is ambiguous, though not necessarily less forceful and marked. . . .

Though the consequent which is actually forthcoming must be possible within the style, it may or may not be of those which was most probable. Or it may arrive only after a delay or a deceptive diversion through alternative consequences. But whether our expectations are confirmed or not, a new stage of meaning is reached when the consequent becomes actualized as a concrete musical event.

"Evident meanings" are those which are attributed to the antecedent gesture when the consequent becomes a physico-psychic fact and when the relationship between the antecedent and consequent is perceived. Since the consequent of a stimulus itself becomes a stimulus with consequents, evident meaning also includes the later stages of musical development which are presumed to be the products of a chain of causality. Thus in the following sequence, where a stimulus (S) leads to a consequent (C), which is also a stimulus that indicates and is actualized in further consequents,

$$S_1 \ldots \ldots C_1 S_2 \ldots \ldots C_2 S_3 \ldots \ldots \text{etc.}$$

evident meaning arises not only out of the relationship between S_1 and C_1 but also out of the relationships between S_1 and all subsequent consequences, in so far as these are considered to issue from S_1. It is also important to realize that the motion $S_1 \ldots \ldots C_2$ may itself become a gesture that gives rise to envisaged and actual consequents and hence be-

comes a term or gesture on another level of triadic relationships. In other words, both evident and hypothetical meanings come into being and exist on several architectonic levels.

Evident meaning is colored and conditioned by hypothetical meaning. For the actual relationship between the gesture and its consequent is always considered in the light of the expected relationship. In a sense the listener even revises his opinion of the hypothetical meaning when the stimulus does not move to the expected consequent.

"Determinate meanings" are those meanings which arise out of the relationships existing between hypothetical meaning, evident meaning, and the later stages of the musical development. In other words, determinate meaning arises only after the experience of the work is timeless in memory, only when all the meanings which the stimulus has had in the particular experience are realized and their relationships to one another comprehended as fully as possible.

THE OBJECTIFICATION OF MEANING

A distinction must be drawn between the understanding of musical meaning which involves the awareness of the tendencies, resistances, tensions, and fulfilments embodied in a work and the self-conscious objectification of that meaning in the mind of the individual listener. The former may be said to involve a meaningful experience, the latter involves knowing what that meaning is, considering it as an objective thing in consciousness.

The operation of intelligence in listening to music need never become self-conscious. We are continually behaving in an intelligent way, comprehending meanings and acting upon our perceptions, cognitions, and evaluations without ever making the meanings themselves the objects of our scrutiny—without ever becoming self-conscious about what experience means. What Bertrand Russell says about understanding language also applies to the understanding of music: "Understanding language is . . . like understanding cricket: it is a matter of habits acquired in oneself and rightly presumed in others."[2]

Meanings become objectified only under conditions of self-consciousness and when reflection takes place. "One attains self-consciousness only as he takes, or finds himself stimulated to take, the attitude of the other."[3] Though training may make for a generally self-conscious attitude, one is stimulated to take the attitude of the other when the normal habits of response are disturbed in some way; when one is driven to ask one's self:

[2] Bertrand Russell, *Selected Papers* (New York: Random House [Modern Library]), p. 358.

[3] George H. Mead, *Mind, Self, and Society* (Chicago: University of Chicago Press, 1934), p. 194.

What does this mean, what is the intention of this passage? Reflection is likewise brought into play where some tendency is delayed, some pattern of habitual behavior disturbed. So long as behavior is automatic and habitual there is no urge for it to become self-conscious, though it may become so. If meaning is to become objectified at all, it will as a rule become so when difficulties are encountered that make normal, automatic behavior impossible. In other words, given a mind disposed toward objectification, meaning will become the focus of attention, an object of conscious consideration, when a tendency or habit reaction is delayed or inhibited.

MEANING AND AFFECT

It thus appears that the same processes which were said to give rise to affect are now said to give rise to the objectification of embodied meaning.

But this is a dilemma only so long as the traditional dichotomy between reason and emotion and the parent polarity between mind and body are adopted. Once it is recognized that affective experience is just as dependent upon intelligent cognition as conscious intellection, that both involve perception, taking account of, envisaging, and so forth, then thinking and feeling need not be viewed as polar opposites but as different manifestations of a single psychological process.

There is no diametric opposition, no inseparable gulf, between the affective and the intellectual responses made to music. Though they are psychologically differentiated as responses, both depend upon the same perceptive processes, the same stylistic habits, the same modes of mental organization; and the same musical processes give rise to and shape both types of experience. Seen in this light, the formalist's conception of musical experience and the expressionist's conception of it appear as complementary rather than contradictory positions. They are considering not different processes but different ways of experiencing the same process.

Whether a piece of music gives rise to affective experience or to intellectual experience depends upon the disposition and training of the listener. To some minds the disembodied feeling of affective experience is uncanny and unpleasant and a process of rationalization is undertaken in which the musical processes are objectified as conscious meaning. Belief also probably plays an important role in determining the character of the response. Those who have been taught to believe that musical experience is primarily emotional and who are therefore disposed to respond affectively will probably do so. Those listeners who have learned to understand music in technical terms will tend to make musical processes an object of conscious consideration. This probably accounts for the fact that most trained critics and aestheticians favor the formalist position.

Thus while the trained musician consciously waits for the expected reso-
lution of a dominant seventh chord the untrained, but practiced, listener
feels the delay as affect.

MUSIC AND COMMUNICATION

Meanings and affects may, however, arise without communication tak-
ing place. Individual *A* observes another individual *B* wink and inter-
prets the wink as a friendly gesture. It has meaning for *A* who observes it.
But if the wink was not intentional—if, for instance, *B* simply has a
nervous tic—then no communication has taken place, for to *B* the act had
no meaning. Communication, as Mead has pointed out, takes place only
where the gesture made has the same meaning for the individual who
makes it that it has for the individual who responds to it.

It is this internalization of gestures, what Mead calls "taking the
attitude of the other"[4] (the audience), which enables the creative artist,
the composer, to communicate with listeners. It is because the composer
is also a listener that he is able to control his inspiration with reference to
the listener. For instance, the composer knows how the listener will respond
to a deceptive cadence and controls the later stages of the composition
with reference to that supposed response. The performer too is continually
"taking the attitude of the other"—of the listener. As Leopold Mozart puts
it, the performer "must play everything in such a way that he will himself
be moved by it."[5]

It is precisely because he is continually taking the attitude of the
listener that the composer becomes aware and conscious of his own self,
his ego, in the process of creation. In this process of differentiation be-
tween himself as composer and himself as audience, the composer be-
comes self-conscious and objective.

But though the listener participates in the musical process, assuming
the role which the composer envisaged for him, and though he must, in
some sense, create his own experience, yet he need not take the attitude
of the composer in order to do so. He need not ask: How will someone
else respond to this stimulus? Nor is he obliged to objectify his own re-
sponses, to ask, How am I responding? Unlike the composer, the listener
may and frequently does "lose himself in the music"; and, in following and
responding to the sound gestures made by the composer, the listener may
become oblivious of his own ego, which has literally become one with
that of the music.

We must, then, be wary of easy and high-sounding statements to the
effect that "we cannot understand a work of art without, to a certain

[4] *Ibid.*, p. 47.

[5] Leopold Mozart, *Versuch einer gründlichen Violinschule*, quoted in *Source Read-
ings in Music History*, ed., Oliver Strunk (New York: W. W. Norton Co., Inc.,
1950), p. 602.

degree, repeating and reconstructing the creative process by which it has come into being."[6] Certainly the listener must respond to the work of art as the artist intended, and the listener's experience of the work must be similar to that which the composer envisaged for him. But this is a different thing from experiencing the "creative process which brought it into being."

However, the listener may take the attitude of the composer. He may be self-conscious in the act of listening. Those trained in music, and perhaps those trained in the other arts as well, tend, because of the critical attitudes which they have developed in connection with their own artistic efforts, to become self-conscious and objective in all their aesthetic experiences. And it is no doubt partly for this reason that, as noted above, trained musicians tend to objectify meaning, to consider it as an object of conscious cognition. . . .

Finally, and perhaps most important of all, this analysis of communication emphasizes the absolute necessity of a common universe of discourse in art. For without a set of gestures common to the social group, and without common habit responses to those gestures, no communication whatsoever would be possible. Communication depends upon, presupposes, and arises out of the universe of discourse which in the aesthetics of music is called style.

[6] Ernst Cassirer, *An Essay on Man: An Introduction to a Philosophy of Human Culture* (New York: Doubleday & Co., Inc., 1953), p. 191.

JACQUES MARITAIN
ART AND BEAUTY

Jacques Maritain (1882–), a leading French Catholic philosopher, is a creative interpreter of the ideas of Thomas Aquinas.

Saint Thomas, who was as simple as he was wise, defined the beautiful as that which, being seen, pleases: *id quod visum placet*. These four words say all that is necessary: a vision, that is to say, an *intuitive knowledge*, and a *delight*. The beautiful is what gives delight—not just any delight, but delight in knowing; not the delight peculiar to the act of knowing, but a delight which superabounds and overflows from this act because of the object known. If a thing exalts and delights the soul by the very fact that it is given to the soul's intuition, it is good to apprehend, it is beautiful.

Beauty is essentially an object of *intelligence*, for that which *knows* in the full sense of the word is intelligence, which alone is open to the infinity of being. The natural place of beauty is the intelligible world, it is from there that it descends. But it also, in a way, falls under the

"Art and Beauty" is reprinted with the permission of Charles Scribner's Sons from *Art and Scholasticism and the Frontiers of Poetry*, pp. 23–37, by Jacques Maritain, translated by Joseph W. Evans. Copyright © 1962 Jacques Maritain.

grasp of the senses, in so far as in man they serve the intellect and can themselves take delight in knowing: "Among all the senses, it is to the sense of sight and the sense of hearing only that the beautiful relates, because these two senses are *maxime cognoscitivi*." The part played by the senses in the perception of beauty is even rendered enormous in us, and well-nigh indispensable, by the very fact that our intelligence is not intuitive, as is the intelligence of the angel; it sees, to be sure, but on condition of abstracting and discoursing; only sense knowledge possesses perfectly in man the intuitiveness required for the perception of the beautiful. Thus man can doubtless enjoy purely intelligible beauty, but the beautiful that is *connatural* to man is the beautiful that delights the intellect through the senses and through their intuition. Such is also the beautiful that is proper to our art, which shapes a sensible matter in order to delight the spirit. It would thus like to believe that paradise is not lost. It has the savor of the terrestrial paradise, because it restores, for a moment, the peace and the simultaneous delight of the intellect and the senses.

If beauty delights the intellect, it is because it is essentially a certain excellence or perfection in the proportion of things to the intellect. Hence the three conditions Saint Thomas assigned to beauty: *integrity*, because the intellect is pleased in fullness of Being; *proportion*, because the intellect is pleased in order and unity; finally, and above all, *radiance* or *clarity*, because the intellect is pleased in light and intelligibility. A certain splendor is, in fact, according to all the ancients, the essential characteristic of beauty—*claritas est de ratione pulchritudinis, lux pulchrificat, quia sine luce omnia sunt turpia*—but it is a splendor of intelligibility: *splendor veri*, said the Platonists; *splendor ordinis*, said Saint Augustine, adding that "unity is the form of all beauty"; *splendor formae*, said Saint Thomas in his precise metaphysician's language: for the form, that is to say, the principle which constitutes the proper perfection of all that is, which constitutes and achieves things in their essences and qualities, which is, finally, if one may so put it, the ontological secret that they bear within them, their spiritual being, their operating mystery—the form, indeed, is above all the proper principle of intelligibility, the proper *clarity* of every thing. Besides, every form is a vestige or a ray of the creative Intelligence imprinted at the heart of created being. On the other hand, every order and every proportion is the work of intelligence. And so, to say with the Schoolmen that beauty is *the splendor of the form on the proportioned parts of matter*, is to say that it is a flashing of intelligence on a matter intelligibly arranged. The intelligence delights in the beautiful because in the beautiful it finds itself again and recognizes itself, and makes contact with its own light. This is so true that those—such as Saint Francis of Assisi—perceive and savor more the beauty of things, who know that things come forth from an intelligence, and who relate them to their author.

Every sensible beauty implies, it is true, a certain delight of the eye

itself or of the ear or the imagination: but there is beauty only if the intelligence also takes delight in some way. A beautiful color "washes the eye," just as a strong scent dilates the nostril; but of these two "forms" or qualities color only is said to be *beautiful*, because, being received, unlike the perfume, in a sense power capable of disinterested knowledge, it can be, even through its purely sensible brilliance, an object of delight for the intellect. Moreover, the higher the level of man's culture, the more spiritual becomes the brilliance of the form that delights him.

It is important, however, to note that in the beautiful that we have called connatural to man, and which is proper to human art, this brilliance of the form, no matter how purely intelligible it may be in itself, is seized *in the sensible and through the sensible*, and not separately from it. The intuition of artistic beauty thus stands at the opposite extreme from the abstraction of scientific truth. For with the former it is through the very apprehension of the sense that the light of being penetrates the intelligence.

The intelligence in this case, diverted from all effort of abstraction, rejoices without work and without discourse. It is dispensed from its usual labor; it does not have to disengage an intelligible from the matter in which it is buried, in order to go over its different attributes step by step; like a stag at the gushing spring, intelligence has nothing to do but drink; it drinks the clarity of being. Caught up in the intuition of sense, it is irradiated by an intelligible light that is suddenly given to it, in the very sensible in which it glitters, and which it does not seize *sub ratione veri*, but rather *sub ratione delectabilis*, through the happy release procured for the intelligence and through the delight ensuing in the appetite, which leaps at every good of the soul as at its proper object. Only afterwards will it be able to reflect more or less successfully upon the causes of this delight.

Thus, although the beautiful borders on the metaphysical *true*, in the sense that every splendor of intelligibility in things implies some conformity with the Intelligence that is the cause of things, nevertheless the beautiful is not a kind of truth, but a kind of good; the perception of the beautiful relates to knowledge, but by way of addition, *comme à la jeunesse s'ajoute sa fleur;* it is not so much a kind of knowledge as a kind of delight.

The beautiful is essentially delightful. This is why, of its very nature and precisely as beautiful, it stirs desire and produces love, whereas the true as such only illumines. "*Omnibus igitur est pulchrum et bonum desiderabile et amabile et diligibile.*" It is for its beauty that Wisdom is loved. And it is for itself that every beauty is first loved, even if afterwards the too weak flesh is caught in the trap. Love in its turn produces ecstasy, that is to say, it puts the lover outside of himself; ec-stasy, of which the soul experiences a diminished form when it is seized by the beauty of the work of art, and the fullness when it is absorbed, like the dew, by the beauty of God.

And of God Himself, according to Denis the Areopagite, we must be so bold as to say that He suffers in some way ecstasy of love, because of the abundance of His goodness which leads Him to diffuse in all things a participation of His splendor. But God's love is caused by the beauty of what we love.

*

The speculations of the ancients concerning the beautiful must be taken in the most formal sense; we must avoid materializing their thought in any too narrow specification. There is not just one way but a thousand or ten thousand ways in which the notion of *integrity* or perfection or completion can be realized. The lack of a head or an arm is quite a considerable lack of integrity in a woman but of very little account in a statue—whatever disappointment M. Ravaisson may have felt at not being able to *complete* the Venus de Milo. The least sketch of da Vinci's or even of Rodin's is more complete than the most perfect Bouguereau. And if it pleases a futurist to give the lady he is painting only one eye, or a quarter of an eye, no one denies him the right to do this: one asks only—here is the whole problem—that this quarter of an eye be precisely all the eye this lady needs *in the given case*.

It is the same with proportion, fitness and harmony. They are diversified according to the objects and according to the ends. The good proportion of a man is not the good proportion of a child. Figures constructed according to the Greek or the Egyptian canons are perfectly proportioned in their genre; but Rouault's clowns are also perfectly proportioned, in their genre. Integrity and proportion have no absolute signification, and must be understood solely *in relation* to the end of the work, which is to make a form shine on matter.

Finally, and above all, this radiance itself of the form, which is the main thing in beauty, has an infinity of diverse ways of shining on matter.[1]

[1] By "radiance of the form" must be understood an *ontological* splendor which is in one way or another revealed to our mind, not a *conceptual* clarity. We must avoid all misunderstanding here: the words *clarity, intelligibility, light,* which we use to characterize the role of "form" at the heart of things, do not necessarily designate something clear and intelligible *for us,* but rather something clear and luminous *in itself,* intelligible *in itself,* and which often remains obscure to our eyes, either because of the matter in which the form in question is buried, or because of the transcendence of the form itself in the things of the spirit. The more substantial and the more profound this secret sense is, the more hidden it is for us; so that, in truth, to say with the Schoolmen that the form is in things the proper principle of *intelligibility,* is to say at the same time that it is the proper principle of *mystery.* (There is in fact no mystery where there is *nothing to know:* mystery exists where there is *more to be known* than is given to our comprehension.) To define the beautiful by the radiance of the form is in reality to define it by the radiance of a mystery.

It is a Cartesian misconception to reduce clarity *in itself* to clarity *for us.* In art this misconception produces *academicism,* and condemns us to a beauty so meagre that it can radiate in the soul only the most paltry of delights.

If it be a question of the "legibility" of the work, I would add that if the *radiance of form* can appear in an "obscure" work as well as in a "clear" work, the *radiance*

There is the sensible radiance of color or tone; there is the intelligible clarity of an arabesque, of a rhythm or an harmonious balance, of an activity or a movement; there is the reflection upon things of a human or divine thought; there is, above all, the deep-seated splendor one glimpses of the soul, of the soul principle of life and animal energy, or principle of spiritual life, of pain and passion. And there is a still more exalted splendor, the splendor of Grace, which the Greeks did not know.

Beauty, therefore, is not conformity to a certain ideal and immutable type, in the sense in which they understand it who, confusing the true and the beautiful, knowledge and delight, would have it that in order to perceive beauty man discover "by the vision of ideas," "through the material envelope," "the invisible essence of things" and their "necessary type." Saint Thomas was as far removed from this pseudo-Platonism as he was from the idealist bazaar of Winckelmann and David. There is beauty for him the moment the shining of any form on a suitably proportioned matter succeeds in pleasing the intellect, and he takes care to warn us that beauty is in some way *relative*—relative not to the dispositions of the subject, in the sense in which the moderns understand the word relative, but to the proper nature and end of the thing, and to the formal conditions under which it is taken. *"Pulchritudo quodammodo dicitur per respectum ad aliquid.* . . . *"Alia enim est pulchritudo spiritus et alia corporis, atque alia hujus et illius corporis."* And however beautiful a created thing may be, it can appear beautiful to some and not to others, because it is beautiful only under aspects, which some discern and others do not: it is thus "beautiful in one place and not beautiful in another."

<p style="text-align:center">*</p>

If this is so, it is because the beautiful belongs to the order of the *transcendentals*, that is to say, objects of thought which transcend every

of mystery can appear in a "clear" work as well as in an "obscure" work. From this point of view neither "obscurity" nor "clarity" enjoys any privilege. [1927]

Moreover, it is natural that every really new work appear obscure at first. Time will decant the judgment. "They say," Hopkins wrote to Bridges apropos the poem *The Wreck of the Deutschland*, "that vessels sailing from the port of London will take (perhaps it should be / used once to take) Thames water for the voyage: it was foul and stunk at first as the ship worked but by degrees casting its filth was in a few days very pure and sweet and wholesome and better than any water in the world. However that may be, it is true to my purpose. When a new thing, such as my ventures in the Deutschland are, is presented us our first criticisms are not our truest, best, most homefelt, or most lasting but what come easiest on the instant. They are barbarous and like what the ignorant and the ruck say. This was so with you. The Deutschland on her first run worked very much and unsettled you, thickening and clouding your mind with vulgar mud-bottom and common sewage (I see that I am going it with the image) and just then you *drew off* your criticisms all stinking (a necessity now of the image) and bilgy, whereas if you had let your thoughts cast themselves they would have been clearer in themselves and more to my taste too." Letter of May 13, 1878, in *The Letters of Gerard Manley Hopkins to Robert Bridges*, edited with notes and an introduction by Claude Colleer Abbott (London: Oxford University Press, 1935), pp. 50–51.

limit of genus or category, and which do not allow themselves to be enclosed in any class, because they imbue everything and are to be found everywhere. Like the one, the true and the good, the beautiful is *being* itself considered from a certain aspect; it is a property of being. It is not an accident superadded to being, it adds to being only a relation of reason: it is being considered as delighting, by the mere intuition of it, an intellectual nature. Thus everything is beautiful, just as everything is good, at least in a certain relation. And as being is everywhere present and everywhere varied the beautiful likewise is diffused everywhere and is everywhere varied. Like being and the other transcendentals, it is essentially *analogous*, that is to say, it is predicated for divine reasons, *sub diversa ratione*, of the diverse subjects of which it is predicated: each kind of being *is* in its own way, is *good* in its own way, is *beautiful* in its own way.

Analogous concepts are predicated of God pre-eminently; in Him the perfection they designate exists in a "formal-eminent" manner, in the pure and infinite state. God is their "sovereign analogue," and they are to be met with again in things only as a dispersed and prismatized reflection of the countenance of God. Thus Beauty is one of the divine names.

God is beautiful. He is the most beautiful of beings, because, as Denis the Areopagite and Saint Thomas explain, His beauty is without alteration or vicissitude, without increase or diminution; and because it is not as the beauty of things, all of which have a particularized beauty, *particulatam pulchritudinem, sicut et particulatam naturam*. He is beautiful through Himself and in Himself, beautiful absolutely.

He is beautiful to the extreme (*superpulcher*), because in the perfectly simple unity of His nature there pre-exists in a super-excellent manner the fountain of all beauty.

He is beauty itself, because He gives beauty to all created beings, according to the particular nature of each, and because He is the cause of all consonance and all brightness. Every form indeed, that is to say, every light, is "a certain irradiation proceeding from the first brightness," "a participation in the divine brightness." And every consonance or every harmony, every concord, every friendship and every union whatsoever among beings proceeds from the divine beauty, the primordial and super-eminent type of all consonance, which gathers all things together and which calls them all to itself, meriting well in this "the name χαλός, which derives from 'to call.'" Thus "the beauty of anything created is nothing else than a similitude of divine beauty participated in by things," and, on the other hand, as every form is a principle of being and as every consonance or every harmony is preservative of being, it must be said that divine beauty is the cause of the being of all that is. *Ex divina pulchritudine esse omnium derivatur.*

In the Trinity, Saint Thomas adds, the name Beauty is attributed most fittingly to the Son. As for integrity or perfection, He has truly and perfectly in Himself, without the least diminution, the nature of the Father.

As for due proportion or consonance, He is the express and perfect image of the Father: and it is proportion which befits the image as such. As for radiance, finally, He is the Word, the light and the splendor of the intellect, "perfect Word to Whom nothing is lacking, and, so to speak, art of Almighty God."

Beauty, therefore, belongs to the transcendental and metaphysical order. This is why it tends of itself to draw the soul beyond the created. Speaking of the instinct for beauty, Baudelaire, the *poète maudit* to whom modern art owes its renewed awareness of the theological quality and tyrannical spirituality of beauty, writes: ". . . it is this immortal instinct for the beautiful which makes us consider the earth and its various spectacles as a sketch of, as a *correspondence* with, Heaven. . . . It is at once through poetry and *across* poetry, through and *across* music, that the soul glimpses the splendors situated beyond the grave; and when an exquisite poem brings tears to the eyes, these tears are not proof of an excess of joy, they are rather the testimony of an irritated melancholy, a demand of the nerves, of a nature exiled in the imperfect and desiring to take possession immediately, even on this earth, of a revealed paradise."

*

The moment one touches a transcendental, one touches being itself, a likeness of God, an absolute, that which ennobles and delights our life; one enters into the domain of the spirit. It is remarkable that men really communicate with one another only by passing through being or one of its properties. Only in this way do they escape from the individuality in which matter encloses them. If they remain in the world of their sense needs and of their sentimental egos, in vain do they tell their stories to one another, they do not understand each other. They observe each other without seeing each other, each one of them infinitely alone, even though work or sense pleasures bind them together. But let one touch the good and Love, like the saints, the true, like an Aristotle, the beautiful, like a Dante or a Bach or a Giotto, then contact is made, souls communicate. Men are really united only by the spirit; light alone brings them together, *intellectualia et rationalia omnia congregans, et indestructibilia faciens.*

Art in general tends to make a work. But certain arts tend to make a *beautiful* work, and in this they differ essentially from all the others. The work to which all the others arts tend is itself ordered to the service of man, and is therefore a simple means; and it is entirely enclosed in a determined material genus. The work to which the fine arts tend is ordered to beauty; as beautiful, it is an end, an absolute, it suffices of itself; and if, as work-to-be-made, it is material and enclosed in a genus, as beautiful it belongs to the kingdom of the spirit and plunges deep into the transcendence and the infinity of being.

The fine arts thus stand out in the *genus* art as man stands out in the *genus* animal. And like man himself they are like a horizon where matter and spirit meet. They have a spiritual soul. Hence they possess many distinctive properties. Their contact with the beautiful modifies in them certain characteristics of art in general, notably, as I shall try to show, with respect to the rules of art; on the other hand, this contact discloses and carries to a sort of excess other generic characteristics of the virtue of art, above all its intellectual character and its resemblance to the speculative virtues.

There is a curious analogy between the fine arts and wisdom. Like wisdom, they are ordered to an object which transcends man and which is of value in itself, and whose amplitude is limitless, for beauty, like being, is infinite. They are disinterested, desired for themselves, truly noble because their work taken in itself is not made in order that one may use it as a means, but in order that one may enjoy it as an end, being a true *fruit*, *aliquid ultimum et delectabile*. Their whole value is spiritual, and their mode of being is contemplative. For if contemplation is not their act, as it is the act of wisdom, nevertheless they aim at producing an intellectual delight, that is to say, a kind of contemplation; and they also presuppose in the artist a kind of contemplation, from which the beauty of the work must overflow. That is why we may apply to them, with the allowance, what Saint Thomas says of wisdom when he compares it to play: "The contemplation of wisdom is rightly compared to play, because of two things that one finds in play. The first is that play is delightful, and the contemplation of wisdom has the greatest delight, according to what Wisdom says of itself in Ecclesiasticus: *my spirit is sweet above honey*. The second is that the movements of play are not ordered to anything else, but are sought for themselves. And it is the same with the delights of wisdom. . . . That is why divine Wisdom compares its delight to play: *I was delighted every day, playing before him in the world*."

But Art remains, nevertheless, in the order of Making, and it is by drudgery upon some matter that it aims at delighting the spirit. Hence for the artist a strange and saddening condition, image itself of man's condition in the world, where he must wear himself out among bodies and live with the spirits. Though reproaching the old poets for holding Divinity to be jealous, Aristotle acknowledges that they were right in saying that the possession of wisdom is in the strict sense reserved to Divinity alone: "It is not a human possession, for human nature is a slave in so many ways." To produce beauty likewise belongs to God alone in the strict sense. And if the condition of the artist is more human and less exalted than that of the wise man, it is also more discordant and more painful, because his activity does not remain wholly within the pure immanence of spiritual operations, and does not in itself consist in contemplating, but in making. Without enjoying the substance and the peace of wisdom, he is caught

up in the hard exigencies of the intellect and the speculative life, and he is condemned to all the servile miseries of practice and of temporal production.

<div align="center">*</div>

"Dear Brother Leo, God's little beast, even if a Friar Minor spoke the language of the angels and raised to life a man dead for four days, note it well that it is not therein that perfect joy is found. . . ."

Even if the artist were to encompass in his work all the light of heaven and all the grace of the first garden, he would not have perfect joy, because he is following wisdom's footsteps and running by the scent of its perfumes, but does not possess it. Even if the philosopher were to know all the intelligible reasons and all the properties of being, he would not have perfect joy, because his wisdom is human. Even if the theologian were to know all the analogies of the divine processions and all the whys and the wherefores of Christ's actions, he would not have perfect joy, because his wisdom has a divine origin but a human mode, and a human voice.

Ah! les voix, mourez donc, mourantes que vous êtes!

The Poor and the Peaceful alone have perfect joy because they possess wisdom and contemplation *par excellence*, in the silence of creatures and in the voice of Love; united without intermediary to subsisting Truth, they know "the sweetness that God gives and the delicious taste of the Holy Spirit." This is what prompted Saint Thomas, a short time before his death, to say of his unfinished *Summa:* "It seems to me as so much straw" —*mihi videtur ut palea*. Human straw: the Parthenon and Notre-Dame de Chartres, the Sistine Chapel and the Mass in D—and which will be burned on the last day! "Creatures have no savor."[2]

The Middle Ages knew this order. The Renaissance shattered it. After three centuries of infidelity, prodigal Art aspired to become the ultimate end of man, his Bread and his Wine, the consubstantial mirror of beatific Beauty. And the poet hungry for beatitude who asked of art the mystical fullness that God alone can give, has been able to open out only onto *Sigê l'abîme*. Rimbaud's silence marks perhaps the end of a secular apostasy. In any case it clearly signifies that it is folly to seek in art the words of eternal life and the repose of the human heart; and that the artist, if

[2] I feel today that I must apologize for the sort of thoughtlessness with which I adopted this phrase here. One must have little experience of created things, or much experience of divine things, in order to be able to speak in this way. In general, formulas of contempt with regard to created things belong to a conventional literature that is difficult to endure. The creature is deserving of compassion, not contempt; it exists only because it is loved. It is deceptive because it has too much savor, and because this savor is nothing in comparison with the being of God. [1935]

he is not to shatter his art or his soul, must simply be, as artist, what art wants him to be—a good workman.

And now the modern world, which had promised the artist everything, soon will scarcely leave him even the bare means of subsistence. Founded on the two *unnatural* principles of the *fecundity of money* and the *finality of the useful*, multiplying needs and servitude without the possibility of there ever being a limit, destroying the leisure of the soul, withdrawing the material *factibile* from the control which proportioned it to the ends of the human being, and imposing on man the panting of the machine and the accelerated movement of matter, the system of *nothing but the earth* is imprinting on human activity a truly inhuman mode and a diabolical direction, for the final end of all this frenzy is to prevent man from resembling God,

> *dum nil perenne cogitat,*
> *seseque culpis illigat.*

Consequently he must, if he is to be logical, treat as useless, and therefore as rejected, all that by any grounds bears the mark of the spirit.

Or it will even be necessary that heroism, truth, virtue, beauty become *useful* values—the best, the most loyal instruments of propaganda and of control of temporal powers.

Persecuted like the wise man and almost like the saint, the artist will perhaps recognize his brothers at last and discover his true vocation again: for in a way he is not of this world, being, from the moment that he works for beauty, on the path which leads upright souls to God and manifests to them the invisible things by the visible. However rare may be at such a time those who will not want to please the Beast and to turn with the wind, it is in them, by the very fact that they will exercise a *disinterested* activity, that the human race will live.

R. G. COLLINGWOOD

THE ARTIST AND THE COMMUNITY

R. G. Collingwood (1889–1943) was an English philosopher and historian.

§ 4. THE AUDIENCE AS UNDERSTANDER

What is meant by saying that the painter 'records' in his picture the experience which he had in painting it? With this question we come to the subject of the audience, for the audience consists of anybody and everybody to whom such records are significant.

It means that the picture, when seen by some one else or by the painter himself subsequently, produces in him (we need not ask how) sensuous-emotional or psychical experiences which, when raised from impressions to ideas by the activity of the spectator's consciousness, are transmuted into a total imaginative experience identical with that of the painter. This experience of the spectator's does not repeat the comparatively poor experience of a person who merely looks at the subject; it repeats the

Reprinted from *The Principles of Art* by R. G. Collingwood, Oxford, The Clarendon Press, 1945, pp. 308–324, by permission of the publisher.

richer and more highly organized experience of a person who has not only looked at it but has painted it as well.

That is why, as so many people have observed, we 'see more in' a really good picture of a given subject than we do in the subject itself. That is why, too, many people prefer what is called 'nature' or 'real life' to the finest pictures, because they prefer not to be shown so much, in order to keep their apprehensions at a lower and more manageable level, where they can embroider what they see with likes and dislikes, fancies and emotions of their own, not intrinsically connected with the subject. A great portrait painter, in the time it takes him to paint a sitter, intensely active in absorbing impressions and converting them into an imaginative vision of the man, may easily see through the mask that is good enough to deceive a less active and less pertinacious observer, and detect in a mouth or an eye or the turn of a head things that have long been concealed. There is nothing mysterious about this insight. Every one judges men by the impressions he gets of them and his power of becoming aware of these impressions; and the artist is a man whose life's work consists in doing that. The wonder is rather that so few artists do it revealingly. That is perhaps because people do not want it done, and artists fall in with their desire for what is called a good likeness, a picture that reveals nothing new, but only recalls what they have already felt in the sitter's presence.

How is any one to know that the imaginative experience which the spectator, by the work of his consciousness, makes out of the sensations he receives from a painting 'repeats', or is 'identical' with, the experience which the artist had in painting it? That question has already been raised about language in general . . . and answered by saying that there is no possibility of an absolute assurance; the only assurance we can have 'is an empirical and relative assurance, becoming progressively stronger as conversation proceeds, and based on the fact that neither party seems to the other to be talking nonsense'. The same answer holds good here. We can never absolutely know that the imaginative experience we obtain from a work of art is identical with that of the artist. In proportion as the artist is a great one, we can be pretty certain that we have only caught his meaning partially and imperfectly. But the same applies to any case in which we hear what a man says or read what he writes. And a partial and imperfect understanding is not the same thing as a complete failure to understand.

For example, a man reading the first canto of the *Inferno* may have no idea what Dante meant by the three beasts. Are they deadly sins, or are they potentates, or what are they? he may ask. In that perplexity, however, he has not completely lost contact with his author. There is still a great deal in the canto which he can understand, that is to say, transmute from impression into idea by the work of his consciousness; and all this, he can be fairly confident, he grasps as Dante meant it. And even the three beasts, though he does not understand them completely (something re-

mains obstinately a mere untransmuted impression) he understands in part; he sees that they are something the poet dreads, and he imaginatively experiences the dread, though he does not know what it is that is dreaded.

Or take (since Dante may be ruled out as allegorical and therefore unfair) an example from modern poetry. I do not know how many readers of Mr. Eliot's poem *Sweeney among the Nightingales* have the least idea what precisely the situation is which the poet is depicting. I have never heard or read any expression of such an idea. Sweeney has dropped asleep in a restaurant, vaguely puzzled by the fact that the Convent of the Sacred Heart, next door, has reminded him of something, he cannot tell what. A wounded Heart, and waiting husbandless women. As he snores all through the second verse a prostitute in a long cloak comes and sits on his knees, and at that moment he dreams the answer. It is Agamemnon's cry—'O, I am wounded mortally to the heart'—wounded to death at his homecoming by the false wife he had left behind. He wakes, stretching and laughing (tilting the girl off his knee), as he realizes that in the queer working of his mind the hooded husbandless nuns and the cloaked husbandless girl, waiting there like a spider for her prey, are both Klytaemnestra, the faithless wife who threw her cloak (the 'net of death') round her lord and stabbed him.

I quote this case because I had known and enjoyed the poem for years before I saw that this was what it was all about; and nevertheless I understood enough to value it highly. And I am willing to believe that the distinguished critic who thinks that the 'liquid siftings' of the nightingales were not their excrement, but their songs, values it highly too, and not everywhere so unintelligently as that sample would suggest.

The imaginative experience contained in a work of art is not a closed whole. There is no sense in putting the dilemma that a man either understands it (that is, has made that entire experience his own) or does not. Understanding it is always a complex business, consisting of many phases, each complete in itself but each leading on to the next. A determined and intelligent audience will penetrate into this complex far enough, if the work of art is a good one, to get something of value; but it need not on that account think it has extracted 'the' meaning of the work, for there is no such thing. The doctrine of a plurality of meanings, expounded for the case of holy scripture by St. Thomas Aquinas, is in principle perfectly sound: as he states it, the only trouble is that it does not go far enough. In some shape or other, it is true of all language.

§ 5. THE AUDIENCE AS COLLABORATOR

The audience as understander, attempting an exact reconstruction in its own mind of the artist's imaginative experience, is engaged on an endless quest. It can carry out this reconstruction only in part. This looks as if the artist were a kind of transcendent genius whose meaning is always

too profound for his audience of humbler mortals to grasp in a more than fragmentary way. And an artist inclined to give himself airs will no doubt interpret the situation like that. But another interpretation is possible. The artist may take his audience's limitations into account when composing his work; in which case they will appear to him not as limitations on the extent to which his work will prove comprehensible, but as conditions determining the subject-matter or meaning of the work itself. In so far as the artist feels himself at one with his audience, this will involve no condescension on his part; it will mean that he takes it as his business to express not his own private emotions, irrespectively of whether any one else feels them or not, but the emotions he shares with his audience. Instead of conceiving himself as a mystagogue, leading his audience as far as it can follow along the dark and difficult paths of his own mind, he will conceive himself as his audience's spokesman, saying for it the things it wants to say but cannot say unaided. Instead of setting up for the great man who (as Hegel said) imposes upon the world the task of understanding him, he will be a humbler person, imposing upon himself the task of understanding his world, and thus enabling it to understand itself.

In this case his relation to his audience will no longer be a mere by-product of his aesthetic experience, as it still was in the situation described in the preceding section; it will be an integral part of that experience itself. If what he is trying to do is to express emotions that are not his own merely, but his audience's as well, his success in doing this will be tested by his audience's reception of what he has to say. What he says will be something that his audience says through his mouth; and his satisfaction in having expressed what he feels will be at the same time, in so far as he communicates this expression to them, their satisfaction in having expressed what they feel. There will thus be something more than mere communication from artist to audience, there will be collaboration between audience and artist.

We have inherited a long tradition, beginning in the late eighteenth century with the cult of 'genius', and lasting all through the nineteenth, which is inimical to this second alternative. But I have already said that this tradition is dying away. Artists are less inclined to give themselves airs than they used to be; and there are many indications that they are more willing than they were, even a generation ago, to regard their audiences as collaborators. It is perhaps no longer foolish to hope that this way of conceiving the relation between artist and audience may be worth discussing.

There are grounds for thinking that this idea of the relation is the right one. . . . [W]e must look at the facts; and we shall find that, whatever airs they may give themselves, artists have always been in the habit of treating the public as collaborators. On a technical theory of art, this is, in a sense, comprehensible. If the artist is trying to arouse certain emotions in his audience, a refusal on the part of the audience to develop these

emotions proves that the artist has failed. But this is one of the many points in which the technical theory does not so much miss the truth as misrepresent it. An artist need not be a slave to the technical theory, in order to feel that his audience's approbation is relevant to the question whether he has done his work well or ill. There have been painters who would not exhibit, poets who would not publish, musicians who would not have their works performed; but those who have made this great refusal, so far as one knows them, have not been of the highest quality. There has been a lack of genuineness about their work, corresponding to this strain of secretiveness in their character, which is inconsistent with good art. The man who feels that he has something to say is not only willing to say it in public: he craves to say it in public, and feels that until it has been thus said it has not been said at all. The public is always, no doubt, a circumscribed one: it may consist only of a few friends, and at most it includes only people who can buy or borrow a book or get hold of a theatre ticket; but every artist knows that publication of some kind is a necessity to him.

Every artist knows, too, that the reception he gets from his public is not a matter of indifference to him. He may train himself to take rebuffs with a stiff lip, and go on working in spite of bad sales and hostile reviews. He must so train himself, if he is to do his best work; because with the best will in the world (quite apart from venality in reviewers and frivolity in readers) no one enjoys having his unconscious emotions dragged into the light of consciousness, and consequently there is often a strongly painful element in a genuine aesthetic experience, and a strong temptation to reject it. But the reason why the artist finds it so hard to train himself in this way is because these rebuffs wound him not in his personal vanity, but in his judgement as to the soundness of the work he has done.

Here we come to the point. One might suppose that the artist by himself is in his own eyes a sufficient judge of his work's value. If he is satisfied with it, why should he mind what others think? But things do not work like that. The artist, like any one else who comes before an audience, must put a bold face on it; he must do the best he can, and pretend that he knows it is good. But probably no artist has ever been so conceited as to be wholly taken in by his own pretence. Unless he sees his own proclamation, 'This is good', echoed on the faces of his audience—'Yes, that is good'—he wonders whether he was speaking the truth or not. He thought he had enjoyed and recorded a genuine aesthetic experience, but has he? Was he suffering from a corruption of consciousness? Has his audience judged him better than he judged himself?

These are facts which no artist, I think, will deny, unless in that feverish way in which we all deny what we know to be true and will not accept. If they are facts, they prove that, in spite of all disclaimers, artists do look upon their audiences as collaborators with themselves in the attempt to answer the question: is this a genuine work of art or not? But

this is the thin edge of a wedge. Once the audience's collaboration is admitted thus far, it must be admitted farther.

The artist's business is to express emotions; and the only emotions he can express are those which he feels, namely, his own. No one can judge whether he has expressed them except some one who feels them. If they are his own and no one else's, there is no one except himself who can judge whether he has expressed them or not. If he attaches any importance to the judgement of his audience, it can only be because he thinks that the emotions he has tried to express are emotions not peculiar to himself, but shared by his audience, and that the expression of them he has achieved (if indeed he has achieved it) is as valid for the audience as it is for himself. In other words, he undertakes his artistic labour not as a personal effort on his own private behalf, but as a public labour on behalf of the community to which he belongs. Whatever statement of emotion he utters is prefaced by the implicit rubric, not 'I feel', but 'we feel'. And it is not strictly even a labour undertaken by himself on behalf of the community. It is a labour in which he invites the community to participate; for their function as audience is not passively to accept his work, but to do it over again for themselves. If he invites them to do this, it is because he has reason to think they will accept his invitation, that is, because he thinks he is inviting them to do what they already want to do.

In so far as the artist feels all this (and an artist who did not feel it would not feel the craving to publish his work, or take seriously the public's opinion of it), he feels it not only after his work is completed, but from its inception and throughout its composition. The audience is perpetually present to him as a factor in his artistic labour; not as an anti-aesthetic factor, corrupting the sincerity of his work by considerations of reputation and reward, but as an aesthetic factor, defining what the problem is which as an artist he is trying to solve—what emotions he is to express—and what constitutes a solution of it. The audience which the artist thus feels as collaborating with himself may be a large one or a small one, but it is never absent.

§ 6. AESTHETIC INDIVIDUALISM

The understanding of the audience's function as collaborator is a matter of importance for the future both of aesthetic theory and of art itself. The obstacle to understanding it is a traditional individualistic psychology through which, as through distorting glasses, we are in the habit of looking at artistic work. We think of the artist as a self-contained personality, sole author of everything he does: of the emotions he expresses as his personal emotions, and of his expression of them as his personal expression. We even forget what it is that he thus expresses, and speak of his work as 'self-expression,' persuading ourselves that

what makes a poem great is the fact that it 'expresses a great personality', whereas, if self-expression is the order of the day, whatever value we set on such a poem is due to its expressing not the poet—what is Shakespeare to us, or we to Shakespeare?—but ourselves.

It would be tedious to enumerate the tangles of misunderstanding which this nonsense about self-expression has generated. To take one such only: it has set us off looking for 'the man Shakespeare' in his poems, and trying to reconstruct his life and opinions from them, as if that were possible, or as if, were it possible, it would help us to appreciate his work. It has degraded criticism to the level of personal gossip, and confused art with exhibitionism. What I prefer to attempt is not a tale of misdeeds, but a refutation.

In principle, this refutation is simple. Individualism conceives a man as if he were God, a self-contained and self-sufficient creative power whose only task is to be himself and to exhibit his nature in whatever works are appropriate to it. But a man, in his art as in everything else, is a finite being. Everything that he does is done in relation to others like himself. As artist, he is a speaker; but a man speaks as he has been taught; he speaks the tongue in which he was born. The musician did not invent his scale or his instruments; even if he invents a new scale or a new instrument he is only modifying what he learnt from others. The painter did not invent the idea of painting pictures or the pigments and brushes with which he paints them. Even the most precocious poet hears and reads poetry before he writes it. Moreover, just as every artist stands in relation to other artists from whom he has acquired his art, so he stands in relation to some audience to whom he addresses it. The child learning his mother tongue, as we have seen, learns simultaneously to be a speaker and to be a listener; he listens to others speaking, and speaks to others listening. It is the same with artists. They become poets or painters or musicians not by some process of development from within, as they grow beards; but by living in a society where these languages are current. Like other speakers, they speak to those who understand.

The aesthetic activity is the activity of speaking. Speech is speech only so far as it is both spoken and heard. A man may, no doubt, speak to himself and be his own hearer; but what he says to himself is in principle capable of being said to any one sharing his language. As a finite being, man becomes aware of himself as a person only so far as he finds himself standing in relation to others of whom he simultaneously becomes aware as persons. And there is no point in his life at which a man has finished becoming aware of himself as a person. That awareness is constantly being reinforced, developed, applied in new ways. On every such occasion the old appeal must be made: he must find others whom he can recognize as persons in this new fashion, or he cannot as a finite being assure himself that this new phase of personality is genuinely in his possession. If he has a new thought, he must explain it to others, in

order that, finding them able to understand it, he may be sure it is a good one. If he has a new emotion, he must express it to others, in order that, finding them able to share it, he may be sure his consciousness of it is not corrupt.

This is not inconsistent with the doctrine, stated elsewhere in this book, that the aesthetic experience or aesthetic activity is one which goes on in the artist's mind. The experience of being listened to is an experience which goes on in the mind of the speaker, although in order to [assure] its existence a listener is necessary, so that the activity is a collaboration. Mutual love is a collaborative activity; but the experience of this activity in the mind of each lover taken singly is a different experience from that of loving and being spurned.

A final refutation of aesthetic individualism will, therefore, turn on anaylsis of the relation between the artist and his audience, developing the view stated in the last section that this is a case of collaboration. But I propose to lead up to this by way of two other arguments. I shall try to show that the individualistic theory of artistic creation is false (1) as regards the relation between a given artist and those fellow artists who in terms of the individualistic theory are said to 'influence' him; (2) as regards his relation with those who are said to 'perform his works'; and (3) as regards his relation with the persons known as his 'audience'. In each case, I shall maintain, the relation is really collaborative.

§ 7. COLLABORATION BETWEEN ARTISTS

Individualism would have it that the work of a genuine artist is altogether 'original', that is to say, purely his own work and not in any way that of other artists. The emotions expressed must be simply and solely his own, and so must his way of expressing them. It is a shock to persons labouring under this prejudice when they find that Shakespeare's plays, and notably *Hamlet*, that happy hunting-ground of self-expressionists, are merely adaptations of plays by other writers, scraps of Holinshed, Lives by Plutarch, or excerpts from the *Gesta Romanorum;* that Handel copied out into his own works whole movements by Arne; that the Scherzo of Beethoven's C minor Symphony begins by reproducing the Finale of Mozart's G Minor, differently barred; or that Turner was in the habit of lifting his composition from the works of Claude Lorrain. Shakespeare or Handel or Beethoven or Turner would have thought it odd that anybody should be shocked. All artists have modelled their style upon that of others, used subjects that others have used, and treated them as others have treated them already. A work of art so constructed is a work of collaboration. It is partly by the man whose name it bears, partly by those from whom he has borrowed. What we call the works of Shakespeare, for example, proceed in this way not simply and solely from the individual mind of the man William Shakespeare of Stratford (or,

for that matter, the man Francis Bacon of Verulam) but partly from Kyd, partly from Marlowe, and so forth.

The individualistic theory of authorship would lead to the most absurd conclusions. If we regard the *Iliad* as a fine poem, the question whether it was written by one man or by many is automatically, for us, settled. If we regard Chartres cathedral as a work of art, we must contradict the architects who tell us that one spire was built in the twelfth century and the other in the sixteenth, and convince ourselves that it was all built at once. Or again: English prose of the early seventeenth century may be admired when it is original; but not the Authorized Version, for that is a translation, and a translation, because no one man is solely responsible for it, cannot be a work of art. I am very willing to allow with Descartes that 'often there is less perfection in works put together out of several parts, and made by the hands of different masters, than in those at which one only has worked'; but not to replace his 'often' by 'always'. I am very willing to recognize that, under the reign of nineteenth-century individualism, good artists have seldom been willing to translate, because they have gone chasing after 'originality'; but not to deny the name of poetry to Catullus's rendering of Sappho merely because I happen to know it for a translation.

If we look candidly at the history of art, or even the little of it that we happen to know, we shall see that collaboration between artists has always been the rule. I refer especially to that kind of collaboration in which one artist grafts his own work upon that of another, or (if you wish to be abusive) plagiarizes another's for incorporation in his own. A new code of artistic morality grew up in the nineteenth century, according to which plagiarism was a crime. I will not ask how much that had to do, whether as cause or as effect, with the artistic barrenness and mediocrity of the age (though it is obvious, I think, that a man who can be annoyed with another for stealing his ideas must be pretty poor in ideas, as well as much less concerned for the intrinsic value of what ideas he has than for his own reputation); I will only say that this fooling about personal property must cease. Let painters and writers and musicians steal with both hands whatever they can use, wherever they can find it. And if any one objects to having his own precious ideas borrowed by others, the remedy is easy. He can keep them to himself by not publishing; and the public will probably have cause to thank him.

§ 8. COLLABORATION BETWEEN AUTHOR AND PERFORMER

Certain kinds of artist, notably the dramatist and the musician, compose for performance. Individualism would maintain that their works, however 'influenced', as the phrase goes, by those of other artists, issue from the writer's pen complete and finished; they are plays by Shakespeare and symphonies by Beethoven, and these men are great artists, who have

written on their own responsibility a text which, as the work of a great artist, imposes on the theatre and the orchestra a duty to perform it exactly as it stands.

But the book of a play or the score of a symphony, however cumbered with stage-directions, expression-marks, metronome figures, and so forth, cannot possibly indicate in every detail how the work is to be performed. Tell the performer that he must perform the thing exactly as it is written, and he knows you are talking nonsense. He knows that however much he tries to obey you there are still countless points he must decide for himself. And the author, if he is qualified to write a play or a symphony, knows it too, and reckons on it. He demands of his performers a spirit of constructive and intelligent co-operation. He recognizes that what he is putting on paper is not a play or a symphony, or even complete directions for performing one, but only a rough outline of such directions, where the performers, with the help, no doubt, of producer and conductor, are not only permitted but required to fill in the details. Every performer is co-author of the work he performs.

This is obvious enough, but in our tradition of the last hundred years and more we have been constantly shutting our eyes to it. Authors and performers have found themselves driven into a state of mutual suspicion and hostility. Performers have been told that they must not claim the status of collaborators, and must accept the sacred text just as they find it; authors have tried to guard against any danger of collaboration from performers by making their book or their text fool-proof. The result has been not to stop performers from collaborating (that is impossible), but to breed up a generation of performers who are not qualified to collaborate boldly and competently. When Mozart leaves it to his soloist to improvise the cadenza of a concerto, he is in effect insisting that the soloist shall be more than a mere executant; he is to be something of a composer, and therefore trained to collaborate intelligently. Authors who try to produce a fool-proof text are choosing fools as their collaborators.

§ 9. THE ARTIST AND HIS AUDIENCE

The individualism of the artist, broken down by collaboration with his fellow artists and still further by collaboration with his performers, where he has them, is not yet wholly vanquished. There still remains the most difficult and important problem of all, namely, that of his relation to his audience. We have seen in § 6 that this, too, must in theory be a case of collaboration; but it is one thing to argue the point in theory, and quite another to show it at work in practice. In order to do this, I will begin with the case where the artist is a collaborative unit consisting of author and performers, as in the theatre, and consider how, as a matter of empirical fact, this unit is related to the audience.

If one wants to answer this question for oneself, the best way to pro-

ceed is to attend the dress rehearsal of a play. In the rehearsal of any given passage, scenery, lighting, and dresses may all be exactly as they are at a public performance; the actors may move and speak exactly as they will 'on the night'; there may be few interruptions for criticism by the producer; and yet the spectator will realize that everything is different. The company are going through the motions of acting a play, and yet no play is being acted. This is not because there have been interruptions, breaking the thread of the performance. A work of art is very tolerant of interruption. The intervals between acts at a play do not break the thread, they rest the audience. Nobody ever read the *Iliad* or the *Commedia* at a sitting, but many people know what they are like. What happens at the dress rehearsal is something quite different from interruption. It can be described by saying that every line, every gesture, falls dead in the empty house. The company is not acting a play at all; it is performing certain actions which will become a play when there is an audience present to act as a sounding-board. It becomes clear, then, that the aesthetic activity which is the play is not an activity on the part of the author and the company together, which this unit can perform in the audience's absence. It is an activity in which the audience is a partner.

Any one, probably, can learn this by watching a dress rehearsal; but the principle does not apply to the theatre alone. It applies to rehearsals by a choir or orchestra, or to a skilled and successful public speaker rehearsing a speech. A careful study of such things will convince any one who is open to conviction that the position of the audience is very far from being that of a licensed eavesdropper, overhearing something that would be complete without him. Performers know it already. They know that their audience is not passively receptive of what they give it, but is determining by its reception of them how their performance is to be carried on. A person accustomed to extempore speaking, for example, knows that if once he can make contact with his audience it will somehow tell him what he is to say, so that he finds himself saying things he had never thought of before. These are the things which, on that particular subject, he and nobody else ought to be saying to that audience and no other. People to whom this is not a familiar experience are, of course, common; but they have no business to speak in public.

It is a weakness of printed literature that this reciprocity between writer and reader is difficult to maintain. The printing-press separates the writer from his audience and fosters cross-purposes between them. The organization of the literary profession and the 'technique' of good writing, as that is understood among ourselves, consist to a great extent of methods for mitigating this evil; but the evil is only mitigated and not removed. It is intensified by every new mechanization of art. The reason why gramophone music is so unsatisfactory to any one accustomed to real music is not because the mechanical reproduction of the sounds is bad —that could be easily compensated by the hearer's imagination—but

because the performers and the audience are out of touch. The audience is not collaborating, it is only overhearing. The same thing happens in the cinema, where collaboration as between author and producer is intense, but as between this unit and the audience non-existent. Performances on the wireless have the same defect. The consequence is that the gramophone, the cinema, and the wireless are perfectly serviceable as vehicles of amusement or of propaganda, for here the audience's function is merely receptive and not concreative; but as vehicles of art they are subject to all the defects of the printing-press in an aggravated form. 'Why', one hears it asked, 'should not the modern popular entertainment of the cinema, like the Renaissance popular entertainment of the theatre, produce a new form of great art?' The answer is simple. In the Renaissance theatre collaboration between author and actors on the one hand, and audience on the other, was a lively reality. In the cinema it is impossible.

The conclusion of this chapter may be summarized briefly. The work of artistic creation is not a work performed in any exclusive or complete fashion in the mind of the person whom we call the artist. That idea is a delusion bred of individualistic psychology, together with a false view of the relation not so much between body and mind as between experience at the psychical level and experience at the level of thought. The aesthetic activity is an activity of thought in the form of consciousness, converting into imagination an experience which, apart from being so converted, is sensuous. This activity is a corporate activity belonging not to any one human being but to a community. It is performed not only by the man whom we individualistically call the artist, but partly by all the other artists of whom we speak as 'influencing' him, where we really mean collaborating with him. It is performed not only by this corporate body of artists, but (in the case of the arts of performance) by executants, who are not merely acting under the artist's orders, but are collaborating with him to produce the finished work. And even now the activity of artistic creation is not complete; for that, there must be an audience, whose function is therefore not a merely receptive one, but collaborative too. The artist (although under the spell of individualistic prejudices he may try to deny it) stands thus in collaborative relations with an entire community; not an ideal community of all human beings as such, but the actual community of fellow artists from whom he borrows, executants whom he employs, and audience to whom he speaks. By recognizing these relations and counting upon them in his work, he strengthens and enriches that work itself; by denying them he impoverishes it.

JEAN-PAUL SARTRE

WHAT IS WRITING?

Jean-Paul Sartre (1905–) is an outstanding French existentialist philosopher and author of numerous plays and novels.

When a writer of past centuries expressed an opinion about his craft, was he immediately asked to apply it to the other arts? But today it's the thing to do to "talk painting" in the argot of the musician or the literary man and to "talk literature" in the argot of the painter, as if at bottom there were only one art which expressed itself indifferently in one or the other of these languages, like the Spinozistic substance which is adequately reflected by each of its attributes.

Doubtless, one could find at the origin of every artistic calling a certain undifferentiated choice which circumstances, education, and contact with the world particularized only later. Besides, there is no doubt that the arts of a period mutually influence each other and are conditioned by the same social factors. But those who want to expose the absurdity of a literary

Reprinted from *What Is Literature?*, Chapter 1, pp. 7–34, by Jean-Paul Sartre, translated by Bernard Frechtman, New York, Philosophical Library, 1949, by permission of the publisher.

theory by showing that it is inapplicable to music must first prove that the arts are parallel.

Now, there is no such parallelism. Here, as everywhere, it is not only the form which differentiates, but the matter as well. And it is one thing to work with color and sound, and another to express oneself by means of words. Notes, colors, and forms are not signs. They refer to nothing exterior to themselves. To be sure, it is quite impossible to reduce them strictly to themselves, and the idea of a pure sound, for example, is an abstraction. As Merleau-Ponty has pointed out in *The Phenomenology of Perception*, there is no quality of sensation so bare that it is not penetrated with signification. But the dim little meaning which dwells within it, a light joy, a timid sadness, remains immanent or trembles about it like a heat mist; it *is* color or sound. Who can distinguish the green apple from its tart gaiety? And aren't we already saying too much in naming "the tart gaiety of the green apple"? There is green, there is red, and that is all. They are things, they exist by themselves.

It is true that one might, by convention, confer the value of signs upon them. Thus, we talk of the language of flowers. But if, after the agreement, white roses signify "fidelity" to me, the fact is that I have stopped seeing them as roses. My attention cuts through them to aim beyond them at this abstract virtue. I forget them. I no longer pay attention to their mossy abundance, to their sweet stagnant odor. I have not even perceived them. That means that I have not behaved like an artist. For the artist, the color, the bouquet, the tinkling of the spoon on the saucer, are *things*, in the highest degree. He stops at the quality of the sound or the form. He returns to it constantly and is enchanted with it. It is this color-object that he is going to transfer to his canvas, and the only modification he will make it undergo is that he will transform it into an *imaginary* object. He is therefore as far as he can be from considering colors and signs as a *language*.

What is valid for the elements of artistic creation is also valid for their combinations. The painter does not want to create a thing. And if he puts together red, yellow, and green, there is no reason for the ensemble to have a definable signification, that is, to refer particularly to another object. Doubtless this ensemble is also inhabited by a soul, and since there must have been motives, even hidden ones, for the painter to have chosen yellow rather than violet, it may be asserted that the objects thus created reflect his deepest tendencies. However, they never express his anger, his anguish, or his joy as do words or the expression of the face; they are impregnated with these emotions; and in order for them to have crept into these colors, which by themselves already had something like a meaning, his emotions get mixed up and grow obscure. Nobody can quite recognize them there.

Tintoretto did not choose that yellow rift in the sky above Golgotha to *signify* anguish or to *provoke* it. It is anguish and yellow sky at the same

time. Not sky of anguish or anguished sky; it is an anguish become thing, an anguish which has turned into yellow rift of sky, and which thereby is submerged and impasted by the proper qualities of things, by their impermeability, their extension, their blind permanence, their externality, and that infinity of relations which they maintain with other things. That is, it is no longer *readable*. It is like an immense and vain effort, forever arrested half-way between sky and earth, to express what their nature keeps them from expressing.

Similarly, the signification of a melody—if one can still speak of signification—is nothing outside of the melody itself, unlike ideas, which can be adequately rendered in several ways. Call it joyous or somber. It will always be over and above anything you can say about it. Not because its passions, which are perhaps at the origin of the invented theme, have, by being incorporated into notes, undergone a transubstantiation and a transmutation. A cry of grief is a sign of the grief which provokes it, but a song of grief is both grief itself and something other than grief. Or, if one wishes to adopt the existentialist vocabulary, it is a grief which does not *exist* any more, which *is*. But, you will say, suppose the painter does houses? That's just it. He *makes* them, that is, he creates an imaginary house on the canvas and not a sign of a house. And the house which thus appears preserves all the ambiguity of real houses.

The writer can guide you and, if he describes a hovel, make it seem the symbol of social injustice and provoke your indignation. The painter is mute. He presents you with *a* hovel, that's all. You are free to see in it what you like. That attic window will never be the symbol of misery; for that, it would have to be a sign, whereas it is a thing. The bad painter looks for the type. He paints the Arab, the Child, the Woman; the good one knows that neither the Arab nor the proletarian exists either in reality or on his canvas. He offers a workman, a certain workman. And what are we to think about a workman? An infinity of contradictory things. All thoughts and all feelings are there, adhering to the canvas in a state of profound undifferentiation. It is up to you to choose. Sometimes, high-minded artists try to move us. They paint long lines of workmen waiting in the snow to be hired, the emaciated faces of the unemployed, battlefields. They affect us no more than does Greuze with his "Prodigal Son." And that masterpiece, "The Massacre of Guernica," does any one think that it won over a single heart to the Spanish cause? And yet something is said that can never quite be heard and that would take an infinity of words to express. And Picasso's long harlequins, ambiguous and eternal, haunted with inexplicable meaning, inseparable from their stooping leanness and their pale diamond-shaped tights, are emotion become flesh, emotion which the flesh has absorbed as the blotter absorbs ink, and emotion which is unrecognizable, lost, strange to itself, scattered to the four corners of space and yet present to itself.

I have no doubt that charity or anger can produce other objects, but

they will likewise be swallowed up; they will lose their name; there will remain things haunted by a mysterious soul. One does not paint signifi-cations; one does not put them to music. Under these conditions, who would dare require that the painter or musician engage himself?

On the other hand, the writer deals with significations. Still, a dis-tinction must be made. The empire of signs is prose; poetry is on the side of painting, sculpture, and music. I am accused of detesting it; the proof, so they say, is that *Les Temps Modernes* publishes very few poems. On the contrary, this is proof that we like it. To be convinced, all one need do is take a look at contemporary production. "At least," critics say triumphantly, "you can't even dream of engaging it." Indeed. But why should I want to? Because it uses words as does prose? But it does not use them in the same way, and it does not even *use* them at all. I should rather say that it serves them. Poets are men who refuse to *utilize* lan-guage. Now, since the quest for truth takes place in and by language conceived as a certain kind of instrument, it is unnecessary to imagine that they aim to discern or expound the true. Nor do they dream of *naming* the world, and, this being the case, they name nothing at all, for naming implies a perpetual sacrifice of the name to the object named, or, as Hegel would say, the name is revealed as the inessential in the face of the thing which is essential. They do not speak, neither do they keep still; it is something different. It has been said that they wanted to destroy the "word" by monstrous couplings, but this is false. For then they would have to be thrown into the midst of utilitarian language and would have had to try to retrieve words from it in odd little groups, as for example "horse" and "butter" by writing "horses of butter."

Besides the fact that such an enterprise would require infinite time, it is not conceivable that one can keep oneself on the plane of the utilitarian project, consider words as instruments, and at the same time con-template taking their instrumentality away from them. In fact, the poet has withdrawn from language-instrument in a single movement. Once and for all he has chosen the poetic attitude which considers words as things and not as signs. For the ambiguity of the sign implies that one can penetrate it at will like a pane of glass and pursue the thing signified, or turn his gaze toward its *reality* and consider it as an object. The man who talks is beyond words and near the object, whereas the poet is on this side of them. For the former, they are domesticated; for the latter they are in the wild state. For the former, they are useful conventions, tools which gradually wear out and which one throws away when they are no longer serviceable; for the latter, they are natural things which sprout naturally upon the earth like grass and trees.

But if he dwells upon words, as does the painter with colors and the musician with sounds, that does not mean that they have lost all significa-tion in his eyes. Indeed, it is signification alone which can give words their verbal unity. Without it they are frittered away into sounds and strokes

of the pen. Only, it too becomes natural. It is no longer the goal which is always out of reach and which human transcendence is always aiming at, but a property of each term, analogous to the expression of a face, to the little sad or gay meaning of sounds and colors. Having flowed into the word, having been absorbed by its sonority or visual aspect, having been thickened and defaced, it too is a thing, increate and eternal.

For the poet, language is a structure of the external world. The speaker is *in a situation* in language; he is invested with words. They are prolongations of his meanings, his pincers, his antennae, his eyeglasses. He maneuvers them from within; he feels them as if they were his body; he is surrounded by a verbal body which he is hardly aware of and which extends his action upon the world. The poet is outside of language. He sees words inside out as if he did not share the human condition, and as if he were first meeting the word as a barrier as he comes toward men. Instead of first knowing things by their name, it seems that first he has a silent contact with them, since, turning toward that other species of thing which for him is the word, touching them, testing them, palping them, he discovers in them a slight luminosity of their own and particular affinities with the earth, the sky, the water, and all created things.

Not knowing how to use them as a *sign* of an aspect of the world, he sees in the word the *image* of one of these aspects. And the verbal image he chooses for its resemblance to the willow tree or the ash tree is not necessarily the word which we use to designate these objects. As he is already on the outside, he considers words as a trap to catch a fleeing reality rather than as indicators which throw him out of himself into the midst of things. In short, all language is for him the mirror of the world. As a result, important changes take place in the internal economy of the word. Its sonority, its length, its masculine or feminine endings, its visual aspect, compose for him a face of flesh which *represents* rather than expresses signification. Inversely, as the signification is *realized*, the physical aspect of the word is reflected within it, and it, in its turn, functions as an image of the verbal body. Like its sign, too, for it has lost its preeminence; since words, like things, are increate, the poet does not decide whether the former exist for the latter or vice-versa.

Thus, between the word and the thing signified, there is established a double reciprocal relation of magical resemblance and signification. And the poet does not *utilize* the word, he does not choose between diverse acceptations; each of them, instead of appearing to him as an autonomous function, is given to him as a material quality which merges before his eyes with the other acceptation.

Thus, in each word he realizes solely by the effect of the poetic *attitude*, the metaphors which Picasso dreamed of when he wanted to do a matchbox which was completely a bat without ceasing to be a matchbox. Florence is city, flower, and woman. It is city-flower, city-woman,

and girl-flower all at the same time. And the strange object which thus appears has the liquidity of the *river*, the soft, tawny ardency of *gold*, and finally abandons itself with *propriety* and, by the continuous diminution of the silent *e*, prolongs indefinitely its modest blossoming.[1] To that is added the insidious effect of biography. For me, Florence is also a certain woman, an American actress who played in the silent films of my childhood, and about whom I have forgotten everything except that she was as long as a long evening glove and always a bit weary and always chaste and always married and misunderstood and whom I loved and whose name was Florence.

For the word, which tears the writer of prose away from himself and throws him into the midst of the world, sends back to the poet his own image, like a mirror. This is what justifies the double undertaking of Leiris who, on the one hand, in his *Glossary*, tries to give certain words a *poetic definition*, that is, one which is by itself a synthesis of reciprocal implications between the sonorous body and the verbal soul, and, on the other hand, in a still unpublished work, goes in quest of remembrance of things past, taking as guides a few words which for him are particularly charged with affectivity. Thus, the poetic word is a microcosm.

The crisis of language which broke out at the beginning of this century is a poetic crisis. Whatever the social and historical factors, it manifested itself by attacks of depersonalization of the writer in the face of words. He no longer knew how to use them, and, in Bergson's famous formula, he only half recognized them. He approached them with a completely fruitful feeling of strangeness. They were no longer his; they were no longer he; but in those strange mirrors, the sky, the earth, and his own life were reflected. And, finally, they became things themselves, or rather the black heart of things. And when the poet joins several of these microcosms together the case is like that of painters when they assemble their colors on the canvas. One might think that he is composing a sentence, but this is only what it appears to be. He is creating an object. The words-things are grouped by magical associations of fitness and incongruity, like colors and sounds. They attract, repel, and "*burn*" one another, and their association composes the veritable poetic unity which is the *phrase-object*.

More often the poet first has the scheme of the sentence in his mind, and the words follow. But this scheme has nothing in common with what one ordinarily calls a verbal scheme. It does not govern the construction of a signification. Rather, it is comparable to the creative project by which

[1] This sentence is not fully intelligible in translation as the author is here associating the component sounds of the word Florence with the signification of the French words they evoke. Thus: FL-OR-ENCE, *fleuve* (river), *or* (gold), and *décence* (propriety). The latter part of the sentence refers to the practice in French poetry of giving, in certain circumstances, a syllabic value to the otherwise silent terminal *e*.—Translator's note.

Picasso, even before touching his brush, prefigures in space the *thing* which will become a buffoon or a harlequin.

> To flee, to flee there, I feel that birds are drunk
> But, oh, my heart, hear the song of the sailors.
> (*Fuir, la-bas fuir, je sens que des oiseaux sont ivres*
> *Mais o mon coeur entends le chant des matelots.*)

This "but" which rises like a monolith at the threshold of the sentence does not tie the second verse to the preceding one. It colors it with a certain reserved nuance, with "private associations" which penetrate it completely. In the same way, certain poems begin with "and." This conjunction no longer indicates to the mind an operation which is to be carried out; it extends throughout the paragraph to give it the absolute quality of a *sequel*. For the poet, the sentence has a tonality, a taste; by means of it he tastes for their own sake the irritating flavors of objection, of reserve, of disjunction. He carries them to the absolute. He makes them real properties of the sentence, which becomes an utter objection without being an objection *to* anything precise. He finds here those relations of reciprocal implication which we pointed out a short time ago between the poetic word and its meaning; the ensemble of the words chosen functions as an *image* of the interrogative or restrictive nuance, and vice-versa, the interrogation is an image of the verbal ensemble which it delimits.

As in the following admirable verses:

> Oh seasons! Oh castles!
> What soul is faultless?
> (*O saisons! O chateaux!*
> *Quelle ame est sans défaut?*)

Nobody is questioned; nobody is questioning; the poet is absent. And the question involves no answer, or rather it is its own answer. Is it therefore a false question? But it would be absurd to believe that Rimbaud "meant" that everybody has his faults. As Breton said of Saint-Pol Roux, "If he had meant it, he would have said it." Nor did he *mean* to say something else. He asked an absolute question. He conferred upon the beautiful word "soul" an interrogative existence. The interrogation has become a thing as the anguish of Tintoretto became a yellow sky. It is no longer a signification, but a substance. It is seen from the outside, and Rimbaud invites us to see it from the outside with him. Its strangeness arises from the fact that, in order to consider it, we place ourselves on the other side of the human condition, on the side of God.

If this is the case, one easily understands how foolish it would be to require a poetic engagement. Doubtless, emotion, even passion—and why not anger, social indignation, and political hatred?—are at the origin of the poem. But they are not *expressed* there, as in a pamphlet or in a confession. Insofar as the writer of prose exhibits feelings, he illustrates them; whereas, if the poet injects his feelings into his poem, he ceases to recog-

nize them; the words take hold of them, penetrate them, and metamorphose them; they do not signify them, even in his eyes. Emotion has become thing; it now has the opacity of things; it is compounded by the ambiguous properties of the vocables in which it has been enclosed. And above all, there is always much more in each phrase, in each verse, as there is more than simple anguish in the yellow sky over Golgotha. The word, the phrase-thing, inexhaustible as things, everywhere overflows the feeling which has produced them. How can one hope to provoke the indignation or the political enthusiasm of the reader when the very thing one does is to withdraw him from the human condition and invite him to consider with the eyes of God a language that has been turned inside out? Someone may say, "You're forgetting the poets of the Resistance. You're forgetting Pierre Emmanuel." Not a bit! They're the very ones I was going to give as examples.

But even if the poet is forbidden to engage himself, is that a reason for exempting the writer of prose? What do they have in common? It is true that the prose-writer and the poet both write. But there is nothing in common between these two acts of writing except the movement of the hand which traces the letters. Otherwise, their universes are incommunicable, and what is good for one is not good for the other. Prose is, in essence, utilitarian. I would readily define the prose-writer as a man who *makes use* of words. M. Jourdan made prose to ask for his slippers, and Hitler to declare war on Poland. The writer is a *speaker;* he designates, demonstrates, orders, refuses, interpolates, begs, insults, persuades, insinuates. If he does so without any effect, he does not therefore become a poet; he is a writer who is talking and saying nothing. We have seen enough of language inside out; it is now time to look at it right side out.

The art of prose is employed in discourse; its substance is by nature significative; that is, the words are first of all not objects but designations for objects; it is not first of all a matter of knowing whether they please or displease in themselves, but whether they correctly indicate a certain thing or a certain notion. Thus, it often happens that we find ourselves possessing a certain idea that someone has taught us by means of words without being able to recall a single one of the words which have transmitted it to us.

Prose is first of all an attitude of mind. As Valéry would say, there is prose when the word passes across our gaze as the glass across the sun. When one is in danger or in difficulty he grabs any instrument. When the danger is past, he does not even remember whether it was a hammer or a stick; moreover, he never knew; all he needed was a prolongation of his body, a means of extending his hand to the highest branch. It was a sixth finger, a third leg, in short, a pure function which he assimilated. Thus, regarding language, it is our shell and our antennae; it protects us against others and informs us about them; it is a prolongation of our senses, a third eye which is going to look into our neighbor's

heart. We are within language as within our body. We *feel* it spontaneously while going beyond it toward other ends, as we feel our hands and our feet; we perceive it when it is the other who is using it, as we perceive the limbs of others. There is the word which is lived and the word which is met. But in both cases it is in the course of an undertaking, either of me acting upon others, or the other upon me. The word is a certain particular moment of action and has no meaning outside of it. In certain cases of aphasia the possibilities of acting, of understanding situations, and of having normal relations with the other sex, are lost.

At the heart of this apraxia the destruction of language appears only as the collapse of one of the structures, the finest and the most apparent. And if prose is never anything but the privileged instrument of a certain undertaking, if it is only the poet's business to contemplate words in a disinterested fashion, then one has the right to ask the prose-writer from the very start, "What is your aim in writing? What undertakings are you engaged in, and why does it require you to have recourse to writing?" In any case this undertaking cannot have pure contemplation as an end. For, intuition is silence, and the end of language is to communicate. One can doubtless *pin down* the results of intuition, but in this case a few words hastily scrawled on paper will suffice; it will always be enough for the author to recognize what he had in mind. If the words are assembled into sentences, with a concern for clarity, a decision foreign to the intuition, to the language itself, must intervene, the decision of confiding to others the results obtained. In each case one must ask the reason for this decision. And the common sense which our pedants too readily forget never stops repeating it. Are we not in the habit of putting this basic question to young people who are thinking of writing: "Do you have anything to say?" Which means: something which is worth the trouble of being communicated. But what do we mean by something which is "worth the trouble" if it is not by recourse to a system of transcendent values?

Moreover, to consider only this secondary structure of the undertaking, which is what the *verbal moment* is, the serious error of pure stylists is to think that the word is a gentle breeze which plays lightly over the surface of things, which grazes them without altering them, and that the speaker is a pure *witness* who sums up with a word his harmless contemplation. To speak is to act; anything which one names is already no longer quite the same; it has lost its innocence.

If you name the behavior of an individual, you reveal it to him; he sees himself. And since you are at the same time naming it to all others, he knows that he is *seen* at the moment he *sees* himself. The furtive gesture which he forgot while making it, begins to exist beyond all measure, to exist for everybody; it is integrated into the objective mind; it takes on new dimensions; it is retrieved. After that, how can you expect him to act in the same way? Either he will persist in his behavior out of obstinacy

and with full knowledge of what he is doing, or he will give it up. Thus, by speaking, I reveal the situation by my very intention of changing it; I reveal it to myself and to others *in order* to change it. I strike at its very heart, I transpierce it, and I display it in full view; at present I dispose of it; with every word I utter, I involve myself a little more in the world, and by the same token I emerge from it a little more, since I go beyond it toward the future.

Thus, the prose-writer is a man who has chosen a certain method of secondary action which we may call action by disclosure. It is therefore permissible to ask him this second question: "What aspect of the world do you want to disclose? What change do you want to bring into the world by this disclosure?" The "engaged" writer knows that words are action. He knows that to reveal is to change and that one can reveal only by planning to change. He has given up the impossible dream of giving an impartial picture of Society and the human condition. Man is the being toward whom no being can be impartial, not even God. For God, if He existed, would be, as certain mystics have seen Him, in a *situation* in relationship to man. And He is also the being Who can not even see a situation without changing it, for His gaze congeals, destroys, or sculpts, or, as does eternity, changes the object in itself. It is in love, in hate, in anger, in fear, in joy, in indignation, in admiration, in hope, in despair, that man and the world reveal themselves *in their truth*. Doubtless, the engaged writer can be mediocre; he can even be conscious of being so; but as one can not write without the intention of succeeding perfectly, the modesty with which he envisages his work should not divert him from constructing it *as if* it were to have the greatest celebrity. He should never say to himself "Bah! I'll be lucky if I have three thousand readers," but rather, "What would happen if everybody read what I wrote?" He remembers what Mosca said beside the coach which carried Fabrizio and Sanseverina away, "If the word Love comes up between them, I'm lost." He knows that he is the man who names what has not yet been named or what dares not tell its name. He knows that he makes the word "love" and the word "hate" *surge up* and with them love and hate between men who had not yet decided upon their feelings. He knows that words, as Brice-Parrain says, are "loaded pistols." If he speaks, he fires. He may be silent, but since he has chosen to fire, he must do it like a man, by aiming at targets, and not like a child, at random, by shutting his eyes and firing merely for the pleasure of hearing the shot go off.

Later on we shall try to determine what the goal of literature may be. But from this point on we may conclude that the writer has chosen to reveal the world and particularly to reveal man to other men so that the latter may assume full responsibility before the object which has been thus laid bare. It is assumed that no one is ignorant of the law because there is a code and because the law is written down; thereafter, you are free to violate it, but you know the risks you run. Similarly, the function

of the writer is to act in such a way that nobody can be ignorant of the world and that nobody may say that he is innocent of what it's all about. And since he has once engaged himself in the universe of language, he can never again pretend that he can not speak. Once you enter the universe of significations, there is nothing you can do to get out of it. Let words organize themselves freely and they will make sentences, and each sentence contains language in its entirety and refers back to the whole universe. Silence itself is defined in relationship to words, as the pause in music receives its meaning from the group of notes around it. This silence is a moment of language; being silent is not being dumb; it is to refuse to speak, and therefore to keep on speaking. Thus, if a writer has chosen to remain silent on any aspect whatever of the world, or, according to an expression which says just what it means, to *pass over* it in silence, one has the right to ask him a third question: "Why have you spoken of this rather than that, and—since you speak in order to bring about change—why do you want to change this rather than that?"

All this does not prevent there being a manner of writing. One is not a writer for having chosen to say certain things, but for having chosen to say them in a certain way. And, to be sure, the style makes the value of the prose. But it should pass unnoticed. Since words are transparent and since the gaze looks through them, it would be absurd to slip in among them some panes of rough glass. Beauty is in this case only a gentle and imperceptible force. In a painting it shines forth at the very first sight; in a book it hides itself; it acts by persuasion like the charm of a voice or a face. It does not coerce; it inclines a person without his suspecting it, and he thinks that he is yielding to arguments when he is really being solicited by a charm that he does not see. The ceremonial of the mass is not faith; it disposes the harmony of words; their beauty, the balance of the phrases, *dispose* the passions of the reader without his being aware and orders them like the mass, like music, like the dance. If he happens to consider them by themselves, he loses the meaning; there remains only a boring seesaw of phrases.

In prose the aesthetic pleasure is pure only if it is thrown into the bargain. I blush at recalling such simple ideas, but it seems that today they have been forgotten. If that were not the case, would we be told that we are planning the murder of literature, or, more simply, that engagement is harmful to the art of writing? If the contamination of a certain kind of prose by poetry had not confused the ideas of our critics, would they dream of attacking us on the matter of form, when we have never spoken of anything but the content? There is nothing to be said about form in advance, and we have said nothing. Everyone invents his own, and one judges it afterward. It is true that the subjects suggest the style, but they do not order it. There are no styles ranged a priori outside of the literary art. What is more engaged, what is more boring than the idea of attacking the Jesuits? Yet, out of this Pascal made his *Provincial*

Letters. In short, it is a matter of knowing what one wants to write about, whether butterflies or the condition of the Jews. And when one knows, then it remains to decide how one will write about it.

Often the two choices are only one, but among good writers the second choice never precedes the first. I know that Giraudoux has said that "the only concern is finding the style; the idea comes afterwards"; but he was wrong. The idea did not come. On the contrary, if one considers subjects as problems which are always open, as solicitations, as expectations, it will be easily understood that art loses nothing in engagement. On the contrary, just as physics submits to mathematicians new problems which require them to produce a new symbolism, in like manner the always new requirements of the social and the metaphysical engage the artist in finding a new language and new techniques. If we no longer write as they did in the eighteenth century, it is because the language of Racine and Saint-Evremond does not lend itself to talking about locomotives or the proletariat. After that, the purists will perhaps forbid us to write about locomotives. But art has never been on the side of the purists.

If that is the principle of engagement, what objection can one have to it? And above all *what objection has been made to it?* It has seemed to me that my opponents have not had their hearts in their work very much and that their articles contain nothing more than a long scandalized sigh which drags on over two or three columns. I should have liked to know *in the name of what*, with what conception of literature, they condemned engagement. But they have not said; they themselves have not known. The most reasonable thing would have been to support their condemnation on the old theory of art for art's sake. But none of them can accept it. That is also disturbing. We know very well that pure art and empty art are the same thing and that aesthetic purism was a brilliant maneuver of the bourgeois of the last century who preferred to see themselves denounced as philistines rather than as exploiters. Therefore, they themselves admitted that the writer had to speak about something. But about what? I believe that their embarrassment would have been extreme if Fernandez had not found for them, after the other war, the notion of the *message.* The writer of today, they say, should in no case occupy himself with temporal affairs. Neither should he set up lines without signification nor seek solely beauty of phrase and of imagery. His function is to deliver messages to his readers. Well, what is a message?

It must be borne in mind that most critics are men who have not had much luck and who, just about the time they were growing desperate, found a quiet little job as cemetery watchmen. God knows whether cemeteries are peaceful; none of them are more cheerful than a library. The dead are there; the only thing they have done is write. They have long since been washed clean of the sin of living, and besides, their lives are known only through other books which other dead men have written about them. Rimbaud is dead. So are Paterne Berrichon and Isabelle Rimbaud. The

trouble makers have disappeared; all that remains are the little coffins that are stacked on shelves along the walls like urns in a columbarium. The critic lives badly; his wife does not appreciate him as she ought to; his children are ungrateful; the first of the month is hard on him. But it is always possible for him to enter his library, take down a book from the shelf, and open it. It gives off a slight odor of the cellar, and a strange operation begins which he has decided to call reading. From one point of view it is a possession; he lends his body to the dead in order that they may come back to life. And from another point of view it is a contact with the beyond. Indeed, the book is by no means an object; neither is it an act, nor even a thought. Written by a dead man about dead things, it no longer has any place on this earth; it speaks of nothing which interests us directly. Left to itself, it falls back and collapses; there remain only ink spots on musty paper. And when the critic reanimates these spots, when he makes letters and words of them, they speak to him of passions which he does not feel, of bursts of anger without objects, of dead fears and hopes. It is a whole disembodied world which surrounds him, where human feelings, because they are no longer affecting, have passed on to the status of exemplary feelings and, in a word, of *values*. So he persuades himself that he has entered into relations with an intelligible world which is like the truth of his daily sufferings. And their reason for being. He thinks that nature imitates art, as for Plato the world of the senses imitates that of the archetypes. And during the time he is reading, his everyday life becomes an appearance. His nagging wife, his hunchbacked son, they too are appearances. And he will put up with them because Xenophon has drawn the portrait of Xantippe and Shakespeare that of Richard the Third.

It is a holiday for him when contemporary authors do him the favor of dying. Their books, too raw, too living, too urgent, pass on to the other shore; they become less and less affecting and more and more beautiful. After a short stay in Purgatory they go on to people the intelligible heaven with new values. Bergotte, Swann, Siegfried and Bella, and Monsieur Teste are recent acquisitions. He is waiting for Nathanaël and Ménalque. As for the writers who persist in living, he asks them only not to move about too much, and to make an effort to resemble from now on the dead men they will be. Valéry, who for twenty-five years had been publishing posthumous books, managed the matter very nicely. That is why, like some highly exceptional saints, he was canonized during his lifetime. But Malraux is scandalous.

Our critics are Catharians. They don't want to have anything to do with the real world except eat and drink in it, and since it is absolutely necessary to have relations with our fellow-creatures, they have chosen to have them with the defunct. They get excited only about classified matters, closed quarrels, stories whose ends are known. They never

bet on uncertain issues, and since history has decided for them, since the objects which terrified or angered the authors they read have disappeared, since bloody disputes seem futile at a distance of two centuries, they can be charmed with balanced periods, and everything happens for them as if all literature were only a vast tautology and as if every new prose-writer had invented a new way of speaking only for the purpose of saying nothing.

To speak of archetypes and "human nature"—is that speaking in order to say nothing? All the conceptions of our critics oscillate from one idea to the other. And, of course, both of them are false. Our great writers wanted to destroy, to edify, to demonstrate. But we no longer retain the proofs which they have advanced because we have no concern with what they mean to prove. The abuses which they denounced are no longer those of our time. There are others which rouse us which they did not suspect. History has given the lie to some of their predictions, and those which have been fulfilled became true so long ago that we have forgotten that they were at first flashes of their genius. Some of their thoughts are utterly dead, and there are others which the whole human race has taken up to its advantage and which we now regard as commonplace. It follows that the best arguments of these writers have lost their effectiveness. We admire only their order and rigor. Their most compact composition is in our eyes only an ornament, an elegant architecture of exposition, with no more practical application than such architectures as the fugues of Bach and the arabesques of the Alhambra.

We are still moved by the passion of these impassioned geometries when the geometry no longer convinces us. Or rather by the representation of the passion. In the course of centuries the ideas have turned flat, but they remain the little personal objectives of a man who was once flesh and bone; behind the reasons of reason, which languish, we perceive the reasons of the heart, the virtues, the vices, and that great pain that men have in living. Sade does his best to win us over, but we hardly find him scandalous. He is no longer anything but a soul eaten by a beautiful disease, a pearl-oyster. The *Letter on the Theater* no longer keeps anyone from going to the theater, but we find it piquant that Rousseau detested the art of the drama. If we are a bit versed in psychoanalysis, our pleasure is perfect. We shall explain the *Social Contract* by the Oedipus complex and *The Spirit of the Laws* by the inferiority complex. That is, we shall fully enjoy the well-known superiority of live dogs to dead lions. Thus, when a book presents befuddled thoughts which appear to be reasons only to melt under scrutiny and to be reduced to heart beats, when the teaching that one can draw from it is radically different from what its author intended, the book is called a message. Rousseau, the father of the French Revolution, and Gobineau, the father of racism, both sent us messages. And the critic considers them with equal sympathy. If they were alive, he would have to choose between the

two, to love one and hate the other. But what brings them together, above all, is that they are both profoundly and deliciously wrong, and in the same way: they are dead.

Thus, contemporary writers should be advised to deliver messages, that is, voluntarily to limit their writing to the involuntary expression of their souls. I say involuntary because the dead, from Montaigne to Rimbaud, have painted themselves completely, but without having meant to—it is something they have simply thrown into the bargain. The surplus which they have given us unintentionally should be the primary and professed goal of living writers. They are not to be forced to give us confessions without any dressing, nor are they to abandon themselves to the too-naked lyricism of the romantics. But since we find pleasure in foiling the ruses of Chateaubriand or Rousseau, in surprising them in the secret places of their being at the moment they are playing at being the public man, in distinguishing the private motives from their most universal assertions, we shall ask newcomers to procure us this pleasure deliberately. So let them reason, assert, deny, refute, and prove; but the cause they are defending must be only the apparent aim of their discourse; the deeper goal is to yield themselves without seeming to do so. They must first disarm themselves of their arguments as time has done for those of the classic writers; they must bring them to bear upon subjects which interest no one or on truths so general that readers are convinced in advance. As for their ideas, they must give them an air of profundity, but with an effect of emptiness, and they must shape them in such a way that they are obviously explained by an unhappy childhood, a class hatred, or an incestuous love. Let them not presume to think in earnest; thought conceals the man, and it is the man alone who interests us. A bare tear is not lovely. It offends. A good argument also offends, as Stendhal well observed. But an argument that masks a tear—that's what we're after. The argument removes the obscenity from the tears; the tears, by revealing their origin in the passions, remove the aggressiveness from the argument. We shall be neither too deeply touched nor at all convinced, and we shall be able to yield ourselves in security to that moderate pleasure which, as everyone knows, we derive from the contemplation of works of art. Thus, this is "true," "pure" literature, a subjectivity which yields itself under the aspect of the objective, a discourse so curiously contrived that it is equivalent to silence, a thought which debates with itself, a reason which is only the mask of madness, an Eternal which lets it be understood that it is only a moment of History, a historical moment which, by the hidden side which it reveals, suddenly sends back a perpetual lesson to the eternal man, but which is produced against the express wishes of those who do the teaching.

When all is said and done, the message is a soul which is made object. A soul, and what is to be done with a soul? One contemplates it at a respectful distance. It is not customary to show one's soul in society

without an imperious motive. But, with certain reserves, convention permits some individuals to put theirs into commerce, and all adults may procure it for themselves. For many people today, works of the mind are thus little straying souls which one acquires at a modest price; there is good old Montaigne's, dear La Fontaine's, and that of Jean-Jacques and of Jean-Paul and of delicious Gérard. What is called literary art is the ensemble of the treatments which make them inoffensive. Tanned, refined, chemically treated, they provide their acquirers with the opportunity of devoting some moments of a life completely turned outward to the cultivation of subjectivity. Custom guarantees it to be without risk. Montaigne's skepticism? Who can take it seriously since the author of the *Essays* got frightened when the plague ravaged Bordeaux? Or Rousseau's humanitarianism, since "Jean-Jacques" put his children into an orphanage? And the strange revelations of *Sylvie*, since Gérard de Nerval was mad? At the very most, the professional critic will set up infernal dialogues between them and will inform us that French thought is a perpetual colloquy between Pascal and Montaigne. In so doing he has no intention of making Pascal and Montaigne more alive, but of making Malraux and Gide more dead. Finally, when the internal contradictions of the life and the work have made both of them useless, when the message, in its imponderable depth, has taught us these capital truths, "that man is neither good nor bad," "that there is a great deal of suffering in human life," "that genius is only great patience," this melancholy cuisine will have achieved its purpose, and the reader, as he lays down the book, will be able to cry out with a tranquil soul, "All this is only literature."

PART IV

CONTEMPORARY
AESTHETIC ANALYSIS

LUDWIG WITTGENSTEIN

LECTURES ON AESTHETICS

*Ludwig Wittgenstein (1889–1951), born in Vienna and edu-
cated at Cambridge, was a powerful force in the develop-
ment of analytic philosophy.*

1. The subject (Aesthetics) is very big and entirely misunderstood
as far as I can see. The use of such a word as 'beautiful' is even more
apt to be misunderstood if you look at the linguistic form of sentences in
which it occurs than most other words. 'Beautiful' [and 'good'—R][1] is an
adjective, so you are inclined to say: "This has a certain quality, that of
being beautiful".

2. We are going from one subject-matter of philosophy to another,
from one group of words to another group of words.

3. An intelligent way of dividing up a book on philosophy would be

Reprinted from Wittgenstein: *Lectures and Conversations on Aesthetics, Psychol-
ogy and Religious Beliefs*, edited by Cyril Barrett (Berkeley and Los Angeles: Uni-
versity of California Press, and Oxford: Basil Blackwell, 1966), pp. 1–11. Re-
printed by permission of the publishers.

[1] According to the editor, "The notes published here are not Wittgenstein's own
lecture notes but notes taken down by students. . . . The most complete version
has been chosen as the text and significant variants have been added in footnote."
R and T refer respectively to the versions of Rush Rhees and James Taylor.

into parts of speech, kinds of words. Where in fact you would have to distinguish far more parts of speech than an ordinary grammar does. You would talk for hours and hours on the verbs 'seeing', 'feeling', etc., verbs describing personal experience. We get a peculiar kind of confusion or confusions which comes up with all these words.[2] You would have another chapter on numerals—here there would be another kind of confusion: a chapter on 'all', 'any', 'some', etc.—another kind of confusion: a chapter on 'you', 'I', etc.—another kind: a chapter on 'beautiful', 'good'— another kind. We get into a new group of confusions; language plays us entirely new tricks.

4. I have often compared language to a tool chest, containing a hammer, chisel, matches, nails, screws, glue. It is not a chance that all these things have been put together—but there are important differences between the different tools—they are used in a family of ways— though nothing could be more different than glue and a chisel. There is constant surprise at the new tricks language plays on us when we get into a new field.

5. One thing we always do when discussing a word is to ask how we were taught it. Doing this on the one hand destroys a variety of misconceptions, on the other hand gives you a primitive language in which the word is used. Although this language is not what you think when you are twenty, you get a rough approximation to what kind of language game is going to be played. Cf. How did we learn 'I dreamt so and so'? The interesting point is that we didn't learn it by being shown a dream. If you ask yourself how a child learns 'beautiful', 'fine', etc., you find it learns them roughly as interjections. ('Beautiful' is an odd word to talk about because it's hardly ever used.) A child generally applies a word like 'good' first to food. One thing that is immensely important in teaching is exaggerated gestures and facial expressions. The word is taught as a substitute for a facial expression or a gesture. The gestures, tones of voice, etc., in this case are expressions of approval. What *makes* the word an interjection of approval?[3] It is the game it appears in, not the form of words. (If I had to say what is the main mistake made by philosophers of the present generation, including Moore, I would say that it is that when language is looked at, what is looked at is a form of words and not the use made of the form of words.) Language is a characteristic part of a large group of activities—talking, writing, travelling on a bus, meeting a man, etc.[4] We are concentrating, not on the words 'good' or

[2] Here we find similarities—we find peculiar sorts of confusion which come up with *all* these words.—R.

[3] And not of disapproval or of surprise, for example?
(The child understands the gestures which you use in teaching him. If he did not, he could understand nothing.)—R.

[4] When we build houses, we talk and write. When I take a bus, I say to the conductor: 'Threepenny.' We are concentrating not just on the word or the sentence in which it is used—which is highly uncharacteristic—but on the occasion on which it is said: the framework in which (nota bene) the actual aesthetic judgment is practically nothing at all.—R.

'beautiful', which are entirely uncharacteristic, generally just subject and predicate ('This is beautiful'), but on the occasions on which they are said—on the enormously complicated situation in which the aesthetic expression has a place, in which the expression itself has almost a negligible place.

6. If you came to a foreign tribe, whose language you didn't know at all and you wished to know what words corresponded to 'good', 'fine', etc., what would you look for? You would look for smiles, gestures, food, toys. ([Reply to objection:] If you went to Mars and men were spheres with sticks coming out, you wouldn't know what to look for. Or if you went to a tribe where noises made with the mouth were just breathing or making music, and language was made with the ears. Cf. "When you see trees swaying about they are talking to one another." ("Everything has a soul.") You compare the branches with arms. Certainly we must interpret the gestures of the tribe on the analogy of ours.) How far this takes us from normal aesthetics [and ethics—T]. We don't start from certain words, but from certain occasions or activities.

7. A characteristic thing about our language is that a large number of words used under these circumstances are adjectives—'fine', 'lovely', etc. But you see that this is by no means necessary. You saw that they were first used as interjections. Would it matter if instead of saying "This is lovely", I just said "Ah!" and smiled, or just rubbed my stomach? As far as these primitive languages go, problems about what these words are about, what their real subject is, [which is called 'beautiful' or 'good'. —R.][5] don't come up at all.

8. It is remarkable that in real life, when aesthetic judgements are made, aesthetic adjectives such as 'beautiful', 'fine', etc., play hardly any role at all. Are aesthetic adjectives used in a musical criticism? You say: "Look at this transition",[6] or [Rhees] "The passage here is incoherent". Or you say, in a poetical criticism, [Taylor]: "His use of images is precise". The words you use are more akin to 'right' and 'correct' (as these words are used in ordinary speech) than to 'beautiful' and 'lovely'.[7]

9. Words such as 'lovely' are first used as interjections. Later they are used on very few occasions. We might say of a piece of music that it is lovely, by this not praising it but giving it a character. (A lot of people, of course, who can't express themselves properly use the word very frequently. As they use it, it is used as an interjection.) I might ask: "For what melody would I most like to use the word 'lovely'?" I might choose between calling a melody 'lovely' and calling it 'youthful'. It is stupid to call a piece of music 'Spring Melody' or 'Spring Symphony'. But the word 'springy' wouldn't be absurd at all, any more than 'stately' or 'pompous'.

[5] What the thing that is really good is—T.

[6] 'The transition was made in the right way.'—T.

[7] It would be better to use 'lovely' descriptively, on a level with 'stately,' 'pompous,' etc.—T.

10. If I were a good draughtsman, I could convey an innumerable number of expressions by four strokes—

Such words as 'pompous' and 'stately' could be expressed by faces. Doing this, our descriptions would be much more flexible and various than they are as expressed by adjectives. If I say of a piece of Schubert's that it is melancholy, that is like giving it a face (I don't express approval or disapproval). I could instead use gestures or [Rhees] dancing. In fact, if we want to be exact, we do use a gesture or a facial expression.

11. [*Rhees:* What rule are we using or referring to when we say: "This is the correct way"? If a music teacher says a piece *should* be played this way and plays it, what is he appealing to?]

12. Take the question: "How should poetry be read? What is the correct way of reading it?" If you are talking about blank verse the right way of reading it might be stressing it correctly—you discuss how far you should stress the rhythm and how far you should hide it. A man says it ought to be read *this* way and reads it out to you. You say: "Oh yes. Now it makes sense." There are cases of poetry which should almost be scanned—where the metre is as clear as crystal—others where the metre is entirely in the background. I had an experience with the 18th century poet Klopstock.[8] I found that the way to read him was to stress his metre abnormally. Klopstock put ◡–◡ (etc.) in front of his poems. When I read his poems in this new way, I said: "Ah-ha, now I know why he did this." What had happened? I had read this kind of stuff and had been moderately bored, but when I read it in this particular way, intensely, I smiled, said: "This is *grand*," etc. But I might not have said anything. The important fact was that I read it again and again. When I read these poems I made gestures and facial expressions which were what would be called gestures of approval. But the important thing was that I read the poems entirely differently, more intensely, and said to others: "Look! This is how they should be read."[9] Aesthetic adjectives played hardly any role.

13. What does a person who knows a good suit say when trying on a suit at the tailor's? "That's the right length", "That's too short", "That's too narrow". Words of approval play no rôle, although he will look pleased when the coat suits him. Instead of "That's too short" I might say "Look!" or instead of "Right" I might say "Leave it as it is". A

[8] Friedrich Gottlieb Klopstock (1724–1803). Wittgenstein is referring to the Odes. (*Gesammelte Werke*, Stuttgart, 1886–7). Klopstock believed that poetic diction was distinct from popular language. He rejected rhyme as vulgar and introduced instead the metres of ancient literature.—Ed.

[9] If we speak of the right way to read a piece of poetry—approval enters, but it plays a fairly small role in the situation.—R.

good cutter may not use any words at all, but just make a chalk mark and later alter it. How do I show my approval of a suit? Chiefly by wearing it often, liking it when it is seen, etc.

14. (If I give you the light and shadow on a body in a picture I can thereby give you the shape of it. But if I give you the highlights in a picture you don't know what the shape is.)

15. In the case of the word "correct" you have a variety of related cases. There is first the case in which you learn the rules. The cutter learns how long a coat is to be, how wide the sleeve must be, etc. He learns rules—he is drilled—as in music you are drilled in harmony and counterpoint. Suppose I went in for tailoring and I first learnt all the rules, I might have, on the whole, two sorts of attitude. (1) Lewy says: "This is too short." I say: "No. It is right. It is according to the rules." (2) I develop a feeling for the rules. I interpret the rules. I might say: "No. It isn't right. It isn't according to the rules."[10] Here I would be making an aesthetic judgement about the thing which is according to the rules in sense (1). On the other hand, if I hadn't learnt the rules, I wouldn't be able to make the aesthetic judgement. In learning the rules you get a more and more refined judgement. Learning the rules actually changes your judgement. (Although, if you haven't learnt Harmony and haven't a good ear, you may nevertheless detect any disharmony in a sequence of chords.)

16. You could regard the rules laid down for the measurement of a coat as an expression of what certain people want.[11] People separated on the point of what a coat should measure: there were some who didn't care if it was broad or narrow, etc.; there were others who cared an enormous lot.[12] The rules of harmony, you can say, expressed the way people wanted chords to follow—their wishes crystallized in these rules (the word 'wishes' is much too vague.)[13] All the greatest composers wrote in accordance with them. ([Reply to objection:] You can say that every composer changed the rules, but the variation was very slight; not all the rules were changed. The music was still good by a great many of the old rules.—This though shouldn't come in here.)

17. In what we call the Arts a person who has judgement developes. (A person who has a judgement doesn't mean a person who says 'Marvellous!' at certain things.)[14] If we talk of aesthetic judgements, we think, among a thousand things, of the Arts. When we make an aesthetic

[10] 'Don't you see that if we made it broader, it isn't right and it isn't according to the rules.'—R.

[11] These may be extremely explicit and taught, or not formulated at all.—T.

[12] But—it is just a fact that people have laid down such and such rules. We say 'people' but in fact it was a particular class. . . . When we say 'people', these were *some* people.—R.

[13] And although we have talked of 'wishes' here, the fact is just that these rules were laid down.—R.

[14] In what we call the arts there developed what we call a 'judge'—i.e. one who has judgment. This does not mean just someone who admires or does not admire. We have an entirely new element.—R.

judgement about a thing, we do not just gape at it and say: "Oh! How marvellous!" We distinguish between a person who knows what he is talking about and a person who doesn't.[15] If a person is to admire English poetry, he must know English. Suppose that a Russian who doesn't know English is overwhelmed by a sonnet admitted to be good. We would say that he does not know what is in it at all. Similarly, of a person who doesn't know metres but who is overwhelmed, we would say that he doesn't know what's in it. In music this is more pronounced. Suppose there is a person who admires and enjoys what is admitted to be good but can't remember the simplest tunes, doesn't know when the bass comes in, etc. We say he hasn't seen what's in it. We use the phrase 'A man is musical' not so as to call a man musical if he says "Ah!" when a piece of music is played, any more than we call a dog musical if it wags its tail when music is played.[16]

18. The word we ought to talk about is 'appreciated'. What does appreciation consist in?

19. If a man goes through an endless number of patterns in a tailor's, [and] says: "No. This is slightly too dark. This is slightly too loud", etc., he is what we call an appreciator of material. That he is an appreciator is not shown by the interjections he uses, but by the way he chooses, selects, etc. Similarly in music: "Does this harmonize? No. The bass is not quite loud enough. Here I just want something different. . . ." This is what we call an appreciation.

20. It is not only difficult to describe what appreciation consists in, but impossible. To describe what it consists in we would have to describe the whole environment.

21. I know exactly what happens when a person who knows a lot about suits goes to the tailor, also I know what happens when a person who knows nothing about suits goes—what he says, how he acts, etc.[17] There is an extraordinary number of different cases of appreciation. And, of course, what I know is nothing compared to what one could know. I would have—to say what appreciation is—e.g. to explain such an enormous wart as arts and crafts, such a particular kind of disease. Also I would have to explain what our photographers do today—and why it is impossible to get a decent picture of your friend even if you pay £1,000.

22. You can get a picture of what you may call a very high culture, e.g. German music in the last century and the century before, and what happens when this deteriorates. A picture of what happens in Architecture when you get imitations—or when thousands of people are interested in the minutest details. A picture of what happens when a dining-room

[15] He must react in a consistent way over a long period. Must know all sorts of things.—T.

[16] Cf. the person who likes hearing music but cannot talk about it at all, and is quite unintelligent on the subject. 'He is musical.' We do not say this if he is just happy when he hears music and other things aren't present.—T.

[17] That is aesthetics.—T.

table is chosen more or less at random, when no one knows where it came from.[18]

23. We talked of correctness. A good cutter won't use any words except words like 'Too long', 'All right'. When we talk of a Symphony of Beethoven we don't talk of correctness. Entirely different things enter. One wouldn't talk of appreciating the *tremendous* things in Art. In certain styles in Architecture a door is correct, and the thing is you appreciate it. But in the case of a Gothic Cathedral what we do is not at all to find it correct—it plays an entirely different rôle with us.[19] The entire *game* is different. It is as different as to judge a human being and on the one hand to say 'He behaves well' and on the other hand 'He made a great impression on me.'

24. 'Correctly', 'charmingly', 'finely', etc. play an entirely different role. Cf. the famous address of Buffon—a terrific man—on style in writing; making ever so many distinctions which I only understand vaguely but which he didn't mean vaguely—all kinds of nuances like 'grand', 'charming', 'nice'.[20]

25. The words we call expressions of aesthetic judgement play a very complicated rôle, but a very definite rôle, in what we call a culture of a period. To describe their use or to describe what you mean by a cultured taste, you have to describe a culture.[21] What we now call a cultured taste perhaps didn't exist in the Middle Ages. An entirely different game is played in different ages.

26. What belongs to a language game is a whole culture. In describing musical taste you have to describe whether children give concerts, whether women do or whether men only give them, etc., etc.[22] In aristocratic circles in Vienna people had [such and such] a taste, then it came into bourgeois circles and women joined choirs, etc. This is an example of tradition in music.

27. [*Rhees:* Is there tradition in Negro art? Could a European appreciate Negro art?]

28. What would tradition in Negro Art be? That women wear cutgrass skirts? etc., etc. I don't know. I don't know how Frank Dobson's ap-

[18] Explain what happens when a craft deteriorates. A period in which everything is fixed and extraordinary care is lavished on certain details; and a period in which everything is copied and nothing is thought about.—T.

A great number of people are highly interested in a detail of a dining-room chair. And then there is a period when a dining-room chair is in the drawing-room and no one knows where this came from or that people had once given enormous thought in order to know how to design it.—R.

[19] Here there is no question of *degree*.—R.

[20] *Discours sur le style:* the address on his reception into L'Academie Française. 1753.—Ed.

[21] To describe a set of aesthetic rules fully means really to describe the culture of a period.—T.

[22] That children are taught by adults who go to concerts, etc., that the schools are like they are, etc.—R.

preciation of Negro Art compares with an educated Negro's.[23] If you say he appreciates it, I don't yet know what this means.[24] He may fill his room with objects of Negro Art. Does he just say: "Ah"? Or does he do what the best-Negro musicians do? Or does he agree or disagree with so and so about it? You may call this appreciation. Entirely different to an educated Negro's. Though an educated Negro may also have Negro objects of art in his room. The Negro's and Frank Dobson's are different appreciations altogether. You do something different with them. Suppose Negroes dress in their own way and I say I appreciate a good Negro tunic—does this mean I would have one made, or that I would say (as at the tailor's): "No . . . this is too long", or does it mean I say: "How charming!"?

29. Suppose Lewy has what is called a cultured taste in painting. This is something entirely different to what was called a cultured taste in the fifteenth century. An entirely different game was played. He does something entirely different with it to what a man did then.

30. There are lots of people, well-offish, who have been to good schools, who can afford to travel about and see the Louvre, etc., and who know a lot about and can talk fluently about dozens of painters. There is another person who has seen very few paintings, but who looks intensely at one or two paintings which make a profound impression on him.[25] Another person who is broad, neither deep nor wide. Another person who is very narrow, concentrated and circumscribed. Are these different kinds of appreciation? They may all be called 'appreciation'.

31. You talk in entirely different terms of the Coronation robe of Edward II and of a dress suit.[26] What did *they* do and say about Coronation robes? Was the Coronation robe made by a tailor? Perhaps it was designed by Italian artists who had their own traditions; never seen by Edward II until he put it on. Questions like 'What standards were there?', etc. are all relevant to the question 'Could you criticize the robe as they criticized it?'. You appreciate it in an entirely different way; your attitude to it is entirely different to that of a person living at the time it was designed. On the other hand 'This is a fine Coronation robe!' might have been said by a man at the time in exactly the same way as a man says it now.

32. I draw your attention to differences and say: "Look how different these differences are!" "Look what is in common to the different cases", "Look what is common to Aesthetic judgements". An immensely complicated family of cases is left, with the highlight—the expression of admiration, a smile or a gesture, etc.

[23] Frank Dobson (1888–1963) painter and sculptor; was the first to bring to England the interest in African and Asian sculpture which characterized the work of Picasso and the other Cubists during the years immediately preceding and following the First World War.—Ed.

[24] Here you haven't made what you mean by 'appreciate Negro Art' clear.—T.

[25] Someone who has not travelled but who makes certain observations which show that he 'really does appreciate' . . . an appreciation which concentrates on one thing and is very deep—so that you would give your last penny for it.—R.

[26] Edward the Confessor.—T.

33. [Rhees asked Wittgenstein some question about his 'theory' of deterioration.]

Do you think I have a theory? Do you think I'm saying what deterioration is? What I do is describe different things called deterioration. I might approve deterioration—"All very well your fine musical culture; I'm very glad children don't learn harmony now." [*Rhees:* Doesn't what you say imply a preference for using 'deterioration' in certain ways?] All right, if you like, but this by the way—no, it is no matter. My example of deterioration is an example of something I know, perhaps something I dislike—I don't know. 'Deterioration' applies to a tiny bit I may know.

34. Our dress is in a way simpler than dress in the 18th century and more a dress adapted to certain violent activities, such as bicycling, walking, etc. Suppose we notice a similar change in Architecture and in hairdressing, etc. Suppose I talked of the deterioration of the style of living.[27] If someone asks: "What do you mean by deterioration?" I describe, give examples. You use 'deterioration' on the one hand to describe a particular kind of development, on the other hand to express disapproval. I may join it up with the things I like; you with the things you dislike. But the word may be used without any affective element; you use it to describe a particular kind of thing that happened.[28] It was more like using a technical term—possibly, though not at all necessarily, with a derogatory element in it. You may say in protest, when I talk of deterioration: "But this was very good." I say: "All right. But this wasn't what I was talking about. I used it to describe a particular kind of development."

35. In order to get clear about aesthetic words you have to describe ways of living.[29] We think we have to talk about aesthetic judgements like 'This is beautiful', but we find that if we have to talk about aesthetic judgements we don't find these words at all, but a word used something like a gesture, accompanying a complicated activity.[30]

36. [*Lewy:* If my landlady says a picture is lovely and I say it is hideous, we don't contradict one another.]

In a sense [and in *certain examples*—R] you do contradict one another. She dusts it carefully, looks at it often, etc. You want to throw it in the fire. This is just the stupid kind of example which is given in philosophy, as if things like 'This is hideous', 'This is lovely' were the only kinds of things ever said. But it is only one thing amongst a vast realm of other things—one special case. Suppose the landlady says: "This is hideous", and you say: "This is lovely"—all right, that's that.

[27]Deterioration of style and of living.—R.

[28] 'Deterioration' gets its sense from the examples I can give. 'That's a deterioration', may be an expression of disapproval or a description.

[29] Cf. 'This is a fine dress'.—R.

[30] The judgment is a gesture accompanying a vast structure of actions not expressed by one judgment.—R.

'This is fine' is on a level with a gesture, almost—connected with all sorts of other gestures and actions and a whole situation and a culture. In Aesthetics just as in the arts what we called expletives play a very small part. The adjectives used in these are closer related to 'correct'.—T.

PAUL ZIFF

THE TASK OF DEFINING
A WORK OF ART

*Paul Ziff is Professor of Philosophy at the University of
Illinois at Chicago Circle.*

One of the foremost problems of aesthetics has been to provide a
definition (or an analysis, or an explication, or an elucidation) of the
notion of a work of art. The solutions given by aestheticians to this prob-
lem have often been violently opposed to one another; e.g., contrast
Tolstoi's answer with that of his predecessors. There is no doubt that the
problem is a difficult one. But what I should like to consider here is just
why it is so difficult. In this way I hope to make clear what is involved
in such a definition and what an aesthetician must do, whether he knows
it or not, to justify his definition of a work of art.

I

Suppose a child does not understand what a book is, is merely puzzled
by people speaking about books. One of the many means at hand to help

Reprinted from *The Philosophical Review*, Volume LXII, No. 1 (January, 1953),
pp. 58–78, by permission of the publisher and Professor Paul Ziff.

him grasp the use of that word "book" would be simply to show him a book. But one would not help or try to help him by picking out a pocket book, or a diary with blank pages, or a loose-leaf note book. What is wanted here is a perhaps fat book, but not too fat, with a hard cover, perhaps a gold-lettered leather-bound book. If someone doesn't know but wants to know what a table is, to learn the use of the word "table," it would not do to begin by showing him an esoteric table with ninety-six legs, only six inches high. Again one would take a good solid oak table with a modest number of legs, an ordinary, everyday sort of table, not a cabinet maker's nightmare. If we begin with a clear-cut case, one no one would ordinarily be tempted to dispute, we can then shift to the less clear-cut, the disputed, cases. A clear-cut case is a place to start from.

What would a clear-cut case of a work of art be? One is inclined to say a painting like Poussin's "The Rape of the Sabine Women," or Da Vinci's "Mona Lisa," or Rembrandt's "Night Watch," would do here, that no one would want to object. But suppose someone were to say, "No, none of these are works of art." If, when we pointed to an ordinary every-day sort of table, someone were to object, "No, that's not a table," we could and should say he was clearly confused, in one way or another. Maybe he imagined we had not pointed at the table, that we had pointed at a chair; or we might suppose that he supposed the word "table" was only and always applied to multiplication tables; and so forth. Perhaps culti-vated confusion at a sophisticated level, but nothing else but confusion, could be the root of a dispute over our clear-cut example of a table; but a refusal to call the Poussin, or the Da Vinci, or even the Rembrandt a work of art, need not be the blossom of a merely blooming confusion. For it is in fact possible to dispute whether any particular painting is a work of art or not, and people do dispute such questions, in a way that it is not in fact possible to dispute whether any particular object is a table or not.

And this is to say simply that there are and can be no clear-cut cases of works of art in quite the same sense as there can be such clear-cut cases of tables, chairs, and so forth. That this is so stems partly from the fact that there are many uses of the phrase "work of art" in a way in which there are very few uses of the word "table." (For even though the word "table" does have many diverse uses, e.g., one can speak of multiplication tables, dinner tables, table lands, etc., there are very few uses of the word "table" in connection with those ordinary everyday objects that one customarily sits at and eats off of, i.e., tables. But in this sense, there are many distinct and different and even "competing" uses of the phrase "work of art.") And it also stems partly from the fact that among these many uses of the phrase "work of art," some are aptly described as laudatory or eulogistic. The many reasons why this is so will, I trust, become clear in the course of this discussion. For the time being, even though the examples of works of art which I have cited might not or need not be accepted by everyone, they are the clearest cases available, and as such they provide a useful base for our explorations.

In selecting a clear-cut example of a carpenter's hammer, one could choose a hammer with a handle exactly twelve and three-quarters inches long. Perhaps the title of the book we pointed to, the leather-bound book with gold lettering, was *Anna Karenina*. But in describing or talking about the example of a hammer to a child who did not grasp the use of the word, one would not say, "The handle of the hammer is exactly twelve and three-quarters inches long." Instead, one would be much more apt to say, "The handle of the hammer is about a foot long," or something of that sort. In the kind of case we have envisaged, the former statement would, at best, be altogether misleading. Whether a description is liable to mislead depends roughly on why it is wanted. In describing the clear-cut case of a hammer, when we want to help someone understand how the word "hammer" is used, we mention those facts about the object that make it, in fact, such a clear-cut case. That is why we would not say, "The handle of the hammer is exactly twelve and three quarters inches long." This really does not matter; it does not affect and is entirely irrelevant to the status of the example as a clear-cut case. But the fact that the handle is about a foot long is really relevant here. Similarly, we would not mention the particular title of the book, which we were using as a clear-cut case; but the fact that it had a title would be relevant.

Suppose we point to Poussin's "The Rape of the Sabine Women" as our clearest available case of a work of art. We could describe it by saying, first, that it is a painting. Secondly, it was made, and what is more, made deliberately and self-consciously with obvious skill and care, by Nicolas Poussin. Thirdly, the painter intended it to be displayed in a place where it could be looked at and appreciated, where it could be contemplated and admired. In short, he intended it to be treated in a way very much like the way that works of art are customarily treated. In saying this I do not wish to suggest that Poussin intended his work to be exhibited in a museum gallery. I do not know, but I would suppose the painting was intended to be hung in some chateau, or something of that sort. So perhaps in this respect the painting is not treated in the way intended by the painter. But there is good reason to believe that the painter did intend the painting to be displayed in an appropriate manner, to be treated with care, and to be preserved for as long as possible. And there is good reason to believe that Poussin did intend the painting to be contemplated, studied, observed, admired, criticized, and discussed by some people, if not by just any people. Fourthly, the painting is or was exhibited in a museum gallery where people do contemplate, study, observe, admire, criticize, and discuss it. What I wish to refer to here by speaking of contemplating, studying, and observing a painting, is simply what we may do when we are concerned with a painting like this. For example, when we look at this painting by Poussin, we may attend to its sensuous features, to its "look and feel." Thus we attend to the play of light and color, to dissonances, contrasts, and harmonies of hues, values, and intensities. We notice patterns and pigmentation, textures, decorations,

and embellishments. We may also attend to the structure, design, composition, and organization of the work. Thus we look for unity, and we also look for variety, for balance and movement. We attend to the formal interrelations and cross connections in the work, to its underlying structure. We are concerned with both two-dimensional and three-dimensional movements, the balance and opposition, thrust and recoil, of spaces and volumes. We attend to the sequences, overlaps, and rhythms of line, form, and color. We may also attend to the expressive, significant, and symbolic aspects of the work. Thus we attend to the subject matter, to the scene depicted, and to the interrelations between the formal structure and the scene portrayed. We attend to the emotional character of the presented forms, and so forth. This is, very roughly, what I have in mind when I speak of contemplating, studying, and observing this Poussin painting. (Lest there be any misunderstanding, let me say explicitly that I am not saying that when ordinary people either contemplate or study or observe or attend to or look at or in any way concern themselves with this Poussin painting, they do in fact always attend to or concern themselves with all of the aspects of the painting that I have here mentioned. This is plainly untrue. But it is true that some people, when they look at this painting, are concerned with some of its many aspects that I have mentioned, while other people concern themselves with other of its aspects. And it is true, certainly, that all of these aspects of the painting are attended to at one time or another, and occasionally even all by one very unordinary person at one time.) Fifthly, this work is a representational painting with a definite subject matter; it depicts a certain mythological scene. Sixthly, the painting has an elaborate and certainly complex formal structure. Finally, the painting is a good painting. And this is to say simply that the Poussin painting is worth contemplating, studying, and observing in the way I have ever so roughly described.

It must be clear that whether the Poussin painting does or does not in fact fit the description that I have given is totally irrelevant to what I am saying. For example, it is at least within the nebulous realm of possibility that I am much mistaken in saying it is a good painting. It is even more than merely possible that I have been misinformed about Poussin's intentions. And maybe I have made other mistakes as well. But whether this is so or not does not in the least matter, for I am not trying to show that the Poussin painting is in fact a work of art. Rather I am trying to clarify what may be meant by saying that the Poussin painting is a work of art. What is important here is this: Because I believe the Poussin painting does fit the description I have given, I believe that it is, and I have chosen it as, one of the clearest available cases of a work of art. Our concern here is only with the description and not with whether the description fits the particular case. Each of the various facts mentioned in the foregoing description are characteristic of a work of art; it is these characteristics that concern us.

In order to make clear what the difficulties are in formulating and

justifying a definition of a work of art, in the following section I shall present what I take to be an adequate definition based on the preceding account of the Poussin painting. However, I shall not here attempt to show that the definition is in fact adequate.

II

All of the characteristics mentioned in the preceding description of the Poussin painting together constitute a set of characteristics. Several characteristics taken together constitute a set of characteristics if and only if all of the characteristics mentioned are relevant in determining whether something is or is not a work of art and if they are the only characteristics that are so relevant. Anything possessing all of these characteristics can then be said to be a characteristic case. Consequently, if the Poussin painting does in fact fit the description given above, it is such a characteristic case.

The set of characteristics given provides us with a set of sufficient conditions for something's being a work of art. Anything clearly satisfying these conditions can be said to be a work of art in exactly the same sense of the phrase "work of art" in which the Poussin painting can be said to be a work of art. It is important to notice that I said "clearly satisfying these conditions." The word "clearly" is crucial here. There is a temptation to say that the preceding description of the Poussin painting provides nothing more than a rough schema of what could be said about the work. This is not quite true, but it is a way of emphasizing the truth that there is a great deal of latitude in the various details of the description given. For example, one of the facts mentioned about the Poussin painting was that it is a representational work. Suppose we now consider a statue of Praxiteles: are we to say that it is representational? Someone might say that a statue cannot be representational in quite the same sense in which a painting can be. On the other hand, it could be claimed that both a statue and a painting can be said to be representational, in the very same sense of the word, but that they are merely different species of representative works. Again, someone might say that a sculptor does not make a statue in quite the same sense in which a painter makes his painting. And again it could be said that there is no difference in sense but only a difference in species. And this kind of question can be raised in connection with each of the characteristics mentioned.

I take it that we are inclined to speak of a difference in sense when we are impressed by, or wish to stress, dissimilarities. But when we are impressed by, or wish to stress, similarities, we are then inclined to speak of a mere difference in species. Now by speaking of a case that "clearly" satisfies the conditions given above, I mean to refer to a case in which there is no inclination to speak of a shift in sense with respect

to any of the characteristics listed. Unless this point is attended to, it might mistakenly seem that we do not have a set of sufficient conditions, for one can conjure up some curious cases.

Suppose an object were found, satisfying the conditions given above, but with this one eccentricity: the scene depicted, and consequently the formal structure as well, changed periodically, without being changed. Imagine an object fitting the description, but having the peculiarity that, without being moved, it moved occasionally about the room. Thus in a way these odd objects behave somewhat like living organisms. One could be somewhat reluctant to call these things works of art. It would indeed be difficult to know what to say. Shall we say that our set of characteristics does not, therefore, provide a set of sufficient conditions? For we have not mentioned the fact that the object is a stable object, that it does not change or move about periodically of its own accord. This would be a mistake. We should be uncertain whether these odd objects were works of art solely because we should be uncertain whether they did in fact fit the description which we have given. It would be queer to say of an object that it was a painting and that it periodically moved about the room of its own accord. It would be equally queer to say of an object that it was a painting depicting a certain scene and that the scene periodically changed of its own accord. For facts like these cast doubt on whether the object is a painting in the sense of the word "painting" originally intended, and on whether the painting depicts a scene in the sense of the phrase "depicts a scene" originally intended. But if an object does clearly satisfy the conditions stated, there can be no doubt but that it can be said to be a work of art in the very same sense of the phrase "work of art" in which the Poussin painting can be said to be a work of art.

Although the above set of characteristics provides a set of sufficient conditions, it does not provide a set of necessary and sufficient conditions. No one of the characteristics listed is necessarily a characteristic of a work of art. But a definition in terms of necessary and sufficient conditions is merely one kind of definition, one way of describing the use of a word or phrase. Another kind of definition, and the kind we are here concerned with, is one in terms of various subsets of a set of characteristics, or, in less exotic language, in terms of similarities to what I have called a characteristic case, a case in which an entire set of characteristics is exemplified.[1] The following examples should serve to clarify what is meant by speaking of similarities to a characteristic case.

Suppose we have a naturally formed stone object that has the shape

[1] Let me note that I am deeply indebted to Professor Max Black, both through his published papers and from discussions with him, for many of the ideas in this paper. In particular, I have, I trust, here profited from his account of a definition in terms of overlapping and interacting criteria: cf. "The Definition of Scientific Method," *Science and Civilization*, ed. by R. C. Stauffer (Madison, University of Wisconsin Press, 1949).

of a woman reclining. Indeed, it looks as though some sculptor has fashioned it, though we know that this is not the case. What is more, it is worth contemplating, studying, and observing in a way analogous to the way described in connection with the Poussin painting. Further suppose that people do in fact contemplate, study, and observe it, that it is displayed in a museum, and so forth. In virtue of its similarities to the characteristic case, this object can be said to be a work of art. The points of similarity between this object and the Poussin painting constitute a particular subset of the set of characteristics listed above. Imagine this sort of case: we have a nonrepresentational painting, deliberately made by an artist, who intended it to be exhibited and displayed, and who wanted people to contemplate, study, and observe it. But in fact the painting is not worth contemplating, studying, and observing. What is more, no one does bother with it all. It is not exhibited, displayed, and so forth; rather it is buried away in some cellar. This too, in virtue of its similarities to the characteristic case, can be said to be a work of art. Again, the points of similarity between this work and the characteristic case constitute another subset of the set of characteristics given above.

In each of the preceding examples, when it was said that the object was a work of art in virtue of its similarities to the characteristic case, it was implicitly assumed that the similarities noted were sufficient to warrant the claim that the objects were works of art. No rule can be given to determine what is or is not a sufficient degree of similarity to warrant such a claim. If for one reason or another the dissimilarities become impressive (and what impresses one need not impress another), one is then reluctant to call the object a work of art. For example, a Greek vase is, in many ways, similar to a New England bean pot. Both are artifacts; both were made to serve domestic purposes; neither was intended to stand in a museum; and so forth. Nonetheless, a Greek vase is a work of art while a New England bean pot is not. To see that this is so, consider those points of similarity between a Greek vase and the Poussin painting that are also points of dissimilarity between a Greek vase and a New England bean pot. We do not, in fact, treat a New England bean pot in a way similar to the way we treat the Poussin painting; whereas we do, in fact, treat a Greek vase in a way quite similar to the way we treat the Poussin painting. We set up Greek vases on pedestals; we do display and exhibit them in museums and galleries, and what is more, it is worth while to do so. We do not in fact contemplate, study, observe, admire, criticize, and discuss bean pots in a way that we do Greek vases or in the way that we do the Poussin painting; furthermore, it seems most unlikely that it would be worth while to do so. Unlike bean pots, and like the Poussin painting, many Greek vases are representational. One is inclined to speak, and one does speak, of the formal structure of a Greek vase in a way similar to the way one speaks of the formal structure of the Poussin painting. We do not, in fact, speak

of the formal structure of a bean pot, nor is there usually any inclination to do so. Now if one starts, as it were, from the Poussin painting and then shifts to the Greek vase, one begins to feel the strain. For a Greek vase was not (or so we are supposing) intended to be treated in a way similar to the way the Poussin painting is treated. It was designed to fulfill a specific utilitarian function. Many Greek vases are not representational. They were not, in the time of the Greeks (or so we are supposing), set up on pedestals. They were not displayed and exhibited in museums and galleries. They were not contemplated, studied, observed, admired, criticized, and discussed in a way similar to the way in which the Poussin painting is. One begins to feel the strain in speaking of a Greek vase as a work of art. Now if one tries to speak of a bean pot as a work of art, the strain becomes too great. We have reached a breaking point, and one is inclined to say things like, "A bean pot *cannot* be classed as a work of art." It is only a matter of degree.

Finally, neither a poem, nor a novel, nor a musical composition can be said to be a work of art in the same sense of the phrase in which a painting or a statue or a vase can be said to be a work of art. For such things as poems, novels, musical compositions, possess none of the characteristics listed in our set of characteristics. E.g., a poem is not exhibited or displayed; one does not contemplate, study, and observe a poem; a poem is not representational; and so forth. And even though a poem may seem to possess some of the characteristics listed, for one can and does speak of a good poem, the dissimilarities between what is meant in speaking of a good poem and what is meant in speaking of a good painting are sufficiently impressive to warrant our saying it is a different sense of the word "good." All of this, however, does not show that one cannot reasonably use the phrase "work of art" to refer to poems, novels, musical compositions, as well as to paintings. If one wished to describe a use of the phrase "work of art" in which there is such a systematic shift in sense, one could do so in terms of several sets of characteristics. One would take a clear-cut case of a poem and obtain a set of characteristics, then a clear-cut case of a novel and obtain another set, and so forth. Then something would be a work of art, in this use of the phrase, if it possessed some subset of the set of characteristics pertaining to paintings, or some subset of the set of characteristics pertaining to poems, and so forth. This may seem an extremely complex way of using the phrase "work of art," but it is actually often used in somewhat this way by critics who speak of the "art of painting," the "art of poetry," and so forth. Such a "blanket" use of the phrase may be warranted by the fact, if it is a fact, that each set of characteristics is analogous in composition to every other set; e.g., the analogue of contemplating a painting is reading a poem, the analogue of a good painting is a good poem, the analogue of display is publish, and so forth.

There is no need to elaborate this definition any further for the pur-

poses of this discussion. The preceding account is sufficiently explicit to stir up and bring to the surface all the important difficulties that must be noted here.

III

The definition just given provides a rough description of only one use of the phrase "work of art." But this phrase is and has been used in many ways. So long as art remains what it has always been, something changing and varied, so long as there are artistic revolutions, the phrase "work of art," or some equivalent locution, will continue to be used in many ways. For when such revolutions occur, there is inevitably a shift in some uses of the phrase "work of art." Some understanding of the nature of the disputes that occur over what is and what is not a work of art during such periods of artistic revolution is essential to an understanding of what an aesthetician is doing in offering some one, and only one, definition of a work of art.

When nonrepresentational and abstract painting first attracted attention in the early part of this century, many people complained bitterly that the nonrepresentational and abstract works were not works of art. Thus one critic wrote: "The farce will end when people look at Post-Impressionist pictures as Mr. Sargent looked at those shown in London, 'absolutely skeptical as to their having any claim whatever to being works of art.' "[2] Other critics insisted, with equal vehemence, that the Post-Impressionist paintings most certainly were works of art. If one looks with an impartial eye at these disputes between the traditional and the modern critics, one thing is quite clear. In many cases the parties to the disputes were using the phrase "work of art" in more or less different ways. Indeed, the modern critics, the defenders of the new works, were introducing a more or less novel use of the phrase. To see that this is so, it is necessary to attend to some of the typical complaints that were voiced against modern art by the traditional critics.

In a review of the first exhibition of modern art in America, Mr. Kenyon Cox claimed that

the real meaning of this Cubist movement is nothing else than the total destruction of the art of painting—that art of which the dictionary definition is "the art of representing, by means of figures and colors applied on a surface, objects presented to the eye or to the imagination." . . . Now the total destruction of painting as a representative art is a thing which a lover of painting could hardly envisage with entire equanimity, yet one may admit that such a thing might take place and yet an art remain that should have its own value. A Turkish rug or a tile from the Alhambra is nearly without representative purpose, but it has intrinsic beauty and some conceivable use. The important question is what it is proposed to substitute for this art of painting which the world has cherished since there were men definitely differ-

[2] Royal Cortissoz, "The Post-Impressionist Illusion," *Three Papers on "Modernist Art,"* (New York, Amer. Acad. of Arts and Letters, 1924), p. 42. Reprinted from *Century Magazine*, April, 1913.

entiated from beasts. Having abolished the representation of nature and all forms of recognized and traditional decoration; what will the "modernists" give us instead?[3]

It is often erroneously supposed that traditional critics held representation to be a necessary characteristic of a work of art. This is not true. Such critics did maintain that it was a relevant characteristic, but few insisted it was necessary in that without representation there could be no work of art. What is true is that traditional critics weighted this characteristic enormously, so that it was of paramount importance in determining whether a given work was or was not a work of art. In their reaction against this view, some of the modern critics have apparently gone to the extreme of suggesting that representation is wholly irrelevant to art.[4] In this respect, our definition would be apt to satisfy neither a conservative traditional critic nor an extreme modern critic. The shift in the notion of a work of art that was brought about through the modern developments was, with respect to the question of representation, primarily a shift in emphasis, and only secondarily a shift with respect to necessary conditions. The point is that representation was of paramount importance in virtue of the fact that "accurate" representation played the role of a necessary condition in determining what was and what was not a good painting. This leads us to another point of difference between the traditional and modern critics.

I am inclined to suppose both traditional and modern critics would accept the seventh characteristic listed in our definition, viz., that the work be a good one, as a relevant characteristic of a work of art. (Whether they considered it to be a necessary characteristic is a difficult question that need not concern us here.) But it is fairly obvious that what the traditional critics meant in speaking of a good painting or a good drawing was somewhat different from what the modern critics meant. For example, Mr. Royal Cortissoz, in reviewing the first exhibition of modern art in America, severely criticized Van Gogh's drawing.

The laws of perspective are strained. Landscape and other natural forms are set awry. So simple an object as a jug containing some flowers is drawn with the uncouthness of the immature, even childish, executant. From the point of view of the Post-Impressionist prophet, all this may be referred to inventive genius beating out a new artistic language. I submit that it is explained rather by incompetence suffused with egotism.[5]

Somewhat later in his review, while discussing Matisse's drawing, Mr. Cortissoz stated that

whatever his ability may be, it is swamped in the contortions of his misshapen figures. The fact is that real genius in these matters will out. Degas, who has been all his life a disciple of Ingres, uses a magic of draftmanship akin to that of his idol, though the style and spirit of his work are wholly his own.[6]

[3] "The 'Modern' Spirit in Art," *op. cit.*, pp. 6–8. Reprinted from *Harper's Weekly*, March 15, 1913.
[4] Cf. Clive Bell, *Art*, pp. 28–30, where such a view is, or seems to be, suggested.
[5] *Op. cit.*, p. 31.
[6] *Ibid.*, pp. 36–37.

It is, I take it, fairly clear that Mr. Cortissoz' notion of a good drawing, of a good painting, would today be objected to. For he, together with most traditional critics, apparently held that a necessary condition (though not, of course, a sufficient condition as is sometimes naïvely supposed) for a drawing to be considered a good drawing is that the perspective be "true," the form "realistic," and so forth. Few if any critics today would subscribe to this view.

Perhaps the clearest indication of the fact that the modern critics were using the phrase "work of art" in a more or less novel way is to be found in the oft-repeated charge that the new works had broken with tradition. For in claiming that there had been such a break, the traditional critics can be taken as claiming that the degree of similarity between the new works and those accepted in the tradition as works of art was insufficient to warrant the claim that the new works were works of art. The dissimilarities were felt to be overwhelming; the gap was held to be too great to bridge. The modern critics, of course, denied that there had been any such rupture, at least not with the tradition as they saw it; rather they insisted that tradition had been reasonably extended and developed. They repudiated the charge of a complete break by exhuming and pointing to the works of such people as El Greco to justify the modern use of distortion, just as somewhat later the Surrealists were to exhume the works of Acrimboldo and Bosch in an effort to make their own fantasies more palatable to the public. It is for this reason, among others, that the works of Matisse have so often been compared with Egyptian portraits, Japanese prints, and so forth, while the similarities between Picasso's work and practically everything in any tradition have been set forth exhaustively. Whether modern art did in fact break with European tradition is not a point that need concern us. But the fact that the tradition was at least extended cannot be denied and is here relevant. For this is merely another way of saying that there was some shift in the notion of a work of art. Let it be quite clear that I am not claiming to have here *shown* that the modern critics were introducing a somewhat novel use of the phrase "work of art." To show that such was the case, it would be necessary to present a great deal more evidence than I have done. But everything about the disputes between the traditional and the modern critics certainly suggests that the modern critics were in fact using the phrase "work of art" in a somewhat novel way. And if the likelihood of this is granted, that is sufficient for the purposes of this discussion.

Once it is realized that the modern critics were most likely using the phrase "work of art" in a somewhat novel way, there is, or is apt to be, a temptation to say that the disputes between the traditional and the modern critics were merely verbal. For one may be inclined to say that in a modern critic's use of the phrase, the new works were in fact works of art, while in a traditional critic's use, they were not. But this is a temptation which we must certainly resist. Even though it may be true

that the new works of art in a modern critic's use of the phrase, and were not works of art in a traditional critic's use, it would be quite absurd to think that, therefore, the disputes were merely verbal. The disputes, in part, arose from conflicting decisions over the way to use the phrase "work of art," but such decisions were not and certainly need not be thought arbitrary. Decisions may not be true or false, but they can be reasonable or unreasonable, wise or unwise. In effect, the traditional critics maintained that their decision to use the phrase "work of art" in a traditional way was the most reasonable one, and consequently their use of the phrase was the most reasonable use; the modern critics made exactly the same claim in favor of their own somewhat radical use of the phrase. Sometimes these claims were made explicitly; at other times, such a claim is implicit in the criticism, favorable or unfavorable, given to the new works. To understand what is involved in such a claim and what is meant by speaking of a "reasonable use" of a word or phrase, it is necessary to see why it may be important to use a word or phrase in one way rather than another, and what there is that may be worth arguing about.

IV

There is no sense in speaking of a "reasonable use" of a word or phrase *in vacuo*. What is or is not a reasonable use depends on the particular context in which the question is raised, on the kind of considerations involved, and so forth. For example, if you want to be understood, you are well advised to use your words in some ordinary and familiar way; but if being understood is not at issue, this advice is not to the point. Not being understood may be one consequence of using a word or phrase in a particular way, but there may be other consequences, and consequences of a different kind. For example, it is, I suppose, no part of the meaning or the use of the phrase "excessive speed" that if a driver of a vehicle involved in an accident is held to have been driving at an excessive speed, he is likely to suffer certain penalties under the law. But even though this may be said to be no part of the use of the phrase, it is nevertheless an important fact which a jurist must keep in mind when attempting to specify the use of the phrase in a court of law. It would be unwise, for example, to lay down a ruling that would constitute a precedent for taking excessive speed to be any speed over posted limits. For a man may drive at a speed greater than the posted limit in an attempt to avoid an impending accident. It would be unreasonable to penalize him for making the attempt if it happened that even so he was unable to avoid the accident.

What I am saying is that once the legal consequences and implications of declaring a person to have been driving at an excessive speed are relatively fixed, we can then, in the light of these consequences and on the basis of certain moral and legal notions concerning the purposes to be accomplished by means of these consequences, say what is or is not

a reasonable definition and a reasonable use of the phrase "excessive speed" in a court of law. (One can, of course, reverse this process and argue that once the notion of excessive speed is fairly well fixed in the sense indicated above, it is unreasonable to penalize a man merely for driving at an excessive speed. Thus someone could argue that his use of the phrase in the sense indicated above was reasonable, the consequences that are likely to occur in the course of using the phrase unreasonable. In a sense, the use of the phrase and the significant legal consequences likely to occur in the course of using the phrase each provide a standpoint for criticism. We can criticize either the use of the phrase in terms of the fairly fixed legal consequences or the legal consequences in terms of the fairly fixed use.)

To ask "What are the consequences and implications of something's being considered a work of art?" is to ask an equivocal question to which there can be no univocal answer. We must first know in what context we are to suppose the phrase "work of art" is being used. (Just so one can speak of the consequences of using the phrase "excessive speed" in one way or another only when the context is specified. In a court of law the use of such a phrase may have significant consequences which, in some other context, simply are not forthcoming.) In the context where critical disputes are carried on, there are in fact many significant consequences arising from the fact that a certain type of work is considered a work of art. For disputes between critics are not private affairs. They are carried on in a social context, and they are significant only when set in the framework provided by such a context.

It is, I suppose, no part of the meaning or the use of the phrase "work of art" that if a certain type of work is considered a work of art, works of this type will eventually find their way into a public museum. Nonetheless, public funds will, in fact, be spent on these works. The public will be advised to see and study such works. Books will be written and read about them, and so on. These are in fact some of the present characteristic social consequences of something's being considered a work of art in Western society. The social consequences and implications of something's being considered a work of art have varied in time, and no doubt they will continue to do so. For they are merely an aspect of the particular role art plays in a particular society, and as the character of the society changes, the role of art in the society may also change, together with the characteristic social consequences and implications of something's being considered a work of art in that society. Now although the traditional and the modern critics almost certainly disagreed about the specific characteristics of a work of art, they agreed both in their desires and in their expectations with regard to the characteristic social consequences and implications of something's being considered a work of art. Their agreement in this respect lent substance to their disputes over the use of the phrase "work of art." Indeed, the traditional critics

explicitly and with great vehemence maintained that the Post-Impressionist works ought not to be placed in museums; that the public funds ought not to be spent on them; that the public would be ill-advised to spend its time looking at them or reading books about them; and so forth. All of this the modern critics explicitly and emphatically denied. (And this is one obvious reason why it would be quite absurd to call such disputes merely verbal.) Now to determine whether a certain type of work ought or ought not to be placed in a museum, purchased with public funds, and so on, it is necessary to consider what purposes it is to serve when once it has been purchased, when public funds have been spent on it, and so on. And this is to say that in order to determine what is or is not a reasonable use of the phrase "work of art," it is necessary to consider not only the characteristic social consequences and implications of something's being considered a work of art, but also the purposes to be accomplished by means of these consequences—i.e., the various functions of a work of art in society. The role that the functions of a work of art play in determining whether a particular use of the phrase "work of art" is reasonable or not, may be clarified by the following example.

Consider the second characteristic mentioned in our definition of a work of art, viz., that the work be made, deliberately and self-consciously with obvious skill and care, by some person. The traditional view would be that this is a necessary characteristic of a work of art. E.g., in *Art as Experience*, Dewey writes:

Suppose, for the sake of illustration, that a finely wrought object, one whose texture and proportions are highly pleasing in perception, has been believed to be a product of some primitive people. Then there is discovered evidence that proves it to be an accidental natural product. As an external thing, it is now precisely what it was before. Yet at once it ceases to be a work of art and becomes a natural "curiosity." It now belongs in a museum of natural history, not in a museum of art.[7]

I am very much inclined to object to Dewey's use of the phrase "work of art," but it is most unlikely that such an objection can be made directly on the grounds that his use of the phrase is unreasonable. To see why this is so, it is necessary to see precisely what is at issue here. This may appear to be a relatively trivial point, one hardly worth disputing over; for there may in fact be fairly few natural objects that one is inclined to exhibit and display. What is and what is not excluded from a museum is in this case, however, of only secondary importance. The exclusion of a natural object from a museum of art is primarily of interest when viewed as symptomatic of a particular orientation toward the works that are in fact displayed in a museum. If one adopts a view similar to that of Dewey, there is a tendency to treat the work of art primarily as a "manifestation" of the artistic activity engaged in by the person who produced the object. One is then tempted to look through the work of art to the artist's "experi-

[7] Page 48.

ences," "feelings," and so forth. Furthermore, one is tempted to say that this "revealing" aspect of the work is essential to its functions as a work of art. Now the relevance of the artist's "experiences" to an appreciation of the work is an extremely complex problem which I shall not even attempt to consider here. But I mention these points in order to stress the fact that such considerations as these are relevant in attempting to determine whether the fact that the object was made by a person is or is not a necessary condition for its being a work of art. To claim that Dewey's traditional use of the phrase "work of art" is unreasonable would, in effect, be to claim that the mere fact that an object is an artifact does not suffice to show that it is thereby incapable of satisfactorily fulfilling the various functions of a work of art. But since such a claim would be made on the basis of a particular view of these functions, Dewey's use of the phrase ought properly to be considered in relation to his own view of what these functions are or ought to be.

There is no doubt but that the explicit disagreements between the traditional and the modern critics stemmed from more or less divergent conceptions of what the functions of a work of art are or ought to be in our society. In writing of the first exhibition of Post-Impressionist works in England, Roger Fry pointed out that the new movement in art "implied a reconsideration of the very purpose and aim as well as methods of pictorial and plastic art."[8] He characterized the purpose of the new art by saying it was devoted to "the direct expression of feeling" and to the making of "images which by the clearness of their logical structure, and by their closely knit unity of texture, shall appeal to our disinterested and contemplative imagination with something of the same vividness as the things of actual life appeal to our practical activities."[9]

What Mr. Fry says here is, of course, quite vague, but he was dealing with an extraordinarily difficult topic. Vague or not, he is quite right in suggesting that modern works serve somewhat different purposes from the accepted works that had preceded them, no matter how difficult it may be to say precisely wherein the difference lies. To consider but one aspect of this enormously complicated question, a traditional view of a function of a work of art was that it was to constitute an object of Beauty, which would inspire, profit, and delight the beholder. Now "Beauty" is not a term likely to be applied to a host of modern works, e.g., to one like Picasso's "Guernica." "Guernica" is no doubt a magnificent, powerful, superbly conceived and executed work, but it is not a thing of "Beauty." It is true that there are many paintings in European tradition to which one would be equally reluctant to apply the term "Beauty," e.g., Grünewald's "Crucifixion" in the Isenheim altarpiece, but it is also true that the obvious religious purpose of the Isenheim altarpiece is something more or less alien to modern art. That modern works do in fact serve somewhat different purposes from the accepted works that had preceded them is perhaps best

[8] *Vision and Design* (Pelican Books, 1937), p. 194.
[9] *Ibid.*, p. 195.

signalized by the technical innovations introduced and employed by the modern artists. The extent of these innovations must not be underestimated.

It is true that the modern use of distortion has its analogue in El Greco's work among others, but it is also true that El Greco's work was practically ignored until the twentieth century. And of course even his work appears naturalistic in contrast with a work like "Les Demoiselles d'Avignon." To feel the full impact of the modern innovations in the use of color, it is merely necessary to see a work by Miro hung in a gallery alongside works done before 1850. Again one may admit that e.g., Poussin employed intense hues, and Giotto's work must have been quite brilliant at one time; but it is impossible to ignore the fact that many modern painters such as Miro and Matisse employ huge flat masses of color in an altogether new way, a way that is simply incompatible with and wholly alien to the spatial character of a Poussin painting. These and many other such technical innovations all herald the fact that modern paintings are devoted to somewhat different purposes and aims from those of the works that had preceded them. For the widespread adoption of new methods of working in art has, in fact, always been correlative to a more or less radical variation in the purposes and aims of art. (Just so the technical innovations of the monodic revolution in music at the beginning of the seventeenth century, the development of the so-called *stile moderno* or *seconda prattica* with its use of the thorough bass, the introduction of the recitative, and so forth, were the technical correlates of the development of secular music. Indeed, in the eyes of the modern critics of the period, the *stile antico* was seen as the sacred style appropriate to church music.)

Whether the traditional critics' disapproval of the purposes and aims of the new works stemmed from a failure to understand fully what these purposes and aims were, or whether this disapproval was based on a full understanding, is a purely historical question that need not concern us here. That they did disapprove is beyond question, for they voiced this disapproval in no uncertain terms; e.g., in concluding his review of the first exhibition of modern art in America, Mr. Cox adjured his readers to remember that

it is for you that art is created, and judge honestly for yourselves whether this which calls itself art is useful to you or to the world. You are not infallible, but, in the main, your instincts are right, and, after all, you are the final judges. If your stomach revolts against this rubbish it is because it is not fit for human food.[10]

Most aestheticians today, I believe, would say the modern critics were right in contending that the Post-Impressionist paintings were works of art. Indeed, few people now dare to question the status of modern art as art, and those who do are at once labeled "Philistines" and "reactionaries." But if we say the modern critics were right—and I do not presume to question the matter here—if we say their decision to use the phrase

[10] *Op. cit.*, p. 18.

"work of art" in a somewhat new way was a wise one and their use of the phrase was the most reasonable, we must not rashly assume that the traditional critics' use of the phrase "work of art" could be held to be unreasonable when examined on the basis of the traditional critics' own view of what the functions, purposes, and aims of a work of art are or ought to be. On the contrary, it is most likely that when so considered, their use of the phrase would prove to be quite reasonable. Thus an objection to their use of the phrase would most likely have to be made, and no doubt could be made, in terms of a prior objection to their view of what the functions of a work of art are or ought to be. (For one can reasonably dispute over the question of what the functions of a work of art are or ought to be just as one can reasonably dispute over what is or is not a reasonable use of the phrase "work of art.") In accepting the modern critics' decision, we are, in effect, accepting something of their view of what the present functions, purposes, and aims of a work of art are or ought to be in our society.

What then is an aesthetician doing when he offers some one and only one definition of a work of art? It should be clear that he is not describing the actual use of the phrase. As I have tried to indicate above, this phrase is and has been used in many ways. No one definition can mirror this manifold and varying usage. Instead, an aesthetician is describing one, perhaps new, use of the phrase "work of art," which he either implicitly or explicitly claims to be the most reasonable use of the phrase in the light of the characteristic social consequences and implications of something's being considered a work of art, and on the basis of what the functions, purposes, and aims of a work of art are or ought to be in our society. What these purposes and aims are or ought to be is a matter of here and now. For as the character of society changes, as new methods of working are developed, these purposes and aims will also change. With the development of new means there will be new ends that can be served, and with the appearance of new ends, new means will have to be developed to serve them. Art neither repeats itself nor stands still; it cannot if it is to remain art. An attempt to provide a definition and a justification of a work of art is, as Collingwood has stated, not "an attempt to investigate and expound eternal verities concerning the nature of an eternal object called Art"; rather it is an attempt to provide "the solution of certain problems arising out of the situation in which artists find themselves here and now."[11] An aesthetician is not and certainly ought not to be expected to be a seer foreseeing the future of art. He is not an oracle, though he may choose to speak like one. As new and different kinds of works are created, as the character of society changes and the role of art in society varies, as it has so often done throughout history, it may and most likely will be necessary to revise our definition of a work of art.

[11] *The Principles of Art*, p. vi.

MORRIS WEITZ

THE ORGANIC THEORY

Morris Weitz is Professor of Philosophy at Ohio State University.

ANALYSIS OF THE FORM-CONTENT DISTINCTION

. . . I should like to propose an empirical theory of art that will resolve the basic issues between formalism and its critics. A number of analyses are required. Let us begin with the analysis of a distinction that, I think, is responsible for more of the difficulties in contemporary aesthetic thought than any other—the form–content distinction.

Now, in order to understand the significance of this distinction in aesthetic (and critical) theory, it may be well to consider the various ways in which the distinction appears in ordinary, common-sense language and in technical logical analysis.

Common sense, to begin with, regards form as a synonym of shape,

Reprinted by permission of the publishers from Morris Weitz, *Philosophy of the Arts*, pp. 35–63, Cambridge, Mass.: Harvard University Press, Copyright, 1950, by the President and Fellows of Harvard College.

and content as synonymous with matter in much of its talk. We say, for example, that two pennies, one copper, the other lead, have the same form, meaning shape, and different content, meaning matter. Or we say of two pieces of silver jewelry, where one is round and the other square, that they differ in form but not in content. Or, if we are in the presence of two round tables, one of which is made of oak, the other mahogany, we may remark that whereas they have the same shape, meaning form, they differ in their matter, meaning content.

But this is not the only way in which common sense distinguishes between form and content. It also employs form as a synonym of appearance, as when it says of a dilapidated house, for example, that its outward form or appearance is ugly.

Further, the distinction manifests itself in ordinary speech in the distinction between the "what" as against the "how" of certain complexes or states of affairs. Consider the presence of four children's playing blocks, called *A*, *B*, *C*, and *D*. These blocks may be arranged in many different ways, as *BACD* or *ACDB*, and so on. In this situation, we could say that the blocks, the "what" of the complex, are the content, and the serial order arrangement, the "how" of the complex, is the form.

The "what–how" usage, however, usually occurs in the distinction between certain elements and the organization of them. Consider the statement of the four freedoms of the Atlantic Charter. The four sentences of the total statement, complete with their meanings, we call the content, the elements, of the total statement. We further recognize that these elements, these individual sentences, the content, can be arranged or organized in different ways. That is, in one case we may write the sentence about freedom of religion above the sentence about freedom from fear; or we may reverse that order and get a new organization of elements. In these two cases the organization of, the relations between, the elements differ; but the elements—the individual sentences—remain the same. The form changes while the content is constant.

Serial order, however, is not always present in the "how–what" variety of the form—content distinction. Consider the message, "Come home!" We may write it, wire it, telephone it, yell it, or gesture it. Here the content remains the same throughout the different modes of expressing it. The form usage in this example is not rooted in "how" as serial order but "how" as the *way* in which something is said, the mode of expression, the medium.

Common sense also means by form in some of its linguistic usages class, kind, or species; and in this context it means by content the members of the class. We say, for example, that England and America have the same kind or form of government; or that the dance and music as art forms are similar; or that the movies are a form of escape; or that Russia is a form of totalitarianism. Now, in all of these cases, England, America,

the dance, music, the movies, and Russia are members of certain classes, the content of certain forms.

The final way that we shall consider in which common sense uses the form–content distinction is in its distinction between abstract pattern and the completion of the pattern. All magazines have in their pages at various times what they call "subscription forms." These are patterns, partly blank, partly filled in. In its original state, each of these has form but no content. It is a variable; we say in logic, a propositional function. When we fill it in, i.e., give values to its variables, we give a content to it; and we may then say it has both a form and a content.

Contemporary logical theory has itself contributed much toward the understanding of the form–content distinction, even as it obtains in aesthetic and critical usage. Bertrand Russell has dealt extensively with the concept of logical form and has elucidated its fundamental meaning. The best way to define form, he declares, is in terms of propositions.

> In every proposition . . . there is, besides the particular subject matter concerned, a certain *form*, a way in which the constituents of the proposition . . . are put together. If I say, "Socrates is mortal," "Jones is angry," "The sun is hot," there is something in common in these three cases, something indicated by the word "is." What is in common is the *form* of the proposition, not an actual constituent.[1]

From any of these propositions we can derive the others, by a process of substitution; and that which remains unchanged when we replace constituents and get different propositions is the form of these propositions. Form is thus the variable invariant of a number of specific propositions. And the content may be designated as the specific values of any of these propositions. The form of the above propositions is subject–predicate, which mathematical logic symbolizes by Px, where P stands for the predicate and x for the subject. From the variable function Px we can derive, by substituting subject values like "Socrates" or "Jones" or "the sun" and predicate values like "hot" or "angry" or "mortal," the propositions, "Socrates is mortal," "Jones is angry" and "The sun is hot."

Besides the variable function Px there are *relational* variable functions; e.g., aRb or $aRbc$, which are the forms of numerous dyadically and triadically relational propositions like "Socrates loves Plato" or "Mary hates John" and "John gives Joan a book." Mathematical logicians have enumerated others of these logical forms which can be abstracted from our language and actual states of affairs; these include molecular, existential, general, and completely general forms. However, detailed considerations of these belong to more technical discussions in mathematical logic and are not relevant to this aesthetic context.

We may now consider the form–content distinction in contemporary aesthetic theory. In the first place, the common-sense usage of form as

[1] Bertrand Russell, *Our Knowledge of the External World*, p. 45.

shape appears in concrete discussions of the arts. Many aestheticians and artists use shape as a synonym of form. Henry Moore and Alexander Calder, for example, talk about certain natural and human forms.

It is difficult to understand the meaning of content in this linguistic context. Presumably, it has both a narrow and an extended meaning. Narrowly, it refers to *what* is shaped, be it the representation of a man, a horse, or a tree. But in its more extended reference, it denotes the entire work, in which case the forms comprise only part of the total content. Consequently, on this first extended adaptation of the form–content distinction, content and form are not taken as coördinate values of the work of art, but as its genus and species.

Aestheticians (including artists and critics) also mean by form and content the "how" as against the "what" of a work of art. And, so far as I can determine, this usage has at least three distinct variations.

(1) The what of a work of art is its theme, "what it is about," the subject, the "Idea"; and the how is the way in which the Idea or theme is expressed. Artist-critics like A. E. Housman and aestheticians like C. J. Ducasse sometimes talk this way.

In this linguistic context, the content is but one element in the work of art, *the most abstract;* and the form becomes everything else: the lines, colors, even the specific representations of people and events! For example, consider two famous "Crucifixions," one by El Greco, the other by Grünewald. One could say, and quite in keeping with aesthetic usage, that the content of both pictures is similar, namely, the crucifixion, which is the theme of both paintings, "what they are about"; and that the form, which is the manner in which the crucifixion is exhibited, is very different because of the colors, the design, *and* the representations near Christ—in the El Greco, the Virgin weeping on the right of Jesus, with no one on His left; and in the Grünewald, the Virgin again on the right of Jesus, but with John the Baptist on His left, pointing his finger at Him.

The form here includes not only the specific individuals represented, but also all the emotions associated with them. Furthermore, on this view, the content may be said to be repeatable from picture to picture, so that all the "Crucifixions" that there are could be said to have the same content. Also, in this context, aesthetic formalism is the doctrine that it is *how* something is said, not *what* is said, that is all-important.

(2) The what, or content, of a work of art is its terms or elements, which may include dramatic entities like people as well as colors, lines, or shapes, tones, etc., in the case of the arts other than painting; and the how, or form, is all the relations—spatial, temporal, or causal—among the elements.

This usage, I suppose, is the most generally accepted one in contemporary aesthetic analysis and corresponds pretty much to the way in which form and content are mostly used in ordinary linguistic contexts. Content is the terms; form, the organization of them.

In present aesthetic theory Ducasse, although he is diversified and even ambiguous in his usage, is the champion of this interpretation of the distinction. "By form is meant simply *arrangement* or order; and by content . . . whatever it happens to be that is arranged, ordered."[2]

Formalism, in this usage, is the view that in art only the relations are important, not the terms related. Such a theory was held by Herbart and Zimmermann.

(3) The what, or content, is the Idea or theme; and the how, or form, is the medium in which it is presented. Hanslick offers us an excellent example of this usage. He is arguing that in music there is no distinction between form and content which, he continues,

presents a sharp contrast to poetry, painting, and sculpture, inasmuch as these arts are capable of representing the same idea and the same event in different forms. The story of William Tell supplied to Florian the subject for a historical novel, to Schiller the subject for a play, while Goethe began to treat it as an epic poem. The substance [content] is everywhere the same . . . and yet the form differs in each case.[3]

A third way in which discussions of the arts employ the distinction between form and content is similar to species (2) of the second, except that it is more specific and normative. The content of the work of art is regarded as the elements and the form as a certain kind of *successful* arrangement, i.e., as an arrangement of elements in which certain principles of balance, proportion, and harmony are realized. This usage is as old as Pythagoras; and both Plato and Aristotle sometimes construed artistic form in this way. In present aesthetics, Parker has also advanced such a doctrine.

Formalism, in this tradition, is the view that in art it is harmony, balance, and proportion that are all-important.

The final way that we shall consider in which the distinction between form and content occurs in contemporary theory leads us away from the common-sense usages to the logical one that we discussed above. Aestheticians speak of the sonata form or the sonnet form or fugal forms. What they mean by these terms are certain generic invariants of structure that can be abstracted from many different works of art in the same way in which mathematical logicians abstract invariant patterns from different propositions and facts by substituting variables for values. The musical aesthetician speaks of the classical *ABA* sonata form, and he means by it what Russell means by the classical subject–predicate form: a pattern that is shared by many different things in the world. The *ABA* sonata form is that abstract "musical propositional function" which becomes a "musical statement," so to speak, when the three variables, *A, B, A,* are filled in with the concrete values: exposition, development, recapitulation. When

[2] Ducasse, *Philosophy of Art*, p. 202.
[3] Eduard Hanslick, *The Beautiful in Music*, pp. 166–167. [See p. 393 of the present book—Eds.]

we say, therefore, that Haydn and Mozart, for example, compose in the sonata form, we mean at least that their symphonies have first movements which are alike in that they all have an exposition section, followed by a development section, in which the themes are expanded, inverted, contracted, etc., and a concluding recapitulation section in which the exposition returns to the tonic.

What is true of the meaning of sonata form obtains in the usage of sonnet form as well. Here, too, we are dealing with an abstract pattern, or series of patterns, if we distinguish between the Italian, Shakespearian, and Spenserian sonnet forms, that is, with the variable invariants of a number of different poems.

In this usage, we may say that many works of art have the same form but differ in their content; which usage is the exact opposite of that in which the content of a work of art is said to be the Idea and the form the way in which the Idea is expressed.

In the light of this discussion of the form–content distinction, let us return to the interpretation of the distinction offered by Bell and Fry. Bell construes artistic form as an aesthetically moving combination of lines and colors. This is a simple enough definition; and yet the more one examines it, the less it seems to be in accord with any of the above usages. His conception of form is not that of shape, mode of expression, relations, organization, or medium. Rather, Bell means by the form of a work of art *certain elements in certain relations;* that is, lines and colors in combinations that excite us. Form does not include certain other elements in relation, namely, the so-called representational ones. These Bell calls the content of the art object.

There is at least one linguistic difficulty with this conception of the distinction between form and content. Consider once more Cézanne's "Italian Girl." When all the representations of objects and the girl are resolved into line and color combinations, the picture, strictly speaking, no longer has a content, but only a form. Now, it seems rather odd, linguistically speaking, to say that this painting and, in fact, all great painting has form but no content. This is, I think, only one of the difficulties aestheticians get into by using the form–content distinction altogether.

In spite of this linguistic oddity, Bell's conception of form is rather good in that he understands by it elements in relation instead of relations versus elements. This usage at least emphasizes the organic character of a work of art, which the mathematical usage of relations versus elements does not.

In Bell's aesthetics, each art object has a "whatness" and a "howness," but both of these include elements in relation, i.e., an *organic complex* of elements and relations. The what, or the content, of a work of art is all the dramatically representative elements in certain causal relations; and the how, or the form, all the lines and colors in spatial relations. Bell's formalism, then, is the doctrine that in painting it is the plastic elements

in relations that are all-important, and the nonplastic elements in relations that are totally irrelevant.

Fry also distinguishes between, and even, in his third period, separates, form and content. Content includes those elements in the work of art that represent people or events and the associations attached to them, as all of these relate to each other. In Raphael's "Transfiguration," for example, Fry designates as the content all the Christian narrative elements in their causal relations to each other, the main one being that of mutual dependency.

Form (in the second period) is all the plastic elements—line, color, light, volume, etc.—as they relate spatially to compose a unity in variety; or (in the third period) it is mere spatial relations as against *any* of the elements. Thus, in his second period, Fry is a formalist in Bell's sense: It is certain elements in certain relations that count for everything in art. In his third period, he returns to the traditional mathematical formalism of Herbart: It is the arrangement, the relations, the how, not the elements, the what, that is all-important in art.

The great importance of both Bell and Fry (at least in his second period) lies in the fact that they offered a new conception of the distinction between form and content, one which comprehended the art object in more organic terms. In rejecting the mathematical approach to art—specifically, in repudiating the form–content distinction in terms of relations versus elements—and in suggesting that the form of a work of art comprises certain elements in relation, as the content includes certain other elements in relation, they brought us closer to an empirical conception of art.

RESOLUTION OF THE DISTINCTION

One of the overwhelming characteristics of contemporary aesthetic theory—and, I daresay, of past aesthetic theory as well—is its insistence upon the form–content distinction. It is, I suppose, one of the basic categories of aesthetic thought, analogous in its fundamental character to the substance–attribute distinction in metaphysical and logical thought. In our previous section we offered a rather extended sampling of the ways in which the form–content distinction has been construed in aesthetic theory. All of these usages have their historical, linguistic roots; hence they cannot be rejected in any cavalier fashion. But what we can do—and this has its parallel in contemporary metaphysics and logic in their repudiation of the substance–attribute, subject–predicate philosophy—is to recommend the rejection of all of these usages on the grounds that none of them does full justice to the nature of the art object; and, furthermore, that they lead to misdirected or specious aesthetic disputes.

I propose now to offer a new usage of form and content which is rooted in a more empirical consideration of the actual nature of works of art.

This total analysis, is based, in part, upon the writings of Bell, Fry, Parker, A. C. Bradley and Dewey in aesthetics and, more importantly, upon the articulated or suggested doctrines of practicing critics and artists like Cleanth Brooks, Albert Barnes, Martha Graham, Frank L. Wright, Elizabeth Selden, Henry Moore, Hanslick, Picasso and Matisse, to mention only a very few.

The hypothesis in terms of which the form–content distinction will be considered has to do with the definition of art. Every work of art, the hypothesis states, is an organic complex, presented in a sensuous medium, which complex is composed of elements, their expressive characteristics and the relations obtaining among them. I hold that this a *real* definition of art: i.e., an enumeration of the basic properties of art.

In many works of art, namely, those traditionally called representational, those which include what Ducasse refers to as "dramatic entities" or Parker "spiritual values," we must single out one element and give it a name: the "subject."

The subject is that element in a work of art that stands for, denotes, represents, means, a specific person, thing, scene, or event which exists *outside* of the work, and which is what we say the work is about. Semantically, the subject functions as a sign of specific entities—i.e., persons, events, etc.

That which the work of art is about, let us call the "referent" or "object" of the work.

Some examples will make clear our terminology. Consider, to begin with, Cézanne's "Mont Sainte-Victoire." The subject is the lines and colors that constitute certain volumes within the art object which stand for, denote, represent, mean, the actual mountain. Semantically, the subject is an iconic sign of its object, for it is like that which it means. It is to the mountain what a photograph is to the person it represents.

The object in this case is real, but it need not be. The object may be imaginary, as it probably is in Rousseau's "The Sleeping Gypsy." In cases of this sort, the object is an idea in the artist's or spectator's mind, which is being represented by the subject.

There is an intimate connection between objects and titles of works of art. In most paintings, at any rate, the title refers to the object of the work, "what it is about."

Consider, next, Miltons' *Paradise Lost*. Its object or referent is the Fall of Man as it exists in the minds of the readers of the Bible or as it existed in the past, if it actually did. The subject of *Paradise Lost* is those elements in it that specify the characters and events involved in the Fall. These include God, Satan, the angels, the revolt of the angels, and so on.

It is worth noting that the subject of *Paradise Lost* is unique in the sense that Milton's God, Satan, etc., are like no one else's; whereas the object of the work may be the referent of many other works of art. Semantically, the subject, in its dimension as words, functions as symbols,

i.e., as signs that have become fixed to connotations through established usage. It is only when the words conjure up images that the subject assumes an iconic significance to its readers.

In music the problem is more complex. The object or referent of the *Eroica*, for example, it is claimed, is heroism. The subject, then, is all of those sounds in the symphony that stand for heroism. However, some aestheticians have argued that music cannot have a referent, in which case, it can have no subject. They conclude from this that music (with the exception of onomatopoetic elements) has no meaning or cannot represent anything. But . . . this is not a correct conclusion since elements other than subjects can mean and represent in art, including music.

Finally, the recent Koestler novel, *Arrival and Departure*, is about the problem of modern salvation, which problem exists quite independently of any work of art. The problem is specified as the conflict between the life of social action and the life of egocentric preoccupation with guilt. In the novel the subject is the hero, Peter, whose inner and outer struggles signify, in semantical terms, the externally existing conflict in modern society.

All of these works of art are similar in that their referents can provide material for many other art objects. As we would say, there are many works of art on the same Idea or theme; they refer to the same thing; they are *about* the same thing. And, as A. C. Bradley pointed out, but with a different terminology, the Idea is primarily outside of the work of art.[4] He is incorrect, however, in supposing that this is the sole existence of the theme (or Idea, referent, object). These *also* exist in the art object in the sense that the subject partakes of the same universal which is embodied in the referent. In fact, and I should regard this as central in any adequate theory of communication, the subject is capable of meaning the object to some person precisely because of the universal that is present in both.

Besides the referent, what Dewey calls the "matter for" the work of art, there are the *associations* of the referent. These comprise all of those experiences that the artist had before or while creating his work of art which are relevant to it. Milton's reflections on the Fall of Man; Koestler's experiences as a Communist (which he narrates so effectively in his *Scum of the Earth*); Beethoven's reactions to democracy and heroism; and Cézanne's feelings for the mountain, Sainte-Victoire, are examples of associations. We get our knowledge of these from the letters, diaries, and autobiographies of artists or from other similar sources left by their contemporaries, or even from Freudian or sociological analyses of their art works. The associations, like the referents, exist primarily outside the art object, but may also exist within, as subjects or other elements.

We come now to the *content* of a work of art. If we are to employ this concept at all, then, in order to avoid getting into the many specious

[4] A. C. Bradley, "Poetry for Poetry's Sake," *Oxford Lectures on Poetry*, pp. 9ff.

disputes which traditional conceptions of content have inspired, and in order to come to grips with the essentially organic character of art, we ought to interpret the content of a work of art as *all* that is in it: all the elements, expressive characteristics and the relations that obtain among them. This interpretation is in keeping with one ordinary usage of content in which we say that the content of anything is what is in it; and is much more satisfactory in its results than interpreting content as theme, subject, or elements as against relations.

On this usage, then, we can speak of our previous examples in the following way. In Cézanne's "Mont Sainte-Victoire," the content can be said to be all the lines, colors, masses, volumes, drawing, design, space—in other words, the plastic—plus the subject and the expressive characteristics, as all of these relate together. In Parker's terminology, the content of the picture is all the linguistic, plastic, and spiritual values as they organically relate to make a total artistic complex.

In *Paradise Lost*, the content includes the subject terms, the images, metaphors, attitudes, ideas, diction, versification, and their expressive characteristics, as they organically relate to each other.

In the *Eroica*, the content comprises all the tones, chords, melodies, harmonies, rhythms, perhaps the subject, their expressive characteristics, also as all of these organically relate to each other.

The content or substance or subject matter of or matter in the work of art is the work itself, the whole thing. It is something that cannot be said in any other way. Many works may have the same theme or referent, be about the same thing, but every work has only one content. Donne, Shakespeare, Shelley, Eliot all speak *of* love, but the content of each of their poems is unique. Nowhere is the Leibnizian principle of the identity of indiscernibles more secure than in the realm of art!

Actual artistic production probably begins with the artist's experiences as they converge upon a theme or Idea. Then he selects and unifies in an imaginative way his material while embodying it in a sensuous medium. He creates an artistic content, to which he usually gives a name. But the name or title is a mere label, not to be confused with the work itself. Most spectators unfortunately regard the content of art as a springboard to the referent, and eventually, to *their* associations. Here Bell and Fry and Bradley are right: Do not respond to the referent or the associations of the referent, but to the content.

If the content of a work of art is conceived as all of its expressive elements organically related to each other, what, then, is the form? Form, I submit, ought to be construed as exactly the same thing: the *organic unification of the several expressive constituents of the work of art*. Concrete artistic form, that is, the form of an individual work of art, ought not to be regarded merely as the relations or mode of expressing an Idea or shape or proportion of the work but as all of the expressive elements in relation. Form and content are to be regarded not as coördinates in art

but as constituting the same coördination of elements, characteristics, and relations. Thus, there is *no* distinction on this usage between form and content in art.

There are elements and there are relations. But there are no elements, relations, or even grouping of them that can be singled out and designated as the content or the form except in an arbitrary and vitiating way.

Our proposal to eliminate the form–content distinction as applied to concrete works of art and to construe them as synonyms is no *mere* stipulation as to the way in which we wish to use terms, no *mere* recommendation to effect an alteration of our aesthetic language in an attempt to abuse the language of common sense. The positivists and the Wittgensteinians are undoubtedly correct in their assertion that much of philosophy is of this character, but it is not our intention either to stipulate usage or commit linguistic abuse. Rather, we are offering a new way of talking about art which will not give rise to unnecessary aesthetic disputes and will be more consonant with its actual organic character. An aesthetic language that does not employ terms like form and content—which, let us be the first to admit, are essential for some philosophical and ordinary modes of discourse—or, if it does use them, regards them as synonyms, so our hypothesis about the nature of art implies, is a more adequate language than those languages found in the aesthetic systems considered thus far. It is more adequate ultimately in the same sense that Russell's relational logic is more adequate in interpreting reality than the traditional Aristotelian subject-predicate logic: that is, it is a truer language because it corresponds to the facts.

Now, in the sense that art is an organic complex of elements, expressive in character, embodied in a sensuous medium, it is significant form. But to say that art is significant form is to say that it is also significant content. The two statements mean the same thing: that art may include as its constituents lines, colors, tones, words, emotions, concepts, feelings, meanings, representations, and subjects. Just as there is no artistic distinction between form and content, so there is no antithesis between form and ideas, representations and emotions. The problem, raised by Bell and Fry, of the legitimacy of these constituents remains, and it will be equivalent to asking whether or not these elements can *integrate* successfully with each other.

The analysis of form and content that we have been offering has, I think, been approximated by at least three recent or contemporary aestheticians, Parker, Barnes and Bradley.

Parker affirms the distinction between form and content in his aesthetic writings. But a careful reading of his formulation of the distinction reveals, I think, a position similar to that which we have been developing. By content, Parker means certain linguistic elements, like line and color, and certain plastic and spiritual representations, all in spatial, temporal, and causal (telic) relations to each other. Parker does not, like Ducasse,

for example, accept the mathematical distinction between form and content (i.e., relations versus elements) as a legitimate aesthetic category, but regards content as being constituted by certain elements in relation.

Form, for Parker, is a set of abstract properties of these elements in relation. It has to do with the unity, variety, balance, evolution, and hierarchy of these elements in relation. Consequently, Parker means by form certain second-order properties of the content of art. But when we consider the concrete individual work of art, the distinction between form and content vanishes since both refer to the same thing; the linguistic and imaginative elements of art in organic relation to each other.

Barnes, in *The Art in Painting*, distinguishes between two inseparable aspects of painting, plastic form and subject matter. The plastic form is the unity of the line, color, light, shadow, design, volume, and composition, whereas the subject matter includes the spiritual and dramatic values of the work of art. Nowhere, however, does Barnes refer to the subject matter as the total content to be contrasted with the total form. Rather, the subject matter is one element among others, to be contrasted with the others only because it is nonplastic in character. Now, if we rephrase Barnes, which we can do without any violation of his doctrine, his similarity to our own position, regarding art as organic and form and content as indistinguishable, becomes apparent. For Barnes, the art object is the unity of plastic and nonplastic elements in relation; and the whole object is significant form, that is, a complex of expressive, ideational, and plastic elements organically related to each other.

In Bradley's "Poetry for Poetry's Sake" there is the same recognition of form and content which are taken as inseparable albeit distinguishable elements of art. The content is regarded as the *whole* poem, the form as the versification. But it is quite arbitrary and unnecessary to call versification the form of a poem. Bradley does so because he persists in thinking of form in mathematical, relational terms. Actually, however, Bradley does deny the coördinate character of form and content. The poem is really an integration of elements organically related to each other, in which one element, among others, is versification.

MEANING OF THE ORGANIC IN ART

Art, we have stated, is an organic complex or integration of expressive elements embodied in a sensuous medium. It is now necessary to examine the meanings of the organic and expressive in order to clarify our definition of art.

First, the nature of the organic in art. In general, at least two kinds of complex or system can be distinguished in the world, the mechanical and the organic.

Consider, as an example of a mechanical system, the *statement* of the four freedoms in the Atlantic Charter. In this "statement system" there

are a number of constituents, including certain elements or terms, their characteristics, and the relations obtaining among them. The terms, i.e., the individual statements, such as "There shall be freedom of religion," are significant and understandable by themselves. Their meanings are not dependent upon each other. The relations that any one of these statements has to each of the others do not change the meaning or the nature of the other statements. Nor do the terms themselves change the nature of the other terms. We may say, then, that the elements, characteristics, and relations of this linguistic complex are externally constituted in the sense that no one element, characteristic, or relation is an attribute of any of the others. The constituents, in their nature and meaning, remain the same no matter what the relations among them. Even the serial ordering of the four statements or their serial reordering makes absolutely no difference to the statements themselves, so far as their meanings are concerned. That is to say, it does not matter to the meanings of the statements if the statement about freedom of speech, for example, comes before or after the statement about freedom from fear. Here, then, is an example of a system in which *what* is said—namely, the four freedoms—is distinguishable from *how* it is said.

In contrast to systems like the statement of the four freedoms, there are complexes in which the constituents *do* make a difference to each other because of the nature of their relations or of their characteristics. If this is taken as the essential feature of an internally constituted complex, then we may say that an organic system is an internally constituted one. That is to say, it is a complex in which every constituent, be it element, characteristic or relation, plays its role not only in terms of itself, but *also* in terms of the other constituents. Every element, every characteristic, every relation, even that of mere serial order, makes a difference to every other. This means that no constituent can be understood by itself but must be seen in its relations to the others as well.

In logical terminology, we may say that an organic complex is one in which any constituent a is an argument variable of all the others $\hat{x}\ (C-a)$, that is, the class of all the constituents minus the original one.

The central difference between a mechanical and an organic system, then, is that in the first every constituent is externally constituted; whereas in the second, every constituent is internally constituted. Unlike the monists and the monadists, we do not mean by an organic system one in which there are no relations or in which relations can be *reduced* to predicates of terms or Wholes; but rather one in which (a) relations, real in the sense of being irreducible, (b) elements, and (c) their characteristics are *part* of the nature of each other.

As a disciple of contemporary realism, which roots itself historically in the rejection of the doctrine of internal relations and a fortiori in the doctrine of internal constituency, I should like very much to deny the existence of organic systems and remain content with a cosmology in

which all complexes are pluralities of terms externally related to each other. But aesthetic inquiry, it seems to me, demands that we recognize and accept at least one kind of internally related and internally constituted complex, namely, the work of art. To resolve a work of art into a mechanical system is tantamount to destroying its aesthetic nature.

Let us see how this distinction between mechanical and organic constituents and complexes applies to art. Consider, to begin with, a novel. Is the cover of the novel a mechanical or an organic constituent? What about the quality of the paper? Both of these, it is obvious, do not make a difference to the novel, i.e., to its characters, plot, themes, etc., hence, are mechanical elements. Change the cover, rebind the book, improve the paper, and the novel has not been affected because these are not factors in it as a work of art.

Contrast this with the frame of a picture or the quality of its surface area! The theory of framing is quite undeveloped today but everyone recognizes that the frame is one element among others, which the artist or museum director must consider when he is concerned with the picture as a work of art.

So far as the quality of the surface area is concerned, that this makes a difference to all the plastic and subject elements of the painting has been recognized by artists for centuries. In contemporary art, the experimentations on wood, glass, cardboard, etc., and the attempt to derive from these materials certain expressive effects show the contributory roles these painting surfaces play. Because they do make a difference to the expressive qualities of the colors, lines, luminosity, even the subject elements, they are organic constituents.

Another way in which the organic character of constituents manifests itself in painting is in the treatment of colors. Artists distinguish between dominant colors, like red and yellow, and recessive colors, like blue and green. Red, when we look at it, has the tendency to come forward; blue, to go backward. (This is a psychological fact, characterizing the perceptual experiences of Western peoples, not necessarily a physical fact characterizing colors all by themselves.) An artist who wishes to preserve a balance within his picture would hesitate to put a large red volume on the front planes of his canvas if there were nothing on the back planes to counteract it, since the volume would tend to "spill over" the frame. Consequently, he paints his large frontal volumes in recessive, soft colors and his back volumes in dominant, loud colors.

There is nothing absolute about this specific treatment of colors, but it is certainly a characteristic of much great art. Two excellent examples are Brueghel's "Peasant Wedding Dance" and Seurat's "Sur La Grande Jatte." In both of these, the two main large front figures are in soft blues. These are related immediately in space to other figures that are in brighter colors, and this relation leads us from the one to the other parts of the canvas. Both artists recognize the organic character of color in relation to

the volume of the figures. They realize, whether consciously or not is irrelevant, that the aesthetic value of the color of the large front figure volume will affect the aesthetic value of the color of the back smaller figure volumes. Hence, they visualize each color volume not only in terms of itself but also in terms of the other color volumes. The contemporary French painter, H. Matisse, has stated this organic character of color in a clear and revealing way:

If, on a clean canvas, I put at intervals patches of blue, green, and red, with every touch that I put on, each of those previously laid on loses in importance. Say I have to paint an interior; I see before me a wardrobe. It gives me a vivid sensation of red; I put on the canvas the particular red that satisfies me. *A relation is now established between this red and the paleness of the canvas.* When I put on besides a green, and also a yellow to represent the floor, between this green and the yellow and the color of the canvas there will be still further relations. But these different tones diminish one another. It is necessary that the different tones I use be balanced in such a way that they do not destroy one another.[5]

We find the same insistence upon the organic character of all the arts in many contemporary critics and artists. The best statement in practical criticism with which I am acquainted of this organic principle that every constituent of an artistic complex must be understood in terms of itself in relation to the other constituents is that of C. Brooks and R. P. Warren, two American exponents of the "New Criticism," instituted by I. A. Richards and T. S. Eliot in England.

A poem is not to be thought of as merely a bundle of things which are "poetic" in themselves. Nor is it to be thought of, as the "message hunters" would seem to have it, as a kind of box, decorated or not, in which a "truth" or a "fine sentiment" is hidden. We avoid such difficulties *by thinking of a poem as a piece of writing which gives us a certain effect in which, we discover, the "poetry" inheres.*

This is very different from considering a poem as a group of mechanically com-bined elements—meter, rime, figurative language, idea, etc.—which are put together to make a poem as bricks are put together to make a wall. The question, then, about any element in a poem is not whether it is in itself pleasing, or agreeable, or valuable, or "poetical," but whether it works with the other elements to create the effect intended by the poet. The relationship among the elements in a poem is there-fore all important, and it is not a mechanical relationship but one which is far more intimate and fundamental. If we should compare a poem to the make-up of some physical object it ought not to be to a wall but to something organic like a plant.[6]

One may raise the question of the ontological character of mechanical and organic complexes. Many philosophers would undoubtedly assert that the essential characteristic of these complexes, which determines their or-ganic or mechanical nature, lies in the complex itself. But this is too dogmatic a view. All that one can say, on empirical grounds, is that the kind of system we have before us depends, in part, at least, upon our

[5] Henri Matisse, "Notes d'un Peintre," quoted in John Dewey, *Art as Experience,* p. 136 (italics mine).
[6] Cleanth Brooks and R. P. Warren, *Understanding Poetry,* pp. 18–19.

human purposes and interests. A chemist, qua chemist, would treat a painting quite differently from a critic interested in it as a work of art. To a chemist, let us say, who is concerned with placing the picture in its historical period of origin, the painting becomes a mechanical system, in that he isolates certain chemical constituents of the colors on the canvas without any concern for their relations to the other constituents. But to the critic, there can be no such isolation since his main concern is with the nature of the constituents as they relate to each other.

MEANING OF THE EXPRESSIVE IN ART

A work of art, according to our hypothesis, is an organic complex of expressive constituents. What, now, do we mean by *expressive* in this context? There has been a great deal of discussion in recent aesthetic theory of this concept, but I should like to propose a real definition of the expressive in art without entering into the diverse usages of the concept.

The meaning which we shall consider is that which affirms of some particular work of art, "the colors are expressive but the general design is not," or "the melodies are deeply expressive." Our problem is, what does the word "expressive" refer to, if anything, in this context, which is the one basic to our general definition of art?

My own view is that anything in art is expressive (in the above sense) if it is construed by some spectator to be a *sign* of (1) a specific emotion or feeling, (2) an emotional quality, or (3) something that is a sign of an emotional quality or emotion. An example of (1) is the emotion of turbulence; of (2) the quality of the lyrical as against the dramatic in human experience; and of (3) the volume figure in Picasso's "Woman in White" that is a sign of the property of voluminousness, which is itself a sign of some emotion to all of us.

I think that this is what we mean when we assert, for example, that "the colors of this painting are expressive"; the colors are functioning as signs of emotions to us. To state that any constituent of a work of art is expressive is to say that that constituent is associated with some emotion or emotional quality by us. This is the basic meaning of the expressive as that term is applied to the art object. Also, it is in this fundamental semantical sense that we may claim of art that it embodies emotions.

As signs, the expressive in art, like all signs, has both a presentational and a representational character. Aestheticians do not question the presentational aspect of the expressive in art; that is, its immediately given sensuous character. But the view that every artistic constituent, because it is expressive, is representational, is certainly a novel one and likely to create some misgivings among many aestheticians. Our thesis, however, is clear: Because every constituent in art—not only the subject—functions as a sign of human emotion, it is representative of, means, denotes, either directly or indirectly, some human emotion or emotional quality.

Expressive properties of artistic elements may represent or mean in different ways. Consider, once again, Brueghel's "Peasant Wedding Dance," specifically, the color red, which is one of the leading colors in the painting. Now, (1) this red color may mean any red color; that is, it may mean its universal. In this context the red color is iconic with all the other instances of red that there are.

(2) The color red may mean the concept "red," in which case we say that the color is a symbol of the concept. (We could equally well say that the concept is a symbol of the color red, if we were reading the word "red" in a poem instead of seeing red in a picture.)

(3) The color red may mean that which we call, but with great inexactitude, warmth, liveliness, gaiety, where these latter are certain emotional qualities of our experiences. Here the color red functions as a symbol of warmth, etc., but because of certain psychological conditioning and general social and cultural (anthropologically speaking) acceptance, it is a symbol which is rather fixed in its meaning, in the way that the word "red" is rather fixed in its meaning. Because of this intimate association between the color red and the quality of warmth in our culture, we may call red in this context a *transparent* symbol of the warm, gay or lively.

(4) In contrast to transparent there are *opaque* symbols. The color red may mean adultery, peace, anxiety, a frog, love, hate, communism—in fact, anything at all. Iconological research, for example, might reveal that the color red in the Brueghel painting represented lechery to the artist and to his contemporaries. Now, in the sense that this red means lechery to Brueghel or anxiety to someone else or a frog to a third person who has a passion for a zoölogical *Weltanschauung*, it does not mean what most of us today call warmth or gaiety or liveliness. The association of red with gaiety is easily made by all of us who share the same conditioning, whereas the association of red with lechery, anxiety, or a frog is made only by those who understand the limited language of the artist or the spectators.

It should be obvious, of course, that the difference between a transparent and an opaque symbol is in part, at least, cultural. Perhaps the whole difference is cultural, but to say so is to commit oneself to a view that is too dogmatic. It may very well be that physiology and psychology will someday disclose the intimate connection between red and the feeling of gaiety in such a way that we could claim that some symbols are physiologically transparent and others physiologically opaque.

(5) The seeing of the red color may be like the experiencing of gaiety, liveliness, or warmth; hence we may say that the visual experience is iconically expressive of the experience of warmth, etc. That is to say, a person who sees the color red may interpret his visual experience as being like an emotional tone of some of his other experiences which he refers to as liveliness or warmth or gaiety, if he is conditioned to do so. To paraphrase Carroll Pratt, red may look the way the lively feels.

The color red, then, even in one picture, may represent or mean in a variety of ways: iconically, either expressively (5) or nonexpressively (1); or symbolically, either transparently (2,3) or opaquely (4).

Consider, next, the progression of chords in the exposition section of the *Eroica*. This chordal progression is said by everyone to be profoundly expressive. Of what? we may ask, and this is tantamount to asking, of what is it a sign? Once more, we may say that the artistic constituent, the chordal progression, is expressive in the sense that it is a sign of many things, all of which are associated with emotional experiences by human beings. To some, the chordal progression means massiveness and its attendant quality of power; to others, Napoleon, or democracy on the march. In the sense that it functions as a sign of massiveness and power, the progression is a transparent symbol because we have been conditioned to associate these loud, full sounds with the massive and the powerful. The *hearing* of the chordal progression is iconically expressive of the powerful or the strong to contemporary Western listeners since, as an auditory experience, it is like our experiences of the powerful. Both the auditory and these other experiences have the qualities of bigness, massiveness, and strength about them. In the sense that the chordal progression is a sign of, means, represents, democracy or Napoleon on the march, it is, either as sound stimuli or our full interpretations of it, opaquely symbolic.

Subject terms are also expressive in art and, as such, are representational. In Cézanne's "Italian Girl," for example, certain of the colors and lines function as a sign of a girl. These configurative colors and lines are iconic signs in the same sense that a photograph is an icon of the person it represents. Now, a girl, all by herself, is a sign to all of us of various emotions, the specific one depending upon our psychological conditioning and growth. In the Cézanne portrait, the girl exhibits the quality of pensiveness; that is, she is a representation of a pensive person. Her pensiveness may further function as a sign of different emotions, some of which may be merely opaquely related to pensiveness. But in any case, as the subject of the painting, the pensive girl represents many things to many different observers.

To sum up: According to our hypothesis, *every* constituent in art— line, color, melody, rhythm, gesture, etc.—not merely the subject, is representational in an expressive sense. That is, every constituent means certain emotions or emotional qualities to every spectator, though, perhaps, different ones to different spectators. The traditional view, which is shared by all aestheticians who dichotomize art into its form and content, and equate content and representation, and representation and subject, and who identify form with the nonrepresentational, is completely unsound from the correct semantical point of view and must be rejected. In art, there are elements, their expressive characteristics, and the relations that these have to each other. But there are no *special* representational elements. A line, a color, a melody, a spatial mass, may mean as much, and in

exactly the same way, as any other element. The whole problem of representation versus nonrepresentation and the legitimacy of representation in art, as raised by both Bell and Fry and their critics, is a specious issue and rests ultimately upon inadequate analyses of form and content, representation, and the expressive in art.

THE ORGANIC THEORY AND THE REQUISITES OF AESTHETIC THEORY

In our general critique of Bell and Fry we suggested that any adequate theory of art, especially one that is sympathetic to the aims of formalism, ought to satisfy the following requisites:

(1) It ought to provide a richer analysis of form than that presented by Bell and Fry. The organic theory, I think, succeeds in this. Artistic form is construed as a complex of various constituents, which is taken to be amenable to analysis, and empirically ascertainable and objective; which is the common referent of discussion and dispute; and, finally, which is open to educational procedures. If, on the organic theory, we ask, Does a particular work of art have significant form? we can reply by inquiring into the presence or lack of integration of the expressive constituents of the work.

(2) It ought to furnish, either explicitly or by implication, certain working criteria for intelligent criticism of the arts. These criteria and the whole general problem of the possibility of a theory of criticism will be dealt with in Chapter 9, where we discuss the nature of artistic appreciation.

(3) It ought to offer an explanation of all the arts. Here, too, the organic theory is successful. Every art object is an organic complex of its several expressive constituents. The problem is always the *specific* one of ascertaining the varying constituents; and these, of course, differ in the different arts.

(4) It ought to render intelligible certain phrases like "French painting," "Russian music," "the proletarian novel," or "the romantic drama"; which are quite meaningless in the formalism of Bell and Fry. The organic theory accepts these concepts as legitimate. Works of art may be French, Russian, proletarian, or romantic in at least two ways: (*a*) through their subjects or themes, where the *kind* of subject or theme, the class struggle, for example, or the defiant hero who stands alone against society, defines the work as proletarian or romantic; or (*b*) through any of their expressive qualities. In painting, for example, we may say—even Fry has said it!—that much of French art is delicate, witty, precise; and these aesthetic adjectives apply to the expressive qualities of the plastic elements.

Our theory allows also of a socio-economic-philosophical interpretation of art. What we do in this case is to abstract certain constituents from different works of art and discuss them in relation to certain categories as a cohesive group.

(5) It ought not to limit in an arbitrary way the range of artistic communication. That is, no theory of art should rule out, unless it must, on the most cogent of grounds, nonplastic, spiritual values. On the contrary, the overwhelming force of the history of art requires from aesthetics a theory that explains how art is able to contain, legitimately and successfully, representations and meanings of any sort, and even different *Weltanschauungen*. Further, aesthetics ought to show, if possible, that fullness of expression and communication in art does not necessarily destroy its purity or provoke sentimental appreciation.

The organic theory, primarily because it rejects the traditional distinction between form and content, which has been basic in the repudiation of meanings, subjects, and representations in art, does not limit the range of artistic expression. Rather, it destroys the props of traditional limitations, and asks only that artistic communication be an expressively integrated one. It refuses to rule out the nonplastic spiritual values for the very simple reason that these can contribute as much to art as line and color.

Furthermore, on the organic view, the purity of a work of art does not consist in the elimination or plastic dissolution of the subject but in the effective working together of *all* the elements. It is the absence of integration, as in the Shelley poem, "Death," which makes for artistic impurity.

Also, there is no reason to suppose that subjects necessarily evoke sentimental, ordinary emotions. As we shall show in Chapter 9, the proper attitude to assume toward art is the contemplative and nonsentimental one, no matter what the constituents of the particular art object may be.

(6) It ought to show that formalism is not necessarily the view that it is of no consequence what a work of art says so long as it says it well; that the what is artistically indifferent and it is only the how that counts.

The organic theory, which may be construed as an *expanded* formalist theory of the art object, repudiates this version of formalism by denying the distinction between the what and the how in art (although it accepts the distinction when it is applied to mechanical systems, including art objects, when they are treated in a mathematical or quantitative, scientific fashion). In art, we have been insisting through our present chapter, *how something is expressed is what is expressed*. Both the how and the what, like the form and the content, refer to the totality of the work, not to any set of separate constituents.

RONALD W. HEPBURN

EMOTIONS AND EMOTIONAL QUALITIES: SOME ATTEMPTS AT ANALYSIS

Ronald W. Hepburn is Chairman of the Department of Philosophy at the University of Edinburgh.

Works of art have, no doubt, something to do with emotion, but it is notoriously hard to determine what, precisely, this something is. Do works of art 'express' emotion, or 'evoke' it, 'represent' it, 'master' it, 'organize' it or 'purge' it? Or can they do several of these things—or all of them?

From the constellation of problems here, problems on the border between aesthetics and the philosophy of mind, let us break off some manageable fragments for discussion. The fragments, I think, are important ones: but be it said at the start that many of the topics I shall *not* single out for treatment are quite as important in aesthetics as those I do. There is no attempt in this article to produce a general or comprehensive theory of 'art and emotion'. That would need a book.

Reprinted from Cyril Barrett, ed., *Collected Papers on Aesthetics* (Oxford: Basil Blackwell, 1965), pp. 185–198 (a slightly amended and extended version of this article, which originally appeared in *The British Journal of Aesthetics*, Vol. I [1960–1961], pp. 255–265), by permission of the publisher and Professor Ronald W. Hepburn.

Certain writers make a sharp distinction between the way in which ideas, concepts, meanings, can be *in* works of art, and the emotions, feelings, which a work is said to *evoke*, to *cause* in the reader or spectator. According to this view, if we often transfer emotion-epithets to works of art, and call them 'jolly', 'joyous' or 'frenzied', we are well aware that we *are* transferring them, that in the last resort it is we who are made jolly or frenzied; and that our epithets are in fact characterizing the poem or piece of music in terms of its effects on us, not in terms of its own qualities. We are entitled to claim that meanings and ideas are 'objectively' in the works concerned: they can, for instance, be adequately and most often unambiguously specified. But since there can be no equally sensitive control of emotional response, we are here in the realm of the subjective.[1]

There are, however, a number of analyses which claim that emotions and feelings can be *in* works of art just as certainly as meanings and ideas can be in them. On this view, if I say 'The music is joyful', I may not be speaking of my own feelings but of what I hear as a 'phenomenally objective quality of the music' itself. It is not the case, for instance, that listeners tend to report wildly divergent emotional qualities when attending to the same pieces of music: some experimental work has shown that if subjects are asked carefully to concentrate on the music (and not on their own feelings and fantasies), their reports on the music's emotional qualities are convergent. If, however, they are allowed to report on their own emotional states, their reports diverge noticeably. As O. K. Bouwsma put it: 'joy and sweetness, and sadness [can be] in the very words you hear'. 'The mood of a landscape', wrote Otto Baensch, 'appears to us to be objectively given with it as one of its attributes belonging to it just like any other attribute we perceive it to have. . . . The landscape does not express the mood, but *has* it. . . .'[2]

Although neither of these two accounts of emotion and art-objects is free of difficulty, I thing the stronger *prima facie* case can be made out for the second, the account which claims that emotional qualities can be described, with perfect propriety, as *in* works of art. We speak of a musical note as being 'high' or 'low'—the highness or lowness being heard as phenomenally in the note. From this there is a gentle transition to speaking of a phrase as 'incomplete', 'questioning' or 'nimble', again reporting the heard quality of the sound, and on to emotional qualities in the strictest sense like 'melancholy', 'tender', 'plaintive'. Similarly in visual art, there is a gentle transition from speaking of a shape as having a 'three-dimensional look', to having an 'awkward, unstable look' to having a 'comic' or a 'melancholy' or 'angry' look. Without any sense of incon-

[1] See, for example, H. Khatchadourian, 'Works of Art and Physical Reality', in *Ratio*, ii, pp. 148 ff.

[2] See Bouwsma, 'The Expression Theory of Art', in *Aesthetics and Language*, edited Elton, pp. 73 ff.; M. C. Beardsley, *Aesthetics: Problems in the Philosophy of Criticism*, pp. 328 f.; O. Baensch, 'Kunst und Gefühl', quoted by S. Langer, *Feeling and Form*, p. 19.

gruity, we can bring together in one description of a shape words from different parts of this scale; for example, the shape is 'comic *and* awkward', 'comically awkward'. At no point is there a shift from talk about the figure to talk about the spectator's response.

Note that the class of 'emotions proper' is not at all sharp-boundaried. In one direction, we gradually approach it from expressions (like 'awkward', 'graceful', 'elegant') that primarily describe manner-of-acting or -appearing. These tend to carry loose implications about what is *non*-behavioural. If, for instance, we say 'John rose to his feet awkwardly', we are normally taken to imply that he lacked inner composure as well as outward grace. But the implication is certainly a loose one. A Bishop might mount the pulpit with great dignity (manner of acting); but the implication that he then experienced an inner sense of reverence and solemnity would be false, if such moments had long ago lost their power to move him. Yet the outward dignity might remain.

There are, however, some emotion-words, well within the territory of emotions proper, that make essential-reference to the non-behavioural. Sadness, nostalgia, depression, ecstasy—one may experience any of these and manage to inhibit most or all of their behavioural concomitants. The spectrum-scale from manner of acting to emotions with essentially 'inner' aspects is important to our present study; since works of art can display not only the former as emotional qualities but also the latter, which is the more remarkable feat.

Again—to resume the main argument—there are occasions when I may wish to say the following: 'The drawing (or the rondo) was joyful, but *I* was not joyful'. If I say 'This curve is graceful, and that jagged line intersecting it is tense and menacing', I do not mean that *I* feel graceful on looking at the curve and then tense and menaced on looking at the jagged line. Instead, I may feel vaguely excited, delighted, or be entirely unmoved.

To claim that the emotional quality can be in the work of art is not of course to say that the word 'in' is used in precisely the same sense as when an emotion is said to be 'in' you or 'in' me. People experience emotions: works of art do not. (Cf. Bouwsma, op. cit., p. 78.) But nothing substantial would be gained by restricting the multi-purpose preposition 'in' to the case of emotions being 'in' persons. Had this been a *genetic* study, a study of the mechanisms by which aesthetic effects are produced, then we should have had to work out some theory of emotional 'projection', and explore the analogies, hints and clues that we go on, when attributing emotional qualities to such inanimate things as carvings, lines, shapes and configurations of sounds. But our inquiry is phenomenological; we are asking what our experience is like, not how it is stage-managed.

Some elementary examples from music may help to clarify our claims so far. Within the classical idiom we feel that in most contexts a dominant seventh, or, say, a thirteenth, 'wants' to move to the tonic chord. The

music wants, strives, to reach its resolution: the wanting is not mine, as I listen to the chord, but the music's. This is one of *its* vicissitudes. If the music modulates into a 'bright' key, the brightness is not my brightness but again the music's. The music has its own phenomenal career. Suppose my radio is switched off while a seventh or leading-note of an ascending scale is being played, in a work of the classical period. It can readily be shown that I do not take this chord or note as a mere stimulus of unrest in me—an unrest that would be relieved by any tonic-chord stimulus in the same key, played fortuitously, say, by a boy in the street with a mouth-organ. What needs its resolution is that particular chord on the radio, not the disquiet aroused in me. But what of the gentleman who, hearing from his bed someone playing a seventh on the piano and carelessly leaving it unresolved, left his bed and resolved it himself? This is not really a counter-example to our theory. For, first, it was upon the same instrument that the seventh had to be resolved—not simply by humming or whistling the tonic chord in the warmth of bed. Second: we laugh at the story precisely because we normally objectify the uneasiness and disquiet as being in the music itself, one of its vicissitudes, and do not think of it as being transferred to the hearer so as to become *his* vicissitude instead.

Furthermore, one tends to be relatively detached from emotions in music. A piece of music may have the emotional quality of despair or grief, but I who listen enjoyably need by no means be in despair. I can relish and savour the anguish of the music: compound its despair with my delight. The emotion I feel, if any, is often a radically transformed version of the emotional quality of the music itself and not identical with it. Awareness of this transforming process helps to distance the music and the emotional qualities in it from me and my (hearer's) emotions. I have also an emotional *inertia:* even when the emotion I feel is roughly identifiable with the emotional quality of the music, the music's emotion may be intense, but mine sluggish. It may be uninterruptedly gay or wild, while my emotional response may be intermittent and fluctuating. In my ordinary perception of the external world I posit various abiding material objects, my house, my telephone, my watch, although my actual perception of these is intermittent and subject to the variations of perspective and lighting. Not very differently, I posit a continuing emotional progress in the music, despite the fact that I do not experience, do not 'have', each successive emotion while the piece plays.

It might be tempting to argue that even if 'This tune is vivacious' does not mean 'This tune makes me feel vivacious now', still it must mean 'This tune *tends* to make me, or most careful listeners, feel vivacious'. But I doubt whether this is so. As a psychological generalization it may be true that quite often vivacious tunes makes us feel vivacious; but I may properly judge a tune to be vivacious by simply recognizing in it the presence of vivacity as a characteristic, without myself—or anyone else—even feeling vivacious on its account.

Try another sort of analysis. 'This musical phrase has emotion E' means 'The hearer of the phrase would experience emotion E (would come to have emotion E), if . . .' *Prima facie*, one feels that this conditional sentence must be completable. But what exactly would complete it? '. . . if the phrase were repeated several times, repeated until motion is experienced.' That would not do; repetitions might cause the phrase to go dead on the hearer, to pall or exasperate or seem banal. '. . . if the phrase were played in isolation, under non-distracting conditions.' Again, no; since out of its musical context it might well take on a quite different emotional tone. These failures do not prove such a conditional-sentence analysis to be impossible, but it is hard to think up any other continuations after the 'if' that are not vulnerable to just as sharp objections.

One might try to make a last-ditch defence of the stimulus-response model of emotion in works of art by saying this: 'If works of art do not evoke full-blooded emotions, they at least arouse *images* of emotions'. 'Image of an emotion' is not an expression for which we often have a use —perhaps because having an emotion is not an affair of any single special sense, as seeing and hearing are. But it can easily be given a use. With emotions such as fear, exhilaration, despondency, the emotion-image would be a combination of kinaesthetic, visceral, visual or verbal images. And, just as, for example, visual images by themselves are most often schematic —a vague shape standing in for the appearance of a house—so with emotion-images: the kinaesthetic image of clenching fists may stand in for a constellation of occurrences and tendencies that make up 'being angry'. Suppose, then, that this is what we understand by an emotion-image. It needs no fresh argument to show that we often see or recognize what emotion is in a work of art without necessarily imaging any emotions at all. We can recognize anger without incipient clenching of fists; tranquillity without imaged relaxing of muscles.

Lastly, we can recall Coleridge's plain words in the *Dejection Ode:* 'I see, not feel, how beautiful they are'. We might substitute for 'beautiful' a more specific human-emotion word like 'fearsome', 'serene'; and the sentences need not be uttered in Coleridge's mood of dejection.

We have been working so far with an unexamined and far too crude conception of emotion itself. Unless this crudeness is removed, our whole project of critically discriminating between rival accounts of emotion and art-works may well be jeopardized. It is not just that we may have to go a certain way with physicists and behaviourists and admit that emotions have much to do with overt, public behaviour. This does have to be admitted. But some recent philosophical analyses of emotion-concepts[3] have shown that when, for instance, we say 'A feels remorse', 'B is indignant', 'C feels bitter', we do something far more complex than claim A and B

[3] See, particularly, E. Bedford, 'Emotions', *Proc. Aris. Soc.*, 1956–57; J. R. Jones, 'The Two Contexts of Mental Concepts', *Proc. Arist. Soc.*, 1958–59.

behave in certain identifiable ways and experience types of inner turmoil. Where is the extra complexity? Roughly speaking, it lies in the way concepts like 'remorse', 'indignation' give interpretations of a situation, interpretations that go beyond the recording of acts and feelings occurring at any particular moment. 'C feels bitter about the way he was treated' carries as part of its meaning 'C believes he *ought not* to have been so treated', 'C believes he was treated *badly*'. That is, being bitter involves making certain evaluations, not simply having feelings or acting in particular ways. It is logically impossible to *hope* for something one does not favourably evaluate; or to *feel contrition*, unless one acknowledges oneself to have done something wrong. Traditional accounts of emotion tended to give central place to determinate, recognizable *feelings*—inner and private. Emotion-words were the labels of these feelings. The current opinion refuses to give pride of place to such feelings, and (in the case of some writers) denies even the *existence* of feelings specific to particular emotions. Instead, their analyses are given in terms of situation-appraisals plus an undifferentiated general excitation.

In the rest of this article I want to draw on these recent analyses of emotion, to the extent that they seem sound and helpful. In other respects, however, we should regard them as being as much *sub judice* as our two accounts of how emotions are communicated.

First of all, they can be invoked to support and reinforce the view that emotional qualities can be in works of art. Suppose I read a poem or attend a drama. I say 'This is jolly', or 'this is pitiable'; and my judgment is possible only if I have made a conspectus, an overall survey of the situation presented, and deemed it appropriate to jollity or pity. Clearly, my judgment is an acknowledgment of qualities in the work itself. With a particular play, I may say 'No, not pitiable really'; and justify my remark by making value-judgments about the characters and situation concerned. 'He is not to be pitied: he is too much morally at fault.' The finale of an opera may ring false, because it simply has set aside all the pain and conflict that happened on the way to it. These, we judge, need to be reckoned with in the finale—as necessarily modifying, qualifying, its brash or headlong gaiety.

With emotional qualities like 'pitiable' or 'jolly' we are thinking of the presentation in a work of art of imagined human predicaments. These comprise the 'situations to be interpreted'. But a work of art *as a whole* may express a distinctive emotional quality, which is not simply that of the human predicaments it presents. Indeed, it may present none: or those it does present may be determined in their precise quality by stylistic factors and the individual handling of the medium. For instance, the emotional quality possessed by a human figure in an El Greco painting is determined both by the dramatic situation depicted and by the colouring, design and texture of the painting throughout.

We are, I think, exploring here one of the chief sources of aesthetic value—both within art and in aesthetic experience of natural objects and

events. First, within art: the complexity of the gestalts, the situation-conspectuses, the fusions of medium and human situations, all contribute to an unusually fine discrimination of emotional quality; and the savouring of this can be counted as one of the basic aesthetic worthwhileness.

On aesthetic experience outside art, two remarks may be offered. We could construct a scale on the following lines. At the one end are occasions when my emotions are based on awareness of only a minute part of my environment, and that sluggishly: or based on a stereotyped, generalized and meagre impression of it. I am sunk in apathy and passivity. I make no complex gestalt of my situation in its particularity. For example, I am aware only of the monotonous drumming of train-wheels, as I sit in my compartment. My emotion is a dull, undifferentiated depression. At the other end of the scale, my emotions are functions of an alert, active grasping of numerous features of my situation, held together as a single gestalt. In my compartment I make into one unity-of-feeling the train-wheels drumming, the lugubrious view from the window (steam and industrial fog), and the thought of meeting so-and-so, whom I dislike, at the end of my journey. My depression is highly particularized. Or again, if one is in love, an encounter with the loved one may acquire a specific, unrepeatable emotional quality—meeting so-and-so, on that particular day, in that particular park, with that wind and those exhilarating cumulus clouds overhead. Our scale, again, is a scale of increased emotional discrimination.

But as Kant reminds us, the world is not a given totality: my synopses can be complex but never complete. And it is one of the many distinctive things about works of art that our synopses of them can be complete: they are limited wholes, and in a great many cases wholes constructed so as to facilitate their being grasped synoptically. Disconsolate in the knowledge that synopses of nature are forever partial and ragged, we may turn to art in relief.

Especially important here are the contrast between apathetic and alert perception, between a sluggish, passive and stereotyped impression and the active enterprise of organizing and unifying a situation. This makes it obvious that however we finally decide to describe the spectators' emotions in aesthetic experience, it will not be simply in terms of emotion-transfusions. For that is a language of passivity—the spectator as suffering manipulation, as having an emotion conjured up in him.

Further: if we locate one source of aesthetic value in fineness of emotional discrimination, we have a second source in the sense of alert conspectus-grasping itself, in the exhilarating activity of unifying far larger and more variegated 'manifolds' than we are accustomed or able to do in ordinary experience.[4]

[4] On these themes see, particularly, H. Osborne, *Theory of Beauty*. Also relevant is my article 'Aesthetic Appreciation of Nature', *British Journal of Aesthetics*, 1963 (Vol. iii, No. 3).

I have indicated the bearing and relevance of these two observations to this study as a whole. It may be pointed out, however, that in the course of them I have

Some pages ago I invoked Coleridge to testify that one can 'see, not feel how beautiful' things are, and suggested a reasonable extension to seeing, not feeling emotional qualities of specific kinds. But this use of Coleridge comes dangerously close to being *mis*use. Coleridge *was* dejected: and surely with some reason. Yet why should he have been, if aesthetic appreciation on its emotional side is simply the recognition of emotional qualities as in objects? Coleridge compels us to make some qualification to our account so far. One is not always content to say 'This music has the emotional quality of exuberance, but I am not in any way stirred up by it'. This could very well be a discontented report; and the discontent can be of more than one kind. In some cases I may feel like a forlorn child looking through a window upon a party to which he has not been invited. Tiredness, anxiety, or some other psychological factors impair my responsiveness. Again, I might say 'I see what it is expressing, but it is too insipid to make a real impact on me'. I cannot feel that music as violent, fearsome or exuberant any more. Perhaps the music idiom has gone jaded on me, or is over-familiar: or it now sounds anaemic because of more powerful effects obtained by more recent musical developments.

It might be asked of this last case, Why not retain the language of recognizing emotional qualities here? If a work is insipid, that could count as a quality of it as it is perceived by us to-day. But this would not really meet the case. It is a loss of *impact* that we are lamenting: the work fails to rouse us—and this is undeniably causal language, unlike the language we have so far examined. So it looks as if the model with which we have been working will not meet all aesthetic requirements.

Confirming this suspicion is the existence of a small class of emotions about which we seem able to speak *only* in the language of stimulus-response, cause-effect. For instance, in talking of that famous surrealist fur-lined cup, we do not say 'This painting is sick, nauseated', but rather 'It makes me feel sick; it is nausea*ting*'. We speak similarly about giddiness: not 'This is a dizzy picture', but 'It makes one feel dizzy'—it is a dizzy-making picture.

The vocabulary of emotion-arousal may play a subordinate part in our talk of art-appreciation, but we seem unable to do without it. The two vocabularies (emotion-arousal and recognition of emotional quality) have interestingly different 'logics'. A conductor may say, while rehearsing an orchestra, 'Now, we'll take the vivacious passage once again—two bars after "M" '. Or, 'Clarinets, you made that lugubrious phrase sound almost skittish'. These and like remarks can be quite intelligible in their context, as they contain a reasonably clear descriptive content. But suppose the conductor says 'Now, back to the thrilling section again', or 'You messed

referred both to the recognition of emotional qualities and to the 'having' of emotions *tout court*. I have not, however, forgotten about the distinction between these: it is taken up again in what follows.

up the exciting (or overwhelming) passage', members of the orchestra may well disagree over which bars are meant. That is to say, these emotion-words contain far less descriptive content, are in fact not emotional-quality words but response-to-stimulus words. We sense an oddness when someone says in a casual, unmoved voice (but without intending sarcasm), 'Yes, that was a sublime movement, wasn't it?' And we could add to the list of such words, 'awesome', 'frightening', 'dreadful', 'harrowing,' 'touching', 'exhilarating', 'hilarious', in most senses: all of which report on the successful arousal of emotion, not merely on the detection of an emotional quality. It is more logically odd to say 'That was exciting, overwhelming, music, but it didn't in the least excite me or make me feel overwhelmed' than to say 'That was tender, or sad, music, but I did not myself feel tender or sad'. With ingenuity, no doubt, contexts could sometimes be found that would mitigate the oddness. It is over-simple to speak of two quite distinct vocabularies, for there are shadings, gradations, from one to the other.

And there are still other sorts of complexity. For instance, I may *recognize* in a painting the emotional quality of pathos, yet for some reason—perhaps because the painting too directly or crudely seeks to move me, because it rants or is sentimental—I feel not pathos nor any analogous emotion, but resentment instead. This would be not just another example of failing to be moved, but of being moved in a direction opposed to the emotional quality of the work, of emotionally resisting it. Alternatively and more happily, I may *submit* to a work of art, acquiesce, be in sympathy with its expression or portrayal of an emotion, whether or not I have the emotion aroused in me subsequently.

'Seeing, not feeling' can be sometimes an aesthetic impoverishment, sometimes normality. It is furthermore quite clear from reports upon aesthetic experience that individuals differ greatly in what proportions of 'recognition' and 'arousal' they judge to be acceptable to themselves in their traffic with works of art; how far lack of excitation is taken as a deficiency, a ground of 'dejection', or how far it is welcome as facilitating a calm awareness of the work of art, enjoyed but at the same time 'distanced'. To do more than note this, however, would involve leaving a philosophical, conceptual study for an empirical, psychological one.

It should be emphasized that to admit the role of emotion-arousal is not to contradict the earlier claim that emotional experience in art is an *active* affair, and not a matter of passively receiving emotion transfusions. There is certainly a passive element in emotion-arousal. Crudely, one wants to say it is what the music, poem, painting does to you, rather than what qualities you discern in it. But only very crudely and misleadingly: for inattentiveness, failure to grasp (actively) the full range of qualities offered to perception in the work, ensures that the emotions actually generated will be only loosely related to the particular work. If it is the work that is to command and control them, the work must be fully present to my consciousness.

To people who wish to deny the occurrence of a host of qualitatively specific inner feelings evoked in a spectator there must be a great attractiveness in an analysis worked out in terms of emotional qualities alone. For that model suggests that the host of nameless spectator-feelings can be replaced by an indefinitely large range of phenomenally different 'looks', patterns of words, shapes or sounds, I want now to argue, however, that we cannot deny the occurrence of highly particularized (and aesthetically relevant) feelings: that to have such feelings is not the same thing as to apprehend looks, aspects and situations, nor is it that plus an undifferentiated excitement.

First, let us deal with the complaint that the hosts of nameless feelings are postulated purely *ad hoc* by theorists attempting to patch up bad theories that seem to require them. Perhaps some of the theories are bad: but to make this complaint is not to demonstrate that no such specific feelings exist. Emotions, agitations, feelings of various kinds get themselves named, only when there is some utilitarian point in their having names—particularly if they tend to recur frequently in ordinary human experience. But, as we earlier reminded ourselves, art deals very little in the repetitive and stereotyped. Its slant on the world is often in striking contrast to that of workaday utility. The probability, then, is that its emotions should show the same contrast: their namelessness is no argument for their non-existence.

Are there such qualitatively distinctive, highly particularized feelings? Some people's aesthetic experience, including mine, prompts the answer, yes. It is difficult to say much more than that. Only introspection can confirm or rebut such a claim. Argument cannot. But if someone hesitates to admit such qualitatively distinctive feelings in art, it may be worth directing his attention for a moment to dream-experience. For the same distinctiveness can also sometimes be found there. If we agreed about dreams, we might in the end carry the insight back into art. With the forms in a dream there may go a feeling peculiar to that dream, one that is quite definitely aroused, not merely recognized as an emotional quality. On waking, I may recall the forms, the dream-events, savouring their character and 'look', and yet lose memory of the precise feeling they evoked; and I may *know* that I have lost it. On other occasions I may be haunted by the feeling, the unnameable particular foreboding or exaltation or whatever it was, and lose altogether the 'look' of the dream-shapes that originally touched it off. *Mutatis mutandis*, the same can be true of the look and the feeling aroused by a peculiarly haunting melody, poem or painting. I recall the notes and the character of a musical phrase, but know very well that it no longer evokes the same poignant and not elsewhere obtainable emotional response that it once did evoke. I can individuate my emotion to the extent of saying 'I once had it: it is now lost: I am trying to recapture it'. I can attain *half*-descriptions of it—'strange, remote, nostalgic', but I utter the words aware of their inadequacy, and

using them only as hook and bait for the return of the unique experience itself. 'Looks' can be imaged, a painting recalled in memory, a tune 'heard in the mind's ear'; general and familiar human emotions can be imaged; but the only way in which these highly specific feelings can be recalled is by actual *revival*, by re-experiencing the feelings themselves, with more or less intensity. These differences should prevent their being assimilated either to the recognition of looks and sound-patterns or to the arousal of emotions that can be analysed in terms of general excitation plus situation-appraisal. This, of course, leaves on our agenda the vexing question, how exactly to analyse the relation between the 'looks' and the 'feelings', a question which the look-recognition theory must judge confused, but which I see no way of eliminating.

To summarize:

(i) Of the two ways of speaking—the evocation of emotion and the recognition of emotional qualities—the latter is truer to our actual experience in probably a majority of aesthetic contexts.

(ii) Yet a significant place needs to be left in aesthetic theory also for the *arousal* of emotion.

(iii) This leads us to ask 'What is it for an emotion to be aroused in one?' Sometimes this may mean that one interprets a situation in a particular way and experiences a general excitement. But this analysis fits not every case. Although excitement may often be undifferentiated, it sometimes is most highly particularized, and this differentiation is taken very often to be one source of aesthetic value.[5]

[5] Since this article was first published, a considerable amount of new writing on its topics has been appearing, both in philosophical psychology and aesthetics (e.g. H. Osborne in the *British Journal of Aesthetics*, 1963 (Vol. iii, No. 1)). To comment on these adequately here, however, would have buried the original article under qualifications and addenda.

FRANK N. SIBLEY
AESTHETIC CONCEPTS

Frank Sibley is Professor of Philosophy at The University of Lancaster, England.

The remarks we make about works of art are of many kinds. For the purpose of this paper I wish to indicate two broad groups. I shall do this by examples. We say that a novel has a great number of characters and deals with life in a manufacturing town; that a painting uses pale colors, predominantly blues and greens, and has kneeling figures in the foreground; that the theme in a fugue is inverted at such a point and that there is a stretto at the close; that the action of a play takes place in the span of one day and that there is a reconciliation scene in the fifth act. Such remarks may be made by, and such features pointed out to, anyone with normal eyes, ears, and intelligence. On the other hand, we also say that a poem is tightly-knit or deeply moving; that a picture lacks balance, or has a certain serenity and repose, or that the grouping of the figures sets up an exciting tension; that the characters in a novel never really

Reprinted from *The Philosophical Review*, Vol. LXVIII (October, 1959), pp. 351–373, by permission of the Editor and Professor Frank Sibley.

come to life, or that a certain episode strikes a false note. It would be natural enough to say that the making of such judgments as these requires the exercise of taste, perceptiveness, or sensitivity, of aesthetic discrimination or appreciation; one would not say this of my first group. Accordingly, when a word or expression is such that taste or perceptiveness is required in order to apply it, I shall call it an *aesthetic* term of expression, and I shall, correspondingly, speak of *aesthetic* concepts or *taste* concepts.[1]

Aesthetic terms span a great range of types and could be grouped into various kinds and sub-species. But it is not my present purpose to attempt any such grouping; I am interested in what they all have in common. Their almost endless variety is adequately displayed in the following list: *unified, balanced, integrated, lifeless, serene, somber, dynamic, powerful, vivid, delicate, moving, trite, sentimental, tragic.* The list of course is not limited to adjectives; expressions in artistic contexts like *telling contrast, sets up a tension, conveys a sense of,* or *holds it together* are equally good illustrations. It includes terms used by both layman and critic alike, as well as some which are mainly the property of professional critics and specialists.

I have gone for my examples of aesthetic expressions in the first place to critical and evaluative discourse about works of art because it is there particularly that they abound. But now I wish to widen the topic; we employ terms the use of which requires an exercise of taste not only when discussing the arts but quite liberally throughout discourse in everyday life. The examples given above are expressions which, appearing in critical contexts, most usually, if not invariably, have an aesthetic use; outside critical discourse the majority of them more frequently have some other use unconnected with taste. But many expressions do double duty even in everyday discourse, sometimes being used as aesthetic expressions and sometimes not. Other words again, whether in artistic or daily discourse, function only or predominantly as aesthetic terms; of this kind are *graceful, delicate, dainty, handsome, comely, elegant, garish.* Finally, to make the contrast with all the preceding examples, there are many words which are seldom used as aesthetic terms at all: *red, noisy, brackish, clammy, square, docile, curved, evanescent, intelligent, faithful, derelict, tardy, freakish.*

Clearly, when we employ words as aesthetic terms we are often making and using metaphors, pressing into service words which do not primarily function in this manner. Certainly, also, many words *have come* to be aesthetic terms by some kind of metaphorical transference. This is so with

[1] I shall speak loosely of an "aesthetic term," even when, because the word sometimes has other uses, it would be more correct to speak of its *use as* an aesthetic term. I shall also speak of "non-aesthetic" words, concepts, features, and so on. None of the terms other writers use, "natural," "observable," "perceptual," "physical," "objective" (qualities), "neutral," "descriptive" (language), when they approach the distinction I am making, is really apt for my purpose.

those like "dynamic," "melancholy," "balanced," "tightly-knit" which, except in artistic and critical writings, are not normally aesthetic terms. But the aesthetic vocabulary must not be thought wholly metaphorical. Many words, including the most common *(lovely, pretty, beautiful, dainty, graceful, elegant)*, are certainly not being used metaphorically when employed as aesthetic terms, the very good reason being that this is their primary or only use, some of them having no current non-aesthetic uses. And though expressions like "dynamic," "balanced," and so forth *have come* by a metaphorical shift to be aesthetic terms, their employment in criticism can scarcely be said to be more than quasi-metaphorical. Having entered the language of art description and criticism as metaphors they are now standard vocabulary in that language.[2]

The expressions I am calling aesthetic terms form no small segment of our discourse. Often, it is true, people with normal intelligence and good eyesight and hearing lack, at least in some measure, the sensitivity required to apply them; a man need not be stupid or have poor eyesight to fail to see that something is graceful. Thus taste or sensitivity is somewhat more rare than certain other human capacities; people who exhibit a sensitivity both wide-ranging and refined are a minority. It is over the application of aesthetic terms, too, that, notoriously, disputes and differences sometimes go helplessly unsettled. But almost everybody is able to exercise taste to some degree and in some matters. It is surprising therefore that aesthetic terms have been so largely neglected. They have received glancing treatment in the course of other aesthetic discussions; but as a broad category they have not received the direct attention they merit.

The foregoing has marked out the area I wish to discuss. One warning should perhaps be given. When I speak of taste in this paper, I shall not be dealing with questions which center upon expressions like "a matter of taste" (meaning, roughly, a matter of personal preference or liking). It is with an ability to *notice* or *see* or *tell that* things have certain qualities that I am concerned.

I

In order to support our application of an aesthetic term, we often refer to features the mention of which involves other aesthetic terms: "it has an extraordinary vitality because of its free and vigorous style of drawing," "graceful in the smooth flow of its lines," "dainty because of the delicacy and harmony of its coloring." It is as normal to do this as it is to justify

[2] A contrast will reinforce this. If a critic were to describe a passage of music as chattering, carbonated, or gritty, a painter's coloring as vitreous, farinaceous, or effervescent, or a writer's style as glutinous, or abrasive, he *would* be using live metaphors rather than drawing on the more normal language of criticism. Words like "athletic," "vertiginous," "silken" may fall somewhere between.

one mental epithet by other epithets of the same general type, *intelligent* by *ingenious, inventive, acute*, and so on. But often when we apply aesthetic terms, we explain why by referring to features which do *not* depend for their recognition upon an exercise of taste: "delicate because of its pastel shades and curving lines," or "it lacks balance because one group of figures is so far off to the left and is so brightly illuminated." When no explanation of this latter kind is offered, it is legitimate to ask or search for one. Finding a satisfactory answer may sometimes be difficult, but one cannot ordinarily reject the question. When we cannot ourselves quite say what non-aesthetic features make something delicate or unbalanced or powerful or moving, the good critic often puts his finger on something which strikes us as the right explanation. In short, aesthetic terms always ultimately apply because of, and aesthetic qualities always ultimately depend upon, the presence of features which, like curving or angular lines, color contrasts, placing of masses, or speed of movement, are visible, audible, or otherwise discernible without any exercise of taste or sensibility. Whatever kind of dependence this is, and there are various relationships between aesthetic qualities and non-aesthetic features, what I want to make clear in this paper is that there are no non-aesthetic features which serve in *any* circumstances as logically *sufficient conditions* for applying aesthetic terms. Aesthetic or taste concepts are not in *this* respect condition-governed at all.

There is little temptation to suppose that aesthetic terms resemble words, which, like "square," are applied in accordance with a set of necessary and sufficient conditions. For whereas each square is square in virtue of the *same* set of conditions, four equal sides and four right angles, aesthetic terms apply to widely varied objects; one thing is graceful because of these features, another because of those, and so on almost endlessly. In recent times philosophers have broken the spell of the strict necessary-and-sufficient model by showing that many everyday concepts are not of that type. Instead, they have described various other types of concepts which are governed only in a much looser way by conditions. However, since these newer models provide satisfactory accounts of many familiar concepts, it might plausibly be thought that aesthetic concepts are of some such kind and that they similarly are governed in some looser way by conditions. I want to argue that aesthetic concepts differ radically from any of these other concepts.

Amongst these concepts to which attention has recently been paid are those for which no *necessary-and-sufficient* conditions can be provided, but for which there are a number of relevant features, A, B, C, D, E, such that the presence of some groups or combinations of these features is *sufficient* for the application of the concept. The list of relevant features may be an open one; that is, given A, B, C, D, E, we may not wish to close off the possible relevance of other unlisted features beyond E. Examples of

such concepts might be "dilatory," "discourteous," "possessive," "capricious," "prosperous," "intelligent" (but see below [p. 580]). If we begin a list of features relevant to "intelligent" with, for example, ability to grasp and follow various kinds of instructions, ability to master facts and marshall evidence, ability to solve mathematical or chess problems, we might go on adding to this list almost indefinitely.

However, with concepts of this sort, although decisions may have to be made and judgment exercised, it is always possible to extract and state, from cases which have already been clearly decided, the sets of features or conditions which were regarded as sufficient in those cases. These relevant features which I am calling conditions are, it should be noted, features which, though not sufficient *alone* and needing to be combined with other similar features, nevertheless carry some weight and can count only in one direction. Being a good chess player can count only *towards* and not *against* intelligence. Whereas mention of it may enter sensibly along with other remarks in expressions like "I say he is intelligent because . . ." or "the reason I call him intelligent is that . . . ," it cannot be used to complete such negative expressions as "I say he is *un*intelligent because. . . ." But what I want particularly to emphasize about features which function as conditions for a term is that *some* group or set of them *is* sufficient fully to ensure or warrant the application of that term. An individual characterized by some of these features may not yet qualify to be called lazy or intelligent, and so on, beyond all question, but all that is needed is to add some further (indefinite) number of such characterizations and a point is reached where we have enough. There are individuals possessing a number of such features of whom one cannot deny, cannot but admit, that they are intelligent. We have left necessary-and-sufficient conditions behind, but we are still in the realm of sufficient conditions.

But aesthetic concepts are not condition-governed even in this way. There are no sufficient conditions, no non-aesthetic features such that the presence of some set or number of them will beyond question logically justify or warrant the application of an aesthetic term. It is impossible (barring certain limited exceptions, see below [p. 582]) to make any statements corresponding to those we can make for condition-governed words. We are able to say "If it is true he can do this, and that, and the other, then one just cannot deny that he is intelligent," or "if he does A, B, and C, I don't see how it can be denied that he is lazy," but we cannot make *any* general statement of the form "If the vase is pale pink, somewhat curving, lightly mottled, and so forth, it will be delicate, cannot but be delicate." Nor again can one say *any* such things here as "Being tall and thin is not enough *alone* to ensure that a vase is delicate, but if it is, for example, slightly curving and pale colored (and so forth) as well, it cannot be denied that it is." Things may be described to us in non-aesthetic terms as fully as we please but we are not thereby put in the position of

having to admit (or being unable to deny) that they are delicate or graceful or garish or exquisitely balanced.[3]

No doubt there are some respects in which aesthetic terms *are* governed by conditions or rules. For instance, it may be impossible that a thing should be garish if all its colors are pale pastels, or flamboyant if all its lines are straight. There may be, that is, descriptions using only non-aesthetic terms which are incompatible with descriptions employing certain aesthetic terms. If I am told that a painting in the next room consists solely of one or two bars of very pale blue and very pale grey set at right angles on a pale fawn ground, I can be sure that it cannot be fiery or garish or gaudy or flamboyant. A description of this sort may make certain aesthetic terms *in*applicable or *in*appropriate; and if from this description I inferred that the picture was, or even might be, fiery or gaudy or flamboyant, this might be taken as showing a failure to understand these words. I do not wish to deny therefore that taste concepts may be governed *negatively* by conditions.[4] What I am emphasizing is that they quite lack governing conditions of a sort many other concepts possess. Though on *seeing* the picture we might say, and rightly, that it is delicate or serene or restful or sickly or insipid, no *description* in non-aesthetic terms permits us to claim that these or any other aesthetic terms must undeniably apply to it.

I have said that if an object is characterized *solely* by certain sorts of features this may count decisively against the possibility of applying to it certain aesthetic terms. But of course the presence of *some* such features need not count decisively; other features may be enough to outweigh those which, on their own, would render the aesthetic term inapplicable. A painting might be garish even though much of its color is pale. These facts call attention to a further feature of taste concepts. One *can* find general features or descriptions which in some sense count in one direction only, only *for* or only *against* the application of certain aesthetic terms. Angularity, fatness, brightness, or intensity of color are typically

[3] In a paper reprinted in *Aesthetics and Language*, ed. by W. Elton (Oxford, 1954), pp. 131–146, Arnold Isenberg discusses certain problems about aesthetic concepts and qualities. Like others who approach these problems, he does not isolate them, as I do, from questions about verdicts on the *merits* of works of art, or from questions about *likings* and *preferences*. He says something parallel to my remarks above: "There is not in all the world's criticism a single purely descriptive statement concerning which one is prepared to say beforehand, 'if it is true, I shall *like* that work so much the better'" (p. 139, my italics). I should think *this* is highly questionable.

[4] Isenberg (*op. cit.*, p. 132) makes a somewhat similar but mistaken point: "If we had been told that the colours of a certain painting are garish, it would be *astonishing* to find that they are *all* very pale and unsaturated" (my italics). But if we say "all" rather than "predominantly," then "astonishing" is the wrong word. The word that goes with "all" is "impossible"; "astonishing" might go with "predominantly."

not associated with delicacy or grace. Slimness, lightness, gentle curves, lack of intensity of color are associated with delicacy, but not with flamboyance, majesty, grandeur, splendor or garishness. This is shown by the naturalness of saying, for example, that someone is graceful *because* she's so light, but, *in spite of* being quite angular or heavily built; and by the corresponding oddity of saying that something is graceful *because* it is so heavy or angular, or delicate *because* of its bright and intense coloring. This may therefore sound quite similar to what I have said already about conditions in discussing terms like "intelligent." There are nevertheless very significant differences. Although there is this sense in which slimness, lightness, lack of intensity of color, and so on, count only towards, not against, delicacy, these features, I shall say, at best count only *typically* or *characteristically* towards delicacy. They do not count towards in the same sense as condition-features count towards laziness or intelligence; that is, no group of them is ever logically sufficient.

One way of reinforcing this is to notice how features which are characteristically associated with one aesthetic term may also be similarly associated with other and rather different aesthetic terms. "Graceful" and "delicate" may be on the one hand sharply contrasted with terms like "violent," "grand," "fiery," "garish," or "massive" which have characteristic non-aesthetic features quite unlike those for "delicate" and "graceful." But on the other hand "graceful" and "delicate" may also be contrasted with aesthetic terms which stand much closer to them, like "flaccid," "weakly," "washed out," "lanky," "anaemic," "wan," "insipid"; and the range of features characteristic of *these* qualities, pale color, slimness, lightness, lack of angularity and sharp contrast, is virtually identical with the range of "delicate" and "graceful." Similarly many of the features typically associated with "joyous," "fiery," "robust," or "dynamic" are identical with those associated with "garish," "strident," "turbulent," "gaudy," or "chaotic." Thus an object which is described very fully, but exclusively in terms of qualities characteristic of delicacy, may turn out on inspection to be not delicate at all, but anaemic or insipid. The failures of novices and the artistically inept prove that quite close similarity in point of line, color, or technique gives no assurance of gracefulness or delicacy. A failure and a success in the manner of Degas may be generally more alike, so far as their non-aesthetic features go, than either is like a successful Fragonard. But it is not necessary to go even this far to make my main point. A painting which has only the kind of features one would associate with vigor and energy but which even so fails to be vigorous and energetic *need* not have some other character, need not be instead, say, strident or chaotic. It may fail to have any particular character whatever. It may employ bright colors, and the like, without being particularly lively and vigorous at all; but one may feel unable to describe it as chaotic or strident or garish either. It is, rather, simply lacking in character

(though of course this too is an aesthetic judgment; taste is exercised also in seeing that the painting has no character).

There are of course many features which do not in these ways characteristically count for (or against) particular aesthetic qualities. One poem has strength and power because of the regularity of its meter and rhyme; another is monotonous and lacks drive and strength because of its regular meter and rhyme. We do not feel the need to switch from "because of" to "in spite of." However, I have concentrated upon features which are characteristically associated with aesthetic qualities because, if a case could be made for the view that taste concepts are in any way governed by sufficient conditions, these would seem to be the most promising candidates for governing conditions. But to say that features are associated only *characteristically* with an aesthetic term *is* to say that they can never amount to sufficient conditions; no description however full, even in terms characteristic of gracefulness, puts it beyond question that something is graceful in the way a description may put it beyond question that someone is lazy or intelligent.

It is important to observe, however, that in this paper I am not merely claiming that no sufficient conditions can be stated for taste concepts. For if this were all, taste concepts might not be after all really different from one kind of concept recently discussed. They could be accommodated perhaps with those concepts which Professor H. L. A. Hart has called "defeasible"; it is a characteristic of defeasible concepts that we cannot state sufficient conditions for them because, for any sets we offer, there is always an (open) list of defeating conditions any of which might rule out the application of the concept. The most we can say schematically for a defeasible concept is that, for example, A, B, and C together are sufficient for the concept to apply *unless* some feature is present which overrides or voids them. But, I want to emphasize, the very fact that we *can* say this sort of things shows that we are still to that extent in the realm of conditions.[5] The features governing defeasible concepts can ordinarily count only one way, *either* for *or* against. To take Hart's example, "offer" and "acceptance" can count only towards the existence of a valid contract, and fraudulent misrepresentations, duress, and lunacy can count only against. And even with defeasible concepts, if we are told that there are no voiding features present, we can know that some set of conditions or features, A, B, C, . . . is enough, in this absence of voiding features, to ensure, for example, that there is a contract. The very notion of a defeasible concept seems to require that some group of features *would* be sufficient *in certain circumstances*, that is, in the absence of overriding or voiding features. In a certain way defeasible concepts lack sufficient conditions then, but they

[5] H. L. A. Hart, "The Ascription of Responsibility and Rights" in *Logic and Language*, First Series, ed. by A. G. N. Flew (Oxford, 1951). Hart indeed speaks of "conditions" throughout, see p. 148.

are still, in the sense described, condition-governed. My claim about taste concepts is stronger; that they are not, except negatively, governed by conditions at all. We could not conclude even *in certain circumstances*, e.g., if we were told of the absence of all "voiding" or uncharacteristic features (no angularities, and the like), that an object *must* certainly be graceful, no matter how fully it was described to us as possessing features characteristic of gracefulness.

My arguments and illustrations so far have been rather simply schematic. Many concepts, including most of the examples I have used *(intelligent,* and so on [p. 576]), are much more thoroughly open and complex than my illustrations suggest. Not only may there be an open list of relevant conditions; it may be impossible to give precise rules telling how many features from the list are needed for a sufficient set or in which combinations; impossible similarly to give precise rules covering the extent or degree to which such features need to be present in those combinations. Indeed, we may have to abandon as futile any attempt to describe or formulate anything like a complete set of precise conditions or rules, and content ourselves with giving only some general account of the concept, making reference to samples or cases or precedents. We cannot fully master or employ these concepts therefore *simply* by being equipped with lists of conditions, readily applicable procedures or sets of rules, however complex. For to exhibit a mastery of one of these concepts we must be able to go ahead and apply the word correctly to new individual cases, at least to central ones; and each new case may be a uniquely different object, just as each intelligent child or student may differ from others in relevant features and exhibit a unique combination of kinds and degrees of achievement and ability. In dealing with these new cases mechanical rules and procedures would be useless; we have to exercise our judgment, guided by a complex set of examples and precedents. Here then there is a marked *superficial* similarity to aesthetic concepts. For in using aesthetic terms too we learn from samples and examples, not rules, and we have to apply them, likewise, without guidance by rules or readily applicable procedures, to new and unique instances. Neither kind of concept admits of a simply "mechanical" employment.

But this is *only* a superficial similarity. It is at least noteworthy that in applying words like "lazy" or "intelligent" to new and unique instances we say that we are required to exercise *judgment;* it would be indeed odd to say that we are exercising *taste.* In exercising judgment we are called upon to weigh the pros and cons against each other, and perhaps sometimes to decide whether a quite new feature is to be counted as weighing on one side or on the other. But this goes to show that, though we may learn from and rely upon samples and precedents rather than a set of stated conditions, we are not out of the realm of general conditions and guiding principles. These precedents necessarily embody, and are used by us to illustrate, a complex web of governing and relevant conditions which

it is impossible to formulate completely. To profit by precedents we have to understand them; and we must argue consistently from case to case. This is the very function of precedents. Thus it is possible, even with these very loosely condition-governed concepts, to take clear or paradigm cases of X and to say "this is X because . . . ," and follow it up with an account of features which logically clinch the matter.

Nothing like this is possible with aesthetic terms. Examples undoubtedly play a crucial role in giving us a grasp of these concepts; but we do not and cannot derive from these examples conditions and principles, however complex, which will enable us if we are consistent, to apply the terms even to some new cases. And when, with a clear case of something which *is* in fact graceful or balanced or tightly-knit but which I have not seen, someone tells me why it is, what features make it so, it is always possible for me to wonder whether, in spite of these features, it really is graceful, balanced, and so on. No such features logically clinch the matter.

The point I have argued may be reinforced in the following way. A man who failed to realize the nature of aesthetic concepts, or someone who, knowing that he lacked sensitivity in aesthetic matters, did not want to reveal this lack might by assiduous application and shrewd observation provide himself with some rules and generalizations; and by inductive procedures and intelligent guessing, he might frequently say the right things. But he could have no great confidence or certainty; a slight change in an object might at any time unpredictably ruin his calculations, and he might as easily have been wrong as right. No matter how careful he has been about working out a set of consistent principles and conditions, he is only in a position to think that the object is very possibly delicate. With concepts like *lazy*, *intelligent*, or *contract*, someone who intelligently formulated rules that led him aright appreciably often *would* thereby show the beginning of a grasp of those concepts; but the person we are considering is not even beginning to show an awareness of what delicacy is. Though he sometimes says the right thing, he has not seen, but guessed, that the object is delicate. However intelligent he might be, we could easily tell him wrongly that something was delicate and "explain" why without his being able to detect the deception. (I am ignoring complications now about negative conditions.) But if we did the same with, say, "intelligent" he could at least often uncover some incompatibility or other which would need explaining. In a world of beings like himself he would have no use for concepts like delicacy. As it is, these concepts would play a quite different role in his life. He would, for himself, have no more reason to choose tasteful objects, pictures, and so on, than a deaf man would to avoid noisy places. He could not be praised for exercising taste; at best his ingenuity and intelligence might come in for mention. In "appraising" pictures, statuettes, poems, he would be doing something quite different from what other people do when they exercise taste.

At this point I want to notice in passing that there are times when it

may look as if an aesthetic word could be applied according to a rule. These cases vary in type; I shall mention only one. One might say, in using "delicate" of glassware perhaps, that the thinner the glass, other things being equal, the more delicate it is. Similarly, with fabrics, furniture, and so on, there are perhaps times when the thinner or more smoothly finished or more highly polished something is, the more certainly some aesthetic term or other applies. On such occasions someone might formulate a rule and follow it in applying the word to a given range of articles. Now it may be that sometimes when this is so, the word being used is not really an aesthetic term at all; "delicate" applied to glass in this way may at times really mean no more than "thin" or "fragile." But this is certainly not always the case; people often *are* exercising taste even when they say that glass is very delicate because it is so thin, and know that it would be less so if thicker and more so if thinner. These instances where there appear to be rules are peripheral cases of the use of aesthetic terms. If someone did merely follow a rule we should not say he was exercising taste, and we should hesitate to admit that he had any real notion of delicacy until he satisfied us that he could discern it in other instances where no rule was available. In any event, these occasions when aesthetic words can be applied by rule are exceptional, not central or typical, and there is still no reason to think we are dealing with a logical entailment.[6]

It must not be thought that the impossibility of stating any conditions (other than negative) for the application of aesthetic terms results from an accidental poverty or lack of precision in language, or that it is simply a question of extreme complexity. It is true that words like "pink,"

[6] I cannot in the compass of this paper discuss the other types of apparent exceptions to my thesis. Cases where a man *lacking* in sensitivity might learn and follow a rule, as above, ought to be distinguished from cases where someone who *possesses* sensitivity might know, from a non-aesthetic description, that an aesthetic term applies. I have stated my thesis as though this latter kind of case never occurs because I have had my eye on the logical features of *typical* aesthetic judgments and have preferred to over- rather than understate my view. But with certain aesthetic terms, especially negative ones, there may perhaps be some rare genuine exceptions when a description enables us to visualize very fully, and when what is described belongs to certain restricted classes of things, say human faces or animal forms. Perhaps a description like "One eye red and rheumy, the other missing, a wart-covered nose, a twisted mouth, a greenish pallor" may justify in a strong sense ("must be," "cannot but be") the judgments "ugly" or "hideous." If so, such cases are marginal, form a very small minority, and are uncharacteristic or atypical of aesthetic judgments in general. Usually when, on hearing a description, we say "it *must* be very beautiful (graceful, or the like)," we mean no more than "it surely must be, it's only remotely possible that it isn't." Different again are situations, and these are very numerous, where we can move quite simply from "bright colors" to "gay," or from "reds and yellows" to "warm," but where we are as yet only on the borderline of anything that could be called an expression of taste or aesthetic sensibility. I have stressed the importance of this transitional and border area between non-aesthetic and obviously aesthetic judgments ([p. 592]).

"bluish," "curving," "mottled," do not permit of anything like a specific naming of each and every varied shade, curve, mottling, and blending. But if we were to give special names much more liberally than either we or even the specialists do (and no doubt there are limits beyond which we could not go), or even if, instead of names, we were to use vast numbers of specimens and samples of particular shades, shapes, mottlings, lines, and configurations, it would still be impossible, and for the same reasons, to supply any conditions.

We do, indeed, in talking about a work of art, concern ourselves with its individual and specific features. We say that it is delicate not simply because it is in pale colors but because of *those* pale colors, that it is graceful not because its outline curves slightly but because of *that* particular curve. We use expressions like "because of *its* pale coloring," "because of *the* flecks of bright blue," "because of *the* way the lines converge" where it is clear we are referring not to the presence of general features but to very specific and particular ones. But it is obvious that even with the help of precise names, or even samples and illustrations, of particular shades of color, contours and lines, any attempt to state conditions would be futile. After all, the very same feature, say a color or shape or line of a particular sort, which helps make one work may quite spoil another. "It would be quite delicate if it were not for that pale color there" may be said about the very color which is singled out in another picture as being largely responsible for its delicate quality. No doubt one way of putting this is to say that the features which make something delicate or graceful, and so on, are combined in a peculiar and unique way; that the aesthetic quality depends upon exactly this individual or unique combination of just these specific colors and shapes so that even a slight change might make all the difference. Nothing is to be achieved by trying to single out or separate features and generalizing about them.

I have now argued that in certain ways aesthetic concepts are not and cannot be condition- or rule-governed.[7] Not to be so governed is one of their essential characteristics. In arguing this I first claimed in a general way that no non-aesthetic features are possible candidates for conditions, and then considered more particularly both the "characteristic" *general*

[7] Helen Knight says (Elton, *op. cit.*, p. 152) that "piquant" (one of my "aesthetic" terms) "depends on" various features (a *retroussé* nose, a pointed chin, and the like), and that these features are *criteria* for it; this second claim is what I am denying. She also maintains that "good," when applied to works of art, depends on *criteria* like balance, solidity, depth, profundity (my aesthetic terms again; I should place piquancy in this list). I would deny this too, though I regard it as a different question and do not consider it in this paper. The two questions need separating: the relation of non-aesthetic features (*retroussé*, pointed) to aesthetic qualities, and the relation of aesthetic qualities to "aesthetically good" (verdicts). Most writings which touch on the nature of aesthetic concepts have this other (verdict) question mainly in mind. Mrs. Knight blurs this difference when she says, for example, " 'piquant' is the same kind of word as 'good.' "

features associated with aesthetic terms and the individual or *specific* features found in particular objects. I have not attempted to examine what relationship these specific features of a work do bear to its aesthetic qualities. An examination of the locutions we use when we refer to them in the course of explaining or supporting our application of an aesthetic term reinforces with linguistic evidence the fact that we are certainly not offering them as explanatory or justifying *conditions*. When we are asked why we say a certain person is lazy or intelligent or courageous, we are being asked in virtue of what we *call* him this; we reply with "because of the way he regularly leaves his work unfinished," or "because of the ease with which he handles such and such problems," and so on. But when we are asked to say why, in our opinion, a picture lacks balance or is somber in tone, or why a poem is moving or tightly organized, we are doing a different kind of thing. We may use similar locutions: "his verse has strength and variety *because of the way* he handles the meter and employs the caesura," or "it is nobly austere *because of* the lack of detail and the restricted palette." But we can also express what we want to by using quite other expressions: "it is the handling of meter and caesura which is *responsible for* its strength and variety," "its nobly austere quality is *due to* the lack of detail and the use of a restricted palette," "its lack of balance *results from* the highlighting of the figures on the left," "those minor chords *make it* extremely moving," "those converging lines *give it* an extraordinary unity." These are locutions we cannot switch to with "lazy" or "intelligent"; to say *what makes* him lazy, what is *responsible for* his laziness, what it is *due to*, is to broach another question entirely.

One after another, in recent discussions, writers have insisted that aesthetic judgments are not "mechanical": "Critics do not formulate general standards and apply these mechanically to all, or to classes of, works of art." "Technical points can be settled rapidly, by the application of rules," but aesthetic questions "cannot be settled by any mechanical method." Instead, these writers on aesthetics have emphasized that there is no "subsitute for individual judgment" with its "spontaneity and speculation" and that "The final standard . . . [is] the judgment of personal taste."[8] What is surprising is that, though such things have been repeated again and again, no one seems to have said what is meant by "taste" or by the word "mechanical." There are many judgments besides those requiring taste which demand "spontaneity" and "individual judgment" and are not "mechanical." Without a detailed comparison we cannot see in what particular way aesthetic judgments are not "mechanical," or how they differ from those other judgments, nor can we begin to specify what taste is. This I have attempted. It is a characteristic and essential feature of judgments

[8] See articles by Margaret Macdonald and J. A. Passmore in Elton, *op. cit.*, pp. 118, 119, 40, 41.

which employ an aesthetic term that they cannot be made by appealing, in the sense explained, to non-aesthetic conditions.[9] This, I believe, is a logical feature of aesthetic or taste judgments in general, though I have argued it here only as regards the more restricted range of judgments which employ aesthetic terms. It is part of what "taste" means.

II

A great deal of work remains to be done on aesthetic concepts. In the remainder of this paper I shall offer some further suggestions which may help towards an understanding of them.

The realization that aesthetic concepts are governed only negatively by conditions is likely to give rise to puzzlement over how we manage to apply the words in our aesthetic vocabulary. If we are not following rules and there are no conditions to appeal to, how are we to know when they are applicable? One very natural way to counter this question is to point out that some other sorts of concepts also are not condition-governed. We do not apply simple color words by following rules or in accordance with principles. We see that the book is red by looking, just as we tell that the tea is sweet by tasting it. So too, it might be said, we just see (or fail to see) that things are delicate, balanced, and the like. This kind of comparison between the exercise of taste and the use of the five senses is indeed familiar; our use of the word "taste" itself shows that the comparison is age-old and very natural. Yet whatever the similarities, there are great dissimilarities too. A careful comparison cannot be attempted here though it would be valuable; but certain differences stand out, and writers who have emphasized that aesthetic judgments are not "mechanical" have sometimes dwelt on and been puzzled by them.

In the first place, while our ability to discern aesthetic features is dependent upon our possession of good eyesight, hearing, and so on, people normally endowed with senses and understanding may nevertheless fail to discern them. "Those who listen to a concert, walk round a gallery, read a poem may have roughly similar sense perceptions, but some get a great deal more than others," Miss Macdonald says; but she adds that she is "puzzled by this feature 'in the object' which can be seen only by a specially qualified observer" and asks, "What is this 'something more'?"[10]

It is this difference between aesthetic and perceptual qualities which in part leads to the view that "works of art are esoteric objects . . . not simple

[9] As I indicated, [p. 574] above, I have dealt only with the relation of *non-aesthetic* to aesthetic features. Perhaps a description in *aesthetic* terms may occasionally suffice for applying another aesthetic term. Johnson's Dictionary gives "handsome" as "beautiful with dignity"; Shorter O. E. D. gives "pretty" as "beautiful in a slight, dainty, or diminutive way."

[10] Macdonald in Elton, *op. cit.*, pp. 114, 119. See also pp. 120, 122.

objects of sense perception."[11] But there is no good reason for calling an object esoteric simply because we discern aesthetic qualities in it. The *objects* to which we apply aesthetic words are of the most diverse kinds and by no means esoteric: people and buildings, flowers and gardens, vases and furniture, as well as poems and music. Nor does there seem any good reason for calling the *qualities* themselves esoteric. It is true that someone with perfect eyes or ears might miss them, but we do after all say we *observe or notice* them ("Did you notice how very graceful she was?" "Did you observe the exquisite balance in all his pictures?"). In fact, they are very familiar indeed. We learn while quite young to use many aesthetic words, though they are, as one might expect from their dependence upon our ability to see, hear, distinguish colors, and the like, not the earliest words we learn; and our mastery and sophistication in using them develop along with the rest of our vocabulary. They are not rarities; some ranges of them are in regular use in everyday discourse.

The second notable difference between the exercise of taste and the use of the five senses lies in the way we support those judgments in which aesthetic concepts are employed. Although we use these concepts without rules or conditions, we do defend or support our judgments, and convince others of their rightness, by talking; "disputation about art is not futile," as Miss Macdonald says, for critics do "attempt a certain kind of explanation of works of art with the object of establishing correct judgments."[12] Thus even though this disputation does not consist in "deductive or inductive inference" or "reasoning," its occurrence is enough to show how very different these judgments are from those of a simple perceptual sort.

Now the critic's talk, it is clear, frequently consists in mentioning or pointing out the features, including easily discernible non-aesthetic ones, upon which the aesthetic qualities depend. But the puzzling question remains how, by mentioning these features, the critic is thereby justifying or supporting his judgments. To this question a number of recent writers have given an answer. Stuart Hampshire, for example, says that "One engages in aesthetic discussion for the sake of what one might see on the way. . . . [I]f one has been brought to see what there is to be seen in the object, the purpose of discussion is achieved. . . . The point is to bring people to see these features."[13] The critic's talk, that is, often serves to support his judgments in a special way; it helps us to *see* what he has seen, namely, the aesthetic qualities of the object. But even when it is

[11] Macdonald, *ibid.*, pp. 114, 120–123. She speaks of non-aesthetic properties here as "physical" or "observable" qualities, and distinguishes between "physical object" and "work of art."

[12] *Ibid.*, pp. 115–116; cf. also John Holloway, *Proceedings of the Aristotelian Society*, Supplementary Vol. XXIII (1949), pp. 175–176.

[13] Stuart Hampshire in Elton, *op. cit.*, p. 165. Cf. also remarks in Elton by Isenberg (pp. 142, 145), Passmore (p. 38), in *Philosophy and Psycho-analysis* by John Wisdom (Oxford, 1953), pp. 223–224, and in Holloway, *op. cit.* p. 175.

agreed that this is one of the main things that critics do, puzzlement tends to break out again over *how* they do it. How is it that by talking about features of the work (largely non-aesthetic ones) we can manage to bring others to see what they had not seen? "What sort of endowment is this which *talking* can modify? . . . Discussion does not improve eyesight and hearing" (my italics).[14]

Yet of course we do succeed in applying aesthetic terms, and we frequently do succeed by talking (and pointing and gesturing in certain ways) in bringing others to see what we can see. One begins to suspect that puzzlement over the "esoteric" character of aesthetic qualities too, arises from bearing in mind inappropriate philosophical models. When someone is unable to see that the book on the table is brown, we cannot get him to see it is by talking; consequently it seems puzzling that we might get someone to see that the vase is graceful by talking. If we are to dispel this puzzlement and recognize aesthetic concepts and qualities for what they are, we must abandon unsuitable models and investigate how we actually employ these concepts. With so much interest in and agreement about *what* the critic does, one might expect descriptions of *how* he does it to have been given. But little has been said about this, and what has been said is unsatisfactory.

Miss Macdonald,[15] for example, subscribes to this view of the critic's task as presenting "what is not obvious to casual or uninstructed inspection," and she does ask the question "What sort of considerations are involved, *and how*, to justify a critical verdict?" (my italics). But she does not in fact go on to answer it. She addresses herself instead to the different, though related, question of the interpretation of art works. In complex works different critics claim, often justifiably, to discern different features; hence Miss Macdonald suggests that in critical discourse the critic is bringing us to see what he sees by offering new interpretations. But if the question is "what (the critic) does and how he does it," he cannot be represented either wholly or even mainly as providing new interpretations. His task quite as often is simply to help us appreciate qualities which other critics have regularly found in the works he discusses. To put the stress upon *new* interpretations is to leave untouched the question how, by talking, he can help us to see *either* the newly appreciated aesthetic qualities *or* the old. In any case, besides complex poems or plays which may bear many interpretations, there are also relatively simple ones. There are also vases, buildings, and furniture, not to mention faces, sunsets, and scenery, about which no questions of "interpretation" arise but about which we talk in similar ways and make similar judgments. So the "puzzling" questions remain: how do we support these judgments and how do we bring others to see what we see?

[14] Macdonald, *op. cit.*, pp. 119–120.

[15] *Ibid.* See pp. 127, 122, 125, 115. Other writers also place the stress on interpretations, cf. Holloway, *op. cit.*, p. 173 ff.

Hampshire,[16] who likewise believes that the critic brings us "to see what there is to be seen in the object," does give some account of how the critic does this. "The greatest service of the critic" is to point out, isolate, and place in a frame of attention the "particular features of the particular object which *make* it ugly or beautiful"; for it is "difficult to see and hear all that there is to see and hear," and simply a prejudice to suppose that while "things really do have colours and shapes . . . there do not exist literally and objectively, concordances of colours and perceived rhythms and balances of shapes." However, these "extraordinary qualities" which the critic "may have seen (in the wider sense of 'see')" are "qualities which are of no direct practical interest." Consequently, to bring us to see them the critic employs "an unnatural use of words in description"; "the common vocabulary, being created for practical purposes, obstructs any disinterested perception of things"; and so these qualities "are normally described metaphorically by some transference of terms from the common vocabulary."

Much of what Hampshire says is right. But there is also something quite wrong in the view that the "common" vocabulary "obstructs" our aesthetic purposes, that it is "unnatural" to take it over and use it metaphorically, and that the critic "is under the necessity of building . . . a vocabulary *in opposition to the main tendency of his language*" (my italics). First, while we do often coin new metaphors in order to describe aesthetic qualities, we are by no means always under the necessity of wresting the "common vocabulary" from its "natural" uses to serve our purposes. There does exist, as I observed earlier, a large and accepted vocabulary of aesthetic terms some of which, whatever their metaphorical origins, are now not metaphors at all, others of which are at most quasi-metaphorical. Second, this view that our use of metaphor and quasi-metaphor for aesthetic purposes is unnatural or a makeshift into which we are forced by a language designed for other purposes misrepresents fundamentally the character of aesthetic qualities and aesthetic language. There is nothing unnatural about using words like "forceful," "dynamic," or "tightly-knit" in criticism; they do their work perfectly and are exactly the words needed for the purposes they serve. We do not want or need to replace them by words which lack the metaphorical element. In using them to describe works of art, the very point is that we are noticing aesthetic qualities related to their literal or common meanings. If we possessed a quite different word from "dynamic," one we could use to point out an aesthetic quality unrelated to the common meaning of "dynamic," it could not be used to describe that quality which "dynamic" does serve to point out. Hampshire pictures "a colony of aesthetes, disengaged from practical needs and manipulations" and says that "descriptions of aesthetic qualities, which for us are metaphorical, might seem to them to

[16] *Op. cit.*, pp. 165–168.

have an altogether literal and familiar sense"; they might use "a more directly descriptive vocabulary." But if they had a new and "directly descriptive" vocabulary lacking the links with non-aesthetic properties and interests which our vocabulary possesses, they would have to remain silent about many of the aesthetic qualities we can describe; further, if they were more completely "disengaged from practical needs" and other non-aesthetic awarenesses and interests, they would perforce be blind to many aesthetic qualities we can appreciate. The links between aesthetic qualities and non-aesthetic ones are both obvious and vital. Aesthetic concepts, all of them, carry with them attachments and in one way or another are tethered to or parasitic upon non-aesthetic features. The fact that many aesthetic terms are metaphorical or quasi-metaphorical in no way means that common language is an ill-adapted tool with which we have to struggle. When someone writes as Hampshire does, one suspects again that critical language is being judged against other models. To use language which is frequently metaphorical might be strange for some *other* purpose or from the standpoint of doing something else, but for the purpose and from the standpoint of making aesthetic observations it is not. To say it is an unnatural use of language for doing *this* is to imply there is or could be for this purpose some other and "natural" use. But these *are* natural ways of talking about aesthetic matters.

To help understand what the critic does, then, how he supports his judgments and gets his audience to see what he sees, I shall attempt a brief description of the methods we use as critics.[17]

(1) We may simply mention or point out non-aesthetic features: "Notice these flecks of color, that dark mass there, those lines." By merely drawing attention to those easily discernible features which make the painting luminous or warm or dynamic, we often succeed in bringing someone to see these aesthetic qualities. We get him to see B by mentioning something different, A. Sometimes in doing this we are drawing attention to features which may have gone unnoticed by an untrained or insufficiently attentive eye or ear: "Just listen for the repeated figure in the left hand," "Did you notice the figure of Icarus in the Breughel? It is very small." Sometimes they are features which have been seen or heard but of which the significance or purpose has been missed in any of a variety of ways: "Notice how much darker he has made the central figure, how much brighter these colors are than the adjacent ones," "Of course, you've observed the ploughman in the foreground; but had you considered how he, like everyone else in the picture, is going about his business without noticing the fall of Icarus?" In mentioning features which may be discerned by anyone with normal eyes, ears, and intelligence, we are singling out what may serve as a kind of key to grasping or seeing something else (and the key may not be the same for each person).

[17] Holloway, *op. cit.*, pp. 173–174, lists some of these briefly.

(2) On the other hand we often simply mention the very qualities we want people to see. We point to a painting and say, "Notice how nervous and delicate the drawing is," or "See what energy and vitality it has." The use of the aesthetic term itself may do the trick; we say what the quality or character is, and people who had not seen it before see it.

(3) Most often, there is a linking of remarks about aesthetic and non-aesthetic features: "Have you noticed this line and that, and the points of bright color here and there . . . don't they give it vitality, energy?"

(4) We do, in addition, often make extensive and helpful use of similes and genuine metaphors: "It's as if there are small points of light burning," "as though he had thrown on the paint violently and in anger," "the lights shimmer, the lines dance, everything is air, lightness and gaiety," "his canvases are fires, they crackle, burn, and blaze, even at their most subdued always restlessly flickering, but often bursting into flame, great pyro-technic displays," and so on.

(5) We make use of contrasts, comparisons, and reminiscences: "Suppose he had made that a lighter yellow, moved it to the right, how flat it would have been," "Don't you think it has something of the quality of a Rembrandt?", "Hasn't it the same serenity, peace, and quality of light of those summer evenings in Norfolk?" We use what keys we have to the known sensitivity, susceptibilities, and experience of our audience.

Critics and commentators may range, in their methods, from one extreme to the other, from painstaking concentration on points of detail, line and color, vowels and rhymes, to more or less flowery and luxuriant metaphor. Even the enthusiastic biographical sketch decorated with suitable epithet and metaphor may serve. What is best depends on both the audience and the work under discussion. But this would not be a complete sketch unless certain other notes were added.

(6) Repetition and reiteration often play an important role. When we are in front of a canvas we may come back time and again to the same points, drawing attention to the same lines and shapes, repeating the same words, "swirling," "balance," luminosity," or the same similes and metaphors, as if time and familiarity, looking harder, listening more carefully, paying closer attention may help. So again with variation; it often helps to talk round what we have said, to build up, supplement with more talk *of the same kind*. When someone misses the swirling quality, when one epithet or one metaphor does not work, we throw in related ones; we speak of its wild movement, how it twists and turns, writhes and whirls, as though, failing to score a direct hit, we may succeed with a barrage of near-synonyms.

(7) Finally, besides our verbal performances, the rest of our behavior is important. We accompany our talk with appropriate tones of voice, expression, nods, looks, gestures. A critic may sometimes do more with a sweep of the arm than by talking. An appropriate gesture may make us see the violence in a painting or the character of a melodic line.

These ways of acting and talking are not significantly different whether we are dealing with a particular work, paragraph, or line, or speaking of an artist's work as a whole, or even drawing attention to a sunset or scenery. But even with the speaker doing all this, we may fail to see what he sees. There may be a point, though there need be no limit except that imposed by time and patience, at which he gives up and sets us (or himself) down as lacking in some way, defective in sensitivity. He may tell us to look or read again, or to read or look at other things and then come back again to this; he may suspect there are experiences in life we have missed. But these are the things he does. This is what succeeds if anything does; indeed it is all that can be done.

By realizing clearly that, whether we are dealing with art or scenery or people or natural objects, this is how we operate with aesthetic concepts, we may recognize this sphere of human activity for what it is. We operate with different kinds of concepts in different ways. If we want someone to agree that a color is red we may take it into a good light and ask him to look; if it is viridian we may fetch a color chart and make him compare; if we want him to agree that a figure is fourteen-sided we get him to count; and to bring him to agree that something is dilapidated or that someone is intelligent or lazy we may do other things, citing features, reasoning and arguing about them, weighing and balancing. These are the methods appropriate to these various concepts. But the ways we get someone to see aesthetic qualities are different; they are of the kind I have described. With each kind of concept we can describe what we do and how we do it. But the methods suited to these other concepts will not do for aesthetic ones, or vice versa. We cannot prove by argument or by assembling a sufficiency of conditions that something is graceful; but this is no more puzzling than our inability to prove, by using the methods, metaphors, and gestures of the art critic, that it will be made in ten moves. The questions raised admit of no answer beyond the sort of description I have given. To go on to ask, with puzzlement, how it is that *when* we do these things people come to see, is like asking how is it that, when we take the book into a good light, our companion agrees with us that it is red. There is no place for this kind of question or puzzlement. Aesthetic concepts are as natural, as little esoteric, as any others. It is against the background of different and philosophically more familiar models that they seem queer or puzzling.

I have described how people justify aesthetic judgments and bring others to see aesthetic qualities in things. I shall end by showing that the methods I have outlined are the ones natural for and characteristic of taste concepts from the start. When someone tries to make me see that a painting is delicate or balanced, I have some understanding of these terms already and know in a sense what I am looking for. But if there is puzzlement over how, by talking, he can bring me to see these qualities in this picture, there should be a corresponding puzzlement over how I learned

to use aesthetic terms and discern aesthetic qualities in the first place. We may ask, therefore, how we learn to do these things; and this is to inquire (1) what natural potentialities and tendencies people have and (2) how we develop and take advantage of these capacities in training and teaching. Now for the second of these, there is no doubt that our ability to notice and respond to aesthetic qualities is cultivated and developed by our contacts with parents and teachers from quite an early age. What is interesting for my present purpose is that, while we are being taught in the presence of examples what grace, delicacy, and so on are, the methods used, the language and behavior, are of a piece with those of the critic as I have already described them.

To pursue these two questions, consider first those words like "dynamic," "melancholy," "balanced," "taut," or "gay" the aesthetic use of which is quasi-metaphorical. It has already been emphasized that we could not use them thus without some experience of situations where they are used literally. The present inquiry is how we shift from literal to aesthetic uses of them. For this it is required that there be certain abilities and tendencies to link experiences, to regard certain things as similar, and to see, explore, and be interested in these similarities. It is a feature of human intelligence and sensitivity that we do spontaneously do these things and that the tendency can be encouraged and developed. It is no more baffling that we should employ aesthetic terms of this sort than that we should make metaphors at all. Easy and smooth transitions by which we shift to the use of these aesthetic terms are not hard to find. We suggest to children that simple pieces of music are hurrying or running or skipping or dawdling, from there we move to lively, gay, jolly, happy, smiling, or sad, and, as their experiences and vocabulary broaden, to solemn, dynamic, or melancholy. But the child also discovers for himself many of these parallels and takes interest or delight in them. He is likely on his own to skip, march, clap, or laugh with the music, and without this natural tendency our training would get nowhere. Insofar, however, as we do take advantage of this tendency and help him by training, *we do just what the critic does*. We may merely need to persuade the child to pay attention, to look or listen; or we may simply *call* the music jolly. But we are also likely to use, as the critic does, reiteration, synonyms, parallels, contrasts, similes, metaphors, gestures, and other expressive behavior.

Of course the recognition of similarities and simple metaphorical extensions are not the only transitions to the aesthetic use of language. Others are made in different ways; for instance, by the kind of peripheral cases I mentioned earlier. When our admiration is for something as simple as the thinness of a glass or the smoothness of a fabric, it is not difficult to call attention to such things, evoke a similar delight, and introduce suitable aesthetic terms. These transitions are only the beginnings; it may often be questionable whether a term is yet being used aesthetically or not. Many of the terms I have mentioned may be used in ways which are not

straightforwardly literal but of which we should hesitate to say that they demanded much yet by way of aesthetic sensitivity. We speak of warm and cool colors, and we may say of a brightly colored picture that at least it is gay and lively. When we have brought someone to make this sort of metaphorical extension of terms, he has made one of the transitional steps from which he may move on to uses which more obviously deserve to be called aesthetic and demand a more obviously aesthetic appreciation. When I said at the outset that aesthetic sensitivity was rarer than some other natural endowments, I was not denying that it varies in degree from the rudimentary to the refined. Most people learn easily to make the kinds of remarks I am now considering. But when someone can call bright canvases gay and lively without being able to spot the one which is really vibrant, or can recognise the obvious outward vigor and energy of a student composition played *con fuoco* while failing to see that it lacks inner fire and drive, we do not regard his aesthetic sensitivity in these areas as particularly developed. However, once these transitions from common to aesthetic uses are begun in the more obvious cases, the domain of aesthetic concepts may broaden out, and they may become more subtle and even partly autonomous. The initial steps, however varied the metaphorical shifts and however varied the experiences upon which they are parasitic, are natural and easy.

Much the same is true when we turn to those words which have no standard non-aesthetic use, "lovely," "pretty," "dainty," "graceful," "elegant." We cannot say that these are learned by a metaphorical shift. But they still are linked to non-aesthetic features in many ways and the learning of them also is made possible by certain kinds of natural response, reaction, and ability. We learn them not so much by noticing similarities, but by our attention being caught and focussed in other ways. Certain phenomena which are outstanding or remarkable or unusual catch the eye or ear, seize our attention and interest, and move us to surprise, admiration, delight, fear or distaste. Children begin by reacting in these ways to spectacular sunsets, woods in autumn, roses, dandelions, and other striking and colorful objects, and it is in these circumstances that we find ourselves introducing general aesthetic words to them, like "lovely," "pretty," and "ugly." It is not an accident that the first lessons in aesthetic appreciation consist in drawing the child's attention to roses rather than to grass; nor is it surprising that we remark to him on the autumn colors rather than on the subdued tints of winter. We all of us, not only children, pay aesthetic attention more readily and easily to such outstanding and easily noticeable things. We notice with pleasure early spring grass or the first snow, hills of notably marked and varied contours, scenery flecked with a great variety of color or dappled variously with sun and shadow. We are struck and impressed by great size or mass, as with mountains or cathedrals. We are similarly responsive to unusual precision or minuteness or remarkable feats of skill, as with complex and elaborate

filigree, or intricate wood carving and fan-vaulting. It is at these times, taking advantage of these natural interests and admirations, that we first teach the simpler aesthetic words. People of moderate aesthetic sensitivity and sophistication continue to exhibit aesthetic interest mainly on such occasions and to use only the more general words ("pretty," "lovely," and the like). But these situations may serve as a beginning from which we extend our aesthetic interests to wider and less obvious fields, mastering as we go the more subtle and specific vocabulary of taste. The principles do not change; the basis for learning more specific terms like "graceful," "delicate," and "elegant" is also our interest in and admiration for various non-aesthetic natural properties ("She seems to move *effortlessly*, as if floating," "So very *thin* and *fragile*, as if a breeze might destroy it," "So *small* and yet so *intricate*," "So *economical* and perfectly *adapted*").[18] And even with these aesthetic terms which are not metaphorical themselves ("graceful," "delicate," "elegant"), we rely in the same way upon the critic's methods, including comparison, illustration, and metaphor, to teach or make clear what they mean.

I have wished to emphasize in the latter part of this paper the natural basis of responses of various kinds without which aesthetic terms could not be learned. I have also outlined what some of the features are to which we naturally respond: similarities of various sorts, notable colors, shapes, scents, size, intricacy, and much else besides. Even the non-metaphorical aesthetic terms have significant links with all kinds of natural features by which our interest, wonder, admiration, delight, or distaste is aroused. But in particular I have wanted to urge that it should not strike us as puzzling that the critic supports his judgments and brings us to see aesthetic qualities by pointing out key features and talking about them in the way he does. It is by the very same methods that people helped us develop our aesthetic sense and master its vocabulary from the beginning. If we responded to those methods then, it is not surprising that we respond to the critic's discourse now. It would be surprising if, by using this language and behavior, people could *not* sometimes bring us to see the aesthetic qualities of things; for this would prove us lacking in one characteristically human kind of awareness and activity.

[18] It is worth noticing that most of the words which in current usage are primarily or exclusively aesthetic terms had earlier non-aesthetic uses and gained their present use by some kind of metaphorical shift. Without reposing too great weight on these etymological facts, it can be seen that their history reflects connections with the responses, interests, and natural features I have mentioned as underlying the learning and use of aesthetic terms. These transitions suggest both the dependence of aesthetic upon other interests, and what some of these interests are. Connected with liking, delight, affection, regard, estimation or choice—*beautiful, graceful, delicate, lovely, exquisite, elegant, dainty;* with fear or repulsion—*ugly;* with what notably catches the eye or attention—*garish, splendid, gaudy;* with what attracts by notable rarity, precision, skill, ingenuity, elaboration—*dainty, nice, pretty, exquisite;* with adaptation to function, suitability to ease of handling—*handsome.*

ISABEL C. HUNGERLAND

THE LOGIC
OF AESTHETIC CONCEPTS

Isabel Hungerland is Professor of Philosophy at the University of California at Berkeley.

There are two sorts of descriptions, or accounts, that we can give of works of art or of anything else that makes up our world of relatively stable objects. I can describe a painting, a chair, a mountain, or a man in terms of colors, shapes, spatial relation of parts, and so on. I can also describe the same four objects by talking about the dynamic tensions of the first, or its lack of visual balance; the grace and elegance of the second; gloominess or majesty of the third; and the trimness or gawkiness of the fourth. The first sort of description, or account, may answer a wide variety of general purposes, central among them that of identifying particular objects. A museum curator might so describe a painting for future reference in identifying the particular work of one painter; an auctioneer

Presidential address delivered, with some omissions, before the Thirty-Sixth Annual Meeting of the Pacific Division of the American Philosophical Association at the University of California, Berkeley, December 27–29, 1962.

Reprinted from *The Proceedings and Addresses of the American Philosophical Association* (October, 1963), pp. 43–66, by permission of The Antioch Press, Yellow Springs, Ohio, and Professor Isabel C. Hungerland.

identifies pieces of furniture by such descriptions; a map-maker, a mountain; and a police department, a Man Wanted. The second sort of account of the same objects could not usefully serve such purposes. The second sort, usually if not always, is found in the context of the evaluating of objects. "This is a fine Sheraton chair—it is graceful, but sturdy." Here, relevant reasons are furnished for an aesthetic rating of an object, and the first sort of description does not, and could not, serve this function.

Furthermore, there are the following *prima facie* differences between the two sorts of features attributed to things in the two sorts of description. The features corresponding to terms like "garish," "graceful," "balanced," seem to require for their apprehension a special sensitivity or training on our part and their presence or absence does not appear to be determinable —at least, not in a straightforward way—by intersubjective tests. (I shall call both features and terms "aesthetic" and employ A and "A", respectively, as short-hand for aesthetic features and terms.) The features corresponding to terms like "red," "rectangular," "continuous to," seem, in contrast, to require for their apprehension no special sensitivity or training beyond the ordinary and their presence or absence appears to be determinable by intersubjective tests or checks, whether these consist in a simple looking at an object by people with normal eyesight or in procedures of measuring and the like. (I shall call both features and terms "non-aesthetic" and employ N and "N", respectively, as short-hand for kind of feature and term.) And yet, despite these apparent differences, there seems to be a close connection between the aesthetic and the non-aesthetic features of things and hence, some sort of logical relation (other than complete independence) between the corresponding terms. The fact that a piece of furniture has certain proportions and curves of certain degrees has surely something to do with its being "graceful, but sturdy." Indeed, much of the talk of art critics is devoted to calling our attention to certain colors, shapes, and their interrelations.

In current writing on the subject, three different views may be found. Two, as might be expected, reflect attempts to put the relation between "N's" and "A's" on one or the other side of the old analytic-synthetic (deductive-inductive) dichotomy. Thus, it has been said that a certain set of statements of the form "X is N" will entail a statement of the form "X is A." For example, "X has such-and-such colors" will entail "X is garish." According to a less strict form of the view, a certain set of statements of the form "It is false that X is N" will entail statements of the form "It is false that X is A." For example, "It is false that X has bright colors" will entail "It is false that X is garish."[1] On the other hand, it has

[1] The less strict form of the view is suggested in "Critical Communication" by Arnold Isenberg, reprinted in *Aesthetics and Language*, ed. W. Elton (New York, Philosophical Library, 1954), pp. 131–146. See p. 132. I have heard the strict form advocated by a competent aesthetician.

been said that the relation in question is that of empirical evidence to inductive conclusion.[2] The third view has the virtue of avoiding the analytic-synthetic dichotomy, but rather mysteriously presents the "A's" as having no truth-conditions, as not being "rule-governed at all," while at the same time permitting "A's" to be in some sense governed "negatively" by "N's."[3]

I regard the first two views as mistaken, the third as somewhat misleadingly stated and in need of supplementation. All three views have, I think, suffered from confining their examination predominantly to the field of aesthetics. The "logic," in a broad sense, of expressions like "This is a graceful vase" cannot, I believe, be made out without distinguishing it, on the one hand, from the logic of expressions like "This vase has such-and-such curves and proportions" and, on the other hand, from the logic of expressions like "I have a searing head-ache." But one cannot make out the relevant differences without going far afield from aesthetics. In the main body of my paper, then, I shall be concerned with general matters of language, of meaning, of informal logic. I make no apology for this. I have, of course, given myself a tall order to fill in the allotted time, but I shall aim to present a rough, schematic account rather than a detailed precise one, of the matters at issue. I shall, then, have to simplify and omit qualifications fairly often. For example, I shall, in general, confine my consideration of the A's to those of visual design and of the N's to colors, though the N's connected in some way with the visual A's are a heterogeneous lot. I shall also have primarily in mind the situation in which we describe an object in whose presence we are, an object at which we are looking.

At this point, it will be convenient to introduce some technical terms.

When we say (in an appropriate context and under appropriate circumstances) something of the form "This is A," I shall call the speech act an "aesthetic ascribing" and the expression, in its employment, an "aesthetic ascription," and a set of such ascriptions for one object, an "aesthetic description" of that object. I shall use analogous terminology for act and abstract linguistic entity in the case of "N's." "A-ascription" and "N-ascription" will be employed as short-hand.[4]

[2] See *Aesthetics* by Monroe C. Beardsley (New York, Harcourt Brace and Company, 1958), pp. 86ff.

[3] See "Aesthetic Concepts" by Frank Sibley, *The Philosophical Review*, Vol. LXVIII, October 1959, pp. 421–450.

[4] N-ascriptions obviously belong to that large and not clearly delineated class of abstract entities called "propositions" or "statements." Whether or not A-ascriptions are also properly placed in that class is a question I do not wish to raise in this paper. Suffice it to say that A-ascriptions are *not* evaluations (gradings), though they may be offered in support of evaluations, and that in making A-ascriptions, we can certainly lie. Falsity, and hence truth, the alleged marks of propositions, are thus at issue.

II

The kind of logical relationships I am interested in for the job in hand has been obscured by the confusion, in a good deal of contemporary philosophical writing, of two radically different questions. These are: "Under what conditions is the speech act of asserting that p justified?"—sometimes phrased as "Under what conditions am I justified in asserting that p?"—and "What are the truth-conditions, necessary or sufficient for p?"—sometimes phrased as "Under what conditions is p true?" (It is important to note that the first question is concerned with justification in the sense of logical support, good reasons for asserting *that*, not with matters of manners or morals. It might, of course, be impolite or immoral for me to assert a certain proposition p in a certain context, even though I could give good logical support to my act of stating that p.)

These questions are categorically different. The first concerns justifying (supporting) reasons for a speech act; the second concerns the relation of entailment between propositions (statements). It does not make straightforward sense to speak of the justification of a proposition (what is stated, what is true or false) and it also does not make straightforward sense to speak of an act as entailing anything, though a statement, or proposition about an act can entail another statement about it. Furthermore, both these questions are different again from a third that crops up in our contemporary condition-ridden discourse, namely, "What are the pre-conditions of the act of asserting that p?"—sometimes phrased as "What is presupposed in asserting that p?"

I propose to make plain the requisite distinctions, comment on their general significance, and then, in the following section make use of them in delineating the role of A-ascriptions. I shall begin with a schematic account of truth-conditions.

1. Truth-conditions

Talk about truth-conditions belongs in the context of talk about propositions (statements) and entailments, whether of ordinary language or formal systems. Thus, the relevant context is that of abstract entities, identifiable in speech acts, and of relations of transformability between one linguistic expression and another. The following examples will suffice for my purposes.

"X is red" is a sufficient truth-condition of "X is colored" and "X is colored" is a necessary truth-condition of "X is red" may be paraphrased, respectively, as "X is red" entails "X is colored" and "It is false that X is colored" entails "It is false that X is red." "X is a male parent" is a necessary and sufficient truth-condition of "X is a father" may be represented as mutual entailment, or logical equivalence.

2. Justifying Reasons, or Criteria

(I shall follow one current philosophical usage in calling the reasons, or conditions, which justify a speech act, "criteria.")

Talk about criteria belongs in the context of talk about acts of stating, not statements (propositions).

Two very important points are immediately plain. First, we do not have to justify our speech acts unless there is some reason for us to do so, unless we have been in some way challenged. Second, what will be adequate justification, or support, will depend on the situation, including the kind of challenge made. It would be foolish, then, to speak of "*the* criterion" of asserting that *p* or even of "*the* criteria," without qualification, or to look for the sort for formulae for criteria that we can find for truth-conditions. However, there are, of course, standard challenges, and standard situations for certain speech acts. These standard challenges and situations are assumed in the following examples. Also, it should be noted, some criteria may be said to be basic, or primary in relation to others—counting, for example, where the number of a set of objects is in question.

The criterion for my being justified in stating that something *is* red, as opposed to its merely looking red to me at the moment of speaking is that it is found to look red to normal observers under normal circumstances; a very good reason for saying that there are 71 sheep in my pasture is that a certain counting procedure has been gone through with certain results; and a good reason for insisting that John does have a tooth-ache may be that he has behaved in such-and-such a fashion.

Criteria are thus concerned with the kinds of tests, the types of considerations, which afford one justifying reasons for speech acts which have been in some way questioned, or challenged. We learn the criteria for making various statements, not by reading dictionaries, grammars, and books on logic, but by learning our way around the world with linguistic expressions. At first, no doubt, we supposed that looking red to us at the moment of speaking was enough to support an attribution of red to an object. But then, we discovered facts about lighting and our sensory organs and so the criterion in question becomes established for us. We learn the difference between saying "This looks red" (in one of the uses of the sentence) and "This is red." Some philosophers might say that we learn the "meaning" of the N-ascription in question; others, that we learn the "correct use." Both ways of talking about criteria may mislead us unless we are clear about the following two matters.

First, all sentential expressions may be employed correctly or incorrectly and hence all may be said to have criteria for correct use. For example, a beginner in English, might say "I have a head-ache" when "I have a stomach-ache" would be correct. But there are *no* criteria, in the sense of supporting, or justifying reasons for saying "I have a head-ache." The only

supporting reason I can give for claiming that I have a head-ache is that I have one. There is no support because none is needed.

Secondly, we should notice that the possibility of our establishing certain criteria in certain situations for saying that . . . , depends upon general facts about the world around us and ourselves. For example, if we were all subject to constantly changing and endlessly varied kinds of what we now call "color-blindness" the criterion for a thing's being red would be useless, and the concept itself, as well as that of "color-blindness," would be empty.

In the next section, I shall develop these points in more detail—for the present, I wish to comment on the general significance of the distinction between truth-conditions and criteria.

The concept of truth-conditions and that of criteria belong to different universes of discourse. Attempts to establish a relation of entailment between statements that belong in the one universe and statements that belong in the other, result either in a vacuous establishing of a logical relation or a false allegation of a non-vacuous one. Thus, to consider vacuity first, the statement that the criteria for making a given statement that p are satisfied could entail p (or the truth of p) only on the vacuous interpretation of the Verifiability Theory of Meaning according to which I am justified in asserting that p if and only if p. This version of the theory is an innocuous but unenlightening attempt to absorb criteria to truth-conditions. The attempt to make the absorption in the other direction is more interesting and less innocuous. It lies at the base, I think, of all those illegitimate forms of behaviorism which take statements ostensibly about people's feelings as *really* about their behavior. I choose my example of a false allegation of an entailment accordingly.

"All the relevant criteria (and they are all in some way behavioral) in the situation in question for a man's being in pain are satisfied" entails "The conditions are what we call 'a man's being in pain'" entails "The man (in question) is in pain." I know of no definitions or logical rules that would validate either of the two steps.

3. Pre-conditions

The third and final general topic which I propose to consider in this section is that of presuppositions, sometimes called "pre-conditions" of speech acts.[5] First, some matters of terminology. When an expression which has pre-conditions of use is a word or phrase, I shall call the pre-conditions, "pre-conditions of applying"; when the expression is a sentence, I shall speak of "pre-conditions of asserting," and I shall use "asserting"

[5] I am using "presupposition" differently from the way in which P. F. Strawson uses it in his well-known account. He defines "presupposes" as a relation between statements, and his account requires the possibility of statements that are neither true nor false, that have no truth-value at all. I find it preferable to say that, when an attempted reference fails—whether because of our ignorance of natural circum-

to cover any logically primary use of a sentence of any kind, for example, interrogatory, imperative.

Pre-conditions of primary uses of linguistic expressions have the following two features. (I attempt no formal definition.) In the first place, they are conditions (I use deliberately, a vague word here) which a user of the expression must believe to exist, or hold, or at least somehow take for granted if he is employing the expression correctly and is not lying. But, secondly, pre-conditions are not part of what the speaker says when he employs expressions that have pre-conditions, nor are they entailed by what he asserts. For example, suppose I make the statement that *This looks blue and that looks red*. Pre-conditions for this act of assertion are: the object referred to by "This" is nearer me (the speaker) than the object referred to by "That"; the objects referred to look as reported *to me (the speaker) at the time of speaking*. Neither of these facts are asserted by me or are entailed by what I assert. If our interest is directed to the rules which are exemplified in uses of expressions, we tend to speak of what "This" and "That" and the present tense of the verb, and so on, *indicate*, or *show;* if we are more interested in speech acts and agents, we tend to speak of what the act or agent *implies*. The kind of implication, which has been called "contextual," can be explicated in terms of logical implication, or entailment, in the following way. A description of a speech act as normal (as not going wrong in the way either of incorrect use of expressions or of attempted deceit) will contain or will entail statements that the agent believes or assumes that the pre-conditions hold. The category of pre-conditions concerns a large and mixed lot of matters. Recent work has shown that certain verbs and adverbs in certain uses indicate or show something about the nature of the speech act—for example, "I *warn* you not to do that," "*Probably*, he'll come." Strawson's account of pre-conditions has been largely concerned with various sorts of referring expressions, "He," "This," "The present king of France," "All my children." We should remember, in this connection, that we can refer in our talk to abstract subject-matters, as well as to individuals. For example, if I attribute certain features to speech acts, I imply that there are speech acts, that I can identify them for you. Also, the non-formal typal requirements of an ordinary language will give rise to pre-conditions in the following way. If you say, for example, "It's square," in an appropriate context, you not only imply that "it" refers to something, but that the thing referred to is the sort of thing that can have a shape. Today, there are contexts of

stance or of our being subject to illusion, and so on—no statement at all is made. However, since, in this case, presumably some of the requirements for making a statement will be satisfied, we can speak of "pseudo-statements" and "pseudo-statings." It should be noticed that, according to the account given here, speech acts can go wrong in ways (lying, incorrect use of expressions) that do not have the consequence, as does referential failure, that no act of stating is accomplished.

discourse in which the implication does not hold, and "it" might well refer to an abstract quality like *virtue*. "Virtue is square" no longer serves as a good example of a type violation in ordinary English.

III

I propose, now, with the aid of these general ways of considering the role of linguistic expressions, to take the first main step towards distinguishing the role of "A's" from the role of "N's." I shall do this in the following way. I shall show (1) that there are certain contrasts between N-ascriptions ("X *is* N") and the use of expressions like "X looks N" and that these contrasts are germane to our having and our describing a common world; (2) that these contrasts between *being* and *looking N* have no exact analogue for the A's, that the extension of these contrasts to the field of the A's is a metaphoric one only, that the extension is germane not to a common world but to coteries, to shared sensitivities, trainings, and tastes. The conclusion of this first step in my argument may be summed up as: *There are no criteria for A-ascribings*, though they have, of course, pre-conditions, and though A-ascriptions have truth-conditions.

For purposes of simplifying the line of argument, I shall follow current practice in considering the role of "A"'s and "N"'s in descriptions, or accounts, of particular, relatively stable objects, like paintings and chairs and mountains. But our common world also contains the phenomenon of shifting, momentary qualities (qualities of colored, changing mists, for example) which cannot be taken as the apparent color and shape and so on, under such-and-such conditions of viewing, of something that throughout maintains one identifying color and shape and so on. However, what is shown about the difference between the role of "N"'s and "A"'s in the main line of argument can be applied, *mutatis mutandis*, to unstable, unindividuated, phenomena. I shall do this, very briefly, in the next section of the paper.

In examining various possible contrasts between merely *looking N* and *being N*, I wish at the outset to disavow the notion that there is a single, basic contrast corresponding to a single basic appearance-reality contrast.

The most obvious possible contrast between merely *looking N* and *being N* holds for such N's as *ill* or *strong*. A man may look ill, but be healthy, and look strong, but be weak. The contrasts point to the fact that for many N's, looking is not the primary or basic way of justifying a seriously challenged N-ascribing, that is, looking affords a clue, but not the primary criterion. Now, for *all* "A"'s applicable to visual objects, the only way of deciding whether a thing is or is not A (*elegant, garish, dowdy* or *delicate*, for example) is to look. For the A's, there is no analogue to statements like *The man looks ill, but (really) isn't*. The reason for the lack of analogue is plain. The "A"'s in question were in-

vented just for the purpose of describing how things look. The old philo-
sophical platitude that aesthetic deals with the (sensible) appearance of
things points to this fact.

This first contrast will not, of course, serve to mark off all "N" 's from
"A" 's. Color-words were also invented to enable us to describe how things
look, but they belong to the class of "N" 's, not "A" 's.[6]

The contrast that will serve to mark off "N" 's like "red" from "A" s, is
the contrast between looking a certain color to normal observers under
normal circumstances (the criterion for asserting that something *is* that
color) and merely looking a certain color under special circumstances,
say, a blue light, or looking a certain color to non-normal observers, say,
the color-blind, under normal circumstances.

Here again, I wish to disavow a view, namely, the notion that there
is always a single answer to the question "What is the color of X?", or,
for that matter, the question "What is the length of X?" One has only to
ask "What is the color of her hair?" to see that for various purposes,
various answers will be given, and that for various answers, there will be
variation in what is taken as normal circumstances (including physical
viewpoint, that is, position of observer in relation to the object) as well,
perhaps, as variation in what constitutes a normal observer.

What I am maintaining is, first, that for the various purposes for which
we may want to give identifying descriptions, it is, in general, possible
to specify what normal circumstances are and what normal observers are
in ways that yield intersubjective results. Further, our decisions of what
is to be taken as normal for certain purposes, are not in any way depend-
ent on our personal experience, cultural background and training, emo-
tional sensitivity, philosophic outlook, and so on. Rather, the possibility
of making these impersonal and workable decisions depends on certain
general facts about ourselves (the constitution of our sense-organs) and
our physical environment. Our decisions do not make a common world,
but because we have a common world we can make *them*.

I come now to an important part of my thesis, namely that no such
general possibility of specifying normal observers and normal circum-
stances exists for the A's, and that therefore the contrast in question, be-
tween *merely looking N* and *really being N* has no exact analogue for
the A's.[7] When I say this, I am not denying that there is a good meta-
phoric extension of the contrast to A's. There are illuminating though
non-literal resemblances in the two cases. Indeed it is these resemblances

[6] To use "red" to represent the whole heterogeneous class of "N"s, as I shall do,
is an enormous simplification, but it is not a weighting of the argument in my favor.
I propose to distinguish the role of "A" 's from the that of "N" 's, and it is much
easier to do this for "N" 's like "length" than it is for color-words. It should also be
remembered, throughout, that the context of discourse assumed for N-ascribings, is
that of identifying descriptions, answers to the question, "Which one?"

[7] In what follows, unless otherwise specified, it is *this* contrast between *looking*
and *being*, that I have in mind, not the first contrast considered.

that have given plausibility to that strand in aesthetics that absorbs A-ascriptions to N-ascriptions, taking the latter as the model for understanding the former.

I can best make out my position by examining the kind of example that might be offered as a counter-example to it. Consider, then, the following sort of remark. "She only looks elegant to you, she really isn't, because you aren't familiar with *haute couture*," "She only looks elegant now, because she's surrounded by all those dowdy women," "It only seems funny to you because you have a perverted sense of humor," "It only seems funny to you because the rest of the book is so dull."

These examples may seem, at first glance, to refer us to normality of observer and circumstance quite analogous to that involved in the *really is —only looks* N contrast. But a closer inspection will show that the examples call our attention, not to the presence or absence of physical defects in sense organs, but to the presence or absence of common sympathies, snobberies, outlooks, personal history, training in certain arts. Similarly, the norm of circumstances, when we are concerned with A's, cannot be stated in terms of physical viewpoint, lighting arrangements, and so on, but in terms of what we concentrate on; what we disregard, our movement of attention, what might be called our whole "mental stance." I shall call the viewpoint relevant to apprehension of A's, "perceptual" to distinguish if from the physical viewpoint relevant to N's, and shall return to discuss it more fully later on. Meanwhile, I wish to call attention to the following two points. First, for the apprehension of A's there is, of course, required the taking of a physical viewpoint from which the N-features related in a special way to the A-features may be seen. I cannot see whether a design is balanced or not unless I can see the design and I cannot see it if I stand 50 feet or 1 inch away. But if I take the "normal" physical viewpoint (and, of course, pay "normal" attention to the object, and so on), I do not automatically see visual balance or imbalance. To do this, I must concentrate on certain relationships of lines, masses, perhaps neglect others, and be possessed of sufficient visual education and sensitivity to be aware of visual tensions.

The second point that calls for attention here is that sympathies and snobberies, trained ways of looking at things and designs, sensitivities to special effects, may be very wide-spread. Note the steadily increasing membership in the international coterie of abstract expressionism in painting. The norms for perceiver and perceptual viewpoint which are implicit in coteries are not necessarily or even usually idiosyncratic or in any ordinary sense "arbitrary." This is why the metaphoric extension of the *really is—only looks contrast* is a good one, on occasion. But the extension is metaphoric *only*, because coteries are not determined by the structure of our organs and of our physical environment. There are thus no tests or checks, no logical support for the presence of A's, *literally* analogous to the tests or checks for the presence of N's, no criteria for A-ascribings

literally analogous to criteria for N-ascribings. For example, I have just spent almost half a year in a country where often the trim and fence of each cottage in a row is painted a different bright color. Combinations of brilliant green, pink, lilac, red, blue, and yellow are favored. At first, I found the aesthetic effect garish. By a process which is neither entirely mysterious nor entirely understandable to me, I came to see the color effect as gay, even as expressive of the kind of gaiety that Yeats explores in one of his late poems. I do not regard the A-ascription I would make today as arbitrarily or foolishly made. But I would think that I was acting arbitrarily and foolishly if I claimed that I was now able to support against challenge my A-ascribing in the way in which I could test and support my account of the color combinations should that account be challenged.

Just as the figurative resemblances between the role of "A" 's and "N" 's led to the tradition in aesthetics which absorbs the A's to the N-model, so the differences I have been pointing out have led to the other main tradition which puts the A's in the category of the "subjective," in the sense of the mental, the private. This tradition has even less plausibility than the other, the "objective" tradition.

Thus far I have presented my rejection of the objective tradition in outline only—it needs filling in. But it will be convenient to conclude this section by pointing to the main reasons why the subjective tradition must be rejected, that is, why A-ascriptions do not belong with reports of a speaker's sensations or feelings. To be sure, there are resemblances. In neither case do my reportings require logical support and I am, in both cases, reporting, asserting, or claiming *that*. . . .[8] Sometimes, pain-expressions ("I am in pain") are not employed with descriptive force and function more like exclamations. However, a doctor will often ask a patient to describe (or report) with care his sensations and feelings and will learn much from the patient's account that he could not possibly learn from a series of "ouches!"

Granted these resemblances, the subjective tradition remains unacceptable. The A's are features of perceived objects, of our "outer," not our "inner" world. This is why I can try (and may often succeed) to get you to share my aesthetic vision, to see the design as I see it, to agree with my A-ascription. But I cannot ask you thus to share my head-ache and

[8] The refusal to accord descriptive import to accounts of sensations or feelings, and hence to accord statement-status and truth-value to what is said has the comforting virtue of dissolving a very vexing problem. I do not (fortunately!) feel called upon to deal with it on this occasion. Briefly, the problem is this. If I can employ "I have a head-ache" to make a statement (true or false) then how is this statement related to your statement that *Mrs. Hungerland has a head-ache?* If we say that on this occasion two statement-making sentences (one containing "I," the other not) are used to make the same statement, then how is it that my making the claim does not require support and yours does? If I reply that I have logically privileged access to a private, mental "world" of my own which you can only guess about from the outside, I raise all the old problems of "inner" and "outer."

to get you to agree with my report of my head-ache is not to get you to be able to truthfully say that you have one, too.

IV

The main conclusion of the preceding section was that there are no criteria (in the sense of logically supporting reasons) for A-ascribings in the literal way in which there are for N-ascribings. I tried to show that the *looks—really is* contrast which is important for N's and which depends on certain stabilities in us and in our environment has no exact analogue for A's. As we might expect, it makes little difference whether we say, for example, "You look elegant" or "You are elegant," "This color scheme looks gay" or "This color scheme is gay." It makes little difference because in *neither* case are we committing ourselves to supporting reasons. If you tell me that something looks red (or round), I can always raise the question of whether it actually is red (or round), but I cannot (so I have argued) raise this question, except metaphorically, when you tell me that a design looks balanced or dynamic.

The differences, however, that I have been pointing to between the role of "N" 's, and the role of "A" 's cannot be fully made out until the following questions are answered: (1) How does the *looks N—is N* contrast apply to non-stable phenomena like sunsets, rainbows, shifting mists and so on? (2) What sort of statements are statements of the form "This looks N"? Are there criteria for stating *that this looks N*? (3) How do statements like "This looks N" differ from law-like statements containing "looks," for example, "Red things look black at night," "Round things look oval at a certain distance," "Red and green look greyish to certain sorts of color-blind people." If the thesis of the preceding section is right, we cannot, without change of logical role, substitute "A" 's for "N" 's in any of these expressions.

The first question may be dealt with briefly. The possibility of our giving, for various purposes, identifying N-descriptions of things depends upon their remaining, on the whole, constant for more than a moment in shape, size, color, and when they change, upon their being easily ascertainable factors accounting for the change. We do not ascribe *a* shape to quick-silver or, in general, speak of "*the* color" of a sunset. However, it is possible to give various other kinds of identifying accounts of unstable "objects"—"that sunset we saw last summer when swimming at. . . ." And we can ask whether the sunset didn't look purple to you, and then bluish because you were wearing those odd colored sun glasses. In brief, we can and do, with appropriate changes, set up standards of normality for circumstance and observer, which require the relevant sort of stabilities in us and in our environment.

The second question cannot be dealt with so briefly. I have said that the *looks N—really is N* contrast, which plays an essential part in our

accounts of our common world has no literal application for the A's. The import of the contrast will become plainer if we examine that use of expressions like "This looks red" for which there are no criteria. Also, an examination of this use will enable us to see better just what the metaphoric extension of the contrast amounts to, and why the extension to the A's is metaphoric only. Excessive antagonism to the various versions of the traditional Sense-Data theory has tended to obscure the use in question of expressions like "This looks N" and call attention to another, quite legitimate, but logically different use. The old example of the penny will illustrate this well. If one asks a person untouched by even an introductory course in philosophy whether or not a penny looks round when he stands some distance from it, he will, I suspect, reply that it looks round. After an introductory course in philosophy (or after a course in painting) the reply is more apt to be that the penny looks (approximately) elliptical. There is nothing wrong with either of these answers, or anything puzzling about the fact that each is, in its own way, satisfactory. But the answers are logically different. The first is a tentative commitment to an N-ascription "The penny is round" and the proper challenge to it is, for example, "No, the penny is not round at all, but a trick one that I made myself." The challenge points to the relevant tests, the criteria, for the claim tentatively made. But to the second sort of answer, no challenge which can be met by criteria, by relevant tests, is possible, for the only reason one can give for saying that a thing looks N, in this use, is that it looks N.

I return now to the example of colors which are nearer the visual A's, than features like shape.

What sort of assertion am I making when I say "This looks red" in such a use that there are no criteria for my speech act? Let us, in answering, first dispose of some well-advertised mistakes of Sense-Data theorists. I am not, in this act, ascribing red to anything at all, let alone a sense-datum. I am, one might say, predicating *looking red* of a physical object. When my eye-doctor questions me about how a chart with letters on it looks to me, we are both concerned with how the chart, a common object for us, looks to me. Glasses are prescribed not to see sense-data better but to see charts and hence, houses and trees and so on, better. (Note that I can ask what color, shape, part of the object, and so on, you see and the appropriate reply will vary according to the "object" in question. But unless I thus explicitly limit the object, *seeing* is of physical things, like tables and mountains.) Furthermore, my assertion, though it has no criteria, is not incorrigible in every way; I am not in this sense "absolutely certain." My speech act may "go wrong" in at least three ways. I may lie. (Eye-doctors employ techniques to detect lying.) Or I may just be inattentive, tired, careless, and say "this letter looks fuzzier than the other" when it does not, not intending to deceive but speaking thoughtlessly. Or I may make a mistake in my employment of language, I may use "red" where "purple" would be correct, or "fuzzy" where "blurred" would be

more accurate. But note, my correct employment of language, and my lack of intent to deceive are implied (contextually) by my act. They are *not* part of what I say nor are they entailed by it. Indeed, if, when I say "This looks red," I were also saying, "This is what is correctly called 'red' ", I should be involved in an endless regress of assertion. Moreover, as I have indicated earlier, when I say "This looks red" I am not saying "to me, now." That the thing referred to looks *red to the speaker at the time of speaking* are pre-conditions for the correct use of "looks" in the example in question.

Finally, we should get rid of the mistaken notion (sometimes associated with the Sense-Data theory) that when I say that an object looks red, I am reporting the presence of something that is private in the way my head-ache is. I usually expect things to look to other people as they do to me, if they take my physical standpoint. However, I do not assert my expectations when I tell you how something looks (to me at the time of speaking) and, of course, my expectations may turn out to be wrong. Perhaps some internal condition of mine, unknown to me, will result in the object looking N_1 to me, but N_2 to everyone else. One of the insights, I think, of the Sense-Data theorists, was to see that when my expectations of agreement are disappointed, I do not say "I was wrong, apparently, it didn't really look N_1 to me at all" but "Well it did look N_1 to me, at the time."

The mistakes of the Sense-Data theorists have been so harped upon of late that this insight and others have been unduly neglected. For my purposes, the other neglected virtue of Sense-Data theories lies in their calling attention to the fact that there are statements (true or false) for the assertion of which there are no criteria. A-ascriptions, reports of sensations and feelings, and statements made with sentences like "This looks N" all fall into this general category, though they differ greatly among themselves.

There is, then, we have just shown, a clear logical difference between saying (in an appropriate context) "This looks red" and "This *is* red." In the former case, we commit ourselves to no criteria, in the latter we do. (Note, we do not assert that the criteria are satisfied—only truth-conditions, not criteria, give the logical content of what is asserted.) If whatever I have said about the lack of criteria for making statements of the "X is A" form is true, then there will be no such clear-cut difference, but a broad similarity only—a metaphoric one—which will on occasion illuminate, but will break down when the analogy is pressed. Consider the following examples. Suppose I stand in the presence of the bright color scheme of the cottages mentioned earlier. "They are gay," I say, and since they do look gay to me at the moment of speaking, so far as my act is like stating *that they look N*, I cannot be shaken or questioned or challenged in my claim. (I can, of course, as we have seen, be accused of lying, or using words incorrectly, or being careless.) If I am inclined

to believe that my apprehension of aesthetic effect is idiosyncratic, or that, for me, the effect has no stability, I shall be inclined to treat my statement as though it were a *looks (to me now)* statement. But if I am a member of a coterie or am hardened in one of the current snobberies of the radicals or conservatives in art, I shall be inclined to treat my statement more like a *This is N* statement, and summon—if challenged—other "normal" observers to look at it as I do, from a "normal" viewpoint. So far, the metaphor works. But a rebel from within, or a Philistine from without, may dispute my standards of "normality." Time and again the rebel or the Philistine has partly or wholly prevailed, in that, partly owing to his efforts, we begin to apprehend different A's in the same objects. In the end, Sensibility does not function like Sense!

Dealing with the third question will help bring out more clearly just what sort of stabilities are lacking in our apprehension of A's, and how our perceptual viewpoint is connected with them. We have seen that, for N's, whether the object in question is stable or not, we can establish standards of normality for observer and circumstance of viewing such that the question "Does it (did it) just look N (at time t_1) or is it (was it, at time t_1) really N?" is answerable for various purposes. Another way of putting the matter would be to say that we can, for changes in the way things look N to us, decide, or tell (a) whether the change is attributable to a change in us or in the object and (b) if the change is in us, what sort of change it is, (drugs, odd glasses, abnormal physiology, or just a stand-point different from the privileged or "normal" one for determining *the*—stable or momentary—N in question.)[9] Now when A's change for us (without change of N's) we may be inclined to say that the A-featured "object" has changed, but, at the same time, we attribute the change to our own sensibilities. I have in mind here as examples of changes in the way things look A to us, not only such relatively slow historical changes as that from seeing El Greco's compositions as ungainly to seeing them as vibrant and soaring to seeing them (as some of us now do) as flaccid and insipid, but also the "instantaneous" changes in A's connected with the flexibility of our perceptual viewpoint. With a little training, one can learn to see objects, or compositions, first in one way and then in another. Some painters, Picasso in one period, for example, have skillfully manipulated this flexibility and painted pictures that "come alive" as visual ambiguity is discovered by the beholder.

Let us, then, in order to understand the role of our perceptual viewpoint, examine certain law-like statements in which the "looks," not of the present tense of *to me now* statements but of tenseless generalization,

[9] The long line of metaphysicians who reject a *substance* metaphysics not only regard as unimportant the difference between stable objects (relatively slow objective changes) and unstable "objects" (constant change), but also, I think, disregard the differences, built into our concepts of the world, between changes in the way things look owing to changes in the object, (whether stable or not) and those owing to changes in our position or condition.

occurs. To begin with we should notice that if I say "This blue door looks purple in the moonlight" I am saying something very different from "This looks purple" in the use examined in answering question 2.[10] Ordinarily, I would not tell you how my door looks in the moonlight, unless it had so looked to me, but I might do so. This is why a blind man could use the first sentential expression to make a statement, but not the second. A blind man cannot employ "This looks red" to make a statement, because he cannot be taught when it is correctly employed. (Criteria, in the narrow sense of *criteria of correct use*, not of logical support, are unavailable to him.)

The more obvious sort of generalizing use of "look" is found in statements like "Red things look black at night," "Red and green look greyish to a certain kind of color-blind person." Instances of subject and predicate classes are, one should note, presupposed in the assertion of such general statements. Also, in the first sort of example, the asserter, I suggest, assumes or takes for granted that the *looking N at night* holds for normal observers, and in the second sort of example, that the *looking N to a certain kind of color-blind* takes place under normal circumstances.

What kind of general statements can we make about things *looking A*, if, as I have maintained, there are no literally analogous stabilities for observer and circumstance which might be taken for granted?

When we turn our attention from A-ascriptions to general statements of the kind in question, an important but often neglected point becomes clear, namely, that the A's belong to the large and heterogeneous family of features studied by gestalt psychologists. This family includes expressive qualities, like the *cheerfulness* of a certain combination of reds and yellows; certain aspects of visual objects that require certain experiences to apprehend, the duck-like look, for example, that a circle and juxtaposed triangle can have for those familiar with ducks; and features of organization like the tension between horizontals and verticals in a design, or the movement of a spiral figure, or the figure-and-ground relation of a line on a plane surface, or the recessive effect of patterns on plane surfaces, and so on. (I shall hereafter refer to members of this family as G's.) The A's seem a distinguishable branch of the family only in requiring a rather special degree of sensitivity or training for their apprehension. It is not easy for the ordinary man to "see" the pattern of tensions in a Mondrian painting or to get the expressive qualities of abstract expressionism. But it is, from an early age, of practical importance for us to recognize certain objects by apprehending G's—the structural pattern of the human face and its range of expressive qualities, for example. The

[10] I have not, for brevity's sake, attempted to examine all relevant uses of "look," in particular, not the generalizing use for a singular subject, for example, "Does this penny really look elliptical from here?" However, the same general sort of differences between N's and A's which I have been making out will hold for the use in question.

G's, then, so central in ordinary perception, might seem to form a bridge between the N's and the A's. The gestalt psychologists have for a long time been pointing out that the G's are as much data of our visual experience as the N's, that, if we want to describe the way the world looks to us (in their terms, the "phenomental" world) then G-ascriptions will form an important part of our description. But the gestalt psychologists have, quite naturally, not been interested in logical roles. To be sure, when they say that the G's are "phenomenally given," one can rephrase the point by saying that the *really is—only looks* contrast exhibited in "He only looks ill, (strong)—he really isn't" is inapplicable to G-features, *visual balance*, or *figure-and-ground organization*, for example. But that G-ascribings are not literally testable or checkable, that there are no criteria for them literally analogous to the criteria for N-ascribings, this has been obscured in the work on gestalt features. Largely perhaps because the gestaltists have worked with simple examples and cases where perceptual viewpoints have become habitual, G-ascriptions may seem very much like color-ascriptions. But an example will suffice to show that they are not. If I order a hat, a car, or a horse of a certain color and the object turns out to be a different color from the chosen one, I can demand my money back and there will be no difficulty in determining what color the object "really" has; as distinguished from the way it might have looked to a salesman in a certain light. But if I order an American flag and try to return it on the basis that I was told it had 7 red stripes on a white background, whereas it *really* has 6 white stripes on a red background, I shall make no headway. I can return a painting sold to me as a picture of a Blue Boy if the picture delivered turns out to be one of a Pink Boy, but I cannot return it on the ground that the art dealer lied in telling me the composition was balanced.

The consequence of these differences is not that gestalt psychologists cannot generalize about G's and A's in statements of the form *All such-and-such objects look G (A) to such-and-such observers in such-and-such circumstances* and make predictions which confirm these law-like statements. They do both these things. For example, "A black line on a white plane surface looks slightly in front of the plane and appears as figure-and-ground." But what is taken for granted, presupposed when not mentioned, in the way of characteristics of observer and circumstances of viewing are, as I showed for the A's, certain special training or habits or sensitivities and what I have called a "perceptual viewpoint," a pattern of concentration, of heeding this and not that, of movement of attention, of looking at certain parts of a design together or in quick succession, and so on. And, as I have said earlier, these characteristics of observer and "perceptual viewpoints" do not provide the kind of stabilities that make criteria for N-ascribings possible. The gestalt psychologists have, I think, somewhat neglected the flexibility of our perceptual viewpoints. Such-and-such a design, we are told, will be seen by children as organized

in this way, by adults as in that. But I have found it quite easy to recapture the vision of the child, and, with a little training the classic figure-and-ground of line on plane can be reversed almost as easily as the deliberately designed ambiguities. More effort is required to banish altogether the figure-and-ground organization from the line on plane design, but it can be done. Painters, of course, have always resorted to a variety of "tricks" to break down habitual ways of looking at things and every new style in painting represents, one might say, a new perceptual viewpoint.

The relation between A-features and perceptual viewpoints enable us to explain the frequent presence of "N"'s and N-ascriptions in the talk of critics and will help, in the next and final section, to make understandable the logical relation of "N"'s and "A"'s.

If we are with a critic in the presence of a picture, "N"'s will often occur in his talk in imperative sentences.[11] "See how that line leads into this," "Look at the color contrasts here and here." In writing, we often find an alternation of N-ascription and A-ascription. For example:

The picture has an upright format, the proportion being approximately 5:4. *This stretches the whole in the direction of the vertical and reinforces the upright character of the figure*, . . . A dark band divides the background into two rectangles. Both are more elongated than the whole frame, the lower rectangle being 3:2 and the upper 2:1. This means that *these rectangles are stressing the horizontal more vigorously than the frame stresses the vertical*. According to Denman Ross, the eyes moves in the direction of diminishing interval—that is, upward in this picture.[12]

Whether the critic employs the imperative or the ascriptive form, however, his purpose generally is to get us to take a certain perceptual viewpoint.

V

We are now in a position to see that the three current views, mentioned at the outset, of the logical relation of "N"'s, and "A"'s are mistaken, how they are mistaken, and what facts about the relationship are pointed to, but distorted in the three accounts.

All three views are initially mistaken in taking the grammatical similarity of A-ascriptions and N-ascriptions as indicative of logical similarity. (If one wants to employ Wittgensteinian terminology here, one could say, "These ascriptions play a role in different language games.") The grammatical similarity, together with the fact that for both sorts of ascription, the subject may be the same ("She is 5 feet ten inches tall, dark-haired and elegant"), leads naturally enough to the question "How are state-

[11] See Hubert Schwyzer, "Sibley's 'Aesthetic Concepts'," *Philosophical Review* (January, 1963).

[12] *Art and Visual Perception* by Rudolf Arnheim (Berkeley, University of California Press, 1954), p. 23. I have underscored the A-ascriptions.

ments of the form *X is N* and *X is A* logically related, that is, can the truth-value of statements of the one sort in any way determine the truth-value of the other?" We are so used to working with the analytic-synthetic (deductive-inductive) dichotomy that again it is natural to take the further step of forcing the relationship into one or the other side.

As we have seen, the deductive view may be held in the strict form for which a certain set of N-ascriptions will be sufficient truth-conditions for (will entail) an A-ascription, or the view may be held in the less strict form for which N-ascriptions are never sufficient, but may be necessary truth-conditions for an A-ascription.

Now, there is an initial plausibility in the deductive view in either of its forms, for there seems to be a connection which we might naturally enough call a connection in "meaning" between "N"'s and "A"'s. Suppose, for example, that a beginner in English has as his native language one in which the word for "delicate" is phonetically like the word for "garish" and vice versa, and that he consequently often mistakes the one English word for the other. If we talked to him about color combinations we would soon find out that he was employing the English words "incorrectly," that he "didn't know their meaning." This discovery would be quite different from a discovery of difference in aesthetic sensitivity.

Neither form of the deductive view, however, is tenable. Suppose, to consider the strict form, that one portion of a painting is blue, another red, and that in describing the painting I make the true N-ascriptions to this effect. I am, then, *ipso facto* logically committed to the N-ascription that these portions are colored. I am not logically committed to any A-ascription about the tension or balance and so on, of the two colored areas. And I could not be so committed because it is possible for me to see the blue and red colored areas but not to see them as in tension or balance and so on. I cannot, though, see blue and red areas without seeing colored areas. The present example should suffice to show that the less strict form of the view is equally mistaken. But since the less strict form is more suggestive of the right view, I shall postpone consideration of it.

The inductive (empirical) view also has an initial plausibility. If it is not necessary that a certain design should be A, if it has a certain combination of colors, still might it not be probable that it would be A? So, the empirical view takes as its model patterns of reasoning like "His face is flushed, so probably he has a fever" and presents N's and A's as related in the following way: this picture design is N_1, N_2, N_3, so probably it is also A_1." But such a relationship could not hold between N-ascriptions and A-ascriptions. I have shown that one's stating that something is A needs and can receive *no* logical support. Evidence is not required.

The third view, that there are no truth-conditions for "A"'s, that they are "not rule-governed at all" is, as I have said, more in need of supplementation than refutation. Moreover, it, too, is at the outset appealing, for if "N"'s and "A"'s can be related neither in an analytic nor in a synthetic

way, if it is neither necessary nor predictable beforehand what, given certain colors, the aesthetic effect will be, perhaps we have to do with concepts that are "governed" by no rules. But the view is mistaken in this respect—the "A" 's can be, and often are, given definitions of the usual dictionary sort in terms of other "A" 's. Thus "Balance (visual) is an equilibrium of visual forces" establishes the obvious sort of entailment relations which constitute truth-conditions exactly analogous to those illustrated in "X is red" entails "X is colored."

What then *is* the logical relationship between "N" 's and "A" s? The answer has been before all of us for a long time—it has just wanted detailed examination in a good light. It is implicit in the traditional name for *A's*, "tertiary qualities" and also in what might be called the "defining accounts" of "G" 's and "A" 's given by gestalt psychologists. These accounts do not, like the conventional truth-condition definition of an "A," given above, offer us a synonymous phrase. Rather, they may be said to "explain" the role of "G" 's as that of terms applying to the visual effects which certain combinations of the N-features of things *may* have for us (Or, one could say, these terms were invented to describe how certain combinations of the N-features of things *may* look to us.) As we learn our way around the world, we learn about differences of sensibility and about how we can alter the aesthetic look of things by altering our perceptual viewpoint. Thus, "figure-and-ground" is a label for an A-feature of visual organization which a line or a plane surface (seen, of course, from a certain physical viewpoint) may have for us if we take a certain perceptual viewpoint. The perceptual viewpoint in question, I have pointed out, though firmly ingrained is not completely inflexible and may be changed at will by some, if not all of us. We can say, then, that the applicability of some "N" or "N" 's is a pre-condition for the applicability of any "A" or "A" 's. This answer, however, will be unilluminating unless the following two questions are dealt with. First, does the answer amount to saying that the truth of some N-ascription is a pre-condition of assertion for any A-ascription? Second, is the applicability of any particular "N" or set of "N" 's a pre-condition for the application of any particular "A," for example, is "pale colors" a pre-condition of application for "delicate"?

The answer to the first question is "No," to the second, "Yes."

The answer to the first question is "No" because the pre-condition for the making of A-ascriptions is not the truth of N-ascriptions, but the truth of expressions like *X looks N*. Whether the object which looks N_1, N_2 . . . N_n is really N_1, N_2 . . . N_n or not (and whether the object is stable or not) does not matter for the correct use of "A" 's. If an object looks N_1, N_2 . . . N_n to a beholder, it may also look A_1, A_2 . . . A_n, and hence he may quite correctly say something of the form, "This is (looks) A" even if none of the relevant N-ascriptions are true of the object. If my dark glasses, for example, make the hillsides look greener

than they "are," or change the colors of the sunset, I do not incorrectly use "fresh" of the one effect, or "garish" of the other.

However, if I am aware that, for example, my dark glasses make the hills of California look greener than they are, I shall, no doubt, treat my statements of the form, "These hills are A" like statements of the form, "These hills look . . . (to me now)." In brief, the metaphoric extension from N to A-ascriptions will not, in this instance, be a good one, will not be warranted. The requirements, in general, for the extension are, I believe, as follows: (a) that the N's which are pre-conditions for the A's in question be ascribable, truly, to the object described, and (b) that there be stability and community (within an era, a cultural group, a coterie) in the apprehension of the A's in question.

I have not, I should like to say here, been trying to show that A-ascriptions cannot, when challenged, be *in any sense* supported (justified). For, to say that the metaphoric extension is a good one, is to say that some non-arbitrary support can be found for it. But, as I have been trying to show, the support will be non-arbitrary within a cultural milieu, a coterie. My thesis has been that the concepts of Sensibility should not be absorbed either to those of Sense or to those of Sensation (feeling).

I turn next to the affirmative answer to the question about any particular N's being pre-conditions for the application of particular "A"'s. We do not have any very precise sets of specifications of particular N's that are pre-conditions for the application of particular "A"'s, but this does not mean that we do not have any particular connections. If we see a pattern of colors very gradually shading into one another, "figure-and-ground" does not apply nor does "balance." The "A"'s that are labels for expressive qualities, "cheerful" and "gloomy," for instance, have, perhaps, even less precisely specifiable pre-conditions. Yet we would find out if someone, learning English, should mistake one adjective for the other.

It remains to show briefly how the three rejected views of the relation of "N"'s and "A"'s pointed to, but distorted, certain facts about the relation. The third view, that "A"'s have no truth-conditions, are not "rule-governed at all" points, I think, to the just mentioned lack of precisely specifiable pre-conditions for "A"'s. It also calls our attention to one of the reasons for this lack. Any N-feature (a certain color, for example) which in one color context contributes to an effect correctly called "A_1" ("garish" for example) may in another color context contribute to an effect correctly called "A_2" ("delicate," for example) which is incompatible with "A_1." These facts are, I believe, reflected in the language we employ. We say that an effect of "delicacy" or "garishness" is "created by" or "achieved by" a set of N-features seen together.

The empirical (inductive) view points to the important possibility of generalizing reliably about the A-features, which certain objects may have for certain perceivers. But the making of a general statement is a quite different thing from the making of an A-ascription.

Finally, the deductive view calls attention to the fact that the relation in question has to do with the correct use of "A" 's and hence with what might, appropriately, be called "the meaning of "A" 's." However, the sense in which pre-conditions of application for terms may be called "necessary conditions" for the use of those terms is very different from the sense in which "X" is colored" is a necessary truth-condition for "X is red."

MARGARET MACDONALD

THE LANGUAGE OF FICTION

Margaret Macdonald (1903–1956) was University Reader in Philosophy at Bedford College in the University of London.

I

Emma Woodhouse, handsome, clever and rich, with a comfortable house and happy disposition seemed to unite some of the best blessings of existence and had lived nearly twenty-one years in the world with very little to distress or vex her.

The opening sentence of Jane Austen's novel *Emma* is a sentence from fiction. *Emma* is a work in which the author tells a story of characters, places and incidents almost all of which she has invented. I shall mean by "fiction" any similar work. For unless a work is largely, if not wholly, composed of what is invented, it will not correctly be called "fiction." One which contains nothing imaginary may be history, science, detection, biography, but not fiction. I want to ask some questions about how an author uses words and sentences in fiction. But my interest is logical, not literary.

Reprinted from *Proceedings of the Aristotelian Society*, Supplementary Volume XXVII (1954), pp. 165–184, by courtesy of the Editor of The Aristotelian Society.

I shall not discuss the style or artistic skill of any storyteller. Mine is the duller task of trying to understand some of the logic of fictional language; to determine the logical character of its expressions. How do they resemble and differ from those in other contexts? What are they understood to convey? Are they, e.g., true or false statements? If so, of or about what are they true or false? If not, what other function do they perform? How are they connected? These are the questions I shall chiefly discuss.

First of all, "fiction" is often used ambiguously both for what is fictitious and for that by which the fictitious is expressed. Thus "fiction" is opposed to "fact" as what is imaginary to what is real. But one must emphasize that a work of fiction itself is not imaginary, fictitious or unreal. What is fictitious does not exist. There are no dragons in the zoo. But the novels of Jane Austen do exist. The world, fortunately, contains them just as it contained Jane Austen. They occupy many bookshelves. Works of fiction, stories, novels are additions to the universe. Any unreality attaches only to their subject matter.[1]

Secondly, everyone understands the expressions of fiction. Or, if they do not, the reason is technical, not logical. One may find it hard to understand some of the expressions of Gertrude Stein or *Finnegan's Wake* but this is due to the peculiar obscurity of their style and not to the fact they occur in works of fiction. No one who knows English could fail to understand the sentence quoted from *Emma*. That Emma Woodhouse was handsome, clever, and rich is understood just as easily as that Charlotte Brontë was plain, sickly and poor. Both are indicative sentences which appear to inform about their subjects. But while the sentence containing "Charlotte Brontë" expresses a true statement of which Charlotte Brontë is the subject, that containing "Emma Woodhouse," cannot work similarly, since Jane Austen's Emma did not exist and so cannot be the logical subject of any statement. "Emma Woodhouse" does not and cannot designate a girl of that name of whom Jane Austen wrote. This has puzzled philosophers.[2] If apparent statements about Emma Woodhouse are about no one, of what is Jane Austen writing and how is she to be understood? Perhaps a subsistent wraith in a logical limbo is her subject? This will not do; or, at least not in this form. Jane Austen is certainly "pretending" that there was a girl called Emma Woodhouse who had certain qualities and adventures. According to one view she is understood because we understand from non-fictional contexts the use of proper names and the general terms in which she describes Emma Woodhouse and her adventure. There is no Emma Woodhouse, so Jane Austen is not writing about her; rather is she writing about a number of properties, signified by the general terms she uses, and asserting that they belonged to someone. Since they did not,

[1] Cf. also "Art and Imagination," *Proc. Aris. Soc.*, 1952–53, p. 219.

[2] See earlier Symposium on "Imaginary Objects," *Proc. Aris. Soc.*, Supp. Vol. 12, 1933, by G. Ryle, R. B. Braithwaite and G. E. Moore.

"Emma Woodhouse" is a pseudo-designation and the propositions are false, though significant. Readers of *Emma* need not, and usually do not, believe falsely that its propositions are true. A work of fiction is, or is about, "one big composite predicate" and is so understood by readers who need neither know nor believe that any subject was characterized by it. If, however, there had been, by chance, and unknown to Jane Austen, a girl called Emma Woodhouse who conformed faithfully to all the descriptions of the novel, its propositions would have been about and true of her and Austen would have "accidentally" written biography and not fiction.[3]

This seems a somewhat strained account of a story. As Moore says,[4] it does seem false to deny that Jane Austen wrote about Emma Woodhouse, Harriet Smith, Miss Bates, Mr. George Knightley and the rest, but is instead, about such a peculiar object as a "composite predicate." He would, surely, find this quite unintelligible. It is also false to say that a work of fiction may be "accidentally" history or biography. For if there were ten girls called "Emma Woodhouse" of whom all that Jane Austen wrote were true, they are not the subject of *Emma*, for Jane Austen is not telling a story of any of them, but of a subject of her own invention. Moreover, it would not only be necessary that Emma Woodhouse should have a real counterpart but that such counterparts should exist for every other element of the novel. You cannot separate Emma from Highbury, her companions and the ball at the Crown. They all belong to the story. Such a coincidence would be almost miraculous. So Moore seems to be right when he says:[5]

I think that what he (Dickens) meant by "Mr. Pickwick" and what we all understand is: "There was only one man of whom it is true both that *I am going to tell you about him* and that he was called 'Pickwick' *and* that, etc." In other words, he is saying from the beginning, that he has one and only one man in his mind's eye, about whom he is going to tell you a story. That he has is, of course, false; it is part of the fiction. It is this which gives unique reference to all subsequent uses of "Mr. Pickwick." And it is for this reason that Mr. Ryle's view that if, by coincidence, there happened to be a real man of whom everything related to Mr. Pickwick in the novel were true then "we could say that Dickens' propositions were true of somebody" is to be rejected *since Dickens was not telling us of him:* and that this is what is meant by saying that it is only "by coincidence" that there happened to be such a man.

I think this can be seen to be true even in circumstances which might appear to support Ryle's view. *Jane Eyre* and *Villette* are known to contain much autobiographical material. Charlotte Brontë knew her original as Dickens did not know of a "coincidental" Mr. Pickwick. Yet *Jane Eyre* and *Villette* are still works of fiction, not biography. They are no substitute for Mrs. Gaskell's *Life of Charlotte Brontë*. For although she may be *using* the facts of her own life, Charlotte Brontë is not writing "about" herself, but "about" Jane Eyre, Helen Burns, Mr. Rochester, Lucy Snowe, Paul

[3] *Loc. cit.*, G. Ryle, pp. 18–43.
[4] *Ibid.*, p. 59.
[5] *Loc. cit.*, p. 68.

Emmanuel and the rest. Or, she is writing about herself in a very different sense from that in which she is writing about the subject matter of her novels.

Ryle and Moore agree, with many others, that the sentences of fiction express false statements and Moore adds, I think rightly, that, so far, at least, as these are fictional, they could not be true. But there is a more radical view of which there is also some excuse. If a storyteller tells what he knows to be false, is he not a deceiver and his works a "tissue of lies?" That storytelling is akin to, if not a form of, lying is a very common view. "To make up a tale," "to tell a yarn" are common euphemisms for "to tell a lie." A liar knows what is true, but deliberately says what is false. What else does the storyteller who pretends that there was a girl called "Emma Woodhouse," etc., when she knows this is false? A liar intends to, and does, deceive a hearer. Does not a storyteller do likewise? "Poets themselves," says Hume, "though liars by profession, always endeavor to give an air of truth to their fictions."[6] Hume is contrasting all other expressions as indifferently lies or fiction, with those which are true of matters of fact. Hume is quite wrong to classify all poetry with fiction, though some stories may be told in verse. But no one could correctly call, e.g., Shakespeare's Sonnets, Keats' Odes or Eliot's Four Quartets, works of fiction. Nor are they statements of fact, but their analysis is not my task here. I wish only to protest against a common tendency to consign to one dustbin all expressions which do not conform to the type of statement found in factual studies. Even though they are not factual statements, expressions in literature may be of many different logical types. It is clear, however, that for Hume storytelling is a form of lying. And, indeed, a storyteller not only says what he knows to be false but uses every device of art to induce his audience to accept his fancies. For what else are the ancient incantatory openings, "Once upon a time . . . ," "Not yesterday, not yesterday, but long ago . . . ," and their modern equivalents, but to put a spell upon an audience so that the critical faculties of its members are numbed and they willingly suspend disbelief to enter the state which Coleridge called "illusion" and likened to dreaming?[7] All this is true. Everyone must sometimes be informed, instructed, exhorted by others. There are facts to learn and attitudes to adopt. However dull, these processes must be endured. But no one is obliged to attend to another's fancies. Unless, therefore, a storyteller can convince, he will not hold an audience. So, among other devices, he "endeavors to give an air of truth to his fictions." It does not follow that what he says *is* true, nor that he is a deceiver. One must distinguish "trying to convince" from "seeking to mislead." To convince is a merit in a work of fiction. To induce someone to accept a fiction, however, is not necessarily to seduce him into a belief that it is real. It is true that some people may be deceived by fiction. They fail to distinguish

[6] *Treatise of Human Nature*, Bk. I, Pt. 3, Sec. 10.
[7] Cf. Notes on *The Tempest* from *Lectures on Shakespeare*.

conviction from deception. Such are those who write to the B.B.C. about Mrs. Dale and the Archers as if they believe themselves to be hearing the life histories of real families in these programs. But this does not show that the B.B.C. has deliberately beguiled these innocents. Finally, a liar may be "found out" in his lie. He is then discredited and his lie is useless. Nor is he easily believed again. But it would be absurd for someone to complain that since *Emma* was fiction he had "found out" Jane Austen and could never trust her again. The conviction induced by a story is the result of a mutual conspiracy, freely entered into, between author and audience. A storyteller does not lie, nor is a normal auditor deceived. Yet there are affinities between fiction and lying which excuse the comparison. Conviction, without belief or disbelief, as in art, is like, but also very different from, unwitting deception. And a liar, too, pretends but not all pretending is lying.

A fictional sentence does not, then, express a lying statement. Does it express a false statement which is not a lie? False statements are normally asserted from total or partial ignorance of the facts. Those who assert them mistakenly believe they are true. This is not true of the storyteller. Neither he nor his auditor normally believes that his statements are true. It is false that Jane Austen wrote *Pickwick Papers* but it is not nonsense to suggest that it might have been true. As already seen, however, no factual discovery can verify a fictional statement. It can then never be true. So it would seem to be necessarily false or logically impossible. But the expressions of fiction are neither self-contradictory nor nonsensical. Most of them are perfectly intelligible. Those which are not are so for reasons quite unconnected with truth and falsity. It is not because James Joyce's statements are false that they are unintelligible. For those of Jane Austen and Dickens are equally false, but not obscure.

Alternatively, it might be said that the propositions of fiction are false, but neither believed nor asserted. Their fictional character consists in the fact that they are merely proposed for consideration, like hypotheses. "Let us suppose there was a girl called Emma Woodhouse, who . . . etc." For a proposition may be entertained, but yet be false. So an author puts forward and his audience considers, but neither affirm, the false propositions of fiction.[8] Now, a storyteller does invite his audience to "Imagine that . . . ," "Pretend that . . ." and even "Suppose that . . ." or "Let it be granted that . . ." He does not often preface his story with just these remarks, but he issues a general invitation to exercise imagination. So far one may liken his attitude to that of some one proposing an hypothesis in other fields. An hypothesis, like a lie or a story, requires some invention; it is not a report of observed fact. But these suggested fictional hypotheses are also very different from all others. Non-fictional hypotheses are proposed to ex-

[8] I understood Professor Moore to hold such a view in a discussion in 1952. I do not, however, claim his authority for this version. Nor do I know if he is still of the same opinion.

plain some fact or set of facts. "If the picture is by Van Dyck, then . . .";
"Suppose that malaria is transmitted by mosquitoes, then . . ." They sug-
gest, e.g., the origin of a painting or the cause of a disease. But a story is
not told to solve any such problem. Moreover, a non-fictional hypothesis
must be testable or be mere speculation without explanatory value. But,
obviously, nothing can count as evidence in favor of a fictional story. And
what no fact can confirm none can disconfirm either. So, if a story consists
of propositions entertained for consideration, the purpose of such enter-
tainment must be for ever frustrated since they can never be asserted as
true, false, probable or improbable. I conclude, therefore, that the expres-
sions of fiction do not function either as propositions or hypotheses.

Nevertheless, as I have said, one can easily understand why people are
tempted to identify fictional expressions with lies, falsehoods, unverifiable
hypotheses. For what it is worth, the English dictionary appears to support
this view. "Fiction," it says, "the act of feigning, inventing or imagining:
that which is feigned, i.e., a fictitious story, fable, fabrication, falsehood."
If the last four terms are intended as synonyms, this certainly suggests
that all fiction is falsehood. Both rationalist and religious parents have
forbidden children to read fairy stories and novels lest they be led astray
into false and immoral beliefs. Yet its logical difference from these seems
to show that fiction is not false, lying or hypothetical statement. It is clear
that "S pretends that p" cannot entail p. This is, again, the point of saying
that the truth of p must be "coincidental." When discovered, no future S
(or storyteller) could pretend that p, for one cannot pretend that a proposi-
tion is true when it is, and is known to be, true. But neither, in fiction, can
"S pretends that p" entail "not-p" or even "Perhaps-p." So, fictional expres-
sions must be of a different type from statements.

An alternative is the familiar emotive answer. This is associated chiefly
with the name of I. A. Richards. I can mention it only briefly. According
to it, sentences in fiction, as in all non-informative contexts, express an
emotional state of their author and seek to induce a similar state in his
audience. A work is judged better or worse according to the amount of
harmonious mental adjustment by which it was caused and which it effects.
This view is difficult to estimate because of its vague use of the word
"express." It tends to suggest that the expressions of fiction are disguised
exclamations such as "Hurrah!" or "Alas!" Or that these could be sub-
stituted for them. This, of course, is impossible. No one could tell the story
of *Emma* in a series of smiles, sighs, tears, shouts or the limited vocabulary
which represents such emotive expressions. Most stories, one must reiterate,
are told in normal English sentences which are common to fact and fiction
and appropriately understood. This is, indeed, just the problem. If the
expressions of Jane Austen were as easily distinguishable from factual state-
ment as exclamation from articulate utterance no one would be puzzled.
"Emotive expression" must, therefore, be compatible with understood

sense.[9] It is true that emotional relationships play a large part in most fiction, but so does much else. Nor need these subjects coincide with the experience of either author or audience. No story, even though told in the first person, can be completely autobiographical without ceasing to be fiction. And whether or not a work of fiction uses autobiographical material, the actual, or suspected, direct intrusion of personal feeling by the author is liable to be fatal to the work.

I opened it at chapter twelve and my eye was caught by the phrase "Anybody may blame me who likes." What were they blaming Charlotte Brontë for, I wondered? And I read how Jane Eyre used to go up on the roof when Mrs. Fairfax was making jellies and look over the fields at the distant view. And then she longed—and it was for this that they blamed her—that "then I longed for a power of vision which might overpass that limit . . . I desired more of practical experience . . . more of intercourse with my kind . . . I believed in the existence of other and more vivid kinds of goodness and what I believed in I wished to behold . . . Who blames me? Many no doubt and I shall be called discontented . . . When thus alone I not infrequently heard Grace Poole's laugh."
 That is an awkward break, I thought. It is upsetting to come upon Grace Poole all of a sudden. The continuity is disturbed. One might say, I continued . . . That the woman who wrote these pages had genius . . . but if one reads them over and marks that jerk in them, that indignation, one sees . . . that her books will be deformed and twisted. (Virginia Woolf; *A Room of One's Own*, p. 104.)

In short, Charlotte Brontë will, or will appear to, express her own feelings too nakedly through her heroine, in order to induce a sympathetic emotional response in her readers, instead of telling her story. Someone may protest that this amounts to *describing*, not expressing, her emotions. But this is not ostensibly so. The passage is still a soliloquy by Jane Eyre, not an introspective report by Charlotte Brontë. Virginia Woolf is giving an interpretation of the passage, but this would not be necessary if it were a simple description of Charlotte Brontë's feelings. If her critic is right and if, nevertheless, the passage is not what is meant by an expression of the author's emotion by fiction, this cannot be because it is a straightforward description of fact. Another objection might be that this is a crude example of expression and does not prove that the task of fiction is not to express emotion. Skilful expression is impersonal, almost anonymous. One cannot tell from their works what Shakespeare or Jane Austen felt. Hence the floods of speculation by critics. One knows only too well from her novels what Charlotte Brontë felt, so she is not truly expressing, but merely venting, her emotions. But then, if one so often cannot tell whose, or even what, emotion is being expressed, what is the point of saying that all fictional expressions are emotive? Should the criterion be solely the effect on their audience? Certainly, a tale may amuse, sadden, anger, or otherwise move a hearer. But is the fact that *Emma* may cause one to laugh or sigh what distinguishes it as a work of fiction from a statement of fact?

[9] Cf. also Empson, *The Structure of Complex Words*, London, 1951, ch. 1.

This must be false for much that is not fiction has the same effect. The answer to the theory is that a work of fiction, like any work of literary art, causes a very special emotional effect, an harmonious adjustment of impulses, a personal attitude, not otherwise obtainable. But no independent evidence of any such pervasive effect is offered, nor can I, for one, provide it from experience of reading fiction. So, if one cannot distinguish fiction from fact by the normal emotional effects which fiction sometimes causes, nor by the pervasive changes it is alleged to cause, the theory only reformulates and does not explain this distinction.

But the theory does emphasize that language has less pedestrian uses than those of the laboratory, record office, police court and daily discourse. Also, that to create and appreciate fiction requires more than intellectual qualities. Most fiction would be incomprehensible to a being without emotions. One must be able to enter imaginatively into its emotional situations though its emotions need not be felt. One need not feel jealousy either to construct or understand Mr. Knightley's censorious attitude to Frank Churchill, but someone who had never felt this might find an account of it unconvincing. Authors differ, too, in what may vaguely be called "climate" or "atmosphere," which is emotional and moral as well as intellectual. The "worlds" of Jane Austen and Henry James, e.g., differ considerably from those of Emily Brontë and D. H. Lawrence. Also, much of the language of fiction is emotionally charged. For it depicts emotional situations which are part of its story. But none of these facts is positively illuminated by a theory which limits the language of fiction to the expression of an emotion transferred from author to auditor even if such a transaction were fully understood. It does not seem to be the feeling which generates them nor that which they cause which wholly differentiates the ironies of Gibbon from those of I. Compton Burnett. Nor is it either Tolstoy or ourselves in whom we are primarily interested when reading *War and Peace*. Rather is it the presentation of characters, actions and situations. The vast panorama of the novel shrinks into triviality as the instrument of the emotional adjustments of Tolstoy and his readers. I conclude, therefore, that the characteristic which differentiates fictional sentences from those which state facts is not that the former exclusively express anybody's emotions, though many of them have a very vital connection with emotion.

II

When someone reports a fact he may choose the language or symbolism of his report. He may choose to use this carefully or carelessly. But there is a sense in which he cannot choose what he will say. No one could report truly that Charlotte Brontë died in 1890; that she wrote *Villette* before *Jane Eyre;* that she was tall, handsome and a celebrated London hostess. No biography of Charlotte Brontë could contain such statements and remain a biography. For what is truly said of Charlotte Brontë must be

controlled by what she was and what happened to her. But Jane Austen was under no such restraints with Emma Woodhouse. For Emma Woodhouse was her own invention. So she may have any qualities and undergo any adventures her author pleases. It is not even certain that these must be logically possible, i.e., not self-contradictory. For some stories, and not the worst, are extremely wild. There is *Finnegan's Wake* as well as *Emma*. A storyteller chooses not only the words and style but also, and I suggest with them, provides the material of a fictional story. I want to stress this fact that in fiction language is used to *create*. For it is this which chiefly differentiates it from factual statement. A storyteller performs; he does not —or not primarily—inform or misinform. To tell a story is to originate, not to report. Like the contents of dreams, the objects of fiction may presuppose, but do not compete with, those of ordinary life. Unlike those of dreams, however, they are deliberately contrived. Hence, they differ too from lunatic frenzies. A lunatic unintentionally offends against fact and logic. He intends to respect them. He thinks he is right, however wild his fancies, when he is always wrong. But a storyteller, though equally wild, is never deluded. He invents by choice, not accident.

As I have already said, most of a storyteller's words and sentences are understood to have the same meanings as the same words and grammatical forms in non-fictional contexts. For all who communicate use the same language, composed mainly of general terms. But language may be used differently to obtain different results. When a storyteller "pretends" he simulates factual description. He puts on an innocent air of informing. This is part of the pretence. But when he pretends, e.g., that there was a Becky Sharp, an adventuress, who finally came to grief, he does not inform or misinform about a real person called "Becky Sharp" or anyone else: he is creating Becky Sharp. And this is what a normal audience understands him to be doing. Of course, he does not thereby add to the population of the world. Becky Sharp is not registered at Somerset House. But this, too, is shown by language. A storyteller, like a dramatist, is not said to create persons, human beings, but *characters*. Characters, together with their settings and situations, are parts of a story. According to Ryle, although "it is correct to say that Charles Dickens created a story, it is wholly erroneous to speak as if Dickens created Mr. Pickwick."[10] But Dickens *did* create Mr. Pickwick and this is not equivalent to saying, as Ryle does, that what Dickens created was a "complex predicate." No one would ever say this. But it is perfectly ordinary and proper to say that an author has created certain characters and all that is required for them to function. "In Caliban," said Dryden, "Shakespeare seems to have *created* a being which was not in nature."[11] He was not in nature because he was part of *The Tempest*. To create a story is to use language to create the contents of that story. To write "about" Emma Woodhouse, Becky Sharp, Mr. Pickwick, Caliban,

[10] *Loc. cit.*, p. 32.
[11] Quoted by Logan Pearsall Smith. S.P.E. Tract XVII, 1924.

and the rest is to "bring about" these characters and their worlds. Human beings are not normally called "characters." If they are, it is by analogy with art. One might say, "I met a queer character the other day; he might have been created by Dickens." This does not show that Dickens wrote or tried to write about such a person, but that his readers now view their fellows through Dickens' works. So may one now see Constable and Cézanne pictures in natural landscapes, which would not have been seen without these artists. Characters play a rôle; human beings live a life. A character, like all else in pure fiction, is confined to its rôle in a story. Not even the longest biography exhausts what could be told of any human person, but what Jane Austen tells of Emma Woodhouse exhausts Emma Woodhouse. A character may be completely understood, but the simplest human being, if any human being is simple, is somewhere opaque to others. A character has no secrets but what are contained within five acts or between the covers of a book or the interval from supper to bedtime.[12] A story may, indeed, have a sequel, but this is a new invention, not a report of what was omitted from the original.

This may be challenged. Surely, it will be said, many characters in fiction are as complex as human beings? Do not critics still dispute about the motives of Iago and the sex of Albertine? But to say that a character is limited to what is related of it in a story does not imply that this must always be indisputably obvious. All it implies is that the only way to find out about a character is to consult the author's text. This contains all there is to discover. No one can find independent evidence which the author has missed. Not even Dr. Ernest Jones for the alleged "complexes" of Hamlet. Assuming that the text is complete and authentic, there may be different interpretations of it and thus of a character but no new evidence such as may render out of date a biography. No one will find a diary or a cache of letters from Hamlet to his mother which will throw light upon his mental state. Nor must this be forever secret in the absence of such evidence. For Hamlet is what Shakespeare tells and what we understand from the text, and nothing more.

What is true of characters is true also of other fictional elements of a story. "Barchester" does not name a geographical place. It is the setting or scene of a number of Trollope's characters. So is his magic island for Prospero and his companions. The words used to "set the scene" of a story paint as it were the backcloth to its incidents. "Scene" is a term of art, a word from the language of the theatre. One would naturally say "The scene of Archdeacon Grantley's activities is laid in Barchester," but not, unless affecting histrionics, "The scene of this Conference is laid in Oxford." It would be more normal to say "This Conference is being held in Oxford." "Scene" is used of natural situations only when they are being treated artifically. Finally, the situations and incidents of a story form its

[12] See also E. M. Forster, *Aspects of the Novel*, Chs. 3 and 4.

plot. They conform to a contrived sequence of beginning, middle and end —or have some modern variety of this shape. But human life and natural events do not have, or conform to, a plot. They have no contrived shape.

It is thus, then, that we talk of works of fiction and their fictional contents. They are contrivances, artefacts. A story is more like a picture or a symphony than a theory or report. Characters, e.g., might for a change, be compared with musical "themes" rather than with human flesh and blood. A composer creates a symphony, but he also creates all its several parts. So does a storyteller, but his parts are the characters, settings and incidents which constitute his story. The similarity is obscure just because the storyteller does, and must, use common speech with its general terms, so that he appears to assert propositions about an independent reality in a manner similar to that of one who does or fails to report what is true. So, philosophers conclude, since pure fiction cannot be about physical objects, it must be about wraith-like simulacra of real objects or equally attentuated "predicates." I do not, however, want to claim a special mode of existence for fictional objects as the contents of fiction. And though it is obvious that fiction writers use our common tongue I do not think that what they do is illuminated by saying that they write about predicates or properties. It is agreed that a storyteller both creates a story, a verbal construction, and the contents of that story. I want to say that these activities are inseparable. Certainly, no one could create pure fiction without also creating the contents which are its parts. One cannot separate Emma Woodhouse from *Emma* as one can separate Napoleon from his biography. I do not say that Emma is simply identical with the words by which she is created. Emma is a "character." As such she can, in appropriate senses, be called charming, generous, foolish, and even "lifelike." No one could sensibly use these epithets of words. Nevertheless, a character is that of which it makes no sense to talk except in terms of the story in which he or she is a character. Just as, I think, it would make no sense to say that a flock of birds was carolling "by chance" the first movement of a symphony. For birds do not observe musical conventions. What is true of characters applies to the settings and incidents of pure fiction. To the questions "Where will they be found?"; "Where do they exist?," the answer is "In such and such a story," and that is all. For they are the elements or parts of stories and this is shown by our language about them.

But the content of very little fiction is wholly fictitious. London also forms part of the setting of *Emma* as it does of many of Dickens' novels; Russia of *War and Peace* and India of *A Passage to India*. Historical persons and events also seem to invade fiction. They are indeed the very stuff of "historical" novels. Do not the sentences in which the designations or descriptions of such places, persons and incidents occur express true or false statements? It is true that these real objects and events are mentioned in such fictional expressions. Nevertheless, they certainly do not function wholly as in a typographical or historical record. They are still part of a

story. A storyteller is not discredited as a reporter by rearranging London's squares or adding an unknown street to serve his purpose. Nor by crediting an historical personage with speeches and adventures unknown to historians. An historical novel is not judged by the same standards as a history book. Inaccuracies are condemned, if they are, not because they are bad history or geography, but because they are bad art. A story which introduces Napoleon or Cromwell but which departs wildly from historical accuracy will not have the verisimilitude which appears to be its object and will be unplausible and tedious. Or if, nevertheless, interesting will provoke the question, "But why call this character Oliver Cromwell, Lord Protector of England?" Similarly, for places. If somewhere called "London" is quite unrecognizable, its name will have no point.

So I am inclined to say that a storyteller is not making informative assertions about real persons, places and incidents even when these are mentioned in fictional sentences. But rather that these also function like purely fictional elements, with which they are always mingled in a story. Russia as the setting for the Rostovs differs from the Russia which Napoleon invaded which did not contain the Rostovs. There was a battle of Waterloo, but George Osborne was not one of its casualties, except in Thackeray's novel. Tolstoy did not create Russia, or Thackeray the battle of Waterloo. Yet one might say that Tolstoy did create Russia-as-the-background-of-the-Rostovs and that Thackeray created Waterloo-as-the-scene-of-George-Osborne's-death. One might say that the mention of realities plays a dual rôle in fiction; to refer to a real object and to contribute to the development of a story. But I cannot pursue this, except that this situation differs from that in which, e.g., Charlotte Brontë uses the real events of her life in *Jane Eyre*. For she does not *mention* herself nor the real places and incidents upon which her story is modelled.

I have tried to say how the expressions of fiction operate and to show that they differ both from statements and emotive expressions. I also began by asking how they are connected. It is clear that their order need not be dictated by that of any matter of fact. Nor are they always even bound by the principles of logic. Do their connections, then, follow any rule or procedure? Is there a conception by which their transitions may be described? Since a work of fiction is a creative performance, however, it may be thought senseless to ask for such rules or such a conception. Is not the creation of that which is new and original, independent of logic and existence, just that to which no rules are appropriate and no conception adequate? But the creation of a work of fiction, however remarkable, is not a miracle. Nor is its author's use of language entirely lawless and vagabond but is directed by some purpose. Certainly, no set of rules will enable anyone to write a good novel or produce a good scientific hypothesis. But a scientist employs his ingenuity to invent a hypothesis to connect certain facts and predict others. He provides an organizing concept related to the facts to be organized and governed by the probability that it pro-

vides the correct explanation. As already emphasized, the situation of the storyteller is different.

In his Preface to *The Portrait of a Lady*, Henry James recalls that in organizing his "ado" about Isabel Archer, having conceived the character, he asked, "And now what will she *do?*" and the reply came immediately, "Why, the first thing she will do will be to come to Europe." He did not have to infer, guess, or wait upon observation and evidence; he *knew*. He knew because he had thus decided. He so decided, no doubt, for a variety of artistic reasons; to develop his conception of a certain character in relation to others, against a particular background, in accordance with his plot. His aim was to produce a particular, perhaps a unique, story; a self-contained system having its own internal coherence. There is certainly a sense in which every work of fiction is a law unto itself. Nevertheless, I think there is a general notion which governs these constructions though its application may give very different results. This is the Aristotelian notion which is usually translated "probability" but which I prefer to call "artistic plausibility." This is not an ideal phrase but it is preferable to "probability" which suggests an evidential relation between premises and conclusion and "possibility" which suggests a restriction to logical conceivability which might exclude some rare, strange and fantastic works. It is, moreover, a notion which applies only to what is verbal. Though some comparable notion may apply to them, one does not normally talk of "plausible" pictures, statues and symphonies, but does talk of "plausible stories." A plausible story is one which convinces; which induces acceptance. But since the plausibility is artistic plausibility, the conviction induced will not be the belief appropriate to factual statement. Nevertheless, one drawback to the notion is that it may suggest that all fiction is, or should be, realistic or naturalistic. It is true that although fiction does not consist of statements about life and natural events, yet much fiction does take lived experience as a model for its own connections. Sometimes, as with Charlotte Brontë's novels, using autobiographical material. Such stories convince by being "lifelike." But by no means all fiction is thus naturalistic. Nor is a story allegedly founded on fact necessarily fictionally convincing. To repeat the Aristotelian tag, "a convincing impossibility is better than an unconvincing possibility." There is, in fact, a range of plausible connections in fiction, varying from the purest naturalism to the wildest fantasy. If any convinces then it is justified. Much should obviously be said about who is convinced and whether he is a reliable judge, but I can do little more here than indicate the type of connection which differentiates works of fiction from descriptions of fact. It is the task of the literary critic to analyze the different types of plausibility, exemplified by, e.g., *Emma*, *War and Peace*, *The Portrait of a Lady*, *Wuthering Heights*, *Moby Dick*, *Alice in Wonderland* and *Grimm's Fairy Stories*. And though, perhaps, no rules can be given for attaining any particular type of plausibility, yet it is sometimes possible to say what does or would make a work unplausible. A

mixture of elements from different plausible systems would, e.g., have this result. It is quite plausible that Alice should change her size by drinking from magic bottles, but it would be absurd that Emma Woodhouse or Fanny Price should do so. Or, to make such an incident plausible, Jane Austen's novels would need to be very different. For it would have needed explanation in quite different terms from the conventions she uses. This also applies to more important plausibilities. Emma Woodhouse could not suddenly murder Miss Bates after the ball, or develop a Russian sense of sin, without either destroying the plausibility of the novel or bringing about a complete revolution in its shape, though these incidents are in themselves more likely than that which befell Alice. But such examples raise questions about fiction and fact; art and life which I cannot now discuss.

R. K. ELLIOTT

POETRY AND TRUTH

R. K. Elliott is Lecturer in Philosophy at Birkbeck College,
University of London.

In oral discussions concerning the criteria appropriate for the evaluation of works of art the claim that truth is an aesthetic criterion is frequently denied, and the manner of the denial often suggests that the speaker conceives himself to be opposing a vulgar error rather than a reflective opinion. In his paper[1] 'The Problem of Belief', Arnold Isenberg makes this denial lucidly and with admirable boldness, not seeking to diminish the offence of those who hold the contradictory view but at least enabling them to understand why this view is felt to be a philistine one. He maintains that if we wish to affirm or deny something which is said to us, we must understand what is said before we can look for evidence of its truth or falsity. This shows that it is *possible* to understand a poem

Reprinted from *Analysis*, Volume 27, No. 3 (January, 1967), pp. 77–85, by permission of Basil Blackwell, Publisher, Oxford. Also by permission of the author.

[1] *Journal of Aesthetics and Art Criticism*, vol. XIII, 1954, reprinted in *Collected Papers in Aesthetics*, ed. C. Barrett, 1966.

without being concerned with its truth or falsity. Adoption of the aesthetic point of view involves a concern for meaning only, and therefore the relinquishment of any concern with truth. Verification, the method by which we criticise belief, plays no part in the criticism of poetry. The aesthetic point of view does not imply any disregard of the content of a poet's sentences, and we may have to refer to the environment to give the right shade of sense to a passage in the work, but it does demand that once the poetic content has been determined, we disregard the relation of this content to observable fact. I trust I am not misrepresenting Isenberg's opinion by summarizing it as follows: aesthetic experience is the contemplation of an imaginary world which is the meaning of a literary work. This imaginary world is the 'aesthetic object,' and only properties internal to it are relevant to aesthetic judgement. If attention is directed away from the aesthetic object in an attempt to discover its value in its correspondence with something external to it, the aesthetic point of view is thereby abandoned, experience ceases to be aesthetic experience, and any evaluative judgement grounded upon any discovered correspondence (or lack of correspondence) is not an aesthetic judgement.

As I have summarized it, this 'no truth' theory of aesthetic relevance has a decidedly *a priori* flavour. But at least three possible versions of the theory can be discriminated. In the first of these the philosopher proposes the 'no truth' criterion for the use of 'aesthetic', but leaves it an open question whether evaluative judgements which are 'mixed' or even 'unaesthetic' according to this criterion may nevertheless be unqualified evaluations of a poem (or work of art) as such. In this version the theory is innocuous, for it is simply a proposal to use 'aesthetic' in a certain way without seeking to impose any limit on the factors which a well qualified lover of poetry would take into account when evaluating a poem. In the second version of the theory it is stipulated that 'aesthetic' should be used according to the 'no truth' criterion, and the further claim is made that only those judgements which are 'aesthetic' in the stipulated sense evaluate works of art as such. If a critic's judgements are 'non-aesthetic' then while they may be of interest to the majority of the critic's readers they do not touch what is of supreme interest to the true connoisseur. The relevance of truth to appreciation and evaluation is absolutely denied, no matter what the character of the individual poem and without reference to the way in which readers well qualified by ordinary standards may in fact experience it. In its third version, the theory claims to delineate the actual structure of our experience of poetry, or perhaps of a mode of experiencing poetry which is common in educated persons. It seems to me that Professor Isenberg's account is fundamentally an instance of the second version of the theory, but it has some features which connect with the third. He quotes a passage from Keats's *Hyperion*, which he interprets as asserting 'a constant and unending process from lower to higher in nature' (p. 126). Later he writes 'I should think that all of you in this room had read

the lines from *Hyperion* many times before and that few of you had ever asked yourselves whether you agreed with them—and this not from any slackness of attention but from the very fullness and fineness of your pre-occupation with the meaning' (p. 129). He goes on to say that his hearers had been regarding the poetic proposition as an aesthetic object, having been concerned with understanding it but not with estimating its truth or falsity. He does not suggest that there is anything unusual about Keats's poem which would tend to inhibit an interest in the truth or falsity of the passage he quotes, so it seems that he believes that attention which is 'aesthetic' according to his criterion is quite normal and ordinary and that considerations of truth and falsity, if they intrude at all, tend to intrude at some relatively late stage in the experience of a poetic passage, or that only an unfortunate minority of poetry readers are troubled by them. Thus if we reflect upon the way in which we read poetry we shall discover that our experience tends to be of the 'aesthetic' kind, and we shall be able to recognise the intrusive character of any interest with truth and falsity which may on occasions disconcert us.

Fortunately both the second and third versions of the theory can be criticised in the same way, by appeal to our common understanding of poetry and to the tradition of criticism by which this understanding was fostered. If, for certain poems, adoption of the theory would make it impossible for us to attain an understanding which is adequate according to our ordinary standards of interpretation or to judge these and other poems successfully according to our ordinary critical standards, then acceptance of the theory must depend upon the superiority of such interpretations and evaluations as it does make possible, and this superiority must be evident to our common intelligence, without benefit of theory. The theory is to be assessed not on the ground of its aesthetic appeal, but by the kind of fruits which would issue from it if any critic were to attempt to practise it seriously.

At the end of his poem *Love's Growth* the poet (Donne) vows that the love which he contracted in the spring shall never decline:

> As princes do in times of action get
> New taxes, and remit them not in peace,
> No winter shall abate the spring's increase.

According to the theory under discussion we are concerned, as critics, with the meaning of these lines, not with the truth or falsity of any proposition they express, so that the general poetic character and aesthetic value of the poem will be exactly the same whether the proposition expressed in the first two lines is true or false. But if as a matter of fact princes tended to abolish taxes in war-time and not to re-introduce them when peace was re-established, the meaning and general emotional character of the poem would be drastically changed. According to our present methods of interpretation we should have to regard the poet as

indicating in these lines that the vow made in the last line is not sincerely meant. When a poet makes a statement which is obviously false we normally assume that he did so intentionally and look for the point of the falsehood. If Donne had written:

> As princes do in times of action raise
> Great captains and mistrust them not in peace,
> No winter shall abate the spring's increase

—we should not ordinarily suppose that he had created an imaginary world in which princes are by disposition generous but imprudent, although the theory forbids us to interpret these lines in any other way. Poetic irony depends very often upon our recognition that some poetic proposition is false, just as almost every simile depends upon our recognition that some poetic proposition is true. Imagine the difficulty in constructing an effective simile of the classical or extended kind of comparing something obviously false with something no less obviously false, even though the terms and the relation between them involves no contradiction.

The lines quoted from Donne's poem raise a further question of interpretation. In terms of the theory, we can recognize the first two lines as political satire, but only as a satire on the merely possible behaviour of imaginary princes, that is to say, as satire on the *idea* of behaviour of this kind. But according to our ordinary standards of interpretation we regard the poet as having successfully satirised the actual behaviour of actual princes, as having scornfully put his finger on a practice which has been too prevalent in the real world. It should not be assumed that the satire of an imaginary evil or of the mere idea of an evil invariably has the same impact as the satire of an evil we know to be actual. So far as Donne's poem is concerned, the transformation from actual to possible robs these two lines of most of their satirical pungency. But if the sting of the real is removed from the preceding lines, the last line will not communicate so strong an impression of sincere and steadfast commitment. In poetry, as we all know, everything depends on everything else.

Perhaps the most obvious objection to the 'no truth' theory is that it cannot accommodate an activity which critics unhesitatingly accept as poetic, that of stating neatly, economically and elegantly what is the case. It is often objected that from the aesthetic point of view it is the neatness, elegance and economy that matter, not the truth. But the pleasure we take in such a couplet as:

> So well-bred spaniels civilly delight
> In mumbling of the game they dare not bite

is not simply pleasure in the neat expression of an idea. We recognize that the poet has accepted truth as an additional norm, and without forgetting this we rejoice in the fact that he has succeeded in writing as if he were absolutely free, without either constriction or the appearance

of wilfulness. But if his expression of the idea had involved the construction of a false or dubious poetic proposition our response would have been different. If the poet had written 'wolfhounds' instead of 'spaniels' a very similar idea would have been expressed with equal neatness and economy, and it seems to me that a critic who believed both that we must be able to understand the meaning of a poetic sentence before we can begin to verify it and that aesthetic experience is a fine preoccupation with meaning would have to pronounce the two couplets to be roughly of equal merit. The situation is complicated by the fact that the 'no-truth' theory tends to identify understanding meaning quite straightforwardly with the creation of a world in imagination on the basis of the poetic text. In a sense the meaning of both couplets is immediately comprehensible, but the worlds they subtend are not equally easily imaginable. The imaginary world of the 'wolfhounds' couplet, if it can be constructed at all, is scarcely capable of persisting for a moment. Undoubtedly it is much inferior to the world of the 'spaniels' couplet in respect of unity and vivacity, in a word, vividness. This suggests that to say that the 'fineness of meaning' of a poetic sentence must be experienceable prior to any verificatory movement or any interest in truth or falsity is not the same as to say that the vividness of an imaginary world must be independent of these things. We may be able to think anything non-contradictory, but what we can imagine vividly is not always unconnected with what we know to be the case or what we are able to believe. In short, reality tends to interpose itself between the meaning which is immediately available and the full poetic meaning or imaginary world which is the object of aesthetic contemplation, and it is often because of this that some particular imaginary world has the vividness that we so much admire.

I have argued that the pleasure we take in the 'spaniels' couplet is not simply pleasure in the neatness of the expression of an idea. In particular, we admire the poet's use of the word 'civilly' because in its context it exactly hits off the quality of the actual ingratiating demeanour which spaniels tend to exhibit in situations of the kind described by the poet. It might be said, however, and with some justification, that this is a case in which we refer to the environment in order to give the exact shade of meaning to a word. But this would imply that in some cases the understanding of meaning is not distinct from the process of verification. We would not be able to give 'civilly' its exact meaning by referring in memory to situations of the kind described, if we could not recognize an affinity between this kind of situation and a kind of situation to which the word is ordinarily applied, that is if our understanding of the ordinary meaning of the word did not enable us to discriminate just those features in the new kind of situation which renders the application of the word to such a situation a non-arbitrary extension of its use. We begin from a preliminary or initial grasping of meaning and proceed to

establish the 'full' or 'exact' meaning which is *the* meaning of the poetic sentence. It is as having this meaning that the poetic sentence is verified, but the process of verification is identical with the process by which the meaning is established.

This account does not do full justice to the poet's creative use of language. The effectiveness of the poetic sentence depends upon its ability to induce us to pluck the meaning spontaneously from the remembered situation. If it succeeds in this, poetic sentence acquires a quasi-revelatory character, and our immediate response is appropriately one of admiration for the poet's artistry felt in the very recognition that his sentence 'hits it off exactly'. In the instance we are considering spontaneity is achieved partly by the use of a word whose sound has a certain affinity with the quality of the behaviour which the meaning of the word is to be extended to cover, though here again the relation between word and world is reciprocal, for our experience of this quality of behaviour in part determines the way in which we pronounce the word. At any rate, the word takes on its extended meaning immediately and naturally, almost as if it were eager to acquire it and not as if word and situation were being brought into communion forcibly by an effort of abstraction and synthesis.[2]

What we admire in this couplet is certainly accuracy of description, but 'accuracy of description' covers a great deal, and many poems can be said to describe accurately without this contributing anything to their value as poems. The view that truth is invariably an aesthetic criterion— that any poem is better insofar as its sentences are true, worse insofar as they are false—is indeed a vulgar and philistine error and I am not seeking to defend it. My point is simply that considerations of truth and falsity are *sometimes* involved both in the interpretation and the evaluation of poetry, and I have tried to show just how they are involved in certain cases. I have suggested that in the example given above we admire a certain sentence as delivering a truth. Admittedly we should not admire it so much if in delivering its truth it did not bring a subtle experienced quality not merely within the referential range of language (for it is easy to use words as a means of pointing to qualities which they cannot be said to describe) but within the limits of the sense of a word, so long as that word is understood in the context of the poetic sentence. But this is only to say that we should not admire it so much if it delivered some truth other than the one it does. We are tempted to think that because 'accuracy of description' is not always an aesthetic criterion, it can never be one—that we must be able to separate truth altogether from meaning and expression and to discover the sources of aesthetic value in qualities

[2] I am influenced here by Merleau-Ponty's distinction between 'parole parlante' and 'parole parlée,' as explicated by M. Dufrenne, *Phénoménologie de l'expérience esthétique*, I, iv.

of meaning and expression alone. This, I believe, is an error at the other
extreme, but no less inimical to poetry.

I shall try to strengthen and extend the relevance of the point con-
cerning meaning and verification by considering a typical instance of the
interpretation of a difficult metaphorical passage. Rilke's *Fourth Elegy*
begins with these lines:

> O Trees of life, what are your signs of winter?
> We're not at one. We've no instinctive knowledge,
> like migratory birds. Outstript and late,
> we force ourselves on winds and find no welcome
> on ponds where we alight.
> (trans. Leishman and Spender)

In the main, the conventional meaning is clear enough, but the open-
ing words indicate that there is a meaning to be found beyond the con-
ventional or literal one. I interpret the passage roughly as follows: 'Our
lives enter into phases of decline—something analogous to a winter
season—but commonly we are not aware that this is happening until we
are deeply pervaded by the unsatisfactory condition. We do not receive
clear indication of its onset, and when we do become aware of our
situation we do not really know what to do to remedy it, even though we
may hit on some course of action which we believe will put things right.
But our efforts introduce changes into the environment without changing
what is unsatisfactory in our relation to it.' This may not be a correct
interpretation, but it will serve as a means of indicating how we proceed
when we interpret poetic sentences of this kind. We are faced with the
task of finding the phenomenon which the poetic sentences are seeking
to delineate. But whereas in the 'spaniel' couplet we are referred very
closely to the situation in which the phenomenon is located, Rilke does
not and could not refer us to some easily discernible region or aspect or
phase of our inner life which strikingly exhibits the phenomenon which
he wants his sentences to mean. He succeeds in communicating his
meaning by the use of images. One of these has a narrative structure
analogous to the temporal structure of the phenomenon and a content
which induces not so much pity for the migratory bird as a feeling of
anxiety and regret, together with a sense of the pain and bewilderment
it suffers. The use of 'we' directs our attention to ourselves, so that we
seem to be both contemplating the bird's predicament from without and,
to some extent, experiencing it from within. The image of the 'trees of
life' indicates the 'situation' which contains the phenomenon, and by having
already something of the nature of lamentation this disturbing first line
helps to establish the emotional importance of the phenomenon. The poet
might conceivably have done more to bring us nearer to the phenomenon,
but he could not have taken us all the way. Eventually, if we are to under-
stand what he is saying it must be by an imaginative leap. The better

the poetry the more spontaneous the leap will be and the greater the 'revelatory' character of the passage. If the poet is successful the meaning of the poetic sentences extends to cover the phenomenon, or, to put it differently, the phenomenon is taken up into the meaning of the words. It is as if the poetic sentences produce the conditions which make possible the ostensive definition of an inner phenomenon. As soon as the phenomenon has been brought to intuition and, as it were, named by the poetic sentences these sentences are grasped as having described it truly. Our interpretation of the passage will not be acceptable if it does not cohere sufficiently well with the interpretation of other parts of the poem, and other criteria may have to be fulfilled. But these considerations do not alter the fact that here again verification of the poetic sentences is accomplished in the process of discovering their meaning. In all such cases, the verificatory movement is a necessary one, and it is a movement towards the object of criticism, not a turning away from it. In many cases the only alternatives are truth and obscurity. Where alternative interpretations are available, we normally prefer that which not only gives the poem a meaning but enables it to mean truly.

A person who supports the view that truth and belief are irrelevant to aesthetic experience might well object that even if we had to verify a poetic sentence in the process of establishing the meaning of the poem we should thereafter 'bracket' belief and experience the aesthetic object simply as our 'imaginary world'. But if we did this, assuming that it is possible, the character of Rilke's poem would be drastically altered, for if we were to 'bracket' our knowledge that Rilke quite often discovers truth we should have no reason to suppose that he is seeking truth in his poem, and we should not be able to understand his use of elaborate imagery and other devices in the light of his intention, even though this intention is accessible in the poem. Signs of his effort to discover and communicate truth would still be perceptible but they would have to be interpreted as signs of an effort to create an imaginary world in conformity only with those norms which this world sets for itself. But this would be misinterpretation. Often Rilke was proceeding in a way very like that of a phenomenologist of mind, and when he was doing so his efforts were different in kind from those of a poet engaged in sheer imaginative creation. It hardly needs to be said that when the relevance of a poem to our own life is proved in the understanding of it, and when this relevance is fixed indelibly by the 'revelatory' character of many of its sentences, it may not be easy to raise a purely imaginary world upon the basis of the text. And there is at least one reason for questioning the rightness of the attempt. According to the 'no truth' theory it is impossible for any part of a poem (*qua* aesthetic object) to have a revelatory quality, but if the presence of this quality is a source of the value of a poem as such, it would be vandalism to try to destroy it, even in imagination.

I have been considering how a certain kind of poetic sentence functions when it is read and understood by someone who has experienced the phenomenon it is intended to delineate. It seems an obvious rejoinder that one need not have experienced what a poet is writing about in order to understand his meaning, and that therefore the process of grasping a poetic meaning need not be at the same time a process of verification. This is only sometimes true. If I have never experienced the condition Rilke describes, not even in a rudimentary form, how shall I discover the significance of his talk about birds and ponds? I might be able to recognize an affinity between the behaviour of the migratory birds and that of some person of my acquaintance. But such an understanding of the condition 'from the outside' is inadequate as a response to the poem. The poet is writing 'from the inside' about what concerns him and me, not about oddities in the behaviour of third persons—it is 'we' not 'they' who are like migratory birds. It might be that I do not merely recognize the signs of the condition in others, but also feel their situation 'from within' by the power of sympathy. But then I have indeed experienced the phenomenon. If although I have experienced it on my own behalf, I have experienced it only obscurely or in a relatively undeveloped form, the poet's sentences, if I succeed in understanding them, will have an additional revelatory aspect, since for me they will not only delineate and fix the phenomenon but will make my own experience clear to me as if by relating it to its archetype. Here again, establishing the meaning is itself verification. Having reached this meaning through the relation set up between the poet's sentences and my earlier experience I do not entertain it as a scholar might entertain an exegetical hypothesis, but grasp the delineated condition immediately as a real possibility for me. This is enough to verify the poet's sentences, whose truth is 'existential' rather than statistical.

In conclusion, I should like to return briefly to the lines quoted from Donne's poem *Love's Growth*. There the poet is actually declaring that he will realise an ideal of love here in this world of ours where there is so much that is cynical and corrupt, not inviting us to contemplate someone's making such a vow in some world where corruption and cynicism are only imaginarily real and steadfast love an idea at two removes from reality. The 'no truth' theory does not allow a poet to declare himself in his own voice but insists that no matter what he conceived himself to be doing he shall be regarded as having made a merely possible world for 'aesthetic' contemplation. Yet our ordinary standards of interpretation permit us to distinguish between deliberate attempts at direct self-revelation *(e.g.* by Wordsworth and Herbert) and the creation of imaginary worlds *(e.g.* certain poems of Spenser, Coleridge and Yeats). A theory which conceives a poem exclusively as an object, whether as a pure structure of meaning or an imaginary world, ignores a tradition of criticism according to which it is permissible to conceive a poem as the

utterance of a person, and which does not consider that because this utterance has regularity of form it cannot therefore be the direct utterance of the poet's feelings, intentions or beliefs, or that this form prevents the poet from speaking about and being understood as speaking about the real world that we all know. This tradition does not assume that a poem is more like the account of a dream than like a letter, a declaration or a prayer, but leaves it to the critic to decide how each poem is best to be understood and leaves him free to employ the criteria of evaluation which he considers most appropriate to the particular case.

MARSHALL COHEN

AESTHETIC ESSENCE

Marshall Cohen is Professor of Philosophy at The Rocke-feller University.

One of the typical assumptions of traditional aesthetic theory has been that certain features must characterize all objects properly regarded as works of fine art. And the further assumption that some of these features characterize only works (or only successful works) of fine art has occasioned both the search for a definition of art and the attempt to elicit an ultimate ground of critical judgement. It has long been apparent that the traditional theories have made inadequate suggestions as to what these features might in fact be. For most of the suggested properties do not seem even to constitute necessary conditions for the application of the notions of art or of successful art. This is true of beauty and of the expression of emotion; it is true of illusion and of *mimesis*. As Nietzsche

From *Philosophy in America*, pp. 115–133, edited by Max Black, Cornell University Press, 1965. Copyright under the Berne Convention by George Allen & Unwin Ltd. Used by permission of Cornell University Press. Also by permission of George Allen & Unwin Ltd., London.

has taught us that tragic art is characterized by terror rather than beauty, Eliot has revealed that poetry 'in the tradition' constitutes an escape from, not an expression of, emotion. Since Maurice Denis it has been understood that the canvas may be treated, not as a three-dimensional illusion, but as a two-dimensional reality. And if Le Corbusier has encouraged the doctrine of *mimesis* in designing the chapel at Ronchamp, he has rejected it firmly at the Villa Savoie. Furthermore, if some feature such as significant form, or organic unity, should ever be described with enough clarity to allow us to determine its presence or absence, it seems obvious that it would not be difficult to show that it is, even if a necessary, not a sufficient condition of art. These difficulties have long been apparent, and in recent years they have often been interpreted in the light of Wittgenstein's cautionary observation that the use of a general term need not be supported by the presence of a property common to the 'objects' to which it properly applies. (Like Wittgenstein I do not mean by 'properties' elaborate disjunctive ones.) As a consequence, many writers have begun to suggest that the difficulty in the philosophy of art is not that we have so far failed to discover the required property or properties, but that we have continued to assume without justification that there are such properties to seek.

In this essay I wish to indicate that analogous assumptions and difficulties pervade other areas of aesthetic investigation. For the notion lingers on (even among philosophers of a Wittgensteinian persuasion) that if there is no property common to all works of art there may yet be some property or properties common to our proper experience of these works of art, or to the preconditions of that experience, or to the criteria of our aesthetic judgements. Indeed, it is arguable that such assumptions are more typical of, and more central to, modern aesthetic thinking than the theory more regularly attacked. (Kant's doctrine of disinterestedness, Schiller's doctrine of play, and Coleridge's doctrine of the suspension of disbelief, are not, after all, primarily doctrines about the nature of works of art.) Certain forms of this doctrine of aesthetic essence, as we may call it, are logically independent of the doctrine of artistic essence and have been maintained by writers who explictly rejected that doctrine. Edward Bullough was in fact driven to his doctrine that there is a feature common to 'all aesthetic impressions' precisely because he believed 'that the discovery in the objective world of Art of a common feature of sufficient concreteness to make it applicable both to all works and to each one separately cannot reasonably be hoped for'. It is because 'theoretical unification of the empirical facts on purely objective lines is either so vague or so artificial as to be practically valueless' that he thought one must turn to psychology and attempt to find some feature 'common to all aesthetic impressions' even if it must be derived from works that are highly 'divergent'. It is in 'aesthetic consciousness', not in artistic objects, that one is to discover the desired 'common meeting ground', the subject

of 'the modern conception of aesthetics'.[1] A search for an aesthetic essence may well succeed the search for an artistic essence. And it may take the form either of a psychological search for features common to aesthetic experience, or its preconditions, or of a logical inquiry into the features common to the criteria of specifically aesthetic judgement. In the discussion that follows, I shall wish to show that there is no reason to believe that either the psychological or the logical form of this doctrine of aesthetic essence is true. There is no reason to believe any property essential to aesthetic experience or certainly, to believe that such a property distinguishes aesthetic from, say, 'practical', or intellectual experience. And it is doubtful whether there is any feature essential to the criteria employed in aesthetic appraisal, not to speak of one that distinguishes them from the criteria employed in scientific or moral, economic or technical, appraisal. In addition to indicating the dubiousness of these doctrines I shall hope to show some of their unfortunate consequences. For their acceptance encourages unfortunate attitudes in artistic education and scholarship, and it may interfere with the enjoyment of art and with the full exercise of critical judgement. In some of its forms the doctrine is incompatible, too, with what I take to be central features of the modern conception of art.

I

It is habitually assumed that there is an element common to our experiences of works of art (or to experiences called 'aesthetic'). Or if not, it is at least supposed that there are certain mental states necessary for the having of these experiences. I call the first assumption the doctrine of aesthetic experience and the second (in view of its most frequent form) the doctrine of an aesthetic attitude. A straightforward commitment to the doctrine of aesthetic experience may be illustrated by a passage from Roger Fry. He writes:

If we compare in our minds responses experienced in turn in face of different works of art of the most diverse kinds—as, for instance, architectural, pictorial, musical or literary—we recognize that our state of mind in each case has been of a similar kind . . . and that (there is something) common to all these experiences (and) peculiar to them (which) . . . we might conveniently label . . . the specifically aesthetic state of mind.[2]

Fry tell us that there is some element common, and peculiar, to our experience of all works of art. But he does not mention any marks by which we can identify it. Other writers have been more specific. Thus, Bullough remarks in his classic discussion of the various ways, aesthetic and non-aesthetic, of regarding a fog at sea that so long as we regard it practically (or non-aesthetically) we shall experience anxiety, strain, and tension. But he holds that once we adopt the aesthetic attitude toward it

[1] Edward Bullough, *Aesthetics*, Stanford 1957, p. 57.
[2] Roger Fry, *Transformations*, Garden City 1956, pp. 1–2.

we shall experience delight and pleasure.[3] This mode of distinguishing aesthetic from practical experience has a long history in hedonistic aesthetics (and Bullough's specific formulation is an obvious attempt to restate in empirical psychological terms Schopenhauer's conception of art as a release from the pressures of the Will), but it is unworkable. Santayana, the acutest of the hedonistic aestheticians, realized that pleasure characterizes not only aesthetic but also practical activity. He knew the doctrines of the *Nicomachean Ethics* and defined the experience of beauty as the experience of pleasure objectified, because he knew that it must be some very special kind of pleasure that could be peculiar to the aesthetic experience of beauty. But, as we may question whether beauty is, indeed, the essential property of art, we may question whether pleasure, which aestheticians have normally supposed to be characteristic of its apprehension is, truly, an essential feature of aesthetic experience. That beauty is the essence of art has been questioned by Nietzsche and Tolstoy, by Veron and Marinetti, by Eliot and Wittgenstein. And most of them would, I expect, deny that delight or pleasure constitutes the essence of aesthetic experience. Surely, anxiety, tension, and stress, which Bullough takes to be incompatible with aesthetic experience, are in fact essential to the effects not only of detective fiction (from Oedipus to the present) but (to suggest only obvious sources) much metaphysical poetry, *Sturm und Drang* music, and expressionist painting. The muzzles of the battleship *Potemkin*, pointed at the audience, are positively menacing. The element of truth in theories of psychical distance may be that there are limits to the degrees of intensity that such states as anxiety, tension, and stress may attain and yet remain compatible with aesthetic experience. But if this is true, it is probably equally true of such states as those of pleasure and delight.

It does not seem possible to determine *a priori* the variety of sensations, feelings, and attitudes that works of art may engender, and empirical investigation does not seem to have revealed any essential property of those already acknowledged. I do not wish to deny, on the other hand, that certain sensations, feelings, and attitudes may be incompatible with the experience of anything we should conceivably regard as art. But it is worth noting that whenever some actual limit has been proposed, in theory or in practice, it has been characteristic of modern artists to attempt to demonstrate its arbitrariness. If there are no specific sensations, feelings, or the like that are peculiarly aesthetic sensations or feelings, it might, nevertheless, be maintained, as by Dewey, that there are certain formal characteristics of experiences that are peculiarly aesthetic. But this thesis, too, is difficult to maintain. It is virtually impossible decisively to refute the various positive suggestions that have been made. For the terms employed, or the uses made of them, are so vague as to defy a confident

[3] Bullough, *op. cit.*, pp. 93–94.

presentation of counter-examples. Nevertheless, one may wonder whether unity (even unity understood to require that the experience be pervaded by a single individualizing quality)[4] will serve to distinguish aesthetic from non-aesthetic experiences. Surely, the experience of riding a crowded subway, or of being badly beaten, has at least as great a degree of unity as (and is more surely pervaded by a single individualizing quality than) the experience of hearing many a sonata or symphonic suite, or of reading many a picaresque novel or chronicle play. And such supplementary characteristics—I choose the least vague—as consummatory quality,[5] or continuity,[6] do not seem any more persuasive. Consummatory quality is more frequently associated with sexual than with aesthetic experience, and various artistic techniques (of which cinematic *montage* is perhaps the most obvious) are often exploited to create just that gappy, 'breathless', or discontinuous quality that Dewey assigns to practical experience. It is true that a writer such as Dewey would be perfectly content to allow that works of art are not the exclusive sources of aesthetic experience. Yet even those who regard this as a desirable theoretical development may hesitate to subscribe to a formal characterization of aesthetic experience that excludes the experience of central works of art and is satisfied by the experience of brushing one's teeth, or still better, of having them pulled. We do not, and I expect that we cannot, possess a theory about the essential nature of aesthetic experience, if this theory is intended (as perhaps it is not) to encompass the experience of all examples and kinds of art. In what follows I shall, nevertheless, use the phrase 'aesthetic experience' to comprehend the experiences that do characteristically arise from the apprehension of works of art.

II

There are plainly certain capacities with which one must be endowed, certain accomplishments one must possess, certain attitudes one must be able to sustain, and certain activities one must be able to perform, if one is to respond adequately to a work of art. Some conditions are logically necessary for particular aesthetic experiences. Thus the man who is tone-deaf cannot enjoy music, and the man who is ignorant of the history of literature cannot apprehend Joyce's *Ulysses*. It is arguable that other conditions are causally necessary. Perhaps one must be capable of patience to enjoy Proust's novel or an Antonioni film, or of concentration to apprehend a complicated fugue. That some such conditions are required for particular aesthetic experiences no one will deny. But whether, as many aestheticians have suggested, there are certain activities or psychological states that are always and everywhere required for (and, even, that

[4] John Dewey, *Art as Experience*, New York 1934, pp. 35 ff.
[5] *Ibid.*
[6] *Ibid.*

insure) the having of aesthetic experience may be questioned. It is important, not only for theoretical reasons, to question such theses. For, in so far as conditions that are not necessary are taken to be so, inappropriate training is proposed, and false instructions are offered, to those who wish to quicken their aesthetic responses. Quickening one's aesthetic responses is not a general problem, but a series of specific problems. In addition, in so far as insufficient conditions are taken to be sufficient, inadequate training and preparation are suggested. I am inclined to believe that there are, in particular, no special activities (such as contemplating) and no psychological states (such as maintaining 'psychical distance') that are required for having aesthetic experience. And as these are, perhaps, the most prestigious candidates I shall discuss them below. But if it is important to question whether any particular states are required, it is even more important to question whether we can know, in advance of the fact, what activities or states of mind will insure the proper apprehension of a work of art. And beyond activities and states of mind, what sensory capacities, what knowledge, courage, or imagination.

The choice of contemplation as the essential precondition (or, indeed, the essential element) of aesthetic experience is, doubtless, influenced by the traditional opposition of the *vita activa* to the *vita contemplativa*. In the modern version that concerns us, however, it is neither philosophical nor religious contemplation that is contrasted with the life of action, but aesthetic contemplation that is contrasted with physical activity, intellectual labour, and practical interest. (In a transitional figure, such as Schopenhauer, the distinction between philosophical or religious and aesthetic contemplation tends to fail.) This elaborate history has left us with a profoundly confused and (as Maritain suggests) perverted term. And this makes a discussion of aesthetic theories in which the concept of contemplation figures crucially exceptionally difficult. The term 'contemplation' is used in aesthetic contexts by many writers simply to comprehend whatever conditions they suppose necessary for obtaining aesthetic experience. But when the term is employed in this manner the question is effectively begged whether there is any feature common to the bewildering variety of psychological states, and even physical activities, that may be required for obtaining the varieties of aesthetic experience. So, too, is the question begged whether the term 'contemplation' can serve both this broad purpose and yet be understood to preclude (as it is normally understood by these same writers to preclude) various physical actions, intellectual operations, or moral interests. There is no point from which one can contemplate Wright's Guggenheim Museum or Le Corbusier's Carpenter Center (the aesthetic experience requires physical movement), no way of appropriating a novel of Broch's or Mann's without engaging in the meditation and cogitation that Richard of St Victor contrasts with contemplation, no way of feeling the excitement of Goya's *The Disasters of War* or Dostoyevsky's *The Possessed* without exercising those moral

and political interests that are typically contrasted with aesthetic, ironic, or disinterested contemplation.

It would not do, however, to represent all theorists as presenting us with so unsatisfactory a situation. No contemporary aesthetician has, so far as I know, investigated the subject of contemplation with the kind of detail that can be found in Richard of St Victor, who in addition to distinguishing contemplation from meditation and cogitation noticed its six varieties. But the term 'contemplation' is at least employed with some sense of its non-technical use by an occasional writer on the visual arts. Thus, Pudovkin, who is interested in establishing that 'the camera compels the spectator to see as the director wishes' knows that the camera 'is charged with a conditional relation to the object shot. Now, urged by heightened interest, it delves into details; now it contemplates the general whole of the picture'.[7] Pudovkin observes the difference between delving into and contemplating a scene. And if the camera can force us to see in these different ways so, I think, can the painter. If one ought to contemplate a Redon or a Rothko, one ought to scrutinize the Westminster Psalter, survey a Tiepolo ceiling, regard a Watteau, and peer at a scene of Breughel.[8] If we attend to these distinctions we shall be in a position to deny that we must contemplate these works to have a proper aesthetic experience of them. Nor is it the case, as might be suspected, that writers who observe these distinctions do so because they are innocent of philosophical plans for the concept of contemplation. Here we come upon an instance where a form of the doctrine of aesthetic essence is not independent of a theory about the nature of art.

From the Greeks onward it has been supposed that contemplation requires special kinds of objects, and sometimes that only contemplation is capable of discerning these objects. Modern aesthetics reflects this tradition. For the artistically embodied Ideas of Schopenhauer and the Significant Forms of Bell and Fry require contemplation. And it is assumed that in so far as other modes of vision are present they must be directed to non-aesthetic or aesthetically irrelevant aspects of the work of art. A hint of this may be found in Roger Fry's discussion of Breughel's 'Carrying of the Cross'. 'We are invited,' he writes, 'by the whole method of treatment, to come close and peer at each figure in turn and read from it those details which expresses its particular state of mind so that we may gradually, almost as we might in a novel, bring them together to build up a highly complex psychological structure.'[9] Fry dislikes Breughel's kind of painting, and what he dislikes about it is what makes it proper to 'peer at it' and 'read it closely' (rather than 'contemplate' it as one

[7] V. I. Pudovkin, *Film Technique and Film Acting*, London 1958, pp. 154–155.

[8] Cf. Paul Ziff, 'Reasons in Art Criticism', reprinted in Joseph Margolis, ed., *Philosophy Looks at the Arts*, New York 1962, pp. 164 ff. I am grateful to Professor Ziff, as well as to Professors Rogers Albritton and Stanley Cavell, for reading and criticizing an earlier version of this manuscript.

[9] Fry, *op. cit.*, p. 19.

would a Cézanne). For peering displays a psychological, rather than an aesthetic, interest, and Breughel is literary, even novelistic, rather than painterly and significantly formalistic. In a word, his painting is non-aesthetic in its appeal, and this is reflected in the fact that it is apprehended by the allegedly non-aesthetic activity of peering. We must, however, stand with Pudovkin and Breughel for the right to delve and peer. The notion that contemplation is the essential condition of aesthetic experience is often no more than a reflection of the theorist's negligent assumption that the rapt Oriental contemplating a Chinese vase is the paradigm of aesthetic experience. When it is not, it is likely to enshrine partisan tastes such as Fry's.

III

In addition to implying misleading accounts of the conditions of aesthetic experience, psychological versions of the theory of aesthetic essence have provided one of the main motivations for false conceptions of the nature and elements of art itself. The notion that some psychological state, such as Bullough's psychical distance, is the necessary (and, indeed, the sufficient) condition of aesthetic experience has led both Bullough and Mrs Langer to attempt to explain its presence or absence by some doctrine about the nature or elements of art. Mrs Langer, for instance, constructs her doctrine that the work of art is an appearance or illusion in order to explain how art imposes an aesthetic 'attitude' and how, by its very nature, it cannot sustain a practical interest.[10] (She falsely assimilates works of art to shadows and rainbows, and forgets the practical uses of signs and wonders.) Bullough's doctrine is less extreme, and despite some remarks in the tradition of Schiller, he does not clearly commit himself to the view of art as appearance or illusion. Nevertheless, it is his view that various features of works of art either encourage, or discourage, the occurrence of a state of mind that he calls 'psychical distance'. I wish to argue that there is no need to assume the presence of such a state as a precondition or element of aesthetic experience. In addition, I shall argue that the interpretation of works of art on the assumption that the function of certain of their stylistic traits is to induce this state leads to a misinterpretation of them.

The psychological state supposed to be the necessary condition of aesthetic experience has been described by Prall as involving a loss of the sense of one's body, by Schopenhauer as involving a loss of the sense of one's self, and by Ethel Puffer as being akin to hypnosis. (Schopenhauer

[10] Susanne Langer, *Feeling and Form*, New York 1953. See the discussion of Mrs Langer's views in Marshall Cohen, 'Appearance and the Aesthetic Attitude', *The Journal of Philosophy*, vol. 56 (November 5, 1959), pp. 921–24. The article is reprinted in Marvin Levich, ed., *Aesthetics and the Philosophy of Criticism*, New York 1963.

discourages an appeal to spirituous drinks or opium to achieve this state, and suggests, rather, a cold bath and a night's sleep.) Bullough's suggestion, if less patently false, is yet communicated in a metaphor susceptible of many interpretations. The most typical interpretation is one under which we may say that James or Brecht, or their readers, maintain their distance from Verena Tarrant or from Galy Gay. However, in this sense, we also say that distance is not maintained from Isabel Archer or Mother Courage. But this cannot be the proper interpretation of Bullough's term, for a lack of distance in this sense is fully compatible with aesthetic experience. (And we may contradict those critics who suppose that the maintenance of distance makes *The Bostonians* a greater novel than *The Portrait of a Lady*. I do not know whether anyone has made so bold a move in the case of Brecht.) How, then, are we to interpret Bullough? While he thinks of distance as a psychic state, we know that on occasion he relates it in an exceptionally straightforward way to certain behavioural manifestations. When we suffer tension, stress, or anxiety we tend to react practically to the situation. It is his view that certain elements of works of art arouse such feelings; in particular, those representing humanly compelling situations. For this reason works of art also include other elements to attenuate or 'distance' those feelings and to inhibit action. In the case of the theatre, for instance, these elements would include the raised stage and the use of costumes and verse. Now Bullough mentions as a clear case of the loss of distance the yokel who leaps upon the stage to save the hapless heroine.[11] Bullough would have us believe that the pressure of his feelings induces the yokel to gain the stage and that the operation of the distancing factors has kept the rest of the audience in their seats. But can we not imagine that the yokel has acted coolly out of an ignorant sense of honour while the carriage-trade has remained in its place seething with emotion? (I assume for the purposes of this discussion that their seething is compatible with the maintenance of sufficient psychical distance.) The operative factors here may not be feelings at all, but rather the presence and absence of knowledge of what a play is and of how one behaves in the theatre. If so, the satisfaction of at least this behavioural criterion of 'psychical' distance, namely, staying put, may be compatible with a wide range of feelings or with none at all. And, indeed, this assumption comports best with the introspective situation.

If knowledge of what a play is should be sufficient to keep the yokel seated, and if no particular feelings or emotions are required to keep the audience in its seats, it will be inappropriate to account for certain elements of a work of art by their tendency to enforce, and others by their tendency to undermine, such psychical states. If the yokel learns what

[11] Bullough, *op. cit.* p. 98. See the discussion of Bullough's views in George Dickie, 'Is Psychology Relevant to Aesthetics?' *The Philosophical Review*, vol. 71 (July 1962), pp. 297–300.

it is to go to a play we shall be able to do the play in a field, without costumes, and in prose, and still expect him to react properly. Thus, the function of the raised stage, costumes, and verse need not be to keep him seated. Indeed, the very stylistic qualities that Bullough supposes to be distancing because of their anti-realistic nature may operate in precisely the opposite fashion. Let us take the theatrical case. The raised stage, appropriate for the performance of Ibsen's plays, tends to make the playgoer less conscious of the rest of the audience. And allowing him to peep into a realistic set peopled with literally costumed characters actually adds to the 'realism' of the play. (Hence the habitual failure of arena-stage productions of Ibsen.) Nor can it plausibly be maintained that the general function of verse is to attenuate responses to the represented events. This does not seem to have been the effect of Aeschylus' verse on the women who gave birth at his plays, or Shakespeare's on Dr Johnson's reaction to the final scene of King Lear. Alternatively, O'Neill's prosy climaxes (Lavinia's 'O fiddlesticks!') hardly seem to increase the reality of these scenes.

If Bullough's suggestions are often misleading, they are even more often irrelevant. He supposes—it is only an extension of his treatment of the yokel—that anti-realistic (highly-distanced) styles are required mainly to inhibit and to render aesthetic the practical impulses of relatively primitive and unsophisticated peoples. But his hypothesis is quite irrelevant to the problem of the modern anti-realistic style that has occasioned the brilliant speculations of Ortega and Malraux. For this 'dehumanized' style is the expression, as Ortega indicates, not of the aesthetically unsophisticated masses, but, on the contrary, of an aesthetic elite.[12] And Malraux's argument is of a logical type that Bullough's mode of analysis does not even allow him. For where Bullough's method would lead him to find in the modern renewal of the anti-humanistic or 'transcendental' style a (psychological) purpose similar to that served by this style in the past, it is open to Malraux to suggest that this style has a (non-psychological) purpose exactly opposite to that which it previously served. (It is, he thinks, a 'photographic negative' of previous transcendental styles and serves to express a new humanism rather than to cancel a discredited one.)[13] The possibility of offering quite different accounts of the functions of similar stylistic elements on different occasions and of finding these explanations not in psychological factors but, perhaps, in considerations of history or of *Weltanschauung* seems all to the good. Bullough's attempt to relate such explanations to the fortunes of some otiose and unidentifiable psychological state cannot be regarded as useful procedure. Like Mrs Langer's theory that all works of art are appearances or illusions, Bullough's notion that stylistic elements should be understood as

[12] José Ortega y Gasset, *The Dehumanization of Art*, Garden City 1956.
[13] André Malraux, *The Voices of Silence*, Garden City 1953; Joseph Frank, "Malraux's Metaphysics', *The Sewanee Review*, vol. 70 (Autumn 1962), p. 646.

increasing or decreasing distance may be dismissed with its questionable motivation. There is no way of determining the precondition of all aesthetic experience just as there is no way of knowing what qualities such experience must bear.

IV

We have analysed the psychological version of the doctrine of aesthetic essence as it bears on aesthetic experience and its preconditions and on the nature and the analysis of art. It will be useful to conclude by examining the logical version of the doctrine in its relation to the problem of aesthetic judgement and the criticism of art. We are characteristically invited to make aesthetic judgements when making them would not be the obvious thing to do or when it is felt that, although this is the obvious thing to do, it has not been done. Thus, we may be asked to pass an aesthetic judgement on a car in a conversation in which we have all along been assessing its technical efficacy, or the economics of running it. Alternatively, and this is typical of critical contexts, we may insist that we have, in fact, made an aesthetic (or an artistic, or a literary) judgement. Our point will be to forestall the objection, or to reject the accusation, that we have in fact made a moral, or a technical, or an economic one. It has been suggested that these various kinds of judgement can be distinguished from one another by reference to the criteria that are relevant to making them. Thus, there is a special set of aesthetic criteria, as distinguished from moral, and intellectual, and economic criteria, and it is on the basis of these aesthetic criteria that we make our aesthetic judgements. J. O. Urmson, for instance, regards it as the central task of the philosopher of aesthetics 'to clarify the principles on which we select the special set of criteria of value that are properly counted as relevant to aesthetic judgement'.[14] And, although he does not commit himself to the view that a single principle specifies this special set of 'criteria', the very assumption that there is such a special set supplies a major source of encouragement for the view that some single property does characterize the criteria of aesthetic judgement. In fact, Urmson himself proposes that at least in the simplest cases (and it is not obvious how he would allow more complicated ones to alter his view) aesthetic judgements are judgements of how things look or smell or otherwise present themselves to the senses. It will not be our purpose in this section to propose any alternative analysis of the nature of aesthetic judgements or to suggest any peculiarity of the logic of aesthetic arguments. Our purpose will be to call into question the suggestion that the criteria of aesthetic judgement can be characterized by a feature such as the one Urmson suggests, or that these criteria form a set that characteristically excludes moral, sci-

[14] J. O. Urmson, 'What Makes a Situation Aesthetic?' reprinted in Margolis, *op. cit.*, p. 20.

entific, or ideological criteria. Urmson writes that 'it would be a very odd person who denied that the sound of the words of a poem was one of the criteria of aesthetic judgement of a poem, or who maintained that being scientifically accurate and up to date was another'.[15] Urmson's notion that 'the sound of the words of a poem' is one of the criteria of the aesthetic judgement of poems is simply a manifestation of his more general principle that aesthetic criteria appear to be those concerned with 'the way the object in question looks or presents itself to the other senses'.[16] There is, of course, some plain confusion here. Urmson does not really propose a criterion. 'The sound of the words of a poem' does not constitute a criterion of evaluation. What is it about these sounds that is aesthetically meritorious? Even if we waive this objection, however, it is worth noting that critics as various as Bradley and Croce and I. A. Richards have denied that any feature of the sounds of the words of a poem constitutes an important source of poetic merit. As Eliot puts it 'the music of poetry is not something that exists apart from its meaning'.[17] It does not, of course, follow from what Eliot actually says that our judgements of poems might not be confined to some quality of their sounds. This might be the case even if this quality 'could not exist' outside meaningful contexts. But, as a matter of fact, we rarely, if ever, judge poems (even the poems of Verlaine, Swinburne, or Wallace Stevens) simply by their sounds (a doctrine with which Urmson appears to be flirting) and often enough we do not judge them by their sounds at all. We may by-pass the question whether, in general, music may be said to have sounds or paintings looks. (To be sure, performed music occasionally has a muffled sound, and paintings often have a faded look. But even when they do have such properties, aesthetic judgements may be required positively to ignore them.) The fact is that even the narrowest conception of aesthetic judgement invokes criteria for assessing the formal structure of the work of art or, say, its success in exploiting the medium. It does not seem possible to extend Urmson's principle even to such indisputably aesthetic criteria, and no further principle suggests itself. But even if some feature could be discovered that might cover such aesthetic criteria it would be necessary to question whether those criteria typically classified as moral, scientific, and ideological are, in fact, as Urmson suggests, irrelevant to the making of aesthetic judgements. If they should, in fact, turn out to be relevant, this would not only be of the greatest interest in itself but it would incalculably increase the improbability of discovering some feature common to all the criteria, moral and scientific as well as aesthetic, relevant to aesthetic judgement. And it would indicate that any such property

[15] *Ibid.*, p. 22.

[16] J. O. Urmson, 'What Makes a Situation Aesthetic?' reprinted in Margolis, *op. cit.*, p. 25.

[17] T. S. Eliot, 'The Music of Poetry', *On Poetry and Poets*, New York 1961, p. 21.

would have to characterize not only aesthetic criteria but certain moral and scientific criteria as well.

A more promising line of objection to the notion that only 'aesthetic' criteria are relevant to aesthetic judgement may seem to be provided by such characteristic critical remarks as that Mary McCarthy's novels are unsuccessful because she is incapable of loving her characters. This may look like a straightforward moral (or psychological) judgement of the novel. And, indeed, it is not impossible to take it that way. But neither is it necessary to take it that way. We may understand the critic to be saying (in an elliptical way that some find misleading) that the characters do not have all the dimensions of life. They lack all those characteristics that only the eye of love can discern. Interpreted in this way the objection may be regarded as an aesthetic judgement criticizing the novels for failing to achieve 'the illusion of life'. If so, it might be argued that Urmson is wrong and that here we have a case where a moral ground (the incapacity to love) is, indeed, 'relevant to' an aesthetic judgement (the novel's lack of verisimilitude). The difficulty with this kind of example is, however, that the 'moral' or psychological fact is relevant to an explanation of why Mary McCarthy cannot write successful 'realistic' novels. What is required is, however, that the fact be relevant to estab-lishing the judgment that the novels do not in fact create 'the illusion of life'. And this it does not do. (Indeed, the psychological fact only becomes relevant to the explanation once the aesthetic fact to be explained has been established.) If the psychological or moral fact is not relevant to making the judgement, certainly it is not its ground. It is true that we say the novels fail to dramatize certain dimensions of reality because Mary McCarthy cannot love her characters. But to take this as establish-ing that the lack of love is a ground for our judgement is to confuse a causal with a criterial use of 'because'. What we are doing is offering an explanation of the aesthetic failure and not saying that it is in virtue of the fact that Mary McCarthy cannot love her characters that we judge the novels to be unconvincing. Mary McCarthy's alleged moral or psycho-logical failing is not operating as a criterion of aesthetic judgement at all, so it cannot be an example of a moral criterion of such a judgement. A more pertinent example is required.

It will be remembered that Urmson chooses as his example of extreme oddity the person who maintained that being scientifically accurate and up to date was in fact a criterion of aesthetic judgement. (In fact, in one form or another, it is a far more usual criterion of aesthetic excellence than is the possession of some quality of sound.) It is, perhaps, unfair to remind Urmson that Pound was exhibiting one of the central motives of the modern aesthetic creed when he demanded that poets 'make it new'. (Unfair, because the newness he had in mind was a kind of newness impossible for science.) But it is surely fair to cite a judgement like the

one Lionel Trilling passes on the recent American novel. 'It is question-able,' he writes, 'whether any American novel since *Babbitt* has told us a new thing about our social life. In psychology the novel relies either on a mechanical or classical use of psychiatry or on the insights that were established by the novelists of fifty years ago.'[18] Unless psychology and social science are ruled out as not really scientific we would appear to have a clear and typical counter-example to Urmson's observation (he rightly sets great store by field work among the critics) and a case of a scientific criterion employed in making an aesthetic judgement. For Trilling means to condemn the recent American novel as an artistic achievement.

It is open to writers of Urmson's persuasion either to deny that such judgements are indeed aesthetic judgements (a position I do not propose to consider here) or to argue that the ostensibly non-aesthetic criteria are in fact really aesthetic ones. Wellek and Warren,[19] for instance, feel that they would have to reject Eliot's dictum that the critic must consider whether a poem is 'coherent, mature, and founded on the facts of experi-ence' unless they could show the criteria in question to be aesthetic ones. They observe, then, that coherence is not merely a logical but also an aesthetic criterion. It is not obvious whether they are saying that 'coher-ence' has two different senses, or whether they are saying that a criterion may fall into a number of different categories. The first, however, seems the more likely. For they go on to suggest that the other criteria, appar-ently psychological and epistemological, are to be understood as aesthetic. Thus, the psychological criterion of maturity is to be understood as a demand for complexity, and they find that the epistemological criterion of truth to experience 'registers itself in aesthetic terms of vividness, intensity, patterned contrast, width or depth, static or kinetic'. This will not do. Obviously, many works regarded as mature (either for their own qualities or because of their position in an *oeuvre*) are not remarkable for their complexity. The maturity of *Oedipus at Colonus*, *The Tempest*, and *When We Dead Awaken*, is evidenced by the authority of their rela-tive simplicity, and they are less complex than *Oedipus Rex*, *Troilus and Cressida*, and *Peer Gynt*. And, surely, the truth to experience Eliot has in mind displays itself in the calm of Dante (as narrator, not pilgrim) rather than in the intensity of Shelley, in the muted measure of *Four Quartets* rather than in the vividness of 'The Hippopotamus' or 'Mr. Apollinax'. It simply does not seem possible to reduce the criterion of maturity to that of complexity. And more importantly, it does not seem possible to reduce the criterion of truth, either as it is invoked by Trilling or by Eliot, to an aesthetic criterion. If that is so, it would appear to be the case that scientific—and, as it would be still simpler to show, moral

[18] Lionel Trilling, *The Liberal Imagination*, New York 1950, p. 263.
[19] René Wellek and Austin Warren, *Theory of Literature*, New York 1949, p. 257.

—criteria are relevant to the making of aesthetic judgements. Urmson's assumption that the sub-set of such criteria will exclude moral, intellectual, and other criteria, is false. And the hope of discovering some property common to the criteria relevant to aesthetic judgement, in so far as it is based on the assumption that such criteria are, indeed, excluded, will lose its plausibility.

If the aesthetic purists cannot show that ostensibly non-aesthetic criteria are really aesthetic ones, they might try to avoid the conclusion we have reached by denying that they are criteria at all. Or, at least, that they are the real or ultimate criteria of aesthetic judgements. The purists might hold that whenever aesthetic judgements appear to rely on non-aesthetic criteria they can be shown actually or implicitly to invoke some further aesthetic criterion. And it will always be the case that the facts relevant to determining whether the non-aesthetic criteria have been satisfied will be relevant to deciding whether the further aesthetic criteria have been satisfied. If these relations did not obtain, it might be held, the judgement would not be accepted as an aesthetic one. Thus, Trilling may praise James' *The Princess Casamassima* for satisfying just those historical and epistemological criteria he regards the modern American novel as having failed to satisfy. But the aesthetic purists might argue that we accept the judgement as aesthetic only because we take an implicit criterion to be a genuinely aesthetic one. In this case, perhaps, that the demands of the genre are satisfied (and in the case of realistic fiction one of these demands is for genuine historical comprehension). Similarly, they might seek to show that often, at least, when we appear to be appealing to scientific, moral, intellectual, and even economic criteria, we are actually appealing to aesthetic ones. If we merely look at what he writes, we may suppose the critic to be praising Mann's *Dr Faustus* simply for the brilliance of his historical diagnosis, D. H. Lawrence's *Women in Love* for its moral profundity, Schoenberg's Opus 23 piano pieces for their intellectual audacity, and Fabergé jewellery or the Taj Mahal for their expensiveness. But it may be possible to argue that in each case the fundamental criterion of judgement is in fact aesthetic. We are really judging that Mann achieves his artistic intentions, that Lawrence has fully realized the potentialities of the novel, that Schoenberg has renewed an exhausted musical art, and that Fabergé has exploited his materials in the manner best calculated to reveal their peculiar virtue. Whether a position such as the one sketched here can be precisely stated (so that one knows, for instance, how the existence and identity of the implicit criterion is to be determined) and whether it can be defended in detail (some such theory is assumed by many to be *a priori* true) cannot be decided here. I am much inclined to doubt it. But I am still more inclined to doubt whether some property will be found that is essential even to the considerable variety of aesthetic criteria that are likely to be acknowledged if the thesis in question is to be defended at all. For aesthetic

criteria are numerous and make reference not only to the sensory and formal features of objects and to expressive and technical qualities of media but also to the intentions of artists, the dialectical demands of particular arts, the expectations of aesthetic elites, and the impersonal progress of the institutions of art.

It is perhaps worth insisting that I do not suppose all judgements of works of art to be aesthetic judgements. And it is important to distinguish those judgements that we regard as aesthetic (even when they are based on moral criteria) from those we do not. For this is to distinguish D. H. Lawrence's judgement of Galsworthy's novels and Santayana's of Whitman's poetry from the Congressional hack's judgment of Martha Graham's dances or the Party hack's judgement of *Dr Zhivago*. But neither do I wish to suggest that we ought never to pass moral or political judgements on works of art. In the Republic it may be necessary to pass Plato's flattering judgement on poets. And in France, at least, it may already be necessary to demand that every writer of fiction ask what would happen if everyone read what he wrote. For the consequences of words are not merely aesthetic consequences. Sartre was, therefore, right to remind us of Mosca's observation beside the coach that carried Fabrice and Sanseverina away.[20] 'If the word Love comes up between them, I'm lost.'

[20] Jean-Paul Sartre, *What Is Literature?* New York 1949. Reprinted as *Existentialism and Literature*, New York 1962, pp. 23–24.

W. K. WIMSATT AND MONROE C. BEARDSLEY

THE INTENTIONAL FALLACY

*W. K. Wimsatt is Professor of English at Yale University.
Monroe C. Beardsley is Professor of Philosophy at Swarth-
more College.*

The claim of the author's "intention" upon the critic's judgment has been challenged in a number of recent discussions, notably in the debate entitled *The Personal Heresy*, between Professors Lewis and Tillyard. But it seems doubtful if this claim and most of its romantic corollaries are as yet subject to any widespread questioning. The present writers, in a short article entitled "Intention" for a *Dictionary*[1] of literary criticism, raised the issue but were unable to pursue its implications at any length. We argued that the design or intention of the author is neither available nor desirable as a standard for judging the success of a work of literary art, and it seems to us that this is a principle which goes deep into some differences in the history of critical attitudes. It is a principle which

Reprinted from *The Verbal Icon*, pp. 3–18, University of Kentucky Press, 1954, by permission.

[1] *Dictionary of World Literature*, Joseph T. Shipley, ed. (New York, 1942), 326–329.

accepted or rejected points to the polar opposites of classical "imitation" and romantic expression. It entails many specific truths about inspiration, authenticity, biography, literary history and scholarship, and about some trends of contemporary poetry, especially its allusiveness. There is hardly a problem of literary criticism in which the critic's approach will not be qualified by his view of "intention."

"Intention," as we shall use the term, corresponds to *what he intended* in a formula which more or less explicitly has had wide acceptance. "In order to judge the poet's performance, we must know *what he intended*." Intention is design or plan in the author's mind. Intention has obvious affinities for the author's attitude toward his work, the way he felt, what made him write.

We begin our discussion with a series of propositions summarized and abstracted to a degree where they seem to us axiomatic.

1. A poem does not come into existence by accident. The words of a poem, as Professor Stoll has remarked, come out of a head, not out of a hat. Yet to insist on the designing intellect as a *cause* of a poem is not to grant the design or intention as a *standard* by which the critic is to judge the worth of the poet's performance.

2. One must ask how a critic expects to get an answer to the question about intention. How is he to find out what the poet tried to do? If the poet succeeded in doing it, then the poem itself shows what he was trying to do. And if the poet did not succeed, then the poem is not adequate evidence, and the critic must go outside the poem—for evidence of an intention that did not become effective in the poem. "Only one *caveat* must be borne in mind," says an eminent intentionalist[2] in a moment when his theory repudiates itself; "the poet's aim must be judged at the moment of the creative act, that is to say, by the art of the poem itself."

3. Judging a poem is like judging a pudding or a machine. One demands that it work. It is only because an artifact works that we infer the intention of an artificer. "A poem should not mean but be." A poem can *be* only through its *meaning*—since its medium is words—yet it *is*, simply *is*, in the sense that we have no excuse for inquiring what part is intended or meant. Poetry is a feat of style by which a complex of meaning is handled all at once. Poetry succeeds because all or most of what is said or implied is relevant; what is irrevelant has been excluded, like lumps from pudding and "bugs" from machinery. In this respect poetry differs from practical messages, which are successful if and only if we correctly infer the intention. They are more abstract than poetry.

4. The meaning of a poem may certainly be a personal one, in the sense that a poem expresses a personality or state of soul rather than a

² J. E. Spingarn, "The New Criticism," in *Criticism in America* (New York, 1924), 24–25.

physical object like an apple. But even a short lyric poem is dramatic, the response of a speaker (no matter how abstractly conceived) to a situation (no matter how universalized). We ought to impute the thoughts and attitudes of the poem immediately to the dramatic *speaker*, and if to the author at all, only by an act of biographical inference.

5. There is a sense in which an author, by revision, may better achieve his original intention. But it is a very abstract sense. He intended to write a better work, or a better work of a certain kind, and now has done it. But it follows that his former concrete intention was not his intention. "He's the man we were in search of, that's true," says Hardy's rustic constable, "and yet he's not the man we were in search of. For the man we were in search of was not the man we wanted."

"Is not a critic," asks Professor Stoll, "a judge, who does not explore his own consciousness, but determines the author's meaning or intention, as if the poem were a will, a contract, or the constitution? The poem is not the critic's own." He has accurately diagnosed two forms of irresponsibility, one of which he prefers. Our view is yet different. The poem is not the critic's own and not the author's (it is detached from the author at birth and goes about the world beyond his power to intend about it or control it). The poem belongs to the public. It is embodied in language, the peculiar possession of the public, and it is about the human being, an object of public knowledge. What is said about the poem is subject to the same scrutiny as any statement in linguistics or in the general science of psychology.

A critic of our *Dictionary* article, Ananda K. Coomaraswamy, has argued[3] that there are two kinds of inquiry about a work of art: (1) whether the artist achieved his intentions; (2) whether the work of art "ought ever to have been undertaken at all" and so "whether it is worth preserving." Number (2), Coomaraswamy maintains, is not "criticism of any work of art *qua* work of art," but is rather moral criticism; number (1) is artistic criticism. But we maintain that (2) need not be moral criticism: that there is another way of deciding whether works of art are worth preserving and whether, in a sense, they "ought" to have been undertaken, and this is the way of objective criticism of works of art as such, the way which enables us to distinguish between a skillful murder and a skillful poem. A skillful murder is an example which Coomaraswamy uses, and in his system the difference between the murder and the poem is simply a "moral" one, not an "artistic" one, since each if carried out according to plan is "artistically" successful. We maintain that (2) is an inquiry of more worth than (1), and since (2) and not (1) is capable of distinguishing poetry from murder, the name "artistic criticism" is properly given to (2).

[3] Ananda K. Coomaraswamy, "Intention," in *American Bookman*, I (1944), 41–48.

II

It is not so much a historical statement as a definition to say that the intentional fallacy is a romantic one. When a rhetorician of the first century A.D. writes: "Sublimity is the echo of a great soul," or when he tells us that "Homer enters into the sublime actions of his heroes" and "shares the full inspiration of the combat," we shall not be surprised to find this rhetorician considered as a distant harbinger of romanticism and greeted in the warmest terms by Saintsbury. One may wish to argue whether Longinus should be called romantic, but there can hardly be a doubt that in one important way he is.

Goethe's three questions for "constructive criticism" are "What did the author set out to do? Was his plan reasonable and sensible, and how far did he succeed in carrying it out?" If one leaves out the middle question, one has in effect the system of Croce—the culmination and crowning philosophic expression of romanticism. The beautiful is the successful intuition-expression, and the ugly is the unsuccessful; the intuition or private part of art is *the* aesthetic fact, and the medium or public part is not the subject of aesthetic at all.

The Madonna of Cimabue is still in the Church of Santa Maria Novella; but does she speak to the visitor of to-day as to the Florentines of the thirteenth century?

Historical interpretation labours . . . to reintegrate in us the psychological conditions which have changed in the course of history. It . . . enables us to see a work of art (a physical object) as its *author saw it* in the moment of production.[4]

The first italics are Croce's, the second ours. The upshot of Croce's system is an ambiguous emphasis on history. With such passages as a point of departure a critic may write a nice analysis of the meaning or "spirit" of a play by Shakespeare or Corneille—a process that involves close historical study but remains aesthetic criticism—or he may, with equal plausibility, produce an essay in sociology, biography, or other kinds of non-aesthetic history.

III

I went to the poets; tragic, dithyrambic, and all sorts. . . . I took them some of the most elaborate passages in their own writings, and asked what was the meaning of them. . . . Will you believe me? . . . there is hardly a person present who would not have talked better about their poetry than they did themselves. Then I knew that not by wisdom do poets write poetry, but by a sort of genius and inspiration.

[4] It is true that Croce himself in his *Ariosto, Shakespeare and Corneille* (London, 1920), Chap. VII, "The Practical Personality and the Poetical Personality," and in his *Defence of Poetry* (Oxford, 1934), 24, and elsewhere, early and late, has delivered telling attacks on emotive geneticism, but the main drive of the *Aesthetic* is surely toward a kind of cognitive intentionalism.

That reiterated mistrust of the poets which we hear from Socrates may have been part of a rigorously ascetic view in which we hardly wish to participate, yet Plato's Socrates saw a truth about the poetic mind which the world no longer commonly sees—so much criticism, and that the most inspirational and most affectionately remembered, has proceeded from the poets themselves.

Certainly the poets have had something to say that the critic and professor could not say; their message has been more exciting: that poetry should come as naturally as leaves to a tree, that poetry is the lava of the imagination, or that it is emotion recollected in tranquillity. But it is necessary that we realize the character and authority of such testimony. There is only a fine shade of difference between such expressions and a kind of earnest advice that authors often give. Thus Edward Young, Carlyle, Walter Pater:

I know two golden rules from *ethics*, which are no less golden in *Composition*, than in life. 1. *Know thyself;* 2dly, *Reverence thyself.*

This is the grand secret for finding readers and retaining them: let him who would move and convince others, be first moved and convinced himself. Horace's rule, *Si vis me flere*, is applicable in a wider sense than the literal one. To every poet, to every writer, we might say: Be true, if you would be believed.

Truth! there can be no merit, no craft at all, without that. And further, all beauty is in the long run only *fineness* of truth, or what we call expression, the finer accommodation of speech to that vision within.

And Housman's little handbook to the poetic mind yields this illustration:

Having drunk a pint of beer at luncheon—beer is a sedative to the brain, and my afternoons are the least intellectual portion of my life—I would go out for a walk of two or three hours. As I went along, thinking of nothing in particular, only looking at things around me and following the progress of the seasons, there would flow into my mind, with sudden and unaccountable emotion, sometimes a line or two of verse, sometimes a whole stanza at once.

This is the logical terminus of the series already quoted. Here is a confession of how poems were written which would do as a definition of poetry just as well as "emotion recollected in tranquillity"—and which the young poet might equally well take to heart as a practical rule. Drink a pint of beer, relax, go walking, think on nothing in particular, look at things, surrender yourself to yourself, search for the truth in your own soul, listen to the sound of your own inside voice, discover and express the *vraie vérité*.

It is probably true that all this is excellent advice for poets. The young imagination fired by Wordsworth and Carlyle is probably closer to the verge of producing a poem than the mind of the student who has been sobered by Aristotle or Richards. The art of inspiring poets, or at least of inciting something like poetry in young persons, has probably gone

further in our day than ever before. Books of creative writing such as those issued from the Lincoln School are interesting evidence of what a child can do. All this, however, would appear to belong to an art separate from criticism—to a psychological discipline, a system of self-development, a yoga, which the young poet perhaps does well to notice, but which is something different from the public art of evaluating poems.

Coleridge and Arnold were better critics than most poets have been, and if the critical tendency dried up the poetry in Arnold and perhaps in Coleridge, it is not inconsistent with our argument, which is that judgment of poems is different from the art of producing them. Coleridge has given us the classic "anodyne" story, and tells what he can about the genesis of a poem which he calls a "psychological curiosity," but his definitions of poetry and of the poetic quality "imagination" are to be found elsewhere and in quite other terms.

It would be convenient if the passwords of the intentional school, "sincerity," "fidelity," "spontaneity," "authenticity," "genuineness," "originality," could be equated with terms such as "integrity,' "relevance," "unity," "function," "maturity," "subtlety," "adequacy," and other more precise terms of evaluation—in short, if "expression" always meant aesthetic achievement. But this is not so.

"Aesthetic" art, says Professor Curt Ducasse, an ingenious theorist of expression, is the conscious objectification of feelings, in which an intrinsic part is the critical moment. The artist corrects the objectification when it is not adequate. But this may mean that the earlier attempt was not successful in objectifying the self, or "it may also mean that it was a successful objectification of a self which, when it confronted us clearly, we disowned and repudiated in favor of another."[5] What is the standard by which we disown or accept the self? Professor Ducasse does not say. Whatever it may be, however, this standard is an element in the definition of art which will not reduce to terms of objectification. The evaluation of the work of art remains public; the work is measured against something outside the author.

IV

There is criticism of poetry and there is author psychology, which when applied to the present or future takes the form of inspirational promotion; but author psychology can be historical too, and then we have literary biography, a legitimate and attractive study in itself, one approach, as Professor Tillyard would argue, to personality, the poem being only a parallel approach. Certainly it need not be with a derogatory purpose that one points out personal studies, as distinct from poetic studies, in the realm of literary scholarship. Yet there is danger of confusing

[5] Curt Ducasse, *The Philosophy of Art* (New York, 1929), 116.

personal and poetic studies; and there is the fault of writing the personal as if it were poetic.

There is a difference between internal and external evidence for the meaning of a poem. And the paradox is only verbal and superficial that what is (1) internal is also public: it is discovered through the semantics and syntax of a poem, through our habitual knowledge of the language, through grammars, dictionaries, and all the literature which is the source of dictionaries, in general through all that makes a language and culture; while what is (2) external is private or idiosyncratic; not a part of the work as a linguistic fact: it consists of revelations (in journals, for example, or letters or reported conversations) about how or why the poet wrote the poem—to what lady, while sitting on what lawn, or at the death of what friend or brother. There is (3) an intermediate kind of evidence about the character of the author or about private or semiprivate meanings attached to words or topics by an author or by a coterie of which he is a member. The meaning of words is the history of words, and the biography of an author, his use of a word, and the associations which the word had for *him*, are part of the world's history and meaning.[6] But the three types of evidence, especially (2) and (3), shade into one another so subtly that it is not always easy to draw a line between examples, and hence arises the difficulty for criticism. The use of biographical evidence need not involve intentionalism, because while it may be evidence of what the author intended, it may also be evidence of the meaning of his words and the dramatic character of his utterance. On the other hand, it may not be all this. And a critic who is concerned with evidence of type (1) and moderately with that of type (3) will in the long run produce a different sort of comment from that of the critic who is concerned with (2) and with (3) where it shades into (2).

The whole glittering parade of Professor Lowes' *Road to Xanadu*, for instance, runs along the border between types (2) and (3) or boldly traverses the romantic region of (2). " 'Kubla Khan,' " says Professor Lowes, "is the fabric of a vision, but every image that rose up in its weaving had passed that way before. And it would seem that there is nothing haphazard or fortuitous in their return." This is not quite clear— not even when Professor Lowes explains that there were clusters of associations, like hooked atoms, which were drawn into complex relation with other clusters in the deep well of Coleridge's memory, and which then coalesced and issued forth as poems. If there was nothing "haphazard or fortuitous" in the way the images returned to the surface, that may mean (1) that Coleridge could not produce what he did not have, that he was limited in his creation by what he had read or otherwise experienced, or (2) that having received certain clusters of associations, he was bound

[6] And the history of words *after* a poem is written may contribute meanings which if relevant to the original pattern should not be ruled out by a scruple about intention.

to return them in just the way he did, and that the value of the poem may be described in terms of the experiences on which he had to draw. The latter pair of propositions (a sort of Hartleyan associationism which Coleridge himself repudiated in the *Biographia*) may not be assented to. There were certainly other combinations, other poems, worse or better, that might have been written by men who had read Bartram and Purchas and Bruce and Milton. And this will be true no matter how many times we are able to add to the brilliant complex of Coleridge's reading. In certain flourishes (such as the sentence we have quoted) and in chapter headings like "The Shaping Spirit," "The Magical Synthesis," "Imagination Creatrix," it may be that Professor Lowes pretends to say more about the actual poems than he does. There is a certain deceptive variation in these fancy chapter titles; one expects to pass on to a new stage in the argument, and one finds—more and more sources, more and more about "the streamy nature of association."[7]

"Wohin der Weg?" quotes Professor Lowes for the motto of his book. "Kein Weg! Ins Unbetretene." Precisely because the way is *unbetreten*, we should say, it leads away from the poem. Bartram's *Travels* contains a good deal of the history of certain words and of certain romantic Floridian conceptions that appear in "Kubla Khan." And a good deal of that history has passed and was then passing into the very stuff of our language. Perhaps a person who has read Bartram appreciates the poem more than one who has not. Or, by looking up the vocabulary of "Kubla Khan" in the *Oxford English Dictionary*, or by reading some of the other books there quoted, a person may know the poem better. But it would seem to pertain little to the poem to know that *Coleridge* had read Bartram. There is a gross body of life, of sensory and mental experience, which lies behind and in some sense causes every poem, but can never be and need not be known in the verbal and hence intellectual composition which is the poem. For all the objects of our manifold experience, for every unity, there is an action of the mind which cuts off roots, melts away context—or indeed we should never have objects or ideas or anything to talk about.

It is probable that there is nothing in Professor Lowes' vast book which could detract from anyone's appreciation of either *The Ancient Mariner* or "Kubla Khan." We next present a case where preoccupation with evidence of type (3) has gone so far as to distort a critic's view of a poem (yet a case not so obvious as those that abound in our critical journals).

In a well known poem by John Donne appears this quatrain:

> Moving of th' earth brings harmes and feares,
> Men reckon what it did and meant,
> But trepidation of the spheares,
> Though greater farre, is innocent.

[7] Chaps. VIII, "The Pattern," and XVI, "The Known and Familiar Landscape," will be found of most help to the student of the poem.

A recent critic in an elaborate treatment of Donne's learning has written of this quatrain as follows:

He touches the emotional pulse of the situation by a skillful allusion to the new and the old astronomy. . . . Of the new astronomy, the "moving of the earth" is the most radical principle; of the old, the "trepidation of the spheres" is the motion of the greatest complexity. . . . The poet must exhort his love to quietness and calm upon his departure; and for this purpose the figure based upon the latter motion (trepidation), long absorbed into the traditional astronomy, fittingly suggests the tension of the moment without arousing the "harmes and feares" implicit in the figure of the moving earth.[8]

The argument is plausible and rests on a well substantiated thesis that Donne was deeply interested in the new astronomy and its repercussions in the theological realm. In various works Donne shows his familiarity with Kepler's *De Stella Nova*, with Galileo's *Siderius Nuncius*, with William Gilbert's *De Magnete*, and with Clavius' commentary on the *De Sphaera* of Sacrobosco. He refers to the new science in his Sermon at Paul's Cross and in a letter to Sir Henry Goodyer. In *The First Anniversary* he says the "new philosophy calls all in doubt." In the *Elegy on Prince Henry* he says that the "least moving of the center" makes "the world to shake."

It is difficult to answer argument like this, and impossible to answer it with evidence of like nature. There is no reason why Donne might not have written a stanza in which the two kinds of celestial motion stood for two sorts of emotion at parting. And if we become full of astronomical ideas and see Donne only against the background of the new science, we may believe that he did. But the text itself remains to be dealt with, the analyzable vehicle of a complicated metaphor. And one may observe: (1) that the movement of the earth according to the Copernican theory is a celestial motion, smooth and regular, and while it might cause religious or philosophic fears, it could not be associated with the crudity and earthiness of the kind of commotion which the speaker in the poem wishes to discourage; (2) that there is another moving of the earth, an earthquake, which has just these qualities and is to be associated with the tear-floods and sigh-tempests of the second stanza of the poem; (3) that "trepidation" is an appropriate opposite of earthquake, because each is a shaking or vibratory motion; and "trepidation of the spheres" is "greater far" than an earthquake, but not much greater (if two such motions can be compared as to greatness) than the annual motion of the earth; (4) that reckoning what it "did and meant" shows that the event has passed, like an earthquake, not like the incessant celestial movement of the earth. Perhaps a knowledge of Donne's interest in the new science may add another shade of meaning, an overtone to the stanza in question, though to say even this runs against the words. To make the geocentric

[8] Charles M. Coffin, *John Donne and the New Philosophy* (New York, 1927), 97–98.

and heliocentric antithesis the core of the metaphor is to disregard the English language, to prefer private evidence to public, external to internal.

V

If the distinction between kinds of evidence has implications for the historical critic, it has them no less for the contemporary poet and his critic. Or, since every rule for a poet is but another side of a judgment by a critic, and since the past is the realm of the scholar and critic, and the future and present that of the poet and the critical leaders of taste, we may say that the problems arising in literary scholarship from the intentional fallacy are matched by others which arise in the world of progressive experiment.

The question of "allusiveness," for example, as acutely posed by the poetry of Eliot, is certainly one where a false judgment is likely to involve the intentional fallacy. The frequency and depth of literary allusion in the poetry of Eliot and others has driven so many in pursuit of full meanings to the *Golden Bough* and the Elizabethan drama that it has become a kind of commonplace to suppose that we do not know what a poet means unless we have traced him in his reading—a supposition redolent with intentional implications. The stand taken by F. O. Matthiessen is a sound one and partially forestalls the difficulty.

If one reads these lines with an attentive ear and is sensitive to their sudden shifts in movement, the contrast between the actual Thames and the idealized vision of it during an age before it flowed through a megalopolis is sharply conveyed by that movement itself, whether or not one recognizes the refrain to be from Spenser.

Eliot's allusions work when we know them—and to a great extent even when we do not know them, through their suggestive power.

But sometimes we find allusions supported by notes, and it is a nice question whether the notes function more as guides to send us where we may be educated, or more as indications in themselves about the character of the allusions. "Nearly everything of importance . . . that is apposite to an appreciation of 'The Waste Land,'" writes Matthiessen of Miss Weston's book, "has been incorporated into the structure of the poem itself, or into Eliot's Notes." And with such an admission it may begin to appear that it would not much matter if Eliot invented his sources (as Sir Walter Scott invented chapter epigraphs from "old plays" and "anonymous" authors, or as Coleridge wrote marginal glosses for *The Ancient Mariner*). Allusions to Dante, Webster, Marvell, or Baudelaire doubtless gain something because these writers existed, but it is doubtful whether the same can be said for an allusion to an obscure Elizabethan:

> The sound of horns and motors, which shall bring
> Sweeney to Mrs. Porter in the spring.

"Cf. Day, *Parliament of Bees:*" says Eliot,

> When of a sudden, listening, you shall hear,
> A noise of horns and hunting, which shall bring
> Actaeon to Diana in the spring,
> Where all shall see her naked skin.

The irony is completed by the quotation itself; had Eliot, as is quite conceivable, composed these lines to furnish his own background, there would be no loss of validity. The conviction may grow as one reads Eliot's next note: "I do not know the origin of the ballad from which these lines are taken: it was reported to me from Sydney, Australia." The important word in this note—on Mrs. Porter and her daughter who washed their feet in soda water—is "ballad." And if one should feel from the lines themselves their "ballad" quality, there would be little need for the note. Ultimately, the inquiry must focus on the integrity of such notes as parts of the poem, for where they constitute special information about the meaning of phrases in the poem, they ought to be subject to the same scrutiny as any of the other words in which it is written. Matthiessen believes the notes were the price Eliot "had to pay in order to avoid what he would have considered muffling the energy of his poem by extended connecting links in the text itself." But it may be questioned whether the notes and the need for them are not equally muffling. F. W. Bateson has plausibly argued that Tennyson's "The Sailor Boy" would be better if half the stanzas were omitted, and the best versions of ballads like "Sir Patrick Spens" owe their power to the very audacity with which the minstrel has taken for granted the story upon which he comments. What then if a poet finds he cannot take so much for granted in a more recondite context and rather than write informatively, supplies notes? It can be said in favor of this plan that at least the notes do not pretend to be dramatic, as they would if written in verse. On the other hand, the notes may look like unassimilated material lying loose beside the poem, necessary for the meaning of the verbal symbol, but not integrated, so that the symbol stands incomplete.

We mean to suggest by the above analysis that whereas notes tend to seem to justify themselves as external indexes to the author's *intention*, yet they ought to be judged like any other parts of a composition (verbal arrangement special to a particular context), and when so judged their reality as parts of the poem, or their imaginative integration with the rest of the poem, may come into question. Matthiessen, for instance, sees that Eliot's titles for poems and his epigraphs are informative apparatus, like the notes. But while he is worried by some of the notes and thinks that Eliot "appears to be mocking himself for writing the note at the same time that he wants to convey something by it," Matthiessen believes that the "device" of epigraphs "is not at all open to the objection of not being sufficiently structural." "The *intention*," he says "is to enable the poet to secure a condensed expression in the poem itself." "In each case the epigraph is *designed* to form an integral part of the effect of the

poem." And Eliot himself, in his notes, has justified his poetic practice in terms of intention.

The Hanged Man, a member of the traditional pack, fits my purpose in two ways: because he is associated in my mind with the Hanged God of Frazer, and because I associate him with the hooded figure in the passage of the disciples to Emmaus in Part V. . . . The man with Three Staves (an authentic member of the Tarot pack) I associate, quite arbitrarily, with the Fisher King himself.

And perhaps he is to be taken more seriously here, when off guard in a note, than when in his Norton Lectures he comments on the difficulty of saying what a poem means and adds playfully that he thinks of prefixing to a second edition of *Ash Wednesday* some lines from *Don Juan:*

> I don't pretend that I quite understand
> My own meaning when I would be *very* fine;
> But the fact is that I have nothing planned
> Unless it were to be a moment merry.

If Eliot and other contemporary poets have any characteristic fault, it may be in *planning* too much.

Allusiveness in poetry is one of several critical issues by which we have illustrated the more abstract issue of intentionalism, but it may be for today the most important illustration. As a poetic practice allusiveness would appear to be in some recent poems an extreme corollary of the romantic intentionalist assumption, and as a critical issue it challenges and brings to light in a special way the basic premise of intentionalism. The following instance from the poetry of Eliot may serve to epitomize the practical implications of what we have been saying. In Eliot's "Love Song of J. Alfred Prufrock," toward the end, occurs the line: "I have heard the mermaids singing, each to each," and this bears a certain resemblance to a line in a Song by John Donne, "Teach me to heare Mermaides singing," so that for the reader acquainted to a certain degree with Donne's poetry, the critical question arises: Is Eliot's line an allusion to Donne's? Is Prufrock thinking about Donne? Is Eliot thinking about Donne? We suggest that there are two radically different ways of looking for an answer to this question. There is (1) the way of poetic analysis and exegesis, which inquires whether it makes any sense if Eliot-Prufrock *is* thinking about Donne. In an earlier part of the poem, when Prufrock asks, "Would it have been worth while, . . . To have squeezed the universe into a ball," his words take half their sadness and irony from certain energetic and passionate lines of Marvel "To His Coy Mistress." But the exegetical inquirer may wonder whether mermaids considered as "strange sights" (to hear them is in Donne's poem analogous to getting with child a mandrake root) have much to do with Prufrock's mermaids, which seem to be symbols of romance and dynamism, and which incidentally have literary authentication, if they need it, in a line of a sonnet by Gérard de Nerval. This method of inquiry may lead to the conclusion

that the given resemblance between Eliot and Donne is without signifi-
cance and is better not thought of, or the method may have the disad-
vantage of providing no certain conclusion. Nevertheless, we submit that
this is the true and objective way of criticism, as contrasted to what the
very uncertainty of exegesis might tempt a second kind of critic to under-
take: (2) the way of biographical or genetic inquiry, in which, taking
advantage of the fact that Eliot is still alive, and in the spirit of a man
who would settle a bet, the critic writes to Eliot and asks what he meant,
or if he had Donne in mind. We shall not here weigh the probabilities—
whether Eliot would answer that he meant nothing at all, had nothing
at all in mind—a sufficiently good answer to such a question—or in an
unguarded moment might furnish a clear and, within its limit, irrefutable
answer. Our point is that such an answer to such an inquiry would have
nothing to do with the poem "Prufrock"; it would not be a critical inquiry.
Critical inquiries, unlike bets, are not settled in this way. Critical inquiries
are not settled by consulting the oracle.

CHARLES L. STEVENSON

ON THE REASONS THAT CAN BE GIVEN FOR THE INTERPRETATION OF A POEM

Charles L. Stevenson is Professor of Philosophy at The University of Michigan.

When we are uncertain about what a poem means, wondering whether to interpret it this way or that way, we normally try to make up our minds in the light of reasons. We realize that we may be missing meanings that are "there," or reading in meanings that "aren't there"; and we hope that our reasons, protecting us from such errors, will help us to interpret the poem correctly.

In the present paper I shall try to explain, though only in the most general way, what sort of reasons are available in such cases. Are they the ordinary reasons of deductive or inductive logic, or are they reasons of another sort? My aim will accordingly be *meta*-critical: I shall not be suggesting or defending poetic interpretations of my own, but shall be attempting, merely, to clarify the sort of issue that interpretations are likely to bring with them.

Reprinted from *Philosophy Looks at the Arts*, pp. 121–139, edited by Joseph Margolis, New York, Charles Scribner's Sons, 1962, by permission of Professor Charles L. Stevenson.

II

An interpretation can be guided, of course, by reasons that appeal to the dictionary. Thus when the sea of faith is described as retreating

> down the vast edges drear
> And naked shingles of the world[1]

an American reader may be temporarily perplexed, feeling that "shingles" obscures the metaphor. He has only to consult the dictionary to find a sense, marked "chiefly British," in which "shingles" refers to gravel-like stones found on the seashore; and his perplexity about the lines will then vanish.

Note, however, that his dictionary reason has only *helped* him to establish his interpretation. For the dictionary, in listing several senses of "shingles," says nothing about which of them is appropriate to Arnold's poem. Our reader has decided that for himself, and in doing so has been tacitly guided by another reason, namely: "The sense I am selecting fits in with the context."

In general, although dictionary reasons, and reasons drawn from the rest of linguistics, manifestly help to establish the foundations of an interpretation, they leave the superstructure to be built by reasons of another sort. Our reader will be encouraged, for instance, to find that his newly discovered sense of "shingles" was current in the nineteenth century; for that frees his interpretation from any suspicion of being anachronistic. The notion of an anachronism, of course, immediately takes him beyond the dictionary. Its connection with the *date of the poem* leads him to take a first step toward relating his interpretation to what he knows about the *poet.*

To find other reasons that can support an interpretation let me turn to a more complicated example—though not without apologies for having to present it so briefly:

In *The Folly of Being Comforted*, by W. B. Yeats, the poet (or imagined speaker) is reminded that his

> well beloved's hair has threads of grey;

but he replies that he will have no comfort for this, insisting that

> Time can but make her beauty over again.

And he concludes with these lines,

> O heart! O heart! if she'd but turn her head,
> You'd know the folly of being comforted!

Now these concluding lines, it will be observed, lend themselves to two sharply different interpretations. Perhaps they reiterate the rest of

[1] From Matthew Arnold's *Dover Beach.*

the poem, affirming with renewed confidence that no comfort is needed. But perhaps, instead, they break sharply with the rest of the poem. The poet can no longer pretend that no comfort is needed; his feelings force him, in the end, to see that for such a loss no comfort is *possible*.[2]

Those who have most studied Yeats, I suspect, will favor the second of these interpretations. But reasons of the sort I have previously mentioned—concerned with conventional English, fidelity to context, and freedom from anachronism—will not be very helpful in showing that their interpretation is more defensible than the first one; so let us see what other reasons they might wish to give.

They might begin by pointing out that the second interpretation is far more in the spirit of Yeats, as one can see by examining his other works—a consideration that is both true and relevant, in my opinion, but by no means final. It remains possible that *this* poem *departs* from Yeats's usual spirit.

Or they might call our attention to the fact that the second interpretation is borne out by Yeats's subsequent revisions of the poem. For after its initial publication he altered it in a way that did much to exclude the first, more obvious interpretation—using quotation marks, for instance, to indicate that the last two lines come as the poet's *answer* to his earlier thoughts. This is again a relevant consideration, but it is still less than decisive. For we must remember that a poem, when revised, may be considered as another, related poem. And if there are two poems, our interpretation of the later one does not require us (though it may indeed incline us) to accept the same interpretation for the earlier one.

Again, they might argue that the poem is much *better* when interpreted in the second way. Such a reason is likely to exchange one type of controversy for another. It remains of interest, however; for it reminds us that the interpretation and evaluation of a poem are rarely separable steps

[2] For the many changes that Yeats made in the poem between 1902 and 1949 see the Variorum Edition of his works, edited by Allt and Alspach (New York, 1957). In *Later Poems* (London, 1929) the complete text reads as follows:

> One that is ever kind said yesterday:
> "Your well-beloved's hair has threads of grey,
> And little shadows come about her eyes;
> Time can but make it easier to be wise
> Though now it seem impossible, and so
> Patience is all that you have need of."
>
> No,
> I have not a crumb of comfort, not a grain,
> Time can but make her beauty over again:
> Because of that great nobleness of hers
> The fire that stirs about her, when she stirs
> Burns but more clearly. O she had not these ways,
> When all the wild summer was in her gaze.
> O heart! O heart! if she'd but turn her head,
> You'd know the folly of being comforted.

in criticism. We do not *first* interpret it and then evaluate it, taking each step with finality. Rather, we test a tentative interpretation by considering the tentative evaluation of the poem to which it leads, progressively altering each in the light of the other.

The reasons that I have been illustrating are very far, of course, from constituting a complete list—nor is it likely that a complete list would be possible. But perhaps they are typical reasons, and will give us a point of departure, at least, for considering how they bear on the interpretive conclusions that they are intended to support.

III

The inconclusiveness of the reasons mentioned (and they remain inconclusive even when used collectively) suggest that they are not premisses in an argument that is strictly deductive. So perhaps they are of an inductive character, each giving to an interpretive conclusion this or that sort of confirmation. That is an initially plausible view, fully deserving our attention. But it is a view that derives its plausibility, I suspect, from an assumption that normally attends it; so we must be careful to make the assumption explicit.

The assumption has to do with the nature of interpretive *questions*. It takes the questions to be concerned, and exclusively concerned, with what the poet had in mind, or intended, or wished to communicate. Or (more or less equivalently) it takes the question, "Is this what the passage means?" to be a way of asking, "If we understand the passage in this way, will we be understanding it as the poet did?" Now any question of this latter sort, whose hypothetical nature does not prevent it from dealing with a matter of fact,[3] is one to which inductive arguments are applicable; and if it typifies all interpretive questions, then perhaps the reasons I have mentioned simply help, directly or indirectly, to place it in an inductive framework. Dictionary reasons are of interest because the poet presumably complied with the dictionary; reasons protesting against anachronisms are of interest because the poet himself couldn't have read his work anachronistically; and so on.

Some of the reasons, to be sure, cannot easily be accounted for in this way—particularly the reason, "It is a better poem when so interpreted." But those who use this reason may think that their sensibilities are akin to those of the poet, and that an interpretation that makes the poem better, *according to their taste*, is more likely than not to be faithful to what the poet had in mind. So even this reason, perhaps, can have its inductive aspects.

[3] There are unquestionably other ways of attempting to identify an interpretive question with a factual one. I shall not discuss them explicitly, but let me remark that I suspect them of confusing standards with definitions, in the manner that I shall explain, somewhat implicitly, in Sect. V.

And yet there are difficulties about this approach to interpretation. I refer not to the general, epistemological difficulties that bear on the meaning of "had in mind," "wished to communicate," "understood," and so on —though these undoubtedly exist—but rather to some relatively specific difficulties that would remain even if the general ones could be resolved.

In particular, we must remember that the poet's thoughts and feelings change as he writes, his first fragmentary notes having perhaps only a remote connection with his finished work. (As Sapir said of all verbal expression, "The product grows with the instrument."[4]) So on being asked whether an interpretation is faithful to what the poet had in mind, we must ask in return, "Had in mind at which time?" And such a reply as, "Just after he made his first clear copy," is not likely, I think, to spring from any genuine literary interest.

Indeed, when a poet has just finished a work he is too close to it, as he may himself acknowledge, to know whether it says much or says little. He has worked so laboriously over certain lines that he has grown numb to them; or he has deleted certain lines that continue to color his understanding of those that remain. Perhaps that is why he so often puts his work aside, to see what he will make of it at later readings.

And what does he make of it at later readings? Does he understand it in a way that is altogether fixed—a way that remains constant for him in every detail, regardless of his varying recollections, moods, and interests?

I should suppose that he understands his work now in one way and now in another—sometimes wondering, perhaps, whether he isn't interpreting it poorly. And how could it be otherwise? His thoughts and feelings of any one time are not, certainly, thereafter visible to him in some display room of his mind; he can half-renew them, but *only with the help of the lines that he has written.* And the fact that he has written them does not free them from that diversity of possible understandings to which language is heir.

This has its obvious bearing on our problem. We can scarcely suppose that the one, legitimate aim of a critic, in interpreting a poem, is that of reproducing the poet's chameleon-like understanding of it in its true color; nor can we suppose that the critic's reasons must always show, inductively, that he has achieved this aim.

I do not wish to imply, of course, that this observation is *fatal* to an inductive view of interpretation. One might just possibly defend it in a modified form. A poet's understanding of his poem, though it varies, will presumably vary only between certain limits. The task of interpretation, then, might be taken as one of establishing these limits. If a critic finds that certain interpretations lie beyond the limits—and for anachronistic interpretations, for instance, the inductive means of doing so is rather straight forward—he may be expected to reject them as incorrect. And of

[4] *Language*, by Edward Sapir (New York, 1921), p. 14.

the *various* interpretations that lie between these limits . . . well, the critic might be expected to say that each has an *equal* claim to being correct, adding that it is no part of his business to choose between them.

One might just possibly, I repeat, defend such a view. Or perhaps one could defend it with still further modifications—making a distinction, say, between the feelings or thoughts that a poet takes to be *expressed* in his poem and the feelings or thoughts that he takes to be *irrelevant* to it, even though the latter happen to come to his mind, occasionally, as he re-reads it. This distinction would help to narrow the limits that I have mentioned. But it would also, let me add, represent the task of interpretive criticism as requiring a curious neutrality, and a curious preoccupation with questions that we should normally classify as belonging to psychology and biography.[5]

In any case, I doubt if anyone will be confident that such a view represents the sole aim of interpretation. It doesn't seem faithful to the interpretive interests that a critic invariably has; and if we ask whether it reveals the interests that he ought to have, then we had better delay our answer until we see what alternatives a critic has before him.

I shall accordingly to go on to one of these alternatives—an alternative that no longer puts exclusive emphasis on what the poet had in mind, and accordingly, one that leads us to view the *reasons* for an interpretation in a different light.

IV

I can best proceed by examining a little more closely the type of *question* that a critic's interpretation is expected to answer. It is a question that is often phrased,

What does this passage in the poem mean?

But the sense of "mean" is here more than usually elusive. In addition to those general difficulties about "meaning" that are now so familiar to us in philosophy there is also a *special* difficulty that I must now briefly describe:

It arises from our conviction (and I think virtually all of us will share that conviction) that when we speak of what a passage "means" we are referring to the way it is understood, or would be understood, by a certain group of people. A passage has a meaning *for* this group. And when the passage is from poetry (though the same could be said, to be sure, for certain types of prose) it is often difficult to specify *what group is in question.*

[5] My views on this matter are partly borrowed from W. K. Wimsatt and M. C. Beardsley. See their article, "The Intentional Fallacy," [*see also pages 91–104 for the complete text. J. M.*] in *Sewanee Review,* LIV (1946), 468–487. But they are concerned largely with the evaluation of poetry, whereas I am transferring their views, with alterations, to the interpretation of poetry.

When we ask what such a passage means we are *not* asking, usually, how it would be understood by the average person who speaks the language in which it is written; for we often suspect that this average person would make very little of the passage, or of poetry in general. And we are *not* asking, presumably, how the passage would be understood by those who are greatly interested in poetry, or even by those who have taken special pains to train themselves in reading poetry; for these people may even so understand the passage in various ways, and we cannot easily suppose that these ways are equally defensible. (I am not denying that there may be alternative ways of understanding the passage, all equally defensible; for that impresses me as an interesting and not implausible view. I am only suggesting that the alternative and equally defensible ways, if they exist, need not coincide with the ways found among "those who are greatly interested in poetry," etc.)

So to what group of readers *are* we referring? The conception of interpretation that I have previously mentioned has not, of course, evaded this question. It specifies the group as having the poet himself as its charter member; and it admits others to the group if and only if they read his poetry in the way (or for my amended version, *in one of the ways*) that he did. And if we are to have an alternative to this not wholly satisfactory view, we must specify the group in another manner; for so long as it remains unspecified the very request for an interpretation—the question typified by "What does this passage in the poem mean?"—will have no fixed sense.

Now the alternative that I wish to consider, and to which I can now directly turn, breaks sharply with other views in this respect: it claims that the group of readers, as implicitly mentioned in an interpretive question, cannot be made explicit by means of factual terms alone, but must be indicated, in part, by means of evaluative terms. I shall accordingly refer to it as an "evaluative" or "normative" conception of interpretation; and in explaining it further I shall want to show that in some respects it is very simple, and in other respects highly complex.

It is simple because it does no more than remind us that the readers in question—those whose understanding of the passage is indicative of what the passage means—must initially be specified as the *best* readers, or as those who read the passage *properly*, or *ideally*. Or to put it otherwise, it translates the question, "What does this passage in the poem mean?" into some such question as this: "How would the passage be understood by those who read it as they should—i.e., by those who bring to it a skill and sensibility that is neither too rich nor too poor, but is just right?"

To that extent the view is almost naively simple. Nor does it lose its simplicity when it is confronted by the question, "But what readers *do* read as they should, and what skills and sensibilities *are* just right, etc.?" A normative conception of interpretation, faithful to its meta-critical aims,

carefully refrains from answering this question. To those who feel that an answer is mandatory it makes this reply: "If you are asking not for remarks that clarify these evaluative terms, but rather for normative judgments that make use of them—judgments that *predicate* them of certain factually described readers or of certain factually described skills and sensibilities—then your question reduplicates, in good measure, the very question that interpretive critics, whether professionals or amateurs, are themselves trying to answer (though they usually try to answer it only for these or those special cases). For in deciding how a passage would be understood by those who read it as they should, the critics must decide, of course, which readers *do* read it as they should. And it is important to see that such a genuinely normative decision belongs to criticism proper. It belongs to philosophy only when philosophy goes beyond meta-criticism, becoming a kind of generalized criticism that defends a *standard* for *good* interpretations of poetry. It does not belong to the meta-critical part of philosophy, whose business is not to answer questions of literary criticism, but only to clarify them."

But if a normative conception of interpretation is in these ways very simple, it suddenly becomes complicated when it goes on to consider the *meaning* of such terms as "should" and "good." That is a different question, as I see it, from any question about the various factual X's of which the evaluative terms are to be predicated; and it is a question that belongs to meta-criticism beyond any doubt. Indeed, it leads to some of the most familiar problems of contemporary analytical philosophy. Do the value-terms refer to non-natural qualities? Or do they refer, say, to the integration of interests? Or do they function expressively or quasi-imperatively?

Now with regard to these matters I have developed my views elsewhere,[6] and cannot undertake within the scope of the present essay to renew my discussion of them. But even so—even when the evaluative terms are temporarily left with the unanalyzed meanings that they have in everyday discourse—I think that the remarks I have been making deserve attention. For although we know that evaluative terms (i.e., normative terms) will require attention somewhere in aesthetics, we are not so likely to think that they will require attention just here, in connection with interpretation. We tend to make a sharp *contrast* between evaluation

[6] See my *Ethics and Language* (New Haven, 1944), and my paper, "Interpretation and Evaluation in Aesthetics," in *Philosophical Analysis*, edited by Max Black (Ithaca, 1950). I there take value-judgments to serve mainly (though not exclusively) to express the speaker's attitude of favor or disfavor, and to do so in a way that invites, as it were, the hearer or hearers to share this attitude. Such a view does not cut off our evaluations from our scientifically established beliefs; for these beliefs, revealing the factual situation that presumably confronts us, normally make a vast difference to the sort of attitude that we express. My remarks about reasons, as developed in the remainder of this paper, are in accordance with this view; but I suspect that much of what I say will be compatible with certain other views as well, and thus will be of interest to some who feel that my general position is open to criticism.

and interpretation. But if any form of a normative conception of interpretation is correct, we must make the contrast much less sharp; for interpretation, too, will have its evaluative aspects.

This is not to deny, of course, that the questions, "What does this poem mean? and "Is it a good poem?" are quite different questions. A normative conception of interpretation can readily distinguish them. The latter is concerned with the value *of the poem*, and the former is concerned with the value of something else—namely, with the value of the way in which this or that reader understands the poem, or with the value of the sensibilities, etc., that yield that way of understanding it. Let me explain this by an example:

Suppose that one critic, having interpreted a poem, is told by another critic, "You are reading a meaning into it that simply isn't there." According to a normative conception of interpretation, the latter critic is in effect saying, "You are making too much of it; you are bringing to it a sensibility and an ingenuity that is excessive—i.e., one that for this poem goes beyond what is fitting, appropriate, or desirable." And if the first critic replies, "The meaning is there, and you're missing it," he is in effect saying, "My understanding of it is as it should be, and by bringing less to the poem you are making too little of it." Note that neither critic has affirmed or denied that the poem is good, but each—granted the paraphrases, of course—has taken a normative stand on how it is to be understood.

A normative conception of interpretation, let me add, impresses me as akin to a conception that critics themselves often have of their work—though they suggest it, rather than expound it, by saying that criticism is less a science than an art. One might develop this by saying that a critic, as artist, need not be required to make a faithful copy of something in the poet's mind (a highly inaccessible model at best, and one that won't stand still) but can be granted a creative freedom of his own. He recognizes limits to this freedom, of course, not wishing to understand words as Carroll's Humpty Dumpty does; but these limits allow him to put something of his own artistic temperament into his interpretations. He shares this freedom with those other interpretive artists (in a different but related sense) who are actors and virtuosos. And if that much can be granted, we can easily see why evaluative terms have a place in the very formulation of interpretive questions. They lead to the central topic of discussion: a discussion of whether or not a critic is exercising his creative freedom in an acceptable way.

V

I cannot pause to provide a normative conception of interpretation with its many needed qualifications, but must go on to its implications with regard to my chosen topic—the topic of *reasons*. Earlier in the paper I

have illustrated reasons of a sort that are commonly used—those that appeal to the dictionary, those that mention the fitness of a word's sense to its context, those that deal with anachronisms, those that refer to the spirit of the poet, those that call attention to the poet's revisions, and those that are concerned with the enhancement of poetic interest or value. What more is to be said about them?

I want to make two points in this connection. The first is that a normative conception of interpretation can readily account for these reasons, showing why critics may be expected to use them. The second is that these reasons cannot, for a normative conception, be taken as typifying all other reasons. They typify only those that are comparatively simple; and there is always the possibility—the theoretical possibility, at least— of supplementing them by reasons of a much broader and more pervasive sort.

To introduce my first point let me return to my remarks in Section III, where I acknowledged that the reasons might conceivably reveal what the poet intended, or what he had in mind. That is *one* way of attempting to show why the reasons are relevant to an interpretation; so let us consider to what extent a normative conception can accept it.

Quite evidently, a normative conception must qualify any such proposal; but all the same it need not abandon it completely. For it will be remembered that the question, "Just who are the good or ideal readers?" is one that a normative conception carefully leaves unanswered: it lets a critic decide as he sees fit about this central matter. It remains possible, then, that certain critics will decide that the good or ideal readers are those who, to whatever extent is possible, respect what the poet intended or had in mind. And for these critics the reasons in question will become relevant in much the same biographical way, so to speak, that Section III has discussed.

To take the very simplest case: suppose that a critic has an explicit *standard* of interpretation—or in other words, suppose that he accepts a normative generalization comparable to a standard of ethics, for instance, save that it is far smaller in scope, dealing only with good ways of reading poetry, or with the ways that poetry should be understood. And suppose that this small-scale standard is particularly respectful of the poet, so that our critic is prepared to formulate it in these words:

A poem is understood as it should be if and only if it is understood in one of the ways that the poet himself understood it.

Now, relative to this standard, it will be evident that the reasons I have illustrated have an intelligible place in criticism. The reasons help to establish—and *inductively*—some implicit statement about the poet's own understanding of his work. The standard in question then relates this statement to a "should." With the help of the standard, then, the reasons support an interpretive conclusion.

This manner of accounting for the reasons, however, is possible only when the critic's standard of interpretation is used as a supplementary premiss. And this supplementary premiss, being genuinely normative, presents additional problems. It is presumably *not* true by definition, as even naturalistic theories often imply; for naturalism usually emphasizes some general end in its definition of evaluative terms, and nothing so specific as a respect for the authority of the poet. So the standard will have to be defended in its turn. It too will require reasons—and reasons of a sort presumably different from any that I have yet illustrated.[7]

These remarks are in keeping with both of my central points. They suggest that a normative conception can account for the reason I have illustrated, and that it also envisages reasons of another sort. But I must continue, since my points are still imperfectly established.

A normative conception of interpretation is not committed, of course, to the simple standard I have mentioned. It *permits* this standard but in no way *requires* it; and it is no less interested, for instance, in a standard that runs like this:

A poem is understood as it should be if and only if: (1) it is understood in a way not altogether foreign to what the poet sometimes had in mind; (2) its words, syntax, and figures of speech are not stretched to such an extent that they couldn't have been so understood by the poet's contemporaries; and (3) within the limits set up by the preceding restrictions, it maximizes the aesthetic value of the poem.

This standard designedly makes less of the authority of the poet, and adds other factors. But it again permits a normative conception to do full justice to the reasons I have illustrated. The reasons help to establish one or more of the numbered points that follow the words "if and only if," and the standard then connects them with a "should." So we have only a complication of the analysis that I gave for the standard previously mentioned. Reasons drawn from linguistics, it will be noted, have as much to do with what the poet's contemporaries made of his work (clause (2) above) as

[7] The standard could be made true by definition, to be sure, provided the definition were of the sort that I have elsewhere called "persuasive." (See my *Ethics and Language*, Ch. IX.) But persuasive definitions are different from any that a neutral, meta-critical study can provide. In their net effect they are tantamount to overt normative judgments: they can be controversial in essentially the same way that overt normative judgments can be controversial, and they have to be supported by essentially the same sorts of reasons.

My objection to the "ideal observer" view of ethics, as developed by Roderick Firth in "Ethical Absolutism and the Ideal Observer" (*Philosophy and Phenomenological Research*, XII, 1952, pp. 317–345) centers on precisely this point. Having introduced the laudatory term, "ideal," he proceeds to define it for his contexts in a highly specific, naturalistic sense; and he assumes that his definition will raise only the usual issues of analytical philosophy. But in my opinion his definition is persuasive —one that, if systematically defended, would introduce in a new terminology all of the genuinely *normative* issues to which ethics is heir. So although I may seem merely to be transferring what he says about ethics to the neighboring field of aesthetics, I am in fact diverging from him quite sharply in my way of handling the word "ideal."

they do with what the poet himself made of it. And the reasons, "That sense of the word fits in with the context," however much it may bear on what the poet had in mind, can also reflect the critic's decision (as in (3) above) about how to maximize the poem's aesthetic value.

As before, however, the reasons become revelant only with the help of the standard. And since a normative conception conceives of this standard, like any other, as distinct from a statement that is true by definition, it still requires us to consider what reasons could be given for the standard itself.

I could mention other standards of interpretation, of course, but I suspect that they would introduce nothing new in principle. Let me consider, then, the possibility of a critic's interpreting a poem without formulating *any* standard of interpretation—as is presumably the usual case. Suppose, for instance, that he uses no more than thumb-rules, of the "so far so good" variety. If the interpretation is close to what the poet sometimes had in mind (he says) then so far so good. If it is faithful to the spirit of the poet's other work, then again, so far so good. And so on. Our critic may be unable to formulate *all* of his tacitly accepted thumb-rules in advance; and he may not have any formulated principle for summing up the "vectors" of interpretive acceptability that his thumb-rules introduce, but instead may estimate their combined force quite intuitively, and even rather differently for each new case; so he need not have any complete, explicit standard of interpretation at all. Even so, he may repeatedly use the reasons that I have previously illustrated; he may use them in affirming the truth of the purely factual, "if" parts of the thumb-rules, and thus in making inferences by *modus ponens* to the evaluative "then" parts.

But how are the thumb-rules themselves to be justified? Why say "so far so good" in the "then" parts, rather than "so far so bad"? We are again led to envisage supplementary reasons, differing from any that have so far been illustrated.

Of the several qualifications that I should here introduce I shall mention only one—a qualification that is needed with regard to very strange suggestions about standards of interpretation or very strange suggestions about thumb-rules. For suppose (absurdly) that a critic's thumb-rule leads him to divert every word in an English poem into some non-English sense. We should say, no doubt, that such a rule prevents him from interpreting poetry at all. The word "interpret" simply doesn't apply to what he is doing; so *quite apart from any normative considerations*, we may dismiss his proposals as aside from the point. If any normative issue arises it will bear on another question, namely, "Ought he stop doing what he is doing, and interpret poetry instead?"

But if certain proposals about meaning can be excluded in advance, by the very definition of "interpretation," it remains the case that a great many can *not* be so excluded. And of the latter only *some* will comply with

standards or thumb-rules that are defensible. So in showing that they are really defensible we shall still need those "other" reasons that I have been mentioning. Just as we cannot, according to a normative conception, eliminate these reasons in favor of linguistic rules governing the common use of such words as "good" and "ideal," so we cannot eliminate them in favor of linguistic rules governing the common use of "interpretation."

VI

It will be well, then, to say a few words about these other and presumably more complicated reasons.

I cannot enter into a full discussion of the matter, but perhaps I can point in the right direction by giving some examples. The examples, let me say in advance, suggest that problems of interpretation are very large problems—so large that it becomes difficult to establish any boundaries within which they can be confined.

Let us consider interpretations that are likely to impress some of us, and perhaps many of us, as "one sided," or "lacking in a sense of proportion." There are literary Fabians, for example, who find Fabian principles underlying the mythology of Wagner's *Ring*. There are extreme Freudians, who take Hamlet's feelings toward Gertrude and Claudius to spring, in essentials, from an incestuous jealousy. And there are also those critics who seem preoccupied not with views about politics or psychology, but rather with views about the complexities of language—as will be evident from the instance that follows:

Mr. F. W. Bateson, in discussing the sonnet of Shakespeare that begins,

The expense of spirit in a waste of shame

points out that "expense," which sounds so much like "expanse," reminds us of the expanse of a desert, for instance, and thus suggests "waste." So when the word "waste" thereafter appears the line acquires a unity of meaning.[8]

Let us now—though for the sake of argument, and without regard to how we actually feel about the matter—take the position of those who reject these interpretations. We find them "obsessive," urging that a good reader would make far *less* of the points they emphasize. Our position is easily stated; but it is another matter, of course, to defend it. And what shall we say to those who, disagreeing with us, feel justified in accepting the interpretations?

In essentials, my answer is this: we could argue that the proposed interpretations are indicative of habits of mind that no one *ought* to have. And we could attempt to show this by pointing out the consequences of

[8] See *English Poetry and the English Language*, by F. W. Bateson (Oxford, 1934) page 21. Such Joycean touches in interpretation can easily be supplemented by Freudian touches, as when Bateson goes on to say that the word "waste," by suggesting "waist," reinforces the sexual implications of the sonnet.

these habits of mind—consequences that may bear not only on our subsequent understanding of poetry, but may indirectly, by developing distorted perspectives, bear on a vast part of our manner of living.

I say this on the following grounds. What we make of a poem (and there is a familiar adage to this effect) depends not merely on the poetic text itself but also on what we *bring to* it. And what we bring to it includes habits of mind (i.e., sensibilities, interests, skills, convictions, etc.) that can scarcely be taken as causally isolated from our daily life. Their importance extends beyond any purely literary importance; and in evaluating them—in deciding which of them are and which of them are not to be cultivated—we shall want, so far as possible, to consider the full psychological context in which they arise. But whatever we decide about them, in the light of this full psychological context, will remain in part a decision about the habits of mind that we shall bring to a poetic text; it will inevitably make a difference to our decision about how poetry is to be understood. So I venture to draw my conclusion: In judging a proposed interpretation of poetry we can appeal to those varied reasons, often of an ethical or of a prudential character, that help us to evaluate the habits of mind with which the proposed interpretation is correlated.

These remarks readily apply to the interpretations that I have mentioned just above. Having called them "obsessive" we might go on to consider such possibilities as these: A sharply Fabian emphasis in understanding the text of the *Ring* might indicate (say) a political interest of such intensity that it crowds out other interests; and these other interests may include some that are essential not merely to a well-rounded critic but also to a well-rounded *person*. An insistence on Hamlet's incestuous jealousy (and to say this is not to deny that Freud has something new to tell us) may be correlated with a lack of concern with those simpler, less arresting aspects of psychology that we need in handling the problems of practical life. And a tendency to read Shakespeare as though he were Joyce, when it goes beyond certain limits, may manifest a trivial, game-playing mentality, of a sort that blunts our powers of distinguishing between oneupmanship and sensitivity. These are manifestly possibilities; and there would be no irrelevancy, to say the least, in our attempting to find out whether they are actualities. Our inquiries might help us, in keeping with the principles mentioned above, to strengthen our interpretive norms by relating them to much more general norms.

Such is the way in which we might supplement (as distinct from replace) the simpler reasons that I have illustrated at the beginning of my paper. It takes us, of course, well beyond that close reading of the text with which interpretive criticism, by common consent, must always begin. And it takes us well beyond anything that can be called "a dwelling, with aesthetic absorption, on the immediacies of experience"—the latter being essential, according to many writers, to our enjoyment of poetry. But that, so far from being surprising, is only to be expected, for it holds true *whenever* we support an interpretive judgment by reasons. The most

commonplace reasons are not exceptions to this rule. We must turn away from the poetic text, and temporarily interrupt our aesthetic absorption, even in the simple act of looking up a word in the dictionary; we must do so again when we enter into historical reflections that bear on anachronisms; and so on. So there can be no heresy, I trust, in saying the same thing about the broader, consequence-regarding reasons that I have just mentioned.

Indeed, my remarks about consequence-regarding reasons, and about the normative conception of interpretation that introduces them, can happily serve to warn us against a type of theory that gives a *misplaced* emphasis to aesthetic absorption, and thus suggests that aesthetics can recognize no values save those that are inherent or intrinsic. It may be the case (or so I shall assume for purposes of argument) that an aesthetic enjoyment of poetry requires us to dwell with absorption on the immediacies of experience. But it is one thing to "dwell" in this manner and quite another thing to ask, for any given poem, *which* experiences we are to dwell upon. The latter cannot be separated from an interpretive question, which in turn cannot be separated from a question about what we *should bring to* the text that we are interpreting. The evaluations that attend our interpretations, then, need not resemble those intrinsic ones that attend (as so many have said) our immediate enjoyment of poetry. They involve inquiries that are usually *preparatory* to our poetic enjoyment; and any contention that they too must deal only with inherent or intrinsic values—that they too must "abstract from" all considerations of the consequences—could only spring from a confusion.

If my view seems in any way strange, then, that is presumably because interpretive criticism is usually conceived as a discipline that is narrower than I have suggested, and more self-contained. But my view is not, I think, strange even in that way. There can be no ground for repudiating narrower conceptions so long as they represent avowed efforts to select and emphasize, with a calculated risk, certain aspects of a total problem. Indeed, the need of such conceptions is beyond practical doubt. But there is also the need of keeping in mind the total problem; and there we must be careful not to exclude *any* of the considerations by which our interpretive judgments are influenced, whether actually or potentially. None of us, I suspect, is immune from the influence of just such broad considerations as I have been mentioning. If we ignore them we shall inevitably make tacit assumptions about them, and assumptions that, when tacitly changed, will leave us unable to understand why our present interpretations are not the same as our old ones.

VII

My consequence-regarding reasons are potentially open, of course, to the same inductive methods that bear on consequences quite generally,

and they show the elaborate use that interpretive criticism could make of these methods. They may or may not, on the other hand, show that interpretive criticism falls *wholly* within an inductive pattern. For interpretive conclusions, as I am here viewing them, remain *normative;* and there are a number of theories—namely, those that oppose an unqualifiedly naturalistic theory of value—that point to a gap, as it were, between inductively supported reasons and any normative conclusion that the reasons, in their turn, are intended to support.

There will be no such gap, of course, if we add to the inductively supported reasons some supplementary normative principle, for the latter can be chosen, and sometimes plausibly chosen, in a way that makes the argument *de*ductive. But in cases where the supplementary normative principle is again controversial (as we have seen in Section V) we have a need of further reasons. Will this process have a termination, or will the further reasons, too, require a supplementary normative principle, the latter again requiring reasons . . . ? Some theorists (namely, the intuitionists) hope for a quite decisive termination—one in which the supplementary normative principles in question are "seen," a priori, to be acceptable. Other theorists (I among them) feel unable to guarantee a termination in this way, and hope for no more than a practical termination —one in which the supplementary normative principles, though they still *could* be questioned, will not in fact be questioned. In either case, it will be noted, the inductively established premises, though manifestly relevant to the argument, do not establish a normative conclusion in quite the way that they might establish a factual conclusion.

I have said nothing to imply, then, that interpretive criticism is a "science." I think that it differs from a science, and wish only to show that it need not, on that account, turn away from a *use* of science. A normative conception can speak of a "science of interpretation" only if it goes on to analyze normative judgments naturalistically—i.e., in a manner that reduces them to factual statements. And the latter view, though it still has respectable adherents, is one that I myself consider implausible.

But these are matters that I cannot (as I have previously suggested) undertake to develop within the scope of the present paper.[9] It will be sufficient to point out that almost all theorists, however much they may differ in other respects, acknowledge that we need to illuminate our evaluations by inquiries into the facts of the case. And the broader reasons that I have been mentioning have always an interest in *that* way—an interest that those holding divergent theories of value may nevertheless be expected to share.

[9] See footnote 6. Let me supplement the comment in that note by this further one: I take reasons for value-judgments to be reasons for favoring or disfavoring, and not just reasons for believing or disbelieving. When the reasons are purely factual (i.e., when they are themselves in no part evaluative) their relation to the value-judgments is one that I take to be only *psycho*logical; so although they can be judged as good or bad reasons, they cannot be shown so by the rules of logic alone.

Any such interest, however, is limited by some practical considerations, and I must not conclude my paper without mentioning them.

There can be no doubt that my broader reasons lead into regions that we can rarely explore. We cannot hope to know *all* the consequences of the habits of mind that we bring to poetry, and we shall be fortunate if we can become reasonably confident about certain aspects of some of them. So if practical reasons must be free from uncertainty, then those that I have mentioned are at best (here and now, at least) only half-practical.

But that is only to say, for our special case, what can be said of evaluative problems in general. When we vote in an election, for instance, there is an even greater discrepancy between what we know and what we need to know. And to know *that*, which is a kind of Socratic wisdom, has its own kind of practicality. It is not to be confused with a ground for discouragement. In common life we get along in spite of our imperfect knowledge; we trust our tentative evaluations for the time, but allow for our fallibility. And there is no reason to suppose that we cannot do the same thing in interpreting poetry.

In our approach to criticism, then, I am not suggesting that we make all the needed inquiries today, using them tomorrow to explain what poetry really means. My moral, if I must have one, lies rather in the reminder that allegedly final interpretations are less final than they may seem. And I for one do not regret this. If final answers could readily be given, perhaps our reading of poetry would cease to be a living thing. Our successively altered answers are of interest long before they can make a pretense, even, of being "the" answer.

STANLEY CAVELL

AESTHETIC PROBLEMS OF
MODERN PHILOSOPHY

Stanley Cavell is Professor of Philosophy at Harvard University.

The Spirit of the Age is not easy to place, ontologically or empirically; and it is idle to suggest that creative effort must express its age, either because that cannot fail to happen, or because a new effort can create a new age. Still, one knows what it means when an art historian says, thinking of the succession of plastic styles, 'not everything is possible in every period'.[1] And that is equally true for every person and every philosophy. But then one is never sure what is possible until it happens; and when it happens it may produce a sense of revolution, of the past escaped and our problems solved—even when we also know that one man's solution is another man's problem.

From *Philosophy in America*, pp. 74–97, edited by Max Black, Cornell University Press, 1965. Copyright under the Berne Convention by George Allen & Unwin Ltd. Used by permission of Cornell University Press. Also by permission of George Allen & Unwin Ltd., London.
[1] Heinrich Wölfflin, *Principles of Art History*, foreword to the 7th German edition. Quoted by E. H. Gombrich, *Art and Illusion*, New York 1960, p. 4.

Wittgenstein expressed his sense both of the revolutionary break his later methods descry in philosophy, and of their relation to methods in aesthetics and ethics.[2] I have tried, in what follows, to suggest ways in which such feelings or claims can be understood, believing them to be essential in understanding Wittgenstein's later philosophy as a whole. The opening section outlines two problems in aesthetics each of which seems to yield to the possibilities of Wittgensteinian procedures, and in turn to illuminate them. The concluding section suggests resemblances between one kind of judgment recognizable as aesthetic and the characteristic claim of Wittgenstein—and of ordinary language philosophers generally—to voice 'what we should ordinarily say'.

What I have written, and I suppose the way I have written, grows from a sense that philosophy is in one of its periodic crises of method, heightened by a worry I am sure is not mine alone, that method dictates to content; that, for example, an intellectual commitment to analytical philosophy trains concern away from the wider, traditional problems of human culture which may have brought one to philosophy in the first place. Yet one can find oneself unable to relinquish either the method or the alien concern.

A free eclecticism of method is one obvious solution to such a problem. Another solution may be to discover further freedoms or possibilities within the method one finds closest to oneself. I lean here towards the latter of these alternatives, hoping to make philosophy yet another kind of problem for itself; in particular, to make the medium of philosophy— that is, of Wittgensteinian and, more generally, of ordinary language philosophy—a significant problem for aesthetics.

TWO PROBLEMS OF AESTHETICS[3]

Let us begin with a sheer matter of words—the controversy about whether a poem, or more modestly, a metaphor, can be paraphrased. Cleanth Brooks, in his *Well Wrought Urn*,[4] provided a convenient title for it in the expression 'The Heresy of Paraphrase', the heresy, namely, of supposing that a 'poem constitutes a "statement" of some sort' (p. 179); a heresy in which 'most of our difficulties in criticism are rooted'. (p. 184)

The truth of the matter is that all such formulations [of what a poem says] lead away from the centre of the poem—not toward it; that the 'prose sense' of the poem is not a rack on which the stuff of the poem is hung; that it does not represent the 'inner' structure or the 'essential' structure or the 'real' structure of the poem. (p. 182) We can very properly use paraphrases as pointers and as short-hand references

[2] Reported by G. E. Moore, 'Wittgenstein's Lectures in 1930–33', reprinted in Moore's *Philosophical Papers*, London 1959, p. 315.

[3] Most of the material in this section was presented to a meeting of the American Society for Aesthetics at Harvard University in October 1962.

[4] *The Well Wrought Urn*, New York 1947. All page references to Brooks are to this edition. 'The Heresy of Paraphrase' is the title of the concluding chapter.

provided that we know what we are doing. But it is highly important that we know what we are doing and that we see plainly that the paraphrase is not the real core of meaning which constitutes the essence of the poem. (p. 180)

We may have some trouble in seeing plainly that the paraphrase is *not* the real core, or essence, or essential structure or inner or real structure of a poem; the same trouble we should have in understanding what *is* any or all of these things, since it takes so much philosophy just to state them. It is hard to imagine that someone has just flatly given it out that the essence, core, structure, and the rest, of a poem is its paraphrase. Probably somebody has been saying that poetry uses ornaments of style, or requires special poetic words; or has been saying what a poem means, or what it ought to mean—doing something that makes someone else, in a fit of philosophy, say that this is distorting a poem's essence. Now the person who is accused in Brooks' writ is probably going to deny guilt, feel that words are being put into his mouth, and answer that he knows perfectly well that a 'paraphrase, of course, is not the equivalent of a poem; a poem is more than its paraphrasable content'. Those are the words of Yvor Winters, whose work Professor Brooks uses as '[furnishing] perhaps the most respectable example of the paraphrastic heresy' (p. 183).[5] And so the argument goes, and goes. It has the gait of a false issue—by which I do not mean that it will be easy to straighten out.

One clear symptom of this is Brooks' recurrent concessions that, of course, a paraphrase is all right—if you know what you're doing. Which is about like saying that of course criticism is all right, in its place; which is true enough. But how, in particular, are we to assess a critic's reading the opening stanza of Wordsworth's 'Intimations' Ode and writing: '. . . the poet begins by saying that he has lost something' (Brooks, p. 116). We can ransack that stanza and never find the expression 'lost something' in it. Then the critic will be offended—rightly—and he may reply: Well, it does not actually say this, but it means it, it implies it; do you suggest that it does not mean that? And of course we do not. But then the critic has a *theory* about what he is doing when he says what a poem means, and so he will have to add some appendices to his readings of the poetry explaining that when he says what a poem means he does not say exactly quite just what the poem means; that is, he only points to its meaning, or rather 'points to the area in which the meaning lies'. But even this last does not seem to him humility enough, and he may be moved to a footnote in which he says that his own analyses are 'at best crude approximations of the poem'. (p. 189) By this time someone is likely to burst out with: But *of course* a paraphrase says what the poem says, and an *approximate* paraphrase is merely a bad paraphrase; with greater

[5] For Winters' position, I have relied solely on his central essay, 'The Experimental School in American Poetry' from *Primitivism and Decadence*, itself republished, together with earlier of his critical works, under the title *In Defense of Reason*.

effort or sensibility you could have got it exactly right. To which one response would be: 'Oh, I can tell you exactly what the Ode means', and then read the Ode aloud.

Is there no real way out of this air of self-defeat, no way to get *satisfying* answers? Can we discover what, in such an exchange, is causing that uneasy sense that the speakers are talking past one another? Surely each knows exactly what the other means; neither is pointing to the smallest fact that the other fails to see.

For one suggestion, look again at Brooks' temptation to say that his readings *approximate* to (the meaning of) the poem. He is not there confessing his personal ineptitude; he means that any paraphrase, the best, will be only an approximation. So he is not saying, what he was accused of saying, that his own paraphrase was, in some more or less definite way, inexact or faulty: he denies the ordinary contrast between 'approximate' and 'exact'. And can he not do that if he wants to? Well, if I am right, he *did* do it. Although it is not clear that he *wanted* to. Perhaps he was *led* to it; and did he realize that, and would his realizing it make any difference? It may help to say: In speaking of the paraphrase as approximating to the poem (the meaning of the poem?) he himself furthers the suggestion that paraphrase and poem operate, as it were, at the same level, are the same kind of thing. (One shade of colour approximates to another shade, it does not approximate, nor does it fail to approximate, to the object of which it is the colour. An arrow pointing approximately north is exactly pointing somewhere. One paraphrase may be approximately the same, have approximately the same meaning, as another paraphrase.) And then he has to do everything at his philosophical disposal to keep paraphrase and poem from coinciding; in particular, speak of cores and essences and structures of the poem that are not reached by the paraphrase. It is as if someone got it into his head that really pointing to an object would require actually touching it, and then, realizing that this would make life very inconvenient, reconciled himself to common sense by saying: of course we *can* point to objects, but we must realize what we are doing, and that most of the time this is only approximately pointing to them.

This is the sort of thing that happens with astonishing frequency in philosophy. We impose a demand for absoluteness (typically of some simple physical kind) upon a concept, and then, finding that our ordinary use of this concept does not meet our demand, we accommodate this discrepancy as nearly as possible. Take these familiar patterns: we do not really see material objects, but only see them indirectly; we cannot be certain of any empirical proposition, but only practically certain; we cannot really know what another person is feeling, but only infer it. One of Wittgenstein's greatest services, to my mind, is to show how constant a feature of philosophy this pattern is: this is something that his diagnoses are meant to explain ('We have a certain picture of how something

must be'; 'Language is idling; not doing work; being used apart from its ordinary language games'). Whether his diagnoses are themselves satisfying is another question. It is not very likely, because if the phenomenon is as common as he seems to have shown, its explanation will evidently have to be very much clearer and more complete than his sketches provide.

This much, however, is true: If you put such phrases as 'giving the meaning', 'giving a paraphrase', 'saying exactly what something means (or what somebody said)', and so on, into the ordinary contexts (the 'language games') in which they are used, you will not find that you are worried that you have not really *done* these things. We could say: *That* is what doing them really is. Only that serenity will last just so long as someone does not start philosophizing about it. Not that I want to stop him; only I want to know what it is he is then doing, and why he follows just those particular tracks.

We owe it to Winters to make it clear that he does not say any of the philosophical things Brooks attributes to him. His thesis, having expressed his total acquiescence to the fact that paraphrases are not poems, is that *some* poems cannot be paraphrased—in particular, poems of the chief poetic talent of the United States during the second and third decades of the twentieth century; that poems which are unparaphrasable are, in that specific way, defective; and that therefore this poetic talent was led in regrettable directions. The merit of this argument for us, whether we agree with its animus or not, and trying to keep special theories about poetic discourse at arm's length, is its recognition that paraphrasability is one definite characteristic of uses of language, a characteristic that some expressions have and some do not have. It suggests itself that uses of language can be distinguished according to whether or not they possess this characteristic, and further distinguished by the kind of paraphrase they demand. Let us pursue this suggestion with a few examples, following Wittgenstein's idea that we can find out what kind of object anything (grammatically) is (for example, a meaning) by investigating expressions which show the kind of thing said about it (for example, 'explaining the meaning').

It is worth saying that the clearest case of a use of language having no paraphrase is its literal use. If I tell you, 'Juliet [the girl next door] is not yet fourteen years old' and you ask me what I mean, I might do many things—ask you what *you* mean, or perhaps try to teach you the meaning of some expression you cannot yet use (which, as Wittgenstein goes to extraordinary lengths to show, is not the same thing as *telling* you what it means). Or again, if I say, 'Sufficient unto the day is the evil thereof', which I take to be the literal truth, then if I need to explain my meaning to you I shall need to do other things: I shall perhaps not be surprised that you do not get my meaning and so I shall hardly ask you, in my former spirit, what you mean in asking me for it; nor shall I,

unless my disappointment pricks me into offense, offer to teach you the meaning of an English expression. What I might do is to try to *put my thought another way*, and perhaps refer you, depending upon who you are, to a range of similar or identical thoughts expressed by others. What I cannot (logically) do in either the first or the second case is to *paraphrase* what I said.

Now suppose I am asked what someone means who says, 'Juliet is the sun'. Again my options are different, and specific. Again I am not, not in the same way, surprised that you ask; but I shall *not* try to put the thought another way—which seems to be the whole truth in the view that metaphors are unparaphrasable, that their meaning is bound up in the very words they employ. (The addition adds nothing: where else is it imagined, in that context, that meanings are bound, or found?) I may say something like: Romeo means that Juliet is the warmth of his world; that his day begins with her; that only in her nourishment can he grow. And his declaration suggests that the moon, which other lovers use as emblems of their love, is merely her reflected light, and dead in comparison; and so on. In a word, I paraphrase it. Moreover, if I could not provide an explanation of this form, then that is a very good reason, a perfect reason, for supposing that I do not know what it means. Metaphors are paraphrasable. (And if that is true, it is tautologous.) When Croce denied the possibility of paraphrase, he at least had the grace to assert that there were no metaphors.

Two points now emerge: (1) The 'and so on' which ends my example of paraphrase is significant. It registers what William Empson calls the 'pregnancy' of metaphors, the burgeoning of meaning in them. Call it what you like; in this feature metaphors differ from some, but perhaps not all, literal discourse. And differ from the similar device of simile: the inclusion of 'like' in an expression changes the rhetoric. If you say 'Juliet is like the sun', two alterations at least seem obvious: the drive of it leads me to expect you to continue by saying in what definite respects they are like (similes are just a little bit pregnant); and, in complement, I *wait* for you to tell me what you mean, to deliver your meaning, so to speak. It is not up to me to find as much as I can in your words. The over-reading of metaphors so often complained of, no doubt justly, is a hazard they must run for their high interest. (2) To give the paraphrase, to understand the metaphor, I must understand the ordinary or dictionary meaning of the words it contains, *and* understand that they are not there being used in their ordinary way, that the meanings they invite are not to be found opposite them in a dictionary. In this respect the words in metaphors function as they do in idioms. But idioms are, again, specifically different. 'I fell flat on my face' seems an appropriate case. To explain its meaning is simply to *tell* it—one might say you don't *explain* it at all; either you know what it means or you don't; there is no richer and poorer among its explanations; you need imagine nothing special in

the mind of the person using it. And you will find it in a dictionary, though in special locations; which suggests that, unlike metaphors, the number of idioms in a language is finite.[6]

One final remark about the difference between idioms and metaphors. Any theory concerned to account for peculiarities of metaphor of the sort I have listed will wonder over the literal meaning its words, in that combination, have. This is a response, I take it, to the fact that a metaphorical expression (in the '*A* is *B*' form at least) sounds like an ordinary assertion, though perhaps not made by an ordinary mind. Theory aside, I want to look at the suggestion, often made, that what metaphors literally say is *false*. (This is a response to the well-marked characteristic of 'psychic tension' set up in metaphors. The mark is used by Empson; I do not know the patent.) But to say that Juliet is the sun is not to say something false; it is, at best, wildly false, and that is not being just false. This is part of the fact that if we are to suggest that what the metaphor says is true, we shall have to say it is wildly true—mythically or magically or primitively true. (Romeo just may be young enough, or crazed or heretic enough, to have meant his words literally.) About some idioms, however, it is fair to say that their words literally say something that is quite false; something, that is, which could easily, though maybe comically, imagined to be true. Someone might actually fall flat on his face, have a thorn in his side, a bee in his bonnet, a bug in his ear, or a fly in his ointment—even all at once. Then what are we to say about the literal meaning of a metaphor? That it has none? And that what it literally says is not false, *and* not true? And that it is not an assertion? But it sounds like one: and people do think it is true and people do think it is false. I am suggesting that it is such facts that will need investigating if we are to satisfy ourselves about metaphors; that we are going to keep getting philosophical theories about metaphor until such facts are investigated; and that this is not an occasion for adjudication, for the only thing we could offer now in that line would be: all the theories are right in what they say. And that seems to imply that all are wrong as well.

At this point we might be able to give more content to the idea that some modes of figurative language are such that in them what an expression means cannot be said at all, at least not in any of the more or less familiar, conventionalized ways so far noticed. Not because these modes are flatly literal—there is, as it were, room for an explanation, but we cannot enter it. About such an expression it may be right to say: I know what it means but I can't say what it means. And this would no longer suggest, as it would if said about a metaphor, that you really do not know what it means—or: it might suggest it, but you couldn't be sure.

[6] In some, though not all, of these respects the procedure of 'giving the meaning' of an idiom is like that in translating: one might think of it as translating from a given language into itself. Then how is it different from defining, or giving a synonym?

Examples of such uses of language would, I think, characteristically occur in specific kinds of poetry, for example Symbolist, Surrealist or Imagist. Such a use seems to me present in a line like Hart Crane's 'The mind is brushed by sparrow wings' [cited, among others, in the Winters essay], and in Wallace Stevens' 'as a calm darkens among water-lights', from *Sunday Morning*. Paraphrasing the lines, or explaining their meaning, or telling it, or putting the thought another way—all these are out of the question. One may be able to say nothing except that a feeling has been voiced by a kindred spirit and that if someone does not get it he is not in one's world, or not of one's flesh. The lines may, that is, be left as touchstones of intimacy. Or one might try *describing* more or less elaborately a particular day or evening, a certain place and mood and gesture, in whose presence the line in question comes to seem a natural expression, the only expression.

This seems to be what Winters, who profitably distinguishes several varieties of such uses of languages, distrusts and dislikes in his defence of reason, as he also seems prepared for the reply that this is not a *failing* of language but a feature of a specific approach of language. At least I think it is a reply of this sort, which I believe to be right, that he wishes to repudiate by appealing to 'the fallacy of expressive (or imitative) form', instanced by him at one point as 'Whitman trying to express a loose America by writing loose poetry', or 'Mr. Joyce [endeavouring] to express disintegration by breaking down his form'. It is useful to have a name for this fallacy, which no doubt some people commit. But his remarks seem a bit quick in their notation of what Whitman and Joyce were trying to express, and in their explanation of why they had to express themselves as they did; too sure that a break with the past of the order represented in modern art was not itself necessary in order to defend reason; too sure that convention can still be attacked in conventional ways. And they suggest scorn for the position that a high task of art has become, in our bombardment of sound, to create silence. (*Being* silent for that purpose might be a good example of the fallacy of imitative form. But that would depend on the context.) The fact is that I feel I would have to forgo too much of modern art were I to take his view of it.

Before we leave him, we owe it to Brooks to acknowledge a feature of Winters' position which may be causing his antipathy to it. Having wished to save Winters from a misconstruction of paraphrase, we gave back to that notion a specificity which, it now emerges, opens him to further objection. For his claim that poems that cannot be paraphrased—or, as he also puts it, do not 'rest on a formulable logic'—are therefore defective now means or implies that all poems not made essentially of metaphorical language (and/or similes, idioms, literal statements) are defective. It is certainly to be hoped that all *criticism* be rational, to be demanded that it form coherent propositions about its art. But to suppose that this requires all poetry to be 'formulable', in the sense that it must, whatever its form

and pressure, yield to paraphrase, the way single metaphors specifically do, is not only unreasonable past defence but incurs what we might call the fallacy of expressive criticism.

In summary: Brooks is wrong to say that poems cannot in principle be fully paraphrased, but right to be worried about the relation between paraphrase and poem; Winters is right in his perception that some poetry is 'formulable' and some not, but wrong in the assurance he draws from that fact; both respond to, but fail to follow, the relation between criticism and its object. And now, I think, we can be brought more unprotectedly to face the whole question that motivates such a conflict, namely what it is we are doing when we describe or explain a work of art; what function criticism serves; whether different arts, or forms of art, require different forms of criticism; what we may expect to learn from criticism, both about a particular piece of art and about the nature of art generally.

The second problem in aesthetics must be sketched even more swiftly and crudely.

Is such music as is called 'atonal' (not distinguishing that, for our purposes now, from the term 'twelve-tone') really without tonality? (The little I will say could be paralleled, I think, in discussing the nature of the painting or sculpture called abstract or non-objective.) The arguments are bitter and, to my knowledge, without issue; and many musicians have felt within themselves both an affirmative and a negative answer.[7] Against the idea that this music lacks tonality are (1) the theory that we are so trained to our perception of musical organization that we cannot help hearing it in a tonal frame of reference; and (2) the fact that one *can*, often, *say* what key a so-called 'atonal' piece is in. In favour of the idea that it lacks tonality are (1) a theory of composition which says that it does, and whose point was just to escape that limitation, while yet maintaining coherence; and (2) the fact that it simply sounds so different. Without our now even glancing at the theories, let us look at the fact we recorded as 'being able to say, often, what key a piece is in'. Does that have the weight it seems to have? An instance which once convinced me of its decisiveness was this: in listening to a song of Schoenberg's, I had a clear sense that I could, at three points, hear it cadence (I almost said, try to resolve) in F♯ minor. Then surely it is *in* F♯ minor? Well, the Chopin *Barcarolle* is in the key of F♯ major. How do I know that? Because I can hear it try to cadence in F♯ major? Three or more times? And after that I am convinced it is, feel slightly relieved and even triumphant that I have been able to hear some F♯ major? But that is absurd. I *know* the key; everyone knows it; everyone knows it from the opening measure—well, at least before the bass figure that begins on the pitch of F♯: it does not take a brick wall to fall on us. I would not even know how to go about doubting its key or *trying* to hear it in its

[7] I am told, by Professor David Lewin, that this was true of Anton Webern, who was in doubt about his own music in this regard.

key. And I know it because I know that now it has moved to the sub-dominant of the key, and now the dominant of the key is being extended, and now it is modulating, and now it is modulating to a more distant key. And to know all this is to know the grammar of the expression 'musical key'. Sometimes, to be sure, a solidly tonal composer will, especially in 'development sections', obliterate the sense of placement in a key; but this is here a special effect, and depends upon an undoubted establishment of key. So if I insist upon saying that atonal music is really tonal (and to be said it has to be insisted upon) I have, so far as my ear goes, to forgo the grammar of the expression 'tonality' or 'musical key'—or almost all of it: I can retain 'almost cadences in' and 'sounds like the dominant of' but not 'related key', 'distant key', 'modulation' etc. And then I am in danger of not knowing what I am saying. Wittgenstein says that 'the speaking of language is part of an activity, or of a form of life' (*Investigations*, par. 23), and also 'To imagine a language means to imagine a form of life' (*ibid.*, par. 19). The language of tonality is part of a particular form of life, one containing the music we are most familiar with; associated with, or consisting of, particular ways of being trained to perform it and to listen to it; involving particular ways of being corrected, particular ways of responding to mistakes, to nuance, above all to recurrence and to variation and modification. No wonder we want to preserve the idea of tonality: to give all *that* up seems like giving up the idea of music altogether. I think it *is—like* it.

I shall not try to say why it is not fully that. I shall only mention that it cannot be enough to point to the obvious fact that musical instruments, with their familiar or unfamiliar powers, are employed—because *that* fact does not prevent us from asking, But is it music? Nor enough to appeal to the fact that we can point to pitches, intervals, lines and rhythm—because we probably do not for the most part know what we are pointing to with these terms. I mean we do not know *which* lines are significant (try to play the 'melody' or 'bass' of a piece of Webern's) and which intervals to hear as organizing. More important, I think, is the fact that we may see an undoubted musician speak about such things and behave toward them in ways similar (not, I think, more than similar) to the ways he behaves toward, say, Beethoven, and then we may sense that, though similar, it is a new world and that to understand a new world it is imperative to con-centrate upon its inhabitants. (Of course there will be the usual conse-quences of mimicry and pretension.) Moreover, but still perhaps even more rarely, we may find ourselves *within* the experience of such com-positions, following them; and then the question whether this is music and the problem of its tonal sense, will be . . . not answered or solved, but rather they will disappear, seem irrelevant.

That is, of course, Wittgenstein's sense of the way philosophical prob-lems end. It is true that for him, in the *Investigations* at any rate, this happens when we have gone through a process of bringing ourselves back

into our natural forms of life, putting our souls back into our bodies; whereas I had to describe the accommodation of the new music as one of naturalizing ourselves to a new form of life, a new world. That a resolution of this sort is described as the solution of a philosophical problem, and as the goal of its particular mode of criticism, represents for me the most original contribution Wittgenstein offers philosophy. I can think of no closer title for it, in an established philosophical vocabulary, than Hegel's use of the term *Aufhebung*. We cannot translate the term: 'cancelling', 'negating', 'fulfilling' etc. are all partial, and 'sublate' transfers the problem. It seems to me to capture that sense of *satisfaction* in our representation of rival positions which I was asking for when I rehearsed the problems of Brooks and Winters. Of course we are no longer very apt to suppose, with Hegel, that History will make us a present of it: we are too aware of its brilliant ironies and its aborted revolutions for that. But as an ideal of (one kind of) philosophical criticism—a criticism in which it is pointless for one side to refute the other, because its cause and topic is the self getting in its own way—it seems about right.

In the *Tractatus* Wittgenstein says: 'The solution of the problem of life is seen in the vanishing of the problem' (6.521); and in the *Investigations* he says: '. . . the clarity that we are aiming at is indeed *complete* clarity. But this simply means that the philosophical problems should *completely* disappear' (par. 133). Yet he calls these problems *solved (Investigations, ibid.);* and he says that when 'there are . . . no questions left . . . this itself is the *answer*' (*Tractatus;* 6.25, my emphasis). In the central concept of his later work, this would seem to mean that the problems of life and the problems of philosophy have related grammars, because solutions to them both have the same form: their problems are solved only when they disappear, and answers are arrived at only when there are no longer questions—when, as it were, our accounts have cancelled them.

But in the *Investigations* this turns out to be more of an answer than, left this way, it seems to be; for it more explicitly dictates and displays the ways philosophy is to proceed in investigating problems, ways leading to what he calls 'perspicuous representation' *(übersichtliche Darstellung).* It is my impression that many philosophers do not like Wittgenstein's comparing what he calls his 'methods' to therapies (par. 133); but for me part of what he means by this comparison is brought out in thinking of the progress of psychoanalytic therapy. The more one learns, so to speak, the hang of oneself, and mounts one's problems, the less one is able to *say* what one has learned; not because you have *forgotten* what it was, but because nothing you said would seem like an answer or a solution: there is no longer any question or problem which your words would match. You have reached conviction, but not about a proposition; and consistency, but not in a theory. You are different, what you recognize as problems are different, your world is different. ('The world of the happy man is a dif-

ferent one from that of the unhappy man' (*Tractatus*, 6.43).) And this is the sense, the only sense, in which what a work of art means cannot be *said*. Believing it is seeing it.

When Wittgenstein says that 'the concept of a perspicuous representation . . . earmarks the form of account we give' (par. 122), I take him to be making a grammatical remark about what he calls a 'grammatical investigation', which is what his *Investigations* consist in (par. 90): no other form of resolution will count as philosophical. He says of his 'form of account' that it is 'the way we look at things'; and he then asks, parenthetically, 'Is this a "Weltanschauung"?' (par. 122). The answer to that question is, I take it, not No. Not, perhaps, Yes; because it is not a *special*, or competing, way of looking at things. But not No; because its mark of success is that the world seem—be—different. As usual, the claim to severe philosophical advance entails a reconception of the subject, a specific sense of revolution.

AESTHETIC JUDGMENT AND A PHILOSOPHICAL CLAIM

Another good cause for stumbling over the procedures of ordinary language philosophy lies in its characteristic appeal to what 'we' say and mean, or cannot or must say or mean. A good cause, since it is a very particular, not to say peculiar appeal, and one would expect philosophers dependent upon it themselves to be concerned for its investigation. I will suggest that the aesthetic judgment models the sort of claim entered by these philosophers, and that the familiar lack of conclusiveness in aesthetic argument, rather than showing up an irrationality, shows the kind of rationality it has, and needs.

Hume is always a respectable place to begin. Near the middle of his essay 'Of the Standard of Taste', he has recourse to a story from *Don Quixote* which is to illustrate that 'delicacy' of taste said to be essential to those critics who are to form our standard of it.

It is with good reason, says Sancho to the squire with the great nose, that I pretend to have a judgment in wine: This is a quality hereditary in our family. Two of my kinsmen were once called in to give their opinion of a hogshead, which was supposed to be excellent, being old and of a good vintage. One of them tastes it; considers it; and after mature reflection pronounces the wine to be good, were it not for a small taste of leather, which he perceived in it. The other, after using the same precautions, gives also his verdict in favour of the wine; but with the reserve of a taste of iron, which he could easily distinguish. You cannot imagine how much they were both ridiculed for their judgment. But who laughed in the end? On emptying the hogshead, there was found at the bottom, an old key with a leathern thong tied to it.

First of all, the fine drama of this gesture is greater than its factual decisiveness—a bit quixotic, so to say: for the taste may have been present and the object not, or the object present and the taste not. Second, and more important, the gesture misrepresents the efforts of the critic and the

sort of vindication to which he aspires. It dissociates the exercise of taste from the discipline of accounting for it: but *all* that makes the critic's expression of taste worth more than another man's is his ability to produce for himself the thong and key of his response; and his vindication comes not from his pointing out that it is, or was, in the barrel, but in getting us to taste it there. Sancho's ancestors, he tells us, in each case after the precautions of reflection, both pronounced in favour of the wine; but he does not tell us what those reflections were, nor whether they were vindicated in their favourable verdict. Hume's essay, I take it, undertakes to explore just such questions, but in his understandable difficulty in directing us to the genuine critic and distinguishing him from the pretender, he says about him just what he, or anyone, says about art itself: that he is valuable, that we may disagree about his merits in a particular case, and that some, in the long run, 'will be acknowledged by universal sentiment to have a preference above others'. But this seems to put the critic's worth at the mercy of the history of taste; whereas his value to us is that he is able to make that history a part of his data, knowing that in itself, as it stands, it proves nothing—except popularity. His value to art and culture is not that he agrees with its taste—which would make him useful for guiding one's investments in the art market— but that he sets the terms in which our tastes, whatever they happen to be, may be protected or overcome. Sancho's descendants would, by the eighteenth century, have risen to gentlemen, exercising distinction in a world which knew what was right, and not needing to make their tastes their own. But it is Quixote who is the patron saint of the critic, desperate to preserve the best of his culture against itself, and surviving any failure but that of his honesty and his expression of it.

The idea of the agreement or 'reconciliation' of taste controls Hume's argument; it is agreement that the standard of taste is to provide, so far as that is attainable. Hume's descendants, catching the assumption that agreement provides the vindication of judgment, but no longer able to hope for either, have found that aesthetic (and moral and political) judgments lack something: the arguments that support them are not conclusive the way arguments in logic are, nor rational the way arguments in science are. Indeed they are not, and if they were there would be no such subject as art (or morality) and no such art as criticism. It does not follow, however, that such judgments are not conclusive and rational.

Let us turn to Kant on the subject, who is, here as elsewhere, deeper and obscurer. Universal agreement, or as he also calls it, the 'harmony of sentiment' or 'a common sense of mankind', makes its appearance in the *Critique of Judgment* not as an empirical problem—which is scarcely surprising about Kant's procedure—but as an *a priori* requirement setting the (transcendental) conditions under which such judgments as we call aesthetic could be made *überhaupt*. Kant begins by saying that aesthetic judgment is not 'theoretical', not 'logical', not 'objective', but one 'whose

determining ground can be *no other than subjective*'.[8] Today, or anyway the day before yesterday, and largely under his influence, we would have said it is not cognitive; which says so little that it *might* have been harmless enough. Kant goes on immediately to distinguish two kinds of 'aesthetical judgments', or, as he also calls them, judgments of taste; and here, unfortunately, his influence trickled out. The first kind he calls the taste of sense, the second the taste of reflection; the former concerns merely what we find pleasant, the latter must—logically must, some of us would say—concern and claim more than that. And it is only the second whose topic is the beautiful, whose role, that is, would be aesthetic in its more familiar sense. The something more these judgments must do is to 'demand' or 'impute' or 'claim' general validity, universal agreement with it; and when we make such judgments we go on claiming this agreement even though we know from experience that they will not receive it. (Are we, then, just wilful or stupid in going on making them?) Kant also describes our feeling or belief when we make such judgments —judgments in which we demand 'the assent of everyone', although we cannot 'postulate' this assent as we could in making an ordinary empirical judgment—as one of '[speaking] with a universal voice'. That is the sort of thing that we are likely nowadays to call a piece of psychology, which is no doubt right enough. But we would take that to mean that it marks an accidental accompaniment of such judgments; whereas Kant says about this claim to universal validity, this voice, that it 'so essentially belongs to a judgment by which we describe anything as *beautiful* that, if this were not thought in it, it would never come into our thoughts to use the expression at all, but everything which pleases without a concept would be counted as pleasant'.[9] The possibility of stupidity here is not one of continuing to demand agreement in the face of the fact that we won't attain it; but the stupidity of going on making aesthetic judgments at all (or moral or political ones) in the face of what they cost us, the difficulties of finding them for ourselves and the risk of explicit isolation.

Kant seems to be saying that apart from a certain spirit in which we make judgments we could have no concepts of the sort we think of as aesthetic.[10] What can the basis for such a claim be? Let us look at the examples he gives of his two kinds of aesthetic judgments.

[8] All quotations from Kant are from sections 7 and 8 of the *Critique of Judgment*.

[9] One might compare with this Wittgenstein's question: 'What gives us *so much as the idea* that living beings, things, can feel?' *Investigations*, par. 283.

[10] Another way of describing this assumption or demand, this thing of speaking with a universal voice, of judging 'not merely for himself, but for all men', Kant also describes as '(speaking) of beauty as if it were a property of things'. Only 'as if' because it cannot be an ordinary property of things: its presence or absence cannot be established in the way ordinary properties are; that is, they cannot be established publicly, and we don't know (there aren't any) causal conditions, or usable rules, for producing, or altering, or erasing, or increasing this 'property'. Then why not just say it *isn't* a property of an object? I suppose there would be no reason not to say this, if we could find another way of recording our conviction that

. . . [someone] is quite contented that if he says, "Canary wine is pleasant," an-
other man may correct his expression and remind him that he ought to say, "It is
pleasant *to me*." And this is the case not only as regards the taste of the tongue, the
palate, and the throat, but for whatever is pleasant to anyone's eyes and ears. . . .
To strive here with the design of reproving as incorrect another man's judgment
which is different from our own, as if the judgments were logically opposed, would
be folly. . . .

 The case is quite different with the beautiful. It would (on the contrary) be
laughable if a man who imagined anything to his own taste thought to justify
himself by saying: "This object (the house we see, the coat that person wears, the
concert we hear, the poem submitted to our judgment) is beautiful *for me*." For
he must not call it *beautiful* if it merely pleases him. . . .*

What are these examples supposed to show? That using a form of expres-
sion in one context is all right, and using it in another is not all right.
But what I wish to focus upon is the kind of rightness and wrongness
invoked: it is not a matter of factual rectitude, nor of formal indiscretion
but of saying something laughable, or which would be folly. It is such
consequences that are taken to display a difference in the kind of judg-
ment in question, in the nature of the concepts employed, and even in the
nature of the reality the concepts capture. One hardly knows whether to
call this a metaphysical or a logical difference. Kant called it a trans-
cendental difference; Wittgenstein would call it a grammatical difference.
And how can psychological differences like finding something laughable
or foolish (which perhaps not *every* person would) be thought to betray
such potent, or anyway different, differences?

 Here we hit upon what is, to my mind, the most sensitive index of mis-
understanding and bitterness between the positivist and the post-positivist
components of analytical philosophy: the positivist grits his teeth when
he hears an analysis given out as a logical one which is so painfully
remote from formality, so obviously a question of how you happen to feel
at the moment, so psychological; the philosopher who proceeds from every-
day language stares back helplessly, asking, 'Don't you feel the difference?
Listen: you *must* see it.' Surely, both know what the other knows, and
each thinks the other is perverse, or irrelevant, or worse. (Here I must
appeal to the experience of anyone who has been engaged in such encoun-
ters.) Any explanation of this is going to be hard to acquire. I offer the
following guess, not because it can command much attention in itself,
but as a way of suggesting the level I would expect a satisfying explana-
tion to reach, a way of indicating why we lack as yet the concepts, even the
facts, which must form a serious accommodation.

 We know of the efforts of such philosophers as Frege and Husserl to

it is one, anyway that what we are pointing to is *there*, in the object; and our
knowledge that men make objects that create this response in us, and make them
exactly with the idea that they will create it; and the fact that, while we know
not everyone will agree with us when we say it is present, we think they are *missing
something* if they don't.

* [See p. 151 of the present book.—Eds.]

undo the 'psychologizing' of logic (like Kant's undoing Hume's psychologizing of knowledge): now, the shortest way I might describe such a book as the *Philosophical Investigations* is to say that it attempts to undo the psychologizing of psychology, to show the necessity controlling our application of psychological and behavioural categories; even, one could say, show the necessities in human action and passion themselves.[11] And at the same time it seems to turn all of philosophy into psychology— matters of what we call things, how we treat them, what their role is in our lives.

For one last glance, let us adapt Kant's examples to a form which is more fashionable, and think of the sort of reasons we offer for such judgments:

1. *A:* Canary wine is pleasant.
 B: How can you say that? It tastes like canary droppings.
 A: Well, I like it.
2. *A:* He plays beautifully doesn't he?
 *B*1: Yes; too beautifully. Beethoven is not Chopin.

Or he may answer:

*B*2: How can you say that? There was no line, no structure, no idea what the music was about. He's simply an impressive colourist.

Now, how will *A* reply? Can he now say: 'Well, I liked it'? Of course he *can;* but don't we feel that here that would be a feeble rejoinder, a *retreat* to personal taste? Because *B*'s reasons are obviously relevant to the evaluation of performance, and because they are *arguable*, in ways that anyone who knows about such things will know how to pursue. *A doesn't have* to pursue them; but if he doesn't, there is a price he will have to pay in our estimate of him. Is that enough to show it is a different kind of judgment? We are still in the realm of the psychological. But I wish to say that the price is necessary, and specific to the sorts of judgments we call aesthetic.

Go back to my saying 'he doesn't have to pursue' the discussion, and compare the following case:

A: There is a goldfinch in the garden.
B: How do you know?
A: From the colour of its head.

[11] Consider, for example, the question: 'Could someone have a feeling of ardent love or hope for the space of one second—*no matter what* preceded or followed this second?'; *Investigations*, par. 583. We shall not wish to say that this is logically impossible, or that it can in no way be imagined. But we might say: given our world this cannot happen; it is not, in our language, what 'love' or 'hope' mean; necessary in our world that this is not what love and hope are. I take it that our most common philosophical understanding of such notions as necessity, contingency, synthetic and analytic statements will not know what to make of our saying such things.

B: But goldcrests also have heads that colour.
A: Well, *I* think it's a goldfinch (it's a goldfinch to me).

This is no longer a feeble rejoinder, a retreat to personal opinion: and the price that would be paid here is not, as it would be in the former case, that he is not very articulate, or not discriminating, or has perverse tastes: the price here is that he is either mad, or doesn't know what the word 'know' means, or is in some other way unintelligible to us. That is, *we rule him out* as a competent interlocutor in matters of knowledge (about birds?): whatever is going on, he *doesn't* know there is a goldfinch in the garden, whatever (else) he thinks he 'knows'. But we do not, at least not with the same flatness and good conscience, and not with the same consequences, rule out the person who liked the performance of the Beethoven: he still has a claim upon us, however attenuated; he *may* even have reasons for his judgment, or counters to your objections, which for some reason he can't give (perhaps because you've brow-beaten him into amnesia).

Leaving these descriptions so cruelly incomplete, I think one can now imagine the familiar response: 'But you admit that arguments in the aesthetic case may go on, may perhaps never end, and that they needn't go on, perhaps can't go on in some cases, and that they may have different "prices" (whatever they may mean), presumably depending on where they stop. How do you get logic out of that? What you cannot claim is that either party to the dispute, whether in the case Kant calls the taste of sense or the case he calls the taste of reflection, can *prove* his judgment. And would he want to even if he could? Isn't that, indeed, what all your talk about criticism was about: The person accounts for his own feelings, and then, at best "proves" them *to* another, shows them to whomever he wants to know them, the best way he can, the most effective way. That's scarcely logic; and how can you deny that it is psychology?'

It may help to reply to this: You call it psychology just because it so obviously is not logic, and it must be one or the other.[12] Contrariwise, I should admit that I call it 'logic' mostly because it so obviously is not 'psychology' in the way I think you mean it. I do not really think it is either of those activities, in the senses we attach to them now; but I cannot describe to anyone's satisfaction *what* it is. Wittgenstein called it 'grammar'; others might call it 'phenomenology'.

Those of us who keep finding ourselves wanting to call such differences 'logical' are, I think, responding to a sense of necessity we feel in them, together with a sense that necessity is, partly, a matter of the *ways* a judgment is supported, the ways in which conviction in it is produced: it is only by virtue of these recurrent patterns of support that a remark

[12] I do think that is the *entire* content of 'psychology' in such objections. Such a person knows what he means by logic: how to do it, how to recognize it when he sees it done, what he can expect from it, etc. But who knows any of this about the 'psychology' in question?

will count as—will be—aesthetic, or a mere matter of taste, or moral, propagandistic, religious, magical, scientific, philosophical. . . . It is essential to making an aesthetic judgment that at some point we be prepared to say in its support: don't you see, don't you hear, don't you dig? The best critic will know the best points. Because if you do not see *something*, without explanation, then there is nothing further to discuss. Which does not mean that the critic has no recourse: he can start training and instructing you and preaching at you—a direction in which criticism invariably will start to veer. (A critic like Ruskin may be a calamity, but he is no accident.) At some point, the critic will have to say: this is what I see. Reasons—at definite points, for definite reasons, in different circumstances—come to an end. (*Cf. Investigations*, par. 217.)

Those who refuse the term 'logic' are responding to a sense of arbitrariness in these differences, together with a sense that 'logic' is a matter of arriving at conviction in such a way that anyone who can follow the argument must, unless he finds something definitely wrong with it, *accept the conclusion*, agree with it. I do not know what the gains or disadvantages would be of unfastening the term 'logic' from that constant pattern of support or justification whose peculiarity is that it leads those competent at it to this kind of agreement, and extending it to patterns of justification having other purposes and peculiarities. All I am arguing for is that *pattern* and *agreement* are distinct features of the notion of logic.

If we say that the *hope* of agreement motivates our engaging in these various patterns of support, then we must also say, what I take Kant to have seen, that even were agreement in fact to emerge, our judgments, so far as aesthetic, would remain as essentially subjective, in his sense, as they ever were. Otherwise, art and the criticism of art would not have their special importance nor elicit their own forms of distrust and of gratitude. The problem of the critic, as of the artist, is not to discount his subjectivity, but to include it; not to overcome it in agreement, but to master it in exemplary ways. Then his work outlasts the fashions and arguments of a particular age. That is the beauty of it.

Kant's 'universal voice' is, with perhaps a slight shift of accent, what we hear recorded in the philosopher's claims about 'what we say': such claims are at least as close to what Kant calls aesthetical judgments as they are to ordinary empirical hypotheses. Though the philosopher seems to claim, or depend upon, severer agreement than is carried by the aesthetic analogue, I wish to suggest that it is a claim or dependence of the same kind.

We should immediately notice an obvious failure in the analogy between aesthetic judgments and the philosophical claim to voice what we say. The philosophical claim seems clearly open to refutation by an empirical collection of data about what people in fact say, whereas it makes no obvious sense to confirm or disconfirm such a judgment as 'The Hammerklavier Sonata is a perverse work' by collecting data to find out

whether the Sonata is in fact perverse. It is out of the question to enter into this difficult range of problems now. But I cannot forbear mentioning several points which I have tried elsewhere to suggest, with, to judge from results, evident unsuccess.[13]

(1) I take it to be a phenomenological fact about philosophizing from everyday language that one feels empirical evidence about one's language to be irrelevant to one's claims. If such philosophizing is to be understood, then that fact about it must be understood. I am not saying that evidence about how (other) people speak can never make an ordinary language philosopher withdraw his typical claims; but I find it important that the most characteristic pressure against him is applied by producing or deepening an example which shows him that *he* would not say what he says 'we' say.

(2) The appeal to 'what we should say if . . .' requires that we imagine an example or story, sometimes one more or less similar to events which may happen any day, sometimes one unlike anything we have known. Whatever the difficulties will be in trying to characterize this procedure fully and clearly, this much can be said at once: if we find we disagree about what we should say, it would make no obvious sense to attempt to confirm or disconfirm one or other of our responses by collecting data to show which of us is in fact right. What we should do is either (*a*) to try to determine why we disagree (perhaps we are imagining the story differently)—just as, if we agree in response we will, when we start philosophizing about this fact, want to know why we agree, what it shows about our concepts; or (*b*) we will, if the disagreement cannot be explained, either find some explanation for *that*, or else discard the example. Disagreement is not disconfirming: it is as much a datum for philosophizing as agreement is. At this stage philosophizing has, hopefully, not yet begun.

(3) Such facts perhaps only amount to saying that the philosophy of ordinary language is not about language, anyway not in any sense in which it is not also about the world. Ordinary language philosophy is about whatever ordinary language is about.

The philosopher appealing to everyday language turns to the reader not to convince him without proof but to get him to prove something, test something, against himself. He is saying: look and find out whether you can see what I see, wish to say what I wish to say. Of course he often seems to answer or beg his own question by posing it in plural form: 'We say . . . ; We want to say . . . ; we can imagine . . . ; We feel as if we had to penetrate phenomena, repair a spider's web; We are under the illusion . . . ; We are dazzled . . . the idea now absorbs us . . . ; we are dissatisfied.

[13] See J. Fodor and J. Katz, 'The Availability of What We Say', in the *Philosophical Review*, January 1963, an attack, primarily, on my paper 'Must We Mean What We Say?' which appeared in *Inquiry* in 1958 (vol. I, no. 3).

. . .' But this plural is still first person: it does not, to use Kant's word, 'postulate' that 'we', you and I and he, say and want and imagine and feel and suffer together. If we do not, then the philosopher's remarks are irrelevant to us. Of course he doesn't think they are irrelevant, but the implication is that philosophy, like art, is, and should be, powerless to *prove* its relevance; and that says something about the kind of relevance it wishes to have. All the philosopher, this kind of philosopher, can do is to express, as fully as he can, his world, and attract our undivided attention to our own.

Kant's attention to the 'universal voice' expressed in aesthetic judgment seems to me, finally, to afford some explanation of that air of dogmatism which claims about what 'we' say seem to carry for critics of ordinary language procedures, and which they find repugnant and intolerant. I think that air of dogmatism is indeed present in such claims; but if that is intolerant, that is because tolerance could only mean, as in liberals it often does, that the kind of claim in question is not taken seriously. It is, after all, a claim about *our lives*; it is differences, or oppositions, of these that tolerance, if it is to be achieved, must be directed toward. About what we should say when, we do not expect to have to tolerate much difference, believing that if we could articulate it fully we would have spoken for all men, found the necessities common to us all. Philosophy has always hoped for that; so, perhaps, has science. But philosophy concerns those necessities we cannot, being human, fail to know. Except that nothing is more human than to deny them.

MONROE C. BEARDSLEY
THE INSTRUMENTALIST THEORY

If we reject the accounts of aesthetic value given by defenders of the Beauty Theory and by those who propose Subjectivist definitions of "aesthetic value," we must look in another direction. And there is another way of approaching the problems of aesthetic value. General judgments of critical praise can be cast in the form: "This is a good aesthetic object." We can also, of course, make specific judgments like "This is a good sonata," or "This is a good landscape." Now, students of value theory have pointed out that we seem to use the word "good" in two very different ways, grammatically speaking.[1] We say things like "Money is good" and "You are very good," and in these statements "good" appears by itself as a

From *Aesthetics: Problems in the Philosophy of Criticism* by Monroe C. Beardsley, pp. 524–543; 571–576, © 1958, by Harcourt, Brace & World, Inc. and reprinted by their permission.

[1] This distinction has been stressed by W. D. Ross, R. M. Hare, and R. S. Hartman, and Helen Knight has pointed out its relevance to critical evaluation. . . .

predicate. But we also speak of "a good character," "a good car," "a good job," "a good way of holding the tennis racquet," and in these phrases the word "good" is adjoined, or affixed, to a noun or noun-phrase. When "good" is used in a phrase of the form "a good X," this is frequently called the *adjunctive* use of the word. It may be that even the apparently nonadjunctive uses are really adjunctive; this does not affect my argument.

The phrase "a good aesthetic object" is, then, an example of the adjunctive use of "good." And our problem is to understand what it would mean to say that something is a good aesthetic object, and how this could be shown to be true.

To help make clear the correct analysis of "a good X," let us first consider an analysis that is certainly not correct, though it might be offered. Suppose someone said

"This is a good X" means "This is an X, and I like it."

Now it is possible to find a few idiomatic phrases in which "good" is used adjunctively, and in which it indicates little more than the speaker's likings: for example, "a good time." But when we say that something is a good wrench, or a good cow, or a good plumber, we are surely saying something more than that it belongs to a certain class and is liked. We are stating the grounds for such a liking, and these grounds consist in the capacity of the wrench, or the cow, or the plumber to perform in a certain way that is to be expected of things of its kind.

Function-Classes

Under what conditions, then, is it appropriate to apply the word "good" adjunctively? Only if the noun to which it is affixed is one that denotes what I shall call a *function-class*. This concept needs a little clarification. Suppose we have a number of objects that are considered as belonging to the same class because of some internal characteristic that they all share, for example, their shape or color or the material of which they are made— but not an external feature, such as being all in Australia or having been made by a blind weaver after 1900. The distinction between internal and external characteristics would take some careful analysis to make very exact, but let us suppose that it can be done. Now after we have marked out such a class, we may find that there is something that the members of this class can do that the members of other similarly defined classes cannot do, or cannot do as well. It may be that an occasional object outside this class can do the job better than a few of the objects in this class, but taking the class as a whole, or on the average, it is the best, or the only, class for the job. Then this class may be said to be a function-class, and its members may be said to have a function.

Function is not necessarily connected with intention: it is the capacity of the objects to serve in a certain (desirable) way, whether or not they

were created for that purpose. Of course, wrenches, which are best for turning nuts, were intended to have a function. Cows were not; still there is something good you can do with, or get from, cows that other creatures will not provide, or provide so cheaply or plentifully or dependably. If another gadget, say a plench (a cross between pliers and wrenches), is invented that turns nuts more easily, or with greater force, or with less likelihood of slipping, then wrenches will lose their function, except in regions where the new invention has not penetrated.

Chair is a function-class, and *desk chair* is also a function-class, since there is a purpose that desk chairs serve better than other types. *Furniture* is not, I think, a function-class, though it includes a number of distinct function-classes; there is nothing you can do with furniture, considered solely as furniture, that you can't do as well with other things. "This is a good piece of furniture," then, would have to mean "This is either a good chair, or a good table, or a good sofa, or . ." It is, in fact hard to find any really good examples of familiar classes that are *not* function-classes, since if there is some difference between this class and other classes, there is always the possibility of some good use to which that difference might be put.

But it is not sufficient that the members of the class have a function; they must differ among themselves in the degree to which they perform that function. If all dimes were exactly similar, then "a good dime" wouldn't make sense; a counterfeit dime is not a dime at all, and you don't say that a nickel is a poor dime. But it is hard to find examples of really nonsensical adjunctive uses of "good," for no matter how odd the combination appears at first, we will almost always, if we dwell on it, succeed in finding some conceivable use to which the class could be put, and which the members might serve more or less well. Thus "a good star" is peculiar, but perhaps one star might be a little better than another for navigation; "a good idiot" might be one most instructive as a textbook example; "a good case of measles" might be the one to show the internes.

The discussion so far, then, might be summarized in the following formula:

"This is a good X" means "This is an X, and there is a function of X's that it successfully fulfills."

Or, to be both more specific and more explicit:

"This is a good wrench" means "This is a wrench, and it is efficient [handy, convenient] for the (good) purpose of turning nuts."

These are not very smooth definitions; they are in fact twisted slightly to bring out the next important point. The second definition does define "a good wrench," in terms of the assumed function of wrenches. But note that it does *not* define the word "good," for this word turns up in the

defining term as well; it is not eliminated by the definition. To make the same point another way, in my definition of "function" I have inserted a reference to value: for an object to have a function, there must not only be something special that it can do, but that something must be worth doing.

In my view, the phrase "a good X" typically presupposes that the use of X is itself a good one. Now, no doubt "good" can be used, and is sometimes used, with what might be called value-neutrality. In this sense, it means nothing more than efficient. But I think that in general—and at least in "a good aesthetic object"—to use the word "good" rather than the word "efficient" is tacitly to endorse the end to which it is put. It would be a little queer for one who believes that torture is never justified to say, "That is a good method of torture," or for a thoroughgoing advocate of nonviolence to say, "Hanging is a good way to execute criminals." To bar any misapprehension, he would do better to say "effective" or "successful," or something of the sort. Statements like "He is a pretty good burglar" and "That is a perfect murder" are likely to sound either ironic or callous.

If we treat "a good aesthetic object" on the same lines as "a good wrench," we come out with some interesting possibilities. First, of course, we should have to establish that *aesthetic object* is a function-class—that is, that there is something that aesthetic objects can do that other things cannot do, or do as completely or fully. Is there something that aesthetic objects are especially good at? Now, the sort of thing you can do with an aesthetic object is to perceive it in a certain way, and allow it to induce a certain kind of experience. So the question, "Is *aesthetic object* a function-class?" is only a somewhat pedantic way of asking an old and familiar question, which we have long postponed: "Is there such a thing as *aesthetic experience?*" We saw in the preceding section that the Psychological Definitions lead into this question, in distinguishing aesthetic likings from other likings. Many Beauty Theorists have discussed it, too. But it is in the present context that the question becomes most pressing.

Aesthetic Experience

The problem is whether we can isolate, and describe in general terms, certain features of experience that are peculiarly characteristic of our intercourse with aesthetic objects. Of course, listening to music is a very different experience in some ways from looking through a cathedral or watching a motion picture. Reading literature certainly does something to us, and probably *for* us, that listening to music cannot do, and vice versa. A full account of our experience of aesthetic objects would have to deal carefully with these matters. But is there something that all these experiences have in common—something that can be usefully distinguished? This is at least an empirical question, open to inquiry. And some inquiry has been made, though many mysteries remain. However, we can be reasonably confident of certain generalizations, which some

writers have obtained by acute introspection, and which each of us can test in his own experience.[2]

These are the points on which, I take it, nearly everyone will agree:

First, an aesthetic experience is one in which attention is firmly fixed upon heterogeneous but interrelated components of a phenomenally objective field—visual or auditory patterns, or the characters and events in literature. Some writers have suggested that in such an experience, as when we are deeply absorbed in the tension of a visual design or in the developing design of music, the distinction between phenomenal objectivity and phenomenal subjectivity itself tends to disappear. This may be overstated, but in any case the experience differs from the loose play of fancy in daydreaming by having a central focus; the eye is kept on the object, and the object controls the experience. It is all right, I think, to speak of the object as *causing* the experience, but of course the connection is more intimate, for the object, which is a perceptual object, also appears *in* the experience as its phenomenally objective field.

Second, it is an experience of some intensity. Some writers have said that it is an experience pervasively dominated by intense feeling or emotion, but these terms still occupy a dubious position in psychological theory; what we call the emotion in an aesthetic experience may be simply the intensity of the experience itself. In any case, the emotion is characteristically bound to its object, the phenomenal field itself—we feel sad *about* the characters, or uncertain *about* the results of an unexpected modulation. Aesthetic objects give us a concentration of experience. The drama presents only, so to speak, a segment of human life, that part of it that is noteworthy and significant, and fixes our minds on that part; the painting and the music invite us to do what we would seldom do in ordinary life—pay attention *only* to what we are seeing or hearing, and ignore everything else. They summon up our energies for an unusually narrow field of concern. Large-scale novels may do more; they are in fact always in danger of dissipating attention by spreading it out into our usual diffuse awareness of the environment.

This is why the expression "feeling no pain" is particularly apt to aesthetic experience. The pleasure is not often comparable in intensity to the pleasures of satisfying the ordinary appetites. But the concentration of the experience can shut out all the negative responses—the trivial distracting noises, organic disturbances, thoughts of unpaid bills and unwritten letters and unpurged embarrassments—that so often clutter up our pleasures. It does what whiskey does, only not by dulling sensitivity and clouding the awareness, but by marshalling the attention for a time into free and unobstructed channels of experience.

But this discussion already anticipates the two other features of aesthetic experience, which may both be subsumed under *unity*. For, third,

[2] In the following pages . . . I rely most heavily upon the work of John Dewey, Edward Bullough, I. A. Richards, and Immanuel Kant. . . .

it is an experience that hangs together, or is coherent, to an unusually high degree. One thing leads to another; continuity of development, without gaps or dead spaces, a sense of overall providential pattern of guidance, an orderly cumulation of energy toward a climax, are present to an unusual degree. Even when the experience is temporarily broken off, as when we lay down the novel to water the lawn or eat dinner, it can retain a remarkable degree of coherence. Pick up the novel and you are immediately back in the world of the work, almost as if there had been no interruption. Stop the music because of a mechanical problem, or the ringing of a phone, but when it is started again, two bars may be enough to establish the connection with what went before, and you are clearly in the *same* experience again.

Fourth, it is an experience that is unusually complete in itself. The impulses and expectations aroused by elements within the experience are felt to be counterbalanced or resolved by other elements within the experience, so that some degree of equilibrium or finality is achieved and enjoyed. The experience detaches itself, and even insulates itself, from the intrusion of alien elements. Of course, it cannot survive all emergencies. I have heard the last movement of Beethoven's *"Waldstein"* Sonata (*Op. 53*) interrupted by a fire chief who suddenly appeared on stage to clear the aisles of standees; and even though the pianist, Paul Badura-Skoda, started off again at the beginning of the movement, he could not, of course, recapture the peculiar quality of that beginning, which moves without pause from the slow section of the sonata. But because of the highly concentrated, or localized, attention characteristic of aesthetic experience, it tends to mark itself out from the general stream of experience, and stand in memory as a single experience.

Aesthetic objects have a peculiar, but I think important, aspect: they are all, so to speak, objects *manqués*. There is something lacking in them that keeps them from being quite real, from achieving the full status of things—or, better, that prevents the question of reality from arising. They are complexes of qualities, surfaces. The characters of the novel or lyric have truncated histories, they are no more than they show. The music is movement without anything solid that moves; the object in the painting is not a material object, but only the appearance of one. Even the lifelike statue, though it gives us the shape and gesture and life of a living thing, is clearly not one itself. And the dancer gives us the abstractions of human action—the gestures and movements of joy and sorrow, of love and fear—but not the actions (killing or dying) themselves. This is one sense of "make-believe" in which aesthetic objects are make-believe objects; and upon this depends their capacity to call forth from us the kind of admiring contemplation, without any necessary commitment to practical action, that is characteristic of aesthetic experience.

One aesthetic experience may differ from another in any or all of three connected but independent respects: (1) it may be more *unified*, that is,

more coherent and/or complete, than the other; (2) its dominant quality, or pervasive feeling-tone, may be more *intense* than that of the other; (3) the range or diversity of distinct elements that it brings together into its unity, and under its dominant quality, may be more *complex* than that of the other. It will be convenient to have a general term to cover all three characteristics. I propose to say that one aesthetic experience has a greater *magnitude*—that is, it is more of an aesthetic experience—than another; and that its magnitude is a function of at least these three variables. For the more unified the experience, the more of a whole the experience is, and the more concentratedly the self is engaged; the more intense the experience, the more deeply the self is engaged; the more complex the experience, the more of the self is engaged, that is, the more wide-ranging are its responses, perhaps over a longer time.

I do not think of magnitude here as implying measurement—it is merely a collective term for how much is happening, intensively or extensively, in the experience. It may be too vague a concept to be useful. That remains to be seen, but there are two sources of legitimate uneasiness about it that should be frankly faced at once. First, note that I am now applying the terms "unity," "complexity," and "intensity" more broadly than before—not only to the phenomenally objective presentations in the experience, but to the whole experience, which includes affective and cognitive elements as well. The terms are still understandable, even in this extended use, I judge, but of course less capable of sure and exact application. Second, though I claim that these three characteristics all have a bearing upon magnitude, and that the magnitude of the experience is a resultant of them, I am not yet raising certain questions—which will shortly come to our attention—concerning the comparability of magnitudes. Evidently it will be possible to say that of two experiences approximately equal in unity and complexity, the one having a greater intensity will have the greater magnitude. But what if they are equal in one respect, and differ in opposite ways in the other two? This question is still open.

The traits of aesthetic experience are to be found individually in a great many other experiences, of course, but not in the same combination, I think. Play, in the sense in which we play games, involves the enjoyment of activity that has no practical purpose. But though the psychology of play has not yielded up all its secrets to psychological inquiry, it seems not necessarily to be an experience of a high degree of unity. Watching a baseball or football game is also generally lacking in a dominant pattern and consummation, though sometimes it has these characteristics to a high degree and is an aesthetic experience. Carrying through a triumphant scientific investigation or the solution of a mathematical problem may have the clear dramatic pattern and consummatory conclusion of an aesthetic experience, but it is not itself aesthetic experience unless the movement of thought is tied closely to sensuous presentations, or at least a phenomenally objective field of perceptual objects.

Such distinctions are vague and tentative; they are some of the problems that most need to be studied at the present time. In any case, we can identify aesthetic experience as a kind of experience, though it is unique only in its combination of traits, rather than in any specific one. And we can say that aesthetic objects, generally speaking, have the function of producing such experiences, even though quite often aesthetic experiences of some degree of magnitude are obtained in the regular course of life from other things than aesthetic objects. This is their special use, what they are good for. On the whole, it is what they do best; they do it most dependably, and they alone do it in the highest magnitude.

Value as a Capacity

We can now define "good aesthetic object," in terms of the function of aesthetic objects—provided we can make another assumption. Suppose that what makes an aesthetic experience itself good, that on account of which it is a good aesthetic experience, is its magnitude, and, moreover, that one aesthetic experience is better than another, more worth having, if it has a greater magnitude. Then we can say,

"*X* is a good aesthetic object" means "*X* is capable of producing good aesthetic experiences (that is, aesthetic experiences of a fairly great magnitude)."

And,

"*X* is a better aesthetic object than *Y*" means "*X* is capable of producing better aesthetic experiences (that is, aesthetic experiences of a greater magnitude) than *Y*."

I shall call these *Functional* definitions of "good" in its adjunctive use as applied to aesthetic objects.

The transition to a definition of "aesthetic value" is now readily made. I propose to say, simply, that "being a good aesthetic object" and "having aesthetic value" mean the same thing. Or,

"*X* has aesthetic value" means "*X* has the capacity to produce an aesthetic experience of a fairly great magnitude (such an experience having value)."

And,

"*X* has greater aesthetic value than *Y*" means "*X* has the capacity to produce an aesthetic experience of greater magnitude (such an experience having more value) than that produced by *Y*."

Since this definition defines "aesthetic value" in terms of consequences, an object's utility or instrumentality to a certain sort of experience, I shall call it an *Instrumentalist* definition of "aesthetic value."[3]

Two clarifying comments are called for at this point. The first concerns the phrase "has the capacity to produce," or "is capable of produc-

[3] Definitions of this sort have been proposed by W. D. Ross, C. I. Lewis, Albert Hofstadter, and Thomas Munro; the usage of other writers appears to approximate it. . . .

ing." The defining term does not stipulate that the effect will happen, but that it can happen. The definition is, of course, nonrelativistic; it even permits us to say that a painting never seen by anyone has aesthetic value, meaning that if it were seen, under suitable conditions, it would produce an aesthetic experience. "Capacity" is called a *dispositional term*, like the term "nutritious." To say that a substance is nutritious is not to predict that anyone will in fact be nourished by it, but only that it would be healthful to—it would have food value for—someone who ate a certain (unspecified) amount of it under certain (unspecified) conditions. Now no doubt we can sometimes make specific predictions about aesthetic objects, just as we do about foods—"This will make you healthier if you eat at least six ounces of it every day for three months." And we sometimes go to people who have read a book and ask questions like, "Did it move you? Do you think I would enjoy it?" But the kind of question a critical evaluator is attempting to answer, I believe, is not of this sort, but rather of the sort: "*Can* it move people?" In other words, the question of aesthetic value, like the question of nutritiousness, seems to be a question about what effects the object is capable of yielding, or, to put it another way, what can be done with it if we want to do it.

The "capacity" terminology, it must be conceded, is a deliberately indefinite one, but not too indefinite, I think, to be useful, so long as it is subject to certain controls. First, a statement about a capacity is required to specify some reference-class, if it is to be readily confirmable.[4] We want to know what class of things we are to try out the object on, in order to see whether it really does have the capacity. What nourishes a horse will not necessarily nourish a man. The narrower the reference-class, of course, the more informative the capacity-statement, but so long as there is some reference-class, the statement can be correct and useful. For statements about aesthetic value, the reference-class is the class of human beings, to begin with, but we can easily narrow that down considerably by adding obvious requirements. To read Baudelaire you must understand French; to listen to music, not be tone-deaf; to see paintings, not be color-blind. No doubt we could go further. Note that this is not the same problem as that of defining "competent critic," for here we are not asking for the criteria of being an expert evaluator, but only ruling out certain classes of people whom it would be useless to expose to the aesthetic object. Even after we have eliminated the impossibles, we still use the "capacity" terminology, for we cannot predict that all who understand French will derive an aesthetic experience from Baudelaire, but only that, as far as this requirement goes, they are not prevented from doing so.

Second, although a capacity statement can be true even if the capacity is never actualized—natural resources are still resources even if they never happen to be exploited—the only direct confirmation of it is its actualiza-

[4] This point has been well made by Albert Hofstadter in a recent symposium on "The Evidence for Esthetic Judgment" . . .

tion. The test of whether an object has aesthetic value is just that some of its presentations actually cause, and enter into, aesthetic experiences.

Third, "capacity" is a positive, rather than a negative, term, and this distinction is important, if not pressed too far. We can speak of the capacity of an aesthetic object to produce an aesthetic experience, or we can speak of the capacity of a person to be affected by the object. But in both cases we assume—and, I believe, on adequate evidence—that there is a direction of development in aesthetic experience, a difference between greater and less capacity. It takes a greater capacity to respond to Shakespeare than to Graham Greene, to Beethoven than to Ferde Grofé, to Cézanne than to Norman Rockwell. People outgrow Graham Greene, but they do not outgrow Shakespeare. People sometimes give up Tchaikovsky's symphonies for Haydn's but they do not, I think, give up Haydn for Tchaikovsky. And if we lose our admiration for Brahms at one stage, and return to him later, it will be for different reasons. We do not say that a person has the capacity to remain unmoved by Shakespeare; this is not a capacity, but the lack of a capacity. Now the object with the greater capacity may not have its capacity actualized as often as the object with less—the heavier the sledge, the greater its force, but the fewer who can use it well. If, therefore, the aesthetic value of Tchaikovsky is more often had and enjoyed than that of Bach, it still may be true that the value of the latter is greater.

The Instrumentalist definition, as I have framed it, contains another unusual feature, that is, the parenthetical insertion. I am not sure that the parentheses are the best notation for my meaning, but they are the best I can think of. The Instrumentalist definition is not a Psychological definition, in the sense of the preceding section, for it does not claim to reduce statements about value to purely psychological terms. Indeed, it does not define "value" at all, for this word appears in the defining term as well as in the term to be defined. It only defines the whole term, "aesthetic value," in terms of a certain kind of experience. But it concedes that this definition cannot be adopted except on the assumption, set forth in parentheses, that the experience is itself worth having.

If the Instrumentalist definition had been stated in purely psychological terms, for example,

"X has aesthetic value" means "X has the capacity to produce an aesthetic experience of some magnitude,"

it would have been open to the objections raised against all Psychological definitions—the "open question" argument and the complaint against Persuasive definitions. This last definition does not really define "aesthetic value" but only "aesthetic power," or something of the sort. To call that power a value is to presuppose that the effect itself has value, and this presupposition should be made clear. Yet the presupposition is not strictly part of the defining term; it is more like a stipulation about the conditions

under which the definition applies, and that is why I have put it in parentheses. The definition might be expanded in this way:

If it be granted that aesthetic experience has value, then "aesthetic value" may be defined as "the capacity to produce an aesthetic experience of some magnitude."

To say that an object has aesthetic value is (a) to say that it has the capacity to produce an aesthetic effect, and (b) to say that the aesthetic effect itself has value. In exactly the same way, the statement, "Penicillin has medical value," means (a) that penicillin has the capacity to produce medical effects, that is, it can cure or alleviate certain diseases, and (b) that curing or alleviating diseases is worthwhile.

In order to decide about the acceptability of the Instrumentalist definition, we must be aware of the spirit in which it is offered. It does not claim to report what critics would say if asked for their definition of "good" (in an aesthetic context); but it does claim to indicate what they can, and probably must, mean, if they wish the reason they actually give for critical evaluations to be logically relevant and persuasive. At least there is no doubt that the Instrumentalist definition fits in very well with practical criticism. For suppose a critic says that a particular aesthetic object is a very good one, and we ask, "Why?" His answer would consist in pointing out certain features of it that contribute to its having a high degree of unity, or complexity, or intensity of regional quality. If we then press him further, and ask why unity, complexity, and intensity are desirable, he can reply that the greater the degree of some or all of these features, the greater the magnitude of the aesthetic experience that the object is then capable of evoking. For example, the more unified the object, the more unified the experience of it will probably be—for this there seems to be a good deal of evidence. Since the evoking of such an experience—assuming it is itself a good—is what constitutes aesthetic value, any argument for its capacity to evoke the experience is by definition an argument for its aesthetic value.

On the other hand, if the critic says that a particular aesthetic object is a poor one, we will, according to the Instrumentalist definition, expect him to produce evidence that it is very deficient in features that would promote a high degree of unity, complexity, or intensity. And this is, as we saw in the preceding chapter, just the sort of Objective reason that the critic does produce. In short, appeal to the three General Canons that seem to underlie so much of critical argument can itself be justified in terms of an Instrumentalist definition of "aesthetic value." For these Canons refer to characteristics of aesthetic objects that enable them to evoke aesthetic experiences, so far as the occurrence of such experiences is under the control of those objects.

But this is to consider the nature of critical argument rather abstractly, and it may nevertheless be felt that the Instrumentalist definition is less plausible when we take into account the actual situation of the critic, the

conditions under which he is likely to make a judgment or offer reasons. For example, it is often emphasized that aesthetic value is something that is *immediately* experienced and known; it does not have to be calculated or inferred, but is open to direct inspection—consummatory, if anything is. But even according to the Instrumentalist definition, what is true in the doctrine of immediacy can still be preserved. If a critic, face to face with a painting, finds himself deriving from it the kind of enjoyment that we have called "aesthetic experience," he possesses direct evidence that the painting has the capacity to produce such an experience, for if it does, it can. His enjoyment is immediate and is strongly evidential. That does not mean, of course, that he cannot be mistaken. For when he says the painting has aesthetic value, he is not saying merely that it can give pleasure, but he is saying what *kind* of pleasure it can give. And it is possible to mistake other experience for aesthetic experience, just as it is possible to mistake other experience for religious experience. The experience I get from a certain landscape may really be a nostalgic feeling caused by a recognition that the barn is like the one on my childhood farm; the shiver and gooseflesh I get from hearing certain music may come from the fact that it is an old hymn tune, associated with long-buried religious experiences of my youth; the excitement I get from reading a novel may be a response to its social message, more like the excitement of helping in a political campaign than that of an aesthetic experience. It is easy for a Scotsman to overrate Burns, a liberal Democrat Whitman, or an Old French scholar *Le Chanson de Roland*.

In short, there may be times when I confuse aesthetic experience with other experience, and incorrectly say the object has aesthetic value, because it moves me in some other way; and here it would be appropriate for the critic to show me by an analysis of the object that it is probably incapable of producing an aesthetic experience of great magnitude, so that my response is therefore probably of a nonaesthetic sort, as I will, he predicts, discover by more careful introspection.

The critic who is actually moved by the work does not, of course, require reasons to justify his being moved. But he may be interested in analyzing the work to find more precisely the basis of his experience. Or if his first reaction is indifferent or negative—if the work seems poor to him—he may wonder whether the reaction is adequate. Perhaps further study will show that the work probably has the capacity to produce an aesthetic experience of some magnitude, even though it has not yet done so, because the difficulties of understanding it have not been overcome. Under other circumstances, the critic may give reasons why people who have not even heard the music yet, or visited the exhibition, or attended the play, would be well advised to do so; for there is evidence in the work itself that it has aesthetic value.

Thus, to revert to an example first alluded to at the beginning of §25, in the preceding chapter, it is true that "This is unified" is not evidence

for "This has aesthetic value" in exactly the same way that "The patient's temperature is 104.5" is evidence for "The patient has pneumonia." For "This has aesthetic value" is a dispositional statement, and "The patient has pneumonia" is not. But compare "This food is dangerous" and "It is crawling with salmonella bacteria." Here the presence of the bacteria is evidence that the food will probably produce ghastly effects if it is eaten, just as the presence of unity is evidence that the work will produce an aesthetic effect if it is perceived with attention.

The Decision Problem

If the Instrumentalist definition of "aesthetic value" is adopted, along with its attendant implications for critical argument, it will then be true that sometimes our preferences for one aesthetic object over another, or our commendation of X as better than Y, can be rationally justified. And it is natural to wonder whether they always can. Philosophers have toyed with the idea of constructing a scale, or unique order, of aesthetic value, perhaps even a grading system, like that suggested by Samuel Johnson in the quotation from Boswell near the beginning of Chapter X. The relation "is better than," for which we may use the symbol ">," is defined Instrumentally so that it is asymmetrical, since if $X > Y$, then it cannot be that $Y > X$. It is not, however, transitive, since if $X > Y$ and $Y > Z$, it does not follow necessarily that $X > Z$. Though we can manipulate such symbols in many highly satisfying ways, we must recognize in the comparative judgment of aesthetic value some serious limitations.

For there are problems involved in deciding whether or not $X > Y$, in certain cases. Suppose we find two aesthetic objects, X and Y, and we can produce no reason why $X > Y$ and no reason why $Y > X$. We may still find ourselves liking one more than the other, and we have no reason not to choose it when it is available. In short, there will be preferences, choices among aesthetic objects, that fall through the wide mesh of critical argument; preferences that cannot be rationally justified. Let us say that such preferences belong to an Area of Rational Undecidability in the realm of critical evaluation—an area where rational argument does not reach, and where choice, if choice occurs, cannot be guided by reasons. Consider, for example, two of Scarlatti's keyboard sonatas, the one in E major (Kirkpatrick 380) and the one in B minor (Kirkpatrick 87). I do not claim that this pair belongs to the Area of Undecidability; indeed the conclusion that any pair does is a negative conclusion, which could only be reached after an exhaustive study of the two works. But both of these works are of a high order, though very different, and let us suppose, for the sake of discussion, that everything good we can say about either can be matched by something good about the other, and we can find no reason why either should be judged a better aesthetic object than the other.

No problem may arise in this case, we may not even like one more than the other, and in fact in these cases, if someone asks me which I like

better, I find it very hard to answer, though perhaps I incline a bit more to the *E Major Sonata*. So suppose we do like that one more, but have no reason to say that it is better. We are still choosing between them, and this may even be a practical decision, as when a friend stands with the pickup arm poised over the record grooves, and invites us to hear one sonata or the other. But though we can give a good reason for listening to the one we like better, we cannot give any reason—to speak a little oddly—for liking one better. If that is the case, then this pair of sonatas belongs in the Area of Undecidability. But note that it is always a pair that belongs to this area. It is quite clear, for example, that we can give reasons for saying that the *E Major Sonata* is a better composition than, say, the *G Major Sonata* (Kirkpatrick 146), and so *this* pair does not belong to the Area of Undecidability.

The Area of Undecidability, then, is the class consisting of all pairs of aesthetic objects, *X* and *Y*, which are such that we cannot prove either is better than the other, or that they are equal in aesthetic value. Undecidability is not the same thing as Relativism, though it is sometimes called Relativism, because the two are related. If we insisted on preserving the expression "is better than" for comparing *X* and *Y* when they fall within the Area of Undecidability, then we could define "is better than" Relativistically, that is, in subjective terms. But I am adopting an alternative usage. When *X* and *Y* fall within the Area of Undecidability, we have no reason to suppose that either has the capacity to produce an aesthetic experience of greater magnitude than that producible by the other. Hence in that area I do not say that one is better than the other or is preferable or is more desirable; but it is all right to say that one is preferred or is desired.

There are two factors in aesthetic value that create this Area of Undecidability.

The first factor is that the critical value judgment makes use of multiple criteria. Suppose we are given a basket of apples, and told to arrange them in a serial order, from the least good to best. To perform this task we are given a list of good-making features of apples, analogous to the General Canons of critical evaluation: quality of taste, firmness, size, color, freedom from bruises and worms, and so forth. Without such a list we would of course not know where to begin, for we would not even know what the task was—just as if someone told us to put in order an apple, a lemon, and a radish, without giving us any instructions about principles to define the order.

Now let us suppose that we know how to arrange all the apples in terms of every particular standard. That is, we can order them according to size—putting those of the same size side by side—or taste, or freedom from blemishes. But this is not the assigned task, for we are not supposed to arrange them in several orders, but in a single order that will somehow

take account of all the standards. How would we set about such a task? First we might pick out all those apples that seem perfectly free from blemishes, and set them at one end, perhaps in two or three groups if we can find a few that are outstanding in some feature, such as taste or size. Then we might pick out all those apples that are very bruised and wormy, and put them at the other end. In between these extremes lies the difficult task, and we of course discover that beyond a certain point it is not performable, with the instructions given. For though we may easily decide that certain apples, taken all around, are better than certain others, there will be many pairs of apples which we cannot decide about; one has excellent taste but is small and slightly bruised, the other has a little less good taste, but is large and rosy. The only way we can do the job is to secure further instructions that would have the effect of weighting, or rating, the standards themselves, for example, "Taste is more important than size; in case of a tie, pay more attention to size than color; when in doubt, ignore the worm, but measure the size of the nonwormy part of the apple." Probably no one could lay down beforehand a complete set of such weighted standards to take care of all eventualities. But as problems arose, rules could be adopted, and in the end we could perhaps eliminate all Undecidability, for the rules would determine, in every case, whether X is better or worse than, or equal to, Y.

Can the same thing be done with aesthetic objects? If we take unity, intensity, and complexity as three independent standards, we will inevitably find many pairs of aesthetic objects that cannot be rated in aesthetic value. Say X and Y are about equally complex, but X is a little more unified, while Y has a rather more intense quality. If one person prefers X, and another Y, there does not seem to be any rational way to resolve the difference. They simply put different weights on different standards. Thus one critic may praise a Mondrian for its precise balance, while admitting the simplicity of the design; another may praise the complexity of a Tintoretto while admitting that his designs are sometimes not so unified. To get certain intense, and admirable, qualities, like the cool necessity of the Mondrian, or the sweeping grandeur and dynamism of the Tintoretto, other features may have to be sacrificed a little. And there is no set of rules that says that one of the three critical standards is to be weighted higher than the others.

Some people seem to set most store by sheer intensity of regional quality, others by clear-cut structure, and there does not seem to be any way of showing either of them to be mistaken. It is possible, of course, that with further study of the nature of aesthetic experience, and of the conditions on which it depends, we could refine our Canons of judgment, and introduce rules of weighting. But at the present time an area of Undecidability remains. If Critic A says of a work that it does not have enough order to suit him, and Critic B that it has enough vividness to

suit him fine, it does not seem that either is able to prove the work is very good or not very good. But of course they can still agree that it is definitely superior, or definitely inferior, to certain other aesthetic objects.

Thus, if we take a handful of Donne's best poems, or of Haydn quartets or Rembrandt etchings, it may be impossible to decide which of the group is better and which is worse. But this need not bother us. After all, when we are dealing with such a group of poems, or quartets, or etchings, we are dealing with aesthetic objects that are all unquestionably of a high rank. What difference does it make whether one of the poems is a little better than the others? It is more important to see what is good in each, and acquire affection for it. This does not in the least imply that we cannot discern the difference in value that separates Donne's best poems from Robinson Jeffers', Haydn's quartets from Milhaud's, or Rembrandt's etchings from Walter Sickert's.

The second factor making for an Area of Undecidability in critical evaluation is the variety of regional qualities in aesthetic objects. Though it depends upon complex perceptual conditions, a regional quality is itself simple, and may be simply liked or disliked—just as is the taste of a ripe or green olive, of buttermilk, parsnips, Camembert, horehound, and Irish whiskey. There are characteristic recurrent qualities in the works of certain composers: the peculiar controlled drive of Bach's bass melodies, as in the cantatas; the whining and yearning of sixths and sevenths in some of Brahms' melodies, as sometimes in his quartets and at the opening of his *E Minor Symphony (No. 4)*; the cutting edge of Bartók when he is both syncopated and dissonant, as in parts of the *Third Quartet*. Now it is perfectly possible for someone to say that, for example, Brahms' *C Minor Quartet (Op. 51, No. 1)* is highly unified, and quite fully developed, and has quite intense regional qualities, so that it is undoubtedly a fine quartet—but he unfortunately cannot stand those Brahmsian qualities. Or he may not be able to decide on rational grounds whether one of Bartók's quartets is greater than Debussy's yet he may enjoy the Debussy quality and abhor the Bartók quality.

This is not to imply that his taste cannot change. The point is, however, that a person may like X more than Y simply on account of its quality, and for this preference he can give no further justification. Of course, he does not have to say that X is *better* than Y, but he is choosing, and his choice is in the Area of Undecidability. I do not know whether it is true that "The very qualities in Manet that attracted Daumier, repelled Courbet,"[5] but this statement expresses concisely a sufficiently common experience: I am sure that the qualities of Faulkner, Kafka, Hemingway, Pope, or Marvell, that attract some readers are the very qualities that put others off. And this is a strong argument in favor of a wide variety of

[5] Quoted from Ambroise Vollard, *Renoir*, New York: Knopf, 1925, p. 47, by B. C. Heyl, *New Bearings in Aesthetics and Art Criticism*, New Haven, Conn.: Yale U., 1943, p. 98 *n*.

literature, for a work whose qualities we cannot learn to like is simply unavailable to us, and yet we may intellectually recognize its value, and convince ourselves that others derive from it an aesthetic experience that is equal in magnitude to experiences that we must obtain elsewhere.

Aesthetic Value

The Instrumentalist definition of "aesthetic value," as we have noted before, is carefully framed to expose the fact that to adopt it is to take for granted that something is already known to be valuable, namely aesthetic experience. It makes the value of the aesthetic object a means to an end. But of course we are immediately confronted with a further question, about the value of the end itself: what justifies the assumption that this experience is valuable? The practical critic does not have to worry about this question: if he can assume that aesthetic experiences are worth having, then he can investigate those features of aesthetic objects upon which such experiences depend. To put it another way, for the critic aesthetic experience is an end-in-view which he need not question, just as life and health are the ends-in-view of the doctor, so far as he is a doctor, and it is axiomatic for him that they are to be preserved when they can be. Of course the man who is a doctor may sometimes think of more ultimate questions, especially when he is faced with difficult situations, as in Shaw's play, *The Doctor's Dilemma*, and there is no reason why the critic should not be a human being, too. To put it still another way, it does not matter to the doctor, *qua* doctor, what his patients do with their lives and their health. And it does not matter to the critic whether the value he ascribes to aesthetic experience is an intrinsic value or only a further instrumental value; if it has any value at all, his work is cut out for him.

But the question that the critic does not ask, someone must both ask and answer. Someone must try to determine whether the critic's assumption is sound. This is a philosophical question, and it belongs to the domain of aesthetics. Does aesthetic experience have value, and if so why? It must be acknowledged that we are now venturing upon uncertain waters, in thus pushing the inquiry one step further. But an adequate aesthetic theory must take the inevitable risks.

At this point there appear to be two main alternatives. One is easy and ready to hand, the other more subtle and perplexing.

The first alternative is to combine the Instrumentalist definition of "aesthetic value" with a Psychological definition of "value" in general, and say that aesthetic experiences are intrinsically valuable in that they are liked, or enjoyed, or desired. Suppose someone were to say, "I am willing to accept your conclusion that good music has aesthetic value, and I suppose if I were to spend a great deal of time listening to it and studying it, I would be able to obtain aesthetic experiences of some magnitude from music, but what good are such experiences? Why should I bother?" You

might reply, "But when you are able to have them, you will enjoy them very much." And if this answer contents you, and him, then, it would seem, no more need be said.

Now it is true that quite often this answer *is* sufficient. But only because it takes certain things for granted. If someone were to justify forging Federal Reserve notes, or pushing people in front of railway trains, on the same grounds, namely, that he enjoys these challenging and exhilarating activities, we would not for a moment accept his justification as conclusive. It is often said that aesthetic experiences are "worth having for their own sake," and that indeed they are supreme examples, prototypes, of what is worth having for its own sake. But though this phrase is clearly a strong commendation, we must examine it more closely. What can it mean? It is certainly true that aesthetic experiences can be enjoyed for their own sake, without thought for yesterday or tomorrow; they give that *sort* of enjoyment, and this is an important fact about them. But does it follow that their value is something that inheres in them, or in their pleasure, without regard to the conditions under which they occur or the sacrifices that may have to be made to obtain them? This is another question raised in Shaw's play.

When we ask whether something is enjoyable, we are asking for information about it, just as when we ask whether it is bulky, or ripe, or likely to get out of order. If that is what we want to know about it, no question of value has yet arisen. But when we ask about the value of something, and require statements about its value to be supported by reasons, we are asking a different sort of question. We want to know about its connections with other things, including other enjoyments that may be precluded by it or enhanced by it; in short, we want to know about its consequences. Thus the question whether aesthetic experience is valuable is not the question whether it is enjoyable, but the question whether its enjoyment can be justified, in comparison with other enjoyments that are available to us as human beings, as citizens in a twentieth century democratic society. This may be putting it rather solemnly, but the question is a big one, as we shall see.

We are led by this line of thought to the second alternative, which is that elected by the *Instrumentalist Theory of Value*.[6] This theory includes the Instrumentalist definition of "aesthetic value," but it also includes a more far-reaching statement. For it denies the basic philosophical assumption common to both the Beauty Theory and the Psychological definitions: the assumption, namely, that all instrumental value leads back ultimately to, or depends upon, intrinsic value. According to the Instrumentalist Theory, there is no such thing as intrinsic value. The arguments that have been set forth for this conclusion are not, I am afraid, very complete or very clear, and they are complicated. We shall have to sum-

[6] My formulation of this theory is based upon John Dewey's writings on ethics and value theory. . . .

marize the position fairly briefly here, just enough to make its main outlines evident.

A stove has value; that is plain. So does a pudding or a teacher. According to the Instrumentalist Theory, when we ascribe value to the stove, we must always have in the back of our minds that it serves some end, say cooking puddings for teachers, and that that end is valuable. You can never judge the value of anything except in relation to other things that are *at that time* taken to be valuable. Of course, you can always shift the question from the means to the end that lies in view. What is the value of cooking? That is a perfectly good question, too, but a different one, for now we are considering this action as a means, and our end-in-view will be, say, feeding people well. This is the familiar chain of means and ends: if we have a watch, we will keep the dentist's appointment; if we keep the appointment, we will get the tooth repaired; if we get the tooth repaired, we will have better health and less pain; and so on.

The question is whether all such chains must lead ultimately to a final step, where something is discovered to be good in itself, not as a means to anything else. The Instrumentalist says No. But the usual answer is Yes, and the argument for it takes several forms, theological, rationalistic, and nationalistic. For example, one answer that has often been given, and with a certain plausibility, is that all roads lead to happiness, and happiness is the sole intrinsic good to which everything else is a means. This answer has some subtle difficulties, and philosophers disagree about it. I am doubtful whether it is really an answer at all. For "happiness" cannot name something to which everything else is a means, unless it is used in such a broad sense as to cover everything that anyone could want or do—monastic vows, the Golden Touch, the Lotus Eaters' paradise, the martyr's death, the advertising executive's life. Happiness is not an end at all, or anything you can aim at or achieve, but a pervasive regional quality of an ongoing life without insoluble problems or irresolvable conflicts—perhaps a life in which no hard problems of value really arise.

Let us consider one other kind of answer. Recall some delightful but harmless pleasure—a walk in the woods, a song, an open fire. Conceive of it as perfectly isolated, in the sense that it has no consequences for the future. Then should we not say that this pleasure is intrinsically worthwhile, and intrinsically better than having a headache during the same stretch of time? I grant that we talk this way, sometimes, but I don't agree that it is the best way to talk. We enjoy the pleasure, to be sure, and if there really are no consequences then there can be no reason why we should not enjoy it. In this case, it is not necessary to say that the pleasure is (intrinsically) good; the question of its goodness or badness does not even arise. There is no problem. But if we ask whether it is good, if we find a problem about it, then we are looking beyond the pleasure itself—as, indeed, we always can. For the example is really artificial, and there are no utterly inconsequential acts. When we were walk-

ing in the woods, or musing before the open fire, we were canceling, or postponing, other activities, and thus making a choice.

If an object were intrinsically valuable, no reason could be given to prove it, according to the Instrumentalist, since the reason would consist in pointing out its connections with other things, but if the value depends upon those connections, then it is not intrinsic. The value would have to be self-evident in some way. Yet if I start with the stove and trace its consequences and their consequences, I do not seem ever to get to anything that is self-evidently valuable.

In the light of this discussion, we can, I think, reply to the two most crushing objections often brought against the Instrumentalist Theory. First, it is said to be self-contradictory. Now, it is self-contradictory to say that there can be means without ends-in-view, or to say X has instrumental value because it is a means to Y, but Y is valueless. But to say that an object has instrumental value only entails that the object to which it is instrumental has value; it cannot be deduced from this statement that any object has intrinsic value. Second, the theory is said to be meaningless. For if nothing has intrinsic value, then, it is argued, "intrinsic value" has no application to the world, and hence no meaning; but then the statement, "All values are instrumental," has no meaning either. But this is a mistake, I believe. "Intrinsic value" has no application, true; but it has a meaning, that is, a designation. According to the determinist, "causeless event" has no application, since every event has a cause; nevertheless he knows perfectly well what he means by "causes" and "causeless," and his denial that there are causeless events is not nonsensical.

The chief lessons of the Instrumentalist Theory of value might, then, be summed up in this way: Statements about value are to be regarded as proposed solutions to *problems* of value, that is, situations in which choices have to be made. Choices are always between particular actions —not abstractions like pleasure or honor or self-realization, but this pleasant or this honorable course of conduct, with its particular chain of attendant consequences. Every such decision, when it is rational, involves deliberation about available means with reference to ends-in-view. There are no ends-in-view that are unquestionable. None is in principle immune to doubt, or examination. But nevertheless there are always, in any problem of value, some ends-in-view that are in fact *unquestioned*. For whenever you weigh alternative means, or alternative ends-in-view, you must always weigh them in relation to other, more distant, ends-in-view that you are not calling into question *at that time*. Later experience may destroy your confidence in those ends, of course, for no ends are absolutely final. We all acquired many ends, that is, goals and desires, before we were capable of asking for a justification of them, and it would be in the nature of the case impossible, according to the Instrumentalist, to call into question all our ends at once. Thus problems about value do get settled, at least provisionally; adjustments among competing means or

conflicting ends are made, we create temporary harmonies of our impulses and our needs and satisfactions. Some solutions last over a long time, while others are soon shaken by new experiences.

Moreover, certain things have proved, in the course of human experience, to be such valuable means to so many ends, that we give them, and with good reason, a privileged and protected position among the values of life. They are not final ends in themselves, but they are constituents of instrumental value almost everywhere, and therefore they are taken as relatively fixed and constant ends-in-view. Such things are truth, love, health, privacy, the common rights of citizens, and the many species of freedom. And the last question that awaits us, in the next chapter, is whether the arts themselves, or the experiences they provide, belong somewhere in this august company.

· · ·

THE INHERENT VALUES OF ART

In the final analysis, then, what good is art? This question, the bluntest and most far-reaching of all questions in the philosophy of art, is many things to many people. It can be asked skeptically by the practical man who has no doubt that the improvement of plumbing, the control of disease, and the development of automotive engineering are ingredients of progress and civilization, but has a hard time fitting concerts, water colors, and lyric poetry into the picture. Not that he would deny these to people who care for them, but he cannot see that they need to be considered in thinking broadly about the basic needs of society. It can be asked ironically by the Aestheticist, who is equally skeptical of plumbing and automatic gearshifts, as in Théophile Gautier's famous Preface to *Mademoiselle de Maupin:*

> What is the good of music? of painting? Who would be foolish enough to prefer Mozart to Monsieur Carrel,[7] or Michelangelo to the inventor of white mustard? Nothing is truly beautiful unless it can never be of any use whatsoever . . .

Have aesthetic objects "no more consequence than a dozen oysters and a pint of Montrachet"?[8]

But whatever its tone, the question deserves an answer. For it goes deep into the philosophy of art. Let us begin by considering what kind of answer it requires. Plumbing, medicine, and automobiles, we may assume, make a contribution to human welfare. They have special functions, but the ends they directly serve are means to many other ends, and there is

[7] Armand Carrel (1800–36), a well-known journalist, was killed in a duel the same year that *Mademoiselle de Maupin* appeared. Gautier presumably thought of him as a man who used the art of writing to serve political and social ends.

[8] W. Somerset Maugham, *The Summing Up*, Baltimore: Penguin, 1938, p. 214. See the whole of sec. 76.

little doubt of their justification, even though sometimes they may be put to bad uses. Aesthetic objects differ from those directly ultilitarian objects in that their immediate function is only to provide a certain kind of experience that can be enjoyed in itself. Can we show that the having of this aesthetic experience is, in turn, justified by longer-range effects that such experience has upon us—in other words, that aesthetic experience makes its own contribution to human welfare?

The question What good is art? probably ought to be divided into two questions, of which the second is the one that concerns us most. What good does the act of creating an aesthetic object do to the creator himself? And what good does the finished aesthetic object do to those who experience it? As regards the first of these questions, our knowledge is limited, but there is something to go on. It makes a considerable difference, however, whether you are talking about the professional creative artist—by this I mean not necessarily one who makes an adequate living at it, but one who has made it his life work—or the amateur. Of course there is no sharp line between them, because the desire to compose music or paint pictures may have any degree of depth. Nevertheless, there are two different kinds of utility involved.

It is almost absurd to ask what good it does the professional creator to do what he does—with an environment that makes it feasible at all, he will find that he cannot help himself. His motivation, and his reward, are out of the common run, for the objects he creates insist upon their existence, and wring themselves out of him in a way that absorbs him completely. His satisfactions are probably not utterly different from those of other kinds of creators—scientists, philosophers, organizers of social and economic institutions—when they can make something that bears the stamp of great goodness, by summoning up and concentrating all their powers.

For the amateur, the dilettante or dabbler, the rewards are different, though they may also be great in their own way. To perform on a musical instrument, to dance, to make up a song, to write stories and poems, to play around with oil paints seems quite clearly to have very beneficial psychological effects upon those who can be encouraged to undertake such activities, even if the results are of little aesthetic value. In recent years educators have widely recognized this fact, and it is pretty much taken for granted now that instruction in music and the fine arts, and participation in plays and concerts, are an important part of elementary and secondary education. Psychologists and psychiatrists may not yet be certain of the exact manner in which creative activity works its effects, but it seems to release pent-up energy, work off frustrations, lessen tensions, restore a sense of balance and perspective, and in these ways promote conditions of mental health. Much of the Aristotelian theory of catharsis, which was summarized in the preceding section, seems to apply here. And indeed some, though not all, of the benefits of art may come as well from

producing an aesthetic object that is only fair as from experiencing one that is great.

Even if the specific value of the arts were limited to their value for the creators themselves, there would be ample justification for putting a good deal of social effort into promoting them—helping everyone to become a painter, a musician, a writer as far as it lies in him to do so. And if the establishment of a National Advisory Council on the Arts, or, better, a United States Art Foundation, would provide the means of increasing education in the arts, it would be well worth the cost. But the private value of artistic creation as mental therapy to the creator must be distinguished from its public value. Of course, the more a person is encouraged to be creative himself, the more he will appreciate and enjoy aesthetic objects created by others. So the two things are connected. But the second question is broader than the first.

Let us now turn to the worth of art to the consumer, so to speak. And let us use the term "inherent value" for the capacity of aesthetic objects to produce good inherent effects—that is, to produce desirable effects by means of the aesthetic experience they evoke. Admirers of the arts from early times have praised them in the highest terms for their inherent value; what we would now like to know is whether this praise is deserved. First of all, to begin very modestly, we do not know that aesthetic experience does people any *harm*. Perhaps it may be overdone, and produce an enervating condition of *fin de sièclism*, though we do not really know whether to blame the decadence of the Decadents on aesthetic objects, or simply to say that these objects failed to cure their deep-seated neuroses. But does aesthetic experience do people any *good?*

Effects of Aesthetic Objects

It is to be expected in any branch of philosophy that the most searching questions have the least confident answers—not because search has not been diligent but because the questions are difficult. Tremendous claims have been put forth for the inherent values of art, and it will take much thorough and delicate psychological inquiry before they can be made good. They are not unsupported by evidence, only the evidence is scattered, uncertain, subject to distortion by faulty introspection and emotional bias. It will reflect the present state of our knowledge best, I think, if we set forth the main kinds of inherent value that have been ascribed to aesthetic objects, but in the form of predications rather than outright assertions. I believe that there is some truth in all of them, and enough evidence for some of them to justify the view that aesthetic objects have a very considerable inherent value; but at the same time the case for their inherent value is not complete, and there is much work to be done.[9]

Thus, we might say:

[9] In drawing up this list, I have made use especially of Shelley, I. A. Richards, and John Dewey. . . .

1. That aesthetic experience relieves tensions and quiets destructive impulses. This is the Aristotelian claim that we have already described; one note might be added. If Bertrand Russell was right when he said in his Nobel Prize acceptance speech that the love of excitement is one of the fundamental motives of man, then art may be valuable because it gives scope to this motive, which otherwise, in a civilized society that no longer hunts, sometimes plays its dangerous part in promoting social unrest and war. For, as Russell also said, the excitement of invention or artistic creation and the excitement of discovery including the discovery and exploration of a new complex work of art are two of the highest, purest, and most satisfying types of excitement. In this light, art would be a moral equivalent for violence.

2. That aesthetic experience resolves lesser conflicts within the self, and helps to create an integration, or harmony. When our attention is held by an aesthetic object and we are taken in hand by it, so to speak, we do often feel a remarkable kind of *clarification*, as though the jumble in our minds were being sorted out. At first there may be a simplification —nothing matters but this chord, or this melody; but later, as complexities arise, the clarity remains, for a place is made for them in a larger, but not less unified, structure. Suppose you are in a restless frame of mind, faced by several obligations that all seem to demand attention, but no one of which predominates to give you a singleness of purpose. Sometimes, under these circumstances, you may read a story, or fall into the contemplation of a picture, or hear a piece of music, and after a while, when you go back to your problems, you may find yourself in a very different state of mind, clearer and more decisive. This is the exhilaration, the tonic effect, of art.

3. That aesthetic experience refines perception and discrimination. Of course we can improve our discrimination of color-tones and musical pitch by practice—that is only saying that aesthetic experience makes you better at having aesthetic experiences. But aesthetic experience does call for an unusual degree of attention to subtle differences in regional quality, not only in the emotions and attitudes of characters in literature, but in the human qualities of paintings and musical compositions. If we can be made more sensitive and perceptive by aesthetic experience, then this would have a wide bearing upon all other aspects of our lives—our emotional relations with other people, for example.

4. That aesthetic experience develops the imagination, and along with it the ability to put oneself in the place of others. In the aesthetic experience we must be open to new qualities and new forms, and the ordinary worn grooves of routine response are broken and passed over. We know what it is to be free of the inhibitions that normally cut down the free play of inventive fancy. And perhaps there is a kind of training of the imagination which would even result in improved ability to think of original scientific hypotheses, to find new ways out of practical dilemmas,

to understand more quickly what is going on in other people's minds. We may become more flexible in our responses, better able to adjust to novel situations and unexpected contingencies.

If aesthetic experience may be regarded as working upon the personality in these four ways, then even more remote effects might be predicted—which would also be, but indirectly, part of the inherent value of aesthetic objects. For example, it might be said:

5. That aesthetic experience is, to put it in medical terms, an aid to mental health, but perhaps more as a preventive measure than as a cure. A world in which people, in the normal course of events, found their streets and buildings and working places filled with harmonious shapes and colors, good for the eye and for the spirit; who spent part of each day listening to or performing musical compositions of high aesthetic value; who loved the subtlety of good language, and used it themselves for poetry and storytelling, would be a society, one might hope, in which many common neuroses and psychoses, some of which begin with mild symptoms, would not arise. It has not been tried, and we cannot say for sure, but the astonishing success of classical music concerts in England during World War II may be indirect evidence.

6. That aesthetic experience fosters mutual sympathy and understanding. If the previous predications are true, we could expect aesthetic experience to draw men together. This is not the same as saying that art is a form of communication, that we understand the Chinese through their art or the French through their novels. But if two people listen to the same music or see the same painting, in so far as they have learned to make similar responses, they share an experience. All shared experience helps to bring people together in friendship and mutual respect, but aesthetic objects play a special role in the world. The reason is partly practical: many aesthetic objects are more portable than waterfalls, caves, deserts, and earthquakes. But also, they represent a quintessence or distillation of certain qualities of experience, and any two people anywhere who enjoy one of these qualities have a bond between them.

7. That aesthetic experience offers an ideal for human life. This social role of the arts is hard to describe briefly. In aesthetic experience we have experience in which means and ends are so closely interrelated that we feel no separation between them. One thing leads to the next and finds its place in it; the end is immanent in the beginning, the beginning is carried up into the end. Such experience allows the least emptiness, monotony, frustration, lack of fulfillment, and despair—the qualities that cripple much of human life. One of the things that trouble us in our society is, according to some philosophers, the wide gap that often exists between means and ends. Much of labor is itself uninteresting, mechanical, and spiritually deadening, and the laborer has no way of seeing a meaningful connection between what he is doing and what the ultimate product will be—the way a craftsman making a chair can be guided at every

step by a vivid realization of its relation to his goal. The means of life lose their satisfaction when the end-in-view is entirely distant and remote —the Saturday night binge, the retirement at sixty-five. But the ends, too, lose their value by the separation. The binge only becomes a wild release, followed by headache and remorse. The retirement brings unutterable boredom and a sense of uselessness. If some of the satisfyingness of the end could be brought into the means, and the means at every stage felt as carrying the significance of the end, we should have in life something more of the quality of aesthetic experience itself. Meanwhile, such experience holds before us a clue to what life can be like in its greatest richness and joy.

ALTERNATIVE
TABLE OF CONTENTS

9. IMITATION

10. MEANING AND TRUTH

17. MUSIC

BIBLIOGRAPHY

CONTENTS FOR BIBLIOGRAPHY

KEY TO ABBREVIATIONS

PERIODICALS

American Journal of Philology	*Am. J. Philology*
American Philosophical Quarterly	*Am. P. Q.*
Annual Review of Psychology	*Ann. R. Psych.*
Australasian Journal of Philosophy	*Aus. J. P.*
British Journal of Aesthetics	*B.J.A.*
British Journal of Medical Psychology	*Br. J. Med Psych.*
Indian Journal of Philosophy	*Ind. J. Phil.*
Inquiry	*Inq.*
International Journal of Psychoanalysis	*Int. J. Psychoanalysis*
International Philosophical Quarterly	*Int. P. Q.*
Journal of Aesthetics and Art Criticism	*J.A.A.C.*
Journal of Existentialism	*J. Exist.*
Journal of Psychoanalytic Psychology	*J. Psychoanalytic Psych.*
Journal of the History of Ideas	*J. Hist. Ideas*
Journal of the History of Philosophy	*J. Hist. Phil.*
Journal of Philosophy	*J. Phil.*
Modern Philology	*Mod. Philology*
Philosophical Quarterly	*Phil. Q.*
Philosophical Review	*Phil. R.*
Philosophical Studies	*Phil. S.*
Philosophy	*Phil.*
Philosophy and Phenomenological Research	*Phil. and Phen. Res.*
Philosophy East and West	*Phil. E. and W.*
Proceedings of the Aristotelian Society	*P.A.S.*
Supplementary Volume	*P.A.S. Supp. Vol.*
Psychoanalytic Quarterly	*Psychoanalytic Q.*
Psychoanalytic Review	*Psychoanalytic R.*
Psychological Review	*Psych. R.*
Publications of the Modern Language Association	*PMLA*

NOTE: *References to other periodicals are given in full.*

BOOKS

Edwards, Paul (ed.), *The Encyclo-* *Edwards,* 1967.
pedia of Philosophy, New York,
Macmillan, 1967.

Elton, William (ed.), *Aesthetics and* *Elton,* 1954.
Language, London, Blackwell, 1954.

Hook, Sidney (ed.), *Art and Phi-* *Hook,* 1966.
losophy: A Symposium, New York,
New York University Press, 1966.

Langer, Susanne K. (ed.), *Reflections* *Langer,* 1958.
on Art, Baltimore, Johns Hopkins
Press, 1958.

BIBLIOGRAPHIES

Albert, Ethel M., and Clyde Kluckholn, *A Selected Bibliography on Values, Ethics, and Esthetics in the Behavioral Sciences and Philosophy, 1935–1958*, New York, Fress Press, 1959.

Beardsley, Monroe C., *Aesthetics*, New York, Harcourt, Brace & World, 1958. Contains annotated bibliographies at the end of each chapter.

Beardsley, Monroe C., *Aesthetics from Classical Greece to the Present*, New York, Macmillan, 1966. Contains bibliographies on individuals and movements in the history of aesthetics.

Beardsley, Monroe C., "History of Aesthetics," in *Edwards*, 1967, vol. 1, pp. 18–35. See for bibliography of the history of art.

Chandler, Albert R., *A Bibliography of Experimental Aesthetics, 1865–1932*, Columbus, Ohio State University Press, 1933.

Coomaraswamy, Ananda K., *The Transformation of Nature in Art,* * New York, Dover, 1934. Contains a bibliography of works on oriental art and aesthetics.

Gayley, Charles M., and Fred N. Scott, *A Guide to the Literature of Aesthetics*, Berkeley, University of California Press, 1890.

Hammond, W. A., *A Bibliography of Aesthetics and of the Philosophy of Fine Arts from 1900–1932*, New York, McKay, 1934.

Hospers, John, "Problems of Aesthetics," in Paul Edwards, ed., *The Encyclopedia of Philosophy*, New York, Macmillan, 1967, vol. 1. See pp. 35–36 for bibliography.

Hungerland, Helmut, *Selected Bibliography for Aesthetics and Related Fields*. Published in each volume of the *Journal of Aesthetics and Art Criticism*.

Pratt, Carroll C., "Aesthetics," *Annual Review of Psychology*, *12* (1961). See pp. 71–92 for bibliography of works in the psychology of art.

Robb, David M., and J. J. Garrison, *Art in the Western World*, New York, Harper & Row, 1942. See for bibliography on the historical development of the arts.

Wollheim, Richard, *Art and Its Objects: An Introduction to Aesthetics,* * New York, Harper & Row, 1968. Contains an extensive annotated bibliography.

ANTHOLOGIES

Aschenbrenner, Karl, and Arnold Isenberg (ed.), *Aesthetic Theories: Studies in the Philosophy of Art*, Englewood Cliffs, N.J., Prentice-Hall, 1965.

Barrett, Cyril, S. J. (ed.), *Collected Papers on Aesthetics*, Oxford, Blackwell, 1965, and New York, Barnes & Noble, 1966.

Beardsley, Monroe C., and Herbert M. Schueller (ed.), *Aesthetic Inquiry: Essays on Art Criticism and the Philosophy of Art*, Belmont, Calif., Dickinson, 1967.

Carritt, E. F. (ed.), *Philosophies of Beauty from Socrates to Robert Bridges*, New York, Oxford University Press, 1931.

Coleman, Francis J. (ed.), *Contemporary Studies in Aesthetics*, New York, McGraw-Hill, 1968.

Elton, William (ed.), *Aesthetics and Language*, Oxford, Blackwell, 1954.

Hofstadter, Albert, and Richard Kuhns (ed.), *Philosophies of Art and Beauty*, New York, Modern Library, 1964.

Hook, Sidney (ed.), *Art and Philosophy*, New York, New York University Press, 1966.

Kennick, W. E. (ed.), *Art and Philosophy: Readings in Aesthetics*, New York, St. Martin's Press, 1964.

* Indicates paperback edition available.

Langer, Susanne K. (ed.), *Reflections on Art*,* Baltimore, Johns Hopkins Press, 1958, and New York, Oxford University Press, 1961.

Levich, Marvin (ed.), *Aesthetics and the Philosophy of Criticism*, New York, Random House, 1963.

Margolis, Joseph (ed.), *Philosophy Looks at the Arts*,* New York, Scribner, 1962.

Philipson, Morris (ed.), *Aesthetics Today*,* New York, Meridian, 1961.

Rader, Melvin (ed.), *A Modern Book of Esthetics*, 3rd ed., New York, Holt, Rinehart and Winston, 1960.

Sesonske, Alexander, *What Is Art?*, New York, Oxford University Press, 1965.

Stolnitz, Jerome (ed.), *Aesthetics*, New York, Macmillan, 1965.

Vivas, Eliseo, and Murray Krieger (ed.), *The Problems of Aesthetics*, New York, Holt, Rinehart and Winston, 1953.

Weitz, Morris (ed.), *Problems in Aesthetics*, New York, Macmillan, 1959.

GENERAL WORKS ON AESTHETICS

"Aesthetics," a short essay in *Western Philosophy and Philosophers*, ed. J. O. Urmson, New York, Hawthorn, 1960.

Aldrich, Virgil C., *Philosophy of Art*,* Englewood Cliffs, N.J., Prentice-Hall, 1963.

Alexander, Samuel, *Art and the Material*, London, Manchester University, 1925.

Alexander, Samuel, *Beauty and Other Forms of Value*, London, Macmillan, 1933.

Ames, Van Meter, "Existentialism and the Arts," *J.A.A.C.*, 9 (1951).

Ashmore, Jerome, *Santayana, Art and Aesthetics*, Cleveland, Ohio, Press of Western Reserve University, 1966.

Ballard, Edward C., *Art and Analysis*, The Hague, Martinus Nijhoff, 1957.

Baudelaire, Charles, *The Mirror of Art*, New York, Phaidon, 1955.

Beardsley, Monroe C., *Aesthetics: Problems in the Philosophy of Criticism*, New York, Harcourt, Brace & World, 1958.

Birkhoff, George David, *Aesthetic Measure*, Cambridge, Mass., Harvard University Press, 1933.

Bosanquet, B., *Three Lectures on Aesthetics*,* London, Allen & Unwin, 1934, and New York, Liberal Arts Press, 1963.

Bossart, William H., "Heidegger's Theory of Art," *J.A.A.C.*, 27 (1968).

Buermeyer, Laurence, *The Esthetic Experience*, Merion, Pa., Barnes Foundation, 1924.

Bullough, Edward, *Aesthetics: Lectures and Essays*, ed. Elizabeth Wilkinson, California, Stanford University Press, 1957.

Capitan, W. H., and D. D. Merrill, *Art, Mind and Religion*, Pittsburgh, University of Pittsburgh Press, 1967.

Carritt, E. F., *An Introduction to Aesthetics*, London, Hutchinson's University Library, 1949.

Carritt, E. F., *The Theory of Beauty*, 3rd ed., London, Methuen, 1928, and New York, Barnes & Noble, 1962.

Carritt, E. F., *What Is Beauty?*, Oxford, Clarendon Press, 1932.

Chaudhury, Pravaijivan, *Studies in Comparative Aesthetics*, Santiniketan, Santiniketan Press, 1953.

Coleridge, Samuel Taylor, *Aesthetical Essays*, ed. J. Shawcross, Oxford, Clarendon Press, 1907.

Collingwood, R. G., *Essays in the Philosophy of Art*,* ed. Alan Donagan, Bloomington, Indiana University Press, 1964.

Collingwood, R. G., *Outlines of a Philosophy of Art*, London, Oxford University Press, 1925.

Collingwood, R. G., *The Principles of Art*,* Oxford, Clarendon Press, 1938, and New York, Oxford University Press, 1938.

Ducasse, Curt J., *Art, the Critics, and You*,* New York, Oskar Piest, 1944, and Indianapolis, Bobbs-Merrill, 1955.

Ducasse, Curt J., *The Philosophy of Art*, New York, Dial Press, 1929; rev. ed.,* New York, Dover, 1963.

Dudley, Louise, and Austin Faricy, *The Humanities; Applied Aesthetics*, 3rd. ed., New York, McGraw-Hill, 1960.

Edman, Irwin, *Arts and the Man*,* New York, Norton, 1939.

Fallico, A. B., *Art and Existentialism*,* Englewood Cliffs, N.J., Prentice-Hall, 1962.

Gauss, Charles Edward, *The Aesthetic Theories of French Artists, 1855 to the Present*,* Baltimore, Johns Hopkins Press, 1950.

Ghiselin, Brewster (ed.), *The Creative Process*,* New York, Mentor (New American Library), 1955.

Gilbert, K. E., *Studies in Recent Aesthetic*, Chapel Hill, University of North Carolina Press, 1927.

Gilson, Etienne, *The Arts of the Beautiful*, New York, Scribner, 1965.

Gombrich, E. H., *Meditations on a Hobby Horse and Other Essays on the Theory of Art*, New York, Phaidon, 1963.

Greene, Theodore M., *The Arts and the Art of Criticism*, Princeton, N.J., Princeton University Press, 1952.

Griggs, E. H., *The Philosophy of Art*, New York, Huebsch, 1913.

Harries, Karsten, *The Meaning of Modern Art: A Philosophical Interpretation*, Evanston, Ill., Northwestern University Press, 1968.

Hauser, Arnold, *The Philosophy of Art History*,* New York, Knopf, 1959, and New York, Meridian.

Heidegger, Martin, "The Origin of the Work of Art," in *Philosophies of Art and Beauty*, ed. A. Hofstadter and R. Kuhns, New York, Random House, 1964.

Heyl, B., *New Bearings in Aesthetics and Art Criticism*, New Haven, Conn., Yale University Press, 1943.

Hirn, Yrjö, *The Origins of Art*, London, Macmillan, 1900.

Hofstadter, Albert, *Truth and Art*, New York and London, Columbia University Press, 1965.

Jaeger, Hans, "Heidegger and the Work of Art," *J.A.A.C.*, 20 (1962).

Jarrett, James L., *The Quest for Beauty*, Englewood Cliffs, N.J., Prentice-Hall, 1957.

Jenkins, I., *Art and the Human Enterprise*, Cambridge, Mass., Harvard University Press, 1958.

Kaelin, Eugene, *An Existentialist Aesthetic: The Theories of Sartre and Merleau-Ponty*, Madison, Wisc., University of Wisconsin, 1962.

Kainz, Friedrich, *Aesthetics, the Science*, trans. with an introduction by Herbert M. Schueller, Detroit, Wayne State University, 1962.

Kallen, Horace Meyer, *Art and Freedom*, 2 vols., New York, Duell, Sloan and Pearce, 1942.

Kuhn, Helmut, "History of Aesthetics," *The Encyclopaedia Britannica*, Vol. 1, Chicago, Encyclopaedia Britannica, Inc., 1963.

Lang, Berel, "The Form of Aesthetics," *J.A.A.C.*, 27 (1968).

Langer, Susanne K., *Feeling and Form: A Theory of Art*,* New York, Scribner, 1956.

Langer, Susanne K., *Philosophy in a New Key: A Study in the Symbolism of Reason, Rite and Art*,* Cambridge, Mass., Harvard University Press, 1942, and New York, New American Library.

Langer, Susanne K., *Problems of Art*,* New York, Scribner, 1957.

Langfeld, H. S., *The Aesthetic Attitude*, New York, Harcourt, Brace & World, 1920.

Lipman, Matthew, *What Happens in Art?*, New York, Appleton-Century-Crofts, 1967.

McMahon, Philip, *Preface to an American Philosophy of Art*, Chicago, University of Chicago Press, 1945.

Malraux, André, *The Voices of Silence*, Garden City, N.Y., Doubleday, 1953.

Margolis, Joseph, *The Language of Art and Art Criticism*, Detroit, Wayne State University Press, 1965.

Maritain, Jacques, *Creative Intuition in Art and Poetry*,* New York, Pantheon, 1953, and New York, Meridian, 1955.

Maritain, Jacques, *The Philosophy of Art*, trans. J. O'Connor, Ditchling, St. Dominic's Press, 1923.

Marshall, H. R., *Aesthetic Principles*, New York, Macmillan, 1895.

Marshall, H. R., *Pain, Pleasure and Aesthetics*, London, Macmillan, 1894.

Mead, Hunter, *An Introduction to Aesthetics*, New York, Ronald Press, 1952.

Millard, Alfred, *Aspects of Art and Philosophy*, New York, Exposition Press, 1960.

Morris, Bertram, *The Aesthetic Process*,* Evanston, Ill., Northwestern University Press, 1943.

Munro, Thomas, "Aesthetics," *The Encyclopaedia Britannica*, Vol. 1, Chicago, Encyclopaedia Britannica, Inc., 1963.

Munro, Thomas, *The Arts and Their Interrelations*, Cleveland, Ohio, Press of Western Reserve University, 1949.

Munro, Thomas, *Toward Science in Aesthetics*, New York, Liberal Arts Press, 1956.

Nahm, Milton C., *Aesthetic Experience and Its Presuppositions*, New York, Russell & Russell, 1946.

Nahm, Milton C., *The Artist as Creator*, Baltimore, Johns Hopkins Press, 1956.

Odgen, C. K., I. A. Richards, and James Wood, *The Foundations of Aesthetics*, London, Allen & Unwin, 1925.

Osborne, Harold, *Aesthetics and Criticism*, London, Routledge, 1955.

Osborne, Harold, *Theory of Beauty*, London, Routledge, 1952.

Parker, DeWitt, *The Analysis of Art*, New Haven, Conn., Yale University Press, 1926.

Parker, DeWitt, *The Principles of Aesthetics*, New York, Appleton-Century-Crofts, 1946.

Pepper, Stephen C., *Aesthetic Quality: A Contextualist Theory of Beauty*, New York, Scribner, 1938.

Pepper, Stephen C., *Principles of Art Appreciation*, New York, Harcourt, Brace & World, 1949.

Pepper, Stephen C., *The Work of Art*, Bloomington, University of Indiana Press, 1955.

Prall, D. W., *Aesthetic Analysis*,* New York, Crowell, 1936.

Prall, D. W., *Aesthetic Judgment*,* New York, Crowell, 1929.

Read, Herbert, *Art and Society*,* London, Macmillan, 1937, and New York, Schocken, 1966.

Read, Herbert, *The Forms of Things Unknown: Essays Towards an Aesthetic Philosophy*, New York, Horizon Press, 1960.

Read, Herbert, *The Grass Roots of Art*, London, Faber & Faber, 1955.

Read, Herbert, *Icon and Idea: The Function of Art in the Development of Human Consciousness*, Cambridge, Mass., Harvard University Press, 1955.

Reid, L. A., *A Study in Aesthetics*, New York, Macmillan, 1931.

Reitlinger, Gerald, *The Economics of Taste*, London, Barrie & Rockliff, 1961.

Richards, I. A., *The Foundations of Aesthetics*, New York, International Publishers, 1929.

Robb, David M., and J. J. Garrison, *Art in the Western World*, New York, Harper & Row, 1942.

Rowland, Benjamin, Jr., *Art in East and West: An Introduction Through Comparison,** Cambridge, Mass., Harvard University Press, 1954, and Boston, Beacon Press, 1964.

Runes, Dagobert D., and Harry G. Schrickel, *Encyclopedia of the Arts*, New York, Philosophical Library, 1946.

Santayana, George, *Reason in Art,** New York, Scribner, 1922, and New York, Macmillan, 1962.

Santayana, George, *The Sense of Beauty,** New York, Scribner, 1896; also in various paperback editions.

Sartre, Jean-Paul, *Essays in Aesthetics*, New York, Philosophical Library, 1963.

Schoen, Max, *Art and Beauty*, New York, Macmillan, 1932.

Sparshott, F. E., *The Structure of Aesthetics*, London, Routledge, 1963, and Toronto, University of Toronto Press, 1963.

Steegman, John, *Consort of Taste*, London, Sidgwick & Jackson, 1950.

Steegman, John, *The Rule of Taste*, London, Macmillan, 1936.

Stolnitz, Jerome, *Aesthetics and the Philosophy of Art Criticism*, Boston, Houghton Mifflin, 1960.

Tejera, Victorino, *Art and Human Intelligence*, New York, Appleton-Century-Crofts, 1965.

Torossian, Aram, *A Guide to Aesthetics*, Stanford, Calif., Stanford University Press, 1937.

Veron, Eugene, *Aesthetics*, trans. W. H. Armstrong, London, Library of Contemporary Science, 1879.

Vivas, Eliseo, *Creation and Discovery,** Chicago, Regnery, 1965.

Weiss, Paul, *The World of Art,** Carbondale, Southern Illinois University Press, 1961.

Weitz, Morris, *Philosophy of the Arts*, New York, Russell & Russell, 1950.

Whitehead, Alfred North, *Adventures of Ideas,** New York, Free Press, 1933, pp. 306–315, 324–340.

Wittgenstein, Ludwig, *Lectures and Conversations on Aesthetics, Psychology and Religion,** ed. Cyrill Barrett, London, Blackwell, 1966, and Berkeley, University of California Press, 1967.

Wölfflin, Heinrich, *Principles of Art History,** New York, Dover, 1950.

Wollheim, Richard, *Art and Its Objects: An Introduction to Aesthetics,** New York, Harper & Row, 1968.

Ziff, Paul, *Philosophic Turnings: Essays in Conceptual Appreciation*, Ithaca, N.Y., Cornell University Press, and London, Oxford University Press, 1966.

HISTORY OF AESTHETICS

Anderson, Howard, and John S. Shea, *Studies in Criticism and Aesthetics 1660–1800*, Minneapolis, University of Minnesota Press, and London, Oxford University Press, 1967.

Anderson, John M., "Art or History?," *J.A.A.C.*, 25 (1967).

Anderson, Wayne V., "A Neglected Theory of Art History," *J.A.A.C.*, 20 (1962).

Bate, Walter Jackson, *From Classic to Romantic: Premises of Taste in Eighteenth-Century England,** Cambridge, Mass., Harvard University Press, 1946, and New York, Harper & Row, 1961.

Bayer, Raymond, "Recent Aesthetic Thought in France," in *Philosophic Thought in France and the United States*, ed. M. Farber, Buffalo, N.Y., University of Buffalo, 1950.

Beardsley, Monroe C., *Aesthetics from Classical Greece to the Present*, New York, Macmillan, 1966.

Berenson, Bernard, *Aesthetics and History,** Garden City, N.Y., Doubleday, 1954.

Bosanquet, B., *A History of Aesthetic*,* London, Allen & Unwin, 1934.

Cassirer, Ernst, *The Philosophy of the Enlightenment*,* Boston, Beacon Press, 1955. See chap. 1 for the aesthetics of the eighteenth century.

Chambers, Frank P., "The History of Art and the History of Taste," *B.J.A.*, *3* (1963).

Dessoir, Max, "Art History and Systematic Theories of Art," *J.A.A.C.*, *19* (1961).

Egan, Rose Francis, *The Genesis of the Theory of "Art for Art's Sake" in Germany and England*, Northampton, Mass., Smith College Studies, 1961.

Egbert, Donald D., "English Art Critics and Modern Social Radicalism," *J.A.A.C.*, *26* (1967).

Focillon, Henry, *The Life of Forms in Art*,* 2nd English ed., New York, Wittenborn, 1948.

Gauss, Charles Edward, *The Aesthetic Theories of French Artists*,* Baltimore, Johns Hopkins Press, and London, Oxford University Press, 1967.

Giedion, S., *The Beginnings of Art*, Bollingren Foundation, London, Oxford University Press, 1963.

Gilbert, K. E., and H. Kuhn, *A History of Aesthetics*, New York, Macmillan, 1939.

Gombrich, E. H., "Evolution in the Arts," *B.J.A.*, *4* (1964).

Hall, Vernon, *Renaissance Literary Criticism*, New York, Columbia University Press, 1945.

Harrison, Jane Ellen, *Ancient Art and Ritual*, New York, Holt, Rinehart and Winston, 1951.

Hauser, Arnold, *The Philosophy of Art History*,* New York, Knopf, 1959.

Hauser, Arnold, *Social History of Art*,* 4 vols., London, Routledge, 1951, and New York, Vintage (Random House).

Hipple, Walter John, *The Beautiful, the Sublime and the Picturesque in Eighteenth Century British Aesthetic Theory*, Carbondale, Southern Illinois University Press, 1957.

Holt, Elizabeth Gilmore (ed.), *A Documentary History of Art*,* vol. 1, Garden City, N.Y., Anchor (Doubleday), 1957.

Holt, Elizabeth Gilmore, *Literary Sources of Art History*, Princeton, N.J., Princeton University Press, 1947.

Johnson, James R., "Art History and the Immediate Visual Experience," *J.A.A.C.*, *19* (1961).

Knight, W. A., *The Philosophy of the Beautiful*, New York, Scribner, 1891.

Kristeller, Paul O., "The Modern System of the Arts," *J. Hist. Ideas*, *12* (1951), and *13* (1952).

Landlow, George P., "Ruskin's Refutation of 'False Opinions Held Concerning Beauty,'" *B.J.A.*, *8* (1968).

Lazerowitz, Morris, "Moore and Philosophical Analysis," *Phil.*, *33* (1958).

Listowel, Earl of, *A Critical History of Modern Aesthetics*, London, Allen & Unwin, 1933.

McKeon, Richard, "Literary Criticism and the Concept of Imitation in Antiquity," *Mod. Phil.*, *34* (1936).

Margolis, Joseph, "Recent Work in Aesthetics," *Am. P. Q.*, *2* (1965).

Marshall, H. R., "Some Modern Aestheticians," *Mind*, *29* (1920).

Mathew, Gervase, *Byzantine Aesthetics*, New York, Viking Press, 1963.

Michelis, P. A., "Comment on Gervase Mathew's 'Byzantine Aesthetics,'" *B.J.A.*, *4* (1964).

Mundt, Ernest K., "Three Aspects of German Aesthetic Theory," *J.A.A.C.*, *17* (1959).

Munro, Thomas, "Do the Arts Evolve? Some Recent Conflicting Answers," *J.A.A.C.*, *19* (1967).

Munro, Thomas, *Evolution in the Arts*, Ohio, Cleveland Museum of Art, Case Western University Press, 1963.

Munro, Thomas, "The Marxist Theory of Art History," *J.A.A.C.*, *18* (1960).

Munro, Thomas, "What Causes Creative Epochs in the Arts?," *J.A.A.C.*, *21* (1962).

Panofsky, Erwin, "The History of Art as a Humanistic Discipline," in T. M. Greene, ed., *The Meaning of the Humanities*, Princeton, N.J., Princeton University Press, 1940.

Pratt, C. C., "Aesthetics," *Ann. R. Psych.*, *12* (1961).

Rader, Melvin, "Art and History," *J.A.A.C.*, *26* (1967).

Rieser, Max, "Contemporary Aesthetics in Poland," *J.A.A.C.*, *20* (1962).

Rieser, Max, "Russian Aesthetics Today and Their Historical Background," *J.A.A.C.*, *22* (1963).

Saisselin, Remy G., "Critical Reflections on the Origins of Modern Aesthetics," *B.J.A.*, *4* (1964).

Schaper, Eva, "The 'History of Art' and the 'History of Taste,'" *B.J.A.*, *3* (1963).

Schon, Donald A., *Invention and the Evolution of Ideas,** London, Tavistock, 1963, and New York, Barnes & Noble, 1967.

Tatarkiewicz, W., "The Classification of the Arts in Antiquity," *J. Hist. Ideas*, *24* (1963).

Tatarkiewicz, W., "Objectivity and Subjectivity in the History of Aesthetics," *Phil. and Phen. R.*, *24* (1963).

Venturi, Lionello, *History of Art Criticism,** New York, Dutton, 1936.

Warry, J. G., *Greek Aesthetic Theory*, London, Methuen, 1962.

Weitz, Morris, "Aesthetics in English-speaking Countries," in Raymond Klibansky, ed., *Philosophy in Mid-century: A Survey*, vol. 3, Firenze, Nuova Italia, 1958.

Wellek, René, *A History of Modern Criticism: 1750–1950*, vol. 2, New Haven, Conn., Yale University Press, 1955.

Wilcox, John, "The Beginning of l'art pour l'art," *J.A.A.C.*, *11* (1952).

PLATO

Principal Works

Plato, *The Collected Dialogues*, ed. Edith Hamilton and Huntington Cairns, New York, Pantheon, 1961.

Plato, *Dialogues*, 4th ed., trans. B. Jowett, Oxford, Clarendon Press, 1953, and New York, Random House, 1937.

General Works

Bosanquet, Bernard, *A Companion to Plato's Republic*, London, Rivingtons, 1906.

Cooper, Lane, *Plato*, Ithaca, N.Y., Cornell University Press, 1941.

Crombie, I. M., *An Examination of Plato's Doctrines*, vol. 1, New York, Humanities Press, and London, Routledge, 1962.

Demos, Raphael, *The Philosophy of Plato*, New York, Scribner, 1939.

Grube, G. M. A., *Plato's Thought,** London, Methuen, 1935, and Boston, Beacon Press, 1958.

Hardie, W. F. R., *A Study in Plato*, Oxford, Clarendon Press, 1936.

Havelock, Eric A., *Preface to Plato,** London, Blackwell, 1963, and New York, Grosset & Dunlap, 1967.

Lodge, Rupert C., *Plato's Theory of Art*, New York, Humanities Press, 1953.

More, Paul Elmer, *The Religion of Plato*, Princeton, N.J., Princeton University Press, 1921.

Read, Herbert, *Education for Peace*, New York, Scribner, 1949, chap. 6.

Ryle, Gilbert, "Plato," in *Edwards*, 1967, vol. 6, pp. 314–333.

Ryle, Gilbert, *Plato's Progress*, London, Cambridge University Press, 1966.

Shorey, Paul, *Platonism, Ancient and Modern*, Berkeley, University of California Press, 1938.

Shorey, Paul, *The Unity of Plato's Thought*, University of Chicago Decennial Pub-
 lications, University of Chicago Press, 1903.
Shorey, Paul, *What Plato Said*,* Chicago, University of Chicago Press, 1933.
Stewart, J. A., *Plato's Doctrine of Ideas*, Oxford, Clarendon Press, 1909.
Taylor, A. E., *A Commentary on Plato's Timaeus*, Oxford, Clarendon Press, 1928.
Taylor, A. E., *Plato: The Man and His Work*, New York, Dial Press, 1927.
Venturi, Lionello, *History of Art Criticism*,* New York, Dutton, 1936, chap. 2.
Warry, J. G., *Greek Aesthetic Theory*, New York, Barnes & Noble, 1962, chaps.
 1–4.
Zeller, E., *Plato and the Older Academy*, New York, Russell & Russell, 1962.
 (Originally published in 1876.)

Special Studies

Anderson, F. H., "Plato's Asethetics Reconsidered," *University of Toronto Quarterly*,
 25 (1956).
Broos, A. F. M., "Plato and Art," *Mnemosyne*, 4th series, *4* (1951).
Collingwood, R. G., "Plato's Philosophy of Art," *Mind*, n.s., *34* (1925).
Ferguson, A. S., "Plato and the Poets ΕΙΚΑΣΙΑ," *Philosophical Essays Presented to
 John Watson*, Kingston, Canada, Queen's University, 1922.
Frank, Erich, "The Fundamental Opposition of Plato and Aristotle," *Am. J. of
 Philology*, *61* (1940).
Gilbert, Katherine, "The Relation of the Moral to the Aesthetic Standard in Plato,"
 Phil. R., *43* (1934).
Green, W. C., "Plato's View of Poetry," *Harvard Studies*, I, *29* (1918).
Grey, D. R., "Art in the Republic," *Phil.*, *27* (1952).
Grube, G. M. A., "Plato's Theory of Beauty," *Monist*, *37* (1927).
Huby, Pamela M., "Socrates and Plato," in D. J. O'Connor, ed., *A Critical History
 of Western Philosophy*, New York, Free Press, 1964.
La Driere, Craig, "The Problem of Plato's Ion," *J.A.A.C.*, *10* (1951).
McKeon, Richard, "Literary Criticism and the Concept of Imitation in Antiquity,"
 Mod. Philology, *24* (1936).
Paton, H. J., "Plato's Theory of ΕΙΚΑΣΙΑ," *P.A.S. Supp. Vol.*, *22* (1922).
Ranta, Jerrald, "The Drama of Plato's *Ion*," *J.A.A.C.*, *26* (1967).
Rucker, Darnell, "Plato and the Poets," *J.A.A.C.*, *25* (1966).
Schipper, Edith Watson, "Mimesis in the Arts in Plato's *Laws*," *J.A.A.C.*, *22*
 (1963).
Tate, J., "Imitation in Plato's Republic," *Classical Quarterly*, *22* (1928).
Tate, J., "Plato and 'Imitation,'" *Classical Quarterly*, *26* (1932).

ARISTOTLE

Principal Works

Aristotle, *Basic Works of Aristotle*, ed. R. McKeon, New York, Random House,
 1941.
Aristotle, *Poetics:* Butcher, S. H. *Aristotle's Theory of Poetry and Fine Arts*,*
 4th ed., London, Macmillan, 1923, and New York, Dover, 1951.
Aristotle, *Poetics:* Bywater, Ingram, *Aristotle on the Art of Poetry*, Oxford,
 Clarendon Press, 1909.
Aritotle, *Poetics:* Cooper, Lane, *The Poetics of Aristotle*, Boston, Marshall Jones,
 1923.
Aristotle, *Poetics:* Else, Gerald Frank, *Aristotle's Poetics: The Argument*, Cam-
 bridge, Mass., Harvard University Press, 1957.
Aristotle, *Politics:* Newman, W. L., *The Politics of Aristotle*, Oxford, Clarendon
 Press, 1924.
Aristotle, *Rhetoric*, trans. J. H. Freese, London, Loeb Library, 1939.

Aristotle, *The Works of Aristotle*, ed. W. D. Ross, Oxford, Clarendon Press, 1910–1952.

General Works

Allan, D. J., *The Philosophy of Aristotle*, London and New York, Oxford University Press, 1952.

Brightfield, M. F., *The Issues of Literary Criticism*, Berkeley, University of California Press, 1932.

Cooper, Lane, *An Aristotelian Theory of Comedy*, New York, Harcourt, Brace & World, 1922.

Cooper, Lane, *The Poetics of Aristotle: Its Meaning and Influence*, New York, McKay, 1927.

Cooper, Lane, and A. Gudeman, *A Bibliography of the Poetics of Aristotle*, New Haven, Conn., Yale University Press, 1928.

Kerferd, G. F., "Aristotle," in *Edwards*, 1967, vol. 1, pp. 151–162.

Mure, G. R. G., *Aristotle*,* London, E. Benn, 1932, and New York, Oxford University Press, 1964.

O'Connor, D. J., "Aristotle," in D. J. O'Connor, ed., *A Critical History of Western Philosophy*, New York, Free Press, 1964.

Randall, John Herman, *Aristotle*,* New York, Columbia University Press, 1960, chap. 13.

Ross, W. D., *Aristotle*, New York, Scribner, 1924, chap. 9.

Taylor, A. E., *Aristotle*, rev. ed.,* New York, Dover, 1956.

Warry, J. G., *Greek Aesthetic Theory*, New York, Barnes & Noble, 1962, chaps. 5–8.

Whitney, J. Oates, *Aristotle and the Problem of Value*, Princeton, N.J., Princeton University Press, 1963, chap. 8.

Zeller, E., *Aristotle and the Earlier Peripatetics*, 2 vols., New York, Russell & Russell, 1962. (Originally published in London, 1897.)

Special Studies

Benn, A. W., "Aristotle's Theory of Tragic Emotion," *Mind*, n.s., *23* (1914).

Else, G. F., "Aristotle on the Beauty of Tragedy," *Harvard Studies in Classical Philology*, *49* (1938).

Gilbert, A. H., "The Aristotelian Catharsis," *Phil. R.*, *35* (1926).

Gilbert, Katherine, "Aesthetic Imitation and Imitators in Aristotle," *Phil. R.*, *45* (1936).

Hardie, R. P., "The Poetics of Aristotle," *Mind*, *4* (1895).

Ingarden, Roman, "A Marginal Commentary on Aristotle's Poetics," *J.A.A.C.*, *19* (1961).

Langbaum, R., "Aristotle and Modern Literature," *J.A.A.C.*, *15* (1955).

McKeon, Richard P., "Literary Criticism and the Concept of Imitation in Aristotle," *Mod. Philology*, *34* (1936).

Marshall, John S., "Art and Aesthetic in Aristotle," *J.A.A.C.*, *12* (1953).

Preston, Raymond, "Aristotle and the Modern Literary Critic," *J.A.A.C.*, *21* (1962).

PLOTINUS

Principal Works

Plotinus, *The Enneads of Plotinus*, 3rd ed., trans. Stephen McKenna, London, Faber & Faber, 1956; also 2nd ed., New York, Pantheon, 1957.

Plotinus, *The Philosophy of Plotinus* (representative books from *The Enneads*), selected and translated by Joseph Katz, New York, Appleton-Century-Crofts, 1950.

Plotinus, *Plotinus** (selections), ed. A. H. Armstrong, London, Allen & Unwin, 1953, and New York, Collier (Macmillan), 1962.

General Works

Armstrong, A. H., *The Architecture of the Intelligible Universe in the Philosophy of Plotinus*, London, Cambridge University Press, 1940.
Bigg, C., *Neoplatonism*, London, Society for Promoting Christian Knowledge, and New York, E. & J. B. Young, 1895.
Bosanquet, B., *History of Aesthetics*, London, G. Allen, 1892, and New York, Macmillan, 1934, chap. 5.
Brehier, Emile, *The Philosophy of Plotinus*, trans. Joseph Thomas, Chicago, University of Chicago Press, 1958.
Inge, W. R., *The Philosophy of Plotinus*, 2 vols., London and New York, Longmans, 1948.
Katz, Joseph, *Plotinus' Search for the Good*, New York, King's Crown Press, 1950.
Mackenna, Stephan, *Plotinus*, London, The Medici Society, Ltd., 1917–1926.
Pistorius, Philippus V., *Plotinus and Neoplatonism*, London, Cambridge University Press, 1952, chap. 7.
Robb, Nesca A., *Neoplatonism of the Italian Renaissance*, London, G. Allen, 1935.
Tonelli, Giorgio, "Plotinus," in *Edwards*, 1967, vol. 6, pp. 351–359.
Whittaker, Thomas, *The Neo-Platonists*, London, Cambridge University Press, 1918.

Special Studies

Anton, P., "Plotinus' Conception of the Functions of the Artist," *J.A.A.C.*, *26* (1967).
Anton, P., "Plotinus' Refutation of Beauty as Symmetry," *J.A.A.C.*, *23* (1964).
Bredvold, Louis I., "The Tendency Towards Neoplatonism in Neoclassical Esthetics, *J. of English Literary History*, *1* (1934).

AUGUSTINE AND MEDIEVAL THEORIES OF ART

Principal Works

Augustine, St., *Basic Writings*, ed. W. J. Oates, New York, Random House, 1948.
Augustine, St., *A Select Library of the Nicene and Post Nicene Fathers of the Christian Church*, ed. P. Schaff, New York, Christian Literature, 1886–1890.
Augustine, St., *The Summa Theologica*, 2nd ed., trans. Dominican Fathers, New York, Benziger Brothers, 1927.
Chapman, E., *St. Augustine's Philosophy of Beauty*, New York, Sheed & Ward, 1939. Passages from Augustine's writings on Aesthetics.
Gilby, T., *St. Thomas Aquinas: Philosophical Texts,** London and New York, Oxford University Press, 1952; 1960.
Pegis, A., *Basic Writings of St. Thomas Aquinas*, 2 vols., New York, Random House, 1945.

General Studies

Baldwin, C. S., *Medieval Rhetoric and Poetic*, New York, Macmillan, 1928.
Barrett, Cyril, "An Introduction to St. Thomas Aquinas," *B.J.A.*, *2* (1962).
Barrett, Cyril, "Medieval Art Criticism," *B.J.A.*, *5* (1965).
Battenhouse, R. W., *et al.*, *A Companion to the Study of Saint Augustine*, New York, Oxford University Press, 1955.
Bourke, Vernon J., "Aquinas," in *Edwards*, 1967, vol. 8, pp. 105–115.
Bunley, M. W., "The Theory of Imagination in Classical and Medieval Thought," Carbondale, *University of Illinois Studies in Language and Literature 12* (1927).

Callahan, J. L., *A Theory of Aesthetic According to the Principles of St. Thomas Aquinas*, Washington, D.C., Catholic University of America, 1927.

Chesterton, G. K., *Saint Thomas Aquinas*,* Garden City, N.Y., Image Books (Doubleday), 1957.

Copleston, F. C., *Aquinas*,* Harmondsworth, Middlesex, 1955, and Baltimore, Penguin, 1965.

Evans, V. Burdwood, "A Scholastic Theory of Art," *Phil.*, 8 (1933).

Frank, Erich, *St. Augustine and Greek Thought*, Cambridge, Eng., The Augustinean Society, 1942.

Gilson, E. H., *The Christian Philosophy of Saint Augustine*,* trans. L. E. M. Lynch, New York, Random House, 1960.

Gilson, E. H., *Painting and Theory*, London, Routledge, and New York, Pantheon, 1958.

Gilson, E. H., *The Philosophy of St. Bonaventure*, trans. Don Illtyd Trethowan and F. J. Sheed, London, Sheed & Ward, 1940.

Gilson, E. H., *The Philosophy of St. Thomas Aquinas*, Cambridge, Eng., W. Heffer & Sons, 1929.

Grabman, M., *Thomas Aquinas*, New York, McKay, 1928.

Little, A. G., *The Platonic Heritage of Thomism*, Dublin, 1949.

McKeon, R., "Rhetoric in the Middle Ages," *Spectrum*, 17 (1942).

Maritain, Jacques, *Art and Scholasticism*,* New York, Scribner, 1962.

Markus, R. A., "Augustine," in D. J. O'Connor, ed., *A Critical History of Western Philosophy*, New York, Free Press, 1964, pp. 79–97.

Markus, R. A., "Augustine," in *Edwards*, 1967, vol. 1, pp. 198–207.

Marrou, H. I., *Saint Augustine and His Influence Through the Ages*, New York, Harper & Row, 1960.

Noon, William T., *Joyce and Aquinas*, New Haven, Conn., Yale University Press, 1957.

Pegis, A., *Introduction to St. Thomas Aquinas*, New York, Modern Library, 1948.

Tolley, W. P., *The Idea of God in the Philosophy of St. Augustine*, New York, Richard R. Smith, 1930.

Tranoy, Knut, "Aquinas," in D. J. O'Connor, ed., *A Critical History of Western Philosophy*, New York, Free Press, 1964, pp. 98–123.

Special Studies

Markus, R. A., "St. Augustine on Signs," *Phronesis*, 2 (1957).

Mazzeo, Joseph A., "The Augustinean Conception of Beauty and Dante's Convivio," *J.A.A.C.*, 15 (1957).

Meyer-Baer, Kathi, "Psychologic and Ontologic Ideas in Augustine's de Musica," *J.A.A.C.*, 11 (1953).

Perl, Carl Johann, "Augustine and Music," *Musical Quarterly*, 41 (1955).

Phelan, Gerald, "The Concept of Beauty in St. Thomas," in Charles A. Hart, ed., *Aspects of the New Scholastic Philosophy*, New York, Benziger Brothers, 1932.

HUME AND EIGHTEENTH-CENTURY ENGLISH AESTHETICS

Principal Works

Hume, David, *Essays: Moral, Political and Literary*, ed. T. H. Greene and T. H. Grose, London, Longmans, 1882.

Hume, David, *Inquiry Concerning the Principles of Morals*, La Salle, Ill. Open Court, 1953.

Hume, David, "Of Tragedy," in *Essays, op. cit.*

Hume, David, *Treatise of Human Nature*, ed. L. A. Selby-Bigge, Oxford, Clarendon Press, 1888; new edition, 1960.

Alison, A., *Essays on the Nature and Principles of Taste*, 4th ed., 2 vols., Edinburgh, Constable, and London, Longmans, 1815.

Burke, Edmund, *A Philosophical Inquiry into the Origin of Our Ideas of the Sublime and Beautiful*, ed. J. T. Boulton, New York, Columbia University Press, 1958.

Hogarth, W., *The Analysis of Beauty*, ed. J. Burke, Oxford, Clarendon Press, 1955.

Hutcheson, F., *An Inquiry into the Origin of Our Ideas of Beauty and Virtue*, 4th ed., London, Midwinter, 1738.

Reid, Thomas, *Works*, ed. Sir W. Hamilton, Edinburgh, Maclachlan and Stewart, 1880.

Reynolds, Sir J., *Literary Works*, ed. E. Malone, London, H. G. Bahm, 1819; 1855.

Shaftesbury, Anthony, Earl of, *Characteristics of Men, Manners, Opinions, Times,** ed. J. M. Robertson, London, G. Richards, 1900, and Indianapolis, Bobbs-Merrill, 1964.

General Works

Bate, Walter Jackson, *From Classical to Romantic: Premises of Taste in Eighteenth Century England,** Cambridge, Mass., Harvard University Press, 1946, and New York, Harper & Row Torchbooks, 1961.

Brett, R. L., "The Aesthetic Sense and Taste in the Literary Criticism of the Early Eighteenth Century," *Rev. of English Studies*, 20 (1944).

Flew, A. G. N., "Hume," in D. J. O'Connor, ed., *A Critical History of Western Philosophy*, New York, Free Press, 1964.

Hipple, Walter John, *The Beautiful, the Sublime, and the Picturesque in Eighteenth Century British Aesthetic Theory*, Carbondale, Southern Illinois University, 1957.

MacNabb, D. G. C., "Hume," in *Edwards*, 1967, vol. 4, pp. 74–90.

Monk, Samuel Holt, *The Sublime: A Study of Critical Theories in Eighteenth Century England,** Ann Arbor, University of Michigan, 1960.

Needham, H. A., *Taste and Criticism in the Eighteenth Century*, London, Harrap, 1952.

Stolnitz, J., " 'Beauty': Some Stages in the History of Ideas," *J. Hist. Ideas*, 22 (1961).

Stolnitz, J., "On the Origins of 'Aesthetic Disinterestedness,' " *J.A.A.C.* 20 (1921).

Special Studies

Brunius, Teddy, *David Hume on Criticism*, Stockholm, Almqvist & Witsell, 1952.

Cohen, R., "David Hume's Experimental Method and the Theory of Taste," *J. of English Literary History*, 25 (1958).

Kallich, David, "The Associationist Criticism of Francis Hutcheson and David Hume," *Studies in Phil.*, 43 (1946).

Kivy, Peter, "Hume's Standard of Taste," *B.J.A.*, 7 (1967).

Noxon, James, "Hume's Opinion of Critics," *J.A.A.C.*, 20 (1961).

Osborne, Harold, "Hume's Standard and the Diversity of Taste," *B.J.A.*, 7 (1967).

Robbins, David O., "The Aesthetics of Thomas Reid," *J.A.A.C.*, 1 (1942).

Stolnitz, J., "Locke and the Categories of Value in Eighteenth Century British Aesthetic Theory," *Phil.*, 38 (1963).

Stolnitz, J., "On the Significance of Lord Shaftesbury in Modern Aesthetic Theory," *Phil. Q.*, 11 (1961).

Wector, Dixon, "Burkes's Theory of Words, Images, and Emotions," *PMLA*, 55 (1940).

KANT

Principal Works

Kant, Immanuel, *Analytic of the Beautiful,** trans. Walter Cerf, Indianapolis, Bobbs-Merrill, 1963.

Kant, Immanuel, *Critique of Judgment*,* trans. J. H. Bernard, New York, Hafner, 1951.

Kant, Immanuel, *Observations on the Feeling of the Beautiful and Sublime*,* Berkeley, University of California Press, 1960.

General Works

Caird, Edward, *The Critical Philosophy of Immanuel Kant*, 2 vols., Glasgow, Maclehouse, 1889.

Cassirer, H. W., *A Commentary on Kant's Critique of Judgment*, London, Methuen, 1938.

Dunham, B., *A Study in Kant's Aesthetics*, Lancaster, Pa., Science Press, 1934.

Hendel, C. W. (ed.), *The Philosophy of Kant and Our Modern World*, New York, Liberal Arts Press, 1957.

Knox, I., *The Aesthetic Theories of Kant, Hegel and Schopenhauer*, New York, Columbia University Press, 1936.

Paton, H. J., *Kant's Metaphysics of Experience*, London, Allen & Unwin, 1936.

Walsh, W. H., "Kant," in *Edwards*, 1967, vol. 4, pp. 305–324.

Warnock, G. J., "Kant," in D. J. O'Connor, ed., *A Critical History of Western Philosophy*, New York, Free Press, 1964, pp. 296–318.

Special Studies

Axinn, Sidney, "And Yet: A Kantian Analysis of Aesthetic Interest," *Phil. and Phen. Rev.*, 25 (1964).

Blocker, Harry, "Kant's Theory of the Relation of Imagination and Understanding in Aesthetic Judgments of Taste," *B.J.A.*, 5 (1965).

Bretall, R. W., "Kant's Theory of the Sublime," in G. T. Whitney and D. F. Bowers, eds., *The Heritage of Kant*, Princeton, N.J., Princeton University Press, 1939.

Dunham, B., "Kant's Theory of Aesthetic Form," in *The Heritage of Kant, ibid.*

Elliott, R. K., Kant's *Critique of Judgment*, *B.J.A.*, 8 (1968).

Eshleman, Martin, "Aesthetic Experience, the Aesthetic Object and Criticism," *Monist*, 50 (1966).

Gotshalk, D. W., "Form and Expression in Kant's Aesthetics," *B.J.A.*, 7 (1967).

Green, T. M., "A Reassessment of Kant's Aesthetic Theory," in *The Heritage of Kant, op. cit.*

Lang, Berel, "Kant and the Subjective Objects of Taste," *J.A.A.C.*, 25 (1967).

Lee, Harold N., "Kant's Theory of Aesthetics," *Phil. R.*, 40 (1931).

Schueller, Herbert M., "Immanuel Kant and the Aesthetics of Music," *J.A.A.C.*, 14 (1955).

Zimmerman, Robert L., "Kant: The Aesthetic Judgment," *J.A.A.C.*, 21 (1963).

HEGEL

Principal Works

Hegel, G. W. F., *The Introduction to Hegel's Philosophy of Fine Art*, trans. B. Bosanquet, London, Kegan Paul, 1905.

Hegel, G. W. F., *The Philosophy of Fine Art*, trans. F. P. B. Osmaston, London, G. Bell, 1920.

General Works

Acton, H. B., "Hegel," in *Edwards*, 1967, vol. 3, pp. 435–451.

Bradley, A. C., "Hegel's Theory of Tragedy," in *Oxford Lectures on Poetry*,* 2nd ed., London, Macmillan, 1909, and Bloomington, Indiana University Press, 1961.

Findlay, J. N., "Hegel," in D. J. O'Connor, ed., *A Critical History of Western Philosophy*, New York, Free Press, 1964, pp. 319–340.

Findlay, J. N., *Hegel: A Re-Examination*,* London, Allen & Unwin, 1958, and New York, Collier (Macmillan), 1962.

Kaminsky, Jack, *Hegel on Art: An Interpretation of Hegel's Aesthetics*, Albany, State University of New York, 1962.

Kedney, J. S., *Hegel's Aesthetics*, Chicago, S. C. Griggs, 1885.

Knox, I., *The Aesthetic Theories of Kant, Hegel and Schopenhauer*, New York, Columbia University Press, 1936.

Mundt, Ernest K., "Three Aspects of German Aesthetic Theory," *J.A.A.C.*, *17* (1959).

Stace, W. T., *The Philosophy of Hegel*,* New York, Dover, 1924; 1955.

SCHOPENHAUER

Principal Works

Schopenhauer, Arthur, *Complete Essays*, 4 vols., trans. T. B. Saunders, New York, Home Library Press, 1923.

Schopenhauer, Arthur, *The Works of Schopenhauer*, ed. I. Edman, New York, Modern Library, 1928.

Schopenhauer, Arthur, *The World as Will and Idea*, 3 vols., trans. R. B. Haldane and J. Kemp, with Supplements, 6th ed., London, 1907–1909.

Schopenhauer, Arthur, *The World as Will and Representation*,* 2 vols., trans. E. F. J. Payne, New York, Dover, 1966.

General Works

Adams, John Stokes, *The Aesthetics of Pessimism*, Philadelphia, University of Pennsylvania Press, 1940.

Copleston, F. C., *Arthur Schopenhauer, Philosopher of Pessimism*, London, Burns, Oates & Washbourne, 1946.

Gardiner, Patrick, "Schopenhauer," in *Edwards*, 1967, vol. 7, pp. 325–332.

Gardiner, Patrick, *Schopenhauer*,* Harmondsworth, Middlesex, Penguin, 1963.

Green, L. D., "Schopenhauer and Music," *Musical Q.*, *16* (1930).

Knox, I., *The Aesthetic Theories of Kant, Hegel and Schopenhauer*, New York, Columbia University Press, 1936.

Taylor, Richard, "Schopenhauer," in D. J. O'Connor, ed., *A Critical History of Western Philosophy*, New York, Free Press, 1964.

NIETZSCHE

Principal Works

Nietzsche, Friedrich, *The Birth of Tragedy*, trans. Clifton Fadiman, New York, Modern Library, 1927.

Nietzsche, Friedrich, *Complete Works*, ed. Oscar Levy, New York, Russell & Russell, 1962.

Nietzsche, *The Will to Power*, 2 vols., trans. Oscar Levy, London, Athena, 1910.

General Works

Danto, Arthur, "Nietzsche," in D. J. O'Connor, ed., *A Critical History of Western Philosophy*, New York, Free Press, 1964, pp. 384–401.

Danto, Arthur, *Nietzsche as Philosopher*, New York, Macmillan, 1965, chap. 2.

Jaspers, Karl, *Nietzsche: An Introduction to the Understanding of His Philosophical Activity*, trans. Charles F. Wallrafand and Frederick J. Schmitz, Tucson, University of Arizona, 1965.

Kaufmann, Walter, A., *Nietzsche: Philosopher, Psychologist, Antichrist*,* Princeton, N.J., Princeton University Press, 1950, and New York, Meridian, 1966.

Kaufmann, Walter A., "Nietzsche and Rilke," *Kenyon Review, 17* (1955).
Knight, A., *Some Aspects of the Life and Works of Nietzsche*, London, Cambridge University Press, 1933.
Lea, Frank Alfred, *The Tragic Philosopher*, London, Methuen, 1957.
Ludovici, Anthony M., *Nietzsche and Art*, London, Constable, 1912.
Morgan, George Allen, *What Nietzsche Means*,* Cambridge, Mass., Harvard University Press, 1941, chap. 8, and New York, Harper & Row Torchbooks, 1967.
Smith, John E., "Nietzsche: The Conquest of the Tragic Through Art," in his *Reason and God*, New Haven, Conn., Yale University Press, 1961.

CROCE

Principal Works

Croce, Benedetto, "On the Aesthetic of Dewey," *J. Aesth., 6* (1948).
Croce, Benedetto, *Aesthetic as Science of Expression and General Linguistic*, 2nd ed., trans. Douglas Ainslie, London, Macmillan, 1922; rev. ed.,* New York, Noonday Press, 1960.
Croce, Benedetto, *Breviary of Esthetic*, Nice Institute Pamphlet II (1915), pp. 229–237, 245–250.
Croce, Benedetto, *The Defense of Poetry: Variations on the Theme of Shelley*, Oxford, Clarendon Press, 1933.
Croce, Benedetto, "Dewey's Aesthetics and Theory of Knowledge," *J.A.A.C., 11* (1952).
Croce, Benedetto, *The Essence of Aesthetic*, trans. Douglas Ainslie, London, W. Heinemann, 1921.

See Bibliography: *Revue Intern. de Philosophe, 8* (1953), 363.

General Works

Carr, H. Wildon, *The Philosophy of Benedetto Croce: The Problem of Art and History*, London, Macmillan.
Cock, Albert A., "The Aesthetic of Benedetto Croce," *P.A.S. 15* (1914).
Harris, H. S., "Croce," in *Edwards*, 1967, vol. 2, pp. 263–267.
Orsini, Gian N. G., *Benedetto Croce: Philosopher of Art and Literary Critic*, Carbondale, Southern Illinois University, 1961.
Santayana, George, "Croce's Aesthetics," in his *The Idler and His Works*, New York, Braziller, 1957.
Seerveld, Calvin G., *Benedetto Croce's Earlier Aesthetic Theories and Literary Criticism*, Netherlands, Kampen, 1958.
Simoni, Frederic S., "Benedetto Croce," *J.A.A.C., 11* (1952).

Special Studies

Bosanquet, B., "Croce's Aesthetic," *Proceedings of the British Academy*, vol. 9, H. Milford, London, Oxford University Press, 1914.
Brown, Merle E., "Croce's Early Aesthetics: 1894–1912," *J.A.A.C., 22* (1963).
Carr, H. Wildon, "Mr. Bosanquet on Croce's Aesthetic," *Mind, 29* (1920).
Carritt, E. F., "Croce and His Aesthetic," *Mind, 62* (1953).
De Gennaro, Angelo A., "The Drama of the Aesthetics of Benedetto Croce," *J.A.A.C., 15* (1956).
Donagan, Alan, "The Croce-Collingwood Theory of Art," *Phil., 33* (1956).
Gilbert, Katherine E., "The One and the Many in Croce's Aesthetic," in *Studies in Recent Aesthetic*, Chapel Hill, University of North Carolina Press, 1927.
Hospers, John, "The Croce-Collingwood Theory of Art," *Phil., 31* (1956).
Mayo, Bernard, "Art, Language and Philosophy in Croce," *Phil. Q., 5* (1955).

Nahm, Milton C., "The Philosophy of Aesthetic Expression: The Crocean Hypothesis," *Journ. Aesth.*, *13* (1955).

Orsini, Gian N. G., "Theory and Practice in Croce's Aesthetics," *Journ. Aesth.*, *13* (1955).

Turner, Father Vincent, S.J., "The Desolation of Aesthetics," in J. M. Todd, ed., *The Arts, Artists and Thinkers*, London, Longmans, 1958.

DEWEY

Principal Works

Dewey, John, "Aesthetic Experience as a Primary Phase and as an Artistic Development," *J.A.A.C.*, *9* (1950).

Dewey, John, *Art as Experience*,* New York, Minton, Balch, 1934, and New York, Putnam, 1959.

Dewey, John, *Experience and Nature*, rev. ed., La Salle, Ill., Open Court, 1929, and New York, Dover, 1929.

Dewey, John, exchange with Croce in *J.A.A.C.*, *6* (1948).

Dewey, John, *Theory of Valuation*, Chicago, University of Chicago Press, 1939.

Special Studies

Ames, Van Meter, "John Dewey as Aesthetician," *J.A.A.C.*, *12* (1953).

Bernstein, Richard J., "Dewey," in *Edwards*, 1967, vol. 2, pp. 380–385.

Croce, Benedetto, "Dewey's Aesthetics and Theory of Knowledge," *J.A.A.C.*, *11* (1952).

Edman, Irwin, "Dewey and Art," in Sidney Hook, ed., *John Dewey: Philosopher of Science and Freedom*, New York, Dial Press, 1950.

Edman, Irwin, "A Philosophy of Experience as a Philosophy of Art," in *Essays in Honor of John Dewey*, New York, Holt, Rinehart and Winston, 1929.

Gauss, Charles E., "Some Reflections on John Dewey's Aesthetics," *J.A.A.C.*, *19* (1960).

Gotshalk, D. W., "On Dewey's Aesthetics," *J.A.A.C.*, *23* (1964).

Grana, Cesar, "John Dewey's Social Art and the Sociology of Art," *J.A.A.C.*, *20* (1962).

Hook, Sidney, *John Dewey, An Intellectual Portrait*, New York, John Day, 1939.

Jacobsen, Leon, "Art as Experience and American Visual Art Today," *J.A.A.C.*, *19* (1960).

Kallen, Horace M., *Art and Freedom*, vol. 2, New York, Duell, Sloan & Pearce, 1942.

Kaminsky, Jack, "Dewey's Concept of an Experience," *Phil. and Phen. Res.*, *17* (1957).

Kuspit, Donald P., "Dewey's Critique of Art for Art's Sake," *J.A.A.C.*, *27* (1968).

Mathur, D. C., "Dewey's Aesthetics (A Note on the Concept of 'Consummatory Experience')," *J. Phil.*, *63* (1966).

Pepper, Stephen C., "The Concept of Fusion in Dewey's Aesthetic Theory," *J.A.A.C.*, *12* (1953).

Pepper, Stephen C., "Some Questions on Dewey's Esthetics," in Paul A. Schlipp, ed., *The Philosophy of John Dewey*, Evanston, Ill., Northwestern University Press, 1939.

Shearer, E. A., "Dewey's Aesthetic Theory," *J. Phil.*, *32* (1935).

Zink, Sidney, "The Concept of Continuity in Dewey's Theory of Eesthetics," *Phil. R.*, *52* (1943).

THE WORK OF ART AND THE AESTHETIC OBJECT

Alexander, Samuel, *Philosophical and Literary Pieces*, London, Macmillan, 1939.

Barrett, C., *et al.*, "Symposium: Wittgenstein and Problems of Objectivity in Aesthetics," *B.J.A.*, *7* (1967).

Beardsley, Monroe C., "The Definition of the Arts," *J.A.A.C.*, *20* (1961).

Berall, Nathan, "A Note on Professor Pepper's Aesthetic Object," *J. Phil.*, *48* (1951).

Broiles, R. David, "Frank Sibley's 'Aesthetic Concepts,'" *J.A.A.C.*, *23* (1964).

Brunius, Teddy, "Uses of Works of Art," *J.A.A.C.*, *22* (1963).

Coomaraswamy, Ananda K., "Art and Craftsmanship," *Rupam*, *1* (1920); also in *Langer*, 1958.

Copi, Irving M., "A Note on Representation in Art," *J. Phil.*, *52* (1955).

Creegan, R. F., "The Significance of Locating the Art Object," *Phil. and Phen. Res.*, *13* (1953).

Danto, Arthur, "The Artworld," *J. Phil.*, *61* (1964).

Devaraja, N. K., "The Nature of Art," *Indian J. Phil.*, *1* (1959).

Dufrenne, Mikel, "The Aesthetic Object and the Technical Object," *J.A.A.C.*, *23* (1964).

Eshleman, Martin, "Aesthetic Experience, the Aesthetic Object, and Criticism," *Monist*, *50* (1966).

Gallie, W. B., "Art as an Essentially Contested Concept," *Phil. Q.*, *6* (1956).

Gotshalk, D. W., "Art and Beauty," *Monist*, *41* (1931).

Heidegger, Martin, "The Origin of the Work of Art," in Albert Hofstadter and Richard Kuhns, eds., *Philosophies of Art and Beauty*, New York, Random House, 1964.

Henze, Donald, "Is the Work of Art a Construct?," *J. Phil.*, *52* (1955).

Henze, Donald, "The Work of Art," *J. Phil.*, *54* (1957).

Hepburn, R. W., "Particularity and Some Related Concepts in Aesthetics," *P.A.S.*, *59* (1958).

Herring, Francis W., "Touch—The Negative Sense," *J.A.A.C.*, *7* (1949).

Hodin, J. P., "The Aesthetics of Modern Art," *J.A.A.C.*, *26* (1967).

Huxley, Aldous, in Morris Philipson, ed., *On Art and Artists*,* New York, Meridian, 1960.

Ingarden, Roman, "Aesthetic Experience and Aesthetic Object," trans. Janina Makota and Shia Moser, *Phil. and Phen. Res.*, *21* (1961).

Jaeger, Hans, "Heidegger and the Work of Art," *J.A.A.C.*, *20* (1962).

Jarrett, James L., "More on Professor Pepper's Aesthetic Object," *J. Phil.*, *49* (1952).

Jordan, E., *The Aesthetic Object*, Bloomington, Ind., Principia Press, 1937.

Kadish, Mortimer R., "The Dogma of the Work of Art Itself," in *Hook*, 1966.

Kennick, William E., "Theories of Art and the Artworld" (abstract), *J. Phil.*, *61* (1964).

Lord, Catherine, "Unity with Impunity," *J.A.A.C.*, *26* (1967).

Macdonald, Margaret, "Art and Imagination," *P.A.S.*, *53* (1952).

Margolis, Joseph, "Describing and Interpreting Works of Art," *Phil. and Phen. Res.*, *22* (1961).

Margolis, Joseph, "The Identity of a Work of Art," *Mind*, *67* (1959).

Margolis, Joseph, "Mr. Weitz and the Definition of Art," *Phil. S.*, *9* (1958).

Margolis, Joseph, "Sibley on Aesthetic Perception," *J.A.A.C.*, *25* (1966).

Meager, R. L., "The Uniqueness of a Work of Art," *P.A.S.*, *59* (1958).

Moore, Jared S., "The Work of Art and Its Material," *J.A.A.C.*, *6* (1948).

Morgan, Douglas N., "Art Pure and Simple," *J.A.A.C.*, *20* (1961).

Mothersill, Mary, "Critical Comments, On the Arts and the Definitions of Arts: A Symposium," *J.A.A.C.*, *20* (1961).

Mothersill, Mary, "'Unique' as an Aesthetic Predicate." *J. Phil.*, *58* (1961).

Natanson, Maurice, "Toward a Phenomenology of the Aesthetic Object," and other essays in his *Literature, Philosophy and the Social Science*, The Hague, Martinus Nijhoff, 1962.

Peltz, Richard, "Ontology and the Work of Art," *J.A.A.C.*, *24* (1966).

Pepper, Stephen, "Evaluation, Definition and Their Sanction," *J.A.A.C.*, *21* (1962).
Pepper, Stephen, "Further Considerations on the Aesthetic Work of Art," *J. Phil.*, *49* (1952).
Pepper, Stephen, "On Professor Jarrett's Questions About the Aesthetic Object," *J. Phil.*, *49* (1952); and in his *The Work of Art*, Bloomington, Indiana University Press, 1955.
Pepper, Stephen, "Supplementary Essay: The Aesthetic Work of Art," in his *Basis of Criticism in the Arts*, Cambridge, Mass., Harvard University Press, 1945.
Pepper, Stephen, *The Work of Art*, Bloomington, Indiana University Press, 1955.
Price, Kingsley B., "Is a Work of Art a Symbol?," *J. Phil.*, *50* (1953).
Sauvage, Micheline, "Notes on the Superposition of Temporal Modes in Works of Art," *Revue d'Esthétique*, *6* (1953); also in *Langer*, 1958.
Saw, Ruth, "What Is 'A Work of Art'?," *Phil.*, *36* (1961).
Schaper, Eva, "The Kantian 'As-If' and Its Relevance for Aesthetics," *P.A.S.*, *75* (1964).
Sibley, Frank, "Aesthetic and Nonaesthetic," *Phil. R.*, *74* (1965).
Sibley, Frank, "Aesthetics and the Looks of Things," *J. Phil.*, *56* (1959).
Sparshott, Francis, "Mr. Ziff and the 'Artistic Illusion,'" *Mind*, *61* (1952).
Stevenson, C. L., "On 'What is a poem'?," *Phil. R.*, *66* (1957).
Thompson, S., "Existence, Essence and the Work of Art," *Int. Phil. Q.*, *3* (1963).
Thurston, Carl, "Major Hazards in Defining Art," *J. Phil.*, *44* (1947).
Tilghman, B. R., "Aesthetic Perception and the Problem of the 'Aesthetic Object,'" *Mind*, *75* (1966).
Tomas, Vincent, "Ducasse on Art and Its Appreciation," *Phil. and Phen. Res.*, *13* (1952).
Wacker, Jeanne, "Particular Works of Art," *Mind*, *59* (1960).
Weitz, Morris, "The Role of Theory in Aesthetics," *J.A.A.C.*, *15* (1956).
Wittgenstein, Ludwig, *Philosophical Investigations*, trans. G. E. M. Anscombe, New York, Macmillan, 1953.
Yoos, George E., "A Work of Art as a Standard of Itself," *J.A.A.C.*, *26* (1967).
Zemach, Eddy M., "The Ontological Status of Art Objects," *J.A.A.C.*, *25* (1966).
Ziff, Paul, "Art and the Object of Art," in *Elton*, 1954.
Ziff, Paul, "The Task of Defining a Work of Art," *Phil. R.*, *63* (1953).
Zimmerman, Robert L., "Can Anything Be an Aesthetic Object?," *J.A.A.C.*, *25* (1966).
Zupnick, Irving L., "Phenomenology and Concept in Art," *B.J.A.*, *6* (1966).

THE AESTHETIC ATTITUDE

Aldrich, Virgil C., "Back to Aesthetic Experience," *J.A.A.C.*, *24* (1966).
Aldrich, Virgil C., "Beauty as Feeling," *The Kenyon Review*, *1* (1939).
Aldrich, Virgil C., *Philosophy of Art*,* Englewood Cliffs, N.J., Prentice-Hall, 1963.
Bosanquet, Bernard, *Three Lectures on Aesthetics*, I. The General Nature of the Aesthetic Attitude-Contemplation and Creation; II. The Aesthetic Attitude in Its Embodiment-'Nature' and the Arts; III. Forms of Aesthetic Satisfaction and the Reverie-Beauty and Ugliness, London, Macmillan, 1931, and Indianapolis, Bobbs-Merrill, 1963.
Bullough, Edward, *Aesthetics*, London, Bowes & Bowes, 1957. See selection in the present text.
Carmichael, Peter A., "The Aesthetic Seer," *J.A.A.C.*, *26* (1967).
Clark, Sir Kenneth, *The Nude*,* Garden City, N.Y., Anchor (Doubleday), 1959.
Cohen, Marshall, "Aesthetic Essence," in M. Black, ed., *Philosophy in America*, Ithaca, N.Y., Cornell University Press, 1965. Included in the present volume.
Cohen, Marshall, "Appearance and the Aesthetic Attitude," ("Symposium: Aesthetics"), *J. Phil.*, *56* (1959).

Copi, Irving M., "A Note on Representation in Art," *J. Phil.*, *52* (1955).

Dickie, George, "Attitude and Object: Aldrich on the Aesthetic," *J.A.A.C.*, *25* (1966).

Ducasse, Curt John, *The Philosophy of Art*,* New York, Dial Press, 1929, chap. 9, pp. 134–150, and New York, Dover, 1963.

Dufrenne, Mikel, *Phénoménologie de l'Expérience Esthétique*, Paris, Presses Universitaires de France, 1953.

Eshleman, Martin, "Aesthetic Experience, the Aesthetic Object and Criticism," *Monist*, *50* (1966).

Hampshire, Stuart, "Logic and Appreciation," in *Elton*, 1954.

Hospers, John, "The Ideal Aesthetic Observer," *B.J.A.*, *2* (1962).

Hungerland, Isabel, "Once Again, Aesthetic and Non-Aesthetic," *J.A.A.C.*, *26* (1968).

Kant, Immanuel, *Critique of Judgment*. See selection in the present text.

Langfeld, H. S., *The Aesthetic Attitude*, New York, Harcourt, Brace & World, 1920.

Mehlis, Georg, "The Aesthetic Problem of Distance," *Logos*, *6* (1916); also in *Langer*, 1958.

Mitchells, K., "Aesthetic Perception and Aesthetic Qualities," *P.A.S.*, *77* (1966).

Nahm, Milton C., *The Aesthetic Response, an Autonomy and Its Resolution*, Philadelphia, University of Pennsylvania, 1933.

Ortega y Gasset, José, *The Dehumanization of Art*,* Garden City, N.Y., Anchor (Doubleday), 1956.

Pepper, Stephen C., "Emotional Distance in Art," *J.A.A.C.*, *4* (1946).

Pole, D. L., "Varieties of Aesthetic Experience," *Phil.*, *30* (1955).

Schapiro, Meyer, "On the Aesthetic Attitude in Romanesque Art," in Bharatha K. Iyer, ed., *Art and Thought: Essays Issued in Honor of Dr. Ananda K. Coomaraswamy*, London, Luzac, 1947.

Schiller, Jerome, "An Alternative to 'Aesthetic Disinterestedness,'" *J.A.A.C.*, *22* (1964).

Sibley, Frank, "Aesthetics and the Looks of Things," ("Symposium: Aesthetics"), *J. Phil.*, *56* (1959).

Sparshott, F. E., *The Structure of Aesthetics*, Toronto, University of Toronto Press, 1963.

Stolnitz, Jerome, "On the Origins of 'Aesthetic Disinterestedness,'" *J.A.A.C.*, *20* (1961).

Urmson, J. O., and David Pole, "Symposium: What Makes a Situation Aesthetic?," *P.A.S. Supp. Vol.*, *31* (1957).

Vivas, Eliseo, "A Definition of the Aesthetic Experience," *J. Phil.*, *34* (1937).

AESTHETIC VALUE

Aiken, Henry David, "A Pluralistic Analysis of Aesthetic Value," *Phil. R.*, *59* (1950).

Alexander, Samuel, *Beauty and Other Forms of Value*, London, Macmillan, 1933.

Ames, Van Meter, "Aesthetic Values in the East and West," *J.A.A.C.*, *19* (1960).

Arnett, Willard E., *Santayana and the Sense of Beauty*, Bloomington, University of Indiana Press, 1955.

Beardsley, Monroe C., "The Discrimination of Aesthetic Enjoyment," *B.J.A.*, *3* (1963).

Bossart, William, "Authenticity and Aesthetic Value in the Visual Arts," *B.J.A.*, *1* (1961).

Bruce, John, "Art and Value," *B.J.A.*, *6* (1966).

Child, Arthur, "The Social Historical Relativity of Esthetic Value," *Phil. R.*, *52* (1944).

Ducasse, C. J., "What Has Beauty to Do with Art?," *J. Phil.*, *25* (1928).

Ekman, Rolf, "Aesthetic Value and the Ethics of Life Affirmation," *B.J.A.*, *3* (1963).

Findlay, J. N., *Meinong's Theory of Objects and Values*, 2nd ed., London, Oxford University Press, 1963.

Findlay, J. N., "The Perspicuous and the Poignant: Two Aesthetic Fundamentals," *B.J.A.*, *7* (1967).

Gotshalk, D. W., "Art and Beauty," *Monist*, *41* (1931).

Hein, Hilde, "Aesthetic Prescriptions," *J.A.A.C.*, *26* (1967).

Hobsbaum, Philip, "Current Aesthetic Fallacies," *B.J.A.*, *7* (1967).

Ingarden, Roman, "Artistic and Aesthetic Value," *B.J.A.*, *4* (1964).

Jackson, Wallace, "Affective Values in Later Eighteenth Century Aesthetics," *J.A.A.C.*, *24* (1965).

Katkov, G., "The Pleasant and the Beautiful," *P.A.S.*, *40* (1940).

Kolnai, Aurel, "On the Concept of the Interesting," *B.J.A.*, *4* (1964).

Laird, John, *The Idea of Value*, London, Cambridge University Press, 1929.

Lawlor, Monica, "On Knowing What You Like," *B.J.A.*, *4* (1964).

Lee, Harold Newton, *Perception and Aesthetic Value*, Englewood Cliffs, N.J., Prentice-Hall, 1938.

Lee, Vernon, *The Beautiful*, London, Cambridge University Press, 1913.

Lee, Vernon, *Beauty and Ugliness*, London, Lane, 1911.

Lepley, Ray (ed.), *Value: A Cooperative Enquiry*, New York, Columbia University Press, 1949.

Lewis, Clarence Irving, *An Analysis of Knowledge and Valuation*,* La Salle, Ill., Open Court, 1946; 1947.

Macdonald, Margaret, "Some Distinctive Features of the Arguments Used in Criticism of the Arts," in *Elton*, 1954.

Marshall, Henry Rutgers, *The Beautiful*, London, Macmillan, 1924.

Montague, W. P., "Beauty Is Not All: A Plea for Aesthetic Pluralism," in his *The Ways of Things*, Englewood Cliffs, N.J., Prentice-Hall, 1940.

Moore, G. E., *Principia Ethica*,* New York, Cambridge University Press, 1929, chap. 6, secs. 113–122; 1959.

Osborne, Harold, "Notes on the Aesthetics of Chess and the Concept of Intellectual Beauty," *B.J.A.*, *4* (1964).

Osborne, Harold, *Theory of Beauty*, London, Routledge, 1952.

Pope, Arthur, "A Quantitative Theory of Aesthetic Value," in *Art Studies: Medieval, Renaissance, Modern*, vol. 3, Cambridge, Mass., Harvard University Press, 1925.

Schaper, Eva, and Frank Sibley, "Symposium: About Taste," *B.J.A.*, *6* (1966).

Stace, W. T., *The Meaning of Beauty*, London, Cayme Press, 1929.

Stolnitz, Jerome, "On Aesthetic Familiarity and Aesthetic Value," *J. Phil.*, *53* (1956).

Stolnitz, Jerome, "On Aesthetic Valuing and Evaluation," *Phil. and Phen. Res.*, *13* (1953).

Stolnitz, Jerome, "Beauty," in *Edwards*, 1967, vol. 1, pp. 263–266.

Ushenko, A., "Beauty in Art," *Monist*, *42* (1932).

Winthrop, Henry, "A Structural Analysis of the Context of Value," *J. Exist.*, *6* (1965).

INTERPRETATION

Beardsley, Monroe C., "The Limits of Critical Interpretation," in *Hook*, 1966.

Empson, William, *Seven Types of Ambiguity*,* 2nd ed., New York, New Directions, 1947; 1967.

Hampshire, Stuart, "Types of Interpretation," in *Hook*, 1966.

Hirsch, E. D., *Validity in Interpretation*, New Haven, Conn., Yale University Press, 1967.

Langer, Susanne K., *Feeling and Form*,* New York, Scribner, 1956. Part is reprinted in the present text.

Macdonald, Margaret, "Some Distinctive Features of Arguments Used in Criticism," *P.A.S. Supp. Vol.*, *23* (1949).

Sparshott, F. E., *The Concept of Criticism*, Oxford, Clarendon Press, 1967.

Stevenson, C. L., "On the Analysis of a Work of Art," *Phil. R.*, *67* (1958).

Stevenson, C. L., "On the Reasons That Can Be Given for the Interpretation of a Poem." Included in the present text.

Valéry, Paul, "Reflections on Art," in his *Collected Works*, trans. Ralph Manheim, London, Routledge, 1964, vol. 8.

Vivas, Eliseo, "Contextualism Reconsidered," *J.A.A.C.*, *18* (1959).

Weitz, Morris, *Hamlet and the Philosophy of Literary Criticism*,* Chicago, University of Chicago Press, 1964, and New York, Meridian, 1967.

Wimsatt, W. K., Jr., "What to Say About a Poem," in his *Hateful Contraries*, Lexington, University of Kentucky Press, 1965.

CRITICAL JUDGMENT AND CRITICAL ARGUMENT

Adams, Hazard, "Criteria of Criticism in the Arts: a Symposium," *J.A.A.C.*, *21* (1962).

Aesthetic Judgment Symposium, *Rivista d. Estetica*, vol. 3, 1958: Hodin, J. P., "Aesthetic Judgment and Modern Art Criticism"; Hungerland, Helmut, "The Aesthetic Judgment." Replies: Michelis, P. A., "Aesthetic Judgment"; Read, Herbert, "Aesthetic Judgment and the Archetype"; Riser, Max, "Object and Forms of Aesthetic Judgment."

Aschenbrenner, Karl, "Critical Reasoning," *J. Phil.*, *57* (1960).

Barrett, Cyril, Margaret Paton, and Harry Blocker, "Symposium: Wittgenstein and Problems of Objectivity in Aesthetics," *B.J.A.*, *7* (1967).

Beardsley, Monroe C., *Aesthetics: Problems in the Philosophy of Criticism*, New York, Harcourt, Brace & World, 1958, chap. 10.

Beardsley, Monroe C., "Concept of Economy in Art," *J.A.A.C.*, *14* (1955–56).

Black, Max, " 'Perfection' as a Term in Aesthetics," in *Hook*, 1966.

Blackmur, Richard P., "A Critic's Job of Work," in *Form and Value in Modern Poetry*,* Garden City, N.Y., Doubleday, 1957, pp. 339–367.

Boas, George, *A Primer for Critics*, Baltimore, Johns Hopkins Press, 1937, pp. 138–149.

Boas, George, *Wingless Pegasus*, Baltimore, Johns Hopkins Press, 1950.

Capitan, William H., "On Unity in Poems," *Monist*, *50* (1966).

Cargill, Oscar, "Viable Meaning in Literary Art," in *Hook*, 1966.

Coleman, Francis J., "On 'Knowing That a Work of Art Is Good,' " in his *Contemporary Studies in Aesthetics*, New York, McGraw-Hill, 1968, pp. 308–320.

Cowley, Daniel J., "Aesthetic Judgment and Cultural Relativism," *J.A.A.C.*, *17* (1958).

Crane, R. S., (ed.), *Critics and Criticism: Old and New*,* Chicago, University of Chicago Press, 1952; 1957.

Day, Douglas, "The Background of the New Criticism," *J.A.A.C.*, *24* (1966).

Diffey, T. J., "Evaluation and Aesthetic Appraisals." *B.J.A.*, *7* (1967).

Downes, Chauncey, "Perfection as an Aesthetic Predicate," in *Hook*, 1966.

Ducasse, Curt John, *The Philosophy of Art*, New York, Dial Press, 1929, chap. 11; rev. ed.,* New York, Dover, 1963.

Ducasse, Curt John, "Taste, Meaning and Reality in Art," in *Hook*, 1966.

Eames, S. Morris, "Valuing, Obligation and Evaluation," *Phil. and Phen. Res.*, *24* (1964).

Eichner, Hans, "The Meaning of 'Good' in Aesthetic Judgments," *B.J.A.*, *3* (1963).

Eliot, T. S., "The Frontiers of Criticism," *Sewanee Review*, *64* (1956).

Eveling, H. S., "Composition and Criticism," *P.A.S.*, *59* (1958).

Fishman, Solomon, *The Interpretation of Art*, Berkeley, University of California Press, and London, Cambridge University Press, 1963.

Forster, E. M., "The Raison d'Etre of Criticism in the Arts," in *Music and Criticism*, R. F. French (ed.), Cambridge, Mass., Harvard University Press, 1948.

Goodman, Nelson, "Merit as Means," in *Hook*, 1966.

Greene, T. M., *The Arts and the Art of Criticism*, Princeton, N.J., Princeton University Press, 1940.

Haezrahi, Pepita, "Propositions in Aesthetics," *P.A.S.*, *57* (1956).

Hampshire, Stuart, "Logic and Appreciation," reprinted in *Elton*, 1954.

Harré, R., "Quasi-Aesthetic Appraisals," *Phil.*, *33* (1958).

Harrison, Bernard, "Some Uses of 'Good' in Criticism," *Mind*, *69* (1960).

Hausman, Carl R., "Intradiction: An Interpretation of Aesthetic Understanding," *J.A.A.C.*, *22* (1964).

Henderson, G. P., "On the 'Orthodox' Use of the term 'Beautiful,' " *Phil.*, *35* (1960).

Hepburn, Ronald W., "Particularity and Some Related Concepts in Aesthetics," *P.A.S.*, *59* (1958).

Heyl, Bernard C., *New Bearings in Aesthetics and Art Criticism*, New Haven, Conn., Yale University Press, 1943.

Heyl, Bernard C., "Relativism Again," *J.A.A.C.*, *5* (1946).

Heyl, Bernard C., " 'Relativism' and 'Objectivity' in Stephen Pepper's Theory of Criticism," *J.A.A.C.*, *18* (1960).

Hirsch, E. D., *Validity in Interpretation*, New Haven, Conn., Yale University Press, 1967.

Hofstadter, Albert, "The Evidence for Esthetic Judgment," *J. Phil.*, *54* (1957).

Hofstadter, Albert, "Significance and Artistic Meaning," in *Hook*, 1966.

Holloway, John, "What Are Distinctive Features of Arguments Used in Criticism?," *P.A.S. Supp. Vol.*, *23* (1949).

Hook, Sidney, "Are There Universal Criteria of Judgment of Excellence in Art?," in *Hook*, 1966.

Hungerland, Helmut, "Consistency as a Criterion in Art Criticism," *J.A.A.C.*, *7* (1948–49).

Hungerland, Helmut, "Perception, Interpretation and Evaluation," *J.A.A.C.*, *10* (1952).

Hungerland, Isabel C., *Poetic Discourse*, Berkeley, University of California Press, 1958, chap. 3.

Isenberg, Arnold, "The Aesthetic Function of Language," *J. Phil.*, *66* (1949).

Isenberg, Arnold, "Critical Communication," *Phil. R.*, *58* (1949).

Janson, H. W., "Originality as a Ground for Judgment of Excellence," in *Hook*, 1966.

Jessup, Bertrum, "Taste and Judgment in Aesthetic Experience," *J.A.A.C.*, *19* (1960).

Jessup, Bertrum, "What Is Great Art?," *B.J.A.*, *2* (1962), 26–36.

Khatchadourian, Haig, "Art Names and Aesthetic Judgments," *Phil.*, *36* (1961).

Kivy, Peter, "Hume's Standard of Taste: Breaking the Circle," *B.J.A.*, *7* (1967).

Knight, Helen, "The Use of 'Good' in Aesthetic Judgments," reprinted in *Elton*, 1954.

Kuhns, Richard, "The Abiding Values in Art," in *Hook*, 1966.

Kupperman, Joel J., "Reasons in Support of Evaluations of Works of Art," *Monist*, *50* (1966).

Longman, Lester D., "Criteria of Criticism of Contemporary Art," *J.A.A.C.*, *18* (1960).

Lovejoy, Arthur O., " 'Nature' as Aesthetic Norm," *Modern Language Notes*, *42* (1927).

McCloskey, H. J., "Objectivism in Aesthetics," *Ethics*, *74* (1963).

Macdonald, Margaret, "Some Distinctive Features of the Arguments Used in Criticism of the Arts," in *Elton*, 1954.

McKeon, Richard P., "Philosophic Bases of Art and Criticism," *Mod. Philology*, *41* (1943).

Margolis, Joseph, "Describing and Interpreting Works of Art," *Phil. and Phen. Res.*, *22* (1961).

Margolis, Joseph, "Proposals on the Logic of Aesthetic Judgment," *Phil. Q.*, *9* (1959).

Margolis, Joseph, "Three Problems in Aesthetics," in *Hook*, 1966.

Martienssen, Heather, "Aesthetic Judgment and the Art Historian," *B.J.A.*, *2* (1962).

Meynell, Hugo, "Remarks on the Foundations of Aesthetics," *B.J.A.*, *8* (1968).

Montefiore, Alan, "The Meaning of 'Good' and the Act of Commendation," *Phil. Q.*, *17* (1967).

Morawski, Stefan, "On the Objectivity of Aesthetic Judgment," *B.J.A.*, *6* (1966).

Morgan, Douglas N., "The Critic Come to Judgment," *Northwestern University Tri-Quarterly*, *1* (1959).

Morris-Jones, H., "The Logic of Criticism," *Monist*, *50* (1966).

Mothersill, Mary, "Critical Reasons," *Phil. Q.*, *2* (1961).

Mothersill, Mary, " 'Unique' as an Aesthetic Predicate," *J. Phil.*, *58* (1961).

Nielsen, Kai, "How Not to Talk About Art," in *Hook*, 1966.

Osborne, Harold, *Aesthetics and Criticism*, London, Routledge, 1955.

Osborne, Harold, "Hume's Standard and the Diversity of Aesthetic Taste," *B.J.A.*, *7* (1967).

Osborne, Harold, "Reasons and Description in Criticism," *Monist*, *50* (1966).

Passmore, J. A., "The Dreariness of Aesthetics," *Mind*, *60* (1951).

Pepper, Stephen C., *The Basis of Criticism in the Arts*, Cambridge, Mass., Harvard University Press, 1945.

Pepper, Stephen C., "Evaluative Definitions in Art and Their Sanctions," *J.A.A.C.*, *21* (1962).

Pepper, Stephen C., "Is Non-objective Art Superficial?," *J.A.A.C.*, *11* (1953).

Petock, Stuart Jay, "Dewey and Gotshalk on Criticism," *J.A.A.C.*, *25* (1967).

Pleydell-Pearce, A. G., "The Objectivity and Confirmation of Value Judgments," *Indian J. Phil.*, *2* (1960).

Redpath, Theodore, "Some Problems in Modern Aesthetics," in *British Philosophy in the Mid-Century*, ed. C. A. Mace, London, G. Allen, 1957.

Schapiro, Meyer, "On Preference, Coherence and Unity of Form and Content," in *Hook*, 1966.

Scriven, Michael, "The Objectivity of Aesthetic Evaluation," *Monist*, *50* (1966).

Seidler, Ingo, "The Iconolatric Fallacy: On the Limitations of the Internal Method of Criticism," *J.A.A.C.*, *26* (1967).

Siegler, F. A., "On Isenberg's 'Critical Communication,' " *B.J.A.*, *8* (1968).

Sireello, Guy, "Subjectivity and Justification in Aesthetic Judgments," *J.A.A.C.*, *27* (1968).

Sparshott, F. E., *The Concept of Criticism*, London, Oxford University Press, 1967.

Spingarn, Joel Elias, *Creative Criticism*, New York, Holt, Rinehart and Winston, 1917.

Stahl, Gary, "An Inductive Method for Criticism," *Monist, 50* (1966).

Stallman, R. W. (ed.), *Critiques and Essays in Criticism*, New York, Ronald Press, 1949.

Stevenson, C. L., "Interpretation and Evaluation in Aesthetics," in Max Black, ed., *Philosophical Analysis*, Ithaca, N.Y., Cornell University Press, 1950.

Stolnitz, Jerome, "On Aesthetic Valuing and Evaluation," *Phil. and Phen. Res., 13* (1953).

Stolnitz, Jerome, *Aesthetics and the Philosophy of Art Criticism*, Boston, Houghton Mifflin, 1960.

Stolnitz, Jerome, "On Objective Relativism in Aesthetics," *J. Phil., 57* (1960).

Sutton, Walter, "Contextualist Theory and Criticism as a Social Act," *J.A.A.C., 19* (1961).

Tomas, Vincent, "What Is the Quarrel About?," in *Hook*, 1966.

Tsugawa, Albert, *The Idea of Criticism*, Pennsylvania State University Studies, 20 (1967).

Tsugawa, Albert, "The Objectivity of Aesthetic Judgments," *Phil. R., 70* (1961).

Ushenko, Andrew Paul, "Four Standards of Criticism," in his *Dynamics of Art*, Bloomington, Indiana University Press, 1953, and New York, Kraus, 1953.

Warner, D. H. J., "Good-Making and Beauty-Making Characteristics: An Exercise in Moral and Aesthetic Evaluation," *Ethics, 78* (1968).

Weitz, Morris, "Criticism Without Evaluation," *Phil. R., 61* (1952).

Weitz, Morris, "Reasons in Criticism," *J.A.A.C., 20* (1962).

Weitz, Morris, "The Role of Theory in Aesthetics," *J.A.A.C., 15* (1956).

Wier, Dennis R., "A Suggested Basis for Literary Evaluation by Computer Processing," *J.A.A.C., 26* (1967).

Wilson, Patrick, "The Need to Justify," *Monist, 50* (1966).

Wimsatt, W. K., Jr., "Evaluation as Criticism," *English Institute Essays*, New York, Columbia University Press, 1951. Reprinted in *The Verbal Icon*, Lexington, University of Kentucky Press, 1954, pp. 235–251, and New York, Farrar, Straus & Giroux, 1958.

Wimsatt, W. K., Jr., and Monroe C. Beardsley, "The Affective Fallacy," *Sewanee Review, 57* (1949).

Wisdom, John, "God," reprinted in his *Philosophy and Psychoanalysis*, Oxford, Blackwell, 1953.

Wright, Edmond, "Some Basic Preferences," *B.J.A., 4* (1964).

Zemach, E. M., "The Pragmatic Paradox in Aesthetics," *B.J.A., 7* (1967).

Ziff, Paul, "Critical Comments," in *Hook*, 1966.

Ziff, Paul, "Reasons in Art Criticism," in I. Scheffler, ed., *Philosophy and Education*, Boston, Allyn & Bacon, 1958, pp. 219–236.

THE ARTIST'S INTENTION

Aiken, Henry David, "The Aesthetic Relevance of the Artists' Intentions," *J. Phil., 52* (1955).

Anscombe, G. E. M., *Intention*, Oxford, Blackwell, 1957, and Ithaca, N.Y., Cornell University Press, 1957.

Aschenbrenner, Karl, "Intention and Understanding," *University of California Publications in Philosophy, 25* (1950).

Carpenter, R., "The Basis of Artistic Creation in the Fine Arts," in *The Bases of Artistic Creation*, essays by Maxwell Anderson, Rhys Carpenter, and Ray Harris, New Brunswick, N.J., Rutgers University Press, 1942.

Centeno, Augusto (ed.), *The Intent of the Artist*, Princeton, N.J., Princeton University Press, 1941.

Fiedler, Leslie A., "Archetype and Signature: A Study of the Relationship Between Biography and Poetry," *Sewanee Review*, 60 (1952).

Gendin, S., "The Artist's Intentions," *J.A.A.C.*, 23 (1964).

Goldwater, Robert, and Marco Treves (eds.), *Artists on Art*, New York, Pantheon, 1945.

Hirsch, E. D., Jr., *Validity in Interpretation*, New Haven, Conn., Yale University Press, 1967.

Hungerland, Isabel C., "The Concept of Intention in Art Criticism," *J. Phil.*, 52 (1955).

Kaplan, Abraham, and Ernst Kris, "Esthetic Ambiguity," *Phil. and Phen. Res.*, 8 (1948).

Kemp, John, "The Work of Art and the Artists' Intentions," *B.J.A.*, 4 (1964).

Kuh, Katherine, *The Artist's Voice*, New York, Harper & Row, 1963.

Kuhns, Richard C., "Criticism and the Problem of Intention," *J. Phil.*, 57 (1960).

Morris-Jones, Huw, "The Relevance of the Artists' Intentions," *B.J.A.*, 4 (1964).

Passmore, J. A., "Intentions," *P.A.S. Supp. Vol.*, 29 (1955).

Pearce, Roy Harvey, "Pure Criticism and the History of Ideas," *J.A.A.C.*, 7 (1948).

Pelles, Geraldine, "The Image of the Artist," *J.A.A.C.*, 21 (1962).

Redpath, Theodore, "Some Problems of Modern Aesthetics," in C. A. Mace, ed., *British Philosophy in Mid-century*, London, G. Allen, 1957.

Roma, Emilio, III, "The Scope of the Intentional Fallacy," *Monist*, 50 (1966).

Shahn, Ben, "Imagination and Intention," *Review of Existential Psychology and Psychiatry*, 7 (1967).

Vivas, Eliseo, "Mr. Wimsatt on the Theory of Literature," *Comparative Literature*, 7 (1955).

Wilson, John (ed.), *The Faith of an Artist*, London, G. Allen, 1962.

EXPRESSION AND EMOTION

Abercrombie, Lascelles, "Communication versus Expression in Art," *Br. J. Psych.*, 14 (1923).

Aldrich, Virgil C., "Beauty as Feeling," *Kenyon Review*, 1 (1939).

Aldrich, Virgil C., "Pictorial Meaning, Picture Thinking, and Wittgenstein's Theory of Aspects," *Mind*, 67 (1958).

Arnheim, Rudolph, "Expression," in his *Art and Visual Perception*,* Berkeley and Los Angeles, University of California Press, 1957.

Arnheim, Rudolph, "The Gestalt Theory of Expression," *Psych. R.*, 56 (1949).

Baensch, Otto, "Art and Feeling," *Logos*, 12 (1923).

Barrett, William, "Art and Being," in *Hook*, 1966.

Bell, Clive, *Art*,* London, Chatto & Windus, 1928, and New York, Putnam, 1959.

Bell, Clive, *Enjoying Pictures*, New York, Harcourt, Brace & World, 1934.

Benson, John, "Emotion and Expression," *Phil. R.*, 76 (1967).

Bouwsma, O. K., "The Expression Theory of Art," in *Elton*, 1954.

Cannon, W. B., "The James-Lange Theory of Emotions: A Critical Examination and an Alternative Theory," *Am J. Psych.*, 39 (1927).

Carritt, E. F., "A Reply to Dr. Patankar on 'Expression,'" *B.J.A.*, 2 (1962).

Cheney, Sheldon, *Expressionism in Art*, rev. ed., New York, Liveright, 1958.

Collingwood, R. G., *The Principles of Art*,* Oxford, Clarendon Press, 1938, chaps. 6, 7, 12, and New York, Oxford University Press.

Croce, Benedetto, *Aesthetic as Science of Expression and General Linguistic*, 2nd ed., trans. Douglas Ainslie, London, Macmillan, 1922, pt. I.

Dickie, George, "Beardsley's Phantom Aesthetic Experience," *J. Phil.*, 62 (1965).

Dickie, George, "Is Psychology Relevant to Aesthetics?," *Phil. R.*, 71 (1962).

Donagan, Alan, *The Later Philosophy of R. G. Collingwood*, Oxford, Clarendon Press, 1962, chap. 5, and New York, Oxford University Press, 1962.

Ducasse, C. J., *The Philosophy of Art, New York*, Dial Press, 1929, chap. 8; also rev. ed.,* New York, Dover, 1963.

Elliott, R. K., "Aesthetic Theory and the Experience of Art," *P.A.S.*, 77 (1966).

Garrod, H. W., *Tolstoi's Theory of Art*, Oxford, Clarendon Press, 1935.

Garvin, Lucius, "An Emotionalist Critique of 'Artistic Truth,' " *J. Phil.*, 43 (1946).

Gilbert, Katherine E., "Santayana's Doctrine of Aesthetic Expression," *Studies in Recent Aesthetic*, Chapel Hill, University of North Carolina, 1927.

Gombrich, E. H., "From Representation to Expression," in his *Art and Illusion, A Study in the Psychology of Pictorial Representation* (Bollingen Series 35), New York, Pantheon, 1960.

Gotshalk, D. W., "Aesthetic Expression," *J.A.A.C.*, 13 (1954).

Hampshire, Stuart, *Feeling and Expression*, London, H. K. Lewis, 1960.

Henderson, G. P., "The Concept of Ugliness," *B.J.A.*, 6 (1966).

Hepburn, Ronald W., "A Fresh Look at Collingwood," *B.J.A.*, 3 (1963).

Hospers, John, "The Concept of Artistic Expression," reprinted (revised) in Morris Weitz, ed., *Problems in Aesthetic*, New York, Macmillan, 1959.

Hospers, John, "The Croce-Collingwood Theory of Art," *Phil.* 31 (1956).

Khatchadourian, Haig, "The Expression Theory of Art," *J.A.A.C.*, 23 (1965).

Knox, Israel, "Tolstoi's Esthetic Definition of Art," *J. Phil.*, 27 (1930).

Langer, Susanne, *Feeling and Form*,* New York, Scribner, 1956. chap. 3.

Langer, Susanne K., *Mind: An Essay on Human Feeling*, Baltimore, Johns Hopkins Press, 1967.

Margolis, Joseph, "Creativity, Expression and Value Once Again," *J.A.A.C.*, 22 (1963).

Morris-Jones, Huw, "The Language of Feelings," *B.J.A.*, 2 (1962).

Nahm, Milton C., *Aesthetic Experience and Its Presuppositions*, New York, Harper & Row, 1946, pt. 3.

Nahm, Milton C., "The Philosophy of Aesthetic Expression: The Crocean Hypothesis," *J. Aesth.*, 13 (1955).

Osborne, Harold, "The Quality of Feeling in Art," *B.J.A.*, 3 (1963).

Patankar, R. B., "What Does Croce Mean by 'Expression'?," *B.J.A.*, 2 (1962).

Perkins, Moreland, "Emotion and the Concept of Behavior," *Am. Phil. Q.*, 3 (1966).

Perkins, Moreland, "Emotion and Feeling," *Phil. R.*, 75 (1966).

Plessner, Helmuth, "On Human Expression," *R.E.P.P.*, 4 (1964).

Reid, Louis Arnaud, "Feeling and Expression in the Arts: Expression, Sense and Feelings," *J.A.A.C.*, 25 (1966).

Santayana, George, *The Sense of Beauty*,* London, Black, 1896, and New York, Collier, 1967.

Sibley, Frank, "Aesthetics and the Looks of Things," *J. Phil.*, 56 (1959).

Sircello, Guy, "Perceptual Acts and the Pictorial Arts; a Defense of Expression Theory," *J. Phil.*, 62 (1965).

Stern, Paul, "On the Problem of Artistic Form," *Logos*, 5 (1914); also in *Langer*, 1958.

Stolnitz, Jerome, "Ugliness," in *Edwards*, 1967, pp. 174–176. Contains bibliography.

Stolnitz, Jerome, "On Ugliness in Art," *Phil. and Phen. Res.*, 11 (1950).

Szathmary, A., "Symbolic and Aesthetic Expression in Painting," *J.A.A.C.*, 13 (1954).

Tolstoy, Leo, *What Is Art? and Essays on Art*,* London, Oxford University Press, 1925, and Indianapolis, Bobbs-Merrill, 1960.

Tomas, Vincent, "Creativity in Art," *Phil. R.*, *61* (1952).

Tomas, Vincent, and Douglas N. Morgan, "Symposium: The Concept of Expression in Art," in American Philosophical Association, *Science, Language and Human Rights*, Philadelphia, University of Pennsylvania Press, 1952, pp. 126–165.

Tomberlin, James E., "A Problem with Expressing?," *Phil. and Phen. Res.*, *28* (1967).

Urmson, J. O., "What Makes a Situation Aesthetic?," *P.A.S. Supp. Vol.*, *31* (1957).

Vivas, Eliseo, "Animadversions on Imitation and Expression," *J.A.A.C.*, *19* (1961).

Werner, Heinz (ed.), *On Expressive Language*, Worcester, Mass., Clark University Press, 1955.

Wollheim, Richard, "Expression," *Royal Institute of Philosophy Lectures 1966–67*, *vol. 1: The Human Agent*, New York, St. Martin's Press, 1968.

Wollheim, Richard, "Expression and Expressionism," *Revue Internationale de Philosophie*, *18* (1964).

Ziff, Paul, "Art and the 'Object of Art,'" in *Elton*, 1954.

Zink, Sidney, "Is the Music Really Sad?," *J.A.A.C.*, *19* (1960).

MEANING AND TRUTH

Abelson, Raziel, "Is Art Really More Real Than Reality?," in *Hook*, 1966.

Aiken, H. D., "The Aesthetic Relevance of Belief," *J. Aesth.*, *9* (1950).

Aiken, H. D., "Some Notes Concerning the Aesthetic and the Cognitive," *J.A.A.C.*, *13* (1955).

Aldrich, Virgil C., "Mothersill and Gombrich: 'The Language of Art'" (abstract), *J. Phil.*, *62* (1965).

Bilsky, Manuel, "Truth, Belief and the Value of Art," *Phil. and Phen. Res.*, *16* (1956).

Boas, Charles A., "The Problem of Meaning in the Arts," in Philosophical Association, *Meaning and Interpretation*, Berkeley, University of California Press, 1950.

Capitan, William H., "Literary Truth Without Empirical Claim," *Revue Internationale de Philosophie*, *16* (1962).

Carver, George Alexander, *Aesthetics and the Problem of Meaning*, New Haven, Conn., Yale University Press, 1952.

Day, John Patrick, "Aesthetic Verisimilitude," *Dialogue*, *1* (1962–63).

Ellis, J. M., "Great Art: A Study in Meaning," *B.J.A.*, *3* (1963).

Feibleman, James K., "The Truth-Value of Art," *J.A.A.C.*, *24* (1966).

Gendlin, Eugene T., "Experimental Explication and Truth," *J. Exist. Psych.*, *6* (1965).

Hayner, Paul C., "Expressive Meaning," *J. Phil.*, *53* (1956).

Hirst, Desiree, "On the Aesthetics of Prophetic Art," *B.J.A.*, *4* (1964).

Hofstadter, Albert, "Art and Spiritual Validity," *J.A.A.C.*, *22* (1963).

Hofstadter, Albert, *Truth and Art*, New York, Columbia University Press, 1965.

Hospers, John, "Art and Reality," in *Hook*, 1966.

Hospers, John, "Implied Truths in Literature," *J.A.A.C.*, *19* (1961).

Hospers, John, *Meaning and Truth in the Arts*,* Chapel Hill, University of North Carolina Press, 1946; 1967.

Isenberg, Arnold, "Perception, Meaning and the Subject-Matter of Art," *J. Phil.*, *41* (1944).

Isenberg, Arnold, "The Problem of Belief," *13* (1954).

Jessup, Bertram E., "Meaning Range in the Work of Art," *J.A.A.C.*, *12* (1954).

Jessup, Bertram E., "Truth as Material in Art," *J.A.A.C.*, *12* (1945).

Kaplan, A., "Referential Meaning in the Arts," *J.A.A.C.*, *12* (1954).

Langer, Susanne K., *Feeling and Form*,* New York, Scribner, 1953.

Langer, Susanne K., *Philosophy in a New Key, A Study in Symbolism of Reason, Rite and Art*,* 2nd ed., New York, New American Library, 1964.

Levi, Albert W., "Literary Truth," *J.A.A.C.*, *24* (1966).

McMahon, Philip, *The Meaning of Art*, New York, Norton, 1930.

Meyer, Leonard B., *Emotion and Meaning in Music*,* Chicago, University of Chicago Press, 1956.

Meyer, Leonard B., "Meaning in Music and Information Theory," *J.A.A.C.*, *15* (1957).

Morgan, Douglas N., "Must Art Tell the Truth?," *J.A.A.C.*, *26* (1967).

Mothersill, Mary, "Is Art a Language?," *J. Phil.*, *62* (1965).

Nagel, Ernst, "A Theory of Symbolic Form," review of Langer's *Philosophy in a New Key*, in Ernst Nagel's *Logic Without Metaphysics*, New York, Free Press, 1956.

Ogden, C. K., and I. A. Richards, *The Meaning of Meaning*,* New York, Harcourt, Brace & World, 1923; 1967.

Osborne, Harold, "Revelatory Theories of Art," *B.J.A.*, *4* (1964).

Panofsky, Erwin, *Meaning in the Visual Arts*,* Garden City, N.Y., Doubleday, 1955; esp. pp. 26–54, 146–168.

Pearce, Roy Harvey, "Pure Criticism and the History of Ideas," *J.A.A.C.*, *7* (1948).

Pratt, Carroll C., *The Meaning of Music: A Study in Psychological Aesthetics*, New York, McGraw-Hill, 1931.

Price, Kingsley, "Is There Artistic Truth?," *J. Phil.*, *46* (1949).

Purser, J. W. R., "The Artistic Approach to Truth," *B.J.A.*, *3* (1963).

Redpath, Theodore, "Some Problems of Modern Aesthetics," in C. A. Mace, ed., *British Philosophy in Mid-century*, London, G. Allen, 1957.

Reid, Louis Arnaud, "Art, Truth and Reality," *B.J.A.*, *4* (1964).

Reid, Louis Arnaud, "Beauty and Significance," *P.A.S.*, *29* (1928).

Rudner, Richard, "Some Problems of Nonsemiotic Aesthetic Theories," *J.A.A.C.*, *15* (1957).

Saw, Ruth, "Sense and Nonsense in Aesthetics," *B.J.A.*, *1* (1961).

Sesonske, Alexander, "Truth in Art," *J. Phil.*, *53* (1956).

Sherburne, Donald W., "Meaning and Music," *J.A.A.C.*, *24* (1966).

Smart, Ninian, and Ruth Saw, "Sense and Reference in Aesthetics," *B.J.A.*, *3* (1963).

Sparshott, F. E., "Truth in Fiction," *J.A.A.C.*, *26* (1967).

Stace, W. T., *The Meaning of Beauty*, New York, 1937.

Stevenson, Charles L., *Ethics and Language*,* New Haven, Conn., Yale University Press, 1944, chap. 3; and 1960.

Tomas, Vincent, "On 'Is Art a Language?'" (abstract), *J. Phil.*, *62* (1965).

Tunalí, Ismail, "Validity of Modern Art," *J.A.A.C.*, *22* (1963).

Vivas, Eliseo, "A Definition of the Aesthetic Experience," *J. Phil.*, *34* (1937).

Walsh, Dorothy, "The Cognitive Content of Art," *Phil. R.*, *5* (1943).

Weitz, Morris, "Truth in Literature," *Revue Internationale de Philosophie*, *31* (1955).

Wilshire, Bruce, "Reality and Art," in *Hook*, 1966.

Ziff, Paul, "Truth and Poetry," in his *Philosophic Turnings: Essays in Conceptual Appreciation*, Ithaca, New York, Cornell University Press, 1966.

Ziff, Paul, "On What a Painting Represents," *J. Phil.*, *57* (1960).

Zink, Sidney, "The Cognitive Element in Art," *Ethics*, *64* (1953–54).

Zink, Sidney, "Poetry and Truth," *Phil. R.*, *54* (1945).

SYMBOL AND METAPHOR

Alston, William, *Philosophy of Language*,* Englewood Cliffs, N.J., Prentice-Hall, 1964, chap. 7.

Beardsley, Monroe C., "The Metaphorical Twist," *Phil. and Phen. Res.*, 22 (1962).

Berggren, Douglas, "The Use and Abuse of Metaphor," *Review of Metaphysics*, 16 (1962).

Black, Max, "Metaphor," *P.A.S.*, 55 (1954–55).

Brooks, Cleanth, "Metaphor, Paradox, and Stereotype," *B.J.A.*, 5 (1965).

Bryson, Lyman, *et al.*, *Symbols and Values*, 13th Symposium of conference on Science, Philosophy, and Religion, New York, Harper & Row, 1954.

Chipp, Herschel B., "Formal and Symbolic Factors in the Art Styles of Primitive Cultures," *J.A.A.C.*, 19 (1960).

Creed, Isabel, "Iconic Signs and Expressiveness," *J.A.A.C.*, 3 (1943).

Edie, James M., "Expression and Metaphor," *Phil. and Phen. Res.*, 23 (1963).

Empson, William, *The Structure of Complex Words*, London, Chatto & Windus, 1951, and Ann Arbor, University of Michigan Press, 1967.

Feidleson, Charles, Jr., *Symbolism and American Literature*, Chicago, University of Chicago Press, 1953; 1959.

Fingeston, Peter, "The Six-fold Law of Symbolism," *J.A.A.C.*, 21 (1963).

Foss, Martin, *Symbol and Metaphor in Human Experience*,* Princeton, N.J., Princeton University Press, 1942, and Lincoln, Neb., University of Nebraska Press, 1964.

Garvin, Lucius, "The Paradox of Aesthetic Meaning," *Phil. and Phen. Res.*, 8 (1947); also in *Langer*, 1958.

Hanslick, Eduard, *The Beautiful in Music*,* New York, Liberal Arts Press, 1957, pp. 20–70.

Henderson, G. P., "Metaphorical Thinking," *Phil. Q.*, 3 (1953).

Henle, Paul, "Metaphor," in his *Language, Thought and Culture*,* Ann Arbor, University of Michigan Press, 1958.

Hepburn, Ronald W., "Literary and Logical Analysis," *Phil. Q.*, 8 (1958).

Herschberger, R., "The Structure of Metaphor," *Kenyon Review*, 5 (1943).

Hester, Marcus B., "Metaphor and Aspect Seeing," *J.A.A.C.*, 25 (1966).

Kaminsky, Jack, "Symbols in Art," in *Hook*, 1966.

Khatchadourian, Haig, "Metaphor," *B.J.A.*, 8 (1968).

Langer, Susanne K., *Philosophy in a New Key*,* Cambridge, Mass., Harvard University Press, 1942, and New York, New American Library, 1967.

Langer, Susanne K., "The Symbol of Feeling," in her *Feeling and Form*,* New York, Scribner, 1953, pp. 24–41.

Mészaros, István, "Metaphor and Simile," *P.A.S.*, 77 (1966–67).

Morgan, Douglas N., "Icon Index and Symbol in the Visual Arts," *Phil. Studies*, 6 (1955).

Morris, Charles, "Esthetics and the Theory of Signs," *J. of Unified Science*, 8 (1939).

Nagel, Ernst, "A Theory of Symbolic Form," in his *Logic Without Metaphysics*, New York, Free Press, 1956.

Panofsky, E., *Studies in Iconology*,* New York, Oxford University Press, 1939, and New York, Torchbooks (Harper & Row), 1962.

Percy, Walker, "Symbol as Hermeneutic in Existentialism," *Phil. and Phen. Res.*, 16 (1956).

Prumières, Henry, "Musical Symbolism," *Musical Q.*, 19 (1933).

Reid, Louis Arnaud, "Symbolism in Art," *B.J.A.*, 1 (1961).

Rudner, Richard, "On Semiotic Aesthetics," *J.A.A.C.*, *10* (1951).

Schaper, Eva, "The Art Symbol," *B.J.A.*, *4* (1964).

Srzednicki, J., "On Metaphor," *Phil. Q.*, *10* (1960).

Stevenson, Charles L., "Symbolism in the Nonrepresentational Arts," and "Symbolism in the Representational Arts," both in Paul Henle, ed., *Language, Thought and Culture,** Ann Arbor, University of Michigan Press, 1958.

Urban, Wilbur M., *Language and Reality*, London, G. Allen, 1939; 1961.

Ushenko, Andrew, "Metaphor," *Thought*, *30* (1955).

Van Steenburgh, E. W., "Metaphor," *J. Phil.*, *62* (1965).

Welsh, P., "Discursive and Presentational Symbols," *Mind*, *64* (1955).

Wheelwright, P., *Metaphor and Reality*, Bloomington, Indiana University Press, 1962.

Whitehead, A. N. *Symbolism: Its Meaning and Effect,** New York, Macmillan, 1927, and New York, Putnam, 1959.

STYLE AND FORM

Ackerman, James S., "A Theory of Style," *J.A.A.C.*, *20* (1962).

Barasch, Moshe, "Gantner's Theory of Prefiguration," *B.J.A.*, *3* (1963).

Beardsley, Monroe C., *Aesthetics*, New York, Harcourt, Brace & World, 1958, pp. 165–266.

Berry, Ralph, "The Frontier of Metaphor and Symbol," *B.J.A.*, *7* (1967).

Bloosfeldt, Karl, *Art Forms in Nature*, London, A. Zwemmer, 1936.

Bossart, William H., "Form and Meaning in the Visual Arts," *B.J.A.*, *6* (1966).

British Journal of Aesthetics, Special Issue, "On Clive Bell," *5* (1965): Dickie, George T., "Clive Bell and the Method of Principia Ethica"; Elliott, R. K., "Clive Bell's Aesthetic Theories and His Critical Purpose"; Meager, R., "Clive Bell and Aesthetic Emotion"; Read, Herbert, "Clive Bell."

Carpenter, Rhys, *Greek Art: A Study of the Formal Evolution of Style*, Pittsburgh, University of Pennsylvania Press, and London, Oxford University Press, 1963.

Collier, Graham, *Form, Space and Vision*, Englewood Cliffs, N.J., Prentice-Hall, 1963; 2nd ed., 1966.

Dewey, John, *Art as Experience,** New York, Minton, Balch, 1934, and New York, Putnam, 1959.

Dickie, George, "Design and Subject Matter: Fusion and Confusion," *J. Phil.*, *58* (1961).

Ducasse, Curt J., *The Philosophy of Art*, New York, Dial Press, 1929, pp. 202–208; rev. ed.,* Dover, 1963.

Fleming, William, "The Newer Concepts of Time and Their Relation to the Temporal Arts," *J.A.A.C.*, *4* (1945–46).

Fry, Roger, *Vision and Design,** London, Chatto & Windus, 1920, and New York, Meridian, 1956.

Gombrich, E. H., *Norm and Form: Studies in the Art of the Renaissance*, New York, Phaidon, 1966.

Gotshalk, D. W., "Form and Expression in Kant's Aesthetics," *B.J.A.*, *7* (1967).

Ingarden, Roman, "The General Question of the Essence of Form and Content," *J. Phil.*, *57* (1960).

Kavolis, Vytantus, "Economic Conditions and Art Styles," *J.A.A.C.*, *22* (1964).

Kennick, W. E., "Form and Content in Art," in *Hook*, 1966.

Kroeber, A. L., *Style and Civilization,** Berkeley, University of California Press, and London, Cambridge University Press, 1963.

Kuhns, Richard C., "Art Structures," *J.A.A.C.*, *19* (1960).

Lang, Berel, "Significance or Form: The Dilemma of Roger Fry's Aesthetics," *J.A.A.C.*, *21* (1962).

Langer, Susanne K., *Feeling and Form*,* New York, Scribner, 1953.

Levertov, Denise, "Some Notes on Organic Form," *Poetry*, *56* (1965).

May, Rollo, "Passion for Form," *Review of Existential Psychology and Psychiatry*, 7 (1967).

Miles, Josephine, "Toward a Theory of Style and Change," *J.A.A.C.*, *22* (1963).

Munroe, Thomas, "Style in the Arts: A Method of Stylistic Analysis," *J.A.A.C.*, *5* (1946).

Podro, Michael, "Formal Elements and Theories of Modern Art," *B.J.A.*, *6* (1966).

Prall, D. W., *Aesthetic Judgment*,* New York, Crowell, 1929; esp. chaps. 3–12.

Read, Sir Herbert, *The Forms of Things Unknown: Essay Toward an Aesthetic Philosophy*,* New York, Horizon Press, 1960, and New York, Meridian, 1967.

Rieser, Max, "Problems of Artistic Form: The Concept of Form," *J.A.A.C.*, *25* (1966).

Rodman, Selden, *The Eye of Man: Form and Content in Western Painting*, New York, Devin Adair, 1955.

Santayana, George, *The Sense of Beauty*,* New York, Scribner, 1896; and various other paperback editions.

Schaper, Eva, "Significant Form," *B.J.A.*, *1* (1961).

Schapiro, Meyer, "Style," in A. E. Kroeber, ed., *Anthropology Today*,* Chicago, University of Chicago Press, 1953, pp. 287–312, and 1962.

Schrecker, Paul, "Phenomenological Considerations on Style," *Phil. and Phen. Res. 8* (1948).

Sebeok, Thomas A., *et al.*, *Style in Language*,* Cambridge, Mass., Press of M.I.T., 1960; 1967.

Shahn, Ben, *The Shape of Content*, Cambridge, Mass., Harvard University Press, 1957.

Stein, Erwin, *Form and Performance*, London, Faber & Faber, 1962.

Stokes, Adrian, "Form in Art: A Psychoanalytic Interpretation," *J.A.A.C.*, *18* (1959).

Thornton, H., and A. Thornton, *Time and Style*, London, Methuen, 1962.

Weitz, Morris, *Philosophy of the Arts*, Cambridge, Mass., Harvard University Press, 1950, chap. 3.

Wölfflin, Heinrich, *Principles of Art History*,* New York, Dover, 1950.

Wollheim, Richard, "Form, Elements, and Modernity: Reply to Michael Podro," *B.J.A.*, *6* (1966).

Zink, Sidney, "The Poetic Organism," *J. Phil.*, *42* (1942).

Zupnick, Irving L., "The Iconology of Style (or Wölfflin Reconsidered)," *J.A.A.C.*, *19* (1961).

THE PSYCHOLOGY OF ART

Books

Arnheim, Rudolph, *Art and Visual Perception*,* London, Faber & Faber, 1967, and Berkeley, University of California Press, 1967.

Arnheim, Rudolph, "Gestalt Psychology and Artistic Form," in L. L. Whyte, ed., *Aspects of Form*,* London, Lund Humphries, 1951, and Bloomington, Indiana University Press, 1967.

Arnheim, Rudolph, *Towards a Psychology of Art*, London, Faber & Faber, 1967.

Bandonin, C., *Psychoanalysis and Aesthetics*, New York, Dodd, Mead, 1924.

Bergler, Edmund, *The Writer and Psychoanalysis*, Garden City, N.Y., Doubleday, 1950.

Bullough, Edward, *Aesthetics: Lectures and Essays*, ed. Elizabeth Wilkinson, London, Bowes & Bowes, 1957.

Chandler, Albert Richard, *Beauty and Human Nature: Elements of Psychological Aesthetics*, New York, Appleton-Century-Crofts, 1934.

Child, Irvin L., "Aesthetics," *International Encyclopedia of the Social Sciences*, New York, Macmillan and Free Press, 1958, vol. 1, pp. 116–121.

Downey, June, *Creative Imagination*, New York, Harcourt, Brace & World, 1929.

Ehrenzweig, A., "The Modern Artist and the Creative Accident," *The Listener*, January 12, 1956.

Ehrenzweig, A., *The Psychoanalysis of Artistic Vision and Hearing*, London, Routledge, 1953.

Freud, Sigmund, *On Creativity and the Unconscious: Papers on the Psychology of Art, Literature, Love, Religion,** ed. Benjamin Nelson, New York, Harper & Row Torchbooks, 1958.

Fry, Roger, *The Artist and Psychoanalysis*, London, Hogarth Press, 1924.

Gombrich, E. H., *Art and Illusion: A Study in the Psychology of Pictorial Representation*, New York, Phaidon, 1960.

Groos, Karl, *The Play of Animals*, New York, Appleton-Century-Crofts, 1898.

Groos, Karl, *The Play of Men*, New York, Appleton-Century-Crofts, 1901.

Gourmont, Remy de, "Subconscious Creation," *Decadence*, New York, Harcourt, Brace & World, 1921.

Guggenheimer, Richard, *Creative Vision in Audience and Artist*, New York, Harper & Row, 1950.

Hacker, Frederich J., "On Artistic Production," in R. M. Lindner, ed., *Explorations in Psychoanalysis*, New York, Julian Press, 1953.

Hauser, Arnold, *Philosophy of Art History,** New York, Knopf, 1959, and New York, Meridian, 1967.

Hoffman, F. J., *Freudianism and the Literary Mind,** Baton Rouge, Louisiana State University Press, 1945, and 1957.

Jacobi, Jolan (ed.), *Complex, Archetype, Symbol in the Psychology of C. G. Jung*, New York, Pantheon, 1959.

Jacobi, Jolan (ed.), *Psychological Reflections: An Anthology of the Writings of C. G. Jung*, New York, Pantheon, 1953.

Jenkins, Iredell, *Art and the Human Enterprise*, Cambridge, Mass., Harvard University Press, 1958.

Jung, Carl Gustar, *The Archetypes and the Collective Unconscious*, vol. 9 of *Collected Works*, New York, Pantheon, 1959.

Jung, Carl Gustar, *Psyche and Symbol,** ed. Violet S. de Laszlo, Garden City, N.Y., Anchor (Doubleday), 1958.

Jung, Carl Gustar, "Psychology and Literature," in his *Modern Man in Search of a Soul,** New York, Harcourt, Brace & World, 1934.

Jung, Carl Gustar, "On the Relation of Analytical Psychology to Poetic Art," in *Contributions to Analytical Psychology*, London, 1928.

Koffka, Kurt, "Problems in the Psychology of Art," in *Art: A Symposium*, Bryn Mawr, Pa., Bryn Mawr College, 1940.

Kretschner, Ernst, *The Psychology of Men of Genius*, New York, Harcourt, Brace & World, 1931.

Kris, Ernst, "Art and Regression," *Transactions of the New York Academy of Sciences*, 6 (1944).

Kris, Ernst, *Psychoanalytic Explorations in Art,** New York, International Universities Press, 1958, and New York, Schocken, 1964.

Kubie, Lawrence S., *Neurotic Distortion of the Creative Process,** Lawrence, University of Kansas, 1958, and New York, Farrar, Straus & Giroux, 1967.

Lange-Eichbaum, Wilhelm, *The Problem of Genius*, trans. Eden and Cedar Paul, New York, Macmillan, 1932.

Lowenfeld, V., *The Nature of Creative Activity*, 3rd ed., New York, Harcourt, Brace & World, 1957.

Malraux, André, *The Psychology of Art*, (Bollingen Series 24), trans. Stuart Gilbert, New York, Pantheon, 1949.

Mauron, Charles, *Aesthetics and Psychology*, London, Hogarth Press, 1935.

Mursell, James L., *The Psychology of Music*, New York, Norton, 1937.

Nelson, Benjamin (ed.), *Freud and the Twentieth Century*,* New York, Meridian, 1957.

Neumann, Erich, *Art and the Creative Unconscious*,* London, Routledge, 1959, and New York, Harper & Row, 1967.

Ogden, R. M., *The Psychology of Art*, New York, Scribner, 1938.

Philipson, Morris, *Outline of a Jungian Aesthetics*, Evanston, Ill., Northwestern University Press, 1963.

Phillips, William (ed.), *Art and Psychoanalysis*,* New York, Criteria, 1957, and New York, Meridian, 1967; esp. Ernst Kris, "The Contribution and Limitations of Psychoanalysis."

Piaget, Jean, *Plays, Dreams and Imagination in Childhood*,* London, Routledge, 1962, and New York, Norton, 1962.

Portnoy, Julius, *A Psychology of Art Creation*, Philadelphia, University of Pennsylvania Press, 1942.

Pratt, Carroll C., "Aesthetics," *Ann. R. of Psychology*, *12* (1961). See bibliography, pp. 71–92.

Rank, Otto, *The Myth of the Birth of the Hero, and Other Essays*,* ed. Philip Freund, New York, Vintage (Random House), 1959.

Rawlins, Francis Ian C., *Aesthetics and the Gestalt, Essays*, Edinburgh, Nelson, 1953.

Rees, H. E. *A Psychology of Artistic Creation*, New York, Columbia University Teachers College, 1942.

Ribot, T., *The Creative Imagination*, Paris, F. Alcan, 1900.

Sachs, Hanns, *The Creative Unconscious*, Cambridge, Mass., Sci-Art Publications, 1951.

Sartre, Jean-Paul, *The Psychology of Imagination*, trans. anon., New York, Philosophical Library, 1948.

Schneider, D. E., *The Psychoanalyst and the Artist*,* New York, Farrar, Straus & Giroux, 1950, and New York, New American Library, 1967.

Segal, H., "The Psychoanalytic Approach to Aesthetics," in Melanie Klein, ed., *New Directions in Psychoanalysis*, New York, Tavistock, 1955.

Smith, Paul (ed.), *Creativity*, New York, Hastings House, 1959.

Spearman, Charles E., *Creative Mind*, New York, Appleton-Century-Crofts, 1931.

Thorburn, John M., *Art and the Unconscious*, London, Routledge, 1925.

Trilling, Lionel, *Freud and the Crisis of Our Culture*, Boston, Beacon Press, 1955.

Valentine, C. W., *The Experimental Psychology of Beauty*, London, Methuen, and New York, Dover, 1962.

Articles

Alexander, Christopher, "The Origin of Creative Power in Children," *B.J.A.*, *2* (1962).

Arnheim, Rudolph, "Information Theory and the Arts," *J.A.A.C.*, *17* (1959).

Aschenbrenner, Karl, "Creative Receptivity," *J.A.A.C.*, *22* (1963).

Auden, W. H., "Psychology and Art Today," in G. Grigson, ed., *The Arts Today*, London, Lane, 1935.

Bartlett, F. C., "Types of Imagination," *J. Phil. Studies*, *3* (1928).

Beloff, John, "Comments on the Gombrich Problem," *B.J.A.*, *1* (1961).

Bergler, Edmund, "Psychoanalysis of Writers and of Literary Production," in Geza Roheim, ed., *Psychoanalysis and the Social Sciences*, Annual I, New York, International Universities Press, 1947.

Bodkin, A. M., "The Relevance of Psychoanalysis to Art Criticism," *Br. J. Psych.*, *25* (1924–25).

Brain, Lord, "Diagnosis of Genius," *B.J.A.*, *3* (1963).

Brittain, W. Lambert, and Kenneth R. Beittel, "Analyses of Levels of Creative Performances in the Visual Arts," *J.A.A.C.*, *19* (1960).

Burke, Kenneth, "Freud and the Analysis of Poetry," in his *Philosophy of Literary Form*,* Baton Rouge, Louisiana State University Press, 1941, and Vintage (Random House), 1957.

Cerf, Walter, "Psychoanalysis and the Realistic Drama," *J.A.A.C.*, *17* (1958).

Crockett, Campbell, "Psychoanalysis in Art Criticism," *J.A.A.C.*, *17* (1958).

Cruickshank, John "Psychocriticism and Literary Judgment," *B.J.A.*, *4* (1964).

Dickie, George, "Is Psychology Relevant to Aesthetics?," *Phil. R.*, *71* (1962).

Ecker, David W., "The Artistic Process as Qualitative Problem Solving," *J.A.A.C.*, *21* (1963).

Ehrenzweig, Anton, "A New Psychoanalytic Approach to Aesthetics," *B.J.A.*, *2* (1962).

Eiduson, Bernice T., "Artist and Non-Artist: A Comparative Study," *J. Personality*, *26* (1958).

Feibleman, James K., "A Behaviorist Theory of Art," *B.J.A.*, *3* (1963).

Fizer, John, "The Problem of the Unconscious in the Creative Process as Treated by Soviet Aesthetics," *J.A.A.C.*, *21* (1963).

Fraiberg, Louis, "Freud's Writings on Art," *Int. J. Psychoanalysis*, *37* (1956).

Fraiberg, Louis, *Psychoanalysis and American Literary Criticism*, Detroit, Wayne State University Press, 1960; review in *J.A.A.C.*, *19* (1960).

Fröhlich, Fauchon, "The Function of Perceptual Asymmetry in Picture Space," *B.J.A.*, *4* (1964).

Frye, Northrop, "The Archetypes of Literature," *Kenyon Review*, *13* (1951).

Gombrich, E. H., "Psychoanalysis and the History of Art," in Benjamin Nelson, ed., *Freud and the Twentieth Century*,* New York, Meridian, 1957, reprinted from *Int. J. Psychoanalysis*, *35* (1954).

Hardin, Herbert, "Psychoanalysis, Modern Art, and the Modern World," *Psychiatric Q.*, *19* (1950).

Harding, D. W., "Psychological Processes in the Reading of Fiction," *B.J.A.*, *2* (1962).

Hargreaves, H. L., "The 'Faculty' of Imagination," *Br. J. Psych.*, *Monograph Supp.*, *3* (1927).

Harré, R., "Art and Psychology," *Ratio*, *2* (1959).

Hausman, Carl R., "Maritain's Interpretation of Creativity in Art," *J.A.A.C.*, *19* (1960).

Hill, J. C., "Poetry and the Unconscious," *Br. J. Medical Psych.*, *4* (1924).

Hyman, Stanley Edgar, "Psychoanalysis and the Climate of Tragedy," in Benjamin Nelson, ed., *Freud and the Twentieth Century*,* New York, Meridian, 1957, pp. 167 ff.

J. Aesthetics and Art Criticism, Special Issue on Psychology, *10* (1952).

Kanzer, Mark, "Applied Psychoanalysis I: Arts and Aesthetics," *Annual Survey Psychoanalysis*, *2* (1951).

Kaplan, Abraham, and Ernst Kris, "Aesthetic Ambiguity," reprinted in Ernst Kris, *Psychoanalytic Explorations in Art*, New York, International Universities Press, 1952.

Klein, Melanie, *et al.* (eds.), *New Directions in Psychoanalysis*, New York, Basic Books, 1955: Riviere, Joan, "The Unconscious Phantasy of an Inner World

Reflected in Examples from Literature," pp. 346–370; Segal, Hanna, "A Psychoanalytical Approach to Aesthetics," pp. 384–406; Stokes, Adrian, "Form in Art," pp. 406–421.

Kris, Ernst, "Approaches to Art," in S. Lorand, ed., *Psychoanalysis Today*, New York, International Universities Press, 1944, pp. 354–370.

Kris, Ernst, "Art and Regression," trans. N.Y. Academy of Science, 6 (1944).

Kris, Ernst, "Ego Development and the Comic," *Int. J. Psychoanalysis*, 19 (1938).

Kris, Ernst, "On Inspiration," *Int. J. Psychoanalysis*, 20 (1939).

Langer, Susanne K., "The Principles of Creation in Art," *Hudson Review*, 2 (1949–50).

Lee, Harry B., "On the Esthetic States of the Mind," *Psychiatry*, 10 (1947).

Lowenfeld, Viktor, "Psychological-Aesthetics: Implications of the Art of the Blind," *J.A.A.C.*, 10 (1951).

Mace, C. A., "Psychology and Aesthetics," *B.J.A.*, 2 (1962).

Marcuse, Ludwig, "Freud's Aesthetics," *J.A.A.C.*, 17 (1958).

Morgan, Douglas, "Creativity Today," *J.A.A.C.*, 12 (1963).

Morgan, Douglas, "Psychology and Art Today: A Summary and Critique," *J.A.A.C.*, 9 (1950).

Munro, Thomas, "Methods in the Psychology of Art," *J.A.A.C.*, 6 (1948).

Munro, Thomas, "The Psychology of Art: Past, Present, Future," *J.A.A.C.*, 21 (1963).

Oberndorf, Clarence, "Psychoanalysis in Literature and Its Therapeutic Value," in Geza Roheim, ed., *Psychoanalysis and Social Science*, New York, International Universities Press, 1947.

Osborne, Harold, "Artistic Unity and Gestalt," *Phil. Q.*, 14 (1964).

Parker, DeWitt H., "Wish-Fulfillment and Intuition in Art," in New York, *Proceedings of the Sixth International Congress of Philosophy*, 1931.

Portnoy, Julius, "Is the Creative Process Similar in the Arts?," *J.A.A.C.*, 19 (1960).

Rader, Melvin, "The Artist as Outsider," *J.A.A.C.*, 16 (1958).

Rau, Catherine, "Psychological Notes on the Theory of Art as Play," *J.A.A.C.*, 8 (1950).

Read, Herbert, "Psychoanalysis and Criticism," in his *Reason and Romanticism*, London, Faber & Faber, 1926, and New York, Russell & Russell, 1963, and expanded as "The Nature of Criticism," in his *Collected Essays in Literary Criticism*, London, Faber & Faber, 1938.

Read, Herbert, "Psychoanalysis and the Problem of Aesthetic Value," *Int. J. Psychoanalysis*, 32 (1951).

Schapiro, Meyer, "Leonardo and Freud: An Art-Historical Study," *J. Hist Ideas*, 17 (1956).

Schapiro, Meyer, "Two Slips of Leonardo and a Slip of Freud," *J. Psychoanalytic Psych.*, 4 (1955–56).

Schnier, Jacques, "Art Symbolism and the Unconscious," *J.A.A.C.*, 12 (1953).

Schrickel, H. G., "Psychology of Art," in A. A. Roback, ed., *Present-day Psychology*, New York, Philosophical Library, 1955.

Stekel, Wilhelm, "Poetry and Neurosis," *Psychoanalytic R.*, 10 (1923), 73–96, 190–208, 316–328, 457–466.

Sterba, Richard, "The Problem of Art in Freud's Writings," *Psychoanalytic Q.*, 9 (1940).

Stokes, Adrian, "Form in Art: A Psychoanalytic Interpretation," *J.A.A.C.*, 18 (1959).

Szathmary, Arthur, "Physiognomic Expression Again," *J.A.A.C.*, 25 (1967).

Thorburn, John M., A. H. Hannay, and P. Leon, "Artistic Form and the Unconscious," in *Modern Tendencies in Philosophy*, *P.A.S. Supp. Vol. 13*, London, (1934).

Tomas, Vincent, "Creativity in Art," *Phil. R.*, *67* (1958).

Trilling, Lionel, "Art and Neurosis," in his *Liberal Imagination*,* New York, Viking Press, 1945.

Trilling, Lionel, "The Legacy of Freud: Literary and Aesthetic," *Kenyon Review*, *2* (1940).

Waley, Hubert, "The Correlation of Expressionist and Aesthetic Theories," *B.J.A.*, *1* (1961).

Wallach, Michael A., "Art, Science, and Representation: Toward an Experimental Psychology of Aesthetic," *J.A.A.C.*, *18* (1959).

Westland, Gordon, "The Psychologist's Search for Objectivity in Aesthetics," *B.J.A.*, *7* (1967).

Wittels, Fritz, "Psychoanalysis and Literature," in S. Lorand, ed., *Psychoanalysis Today*, London, G. Allen, 1948.

ART, SOCIETY, AND MORALITY

Books

Adler, Mortimer, *Art and Prudence*, New York, McKay, 1937.

Bell, Clive, *Art*,* London, Chatto & Windus, 1928, and New York, Putnam, 1959.

Bergson, Henri, *The Two Sources of Morality and Religion*,* Garden City, N.Y., Doubleday, 1954.

Cogley, John, *Report on Blacklisting*, 2 vols., New York, Fund for the Republic, 1956.

Farrell, James T., *Literature and Morality*, New York, Vanguard Press, 1947.

Finkelstein, S., *Art and Society*, New York, International Publishers, 1947.

Fischer, Ernst, *The Necessity of Art: A Marxist Approach*,* Baltimore, Penguin, 1964.

Goodman, Paul, *Art and Social Nature*, New York, Vinco, 1946.

Gotshalk, D. W., *Art and the Social Order*,* Chicago, University of Chicago Press, 1947, and New York, Dover, 1962.

Harap, Louis, *Social Roots of the Arts*, New York, International Publishers, 1949.

Hauser, Arnold, *The Social History of Art*,* vols. 1–4, London, Routledge, 1962, and New York, Vintage, 1967.

Kallen, Horace M., *Art and Freedom*, New York, Duell, Sloan & Pierce, 1942.

Lawrence, D. H., *Sex, Literature and Censorship*, New York, Viking Press, 1959.

Lukács, George, *Studies in European Realism*,* London, 1950, and New York, Grosset and Dunlap, 1964.

Marx, K., and F. Engels, *Literature and Art* (collection), New York, International Publishers, 1947.

Mukerjee, R., *The Social Function of Art*, New York, Philosophical Library, 1954.

Ortega y Gasset, José, *The Dehumanization of Art, and Other Writings on Art and Culture*, Garden City, N.Y., Doubleday, 1956.

Plekenov, George V., *Art and Social Life*, London, Lawrence & Wishard, 1953.

Plekenov, George V., *Art and Society*, New York, Critics Group, 1936.

Read, Sir Herbert, *Art and Alienation: The Role of the Artist in Society*, London, Thames & Hudson, 1967.

Read, Sir Herbert, *Art and Industry*,* New York, Horizon Press, 1954, and Bloomington, Indiana University Press, 1961.

Read, Sir Herbert, *Art and Society*,* London, Faber & Faber, 1967, and New York, Schocken, 1966.

Read, Sir Herbert, *Education Through Art*, 3rd ed., rev., New York, Pantheon, 1958.

Saw, Ruth, *Conversation and Communication*, Inaugural Lecture, London, Birkbeck College, 1963.

Schiller, Friedrich, *On the Aesthetic Education of Man*, New Haven, Conn., Yale University Press, 1954.

Shelley, Percy Bysshe, "Defense of Poetry," reprinted in *Criticism*, ed. Mark Schorer, Josephine Miles, and Gordon McKenzie, New York, Harcourt, Brace & World, 1948, pp. 455–470.

Smith, Marian W. (ed.), *The Artist in Tribal Society*, London, Routledge, 1961.

Snell, B., *Poetry and Society*, Bloomington, Indiana University Press, 1961.

Sparshott, F. E., "Art and Society," in *The Structure of Aesthetic*, Toronto, University of Toronto Press, 1963, chap. 10.

Trotsky, Leon, *Literature and Revolution*,* New York, Russell & Russell, 1957, and Ann Arbor, University of Michigan Press, 1960.

Willett, John, *Art in a City*, London, Methuen, 1967.

Articles

Adam, Ian W., "Society as Novelist," *J.A.A.C.*, *25* (1967).

Alford, John, "Problems of a Humanistic Art in a Mechanistic Culture," *J.A.A.C.*, *20* (1961).

Bayley, John, "Vulgarity," *B.J.A.*, *4* (1964).

Baxandall, Lee, "Marxism and Aesthetics: A Critique of the Contribution of George Plekhanov," *J.A.A.C.*, *25* (1967).

Bedel, Maurice, "The Rights of the Creative Artist," in Dorothy Lee, ed., *Freedom and Culture*, Englewood Cliffs, N.J., Prentice-Hall, 1959.

Chatterji, P. C., "Ethical and Aesthetic Problems," *B.J.A.*, *1* (1961).

Child, Arthur, "The Social-Historical Relativity of Aesthetic Value," *Phil. R.*, *53* (1944).

Cowley, Daniel, "Aesthetic Judgment and Cultural Relativism," *J.A.A.C.*, *17* (1958).

Crawford, Donald W., "Can Disputes Over Censorship Be Resolved?," *Ethics*, *78* (1968).

Dewey, John, "Art and Civilization," in his *Art as Experience*,* New York, Minton, Balch, 1934, pp. 326–349; and New York, Putnam, 1959.

Duncan, Elmer, H., "Arguments Used in Ethics and Aesthetics: Two Differences," *J.A.A.C.*, *25* (1967).

Ekman, Rolf, "Aesthetic Value and the Ethics of Life Affirmation," *B.J.A.*, *3* (1963).

Eliot, T. S., "Tradition and the Individual Talent," in *The Sacred World**, New York, Barnes & Noble, 1950.

Feyerabend, Paul K., "The Theatre as an Instrument of the Criticism of Ideologies," *Inquiry*, *10* (1967).

Gardner, P., R. Hebden, and Ken Adams, "Symposium: Theoretical Problems of Art Education," *B.J.A.*, *6* (1966).

Haag, W. C., "The Artist as a Reflection of His Culture," in Gertrude Dole and Robert Carniero, eds., *Essays in the Science of Culture*,* New York, Crowell, 1960.

Jenkins, John J., "In Defense of the Aesthetic," *B.J.A.*, *7* (1967).

Kaplan, Abraham, "Obscenity as an Aesthetic Category," in Robert Kramer, ed., *Law and Contemporary Problems*, Durham, N.C., Duke University Press (Fall, 1955), pp. 544–559, and reprinted in Sidney Hook, ed., *American Philosophers at Work*, New York, Criterion Books, 1956, pp. 397–417.

Kuhns, Richard, "Art and Machine," *J.A.A.C.*, *25* (1967).

McKeon, Richard, "Character and the Arts and Disciplines," *Ethics*, *78* (1968).

McWhinnie, Harold James, "The Problem of Structure in Art Education," *B.J.A.*, *6* (1966).

Martland, T. R., "An Analogy Between Art and Religion," *J. Phil.*, *63* (1966).

Meager, R., "The Sublime and the Obscene," *B.J.A.*, *4* (1964).
Mitchells, K., "The Work of Art and Its Social Setting and in Its Aesthetic Isolation,"
 J.A.A.C., *25* (1967).
Morawski, Stefan, "Art and Obscenity," *J.A.A.C.*, *26* (1967).
Nahm, Milton C., "The Function of Art," in *Art: A Bryn Mawr Symposium*, Bryn
 Mawr, Pa., 1940, pp. 312–350.
Newton, Eric, "Art as Communication," *B.J.A.*, *1* (1961).
Rader, Melvin, "Marx's Interpretation of Art and Aesthetic Value," *B.J.A.*, *7*
 (1967).
Rawlins, F. I. G., "Religion and Aesthetics," *B.J.A.*, *6* (1966).
Schwartz, Delmore, "The Vocation of the Poet in the Modern World," in Stanley
 Romaine Hopper, ed., *Spiritual Problems in Contemporary Literature*,* New
 York, P. Smith, 1958, pp. 59–69; and New York, Harper & Row Torchbooks,
 1957.

MUSIC

Harvard Dictionary of Music, Willi Apel (ed.), Cambridge, Mass., Harvard Uni-
 versity Press, 1945.
"Musik-Asthetik," in *Die Musik in Geschichte und Gegenwart*, F. Blume (ed.),
 Barenreiter Kassel, London and New York, Blackwell, 1961. See for extensive
 bibliography of German, French, and English works on the Aesthetic of
 Music.

Books

Abraham, Gerald, *A Hundred Years of Music*, London, Duckworth, 1949, and
 New York, Aldine, 1964.
Allen, Warren Dwight, *Philosophies of Music History*,* New York, Dover, 1939.
Austin, William W., *Music in the Twentieth Century*, New York, Norton, 1966.
Brown, Calvin Smith, *Music and Literature, A Comparison of the Arts*, Athens,
 University of Georgia Press, 1948.
Buck, P. C., *The Scope of Music*, 2nd ed., London, Oxford University Press, 1927.
Chávez, Carlos, *Musical Thought*, Cambridge, Mass., Harvard University Press,
 1961.
Cooke, Deryck, *The Language of Music*,* New York, Oxford University Press,
 1959.
Cooper, G. W., and L. B. Meyer, *The Rhythmic Structure of Music*,* Chicago,
 University of Chicago Press, 1960.
Copland, Aaron, *Music and Imagination*,* Cambridge, Mass., Harvard University
 Press, 1952, and New York, New American Library, 1967.
Copland, Aaron, *The New Music: 1900–1960*, rev. ed., New York, Norton, 1968.
Debussy, Claude, Ferrucio Busoni, and Charles E. Ives, *Three Classics in the
 Esthetics of Music*,* New York, Dover, and London, Constable, 1963.
Demuth, Norman (ed.), *An Anthology of Musical Criticism*, London, Eyre &
 Spottswoode, 1947.
Donington, Robert, *The Interpretation of Early Music*, London, Faber & Faber,
 and New York, St. Martin's Press, 1963.
Ehrenzweig, Anton, *The Psychoanalysis of Artistic Vision and Hearing*, New York,
 Braziller, 1965.
Einstein, Alfred, *Greatness in Music*, New York, Oxford University Press, 1941.
Einstein, Alfred, *Music in the Romantic Era*, New York, Norton, 1947.
Ferguson, D. N., *Music as Metaphor; The Elements of Expression*, Minneapolis,
 University of Minnesota, 1960.
Goldman, Richard Franks, *Harmony in Western Music*, New York, Norton, 1965.

Graf, Max, *Composer and Critic: Two Hundred Years of Musical Criticism*, New York, Norton, 1946.

Grout, Donald, *A History of Western Music*, New York, Norton, 1960.

Grove's Dictionary of Music and Musicians, New York, St. Martin's Press, 1955.

Hansen, Peter, *An Introduction to Twentieth Century Music*, 2nd ed., Boston, Allyn & Bacon, 1967.

Hanslick, Eduard, *The Beautiful in Music*,* New York, Liberal Arts Press, 1957, pp. 20–70.

Hindemith, Paul, *A Composer's World*,* Cambridge, Mass., Harvard University Press, 1952, and Garden City, N.Y., Anchor (Doubleday).

Lang, Paul Henry, *Music in Western Civilization*, New York, Norton, 1941.

Langer, Susanne K., *Feeling and Form: A Theory of Art*,* New York, Scribner, 1953.

Liepmann, Klaus, *The Language of Music*, New York, Ronald Press, 1953.

Lippman, Edward A., *Musical Thought in Ancient Greece*, New York, Columbia University Press, 1964.

Meyer, Leonard B., *Emotion and Meaning in Music*,* Chicago, University of Chicago Press, 1956.

Meyer, Leonard B., *Music, the Arts, and Ideas: Pattern and Predictions in Twentieth Century Culture*, Chicago, University of Chicago Press, 1967.

Meyer, Leonard B., and Grosvenor W. Cooper, *The Rhythmic Structure of Music*,* Chicago, University of Chicago Press, 1961.

Meyer, M., *Contributions to a Psychological Theory of Music*, Columbia, University of Missouri Press, 1901.

Mitchell, Donald, *The Language of Modern Music*, London, Faber & Faber, 1963, and New York, St. Martin's Press, 1964.

Morris, R. O., *The Structure of Music*, New York, Oxford University Press, 1935.

Mueller, John H., and Kate Hevner, *Trends in Musical Taste*,* Bloomington, Indiana University Press, 1942.

Portnoy, Julius, *The Philosopher and Music*, New York, Humanities Press, 1955.

Pratt, Carroll Cornelius, *The Meaning of Music: A Study in Psychological Aesthetics*, New York, McGraw-Hill, 1931.

Ratner, Leonard G., *Harmony: Structure and Style*, New York, McGraw-Hill, 1962.

Salzman, Eric, *Twentieth Century Music: An Introduction*,* Englewood Cliffs, N.J., Prentice-Hall, 1967.

Saminsky, L., *Physics and Metaphysics of Music*, The Hague, Martinus Nijhoff, 1957.

Schoen, Max, *The Effects of Music*, New York, Harcourt, Brace & World, 1927.

Schoen, Max, *The Understanding of Music*, New York, Harper & Row, 1945.

Schönberg, Arnold, *Style and Idea*, New York, Philosophical Library, 1950.

Scott, C., *The Influence of Music in History and Morals*, London, Theosophical Pub. House, 1928.

Seashore, C., *In Search of Beauty in Music*, New York, Ronald Press, 1947.

Sessions, Roger, *The Musical Experience of Composer, Performer, Listener*,* Princeton, N.J. Princeton University Press, 1950, and New York, Atheneum, 1962.

Stravinsky, Igor, *Poetics of Music*,* New York, Vintage (Random House), 1959.

Symposium on Music Criticism: Music and Criticism, ed. R. F. French, Cambridge, Mass., Harvard University Press, 1948.

Tovey, Donald F., *Essays in Musical Analysis*, New York, Oxford University Press, 1935–1937.

Tovey, Donald F., *The Forms of Music*,* New York, Meridian, 1956.

Tovey, Donald F., *The Main Stream of Music and Other Essays*,* New York, Oxford University Press, 1959, and New York, Meridian.

Walker, Alan, *A Study in Musical Analysis*, London, Barrie & Rockliff, 1962, and New York, Free Press, 1963.

Zuckerkandl, Victor, *The Sense of Music*, Princeton, N.J., Princeton University Press, 1959.

Articles

Albersheim, Gerhard, "Mind and Matter in Music," *J.A.A.C.*, 22 (1964).

Albersheim, Gerhard, "The Sense of Space in Tonal and Atonal Music," *J.A.A.C.*, 19 (1960).

Ames, Van Meter, "What Is Music?," *J.A.A.C.*, 26 (1967).

Asenjo, F. G., "Polarity and Atonalism," *J.A.A.C.*, 25 (1966).

Bayer, Raymond, "The Essence of Rhythm," *Revue d'Esthetique*, 6 (1953); also in *Langer*, 1958.

Brelet, Gisèle, "Music and Silence," *La Revue Musicale*, 22 (1946), 169–181; also in *Langer*, 1958.

Carpenter, Patricia, "But What About the Reality and Meaning of Music?," in *Hook*, 1966.

Castelnuovo-Tedesco, Mario, "Problems of a Song-Writer," *Musical Q.*, 30 (1944); also in *Langer*, 1958.

Cazden, Norman, "Sensory Theories of Musical Consonance," *J.A.A.C.*, 20 (1962).

Clarke, Henry Leland, "The Basis of Musical Communication," *J.A.A.C.*, 10 (1952).

Crocker, Richard L., "Pythagorean Mathematics and Music," *J.A.A.C.*, 22 (1963), pt. 1, 189 ff., and (1964), pt. 2, pp. 325 ff.

De Selincourt, Basil, "Music and Duration," *Music and Letters*, 1 (1920); also in *Langer*, 1958.

Dräger, Hans Heinz, from *Archiv fur Musikwissenschaft*, 9 (1952); also in *Langer*, 1958.

Hall, Robert W., "On Hanslick's Supposed Formalism in Music," *J.A.A.C..*, 25 (1967).

Hutchings, A. J. B., "Organic Structure in Music," *B.J.A.*, 2 (1962).

Hutchinson, William, "Aesthetic and Musical Theory: An Aspect of Their Juncture," *J.A.A.C.*, 24 (1966).

Howes, Frank, "A Critique of Folk, Popular and 'Art' Music," *B.J.A.*, 2 (1962).

Keil, Charles M. H., "Motion and Feeling Through Music," *J.A.A.C.*, 24 (1966).

Kraussold, Max, "Music and Myth in Their Mutual Relation," *Die Musik*, 18 (1925–26); also in *Langer*, 1958.

Laszlo, Ervin, "Aesthetics and Live Musical Performance," *B.J.A.*, 7 (1967).

Laubenstein, Paul F., "On the Nature of Musical Understanding," *Musical Q.*, 14 (1928).

Lippman, Edward A., "The Problem of Musical Hermeneutics: A Protest and Analysis," in *Hook*, 1966.

Lissa, Zofia, "The Aesthetic Functions of Silence and Rests in Music," *J.A.A.C.*, 22 (1964).

Lissa, Zofia, "On the Evolution of Musical Perception," *J.A.A.C.*, 24 (1965).

Marcel, Gabriel, "Bergsonism and Music," *La Revue Musical*, 6 (1925); also in *Langer*, 1958.

Martin, R. David, "The Power of Music and Whitehead's Theory of Perception," *J.A.A.C.*, 25 (1967).

Meyer, Leonard B., "Meaning in Music and Information Theory," *J.A.A.C.*, 15 (1957).

Meyer, Leonard B., "Some Remarks on Value and Greatness in Music," *J.A.A.C.*, 17 (1958).

Meyer, M., "Experimental Studies in the Psychology of Music," *Am. J. Psych.*, *14* (1903).

Michell, Joyce, "Aesthetic Judgment in Music," *J.A.A.C.*, *19* (1960).

Michell, Joyce, "Criteria of Criticism in Music," *J.A.A.C.*, *21* (1962).

Pike, Alfred, "Perception and Meaning in Serial Music," *J.A.A.C.*, *22* (1963).

Pike, Alfred, "The Theory of Unconscious Perception in Music: A Phenomenological Criticism," *J.A.A.C.*, *25* (1967).

Prumières, Henry, "Musical Symbolism," *Musical Q.*, *19* (1933).

Reinold, Helmut, "On the Problem of Musical Hearing," *Archiv fur Musikwissenschaft*, *11* (1954); also in *Langer*, 1958.

Schoen, M., "The Meaning of Music in Art," *Musical Q.*, *28* (1942).

Sherburne, Donald W., "Meaning and Music," *J.A.A.C.*, *24* (1966).

Stadlen, Peter, "The Aesthetics of Popular Music," *B.J.A.*, *2* (1962).

Stechow, Wolfgang, "Problems of Structure in Some Relations Between the Visual Arts and Music," *J.A.A.C.*, *11* (1953).

Wellek, Albert, "The Relationship Between Music and Poetry," *J.A.A.C.*, *21* (1962).

Whittick, Arnold, "On the Genesis of Musical Composition," *B.J.A.*, *6* (1966).

Wylie, Ruth, "Musimatics: A View from the Mainland," *J.A.A.C.*, *24* (1965).

LITERATURE

General Works

Anthologies

Crane, Ronald S., *et al.* (eds.), *Critics and Criticism: Ancient and Modern*, Chicago, University of Chicago Press, 1952.

Gilbert, Allan H. (ed.), *Literary Criticism: Plato to Dryden*,* Detroit, Wayne State University Press, 1962.

Stallman, R. (ed.), *Critiques and Essays in Criticism, 1920–1948*, New York, Ronald Press, 1949.

Books

Abrams, Meyer Howard, *Literature and Belief*, New York, Columbia University Press, 1958.

Abrams, Meyer Howard (ed.), *The Mirror and the Lamp: Romantic Theory and the Critical Tradition*,* New York, Oxford University Press, 1953, and New York, Norton.

Auerbach, Erich, *Mimesis: The Representation of Reality in Western Literature*,* trans. Willard Trask, Princeton, N.J., Princeton University Press, 1953, and Garden City, N.Y., Anchor (Doubleday), 1957.

Beebe, Maurice (ed.), *Literary Symbolism: An Introduction to the Interpretation of Literature*, San Francisco, Wadsworth, 1960.

Bentley, Eric (ed.), *The Importance of Scrutiny: from Scrutiny, A Quarterly Review, 1932–1948*,* New York, New York University Press, 1964.

Bodkin, Maud, *Archetypal Patterns in Poetry: Psychological Studies of Imagination*,* New York, Oxford University Press, 1934.

Booth, Wayne C., *The Rhetoric of Fiction*,* Chicago, University of Chicago Press, 1962.

Bradley, A. C., *Oxford Lectures on Poetry*,* Indianapolis, Indiana University Press, 1961.

Brooks, Cleanth, *The Well Wrought Urn*,* New York, Harcourt, Brace & World, 1947, pp. 215–251; and 1956.

Burke, Kenneth, *A Grammar of Motives, and Rhetoric of Motives*,* New York, P. Smith, and New York, Meridian.

Burke, Kenneth, *Language as Symbolic Action: Essays on Life, Literature, and Method*, Berkeley, University of California Press, 1966.

Burke, Kenneth, *The Philosophy of Literary Form*,* Baton Rouge, Louisiana State University Press, 1941, and New York, Vintage (Random House).

Casey, John, *The Language of Criticism*, London, Methuen, 1966.

Cassirer, Ernst, *The Philosophy of Symbolic Forms*, 3 vols.,* New Haven, Conn., Yale University Press, 1953–1957.

Claudel, Paul, *Poetic Art*, New York, Philosophical Library, 1948.

Cooper, Lane (ed.), *Theories of Style*,* New York, Macmillan, 1907; New York, Burt Franklin, 1966.

Daiches, David, *Critical Approaches to Literature*,* Englewood Cliffs, N.J., Prentice-Hall, 1956, and New York, Norton.

Eliot, T. S., *The Frontiers of Criticism*, Minneapolis, University of Minnesota Press, 1956.

Eliot, T. S., *The Use of Poetry and the Use of Criticism*, Cambridge, Mass., Harvard University Press, 1933, and New York, Barnes & Noble, 1955.

Empson, William, *Seven Types of Ambiguity*,* New York, New Directions, 1963.

Empson, William, *Some Versions of Pastoral*,* New York, New Directions, 1950.

Empson, William, *Structure of Complex Words*, Ann Arbor, University of Michigan Press, 1967.

Feidleson. Charles, Jr., *Symbolism and American Literature*,* Chicago, University of Chicago Press, 1959.

Fergusson, Francis, *Idea of a Theatre: A Study of Ten Plays*,* Garden City, N.Y. Anchor (Doubleday), 1953.

Foss, Martin, *Symbol and Metaphor in Human Experience*, Princeton, N.J., Princeton University Press, 1942.

Frye, Northrup, *Anatomy of Criticism*,* Princeton, N.J., Princeton University Press, 1957, and New York, Atheneum, 1966.

Frye, Northrop (ed.), *Blake: A Collection of Critical Essays*,* Englewood Cliffs, N.J., Prentice-Hall, 1966.

Frye, Northrop, *Educated Imagination*,* Bloomington, Indiana University Press, 1964.

Harding, D. W., *Experience into Words*, London, Chatto & Windus, 1963, and New York, Horizon Press.

Hill, Knox C., *Interpreting Literature*,* Chicago, University of Chicago Press, 1966.

Hirsch, Eric D., Jr., *Validity of Interpretation*, New Haven, Conn., Yale University Press, 1967.

Holt, Elizabeth Gilmore, *Literary Sources of Art History*, Princeton, N.J., Princeton University Press, 1947.

Hungerland, Isabel, *Poetic Discourse*, Berkeley, University of California Press, 1958.

Hyman, Stanley Edgar, *The Armed Vision*,* New York, Knopf, 1955.

Hyman, Stanley Edgar (ed.), *The Critical Performance: American and British Literary Criticism of Our Century*,* New York, Vintage (Random House), 1956.

Kermode, Frank, *Romantic Image*,* New York, Vintage (Random House), 1964.

Kermode, Frank, *The Sense of an Ending: Studies in the Theory of Fiction*, New York, Oxford University Press, 1967.

Kitto, H. D. F., *Form and Meaning in Drama*, London, Methuen, 1956.

Knight, Everett W., *Literature Considered as Philosophy*,* London, Routledge, 1957, and New York, Collier (Macmillan), 1962.

Knight, G. Wilson, *Wheel of Fire*,* New York, Meridian, 1962.

Krieger, Murray, *New Apologists for Poetry*,* Bloomington, Indiana University Press, 1963.

Krieger, Murray, *Play and Place of Criticism*, Baltimore, Johns Hopkins Press, 1967.

Krieger, Murray, *Tragic Vision: Variations on a Theme in Literary Interpretation*,*

New York, Harcourt, Brace & World, 1960, and Chicago, University of Chicago Press.

Leavis, F. R., *Revaluations*,* New York, G. W. Stewart, 1947.

Lewis, C. S., *An Experiment in Criticism*, London, Cambridge University Press, 1961.

Livingston, Ray *The Traditional Theory of Literature*, London, Oxford University Press, 1962.

Lubbock, Percy, *Craft of Fiction*,* New York, Viking Press, 1957.

Maritain, Jacques, *Creative Intuition in Art and Poetry*,* New York, Pantheon, 1953.

Natanson, Maurice, *Literature, Philosophy and the Social Sciences*, The Hague, Martinus Nijhoff, 1962, pt. 2.

Nowattny, Winifred, *The Language Poets Use*, London, Athlone Press, 1962.

Prescott, Frederick Clark, *The Poetic Mind*,* New York, Macmillan, 1962.

Ransom, John Crowe, *The New Criticism*, New York, New Directions, 1949.

Read, Herbert, *The Nature of Literature*, New York, Horizon Press, 1956.

Richards, I. A., *The Philosophy of Rhetoric*,* New York, Oxford University Press, 1936.

Richards, I. A., *Practical Criticism*,* New York, Harcourt, Brace & World, 1929.

Richards, I. A., *Principles of Literary Criticism*,* New York, Harcourt, Brace & World, 1938.

Santayana, George, *Essays in Literary Criticism*, ed. Irving Singer, New York, Scribner, 1956. Includes an introduction by Irving Singer.

Santayana, George, *Interpretations of Poetry and Religion*,* New York, Scribner, 1927.

Santayana, George, *Three Philosophical Poets*, Cambridge, Mass., Harvard University Press, 1947.

Sartre, Jean-Paul, *What Is Literature?*,* New York, Philosophical Library, 1949.

Sewell, Elizabeth, *The Structure of Poetry*, London, Routledge, 1951.

Shumaker, Wayne, *Elements of Critical Theory*,* Berkeley, University of California Press, 1952.

Sörborm, Göran, *Mimesis and Art: Studies in the Early Development of an Aesthetic Vocabulary*, Bonniers, Svenska Bok forläget, 1966.

Spurgeon, Caroline, *Shapespeare's Imagery*,* London, Cambridge University Press, 1952.

Sypher, Wylie, *Four Stages of Renaissance Style*,* Garden City, N.Y., Doubleday, 1955.

Tate, Allen, *On the Limits of Poetry*, Denver, Colo., Alan Swallow, 1948.

Trilling, Lionel, *The Liberal Imagination*,* Garden City, N.Y., Anchor (Doubleday), 1953.

Vivante, Leone, *English Poetry and Its Contribution to the Knowledge of a Creative Principle*, London, Faber & Faber, 1950.

Weitz, Morris, *Hamlet and the Philosophy of Literary Criticism*,* Chicago, University of Chicago Press, 1964.

Weitz, Morris, *Philosophy in Literature: Shakespeare, Voltaire, Tolstoy and Proust*,* Detroit, Wayne State University Press, 1963.

Wellek, René, *A History of Modern Criticism, 1750–1950*, New Haven, Conn., Yale University Press, 1955.

Wellek, René, and Austin Warren, *Theory of Literature*, New York, Harcourt, Brace & World, 1949; rev. ed.,* (Harvest Books).

Wheelwright, Philip, *Metaphor and Reality*, Bloomington, Indiana University Press, 1962.

Wimsatt, William K., and Cleanth Brooks, *Literary Criticism: A Short History*,* New York, Knopf, 1957.

Winters, Yvor, *The Function of Criticism*, London, Routledge, 1962.

Winters, Yvor, *The Function of Criticism; Problems and Exercises*,* Denver, Colo., Alan Swallow, 1957.

Articles

Aiken, Henry, "The Aesthetic Relevance of Belief," *J.A.A.C.*, *10* (1951).

Black, Max, "Metaphor," *P.A.S.*, *55* (1954–55).

Britton, Karl, "Philosophy and Poetry," *Phil.*, *36* (1961).

Brooks, Cleanth, "Metaphor and the Function of Criticism," in Stanley Romaine Hopper, ed., *Spiritual Problems in Contemporary Literature*,* New York, P. Smith, 1958, pp. 127–137, and New York, Harper & Row Torchbooks, 1957.

Burke, Kenneth, "Freud and the Analysis of Poetry," in his *Philosophy of Literary Form*,* Baton Rouge, Louisiana State University Press, 1941.

Burroughs, John, "A Boston Criticism of Whitman," *Poet Lore*, *4* (1892); also in *Langer*, 1958.

Cannavo, Salvator, and Lawrence Hyman, "Literary Uniqueness and Critical Communication," *B.J.A.*, *5* (1965).

Detweiler, Alan, "Music and Poetry," *B.J.A.*, *1* (1961).

Dougherty, James P., "The Aesthetic and Intellectual Analyses of Literature," *J.A.A.C.*, *22* (1964).

Elliott, R. K., "The Aesthetic and the Semantic," *B.J.A.*, *8* (1968).

Empson, William, "Rhythm and Imagery in English Poetry," *B.J.A.*, *2* (1962).

Goldstein, Harvey D., "Mimesis and Catharsis Reexamined," *J.A.A.C.*, *24* (1966).

Harding, F. J. W., "Fantasy, Imagination and Shakespeare," *B.J.A.*, *4* (1964).

Harrison, Andrew, "Poetric Ambiguity," *Analysis*, *23* (1963).

Heidegger, Martin, "Hoelderlin and the Essence of Poetry," in W. Brock, ed., *Existence and Being*, London, Vision Press, 1949.

Henderson, G. P., "The Idea of Literature," *B.J.A.*, *1* (1961).

Hill, J. C., "Poetry and the Unconscious," *Br. J. Med. Psych.*, *4* (1924).

Hofstadter, Albert, "The Tragicomic: Concern in Depth," *J.A.A.C.*, *24* (1965).

Hospers, John, "Implied Truths in Literature," *J.A.A.C.*, *19* (1960).

Hospers, John, "Literature and Human Nature," *J.A.A.C.*, *17* (1958).

Hyman, Lawrence W., "Moral Values and the Literary Experience," *J.A.A.C.*, *24* (1966).

Isenberg, Arnold, "The Problem of Belief," *J.A.A.C.*, *13* (1955).

Kahn, S. J., "What Does a Critic Analyze?," *Phil. and Phen. Res.*, *13* (1952).

Kaplan, Abraham, "Referential Meaning in the Arts," *J.A.A.C.*, *12* (1954).

Kaufmann, Walter, "Literature and Reality," in *Hook*, 1966.

Kell, Richard, "Content and Form in Poetry," *B.J.A.*, *5* (1965).

Kell, Richard, "A Note on Versification," *B.J.A.*, *3* (1963).

Killham, John, "Autonomy versus Mimesis," *B.J.A.*, *7* (1967).

Killham, John, "The 'Second Self' in Novel Criticism," *B.J.A.*, *6* (1966).

Langman, F. H., "The Idea of the Reader in Literary Criticism," *B.J.A.*, *7* (1967).

Lees, F. N., "Identification and Emotion in the Novel: A Feature of the Narrative Method," *B.J.A.*, *4* (1964).

Linnér, Sven, "The Structure and Functions of Literary Comparisons," *J.A.A.C.*, *26* (1967).

Masson, David I., "Sound and Sense in a Line of Poetry," *B.J.A.*, *3* (1963).

Morgan, Charles, "The Nature of Dramatic Illusion," *Transactions of the Royal Society of Literature*, *12* (1933), *Essays by Divers Hands*; also in *Langer*, 1958.

Müller, Günther, "Morphological Poetics," *Helicon*, *5* (1943); also in *Langer*, 1958.

Mylne, Vivienne, "Illusion and the Novel," *B.J.A.*, *6* (1966).

Perry, John O., "The Temporal Analysis of Poems," *B.J.A.*, *5* (1965).

Pleydell-Pearce, A. G., "Sense, Reference and Fiction," *B.J.A.*, *7* (1967).

Pole, David, "Milton and Critical Method," *B.J.A.*, *3* (1963).

Rackin, Phyllis, "Hulme, Richards, and the Development of the Contextualist Poetic Theory," *J.A.A.C.*, *25* (1967).

Read, Herbert, "The Poet and his Muse," *B.J.A.*, *4* (1964).

Rodway, Allan, "Life, Time and the 'Art' of Fiction," *B.J.A.*, *7* (1967).

Rohden, Peter Richard, "The Histrionic Experience," in Ewald Geissker's *Der Schauspieler*, Berlin 1926; also in *Langer*, 1958.

Schipper, Edith Watson, "The Wisdom of Tragedy," *J.A.A.C.*, *24* (1966).

Stevenson, Charles L., "On 'What Is a Poem?'," *Phil. R.*, *66* (1957).

Utley, Francis Lee, "Structural Linguistics and the Literary Critic," *J.A.A.C.*, *18* (1959).

Valéry, Paul, "Poetry and Abstract Thought," in J. L. Hevesi, ed., *Essays in Language and Literature*, London, Wingate, 1947.

Walsh, Dorothy, "The Poetic Use of Language," *J. Phil.*, *35* (1938).

Weitz, Morris, *Philosophy of the Arts*, Cambridge, Mass., Harvard University Press, 1950, chap. 8.

Zink, Sidney, "The Poetic Organism," *J. Phil.*, *42* (1945).

ARCHITECTURE, PAINTING, AND SCULPTURE

General Studies

Banham, Reyner, *Theory and Design in the First Machine Age*, London, Architectural Press, 1960.

Bernheimer, Richard, *The Nature of Representation: A Phenomenological Inquiry*, H. W. Janson, ed., New York, New York University Press, 1961.

Carpenter, Rhys, *The Esthetic Basis of Greek Art of the Fifth and Fourth Centuries B.C.*, rev. ed., Bloomington, Indiana University Press, 1959.

Clark, Sir Kenneth, *Looking at Pictures*, New York, Holt, Rinehart and Winston, 1960.

Clark, Sir Kenneth, *The Nude*,* Garden City, N.Y., Anchor (Doubleday), 1959.

Collins, Peter, *Changing Ideals of Modern Architecture, 1750–1950*, London, Faber & Faber, 1965.

Doxiadis, Constantinos, *Architecture in Transition*, New York, Hutchinson, 1963.

Emond, Tryggve, *On Art and Unity: A Study in Aesthetics Related to Painting*, Gleerups, Lund, 1964.

Fiedler, Conrad, *On Judging Works of Visual Art*, Berkeley, University of California Press, 1949.

Fishman, Solomon, *The Interpretation of Art*, Berkeley, University of California Press, 1963.

Fitch, James Marston, *Architecture and the Aesthetics of Plenty*, New York, Columbia University Press, 1961.

Focillon, H., *The Life of Forms in Art*, New Haven, Conn., Yale University Press, 1942.

Fried, Michael, "Shape of Form: Frank Stella's New Paintings," *Art Forum*, November, 1966.

Fry, Roger, *French, Flemish and British Art*,* New York, Coward-McCann, 1951.

Fry, Roger, *Last Lectures*,* Boston, Beacon Press, 1962.

Fry, Roger, *Transformations*, New York, Doubleday, 1956; 1961.

Fry, Roger, *Vision and Design*,* Cleveland, World, 1956.

Giedion, Sigfried, *The Eternal Present, a Contribution on Constancy and Change* (Bollingen Series 35), New York, Pantheon, 1962–1964.

Giedion, Sigfried, *Space, Time and Architecture: The Growth of a New Tradition*, 3rd. ed., Cambridge, Mass., Harvard University Press, 1956.

Gilson, Etienne, *Painting and Reality*,* (Bollingen Series 35), New York, Pantheon, 1957.

Goldwater, W., and M. Treves (eds.), *Artists on Art*, New York, Pantheon, 1945.

Gombrich, E. H., *Art and Illusion: A Study in the Psychology of Pictorial Representation* (Bollingen Series 35), New York, Pantheon, 1960.

Gombrich, E. H., *Meditations on a Hobby Horse*, London, Phaidon Press, 1963.

Gombrich, E. H., *Norm and Form: Studies in the Art of the Renaissance*, London, Phaidon Press, 1966.

Gombrich, E. H., and Ernst Kris, *Caricature*, London, Penguin, 1940.

Greenberg, Clement, *Art and Culture; Critical Essays*, Boston, Beacon Press, 1961.

Gropius, Walter, *The Scope of Total Architecture*,* London, G. Allen, 1956.

Jarvia, James Jackson, *The Art-Idea*, B. Rowland, Jr., ed., Cambridge, Mass., Belknap, 1960.

Kubler, George, *The Shape of Time: Remarks on the History of Things*,* New Haven, Conn., Yale University Press, 1962.

Kuh, Katherine, *The Artist's Voice*, New York, Harper & Row, 1960.

Loran, Erle, *Cézanne's Composition*, Berkeley, University of California Press, 1943.

Lowry, Bates, *The Visual Experience: An Introduction to Art*, Englewood Cliffs, N.J., Prentice-Hall, 1961.

Malraux, André, *The Metamorphosis of the Gods*, Garden City, N.Y., Doubleday, 1960.

Malraux, André, *The Voices of Silence*, Garden City, N.Y., Doubleday, 1953.

Merleau-Ponty, Maurice, "Cézanne's Doubt," *Sense and Non-Sense*, transl. H. L. and P. A. Dreyfus, Evanston, Ill., Northwestern University Press, 1964.

Merleau-Ponty, Maurice, "Eye and Mind," in James Edie, ed., *The Primacy of Perception*, Evanston, Ill., Northwestern University Press, 1964.

Myers, Bernard Samuel, *Understanding the Arts*, rev. ed., New York, Holt, Rinehart and Winston, 1963.

Newton, Eric, *The Arts of Man; An Anthology and Interpretation of Great Works of Art*, Greenwich, Conn., New York Graphic Society, 1960.

Panofsky, Erwin, *Gothic Architecture and Scholasticism*,* Garden City, N.Y., Doubleday, 1957.

Panofsky, Erwin, *Meaning in the Visual Arts*,* Garden City, N.Y., Doubleday, 1955, esp. pp. 26–54 and 146–148.

Panofsky, Erwin, *Studies in Iconology; Humanist Themes in the Art of the Renaissance*,* New York, Oxford University Press, 1939.

Parker, Dewitt H., *The Analysis of Art*, New Haven, Conn., Yale University Press, 1926.

Pepper, Stephen C., *Principles of Art Appreciation*, New York, Harcourt, Brace & World, 1949.

Read, Herbert E., *Art Now; An Introduction to the Theory of Modern Painting and Sculpture*, rev. ed., London, Faber & Faber, 1960.

Read, Herbert E., *The Meaning of Art*,* New York, Pitman, 1951.

Sandström, Sven, *Levels of Unreality; Studies in Structure and Construction in Italian Mural Painting During the Rennaissance*, Stockholm, Almqvist and Wiksell, 1963.

Schapiro, Meyer, *Paul Cézanne*, New York, Abrams, 1952.

Schapiro, Meyer, *The Sculpture of Souillac*, Cambridge, Mass., Harvard University Press, 1939.

Schapiro, Meyer, *Vincent Van Gogh*, New York, Abrams, 1950.

Stokes, Adrian, *Painting and the Inner World*, London, Tavistock, 1963.

Venturi, Linello, *Four Steps toward Modern Art*,* New York, Columbia University Press, 1962.

Venturi, Linello, *History of Art Criticism*,* New York, Dutton, 1963.

Wittkower, Rudolph, *Architectural Principles in the Age of Humanism*,* London, University of London, Warburg Institute, 1949.

Wölfflin, Heinrich, *Principles of Art History*,* New York, Dover, 1950.
Wollheim, Richard, *On Drawing an Object*, London, H. K. Lewis, 1965.

Special Studies

Problems of Criticism: A Symposium

Goldwater, Robert, "Varieties of Critical Experience," *Art Forum*, September, 1967.
Greenberg, Clement, "Complaints of an Art Critic," *Art Forum*, October, 1967.
Kozloff, Max, "Venetian Art and Florentine Criticism," *Art Forum*, December, 1967.
Rose, Barbara, "The Politics of Art I," *Art Forum*, February, 1968.

Arnheim, Rudolph, "Perceptual and Aesthetic Aspects of the Movement Response," *J. Personality*, *19* (1950–51).
Arnheim, Rudolph, Wolfgang M. Zucker, and Joseph Watterson, "Inside and Outside in Architecture: A Symposium," *J.A.A.C.*, *25* (1966).
Bossart, William, "Authenticity and Aesthetic Value in the Visual Arts," *B.J.A.*, *2* (1961).
Brook, Donald, and L. R. Rogers, "Sculptural Thinking," *B.J.A.*, *3* (1963).
Carpenter, R., "The Phenomenon of Spirit as a Content of Visual Art," *Int. P. Q.*, *3* (1963).
Carritt, E. F., "The Aesthetic Experience in Architecture," *B.J.A.*, *3* (1963).
Coloquhoun, Alan, "The Modern Movement in Architecture," *B.J.A.*, *2* (1962).
Flannagan, John B., "The Image in the Rock," in *The Sculpture of John B. Flannagan*, New York, Publications of the Museum of Modern Art, 1942; also in *Langer*, 1958.
Gauldie, W. Sinclair, "The Architect as Artist," *B.J.A.*, *7* (1967).
Gauldie, W. Sinclair, "Architecture and the Human Condition," *B.J.A.*, *6*, (1966).
Gombrich, E. H., "Moment and Movement in Art," *J. of Warburg and Coutauld Institute*, *27* (1964).
Hepburn, R. W., "Aesthetics and Abstract Painting: Two Views," *Phil.*, *35* (1960).
Herbert, Gilbert, "Architectural Design Process," *B.J.A.*, *6* (1966).
Jacobsen, Leon, "Art as Experience and American Visual Art Today," *J.A.A.C.*, *19* (1960).
Kaelin, Eugene, "The Visibility of Things Seen: A Phenomenological View of Painting," in James Edie, ed., *Invitation to Phenomenology*, Chicago, Quadrangle Books, 1965.
Kavolis, Vytantas, "Abstract Expressionism and Puritanism," *J.A.A.C.*, *21* (1963).
Levey, Michael, "Looking for Quality in Pictures," *B.J.A.*, *8* (1968).
Lyons, Joseph, "Paleolithic Aesthetics: The Psychology of Cave Art," *J.A.A.C.*, *26* (1967).
Modisette, Eldon L., "The Legitimation of Modern American Architecture," *J.A.A.C.*, *20* (1961).
Rogers, L. R., "Sculptural Thinking," *B.J.A.*, *2* (1962).
Schapiro, Meyer, "The Nature of Abstract Art," *The Marxist Quarterly*, (1937).
Souriau, Etienne, "Time in the Plastic Arts," *J.A.A.C.*, *7* (1949); also in *Langer*, 1958.
Steinberg, Leo, "The Eye Is a Part of the Mind," *Partisan Review*, *20* (1953); also in *Langer*, 1958.
Stokes, Adrian, "The Impact of Architecture," *B.J.A.*, *1* (1961).
Szathmary, A., "Symbolic and Aesthetic Expression in Painting," *J.A.A.C.*, *13* (1954).
Ushenko, A. P., "Pictorial Movement," *B.J.A.*, *1* (1961).
Wallis, Mieczyslaw, "The Origins and Foundations of Non-objective Painting," *J.A.A.C.*, *19* (1960).